Comics
Between the Panels

Steve Duin
Mike Richardson

Key to Letters on Cover:

- **A:** Action Comics
- **B:** Boy Comics
- **C:** Crime Does Not Pay
- **D:** Donald Duck
- **E:** Archie
- **F:** Fight Comics
- **G:** Groo
- **H:** Horrific
- **I:** Spirit
- **J:** Jungle Comics
- **K:** Krazy Kat
- **L:** Little Lulu
- **M:** Mad
- **N:** Planet
- **O:** Little Orphan Annie
- **P:** Pogo
- **Q:** Aquaman
- **R:** Captain America
- **S:** Superman
- **T:** Terry & the Pirates
- **U:** Famous Funnies
- **V:** Prince Valiant
- **W:** Spawn
- **X:** X-Men
- **Y:** Sin City
- **Z:** Zap.

JACKIE ESTRADA, Editor
TOM GOULD, Designer

DARK HORSE COMICS:

MIKE RICHARDSON • publisher
NEIL HANKERSON • executive vice president
DAVID SCROGGY • product development
ANDY KARABATSOS • vice president and controller
MARK ANDERSON • general counsel
RANDY STRADLEY • director of editorial
CINDY MARKS • director of production and design
MARK COX • art director
SEAN TIERNEY • computer graphics director
MICHAEL MARTENS • director of sales and marketing
TOD BORLESKE • director of licensing
DALE LAFOUNTAIN • director of m.i.s.
KIM HAINES • director of human resources

Images and likenesses of Marvel characters are ™ and © 1998 Marvel Characters, Inc. Images and likenesses of DC characters are ™ and © DC Comics, Inc. All quotes from *The Comics Journal* © 1998 Fantagraphics Books, Inc. All photographs © Jackie Estrada, except those of Paul Chadwick (p. 80), Bob Overstreet (by Mike Naiman, p. 342), Jerry Robinson, (p. 372), Mike Suchorsky (p. 425), and Jerry Weist (by Mike Naiman, p. 468), which are © by their respective photographers.

©1998 Mike Richardson and Steve Duin. All rights reserved. No portion of this publication may be reproduced or transmitted, in any form or by any means, without the express written permission of the copyright holder(s). Dark Horse Comics® and the Dark Horse logo are trademarks of Dark Horse Comics, Inc., registered in various categories and countries.

Published by
Dark Horse Comics, Inc.
10956 SE Main Street
Milwaukie, OR 97222

First edition: September 1998
ISBN: 1-56971-344-8

1 3 5 7 9 10 8 6 4 2
Printed in Singapore

Preface

MIKE RICHARDSON'S marching orders for this book—delivered in the fall of 1990, four years after he began plotting the project—were simple enough. The "real" history of the comics had yet to be written, Mike said. The best anecdotes were too often poured out in bars after convention rooms had closed down for the night, then abandoned with morning's light.

Let's tell it like it is—or was, Mike said. Go back to the beginning and strip this business down to its creative essentials. Take no prisoners. Pull no punches. Lend an ear to all the originals before they leave the planet.

In those early days of the project—when Jack Kirby, Alex Schomburg, and Harvey Kurtzman were still alive—Paul Levitz, vice president of DC Comics, told me I would never finish this book unless we narrowed the focus. "The anecdotal history of how these things happened is all over the place," he said. "There are hundreds of guys who have interesting stories. It's all wonderful stuff . . . but it gives you more research than you can survive."

Levitz almost had that right.

Comics: Between the Panels is the product of more than seven years of research. It is the distillation of more than 150 interviews with the trailblazers and road warriors who had interesting stories about life in the comics publishing world. And it pays proper respect to the sense and sensibility of historians such as Hames Ware and James Vadeboncoeur who began collecting these anecdotes long before we came along.

Mike and I had some favorites when we embarked on this history; we have even more as we deliver this first edition. We have taken pains not to catalog the ten "best" covers or ten "best" cover artists but rather our ten personal favorites of each. We also tried to keep our focus as broad as possible in the hope that the book will do right by your favorites, too, whether they be the seminal super-hero comic books of the Golden Age, the great adventure newspaper strips, the EC horror titles, underground comix, or modern classics such as *Maus* and *Watchmen*.

We know this history is incomplete. This was never intended to be a comprehensive reference work. But as Paul Levitz suggested years

ago, we had to stop somewhere. If we stopped short of a story you've discovered between the panels, or if you think something needs correction or clarification, don't hesitate to write me care of the Dark Horse address. We expect this book to go to a second edition and beyond.

In the meantime, enjoy the first. The history of comics is far too complex to be told in a linear fashion, much less read in one, so we've used the alphabet as a crutch to get us moving on our way. But don't go looking for everything in its proper place. The comics didn't begin with *Action,* and they won't end with *Zippy the Pinhead.* And what remains so compelling about them after all these decades can't be squeezed in between Jack Cole and the Comics Code.

Two months after I began my research, I stood with Alex Schomburg in the cramped, musty bedroom of his Newberg, Oregon home. As I flipped through several dozen of his Golden Age covers, crammed corner to corner with heroes, villains, monsters, and machinery, I turned to him and asked, "How do you feel about these covers today? Why do I feel this incredible intensity when I hold them in my hands?"

"Because you're one of us," Schomburg said.

You're one of us, too. You've read this far. Don't stop now.

STEVE DUIN

April 1998

Acknowledgments

Special thanks must go to many people for helping to make this book a reality.

Alex Schomburg, Murphy Anderson, Bob Lubbers, Bob Fujitani, George Evans, Malcolm Willits, and dozens of other creators, comics industry insiders, and collectors went far beyond what was necessary to share their hearts and memories for the anecdotes in the book.

Dark Horse editor Diana Schutz provided valuable input to the initial draft. Jackie Estrada not only edited the final manuscript but coordinated the art program, scoured her own personal collection for covers and other art, provided almost all of the photos, and supervised the design and production. Tom Gould designed and produced the book over a long, arduous three-year period. Tom worked with ColorType Digital Prepress in San Diego to get the best possible color reproduction of the photos and art in the book.

Michelle Nolan and Hames Ware provided valuable feedback as reviewers of the manuscript. Gary Carter offered many useful insights to the finished manuscript. George Olshevsky did a bang-up job as proofreader, and Dave Estrada handled many chores, from word processing to proofing to producing the extensive index.

The bulk of the Golden and Silver Age comics covers in the book came from the Ernie Gerber slide collection—many thanks to Bill Schanes and Jim Kuhoric at Diamond Comic Distributors for making sure we got the slides we needed for the book. Thanks must also go to the many individuals who provided items from their collections, including Troy Beaver, Gary Carter, Paul Chadwick, Gary Colabuono, Jack Dickens, Dave Estrada, Michael T. Gilbert, Batton Lash, Michael Naiman, Michelle Nolan, Greg Pharis (San Diego Comics & Collectibles), Chris Taylor (Comics 'n Stuff), Jim Vadeboncoeur, Jr., and Hames Ware.

To my wife, Nancy, my true obsession.
STEVE DUIN

To my mom, dad, wife, and kids—
the people who have put up with and
encouraged my obsession with
comic books.
MIKE RICHARDSON

Aamodt, Kim

Too few writers in the '50s got their due, and we have it on good authority—Alex Toth's—that Kim Aamodt warrants a round of applause. "A marvelous writer who told a fine story," Toth told *Graphic Story Magazine*. "Luckily, I got many of his scripts to illustrate. They were simple well-structured stories, with very clever twists and turns, and well-honed dialogue . . .

"The characters' reactions are what made his stories work. Subtle reactions. In his scripts, the characters' expressions were critically important to the dialogue—and there were lots of closeups to 'plus' it with. That's what developed my bent for cuing facial expressions to dialogue—to 'plus' the writer's dialogue and captions. Kim had a remarkable storytelling talent, and I worked hard to match it."

Aamodt's best-known work appears in early 1950s romance comics for Pines and *Frogmen* for Dell.

Abruzzo, Tony

"The finest artist in the romance field bar none," Bob Kanigher once said. The late Roy Lichtenstein certainly agreed, using several of Abruzzo's obscure panels (such as the one below) from pedestrian DC romance books as the launch pad for his pop art paintings of the 1960s.

© DC Comics, Inc.

AC Comics

AC has published Golden Age reprints and bathing-suit heroines since 1969. The good-girl art from the '40s, including the work of Matt Baker and Bob Lubbers, consistently exposes the shabbiness of publisher Bill Black's current cheesecake.

Ace "F" Series

When Ace reprinted the works of Edgar Rice Burroughs in the mid-1960s, the combination of Frank Frazetta and Roy Krenkel covers, Krenkel's interior line art, and the heroes of Tarzan and John Carter made this the best-loved paperback series of comic book fans in that era. Here's a list of the Frazetta and Krenkel "F" series covers (including some non-Burroughs titles):

Frank Frazetta:

F-169, *Tarzan and the Lost Empire;* F-180, *Tarzan at the Earth's Core;*
F-182, *The Monster Men;*
F-189, *Tarzan the Invincible;* F-193, *The Son of Tarzan;* F-203, *The Beasts of Tarzan;* F-204, *Tarzan and the Jewels of Opar;* F-205, *Tarzan and the City of Gold;*
F-206, *Jungle Tales of Tarzan;* F-212, *Tarzan and the Lion Men;* F-221, *Lost on Venus;*
F-235, *The Lost Continent;* F-247, *Carson of Venus;*
F-256, *Land of Terror;* F-270, *The Mad King;*
F-280, *Savage Pellucidar;* F-282, *Beyond the Farthest Star*

Roy Krenkel:

F-156, *At the Earth's Core;* F-157, *Moon Maid;*
F-158, *Pellucidar;* F-168, *Thuvia, Maid of Mars;*
F-170, *The Chessmen of Mars;* F-171, *Tanar of Pellucidar;* F-179, *Pirates of Venus;*
F-181, *The Master Mind of Mars* (with Frazetta);
F-190, *A Fighting Man of Mars;* F-194, *Tarzan Triumphant* (with Frazetta);
F-213, *The Land That Time Forgot;*
F-220, *The People That Time Forgot;* F-232, *Land of Hidden Men;* F-233, *Out of Time's Abyss;*
F-234, *The Eternal Savage;* F-245, *Back to the Stone Age;*
F-258, *The Cave Girl;* F-268, *Escape on Venus*

The first of Frazetta's classic Tarzan covers for the Ace "F" series.
(© Ace Publishing)

Action Comics

When Max Gaines casually handed National Periodical Publications publisher Harry Donenfeld an unused strip called "Superman," the most important book in the history of the comic book medium was off and running.

"*Action* #1 was taken directly from the newspaper strip," Joe Shuster said in *Nemo* #2. "It was pasted up. They were in a rush to meet the

The comic book that started it all: *Action* **#1 (June 1938).**
(© DC Comics, Inc.)

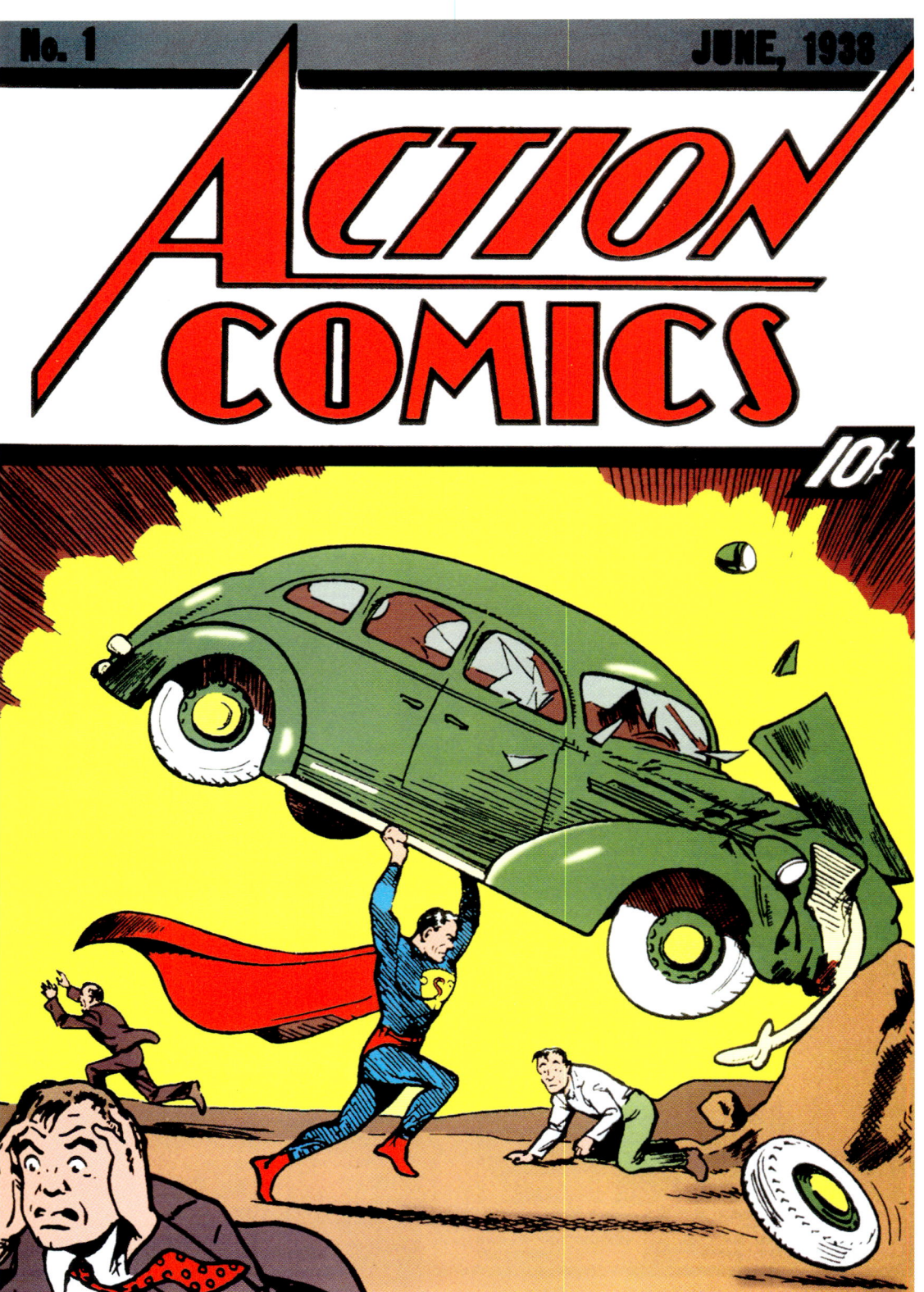

deadline on the first issue. Everything happened very fast: They made the decision to publish it and said to us, 'Just go out and turn out 13 pages based on your strip.' It was a rush job, and one of the things I like least to do is to rush my artwork. . . . The only solution Jerry [Siegel] and I could come up with was to cut up the strips into panels and paste the panels on a sheet the size of the pages. If some panels were too long, we would shorten them—cut them off; if they were too short, we would extend them."

The first issue—cover-dated June 1938—had a print run of 200,000 copies. Bob Overstreet and Ernie Gerber estimate that somewhere between 25 and 75 have survived. More than 60 years—and more than 700 issues—later, *Action Comics* is still kicking, and Superman still lives in its pages.

In 1973 Bruce Hamilton sold a copy of *Action* #1 to 18-year-old Mitchell Mehdy for $1,801.26. (Twenty-six cents? Go figure.) The sale earned Mehdy a Dubious Achievement Award from *Esquire*, and considerable enmity from collectors who heard cash registers in the distance.

Nineteen years later, another copy of *Action* #1 sold for $82,000 (including house commissions) at a Sotheby's auction. In the summer of 1994, the Pacific Comics Exchange listed a VF copy of the comic for $160,000. A year later, Steve Geppi, the president of Diamond Comic Distributors, offered $400,000 for the exclusive Mile High copy of the book.

Key issues: #1, first appearance of Superman; #6, first Jimmy Olsen; #23, first Lex Luthor; #40, first Star-Spangled Kid; #51, first Prankster; #242, first Brainiac; #252, first Supergirl; #267, first Chameleon Boy (that is you, isn't it, Chameleon Boy?); #276, first Brainiac 5 and Tri-Tri-Triplicate Girl; #285, President John F. Kennedy and First Lady (Jackie, not Marilyn) guest appearance; #309, JFK reappears in issue dated February 1964; #484, Lois and Superman tie the knot on Earth II; #660, Lex Luthor death scene; #684, Doomsday mega-marketing issue.

Adams, Art

When Bob Schreck was working for Creation Con in the late '70s and early '80s, the con organizers retained a soft spot for young artists, assuming that if the artists ever hit the top of the marquee, they'd do freebie appearances at future cons. If the starving artists called ahead and sent Schreck samples of their work, he'd reserve them a table.

Schreck was in San Francisco when Arthur Adams showed up, four or five friends in tow. "Could I get a table here?" he asked.

"We haven't any room," Schreck said. "You should've called ahead."

"Would you at least look at my art?" Adams asked.

"Are you sure?" Schreck said. "Because I'll criticize it."

No problem, Adams said. Schreck opened the portfolio, chewed on its contents for about 15 seconds, then turned back to Adams and said, "How many tables do you want?"

Schreck didn't scare Adams; after all, Adams had already met Godzilla. They first bumped into each other in the mid-1970s when the King of the Monsters was prowling the outskirts of Fairfield, California. He caught up to the 12-year-old Adams in a small movie theater showing one of those double creature features: *The Two-Headed Transplant*, which was altogether forgettable, and *Destroy All Monsters*.

Adams wasn't scared or impressed by his first brush with the clumsy Japanese brute. Pushed a bit, he might admit he giggled a couple of times at the guy in the suit.

Godzilla had the last laugh.

Godzilla has had his revenge.

Art Adams and his version of Godzilla.

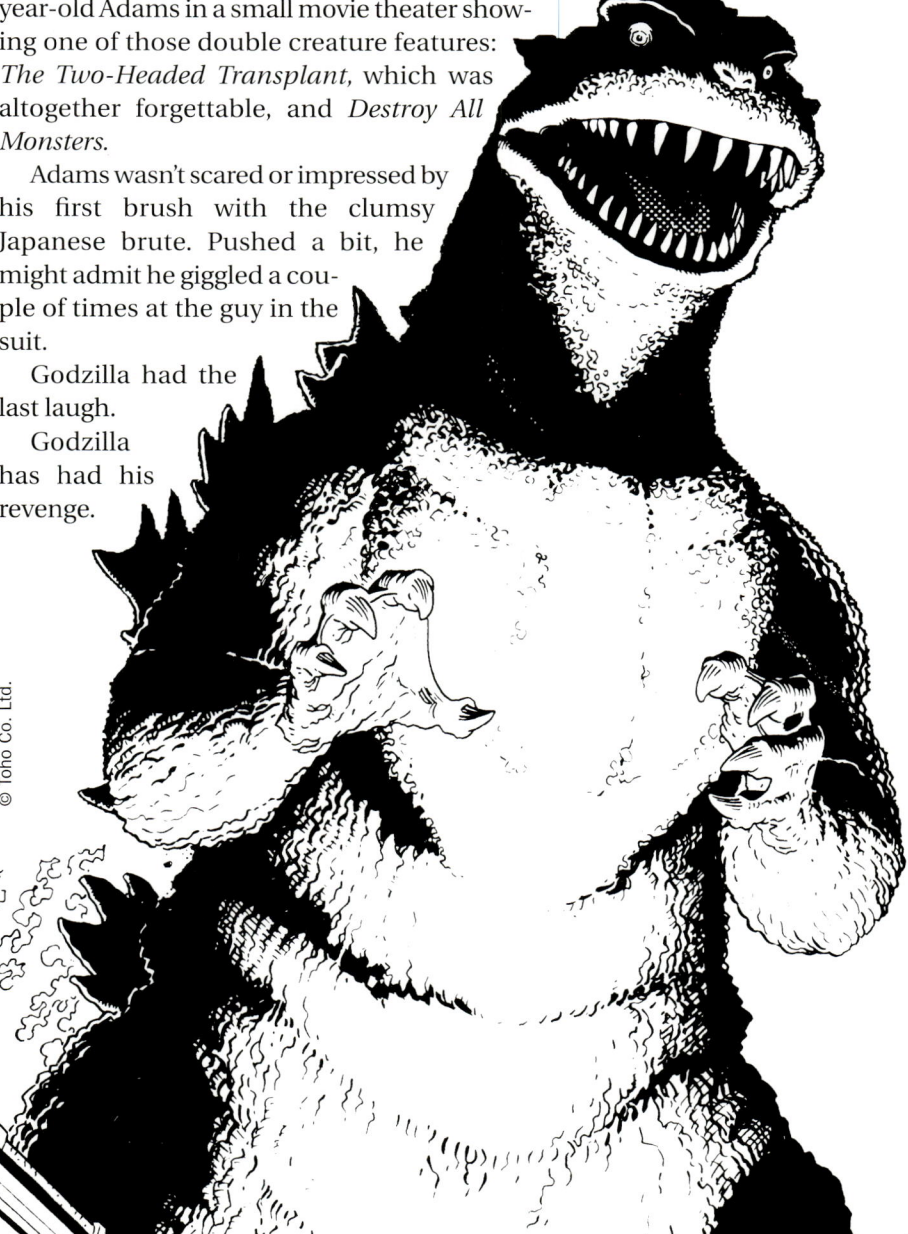

© Toho Co. Ltd.

In the 8-foot by 10-foot room in Northwest Portland where Adams now spends 8- to 10-hour days bent over a drawing board, Godzilla lurks over his shoulder… and at his elbow, on his desk, and in the shadows of his bookshelves.

More than 70 Godzillas roam through Adams's studio. They range from the original 1969 Aurora model kit, which stands 8 inches high and has glow-in-the-dark parts, to a soft-vinyl carnivore that stretches 8 feet from nose to tail.

"You can get it for $900," said Adams, "but I couldn't wait. It was airmailed and everything; it cost me $1,800."

Airmailed from Japan, where Godzilla, the spawn of an atomic disaster, first bubbled to the surface in 1954, ten years before Adams was born.

Few kings are so lacking in personality as Godzilla. But what he had, for kids growing up in the '60s and '70s, was stage presence: The spike-spined prima donna was always on view. If *Godzilla vs. Gigantus* wasn't playing the local cinema, *Godzilla vs. Mothra* was atop the marquee. Or *Godzilla vs. Mechagodzilla.* Or *Godzilla vs. the Smog Monster.* Who cared if the movies were awful? "Sometimes that's what I like, the awfulness of them," Adams said.

So, he has bought one awful model of Godzilla after another. He's bought one for each stage of Godzilla's growth spurt, from 180 feet in his first movie to his current height of 300 feet. He's gone for the flabby ones and for those with muscle tone and a remote control, all of which Adams used as models when he drew *Godzilla's Color Special* for Dark Horse.

He's brought home so many that his former girlfriend, Grace Tanaka, once suggested, "You love Godzilla more than me."

No, Adams said, I've just known him longer.

And whenever he looks up from Monkeyman on the drawing board, this old friend—all 70 versions of him—takes Adams back to the Saturdays when you could curl up all afternoon with a good monster in a bad suit.

Adams, Neal

"One of the pivotal figures in the industry," Mike Friedrich said. "More than any other person in the last 30 years, he revived the craft side of the business. You have to credit Stan Lee with bringing back the business, but Neal brought back the art. Through personal discipline, a great deal of example, and a lot of rhetoric, he was out there as the angry young man, from the age of 25 on, pounding on tables, trying to improve the quality of the comics. He said, 'The comics can be better. We can draw better. We can tell better stories.'"

Adams got a running start in the art world when, at the age of 19, he joined ad agency Johnstone and Cushing. Two years later, in 1962, he signed on as a background artist with Howard Nostrand on the *Bat Masterson* newspaper strip.

"When Neal came into the business, he brought Johnstone and Cushing into comics,"

A classic Neal Adams "floating heads" cover from the 1970s: *Strange Adventures* #207 (December 1967).
(© DC Comics, Inc.)

Gil Kane told *The Comics Journal*. "Neal made the world safe for commercial art. He brought commercial art techniques into comic books… Neal himself is almost totally influenced by an artist named Stan Drake, who brought in the surface technique that Neal is using … Stan Drake was influenced by a man named Creig Flessel years before him.'

Beginning in 1964, Adams worked on the *Ben Casey* newspaper strip for two years, then did some ghost work. He joined DC in 1967, apparently hired by Murray Boltinoff to work on the Bob Hope and Jerry Lewis books. Adams endured a baptism of fire by doing some war stories for Bob Kanigher, then shortly thereafter he began work on *The Spectre* and *Deadman*.

"He was 25 and he was the youngest guy drawing for the company by a generation," Friedrich said. "It had been 15 years since anyone had drawn comics as a kid. Everyone was in their 40s and Neal was 25."

As much for his heart as for his art, the young creators coming on at DC—guys like Bernie Wrightson, Marv Wolfman, and Steve Englehart—clustered around Adams. Once he was established, he would let rookies ink his stuff. He gave Wolfman and Len Wein their first big break when he drew a Batman story of theirs that Julie Schwartz had rejected. When Adams asked Schwartz for a second opinion on the story, Schwartz found a lot more to like.

Adams "made an extraordinary effort to help change the course of comics history, and succeeded," Frank Miller said. "Mostly he did this by talking to each of us individually, for as long as it took, as often as we wanted. An extremely patient man. After a while, we started seeing happen in our generation the same things that had happened to Jack Kirby and Steve Ditko and the people who built the thing. Neal's words were all the more valuable."

"Neal was the typical young Turk of the times," former DC editor Dick Giordano said. "He had the skill and the talent to get his opinions heard. And he appointed himself as a spokesman for that group of talent because he would be heard. A lot of the advantages the talent has now is a result of the saber-rattling Neal did at that time.

"We put together the Academy of Comic Book Arts. The fact that we were organized and talking to each other was enough that the publishers realized that they had to treat us more seriously than they'd treated us before. Immediately they started returning artwork. A little after that came reprint fees. Later on came hospitalization and contracts, and all of the things that are pretty much taken for granted.

"Neal was in the forefront. He came up with all sorts of outrageous demands that weren't met, but the compromise was better than nothing. They didn't meet his demands for page rate, but the page rate went up. They didn't meet his demands for the way artwork was returned, but the artwork was returned. I think everyone's lives were improved because of that."

Miller first met Adams in 1976, when Frank was 19. "I came to his studio, Continuity, and he looked over my portfolio and told me, 'Give up, you're no good,'" Miller recalled. "He was amazingly generous with his time and amazingly harsh with his criticism. I think he told me to give it up six or seven times; then he grudgingly admitted that I might be able to get some work and set me up with my first job with Gold Key Comics.

"He was always a champion. He said what we did was a worthy thing; and we had to take a stand on it. Mostly he was ignored. Certainly, he was slandered professionally for this. People immediately branded him a crackpot. But he did teach a lot of us. We really wouldn't have moved forward without him."

When he wasn't raising a ruckus, Adams did some breathtaking, groundbreaking work on *Deadman*, *Batman*, *X-Men*, and *Avengers*. "Steranko and Adams showed there were some people out there with a dedicated approach to comics as an end in itself," Matt Wagner said. "They were caught in the sludge that fell on them."

Neal Adams

"Neal made the world safe for commercial art. He brought commercial art techniques into comic books."
GIL KANE

Adam Strange

This science fiction strip, a Julius Schwartz creation, first appeared in *Showcase* #17 but gained the most exposure in *Mystery in Space* #53–#100. The scripts of Gardner Fox and the artwork of Carmine Infantino and Murphy Anderson gave Adam Strange—"the thinking man's super-hero"—the energy he needed to become the most popular of DC's sf characters.

Addams, Charles

Addams was the ghoulish imagination behind the cartoons that inspired both the television and theatrical versions of *The Addams Family*. In 1988, at the age of 76, Addams died of a heart attack while sitting in a parked car in Manhattan. "He's always been a car buff, so it was a nice way to go," noted his wife, Marilyn.

Adventure Comics

One of the longest-running DC titles, *Adventure* began as *New Comics* in December 1935—debuting 30 months before *Action* #1—and mutated into *New Adventure Comics* with issue #12. The *New* was dropped after issue #30.

In its infancy, *Adventure* struggled to find a marquee character who could carry the book. Sandman, Hourman, and Starman all tried and failed. Superboy, the Legion of Super-Heroes, and Supergirl all had longer runs under Mort Weisinger.

Adventure was canceled twice, for seven months in 1982 and permanently after issue #503 in September 1983.

Key issues: #40, start of Sandman series (second overall appearance); #48, first Hourman; #59, first Manhunter; #61, start of Starman series; #66, first Shining Knight; #103, Superboy begins long run after move from *More Fun*; #210, first appearance of Krypto, the Superdog; #247, first appearance of Legion of Super-Heroes; #283, first General Zod; #290, first appearance of Sun Boy (and we're just warming up); #306, first appearance of Fire Lad, first Chlorophyll Kid; #307, first Element Lad; #318, first Dream Girl; #331, first Animal Lad; #334, Supergirl crossover as Unknown Boy; #341, Triplicate Girl becomes Duo Damsel; also first appearance of Beast Boy; #428, first appearance of Black Orchid; #431–440, Michael Fleisher's Spectre.

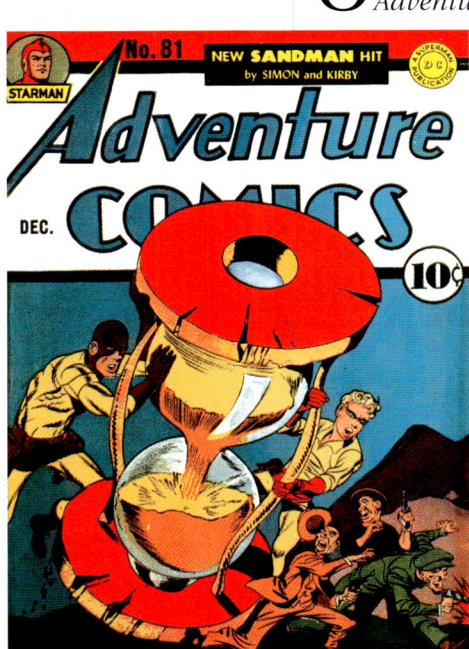

Adventure Comics #81 (December 1942). This cover features Simon and Kirby's rendition of the Sandman.
(© DC Comics, Inc.)

> ### Aging
>
> *Comic books are a business where you're an old man by the time you're 25. I married Leslie [Zahler] eight years ago. I would take her to a convention, and these chuckleheads would come over to her with these attitudes of concern and condescension that she'd married this complete, washed-out fucking loser. And I was 27 years old! It's a business where, if you're not a pistol by the time you're 23, you're dead by the time you're 27. How many illustrators do you know who have made any kind of inroad with their work before they were 30? I mean, Christ! It drives me nuts.*
> HOWARD CHAYKIN
> THE COMICS JOURNAL

The Adventures of Bob Hope

Count 'em: 109 issues. One hundred and nine issues, sprawled across the '50s and '60s. That means Bob had 104 more adventures than Ozzie and Harriet and 63 more than Rex the Wonder Dog. All this without a single assist from Brooke Shields or the Kodak All-America football team. Neal Adams, on the other hand, did provide the final four covers of this epic run.

Advice Columnists

Almost every romance book had one. At Orbit, editor and publisher Rae Herman wrote under the pseudonym "Ray Mann."

At Crestwood/Prize, there were Nancy Hale and Charmaigne. "Nancy Hale received mail sacks full of letters from emotion-torn teenage girls seeking advice of the heart," Joe Simon once said. "They poured out intimate facts that not even their mothers were aware of. We [Jack Kirby and Simon] took turns being Nancy Hale, answering letters to the column, giving comfort and advice. Advice was easy to dispense, and surprisingly, we got away with it. Thousands of girls were eased into puberty by a couple of comic book artists who were too cheap to hire a competent female counselor."

And at EC, there were Amy ("Advice from Amy" in *Modern Love*) and Adrian ("Advice from Adrian" in *A Moon, A Girl … Romance*).

"You want to know who Adrian and Amy were?" Bill Gaines asked at the 1972 EC Con: "Us."

Airboy

This Charlie Biro creation first appeared in *Air Fighters Comics* #2 (November 1942) and so dominated the book that it was renamed in his honor with the 23rd issue. The Airboy—Davey Nelson—was 12 years old at his inception and, in a violation of comic book pacing, aged at a normal rate. He also had considerable longevity: *Airboy Comics* survived until 1953. His adventures were detailed by a variety of artists, including Fred Kida, Dan Barry, John Giunta, and Dan Zolnerowich. Eclipse resurrected the character in 1986 for an unremarkable 50-issue run best known for Dave Steven's Valkyrie cover on issue #5.

Air Fighters Comics

The first issue of *Air Fighters*, published by Lloyd Jacquet's Funnies Inc., appeared in November 1941 and didn't fly. A year later, Hillman introduced Airboy in issue #2 (the "Greatest Comic Book Yet!!"), who kept this baby airborne. Charles Biro didn't sign most of the covers, owing to his commitments at Lev Gleason, but he packed them with some of the most vivid, and vicious, racial caricatures of the Golden Age. *Air Fighters Comics* became *Airboy Comics* with issue #23.

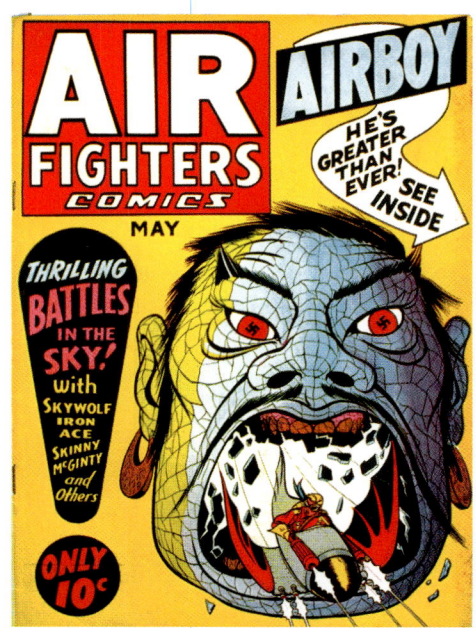

Air Fighters #8 (May 1943), one of many racial caricature covers that spiced them up.

(© Hillman Periodicals)

ADVERTISING

Ads in comics were often more memorable than the stories. Who could forget Charles Atlas's various offers to help impressionable young men defend themselves from bullies on the beach? A classic Christmas movie (Jean Shepard's *A Christmas Story*) was built around a boy's desire to get that Daisy Red Ryder rifle. And how many of us fell for the sea monkeys ad and ended up with a packet of brine shrimp?

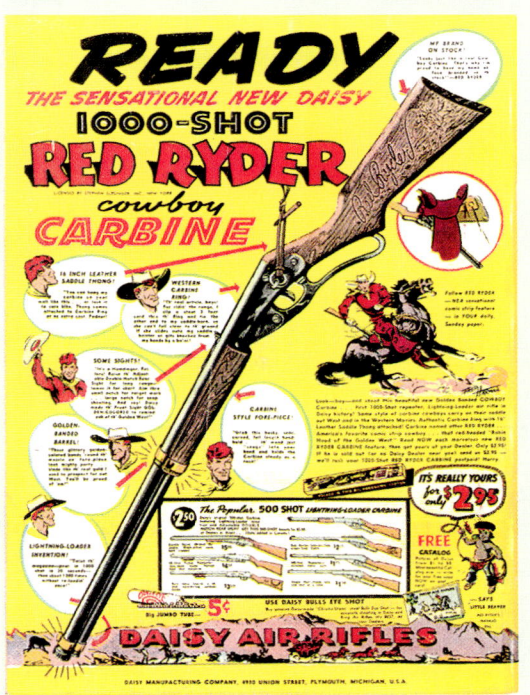

Air Pirates

Dan O'Neill

"We figured they'd sue us for $400,000, and they hit us for $870,000. We were wild in our success."
DAN O'NEILL

To raise funds for his legal bills, O'Neill created the "Mouse Liberation Front," an exhibit with pieces from a number of top underground artists.

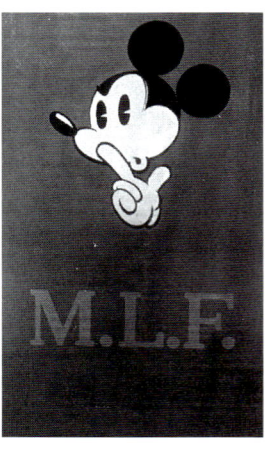

Those were the days, Dan O'Neill said, when "if you didn't have the FBI at your door, you weren't an American." But when the law came after the Air Pirates, the cops had a hell of a time finding the door handle. "We were listed in the Yellow Pages in San Francisco as 'Air Pirates Secret Hideout,'" O'Neill said, "and it took them four months to find us."

Why the "Air Pirates"? "We were going to pirate the airwaves," O'Neill explained.

Why the Pinkerton detectives and, later, the FBI? Because the Air Pirates parodied the wonderful world of Disney and, in 1970, such parody was against the law.

The Air Pirates' starting lineup included O'Neill, Bobby London, Ted Richards, Shary Flenniken (the future comics editor of *National Lampoon*), and Gary Hallgren. "Then there were the 'B List' members," Flenniken said. "They couldn't stand O'Neill's personality and whatever they were put through. O'Neill was using improvisational theater techniques to create a studio that was similar to the Disney ideal. They lost their individual style. People would come into the studio and learn to draw in other people's styles. They would do these comic jams where each person would take a panel and the object would be to not be able to tell who had done what.

"In improvisational theater, the object is to lose your ego. You don't want to one-up someone when you're on the stage, the stage being the comic page. You want the piece of work to be the priority. You can't survive if you're all having ego battles."

When the Air Pirates tired of battling each other, they took on Walt Disney.

Disney was targeted not simply because the corporation was big and obvious but because O'Neill knew Disney would fight back. When the dust settled, O'Neill believed that these, too, would be settled: a cartoonist's right to parody and an artist's right to protect his property.

O'Neill argues, "Before the Air Pirates, people could just grab your stuff and take it. In the contract you signed in those days, the artist signed away the copyright. The syndicate had the copyright. They could toss you out the door and hire someone else to be Dan O'Neill and sign your name. You could steal anyone's ideas, and now you can't."

And for that you can thank the Air Pirates.

In the Air Pirates' Secret Hideout—actually the Zoetrope warehouse, which O'Neill rented from Francis Ford Coppola—the Pirates enlisted Mickey, Minnie, Donald, and Daisy and turned them into Disney's worst nightmare. "They were taking psychedelics. They were having sex; Minnie was sleeping around," O'Neill said. "They were divorced ex-movie stars who were kidnapped by their nephews, who turned out to be their illegitimate children." And they were drawn in the inimitable Disney style.

Distribution of *Air Pirates Funnies* was somewhat roughshod. O'Neill's "idea of how to distribute comic books was to hire winos," Flenniken told *The Comics Journal*. "They'd come in the morning, he'd give them a bottle of wine and a police uniform, and they would go and lie around the streets all day, wearing their police uniforms and selling comic books to people. And then it would be firemen, and then it would be something else. He wanted to get a blimp and drop the comics from a blimp."

When the first issue hit the streets, O'Neill expected Disney to send in the stormtroopers. But nothing happened. Disney execs didn't cool their heels at head shops or buy comic books from drunks. Fortunately, O'Neill had a friend whose father worked for Disney in San Francisco: "He took a whole bunch of our comic books and slipped them around their board room. They had no knowledge of us until we stuffed it in their face."

Disney responded; Disney is zealous in defense of its properties. "We figured they'd sue us for $400,000," O'Neill said, "and they hit us for $870,000. We were wild in our success. Every time a comic strip character appeared in one of the panels, they would say, '$5,000 for this one, $5,000 for that one.'"

The case landed in U.S. District Court in San Francisco on July 7, 1972. O'Neill retained Michael Kennedy, a lawyer who would later represent Ivana Trump and Yassir Arafat. "What made it fun is we didn't have a damn thing. We had seven bucks," O'Neill said. "Our crime was drawing Donald Duck. We paid our lawyers by drawing more pictures of Donald Duck and selling them. It was like a dope dealer raising money by selling more dope."

In a defendants' brief, O'Neill and London argued that there was no conflict between their

comics—*Air Pirates Funnies* and *Mickey Mouse Meets the Air Pirates*—and Disney's, because Disney was only seeking to entertain and make money while the Pirates were seeking to criticize through satire and parody. Furthermore, the defendants argued that they'd taken no more than was necessary to make a parody possible. ("We stole everything," O'Neill said 20 years later. "We took everything, including the silverware.")

The Pirates got plowed; Judge J. Wollenberg found for the plaintiffs and enjoined the Pirates from selling other parodies. O'Neill appealed; lost and appealed again; lost and kept right on appealing. When the case reached the U.S. Supreme Court and he lost again, O'Neill quickly cranked out another four-page Mickey Mouse comic. "That made it contempt," he said. "That made it a felony. And that made for a speedy trial."

Disney, O'Neill said, wanted him in jail more than they wanted the $870,000. "But during the last seven years," O'Neill said, "I'd managed to get every cartoonist off into the corner for a drink. At the second-level court, they'd ruled that if you want to do parody, you can do one. So I got 900 artists to do one each. Wherever Disney went for the next four months, all the big conventions, this big show would appear. It made all the papers. Embarrassed the hell out of them.

"After about four months, Disney settled. We forgot about the $800,000. We forgot it ever happened because now the law was fixed. We weren't making money off their characters. We weren't running off four million copies, we were running off 10,000 underground comics."

By that time, the Air Pirates had flown their separate ways. Flenniken landed at the *Lampoon,* Ted Richards in the Silicon Valley, Bobby London with a chip on his shoulder. "He's been nuts on the subject of me for years," O'Neill said. "I probably did wreck his life.

"It was rough. But it was the right thing to do. When you're in the business of being a writer, every now and then you get your tail in a sling over the copyright thing. If you just roll over, the next artist down the road is going to get it.

"Mickey Mouse was just the tip of the iceberg. He represented all those things that we couldn't say or use that were being used on us. People always burn the flag, and they never burn the right one. They should burn the Pirates' flag. Those were political times, and those were political statements."

What did O'Neill take away from the whole affair? "Seven bucks. I still had it at the end of the nine years. Never had much more than that, but they never got that away from me."

And, not surprisingly, O'Neill walked off with the last word. When Disney released the movie *Who Framed Roger Rabbit,* O'Neill pointed to a minor character of the the same name in *Air Pirates Funnies*. Perhaps, he said, Disney had only come after him in the first place because they planned to steal his bunny.

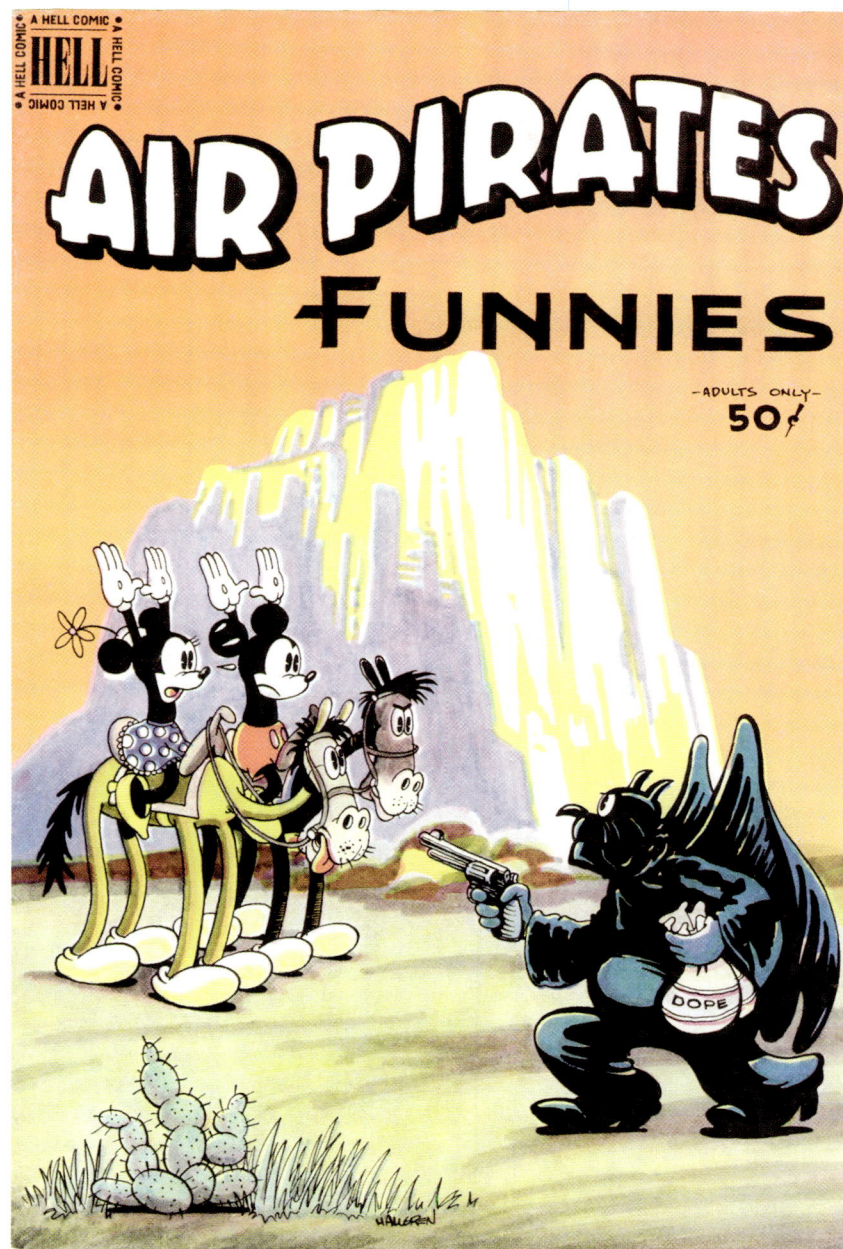

Legitimate parody?
(© Dan O'Neill)

Akira

The class act in the career of Japanese illustrator Katsuhiro Otomo, Akira is a 2,000-plus page science fiction odyssey that occupied 10 years of the artist's life. The title character—a "paranormal giant"—touched the fuse to World War III with a psychic blast and is only now, in the Neo-Tokyo of 2030, awakening from his cryogenic snooze.

Otomo, born in 1954, also scripted, designed, and directed the animated film version of Akira, which appeared in 1988, the same year Marvel Comics began publishing the translated version of the comic in the United States.

Alfred

Alfred Thaddeus Crane Pennyworth (his last name was "Beagle" in Detective #96) first appeared in Batman #16, lagging four years behind his master.

He was scheduled to disappear for good in Detective #328 (June 1964); Julius Schwartz killed him off in his second new-look saga ("In those days, you must understand, there were three males living in the house, and there was a lot of talk going on," Schwartz said), replacing him with Aunt Harriet. But before the earth had hardened over Alfred's grave, William Dozier—the producer of the Batman television show—stomped up to Schwartz and said, "What's this about Alfred no longer being in the magazine?"

"I killed him off," Schwartz said. "I wanted to create some excitement."

"No," Dozier said, "we want Alfred back in the show; you have to bring him back."

"But I killed him off," Schwartz said. "How am I supposed to bring him back?"

"You're the editor," Dozier said, "figure it out."

"So," Schwartz said, "I figured out that the Outsider was really Alfred..."

And Alfred figured out a way to putter on for another 30 years.

Alfred E. Neuman

Now that Bill Gaines is gone, Alfred E. Neuman remains the bit of the eternal in Mad magazine.

Alfred E. Neuman—the idiot kid—first showed his face in the Mad universe on the back cover of The Mad Reader, Gaines' first reprint collection. Harvey Kurtzman provided the introduction: The face had been floating through his subconscious for years before he spied it on a postcard in the office of Bernie Shir-Cliff, an editor at Ballantine Books.

The postcard was captioned, "Me worry?" "It was a face," Kurtzman told Frank Jacobs, "that didn't have a care in the world, except mischief." He took the postcard back to Mad and signed the face to a long-term contract.

The character had no name, not even after popping up in Mad #21. It was another eight issues before the face was finally wedded to "Alfred E. Neuman," a veritable house name at Mad. The magazine writers had swiped the name from Henry Morgan's radio show, where Alfred Newman was a running gag. Like Morgan, Kurtzman appreciated

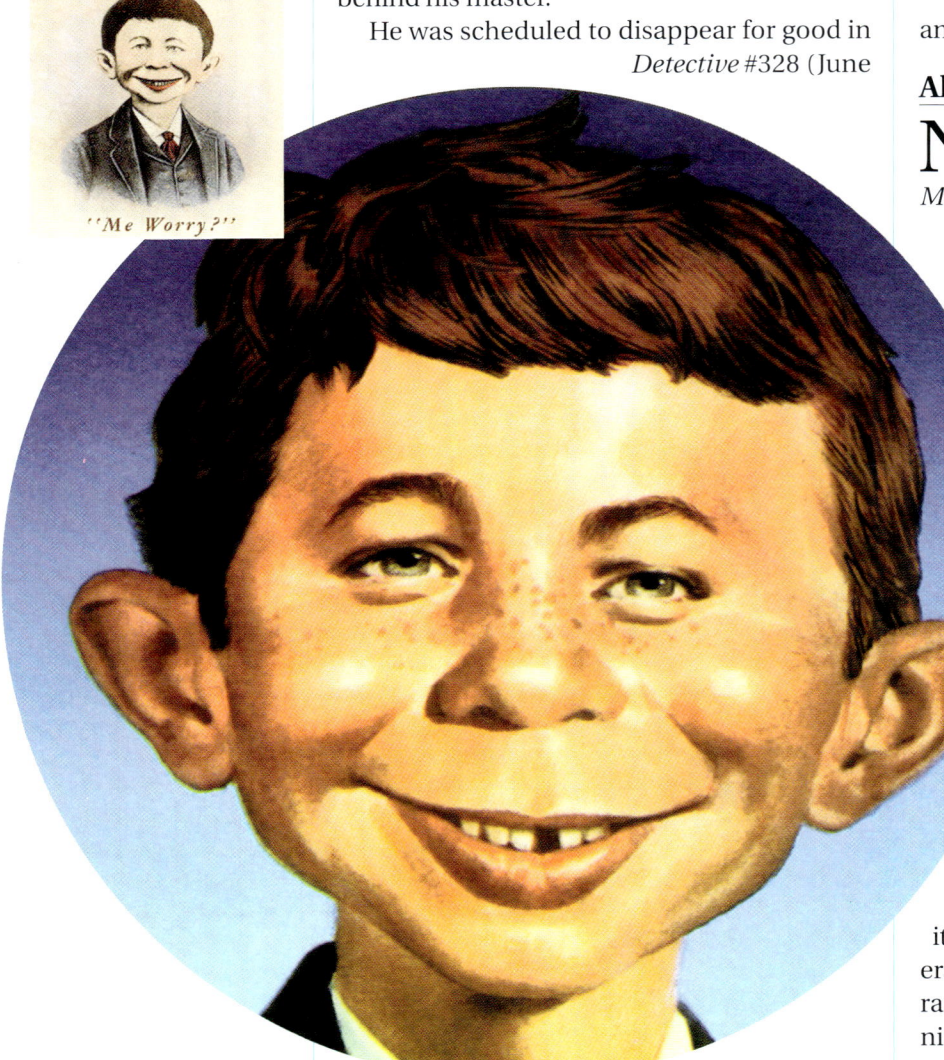

The original version of "Alfred E. Newman" and the Mad version.
(© E.C. Publications, Inc.)

the name for its vacuousness and made off with it, changing the spelling and adding the middle initial.

As that "What, me worry?" grin became a fixture in the magazine, *Mad* had nothing but Shir-Cliff's postcard to use as a model. So Al Feldstein advertised for an artist to draw a more indelible image.

Norm Mingo, a World War I veteran and graphic artist, was the first guy to answer the call. Mingo's portrait of Neuman debuted on the cover of *Mad* #30. Mingo, Jerry De Fuccio once said, "did for Alfred E. Neuman what Leonardo da Vinci had done for the Mona Lisa: create an image that would endure."

Not until *Mad* had to defend itself—successfully—in a copyright infringement suit involving Neuman's image did the staff realize how long the image had been around before Shir-Cliff pinned it to his bulletin board. The kid had been Republican propaganda in 1940 ("Sure—I'm for Roosevelt"), a poster child for war bonds, and the mascot for Bob Adamcik's 26-hour cafe in Schulenburg, Texas. The gap-toothed face helped sell Happy Jack and Cherry Sparkle sodas, medicinal remedies, dental services, musicals, and vaudeville shows, all before Norm Mingo headed off to war.

Aliens

This 1988 book helped change the way movie buffs looked at comic books based on motion pictures. Marvel and DC had traditionally hustled out movie adaptations, hoping to pick up a few bucks in the publicity rush. Dark Horse tried a new approach—presenting *Aliens* as a sequel to the movie—and sales proved it was the right one.

All-American Comics

This early publishing company was founded by Max Gaines, who had an arrangement with Harry Donenfeld at DC: Their books shared ad revenues and distribution. Donenfeld had Superman and The Batman; All-American was stocked with the Flash, Green Lantern, Justice Society, and Wonder Woman.

When the partnership soured in 1945, Gaines demanded that Donenfeld buy him out for $500,000; he used that stake to start Educational Comics. When All-American's editorial director, Sheldon Mayer, resigned two years later, his characters hit the skids. As superheroes fell out of favor, many All-American stars were among the first to hit the showers.

Allentown Collection

The so-called Allentown collection is one of the half-dozen pedigree collections of comic books that pale beside the Mile Highs but still deserve mention.

The original owner of this collection thought his mother had done what mothers do best and thrown his comic books away. When he finally put her in a nursing home and cleaned out her house in 1987, he found 137 comics tucked away in a closet.

He thought about dumping them at a flea market, then plucked the names of six advertisers out of the *Overstreet Comic Book Price Guide* and asked for bids. Jim Payette of Bethlehem, New Hampshire, was the final dealer the Golden Age collector called, and Payette offered the most: $75,000. He eventually paid $70,000 for his share of the collection, sharing the buy with Steve Fischler of Metropolis Comics in New York.

Payette said the Allentown copies of *Detective* #27 and #29 are the best existing copies. He sold his copy of *Detective* #27 for $35,000, approximately twice the price listed in *Overstreet*. That buyer sold it back to Metropolis, which sold it within the year to a Virginia dentist for $82,000.

Alley Oop

First appearing in August 1933, Vincent Trout Hamlin's Alley Oop was a prehistoric cave man with—thanks to Professor Wonmug's time machine—a penchant for time travel. Over the years (36 with Hamlin at the controls of the dailies), Alley Oop charmed Cleopatra, cozied up to Helen of Troy, and was shipwrecked with Robinson Crusoe, but he could never find a woman with the style and passion of his own Ooola.

All-Flash

One Flash story in *Flash Comics* wasn't enough, so how about a 64-page comic that was . . . ALL Flash? The book debuted in the summer of 1941 and survived 32 issues, expiring in early 1948, one year before *Flash Comics* went on its ten-year hiatus.

"The original owner of this collection thought his mother had done what mothers do best and thrown his comic books away."

V. T. Hamlin's Alley Oop.
(© NEA, Inc.)

All Star Comics

The third issue of this seminal title introduced the Justice Society of America, the first team of super-heroes. The eighth issue, Jerry Bails notes, "was the first comic ever to provide a free bonus insert introducing a brand-new character": Wonder Woman. There is no mention of the bonus story, Bails added, on the cover.

"In the early days of comic fandom," Don Thompson wrote in the introduction to the *All Star Comics Archives,* "the crown jewel of any comics collection was *All Star Comics.* In Chicago comic-collecting circles, it was considered basic and essential—if you did not have a complete collection of *All Star Comics,* you were not considered a real collector."

With issue #58, *All Star Comics* became *All Star Western,* much to the chagrin of 11-year-old Roy Thomas, who had finally scrounged up enough money to buy a subscription to the superhero title he loved. The first issue of Thomas's subscription was #57.

> ### All in Color for a Dime
>
> *A dime in 1936 or '37 bought you round trips on the subways, trolleys, bus lines, ferries or, at the automat, a bowl of soup and coffee, or pie and coffee, or two hot dogs, or a hamburger, two chocolate bars or four jelly doughnuts, a loaf of bread, four Kaiser poppyseed rolls, lots of candy, five daily papers, two copies of* Liberty *or* SatEvePost, *one* Life, *two shoeshines, ten #2 pencils, a bottle of ink, 20 pen nibs, almost a pound of coffee or a dozen eggs, or into an all-day Saturday matinee—or an account of your own at the Dime Savings Bank with a chrome pocket dime-saver to get you started . . .*
>
> ALEX TOTH
> ROBIN SNYDER'S HISTORY OF THE COMICS
>
> A dime also bought a kid a comic book, and it was that object of desire, not the Kaiser rolls, that prompted Don Thompson and Dick Lupoff to title their 1970 essay collection *All in Color for a Dime.*

All Winners Squad

Timely's first team of super-heroes arrived unfashionably late in *All Winners Comics* #19 (Fall 1946). The team's starting lineup featured Captain America, Bucky, the Sub-Mariner, Miss America, the Whizzer, and the Human Torch and Toro, who were at their best when the heat was on. The squad had only one more appearance after their debut, in *All Winners* #21.

Alpha Flight

John Byrne's only original creation for Marvel Comics, the Canadian band first appeared in *X-Men* #120, then spun off into its own book in August 1983. Byrne left *Alpha Flight* after 28 issues (swapping Bill Mantlo for *The Incredible Hulk*); since then, the series has been known for little more than Jim Lee's first work at Marvel (#51) and the media circus Marvel orchestrated when team-member Northstar announced he was gay.

Alter Ego

Alter Ego was one of the best of the early fanzines and one of the first to focus on the Silver Age. Jerry Bails and Roy Thomas delivered the first issue in the spring of 1961. The first issues were mimeographed in Detroit on a "portable Spirit duplicator" that Bails offered for sale in issue #2. "I now plan to buy an expensive electrical model," he wrote.

"I was officially listed as 'assistant editor,'" Thomas said, "but I was just a major contributor and cheerleader. Jerry decided to start it after a trip to New York to see the DC offices in late 1960. Julie Schwartz and the other DC editors were so encouraging to him about getting advance news that he got the idea of putting out a newsletter. Very quickly, it grew into more than that. It spawned the first ad magazine and developed into a fanzine."

According to the opening editorial, *Alter Ego*

was "devoted to the revival of the costumed heroes." And to tracking down Golden Age books for the editors. The first issue finds Thomas, who was living in Jackson, Mississippi, seeking to buy or trade for *All Star Comics* #13–#17, #26, #28, #30, and #46.

By the third issue, Bails bragged of a print run of "over 300." The contributors included Ron Haydock, George Paul, and Linda Rahm, Thomas's girlfriend at the time.

Alyn, Kirk

Alyn was the first actor to tug on Superman's cape until it fit comfortably over his shoulders. He never had to worry about guide wires or wind machines in Columbia's two *Superman* serials: Whenever he went airborne, he turned into a cartoon.

Amazing Adult Fantasy

This early '60s Marvel "monster" title labored to be forgotten until Stan Lee decided to send it out in style. Begun as *Amazing Adventures,* the book veered toward the grown-ups with issue #7, which was tagged, "The Magazine That Respects Your Intelligence."

Jack Kirby did the covers for the first seven issues, then Steve Ditko took over for the final eight, including *Amazing Fantasy* #15 (the "Adult" was dropped), the first appearance of Spider-Man.

Amazing Man

A Tibetan orphan, Johnny Aman was trained to combat snakes with his teeth and disappear in a puff of green smoke. Aman the Amazing Man, as he came to be known, debuted in *Amazing-Man Comics* #5 and first appeared in costume six issues later. This character is the first triumph of Bill Everett, much better known for baptizing the Sub-Mariner.

Amazing Mystery Funnies

This title was the top of the Centaur line, introducing Fantom of the Fair, Speed Centaur, and Basil Wolverton's Space Patrol. The first issue—with Bill Everett's first cover—appeared in August 1938.

Amazing Spider-Man

Featuring the quintessential hero of the Silver Age, *Amazing Spider-Man* was also the era's essential series. Stan Lee and artist Steve Ditko created Spider-Man and high school nerd Peter Parker, dumped them into the farewell issue of *Amazing Fantasy* (August 1962), and turned the comics industry on its ear.

The character, with Lee at the controls, was the perfect blend of teenage angst, self-depre-

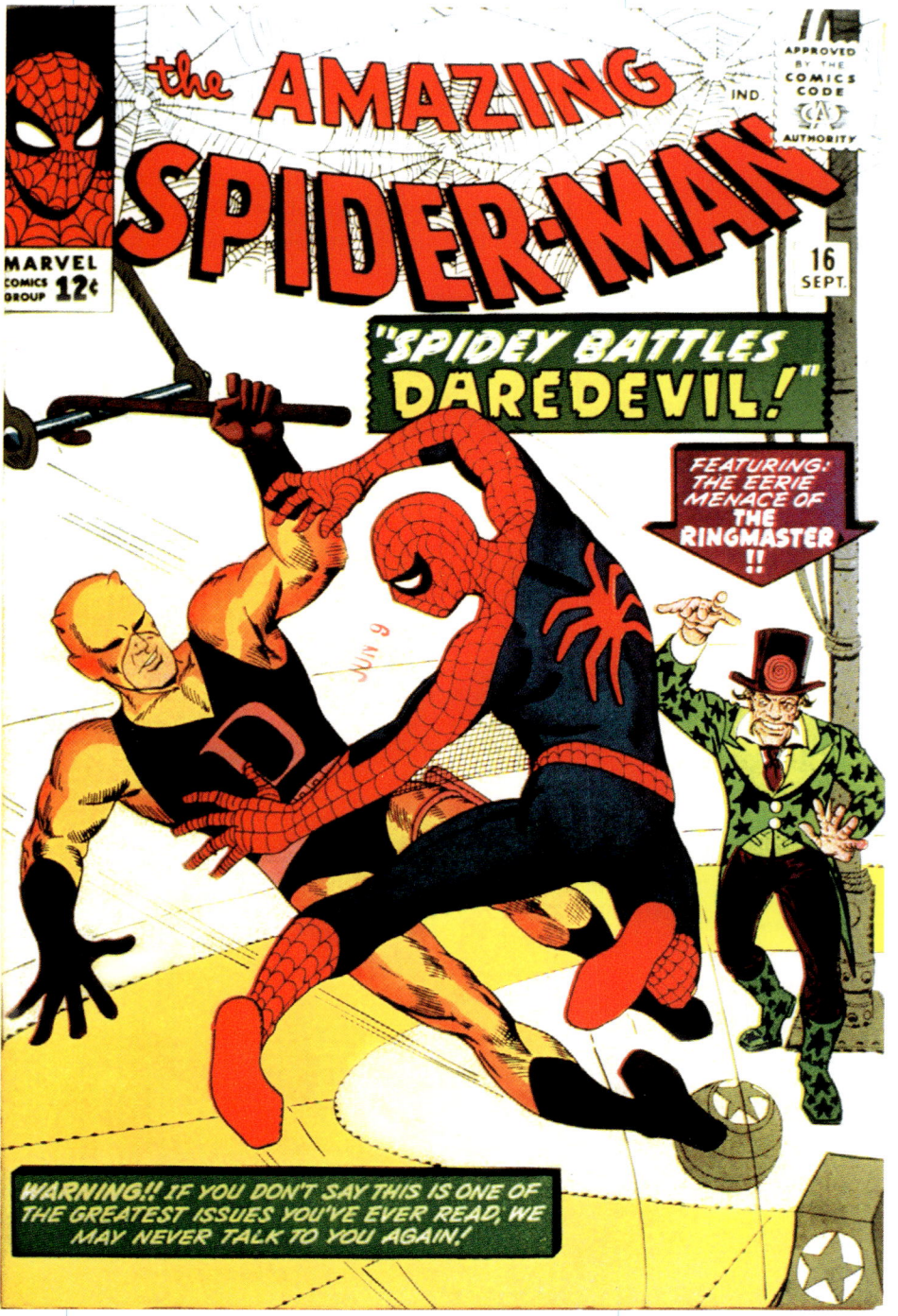

Amazing Spider-Man #16 (September 1964), with a classic Steve Ditko cover. (Yes, Marvel was already doing crossovers then.)
(TM & © 1998 Marvel Characters, Inc. All rights reserved.)

> **Ambition**
>
> *Anyone who's in the industry who says he started out with the intention of being a cartoonist is one of two things: a liar, or someone with a superficial understanding of art. We all started out wanting to be something else.*
> JOHN ROMITA, JR.

cating candor, and earnest possibility. His reputation was secured in *Amazing Spider-Man* #1 when, at a time that crossovers were totally out of fashion, he jousted with the Fantastic Four and retired still atop his high horse.

Who was this rebel? James Dean in Spandex?

From the beginning, Spider-Man reflected the readers' insecurities without ever being ensnared by them. Whenever Ditko backed Spidey into a peevish corner, Lee allowed him to escape with a glib wisecrack. Each time Aunt May grew insufferable, Gwen Stacy or Mary Jane Watson rang the front bell.

As the Marvel universe dissolved into an unreadable, impenetrable heap in the mid–'90s, Spider-Man remained (by the thinnest strand) just above the rubble.

Key issues: #2, first Vulture; #3, first Doc Octopus, who calls our hero "Super-Man"; #4, first Sandman, first Betty Brant, first Liz Allen; #5, first Lizard; #6, first Electro; #13, first Mysterio; #14, first Green Goblin; #15, first Kraven; #20, first Scorpion; #38, last Ditko; #42, first Mary Jane Watson; #50, first Kingpin; #90, death of Capt. Stacy; #96–98, drug issues lacking the Comics Code seal; #101, first Morbius; #121, death of Gwen Stacy; #122, death of Green Goblin; #129, first Punisher; #238, first Hobgoblin; #243, return of Mary Jane; #298, first Venom; #298–328, McFarlane issues.

Amazing Stories

Possibly the preeminent sf pulp sf magazine, *Amazing* first appeared in April 1926, published by Hugo Gernsback. Unlike the standard 7" × 10" pulps, *Amazing* measured 8½" × 11" and packed 92 thick pages. The pulp debuted a letters column, "Discussions," in 1927, which printed the addresses of science fiction fans, allowing them to get in touch with one another. In 1938 *Amazing Stories* was sold to Chicago-based Ziff-Davis, where it was rejuvenated under the direction of editor Raymond Palmer. At the 1939 New York World's Fair, a copy of the October issue of *Amazing* was buried in a time capsule called the Westinghouse Time Record.

Adventures into the Unknown was the first continuously published horror comic. The first issue was published by the American Comics Group in fall 1948, and it ran for 19 years. This is issue #14 (December 1950/January 1951) with cover art by Ogden Whitney.
(© ACG)

The American

Having first appeared in 1987, Mark Verheiden's award-winning patriotic hero is in step with the '90s, when symbolism has given way to cynicism. He is the sort of hero who sells his autograph and believes freedom fighting is a great merchandising gimmick.

"The American," said Mike Richardson, the publisher of Dark Horse Comics, "is Captain America disillusioned and without a purpose. He's where Captain America would have ended up if he were allowed to have a life."

American Comics Group (ACG)

The home of the first continuously published horror comic, *Adventures into the Unknown,* the American Comics Group started off on a light note—*Giggle Comics* and *Ha Ha Comics,* both of which debuted in October 1943—and matured into a reasonably formidable house of horror and mystery titles.

Much of ACG's momentum was supplied by editor Richard Hughes, who rolled out the first of *Adventures into the Unknown*'s 174 issues in the fall of 1948. A company sibling, *Forbidden Worlds,* which featured several Al Williamson sightings, debuted in 1951. All systems finally shut down in 1967 with *Gasp* #4 (August 1967).

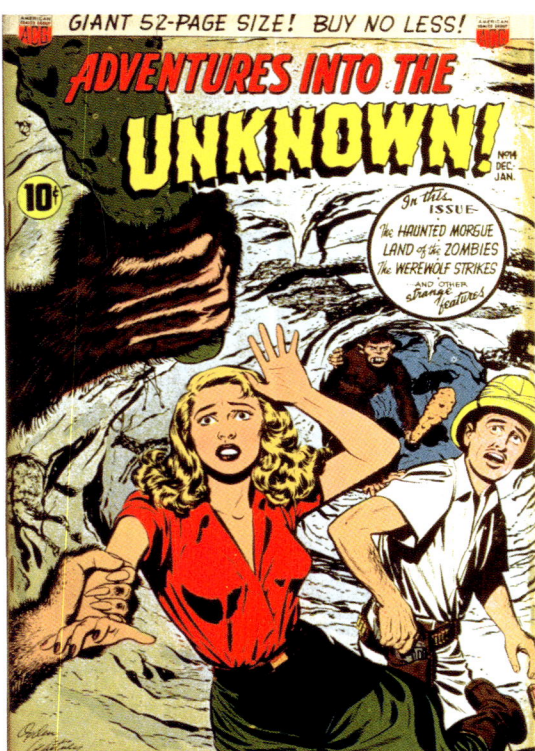

AMERICAN FLAG

When the book-burning mobs put the torch to these red, white, and blue issues in the 1950s, did anyone call for a constitutional amendment?

Air Fighters Vol. 2 #5 (February 1944)
All-American #4 (July 1939)
All Star #22 (Fall 1944)
America's Best Comics #6 (July 1943) and #10 (July 1944)
Big 3 #3 (May 1941)
Boy #7 (December 1942) and #17 (August 1944)

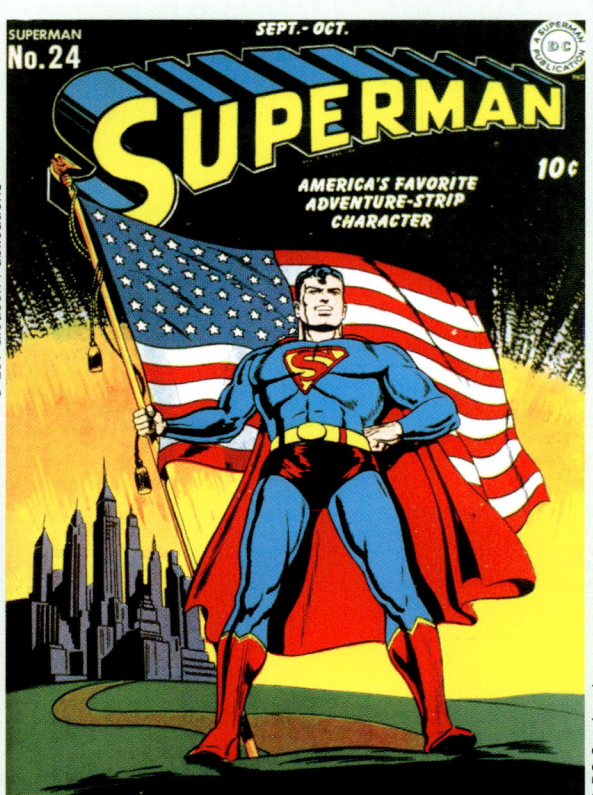
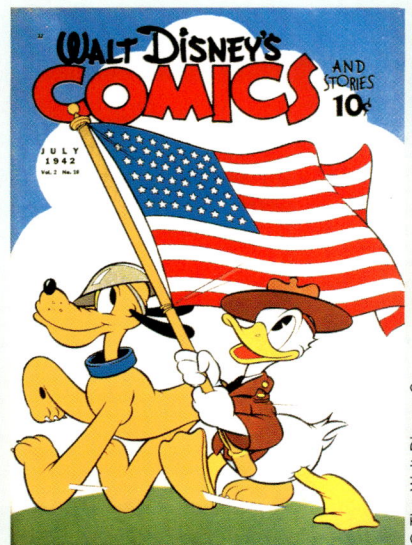

Calling All Girls #9 (August 1942)
Captain Marvel #26 (August 1943)
Captain Marvel Jr. #9 (July 1943) and #25 (November 1944)
Captain Midnight #10 (July 1943)
Catman #27 (April 1945)
Crack #26 (November 1942)
Don Winslow of the Navy #6 (August 1943)
Four Color #18 (1942)
Four Favorites #1 (September 1942) and #2 (November 1942)
4 Most #3 (Summer 1942)
Frisky Fables #7 (July 1946) and #19 (July 1947)
Funny Animals #8 (July 1943)
King Comics #76 (August 1942)
Looney Tunes and Merrie Melodies #10 (August 1942)
Magic #36 (July 1942)
Man of War #1 (November 1941)
Marvel Mystery #48 (October 1943)
Master #30 (September 1942) and #40 (July 1943)

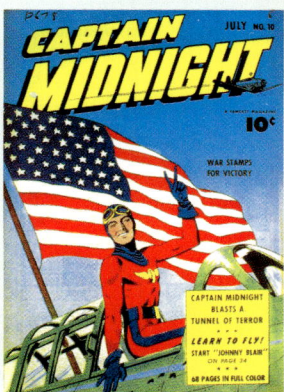
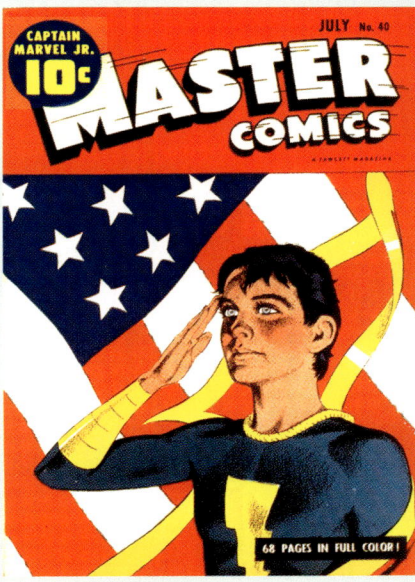
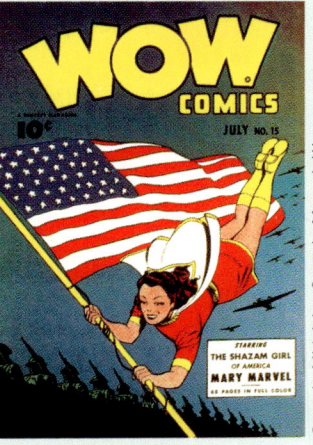

Mickey Mouse Magazine Vol. 4 #10 (July 1939)
Military #11 (August 1942)
National Comics #9 (March 1941)
Picture Progress Vol. 2 #4 (September 1954)
Prize #21 (May 1942)
Speed #26 (April 1943) and #38 (May 1945)
Stars and Stripes #2 (May 1941)
Super Comics #62 (July 1943)
Superman #24 (September/October 1943)

Some representative flag covers. Not surprisingly, most have July or August cover dates.

Target Vol. 2 #1 (March 1941)
Tick Tock Tales #19 (July 1947)
True Comics #15 (August 1942)
Walt Disney's Comics and Stories Vol. 2 #10 (July 1942)
Whiz #44 (July 1943)
Wonder Comics #6 (January 1946)
World Famous Heroes Magazine #1 (October 1941)
Wow #15 (July 1943)

American Flagg

This 1983 Howard Chaykin creation landed with quite a splash, yet left few ripples. "I produced one of the five best comics of the past five years," Chaykin said midway through its 50-issue run, "and I still think it's a piece of shit."

American Splendor

Harvey Pekar's autobiographical work, straight off the streets of Cleveland, raises morbid preoccupation with self to a new art form. Self-published on an annual basis for 17 years, *American Splendor* is now produced by Dark Horse.

Anderson, Murphy

Murphy Anderson

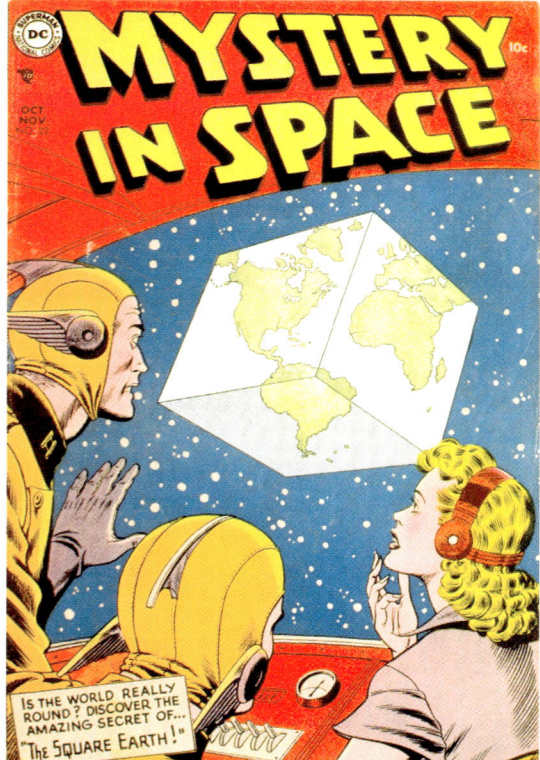

Mystery in Space #22 (October/November 1954) sports a classic Murphy Anderson cover.
(© DC Comics, Inc.)

"When I was four or five years old," Murphy Anderson said, "I'd bug my mother to read the comics so much that she taught me to read." He chewed on *Wings Winfair* in *The Gulf Comic Weekly*, a little four-page giveaway that he picked up every week down at the Gulf station. He nibbled on *Li'l Abner* in the Greensboro (North Carolina) papers, and he feasted on the Fox and Fiction House books at the local drugstore.

But after two quarters at the University of North Carolina at Chapel Hill in 1944, Anderson realized he'd never have his fill of the comics if he stayed in the Tar Heel State. He began bugging his father to let him sneak off to New York and look for a job before he turned 18 and had to register for the draft. Anderson's father didn't like the idea, but he finally pulled $100 from his wallet, handed it over, and said, "When that's gone, that's it, you'll have to come home."

When Anderson hit the streets of New York the following Monday, each publisher checked his sketches and said, "Nothing now, maybe later." Anderson couldn't afford to wait. On Friday morning, he finally met Harry Chesler. Chesler had quit publishing comic books at the time but told Anderson that Fiction House had a science fiction title he could handle.

"I've already been there," Anderson said, "and Mr. Eisner told me to come back in a couple of weeks."

"Wait a minute," Chesler said. He called up Jack Burne at Fiction House and, Anderson said, "gave me such a build-up that when he hung up, he said, 'You have a 10:30 appointment. Can you make it?'"

Anderson's tryout at Fiction House was a "Star Pirates" script for *Planet Comics*. "I was too dumb to know it was a tough assignment," Anderson said. "I penciled the thing the first week and they seemed pleased with it." By that time he was paying $8 or $9 a week for a room at the YMCA—"Later I learned the YMCA was not the place for a straight male to be"—and he had just enough of his dad's money to scrape by until he got his first paycheck.

"After my second week there, another young artist who was looking for a summer job came by," Anderson said. "That was Gene Colan. They hired him because I worked out."

When the draft board finally called, Anderson moved back to Greensboro and registered, but his medical exam revealed a lazy left eye. He was eventually stationed in Chicago, where he signed to take over the *Buck Rogers* comic strip from Dick Calkins. Anderson was paid only $65 a week, a cut from his days at Fiction House: "I struck a deal that I would get a percentage of any foreign comics they sold; I could never get an accounting, so I finally left."

He worked for his dad for 18 months and freelanced for Ziff-Davis back in New York before Julius Schwartz hired him at DC. And that, of course, is the work for which Anderson is best remembered. The wedding of Ander-

son's inks with Carmine Infantino's pencils produced DC's dream team during the late '50s and early '60s. Best known for his work on Adam Strange in *Mystery in Space,* Anderson also drew *Hawkman, Atom, Green Lantern,* and *Atomic Knights.*

Anderson finally left DC to work on *P.S.,* the Army's preventive maintenance magazine, with Dan Zolnerowich, an old Fiction House artist. After ten years with *P.S.,* Anderson formed his own color separation business, bringing him back to comics, his first love.

Angel and the Ape

This Bob Kanigher–Bob Oksner odd couple first appeared in *Showcase* #77 (November/December 1967). The lead character, Angel O'Day, had a remarkable resemblance to one April O'Day, a character from the Kanigher-Oksner romance comic *Girls' Love Stories.* Wally Wood—yes, this is depressing—inked the final five issues when Angel and the Ape got their own book in 1968.

Ant-Man

For Ant-Man's first appearance—*Tales to Astonish* #27—the Lieber brothers, Stan and Larry, provided the script, and Jack Kirby and Dick Ayers handled the art. The marriage of scientist Henry Pym and a shrinking serum was not made in heaven; in less than two years (*Tales to Astonish* #49), Ant-Man had already evolved into Giant-Man. Shortly thereafter, he joined the Avengers, where he underwent two more transformations, molting into Goliath and Yellowjacket. The last time we checked . . .

Was there a last time we checked?

APA-5

This seminal amateur press association was formed by Mark Verheiden in 1971. Its membership eventually included Frank Miller, Paul Chadwick, Jim Vadeboncoeur, Mike Richardson, Randy Stradley, and Chris Warner.

At the age of 14, Verheiden had joined Exponent, an APA of Los Angelinos, including Mark Evanier. "It was a real rambunctious APA, where everyone was tearing one another to pieces all the time," Verheiden said. "It was really juvenile, but when you're 13 or 14, you *are* juvenile."

A year later, Verheiden—who was living in Aloha, Oregon — decided to form his own APA. Why APA-5? "I thought it was the fifth one; I was totally wrong," Verheiden said. "*APA-5* was always meant to be temporary, but the best anyone came up with as a real title was *Druid.*"

Most of the early members were from Oregon; Chadwick and Miller joined after reading about APA-5 in Vadeboncoeur's newsletter. "I didn't feel worthy to join CAPA-Alpha, the big APA, so I thought I'd try this little one," Chadwick said. "It was really energizing. There were enough young members that I wasn't intimidated. And it was the immediate feedback, sort of the common purpose, the common enthusiasm, caring more about something than the rest of the world. I'd say APA-5 was more my community of friends as a teenager than the kids at my school."

What was Miller producing when he was 15? "I hesitate to offer psychological evaluations of Frank at that age," Chadwick said. "He was hugely productive, a great imagination; he was bright beyond his years. I think that alienated him from his peers. He also had two very intellectual brothers—Steve Miller and Sarge Miller—although I always wondered if Sarge was a hoax. Hoax members are a long tradition in APAs. We had a hoax that Wally Stoelting perpetrated, a girl named Corinna West. The APA was 99 percent lonely teenage boys who didn't have girlfriends, and Corinna was sort of this weird, erotic daydream . . . which someone eventually saw through."

Aparo, Jim

A journeyman artist, Aparo managed to make his mark on a wide variety of DC books in four different decades, beginning in the 1960s. Best known for his work on *Batman, Phantom Stranger,* and the Spectre, Aparo detoured through most of DC's mainstream titles at one time or another.

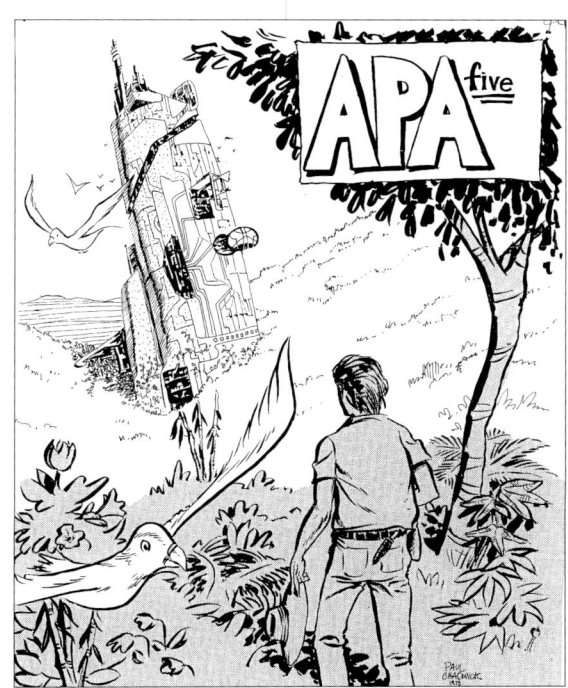

An issue of *APA-5* with a Paul Chadwick cover.

"I'd say APA-5 was more my community of friends as a teenager than the kids at my school."
PAUL CHADWICK

Aquaman

One of those washed-out DC superheroes who's been around forever… or at least since *More Fun* #73 (November 1941). Created by Mort Weisinger and Paul Norris, Aquaman saved his best moments for Ramona Fradon's pencils at the end of his 182-issue run in *Adventure Comics*. Nick Cardy escorted the character into his own book in 1962.

Aragonés, Sergio

At the age of 24, Sergio Aragonés left Mexico City with a portfolio of cartoons under his arm and one thought in mind: "To seek fame and fortune, of course." He was bound for glory, but—it being 1962 and Aragonés being of somewhat limited means—he had to get there on the 'Hound. Aragonés would sleep on the bus, shower in the Greyhound stations, and explore the Southern towns along the route. The trip took ten days (the New Orleans exploration required a long weekend, Aragonés admitted), and when the cartoonist finally disembarked in New York, he had only 20 bucks left on his hip.

Aragonés headed straight for the Village. "I always thought of the Village as a mecca for artists," he said, "and I imagined it pretty much the way it was." Unwilling to break that $20, he spent his first night sleeping down by the piers, and his second night in the basement of the El Flamenco coffeehouse. "The next morning the maid was reciting poetry," he said.

"I was never treated badly," Aragonés said. "The city itself was frightening but the people were not. I could go to a restaurant and they would even give me free food. There was a little Greek place in the 20s, 'Well, when you have money, you pay me.' I went to an art supply store, the guy knew I had just arrived from another country, and he gave me a job in the shop so I could get free materials. It was incredible."

When Aragonés finally dropped by the *Mad* magazine offices, six months after that night beneath the piers, it was simply as a fan, desperate to meet his heroes. "I never thought I could sell anything to *Mad*," he said. "My theory was that as a cartoonist you have to start at the bottom and slowly you get to the top magazine. Every place I went, they said, 'Well, we don't use this style, you should go to *Mad*.' I couldn't figure it out, because *Mad* was a satire magazine and I was doing pantomime cartoons. *Mad* doesn't use pantomime cartoons. I knew what was best for me, and everyone told me to go to *Mad*. At *Mad*, I knew they were going to reject me because they don't do what I do.

"So when I was there I was in a panic," Aragonés said. He asked to see Antonio Prohias, the creator of *Spy vs. Spy*, figuring Prohias was the only one in the building who might speak Spanish. As they talked, editor Jerry De Fuccio bopped out and Prohias introduced Aragonés—as he introduced most everyone else—as "Hey, mi amano, mi amano, my brother." Before Aragonés knew it, De Fuccio was calling him "Mr. Prohias."

No, Sergio repeated, Aragonés! Aragonés!

Nick Meglin finally interrupted and asked if Aragonés was a cartoonist and if he could see his work. Meglin then disappeared with the cartoons, and Aragonés had to sit and listen to Prohias babble on about Cuba and Castro while wondering what was going on behind closed doors.

"Then Feldstein comes out and says, 'Do you sell your cartoons?' What kind of question is that? They said, 'We decided to buy a few of these gags and make it a two-pager. Wait, and we'll give you a check. Then they came out with

American Dream

I'll tell you my biggest gripe about this business and it's not just mine … [U]ntil very recently, the comic book industry was guilty of violating the American Dream.

That's the dream that says if you come up with a good enough idea, you can become rich. If you write a great movie, you can become rich. If you write a great novel, you become rich.

In comics, the way it worked was that, if you created a comic book that made the company a few thousand bucks, they paid you $20 a page for writing it. If you created a comic book that made the company a few million bucks, they'd reward you and pay you $23 a page. Men like Jack Kirby have spent their lives being told, 'Hey, Jack, that Hulk guy you designed was great. Here's a two-dollar raise, come up with more characters like that next month.' The amount of money the Hulk has made for Marvel is staggering. The Hulk himself couldn't lift it all …

That was the way it was in comics until very recently. If you had the greatest idea for a comic book—the new Spider-Man—there was no American comic book publisher to whom you could take the damn thing and share in its success. No one. They wouldn't guarantee you creative control of it, they wouldn't guarantee you a continuing credit on it, they wouldn't guarantee not to fire you and bring in someone else.

MARK EVANIER
THE COMICS JOURNAL

© 1998 E.C. Publications, Inc.

a check. It was amazing. After that, they made the mistake to tell me, 'Mi casa es su casa,' and I took it literally and never left."

The first gag Aragonés sold to *Mad* was about astronauts, the second about motorcycles. He has never missed an issue. But he didn't start writing for the magazine until 1968. After several years in Europe, Aragonés returned to New York to find Joe Orlando had left *Mad* for DC. Unbeknownst to Aragonés, Orlando had broken up with his girlfriend, a long-time secretary at *Mad*, and Gaines—realizing he couldn't keep both and maintain peace in his temple—told Orlando to hit the road.

Aragonés dropped by DC and found Orlando in the grip of a miserable day. "He was a little upset because he needed a couple of stories for his artist in *Young Romance*," Aragonés said. "The writer wasn't there and the artist had driven a long way, so I told him to go to lunch with the artist. 'When you come back, I'll give you two stories.' He went to lunch, I wrote two seven-pagers and gave them to him when he came back.

"One was about a young American girl going to Mexico to study and finding love with a mariachi... and the parents telling them he was no good, and he was going to use her. But no, he goes back to the States for her, he was only a part-time mariachi, he was doctor or something like that. The classic boy meets girl, loses girl, and they get together in the end."

How was it possible to conceive, and map out, two seven-page plots in less than an hour?

"Creation," Aragonés sighed, playing this for all it was worth: "It takes a lifetime to be able to create, but creation itself takes a few seconds. It's almost instantaneous."

And it doesn't hurt when one of the plots is the story of how you met your first wife.

In 1982 Aragonés created *Groo the Wanderer*, hoping to fill the inexplicable absence of barbarian humor in the comics. His hero first appeared in *Destroyer Duck*, the benefit book designed to pay Steve Gerber's legal fees in his lawsuit against Marvel over Howard the Duck. Aragonés had gone to both Marvel and DC to see if they would publish *Groo* and let him retain the rights. Jim Shooter's response? "Over my dead body you'll see that happen." OK, Aragonés told him, I'll publish it myself. Pacific Comics gave him the chance, and though Shooter was still alive when Marvel's Epic imprint agreed to Aragonés's terms, he was dead meat in the Marvel universe.

In truth, Aragonés has always been more at home in *Mad*'s universe than in Marvel's. When Bill Gaines took the crew to Italy on one of the magazine's infamous field trips, the gang ended up one morning standing by the baptistry of a Florentine cathedral.

"I wanted to take a picture of the whole *Mad* group," Aragonés said, "but I didn't have a wide angle so I had backed off the steps to take the picture." As he stepped into the street, he saw a group of Italian protesters marching

Sergio Aragonés and one of his *Mad* marginals.

Groo the Wanderer with sidekick Rufferto.

(© Sergio Aragonés)

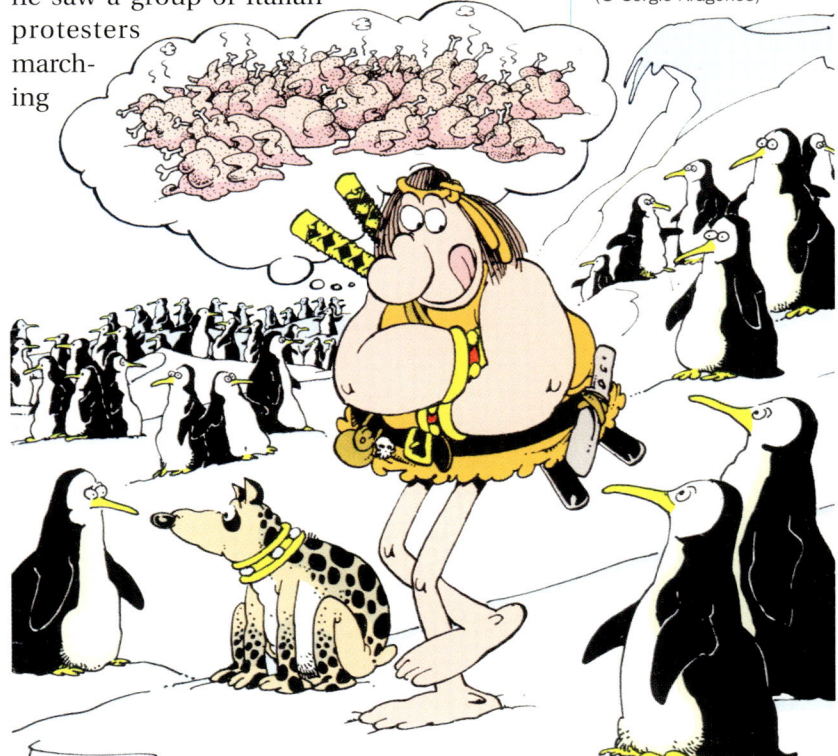

> "*'Do you sell your cartoons?' What kind of question is that?*"
> SERGIO ARAGONÉS

his way, dozens of placards raised above their heads.

"They were shoemakers who wanted an increase in pay, but they were singing and having a very good time," Aragonés said. "I went there and took one of the signs and hid behind them, and when I came to the steps I started shouting, 'Filthy Americans! Go home, you filthy imperialist, capitalistic dogs. Go home. You just come to Italy and ruin our lives!'

"What I didn't realize was that next to the *Mad* group, there was another tourist group. They started running away, totally panicked, scared. They thought I was really an Italian madman. So they ran away, and I gave the sign back to the lady and stood up there with the *Mad* group, continuing to enjoy the view, and the people didn't know what to make of the whole thing."

Aragonés had them dazed and confused, just where he wanted them. No wonder he was enjoying the view.

Archie

Publisher John Goldwater may have popped up with the idea, but cartoonist Bob Montana deserves the lion's share of credit for the creation of Archie Andrews, who first appeared in *Pep Comics* #22 (December 1941). The original hayseed, a cross between Mickey Rooney and Tom Sawyer, was nicknamed "Chick." Archie and his pals—Betty, Veronica, Reggie, and Jughead—have become icons of American pulp literature.

Archie Publications

Six years after Archie Andrews moved in, MLJ dumped the last of its super-heroes (the Black Hood, the Shield) and Archie—America's Top Teenager—had the run of the place. What followed was *Archie and Me, Archie at Riverdale High, Archie Comics, Archie Comics Digest, Archie Giant Series Magazine, Archie's Girls, Betty and Veronica, Archie's Joke Book Magazine, Archie's Madhouse, Archie's Pal, Jughead, Archie's Pals 'n' Gals, Betty and Me, Everything's Archie, Life with Archie,* and *Little Archie*.

Slightly less exposed was Katy Keene, who first appeared in *Wilbur* #5 (Summer 1945), then had several titles of her own.

Archie Publications tried to bring its MLJ super-heroes back in 1959, 1965, and—under the Red Circle label—1983, but to no avail.

Arlington, Gary

"At the end of the 1960s," Clay Geerdes wrote in his *Comix Wave* newsletter, "the hub of Bay Area underground comix activity was Gary Arlington's San Francisco Comic Book Store in the Mission District. Any Saturday afternoon you would find people like Kim Deitch, Robert Crumb, Spain, Larry Todd, Vaughn Bodé, Roger Brand, Joel Beck, and countless others wandering in and out."

Arlington was, Geerdes noted, an ex-Army supply sergeant, "an amiable guy who had two full collections of EC Comics. For him underground comics meant a revival of the best of the EC horror line."

And Arlington was jazzed about an EC revival. In 1973, Charles Dallas noted in *Blab* #1, "Gary was publishing, one page at a time, a 500-page collection of classic reprints and original art called *The Nickel Library*. In that format he decided to publish new covers for old EC titles, starting with the numbers at which they had suspended publication. He was paying $25 a page for original artwork, so I contributed about six covers for different titles, more for the fun of it than for the money (though that helped) . . . Gary used a beautiful, unpublished Wally Wood from his collection for a *Frontline*

The cover for *Archie Annual* #3 (1952) summarizes the classic conflict that has kept Archie Andrews going for well over 50 years.
(© Archie Publications)

Artists, Most Influential

Here are our picks for the twelve most influential comics artists of all time.

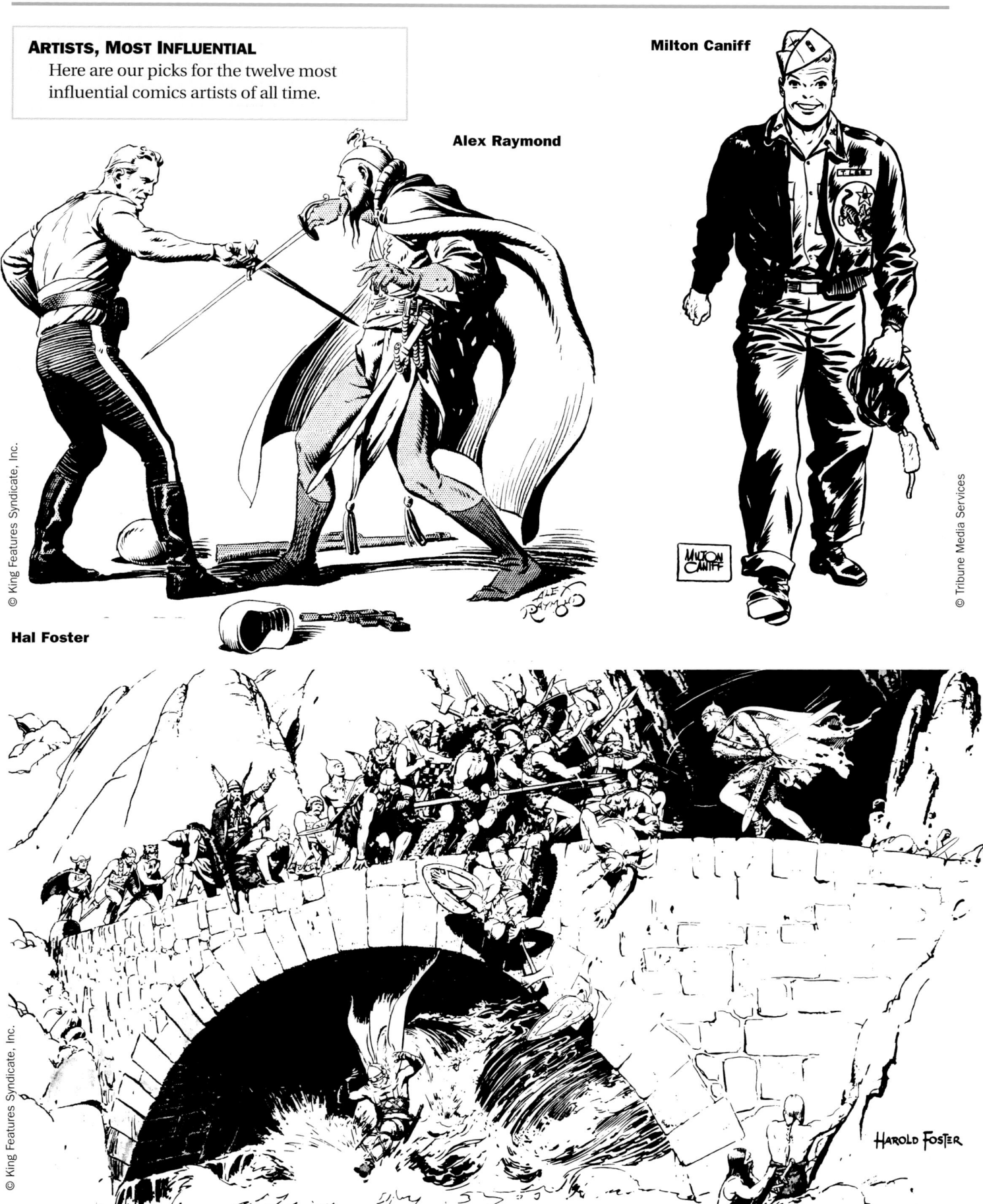

Alex Raymond

Milton Caniff

Hal Foster

Artists, Most Influential

Carl Barks

Steve Ditko

TM & © 1998 Marvel Characters, Inc. All rights reserved.

Harvey Kurtzman

Will Eisner

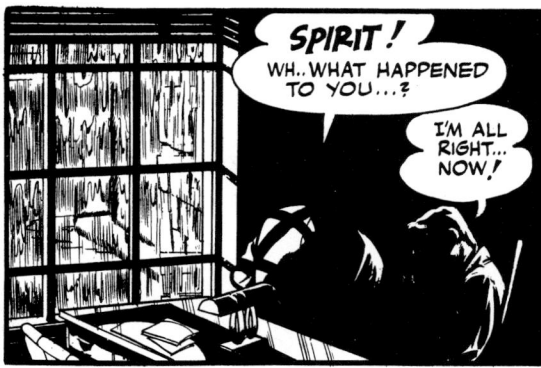
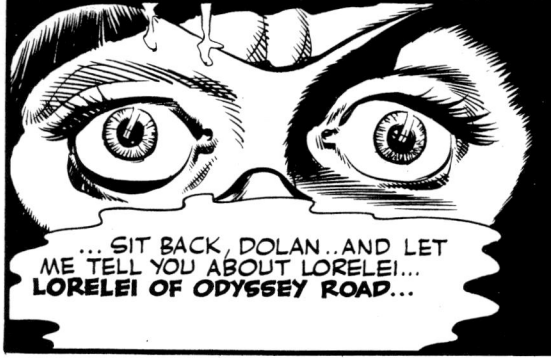

© Will Eisner

Artists, Most Influential

Neal Adams

Jack Kirby

Frank Frazetta

Artists, Most Influential 25

Alex Toth

© Alex Toth

Frank Miller

© Frank Miller

> "*[Busy Arnold] didn't know his ass from his elbow about art.*"
> BOB FUJITANI

Combat cover. This went on for several months, until Gary made the mistake of sending a set to Bill Gaines, hoping perhaps for some word of encouragement, but receiving instead a letter from his legal department threatening to sue if Gary didn't desist immediately and destroy all the original artwork. So much for the unauthorized resurrection of EC in San Francisco.

But Arlington was—in Jack Jackson's words—"the kingpin behind the EC influence in underground comix." As Tom Veitch said, "In the early days of Gary's comic book store, the walls were covered floor to ceiling with precious old comics, all for sale, most of them ECs. These books were constantly in the face of the artists such as Rory Hayes and Simon Deitch to whom Arlington gave jobs in his store. What's more, if the local artists couldn't afford to buy the books, Arlington would loan them out or trade them for original art."

"Greg Irons, Rick Griffin, and I traded a lot of our original art to Arlington for mint condition ECs," Jackson said. And after the artists took those ECs home to their Ashbury street lofts and studied them, their work began to betray more and more of Harvey Kurtzman, Jack Davis, or Will Elder.

Jackson said Arlington's "obsession with EC horror comics gave birth to *Skull* [his title] and the energy was carried over to *Slow Death*, our stab at science fiction." Arlington also published several titles, including *Bogeyman* and a tabloid known as *Erich Fromm's Comics and Stories*.

Arnold, Everett "Busy"

When comics historian Hames Ware asked Fawcett editor Wendell Crowley if publisher Busy Arnold purposely kept the artists' names out of the Quality books, Crowley said, "That would be a policy of Arnold's. He wouldn't want them to become famous and want more money. Arnold came from the printing end. A hale fellow well met. With a capacity to drink. I just wasn't the type to work with Arnold. I like his style, the approach he had, but I never could have gotten along with him."

Crowley was, apparently, an anomaly; not only did Busy Arnold muster one of the finest ensembles of artists up at Quality, but he somehow managed to keep them happy.

Born in 1902, Arnold was a veteran of the printing business when, at the age of 34, he helped Bill Cook and John Mahon launch the Centaur line of comics. After watching the Centaurians struggle and stall with original material, Arnold decided to take the reprint route. In 1937 he published the first issue of *Feature Funnies*, reprinting such strips as *Joe Palooka*, *Dixie Dugan*, and *Mickey Finn*.

Less than two years later, the renamed *Feature Comics* #21 became the first issue of Arnold's Quality Comics.

As the independent art studios began to fall by the wayside, Hubert Crawford noted, "Arnold proved to be the exception among his publishing peers. He continued to maintain an informal arrangement with many outside studios, which, as they began to lose their clients, decided to pool the best of their freelance talent and form a single group to produce art for Arnold's new titles."

The artists filling Arnold's books included Lou Fine, Reed Crandall, and Jack Cole, a trio that no other publisher could match.

And what makes that particularly interesting, artist Bob Fujitani observed, is that Arnold "didn't know his ass from his elbow about art." Witness Arnold's attitude toward Fine. Will Eisner and Lou Fine did not get along, Fujitani said, adding, "Eisner had poisoned Arnold's mind on Lou Fine. Eisner used to tell him that Lou didn't know how to 'break down,' which was the term we used for taking the script and laying out the story. I remember Arnold calling me and saying, 'Gee, I know Lou's not going to like this, but could you "break down" for Lou?'"

Arnold and Quality Comics stayed in business until 1956, when he finally broke down, sold out to DC, and retired.

Ashcans

Golden Age ashcans, by their very name, were designed for the ashcan. They were publications jammed and hand-stapled together for one solitary reason—to secure the copyright for a new comic book title and title design—and then stuffed into a filing cabinet and forgotten.

At the dawn of the Golden Age, comic book publishers were desperate to lay claim to the short, sweet titles that would radiate bursts of incandescent energy on the newsstand:

Feature Comics, "Busy" Arnold's flagship title. It ran for 144 issues. After containing mostly comic strip reprints (as *Feature Funnies*), it started carrying new material, starring such characters as Doll Man and Captain Fortune. This is Issue #34 (July 1940).
(© Harry "A" Chesler/Quality Comics Group)

Action! Flash! Marvel! Thrill! Wonder! The first publisher to slap the desired title and a unique logo on a cover and get that book to the Library of Congress could use it for all eternity.

Never knowing which title would strike the right nerve with the buying public, publishers would copyright numerous variations of a title. There are ashcans for *Action Comics* and *Action Funnies*; for *Real Screen Funnies*, *Real Screen Gems*, and *Real Screen Cartoons*.

Because only the title and logo mattered for copyright purposes, most ashcans were copies of previously published art wrapped around the nearest available coverless book.

The art was superfluous; DC used the cover art for *Boy Commandos* #1 for dozens of ashcans in the early '40s. According to Gary Colabuono, all the covers were in black and white. Because publishers had to produce only two copies of each ashcan—one for the Library of Congress and a second for their files—fewer than five copies exist for most of these beasts. In some cases, there are only one or two.

Probably 90 percent of the known ashcans emerged from the personal file of former DC president Sol Harrison. When Joe Desris went to interview Harrison in 1985, Harrison showed him a half-dozen ashcans that had been in his files when he retired from DC in 1980. Much of the original art in Harrison's collection had perished in a flooded basement while Harris-

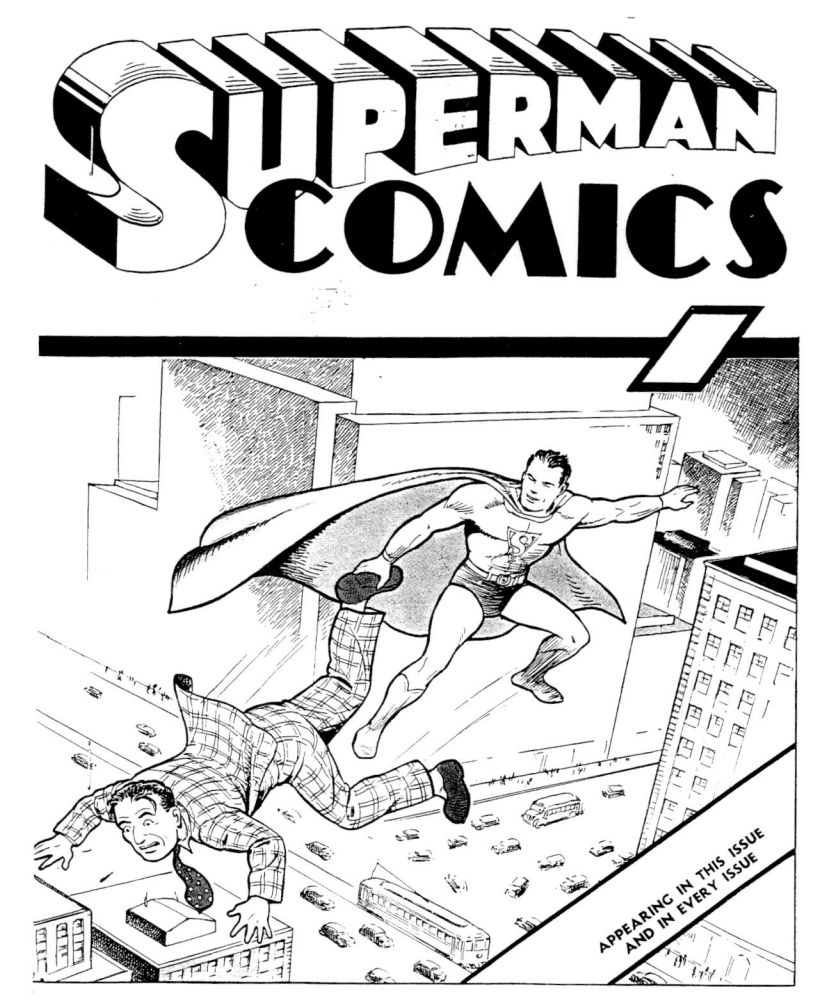

on lived in Connecticut, but the ashcans had survived.

Desris took the half-dozen books to a Chicago convention and sold the lot to Colabuono, the owner of Moondog's. He got a good enough price that he returned to Harrison and cleaned out the rest of his ashcan stock. Colabuono eventually bought them all. There was spirited bidding, he said, "but the people who wanted them didn't have the money, and the people who had the money were scared of them because there is no market for them." After all, many ashcans are one-of-a-kind items. There is no price guide. There are few, if any, in general circulation.

Almost all the known ashcans were produced by DC or Fawcett. "People have said Marvel did, but I've never seen one," Colabuono said. "They've said Fiction House did, but I've never seen one. I've never talked to anyone who's seen one."

Valuable ashcans. According to Gary Colabuono, the *Superman Comics* ashcan (above) is the most valuable, followed by *Wonder Woman* (left).
(© DC Comics, Inc.)

It was not unusual for ashcans for different titles to have the same cover—usually featuring a character unrelated to the title.
(© DC Comics, Inc.)

"You could take a damn toothpick and ink with it if your drawing is accurate."
RAFAEL ASTARITA

The best known ashcan race was the rush to secure the copyright for *Flash Comics* in 1939. DC beat Fawcett to the tape. Its ashcan featured the shark-infested cover of *Adventure* #41; Fawcett's had no cover art. Fawcett then retitled the book in an ashcan for *Thrill Comics,* but by the time that book reached the Library of Congress, Better/Nedor Publications already had dibs on *Thrilling Comics.*

So *Whiz* it was.

According to Colabuono, the five most valuable ashcans are:

1. *Superman Comics.* "By far the most treasured of all of them, with a great Superman cover from *Action* #1, and a Superman story inside. It says *Superman Comics* for the first time. It's unsurpassed in its rarity, importance, and value. It's by far the most valuable comic book in the world. Who agrees with me? I don't know who agrees with me. There are only two copies known to exist. It was in the files of the past president of the company, who may have even hand-stapled the thing together when he was a kid. Plus there's the fact that every Superman collection in the world doesn't have this. I have them both."

2. *Wonder Woman.* "It's the second most valuable because it has the cover to Sensation #1 and the Wonder Woman logo," Colabuono said. No ashcan for *Detective* #27 or *Batman* #1 has ever been found. "The Batman one, if one exists, has to be the second most valuable."

3. *Action Comics.* This ashcan has nothing to do with Superman; the cover art appears to be a Creig Flessel panel of a pirate with a dagger. Not to be confused with the *Action Funnies* ashcan, which surfaced first. The art for *Action Funnies* is the cover art for *Action* #3.

4. *Superwoman.* An idea whose time still hasn't come.

5. *All Star Comics.* Jon Warren owns the only known copy, which has the cover art of *Flash Comics* #1.

Astarita, Rafael

In 1956 Fred Hames pulled out the Manhattan telephone book, tucked it inside a plain brown wrapper, and shipped it off to his grandson in Arkansas. Hames Ware was on a mission, trying to track down the forgotten comic book artists from beneath a lamp in Little Rock . . . and he must have treated that book as if it were a treasure map.

He began to pore through the telephone book, page after page, jotting down the telephone number beside every name that sounded vaguely familiar, compiling a list that would become the rough draft for Jerry Bails's *Who's Who of American Comic Books.*

"Astarita was in the A's," Hames Ware said 35 years later. "Thank God he was."

Astarita—the name means "Little Star"—was, Ware would later discover, "the first artist to walk in and answer Harry Chesler's ad for the first comic book shop." In 1935 Astarita considered himself an artist in training; he loved to paint and he chose the comic shops—Chesler's, then Jerry Iger's, and later Fiction House—to perfect his style.

He chose Hames Ware to listen to his story. In ten years of letters and audio tapes, Astarita dug through his photographic memory and dumped the outtakes into Ware's mailbox. During the years that Ware poured into researching his old heroes, he confessed, "Astarita was like the Old Testament for me."

Astarita might not have approved. "It's wrong and unhealthy to live backward," he once said. "It's unnatural to have the dead control the living. I would regret becoming so mentally arthritic that I could only see virtue in the old and resist everything new."

He didn't see much virtue in the early days of the comics. "The stories were so uniformly poor that I don't think they could stand on their own," Astarita said. "I won't even make an exception of *The Spirit*. That story had a fairly good premise, but it wasn't original or unusual. It seemed so in comparison with the other things, which were really atrocious. The descriptions were poor. The dialogue was hardly to be believed. The writers had no concept of what kind of actions belonged in one picture."

And the editors? Don't get Astarita started on the editors. When he first met Chesler, Harry and his cigar were parked in a room off Fifth Avenue, empty save for a desk and two chairs. By the time Astarita walked out on Chesler for the last time, he'd decided the desk had the better personality.

Chesler was so cheap, Astarita recalled, that he gave his staff the choice of taking Thanksgiving or Christmas off, but not both. Not surprisingly, most of the staff chose Christmas, so for Thanksgiving dinner, Chesler

took the team down to Silver's Cafeteria for an atrocious meal.

"Rubber turkey and greasy gravy," Astarita said. "I hated Chesler so much for making us do that that I refused to eat anything. I wanted to punish him, so I said, 'No, I won't eat anything.' He said, 'Have some coffee, Astarita.' I said, 'I don't want any coffee.' He said, 'Have anything you want, price is no object, everything is on me.' I think I decided to have some orange juice. That's the only concession I would make to Harry Chesler at Thanksgiving."

When he couldn't take Chesler anymore, Astarita organized a walkout of the staff artists. All but Astarita walked as far as the front door, then slunk back to their drawing boards. Astarita kept right on walking, ending up at Jerry Iger's studio (see entry).

At Fiction House—where Astarita was best known for replacing Will Eisner on The Hawk and for Ghost Squadron in *Wings Comics*—George Evans remembered him as "the best of the artists up there. Raf did every picture as though he were Rembrandt, trying to create a first-class piece of work. He never got into the business of hacking it out on a formula basis.

"He inked a panel once on a dare with a toothpick," Evans said. "Everyone else was talking about the quality of the brushes going to hell... Winsor & Newton, even. If you were low-income like me, the company had some on hand called Favor Ruhl. I'd sooner ink with a squirrel's tail. While everyone else was moaning they weren't getting the effect they wanted because of the quality of the brushes, Astarita said, 'When the hell are you going to learn that a picture isn't based on a line that's thick here or thin there' (which cartooning is, to a degree). He said, 'You could take a damn toothpick and ink with it if your drawing is accurate. You're going to have a reasonably good picture when it's done.'

"John [Celardo] and Bob [Lubbers] challenged him: 'Put your money where your mouth is. I bet you can't.' And he did. They paid him up, grudgingly—'You son-of-a-bitch'—but they did it. And it was published, one of the panels in Captain Wings in *Wings Comics*."

Astarita came back to Fiction House after the service, then moved on to "salvage work" at Better Publications. "He languished in the comics," Ware said, "desperate to be doing something else. He couldn't understand people who didn't aspire to be more."

He did some ad work, and some trading cards for Topps, before finally disappearing with his paints. He left a big impact on almost everyone he met. "There was not one phony thing about Raf," Evans said. "He was uninhibited, outspoken... and he was right. I modeled a lot of my outlook after his."

Ware found him, many years later, to be "the most remarkable individual I have ever come in contact with. There wasn't a lie in the man. He was a fantastic artist... Chesler said Astarita was the finest artist of all he'd ever seen."

And Chesler was elated when he read Jim Steranko's *History of the Comics* and realized

An Astarita page from "Ghost Squadron" *(Wings #75, November 1946).*
(© Fiction House)

Astarita was still alive. Chesler begged Steranko for his phone number, then called the "Little Star" with one request. A decent Thanksgiving dinner? Hardly. Chesler pleaded with Astarita to give him some of his artwork so that Chesler could hang it on his wall.

Astarita thanked Chesler for his call and declined.

Atkinson, Ruth

Atkinson was a Fiction House artist in the 1940s who went on to become the art director there. She also drew romance comics and the early *Patsy Walker*s and *Millie the Model*s before leaving the fold for good in the early 1950s. Trina Robbins found and interviewed Atkinson in San Francisco shortly before the artist's death in 1997.

Atlas/Seaboard

How, Jeff Rovin once asked, could a company featuring the talents of Steve Ditko, Alex Toth, Wally Wood, Neal Adams, Walt Simonson, Jeff Jones, and Archie Goodwin collapse in little more than a year?

Because Martin Goodman thought he could run a 1930s-style comic book company in the 1970s.

And he did. Straight into the ground.

When Goodman sold Marvel and the rest of the Magazine Management Company to Cadence Industries, he couldn't sell the new owners on the idea of letting his son, Chip, man the bridge. So, Goodman gave Chip his own comic book company to play with.

From the beginning, noted Rovin, who signed on as an editor, Atlas was an intensely personal response to Marvel: "The bitterness [the Goodmans felt] about Chip's falling out was clear not only in the similar nature of the Seaboard titles in production and on the drawing boards but in the choice of Atlas as a name for the comics, Atlas having been a Marvel *imprimatur* during the 1950s."

Co-editing the Atlas color comics with Rovin was Larry Lieber, Stan Lee's brother, but Goodman ruled the roost. When Goodman announced, at one point, that Atlas would only hire Marvel artists and writers, Rovin handed in his resignation, only to be talked out of the gesture over lunch with Chip. On another occasion, Goodman, distraught over some "messy and confusing" cover art, told Rovin he would never sign another check made out to Jeff Jones.

Rovin didn't have the heart to tell his boss that he'd already bought two other Jones paintings.

Goodman didn't have the temperament to take advice, anyway. He'd christened one comic book company 35 years back; he knew what he was doing. By the time Goodman realized he no longer had the touch, the "NEW House of Ideas" was foreclosed.

Atlas checklist:, *Barbarians* #1, *Blazing Battle Tales* #1, *Brute* #1–3, *Cougar* #1–2, *Demon Hunter* #1, *Destructor* #1–4, *Devilina* #1–2, *Fright* #1, *Grim Ghost* #1–3, *Hands of the Dragon* #1, *Iron Jaw* #1–4, *Morlock 2001* #1–3, *Movie Monsters* #1–4, *Phoenix* #1–4, *Planet of the Vampires* #1–3, *Police Action* #1–3, *Savage Combat Tales* #1–3, *Scorpion* #1–3, *Targitt* #1–3, *Tales of Evil* #1–3, *Thrilling Adventure Stories* #1–2, *Tiger-Man* #1–3, *Weird Suspense* #1–3, *Weird Tales of the Macabre* #102, *Western Action* #1, *Wulf the Barbarian* #1–4.

Atlas Implosion

From Jim Vadeboncoeur's newsletter, *an indispensable extra* (with an assist from Brad Elliott):

If you pay any attention to the names in the Ownership Statements, you'll notice that up until 1952, Robert Solomon was listed as the Atlas Business Manager. In that year, a new name appears in that position: Monroe Froehlich, Jr. Remember him. He created comics as we know them. Honest!

In 1957, cover-date time, Atlas published 75 different titles (monthlies, bimonthlies, and one-shots) during the July through October period. In November and December of that year, it put out 16 (all bimonthlies). So what happened? And who the hell is Monroe Froehlich, Jr.? Here's the script.

Atlas/Seaboard Comics had some young talents doing covers—such as this one by Neal Adams.
(© Atlas/Seaboard)

The Setup: Atlas, as you may have known, was not really a comic company, but was in fact a distribution company. The comics were published by Martin Goodman's various corporations (Chipiden, Timely, Red Circle, etc.) and distributed by Atlas Magazines, Inc.: all legitimate incorporated entities. Atlas Magazines (wholly owned by the Goodmans, Martin and Jean) was paid a fee to distribute Goodman's comics. Profits, profits, profits.

The Catalyst: Monroe Froehlich, Jr. was Goodman's golfing partner who somehow finagled himself into the business manager position. He pretty much had a free rein with the comics, the pulps, and the newsstand magazines, but he was kept out of the distribution end of the business. Being apparently an ambitious sort, he wanted to expand his political base in the company to include some measure of control over distribution. Arthur Marchand was the man in charge of Atlas Magazines, Inc. and exerted every effort to prevent this.

The Ploy: As Froehlich was frustrated in his attempts to gain control over the distribution arm, he eventually resorted to some subtle business maneuvering to accomplish what office politics had failed to do. He somehow renegotiated the contract between the publishing arm and Atlas Magazines so that the latter received a lesser percentage of the price of each publication for the distribution service. On paper, Atlas Magazines, Inc. began to lose money.

The Sting: Froehlich exploited this apparent change in the distribution situation to convince Goodman that he needed to switch to a national distributor. In the summer of 1956, when Goodman gave the go-ahead, Froehlich negotiated a five-year contract with American News Co. (the ANC on the covers of so many comics in the early fifties) to distribute the comics, magazines, and Lion paperbacks. Goodman disbanded his distribution system and Froehlich was apparently "king of the hill."

The Zinger: The American News Co. was a mysterious outfit under investigation by the government for less-than-legal transactions of some sort. (ANC was into a lot more than periodical distribution—restaurants, for example—and it was there the troubles lay.) Rumors flew that ANC would soon be out of business. Even before the contract, Arthur Marchand had tried to warn Goodman of the potential problems, but he was viewed as merely playing in office politics against Froehlich.

The Crash: American News Co. assumed the distribution of the Goodman line November 1, 1956. Six months later, American ceased operations. Not having time to reestablish his old network, Goodman was forced to lay off the entire staff with the exception of Stan Lee, while he searched for an alternative distributor. It took about a month (corresponding to the October 1957–dated books).

The Aftermath: Goodman did find himself a distributor. It was DC-owned Independent News Co. They agreed to take him as a new account, but the terms were tough indeed: Independent would handle all of Goodman's magazines, but Lion Books had to go (IND was already handling New American Library) and, since DC wasn't about to support its biggest rival, IND insisted that only 8 comics per month could be accommodated.

Goodman and Lee opted to use that allotment to publish 16 bimonthly titles. The first 8 (*Gunsmoke Western, Homer the Happy Ghost, Kid Colt Outlaw, Love Romances, Marines in Battle, Millie the Model, Miss America,* and *My*

Jungle Action was one of 75 titles Atlas published in the mid-1950s.
(TM & © 1998 Marvel Characters, Inc. All rights reserved.)

> "Stan Lee would probably just be a name in an Ownership Statement, as it is only with hindsight that the occasional story he wrote and signed takes on any significance."
> JIM VADEBONCOEUR

Own Romance) came out dated November 1957; the second batch (*Battle, Navy Combat, Patsy and Hedy, Patsy Walker, Strange Tales, Two-Gun Kid, World of Fantasy,* and *Wyatt Earp*) in December. With inventory on hand to fill 75 titles, Lee simply cancelled 59 of them and hardly bought a story for over a year. Most 1958 material was produced in 1957.

It wasn't until December 1958/January 1959 that Lee gathered around him the core of what was to be Marvel Comics: Kirby, Ditko, Heck, Ayers, and Reinman.

The Results: Over the next few years Goodman was free to publish whatever he liked, but whenever he wanted to introduce a new title, another had to be sacrificed. (*Battle* died June 1960 to make way for *My Girl Pearl* in August, which faded away in April of 1961 to allow *Amazing Adventures* a slot in June.) They finally added a 17th title in 1961 and, ironically enough, it was *Fantastic Four*. But with the exception of annuals and reprint titles, that number, though Goodman had managed to upgrade most of them to monthly, held until early 1968.

It was time to renegotiate the contract with Independent News. At that point Marvel Comics was a force to be reckoned with in the industry, and IND didn't want to lose a good client. The restriction on the number of books was lifted and Marvel exploded. The three split books (*Tales to Astonish, Strange Tales,* and *Tales of Suspense*) spun off into six individual titles (*Iron Man, Captain America, Doctor Strange, Nick Fury: Agent of S.H.I.E.L.D., Hulk,* and *Sub-Mariner*), and *The Silver Surfer, Captain Marvel,* and *Mighty Marvel Western* were launched. [A year later, IND lost Marvel anyway, to Curtis Circulation Corp., a subsidiary of Marvel's new owner, Curtis Publishing, and Marvel really went wild!]

Historical Interlude: In 1957 Atlas was simply the largest comic company that had ever existed, but they had never been a leader or innovator. Goodman's empire had been built on selling paper, not innovation. If one western comic was good, ten were better. If super-heroes were selling, you can bet your boots that Atlas would have been publishing them indiscriminately.

Stan Lee *had* resurrected the Marvel/Timely heroes in 1953, dropping most after three or four issues. In fandom lore, DC has been credited in 1956 with bringing super-heroes back from their oblivion in the dark ages with the appearance of Flash in *Showcase* #4. The reality is that it had been only seven years since the original *Flash* comic; *Batman* and *Superman* had continued uninterrupted during that time; and the marketplace was *not* clamoring for more of them.

DC was giving their heroes tryouts in *Showcase* and as backup features, but none was setting the stands on fire. It wasn't until Atlas self-destructed in 1957 that rack space opened up for a potential resurgence of the genre. It would still be over a year before the Flash got his own book.

Two of the 1958 Atlas titles that featured inventory material stockpiled during Atlas's glory years.
(TM & © 1998 Marvel Characters, Inc. All rights reserved)

The Legacy: Monroe Froehlich's abortive attempt to manipulate Goodman's empire left Goodman with a scaled-down operation. Its size was artificially held at a level where it was feasible for one man (Stan Lee) to actually control the content of *all* the books. He couldn't get bigger, which had been the goal for the previous 17 years, so he ended up getting better.

The pre-super-hero Marvel stories were done originally with tongue in cheek, but they soon developed a moral stance reminiscent of EC. Lee was getting interested in comics again. When Goodman asked him to develop a superhero team, he could easily have brought back all of the old Timely characters with which he was so familiar—just as he'd done back in 1954. Instead, he expended some creative effort to think of something innovative for a change. Those early Marvel super-heroes were indirectly created by Froehlich, whose actions allowed Lee and the bullpen to devote the time and thought necessary to the creation of interesting characters.

If Atlas had continued to expand through the late fifties, it is extremely doubtful that comics as we know them today would exist. Stan Lee would probably just be a name in an Ownership Statement, as it is only with hindsight that the occasional story he wrote and signed takes on any significance. Lee, or more properly his writing staff, would have continued to churn out a full spectrum of romance, teen, war, and western books (just look at the list of titles that continued after the implosion …), and super-heroes wouldn't exist in the same sense they do today. Oh, we'd have heroes aplenty, but they'd be the same stale commodity they had been, with only slight variations on the theme.

There would probably be no "continuity," no "angst," no "universes," nothing but that formula which had served so well for decades … until a coercive business contract, precipitated by the actions of Monroe Froehlich, Jr., put spare time into the hands of Stan Lee for the first time in his life.

The Atom (Golden Age)

At 5-foot even, Al Pratt, the Golden Age Atom, towered over many of the sidekicks and half-pints of the Golden Age, but he was a lightweight until a washed-up boxing trainer whipped him into shape.

Created by Bill O'Connor and Ben Flinton, the Atom first appeared in *All-American Comics* #19 (October 1940) and later muscled his way into the back pages of *All Star Comics* and, afterward, *Flash Comics*. But he was a bit player until Harry Truman revived his career by tossing two atomic bombs at Japan in 1945. The Atom rode the shock waves of the public's fascination with the bomb for another five years.

The Atom (Silver Age)

Gardner Fox, a veteran of numerous revivals, handled the introductions for the Atom's first appearance in *Showcase* #34 (Sep-

The Silver Age Atom, as depicted by Murphy Anderson (The Atom #2, September 1962).
(© DC Comics, Inc.)

Atomic Bomb Covers

Action #101 (October 1946)

Adventures of Rex the Wonder Dog #11 (September 1953)

Atom-Age Combat #1 (St. John's, June 1952)

Atom-Age Combat #2 (Fago, January 1959)

Atoman #1 (February 1946)

Atomic Attack #5 (January 1953)

Atomic War #1 (November 1952)

Atomic War #3 (February 1953)

Black Cat #35 (May 1952)

Captain Marvel #66 (October 1946)

Captain Marvel Jr. #53 (August 1947)

Fightin' Navy #74 (January 1956)

Forbidden Worlds #14 (February 1953)

G.I. Combat #32 (January 1956)

Mystery in Space #56 (December 1959)

Picture Parade #1 (September 1953)

Real Facts #15 (July/August 1948)

Real Life #27 (January 1946)

Science Comics #1 (January 1946)

Showcase #23 (December 1959)

Spy Cases #8 (December 1951)

Strange Adventures #226 (October 1970)

True Comics #47 (March 1946)

Weird Science #5 (January 1951)

Weird Science #18 (March 1953)

World War III #1 (March 1953)

tember/October 1961). A scientist at Ivy University, Ray Palmer (the name was Julius Schwartz's homage to the editor of *Amazing Stories* and *Weird Tales*) used a dwarf star lens to shrink his 6-foot frame into a 6-inch package. The Atom snuck into his own book in the summer of 1962.

Atomic Knights

These six ironclads debuted in *Strange Adventures* #117 (June 1960), in a story written by John Broome and illustrated by Murphy Anderson.

Gardner Grayle pops out of an amnesic stupor in the late 1980s to find a world stripped of plants, animals, and humanitarians by the Super–H bombs of World War III. What's left is ruled by the nuclear "raguns" of the Black Baron ("He runs this town with an iron hand! If you want to eat, you have to lick his boots! But you don't look like a bootlicker, Gardner—or act like one.") Grayle and five other volunteers don handy suits of armor, which fit like spandex and still provide sterling protection against raguns, and clang off to establish a brave, new world.

The series was unique, suggested comics historians Will Jacobs and Gerard Jones, "because it represented the only instance in the Schwartz science fiction universe in which science, rather than elevating and benefiting mankind, has wrought terrible destruction."

By *Strange Adventures* #160, science finally proved too much for the knights. And years later, fiction caught up to them. After a *Dallas*-style sacrifice to DC continuity, in *Crisis on Infinite Earths*, the Knights were just a dream.

Aunt May

If Spider-Man is royalty in the Marvel Universe, Aunt May is the royal pain in the ass.

Aunt May. That's "aunt" as in "fire ant."

You want the highlights? Her first appearance was in *Strange Tales* #97, believe it or not. As Ben Streckler wrote in *Overstreet Update* #15:

"In a Lee/Ditko story entitled 'Goodbye to Linda Brown,' two characters bearing more than casual resemblance to Peter Parker's guardians are featured prominently and identified as 'Aunt May and Uncle Ben.' No surname is given for the couple, and the story does not contribute to the Spider-Man continuity, but hey, how could it? This issue, dated June 1962,

predates *Amazing Fantasy* #15 by three months. Even more significant is the fact that this is the only story Uncle Ben lives through."

May's first words: "I cooked your favorite breakfast, Petey—wheatcakes!"

And let's give ol' Aunt May credit: She gives Petey his first camera (Uncle Ben's, of course), introduces him to Mary Jane Watson, and inspires Ditko's most famous scene, the one in *Amazing Spider-Man* #33 wherein Spidey overthrows Bethlehem Steel.

Then there's this immortal exchange between two doctors from *Amazing Spider-Man* #31. When one doctor suggests they run the tests again, the other responds, "Very well, but the results are sure to be the same! All the evidence points to the same inescapable conclusion…The poor woman can't last much longer."

Yeah, right. Only another 30 years . . . when May finally kicks the can in *Amazing Spider-Man* #400.

In *Amazing Spider-Man* #1–#128 (or until the Punisher replaces Aunt May as the biggest pain in the Marvel universe), May has a total of 22 bedridden issues, 85 bed pan(el)s, and 15 wheelchair panels.

Want to avoid the old Biddy? Try *Amazing Spider-Man* #8, #35–#37, #51, #52, #62–#65, and 34 of the issues between #71 and #128.

Key issues (all *Amazing Spider-Man*): #4, first time seen on a bed; #9, first time bedridden; first visit to a hospital; first operation; first sedative; first gurney; #10, first blood transfusion; #15, first attempt to arrange a marriage for Peter; #17, "Another heart attack"; #18, first appearance in a wheelchair; #29, first near faint; #32, FIRST COVER: And yes, lying on a bed! Eyes closed! Chin protruding! Rigor mortis en route; #43, "Aunt May! What's wrong? You look so pale—so listless!" #54, second cover; fainted, of course. "At her age," Dr. Bromwell says, "the next such attack could be fatal!" #96, DRUG ISSUE: and is it any coincidence that Peter notes, "And now, Aunt May—looking happier than I've seen her in months"; #115, finally makes the cover with her gun drawn; #123, asks the tantalizing question, at Gwen Stacy's funeral, "Why do old fools like me live on …?"

The Avengers

The original quintet—Thor, Iron Man, the Hulk, Ant-Man, and the Wasp—strolled into the Marvel Universe in September 1963 in *Avengers* #1. Three issues later, Captain America reappeared . . . on the rocks.

The Avengers were a Stan Lee–Jack Kirby production, although Kirby only penciled the first eight issues. Lee and Kirby had created the Fantastic Four two years earlier to cash in on the success of DC's Justice League of America. The Avengers *was* their JLA.

Who hasn't joined the club at one time or another? Give us a moment. We'll think of someone.

Key issues: #4, first Silver Age appearance of Captain America; #5, Hulk gets cold feet; #16, new lineup; #28, new Giant-Man in old lineup; #63, new Yellowjacket, new Goliath, same old tired plots; #70, no new lineup changes; #150, new lineup; #181, new lineup; #183, Ms. Marvel lines up; #200, Ms. Marvel jumps out of line; #211, new lineup; #213, Yellowjacket lines out; #221, new lineup; #230, Yellowjacket lines out again; #297, 1990 census reveals Avengers have more members than United Auto Workers.

Avery, Tex

The co-creator of such Warner Bros. stalwarts as Bugs Bunny, Daffy Duck, Porky Pig, and Elmer Fudd, Tex Avery was born in Taylor, Texas in 1908, a descendant of Judge Roy Bean.

Avery began working as an animator with Walter Lantz in the early 1930s, a stint marred by the loss of his left eye to a co-worker's rubber band and paper clip. Avery joined Warners in 1935 and was immediately thrust together with Chuck Jones and Bob Clampett. Much tamer than his later MGM work, his Warner cartoons included the debuts of both Daffy Duck (*Porky's Duck Hunt*) and Bugs Bunny (*A Wild Hare*).

In 1941 Avery moved to MGM, where he ran his own cartoon unit for the next 13 years, fashioning such characters as Screwy Squirrel, Droopy Dog, and Red Hot Riding Hood. His cast always had a rougher edge than the crew over at Anaheim, Avery said, "because we couldn't top Disney, and we knew he had the kid following, so we went for adults and young people."

Known for his timing, double-takes, and erotic innuendo, Avery produced his most famous cartoon—*King-Size Canary*—in 1947. He died of cancer in 1980 at the age of 72; 14 years later, his impact on cartoon action helped animate *The Mask*.

"Tex never understood the quality and extent of his own genius," Heck Allen, Avery's "story-man" at MGM, once told Joy Adamson. "Otherwise he would have simply picked up his briefcase, gone up on the front lot, and said, 'I'm Tex Avery. I can make you the funniest goddam live-action pictures you ever saw in your life, and we'll get rich together'. But he never did …

One of many crises in the life of Aunt May. From *Amazing Spider-Man* #31 (September 1965).
(TM & © 1998 Marvel Characters, Inc. All rights reserved)

"The poor woman can't last much longer."
AMAZING SPIDER-MAN #31

Lem, a character Tex Avery created for MGM in 1946 for *The Hick Chick* cartoon.
(© MGM)

One of Wally Wood's Avon covers: *Strange Worlds* #4 (August 1951).
(© Avon Periodical Publications)

"The most unbelievable thing was that they didn't appreciate it, that they didn't snare him and elevate him to the papacy of humor on the front lot. Tex could have been a Frank Capra or whatever at this business, could have gone completely to the top. The cartoon business is full of brilliant people like that who never get heard of. Their tragic flaw is that they're hung up on these goddam little figures running around on that drawing board."

Avon Periodicals

Far better known for its paperbacks, Avon published the first horror comic—*Eerie* #1 (January 1947)—and numerous other books that sent chills up any connoisseur's spine.

When Avon brought *Eerie* back in 1951, the book ran another 17 issues, but most of Avon's horror titles were one-shot anthologies such as *Secret Diary of Eerie Adventures* and *Night of Mystery*. As you might expect from a book publisher, Avon loved one-shots, including *The Hooded Menace* (1951), *Earth Man on Venus* (1951), and its first comic, *Molly O'Day* (February 1945).

Avon hit its peak in the early 1950s when Wally Wood, Joe Orlando, and Harry Harrison worked under the direction of Sol Cohen. Wood did at least 270 pages of interior art for Avon, as well as the covers for *Eerie* #2–#5, *Mask of Dr. Fu-Manchu*, *Rocket to the Moon*, and *Strange Worlds* #4–#6.

In 1956 Avon quit the field. Cohen was the last soldier on duty. "Avon was on the rocks, going bankrupt, all the editors had quit because they couldn't afford to pay them, and only Sol hung on for a share of the corporation," Harrison said. "He was the whole corporation, in fact."

Axa

A British good-girl comic strip, *Axa* boasted art by Enrique Romero, story by Donne Avenell, and reprints by cat yronwode. Romero and Avenell are veterans of such titillating strips, Romero having taken over *Modesty Blaise* after Jim Holdaway's death and Avenell writing *Tiffany Jones*.

Axa needed three strips to bare her breasts for the first time, explaining, "Free is beautiful." And full-figured. Free is full-figured.

Her adventures take place in the year 2080, in an age when sex is "a matter of hygenic selection . . . not passion." The strip is spiced with lines such as, "Someone tried to kill me . . . and all you're worried about is my nakedness! What kind of people are you?"

Why, your typical comic book readers.

In his introduction to a 1983 Ken Pierce reprint of *Axa*, C. C. Beck wrote, "Above all, Axa is believable; she has no X-ray vision, she doesn't fly around like Peter Pan, she doesn't pull up continents and divert colliding galaxies. She's just a Little Orphan Annie with tits and I love her."

Pierce edited the final line to read, "She's an innocent little girl, and I love her."

Ayers, Dick

A prolific inker for both Marvel and DC, Dick Ayers refused to share the details of his life, lest they steal the thunder from his own book. But as John Buscema put it, "Who the hell is going to buy a book by Dick Ayers?"

Ayers was Jack Kirby's shadow through most of the 1960s. "He was very prolific, I was also prolific, so Stan kept the two of us together," Ayers said. "I'd ink seven pages a day. Stan always stressed, 'Don't trace.' If he wanted someone to trace, he could pull in anyone off the street. He wanted someone to embellish."

By Ayers's count, he embellished 18,132 pages between 1947 and 1989: 10,300 for Marvel, 4,190 for DC, 1,189 for Magazine Enterprises, and the rest for Archie, Charlton, Western, Skywald, ACG, and several others.

Bad Guys

Every great hero has an imaginative villain who seeks to destroy him and helps to define him. Match these villains with the heroes who had to stretch to beat them:

1. Beagle Boys
2. Captain Nazi
3. Dr. Doom
4. Dr. Sivana
5. Green Goblin
6. Joker
7. Kingpin
8. Lex Luthor
9. Loki
10. Red Skull

a. Superman
b. Captain America
c. Daredevil
d. Thor
e. Uncle Scrooge
f. Captain Marvel Jr.
g. Captain Marvel
h. Spider-Man
i. Fantastic Four
j. Batman

[Answers: 1. e; 2. f; 3. i; 4. g; 5. h; 6. j; 7. c; 8. a; 9. d; 10. b.]

Bagge, Peter

Bagge is the real Generation X-man. After doing some early work for such magazines as *Screw, High Times,* and *Swank,* Bagge succeeded Robert Crumb as the editor of *Weirdo* in 1984. The cartoonist went on to do his own popular titles for Fantagraphics: *Neat Stuff* and *Hate.*

Why *Neat Stuff*? "I was very much wallowing in junk culture ... like Big Daddy Roth, and old Topps bubblegum cards," Bagge said in *Amazing Heroes.* "I was researching that kind of thing, since I was beginning to edit *Weirdo,* and I wanted to reprint a lot of that stuff ... Plus at the time I was living in the suburbs without any transportation, so that's all I had to live for—this garbage. I was watching all the repeats of the old *Dick Van Dyke Show.* It was pretty disgusting."

Baily, Bernard

A graduate of the Eisner-Iger shop, Baily designed the Golden Age Spectre and his sidekick, Percival Popp the Super Cop. He joined National (DC) in 1938, drawing the likes of Hourman, the Buccaneer, and Tex Thompson. But the highlight of the artist's résumé may be the string of 11 covers he drew for Gilmore Publications' *Weird Mysteries* from 1952 to 1954. The gallery—particularly the covers featuring a dagger through the eye of a skull (#4—see **Horror Comics** entry) and a brain transplant (#5)—are considered two of the truly memorable snapshots from the pre-Comics Code horror scrapbook.

Baily opened his own shop in the mid '40s and provided art for the likes of National, Marvel, Archie, Harvey, and *Cracked* through 1962.

Bails, Jerry

One of the founding fathers of comics fandom has long been a science teacher at Wayne State University in Detroit.

Bails dissected his first full run of *All Star Comics* and glued the pieces into a scrapbook. He treated his second set with considerably more respect.

Bails admits that he succumbed to "real addictive collecting" in 1960, two years after rediscovering the Flash in *Showcase* #13. He managed to complete his set of *All Star Comics* that year when he purchased the private collection of Gardner Fox.

Bails and Roy Thomas—who were both deluging Fox with letters in the early 1960s—published the first issue of their fanzine *Alter Ego* in 1961.

"I believe that Roy and I were somewhat instrumental in encouraging Gardner and his editor, Julie Schwartz, to bring back other heroes, especially Hawkman and the Atom," Bails said in a 1992 interview. "I do know that we both bombarded DC with scores of letters. Issue #4 of *Justice League of America* is filled with letters from me under different pen names. Don't blame Julie for this. I did everything I could to fool him, including mailing the letters from all across the country."

Bails published the first adzine, *The Comicollector;* founded CAPA-Alpha and the Alley Awards; published the *Collector's Guide: The First Heroic Age* in 1969; and has spent 35 years stuffing names and numbers into the *Who's Who of American Comic Books.*

Although he helped Shel Dorf set in motion the Detroit Triple Fan Fair in 1965, Bails told Bill Schelly that he quit attending comic conventions when "they became overcommercialized and lost the sense of intimacy that I loved."

Baker, George

Twin tours of duty, the first with Disney and the second with the Army, prepared George Baker for his final maneuver: the creation of *Sad Sack.* The pathetic private, who first appeared in *Yank* in May 1942, stumbled into

Jerry Bails

Peter Bagge

Matt Baker's covers for *Phantom Lady* are highly prized by collectors.
(© Fox Features Syndicate)

An example of Baker's interior art, from *Jumbo*.
(© Fiction House)

his own newspaper strip in 1946 and reached Hollywood in 1958 in a film with Jerry Lewis in the title role.

Baker, Matt

Matt Baker left a lot of mysteries behind. Did he die of that legendary bad heart, or in a bar fight? And did the comics field offer any refuge from the animosity that was routinely directed at any black man in the turbulent, segregated '40s and '50s? We may never know anything for sure, save this: No one could draw beautiful women like Matt Baker. Black or white. Then or now.

Born in Homestead, Pennsylvania, a black township on the outskirts of Pittsburgh, Baker was 21 when he joined Jerry Iger's shop in 1944.

A year later, Ray Osrin—today one of the few surviving members of Iger's studio—arrived. A high school dropout, Osrin admits he wasn't the most ambitious kid in the world. He was spending his summer playing stickball in Brooklyn. Now and then, he'd stiff-arm his nagging mother by telling her he'd go to work when a comic book studio ran an ad in *The New York Times* seeking a talented apprentice, 17 years or older, who could learn the business and the art of inking pages.

"And damn it," Osrin said, "if that wasn't the ad that ran. I started at $25 a week and swept floors and delivered pages to Fiction House. In a studio full of people, Matt Baker was the only guy who reached out to me."

For the next dozen years, they were steadfast friends, an unusual alliance even in New York City. Baker was godfather to Osrin's first child and was Osrin's first choice to be the best man at his wedding. "My father was from Johannesburg in South Africa, and Matt turned me down, thinking my father would object," Osrin said. "He wouldn't have, but Matt thought it wasn't right for the time."

They were a good team from the beginning, Osrin putting his ink down over Baker's pencils. If Baker had a weak spot, it was with deadlines. "Matt had a reputation—at least when I knew him with Jerry Iger—for not meeting a deadline or two, and being pretty cavalier about it," Osrin said. "He often said it was his heart. Most people thought that was an excuse, but in those days, because he was black, people would say, 'He's just a lazy guy.' When he wanted to work, he worked like a bastard. He kept a lot of inkers going.

"He was my hero and my idol," Osrin said. "I got a real education being his friend. He taught me a lot about eating, about dressing. He wore his clothes magnificently. He could have been a male model. His big expense was clothes, and he looked great in them. I always envied him because I was a short, fat guy."

Baker and Osrin worked together at Iger's until 1949, then switched over to St. John for the next eight years. As Baker became more successful, he supported his mother back in Homestead and his brother, John, who worked in a dry-cleaning store. John had some of his brother's talent, but not enough. Matt got him an occasional job, but his brother kept sliding back to the dry cleaner's.

When Baker wasn't drawing Phantom Lady, he was often listening to Sarah Vaughn. When he wasn't dancing with *Flamingo,* his only syndicated strip, he was out in his yellow convertible, playing the field. "He had girlfriends," Osrin said. "I saw him with lots of women, and they were crazy about him. When I heard the rumor he got killed in a fight at a dance hall in Harlem, I never even tried to track that down.

"He could draw like a son of a gun. His sense of anatomy was superb. He drew the most beautiful women in comics. He prided himself on that. Publishers loved guys who could do that. They were really only good when he inked them himself. I inked many of his women, and Lou Morales inked them, but they were never as good."

Osrin understood that Baker had suffered rheumatic fever as a child, weakening his heart. He was with Baker several times in New York when he had what Osrin called "spells," including one at the automat, their favorite hangout. "We were just sitting there one day and he started to become ill. He turned ashen, almost

white. It wasn't a heart attack, probably a fibrillation." And it wasn't enough to call a doctor. Osrin simply took Baker back to his apartment and helped him to his medication.

By 1957 Osrin had soured on comics. "The witch hunt," he explained. "I had little children by that time, and it was an embarrassment; some kids weren't allowed to play with my kids." So he quit St. John and headed for Pittsburgh. While Osrin drew unemployment and waited for his lucky break (which turned out to be a cartoonist job with the *Pittsburgh Press*), Baker mailed him pages to ink. "Out of kindness. Just to tide me over," Osrin said. "He was that kind of guy."

Fellow artist Lou Cameron remembers bumping into Baker at Bloomingdale's in 1959. "He was working, looking prosperous and natty," Cameron said. It couldn't have been much later when the phone rang in Pittsburgh, and Osrin's wife came in to tell him that Matt Baker was dead of a heart attack. Because he couldn't afford the airplane ticket, Osrin didn't go to the funeral. But more than 30 years later, "Matt Baker" is the only name he needs to hear to bring him running for the phone.

Matt Baker covers: *Apache* #1; *Approved Comics* #6, 9, 11, 12; *Authentic Police Cases* #6, 8–20, 22–24, 29, 31, 33–38; *Blue Ribbon Comics* #2, 4, 5; *Canteen Kate* #1–3; *Cinderella Love* #15, 25, 29; *Classic Comics* #32 ("Lorna Doone"); *Crime Reporter* #2, 3; *Crown* #4–7; *Exotic Romances* #27, 31; *Fightin' Marines* #1, 3, 5–10, 15; *Giant Comics Edition* #5, 6, 11, 12, 15; *Going Steady* #10–14; *The Hawk* #8–12; *Love Diary* #42; *Northwest Mounties* #4; *Phantom Lady* #13–23; *Pictorial Confessions* #1, 3; *Pictorial Love Stories* #1; *Pictorial Romances* #5–17, 19, 21–24; *Record Book of Famous Police Cases* #1; *Romance and Confession Stories* #1; *The Saint* #4; *Seven Seas* #3–6; *Strange Mysteries* #19; *Teen-Age Romances* #1–3, 9–27, 31–45; *Teen-Age Temptations* #1–9; *The Texan* #4–11; *3D The Hawk* #1; *True Love Pictorial* #2–11; *Vooda* #20–22; *War-Time Romances* #1–18; *Western Bandit Trails* #1–3; *Wild Boy of The Congo* #12–15; *Zago* #4

Matt Baker art: *All Picture All True Love Story* #1; *Anchors Andrews* #1; *Bride's Romances* #15, 18, 22; *Crown Comics* #2–8; *Dear Lonely Heart* #3; *Exotic Romances* #27, 28, 30, 31; *Fight* #36–60, 62–65, 67; *Four Color* #588; *Fugitives From Justice* #2; *Gunsmoke Western* #34, 56; *Journey into Fear* #1; *Jumbo* #69–130; *Jungle* #101–103, 105–113, 115, 116, 156, 157, 159; *Movie Comics* #2–4; *Northwest Mounties* #1–3; *Phantom Lady* #1; *Planet Comics* #55–59; *Quick Trigger Western* #12; *Rangers* #36–38; *Robin Hood Tales* #2–5; *Select Detective* #1, 2; *Voodoo* #1, 2, 4, 8, 19; *Weird Adventures* #1; *Whodunit?* #1

Bangs

"We used exclamation points for periods," Bill Gaines said at the 1972 EC Fan-Addict Convention. "This was something that came out of comic book writing,* but we did it, I think, far beyond any other comic house, and it got to the point where there was no such thing, literally as a period in an EC comic. Periods were exclamation points. We called them 'bangs.' You know, 'The man came down the road. Bang. What did he want? Question mark. He wanted to rape six women. Bang, bang.'"

The only writer who ever complained, Gaines said, was Ray Bradbury. "Bradbury couldn't stand those bangs. And somewhere along the line, you may notice that the bangs disappeared from Bradbury's stories. The latest stuff didn't have it because he never could get used to it. All our readers were used to it. We were used to it; we were so used to it we didn't notice it."

*Exclamations and ellipses were often used in the early days of comics due to the poor quality of printing; periods often didn't reproduce. In *Punctuate It Right!*, Harry Shaw lectures, "When you do use an exclamation mark, use only one. Adolescents and comic-strip writers try to intensify by using two or more in one place; don't make this mistake yourself."

Barks, Carl

I think love in professional comics died about the time Carl Barks retired.
DWIGHT DECKER

I am pleased to see reprints of my works, especially as I thought the ducks and their adventures to be mere blips on the radar screen of human forgetfulness.
CARL BARKS

In the beginning, Donald was just a duck. A silly, stupid duck. He had neither nephews nor nemesis. Personality? Character? C'mon, he

Even a typical husband-wife conversations is fraught with exclamation marks in an EC comic.
(© 1998 William M. Gaines, Agent, Inc.)

Carl Barks's oil paintings are highly prized in the collectors market.
(© The Walt Disney Co.)

was just a duck. He had no charm. No future. No storyteller.

And then who should come along but Carl Barks, the son of eastern Oregon wheat ranchers and a survivor of what he would later call that "windy, dusty, profitless life."

In stories that first appeared in 1942, Barks supplied the Duck with flesh and blood. He gave Donald an uncle (Scrooge McDuck), three nephews, a home (Duckburg), a passport—Barks sent the Duck clan all over the globe—and an audience.

Barks didn't do this for Disney Studios. Disney and its animators didn't have much truck with the Duck. "They never did anything with comic books," said Don Rosa, an artist who grew up on Barks's stories and has never outgrown his love for them. "All Disney ever did was produce movies, run theme parks, and sue people. Those were their three industries.

"Disney just used Donald Duck and Mickey Mouse as actors, more or less," Rosa said. "They were images. Dell [Comics] turned both of them into true characters. And it's Barks who defined the character of Donald Duck for comic books, the only place where the character was ever developed."

Once Barks signed on as the ducks' official storyteller, Donald became quite famous. So, of course, did Disney. Donald toured the world. Disney swallowed central Florida. And what of Barks, whose comics sold 3 million copies each during most of the 1950s and captivated an estimated 10 million readers?

He ended up in Grant's Pass, Oregon, ducking publicity, a virtual recluse. In 1983 he returned to the same valley where he had weathered the Depression, expecting to age mellowly in a rocking chair and die with a paintbrush in his hand. But it just didn't work out that way. The enduring charm of his Duck stories did not subside; they were reprinted for an entirely new audience. The oil paintings he's been doing for the past 20 years—often recreations or variations of his most famous covers—have sold for as much as $200,000. Now in his 90s, Barks makes $6,000 a day when he paints, according to Bill Grandey, one of the overprotective managers at Barks's studio.

And on a 1994 tour of Europe, one queen, two presidents, eleven mayors, and countless ambassadors got in line to pay their respects. Why? Because, Barks said, "The people in Europe like to read. In some countries in Europe 97 percent of the people read stories about Uncle Scrooge and Donald Duck."

They read stories by Carl Barks. They gratefully surrender each month to one of the most imaginative and prolific storytellers the comics have ever known.

Barks's amazing life began in the wind and dust of Merrill, in southern Oregon. "My dad's ranch was one square mile," Barks said. "We had no irrigation. I plowed the same acreage year after year with horses. I would ride my horse, Spunky, five miles into Merrill as a diversion. In those days, there were people in my life that had fought in the Indian wars, true cowboys well-armed, and those that had come over the Oregon Trail."

Those days were the opening act in a life that Barbara Boatner, an authority on Barks, once

observed could have been "written for pathos: a harsh isolated childhood, few friends, long hours of work, an early loss of hearing, his father's breakdown and mother's death (when Barks was 15), his many years of demanding physical labor and two failed marriages."

But Barks was as resilient as he was resistant to self-pity. "I didn't draw through a veil of tears," he told Boatner. And he didn't pack a broken heart. He moved on with a sense of humor and perspective, gifts from "the cowboys, ranchers, loggers, and steelworkers with whom I worked before I broke into the 'soft' field of cartooning."

They were "all satirists," Barks wrote in a letter to a fan. "They had the ability to laugh at the most awesome miseries. If they hadn't seen the humor in their hard-bitten lives, they'd have gone crazy."

Barks's stint as an animator at Walt Disney Studios began in 1935. In the early 1930s, he sold cartoons—some surprisingly bawdy—to the *Calgary Eye-Opener* and freelanced whatever it took to dodge the breadlines. When he won a tryout with Disney, he couldn't afford the trip to Hollywood, so Disney sent him a plane ticket. The company was adequately compensated: Barks worked in Disney's story department for seven years and helped turn Donald Duck into the company's premiere attraction.

In 1942, his sinuses frazzled by the studio's air conditioning, Barks took his leave. "I got wind Western Printing and Lithography was in need of stories and art for original Disney comics," Barks once wrote, "so I did a little art for them while still in the studio. My first comic book work was for 'Donald Duck Finds Pirate Gold' in 1942 . . . I took a chance, quit Disney, and moved to the San Jacinto desert to dry out my sinuses and raise chickens. Luckily, I caught on quick with Western. I started to do them a few Donald Duck 10-page stories in my spare time and was soon so swamped with work, I gave up the chickens and went into full-time Duck production. My first full-length story-and-art combo was 'Donald Duck and the Mummy's Ring' in 1943."

Writing and drawing stories for Western, Barks mined humor from the gag-smitten lives of the Ducks. He yoked Donald and his strong supporting cast to "human frailties like greed, pride, and arrogance." He pitted them against "the perversity of beasts, machines, and nature" that he knew by heart.

And whenever the ducks had reached the mischievous limit in Duckburg, Barks—inspired by the photographic essays in *National Geographic*—transported Donald, Scrooge, the nephews, and his readers on one treasure hunt after another. They invaded the Land of the Totem Poles. Volcano Valley. Atlantis. The Andes, in search of square eggs. Underground with the Terries and the Fermies and on to the lost paradise of Tralla La.

His goal? "Escapist entertainment." A yarn that survived, even if the comic book didn't.

In that light, Barks's greatest creation was Uncle Scrooge. Scrooge was the successful entrepreneur that Barks wasn't. They had the same work ethic, but only Scrooge hit the jackpot. It once took Scrooge 13 years to count the coins inside his impervium-metal money bin. He loved to dive like a porpoise into his three cubic acres of cash.

The most Barks ever got paid for a page of story and art was $45.50. "My wallet didn't fatten up until I was 85 years old," Barks said. "It has made no difference in my life, as I have all my earlier spending habits. My accountant likes my style."

When Barks started, comic books were hack work, a grimy little detour for the cartoonist who couldn't land a Sunday comic strip. Barks wrote through the '50s, when censors and philistines condemned comics as the devil's work. By

Carl Barks

"My wallet didn't fatten up until I was 85 years old. It has made no difference in my life, as I have all my earlier spending habits. My accountant likes my style."
CARL BARKS

Uncle $crooge, Carl Barks's most memorable creation.
(© Walt Disney Co.)

the time he "retired" to Oregon with his wife, Garé, in 1967, super-heroes were the rage, the collecting staple.

Barks and the Ducks have outlived the mood swings. By the time he toured Europe, even Disney—which could never repay Barks what it owes him—wanted to horn in on the celebration. Euro-Disney had 120 trained ducks prepared to "honk" Barks a belated happy birthday.

That's right, ducks. Silly, stupid ducks. The mold the Duck Man broke.

Barney Google

Barney Google's self-titled comic strip debuted on the sports pages of the Hearst papers on June 17, 1919. Created by Billy DeBeck, Google was a boxing buff until he intercepted a nag named Spark Plug, who was earmarked for the "gravy train." Spark Plug won the $50,000 Abadaba Handicap the first time he stepped foot on a track, and kept plugging away until he gained equal billing in the strip *Barney Google and Spark Plug*. Google was later upstaged by another DeBeck character, Snuffy Smith.

DeBeck created a lot of hits for the *Dictionary of American Slang,* including such phrases as "heebie jeebies" and "horse feathers."

Comics

Comics ... 90 percent of them are trash. They're scum. They're written by idiots who are dragged off the street. Who've never lived real lives. Who don't know how to write. Who have no experience in the real world. There are certain large publishing houses which refuse to hire real writers. They'd rather hire the janitor down the hall. They absolutely insist on in-house production of their books. They don't care about talent.

MIKE BARON
THE COMICS JOURNAL, 1986

Mike Baron

Baron, Mike

When he wasn't mincing words, Baron created Nexus and the Badger, the former with Steve Rude. A graduate of the Boston alternative press in the early 1970s, Baron is a devotee of both kung-fu and Carl Barks. He wrote to Barks throughout high school. "He answered every letter," Baron said. "When I was so young and stupid as to be pre-venal I requested an original drawing of Uncle Scrooge. It's now framed on my wall . . . When I write The Badger I often think of those Uncle Scrooge stories and the way he would develop tension and plot and throw in real danger and yet keep the humor. So, to me, he is the greatest of comic book storytellers."

Baron has been a mainstay comics writer for both DC and Marvel, having put in memorable stints on both *The Flash* and *The Punisher.*

Barry, Dan

The highlight? Probably the day in 1951 when Dan Barry began his 40-odd (we'll get back to just how odd) years doing the *Flash Gordon* comic strip.

Barry had kicked around the business for ten years—including tours of duty in Jack Binder's studio ("a factory in a barn") and in Lev Gleason's shop—before King Features called. Barry's first inclination was to say no. "The money was insulting," he said later. "I didn't want to do *Flash Gordon*. I hadn't been a science fiction fan. A friend of mine from the Fawcett days, Mac Raboy, was drawing the Sunday [strip], and he was having all sorts of agony with the script and his artwork was showing it."

Barry eventually decided to tough it out. "The scientist's job is to get man into space and onto the planets," Barry said after Neil Armstrong finally stepped onto the surface of the moon. "Mine is to presume he is already there and to carry on with the uses and misuses of the accomplishments."

Barry got credit for his presumptions long after he ceased being the main artistic force on the strip. When Barry moved to Europe in the late '50s ("At that time, if you worked outside the country, you didn't have to pay income tax," said his assistant, Bob Fujitani), he would mail the penciled dailies to Fujitani. "Very detailed penciling," Fujitani said. "I would ink it and deliver it to letterer Ben Oda, who would deliver it to King Features."

And in later years? "In later years, when I was doing the whole strip, I'd just drive it down to

Ben," said Fujitani, who signed the strip "Barry and Fujitani" for a good ten years after Barry had abandoned the art chores and was simply scripting *Flash Gordon*. "Every now and then when he needed extra money, he would say, 'Gee, Bob, next month couldn't I do some inking and you pencil it?' When he would pencil, every rivet would have a cast shadow. He would really struggle with it. It was fun for him to ink my pencils, because they were very loose, and easier to ink.

The lowlight? Probably the day in 1982 when Barry was fined $10,000 and sentenced to a year in jail for income tax evasion.

Barry had been charged with four counts of tax evasion for failing to file returns from 1975 through 1978. In a plea bargain, three counts were dropped and the cartoonist received the maximum sentence for the fourth. "I think paying taxes and filing income tax returns is a fundamental obligation of all citizens," observed U.S. Magistrate Thomas Smith. "Failure to do so reflects breathtaking audacity... and strikes me as nothing more than chutzpah."

The defendant argued that his failure to file returns was a result of "being buried by emotional factors." As Barry headed off to jail, Bill Yates, the comics editor at King Features, told *The New York Times* that everything was cool. "Nothing's going to happen to *Flash Gordon*," Yates said. "Being in jail doesn't preclude Dan's doing the strip."

And it didn't. Barry—who died in 1996—was "stationed down at Eglin Air Force Base in Florida, that country-club jail," Fujitani said. "I think that's where Haldeman and Erlichman went. Dan would write an outline to his wife, she'd call me and I would get it out. When he came out of jail, he was all excited. He'd met some wonderful friends there: airline pilots who'd been caught smuggling contraband into the country, lawyers, and bank embezzlers. And he had the best tan he ever had in his life, because he was the greenskeeper on the golf course."

Basements

One summer afternoon in the early 1970s, Phil Seuling took Dick Swan, Bud Plant, and several other San Francisco Bay Area dealers to a dingy basement somewhere in the Bronx. All the comics returns in the New York area poured into this basement (direct distribution was still a twinkle in Seuling's eye), and Swan recalled "the basement must have been 8-feet deep in 300-copy boxes of comics." Seuling reached down and pulled out a box of 300 *Conan* #1's, but Swan said the Bay Area boys sank their money into "massive quantities of *Creepy* #1 and anything else with a Frazetta cover."

"I'd bet it's all still sitting somewhere in New York," Swan added. "I still think there are some more basements somewhere where those books sit. There is always another deal."

Bat Lash

This Sergio Aragonés western character first appeared in *Showcase* #76. According to Denny O'Neil, Aragonés wrote the Bat Lash adventures in "his inimitable Sergio thumbnail sketch form," after which O'Neil supplied the dialogue and Nick Cardy the final art.

Not to be confused with *Batton* Lash, the writer/artist of *Wolff & Byrd, Counselors of the Macabre*.

Batman

Jerry Siegel and Joe Shuster, awash in heroism, dreamed up a savior; Bob Kane went home one weekend and cranked out a product,

Dan Barry's version of Flash Gordon.
(© King Features Syndicate)

"Nothing's going to happen to Flash Gordon. *Being in jail doesn't preclude Dan's doing the strip."*
BILL YATES

Batman #9 (February/March 1942), with a cover by Jack Burnley.
(© DC Comics, Inc.)

handing it off to writer Bill Finger, who added most of Batman's unique features. "One character is sheer hope," said Matt Wagner, "the other is sheer cynicism."

BEST TEAMS

Jerry Siegel and Joe Shuster
Joe Simon and Jack Kirby
Stan Lee and Jack Kirby
Al Feldstein and Bill Gaines
Carmine Infantino and
 Murphy Anderson
Jack Burnley and Charles Paris
Otto Binder and C. C. Beck
Bob Kanigher and Joe Kubert
Chris Claremont and John Byrne
Alan Moore and Dave Gibbons

Cynicism has been selling ever since.

The Batman first appeared in *Detective* #27 (May 1939).

Batman: The Dark Knight Returns

Robin is a 13-year-old girl named Carrie. The Batmobile is a tank. The Joker is reduced to killing Boy Scouts with free cotton candy at the county fair. Alfred suggests to his boss that he make a charitable contribution to the Committee for the Prevention of Obsessive Behavior in Middle-Aged Men.

And the Batman is 50.

Frank Miller's 1986 revision of the Dark Knight inspired the industry, and Tim Burton, to take apart more of its heroes and put them back together again, usually with less inspirational results.

In this four-issue miniseries, Miller exhibits—in the words of the Dark Knight—"no respect for history."

So it is that Selina Kyle runs an escort service. Ronald Reagan is draped in the flag. Superman takes a nuclear warhead in the breadbasket. The Joker dies in the Tunnel of Love. And a classic character, dead—creatively—for years, is reborn.

Batter Up

The comics' all-time starting lineup:

Jackie Robinson, Brooklyn, 2B (*Jackie Robinson* #1)
Willie Mays, San Francisco, OF (*The Amazing Willie Mays*)
Joe DiMaggio, New York, OF (*True Comics* #71)
Stan Musial, St. Louis, OF (*True Comics* #78)
Lou Gehrig, New York, 1B (*Sport Comics* #1)
Roy Campanella, Brooklyn, C (*Roy Campanella*)
Pepper Martin, St. Louis, 3B (*Sport Stars* #4)
Phil Rizzuto, New York, SS (*Phil Rizzuto* #1)
Bob Feller, Cleveland, P (*Boy Commandos* #30)
Mickey Mantle, New York, DH (*Mickey Mantle*)
Casey Stengel, New York, Manager (*Thrilling True Story of the Baseball Yankees* #2)

Beck, C. C.

The co-creator and definitive illustrator of Fawcett's Captain Marvel, Beck joined the company in Minneapolis in 1934, at the age of 23. By 1941 he was Fawcett's chief artist in New York and had opened a studio with Pete Costanza.

Beck prospered with what Jim Steranko called "the most consciously simple, straight-

forward style that has yet been seen in comics." He was, noted Stanley Kauffman, an editor at Fawcett, "a quiet little man who took his work very seriously." Beck also took criticism quite well. "Suppose you told me that I'm short, I'm five-foot-four, I'm bowlegged, I've got big feet and big ears, and a big nose, and a lot of hair that needs cutting and so on," Beck said in *The Comics Journal*. "That's absolutely correct. Why should I argue with you?"

Beck attempted a return to comics in 1967 with *Fatman, the Human Flying Saucer*, and in 1973 when DC revived Captain Marvel in *Shazam!* Neither effort earned Beck as much acclaim as his occasional column in the *Journal*. Under the banner, "Crusty Curmudgeon," the column ran from 1987 until Beck's death two years later. He also aired his opinions in his own self-published newsletter, *FCA/SOB*.

Betty Boop

The star of Fleischer cartoons, comic strips, Big Little Books, and memorabilia shows was curiously absent from comic books. Betty was created by animator Grim Natwick in 1930.

Bigfoot

Before the word was attached to the abominable forest creature of the Pacific Northwest, "Bigfoot" described a low-brow, slapstick cartooning style.

"It comes from Johnstone and Cushing," Dik Browne told Rick Marschall, "and I have a collateral interest [in inventing it] . . . Stan Drake used to sit next to me, and Stan used to say, 'Jesus Christ, look at the feet! That's not a foot! That's a goddamn loaf of bread. You do really gorgeous drawings with these damn big feet!' And it used to bother the hell out of him, so I once made a little dotted line that separated our desks, the high-class artists [who] use things like anatomy and crap like that, and the bigfoot art. Later on I heard someone describe Stan Drake as a wrinkle artist. But that was not the term used then. I think they just called themselves 'real artists.'"

Big Little Books

Published by the Whitman Company of Racine, Wisconsin, the Big Little Books, which were reprints of panels from newspaper

Bed

One final note: Bed. [Milton] Caniff introduced coitus as a concept in the American comic strip. The idea that men slept with women was, until the advent of Pat Ryan's subtly suggestive romances, never hinted at by Caniff's contemporaries. Polly did not sleep with her Pals any more than Boots slept with her Buddies. Dixie Dugan, Ella Cinders, Winnie Winkle, Etta Kett— none of these heroines of comic strips had ever been to bed with a man. And the same was true for their male counterparts. Tailspin Tommy clocked more air time but no more bed time than Flyin' Jenny. Both died virgins. As did every comic character, including the ones with children. Mandrake the Magician never once turned a trick. Blondie never slept with Dagwood except in 3"× 5" porno books. And Dick Tracy's first name was a vernacular for his job of detective, not for his mythic dimensions as a lover

Before Caniff introduced the Dragon Lady to Pat Ryan, before Burma and Raven Sherman and Normandie Drake fell for our hero, there was not a hint of sex to be found in the American newspaper strip. Caniff changed all that.
JULES FEIFFER
INTRODUCTION TO THE COMPLETE COLOR TERRY AND THE PIRATES

© Tribune Media Services, Inc.

Whitman's Big Little Books (and later, Better Little Books) were short, fat, and full of popular strip characters of the day.

(© Whitman Publishing)

strips, measured 3¾" high by 4½" wide and ran up to 424 pages. The format was originally determined by the strip left over after trimming the newspaper rolls during printing of the Sunday funnies.

Binder, Jack

One-third of the most productive sibling set in comics history, Jack Binder was born in Hungry in 1902. The son of a blacksmith, Binder first felt the ink on his fingertips as a printing apprentice. His first production line, christened in 1926, pumped out Christmas cards.

When Binder moved with his brothers, Otto and Earl, to New York in 1934, he didn't know what a comic book was. He'd figured it out, presumably, when he became art director at Harry Chesler's shop in 1937. Three years later, Binder quit Chesler to open his own shop, moving it to Englewood, New Jersey in the spring of 1941. Eighteen months later, the Binder shop was cranking out more than 4,000 penned and inked pages each year. Its main clients were Fawcett, Street & Smith, and Nedor. The doors to the shop never closed. "People began to get suspicious about the lights being on all night long," Binder once told Jim Steranko. "The neighbors must have thought we were a Nazi spy nest."

After helping to dispose of the Nazis, Binder moved out to a New York farm in 1948, switching to a career as a commercial sculptor.

Binder, Otto

"Too busy to dress," says a footnote in one of Russ Cochran's boxed EC sets, "Binder usually wore pajamas and a robe as he typed furiously in the writing studio of 'The House That Captain Marvel Built.'"

Why so busy? Jim Steranko supplies the stats: By Binder's count, he wrote 57 percent of the *Captain Marvel* family saga between 1941 and 1953. He wrote 451 *Captain Marvel* stories, 162 *Marvel Family* adventures, and 161 episodes with Captain Marvel Jr.

And the count doesn't end there: Throw in another 2,000 stories for 91 other heroes, starring in a total of 198 different books, and Binder cranked out more than 50,000 pages of comics.

Before his death in 1974, Binder—C. C. Beck begs us to remember that the name rhymes with cinder, not finder—described for Steranko how the first issue of the pulp *Amazing Stories* changed his life.

"Otto was 15 when he bought the first copy and read it from cover to cover," Steranko wrote. "From then on, he never missed an issue." Otto's older brother, Earl, shared his enthusiasm. Working together, often through the night, the two brothers, writing as "Eando,"

BEST-DRESSED CHARACTERS

Designed to please and dressed to kill. Our ten favorites:

- Adam Strange
- Dr. Fate
- Flash
- Green Lantern
- Joe Kubert's Hawkman
- Midnight
- Katy Keene
- Red Bee
- Spider-Man
- Superman

And at the other end of the fashion spectrum:

- Bart Simpson
- Black Terror
- Blue Beetle
- Bob Hope
- Cable
- Catman
- Incredible Hulk
- Li'l Abner
- Little Orphan Annie
- Plastic Man

© DC Comics, Inc.

© Fox Features Syndicate

pumped out one script after another, running up a postage bill of $105 before one of their manuscripts, "The First Martian," was accepted in 1930 for publication in *Amazing Stories* … at ¼ cent a word.

"Little did they realize," Steranko noted, "that the story wouldn't be used until 1932 and that they wouldn't be paid until two years after that."

The Binders kept writing, primarily for the pulps, until their brother, Jack, became art director for Harry Chesler's shop. A Dan Hastings script was Otto Binder's first assignment for Chesler; he also wrote Captain America and Black Owl stories before Fawcett hired him in 1941. Fawcett and Binder made each other rich; in 1943, by one estimate, Binder earned $17,500 from his comic book scripts.

After Fawcett bailed out on *Captain Marvel* in 1953, Binder went to work for DC, where he had a hand in the creation of the Legion of Super-Heroes, Bizarro Superman, and Titano the gorilla. Before Binder could inflict further damage, he retired from DC in 1960 to write science pieces.

Biro, Charles

Charlie Biro used to love it when Stan Lee grew desperate enough to pick up the telephone. "Stan Lee used to call him all the time and ask, 'What's the secret, Charlie?'" Bob Fujitani said.

"He [Biro] would hang up the phone and say, 'That poor guy, he wants to know the secret. There's no secret. The secret is Charlie Biro.'"

Beginning in the mid-1940s, the comics industry *was* Charlie Biro. As World War II wound down and comic book readers began to step on Superman's cape, Biro's brutal covers and superb scripts made three Lev Gleason titles—*Boy*, *Daredevil*, and *Crime Does Not Pay*—three of the best-selling and best-read comics of the era.

"I remember him saying so clearly, 'You have to think like a kid,'" said Fujitani, who worked with Biro for five years after the war. "He always thought like a big kid himself. He'd say, 'You have to know what kids like. Kids like detail. Forget about art. Go in for the detail, the nuances. Bullets going through the head. Brains blowing out the back' . . . Charlie liked that stuff. He'd say, 'Kids want to see that piece of meat with the little hair on it going out the back. That's the thing that sells.'

"I think he had a point. His crime covers weren't good art, but when he had some guy pushing a woman's face down onto a gas stove, you knew it was a gas stove you'd find in ordinary people's kitchens."

Biro warmed up at the Chesler studio and MLJ—where he created Steel Sterling—then hit his stride at Gleason. Biro arrived at Gleason in 1941, a year before *Crime Does Not Pay* debuted as the first crime comic. Biro drew many of the early *Daredevil* tales, but his scripts made a much bigger impact, especially after the war. Aided by the art of Norman Maurer and Dan Barry, Biro produced the Crimebuster stories in *Boy*, the Little Wise Guys tales in *Daredevil*, and many true crime pieces in *Crime Does Not Pay*.

Biro's best stories were morality plays, rich in characterization, thick with dialogue, dripping with subplots, and capped by a corny, heavy-handed moral hook.

In one of Biro's most written-about stories, a woman is shot, dumped, and set on fire—yet manages to survive. From *Crime Does Not Pay* #52.
(© Lev Gleason Publications)

Biro's cover for *Boy* #9 shows two of the popular characters he created: Crimebuster and Iron Jaw. But what's this He-She thing all about?
(© Lev Gleason Publications)

> "Charlie Biro and Bob Wood were alcoholics, living in fancy penthouse apartments with fancy cars, spending money like water. Bob Wood told me they were always living on their next big take."
> — BOB FUJITANI

"Eisner worked on one side of the street … He was an extra-ordinary, creative, but highly stylized interpreter of a story," Gil Kane observed in *Alter Ego* #10. "On the other hand, Charlie Biro told a very direct story, but he told a very substantial story…

"What Biro did was create a kind of 'B' picture realism, a documentary effect. He had stories that were more erotic than anything I had seen up to that day," Kane said. Using nine panels per page, and sometimes stretching his story across 35 pages, Biro would go where no writer had gone before in developing character and plot.

"The payoff," Kane said, "was that he bucked every major publisher. . . . Here were these magazines that were distributed and merchandised by the biggest outfits in the world, and he came in with three stinking little magazines, and within a period of two years, he was outselling every one of them, including *Superman*."

The secret, Biro told everyone, was Charlie Biro. It didn't hurt, Fujitani noted, that Gleason had a superb paper allotment during the war years and no qualms about violence. Qualms? "We were young, we thought it was great," Fujitani said. "The more vivid you could make it, the more gruesome, the better it seemed."

Behind the "Uncle Charlie" figure who preached so diligently to the kids in the audience was a gregarious, uninhibited character. "I don't remember him telling stories, except for the stories of his own exploits," Fujitani said. "He was a big guy, six-foot-three, something like that. An imposing figure, very outspoken and loud. When he stepped into the room, you knew he was there."

Biro and the infamous Bob Wood, another Gleason editor, are linked in many of the rowdiest stories from those days. Gill Fox remembers the two of them leading him to a hotel room around 29th and Park and showing him just how they got women to take the same stairs. "They had a half-finished painting under the bed," Fox said, "a painting of a woman. They'd left the head blank." If a woman was willing to come along for the ride, they were more than happy to complete the painting.

Another artist remembers seeing Biro at a Lev Gleason Christmas party, "with three broads on his lap, boozing it up like it's going out of style." That doesn't surprise Fujitani: "Charlie Biro and Bob Wood were alcoholics, living in fancy penthouse apartments with fancy cars, spending money like water. Bob Wood told me they were always living on their next big take."

But Biro set the tempo for the fast living. "Charlie was the gregarious guy, the outgoing guy. Everything revolved around Charlie," Fujitani said. "Bob was just into production. Charlie left the ordinary things up to Bob Wood: Get after the artist, make sure they get the work in on time, count the pages, and make sure none are missing. But Charlie was the genius. Or he thought he was. He knew what would sell."

It stopped selling after a while, and Biro moved on. He joined NBC as a graphic artist in 1962—about the time Stan Lee stumbled upon a few secrets of his own—and died 10 years later. "One day he was going home," Fujitani recalled, "and he didn't feel so hot. He pulled over and just dropped dead."

Bissette, Steve

Born in 1955, Bissette enlisted in the first class at the Kubert School at the age of 21, graduating in 1978. His favorite professor? Hi Eisman, a journeyman who'd worked on *Little Iodine*, and a marvelous storyteller. "Hi would tell us these stories, which were hilarious," Bissette said. "We'd be in tears laughing. But the message coming through was, 'Watch out. You will be exploited from every end possible.' As I look back, that was some of the most valuable information we got from the school."

Bissette understood that he and other graduates from the school were being groomed to work at DC, but his prospects dimmed when Kubert's relationship with DC soured. "There was this edict at DC: 'No Kubert School students,'" Bissette said. "That was an insane time. They kept him [Kubert] on the payroll because they were terrified he'd go to Marvel."

After a number of what he called "disorient-

Birth Control

I've had some of these guys call me up looking to buy art, and on the phone you can hear their kids screaming in the background. You can just imagine they've gotten themselves into situations where they have to make a lot of money. And if I had been stuck in that situation a couple of years ago, there's no way I could have done Eightball. *I like to think I would have gone into commercial art or something a little better than super-hero comics! But God knows, I might be inking Thor right now if it weren't for birth control.*
— DAN CLOWES

ing" interviews with DC editors, Bissette finally got a 1983 tour of duty with Alan Moore on *Swamp Thing.* When he departed DC, muzzled by a nondisclosure agreement, Bissette edited the horror anthology *Taboo* (co-published by Tundra for some issues and the first home of Alan Moore and Eddie Campbell's "From Hell") before launching into his personal self-publishing with *Tyrant.*

"There is this real corrupt and smarmy side of the industry. The underbelly of the industry, if you will," Bissette said. "There are so many forces at play. Nepotism. Opportunism. Box office. It's not a conspiracy of any kind, it's just the nature of the beast. The effects can be evil, but I rarely see directed maliciousness in the industry. It usually comes out of stupidity, adherence to some insane hidden agenda, or company policy.

"It really comes down to luck."

Black-and-White Glut

This was the price retailers paid for getting caught with their comics shelves bare of *Teenage Mutant Ninja Turtles* in 1984. When Kevin Eastman and Peter Laird hit the big time with *their* black-and-white book, every wannabe publisher with a drawing pad and a stapler in the garage tried to follow suit. With no clue as to which book would tickle the fancy of fickle fandom, retailers had to stock them all.

Early in the glut, Mike Richardson—who then controlled four retail outlets in the Portland area—demanded that his distributor, Richard Finn at Second Genesis, carry each and every one of the black-and-white titles. Three weeks later, Richardson staggered back through his distributor's door and begged Finn to drop them all.

Out of the morass came more adjective-adjective-adjective-noun books—such as *Radioactive Adolescent Blackbelt Hamsters* and *Pre-Teen Dirty-Gene Kung-Fu Kangaroos*—and little else. The fans turned back to the X-Men and, thanks to the nonreturnable nature of the direct market, the retailers took the direct hit.

Black Canary

One of Robert Kanigher's "femme fatales," the Black Canary first appeared in *Flash Comics* #86 (August 1947). Within four months, she was Johnny Thunder's tag-team partner, and by *Flash Comics* #92 she had usurped the book's backup feature. Dinah Drake in the dull, drab world, the Black Canary joined the Justice Society of America in *All Star Comics* #41.

Black Cat

Hollywood's Glamorous Detective Star first appeared in *Pocket Comics* #1 (August 1941). Created by Al Gabrielle, the Black Cat—whose alter ego was Linda Turner, a movie star with time on her hands—spent the war in *Speed Comics,* then came home to her own book. Gabrielle, Pierce Rice, Arturo Cazeneuve, and Joe Kubert escorted the character through the war, then handed her off to Lee Elias.

Steve Bissette has chosen to self-publish his dinosaur biography, *Tyrant,* at a leisurely pace.
(© Steve Bissette)

Reed Crandall was the *Blackhawk* cover artist in the late 1940s and early 1950s. This cover is for #34 (November 1950).
(© Clare C. Arnold/Quality Comics)

Blackhawk

Blackhawk is the first comic book I ever stole.

HOWARD CHAYKIN

For many others *Blackhawk* was simply the first comic they ever owned.

A Polish flyer whose brother and sister were killed in a Nazi bombing raid, Blackhawk first appeared in *Military Comics* #1 (August 1941). The marquee player in the Quality universe, Blackhawk was created by Will Eisner, with hefty assists from Chuck Cuidera and Bob Powell. The character survived on Cuidera's scripts and the artwork of Powell (who was born Stanley Pulowski) and the peerless Reed Crandall. Powell's influence was so significant, artist Howard Nostrand once said, that "the fact that the hero was Polish was no mistake. I'm just surprised that Blackhawk's civvy name wasn't Pulowski." At one point during World War II, Jim Steranko notes, "Blackhawk was outselling everything but Superman."

The Blackhawks—Andre the Frenchman, Stanislaus the Pole, Olaf the Swede, Chuck the American, Hendrickson the German, and Chop-Chop, the meat-cleaver-packing Chinaman—were like the heroes in a Howard Hawks film, united by a daring blend of courage and camaraderie. Freedom fighters on Blackhawk Island—an outcrop in the North Atlantic, until the Red Peril forced a transfer to the Pacific—the fighter pilots chased Nazis and countless other international outlaws in their Grumman F5F's.

Steranko, who devotes a chapter to the Blackhawks in the second volume of his *History of Comics,* notes that Blackhawks tales in both *Military* (later *Modern*) *Comics* and *Blackhawk* showcased the work of a number of top writers, including Bill Woolfolk, Harry Stein, Ed Herron, and Bill Finger.

When Quality closed its doors in 1956, the copyright passed to DC, whose creators messed seriously with the minds of the hero's fans by casting him in the mindless dramas so typical of DC in that era. Like most of the freedom fighters, the Blackhawks died any number of deaths until Mark Evanier and Dan Spiegle were charged with resurrecting the characters in the early 1980s.

"Everyone turned it down," Evanier told *The Comics Journal.* "The guy who comes in to fix the DC Xerox machine probably turned it down, so I got it. You know, of course, that the book was revived because Steven Spielberg had optioned the movie rights."

When Spielberg lost interest, so did DC.

Black Panther

The African king T'challa first appeared in *Fantastic Four* #52 (July 1966) but came into his own seven years later in *Jungle Action* #6–#18.

"The Panther became a strong, complex character," wrote comics historians Will Jacobs and Gerard Jones, "forced to choose between the foreign lands that fascinated him—here represented by an urbane Afro-American lover—and the land to which he felt an inherited duty. To portray the Panther's journey, [Don] McGregor dropped all pretense of writing for children . . . Mixing a style more florid and rococo than Roy Thomas's, with large doses of popular psychology and philosophy, he filled pages with detailed discussions of values and self-perceptions."

When the Black Panther snared his own book in 1977, Jack Kirby provided the scripts, pencils, and cover art for the first 12 issues.

Blackthorne

This company was Steve Schanes's attempt to publish comics after his brother, Bill (his partner in Pacific Comics) joined Diamond Comic Distributors. Asked to explain his discriminating taste, Steve Schanes once said, "I don't know what sells. I just throw 50 titles at a wall and see what sticks."

Black Widow

The comics' first super-heroine with her own strip, the Black Widow spun into view in *Mystic Comics* #4 (August 1940). Who knows what the psychic, Claire Voyant, sold, but her

The original Black Widow worked for the devil himself. This page is from *Mystic Comics* #4 (August 1940).

(TM & © 1998 Marvel Characters, Inc. All rights reserved.)

powers came straight from the devil.

"When Claire is murdered, she goes straight to Hell, where Satan appoints her as his assistant," Jeff Rovin observed. "Endowing her, literally, with the touch of death—not to mention the darkest eyebrows of any character in comics history—he sends her back to earth. Her mission: to find criminals and kill them, so that Hell will have them all the sooner."

Marvel Comics brought a different Black Widow back into the headlines in *Tales of Suspense* #52 (April 1964). A Commie agent at the onset, the Black Widow was eventually reduced to sleeping with both Hawkeye and Daredevil. The tramp.

Blaisdell, Philip "Tex"

In Will Eisner's studio at Tudor City, Bob Fujitani said, "Tex was the guy. Tex was the supervisor in the studio. He had a tremendous sense of humor. He wasn't a very good straight artist, but he was good at cartoons. Eisner liked cartoon-type drawing, as you could see in *The Spirit*. If you had any trouble, Tex would come around; he'd help you break down and lay out the panel so it had a little humor in it. So many of us were involved in the technical part of drawing that we'd lose the humor. Tex was important. Eisner relied on him."

A journeyman artist at Quality—with moonlight tours at DC and Timely—in the 1940s, Blaisdell eventually hooked up with *Little Orphan Annie* in the '60s and '70s before his journey eventually ended with a teaching gig at the Kubert School.

Blazing Combat

When Jim Warren sought to re-create EC Comics, *Blazing Combat* was his *Two-Fisted Tales*, complete with Frank Frazetta covers. EC artists George Evans, Joe Orlando, John Severin, Angelo Torres, Al Williamson, and Wally Wood all popped up in the four black-and-white issues that ran from October 1965 until mid-July 1966.

So did the ghost of Harvey Kurtzman, who had edited *Two-Fisted Tales*. "Anytime I tried to sit down and tried to think up a plot for a war story," said Archie Goodwin, "it would seem that Kurtzman had covered the ground one way or another."

Blondie

Named for Blondie Boopadoop, who on February 17, 1933 married Dagwood Bumstead. When King Features first tried to sell the *Blondie* strip, it sent suitcases stuffed with lingerie to newspapers across the country, followed immediately by a telegram from Blondie: "Has my stuff arrived yet?"

Blonde Phantom

The queen of Timely's B titles, the Blonde Phantom first appeared in *All-Select* #11 in the fall of 1946. Talk about contagious: Two autumns later, she was on active duty in seven different books. And talk about flashes in the pan: Six months later, she was gone.

When she wasn't showing off in her evening gown, the Blonde Phantom was Louise Grant, the deft secretary of a dufus private dick named Mark Mason. Otto Binder wrote her first story and Syd Shores dressed her to kill so that

© King Features Syndicate

Timely's pubescent readers wouldn't confuse her with another secretary, Tessie the Typist.

Golden Age appearances: *All Select* #11; *Blonde Phantom* #12–22; *All-Winners* (2nd) #1; *Blackstone* #3–4; *Marvel Mystery* #84–91; *Namora* #2; *Sub-Mariner* #25–28, 30; *Sun Girl* #2–3

Blue Beetle

A rookie cop in chain mail, the Blue Beetle first appeared in *Mystery Men Comics* #1 (August 1939) and later benefited from the talents of Jack Kirby, Bob ("One summer I wrote 100 pages a week") Kanigher, and Steve Ditko.

"His creation," comics historian Mike Tiefenbacher notes, "has been credited to veteran artist Charles Nicholas (nee Wojtkowski), who, ironically, would later spend 20 years under the same publishing roof as his creation and never once draw him again."

Originally published by Victor Fox, the Blue Beetle later starred for Charlton—first appearing in a Fox reprint in *Space Adventures* #13 (October/November 1954)—and played back-up during a brief 1986 revival at DC. The height of his fame came during the hero's second tour of duty with Fox in 1946 when Jack Kamen began undressing women on *Blue Beetle* covers. Freddy Wertham noticed.

Blueberry

Jean-Michel Charlier and Jean (Moebius) Giraud's epic, and cinematic, western, written between 1963 and 1986, featured the austere Lt. Blueberry, a Confederate soldier for whom the wars never end.

The series, set in nineteenth-century Arizona, debuted with *Fort Navajo*. The final installment, *Arizona Love*, was published after Charlier's death in *Dark Horse Presents*.

The Blueberry books: *Fort Navajo, Thunder in the West, The Lone Eagle, The Lost Rider, The Trail of the Navajos, The Man with the Silver Star, The Iron Horse, Steel Fingers, The Trail of the Sioux, General Golden Mane, The Lost Dutchman's Mine, The Ghost with Golden Bullets, Chihuahua Pearl, Ballad for a Coffin, Angel Face, The Ghost Tribe, The End of the Trail, Arizona Love*

Blue Bolt

The first Joe Simon–Jack Kirby production flashed into view in *Blue Bolt* #1 (January 1940). Blue Bolt (Fred Parrish) was proof positive that lightning could strike twice in the same place; it tattooed his butt several times before he was sufficiently charged to go to war against the Nazis.

Blue Ribbon Comics

The first title from MLJ, *Blue Ribbon Comics* debuted in November 1939 and ran 22 issues, the last 14 with *Blue Ribbon Mystery Comics* on the marquee.

Whoever else was reading the book, Stan Lee must have taken a look at the fourth issue and the origin of the Fox. The character's alter-ego was a newspaper photographer named Paul Patton, who attached a camera to his costume so he could photograph the punks he fought on the streets.

Rang-A-Tang "The Wonder Dog" padded through the entire 22-issue run. At the other end of his leash was Joe Blair, who wrote most of the main *Blue Ribbon* features, including Mr. Justice, Captain Flag, and Ty-Gor. Mort Meskin inked Ty-Gor in and out of trouble in issues #4–#20.

Seven years after MLJ put Rang-A-Tang to sleep, St. John slapped the same *Blue Ribbon* tag on a 6-issue run that mixed Heckle and Jeckle and "Teenage Diary Secrets" with Matt Baker covers.

Bodé, Vaughn

The first editor of the *Gothic Blimp Works*—admittedly a brief sojourn on his way to drawing "Deadbone Erotica" for *Cavalier* magazine—Bodé is best known for creating Cheech Wizard and Masked Lizard. Neither of those creatures left a stranger legacy than their master, who died of accidental suicide at the age of 33.

"Bodé's self-inflicted death came as no surprise to his close associates," Patrick Rosenkranz, an underground historian, wrote in *Counter Media*. "He'd been undergoing a strange personal and career change, calling himself the Cartoon Messiah, hanging out with the late-night S&M crowd, preparing for a sex-change operation, and practicing bizarre masturbation/strangulation techniques. According to his friend Larry Todd, Bodé at the time of his move to San Francisco in 1974 was already a transvestite and a sadomasochist with a rubber fetish. Once in San Francisco, he fell in with glitter dolls, suicide freaks, and assorted male and female lovers . . .

"On July 18, 1975, Bodé's 12-year-old son, Mark, was visiting him. Bodé told his son that he would be meditating in his room and that

The Blue Beetle was relegated to the background in Jack Kamen's famous covers for the character's book. This is issue #48 (September 1946).
(© Fox Features Syndicate)

Sex and violence permeated Vaughn Bodé's work.
(© Wonderful Publishing Company)

he was not to be disturbed. In a doorway in his room there was a chinning bar, over which Bodé looped a leather belt with the buckling pin removed. He arranged pillows on the floor underneath the belt, put on a red rubber devil's mask, and slipped his neck through the loop. This was his version of a Sufi meditation practice that involved choking the air off from the body. With one hand he pulled the belt tight around his neck, and with the other hand he masturbated, striving to achieve what he once described as the sublime moment of simultaneous orgasm and unconsciousness, the 'ecstatic State of Con--sciousness, Samadi, Oneness!'

"However, this time, for some reason the belt didn't release as usual, and as he sagged into unconsciousness, he remained hanging. After several hours, his son became anxious. Vaughn's brother, Vincent, showed up and kicked down the door to the room where they found him purple-faced and very dead."

Bolland, Brian

When *Judge Dredd* came to the British weekly *2000 A.D.*, Brian Bolland was there to provide the character with a scowl and an edge that even Sylvester Stallone couldn't take away.

Bolland made his first serious move into the American market with the art for *Camelot 3000*, published by DC in 1982. His 1988 work on *Batman: The Killing Joke* added to his reputation as one of today's top comics artists; his cover art has taken center stage in recent years with his award-winning creations for *Animal Man* and *Wonder Woman*.

Fellow Brit John Bolton tells the story of the day an agent arrived at his door and invested a wealth of time and energy telling Bolton what a tremendous talent he was. The extraordinary lobbying effort was entering its second hour when Bolton finally realized the agent thought he was talking to Brian Bolland.

Boltinoff, Murray

He never was all that friendly when he first came to the phone. His wife, who had grown old and weak, was in a nursing home, and he would never have her back again. He sometimes got tired out running for the phone. You just had to hold on and wait, wait for him to remember he didn't mind talking about all those years at DC, or that he didn't have any-

Brian Bolland has created numerous award-winning covers for DC titles such as *Wonder Woman*.
(© DC Comics, Inc.)

where else to go. "Has my voice changed?" he asked late one afternoon, surprised by the sound of it. "You're the first person I've talked to all day." Then he thought about that for a moment and added, "Except the clerk at the grocery. She said her legs hurt."

A lot of Murray Boltinoff hurt. He had a dry wit but you could tell he was dried out and still getting used to the fact that he could have been a contender. It happened after the war, Boltinoff said (the war in which he stumbled across Jack Kirby lying among the wounded in a railroad station in Paris). Boltinoff and a guy named Marty Rankin had written and sold a novel to Paramount and a screen treatment to Columbia. The latter studio invited him out to California to work on the screenplay, and Boltinoff was nervous about the promises Harry Cohn was making. So, he made a mistake. He went and asked Jack Liebowitz, his boss at DC, what he should do.

Boltinoff was editor of lots of fun titles at DC.
(© DC Comics, Inc.)

"Liebowitz screwed me," Boltinoff said. "He gave me this song and dance about belonging to this wonderful family at DC. He said, 'Why in the world would you want to leave?' and convinced me to stay." Boltinoff has never forgiven him, or himself, for that. If he'd gone to California, he could have been a contender. Instead, he stayed at DC and worked with the likes of Mort Weisinger and Bob Kanigher. He edited comic books until DC didn't need him anymore and shipped him off to Florida to grow old with the grocery clerks with the bad legs.

Boltinoff was a newspaperman before Whit Ellsworth, acting on the suggestion of DC cartoonist Henry Boltinoff (Murray's brother), hired him at 480 Lexington Avenue. He wasn't there long before he got his draft notice and headed to Europe. When he got back, early in 1946, he wasn't sure he wanted to go back up to the sixth floor with the comic book makers. His discharge button was always good for drinks: "It was always, 'Don't pay, sergeant, this is on me.' It was easy to be a freeloader, you could get loaded every night." But you could also get lonely. When Boltinoff got tired of the loneliness, he took the elevator up to the sixth floor and told the receptionist he wanted to see Ellsworth.

"She said, 'Yes? Who are you?' She was indignant. 'You can't see Whit Ellsworth.' 'Listen, you young bag, if it weren't for people like me, you wouldn't be sitting there right now.'"

Who are you, she asked again. "Murray Boltinoff," he said. "'You're Murray Boltinoff?' she said. Someone must have mentioned my name."

They all had their own turf after the war, Weisinger and Jack Schiff and Boltinoff, who served as art director on Schiff's books until 1962 and then sole editor of dozens of books thereafter. Julie Schwartz lorded over the story conferences, but Boltinoff only bowed to Ellsworth. "I loved the man, I really loved him," he said. "He could have been a great guy if he wasn't such a damn lush. He would have been president of the company if he would have stayed sober."

Boltinoff considered Bob Kane "a nut, another egomaniac" and Joe Orlando a prince. He couldn't stomach Kanigher but truly admired Joe Kubert. Ramona Fradon? "She had a home in Connecticut and a couple of cats; that made her a warm soul to me. And she was always pleasant to look at, instead of Mort Weisinger."

He kept their company until 1975, when DC pushed him out the door. Boltinoff ended up in Florida, not far from his brother Henry, chewing on the kind of loneliness that reminded him of those days after the war. That's why he always reached for the phone with a voice he barely recognized, a voice that abandoned him for good on a March afternoon in 1994.

Bolton, John

One of the more gifted cover artists for the last dozen years, John Bolton was working in the boutiques on London's Bond Street in the early 1970s when he was first advised to take his portfolio to art school.

East Ham Technical College had already sent Ralph Steadman and Barry Windsor-Smith on to greater things, which meant nothing to Bolton. He had no idea who they were. Comics were among the childish things Bolton had long ago put away, until the afternoon a woman

popped into one of his classrooms to give a slide show on the medium.

"I was studying illustration. She was projecting comic covers on screen," Bolton said. "As 12-foot square images, they suddenly went beyond comic covers. They required everything that any painting required: Impact. Composition. Good art."

There was a comic shop along the morning commute. Bolton began dropping in. It wasn't long before he was drawn to Smith's work on *Conan*. "That's when they told me that he'd left the school a year earlier and was coming in the following week," Bolton said.

"I showed Barry my work. He gave me quite a dressing down. I rib him about it now. He gave me exactly what I needed and what I wanted: a lot of criticism. I ignored most of what he said and just kept on doing what I wanted to do."

Bolton has done a variety of covers—most notably *Aliens vs. Predator: Deadliest of the Species*, a 12-issue miniseries—and *Army of Darkness* for Dark Horse, and *Black Dragon, Manbat,* and *Camelot 3000* for DC.

Oops—not *Camelot 3000*. "This guy came up to me at the San Diego Comic Convention a few years back," Bolton said. "He sat with me for 15 minutes telling me how much he loved my work. As he was building up to buying some artwork or asking me to draw something, he said *Camelot 3000* is the best thing I'd ever done. At which point I thought I should point out I'd never actually done it.

"It evens out," Bolton said. "I know Brian Bolland has been asked to sell some of his *Army of Darkness* artwork. We've even seen John Bolland artwork for sale."

Just not in *Glamour International*. When the flamboyant Italian magazine commissioned Bolton to do a series of five vampire paintings, the magazine's brief suggested he could paint whatever he wanted as long as the vampires were naked.

"Completely naked?" Bolton asked. You got it.

"Even the wraparound cover?" Go for it.

"What about pubic hair?" Yes, even pubic hair.

"That was a liberating experience," Bolton said. When he attended a signing in Milano, his desk was placed before a billboard-sized color reproduction of the magazine's cover, a vampire nude rising from a slab. And back in merry old England? "Just the magazine," Bolton said. "With three strategically placed price tags."

Bondage

In the beginning, author Andrew Vachss has observed, rescuing the damsel-in-distress was the literary rage. So what happened? "The distress is more interesting than the rescue to most people," says Vachss.

In the meantime, the two major contributors to the sustained interest in comic book bondage have been Dr. Fredric Wertham, who included the cover of *Phantom Lady* #17 in *Seduction of the Innocent* with the caption, "Sexual stimulation by combining 'headlights' with the sadist's dream of tying up a woman," and Bob Overstreet, who continues to highlight bondage covers in the *Overstreet Comic Book Price Guide*.

John Bolton's art for *Batman: Manbat* won him the 1996 Will Eisner Comic Industry Award for Best Painter.
(© DC Comics, Inc.)

This Matt Baker babe for *Jo-Jo* comics (#25) is your standard bondage cover.
(© Fox Features Syndicate)

The Bonomo Ritual

As advertised in *Young Romance* #29 (January 1951), *The Bonomo Ritual* featured 128 photographs, charts, and diagrams, including tips on "Four Types of Breasts," "The ABC's of Brassieres," and "The Worshipper and the Supporter." The $1 booklet was delivered in a plain wrapper, just in case the boys wanted to order, too.

Boring, Wayne

The best—and worst—move of Wayne Boring's life was answering the *Writer's Digest* ad when Joe Shuster was looking for a little help drawing Superman. Boring spent almost 30 years drawing the Man of Steel, from 1938 until that cheerful day in 1966 when Mort Weisinger told Boring to clean out his desk.

Boring spent his first year on the job in "the smallest office in Cleveland," then followed Superman's creators to New York in 1940. Wherever he was cramped over a desk, Boring rarely if ever signed his DC work.

"Boring was kind of the Ernie Bushmiller of super-hero comics," Bill Griffith once said, "someone who boiled down that style, a kind of minimalist purity."

When Shuster and Jerry Siegel finally sued DC over the ownership of their character, Boring wound up in the thick of the fight. "Jerry hired a lawyer, the lousiest lawyer I've ever seen," Boring told Richard Pachter. Because Boring was drawing Siegel's character, Siegel sued him for abrogation of contract and told him he was fired. "Why Siegel's attorney advised him to do that, I don't know," Boring said, "but he said, 'You're no longer drawing Superman.'"

Jack Liebowitz at DC vetoed Boring's dismissal; DC figured only DC could fire Wayne Boring. The artist continued to draw the character until 1966, when Weisinger whistled Boring into his office and canned him. According to Boring, Weisinger's send-off line was, "Do you need a kick in the stomach to know when you're not wanted?"

Boring survived, ghosting for Hal Foster on *Prince Valiant* and John Prentice on *Rip Kirby*. His last job before his death in 1986 was as a security guard.

Boy Commandos

This Joe Simon–Jack Kirby team first appeared in *Detective Comics* #64 (June 1942) and commandeered their own book the following winter.

The original teenage lineup consisted of England's Alfy, France's Andre, a Dutch kid named Jan, and a Canadian separatist named Brooklyn (just kidding). *The Overstreet Price Guide* reminds us that many more Boy Commando tales bear Simon and Kirby's signatures than their actual artwork.

Boys' Club

> Though I may have pirated the super-heroes, I never went near their boy companions. I couldn't stand boy companions.
> JULES FEIFFER

> Bruce Wayne is described as a "Socialite" and the official relationship is that Dick is Bruce's ward. They live in sumptuous quarters, with beautiful flowers in large vases, and have a butler, Alfred. Batman is sometimes shown in a dressing gown. As they sit by the fireplace the young boy sometimes worries about his partner: "Something's wrong with Bruce. He hasn't been himself these past few days." It is like a wish dream of two homosexuals living together.
> FREDRIC WERTHAM
> SEDUCTION OF THE INNOCENT

Okay, so Freddy Wertham is floating face down in the deep end; if he were still around, he'd find latent homosexuality in Bugs

Wayne Boring's Superman is the quintessential version for a number of long-time fans.
(© DC Comics, Inc.)

Bunny. But think about the sidekicks. Line 'em up—Robin the Boy Wonder, Tim, Toro, Sandy, Roy, Speedy, and the rest—and what do you see?

The boys' club.

One freckle-faced, pimply kid after another.

It's only coincidence. Habit. Flattery. We're not talking about the seed colony for the North American Man-Boy Love Association. But you have to wonder. If you were a typical lusty, virile, red-blooded super-hero and, quite naturally, you had your choice of youthful companions, wouldn't your first choice be a teenage girl?

Only Wonder Woman and—almost half a century later, Frank Miller's Dark Knight—ever did.

The Brave and the Bold

One of DC's showcase-style titles, *B&B* featured the first appearance of the Justice League (#28) and the first Silver Age appearance of Hawkman (#34).

Some of Joe Kubert's most memorable art is featured in the first 24 issues and the 6 Hawkman issues. The book debuted—eight months before *Showcase* #1—with a cover shared by Kubert's Viking Prince and the Golden Gladiator and Silent Knight, both by Russ Heath.

After taking turns on the cover with that pair and Nick Certo's Robin Hood, Viking Prince became *B&B*'s lead feature in #20 and took over the whole comic in #23. The other tryouts began in #25 with Suicide Squad by Ross Andru and Mike Esposito, then hit the big time with the Justice League.

Issues of interest: #23, first full-length Viking Prince; #25–27, Suicide Squad; #28–30, Justice League by Sekowsky; #31–33, first Cave Carson by Meskin; #34–36, first Silver Age Hawkman, by Kubert; #37–39, Suicide Squad; #40–41, Cave Carson; #42–44, Hawkman; #45–49, Strange Sports Stories; #50, Green Arrow and J'onn J'onzz; #51, Aquaman and Hawkman; #52, Sgt. Rock; #53, Atom and Flash by Toth; #54, first Teen Titans concept; #57–58, Metamorpho; #61–62, Starman and Black Canary; #79, Neal Adams's first solo Batman story; #197, Joe Staton's tribute to Dick Sprang's Batman, scripted by Alan Brennert.

Breger, Dave

Breger created the tag "G.I. Joe" for a single-panel autobiographical cartoon when it appeared in Yank in 1942. Originally dubbed "Private Breger" for the *Saturday Evening Post,* the panel ended with the cartoonist's death in 1970.

Brenda Starr

Dale (nee Dalia) Messick, the first woman to crank out an adventure comic strip, originally intended her heroine to be a bonny bandit. The idea was flat-out rejected by the *Chicago Tribune,* but an editorial assistant with the Trib, Mollie Slott, suggested Messick redesign the character as a reporter. A "Starr" reporter, dubbed "Brenda" after celebrated society girl Brenda Frazier.

The strip first appeared on June 30, 1940. Over the years, Messick had the help of several assistants, including John Oleson and Mike Grell, but she never surrendered the women's

Joe Kubert produced a number of stunning covers for *The Brave and the Bold.*

(© DC Comics, Inc.)

Dale Messick kept readers enthralled for years over the romance between Brenda Starr and her Mystery Man.
(© Tribune News Syndicate)

fashions. In 1985 she handed *Brenda Starr* off to Ramona Fradon and Mary Schmich.

Brick Bradford

William Ritt's time traveler crashed the funny pages on August 21, 1933, almost five months before Alex Raymond arrived with *Flash Gordon*. Bradford's exotic adventures, scripted by Ritt, a Cleveland newshound, and drawn by Clarence Gray, were reprinted in the first issue of *King Comics* (April 1936) and the next 110 issues thereafter.

The *Brick Bradford* comic strip ran for 54 years, finally passing on in 1987. The comic book of the same name includes a superb exercise in perspective by Alex Schomburg on the cover of issue #6.

Bridgeman, George

This author of two books—*Bridgeman's Guide to Drawing from Life* (Sterling) and *Bridgeman's Life Drawing* (Dover)—has had a fierce impact on artists from Stan Drake and Bob Lubbers to Jim Lee.

"Bridgeman is my principal reference," Lee told *Amazing Heroes*. "I didn't really discover his work until I had already started drawing anatomy. I went to the library looking for books on drawing, and I'd never heard of Bridgeman before, but when I picked up his book, something clicked. Of all the books I got—Hogarth and everything—his work made the most sense to me."

Drake took life-drawing classes from Bridgeman in 1938 at the Art Students League. "A lousy instructor," Drake once said. "But he knew every bone, every muscle. He knew how it connected, and he would show you.

"Bridgeman's approach was to come into the room in his black suit and the gold chain across the vest and the watch in the pocket, dressed a là 1890. He would stand there and snap his fingers like this, and the class monitor, the guy who was in charge of the class, would then go out and bring in the model. She would have a robe on. Bridgeman would direct her up to the podium, and she would sit on this stool or stand there or assume a pose and remove her robe. She was naked."

(No wonder both of Bridgeman's books are listed in the bibliography of Stan Lee's *How to Draw Comics the Marvel Way*.)

Bridgeman would dive into the corner of the room, Drake said, and position himself below a large blackboard with a three-foot-long stick with a piece of chalk clipped to the end. "He would stand there and make sketches of this body in the position that he wanted to be posed that day. He would just zoom-zoom-zoom, zoom-zoom-zoom, and all the muscle would be right there. A flick of the finger and the whole gluteus maximus would be in. Then he'd go down and the calf muscle would be in.

"Then we would begin drawing and he'd disappear," Drake said. "This was Monday morning. He wouldn't come back until Friday. That model would assume that position all week long."

"He was hitting applejack all the time, too," Lubbers said, "but he could do a trapezius stuck on to a scapula like no one I ever knew. He showed us how the human being and all the animals could move. That's what he did, half-crocked as he was.

"He taught by drawing. It was inspiring to watch him. Bridgeman would look at the same model we were drawing and take out a portion from the waist up. He had the bones underneath... and I had no idea what was underneath the skin. You got the sense that he was moving everything. This model suddenly started to move. You began to realize that what you saw had something underneath it that made it

Brick Bradford #6 sports a classic robot cover.
(© Standard Comics)

work. That's what he gave us: an in-depth look at the human figure. Everything I drew for the rest of my life, I would always twist things. I remember when I was doing *Tarzan,* all the lions and rhinoceri, they all had that same feeling behind it. Everything twisting and turning and pulling."

George Bridgeman? "That's where the action came from," Lubbers said.

Bridwell, E. Nelson

He found a safe place in life... In an older time, he would have been a monk: one of the guys who would have been in the basement doing the illuminated manuscript, studying and praying and meditating as his place of safety from the world. The monastery that he chose to run to was just this business. The world in his head was much more interesting than the world outside it.
PAUL LEVITZ

He was a strange guy. How strange? "Between very and extremely," said Levitz, the DC assistant editor who probably knew him as well as one could during the '70s. Few ever visited the world in Nelson Bridwell's head, but they got a glimpse of its dimensions when they peeked into his apartment after his death from lung cancer in 1987.

When Steve Fishler contacted Bridwell's estate about buying his comic book collection, the lawyer took him by the Greenwich Village apartment. "I swear to God, I've never seen anything like it," Fishler said. "There were literally 25,000 books there without a single comic book box. I couldn't see furniture, just six-foot high stacks of comic books in the middle of the room. It was like someone would just take books and throw them in. After I saw the apartment, I didn't want to go near that collection."

Bridwell was a nudist, a loner, and the official handbook of the DC universe. "His greatest areas of expertise were comics, Shakespeare, the Bible, and pornography," Levitz said. Bridwell taught himself to read Latin and Greek when he was a child because he wanted to read the classics and scripture, and he never forgot anything he'd ever read when his tastes turned to comics.

Hired by Mort Weisinger in 1964, Bridwell was DC's "continuity cop." After Julie Schwartz replaced Weisinger as editor of the Superman books, he frequently turned to Bridwell to find out what had been tried before. Bridwell's command of Superman's past was such that no one thought to complain when he established his own birthdate—September 22—as Supergirl's.

Bridwell created the Inferior Five and wrote some of the adventures of the Secret Six, but Curt Swan remembers him as a frustrated writer and a guy who got along famously with Weisinger because Weisinger found him so easy to manipulate.

Schwartz called Bridwell the "ultimate fan" but couldn't recall anyone who was particularly close to him. "He might have had friends," Schwartz said, "but none that I would know about. He was quite sick the last few years. He was living almost in poverty. He wore that one suit all the time. I finally said, 'Nelson, you have a tremendous collection of comic books, books, *Playboys.* Why don't you sell a good part of your collection and go out and enjoy yourself?' Whatever that might mean with Nelson. But he never did. When he died, they found everything there."

Levitz challenged the idea that they found the remains of a sad or pathetic figure. "I don't think that's fair," he said. "Had Nelson not found what he did, he was in danger of having a very pathetic life. If he had not found a way to work at what he loved, he might not have been able to work at anything.

"I think he felt he had a wonderful life. There wasn't a bitter or unhappy bone in his body that anyone ever saw. He had no frustrated ambitions because I don't think he had ambitions the way a conventional person would. His ambition was to have the books he wanted, the things he wanted, to have his world filled with the things he loved. He found home."

Briefer, Dick

Born in 1915, Dick Briefer worked the comic book trenches from 1936 to 1954 before finding salvation in commercial art. Best known for his work on "Frankenstein," which first appeared in *Prize Comics* #7, Briefer also

E. Nelson Bridwell

Dick Briefer's version of Frankenstein was unique.
(© Prize Publications)

The "Brothers of the Spear" strip featured Russ Manning art.
(© Dell Publishing Co.)

chipped in on enough backup features to *Jumbo, Daredevil Comics, Mystery Men Comics,* and *Crime Does Not Pay* to deserve more than this brief mention.

Broome, John

The author of most of the Silver Age scripts for the Flash and the Green Lantern, Broome wrote his swan song for DC with *Green Lantern* #75 (March 1970). The cause of his axing, Mike Barr argues in *W.A.P* #5, was that he got caught up in the crusade by DC writers to form a union.

A longtime friend of DC editor Julius Schwartz, Broome and Gardner Fox were the two DC writers who survived the comics purge of the 1950s. By the late 1960s, Broome had moved to Paris, from whence he continued to pen the Flash and Green Lantern.

Back in New York, writers such as Fox, Bill Finger, and Arnold Drake were pushing their editors for better page rates, health insurance, and a share of the profits. Artists such as Kurt Schaffenberger and Mort Meskin were also involved in the push. Drake told Barr that Broome "would have made a big difference, if John had lived in the country," but Broome was, at the very least, sympathetic to the DC staffers he'd left behind.

When the strike, and most of the writers, went down in flames, Broome's comics career was over. He was, according to comics historians Will Jacobs and Gerard Jones, "a faultless plotter... Broome had the genius for finding the little twist that would make an old plot feel fresh."

At least he had Paris.

Brothers of the Spear

This backup feature in the Dell *Tarzan* books was made famous by Russ Manning's stunning art. Written by Gaylord DuBois, "Brothers of the Spear" began in *Tarzan* #25. Jesse Marsh was the original artist for the saga of the blood brothers, Natongo and Dan-El, but Manning took over with issue #39. He didn't let go for 15 years, taking up many of the writing chores and drawing the six-page feature through issue #156 (excluding only #127).

Brown, Chester

Worst of all was the sign: Batman, Robin, a dead rabbit, and the entreaty, "Buy my book."

"This actually wasn't a good sign," Chester Brown told *The Comics Journal*. "It's too complicated."

Too complicated for what? For selling *Yummy Fur* minicomics on the streets of Toronto. In the summer of 1983, Brown stood on the street with the other local self-publishing putzes, bearing that sign on the end of a rope around his neck.

"It was a boiling hot day," Brown said. "It was so hot, and I had to take off my shirt, and [my friend] Kris was saying, 'Don't take off your shirt. People won't buy from you if you're half-naked.' But no one bought a copy. I thought, you know, '25 cents, sure, someone'll buy an issue.' But no one bought an issue. Some people would come by and read the sign and walk on. A couple people asked what it was about."

As if Brown could sum that up in less than three complicated words.

Born in 1960, Brown had his first strip published in a local paper when he was 12. By the end of 1986, Vortex was publishing *Yummy Fur*, which featured Ed the Happy Clown and Brown's retelling of the four Gospels. Brown was inspired to tackle the Gospels by his reading of Morton Smith's *Jesus the Magician.*

Brown continued *Yummy Fur* for 23 issues (published by Vortex and Drawn & Quarterly) before shifting gears to the more obscure *Underwater* series in 1994.

Browne, Dik

The artist who supplied the pictures for *Hi and Lois* and the laughs for *Hagar the Horrible,* Browne got his start as a copyboy for

the *New York Journal.* He moved to the art department on the advice of one Leo Monsky ("Put him in the art department," Monsky said, "because we are going to need art. World War II is coming, our maps are in terrible shape, no one knows where Germany is") and served as the courtroom artist at the Lucky Luciano and Murder, Inc. trials.

After Germany was located and the war ended, Browne joined the advertising firm of Johnstone and Cushing, where he fashioned the Chiquita Banana symbol and overhauled the Campbell Soup kids. He also drew "The Tracy Twins" for *Boys' Life* with Al Stenzel.

Ad work was so lucrative that Browne would have stayed at the agency and died happy but for Sylvan Byck's impacted wisdom tooth. As Browne told the story in a *Nemo* interview, he rarely signed his work. "You didn't sign your name, because that limited your income," he noted. "They ask, 'What do you draw like?' and I'd say, 'Who do you want?' So I never signed anything, except once I signed a Peter Paul account that I did. Mort Walker saw it, and he liked it, wrote my name down, because the two of them [Byck and Walker] had been looking for an artist to work with Mort on a new strip still unnamed."

Browne's name would have been just another one on a long list, except Byck had that toothache. At the dentist's office, he opened *Boys' Life,* spotted "The Tracy Twins," and also jotted down Browne's name.

"The next day they had an appointment together," Browne said. "And one guy says, 'I saw a guy's work I like,' and the other says, 'I'll be damned, I saw the same thing, Dik Browne. How do you get in touch with him?'"

They found Browne at Johnstone and Cushing and offered him enough money to draw *Hi and Lois.* Browne began *Hagar* in 1973 and had his Viking buffoon in 1,400 newspapers a decade later.

Brundage, Margaret

The most striking and evocative of the pulp cover artists, Margaret Brundage produced 66 covers for *Weird Tales* between 1932 and 1941. As Robert Weinberg notes on the *Weird Tales* card set, "A lifelong resident of Chicago, Brundage originally studied at the famous Art Institute, but received her formal training at the Chicago Academy of Fine Art. In 1927, she married Myron 'Slim' Brundage, a notorious Chicago man-about-town. Her only child, a son, Robert, was born in 1929. Her marriage led to her art career, since her wandering husband often disappeared for weeks at a time, leaving Brundage the sole support of both her baby and her invalid mother. Originally employed as an agency artist and fashion designer, she was forced by the Depression to seek new markets for her art. That path led her to the offices of *Weird Tales.*

"The Unique Magazine" was edited by Farnsworth Wright, who was convinced—once he saw Brundage's ability to render naked women with her pastel chalks—that cover nudes would make the pulp both unique and indispensable to readers.

One of the 66 sensuous covers Margaret Brundage produced for *Weird Tales.*
(© Popular Fiction Publications)

Brundage couldn't draw men—"Slim," apparently, was seldom around to model for her—but her women were both sensuous and glorious. Her first cover appeared on the September 1932 issue of *Weird Tales;* Wright and the readers were so captivated by her images that the pulp ran 40 consecutive Brundage covers beginning in June 1933.

The work never made Brundage rich; she was paid only $90 for each pastel. When Ziff-Davis bought *Weird Tales* in 1938 and moved its editorial offices to New York, her pulp career ended. Weinberg writes that she died impoverished in 1976, at the age of 76, "forgotten by all but a few of her fans." For all the good it does Brundage, our collective memory has greatly improved.

Buck Rogers

A pulp splash by Philip Nowlan, Buck Rogers first appeared in *Amazing Stories* (August 1928), before reaching the comics page on January 7, 1929. John Flint Dille convinced Nowlan to transform his hero ("Anthony" Rogers in the pulps) into a daily feature and hired Dick Calkins for the artwork. At the onset, Buck played in an age 500 years in the future; the popularity of the strip waned when the character was unable to remain quite so far ahead of his time.

© John F. Dille Co.

Buffalo Bill, Jr.

Jim Vadeboncoeur and Hames Ware were forever collecting good comic book artwork in the 1960s and 1970s, even if they couldn't name the artists. They'd pick up on an unknown artist's style and begin searching for his work. It wasn't a tough job, Vadeboncoeur said: "The comic books weren't in plastic bags back then."

When the two sleuths couldn't name the artist, they'd come up with a code name for him. "This is Mr. Mystery, this is Buffalo Bill, Jr., this is Slit Eyes," Vadeboncoeur said. The code name "would trigger the image of his style."

"Mr. Mystery" turned out to be a gentleman named Harry Anderson. About a month after Ware identified him, Vadeboncoeur was in a Bay Area record store, searching for Frank Frazetta art on Jonathan Winters albums. When he reached the counter, the kid behind the cash register asked him why he was buying 13 copies of the same album.

Because of the cover artist, Vadeboncoeur said.

"My dad was an artist," the kid replied.

"Well, this guy worked in comic books," Vadeboncoeur said.

"My dad worked in comic books," the kid pressed on.

"It was Harry Anderson's son," Vadeboncoeur said. "He was a great artist. He moved to Palo Alto in 1954. He was working at Atlas at the time, and in the middle of a strip, he said, 'I can't do this anymore, and packed up his son and moved to Palo Alto and worked in an advertising firm until he died."

And Buffalo Bill, Jr.?

"We don't know yet," Vadeboncoeur said. "Buffalo Bill, Jr., is a swipe-ist who did *Buffalo Bill, Jr.* for Dell Comics. He basically had a bunch of old comics, and he would lift a pose from Syd Shores here and a pose from Alex Toth there and build collages. He did *Turok, Son of Stone* for a while, he did movie adaptations for Dell, and he never drew an original panel in his life. Just projected collages. Everybody looks and says, 'Yeah, this guy is really good, kinda reminds me of Toth.' And I say, 'Yeah, it should.'"

Bulletman

"The most powerful man in the world"—not to mention the first of the Coneheads—Bulletman debuted in the first issue of *Nickel Comics* (May 1940).

Bulletman (alias Jim Barr) dived headfirst through all eight issues of *Nickel* (one of only two comic books ever sold in America for the same price as its cover title). That wasn't enough money for Fawcett to put out a ninth issue, so Bulletman shot over to *Master Comics*.

The highlight of his 11-year *Master* stint came late in 1941: a three-part battle featuring Bulletman, Captain Marvel, Captain Marvel Jr., and Captain Nazi that began in *Master* #21, veered through *Whiz* #25, and ended in *Master* #22. The middle issue saw the birth of Captain

Bulletman No. 5, May 1942.

Marvel Jr., which meant the death of Bulletman as the *Master Comics* cover boy. The handsome Captain Marvel Jr. took over the *Master* cover with #23 and refused to give it up.

Burden, Bob

Flaming Carrot was only the beginning. Crazed cartoonist Bob Burden's comic ideas include Pizza Warriors, who fight their way through the futuristic landscape to ensure home delivery; Two-Fisted Crime Reporters, renowned for their ability to beat stories out of innocent bystanders; and The Shovler, who defies those of us who never guessed King Arthur's sacred shovel could be used to combat crime.

None of these characters, however, is quite as eccentric as their creator. Friends of Burden still remember the night at the 1989 International Association of Direct Distributors' convention when the owner of a New Orleans strip joint was convinced to open after hours so Burden could recite poetry on stage.

The audience was so engaged that one of the strippers, mistaking the crowd's enthusiasm for an opportunity to make more tips, came back onto the stage. The comic enthusiasts on hand were a lot more generous with their applause than their tips, but no one was more impressed than Burden.

"Bob fell in love with the stripper," said one reveler in attendance. "He was so taken by her that he did a full-length picture of her in the men's room."

Burgos, Carl

The creator of the Human Torch was born in uptown Manhattan in 1917. A design-school dropout, Burgos enlisted at the Franklin Engraving Company in 1934 and soon came face-to-face with the engraving plates for the comics produced by the Harry Chesler studio.

The artwork was atrocious, Burgos's something less than that, so he signed on with Chesler. He soon moved to Centaur, where he met Lloyd Jacquet and Bill Everett, who would join him as the founding partners of Funnies, Inc.

The new shop had made its first sale to Martin Goodman, Burgos told Jim Steranko, when he and Everett sat down at the Webster Bar and, over cool drinks and hot hors d'oeuvres, conjured up the Human Torch and the Sub-Mariner. The Torch was not the last android Burgos created, just the last worth mentioning.

The artist found more strenuous work when he was drafted in 1942. Burgos "started in the Air Force," as he told Steranko, "took infantry ranger training, went overseas as a rifleman, was transferred to the Signal Corps, and came back in the engineers. It sounds crazy, but it could only happen to a comic book man."

Little else that happened to this comic book man has ever found its way to the public record. Burgos veered into advertising in the mid-1950s, and later edited Eerie Publications. He died in 1984; his most famous quote could serve as his epitaph: "The miserable drawing was all mine."

Burnley, Jack

Jack Burnley would like you to read his lips: No more Gardner Fox. No more of this nonsense that Fox was the creator of Starman.

Better known for his work on Batman and Superman, Burnley co-created Starman, drawing the character's first appearance in *Adventure* #61, and insists the prolific Fox was nowhere in sight. Several editors, including Whit Ellsworth and Murray Boltinoff, were part of the first story conference, and Burnley gives Boltinoff major credit for the first script.

In addition to starring in *Master Comics*, Bulletman had his own book for 16 issues. This is #5 (May 1942), with a Mac Raboy cover. All covers but one also featured Bulletgirl.
(© Fawcett Publications)

Bob Burden with "Silent Bob" lookalike Bob Schreck.

Jack Burnley's cover for *New York World's Fair Comics* featured the first team-up of Batman and Superman.
(© DC Comics, Inc.)

Born in Manhattan, not far from the Polo Grounds, Burnley was hired at King Features at the age of 14 and had his own syndicated sports cartoon three years later. "I was mainly a boxing and baseball fan," Burnley said. "I saw Babe Ruth hit home runs and Jack Dempsey work out. It was the Golden Age of sports before it was the Golden Age of comic books."

When Burnley lost his sports cartoon, he marched over to DC, where Ellsworth, a fan of the cartoon, hired him immediately. Burnley had little experience in the comics: A year earlier, Burnley had produced a character called Bullet Bob for a small outfit, but the feature had never been published. He said he did sports fillers "while they were trying to decide what to assign me. Then Whit gave me some originals from Joe Shuster and asked me to do up a sample page of Superman." Ellsworth was sufficiently impressed to give Burnley the lead story in *Action* #28.

Burnley drew close to 100 covers for DC, including the first team-up of Superman and Batman for *New York World's Fair Comics 1940*, and stuck the gravity rod in Starman's hand in early 1941.

He was a superb ghost, doing yeoman's work on both Batman and Superman, usually in the newspaper strips. "I'm not an egotist, like so many artists," Burnley said. "Bob Kane is a great example of an egotist. One time when I was in [Jack] Liebowitz's office, Kane was in there and said he liked my work. It was one of the few times he ever complimented one of his ghosts."

Whenever Burnley was assigned pencils and inks on a story, he got his brother Ray to help with the backgrounds and assigned his sister, Betty, to do the lettering. Burnley quit DC in 1947, joining the Hearst syndicate and returning to sports cartooning at the *Pittsburgh Sun-Telegraph*. He retired from another Hearst paper, the *San Francisco Examiner*, almost 30 years later.

Buscema, John

After 45 years, John Buscema has clearly figured out what he likes and what he doesn't about the comics.

Roy Rogers? "I did *Roy Rogers* for a few years, and hated it with a passion," Buscema said. "I hated drawing Roy Rogers' face."

Those damn inkers? "They screwed up my drawings," Buscema said, "especially the Filipino inkers. They drew characters from the '30s."

These young upstarts? "Thirty years ago, these kids would never have been able to get a job. I'm amazed at the garbage they're putting out."

And, finally, John, how about good ol' DC comics?

"I did go to DC once," Buscema said. Keep in mind that those weren't the best of times for the artist. Originally hired by Stan Lee at Marvel in 1948 at the age of 21, Buscema and the rest of the bullpen (including Syd Shores and Carl Burgos) had been transformed into freelancers in 1950. Within a year, the work was getting scarce, so Buscema had branched out to outfits like Our Publishing. The houses were smaller; so were the paychecks.

And so, Buscema headed over to DC, portfolio in hand. "I went up there and no one came out to talk to me," he recalled. "They brought the portfolio inside and showed it to someone. They looked at it; apparently they looked at me, then they gave it back to me and said, 'We don't have anything for you.' I never went back again. Years later, I guess it was the late '60s, I got a call from Carmine Infantino. He asked me if I'd be interested in going up to DC. No way, man. He said, 'Why don't you come up here?' I said, 'I was up there. Where the hell were you when I needed a job?'"

In 1958 Buscema tried to sign on again with Stan Lee, but the Atlas implosion (see entry) had left Lee with only eight books a month, and he didn't have enough work to pass on to Buscema. While waiting for a return of the good times, Buscema spent eight years in advertising, working for Chaite and Triad Studios. "It was a rough, rough period in my life," Buscema said, rough

enough to put Roy Rogers's face in a different light. "Everything was due yesterday."

Lee finally called in 1966, and Buscema climbed back on board at Marvel, eventually handling almost every major character, including 17 of the 18 issues of the *Silver Surfer*. "Then I got *Conan,* which was my baby," Buscema said. "I never enjoyed doing super-heroes; Conan had no supernatural powers. I liked the idea that I could invent my own backgrounds. I hate drawing buildings, I hate drawing cars, anything mechanical. With Conan, you have free rein. No one was telling you to draw a rifle or a pistol. You just draw a sword, any kind of sword that comes into your mind. No one could tell you this was wrong, because they didn't exist."

Bushmiller, Ernie

"Dumb it down," was Ernie Bushmiller's priceless advice to his less successful peers. *Nancy*—his long-running comic strip—was Exhibit A.

"Someone once said that it takes more effort not to read *Nancy* than it does to read it," Art Spiegelman observed. "Now that's *instant* communication."

"Bushmiller made lots of money, you know," Arnold Roth told *The Comics Journal*. "That was one of Harvey [Kurtzman]'s old jokes. He said, "If a person killed somebody, he should go to jail for a long time. But if he blows up a busload of crippled orphans, he should have to draw *Nancy.*"

Buster Brown

This kid, and not the Yellow one, was the Richard Outcault creation that became the first national character in the comics.

While the Yellow Kid never ventured out of New York, historian John Snyder argues, *Buster Brown* was nationally syndicated and, after the 1904 World's Fair in St. Louis, was nationally recognized outside the comics page.

Buster Brown debuted in May 1902. Two years later, Outcault had gained two things from his legal wrangles with publisher Joseph Pulitzer over the Yellow Kid: enough money to be financially independent, and the desire to enjoy the same freedom with his little rich kid.

At the 1904 World's Fair, Outcault set up a booth to market Buster Brown to all comers. One of the first arrivals was the Brown shoe company, which was based in St. Louis. When the marriage of the character and the corporation was consummated, the shoe company took the groom's name. (Baby boomers may remember the 1950s TV ads: "I'm Buster Brown, I live in a shoe. This is my dog Tige, he lives here, too!")

The partnership was so productive that other companies began combing the funny pages for four-color spokesmen.

Byrne, John

He could play the company man—and brag about it—when it suited him. But let's give John Byrne credit: He did lend a hefty assist when those wacky guys in the Marvel bullpen decided to burn Jim Shooter in effigy.

TM & © 1998 Marvel Characters, Inc. All rights reserved.

John Buscema drew all but one issue of the original *Silver Surfer*.

John Byrne

A typical *Uncanny X-Men* page from Byrne.
(TM & © 1998 Marvel Characters, Inc. All rights reserved.)

When life with Shooter became particularly unpleasant in early 1987, one of the editors at Marvel suggested the burning "just so we could all purge our soul," Byrne said. "He was going to do it in his apartment, and he had a one-room apartment in New York. Since I had a 17-room house with two and a half acres around it, I said, 'Let's do it at my place.'

"Essentially everyone who worked at Marvel came up. They bought a cheap polyester suit and built an effigy that was filled with New Universe and Star Brand [comics], and set fire to it. We all felt a great catharsis. Eleven days later, Shooter was fired. The voodoo worked."

Born in England and raised in Canada, Byrne was a fan, a reader, when he saw the opening that turned his hobby into his job. When a traveling show on comic art was scheduled for the local art school, Byrne was asked to produce a giveaway comic as a program booklet for the show.

"So, I did thing this called the *Death Head's Knight*," Byrne said. "One of the guys who picked it up was a guy named John Mansfield, who was in the Canadian Armed Forces and a comics fan. Which is why Canada is not a world power. He got in touch with me through the college and said, 'Is that something you want to do for a living? Oddly enough, it hadn't occurred to me.

"I was 21. My parents bought me a trip to New York for my 21st birthday. I went down with this John Mansfield guy. He introduced me to everyone at Marvel and DC and they said, 'Boy, do you stink. Come back when you're good.' And I did. I went away and did a lot of work for American fanzines for four years. Then I started to get real work."

Like *X-Men* from 1977 to 1981. *The Fantastic Four*. DC's 1986 revamping of *Superman*. *The Incredible She-Hulk*. *John Byrne's Next Men*, and back to DC for *Wonder Woman*.

"I had my turn," Byrne said in 1994. "I was exactly where Todd [McFarlane] and Jim [Lee] and the other Image guys are 10 years ago, when there were no royalties and no creator ownership. When I was No. 1 dog, I didn't make a billion dollars. Todd happened to happen when he did make a billion dollars. The big difference is I never got into this to make a billion dollars. And Todd did. He achieved what he wanted to do and I achieved what I wanted to do."

Cameron, Lou

"No list of comic book artists will ever be complete," comic art historian Hames Ware said, "if the top six artists don't include Lou Cameron. He is one of the finest artists who ever picked up a brush, pen, or pencil. Had John Wayne drawn comic books, he would have been Lou Cameron. He was a Purple Heart recipient in World War II. He lived a lot of things that other people would like to live, or would dread living."

Cameron, Ware noted, served most of his time in the comics field at minor companies, producing "loads of romance and horror, mostly at Ace. It's a shame that he came along at the end of the Golden Age and that his comics career was limited by the period he began to draw in."

Cameron's best work appeared in such *Classics Illustrated* titles as "The Bottle Imp" (February 1954), "The Hurricane" (June 1954), "The War of the Worlds" (January 1955), and the 1953 reprint of "Dr. Jekyll and Mr. Hyde."

"Had he filled the slot at EC that Jack Kamen held, he would be acclaimed to the skies," Ware said. "Had he connected with EC, his name would be up there. As it was, he did not push nor promote himself. He simply did good work. And he rose to the heights in those *Classics Illustrated*s of the mid-1950s.

"Those *Classics Illustrated*s that Lou Cameron put his heart and soul into are some of the finest work that ever appeared. Like Orson Welles with Citizen Kane, he didn't know what he wasn't supposed to be able to do—so he did it anyway!"

Ware said Cameron's career in the comics came to an end when the *CI* art director farmed out a cover to a relative who painted a different hero with a different hair color than Cameron had done for the interior art.

"This character forced Cameron to go back and redraw every head of the hero. He said it so disgusted him that he lost heart and began to look for other employment."

Cameron ended up writing series genre fiction under many different pseudonyms as well as his own name. He was a successful writer of war and western novels that have been adapted for films and television. "I have reams of letters from him," Ware said, "laced with blue language that's right on target. He's never looked back."

Lou Cameron's art graced some of the most popular titles in the *Classics Illustrated* series, including "War of the Worlds."
(© Gilberton Co.)

Caniff, Milton

Caniff was the most generous cartoonist, and one of the most openly kind men I've met anywhere.
JULES FEIFFER

As far as I'm concerned, Caniff is God.
HOWARD NOSTRAND

An old Ohio newspaper man named Heinie Reiker once told Milton Caniff, "Always draw your stuff for the guy who pays for the paper. Kids will never see it if the old man doesn't buy the paper and bring it home."

Caniff tucked that advice away when the Associated Press hired him and brought him from Ohio to New York in 1932. He was 25 years old. A year later, he was handed a kiddie adventure strip called *Dickie Dare*.

Acting on Reiker's admonition—and the influence of such strips as *Flash Gordon* and *Brick Bradford*, both fresh out of the box—Caniff took Dickie on the ride of his life.

No one was more impressed by Dickie's disappearance into exotic bands and foreign lands than Joseph Patterson at the *New York Daily News*. Patterson quickly hired Caniff for a new adventure strip called *Terry and the Pirates*, which debuted in October 1934.

Caniff's chiaroscuro style in *Terry and the Pirates* has influenced untold numbers of cartoonists.
(© Tribune Media Services)

"I was raised on his stories. I idolized him. I worshipped him."
IRWIN HASEN

As Rick Marschall has written in his formative histories of Caniff, the cartoonist's early work on *Terry* was fairly rough until Noel Sickles arrived to help iron out the wrinkles. Caniff and Sickles had shared a studio in Ohio, and when AP hired Sickles to produce the strip *Scorchy Smith*, the reunion was on.

"The relationship between the two cartoonists grew not only symbiotic, but collaborative," Marschall wrote in *America's Great Comic Strip Artists*. "For several years, Caniff did most of the writing on both their strips and Sickles did most of the artwork."

The collaboration—and Caniff's later solo flights—produced some of the most memorable strips in the history of the medium. In the dozen years he spent on *Terry,* Caniff displayed his mastery of lighting and camera angles, dialogue and characterization, romance and sex.

"When he drew men and women in action," Feiffer once said, "their poses became definitive. The ultimate sock in the jaw, the ultimate leap into space, the ultimate tumbling body, the ultimate kiss, the ultimate raised eyebrow, the ultimate lonely walk off into the distance."

And all the while, Feiffer argued, Caniff was shepherding "the adventure strip from boyhood and innocence" onto its ultimate destination, the stage of "adulthood and sexual shenanigans."

"I once asked Caniff if this had been his plan from the start, expecting him to say no, that like so many groundbreaking acts of creation, it was strictly an accident," Feiffer wrote. "But it was no accident. Caniff explained that he created the G-rated *Terry* with the PG-rated *Terry* in mind all along. But he well understood that in the chaste moral climate of the 1930s, he had to move with canny caution and cleverness. And so he did."

Caniff ignored the shortcuts and cheap shots to indulge in exquisite storytelling. Few of the cartoonists who were reading over his shoulder ever got over the thrill of seeing where the comic strip could go with Caniff at the controls. "I was raised on his stories," cartoonist Irwin Hasen said. "I idolized him. I worshipped him."

When World War II began, Caniff—"America's most effective morale officer" during the war, Marschall argues—moonlighted with a new strip called *Male Call,* featuring the sensual Miss Lace. The best part of a hundred camp papers, *Male Call* debuted in January 1943 and ran for more than three years.

In early 1947 Caniff, aching for more control of his comic creations, jumped to the *Chicago Sun-Times* and created *Steve Canyon*. An Air Transport pilot seeking adventure, Canyon was a veritable recruiting poster; yet the strip never matched *Terry* at its best.

Not that Caniff's reputation suffered. "Forget about his art and his storytelling: He was still the ultimate human being," Hasen said. "He

was the paragon of virtue. He was unbelievable in his attention to writing you a letter if something good happened to you." When the *Daily News* dropped Hasen's *Dondi* from its pages, then relented and brought the strip back, Caniff wrote a note to Hasen which read, "Irwin, you'll be there forever."

"I was on the back page of the *Daily News* for 18 years," Hasen said, "but it's Caniff's note that I'll never forget."

In the final years of Caniff's life, he, his wife, and Hasen would often share drinks together at the Algonquin, one of Caniff's favorite hangouts. "We'd share these moments over two martinis," Hasen said. "And would you believe it, I was the one who always had to leave and go to bed, leaving this 80-year-old man at the bar."

Capital City

Formed in 1980 by John Davis and Milton Griepp, Capital City Distribution evolved into the industry's second-largest direct distributor, albeit a poor second behind Steve Geppi's Diamond Distribution. Based in Madison, Wisconsin, Capital City kicked off with 17 retail customers and collected its first dollar from Polaris Comics in Milwaukee.

After New Media/Irjax went belly-up in 1981 (see entry for **Direct Distribution**), Capital City began to expand its base and open new warehouses. By 1988 the distributor had 15 warehouses stretching from Ft. Lauderdale, Florida to Commerce, California and had expanded into games and baseball cards. In the early 1990s, when the comics industry boomed from the investment frenzy, Capital flourished as well and invested huge sums in computer systems and state-of-the art facilities.

But with the collapse of the investors' market, Marvel Comics bought the third largest distributor, Heroes World, in 1995, and the handwriting was on the wall for Capital City. Diamond outbid Capital for exclusive contracts with DC, Dark Horse, and Image. Capital City responded by closing its warehouse system and forming some exclusive distribution deals of its own (most notably with Kitchen Sink and Viz.) In mid-1996 Davis and Griepp realized they either had to declare bankruptcy or sell their assets to Diamond. They chose the latter, making Steve Geppi the kingpin of comics distribution.

Capp, Al

To add the last bit of color to the cheeks of Al Capp, you must first turn to "I Remember Monster," a piece Capp wrote for *Atlantic Monthly* in 1950 (see sidebar, page 70). This garish portrait of Ham Fisher, Capp's mentor and "benefactor," should have been the final word on the evil that lurks in the hearts of men. But anyone who has seen the movie *Imagine* and remembers Capp's invasion of John Lennon and Yoko Ono's 1969 "bed-in," knows that is not so.

Fisher, who created *Joe Palooka*, literally swept Capp off the streets of Manhattan one day and took him under his wing. How Capp survived the weight of that wing, we'll never know, but he eventually learned enough to leave the nest and create *Li'l Abner*. Fisher never forgave Capp his success, swearing he'd swiped the inspiration behind Li'l Abner from Big Leviticus, one of the wooden boxers Palooka cut down in his prime. When that charge didn't stick, Fisher accused Capp of hiding pornographic smut in the nooks and crannies of his artwork.

Capp didn't work too hard to garner the sympathy of his peers. When Charles Paris stumbled into political debates at the Cartoonists Guild in those days, he remembers Rube Goldberg and Russell Patterson as "the ram-rods on the right" and Capp and Milt Caniff defending the left. But after Capp "became successful, his point of view changed," Paris said. "He was quite left-wing before

CAPP'S WAKE

When Al Capp finally went, with muted applause, to his final reward in 1979, members of the National Cartoonists Society met to toast him at Costello's. A regular drinking hole for the regular drinkers—a fraternity to which Capp did not belong—Costello's was next to the office of King Features. Several dozen illustrators met to mumble a few words about Capp, who had long since worn out his welcome. Then Irwin Hasen rose to score the final point of the evening.

"It's a sad time for American cartoonists," Hasen said, "when we come here to honor one of the great geniuses of our time . . . who never had a drink. It's a hell of a commentary on his professional organization to honor him in the back of a saloon he would never enter."

"After Capp became successful, his point of view changed. He was quite left-wing before his name was a household word. After he became successful, he moved to the right."
CHARLES PARIS

© Capp Enterprises

I REMEMBER MONSTER

In the April 1950 issue of *The Atlantic Monthly,* Capp explained how he thought up the monsters—"those unsanitary, uncouth, unregenerate, unspeakable apes, fiends, and human horrors"—that haunted his strip, *Li'l Abner.*

"The truth is, I don't think 'em up," Capp wrote. "I was lucky enough to know them—all of them—and what was even luckier, all in the person of one man. One veritable goldmine of human swinishness.

"It was my privilege, as a boy, to be associated with a certain treasure-trove of lousiness, who, in the normal course of each day of his life, managed to be, in dazzling succession, every conceivable kind of a heel. It was an advantage few young cartoonists have enjoyed—or could survive.

"I owe all my success to him. From my study of this one li'l man, I have been able to create an entire gallery of horrors."

At its peak, Ham Fisher's *Joe Palooka* appeared in over 600 newspapers and earned its creator more than $250,000 per year, but Capp portrays him—without ever naming him—as the most miserly, greedy, and selfish of sleazebags.

Most of "I Remember Monster" is wrapped up in Fisher's brusque treatment of a desperate cowhand named Stubby Wilson. "It happened back when the country was still deep in the depression—when decent, unskilled, but willing little guys like Stubby Wilson had by the thousands given up the fight and could be seen, every night, shivering in the soup lines on Times Square. Stubby was, at the time I met him, still fighting. He wasn't quite in the soup line. But you could see from the perilous shabbiness of his clothes, from the cornered, desperate look in his eye, that one more bad break, one trifling miscalculation, would snap the thread by which he hung on to respectability and drop him into the gray-faced line of the shivering and shamed and hopeless."

Before Fisher was done with Wilson, the urban cowboy was "one sweating, trembling, inarticulate li'l human hell."

INSTEAD OF A SELF PORTRAIT I HAD PALOOKA DRAW ME! HAM FISHER

"That was supposed to be the end of this memoir," Capp writes, aiming his scalpel for the cruelest cut of all. "But when I finished, I had the uneasy feeling that it hadn't come out correctly. I had told the story of an Evil man. In all the other stories of Evil men that I had ever written, they were punished in the end; in all the books and plays and movies about Evil men I had ever read or seen, they were punished in the end. How come this Evil man had not been? I thought about that, and I found the answer. This Evil man was real, and the ones I'd written about, or read about, were not.

"In plays and novels and comic strips the Evil are always, in the end, paid off. We grow, therefore, to believe that all Evil, in the end, will, somehow, be paid off. It helps us to endure Evil. But, on the other hand, it helps the Evil. They know they are not trapped in a book that's got to come out right, or a play that must have a Curtain that rewards the Good Ones and frustrates the Bad Ones. They know that in life the chances are damned good that they'll get away with it.

"For the real Evil operate in a vast, ever changing lifestream. Those they hurt, as their lives touch, cry out in pain, lick their wounds, and pass on. Because life must be lived, and there is no time to stop and take revenge. Especially when the wounded have been beguiled by books and sermons and comic strips into believing that something called Life itself will, itself, punish the Evil.

"Mostly, it doesn't . . ."

Mostly. Ham Fisher committed suicide in 1955.

his name was a household word. After he became successful, he moved to the right."

Capp's success—John Steinbeck once suggested he was the "best satirist since Laurence Stern"—was secured by the hillbillies who raged through *Li'l Abner.* Born in New Haven, Connecticut, Capp often claimed that he found his inspiration for the strip while on a tour of Appalachia when he was 15. His wife, Catherine, would later suggest that the idea took root while they were watching a hillbilly act at a vaudeville theater in Columbus Circle. "We walked back to the apartment that evening," Catharine said, "becoming more and more excited with the idea of a hillbilly comic strip."

In his early rounds with *Li'l Abner,* Capp had

lots of fun with the Yokums and Scraggs of Dogpatch, Kentucky. "Death, love, and power are the three great interests of man," Capp once told Judith Sullivan. "They are the sources of all the stories in *Li'l Abner,* mainly because there are no others." Those stories clearly held Capp's interest, and that of readers for years. But the satiric bite of the strip became increasingly nasty as Capp got longer in the tooth. The creator of Sadie Hawkins Day dissolved into a bitter thug, as abrasive to his many ghosts—Frank Frazetta, Bob Lubbers, and Stan Drake among them—as he was to any and every liberal cause.

"What was disturbing about Capp's right-wing politics was that it was done within the context of a rotten guy," Jules Feiffer told *The Comics Journal.* "He was simply mean, nasty, angry. Angry without generosity of spirit. And I must say, without integrity . . . Capp was one of my boyhood heroes along with Kelly and Caniff and Eisner, but Capp really got increasingly bitter, and his work changed. As his bitterness took over, the quality of the work declined."

When Capp entered Room 1208 at the Queen Elizabeth Hotel in Montreal in May 1969, the bitterness had overwhelmed him. Lennon had invited Capp to the seven-day bed-in he staged to attract attention to his politics, and the cartoonist entered the hotel room brandishing the *Two Virgins* album cover showing John and Yoko in the nude.

"Everybody owes it to the world to prove they have pubic hair, and you've done it!" Capp said.

They begin to spar, the three of them, flailing away while the camera rolled. When Lennon suggested he occasionally spoke for the entire human race in his lyrics, Capp responded, "I didn't permit you to speak for me. Whatever race you're a representative of, I ain't part of it. You belong to a race of your own."

When Yoko began a counterargument by saying, "You and I are not married together …" Capp spit back, "That is a very unkind thought to plant in my mind. That may stay with me. I may end up screaming."

And it got worse. At one point, Capp said to Lennon, while nodding at his wife, "Oh, God, you have to live with that?" He exited by saying, "I'm delighted to have met you, Madame Nu." As Lennon yelled after him, "It was great meeting you, Barrabas," Capp shook hands with Lennon's entourage and mugged for the camera.

It's a frightening, revealing portrait for anyone who never met a monster but needs to remember one.

Captain America

When he was new, fresh out of the lab, Captain America had the world on a string. He was surrounded by the Japanese and the Nazis, spies and saboteurs, ancient mummies and ageless Orientals who wouldn't die. Whenever life grew a little dull, Cap knew he could count on Doctor Togu's vampire to bail out over America, screaming, "Blood! I must have blood! The blood of American swine!"

Those were the days. Captain America was

Jack Kirby, who co-created Captain America with Joe Simon, is acknowledged as *the* definitive Cap artist in both the Golden and Silver ages.
(TM & © 1998 Marvel Characters, Inc. All rights reserved.)

In his brief stint on Captain America, *Jim Steranko added his distinctive design-oriented look to the comic.*
(TM & © 1998 Marvel Characters, Inc. All rights reserved.)

"Cap brought out the best in everyone. He had no doubts, no past, no private agonies, no identity crisis, no purpose but to carry America's colors onto the battlefield."

not the first patriotic hero, but he was the only patriot to last. Created by Jack Kirby and Joe Simon, he was so good, so pure in motive, that he was the perfect match for the evil of Nazi Germany.

As Jim Steranko once observed, Cap finally gave the comics a reason to exist. He was the American ideal, as perfectly in sync with the 1940s as he is out of step with the 1990s.

Cap didn't carry the flag, he wrapped himself in it. "The costume is still irresistible," Steranko said. "You look at the stars and stripes and you say, 'Yes, I believe this man. He's my type of hero.' It's positively un-American not to salute when Captain America walks by. The costume is so well-conceived, so classic, so right.'

So doggone obvious. When Wolverine, the mutant with Freddy Krueger's fingernails and Fred Flintstone's subtlety, first saw the costume, he sneered, "I like the suit. Just the thing for playing it sly and sneaky."

"That's not my style," Cap replied. "I'm supposed to be a symbol."

When he was new, this country needed symbols. We needed a poor sap like Steve Rogers—a frail delivery boy who couldn't pass his Army physical—to volunteer to become America's first laboratory-created fighting machine. He took a hit off Professor Reinstein's "super soldier serum" and was reborn. He was still flexing his new muscles when a Gestapo agent, screaming "Death to the dogs of democracy!" burst into the lab, killing Reinstein, destroying the serum, and preserving Cap's uniqueness.

He was, *Captain America* #1 announced, "a symbol of courage to millions of Americans, and a by-word of terror in the shadow-world of spies!" On the final page, Cap and Bucky, his teenage sidekick, invited all their readers to enlist in "Captain America's Sentinels of Liberty." All Timely Publications required for the official membership badge was ten cents and a pledge to "assist Captain America in his war against spies in the USA." Who could pass that up? So few kids, it turned out, that Cap was soon forced to tell his readers that Uncle Sam "sorely needed" the metal in those membership badges for ammunition.

No problem. The kids were happy to take plastic. Cap brought out the best in everyone. He had no doubts, no past, no private agonies, no identity crisis, no purpose but to carry America's colors onto the battlefield.

Not surprisingly, at war's end, Cap had no purpose, period. In 1949 Captain America disappeared from the racks. Other than a brief reappearance in 1953–54 with anti-Communist stories in a few issues of *Young Men, Men's Adventures,* and *Captain America* (#76–#78), he was pretty much forgotten.

Not until 1964, when Marvel was in the resurrection biz, did his fans discover where Cap had been hiding out: frozen inside a block of Arctic ice. After a long overdue thaw, Cap barreled into the 1960s still driven by the patriotic fervor of the 1940s.

What a mismatch.

Captain America was all revved up to defend America against her enemies but "there wasn't a clear enemy out there," said the late Mark Gruenwald, the Marvel editor who began plotting his career in 1985. There were only costumed clowns like the Adaptoid, who could change direction or persona at a moment's notice. Cap, obviously, couldn't relate to the Adaptoid.

Desperate, Stan Lee again rolled the stone back from the tomb and dragged out the Red Skull, Cap's Nazi nemesis. In one classic sequence, the ol' Redhead rhapsodized, "So long as men take liberty for granted—so long as they laugh at brotherhood, sneer at honesty, and turn away from faith—so long will the forces of the Red Skull creep ever closer to the final victory. But first you—you who make men remember their heritage, their ideals—must be forever destroyed." But the readers wanted action, not speeches.

Captain America "was a great concept," Steranko said, "but he's a character out of his time. He was and still is the American ideal. Of

course, the American ideal has changed. It isn't easy to represent all the things the country has been through since Kennedy."

And that, of course, is Cap's charge: to represent America in all its perplexing complexity. Superman got off easy; he got to fight midgets who would disappear when they said their name backward. Captain America had to defend a country in indefensible times.

While trying to breathe new fervor into this anachronism, a half-century after the best years of his life, Gruenwald was under heavy restraints. "You can't write a story where he ever makes a mistake," he said. "Spider-Man can make a mistake. The Hulk makes lots of them. Captain America really can't. He still has to represent the moral high ground on which this country was founded."

That tiresome chore has worn Cap out—not to mention Marvel, which has recently turned Steve Rogers into a comic book artist—but he has walked the straight line without stumbling, while the marriage of America and her idealism has dissolved around him. If he has outlived his calling, Cap has never outlived his usefulness.

Key issues: *Captain America* #1–10, Simon and Kirby issues; #46, Alex Schomburg Holocaust cover; #74–75, *Avengers* #4, return of Captain America; *Captain America's Weird Tales*; #100, new magazine (picking up *Tales of Suspense* #99); #110–111, 113, Jim Steranko art; #117, first appearance, the Falcon.

Captain Flash

Don Rosa argues that Captain Flash qualifies as the "first modern super-hero" because, whereas "all the other new heroes of the early to mid-'50s either had no powers or obtained their powers through mechanical devices," Captain Flash gained super powers through exposure to radiation.

Mike Sekowsky handled the artwork for the four-issue 1954 *Captain Flash* from Sterling Comics.

Captain Marvel (Fawcett)

As Otto Binder, the biographer of the Big Red Cheese, told Jim Steranko, "Superman was a personality, too. But Captain Marvel was a person."

A big, dumb, uncomplicated kid, actually. "A friendly fullback of a fellow with apple cheeks and dimples, he could be imagined being a buddy rather than a hero, an overgrown boy who chased villains as if they were squirrels," Jules Feiffer wrote.

"A necessary evil," according to C. C. Beck, who penciled in the dimples. "The part I liked best was Billy Batson."

Creator Bill Parker originally envisioned a cast of six, each sporting a different gift, but Ralph Daigh, who was calling the shots, ordered one super-hero with split personalities. All Billy had to do was whisper "Shazam"—an acronym of the first letters of Solomon, Hercules, Atlas, Zeus, Achilles, and Mercury—and he was transformed into a Fred MacMurray lookalike who packed their powers.

Captain Marvel debuted in *Whiz Comics* #2 (February 1940)—the first issue of *Whiz* was an ashcan featuring one Captain Thunder—and the friendly fullback quickly caught up to Superman in monthly sales, sometimes even surpassing the Man of Steel.

"Captain Marvel was gifted with the light touch," Feiffer wrote, and the Fawcett theme

The significance of "SHAZAM" and the origins of Captain Marvel were spelled out on many a title page.
(© Fawcett Publications)

> ### Thick as a Brick
>
> *Captain Marvel comics had no lengthy introductions. This was probably because its editors doubted any of its fans could read. And while the fans of Superman and Batman could only look up to the superior qualities of their heroes, a rock could feel superior to Captain Marvel. It must have taken "Cap" a year just to learn the word "Shazam."*
>
> *And talk about gullibility! Each issue, Dr. Sivana could wreck half the Earth and Captain Marvel would let him go if he promised to reform. A lowly worm, Mr. Mind managed to best him for most of 1943. But the artwork was clean and it was one of the few comic books which managed to improve as the years went by. Plus, the Captain had no mushy love interest. This was probably because Captain Marvel was really Billy Batson, a teenage radio announcer too young to be interested in the facts of life.*
>
> *But even as Captain Marvel, no one seemed interested in the Big Red Ox. Sivana's daughter always had the good sense to spurn him. It is true that Batman also never had a love life, but at least there was the Catwoman, whose very name and supple appearance indicated interesting if unfulfilled possibilities. For Captain Marvel, there was nothing, which was just what the kids of the day wanted. Lois Lane was a pain, and everybody knew it. Having a woman in a comic book story was too much like living at home or being in the classroom where the girls got the better grades.*
> MALCOLM WILLITS
> OWNER, COLLECTORS BOOK STORE, HOLLYWOOD

park was "a Disneyland of happy violence." It finally shut down in 1953 when Fawcett wearied of its endless legal battle (over copyright infringement) with National Periodicals.

Captain Marvel (Marvel)

Marvel's Captain Marvel first appeared in *Marvel Super-Heroes* #12 (December 1967), leading quite a few old Fawcett fans to wonder if Stan Lee had any respect for the industry's Golden Age. Lee wrote the first adventure for Captain Mar-Vell, the Kree sentinel, then handed the scripting to Roy Thomas. Thomas passed it on, then snatched it back 18 months later for a story in which Mar-Vell and Rick Jones traded atoms. The duo was at the eye of the hurricane during the Skrull-Kree battle royale in *Avengers* #89–#97.

Mar-Vell would have passed on, or passed away, in 1972, but his publisher wanted to deny DC, which had acquired the rights to the original Golden Age character, from slapping *Captain Marvel* atop its revival.

The character's days were, however, numbered; his number finally came up in Marvel's first graphic novel, published in 1982. Jim Starlin was controlling both the plot and the art when the art that began to brood in Mar-Vell during the '70s finally killed him.

Captain Midnight

Captain Midnight wants you to drink rich, chocolaty Ovaltine because he wants you to grow up stronger and huskier, with more pep and ginger!
1940 RADIO PITCH

If you think comic books were where the heroes of the Golden Age began and ended, Captain Midnight needs to set you straight.

By the time Fawcett enlisted him for his own comic book in 1942, Captain Midnight was already the star of a radio show and Ovaltine commercials; the character also starred in a comic strip, Columbia movie serials, and a children's book (*Joyce of the Secret Squadron*).

Created by two World War I vets, Robert Morris Burtt and Wilfred Gibbs Moore, Captain Midnight first appeared on Chicago radio station WGN in 1939, sponsored by the Skelly Oil Company.

"Burtt and Moore gave their hero his own air force, secret bases around the United States, and access to all the scientific devices they and other scriptwriters could dream up," Jay Spenser noted in a 1987 issue of the Smithsonian's *Air & Space* magazine.

And Ovaltine gave him a national audience when, on September 30, 1940, it introduced the leader of the Secret Squadron on the Mutual Radio Network.

The *Captain Midnight* comic book (published by Fawcett) was not only a minor part but a late arrival to the overall marketing campaign. How excited could kids get about a comic when they had their ears pressed up to the radio, waiting for Captain Midnight to give them another secret message to decode on their Code-O-Graph badge?

Captain Midnight survived six years on the newsstand, degenerating into sloppy science fiction at the end of its 67-issue run. The character was revived in a 1954 television series starring Richard Webb. He wound up in reruns bearing the name "Jet Jackson" because rich, chocolatey Ovaltine was no longer the sponsor.

Captains Contagious

Name, rank, and serial number, please:

Captain Action Based on the Ideal doll, which documented, as early as 1968, that DC would try to sell anything.

Jim Shooter, Mort Weisinger, Wally Wood, Julius Schwartz, and Gil Kane were all accessories to the crime.

Captain Aero Holyoke hero who first appeared in *Captain Aero Comics* #1 (December 1941).

Captain America The guy who, Jim Steranko said, gave the comics a reason to exist. Cap hit the newsstands in December 1940 (dated March 1941).

Captain Atom Steve Ditko's radioactive pile, who could direct thermonuclear blasts with his fingertips. His atoms first split in Charlton's *Space Adventures* #33 (May 1960).

Captain Battle A one-eyed Jack armed with a "curvo-scope," a telescope that allowed him to "see anywhere on Earth, because its lenses follow the Earth's curves." Ron Goulart loves his first words in *Silver Streak Comics* #10: "Strange, a race of birdmen seem to be conquering our European brothers."

Captain Battle Jr. "America's Invasion Ace" picked up where Captain Battle left off, going to war for Lev Gleason in Fall 1943.

Captain Billy's Whiz-Bang The dirty-joke book that made it all possible for Wilfred Fawcett and his descendants. An Army captain during World War I, Fawcett collected soft-core smut; the stuff so amused him that he mimeographed the real thigh-slappers, titled it *Captain Billy's Whiz-Bang,* and slipped it to his old Army buddies. By the middle of the Roaring Twenties, *Whiz-Bang* was being professionally printed and was selling half a million copies a month.

Captain Boomerang Another pan in the *Flash* #117.

Captain Britain The hero of a British strip that first reached the New World in *Marvel Team-Up* #65.

Captain Canuck The Richard Comely character whose arrival, in 1975, launched the "silver age" of Canadian comics. "The first appearance," John Bell noted, "of a Canadian super-hero since the demise of Johnny Canuck, Sergeant Canuck, and Canada Jack in 1945."

Captain Carrot First appeared in *New Teen Titans* #16 (February 1982).

Captain Combat The star stud of *Star Studded* (1945).

Captain Comet Librarian Adam Blake's first book was *Strange Adventures* #9 (May 1951). One of John Broome's Comet stories later provided the inspiration for his Guardians of the Universe.

Captain Commando First appeared with his Boy Soldiers in *Pep* #30.

Captain Confederacy A black-and-white production from Steeldragon Press in 1986 in which the title character oversaw the racist status quo in the Confederate States of America. A Will Shetterly and Vince Stone production.

Captain Courageous First appearance was in *Banner Comics* #3 (May 1941).

Captain Daring Simon and Kirby first sent him off to war in *Daring Mystery* #7 (April 1941).

Captain Easy Roy Crane's comic book soldier of fortune, debuting in 1929.

Captain Electron Jay Disbrow's 1986 one-shot, a misfit of computer science and the comics.

Captain EO You're serious? Methinks you bought the wrong book.

Captain Fear A Caribbean-born pirate, whose brief adventures in *Adventure Comics* in the mid-1970s were scripted by Steve Skeates.

Captain Fearless First appeared in *Captain Fearless Comics* #1 (August 1941).

Captain Fight High school coach Jeff Crocket in his off-hours. An Iger factory production, first appearing in *Fight Comics* #16.

Captain Flag First appeared in *Blue Ribbon Comics* #16.

Captain Flash "America's Ace Defender" guarded the unfriendly skies against atomic rockets and flying saucer invasions in the Fifties. *Captain Flash* #1 had a November 1954 cover date.

Captain Fleet A 1952 Ziff-Davis comic featuring "action-packed tales of the sea."

Captain Flight Four Star Publications's "master of the sky" had an 11-issue run, beginning in March 1944, that culminated with five of L. B. Cole's finest, and least cluttered, covers.

Captain Freedom First appeared in *Speed Comics* #13.

Captain Future The effect of gamma rays on…Dr. Andrew Bryant, first evident in *Startling* #1 (June 1940).

Captain Gallant of the Foreign Legion A 1955 Charlton comic based on the TV show starring Buster Crabbe and his son, Cuffy.

© MLJ Magazines

© Fawcett Publications

Captain Hero Jughead's stab at playing superhero. Jughead as *Captain Hero?* Surely, you have the entire set.

Captain Hobby Comics A 1948 Canadian giveaway "featuring Captain Hobby in an exciting Hobby Story 'Old Coins Tell Strange Tales.'"

Captain Jet "America's War Ace," shabbily rendered by the folks at Farrell in the early Fifties.

Captain Kidd A place-holder for Victor Fox after he decided his audience was tired of *Dagar, Desert Hawk* and before he realized they were ready for romance.

Captain Marvel (Fawcett) The best-selling superhero of the Golden Age. The Big Red Cheese, drawn by C. C. Beck, first appeared in *Whiz Comics* #2 (February 1940).

Captain Marvel Jr. After a near-death experience with Captain Nazi in *Whiz* #25, crippled newsboy Freddy Freeman was rescued by Billy Batson and injected with the spirit of Shazam.

Captain Marvel (Marvel) The noblest of the Kree warriors first appeared in *Marvel Super-Heroes* #12 (December 1967) and died in the first *Marvel Graphic Novel* (1982).

Captain Midnight The star of radio, movie serials, Big Little Books, and the television screen first appeared in the comics with *The Funnies* #57 (July 1941)

Captain Nazi Captain Marvel's most despicable foe, first greasing the pages of *Master Comics* #21 (December 1941).

Captain Nippon Another monument to ethnic caricature, first unveiled in *Captain Marvel Jr.* #2 (December 1942).

Captain Power The juice came on in *Great Comics* #1 (1945).

Captain Red Blazer The coverboy of *All-New* #5–#12, but the only mentions of him between the covers are in text features.

Captain Red Cross Another Harvey text piece, in *War Victory* #3.

Captain Rocket A Harry Harrison production, arriving in *Captain Rocket* #1 (November 1951).

Captain Savage That's Captain Steve Savage, thank you. Over Korea! And the Rockets of Death! Gearing up for his Flight to Kill! An Avon series from the early Fifties with E. R. Kinstler cover art.

Captain Science Best known for Wally Wood's covers and interior art; first issue November 1950.

Captain Stone Another bite-sized Holyoke hero from the mid-Forties.

Captain Storm One of the losers wandering through the DC war books, first bearing arms in *Captain Storm* #1 (May–June 1964).

© Youthful Magazines

Captain Swastika A Nazi foe worthy of the Hangman.

Captain Terror First appeared in *USA Comics* #2.

Captain Thunder The given name of Captain Marvel. Unfortunately for Fawcett Publications, Captain Thunder first enlisted at Fiction House (*Jungle Comics* #1), and Fiction House's subsequent legal action forced Fawcett to change its hero's name.

Captain Tootsie and the Secret Legion A Toby Press paid advertisement strip for Tootsie Rolls that debuted in October 1950. C. C. Beck drew Captain Tootsie's earlier appearances in *Monte Hale* #30 and *Real Western Hero* #71–#72.

Captain Triumph A super-hero who evolved when the spirit of a dead brother entered his twin. Created by Alfred Andriola in *Crack Comics* #27 (January 1943).

Captain Truth Bob Fujitani did the art in his baptismal for *Gold Medal Comics* (1945).

Captain V Alan Dale pops up late in the Big One in *The Book of Comics*.

Captain Valiant Check out *Variety Comics* #1 (1944).

Captain Venture The Gold Key character first appeared, near as we can tell, in *Space Family Robinson* #6.

Captain Victory Not to mention the Galactic Rangers. Jack Kirby's short-lived direct-sales production for Pacific Comics in 1981.

Captain Video "The Famous Star of the Dumont Television Network" appeared—"Directly from Television"—in *Captain Video* #1 (February 1951). George Evans contributed art to the six-issue run.

Captain Wings Fiction House's gallavanting flyboy got his wings in *Wings* #16 (December 1941).

Captain Wizard Debuted in *Meteor Comics* #1 (November 1945), but was inevitably obscured by bare-breasted mermaids.

Captain Wonder Wandered into public view in *Kid Komics* #1 (February 1943).

Captain Zahl The Nazi war criminal who—with Madame Rouge—blew up the Doom Patrol in *Doom Patrol* #121 (May 1968).

Cardy, Nick

Originally signing his work with his real name, Nick Viscardi joined the Eisner-Iger shop at the age of 19 and did superb work for both Fiction House and DC Comics—where he spent 20 years beginning in the mid-1950s.

Cardy drew Señorita Rio and Camilla for Fiction House before he was drafted in 1943. A tank driver in the Third Armored Division, Cardy once said he received nine Purple Hearts: "seven doing comics and peddling strips, and two from the Army."

Best known at DC for his pencils on *Tomahawk* and *Aquaman*, Cardy retired fairly quietly in the mid-1970s. "Nick was one of those people who always felt the comic industry had done him in," Dick Giordano said. "He was a failed illustrator in his mind; that he was one

of the greatest cartoonists around was completely lost on him. Talk to Nick today and he'll talk about the paintings he's done and the movie posters. He never felt particularly comfortable in comic books."

Caricatures, Racial

During the Golden Age, "There were all sorts of racial caricatures," said Stanley Kauffman, a Fawcett editor and, more recently, a movie reviewer at *The New Republic*. "They are deplorable now; I suppose they were deplorable then. But the wartime atmosphere is something else. Television has made a very big difference in the way we think about people on the other side. It's very difficult to turn enemies into drooling beasts. People took it for granted [back then] that that was the way you talked about them in cartoons. If you look at Hollywood films from that time, the Japanese don't have splayed teeth, or the Germans thick necks, but they are close to caricatures. The atmosphere of that war doesn't excuse a lot of things, but it explains it. Of course it was cruel and unjust. But at the time, it could not have happened otherwise. The injustice of it was part of the atmosphere at the time."

Few artists were as explicit with their caricature as Alex Schomburg. Examples of his buck-toothed Japanese and wretched Germans include *Exciting* #27; *Fighting Yank* #6, #8, #9, #12, and #13; *Human Torch* #12–#14; *Startling* #24; and *Marvel Mystery* #46, in which the German soldiers are transformed into skeletons. Also notable are *Air Ace* Vol. 2 No. 2 and *Air Fighters* #6.

Several strenuous caricatures of African Americans include *Star Comics* #3–#5 (the latter two drawn by Winsor McCay Jr.); *Startling* #14, in which the black warriors have sprouted horns; and the *Young Allies*'s covers featuring "Whitewash."

Carlson, George

The artist for the original dust jacket of Margaret Mitchell's *Gone With the Wind*, Carlson was never hungry again. Quite prolific in gags, puzzles, cartoons, and illustrations, Carlson was 55 when he dove into his first *Jingle Jangle* comic in 1942. His two regular features in the comic's 42-issue run—"Jingle Jangle Tales" and "The Pie-Face Prince of Old Pretzelburg"—remain relatively unknown motherlodes from the Golden Age of comics.

Once upon a time—a typical "Jingle Jangle Tale" would begin—*there lived a splendid but self-winding organ-gander who, one sweet day, packed up all he owned and set out to find a long lost key to his money-making apple pie mine.*

Typos, you're thinking. Organ-gander? Apple pie mine?

Long, long ago, during the reign of old Sultan Whoozis, there was, in the city of old Rag-Bhag, a most wonderful flea circus, owned by the famous flea trainer, Alla Bamma.

"George Carlson," Harlan Ellison wrote in the final chapter of *All in Color for a Dime*, "is Samuel Beckett in a clever plastic disguise. He is Harold Pinter scrubbed clean of the adolescent fear and obscurity, decked out in popcorn

This typical Alex Schomburg cover from *Young Allies* (#11—March 1944) has Bucky, Toro, and their pals (can you spot the African American?) fighting stereotypical "Japs" and, uh, lions.
(TM & © 1998 Marvel Characters, Inc. All rights reserved.)

George Carlson drew the covers for the first seven issues of *Jingle Jangle Comics* (this is #5, October 1942), and his stories appeared in most issues.
(© Eastern Color Printing)

balls and confetti. He is Ionesco with a giggle. He is Genet without hangups. He is Pirandello buttered with dreamdust and wearing water wings. He is Santa Claus and Peter Pan and the Great Pumpkin and the Genie in the Jug and what Walt Disney started out to be and never quite made."

Ellison exaggerates . . . but not by much. In Carlson's world, there is no end to the word play, the double takes, the puzzles, and the puns.

Look, there strides a hot-cross bun, bearing the placard, "Buy War Buns."

Every panel urges readers on to some new adventure, then lures them back for the clever gag they might have missed the first time around.

By 1949, Carlson's work in *Jingle Jangle*, and comics altogether, was done. He would ghost the *Reg'lar Fellers* daily strip for a spell, before returning to his career in children's books, where he had originally gained fame as the illustrator for the Uncle Wiggily books.

Casper, the Friendly Ghost

Think about it: Three decades of jokes about a dead child . . .

Casper first crept out beneath the sheet in a Paramount Pictures cartoon, "The Friendly Ghost," in 1945. Joe Oriolo and Seymour Reit created the character for Famous Studios, which produced the cartoons. According to Mark Arnold, editor of *The Harveyville Fun Times!,* Oriolo sold his rights to the character for $175.

Arnold reports that the ghost didn't have a name for the first three cartoons, including "There's Good Boos Tonight" (1948) and "A Haunting We Will Go" (1949).

The first five issues of the *Casper* comic book were published by St. John, which sold the rights to Harvey Publishing in 1952. Harvey published 65 issues of *Casper, the Friendly Ghost* (*Harvey Comics Hits* #61, followed by *Casper* #7–#70) before acquiring all rights to the character in 1958. Harvey then started from scratch with a new comic, *The Friendly Ghost, Casper,* which ran 253 issues before dying in 1989.

In 1995 director Steven Spielberg brought *Casper* to your neighborhood theater, sending chills down the spine of the Harvey brothers. After watching the ghastly array of suicides, murders, and resurrections, the Harveys condemned the film in a letter to the *Comics Buyer's Guide*.

Catwoman

Only two artists ever knew how to handle the Catwoman: Bill Finger, who created the character, and Michelle Pfeiffer, who brought her back to life in *Batman Returns*.

Finger created Catwoman for *Batman* #1, making the little thief so alluring and conniving that a smitten Batman quickly gave his current flame, Julie Madison, the boot. In the next two issues of the book, Finger continued the fun and games, using Robin and the Joker as props in their stand-offish romance. By the time

Catwoman kissed Batman for the first time in *Batman* #3—knocking him off-balance so she could make her escape—readers knew just what was in store for the panting pair: Phone sex.

Before Finger could dial that number, he left the book; Catwoman—and her alter ego, Selina Kyle—was subsequently abused by a number of scripters. On Earth-2, she recovered and married Batman (*Brave and the Bold* #197), but on this planet, she was melded to several actresses for the *Batman* television show, none more memorable than Julie Newmar.

Not until Pfeiffer slipped into the character in 1992 were the delicious lines and erotic mystery of Finger's original inspiration restored.

Celardo, John

You never know when the wheels of coincidence will begin to turn and you can hitch a ride. Owing to the Depression, John Celardo couldn't accept a scholarship to art school when he graduated from high school in 1936. The eldest of five brothers, Celardo had to provide for his family. Those were the breaks, he figured, knowing he was luckier than most. His lot was the National Youth Administration program; someone else would have to paint the world.

Curiously, though, there was a place for an artist in Franklin Roosevelt's make-work program. Celardo was assigned to the Barrett Park Zoo, not far from his home on Staten Island. The zoo needed new name plates for its cages. Celardo would go down several mornings each week, set up on a small drawing board, and sketch two or three of the local animals in watercolor. Then he would hit the zoo files and scrape up enough material to produce a quick profile.

Now imagine the smile on Celardo's face, years later, when he was asked if he could handle *Jungle Comics* or the *Tarzan* comic strip.

Like half the cartoonists in New York in the late 1930s, Celardo got his start from Will Eisner. Eisner's shop was servicing Fiction House, and when Gene Fawcette asked Celardo to jump ship and become assistant art director at Fiction House, he didn't look back.

Before he could get warmed up, Celardo was off to war, serving five years in Europe. When he returned, he was given covers and features in *Jungle Comics* and *Kaänga*, and precious little time to adjust to a world at peace.

Fiction House kept everyone well paid and well fed until 1948, when the staff was disbanded. Celardo and Bob Lubbers opened up their own shop for a spell, then joined Stan Drake in another office at 5th Avenue and 45th.

Celardo had been assisting Burne Hogarth on the pencils for *Tarzan*, and in 1953 he took over the entire strip. Celardo drew the daily and Sunday strip until 1968, when the Edgar Rice Burroughs estate decided it wanted more control of the product. He then freelanced until joining King Features as a comics editor in 1973; his last major project was drawing the *Buz Sawyer* strip before he retired to the golf links.

Although John Celardo's specialty was drawing animals, they usually took a back seat to the women on Fiction House covers (*Jungle Comics* #99, March 1948). Note the dynamic composition of the elements, a Celardo trademark.
(© Fiction House)

Centaur

Centaur rose from the ashes of the Comics Magazine Company and, after running its course, supplied the work force at Timely.

After resigning from National Periodicals, William Cook and John Mahon fired up the Comics Magazine Company in 1936, leading off with *The Comics Magazine* #1 (May 36). As the *Overstreet Comic Book Price Guide* notes, Cook and Mahon bought the cover and contents (the first installment of Jerry Siegel and Joe Shuster's historic Dr. Occult story) of that book whole-sale from National. (Dr. Occult continued his rounds in *More Fun* #14– 17.)

In 1938, Joseph Hardy bought Cook and Mahon's titles and launched Centaur. By the end of the year, Centaur had eight titles up and running compared with National's four.

Centaur featured covers and interior art by Bill Everett (who introduced Amazing Man in *Amazing Man* #5), Carl Burgos, Jack Cole, Basil Wolverton, Tarpe Mills, and Paul Gustavson. They also featured fiercely unpredictable distribution, which may explain why the company filed for bankruptcy in November 1940. The Centaur line included *Amazing Mystery Funnies, Keen Detective Funnies,* and *Star Ranger Funnies.*

Cerebus

Dave Sim's aardvark, born a barbarian in 1977 (parodying Roy Thomas and Barry Windsor-Smith's version of Conan), has evolved into the industry's most successful self-published comic.

"The foundation upon which *Cerebus* is built and the reason it is a success in the direct market is a monthly frequency, a 6,000-page storyline, and a single title character," Sim said at Oakland's Pro/Con in 1993. "It makes sense to me to devote 26 years of my life to a single story and a single character. In the direct market your success is largely dependent on your continuing presence."

And Sim is ever-present in *Cerebus*, not only in its consistent persistent storyline but in its intimate "Notes from the Publisher."

"*Cerebus* is mine," Sim once told *The Comics Journal.* "I'm the guy you negotiate with for *Cerebus*. There's no Jenette Kahn, or Dick Giordano, or Diana Schutz."

There is, however, Dave's longtime assistant and background whiz, Gerhard, providing art if not a voice.

Chadwick, Paul

He's introduced a sense of gentility into the comics, which has been sorely missed.
MATT WAGNER

The creator of the award-winning *Concrete* (which first appeared in *Dark Horse Presents* #1), Chadwick has also had a significant career in Hollywood, storyboarding such films as *Cheaper to Keep Her* with Mac Davis ("I've often wondered if that wasn't what put the brakes on Davis's acting career"), *Pee-Wee's Big Adventure, Racing with the Moon, Johnny Dangerously,* and part of *The Big Easy.*

He admits he couldn't handle the politics of Hollywood, which may have been why he turned down the chance to storyboard Tim Burton's *Batman*. "It made for a wistful afternoon," Chadwick said. "I went back to the Concrete page I was inking after I told him I couldn't do it."

Chadwick grew up on Evergreen Point, across Lake Washington from Seattle. At the age of 15, he joined Mark Verheiden's APA-5, which would later include Frank Miller, Chris Warner, and Dark Horse publisher Mike Richardson. "It was really energizing," he said. "It was . . . the common purpose, the common enthusiasm, caring more about something than the rest of the world."

He began storyboarding in 1979, at the age of 22; a year later, he joined Disney as a staff illustrator, working on EPCOT specials. A graduate of the Art Center College of Design, Chadwick did several science fiction covers for Isaac Asimov's magazine in the early 1980s.

At 26, Chadwick wrote his first Concrete story, submitting it to a variety of publishers, but drew only a nibble from Mike Gold at First Comics. Three years later, his creation helped launch Dark Horse Comics; Concrete was the backup feature in *Dark Horse Presents* #1. When Chadwick's agent, Mike Friedrich, then suggested that Paul put the feature out to bid, Dark Horse successfully outbid seven other companies to retain publishing rights.

Paul Chadwick

Dave Sim is well on his way toward his goal of publishing 300 issues of *Cerebus.*
(© Dave Sim)

"I'd always thought of myself as an illustrator," Chadwick said. "I had never written before. I didn't have the confidence to turn my back on my art skills, which are a big part of my identity, and be just a writer. Comics were the perfect way to ease into writing with that safety net. Gradually, I've realized that I'm a stronger writer than I am a comic artist."

On the strength of *Concrete*, *Concrete: Fragile Creature*, and *Concrete: Killer Smile*, most of Chadwick's fans aren't faulting either of his gifts. Neither are the Eisner Awards voters, who honored Chadwick and his creation seven times in the first half of this decade.

Challengers of the Unknown

The second of DC's Silver Age heroes followed the Flash by four months in *Showcase* #6 (January 1957), but they were the first to gain their own book: *Challengers of the Unknown* #1 (May 1958). The title was written and drawn by Jack Kirby, whose pencils occasionally struggle beneath the heavy hand of Wally Wood's inks.

DC's Jack Schiff claims the "concept" behind the Challengers was his, fleshed out in "office discussion."

And Kirby? "The science fiction pictures were beginning to break, and I felt that the *Challengers of the Unknown* were part of that genre," Kirby said in a *Comics Journal* interview. "I began to think about three words which have always puzzled me: What's out there? OK? What's out there. I didn't care about the East Side anymore. I didn't care about Earth or anything like that. I thought, what's really out there? Then I began to draw characters from outer space, characters from beneath the Earth, characters from anywhere that we couldn't think of. The Challengers were us contending with these very strange people."

The original cast: Rocky Davis, an Olympic wrestling champion; Professor Haley, a Hugh Hefner with 800 on his math SATs; astronaut and Korean War vet Ace Morgan; and Red Ryan. And challenging the Challengers? How about Multi-Man, Volcano Man, Sponge Man, and the League of Challenger-Haters?

Charlier, Jean-Michel

The Belgian-born Charlier, who died in 1989 at the age of 64, teamed with artist Jean (Moebius) Giraud to produce *Lieutenant Blueberry*, the superb western series first published in Europe in 1963. Charlier also wrote a variety of adventure strips following World War II, including *Jean Valhardi*, *Marc Dacier*, and *Tiger Joe*.

Charlton

Dick Giordano, who treaded water at Charlton Comics for some 15 years, laid it all on the ping-pong table.

"They had a ping-pong table at the plant," Giordano said. "Though we were working on staff, we were working piecemeal; when we went down to play ping-pong, it was our business: We were losing our money. We used to play a lot of ping-pong together."

Better that than whacking away at Judomaster, the Blue Beetle, or Professor Coffin.

Charlton was, Giordano said, the only operation at that time (and to this day) that was completely self-contained. The pages were drawn, written, engraved, color-separated, printed, and distributed from the same building in Derby, Connecticut. "Charlton really had the capacity to put a lot of pressure on a lot of publishers if they'd made a commitment to quality early on."

What Charlton was truly committed to, historian Will Murray suggests, was keeping its in-house printing presses churning. Comic books simply plugged the gaps between the company's best-selling magazine runs.

"The commitment was never made to the material," Giordano said. "The commitment was never made to spend the few extra bucks and take advantage of the uniqueness of their operation."

Giordano arrived in 1952, seven years after Charlton got rolling with *Zoo Funnies* #1. The company never suffered from a lack of talent. Roy Thomas and Denny O'Neil dropped by. Al Williamson and John Severin passed through. Pete Morisi and Joe Gill picked up a paddle.

And, of course, there was Steve Ditko, who— along with Giordano's editing—finally brought Charlton into the Silver Age with his 1960 creation of Captain Atom. After his classic stint at Marvel in the early 1960s, Ditko returned to Charlton to produce memorable work on the horror titles but really outdid himself on *Blue Beetle* and his own *The Question*.

"I thought, what's really out there? Then I began to draw characters from outer space, characters from beneath the Earth, characters from anywhere that we couldn't think of."
JACK KIRBY

Howard Chaykin's landmark work was his *American Flagg*, especially the first 12 issues, published by First Comics in the early 1980s. The distinctive lettering was provided by Ken Bruzenak.
(© Howard Chaykin)

Ditko's art is the highlight of any Charlton collection, although we'd also like to pay our respects to Morisi's *Thunderbolt*. On the Charlton timeline, you'd have to circle 1969, when Popeye, Flash Gordon, and the Phantom arrived from King Features; 1981, when Charlton decided to publish without the approval of the Comics Code Authority; and 1983, when DC bought Blue Beetle, Peacemaker, Captain Atom, the Question, and the rest of the Charlton super-hero cast for less than $50,000.

The company closed its doors in 1985, quitting on a rather dour note, *Professor Coffin* #21. A year later, DC opened the doors of the crypt and brought back the Charlton heroes, albeit reshaped by Alan Moore and Dave Gibbons. The Watchmen, in the end, may be Charlton's enduring legacy.

Chaykin, Howard

He was eight years old when he stole his first issue of *Blackhawk*.

"I stole it from a candy store," Chaykin said. "I loved comic books insanely, and my mother wouldn't give me any money for them. So, I stole them. I folded [*Blackhawk*] four ways—I was always more of a reader than a collector—and stuck it down my pants, once again drawing the relationship between sexual assault and comic books."

And Howard Chaykin wants that relationship in the lead: "I think sex is the roiling undertext of comics. Someone once told me that the reason I'm so roundly despised by the profession is that I'm very comfortable with my demons. I welcome their presence. I think that's true. Comics have always managed to conceal sexual content behind symbol and embolism. I just get it out front."

American Flagg. Time2. Black Kiss. You don't get much more out front than that. And Chaykin has never been one to back down when he comes under attack. Not many years ago at a British convention, Chaykin was "ambushed" (his phrase) by a group of fans, one of whom said, "Given that *Black Kiss* is disgusting and pornographic, aren't you ashamed of yourself?"

The F-word popped out before Chaykin got his hand over the microphone. "You know me," he told the British twink, "you know my reputation, you know what I'm capable of. Either apologize or leave."

"One of my problems with the comic book audience is it doesn't get out enough," Chaykin said. "Hey, I was a fanboy. A 235-pound fat fanboy. I was your classic Merry Marvel Marching Society Stan Lee–loving geek. If I can outgrow it, they can, too."

Chaykin had some help. He learned by working with Gil Kane in his early teens and actually listening to the man. "When Gil Kane talked about Lou Fine, I went and looked at Lou Fine," Chaykin said. "By looking at the stuff the people I admired were looking at, I got over an insipid case of cultural amnesia. Whereas comic books are based on cultural amnesia."

And he learned by stepping into Wally Wood's studio and watching the man disintegrate. "Woody was a guy I worshipped," Chaykin said. "I was there for six months. Woody spent the days in a lotus position sitting in front of a desk with a jug of black tea, vilifying the world. He was misogynistic, bilious, and vile. By that time, Woody had become this unbelievably hostile, embittered, foul, hate-mongering guy. He was filled with all the good, negative shit . . . most of which I've come to agree with. The difference between his bitterness and mine is I'm able to articulate mine without foaming."

After splitting with Wood, Chaykin lived and worked with Jim Starlin, Walt Simonson, and Val Mayerik. "It wasn't so much a group effort as it was a place to work, but we did throw some bitchin' May Day parties," Chaykin said. "We'd celebrate workers' freedom by hitting one another with T-squares."

Now transplanted to Los Angeles, Chaykin notes, "I love comic books. I like the language. I just don't have much respect for the content. I love what I'm doing for a living, but I have contempt for the little whores who are bleeding this industry dry with their poster art."

Cherokee Book Store

One of the first used-book stores in the U.S. to stock quantities of old comics, the Cherokee Book Store was parked at 6607 Hollywood Boulevard, opposite Frederick's of Hollywood. Jack Blum sold the used books; his son, Burt, sat atop the pile of comics in his own inner sanctum at the back of the store in an upstairs loft.

As Rob Gluckson records in Bill Schelly's *The Golden Age of Comic Fandom*, collectors who stumbled into the store in the early '60s would tell Jack, "We're here for the old comics," and Blum would motion them up to the loft. "Past the [upstairs] cashier, you entered a hall, winding between floor-to-ceiling shelves full of boxes of comics. Many boxes had covers ripped off a comic and taped to the front so you knew what title the box contained." The hallway ran parallel to Hollywood Boulevard. At the far end, Gluckson said, "There was a small window set in the right hand wall of books that allowed Burt to see into the hall, but you couldn't see him." If one wanted entry to the Inner Sanctum, where books from the '40s and '50s were stored, Gluckson said, "[Burt] would only let you in the room for long enough to price your finds from the outer rooms, and to look at one or at most two boxes of the rarer comics."

"The Cherokee Book Store was your weekly convention," Michelle Nolan said. "Burt was a hippie, rather sardonic. He was a nice, pleasant person when I visited him, but you couldn't get to his stuff. It wasn't organized. If you really wanted certain books, you had no idea where they were."

Competitor Malcolm Willits had little patience with Burt Blum's haphazard nonchalance. "His father put him in charge of the comics to keep him out of trouble," Willits said. "Burt was a good guy, but he didn't like comic books and he didn't like comic book collectors. He liked to sit up there and vegetate. He was stone lazy; he'd sit there like a bump on a log. People were stealing from him right and left. We'd tell kids to go down there and tell them what to swipe."

Convinced they could do a grand business at the Blums' expense, Willits and Leonard Brown opened Collectors Book Store just down the street in the spring of 1965. For comics and pop culture fans, a short two-block area of Hollywood Boulevard soon became a mecca. "Every six months or so, my boyfriend and I would drive up from San Diego," says Jackie Estrada. "We would go to Collectors (which was in an old bank building) and to all the used bookstores, and to Larry Edmunds for movie memorabilia. But the highlight was always Cherokee. In the hallway we'd find Barks comics and *Little Lulu*s in the 10 cents apiece or three-for-a-quarter bins. We'd load up on a hundred comics at a time. But then one trip, I think it was in 1968, we walked into the comics hallway and—no bins. Suddenly everything was individually priced, in boxes in Burt's inner sanctum. I guess that's when comics collecting—especially Barks—must've really caught on."

Howard Chaykin

"I love comic books. I like the language. I just don't have much respect for the content."
HOWARD CHAYKIN

Burt Blum, who billed himself as "King of the Comics," in his inner sanctum at the Cherokee Book Shop.

Chesler, Harry "A"

"Harry always had a cigar in his mouth," Rafael Astarita said. "Harry always talked out of one corner of his mouth because he had a cigar in the other corner.

"He always talked around the cigar. His mouth was always twisted. One of the first things Harry said to me around the cigar was, 'You see, Astarita, this here character is a big bastard. He's a big son of a bitch. And he don't give a shit for nobody. And he's going to be the hero of this here strip, see. Get the angle?' That was the phrase I was to hear hundreds of times. Harry seemed afraid you wouldn't understand the way he put things."

Subtlety didn't suit Chesler, with or without the cigar. Astarita remembered a writer testing the publisher's patience at a time when Chesler's magazines weren't selling as well as he'd like.

"I remember Chesler chasing him down the hall," Astarita said. "It was like a scene from some bizarre comedy. The poor man. We heard these muffled voices and this commotion. Harry Chesler came back into the room, munched on the cigar, and said, 'You can't satisfy some guys nohow. I told that son of a bitch we didn't need no friggin' writers and I couldn't convince him. So, I kicked his ass out of here.'"

In earlier, better days at the Chesler shop, Harry was a kinder, gentler soul. When Joe Kubert and Norman Maurer used to play hooky from the School of Music and Art and make the 100-block trip down to Chesler's place, he usually had the welcome mat out. "Harry was the kindest man in the world to me," Kubert said.

When Astarita first met Chesler—"in a little office on lower Fifth Avenue"—the artist had just arrived in New York from Chicago, where his advertising business had given him all the contacts he needed to get into publishing. Astarita, one of the first artists Chesler hired in 1935 for his comic book assembly line, recalled a converted loft at Fifth Avenue and 32nd Street, with two long lines of desks. Once Astarita got settled, Creig Flessel, Charlie Sultan, Charlie Biro, Bob Wood, Paul Gustavson, Jack Kamen, and Gill Fox began to fill up the desks around him. The writers—Wade Wellman, Ken Fitch, George Nagle, and, eventually, Otto Binder—worked in an office down the hall.

With this crew, Chesler produced stories for Centaur, Fawcett, MLJ, Quality, Timely, and 14 other publishers. "He assigned eight or nine writers and packaged complete magazines, including plates, for publication," Kubert said. "Harry would say, 'What do you want, an adventure book? You got it.' Twenty stories? One story? A horror book? He'd deliver the

Some of the most interesting covers in the history of comics came out of Harry Chesler's shop. Gus Ricca's cover for *Punch* #9 (July 1944) may offer some insights into working for Chesler; *Scoop* #2 (January 1942) sports a nice underwater composition by Charles Sultan.
(© Harry "A" Chesler)

book to anyone who wanted to buy it."

Astarita doesn't remember the delivery process as a labor of love. "Harry would stand in the front of the room in the morning, talking out of the corner of his mouth, and around the cigar, 'Okay, you guys, let's clean up this shit and get to work. What are you fooling around for, Astarita? Let's get to work, what do you say?' Then he'd go to the back of the room, against the wall, wearing the hat and the vest and no coat. Every once in a while he'd tell a dirty joke. That's the way things generally went in the studio in the morning. If you came in five minutes late, he would dock you for an hour. Then he'd get feelings of remorse and go downstairs and buy wine and fruitcake—what a rotten combination—and he would give us a five-minute rest while we ate fruitcake and drank wine.

"Nothing was ever simple for Harry," Astarita said. "He was always out to fool someone. Later, he was to be the ultimate in offensiveness. I don't remember the writer who was seduced into doing this terrible strip Harry thought of, but it was supposed to be about a Jewish cowboy. Chesler wanted to call it 'The Bar Mitzvah Ranch.' One of the Jewish leaders in New York [wrote and] Chesler said, 'Look at the letter I got here! Guess who wrote me a letter! But we don't care. We step on everybody's toes. Get the angle? Get the angle?'"

Chesler kept pushing the angle until 1953, when he retired to the farm—Horseshoe Lake Farm in northern New Jersey. Twenty years later, Kubert bumped into Chesler again, living in a house filled with dogs near Roxbury. They were still close when Chesler lay dying in December 1981 and Kubert snuck into his hospital room and sketched Harry on his deathbed. "He didn't even know I was there," Kubert said. "I think it was the last sketch of him."

Or the first without the cigar.

Christman, Bert

He was drawing *Scorchy Smith* at the age of 21. He was the first artist to breathe life into the Sandman. But if Bert Christman wanted to be remembered for anything he drew, it would surely be the panda bear mascot he designed for the Flying Tigers.

Long before his Sandman hit the streets in 1939, in *Adventure* #40, Christman was in Pensacola, training to fly for the U.S. Navy. Scorchy deserves an assist. "That was *the* aviation cartoon," says Tex Hill, one of the fliers who met Christman at Pensacola and stayed with him until the end, "and he lived it. I'm sure that's one of the reasons Bert went into the Navy. To carry on his work as a cartoonist. To live the adventure he was depicting."

"Ah, adventure!" Don Quixote boasts in *Man of La Mancha*. "And misadventure, too," pipes in Sancho Panza. Christman would have felt right at home with both the knight errant and his clown. When he earned his wings at Pensacola, he drew duty on a bombing squadron aboard the aircraft carrier *Ranger*.

In June 1941, Christman and two squadron mates—Hill and Ed Rechtor—jumped ship and joined the American Volunteer Group. The AVG was the aerial circus General Claire Lee Chennault was recruiting to help the Chinese fend off the Japanese in the skies above the Burma Road. The outfit was soon known as the Flying Tigers.

Christman, Rechtor, and Hill crossed the Pacific aboard a Dutch tub, the *Bloem Fontain;* their P-40s were shipped over in crates and assembled in Rangoon, then shipped up to central Burma.

Christman wanted combat experience, but he never had learned to fly as well as he could

Here's another bizarre Gus Ricca cover for Harry Chesler: *Dynamic Comics* #8 (May 1944).
(© Harry "A" Chesler)

"I don't remember the writer who was seduced into doing this terrible strip Harry thought of, but it was supposed to be about a Jewish cowboy. Chesler wanted to call it 'The Bar Mitzvah Ranch.'"
RAFAEL ASTARITA

The young Bert Christman's love for airplanes and flying came across in his work for the *Scorchy Smith* newspaper strip.
(© AP Newsfeatures)

draw. Each time Chennault gave him the keys to a P-40, Christman failed to bring the plane home. Two were shot out from under him. Waiting for his next flight, he designed the panda bear that became the squad's insignia. As best as Hill can remember, Christman painted personalized bears on eight of the planes. Hill's panda had a 10-gallon hat and six-shooters; Gil Bright's had a parachute. "He never had time to do a panda for his own plane," Hill said. "But then again, he didn't think he was going to get killed. Time ran out on him."

On January 23, 1942, Chennault let the 26-year-old Christman loose for one more mission. When 72 Japanese planes attacked Rangoon, 18 Tigers went up to meet them.

"The report was unknown bogeys to the northeast," Rechtor remembers. "We climbed as fast as we could. When I looked ahead, there was a giant formation of 27 dive bombers with escort fighters. We got above them, about 800 feet above them, and as they came in, I made an attack.

"It was a tight formation; I didn't aim at any one airplane, just made a raking pass and kept up speed. I continued to dive, then pulled it back up and headed back into the fray. Bert followed me and I saw him pull up behind me, then head back into the fight. I never saw Bert after that. A Jap got on my tail and I had to dive away again."

Christman bailed out when his engine was hit. He was parachuting toward the jungle sanctuary below when a Japanese fighter returned and strafed him. "No, there was nothing sporting about World War II," Hill said. "All that passed in World War I."

When the Burmese returned Christman's body, it was riddled with bullets, the fatal wound at the base of his neck. Rechtor and Hill's final flight with their buddy found him in a coffin. "That was a sad day," Hill says. "They didn't have any way to embalm people, and bodies deteriorated real fast. Here's your best friend in the box and you could barely sit in the lorry."

Christman was first buried in Rangoon, then in New Delhi. In 1950 his body was returned to his home in Fort Collins, Colorado, where the local airport was renamed Christman Field.

Claremont, Chris

The self-proclaimed "god-emperor of the mutants" until he departed writing chores on *X-Men* in 1992, Claremont was born in London and immigrated to the U.S. at the age of 2. He never lacked for chutzpah. At the age of 4, Claremont walked up behind a Florida sheriff, "pulled his gun out of the holster, stuck it in his back and said, in my British accent, 'Put your hands up, I'm going to shoot you.' He had a cow. I don't know if that indicates I was too stupid to live or incredibly fearless."

After two months at Bard—a college, he said, that would have ranked #1 on the Drug Enforcement Administration's hit list if Cal-Berkeley wasn't in a class by itself—Claremont went to work on a kibbutz at Nativ Hallamad He, north of Hebron and near the old Jordanian border.

The ashes from the 1967 war were still smoldering. "In America," Claremont said, "war was an abstraction; in Israel, it was your life. I almost didn't come back, thinking, 'Here was something worth fighting for.' One weekend, we all

Circus

Comics should be like the circus. The circus doesn't change very much, but the audience changes. Old fans grow out of it, new fans grow into it.
WALLY GREEN
EDITOR AT WESTERN PUBLISHING FROM 1959 THROUGH 1984

went to the Sinai in two minibuses. We had just gone past a nuclear plant, despite being 50 miles from the sea—when we were suddenly surrounded by tanks. There were searchlights, flares, guys in combat gear. Earlier that day, the Israeli air force hit Cairo and bombed a school by mistake, killing a bunch of kids."

Revenge was in the air, Claremont said, "so the Israeli defense forces were setting up a convoy. I found out later that if there was a firefight, the lead bus, the other bus, was going to take the fight, and we were supposed to get the hell out of there."

Claremont made it back to Bard, where he changed majors, abandoning political theory for acting. "I loved it. I had an acting teacher who said my twenties would be hell, but when I hit 30, I'd be a great character actor, a character actor like Brian Dennehy who never has to look for work again. I could get into that. I loved it with a passion, but I was always writing. It dawned on me years later that as much as I loved acting, I only loved it. Writing was as integral a part of me as breathing."

For years, he was ashamed that he was writing comics. "I used to be embarrassed by it," Claremont said. "Now, it's the reverse. You think you can do better, you try it. To hell with writing *comics*; just try writing."

Claremont has been trying for years, and succeeding more often than not. He wrote X-Men comics for 17 years. His thanks for such loyalty was to be dumped off the book when Jim Lee asked for writing control. Claremont was wooed back to the foundering Marvel in late 1997 as editorial vice president.

Classics Illustrated

> *Comics thought they were doing classic material. Well, that's the way comics squeeze the life out of everything."*
> GIL KANE

> *I can assure you the Classics Illustrated were the* Cliffs Notes *of the '50s.*
> HAMES WARE

When Joseph Witek fanned their pages, he inhaled "the faint whiff of absurdity." Dr. Fredric Wertham caught more than a faint whiff: He suggested in *Seduction of the Innocent* that the *Classics* comics corrupted both the original text and its newest readers. "The comic books of 'classic' and 'famous authors' show our disregard for literature and the children as well," Wertham wrote.

The first such purportedly corrosive Classic—distilling *The Three Musketeers* with total disregard for Alexandre Dumas—appeared in October 1941. The editor was Albert Kanter, who was born in Baranovitchi in czarist Russia.

By the fourth issue, Kanter's Gilberton Company—located at 510 Sixth Avenue in New York—had formed and was publishing the series. (In the early 1950s, the company moved to its more memorable address, 101 Fifth Avenue, near Greenwich Village.)

Classics Illustrated changed its name from *Classic Comics* with the 35th issue to gain some aesthetic distance from the comics rack. Also lending some distance was Gilberton's alliance with Curtis Distribution. "The *Classics* were distributed with the *Saturday Evening Post, Atlantic Monthly,* and other esteemed publications," said Bill Jones, an Arkansas collector and the author of *Classics Illustrated: An Illustrated History.* "You had to go to special places to find them. Generally, they had their own spinner racks with the *Classics* logo."

Because Gilberton began reprinting the *Classics* in early 1943, that spinner rack was invariably filled with dozens of different books. *Ivanhoe,* for example, was reprinted 24 times between 1943 and 1971, *Moby Dick* just one less than that. Most *Classics* had a first printing of 250,000 and subsequent print runs of 100,000.

Many of the early *Classics* were rather embarrassing rewrites (*The Hunchback of Notre Dame* with a happy ending) with amateurish artwork. That awkward infancy ended in 1944 when Jerry Iger took over as art director. Iger held the post for almost 12 years, assisted by editor/adapter/heart throb Ruth Roche, and he had the extreme good fortune to direct artists Henry Kiefer, Alex Blum, Robert Webb, and Rudy Palais.

That artistic quartet dominated the *Classics* until 1953 when, as the rest of the industry headed for the woodshed, the *Classics* hit their stride. Norman Nodel was the adept and reliable house artist, and Lou Cameron was on board. No one else in comics, Ware argues, was doing the sort of full-page drawings that Cameron supplied for "The Bridge of Falsea,"

Chris Claremont

"If you were a compulsive, obsessive perfectionist, what better way to pursue it than to collect all these numerical fathers and their various aberrational stepsons?"
HAMES WARE

Most *Classics Illustrated* titles were recycled numerous times, sometimes with the same cover and sometimes with different ones.
(© Gilberton Co.)

Dan Clowes

the backup story to *The Bottle Imp (CI #116)* in 1953. And when EC folded in 1954, Gilberton—not DC or, most certainly, Atlas—provided a reliable paycheck for such EC stalwarts as George Evans, Al Williamson, Reed Crandall, Graham Ingels, and Joe Orlando.

Supervising the lot of them was editor Roberta Strauss Feuerlicht, a rather dynamic perfectionist. When Feuerlicht wasn't counting the buttons on the uniforms of the Napoleonic soldiers from page to page in Ingels's *Waterloo*, she was contacting the British Admiralty to get the scoop on British naval court martial proceedure for *The Dark Frigate*.

L.B. Cole also had a stint as *CI*'s art director, beginning in 1958, and contributed several painted covers to the *CI Junior* series.

Classics Illustrated ceased publication in April 1971, four years after Kanter sold the rights to Patrick Frawley. Although Gil Kane and Fredric Wertham would have brought criminal charges against the series, many mourned their passing. Reading the *Classics* in the 1950s, Jones said, had "a profound effect on my attitude about literature as I grew older. I was not intimidated by *The Last of the Mohicans* or *The House of the Seven Gables*. I knew them already as good stories I'd read at seven or eight in *Classics Illustrated*."

Collecting the *Classics* is an exhausting enterprise, fraught with the reorder list ("You can't underestimate the mystique of the reorder list," Jones said), next-issue ads, and such classic acronyms as HRN (Highest Reorder Number), O (Original), PC (Painted Covers) and LDC (Line Drawn Covers). But that enterprise had its charm for a lot of collectors in the 1950s, Ware said: "If you were a compulsive, obsessive perfectionist, what better way to pursue it than to collect all these numerical fathers and their various aberrational stepsons?"

The *Overstreet Comic Book Price Guide* does an adequate job in pruning the numerous branches of the Gilberton family tree.

Key issues (originals only): 8, *Arabian Nights;* 13, *Dr. Jekyll and Mr. Hyde,* first *Classics* horror title; 18, lauded in New York State Joint Legislative Committee report for "pictorial scenes of terror, torture and violence"; 32, *Lorna Doone,* Matt Baker cover and art; 33, rare in high grade; 35, first issue under *Classics Illustrated* logo, March 1947; 41, *Twenty Years After, CI*'s grisliest horror cover; 43, *Great Expectations,* derided by Wertham as a "crime comic"; 44, last *CI* horror title and last 56-page edition, Kiefer cover; 50, rare *CI* appearance of Wertham's "injury-to-eye motif"; 81, *The Odyssey,* first painted cover; 116, *The Bottle Imp,* Lou Cameron art; 124, *The War of the Worlds,* Cameron art; 125, *The Ox-Bow Incident,* first Norman Nodel art; 167, *Faust,* which inspired Kantor to say, "We're producing Cadillacs and marketing them as Chevrolets"; 169, *Negro Americans: The Early Years,* final issue.

Clowes, Dan

The creator of *Lloyd Llewellyn* (is the LL certified proof that he was heavily into the Superman mystique as a kid?) and *Eightball,* Clowes's critically acclaimed work is published by Fantagraphics. He avoids mainstream comics like the plague.

And what about mainstream fans? "I'm sick of the whims of nerdy comic fans keeping me

from making millions of dollars," Clowes told Gary Groth in 1992. "'Cause if they would use their brains at all, they would buy my comic instead of the crap they buy now."

Cochran, Russ

Longtime comics collectors remember the familiar address: P.O. Box 437, West Plains, MO 65775.

"The first time I ever heard from Russ Cochran," Bill Gaines told *The Comics Journal* in 1983, "he wrote me a letter: 'I just thought you'd like to know what happened to the members of the EC Fan-Addict Club, Chapter so-and-so. There were five of us, and I'm a Ph.D in physics, chairman of the Physics Department of Drake University, and my friend is an attorney and this friend is a doctor and this friend is something else and this friend is something else, and that's what happened to the five members of this chapter in which you ruined and fucked up our minds so many years ago."

That letter sparked an enduring friendship between Cochran and Gaines. It helped fuel the mail-order auctions that the physics professor ran out of that West Plains address. And it led to *The Complete EC Library*, the reprint series that made Cochran's address famous.

"I am a speciality publisher, publishing for a small but discriminating group of comic art collectors," Cochran wrote in *The Complete Tales from the Crypt*. He made one foray into the world of the nondiscriminating when fellow collector Bruce Hamilton introduced him to a Houston attorney named Burrel Rowe.

"The three of us," Rowe said, "became big buddies. As the '70s went on, I was making a lot of money in my law practice, so I got the idea of opening a comic book store, the three of us together. We opened Camelot in 1978.

"We were the first ones to ever have a color ad in the [Overstreet] Price Guide. We had a comic art gallery on the second floor. Our carpet was Walt Disney." When Chuck Rozanski visited Houston shortly after uncovering the Edgar Church collection, Rowe said, "He took one look at Camelot and said, 'You're going to lose your ass.' He was absolutely right. He knew how to be a businessman. All I was was a lawyer who was just throwing money around."

All Cochran turned out to be was the EC Fan-Addict who introduced EC comics to several other generations. It was fitting, then, that Cochran was at Gaines's side in 1992 when the old man opened his vault and pulled out his legendary file copies. They have since been auctioned and are squirreled away in collections of people who no doubt got their start sending away for catalogues from Russ Cochran in West Plains, MO.

Colan, Gene

Born in 1926, Colan began his comics career at Fiction House, walking through the door a mere two weeks after Murphy Anderson arrived. Over the next two decades, Colan enlisted with Quality, St. John, Ziff-Davis, Dell, DC, and Ace before settling in at Marvel in 1965. At Marvel, Colan had lengthy turns with *Daredevil* and *Sub-Mariner* before landing *Tomb of Dracula* in 1972. Critics count Colan's 72-issue run with The Count as some of his best work, particularly when it was illuminated by Marv Wolfman's scripts.

A mild-mannered gentleman, Gene Colan walked out the door at Marvel when he decided he preferred retirement to following Jim Shooter's penciled suggestions on Colan's original art.

Cole, Jack

> *One artist of Eisner's generation whom I really loved as a kid was Jack Cole, who I still think is one of the great geniuses of comics. He transcended his genre completely. Both transcended the super-hero genre and the spoofing of the super-hero genre, which is a real tightrope act.*
> BILL GRIFFITH

Because, in the end, Jack Cole put a bullet in his head, that transcendence apparently was not the artist's only tightrope act.

His life, which ended in 1958 when Cole was but 44, never lacked for creative energy. When the cartoonist was only 17, he hopped aboard his bicycle, Betsy, in New Castle, Pennsylvania, and took off for Los Angeles. Twenty-three days

Collector's Item

I've never heard of a collector's item that had a print run of eight million. "Get your collector's items here! Roll up, roll up, form a queue." A collector's item is something that one person has and no one else has.
EDDIE CAMPBELL

One rule to live by: If it says "Collector's Item" on the cover, it ain't.

Here's one of Jack Cole's classic covers: *Silver Streak* #6 (September 1940).
(© Lev Gleason Publications)

Jack Cole's fluid and dynamic storytelling make every page of *Plastic Man* a treat for readers.

(© Quality Comics Group)

later, he scraped the dust of 3,500 miles from his spokes, then saddled up for the return trip.

Cole completed a correspondence course in cartooning when he was 15 and dreamed of being a gag cartoonist. He made his first sale to *Boys' Life* in 1935, shortly after arriving in New York; joined Harry Chesler's studio in 1937; and caught Busy Arnold's eye with his work on Silver Streak and the Claw for Your Guide Publishing.

Arnold brought Cole to Quality and was rewarded, in 1941, with Plastic Man.

Plas would have enough of an accomplishment—Cole maintained the incredible elasticity of his rubber man for 102 issues of *Police Comics*. But he also created the Comet for MLJ's *Pep Comics*, Dickie Dean for *Silver Streak,* and a masked detective named Midnight for Arnold (just in case, Will Eisner noted, that Eisner died during World War II and Busy needed a quick sub for The Spirit).

Cole's inventive layouts were almost a match for Eisner's; in fact, he ghosted the daily *Spirit* strip in 1942. By the late 1940s, he was drawing crime and horror comics, which was where the industry action was. He moved to Chicago in 1955 to draw "Females by Cole" for *Playboy*. Three years later, Cole woke up from a long party that had celebrated "Betsy and Me," his new *Playboy* comic strip, and drove down to the local gun shop to buy a .22 pistol.

He drove several miles down the highway before putting the gun to his head.

Cole, L. B.

Chaplains at War? Frisky Animals? The Living Bible? Jeep?

Welcome to the world of Leonard B. Cole.

He produced several hundred comic book covers, and you can file almost all of them under Esoteric. *Law-Crime? Patches? Blue Bolt Weird? Picture-Scope Jungle Adventures?* The list goes on and on. If ol' L. B. didn't exist, Scott Shaw! would have had to invent him.

Cole was born in 1918. His mother was an illustrator, but his first love wasn't drawing, but animals. After his parents divorced, Cole was living on his own at the age of 14, and he met Man o' War while hanging out in the bluegrass of Kentucky.

"I was enchanted," Cole told E. B. Boatner, "and I drew horses almost exclusively for two or three years." Dogs were also an old favorite; Boatner reports that Cole's German shepherd, Gin-Tin-Tin, was an original litter mate of the irrepressible Rin.

Cole started in commercial art, designing cigar bands and liquor labels, betraying none of the flexibility that would enable him to survive *Popular Teen-Agers, Smash-Hit Sports, Captain Aero,* and *Confessions of Romance*.

Cole reached the comics in 1939. Continental Magazines was his first major stop, but he did primarily freelance work for dozens of companies until 1949, when he and a friend, Jerry Kramer, created Star Publishing. For five years, the company was a machine, operating with a five-person staff and precious little overhead, turning out several comics a month.

When he wasn't cranking out paperback covers—*Sinner! Two Sinners! Reckless Virgin! Raging Passion!*—Cole was drawing for crossword-puzzle and men's adventure magazines. He moved to St. John in 1956 and to Gilberton in 1959 before Dell hired him as art director of its comics division in 1961.

The job didn't keep. Cole was always moving on. In the '70s, he was even illustrating children's textbooks and reveling in his ancient love for animals with his cover art for *World Rod & Gun*. He was still producing wildlife art up until a few months before his death in December 1995, at the age of 77.

L. B. Cole Covers

L. B. Cole worked in a mind-boggling variety of styles and genres for all sorts of obscure companies, including his own Star Publishing. Here's a small sampling of his range, from wacky funny animal books to science fiction, aviation, horror, superhero, and romance. His strong senses of color and composition are the connecting threads.

L. B. Cole

This comic book (*Love Problems* #36) was apparently at the printers when the Comics Code hit. "Offending" material seems to have simply been blacked out, while inappropriate narrative and dialogue has either been whited out or replaced.
(© Harvey Publications)

Comico

Launched in 1982 by four art school buddies—Bill Cucinotta, Gerry Giovinco, Phil Lasorda (the nephew of Los Angeles Dodgers Manager Tommy Lasorda), and Matt Wagner—Comico began as a collaborative effort in self-publishing. After several years of bleeding (debit red as opposed to Dodger blue), the company collapsed into bankruptcy in 1990.

Comico was created to publish its founders' black-and-white work, most notably Matt Wagner's *Grendel*, which first appeared in *Comico Primer* #2. After Wagner and Cucinotta departed, Lasorda enlisted the help of his brother, Dennis, and Comico began to publish both creator-owned and licensed books in color.

The company took a big gamble—and lost big time—on newsstand distribution just as the direct market was coming into its own. There was also a lack of financial smarts: The Lasordas tried to turn a profit without knowing what a P&L statement was. When DC took over Comico's distribution in 1989, editor Diana Schutz ran spreadsheets and discovered the company was $750,000 in debt. When the Lasordas refused to make plans for Chapter 11, Schutz said she and fellow editor Bob Schreck quit the company, narrowly missing the collapse of Comico's house of cards.

The Comics Code

The Comics Code never helped anybody who was worth a damn. It was nothing but a vicious, cowardly attempt to put the best publisher in comics history out of business. We've been stuck with that wretched, dumb-as-a-brick Code for decades—I hear Malibu still reports to it!—all because a pack of lousy publishers couldn't compete with William M. Gaines 40 years ago. You bet it has stopped good comics from being published, and not to protect children. That's never been the purpose of the Comics Code. I've worked under the Code. I know. It's garbage, it's jetsam, it's flotsam, it's excrement. We've gotta flush it down the crapper and remember it as the disgrace it is to our history.
FRANK MILLER
SUMMER 1994

The Comics Code was established in 1954, following the U.S. Senate investigations into the relation between comic books and juvenile delinquency. Despite the fact that comics were exonerated by the Senate probe, the comics industry decided to police itself by setting up the Comics Code Authority.

Many of the provisions of the Comics Code seemed aimed directly at EC Comics: "No comic magazine shall use the word 'horror' or 'terror' in its title"; "The letters of the word 'crime' on a comics magazine cover shall never be appreciably greater in dimension than the other words contained in the title"; "Scenes dealing with, or instruments associated with, the walking dead, torture, vampires and vampirism, ghouls, cannibalism and werewolfism are prohibited."

Among the other prohibitions listed in the code:

> No comics shall explicitly present the unique details and methods of a crime.
>
> If crime is depicted, it shall be as a sordid and unpleasant activity.
>
> In every instance good shall triumph over evil and the criminal punished for his misdeeds.
>
> Scenes of excessive violence shall be prohibited. Scenes of brutal torture, excessive and unnecessary knife and gun play, physical agony, gory and gruesome crime shall be eliminated.
>
> All scenes of horror, excessive bloodshed, gory or gruesome crimes, depravity, lust, sadism, or masochism shall not be permitted.
>
> Profanity, obscenity, smut, vulgarity, or words or symbols which have acquired undesirable meanings are forbidden.

Although slang and colloquialisms are acceptable, excessive use should be discouraged and wherever possible good grammar shall be employed.

Suggestive and salacious illustration or suggestive posture is unacceptable.

All characters shall be depicted in dress reasonably acceptable to society.

Illicit sex relations are neither to be hinted at nor portrayed. Violent love scenes as well as sexual abnormalities are unacceptable.

The treatment of love-romance stories shall emphasize the value of the home and the sanctity of marriage.

Passion or romantic interest shall never be treated in such a way as to stimulate the lower and baser emotions.

Sex perversion or any inference to same is strictly forbidden.

Western Publishing never sweated the "approval" of the Comics Code Authority, but the telltale postage-stamp sized sticker was an essential part of most other comic book covers for the next four decades. Marvel made headlines when the CCA refused to approve three issues of *Amazing Spider-Man* (#96– #98) that featured drug use in 1971. The code now has as much impact on the industry as Dr. Fredric Wertham's ghost.

The Comics Journal

A monthly magazine that aspires to critique the comics industry, *The Comics Journal* succeeds in delivering some of the medium's better interviews.

Comp Lists

Mike Friedrich had the distinction of turning down the opportunity to publish both *Cerebus* and *Elfquest*, but as editor of *Star*Reach*, he published some of Dave Sim's early work and tossed Sim onto his comp list. "So, when he started producing *Cerebus* on his own, he put me on *his* comp list," Friedrich said. "I stopped publishing, but he kept me on the comp list for months and months, years and years. I'd move and the books would follow me around.

"I'd write him a note every couple of years, thanking him for sending me these things. About two years ago, I wrote him a note that said, 'Thanks for sending me the books. By now, you've certainly sent me more comics than I ever paid you royalties.' And Dave wrote me back this note and said, 'You know, you're right, and by the way, we're taking you off our comp list.'"

Comstock Lode

Ed Lawseth spent half of his lifetime in the Nevada desert, searching for junk. Sometime in the mid-1950s, he had left his wife and kids and disappeared into the heat, choosing to live as a hermit. For two or three months at a time, he'd wander from ghost town to ghost town, returning to his shacks near Comstock to bury the loot, then shuffling off into the desert again.

Lawseth had 11 shacks all told. "Visualize a building where everything is piled to the ceiling and there are no openings more than three feet wide," said Ernie Gerber. "You wandered around like a worm through the ground." The bricks of the tunnel walls were newspapers, scientific journals, paint cans, and thousands of books and magazines; the mortar was stamps, old cameras, and matchbook covers.

"Anything he came into contact with, he saved," Gerber said, "but he never organized a thing. Once he bought it, he would throw it into a box and it was long forgotten."

Now, Gerber must take his leave from this story, for his time has not yet come. A year before Gerber saw those 11 shacks in 1992, Ed Lawseth realized he was too old and tired to survive without some help. He had befriended a pair of scavengers in the Carson City area, a couple who lived in a trailer and who had scraped by over the years on garage sales, flea markets, and returnable bottles. They made a deal: These antique dealers would take care of Lawseth in his old age; in return, he would give them his property, his 11 shacks, and everything inside them.

The Comstock Lode copy of *New York World's Fair Comics 1939* was sold in 1994 to Jon Snyder of Diamond International Galleries for $20,000.
(© DC Comics, Inc.)

If Lawseth had known what he had, he could have bought himself a nursing home. As it was, his caretakers spent three months clearing away the debris in the shacks before they realized they'd hit the motherlode.

They were not particularly honest people, as we shall see, but neither were they stupid. Each time they opened another box, waiting for them was a batch of rare stamps or another surprise. And each time they opened an old newspaper section, they found another comic book or old movie magazine in near-mint condition.

To move the comic books, the woman picked up the *Overstreet Comic Book Price Guide* and called the guy with the biggest ad: Mark Wilson of World's Finest Comics and Collectibles.

She told him an amazing story when he flew down from Washington state to look at the books. Her father used to own a newsstand, she said, and when he passed away, they began carting his mounds of old newsprint to the local dump. Three-fourths of it was at the landfill, she said, before someone took the time to open one of the newspaper sections. Inside was a movie magazine. The next section yielded a *Playboy*, the next a comic book.

Ed Lawseth? The name never came up.

Although Wilson could only dream of the comic books lost to the dump, he was stunned by what was left: an incredible array of first issues, including *Marvel* #1, *Four Color* #1, *All Star* #1, *Weird* #1, *Speed* #1, *Smash* #1, *Flame* #1, *Mystery Men* #1, *Green Mask* #1, *Suspense* #1, *Movie Comics* #1, and *New York World's Fair Comics 1939*. Wilson had seen most of the pedigree collections, and the copies of *Fair '39*, *Four Color* #1, and *Movie Comics* #1 were, he was sure, the best in existence. Nothing quite matched the NM copy of *Fair '39*. One look at the cardboard spine and Wilson knew the book had never been cracked open.

Wilson and the woman had no problem closing the deal. They got along famously. He wrote her a check for around $25,000; she baked him cookies and gave him a hug when he left. If she stumbled across any other comics, she said, she'd be sure to call. With that in mind, Wilson returned home and quickly shipped her a copy of Ernie Gerber's *Photo-Journal Guide to Comics*, as a token of his appreciation.

Yo, Ernie: That's your cue.

When Gerber got his phone call in mid-June of 1992, there was no mention of the old newsstand or the trips to the dump. Instead, the woman said she'd been ripped off royally by another comic book dealer before she'd stumbled across his *Photo-Journal*. She wanted to sell him what was left of Ed Lawseth's collection.

Gerber was a little less naive than Wilson. Once he got a look at the shacks, he realized that most of the collectibles he was being offered had already been sorted. Take the stamps. "When I bought the stamps," Gerber said, "there were 30 boxes. Clearly, they went through the boxes. When I went through them, I realized this guy collected from 1925 to 1955, and there was a chance we'd have the Graf Zeps and some other extremely valuable stamps."

Gerber offered $5,000 for all the stamps in all the sheds. The woman took the deal, then suggested Gerber come back in a couple months when she'd had time to sort through a few more shacks.

No way, Gerber said. "I'll see you at six tomorrow morning."

And on the morrow he disappeared into those tunnels and discovered another 15 unsorted boxes that contained the Graf Zeps and every other stamp he was looking for. He found $10 worth of stamps for every dollar he'd spent.

Gerber also took home the rest of the Comstock Lode. The second lot didn't quite match Wilson's, but there was an *All Select* #1, *Jumbo* #1, and *The Big All-American Comic Book* in the cache. There was more than enough to send Steve Geppi, the owner of Diamond Comic Distributors, off the deep end. He was so hot to scarf up what he could of the Lode that when Gerber demanded that he also buy the rest of Gerber's comic book inventory, including several thousand Mile Highs, Geppi agreed.

That may be the end of the story . . . at least until one of those Nevada shacks coughs up another cardboard box of collectibles. The last time we checked, Mark Wilson was left shaking his head, Ernie Gerber had an annuity in his old age, and Steve Geppi had

> "Each time they opened another box, waiting for them was a batch of rare stamps or another surprise. And each time they opened an old newspaper section, they found another comic book or old movie magazine in near-mint condition."

Comic Strips

Comics at that time [the 1940s] were regarded as pretty chintzy things, about two stages above pornography, really. Comic books, I mean. The comic strips were essentially regarded as entertainment, but as far as I was concerned, the newspaper cartoonists were the upper aristocracy.

WILL EISNER, *PANELS* #1

another batch of pedigree comic books.

And sadly enough, there's no sign that anyone ever told Ed Lawseth what happened when the fruits of his toils in the desert finally saw the light of day.

Conan the Cimmerian

Robert E. Howard's barbarian—created in 1932 to run amok in the pulp *Weird Tales*—was finally adapted for comic books by Roy Thomas and Barry Smith in *Conan the Barbarian* #1 (October 1970).

"Conan simply grew up in my mind a few years ago when I was stopping in a little border town on the lower Rio Grande," Howard wrote in a letter to Clark Ashton Smith. "I did not create him by any conscious process. He simply stalked full grown out of oblivion and set me to work recording the saga of his adventures.

"He is simply a combination of a number of men I have known, and I think that's why he seemed to step full grown into my consciousness when I wrote the first yarn of the series. Such mechanism in my subconsciousness took the dominant characteristics of various prizefighters, gunmen, bootleggers, oil-field bullies, gamblers, and honest workmen I have come in contact with, and combining them all, produced the amalgamation I call Conan the Cimmerian."

Barry Smith produced the finest comic book art of his career in the first 24 issues (all save #17 and #18) of *Conan*, then abandoned the book, making room for John Buscema, who always considered Conan "my baby. I never enjoyed doing super-heroes. I preferred the realistic-type heroes. Conan has no supernatural powers. The guy has normal fears; he's afraid of the supernatural."

Thomas scripted the first 115 issues of *Conan*, aging the character approximately one month per issue. "There was something very appealing on an elemental level about Conan, who reacts viscerally to things and yet has enough intelligence to deal with problems," Thomas said. "Plus, I have a great respect for Howard's writing, which at its best was very, very fine."

Thomas returned to script the final three years of *Conan*, which expired in 1993 with issue #275.

Barry Smith's rendering of Conan for Marvel Comics helped bring the obscure Robert E. Howard character into the public consciousness.

(© The Gorblimey Press)

Concrete

"Just a falling-asleep reverie that got out of hand," creator Paul Chadwick said. In a *Comics Journal* interview, he explained the reverie: "I've always liked a lot of heavy covers on me as I sleep, and I used to picture myself, while drifting off, being partially buried in rubble or rocks.... Somehow this evolved into seeing myself actually made of rock, a sentient but motionless and invulnerable entity lying out in a mountain field, staring up into the sky as the stars wheeled, being pelted by the rain and hail, but being sort of impervious to it all."

Concrete first appeared in *Dark Horse Presents* #1.

Conflict Balloon

"It became a joke around the Marvel office: the conflict balloon," says Ann Nocenti,

who edited the Mutant books under Jim Shooter. "If you didn't stick it in, Shooter would find a place to stick it in. You know, 'Oh, my God, I have to save the world, but my grandmother is sick and I have to save her first.'

"He became so obsessed with the idea of a good story, and what a good story was to him. A good story had to have conflict; you had to put obstacles in front of your protagonist." Books would be halfway to the printer, Nocenti said, when Shooter would start "ripping them apart . . . and adding conflict in big thought balloons. Rather than let people absorb what were good principles, he used an iron crowbar to get that into each comic."

Conventions

We can hardly imagine, more than 30 years after the first comic book convention was staged in Detroit, how isolated collectors were back in the 1960s. If they weren't desperate for company, they were desperate for the company of new books.

The very idea of a "convention" was stolen, Malcolm Willits and Michelle Nolan agree, from science fiction fandom, which first convened at the 1939 New York World's Fair. But the genesis of the first Detroit Triple Fan Fair, Shel Dorf said, owed to the weekly communions at Ableman's Book Store in Hamtramck.

"The guy who owned the store [Tom Altshuler] was very shrewd," Dorf said. "He had a crew of guys who would go around to these old homes in Detroit where people had lived for more than 30 years. Their kids had grown up and moved away and now there were a couple of old people rattling around in this big home with a lifetime of stuff up in the attic.

"This crew of workers would, at no charge, clean out the attics of old people who didn't have the energy to clean the attics out themselves," Dorf said. "They just got to keep all the periodicals they found: old *Collier's*, newspapers, and children's old comic books. Tom put all these old things on the second floor of Ableman's. Not everyone got up there; the upstairs was for the serious collector who would pay a few bucks for a Big Little Book from the Forties or an old pulp magazine. All of us gathered there, usually on a Saturday. And that was the nucleus of the first comic book convention."

In the beginning, cons were little more than swap meets. "Pros weren't advertised," said Nolan, who began collecting in 1956. "Collectors began to attend the conventions because they wanted the books."

Seventy people brought their want lists to Detroit's Hotel Tuller in May 1964. Two months later, the New York ComiCon was staged at the Workman's Circle Building near Union Square. Entertaining the crowd of 50 fans were Steve Ditko, Larry Ivie, and Flo Steinberg; the stalwarts in the dealers' room included Phil Seuling, Claude Held, Bill Thailing, Howard Rogofsky, and Willits.

In 1965 comic fans got their first taste of regularity: The Detroit Triple Fan Fair, with Shel Dorf at the helm, returned to the Motor City on the weekend of July 24–25. A week later, Dave Kaler—who shared an apartment with Roy Thomas and Denny O'Neill—brought the New York ComiCon to Greenwich Village. Attendance in the Village reached 200, with guest appearances by Bill Finger, Gardner Fox, and Otto Binder.

The following year, there were two New York conventions—the first sponsored by John Benson, the second by Kaler—the first Southwest Con (in Houston) and Gateway Con in St. Louis. Small groups of fans held low-key conventions closer to home. Nolan still has the program from the con Rudi Franke hosted at his house in Oakland in January 1966. "There must have been two dozen people there," Nolan said. "He showed the *Captain America* serial on the garage wall. Afterwards, Barry Bauman took us to his house; we went up to the attic, and there were literally thousands of Golden Age comics."

A typical Saturday on the exhibit hall floor of the San Diego Comic-Con in the late 1980s.

In 1968 Phil Seuling, an English teacher at Lafayette High School in Brooklyn, began taking control of the New York convention scene, eventually renaming the con the Comic Art Convention and locking it in on the July 4 weekend.

And in 1970, Dorf—who had since moved to southern California—reinvested his experience with the Detroit Triple Fan Fair and, with a group of young fans, started the San Diego Comic-Con, now the largest and longest-running comic convention in the United States (see entry).

Conway, Gerry

He was the writer who murdered Gwen Stacy. The scene of the Crime? *Amazing Spider-Man* #121.

According to Stan Lee: "I'd gone to Europe and turned the book over to him. He said, 'How do you want me to write it?' and I said, 'Write it any way you want to, it's your book now.'

"I didn't mean to kill Gwen Stacy. When I came back from Europe, he'd killed her and there was nothing I could do about it. I had always planned that Spider-Man would marry Gwen Stacy. I never would have wanted to kill her, because several issues earlier I'd killed Captain Stacy. It must have seemed that we were out to decimate the entire family."

Conway had a talent for decimation: Witness his 1974 creation, the Punisher. Only 17 when he joined Marvel in 1970, Conway became the company's sixth editor-in-chief in 1976, lasting a mere month in that august chair before returning to more deadly assignments.

Copycats

On September 14, 1947, a coroner's jury in Pittsburgh decided that, yes, 12-year-old Billy Becker had hung himself with a clothesline from the rafters of his Sewicky home because he had reenacted a scene from a comic book. "I burned every one I found," Mrs. Charles Becker told the jurors, "but Billy always found ways of hiding them."

On May 21, 1948, two Oklahoma kids— Jimmy Bodard, 11, and Ronnie Peterson, 12— hopped into a two-seat Ercoupe at an Oklahoma City air park and flew the plane to Cheyenne, 120 miles away. After their perfect landing, the kids explained to the cops that their flying lessons had come all in color for a dime. "They had looked at some comic books that told all about it," state trooper Arch Hamilton said. "They thought we were silly not to know how."

And on August 18, juvenile officials in New Albany, Indiana, discovered that three boys, ages 6 to 8, strung up one of their playmates, stealing the scene directly from a comic book. The victim—the 7-year-old son of a minister— was forced into the woods at knifepoint, was ordered to strip, and had his hands tied behind his back. Tying another rope around his neck, his buddies looped it over an overhanging tree branch and jerked him up on his tiptoes. They then danced around him, sticking him with burning matches in mid-waltz. The kids told probation officer Frank Kelley that they loved comic books, particularly the crime and horror ones, and that they planned to "hang one kid every third Sunday."

"After their perfect landing, the kids explained to the cops that their flying lessons had come all in color for a dime."

And you still think comic books didn't create—and inspire—an entire generation of juvenile delinquents?

The Corner Grocery

Somewhere in the midwest, on a dusty street corner and an oversized lot, stood a grocery store with, let us suppose, a Coke machine out front, an old dog beneath the porch, and comic books on the racks. The store was like a thousand others, but for one sign of idiosyncratic neglect by the owner: He never returned his unsold comics.

Almost every store owner did, you know. They ripped off the covers of the comics they couldn't sell and returned them for a refund. Not this guy. Maybe he couldn't be bothered; maybe he liked to packrat stuff away. Over the years, the old comics began to pile up, and rumors of the hoard—"somewhere in the midwest"—popped up in New York, Los Angeles, and Florida.

In those days, the early 1970s, there was only one price guide, and fanzines were the only way to communicate with people. You heard a lot of rumors, David T. Alexander said, and he wasn't going to drive the length of Kansas and Nebraska to check this one out.

When the old man in the grocery store finally decided to sell the comics, he wanted $50,000 for 50,000 books from the 1940s and 1950s. Alexander didn't get the call; he heard about the deal secondhand from another dealer who needed some of Alexander's money to close the sale. The dealer wouldn't tell Alexander where he planned to spend his money.

"Somewhere in the midwest."

Sometimes the circle never closes. You never find out if the deal is real. You never pump a quarter into the Coke machine, take a long, hard drink, and step through the screen door into the moody darkness of what you can only imagine.

But Alexander finally found that grocery store. It took a couple more phone calls and a few more years, but he made it. By then, most of the best Golden Age books—the Timelys and DCs—were gone, but there were rooms and basements and garages filled with comics, paperbacks, toys, and Big Little Books.

Alexander tore up the second half of his round-trip plane ticket and rented two trucks, a panel van, and an 18-wheel semi. In the next several days, he spent 40 hours moving stuff out, boxing it up, loading it onto the van, then transferring it to the semi. Each time Alexander cracked open a door—in the two-car garages behind the grocery store, in the attic, in a basement filthy with coal dust—there was more fantastic stuff.

After 40 hours, however, Alexander had enough. "The coal dust finally stopped me," he said. "You get so overloaded. After 40 hours, you get so sick of the stuff, you don't care anymore what they show you." He hopped in the semi and headed home, and only after the grocery store was several days behind him did he realize he'd never gotten to the bottom of the treasure chest. He'd only pried open one of the garages. "The actual house? I never said, 'Let me go in there and look.'"

So it is, that a dozen years later Alexander still thinks about that corner grocery store, wondering if another dealer ever showed up to clean up after him. Until he finds out, until he goes back, he's going to keep the location of the store to himself.

Missouri? Iowa? Just off the Oregon Trail? "Somewhere in the midwest," Alexander says, and that's all he'll say.

Corto Maltese

Hugo Pratt's marauder—once described as "a combination of the Spirit and Indiana Jones"—first appeared in *Sgt. Kirk* magazine in 1967. Born on the island of Malta, Corto is a wanderer whose adventures bring him into the company of Ernest Hemingway, Jack London, Merlin, and the Red Baron.

Cosmic Code Authority

An Al Milgrom gag—altering the "Comics Code Authority" sticker on the corner of an issue of *Captain Marvel*—didn't escape the scrutiny of the Marvel editors. While they were congratulating themselves, Tom Orzechowski slipped the same anagram past them on the cover of *Strange Tales* #179. "My only footnote in the history of comics," Orzechowski said.

Costanza, Pete

A pulp illustrator recruited to draw the second issue of *Whiz Comics*, Costanza became one of the main artists in two C. C. Beck

"...there were rooms and basements and garages filled with comics, paperbacks, toys, and Big Little Books."

studios, the first in Manhattan and the second, after the war, in Englewood, New Jersey.

Costanza studied under George Bridgeman before maturing alongside Beck. Along with Beck, he produced the art that kept Captain Marvel animated for the last seven years of the super-hero's life.

Cover Blurbs

Once upon a time, a comic book needed more than "Marvel Comics Group" across the top of its cover to strike the buying public's fancy. The cover blurb was, with few exceptions, a Golden Age phenomenon.

In the 1960s, Marvel shot its wad with the *Fantastic Four*, subtitling it "The World's Greatest Comic Magazine." (The blurb first appeared on *FF* #3 as "The Greatest Comic Magazine in the World," hoping to distract readers from the first 12-cent price tag on a mainstream comic.) For 108 issues, the book came as advertised. Marvel has never delivered a blurb to match it.

Some of the best Golden Age blurbs were eye-catching one-shots.

Frontier Romances #1 boasts, "She Learned to Ride and Shoot, and Kissing Came Natural."

Range Romances #3 bragged of "Throbbing Love Sagas of the West"; *Daredevil* #11 screamed "Extra! Play 'Slap the Jap'"; and *G.I. Joe* #15 sang, "Cold Steel, Hot Lead, Wet Dogs in DRY SOCKS."

And the newsstands couldn't keep *Picture Stories from Science* #2 in stock, what with its "Amazing Discoveries About Food and Health."

But the common cover blurb was as crucial to its sales pitch as the comic book's title. Some of the best:

"The Magazine That Respects Your Intelligence"
 Amazing Adult Fantasy
"The Mirth of a Nation"
 Archie
"The Darling of Comics"
 Black Cat
"Featuring America's Fighting Nemesis of Crime"
 Black Terror
"The Modern Magazine for Girls and Sub-Debs"
 Calling All Girls
"Pulsating Tales of the Care-Free Lives and Intimate Loves of Enchanting Co-Eds"
 Campus Loves
"Famous Star of the Dumont Television Network"
 Captain Video
"Commit a Crime and the World Is Made of Glass"
 Real Clue Crime Stories
"Glimpses into the Intimate Secrets of Girls in Love"
 Diary Loves
"Action Stories of the Devil Dogs of Korea"
 Fightin' Marines
"Smoldering Secrets of Sultry Sirens"
 Forbidden Love
"Sex Crimes on the Increase"
 Honeymoon Romance
"America's Pin-Up Queen"
 Katy Keene
"Crime Never Pays"
 Murder Incorporated
"No Ifs or Buts—This Comic is —"
 Nuts
"We Will Buy Your Dreams"
 Strange World of Your Dreams
"Truth is Stranger and a Thousand Times More Thrilling Than Fiction"
 True Comics
"She's Rich in Laughs"
 Vicky
"Tales of Valor on Far-Flung Battlefields"
 War Comics
"New, Pick-A-Boyfriend G.I. Listings"
 Wartime Romances
"True Stories Where the Gun Was Law"
 Western Fighters
"America's Son of Fun"
 Wilbur

Crabbe, Buster

He was Flash Gordon and Buck Rogers in the Saturday morning serials. He was an Olympic gold medal winner and Tarzan in the pool. He was Captain Gallant on black-and-white TV and a six-gun strappin' stud at the drive-in.

But when Buster Crabbe got an invitation to be the guest of honor at the first Multi-Con in 1970, he couldn't for the life of him figure out why. He was just another stocks-and-bonds trader in New York. Did anyone out in Oklahoma City know who he was?

Don Maris, a Texas memorabilia dealer, wasn't sure he convinced Crabbe over the phone that a lot of Okies remembered him. But Crabbe agreed to make the trip to Multi-Con. He'd pay his own airfare but he wanted $500 when he stepped off the plane and decent room and board.

The first night Crabbe was in town, Maris called a restaurant in Oklahoma City to make dinner reservations. "I'm sorry," a woman told him, but we don't take reservations.

Buster Crabbe inspired Al Williamson's version of Flash Gordon.

(© King Features Syndicate)

Covers—Our Ten Favorite

COVERS—OUR TEN FAVORITE
Considering the art, the color, the impact… consider these classic treasures:

Superman #14 by Joe Shuster
(© DC Comics, Inc.)

Famous Funnies #214 by Frank Frazetta
(© Eastern Color Printing Company)

Startling Comics #49 by Alex Schomburg (© Nedor Publications)

Seven Seas #4 by Matt Baker
(© Universal Phoenix Features)

Fight #35 by Joe Doolin
(© Fiction House)

Covers—Our Ten Favorite 101

Detective Comics #31 by Bob Kane
(© DC Comics, Inc.)

Dell Four-Color #387 by Carl Barks
(© The Walt Disney Co.)

Weird Science-Fantasy #29 by Frank Frazetta (© 1998 William M. Gaines, Agent, Inc.)

Weird Tales of the Future #2 by Basil Wolverton (© Aragon Publications)

Hit #17 by Lou Fine
(© Quality Comics Group)

COVER ARTISTS: OUR TEN FAVORITES

Our top ten favorite cover artists (and examples of some of their best work):

Matt Baker
Joe Doolin
Lou Fine
Frank Frazetta
Jack Kirby
Harvey Kurtzman
Frank Miller
Mac Raboy
Alex Schomburg
Wally Wood

Joe Doolin
(© Fiction House)

Harvey Kurtzman
(© 1998 William M. Gaines, Agent, Inc.)

Lou Fine
(© Quality Comics Group)

Alex Schomburg
(© Nedor Publications)

Mac Raboy
(© Fawcett Publications)

"Does it make any difference that we have Buster Crabbe?" Maris asked.

"You have Flash Gordon with you!" the woman shrieked.

"We most certainly do," Maris said.

"Well, how many and what time," she said, "because we'll take that reservation."

The next night, Maris and his best friend, Robert Brown, were on the dais, introducing Crabbe. It took Brown at least a minute to run through Crabbe's résumé, from the 1928 Olympics through the Eastern Publishing comics in the early 1950s. It took Crabbe another minute to walk from his seat through the standing ovation to the dais.

"Tears were in his eyes when he got there," Maris said. "He said to Robert, 'Could you please speak a minute or two until I compose myself?' Robert said a few more things, then Buster Crabbe wiped off the tears and started talking."

Over the weekend, Crabbe signed hundreds of autographs and had dozens of people tell him how much seeing him had meant to them as kids. And what Maris heard was that when Crabbe went back to New York, he got to thinking about that reception he'd gotten out in the sticks of Oklahoma.

Folks, he realized, did remember who Buster Crabbe was. Why not give them a little more to remember?

And so, Crabbe said good-bye to the stocks and bonds and got himself an agent. He hit *The Tonight Show* and hooked up with a sponsor on the official Buster Crabbe swimming pools. He became a regular at the trade shows. He got back into the life . . . and found that from Oregon City to Oklahoma City, restaurants were always happy to take his reservation.

Craig, Johnny

The senior member of the EC staff, Craig was also the company's foremost cover artist; when publisher Bill Gaines was asked to defend the cover of *Crime SuspenStories* #22, featuring the severed head of an ax victim, he was face-to-face with the best of Johnny Craig.

Born in Pleasantville, New York in 1926, Craig joined the Merchant Marine at the onset of the war. After enlisting in the Army as a combat communications specialist, Craig was wounded in Germany.

His peers remember him for the pristine

"His peers remember him for the pristine pencils and his wretchedly slow pace."

pencils and his wretchedly slow pace. "When John did a horror story or *Crime Suspense* or *Shock Suspense* type story," Bill Gaines observed, "the contrast between the beautiful, clean, charming artwork and the dreadful things which eventually happened at the tip of his pen added to the effect."

"I always felt he didn't belong in comics," Wally Wood once said. "He didn't seem happy with it." When EC closed its doors, Craig didn't linger in the funny books, switching over to advertising. According to George Evans, Craig did some work for Warren—signing his pages "John T. Craig" or "Jay Taycee"—but the demands of his art-directing job required that he make everyone forget his work in comics.

Many EC experts feel that Johnny Craig's work for *Crime SuspenStories* was his best: in writing, drawing, and storytelling technique. This splash panel is from issue #4 (April/May 1951).
(© 1998 William M. Gaines, Agent, Inc.)

Crandall, Reed

He was born in Indiana, but he did much of his growing up in Kansas, and when he was through—through with Quality, EC, Atlas, and the best 20 years of his life—to Kansas Reed Crandall returned. He went back to Wichita and a shabby little one-bedroom apartment in the shadow of Lawrence Stadium. That bedroom doubled as Crandall's studio, and it was there on Saturday afternoons that Bob Barrett would always find him.

From 1962 until some time in 1967, Barrett rarely missed a Saturday with Crandall. A devout Edgar Rice Burroughs fan, Barrett was stunned when he first discovered that the artist lived near him in the Kansas wasteland. He would arrive at the apartment and invariably find Crandall's 70-year-old mother in the living room, entrenched before the television set. There was little else in the apartment to distract her. Only two paintings hung on the walls. One was a modernistic montage; the other was a self-portrait of Crandall in his late teens, an oil that was barely a shadow of the obese, balding, round-faced artist who sat drawing in his bedroom.

For several hours, they would sit and talk while broadcasts from the Metropolitan Opera played on the radio and Crandall sketched at his drawing board. He might be working on a piece for Jim Warren or finishing up a comic book page. "He could sit there and draw and chat and listen to the radio all at the same time," Barrett said. "He never seemed to need any reference material. He would draw stuff right out of his head."

Crandall was a jealous guardian of the stuff in that head. He was more at ease talking about the Met than about all his years in Metropolis. "In all the time I spent with him," Barrett said, "and all the things we talked about, I never realized he'd been married and had children until after he was dead." Neither did Barrett realize that he was spending his Saturdays with an alcoholic: Crandall never had more than a single drink in the three hours the two of them would spend together. He would just draw, draw while he still could. "He was very cavalier about his art," Barrett said. "If you expressed a liking for something, it was not unlike him to just give it to you. He'd be doing something really nice and when he was through with it, he'd toss it in the trash can. I rescued a lot of neat sketches."

In the best years of Reed Crandall's life, the sketches he would toss off gave his editors the chills. Because Everett "Busy" Arnold, the publisher at Quality Comics, lorded over the likes of Will Eisner, Lou Fine, and Jack Cole, he had the right to argue, "I always thought my artists over the years were the best in the business."

And? "And I rate Crandall as the best man I ever had."

Arnold first noticed Crandall not long after Crandall arrived in New York in 1940. He was freelancing for the Eisner and Iger shop when Arnold spotted his breathtaking figures in the work Eisner and Iger were producing for Fiction House. "I learned his name was Reed Crandall," Arnold told Jim Steranko, "and since neither Iger nor Eisner rated him very highly, they very willingly took Reed off Fiction House work and put him exclusively on features for Quality Comics."

Arnold wasn't the only one who appreciated Crandall's work on Kaänga in *Jungle Comics*. According to George Evans, Crandall had two Kaänga stories "on the stands at the time Burne Hogarth told United Features he was leaving

to do his own strip elsewhere. Looking for an artist to fit into Tarzan, someone at United came across Reed's Kaänga and they called Fiction House to ask for the name of the artist doing that feature. Though Reed's work was in print, he had gone on, and the current artist was Ruben Moreira (signed 'Rubimor'). So, on the basis of Reed's work, Rubimor got the job ... There was Reed's chance to make the big-time syndicate stuff."

At Quality, Crandall drew Hercules, the Ray, Doll Man, Uncle Sam, and Firebrand. He drew so much, and so well, that he eventually left Iger and Eisner and went to work for Arnold. The publisher rewarded him by handing him Blackhawk.

"Where [Chuck] Cuidera made Blackhawk a best-seller," Steranko writes in his *History of Comics*, "Crandall turned it into a classic, a work of major importance and lasting value ... Crandall's approach to comics was that of an illustrator, not a cartoonist. If his drawings lacked the stylized power of Meskin or Kane, he made up for it ten times over with his unerring craftsmanship. He handled groupings of figures as easily as others might handle a two-shot. Crandall relied on his fine art schooling for these compositions, which have yet to be equaled by an artist since. As a draftsman, he was every bit as proficient as Foster, Raymond, or Caniff."

Reed Crandall kept *Blackhawk* airborne until 1953—he did almost all the covers during his last four and a half years on the book—then marched over to EC. "Almost everybody that ever came to EC walked in," Bill Gaines once said. "Crandall walked in; he was the last EC artist to walk in. He walked in, he said, 'I'm Reed Crandall.'

"I said, 'So what took you so long? We've been sitting here waiting for you.'"

He was worth the wait. "I think Wally Wood was the best cartoonist [EC] ever had," Al Williamson once said, "and the best illustrative cartoonist was Reed Crandall." He lit up the covers of *Piracy* and *Terror Illustrated*, as well as the interiors of many of the last New Trend science fiction books.

Years after Evans and Crandall worked together at EC, Evans was scratching around for work and could find nothing but *Classics Illustrated*. "If their rates weren't the lowest in

Crandall's black-and-white work for Warren Publications, especially the adaptations of Poe stories, highlights his draftsmanship.
(© Warren Publications)

the comics industry, they weren't far from it," Evans said in *Squa Tront* #4. "But they gave out whole books, so the answer, obviously, was to work as fast as possible. Bash it out, cutting corners, and faking it all the way.

"The first couple of jobs I did for them were done that way. They were satisfied, and for time spent, the money wasn't too bad. Then Al Williamson told me Reed was able to take on some work, if it could be handled by mail. I checked, and Reed agreed to pencil, even at the rates I could offer.

"I told him the plan: Fast, Free-wheeling, Faked—and Forgotten, to paraphrase an old line. I sent the whole script, which he was to return in segments... Shortly, half the penciled stuff was back. I thought, 'Gee, I said fast, but this fast? It has to be lousy.' Then I opened it, and by God, there in meticulous tight penciling was the most beautiful comic art I ever saw. And friends, I included Alex Raymond and Harold Foster in their prime at that.

"Well," Evans continued, "do you think I could sit down and ink that kind of stuff with both hands flying? In common sense, I should have lumped mob scenes into silhouettes, slashed out backgrounds, cut all the beautiful shadow-modeling down to straight outline. Couldn't do it. So, I sat on my tail and sweated and lost money like a fool—but, fortunately, only for the time. Because I couldn't help learning a little. The stuff got noticed. I got better offers. So did Reed."

By 1962—when Bob Barrett discovered him living in his neighborhood—Crandall was back in Wichita, accepting assignments by mail and sending his meticulous, tight pencils back on their way. Most of the opportunities were elsewhere, but his mother was slowly dying and there was no one else to take care of her.

When Williamson heard that Crandall's life was falling apart, he brought him up to his home in Pennsylvania to live with him. Williamson remembers those as painful years in both their lives, and refuses to talk about them. "It was a long time ago," Williamson said, "and I'd rather not go back. A lot of shit happened, none of which had anything to do with Reed. He was a sweetheart. He tried at the end to do some things to clean up his life, but I suspect it was a little too late."

He stopped drinking, at the very least. In the final years of his life, Crandall returned to Wichita and held some pathetic jobs—night watchman and fast-food cook—before several strokes put him into a nursing home. Before he suffered the heart attack that killed him, Crandall and Barrett would go on long walks near the nursing home. Crandall was paralyzed on one side of his body; there was no echo of the portrait of the young man who once hung on his living room wall, or of the radio that played in his bedroom. But they still talked about the opera.

Crane, Roy

Roy Crane is sort of the granddaddy of the modern comic strip... You can't imagine how brilliant he was. He had a quality of drawing, and action, and composition, and design that used to send virtuoso illustrators on their backs.
GIL KANE
THE COMICS JOURNAL #75

Everyone gets a little breathless when they talk about Roy Crane, the creator of the comic strips *Wash Tubbs*, *Captain Easy*, and *Buz Sawyer*.

A Sweetwater, Texas, kid, Crane was a college dropout, a hobo, and a wandering seaman before he got his first strip—*Washington Tubbs II*—in 1924.

Crane had been handed a gag strip about a shop clerk, and he had no interest in the premise. Within a year, Wash Tubbs had abandoned the stock room for the South Seas, and Crane had embarked on what Maurice Horn has called "the definitive debut of the adventure strip."

Captain Easy arrived in 1928 and gained his

Reed Crandall drew several exceptional covers for *National Comics*; this is issue #26 (November 1942).
(© Quality Comics Group)

own strip the following year, heralding a decade in which Crane's gifts lit up the comics page ev-ery day of the week. His narrative was powerful, his action both poetic and violent, and his graphics unconventional. In Crane's hands, even the lettering was explosive or expressive, as were his experiments with Craftint doubletone paper.

Captain Easy, Soldier of Fortune, debuted as a Sunday page in 1933, an arrival Crane would live to regret. Up to that point, Crane once wrote, "Working was fun. It could be done in a leisurely work week of about 45 hours, including research. I played golf, and had little trouble in getting ahead for a vacation to search for background material in Latin America, or to clown with a circus.

"So I started a Sunday page. BAM! . . . Twenty hours of extra work dumped onto my lap! No more golf, research, or vacations! . . . I thought I was continuing to do good work, but soon the zip and sparkle disappeared. By 1938 I was whipped down."

Crane lightened the load by passing some of the art chores to Les Turner, with whom he'd hired out as a seaman 20 years earlier. In 1943, he created *Buz Sawyer* for King Features, assuming Turner would assist him on Sawyer's aerial adventures in the Pacific theater. No such luck. Turner took over *Wash Tubbs,* and Crane had another daily-and-Sunday dilemma on his hands.

"For month after month," Crane wrote, "I would draw six strips in one 16-hour day—less than an hour per picture—and some of the pictures crammed with endless detail of aircraft carriers, planes, and flight gear, which had to be done accurately, or the new strip would fail to gain a sense of reality and prestige. It became standard procedure for me to have Buz shot down on a Pacific island in every other story so I could rest up a little from all that laborious naval aircraft detail. How I regretted taking on that Sunday. It soon became a question of time whether I could outlast the Japanese. I barely made it."

Buz Sawyer remained tremendous entertainment, barely failing to unseat Milton Caniff's *Terry and the Pirates* as the best adventure strip of the war. After the war, Crane's innovativeness was spent: "*Buz Sawyer,*" Rick Marschall observed, "for all its simultaneous solidity and verve, became a recruiting poster for the military, whereas *Wash Tubbs* had been a travel poster for imaginative romance."

Crane died in 1977.

Creator Rights

In the beginning . . . Jerry Siegel and Joe Shuster signed away their rights to Superman—the great sire of the comics' industry—for $130.

> *In consideration of $130.00 agreed to be paid to me by you, I hereby sell and transfer such work and strip, all good will attached thereto, and exclusive right to use the characters and story, continuity and title of strip contained therein, to you and your assigns to have and hold forever and to be your exclusive property . . .*

In the beginning, Jerry Robinson—who created the Joker, with a slight assist from Bob Kane—sold off the most creative impulses of his young life for pennies on the dollar.

"We didn't know what our rights were," Robinson told Steve Gerber in 1976. "We were certainly aware of the characters' popularity. We were minor celebrities with kids. But it was so new. We were feeling our way. We had nobody to turn to. There were no rules."

Oh, yes there were: The creators perspired; the publishers ruled.

The evolution of "creator rights" has been painful and slow. The earliest inventors, as

Roy Crane's newspaper strips (Wash Tubbs, Captain Easy, and Buz Sawyer) were innovative in their style and storytelling; his work has influenced innumerable cartoonists in both strips and comic books.

(© King Features Syndicate)

Robinson termed the likes of Siegel and Shuster, could not patent their inventions. Forty years later, DC's work-for-hire agreements—a provision of the Copyright Act of 1976 which presumes that the employer, not the employee, is the author of the work—required that they sign away their rights each time they signed their paycheck.

> *The undersigned affirms that he was engaged by National Periodical Publications, Inc. to produce said work, and it has the full and sole right to copyright said work and to renew and obtain extensions of copyright in its own name for its sole benefit…*

"By denying legal authorship to the artist," Frank Miller once wrote, "work-made-for-hire promotes an attitude of contempt for talent, and self-contempt on the part of the talent, thereby, incidentally, discouraging the artist from investing more than craft in what is, after all, not his work in the eyes of the law. I believe this to be the central act of self-destructiveness, or, if you will, the blade with which our industry continuously attempts ritual suicide."

If Siegel and Shuster are the most publicized casualties of the publishers' casual disdain for their creative base, Jack Kirby is a close third. Miller has long argued that the "Marvel Age of Comics" is a misnomer. Almost everything that Marvel made money on over the years, Miller said, was created by Kirby. The King was the true light bulb in the "House of Ideas."

Kirby filed for divorce from Marvel in 1970. Fifteen years later, Marvel was still refusing to acknowledge Kirby's unrestricted right to his original art. A dozen years after DC agreed (in the words of Jenette Kahn, Dick Giordano, and Paul Levitz) that "the return of artwork is an artist's inalienable right," Marvel would only agree to cough up 88 Kirby pages if he signed an "artwork release":

> *The Artist shall never contest or dispute, or assist others in contesting or disputing, Marvel's complete, exclusive, complete and unrestricted ownership of the copyright in the Artwork or Marvel's exclusive, complete and unrestricted worldwide right to exploit the Artwork in any manner or media…*

Kirby, at the time, was approaching 70. Marvel, at the time, was still getting rich off his fumes.

Although Marvel backed off from its

Credits

I find this obsession with credit for the uncreditable disgusting…
BOB KANIGHER

One of the first outfits I worked for was Fox Features. They didn't allow you to sign your name, so in the background, normally in a restaurant window, there'd be "Morisi Special," a sandwich for 45 cents. At the time, I was going out with my wife Louise—Lulu—so you'd also see "Lulu's Ice Cream." The perfect spot, where editors never check, is where you feature a newspaper. The headline will say "Joker Escapes," which is what the reader sees. But in the scribbly lines underneath, that's where you'd put your name. One or two outfits caught it, but there was nothing to say about it. They just whited the damn thing out.
PETE MORISI

An interesting sidelight is that the California office of Western was reluctant to allow their artists to sign their work. Consequently, Russ [Manning] went to great lengths to see that his name appeared somewhere in the stories he illustrated. It would appear on buildings, signs, newspapers, or books. He also indulged himself by printing the names of his wife, friends, and relatives in his stories. He once remarked: "Ever notice how often Manning or Doe [his wife, Doris] appear in towns frequented by Mike Nelson, Dale Evans, or Wyatt Earp? One issue of Wyatt Earp had every building which was named carrying ours or brother's or sister's or friends' names."
BOB BARTLETT

I operated under a false premise, so I found a lot of other things people didn't, and that premise was that every artist signed everything. I've found their names on third panels, on end panels, sneaked onto storefront windows. In the DC books, you'll often find the artist's name on a storefront or a license plate or a billboard.
HAMES WARE

Most artists have an ego, just like actors. There are some that kept their work because they took pride in it. Other artists just didn't care. "Give me the next job." It's just another drawing. Picasso used to draw and throw rejects in the wastepaper basket until his agent said, "What are you doing?" Only those who had an ego kept a record of all their work.

I created the Bat Mite. But I didn't put at the bottom of the page, "Bat Mite created by Sheldon Moldoff." I'm working for Bob Kane, he gets the credit. Today, they're giving credit to the colorist, credit to the letterer. Credit for what, lettering a page? What's the big deal?
SHELDON MOLDOFF

demands before Kirby's death in 1993, the climate for creators elsewhere in the industry had been slow to improve until such companies as Dark Horse, Eclipse, and First Comics had arrived and allowed creators to hold onto the copyright on their work.

That more of the talent didn't take advantage of that option suggests that much of the talent could handle the self-contempt if it came hand-in-hand with a steady paycheck. "Most creators just want to get to the contract and sign their name so they can start drawing," Dave Sim, the creator of *Cerebus*, told *The Comics Journal* in 1989. "We're just trying to give some sort of guideline to a 21-year-old kid who's about to sign his life away. Because there's really nothing stupider than a 21-year-old kid . . . my job is to make a 21-year-old-kid aware that he's in a pool of sharks. He thinks he's just landed in wonderland."

Wonderland is still a few miles off. Alan Moore and Dave Gibbons are the authors of *Watchmen,* one of the most acclaimed series of the last 20 years, but DC owns the rights as long as *Watchmen* remains in print

But Dave Sim owns *Cerebus*. Frank Miller is the lord high executioner of *Sin City*, Todd McFarlane the sole beneficiary (save for a reader or two) of *Spawn*.

And Kevin Eastman and Peter Laird never let the Teenage Mutant Ninja Turtles slip from their grasp. "If only Jack Kirby," Eastman and Laird wrote as their millions in licensing agreements were still pouring in, "had had the same option with just one of his famous creations."

Creepy

Jim Warren's first comic magazine, *Creepy* debuted in 1964 with a Jack Davis cover and Frank Frazetta's final comics story, "Werewolf."

Warren snatched Archie Goodwin off the art desk at *Redbook* to edit the magazine. In no time at all, almost the entire EC gang was adding pages to this horror jam—Joe Orlando, Al Williamson, Johnny Craig, George Evans, and John Severin, among others.

The Crestwood Five

As a protest of the witchhunt of the Fifties, for the cover of *Justice Traps the Guilty* #56 (November 1953), Marvin Stein placed Crestwood Publishing stalwarts Ben Oda, Joe Simon, Joe Genalo, Mort Meskin, and Jack Kirby—each rumpled and dour—in a police lineup. A handy reference guide for parents who wanted to see the creeps who were corrupting their kids.

Crime Comics

When the superheroes crashed, burned, and retired after VJ Day, the other comic book publishers looked around and said, "Hey, what's Charlie been doing?"

Charles Biro was editing crime comics, and had been since 1942. Early that year, he had taken *Silver Streak Comics* and renamed it *Crime Does Not Pay* with issue #22. The comic paid Biro, Lev Gleason, and Bob Wood quite well as its monthly circulation surged steadily toward the 1 million mark.

Bob Fujitani, one of the artists working for Biro, said his boss was convinced that his own special genius was responsible for the comic's success; Fujitani, on the other hand, chalked it up to the company's huge paper allotment. Once the war ended and all the paper restrictions were removed, the other publishers set out to show Biro that anyone and everyone could sell crime comics.

Anyone and everyone did. Thirty new crime books were unveiled in 1948 alone, pushing the genre's share of the market to 14 percent.

Fredric Wertham would later describe crime comics as "the distillation of viciousness." He got that right. Even by the standards of the late 1940s, these comics—usually disguised as morality plays—were nasty. Witness the third issue of *Crime Does Not Pay*, in which two women were lowered into a well and hung upside down in water that came up to their waists.

"Then we hung them down the well head first—to let the drug run out of their bodies,"

"The Crestwood Five"—Ben Oda, Joe Simon, Joe Genalo, Mort Meskin, and Jack Kirby—make for a surly looking lineup.

(© Crestwood Publishing)

the caption read. "There were some bubbles at first—then they were quiet."

"Sex was out" in those days, Fujitani recalled. "That was taboo. We were still barely out of the Victorian age. There was a sex neurosis. Sex was out; violence was in.

"We were young, we thought it was great. The more vivid you could make it, the more gruesome, the better it seemed. It didn't bother me at all. As I'm older, I realize the stuff we did was really bad. You ever see this *Friday the 13th* stuff? This guy getting his head split open with an ax? Horrible stuff. We used to do the same thing in comics, and we thought it was great."

When a few dissenting opinions were heard, Fox slapped "For Adults Only" on its crime comics and Gleason pasted "Not Intended for Children" on his. But even the 1948 formation of the Association of Comics Magazine Publishers, a stab at self-policing, didn't slow the creeping tide of criticism. The crime comics' ascendancy was matched by Wertham's, and—in the end—they proved no match for him. The publication of Wertham's *Seduction of the Innocent* in 1954 provoked a panicked industry to saddle itself with the Comics Code, which put the kibosh on the crime books.

Crime Crusaders Club

The lone appearance of Fawcett's crime-fighters' club came in *Master Comics* #41 (August 1943). Captain Marvel Jr., Bullet Girl, Bulletman, and Minute Man answered the call to be careful out there.

Crime comics—"the distillation of viciousness," according to Wertham—didn't pull punches on their covers. Charles Biro's cover for *Crime and Punishment* #2 (May 1948) shows a thug robbing a blind man. Women made good victims too, as in this Matt Baker cover for *Authentic Police Cases* #6 (November 1948). Then there's good old-fashioned gun battles, as dramatized by L. B. Cole in *Shocking Mystery Cases* #56 (September 1953).

Crime Does Not Pay

You don't think so? According to Bill Gaines, the Lev Gleason book sold 4 million copies a month in its heyday during the late 1940s. Beginning with the December 1947 issue (#58), the comic's cover claimed "More Than 6,000,000 Readers Monthly!" When circulation began to subside ten months later, that blurb was replaced by "A Force for Good in the Community!"

The first issue of *Crime Does Not Pay* (#22) appeared in July 1942, picking up where *Silver Streak* #21 had left off. Issues #25–#28 advertised "The ONLY Magazine of Its Kind," but by mid-1945 the mob of imitators was too great to ignore.

Charlie Biro did the first 57 covers of the magazine; at least 16 of the first 35 feature bleeding bodies. On the cover of #24, a gleeful gangster pushes a woman's head down onto the burner of a gas stove, catching her hair on fire. Biro sought to improve on that scene in subsequent issues, depicting ax murders, high dives down an elevator shaft, and live burials. A force for good in the community? Six million readers couldn't be wrong.

Crossover

The appearance of a major character on another character's home field. The first crossover, dreamed up by Bill Everett and Carl Burgos, occurred in *Marvel Mystery* #8, with a clash between the Sub-Mariner and the Human Torch.

Crowley, Wendell

When it came time to dedicate the first edition of *The Who's Who of American Comic Books,* Jerry Bails and Hames Ware didn't hesitate. Their inscription read:

> To Wendell Crowley, 1921–1970
> The whimsical giant who cared…
> About the comics he produced
> About the kids who read them
> And the adults they became…

Crowley had a long career in comics starting at the Jack Binder shop and graduating to editor for the Fawcett Comics line, where "his love for the medium permeated everything and everyone he came in contact with," according to Ware. "Unlike so many professionals, Wendell maintained his delight with that period of his life long after he'd left it, happily sharing with fans the unique world he'd been such a vital part of."

Nearly 7 feet tall, Crowley was a "giant" in the comics industry in more ways than one.

Crumb, Robert

Robert's shadow wasn't anything anybody wanted to stand in.
BILL GRIFFITH

All I can say in my own defense is that it's honest.
ROBERT CRUMB

"When I was five or six," Crumb said in Terry Zwigoff's award-winning film about the cartoonist, "I was sexually attracted to Bugs Bunny. I cut out this Bugs Bunny from the cover of a comic book and carried it with me. I'd take it out and look at it periodically and it got all wrinkled up from handling it so much that I asked my mother to iron it."

And Mrs. Crumb apparently failed to get all the wrinkles out. "As a teenager," Crumb later said, "there was no place I fit in at all. I saw no hope of ever connecting with anything. The instant I realized I was an outcast, I became a critic, and I've been disgusted with American culture from the time I was a kid."

Crumb was born in Philadelphia, the son of

The first and quintessential crime comic boasted of its popularity. Here are a couple of Charlie Biro's blood-red covers for the title.

(© Lev Gleason Publications)

Crumb loomed larger than life at a special exhibition of his works in Angouleme, France, in 1992.

a Marine, the second of three brothers. His older brother, Charles, easily the most compelling figure in Zwigoff's *Crumb*, forced his two younger brothers to draw for several hours each day. "My father? He was an overbearing tyrant," Charles told Zwigoff. "Maybe I was unconsciously imitating him when I forced [them] to draw comic books."

That earnest apprenticeship that would one day allow Crumb to imitate the style of a wide variety of artists.

"All three brothers are sexually fetishistic," Zwigoff noted in *Subliminal Tattoos*. "Robert wants piggy-back rides, Max is always pulling down girls' shorts, and Charles was fixated on some 9-year-old, so . . . who knows? I mean, we're all pretty twisted, aren't we? I also don't think his family was all that strange. I thought they were a rather typical American family of the '50s, although certainly a little more interesting than most families."

After surviving the '50s, Crumb took a job with American Greetings in Cleveland, cranking out its Hi-Brow cards. His submissions to the *East Village Other*, *Yarrowstalks*, and Harvey Kurtzman's *Help!* eventually moved Kurtzman to invite him to New York in 1965 to replace Terry Gilliam on the magazine staff. Crumb had just arrived in town when James Warren, Kurtzman's publisher, folded the magazine.

When you're disconnected, it's not hard to move on. Two years later, Crumb produced *Zap* #0 for Brian Zahn in Philadelphia, only to have Zahn disappear with the artwork. Only then did Crumb stumble upon Charlie Plymell and his assistant, Don Donahue, who printed the landmark *Zap* #1.

"Crumb and Donahue loaded the trunk of an old Hudson with *Zap Comix* and set out to spread the word," *Inside Comics* noted in 1974. "They started on San Francisco's Haight Street—and the day's proceeds were desperately needed. Crumb was living in a dive on Mission Street for $3 a day, poring over a drawing board day and night. Within months, Crumb and Donahue had birthed an industry."

Was that a natural childbirth? No—Crumb needed medication. In 1966, he said, "I took this very weird drug. Supposely it was LSD, but it had this weird effect. It made my brain all fuzzy. This effect lasted for a couple of months . . . I let go of trying to have any coherent, fixed idea of what I was doing. I started drawing these stream-of-consciousness comic strips, making up stuff that didn't have to make any sense. All the characters I used in the next several years all came to me in this period."

Those characters included Fritz the Cat, Mr. Natural, Shuman the Human, Lenore Goldberg, Angelfood McSpade, and Whiteman. Crumb was also happy to deliver himself in any number of grotesque poses. "After a year of recognition and all the BS of fame," he explained to Zwigoff, "I started drawing the dark side of myself again in comics."

He was, Crumb said in an introduction to his collected works, "a regular one-man comic

book factory. I churned the stuff out. Now that I was famous, it was expected of me. The world cried out with outstretched hands, 'Give us comics! We want comics!' So it seemed to me. All the small publishers of underground comics at that time pleaded with me to supply them with comics. I was the most popular artist. A book or story by me always sold well. I felt it was my sole responsibility to keep these several little companies in business. Isn't that what they call 'co-dependency' now? I had a huge ego. I thought they'd all go under if I didn't keep feeling them R. Crumb comics on a regular basis. The whole WORLD would come part at the seems ... Civilization would crumble, if I didn't keep those comics coming."

One publisher Crumb did refuse was Hugh Hefner, rejecting an offer to deliver a monthly page of cartoons for $500. Michelle Urry, *Playboy's* cartoon editor, was enraged, Crumb recalled in 1974. "She said, 'Some day when the underground fad is over, you'll come crawling back, begging for work.' And she's probably right."

Crumb didn't need *Playboy*, he had plenty of his own playmates. "I was uncoolness personified," Crumb wrote in *The Complete Crumb Comics*, "the complete antithesis of the romantic hippie boys with flowing locks," but he was also famous. On his 26th birthday, "the perfect bad girl of my Catholic-boy dreams" opened the door of a summer cabin in upstate New York, "her voluptuous body gloriously displayed in a shiny, tight, black low-cut mini-dress, a wide black leather belt around her waist, dark, seamed tights, high lace-up black boots, black 'choker' collar around her pale white neck, the whole image finished off with a vintage Nazi swastika emblem dangling in the cleavage of her heaving chest ... My birthday present. Garsh, I just had to laugh and shake my head. It'd only been, like, a year ago that I was one of life's losers, undeserving of a second glance."

Life's losers—as well as life's sleazeball opportunists—continued to flourish in Crumb's cartoons. Fritz the Cat, alas, did not; disgusted by Ralph Bakshi's film treatment of the feline, Crumb killed Fritz off with an icepick to the back of the head.

Women often didn't fare much better. "I have this hostility toward women, I admit it,"

Crumb's favorite cartoon character is himself.
(© R. Crumb)

Crumb once told Peggy Orenstein. "It's out in the open."

Crumb eventually tired of sharing the same space. When he stopped supplying comics for every nickel-and-dime outfit, and civilization didn't crumble, Crumb fled to France with wife Aline Kominsky and their daughter Sophie, laying low until Zwigoff's film obliterated that possibility. "I'm a has-been," he said, somewhat wistfully, 20 years ago. "Jeez, I'm old hat. There are a million stories about me. I'm part of the 1960s—passé."

The Crusaders

The life story and libelous revelations of Alberto Rivera were brought to you by Chick Publications, which hands out millions of religious tracts each year in 30 languages.

Rivera—supposedly a former Jesuit priest—argues that the Catholic Church is the mother of abominations, two of its offspring being the Nazi party and the Communist party.

What's more, according to Rivera, the Catholics engineered the Holocaust and the Russian Revolution and command the Ku Klux Klan; the Jesuits murdered Abraham Lincoln; and the Pope is the anti-Christ.

When the Catholics and the attorneys came after Rivera, they found he had never been a

Jesuit; in fact, he sired two children during his purported years of celibacy. According to his police file, Rivera was also guilty of credit-card theft.

Cruse, Howard

The most visible gay artist in the comics, Howard Cruse has had several unique collisions with history. He is, undoubtedly, the only member of the funny book fraternity who attended the funeral of the four black girls killed in the bombing of Birmingham's Sixteenth Street Baptist Church on September 15, 1963 … less than three weeks after the march on Washington.

"That church bombing was the turning point for Birmingham," Cruse, who grew up in Alabama and went to school at Indian Springs, once told *The Comics Journal*. "The crime was so horrific: to kill little girls while they were in Sunday School. It took the wind out of Birmingham's sails. People didn't want to live in a town where children could be murdered in Sunday School."

Most of the crowd at the funeral, understandably, was black. "Martin Luther King gave a eulogy inside the church and then came out, and he was followed by pall bearers with the caskets and the parents weeping," Cruse said. "And then the whole crowd sang, 'We Shall Overcome.' I didn't sing it. I felt it would be presumptuous; I didn't feel I'd earned the right to."

When Cruse subsequently moved to New York, he admits he indulged in "all the stuff under the psychedelic umbrella that was popular in the '60s and early '70s." And it just so happened that he was tripping on acid in the West Village when the Stonewall riot occurred in June of 1969.

"It was just a funny coincidence to stumble upon a historic event in the middle of something as unhistoric as taking an acid trip," Cruse said.

"Some friends and I were just bumming around the Village after having been up in Central Park listening to a Tiny Tim concert … and there was all this excitement. It was violent, but contained within a space, sort of. Actually things could have flown out of that crowd and hit us, but they didn't.

"Y'know, we used to have this glib little phrase: 'God protects happy campers.' Some how or other, most of us came out okay … In this case, we just stood on the fringes of this riot and watched it as though it were a movie or a play. We didn't know what the significance was. I thought the government was being overthrown."

Cruse distilled many of his experiences into his magnum opus graphic novel, *Stuck Rubber Baby*, published by Paradox Press in 1995.

Cuidera, Chuck

An artist in Will Eisner's Golden Age studio, Cuidera is best known for his work on Blackhawk and for several superb covers for *Military Comics* in the '40s. "A hard-working guy," said studio mate Bob Fujitani, "but he had very little confidence. It took him forever without Alex Raymond's swipes in front of him. On the Blackhawk figures, I can still see him working on the boots, those boots the flyers were supposed to wear. He'd be struggling away. The end result was good, but it was so much labor for him it was hardly worth it."

Howard Cruse

Daredevil

The idea of a blind super-hero had clicked in 1940 (The Mask, in *Exciting Comics* #1), so Stan Lee decided he could recirculate it in 1964. First drawn by Golden Age artist Bill Everett, Daredevil was blinded by a head-on collision with a radioactive canister. The nimble, acrobatic crime-fighter's original costume was redesigned and colored red by Wally Wood on the character's first anniversary.

Daredevil is one of the few Marvel heroes whose best moments came years after his creation. If Lee gave the character life, Frank Miller gave him Elektra (see entry), one of the more memorable characters in comics history. Daredevil's duels with the Kingpin, scripted by Miller, are far more elaborate and primeval than the Silver Age collisions between the Hulk and the Thing.

"Batman is like the Shadow, and Daredevil is a character a bit more like the Continental Op or Sam Spade," Miller once said. "He's a smaller character. He has to be convincing. He isn't quite such a roaring force of nature."

Daredevil Comics

This Lev Gleason book hit the ground running in 1941 with "Daredevil Battles Hitler" and continued for 134 issues. Jerry Robinson's account of that first issue is worth repeating: "When the Golden Age *Daredevil* was finally given his own magazine, I was sharing a small studio across from Rockefeller Plaza with Dick and Dave Wood, Charlie Biro, George Roussos, and a few others.

"The weekend we had to get *Daredevil* #1 out, New York City received one of the worst snowstorms in its history. By Sunday, we were awfully hungry, and we decided to draw straws to decide who would go out and forage for food. They were gone for about six hours; in those days New York was pretty dead over the weekends anyway, but this weekend there was absolutely nothing open downtown. They had to dig their way down to Sixth Avenue and then trek down to 23rd Street before they found anything open. Finally, they located a luncheonette which managed to scrounge together a couple dozen eggs and a can of beans for some starving cartoonists on 51st Street.

"They returned hours later to a loft filled with ravenous, half-dead artists and writers. Suddenly, it occurred to us that we were in a bare office. We had absolutely nothing to cook food on. Finally, someone suggested building a small oven with the bathroom tiles. In desperation, we tore the tiles from the wall, built a tiny fireplace in the middle of the floor and fried the eggs on the makeshift oven. We didn't have a can opener either, so we banged open the can of beans using a T-square and keys as hammer and chisels."

Daring Mystery Comics

As Timely historian George Olshevsky noted, of the seven features in *Daring Mystery* #1 (Timely's second title out of the gate), only two—"The Fiery Mask" (Joe Simon's first published strip) and "Monako, Prince of Magic," a Mandrake ripoff—were ever seen again.

Daring Mystery #1 also featured Alex Schomburg's first cover for Timely. Schomburg said he went to a 1975 convention in Portland, Oregon, "and I saw one of the dealers had a copy of it marked at $200. He didn't know it was mine; no one in the world knew it was a Schomburg. When I told him I'd done the cover, he put the price up to $1,500. I should have told him that about 10 minutes later" (after buying it).

Dark Horse Comics

Mike Richardson opened his first comic book store—in central Oregon, of all places—by borrowing $2,000 on a maxed-out credit card. He jump-started his first comic book company shortly after repaying the debt.

"I thought the comic book marketplace was one-dimensional—nothing but super-heroes," Richardson said. "I wanted to produce the kind of comics I wanted to read. I also wanted to have a large selection, and whether it was super-heroes or undergrounds, I wanted there to be content. I also wanted to let creators own and create their own work."

In the mid-'80s, that approach played better with the creators than with the critics. "Dark Horse seemed appropriate," said Randy Stradley, who met Richardson when he opened a store in

The 'original' 1940s Daredevil.
© Lev Gleason Publications

Frank Miller's version of Marvel's Daredevil.
(TM & © 1998 Marvel Characters, Inc. All rights reserved.)

In 1996 Dark Horse celebrated its 10th anniversary in part by putting out five versions of the 100th issue of *Dark Horse Presents*, the company's flagship title.
(© Dark Horse Comics)

Beaverton, Oregon, and subsequently introduced him to APA-5 (see entry). "We didn't know if we had a chance and no one else thought we had a chance."

Stradley was in Los Angeles in the summer of 1985 when Richardson called, asking whether Stradley wanted to be the editor at his new company. The start-up plan called for two books, *Dark Horse Presents* and *Boris the Bear*.

"With the first issue of *DHP*, we were saying wouldn't it be great if we could sell 15,000 copies," Stradley said. "We sold 80,000. Part of it was luck. Our first issues came out a month before the black-and-white market began to collapse. But we were striving to put out quality material. We knew we didn't have characters that had been around for a million years. We thought we could attract good talent by giving people full ownership of their material. And we set out to aim our books at an older audience. That came out of running the stores and watching the readers get older and say, 'There's nothing here to interest me. There's nothing here to make me come back.'"

Paul Chadwick, another APA-5 alum, helped bring those readers back. When Chadwick introduced Richardson to Concrete, Richardson told him, "This is what I want Dark Horse to be about."

Chadwick was Dark Horse's first major catch; Frank Miller was a later and considerably more dramatic arrival. When Miller decided to break with Marvel and DC in 1989, a variety of companies bid for the rights to publish *Hard Boiled* and *Give Me Liberty*. Richardson asked Geof Darrow, Miller's collaborator on *Hard Boiled*, to arrange for him to talk to Miller when Frank was ready to make a decision.

Darrow did just that, calling Richardson and telling him to meet him and Miller at a Los Angeles restaurant.

Before the meeting, Richardson and company vice-president Neil Hankerson had prepared a balance sheet that detailed every Dark Horse cost for a possible Miller project with the company. "Creators traditionally didn't trust publishers," Richardson said. "I wasn't going to play any games with him. I was going to give him everything."

After a few minutes of small talk in the restaurant, Miller pulled out a pen and pad and suggested they get down to business. "Before you say another word, take this," Richardson said, handing Miller the balance sheet.

Miller looked at the figures for a few minutes, then put away his pen and paper. "Meet me here tomorrow," Miller said. "Same time." Then he left.

"He told me later," Richardson said, "that he'd been looking for that sheet for years, but no one had given him the recipe. He went home and told people I'd given him the secret formula. All the costs. *Our* price. It was like having the keys to the kingdom."

When Miller returned the next day, he said, "It looks like we have a deal." Richardson offered him a frightening percentage, but Miller turned it down. "I want to be fair," he said. "We can both make money."

And Dark Horse *has* made money—by publishing more creator-owned material than any comics company in history, alongside such licensed titles as *Aliens, Predator, Terminator*, and *Star Wars*.

Darrow, Geof

> *[Frank Miller and I] have two different ways of working: He's interested in moving the story along and I'm interested in stopping it dead in its tracks from panel to panel. I like to make each panel its own little world. I'm always afraid people are going to look at my drawings and think they're really lousy. I figure if I put a lot of work into them, people won't think I'm sloughing off.*

Geof Darrow has a different way of working than a lot of folks, as illustrated by the time he bumped into George Takei, the navigator of the *Enterprise*, outside a Star Trek convention in

Chicago. Darrow had just been refused free admission—the gatekeepers refused to believe he was William Shatner—and he was a little miffed. So when Takei, who was a guest at the convention and scheduled for an upcoming panel discussion, started asking him questions about the Chicago subway system, Darrow was only too happy to help him out.

"We were talking about the trains and I put him on the Dan Ryan Express," Darrow said. "He was gone for two or three hours. He didn't get hurt, but he got lost. How, I don't know: It's a loop. I always thought it was funny that the navigator of the *Enterprise* couldn't navigate the Chicago subway."

Born in Cedar Rapids, Iowa, Darrow successfully navigated his way out of the "Pork Capital of the World" and several early career opportunities at Quaker Oats, including some personal contact with the 5-ton bathyspheres that cooked the oat hulls and corn cobs. "When the mixture was fully cooked, I'd download the steam pressure, crack the hatches, and spin the spheres till the contents were discharged on conveyer belts," Darrow once explained. "It was hot, stinky, and sweaty work, but it helped me develop a work ethic and a fascination for machinery. I also worked at Hanna-Barbera on *Richie Rich, The Super Friends, Pac-Man,* and *The Smurfs*. It was hot, stinky, sweaty work."

Darrow was a comics fan in his teens, but he first warmed to comic art in 1973 when he spied some of Jean Giraud's work in a Bud Plant catalog. He quickly sent away for one of the Blueberry volumes. "I couldn't believe anyone could draw this stuff," Darrow said. "I don't draw guys with tall hats riding around on pterodactyls, but it's his approach that made me think about drawing."

Curiously, Darrow's first comics work was teaming up with Moebius for *City of Fire*. He met Frank Miller in 1987, and they began their collaboration with *Hard Boiled* (1990). That collaboration almost ended shortly thereafter when Miller and Darrow took a wild ride in Darrow's Metropolitan Nash. "The brakes went out heading down a hill in Hollywood," Darrow said. "We cruised through a couple red lights before we got hit and the car flipped over. My first thought was, 'My God, I've killed Frank Miller.' The car was spinning around when I looked over at him. I could see his face silhouetted against the pavement. I wasn't sure but that when he looked over at me, half his face would be gone. I think he thought I was reenacting something I drew in *Hard Boiled*."

Darrow is notorious for investing so much macabre detail in each panel that each one is a long time coming. He is almost as famous for stuffing his little world with—in the words of good friend Randy Stradley, an editor at Dark Horse—"a level of violence that goes far beyond what Quentin Tarantino imagines." In person, Darrow has a relentlessly wry sense of humor, but to find that person, you need to head to Paris, where Darrow and his wife, Loraine, recently settled in with their new daughter, Alice.

Davis, Jack

When Jack Davis arrived in New York in 1950, it took him three weeks to get fleeced of his last 35 bucks on a diamond ring scam, three months to have his car stolen . . . and a year to find a job. Convinced romance comics were his ticket through the transom at EC, Davis concocted a few pages of "Varsity Romance" and tossed them at Al Feldstein. "He gave me my first horror story, probably because it was such horrible stuff," Davis said.

Davis was EC's fastest artist—which explains the 29 covers and 163 stories he delivered—and its most even-tempered. "He was probably the most well-adjusted guy in the whole crew of people that we had at EC," Harvey Kurtzman once said. "He was a guy who never had tantrums, never got angry, was always courtly, polite, and an asset to any group."

Beginning with his first EC story, "The Beast of the Full Moon" in *Vault of Horror* #17 (February/March 1951), Davis did a total of 70 stories

Geof Darrow

Jack Davis's version of EC's Crypt Keeper is considered to be definitive by many aficionados.

(© 1998 William M. Gaines, Agent, Inc.)

in EC's three horror books. He drew them too quickly to ever be annoyed by the brutality of the tales, including "Foul Play," the lovable story in *Haunt of Fear* #19 that ended with the organs of a disemboweled schlep spread across a baseball diamond. And of course Davis was one of the stalwarts of the early *Mad*.

When EC folded, Davis (who'd done his first advertising work in 1949) had few problems. Everytime he went looking for a job, he ran into a *Mad* fan who remembered his work in both the comic book and magazine. One such fan at RCA Victor gave Davis his first album jacket assignment. "They paid about $300 a cover, which was pretty good next to comic book work," Davis said. By 1984, Davis had drawn 60 album covers, including eight Homer & Jethro albums, *The Best of the Cowsills,* and Sheb Wooley's *Harper Valley PTA*.

Davis also did 36 *Time* magazine covers, 23 *TV Guide* covers, 43 movie posters—the most famous of which remains *It's a Mad, Mad, Mad, Mad World*—numerous *Playboy* illustrations, and several dozen stories for Atlas Comics.

Davis, Jim

In a cartooning career that spanned almost 40 years, Jim Davis drew DC's *Fox and Crow* from 1945 through 1968, the longest single run by a cartoonist on a comic book. Born in 1915, Davis worked as an animator on the Superman serials in 1941. He began drawing funny animal books for Ned Pines and the American Comics Group in the early 1940s. Other DC credits include *Hound & the Hare* and *Tito and His Burrito*.

Dazzler

The debut issue *Dazzler* in 1981 was not only the first comic to feature a disco diva heroine but was the first direct-sales only comic book produced by a major publisher.

Marvel Comics had been fielding requests from comic shops for titles that would be distributed solely to them, and some smaller companies such as Pacific Comics were beginning to look at publishing specifically for the direct market. *Dazzler* was Marvel's experimental dip in the direct-sales pool; the first issue sold about 300,000 copies, so the experiment was pronounced a success. DC followed with *Madame Xanadu,* which sold well enough to the comics shop market that the Big Two were hooked on the concept, and the flood of direct-market-only comics began.

DC Comics

Sears never cared that Wal-Mart was on its tail, swallowing up one rural town after another. For years on end, the top brass at General Motors dined in the same executive dining room, sipping on their arrogance, reminding one another that big cars were safer and the American car buyers would just have to come around.

In the late 1950s and early 1960s, DC Comics had this same sort of attitude. "The entire company was, in its own mind, the *Wall Street Journal* of the comic publishing business," former DC editor Dick Giordano said. "The editors had a dress code. We had to come to work at a particular time with a shirt and tie and jacket on. That was typical of the whole mindset."

"The company as a whole was looking backwards rather than at the present," said Paul Levitz.

The view out the back was something to behold. Superman. Batman. *All Star Comics* and *All-Flash*. *Detective Comics,* which gave the company its name. Hawkman, Sandman, and Manhunter. The Green Arrow and the Green Lantern. Bill Finger and Jerry Robinson. Charles

> *"[At DC] the editors had a dress code. We had to come to work at a particular time with a shirt and tie and jacket on. That was typical of the whole mindset."*
> DICK GIORDANO

"WE SELL SEX"

After graduating from the Kubert School, Steve Bissette had several interviews at DC Comics, the most disorienting of which was with editor Joe Orlando.

"Joe Kubert set up the interview," Bissette said. "He really liked my work, and really saw a lot of possibilities there [at DC] for me. So I go up to meet with Joe Orlando. In going through my portfolio, Joe immediately notices there are no drawings of nude women." Orlando, Bissette said, made special note of their absence. "It was just a shattering interview. I wasn't being assessed for what I could or couldn't do. There was some other agenda here.

"At one point, Orlando said to me, point-blank, 'We do not sell comics. We sell sex.' That's coming from one of the head editors at DC. This would be 1977. He had worked under, and with, Wally Wood for a number of years, and Wood loved doing cheesecake, but I couldn't figure out where this was coming from. 'We sell sex, not comics?' What got me into drawing comics was the undergrounds. There was no way an editor at DC could have me believe they were actively pursuing that. But we did see examples . . .

"Rick Taylor was one of my fellow students; he had a very crisp and sharp ink line. Rick was one of the first of us to get inking jobs through DC, a *Legion of Super-Heroes* job. It was full pencils, not just sample work. And we'd never seen anything like this. The pencils were drawn with all the characters nude, and in provocative sexual positions. It was the inker's job to put the costumes on. And there were all kinds of blue lining, in which the editors would indicate, 'Get Superboy away from Supergirl's ass here.' That kind of thing. The whole thing had been penciled by an artist, and accepted by an editor, and it was soft-core porn. Which would then be cleaned up. Once it was published, that stuff was subliminal, almost, which is a very insidious way of putting out Code-approved comics."

Paris and Dick Sprang. DC got the jump on the field and, for almost 30 years, the company was never bested.

"We were top dog for so long, we became impervious to any criticism or new ideas," former editor Murray Boltinoff said. "We thought everything we did was right."

Groupthink, they call it. The arrogance was insufferable. There was, in the late 1950s, "a period of personal tyranny by many editors who . . . absolutely threatened, intimidated, vilified, crucified artists," Gil Kane said one year in Dallas. "It didn't mean anything if you were good. Because I saw [John] Severin go flying out of [Bob] Kanigher's office, followed by his pages, having turned in a perfectly competent job."

DC Comics began with *Detective Comics* #1 (March 1937), sporting a Vin Sullivan cover. Subsequent decades are represented by *Adventure Comics* (a typical 1940s Superboy cover), and an early 1950s genre title, *Star-Spangled War Stories*.
(© DC Comics, Inc.)

The parade of DC covers over the decades continues with a 1960s "go-go checks" cover (by Carmine Infantino and Murphy Anderson), a social consciousness cover from the 1970s (by Joe Kubert), a Bissette/Totleben *Swamp Thing* cover from the 1980s, and a Dave McKean *Sandman* cover from the 1990s.
(© DC Comics, Inc.)

"The epitome of working in the field was working for DC Comics," Joe Orlando said. "That was the era of Carmine Infantino and Alex Toth and Joe Kubert. If you wanted to work for DC, you developed a house style. That's why they had very little use for Frank Frazetta, because Frank Frazetta didn't conform to the house style."

Neither did Jack "Plastic Man" Cole. "Like many of the best, he came up to DC and was turned away," Kane said. "They were turned away for two reasons. Most of the jobs were filled and, incredibly, [DC] didn't even know who they were . . . They just didn't know. Julie [Schwartz] wouldn't know one artist from another. Most of the editors were dumb and blind . . ."

Levitz argues you can't fault only Schwartz. "I don't think Julie ever had enough control that you can lay the blame on him," Levitz said.

So be it. There's plenty of blame to go around.

How severely did DC have Marvel over the barrel in the late 1950s and early 1960s? Look at it this way: DC owned the Independent News Co., Marvel's distributor, and had the ability to limit Marvel to publishing eight magazines a month (see **Atlas Implosion** entry).

No wonder DC pretended not to notice when Marvel began to redefine super-heroes in the early '60s. "Even though sales throughout the industry were atrophying," Mark Evanier once said, "DC was just madly in love with its product." In love with the originals, in love with the recyclables.

"They didn't think it was dignified to sit there and get into a competition with Marvel," Giordano said. "They never had to; they'd always been at the top of the heap. Some of that attitude is why I left three years later [in 1972]. I didn't think we were making the commitment to chase Marvel.

"We were a little stronger than Marvel when I first got there [in 1967] and getting weaker by the minute. They overtook us in sales, then pulled away. I don't know if there ever was any real intent on the part of management to compete with Marvel.

"The atmosphere then was anti-creator. During my indoctrination period I was told, 'Maybe you shouldn't work with that guy,' or 'We don't like this guy's stuff, we don't think he's capable of writing.'

"When I got in and dealt with these people, I realized the ones I was supposed to ignore were the ones who had the best chance of competing with Marvel."

This goofy sense of superiority was still

intact even when DC was solidly in second place. "When I came on staff in the early '70s, we were still attending editorial meetings where the then-management was announcing that Marvel would be out of business in six months," Levitz said. *The then-management?* "Carmine [Infantino]. There were no reality checks whatsoever."

Neither did that change when Jack Kirby came over from Marvel in 1970. Numerous Marvel artists were willing to follow Kirby's lead, Evanier noted, "but the attitude at DC was, 'We've already got all the good artists.' DC could have cleaned Marvel out of good artists, but they weren't about to admit that the artists were good."

It took years for DC to jerk its head out of its past. Some argue that it also took the competition from Marvel under the reign of Jim Shooter; others credit Jenette Kahn. By the 1980s, Barbara Kesel said, "Marvel was the big huge monster we couldn't compete with head on. We didn't have the weight. We didn't have the distribution network. We didn't have the sales department. DC chose to emphasize higher quality in writing and art, go after the direct market, and write off the newsstand material. The attitude on the staff tended to be, 'We're smart. We have better backgrounds. We're the college company, they're the high school football team.' Quality became the motivation."

And so we got *Dark Knight* and *Watchmen, the* two comic events of the 1980s. We got Neil Gaiman's *Sandman* and the diverse, often dizzy, pleasures of Vertigo in the 1990s. We got the oversight of Warner Brothers, which took over DC in 1968 and ensured that movies featuring DC characters (unlike Marvel's) would actually get made. We got a company that, if it hasn't regained its status, has—unlike Marvel—restored its pride.

"In the entertainment industry," Steve Bissette said, "a corporate entity becomes adventurous because they can't sink any lower. If they don't pursue alternatives, they're going under. Having been with DC in 1983, I know what was going on at the time. They were fighting so desperately to turn the tables on Marvel that they became a haven for people like Frank Miller, who was experimenting with *Ronin*, and they would indulge a writer like Alan Moore, who was completely new to American comics. It was an open-door policy all of

"The attitude at DC was, 'We've already got all the good artists.' DC could have cleaned Marvel out of good artists, but they weren't about to admit that the artists were good."
MARK EVANIER

> **Dealing**
>
> *I really like to compare comic collecting to being addicted to drugs. Once you're into it, you've got to deal it to make enough money to support your hobby.*
> BUD PLANT, LONG-TIME BOOK DEALER

a sudden. There was a lot more room to play at DC."

As Superman hit his 60th birthday and Marvel haunted bankruptcy court, DC played the role of industry pacesetter in 1998. Although Marvel may have sold more comics in 1997 (36 million to DC's 28 million), DC published more titles and issues—956 different books in all, 360 more than its closest competition.

DEATH WITH INDIGNITY

Give the Golden Age—and its gutty aftermath—credit: In the old days, they weren't squeamish. They knew how to blow people away. We're not talking simply a bullet in the gut, a knife in the eye, or a vampire by the throat, but truly novel ways to die, stretched across the cover like a patient etherized upon a . . .

You want death by flagstick in this comic wasteland? Charlie Biro jammed the No. 13 pin in the bad guy's back on the cover of *Boy Comics* #23 (August 1945).

Death by paper cutter? The blade's about to fall on the cover of *Super Mystery* Vol. 6 No. 3 (December 1945).

Fire ants? Why not? Whatever it took to move *Mister Mystery* #11 (May/June 1953) off the rack. And when fire ants weren't in the mood, *Mister Mystery* rolled out the praying mantis, the acid bath or that old favorite, the flaming stick in the eye.

Other glorious death scenes? Man-eating sharks are Alex Schomburg's deadly weapons on the cover of *Daring* #9 (Fall 1944). You like snakes? They don't get any nastier than on *Dynamic* #16 (October 1945). Gnawing rats? They're putting their teeth to the task on *Black Cat* #49 (April 1954).

That's not all. Other gruesome deaths include those from burning at the stake (*Dark Mysteries* #10), decapitation (*Fight Against Crime* #20), radium (*Black Cat* #50), your typical facial explosion (*Tomb of Terror* #15), electric chair (*Web of Evil* #5), fingernails (*The Thing* #7), lightning (*Shock SuspenStories* #7), steam iron (*Clue* #14), and that deadly duo, Punch and Judy (*Daredevil* #24).

Deadman

Fathered by Arnold Drake and Carmine Infantino, Deadman made his real mark as the adopted son of Neal Adams. Dead before the close of his first appearance, *Strange Adventures* #205 (October 1967), Deadman—circus savant Boston Brand—was first revived by Adams the following month. Deadman had an ability to inhabit other bodies and a tendency to inhabit other comics, including *Challengers of the Unknown*, *The Forever People*, and *Swamp Thing Annual* #2.

DeBeck, Billy

The one-time Pittsburgh political cartoonist introduced *Barney Google* in 1919. DeBeck once advised young cartoonists, "If your artistic bent is for the creation of nonsense, don't let the greatest artist in the world talk you out of it."

DeCarlo, Dan

I'm always watching girls. I just haven't been arrested for it yet.

He graduated from the war, joined the "52-20 Club"—$20 a week for 52 weeks of unemployment—and went looking for an advertising job. After a couple months of hanging storm windows, Dan DeCarlo, like many artists, ended up in the funny books, joining Stan Lee and the rest of the Timely staff in 1947.

DeCarlo survived less than three years on staff before he was swept up and spit out in one of the periodic Timely purges, but that was time enough to revitalize *Millie the Model* using Marilyn Monroe as his inspiration. He also teamed up with Lee on a syndicated strip, *Willie Lumpkin*. United Features, DeCarlo said, was also interested in a second strip starring a character named Josie, but he eventually sold the idea to Archie Publications.

"In the beginning, they were giving me a piece of the action," DeCarlo said in 1996. "They stopped that when they went public. They changed it to 'Josie and the Pussycats,' and for years I never got a penny. I signed away the rights to it. A lawyer told me that doesn't hold water, but he said he wouldn't advise suing because back then you were going to be blackballed from the whole industry. Plus, he said, there wasn't going to be that much money. Only $50,000.

"I also fainted. $50,000? $50,000 and I would have left town."

DeCarlo did freelance work for several years at Standard, Ziff-Davis, and Timely before tying the knot at Archie in 1958. The marriage has lasted 40 years. DeCarlo brought a little of Millie and a little of Marilyn to Betty and Veronica. "I was just keeping with the [Bob] Montana style but making them a little sexier," he said. "And a little more fashionable. I used to carry a pad of paper in the car, just to make quick sketches of how women stand and how they rest. My granddaughters—Christie is 20 now, Jessica is 11—are a big help about what girls should be wearing.

"All my friends, or my nonartist friends, ask me when I want to retire. What am I going to do if I leave now? Take up painting?" said DeCarlo, who's in his late 70s. "I think I keep it young, even though I'm old."

Dell

That's "Dell" as in George Delacorte, who helped publish the first comic book—Eastern Color's *Famous Funnies*—in 1934, then returned to the fray with *Popular Comics* #1 in 1936.

Eastern Color was the first company to regularly publish comic books, National Periodicals the second, and Dell the third. Western Printing and Lithography, which

Dedication

When retailers tell me that they don't think anyone will ever match Cerebus *as an achievement; that no one will ever again commit themselves to a project of its size and scope in the history of comics; I think they're very much surprised when I disagree with them and, further, that I pray often that they're wrong.*

Because what comic books mean to me; what it means to the optimistic and dedicated part of you; the part of you that made you open a comic book store in the first place against all the odds and forces at work against you; what it means to us is exactly the day-in and day-out dedication that we need now as we've never needed it before. The dedication which informed the first 38 issues of Amazing Spider-Man, *the dedication that allowed Marv Wolfman and Gene Colan and Tom Palmer to do 70 issues of* Tomb of Dracula, *the dedication that kept Stan Lee and Jack Kirby on the* Fantastic Four *for almost a decade; the nearly unimaginable dedication that kept Carl Barks laboring in virtual obscurity for a longer period than that. The dedication that kept Sergio and Mark and Stan producing* Groo, *month after month, without fail and without let-up.*

That's what comic books mean.
DAVE SIM

A PLEDGE DELL COMIC TO PARENTS

The Dell Trademark is, and always has been, a positive guarantee that the comic magazine bearing it contains only clean and wholesome entertainment. The Dell code eliminates entirely, rather than regulates, objectionable material. That's why when your child buys a Dell Comic you can be sure it contains only good fun. "DELL COMICS ARE GOOD COMICS" is our only credo and constant goal.

owned the comic book rights to the characters of Walt Disney, Walter Lantz, and Warner Brothers, published those books under the Dell imprint from the late 1930s until 1962. As Mark Evanier once noted, "Carl Barks never worked for Dell. He still receives a pension from Western Publishing."

As many as 300 million "Dell" books appeared annually in the early 1950s. After Western went its own way in 1962, publishing its wares under the Gold Key imprint, Dell produced a new line of books that included *The F.B.I.*, *The New Adventures of Pinocchio*, and a variety of other TV tie-ins.

The Demon

Jack Kirby created Etrigan, Merlin's demonic guardian, in 1972 and kept him moving through 16 issues of his original title. DC has brought the Demon back numerous times, animated by Steve Ditko in *Detective* #483–#485 and by Matt Wagner in a 1987 miniseries.

Kirby freely admits that he swiped the idea for the Demon from Hal Foster's *Prince Valiant*. In a set of Sunday strips running from 12-18-37 through 1-8-38, Val, in order to frighten the Ogre of Sinstar Wood, disguised himself as a demon, using the skin of a goose for a face mask, quills for tusks, and webbed feet for ears. The ogre was literally scared to death.

Caught up in the thrill of the swipe, Kirby also used Camelot—Foster's setting—for the origin of the Demon.

Dennis the Menace

Hank Ketcham's comic strip character first appeared in comic book form under the Standard flag in August 1953. Fred Toole handled much of the writing for the series, which passed—immediately after the first appearance of Dennis's pal, Joey, in #31—to Fawcett. Over the years, there have been several different series starring Dennis, including *Dennis the Menace and the Bible Kids*; an incongruous team-up written by Ketcham and published by Word Books in 1977. But the best of the lot are the superbly written Giants, published by Standard and Hallden in the late '50s and early '60s, that sent Dennis on vacations to Hawaii, Hollywood, Mexico, and other climes.

The Denver Collection

A collection of 153 Golden Age #1 issues, the Denver collection actually originated in Pennsylvania, where a pair of Denver antique dealers stumbled across two lots of Golden Age comics in an auction. The dealers paid $8,000 for the first lot and only $1,000 for the second—their dispirited bidding opponents departed between lots—then sent out a list to a dozen dealers. "I got on the stick a little quicker than the others," purchaser Jim Payette said.

The collection had been put together in the 1940s by a woman who stored the #1 issues away but, Payette said, "never pulled her relatives aside and said, 'Look, if something happens to me, this is what you should do.'" Payette split the collection with Sparkle City Comics, paying $45,000 for approximately 90 of the books. By 1992 the New Hampshire dealer had only four of the books left: *Planet* #1 (part of his complete run), *Classic Comics* #1, *Catman* #1, and *Spy Smasher* #1.

Destroyer Duck

The profits from the first of seven issues of *Destroyer Duck*, the "Special Lawsuit Benefit Edition," went straight to scripter Steve Gerber to pay the legal bills in his futile skirmish with Marvel Comics to retain the rights to his creation, Howard the Duck. The first issue (published by Eclipse in 1982) also contained the first appearance of Sergio Aragonés's Groo the Wanderer.

Detail

That's right, detail. As in, "Look at the *detail* on this cover." It's the ultimate compliment from people who don't know anything about art.

For retailers, "Look at the detail" used to be a major selling point, particularly when they were trying to sell artists such as George Peréz, Art Adams, Rob Liefeld, and Jim Lee.

And it was a frighteningly easy sell. "There are artists that everyone in the industry loves, like Alex Toth, someone who with very few lines would tell a beautiful story," Ann Nocenti said. "But the fans didn't like Alex Toth."

Hal Foster's demon compared with Jack Kirby's Demon, as rendered by fan artist Jim Jones.

Jack Kirby rendered the wacky cover for Steve Gerber's benefit book, *Destroyer Duck*.
(© Steve Gerber and Jack Kirby)

The fans don't like the simplifiers. The fans like *detail*. "The fans like the complicators," Nocenti said. The complicators, she explained, are the artists who "aren't satisfied with a few lines; they have to draw every hair on the head, every brick in the wall, every crease in the suit. It's gotten to be neurotic."

Not to mention self-defeating, when the artists' work is printed on such lousy paper that guess what drops out?

The *detail*.

Detective Comics

The "DC" in DC. The title kicked off in March 1937, two years after *New Fun Comics*, the company's first anthology, and 15 months after *New Comics* #1. More important, Major Malcolm Wheeler-Nicholson launched the title four months after the Comics Magazine Company had published the true original, *Detective Picture Stories* #1.

Batman rescued *Detective Comics* from future obscurity when he fluttered into view with issue #27 (May 1939).

Key issues: #20, first Crimson Avenger; #27, first Batman; #38, first Robin; #40, first Joker cover; #58, first Penguin; #64, first Boy Commandos; #66, first Two-Face; #122, first Catwoman; #140, first Riddler; #225, first Martian Manhunter; followed by 30 years of last gasps.

Detective Dan

Delivered to the newsstand by Humor Publishing in 1933, Detective Dan, Secret Operative No. 48 was an oversized (9½" × 12") one-shot. Slapped together by Norman Marsh to soak up some of the Dick Tracy spillover, the character evolved into the newspaper strip Dan Dunn. When Joe Shuster and Jerry Siegel encountered Detective Dan and a companion one-shot, Ace King, they tried to sell Humor Publishing on their cartoon hero, The Superman. Humor was initially enthusiastic, then backed out of the deal. Which is why the publisher—unlike Superman—was never heard from again.

Detective Picture Stories

The first comic book devoted to a single theme, *Detective Picture Stories* #1 may be one of the most undervalued books in the *Overstreet Comic Book Price Guide*.

In 1936, The Comics Magazine Company and National Periodicals were both scrambling to put out the first comic featuring detective stories, a successful format in the pulps.

The Comics Magazine Company landed first with *Detective Picture Stories* #1, cover dated December 1936. The closest National got to matching that was an ad in *New Comics* #8 advertising *Detective Comics* #1 with the same cover date. Unfortunately, National didn't get that little piggie to market for another four months, finally publishing *Detective* #1 in March 1937.

The two books—*Detective Picture Stories* #1 and *Detective Comics* #1—are quite similar. All the stories harp on the detective theme, of course. Both open in color and fade to black and white. *Detective Picture Stories* #1 is the rarer of the two, according to Mark Wilson of World's Finest Comics and Collectibles.

So, how do they compare in Overstreet? In the 27th edition, the NM price for *DPS* #1 is $3,300. The VF tab for *Detective Comics* #1 is $50,000.

"There's no reason for it," Wilson said. "People will drill me full of holes for saying this, but *Detective Comics* #1 is not an important book. *Detective Picture Stories* should be more valuable. But because Batman came out in *Detective*, it's always been given the nod."

Those are fighting words for DC buffs.

The cover and lead story of *Detective Picture Stories* #1 were drawn by W. A. Allison. His panel construction is unpredictable and unique, with cut-ins and odd shapes that didn't exist in comics in 1936.

That first issue also includes "Murder in the Blue Room" featuring "Shurlock and Watkins," and ten pages of full-color art by Bert Christman, "The Tale of Timothy O'Toole."

Detective Picture Stories #1: Why isn't it worth as much as *Detective* #1?
(© Comics Magazine Co.)

Dignity

Comics are such a wonderful medium. Those of us who like to escape into comics perhaps were a little overeager. Most of us, as young men and women, would have done it for free, and that's not necessarily a good way to begin if you plan to maintain your self-respect and dignity.
SCOTT MCCLOUD

Diamond Comic Distributors

The industry's primary distribution company, Diamond grew out of Steve Geppi's Baltimore-based retail enterprise (see **Direct Distribution** entry). When New Media/Irjax filed for Chapter Seven bankruptcy in early 1982, Geppi was perfectly positioned to take

Dick Tracy with his "boss."
(© New York News Syndicate)

"The move to direct distribution is the pivotal event in the modern history of comics."

over New Media's office and warehouse space. "It was an incredibly risky and gutsy move," said Chuck Rozanski of Mile High Comics. "He had to sort out the good customers from the bad overnight. He had to take on the responsibility of all those leases and negotiate with all the creditors. I don't know how he did it, but it was pretty damn smart. He went from being a retailer in Baltimore to having warehouses all over the place."

Geppi and Diamond weathered a small storm of criticism in 1983 when Geppi balked at listing several books in the Diamond catalog unless they carried "Adult Only" advisories. Particularly annoyed by a graphic childbirth scene in *Miracleman* #9, Geppi wrote to retailers, "Diamond values its retailers too much to take chances on such a dangerous situation … We are not censors. We no more want someone deciding for us than you do. We cannot, however, stand by and watch the marketplace become a dumping ground for every sort of graphic fantasy that someone wants to live out. We have an industry to protect; we have leases to abide by; we have a community image to maintain."

Geppi soon shifted his focus from protecting the industry to overwhelming it. He bought Bud Plant's distribution service in 1988; Ernst Gerber Publishing in 1992; Russ Cochran Publishing in 1993; and Overstreet Publishing in 1994. After Marvel bought out Heroes World in 1995 and took its distribution in-house, Diamond maintained its preeminence by signing exclusive deals with DC Comics, Dark Horse, Image, Acclaim, Wizard, and several smaller companies. Geppi became the sole king of comics industry distribution in the summer of 1996 by buying his main competitor, Capital City Distribution, and welcoming back Marvel when its self-distribution plan failed.

Dick Tracy

Chester Gould brought crime and punishment to the comic strip in October 1931, when *Dick Tracy* first swore to saddle the former with the latter in the pages of the *Detroit Mirror*.

Little that readers saw on the front pages of their paper could match the brutality of the detective's run-ins with Pruneface, Breathless Mahoney, Flattop, the Brow, Mumbles, and the Blank.

The chase scenes were superb, the death scenes surreal, and the love scenes a mere distraction. Just when the violence threatened to turn the reader's head, Gould caught the reader's eye with a savage display of storytelling or administration of justice. Tracy made the jump to comic books in May 1937 in *Feature Book*.

Gould was faithful to his creation until Christmas Day 1977, when he deeded the detective to writer Max Allan Collins.

Direct Distribution

The move to direct distribution is the pivotal event in the modern history of comics.

Before Phil Seuling supplied the comics industry with the lever and fulcrum with which to move the world, comics publishers were convinced the business was dying. By 1972, the 40-year-old means of distributing comics—on a returnable basis via independent magazine distributors to newsstands, grocery stores, and other outlets—was showing signs of decay.

Whether Seuling's appearance on the distribution scene was miraculous or inevitable is immaterial. Because he was, in the words of Paul Levitz, "the most significant figure in New York fandom," Seuling understood the frustrations of the comic shop owners who could buy new comics from independent distributors only in bulk assortments.

"You want 10 *Superman*s, you gotta take 10 *Archie*s."

"But I want 20 *Superman*s."

"Fine. Then you take 20 *Archie*s."

"I can't sell two *Archie*s, much less 20."

"Well, send 'em back."

Seuling had a better idea, and—through his New York conventions—he had the publishers' ear. "The publishers were very unapproachable in that period," Levitz said, "so it took a courage, an arrogance, an entrepreneurism to walk in

and hit your head against the wall and say, 'There's got to be a better way.'"

Sell the books directly to me, Seuling suggested, and forget the returns. I'll get the orders and I'll take the risk. You'll sell 100 percent of what you print.

Levitz was working at DC—"the company's pet fan"—when Seuling made his pitch to company vice-president Sol Harrison. "Sol came up to me and said, 'Phil has this idea, what do you think?'" Levitz recalled. "I couldn't vouch for the idea; I was 16 at the time. But I said I could vouch for Phil as an individual."

The Seuling Monopoly The major publishers knew Seuling well enough to give his plan a shot. Yet it was Phil Seuling's ballgame, and he also figured it was Phil Seuling's ball. "He was a great guy," said Chuck Rozanski of Mile High Comics, "but he was aware of the goldmine he had, and he tried to maintain that monopoly. The only thing direct about his direct market was that Phil was selling the material directly to the stores. It was essentially a private fishing hole for Phil Seuling. He had his own best interest in mind. He fought tooth and nail to keep the system his. I know that for a fact, because I'm the one he fought with."

By the summer of 1979, Rozanski argued, Seuling had done little with his opportunity. "In the seven years that Phil had a monopoly, he was only able to capture 6 percent of a dying market," Rozanski said. The internal systems at Seuling's company, Seagate, "were catastrophically poor. He required advance payment with all orders. They had no computer system for tracking who had paid them for what. It was very seldom that you could get credit out of them."

Seuling's monopoly had been broken, Rozanski said, by the Irjax lawsuit in 1978. New Media/Irjax was a paper distribution company formed by Hal Shuster with his father, Irwin, and his brother, Jack.

"Phil had not succeeded in keeping everyone out," Rozanski said. "Four or five distributors had gotten started, but there was one big difference between them and Seuling. Seuling had been given this unique status of being able to ship from the Sparta [Illinois] plant [where all comics were printed at the time] straight to the retailer's doorstep. No other distributor could ship door-to-door at the publishers' expense.

Phil Seuling advertised his fledgling distribution company in his ads for the 1978 *Overstreet Comic Book Price Guide*. (The illustrator, by the way, was Denis Kitchen, who later made his mark in comics as publisher of Kitchen Sink Press.)

When the legal departments at Marvel and DC took one look at this sweetheart deal, they threw up their hands and said, 'We can't do this.'"

The Rozanski Letter In May 1979, Rozanski wrote a letter to Robert Maiello, the manager of Marvel's sales department. Rozanski had succeeded in carving out a growing chunk of the retail business through the sales of the Mile High collection (see **Mile High** entry), but his efforts to expand were thwarted by Marvel's distribution system.

Rozanski wanted Marvel to know that comic shop owners "were professionals with some questions into their business practices that went beyond the superficial inquiries from fan-boys."

His letter noted, "Ours is a dying industry and if we don't get together and cooperate there will be no comic books at all. If you don't believe me, check with John Goldwater, the president of the Comic Magazine Association of America. According to him, circulation from 1959 to 1978 dropped from 600 million to 250 million."

Marvel's policies, Rozanski argued, were restricting the ability of comic book retailers to survive. Among newsstand distributors, comic

Chuck Rozanski

DIAMOND COMIC DISTRIBUTORS, INC.

'the Gem of Distributors'
612½ Edmondson Ave., Balto., Md. 21228
Phone (301) 788-8222

NOW DIRECT FROM THE PUBLISHERS FOR BEST SERVICE

- Marvel Comics
- Pacific Comics
- Whitman Comics
- Elfquest
- O'Quinn Mags
- Sal Q Productions
- All Fanzines
- Comic Bags
- DC Comics
- Richie Rich Comics
- Archie Comics
- NMP
- Warren Mags
- Fantagraphics
- All Magazines
- Comic Boxes

Start Up Programs For All Size Shops
Display Analysis Computer Billing

Ask for Steve Geppi
(301) 788-8222

Steve Geppi also announced his new distribution company in the 1982 *Overstreet Comic Book Price Guide*.

books were a low-priority item. "At 40 cents and up, comics are no longer able to sell themselves," Rozanski wrote. "You have made the product so thin and unattractive with advertising that it takes salesmanship to get them to sell, even to collectors. How much salesmanship do you get in a 7-Eleven? We go out of our way to sell comics; they are our main business."

Rozanski had eight suggestions for Marvel, including a cooperative advertising campaign to promote comics; promotional tours for artists and writers; better information about future issues; and an end to advance payment.

He got an immediate answer from Ed Shukin, the vice-president in charge of circulation at Marvel. Rozanski's letter struck a nerve with Shukin because he had researched and supplied the circulation data to the CMAA.

Two months later, Rozanski arranged a meeting at the 1979 San Diego Comic-Con with Shukin, editor Jim Shooter, and Barry Kaplan, Marvel's director of finance. All retailers were invited. As a result of that meeting, Rozanski argues, Marvel changed its trade terms, eliminating the advance-payment requirement, and hired its first direct-sales manager. Rozanski was offered the job; when he turned it down, the position went to Mike Friedrich.

Marvel's aggressiveness in the direct-sales market was as reckless as it was prescient, Friedrich said. As usual, DC sat back and watched, waiting for Marvel to slide out and test the ice. "DC was always much more cautious," Friedrich said. "The approach at Marvel from the top was, 'This is quick, cheap gravy, let's grab it while we can.' DC wasn't interested in regional entrepreneurs, partially because they had no means of verifying if the guy who said, 'Hi, I'm a distributor in Colorado,' had the accounts or the resources they'd want to deal with. Marvel was more lenient. Marvel's attitude was one of contempt at the upper levels. They had no faith in the market long-term. They treated it as quick money."

And that left plenty of room for someone with twice the smarts and half the contempt to grab a dominant share of the direct-distribution market: Steve Geppi.

Enter Steve Geppi Geppi was a fervent Golden Age collector/dealer and one of Hal Shuster's subdistributors in the late 1970s. He had several stores in the Baltimore area and no lack of ambition or intuition. "I don't use the word 'brilliant' very often, but Steve Geppi is brilliant," Rozanski said. "And his brilliance manifests itself in that he's an opportunist."

Geppi's opportunity arrived when Irjax went bankrupt in 1981. Shuster was a paper-pusher, and a man of limited vision, but he had a sizable chunk of the direct-distribution market. His only goal, seemingly, had been to increase the size of that chunk. Marvel had a program in the late 1970s in which it sold bags of comics to Western Publishing at 80 percent off the cover price. Such a hefty discount required a volume point, and Shuster, determined to receive a similar discount, hustled to push the same volume. The hustle didn't float. "Before they went under, Irjax was offering discounts of up to 62 percent on new comics, just trying to keep themselves alive," said John Barrett, then at Comics and Comix in Berkeley. "They were just passing the comics on, trying to stay alive on cash flow."

Shuster had a thin profit margin and a thinner margin of error. When Irjax went under, Geppi stepped up and over the corporate corpse to take over what was left of Shuster's accounts. "Sort of like a feudal lord who takes over when the king abdicates," Rozanski said. "It was a risky and gutsy move. He took on all those liabilities. Overnight, he had to sort out the good customers from the bad. He had to negotiate with all the creditors."

Geppi (and his company, Diamond Comic Distributors) came out smelling like a rose. "Primarily, it was a matter of integrity," Friedrich said. "He was someone whose work you could trust, who had a good reputation for honesty in the field. In addition to being a

retailer and a distributor, he was very visible in the Golden Age collectible market. All very quiet and behind the scenes."

But Geppi's ascendancy, Rozanski notes, "is just the beginning of the tale" of how Diamond and its main rival, Capital City Distribution, would, in the next decade, control more than 70 percent of comic distribution. The next chapter was Marvel's freight rebate program.

Marvel and DC's Roles "Prior to that point," Rozanski said, "publishers would ship product to everyone on the same day. If you were closer to the printing plant, you got your books first. If you were farther from the printing plant, you got your books later. Everything was shipped at the same time and the publishers paid freight to your door."

Then Marvel had a brainstorm: Instead of shipping the comics by common carrier, why not establish the cost of shipment and rebate it directly to the distributors who were willing to pick up the material at the Sparta dock door?

"It seems reasonable and egalitarian, but it was not," Rozanski said. "It encouraged the larger distributors to do what the small retailers could not: put together their own freight network to take advantage of the rebate. Therefore, small retailers had two disadvantages. They could not get the material quickly, so they were always days behind the large distributors. Secondly, an efficient freight system beats the cost of common carrier."

Geppi had the warehouses in the major population centers along the East Coast; he benefited big time from the rebate program. The person who administered that program at Marvel? Carol Kalish.

One other factor, Rozanski said, played into the hands of the major distributors such as Capital and Diamond: When DC finally issued trade terms in 1981, they offered the large-volume distributors an extra 5 percent off the purchase price of the books.

"DC set it up so that the large distributors would put the small ones out of business," Rozanski said. "If you're in the game long enough, you realize the house always wins because they have a percentage advantage. Steve Geppi ended up with a percentage advantage. If there has ever been a gutless group, it's the small distributors who were in IADD [International Association of Direct Distribution] in 1981 and 1982. They acquiesced to trade terms that gave the advantage to Diamond or Capital, and they didn't say boo. They watched the inevitable happen. If the big guys are buying cheaper than you are, you're going to get killed."

"If you analyze the structural changes that have gone on in the business since 1973, every single one flows back to that change," Levitz said. "You move from a system of controlled distribution, with an extraordinarily high cost of entry, with a tonnage-driven system that was disinterested in content and highly randomized, where there was no risk to anyone in the process and no commitment to any individual product. You move from there to a system characterized by no cost of entry, which ultimately allows multiple publishers to emerge on low capitalization; to a system where everyone has to have a high commitment to the risk factor of the product because it's no longer returnable."

Bill Schanes, who with his brother Steve had owned Pacific Comics Distribution, went to work for Steve Geppi at Diamond after Pacific went under. Bill is now vice-president for purchasing at Diamond.

John Davis was a founder (along with Milton Griepp) of Capital City Distribution, which has now been absorbed by Diamond.

The Boom Years. "Take those as your analytic building blocks," Levitz said, "and you trace back to the ability of small publishers to emerge, as well as to the talent being name-driven rather than being generic, because you are now selling the product on the product's intrinsic merits."

Comics had been, Levitz argued, part of the free media that are delivered so cheaply and randomly that the creator's identity plays no role. "You suddenly moved to a system where someone had to make a bet on whether they're going to buy *Fantastic Four* before they've even seen it."

The direct market hit a giant boom in 1993 (when speculation fever hit and parents were buying unopened boxes of single issues, expecting the "investment" to put their kids through college), and an even bigger crash in 1995, when (as the result of a variety of factors, including Marvel's decision to distribute its own comics exclusively through its wholly owned distributor, Heroes World Distribution; the resultant reduction of major distributors of other publishers' comics to just two, and the formation of exclusive distribution deals between publishers and those distributors), the number of comics shops dropped from a high of some 7,000 to an estimated 4,500. The direct market narrowed even further in 1996 when Diamond bought out its main competitor, Capital City, and Heroes World collapsed. Diamond was left as the sole source of most new comics products to comics specialty shops—sparking an investigation by the U.S. Justice department for possible antitrust violations.

> **DIRECT DISSENT**
>
> Direct sales, argues Kurt Busiek, writer of some of the top comics of the 1990s (*Marvels, Astro City*), should have been a temporary solution, a tourniquet to stop the industry's massive hemorrhaging in the 1970s. "The direct market constituted a life raft," Busiek said. "But instead of paddling that life raft to a new ship, we said, 'Hey, this life raft is cool. Let's live on this life raft.'
>
> "And we ran out of food."
>
> The direct market, Busiek said, solved one dramatic problem that had been building since the late 1940s. While Superman was fighting the Axis powers during World War II, both his comic book and *Time* magazine sold for a dime. They each had a similar number of pages and generated the same amount of profit for the newsstand owner, which is why he accorded them equal space.
>
> Because publishers wanted to keep comic books a cheap form of entertainment, they chose to cut pages instead of raising the cover price. Ten cents bought you (more often than not) 64 pages of entertainment in 1943; by 1961, that dime was only worth 20 to 24 pages of story. If the "10¢" tag remained impressive until it changed to 12¢ in late 1961, the size of the package did not. And no one was less impressed than the newsstand owner. Because he or she no longer made the same profit on the copy of *Time* and the copy of *Detective Comics*, there was no reason to grant that comic equal time or space on the rack.
>
> "As an industry, we ghettoized ourselves by making the magazine less profitable, less able to compete with other magazines," Busiek said. As rack space dwindled, so did sales.
>
> Phil Seuling's solution did not provide readers with more value for their buck. His solution was to sell the comics directly to the fans. Call it a complicated subscription plan. The plan worked . . . to distraction. "We focused our energy more and more on this efficient way of selling comics," Busiek said, "ignoring the fact that it was an inefficient way of creating new readers."
>
> Why was it so inefficient? With comic books hidden away in direct sales outlets, the audience unfamiliar with the product is rarely exposed to it. There is no feeder market, only a specialty market. Ask yourself, Busiek said, how many albums Hootie and the Blowfish would sell at Tower Records if FM radio wasn't feeding the audience a daily dose of their music.
>
> "We need to reshape the industry to make that connection to the audience again," Busiek said. "We've spent so long retreating from the mass market. We need to get comics back into newsstands, bookstores, supermarkets. Publishers are only keeping the direct market alive because they don't know where else to go. There is no new generation of comic book readers. There is no new generation because we didn't go out and make one."

Dirks, Rudolph

Because of him, the comics told tales, not just jokes.
RICK MARSCHALL

Dirks, the German genius behind *The Katzenjammer Kids,* first set the cats to howling on December 12, 1897, at the behest of William Randolph Hearst. The newspaper tycoon wanted a strip that would remind him of Wilhelm Busch's work on the German cartoon *Max und Moritz.* In 1903 the *New York American and Journal* reprinted the first collection of the Katzenjammer Kids in booklet form.

Disney, Walt

He served in the same Army company with Ray Kroc (owner of MacDonald's) and, like

Kroc, survived to stuff the masses full of junk food.

Born in Chicago in 1901, Walt Disney spent most of his boyhood in Kansas City and on a Missouri farm. When he finally erected his magic kingdoms, he built them as far from his roots as possible.

His was the original voice of Mickey Mouse, a squeaky little rodent that might have been named "Mortimer" but for his wife's intrusion.

When *Esquire* celebrated 50 American originals on the magazine's 50th birthday, it noted the following about Uncle Walt:

> *Disney stood five feet ten inches tall and was a dapper dresser. He wore bold-colored jackets over gray or blue sweaters. He liked moccasins and hats—Tyroleans, fedoras, and Panamas.*
>
> *He drove a silver Thunderbird convertible, but was never known to put the top down, even in the hottest weather.*
>
> *He played polo at the Riviera Club with Spencer Tracy, Will Rogers, and Darryl F. Zanuck. However, he always preferred his family to the social life.*
>
> *His favorite meal was a bowl of chili, a glass of V-8, and soda crackers. He carried crackers and nuts in his pockets to snack on while working. The only type of cake he liked was banana cream. Later in life, as his weight climbed above 185 pounds, he began to diet…*
>
> *When he decided he needed a legal adviser, he hired Gunther Lessing, who had advised Pancho Villa. "If he could help Poncho Villa," Disney asserted, "he's just the man we need"…*
>
> *He was disappointed in 1960 when the Los Angeles police said they could not provide sufficient protection to allow Nikita Khrushchev to visit Disneyland. Disney wanted to say to the Soviet premier, "Here's my Disneyland submarine fleet; it's the eighth largest in the world."*

Disney cared about many things, but comic books was not one of them. Western produced and published the comics featuring the Disney characters or their kin. After Western gave up the ghost in 1984, Gladstone picked up the torch two years later. The comics sold; the trains ran on time. And then in 1990, 24 years after Uncle Walt's death, the Disney corporation revoked Gladstone's license and tried to publish the comics in house.

Within a year, the circulation for Disney's five titles plummeted to less than 80,000. For the sake of comparison, Gutenberghus (now Egmont), Disney's European licensee, was averaging over a million copies in Germany alone.

Disney sent the comic license back to Gladstone (and for a short time to Marvel on such titles as *Little Mermaid* and *Aladdin*) and went back to what they did best: animating for kids, etching fairy tales, and enticing the masses into their theme parks.

Even though his name was on all the comics, Walt had no involvement in them. The Disney comics line did illuminate such great talents as Carl Barks, Floyd Gottfredson (Mickey Mouse strips), and Walt Kelly, shown here in top form.
(© The Walt Disney Co.)

Ditko, Steve

Steve had a handicap. He couldn't junk his principles.
JOE GILL

My not being interested in the history of comics has an unstated corollary: I'm not interested in the history of Steve Ditko.

I have a routine. Early in December I get all the work that I had published that year and spend some time during the month reviewing, reflecting on the work. Near the end of the month I put the material in a package and on a shelf. I am free to start the new year without any baggage from last year.

I should have also done it with my life. I meet too many people who want me to go back to some package on the shelf—20–30-year-old files—and open it like I'd open an old comic book. The past is over, done.

When penciler Paul Smith was once asked to name the great Spider-Man artists, he set the record straight. "Ditko," he said. "He was the only great Spider-Man artist."

Many packages ago, the one and only reached up onto the shelf of his past and pulled down enough to write a letter to *The Comic Reader*.

"I was born in 1927 in Johnstown, Pennsylvania," Ditko wrote. "Through the years I became interested in doing comic art and went to New York to enter the comic book field. I enrolled in the Cartoonist and Illustrators School where my style was greatly influenced by my instructor—Jerry Robinson. During the next three years I regularly made the rounds of the comic publishers and just as regularly had been turned down.

"My first job was with a very small comic publisher. However, this job led to Headline Publications, where I worked on *Black Magic*. [Overstreet claims that Ditko's first published art appeared in *Black Magic* #27 (November/December 1953).]

"Later in 1953," Ditko continued, "I became a regular artist for Charlton Press, working on their line of fantasy books, including *The Thing* and *This Magazine Is Haunted*." Ditko then took an 18-month leave of absence, "returning in the last part of 1955 to work for Stan Lee at Marvel. During 1956 I drifted away from Marvel and back to Charlton Press." He worked for both companies, but primarily for Charlton, until late in 1962, when he took on Spider-Man.

"The Ditko *Spider-Man* was the finest superhero comic ever," Michael T. Gilbert once said. Stan Lee made the kind of decision from which legends are born when he shrugged off Jack Kirby's six-page stab at the feature and handed Spider-Man to Ditko.

At the time, Ditko was sharing a studio with Eric Stanton, an artist who got his start working for photographer Irving Klaw, the photographer who had so much fun putting Bettie Page into leopard suits and chains. When Ditko brought Spider-Man home for the first time, it didn't do much for Stanton—Ditko was into

Whatever else Steve Ditko has done in his career, he made a lasting mark as co-creator of Spider-Man.
(TM & © 1998 Marvel Characters, Inc. All rights reserved.)

cartoons, Stanton once said, "and I was into girls"—but he helped choreograph some of the fight scenes.

Kirby, of course, could have handled the fight scenes, but he couldn't have conceived of the little twerp that Ditko dropped on Lee's desk. In *Amazing Fantasy* #15 and the first 37 issues of *Amazing Spider-Man,* Lee and Ditko produced a classic comic book series. Lee knew very little about the increasingly private artist—"I don't know what he did, or where he lived, or who his friends were, or what he did with himself," he said 30 years later—but he knew enough to get out of Ditko's way. "He did most of the plots as we went down the road," Lee said. "He had more to do with the plots than I did after a while."

Ditko, Gilbert Hernandez figured, "was sort of the dark side of Kirby, the dark side of Marvel." And the dark side couldn't stand all that light after a while. Marvel knew the party was over, Flo Steinberg said later, when Ditko refused to go into the recording studio and sing along with Stan and the rest of the gang on the Merry Marvel Marching Society song.

"He was a joy to work with, as Jack had been," Lee said, "but little by little, he became more unfriendly. Instead of bringing his artwork in, he sent it in by messenger. I don't remember what happened. Then one day he said he wasn't going to do the strip anymore. He never told me why.

"I've had theories advanced by other guys in the office. Letterers who said he hated me putting in the sound effects. Sometimes I would add speed lines to his artwork and he hated that. He thought I was doing too much dialogue or too little dialogue. Maybe he felt … I really don't know. I just know that years later when I met him and said why don't you do Spider-Man again, he said, 'I don't ever want to do Spider-Man again, and I don't want to do Dr. Strange again.' He's never sat down and told me why."

Les Daniels's official handbook to Lee's Universe—*Marvel: Five Fabulous Decades of the World's Greatest Comics*—said the Green Goblin caused the final breakup: When it came time to show the villain's face, Lee wanted a familiar face, Ditko a nonentity. The latter resigned without drawing the story.

Because Dick Giordano, an assistant managing editor at DC, worked with Ditko at both Charlton and DC, he also witnessed the artist's change-of-life. "In his pre–Ayn Rand days, he was more interested in having fun and drawing comic books," Giordano said. "[At Charlton] we spent more time playing ping-pong together than talking about anything that resembled social issues.… He was a lot of fun. Laughed a lot. Joked a lot. I remember once in the weeks preceding Christmas, he came up with this horror story with Santa Claus in it. There was Santa Claus in his usual form but every one of the other characters was hideous. It was funny as hell. He would bring in one sequential color page every week and put it on the wall. It got to the point after the fifth or sixth week that people on Mondays would line up in the hall waiting for Steve to come in."

At the end of Ditko's *Amazing Spider-Man* run at Marvel, Giordano could tell he "was getting angrier and angrier. I couldn't figure out why. It wasn't directed at me; it wasn't directed at Charlton in any way.

"He became more and more difficult to deal with by the time we got to DC. At one point, Denny O'Neil had written a script and in the description of art, not in the copy, he had writ-

Ditko fans actively seek out his interior and cover work for Charlton's mystery/horror titles.
(© Charlton Comics)

Ditko rendered a number of memorable stories for Jim Warren's line of black-and-white horror magazines.
(© Warren Publications)

In brief stints at DC in the late 1960s and mid-1970s, Ditko created Hawk and Dove, The Creeper, and Shade, the Changing Man.
(© DC Comics, Inc.)

Ditko has produced numerous "personal" comics with philosophical/political themes.
(© Steve Ditko)

ten a fairly innocuous line saying this guy was a former criminal. Steve couldn't pass it up. He wrote a marginal note saying, 'There is no such thing as a former criminal. Once you're a crook, you're always a crook.' It was about that time that he decided he didn't want to do the Creeper anymore and he didn't want to do Hawk and Dove anymore because he didn't want to work with the writers, who were obviously too lenient on social issues for him."

In *Alter Ego* #10, Gil Kane said, "Ditko created [with Dr. Strange, his other Marvel claim to fame] a concept of mysticism and interdimensional travel which I have never seen before in comics. It was absolutely unbelievable... Good comics drawing has force, power, and emotion behind it; and that's what Ditko has, and that's what Eisner has, and that's what Kurtzman has, and that's what Severin has, and that's what Kirby has."

But unlike some of these other hall-of-famers, Ditko also had an affair of the head going with Rand, author of *Atlas Shrugged* and *The Virtue of Selfishness*, and the enemy of altruism. Peter Parker didn't fit into that universe by the mid-1960s; The Question (a character he created for Charlton) and Mr. A did. Why mess with a boy and his spider when you've dreamed up a character based on Ayn Rand's theory of justice, on Aristotle's law of identity, on Ditko's view of man and of art?

And so Ditko moved on, covering his tracks, discouraging photographs, interviews, or questions. A lot of people were left shaking their heads. "Ditko is irrational," Gil Kane would sigh: "Ditko had a fundamentalist's fixation about right and wrong. There is no gray." In recent years, the artist has written numerous essays on creation and art for Robin Snyder's *History of the Comics*, most of which are a little too close to Rand's John Galt for comfort. To wit, a single paragraph from a 13-page "commentary" on "Art—the Panel":

Some antonyms of art—lack of skill, ineptitude, incompetence, inability—could apply to the final result of many comic story/art panels/pages. It might be correct, honest, to call these original pages anti-art. Then the entire process, including the comic books, would have more coherence, unity and "integrity" with their anti-heroes, anti-rational heroes/characters, anti-justice themes, anti-life stories and anti–A-is-A premises. To be really consistent, the goal should be: the anti-hanging of the anti-art in an anti-museum.

Maybe Ditko's fans are still asking about the old packages on the shelf because the new ones seem so user-unfriendly.

Doc Savage

The Man of Bronze was conceived by Henry Ralston, pulp publisher Street & Smith's business manager, and John Nanovic, editor of *The Shadow*, but he was brought to life by pulp writer Lester Dent.

Savage—aided by Monk Mayfair, Ham Brooks, Johnny Littlejohn, Renny Renwick, and Long Tom Roberts—first appeared in the *Doc Savage* pulp on February 17, 1933. A year later, Doc Savage was a radio star; Jerry Siegel and Joe Shuster must have been listening, for the "Man of Steel"—like the Man of Bronze—was named Clark. In 1940 Doc gained his own comic book. Other comic book debuts were brought to you by Gold Key (1966), Marvel (1972), DC (1987), Millennium (1991), and Dark Horse (1994).

Doll Man

Eight inches high at the outset, Doll Man stretched out his career for 14 years. Created by Will Eisner for *Feature Comics* #27 (December 1939), Doll Man was truly brought to life by Lou Fine. After his final appearance in *Feature Comics* (#139), Doll Man survived another four years in his own book.

Donald Duck

Perfected—as so many other creatures were—by Carl Barks, Donald Duck was first *defined* by Clarence Nash.

In 1933 Nash was making a living as "Whistling Clarence, the Adohr Birdman," Adohr being a milk company that thought it could better push its products on kids by pro-

moting it with a guy who did animal imitations.

When Nash took his act to Disney, nothing impressed that group of adults until he broke into a rasping version of "Mary Had a Little Lamb."

"When I started to recite it," Nash recalled in Marcia Blitz's *Donald Duck*, "[director Wilfred] Jackson secretly switched on the intercom that went to Walt's office. Disney raced in, listened to me some more, and cried excitedly, 'Stop! Stop! That's our talking duck.'"

That duck first appeared in "The Wise Little Hen," one of Disney's *Silly Symphonies*. Jack Hannah, whose cartoons were nominated for 18 Oscars, deserves considerable credit for developing Donald into a more complex, popular character than Mickey Mouse. And Hannah was also on hand, contributing 32 pages of art, when Carl Barks took an old movie treatment—*Donald Duck Finds Pirate Gold*—and molded it into a 64-page yarn for *Four Color* #9 in 1942.

Donald Duck first appeared in the funny pages on September 16, 1934 as part of Disney's *Silly Symphony* series. He graced the cover of *Walt Disney's Comics & Stories* #1 (October 1940), one of only several of his early comic book appearances.

Fifty-five years later Donald and his nephews continue to grace comics published around the world, as well as original paintings by Barks that sell for $100,000 and up.

Donenfeld, Harry

When Major Malcolm Wheeler-Nicholson split with his comic book company, National Periodical Publications (later to become DC), in 1937, Harry Donenfeld caught it on the rebound.

The historians at DC would have you believe that Donenfeld first came up with the idea of wrapping a comic book around a single theme. If that's true, Donenfeld sublet it to The Comics Magazine Company, whose *Detective Picture Stories* beat DC's much delayed *Detective Comics* out of the gate by four months.

After Wheeler-Nicholson took his leave, Donenfeld asked Max Gaines if he had enough stuffings lying around to keep the first issue of *Action Comics* from being a turkey.

Nothing, Gaines said, but this piece of white meat from a couple of nerds in Cleveland . . .

For the most part, Donenfeld let his partner, Jack Liebowitz, handle the creative end of DC and ran the business operation until his death in 1965.

Doolin, Joe

Fiction House's most prominent cover artist, Joe Doolin was the old man in the shop, somewhere in his early 40s when World War II began and most of the staff went off to war.

"Joe Doolin sat across from Bob Lubbers, and they were about as contrasting a pair as you can possibly imagine," Rafael Astarita said. "Bob

For the comic books, Carl Barks made Donald Duck and nephews into adventurers.
(© The Walt Disney Co.)

> ### Divorce
>
> *Divorce is one of the leading reasons that collections come on the market. Wives go, "Hey, you told me the stuff is worth half a million dollars. Give me my $250,000." Simple as that.*
>
> RON PUSSELL, REDBEARD'S BOOK DEN

From 1944 to 1947 Joe Doolin produced nearly three dozen dazzling covers for *Fight*. This is #54 (February 1948).
(© Fiction House)

One of Gustav Doré's illustrations for Dante's *Inferno*.

Lubbers was tall and strong looking; he had the most mischievous eyes I've ever seen…

"Joe Doolin was like Bob Lubbers in that he was always nicely dressed. He wasn't tall; he may have been five-foot-eight. He was a weightlifter and extremely strong. I'd been lifting weights but I was no match for Joe Doolin. He had a bull neck and the sort of shoulders that wrestlers have. He was so extremely developed . . . Even when he wore a jacket, when he bent his arms to make the strokes on the cover, I could see his biceps swell, even inside the coat.

"When he stood up," Astarita said, "he gave such a suggestion of strength, it was almost superhuman. He looked more like an ox than a man. That was contradicted by his extraordinary sweetness and gentleness. He was an awfully nice man."

Besides his cover work, Doolin drew Red Comet, Mars, Gale Allen, Flint Baker, Auro, and Crash Barker for *Planet Comics*.

Doolin's Fiction House covers: *Fight* #30–34, 36–46, 48–62; *Jumbo* #66–94, 96–113, 115–118, 122, 123, 125, 127; *Jungle* #45–87, 89–97; *Rangers* #18–39; *Wings* #49, 73, 110, 111; *Planet* #26–32, 34, 36–38, 40–65

Doom Patrol

In 1963, when every super-hero team needed its leader confined to a wheelchair, Doom Patrol was the first out of the box, arriving in *My Greatest Adventure* #80 (June 1963) three months before the premiere issue of *The Uncanny X-Men*.

Elasti-Girl, Negative Man, Robotman, the Chief, and his wacky chair (you thought the Fantasti-Car had nifty gadgets) were Murray Boltinoff's attempt to squeeze a little more life out of a dying book. Arnold Drake wrote the first script—with an assist from Bob Haney—and the artwork was that of Bruno Premiani, a political cartoonist who was booted out of two countries, Italy and Argentina, before deciding the DC Universe was the land of his dreams.

The original Doom Patrol lasted 42 issues before they were blown to bits by Captain Zahl in *Doom Patrol* #121. Various pieces were reassembled in the late 1970s before Grant Morrison's scripts brought the book back to life a decade later.

Doré, Gustave

One of the world's most renowned illustrators and a significant influence on comics artists such as Bernie Wrightson, Doré was born in Strasbourg (then a part of Alsace between Germany and France) in 1832. He got an early start on his prolific career: On his first trip to Paris, at the age of 15, he was signed to a three-year contract by Auber and Philipon, a publishing house of caricatures and comic magazines.

Historian Daniel Malan argues that the ink was barely dry on that contract when Doré wrote and drew his first "comic book," *Les Travaux d'Hercule (The Labors of Hercules)*.

Doré had a superb memory, an exceptional eye, and an insatiable appetite for work. "In the 1850s, Doré had almost the monopoly on illustration in Paris," Millicent Rose wrote in her introduction to a 1970 edition of Doré's illustrated *Rime of the Ancient Mariner*. "At the beginning of his career he had worked largely

in lithograph, drawing upon the stone itself, but in the years of greatest fame nearly all his work was engraved on wood. He used to draw the designs directly upon the blocks, working on several at once and going from one to another with small rapid touches until all were finished."

After laboring on wood in the mornings, Doré retired to his paints in the afternoon, a medium in which he failed to receive similar acclaim. He aimed to illustrate most of the great literary classics in his lifetime, and tore through Rabelais, Balzac, Cervantes, Dante, Milton, and the Bible before succumbing to a stroke at the age of 51.

Doyle, Frank

One of the most prolific script writers in the history of the comics, Frank Doyle started his career as a penciler at Fiction House in 1941. When he graduated from the Pratt Institute, Doyle realized, "The best-paying job I could find was in comics. I never did get out."

After serving as an Air Force engine mechanic in Germany, Africa, and Italy during the war, Doyle returned to Fiction House in 1945. He was inking pages when the company eliminated its art department. When Doyle hit the streets as a freelancer, he discovered he was better at writing comics than at drawing them.

"It was easier. My mind worked better that way," Doyle said. The editors at Archie Publications agreed. They hired Doyle in 1951 and the last time we checked, he estimated he'd cranked out almost 11,000 Archie scripts, many of them written on the worn wood of Fran Hopper's desk, which he bought from Fiction House.

Drake, Stan

"My big problem in life has been women," Stan Drake was saying. "I've had three wives. The first one was gorgeous, she was a redhead. The second was a brunette, the third was a blonde. They were all gorgeous. My first wife, it didn't work out. The second one, I bought her everything, I loved her and adored her, she was an 8-handicap, she could go and shoot 75. I loved her and she left me. She just ran way with some dumb alcoholic."

"Son of a gun," John Prentice said from the other side of the barroom table, "I didn't know she was an 8."

Okay, so if he couldn't live with 'em, Stan Drake drew women so well that he convinced us we can't live without 'em.

When Bob Lubbers walked into George Bridgeman's life-drawing classroom at the Art Students League in 1938, he said he circled the room and sat down next to the guy who drew the best-looking women.

That, of course, was Stan Drake.

Drake was the son of Alan Drake, a radio actor ("He's an actor at heart," said Lubbers) and almost followed his father onto the stage. When he was 20 years old, his girlfriend—Elvi Daniels—entered the two of them in a competition for a Paramount Pictures screen test.

Kelly Green was the heroine of several European-style graphic albums written by Leonard Starr and lovingly drawn by Stan Drake.
(© Starr and Drake)

ST. PATRICK'S DAY

In the late 1940s, Stan Drake strained his prostate while digging post holes and putting fences around his house.

Worried about a discharge, Drake checked with his doctor, who gave him some dill pills to take care of the problem. But the good doctor warned Drake that his urine would run blue for the next week.

"Pure blue," Drake said. "For about a week I'm pissing blue."

When word of this phenomenon got around the office at Johnstone and Cushing, Dik Browne dropped by to see Drake with a small brainstorm.

"Look," Browne said, "St. Patrick's Day is coming up. You're taking a pill that is turning your urine blue. But if you don't take it one day, the color will be weakened. And since you normally piss yellow, and Wednesday is St. Patrick's Day . . . "

Say no more, Drake said. "So, on Tuesday, I didn't take a pill. And Wednesday morning I let a little squirt come out and, Jesus Christ, it was green. At noon, Dik had gone down the hall and invited everyone on the 14th floor of Johnstone and Cushing into the men's room. So, I took it out and peed this brilliant green piss on St. Patrick's Day.

"A cheer went up. They took me up on their shoulders and carried me out of the men's room, the hero of the urination coronation."

Elvi didn't make the final cut, but Drake did, winning a trip to Hollywood in late 1941. He made the screen-test with Claudette Colbert, and he came off so well that Mark Sandridge—who directed most of the musicals starring Fred Astaire and Ginger Rogers—told Drake he wanted him for a role in *Janie,* an *Andy Hardy* ripoff. Drake agreed and went to bed with stars in his eyes.

The next morning, the Japanese bombed Pearl Harbor. "Obviously, the whole thing was canceled," Drake said. "World War II fucked up my whole film career."

He got over it. He survived the war thanks to an appendicitis attack; he was laid up in a hospital bed when his unit, the 936th Engineers, was sent over to Italy and died on the beach at Anzio.

"When I got out of the Army," Drake said, "an art director said to me, 'If you're going to succeed in this business, you have to be able to draw pretty girls and handsome men. So, I used to buy these women's magazines and I would take them home at night. I bought this pad of vellum and I would trace these pretty girls. I traced 700 girls' faces until I found out what made them pretty. After a while, I didn't have to trace anymore."

After several years at ad agency Johnstone and Cushing, Drake and Elliot Caplin created the newspaper strip *The Heart of Juliet Jones* in 1953. In 1984 he joined Dean Young on *Blondie,* and in between he watched his world change.

"After World War II, newspapers didn't know what the hell to do," Drake said. "*Juliet Jones* sold like crazy, 600 papers in one year. It was soap opera and there were no television sitcoms. There was nothing. When television came in, it knocked all of the storytellers off the roof. The women who were waiting and looking for these stories didn't have to bother anymore. Suddenly there on television were these soap operas in living color, talking. They gave up the little newspaper thing.

"We are dinosaurs."

Drake was still drawing *Blondie* when he died in 1997.

The Drawing Book

An eight-page comic book produced by R. F. Outcault and published in 1906 (more than a quarter-century before the first *Famous Funnies*), *The Drawing Book* featured Buster Brown. It included tracing paper, which allowed the reader to practice the first swipes in comic history. Outcault earlier had created the Yellow Kid, which helped usher the comic strip into existence.

Dr. Fate

A Gardner Fox creation that first appeared in *More Fun* #55, the character was originally dubbed "Doctor Droon," but fate had the last word.

The character's alter-ego is Kent Nelson. While searching for the builder of the pyramids in 1920, Nelson stumbles on Nabu, who has been in suspended animation for the last million years. For the next two decades—Nelson is obviously a pretty slow learner—Nabu instructs him in the arts of magic, levitation, and altering the molecular structure of his body.

An original member of the Justice Society of America, Dr. Fate appeared in *More Fun* #55–#98 and *All Star Comics* #3–#12, #14–#21.

Dr. Hyde

This hero of the Hippocratic Oath, introduced in *Marvel Mystery* #24, had a curious surgical approach: He plucked the eyeballs from his sleeping victims (at least they were sleeping when the operation began), then offered to reinsert them for $100,000.

And you wondered why it's called the Golden Age of comics.

Dr. Sivana

Captain Marvel's nemesis first appeared in *Captain Marvel Adventures* #1 (March 1941). "[Bill] Parker created the name of the World's Maddest Scientist by combining the Indian words Siva and Nirvana," Jim Steranko wrote. "[C. C.] Beck pictured him as the spittin' image of his local Long Island druggist (whose real name was Horne), complete with horn-rimmed glasses, bald pate, and white pharmacist's jacket."

Dr. Strange

Ah, the Mindless Ones. "Primitive, savage, totally devoid of love, or kindness, or any type of intelligence!"

The Merry Marvel Marching Society?

Of course not: the denizens of the realm of dread Dormammu. And a few of the surreal

Dr. Sivana sprang many an evil plan on Billy Batson and Captain Marvel.
(© Fawcett Publications)

props in the world of Dr. Strange, master of the mystic arts.

Created by Stan Lee ("unchallenged master of the dramatic word!") and Steve Ditko ("unquestioned innovator of the occult illustration"), Dr. Strange first appeared in *Strange Tales* #110 (July 1963).

In his origin, first delivered in *Strange Tales* #115, Stephen Strange was an elitist, arrogant surgeon until a car accident damaged the nerves in his hands. When Strange traveled to India to seek healing from the Ancient One, he was persuaded to dedicate his life to battling evil through the mystic arts.

The mystic, psychedelic art of Steve Ditko was the ideal companion to Lee's spellbinding scripts, which introduced readers to the vapors of Valtorr, the hoary hosts of Hoggoth, and—last but, God knows, not least—the effigy of Tiboro, lord of the seething volcano, evil ruler from the dim, dead past.

The dim, dead past? That must have been DC in the 1950s.

Drucker, Mort

His training ground was the bullpen at National Periodicals in the early 1950s, where he worked on the war books and—apparently anticipating Vietnam—*The Adventures of Bob Hope*.

His break came in 1957 when Al Feldstein ushered him into an audience with William Gaines when *Mad*'s publisher was crackerjack deep into a Brooklyn Dodgers game. Gaines gave Drucker's work application a thoughtful, thorough look, then said, "If the Dodgers win, you're hired."

Drucker's good fortune was that he didn't arrive at 225 Lafayette during the early years of the New York Mets.

His gift is caricature, the ability to capture politicians and Hollywood personalities with such precision and wit that both *Mad*'s youngest readers and its oldest get the joke. The editors at Time-Life were so impressed that

Dormammu versus Eternity: just another "ordinary event" in the life of Dr. Strange, Master of the Mystic Arts, courtesy of Stan Lee and Steve Ditko.
(TM & © 1998 Marvel Characters, Inc. All rights reserved.)

Mort Drucker's dead-on caricatures have entertained *Mad* magazine readers for decades.
(© 1998 E.C. Publications, Inc.)

they elevated more than 15 of his caricatures to the cover of *Time*. After almost 40 years, Drucker is still wowing *Mad* readers with his movie and TV parodies.

Druillet, Philippe

Arguably more inspirational than productive, Druillet was born in Toulouse, France, and finished his first Lone Sloane story, *Le Mystere des Abimes*, in 1966. He arrived at *Pilote* magazine three years later, where—reportedly lavishing up to two weeks on each page—he delivered *Les Six Voyages de Lone Sloane* for serialization beginning in 1970.

Druillet may be as best known for some of his failures and misfires, *Salammbo* and a never-completed Elric project to name two. His drawing was at its most eloquent in *La Nuit*, serialized in 1975 and 1976, which was heavily influenced by the final days and death of his wife from cancer.

"For us professionals," said Rene Goscinny, the co-author of *Asterix*, "Druillet has exploded the comic strip, taking it out of the narrow confines of small boxes."

Druillet was one of the central figures in *Les Humanoides Associes*, which started and dominated the early issues of the legendary *Metal Hurlant*, the French graphic magazine that landed on American soil as *Heavy Metal*.

Dubois, Gaylord

One of the most prolific comic book writers, DuBois had a career spanning 40 years and approximately 3,700 stories. He began writing the Dell/Gold Key *Tarzan* series with issue #2 (March 1948) and spent two decades in the jungle; he also created Brothers of the Spear, a backup feature in the *Tarzan* books.

Born in 1899, DuBois gained his first comic work at the age of 38 when Lloyd Smith, an editor at Whitman, asked him to script several original western plots. He also wrote *Turok, Lost in Space, Space Family Robinson, Bonanza, Tom and Jerry*, and *Sergeant Preston of the Yukon*.

"There is a difference in the quality of Gaylord's and my writing," Paul Newman, perhaps the only writer to top DuBois's output, noted in a letter to the *Comic Buyer's Guide*. "His stories, especially those featuring animals, tended to be far more poetic and had a spiritual quality mine never attained."

DuBois died at his Florida home in 1993.

A typical Druillet "psychedelic" page.
(© Philippe Druillet)

Eastman, Kevin

Give him credit: He turned a garage workbench idea into an empire. Eastman's co-creation with Peter Laird, the Teenage Mutant Ninja Turtles, offered a funny name and the perfect handle for licensing agreements. The Turtles sparked the black-and-white explosion of the mid-1980s, sent Eastman's tax bills through the roof, and allowed him to fund Tundra, a wildly spending publishing company that put out esoteric products; it eventually merged with Kitchen Sink.

Many industry analysts are still waiting for Eastman's second-best idea.

EC Comics

All the older kids (the ones with brains) read EC's. So at nine or ten, I started reading them. By this time I could identify the different artists: Wood, Elder, Davis, Kurtzman, etc., and then came Mad!!! *I was SEDUCED! RAPED! I say more like KIDNAPPED, MOLESTED, and FOREVER PERVERTED! They poisoned a generation. I'M A LIVING TESTIMONY.*
ROBERT WILLIAMS
BLAB #1

They were all GI's, Joe Orlando said: "Even Bill Gaines. Hard to believe. He had a crew-cut when I first met him, and a hatred for authority. We all had a hate for supercilious authority."

Jack Kamen fought at Manila and Leyte Gulf; the Merchant Marine ferried Wally Wood to Guam, the Philippines, and Italy. "We were all in the Army, World War II. We were all of that age," Harvey Kurtzman said in *Squa Tront* #9. "And after the war, our condition was very similar: out of the Army, looking for jobs."

Out of the Army and ticked off. "It was hard to even get an interview right after the war," Orlando said. "We had a wonderful, resplendent, American time in the sun during the war, but getting it started right afterwards was very hard.

"There was very little housing, and the jobs, they were all taken. Wally Wood and I felt we'd been screwed. Every time we went for a job, some son of a bitch who hadn't been in the Army was there first. Our point of view was the jobs were all taken by the 4-Fs. We had an anger against the 4-Fs for staying home and taking our jobs and marrying our women.

"And that anger, in the end," Orlando said, "was what spawned EC Comics and *Mad*. We were all the same. We were all GI's. We were all angry. We'd all been screwed. Or we thought we had."

That anger—that passion and restlessness—and its sobering aftermath produced the best collection of comics the industry has ever seen. The quality of the writing and art was so much better than the competition's that the competition—in an act smacking of ritual suicide—banded together in 1954 to invoke the Comics Code Authority that in essence drove EC out of business.

At the heart of EC were Bill Gaines, who had inherited a stuffy comic book company called Educational Comics in 1947 when his father, Max, died in a boating accident; Al Feldstein, a good-girl artist at Fox who signed on when he wearied of bouncing off Victor Fox's bad checks; and Harvey Kurtzman, who would betray his genius in EC's war books—*Frontline Combat* and *Two-Fisted Tales*—and certify it with *Mad*.

When he first took control of his father's Manhattan-based company, Gaines was only marginally interested in the comics and was putting out only marginally interesting books. Inspiration finally caught up to him. "The long

Kevin Eastman

The mainstay EC books were the horror titles: *Haunt of Fear, Tales from the Crypt,* and *Vault of Horror*. Here's one of the most memorable covers by "Ghastly" Graham Ingels.
(© 1998 William M. Gaines, Agent, Inc.)

In addition to horror, EC staked out science fiction/fantasy, crime, and war as its prime genres.
(© 1998 William M. Gaines, Agent, Inc.)

The EC crew, as portrayed by Marie Severin.
(© 1998 William M. Gaines, Agent, Inc.)

and short of it was the teenage market was collapsing," Al Feldstein said. "One day I went to Bill and said, 'You know what the problem is? This whole industry feeds on itself. Instead of being imitators, we should be innovative. Let's do something so we can survive when the debacles come.'"

Such as? Feldstein was a big horror fan, having seen *Frankenstein* when he was only seven. "Why don't we put out horror comics?" he asked Gaines. "Scare the hell out of people.

Have some fun."

They did both. Once EC got rolling with the New Trend titles in 1950, Gaines would arrive each morning at 225 Lafayette Street with a handful of "springboards"—story ideas he'd culled from reading science fiction pulps, the daily tabloids, and Ray Bradbury. After the morning bull sessions and pasta at Patrissy's, Feldstein would sit down and crank out the story directly onto the illustration board. For five years, he came up with four stories a week.

Then Gaines would turn to his artists, handing off the fatal love-triangle tales to Jack Kamen, the ghoulish horror to Graham Ingels, the science fiction to Wally Wood and Al Williamson, the American tragedies to Jack Davis, the stories that required a month of Johnny Craig's time to Johnny Craig, and the stories that fell through the cracks to George Evans, John Severin, Reed Crandall, or Bernie Krigstein.

"They had tremendous admiration for one another," Gaines told *The Comics Journal* in 1983. "Wally Wood would come in with a story and three artists would crowd around him and *faint,* just poring over every brushstroke and every panel, and of course Wally, who's getting this adulation, just sits there and loves it. Next time around it's his turn to adulate someone—

Williamson comes in with his story and Wally Wood faints. And everybody tried to outdo each other, which is one of the reasons we got such incredibly good art. They were all in a friendly competition to see who could make everybody faint more than the other guy. And it was wonderful. Just a nice, warm place."

When EC wasn't giving people the creeps with *Tales from the Crypt* and *The Vault of Horror*, or showing them the effects of the bomb in *Weird Science* and *Weird Fantasy*, the company was stripping war to its bare bones in Kurtzman's books or preaching a postwar ethic in *Shock SuspenStories*.

"We came out of World War II, and we all had great hopes for the marvelous world of tomorrow," Gaines once told Bill Spicer. "And when we started writing our comics, I guess one of the things that was in the back of our minds was to do a little proselytizing in terms of social conscience."

The best *Shock SuspenStories*—head-on collisions with bigotry, anti-Semitism, racism, and rape—were designed to have an impact, but no EC book had quite the impact of *Mad*, particularly among a future generation of underground cartoonists.

"One rare autumn afternoon my young mind was inspired, expanded and unhinged

BRADBURY STORIES

Under the strain of allegedly spinning out one story each day, Bill Gaines and Al Feldstein did the only smart thing: They borrowed liberally from the Ray Bradbury library.

EC's first swipe of a Bradbury short story appeared in *Vault of Horror* #22. Bradbury apparently missed the transformation of his story, "The Emissary," into a tale called, "What the Dog Dragged In."

When Gaines and Feldstein returned for a second dip of Bradbury, however, a fan tipped the science fiction writer off. Fortunately, that fan wasn't a lawyer: Bradbury, then 31, simply wrote a letter to 225 Lafayette, inquiring about the whereabouts of his adaptation fee.

Gaines quickly called Bradbury back. "I was there when Ray Bradbury was on the phone," George Evans said. "For Bill, it was like he'd gotten a Christmas present. He was delighted that Bradbury had gotten in touch. He said, 'Yeah, it's your work, we were hoping you'd get in touch with us.'"

That was the start of a beautiful friendship and quite a few adaptation fees. Following are the Bradbury stories adapted by EC, listed in chronological order, with the artists:

"What the Dog Dragged In" (from Bradbury's "The Emissary"), *Vault of Horror* #22 (December 1951–January 1952), Jack Kamen
"Home to Stay!" (from "The Rocket Man" and "Kaleidoscope"), *Weird Fantasy* #13 (May–June 1952), Wally Wood
"The Coffin!" *Haunt of Fear* #16 (November–December 1952), Jack Davis
"There Will Come Soft Rains," *Weird Fantasy* #17 (January–February 1953), Wood
"The Long Years," *Weird Science* #17 (January–February 1953), Joe Orlando
"Let's Play Poison!" *Vault of Horror* #29 (February–March 1953), Davis
"The Screaming Woman!" *Crime SuspenStories* #15 (February–March 1953), Kamen
"The Small Assassin!" *Shock SuspenStories* #7 (February–March 1953), George Evans
"There Was an Old Woman," *Tales From the Crypt* #34 (February–March 1953), Graham Ingels
"Mars Is Heaven!" *Weird Science* #18 (March–April 1953), Wood
"Zero Hour" *Weird Fantasy* #18 (March–April 1953), Kamen
"The Black Ferris," *Haunt of Fear* #18 (March–April 1953), Davis
"King of the Grey Spaces!" (from *R Is for Rocket*), *Weird Fantasy* #19 (May–June 1953), John Severin and Will Elder
"The One Who Waits," *Weird Science* #19 (May–June 1953), Al Williamson
"The Lake," *Vault of Horror* #31 (June–July 1953), Orlando
"Touch and Go," *Crime SuspenStories* #17 (June–July 1953), Johnny Craig
"The October Game," *Shock SuspenStories* #9 (June–July 1953), Kamen
"The Handler," *Tales from the Crypt* #36 (June–July 1953), Ingels
"I, Rocket," *Weird Fantasy* #20 (July–August 1953), Williamson and Frank Frazetta
"Surprise Package" (from "Changeling"), *Weird Science* #20 (July–August 1953), Kamen
"The Million Year Picnic," *Weird Fantasy* #21 (September–October 1953), Severin and Elder
"Punishment Without Crime," *Weird Science* #21 (September–October 1953), Kamen
"The Silent Towns," *Weird Fantasy* #22 (November–December 1953), Reed Crandall
"Outcast of the Stars," *Weird Science* #22 (November–December 1953), Orlando
"The Flying Machine," *Weird Science-Fantasy* #23 (March 1954), Bernie Krigstein
"A Sound of Thunder," *Weird Science-Fantasy* #25 (September 1954), Williamson and Angelo Torres

> **"I'll Take Your Word for It"**
>
> This was Harvey Kurtzman's classic comeback to EC fanaticism.
>
> The obsession of the EC fan-addicts is legendary; it's on display in the various EC fanzines, as well as in the liner notes of Russ Cochran's EC Library. As Al Feldstein once said, "I'm absolutely amazed at the analysis that you guys do for the notes for the EC Library . . . Primarily, while reflecting our personal feelings and maybe reflecting a lot of our unconscious feelings, these stories that Bill [Gaines] and I wrote were commercial ventures to produce a magazine that would entertain people and sell."
>
> The *Haunt of Fear*, in other words, was never intended for Bill Moyers or Northrop Frye.
>
> In an interview for Cochran's *Mad* set, John Benson "reminded" Kurtzman of the hefty Mickey Spillane influence on his work, betrayed notably by a line in "Miltie of the Mounties"—"It was easy" — lifted from Spillane's *I, the Jury*.
>
> Kurtzman didn't miss a beat: "I'll take your word for it."

forever when I saw 'Superduperman' by Wally Wood exploding from the lead story of *Mad* #4," S. Clay Wilson said in *Blab*'s 1986 tribute to EC. "To this day I've yet to meet any artist, writer, etc., of my generation, who wasn't permanently influenced by EC Comics."

"The reason I loved" those first issues of *Mad*, Foolbert Sturgeon said in the *Blab* tribute, "was that I knew that they were done for me. Kurtzman and crew were reading, hearing, and seeing what I was reading, hearing, and seeing, and they were satirizing *everything*— and it really did seem like everything—with merciless exuberance. They seemed to know and not care that adults would hate it. Kurtzman, Elder, Severin, Wood, and Davis were hardly more than kids themselves when they started doing *Mad*. It seemed, reading *Mad*, that we were all discovering fraud and schmaltz and schlock in popular culture and laughing at it, not in anger that we had been lied to, but with relief that we saw through it now."

Of all the EC's, only *Mad*—converted to a magazine with its 24th issue—survived more than a year after the other comics publishers rang in the Code. And once the rest of the EC's were gone, obliterated by another display of supercilious authority, most readers saw through the schmaltz and schlock that sat unread on the comics rack for years to follow.

EC Comics Collection

When Jim Stewart sought safety for his EC collection in 1956, he couldn't afford to make a mistake. One slip, and his ECs would disappear like all his friends' comics had. "People were burning ECs back then," Stewart said, and his mother had a box of matches in her apron. "She would have loved to burn mine."

The only safe haven, Stewart decided, was a wooden chest, a family heirloom that had traveled the Oregon Trail strapped to the side of a covered wagon and now rested at the foot of his bed in his northeast Portland home.

"I knew there was only one way to protect the comics," Stewart said. "I put them in the chest my mother loved, and took the key."

In the winter of 1956, Stewart wrapped his EC comics in storm-window plastic, lay them carefully in the bottom of the chest, and forgot about them for a good 20 years. By then he was 38, a parole officer for the state of Oregon, and married to a woman who had one demand for their move across town: "The one thing I'm not going to move to the new house," Janet Stewart said, "are those filthy comic books."

All right, Stewart thought. In the old days, you could get a nickel apiece for used comics, he remembered, so he picked up the Portland Yellow Pages and called the first store—Apache Books—that advertised for old comic books.

"You buy comics?" Stewart asked.

"Sometimes," Apache answered, "but we're pretty stocked. What kind do you have?"

"I've got EC comics," Stewart said.

"Did you say DC comics? Like *Superman*?"

"No, EC comics," Stewart said. "It's a company that went out of business in the Fifties."

"I know who they are," Apache said. "How many ya got?"

Five or six hundred, Stewart said. "It was just a guess," he says now. "It might have been low."

Suddenly, he couldn't hear breathing at the other end of the line. "Are you still there?" Stewart asked.

"Yeah," Apache sighed. "What condition are they in?"

The majority had never been opened, Stewart said. "And then it got quiet again."

"Are you still there?" he asked again.

"Yeah, I'm here," Apache said.

"Well, do you want to buy the comics or don't you?" Stewart asked. He admits now he was ready to let the comics go for a solid 40 bucks.

"Yeah, I'll give you a thousand dollars," Apache said.

"What?" Stewart stammered.

"Two thousand," Apache snapped.

"What?"

"Four thousand," Apache panicked.

"At that point," Stewart says now, "I hung up the phone. I knew something was wrong. He had some information I didn't have."

A more subtle phone call to Hazel Harold at Ol' Weird Harold's, and Stewart got the info he needed. He was told his ECs were worth somewhere between $30,000 and $40,000. Over the next three years, he traded some of his rattier doubles for the comics he needed trying to complete the set.

Stewart's story might have ended there, with him holding onto one of the finest EC collections short of William Gaines's file copies, but for the medical horrors awaiting his wife. The friction between an artery and a vein behind Jan's temple had caused the tissue separating them to wear thin. Because the tissue damage was near the auditory bones of her inner ear, Jan could hear her heart beating at times.

Doctors told Stewart that only delicate surgery could resolve the problem. The true specialist in the field, a Pittsburgh physician, had perfected a novel, and relatively safe, surgical technique, but the Stewarts and their insurance couldn't afford his fee.

Stewart turned once again to the wooden chest, and those filthy comic books came through. In the next several weeks, he sold off the bulk of the ECs, personally delivering two briefcases to a San Antonio buyer and returning on the plane with the cash tucked into his socks. When the cupboard was bare, the Stewarts not only had enough cash for Jan's operation, but enough loose change to fund a tour of the Caribbean where she could convalesce.

Somewhere on the beach in Nassau or St. Thomas, Jan Stewart admitted she'd changed her mind about those wretched ECs.

Eclipse Comics

Established in April 1978 by Dean Mullaney with brother Jan's $2,000, Eclipse published the first graphic novel—Don McGregor and Paul Gulacy's *Sabre*—four months later. Editor cat yronwode (she was born with the surname "Manfredi") joined the staff in 1982 and married Dean in 1987. The couple parted in 1993, and the company did not survive the divorce.

In its infancy, Eclipse allowed creators to retain the rights to their work; its determination to publish creator-owned material made it a precursor to Pacific, Comico, and Dark Horse. When Eclipse reprinted various horror comics from the 1950s, it paid the artists and writers reprint fees even though the copyrights were not in their names.

That doesn't mean the editors at Eclipse took it particularly well when one of those creators carted his work to another publisher. When Dave Stevens and *The Rocketeer* left Eclipse for Comico, yronwode called Comico editor Diana Schutz at home and announced, "You sleep with pigs."

In 1981 Eclipse published *Destroyer Duck* to help finance Steve Gerber's turbulent lawsuit against Marvel. Unlike Pacific, the company survived the glut of 1983, picking up Pacific's cast-offs, including *Groo*.

When Eclipse put out its 1,000th issue in 1992, Dean Mullaney announced that the company had published more titles than any other company formed since World War II. More than Fiction House. More than EC or St. John or Avon or Fox or Prize.

They don't make 'em like they used to.

Notable Eclipse titles include *Zot!, Ms. Tree, Mr. Monster, Miracleman,* and Clive Barker's *Tapping the Vein* and *Son of Celluloid*.

The remaining Eclipse assets were purchased at auction in 1995 by a surprise bidder: Todd McFarlane.

Eerie

Jim Warren was set to publish the inaugural issue of *Eerie* in 1965 when he learned that a competitor—who used the same distributor—was preparing a horror magazine with the same title on the marquee.

Scott McCloud's *Zot!* was one of Eclipse's longest running and most acclaimed titles.
(© Scott McCloud)

The first "official" *Eighty-Page Giant* from DC was the 1964 Superman Annual.
(© DC Comics, Inc.)

"Since Warren's rival was going to be reprinting old horror comics material from the 1950s, there seemed little chance of beating them into print," Archie Goodwin, a Warren editor, told Steve Bissette. "All of our stories for the first issue of Warren's *Eerie* were still with the artists, and none of them were near completion. The distributor was after Warren to give in, as the other publisher had a much larger line of magazines and was therefore considered a more valuable customer."

In a move reminiscent of the Golden Age, when publishers hustled out ashcans to secure the copyright on specific titles, Warren called in Goodwin and a letterer, Gaspar Saladino.

"Utilizing some inventory material from *Creepy* [Warren's flagship title] as well as some material already printed, the three of us cobbled together a pamphlet-sized little magazine emblazoned with the *Eerie* logo already designed for us by our regular letterer, Ben Oda," Goodwin said. "Warren had simple line repro printing done on it overnight. By the next morning, there were about 200 copies of *Eerie* #1 in existence."

On his way to a meeting with his competitor, Warren, said Goodwin, "tipped the newsstand operator outside his distributor's building so that several copies of our freshly printed 'magazine' would be displayed. Entering the meeting, Warren handed a shocked distributor and competitor copies of *Eerie* #1 and announced that it was on sale downstairs. Confirming this, the pair capitulated."

That first issue was a 5½" x 7¼" 24-page black-and-white magazine with a Jack Davis cover. Warren obviously tossed out a few copies to fool his distributor, but the rest of the 200 copies were stacked in the office and handed out in slapdash fashion. None were sold. Someone, however, made money off *Eerie* #1: a counterfeit version with "uneven, untrimmed edges" and blue-striped staples soon appeared, earning an odd "second printing" designation from the *Overstreet Comic Book Price Guide*.

Warren returned with the second issue of *Eerie*'s 139-issue run in March 1966. The early magazines featured art by many of the players from the EC lineup: Frank Frazetta, Jack Davis, Al Williamson, Joe Orlando, Angelo Torres, and—using the pen name "Jay Taycee"—Johnny Craig.

Eerie Tales

This one-shot 1959 magazine featured black-and-white art by Al Williamson, Bob Powell, and Angelo Torres. It was published by Hastings Associates.

Eighty-Page Giants

These books were kid heaven for DC fans in the Sixties. They were the comic books you wore out in a week-long rampage. Although the *Overstreet Comic Book Price Guide* suggests the first *Giant* appeared in August 1964, the pattern was set with the 1960 appearance of the first Superman Annual.

Eisner, Will

How I grew up influences how I draw. I see light coming from above or below, because when you live in New York City the light comes from above or below.

Wherever Will Eisner takes his place in the pantheon of comics, the light comes from above.

"Nobody can top Will Eisner when it comes to art, story, graphics, and characters (what else is there?)," Flo Steinberg once observed in the rollicking hyperbole of a letters column, but she had a point. No one can.

"Comics before that [*The Spirit*] were pretty much pictures in sequence, and I was trying to create an art form," Eisner told Jim Steranko. "It was almost a continuing laboratory, and I was very lucky, because there wasn't anybody who could stop me from doing what I wanted."

What did he do? Eisner wasted no opportunity to test his creativity and his passion for comics. ("I was writing my heart out, literally, because it was my medium," Eisner once said.) Whether he was experimenting with lighting effects, point of view, or, more simply, different means to blend *The Spirit* logo into his gritty landscapes, Eisner had a wild eye and no lack of guts.

Born in Manhattan in 1917, Eisner studied under George Bridgeman at the Art Students' League before his first strip was published (when he was 19) in *Wow, What a Magazine*. His first cartoon sale, Eisner said in *Panels* #1, was to "Grease Solvent, which was a gritty soap compound for printers and people who work with oils and grease. I got it through the printer; it was his account."

The following year Eisner invested $35 and formed a partnership with Jerry Iger.

Their shop "was run pretty much the way a Roman galley operates," Eisner once said. "I sat at the end of a long row of sweating artists." From that seat, Eisner would get an idea rolling, then pass it down to oarsmen who specialized in backgrounds or balloons or letters.

The Iger-Eisner shop produced a variety of features, including "Sheena" and "Hawks of the Seas," and made Eisner a bundle, but he found a much more profitable partner when Busy Arnold came looking for new blood for the art staff at Quality Comics.

Iger told Eisner he was nuts to take a chance with Arnold, who was plotting a move into syndication. "We're making a lot of money; it would be ridiculous," he said. "Besides, the syndication business is a very risky thing."

But Eisner was young and foolish. The two men shook hands. Iger got the sweatshop; Arnold got Lou Fine, Bob Powell, Nick Viscardi, and a young kid named Joe Kubert, who cleaned the trash off the floor of Eisner's new studio at Tudor City.

And Will Eisner fans got *The Spirit*.

When Arnold sold several newspaper editors on a comic book supplement syndicated in their Sunday papers, Eisner delivered *The Spirit*.

"When I started, Harry Donenfeld and [Jack] Liebowitz, who were then running DC Comics, regarded the readership of comics as ten-year-old cretins from Kansas City," Eisner said.

He wrote for a different audience—an audience that was taken with his dogged victims of inexorable fate, the lowlifes and outcasts who were cut down by bullets appearing from nowhere and who collapsed with no one near (save Eisner) to record their dying words. An audience that could appreciate what Steranko called "the sexiest females ever to slink across a comic page . . . Other artists have drawn them more voluptuously but never with more character."

Eisner wrote for a flock of stunned readers that could handle his dizzying experiments with point of view without succumbing to vertigo.

"Eisner was interested in comics," Jules Feiffer told *The Comics Journal*. "And if you're in comics, somebody has to hit somebody else, somebody has to drive a car over a cliff, somebody

Will Eisner

Eisner gave a fictionalized account of the beginning of the Eisner-Iger studio in his graphic novel, *The Dreamer*.
(© Will Eisner)

After more than 50 years of writing and drawing graphic narratives, Eisner continues to be best known for *The Spirit*, the innovative weekly strip he created as a comic book insert for newspapers.
(© Will Eisner)

has to blow up an airplane, somebody has to be a good guy, and somebody has to be a bad guy.

"But more than anyone else in that form, up to that time, and past that time, Eisner was able to squeeze more human interest and more dimension and take heroes and use them—as he used the Spirit—as side characters to tell another story. Sometimes that story was too sentimental, sometimes the story was too trite, but often enough it was full of wit and cautionary values and fascinating visual perception… Whatever you think of Eisner, the world was redefined by his eye, his camera eye. That contribution was so original and so innovative … You cannot tell me that this is less than the contribution that Jack Kirby has made, or less than the contribution that Frank Miller is making."

We wouldn't even try.

And Eisner helped to set up Kirby and Miller for their future fights over creator rights by holding tight to the copyright for *The Spirit*.

As Eisner explained on a segment of the Canadian TV series *Prisoners of Gravity*, "I knew that owning my own property gave me the creative sovereignty that I needed. I was in a world at a time where when you gave up your child for adoption, you lost that child forever. I took on *The Spirit* not because it promised to make me a very wealthy man, but because it promised me creative and intellectual freedom."

And with that freedom came a getaway driver named "Motors," a gangster named "Bullets Rodd," and women the likes of Powder Pouf, P'Gell, Silken Floss, Silk Satin, Thorne Strand, Autumn Mews, Ellen Dolan, Castanet, and Sand Saref.

Among the talent at Tudor City, Bob Fujitani said, "We thought a lot more of Lou [Fine], purely on his artwork. Will Eisner was the complete cartoonist. He used to dream these stories up. When I worked there, he would be pacing the floor, trying to think up an idea for a story. He'd get some germ of an idea and start working. He'd work like a madman, not eating any lunch except for a box of cookies."

To use the studio bathroom, Fujitani said, the artists had to march through Eisner's office. "You'd go in the door about 12 feet and on the right was the bathroom. He wouldn't even look at you. I always thought he was a genius."

When some attempts at self-publishing failed, Eisner went to work for the Department

> **MOVIE IMPACT**
> Paying tribute to Will Eisner, director William Friedkin observed, "Look at the dramatic use of montage, of light and sound. See the dynamic framing that Eisner employs and the deep vibrant colors. Many film directors have been influenced by The Spirit, myself included."
>
> Displaying an Eisner cover of a man being chased by an elevated train, Friedkin noted, "This is where I got ideas for the chase in *The French Connection*."

of Defense in 1950, lending his gifts to *P.S. Magazine*, a journal of preventive maintenance. That stint lasted 25 years. When Eisner came back to comics, he said, "I came back largely to scotch the rumors of my death."

Dead? Not hardly. Bigger than life, as his 1990s award-winning graphic novels have proven.

Elder, Will

> *Willie had a way of putting people at ease—so they wanted to commit suicide rather than be tortured to death.*
> ARNOLD ROTH

> *You get pleasure from the clown at his expense. And Will was always aware of that.*
> HARVEY KURTZMAN

"I was the Manson of the zanies. The Charles Manson of the nuts," Will Elder said in a 1976 interview. "I was a frenetic humorist."

And he was a man who understood, from the very beginning, that there was something about his humor that always left a little too much blood on the drapes.

"He was a crazy, maniac kid," his close friend Harvey Kurtzman once said. "He told me this particular story, which is very distasteful but very funny, where he ran with a gang of kids in the railyard in the Bronx, and they found an unsealed refrigerator car filled with joints of meat. So, they borrowed some children's clothes from a local clothesline, and they dressed the meat and spread the joints along the right of way, and then stood on the overpass, yelling, 'Oh, Shloimie, what happened? Shloimie fell on the tracks!' And the police came and gingerly gathered up everything in baskets. They eventually came after Willie."

Everyone has Will Elder stories. "The nuttiest guy that ever walked in the doors here," said Bill Gaines, his editor at EC. "He actually sent his wife a heart out of a slaughterhouse for Valentine's Day."

"Will used to have this painting of a deer... I guess it was one of those Five-and-Dime store things," Marie Severin said. "It had a deer, a mountain, some trees, a path, flowers and the like... and he'd change it for the seasons! If it was winter, he would paint snow on the deer, and then he would paint over that and put the sun out for the springtime with flowers coming up."

Harvey?

"[In high school] we used to have a study hall in the auditorium balcony, and when the students would file into the balcony, they'd fill in what was called a 'Delaney Card' and leave it with the teacher, and then he'd take attendance at the end of the period," Kurtzman said. "Well, Willie would come in and fill out a Delaney Card, and then he'd secretly drop over the edge of the balcony some 10 feet to the auditorium below, go around, get another Delaney Card, and another Delaney Card... Later, the teacher would take attendance and he'd have these phony Delaney Cards. So, he'd call out 'Losophy? Is Phil Losophy here? Or Tom Mato?'"

Elder readily admitted, in that 1976 interview, that his looniness in high school was designed to cover up his other inadequacies. "I wasn't a topnotch student, average, or even below average, because I really didn't care," Elder said. "My interest didn't lie there. I wasn't getting anywhere through my grades, wasn't becoming popular as a bright student. But I noticed people looking at me. I could see myself becoming popular as a nut. The dividends were greater. Not only did I better my humor by actually experiencing it and doing things, and getting the feeling of freedom of expression, but I gained friends."

What Elder needed was someone to challenge and channel his humor. Who he needed was Harvey Kurtzman. "[My humor] was uncontrolled, in a great sense. I need[ed] Harvey's control. He harnessed whatever energies I had into the proper channeling... I felt

A Contract with God **was the first of the many award-winning graphic novels Eisner has produced since the late 1980s.**
(© Will Eisner)

Marie Severin drew this caricature of Will Elder for the 1953 EC Christmas party.

"He was a man who understood, from the very beginning, that there was something about his humor that always left a little too much blood on the drapes."

Will Elder packed visual laughs into every panel he drew for *Mad*.
(© 1998 E.C. Publications, Inc.)

that all my wild energies had to be harnessed into saying something important, something where it needed to be said."

Following the war, Elder—who was 23 when the bomb fell at Hiroshima—joined with Kurtzman and Charlie Stern to form the Charles William Harvey Studio. Another ex-GI, John Severin, joined them in 1948 and—after Stern departed for Europe—the trio enlisted at EC, where they did their best work on the war books.

From there, it was on to *Mad:* "When I was writing the *Mad* stories that Will illustrated, there was magic between us, and he would be inspired to go far beyond what I wrote for him," Kurtzman wrote in *From Aargh! to Zap!* "Wally Wood, as talented as he was, never did much more than take my ideas and turn them into magnificent drawings with lots of cuteness. Will would take my ideas and add 20 more subgags in the background. And they would be *funny* subgags; he would carry my stuff forward and enrich it by a multiple of ten."

Kurtzman and Elder would move on, away from the comics, to the lucrative *Little Annie Fanny* for *Playboy*, with Elder pumping watercolors onto Kurtzman's storyboards. Also on hand was Bill Stout, who noted, "I had heard all the stories about Willie. He was always the wackiest of the EC guys . . . and there was a sense of pride in the wackiness of those times. But when I was working with him, he was a very mellow, philosophical guy. He didn't hesitate to tell me the stories of the old days, but by that time he really gave a lot of thought to the stuff he was doing."

The stories from the old days still follow him around. Stout tells that "classic story" from Elder's Army days when he hid a water bottle filled with beef stew under his shirt and staggered like a drunk into a bar. Or the time he put a cardboard silhouette of a man with a knife chasing a woman on a slow-moving turntable so the shadow would be thrown up on the curtains of his home.

Joe Orlando? "He [Elder] was mad once at his buddy, John Severin," Orlando said. "Severin was a big-time gun collector and they were always buying rifles. Severin bought a new rifle and brought it to the studio, and that evening when he left . . . Elder knew Severin was going to go home over the George Washington Bridge, so he called the Bridge Authority to tell them he was from some mental institution, and they had an escaped patient carrying a rifle and he was expected to go over the George Washington Bridge at such and such a time. I don't know if it's a true story or not, but it's a great story."

They were all great stories, and they lose a little bit of their nastiness—their Manson zaniness—each time they're told.

"You know," Elder once said, "when Harvey goes around telling people about my practical jokes, people think it's wildly funny. But while it was happening I got a lot of nasty looks. People were really injured by it. And I never found anything amusing in it after it was done. I got booted on the ear every time I did something like that. But when the story's related to strange ears, to people who are safe from the scene of the accident, time, and distance, the thing's *hilarious*."

Elektra

She was Daredevil's Sand Saref and one of Frank Miller's most engaging characters.

"I was immersed in the work-for-hire mentality. I had no idea what intellectual property meant. So I ripped off my favorite cartoonist [Will Eisner]," Miller said. "Stole wholesale a plot from him from a story in *The Spirit* called "Sand Saref," which featured the Spirit's old girlfriend, who came back as a bad guy. He had to hunt her down and bring her in; it ended on the docks. Just exactly what I did. It was larceny. But he can't sue me because I don't own it. That's how stupid times were"

Elektra first appeared in *Daredevil* #168 (March 1980) and died 13 months later. Her spirit has energized several limited series and graphic novels since, most notably *Elektra: Assassin* (1986), written by Miller with art by Bill Sienkiewicz, and *Elektra Lives Again* (1990), written and drawn by Miller.

Although Marvel promised Miller it would never resurrect Elektra in his absence, she returned to *Daredevil* in 1994. Miller was furious but couldn't sue. He didn't own her.

Elias, Lee

English born but New York bred, Lee Elias teed off at Fiction House in 1943, drawing Captain Wings and Firehair, and kept his pencils moving for almost 40 years.

Elias handled *Black Cat* for Harvey for years and the Flash for DC, ghosted *L'il Abner,* and teamed with Jack Williamson on *Beyond Mars* in the *New York Daily News*. He eventually landed at the Kubert school. "The students called him, 'The Midnight Philosopher,'" Joe Kubert said. "He used to stay overnight in the old building, which is now a dorm. Invariably, around twelve or one in the morning, he'd be scavenging through this old building. If he came across a student, they'd sit and philosophize about life and art. He was a tremendously underrated artist and a terrific violinist."

Ellison, Harlan

The newsstand in Painesville, Ohio, was at the far end of Main Street in 1940, just before you hit the park. Next to the Utopia Theater was a cigar store, and out in front of the cigar store was a huge wooden rack that held 200, maybe even 300 comic books.

"For those of us who read them first-hand, they were absolutely a necessity," Harlan Ellison said. "They were the end-all and be-all. We would rush to the newsstand on a Wednesday or Thursday when the comics would come in with all the other magazines in big wired bundles. And we would stand around like carrion birds waiting to rip a piece of meat off a dead antelope, waiting for the newsstand owner to come out with the wire snips and snip open the steel bands. Then he would check off how many of each title he had against his list, and he would put them on the rack.

"We wouldn't even wait for them to reach the rack. If it was the day that *Captain Marvel Adventures* came out, we were all over him like ants on a honey pot. We would grab those comics right out of his hand. And we're not talking here about a large city. We're talking Painesville, Ohio, a little town 30 miles northeast of Cleveland. And yet Joe Tobul and Leon Miller and me, and many other kids, would go downtown on our bikes and sit there and wait. We placed enormous significance on comic books. We talked about them. We exchanged them. We sat and read them together. We talked about them as if we were a literary society, getting together to discuss the latest Jane Austen.

"It wasn't a ritual or a rite, it was a common day-to-day occurrence," Ellison said. "There was a commonality of appreciation of what the comics were about and what they were doing. We saw them less in terms of violence than we did in terms of magic lessons. A modern *Arabian Nights*. Stories being spun for our pleasure."

The Frank Miller version of Elektra, from the cover of *Elektra Lives Again*.
(TM & © 1998 Marvel Characters, Inc. All rights reserved.)

"We placed enormous significance on comic books. We talked about them. We exchanged them. We sat and read them together. We talked about them as if we were a literary society, getting together to discuss the latest Jane Austen."
HARLAN ELLISON

Harlan Ellison

"'Harlan lives for conflict,' Dark Horse editor Diana Schutz said, and he takes no prisoners."

In the years since leaving Painesville—leaving, we might add, with all the comic books he bought as a kid—Ellison has spun quite a few stories of his own. He has also had several adventures that would have given Captain Marvel pause. He ran away from home at the age of 13 and joined a carnival. ("I couldn't find a circus," Ellison said.) Picked up by Pinkerton detectives in a Kansas City jail and dragged home, Ellison soon skipped town again, working for a Canadian lumber company, hitchhiking across country, riding the rails. He worked tuna boats off the coast of Galveston, drove a dynamite truck in North Carolina and—to conjure up enough material for his first novel in 1955—joined a Brooklyn street gang.

He had already sold Bill Gaines an EC story by then, but he was soon stuck in the Army and getting wrapped up in science fiction. "It was the standard story of why someone leaves comics," Ellison said: "I became an adult. I put aside the things of childhood until I became enough of an adult to understand that those things of childhood are some of the most important things to preserve."

Ellison has written stunning fiction ("I Have No Mouth and I Must Scream"), seminal criticism on television ("The Glass Teat"), television screenplays, short stories, essays, and introductions to comic book adaptations of his work (*Dream Corridor*). "He lives for conflict," Dark Horse editor Diana Schutz said, and he takes no prisoners. Even after surviving quadruple bypass surgery in 1995, Ellison can still play the carrion bird when the mood suits him . . . or when some antelope has ticked him off.

When he wearied of running, Ellison and his comics ended up in a marvelous house in Sherman Oaks, Calif., that is known as "Ellison Wonderland." Said Schutz, "It's a 5-year-old's dream house built with a successful 60-year-old's money." The house contains Ellison's collection of 285,000 books; it also contains his *Jingle Jangle Comics* and his Quality comics and his *Captain Marvel Adventures*.

"Very early in life," Ellison said in a 1994 interview, "I learned from comics the difference between good and evil, honor and integrity, rational and irrational behavior." He's never tired of delineating as much to those with a flatter learning curve.

Elmer

"The guy's name was Elmer," David T. Alexander said. "Elmer was a real alcoholic; he was a wreck. He has since died, but back then he had a house in Los Angeles that was full of stuff."

How full?

"To walk into his house," Alexander said, "you had to walk in sideways and suck your stomach in."

Alexander had sucked in that stomach before. He'd run into an old guy like Elmer every now and then. Usually, the guy's wife had died or run off, taking with her the only sense of control the old man had. He didn't collect stuff anymore, he hoarded it. And he could not get enough.

"Elmer collected everything," Alexander said. In the beginning, he bought his comics and pulps and magazines fresh off the newsstands, way back in the '40s and '50s. By the time Alexander met him in the mid-'70s, Elmer was haunting the garage sales, bidding a couple of bucks on unopened boxes of junk. He'd bid on however many boxes he could squeeze into his battered station wagon, then head for home.

To step into that house was to walk on the wild side. "One bedroom," Alexander said, "was filled with high school gym lockers he'd picked up at some auction. They were absolutely full of stuff. You wouldn't want to open them, or they'd explode. One of them was full of Avon fantasy readers, another had silver dollars."

Every inch of wall space was covered with paintings. Elmer couldn't face blank space. Under his bed were hundreds of Big Little Books, many of which had been food for rats. Out on the sun porch were the pulps, breathtaking runs of *Doc Savage* and *Weird Tales*. The Golden Age comics and *Spicy Mystery* pulps were in the basement. The bathroom, Alexander recalled, was crammed with bookshelves, but so much furniture was piled in front of the door that you couldn't reach them. "It was like reaching through a jungle gym."

The kitchen? "Elmer was also a coin collec-

tor," Alexander said. "His kitchen table was filled with stacks of coins, little cylinders of pennies, dimes, and quarters. Magazines, letters, and the rest of the mail would be laid on top of those stacks, and other stacks of coins would be on top of the mail. It was a real balancing act. There was only one little area cleared where he could put a plate."

Or a bottle. Elmer had a 9-to-5 job, managing the department that painted numbers on the curbs of L.A., but when he punched out, he came straight home, poured himself a drink, and started poring through magazines and stacking coins.

He was oddly amenable to visitors. One night, Alexander and several friends dropped by. Elmer opened the door, registered sexes, and squealed, "Oh, you've got women with you! Women! I have to get dressed."

"He closed the door," Alexander said, "and you could hear these explosions as he staggered back down the hallway. He was falling over stuff, knocking over stuff. After 15 minutes—we thought the guy had died—he came back and said, 'Okay, I'm dressed,' and opened the door. And he was just wearing a pair of jockey shorts."

No matter. Elmer was sitting on a goldmine. "You could go over and mine for a little while," Alexander said. "You wouldn't always buy something, but it would be such a riot."

Alexander always thought he'd get a major chunk of Elmer's gold, but it didn't work out that way. Sometime in 1988, another dealer dropped by to find Elmer's brother on the front walk, with Elmer's body at the undertaker's. Elmer's brother didn't have the stomach to wade through the collection, so he sold it all on the spot. Alexander eventually got a few of the comics and pulps, but when they arrived and he leafed through them in a room where the walls and his elbows had a little breathing room, it wasn't the same.

Enemy Ace

Introduced by a question mark (and five questions, four of them "Who?") on the cover of *Our Army at War* #151, Enemy Ace began as a backup feature.

The moody, captivating German pilot was created by Robert Kanigher and illustrated by Joe Kubert.

Kanigher won't let anyone else tell this story.

"My first tactical problem," Kanigher said in *Robin Snyder's History of Comics*, "as an American-Jewish writer-editor of *Our Army at War*, for a Jewish firm, owned and operated by Jews, was to ask Mr. Jack Leibowitz who ran the company, to star a German World War I Ace, whose enemy America was in two world wars; whose sole duty was to Germany, his own country; and to be told from his point of view, in his own words, first-person singular... Some chance! Some chutzpah! So I didn't... No one knew at DC what I was doing. They never did anyway."

Kanigher said he "stole pages from Sgt. Rock, star of *Our Army at War*, and gave them to Enemy Ace." Rittmeister Hans Von Hammer—

The definitive Enemy Ace cover (*Star-Spangled War Stories* #138, May 1968), by the character's definitive artist, Joe Kubert.
(© DC Comics, Inc.)

the "Hammer of Hell"—first landed on the cover of *Showcase* #57, but his most memorable run remains *Star Spangled War Stories* #138–#150.

Kubert—contributing superb artwork—and Kanigher fueled Von Hammer in a total of 17 books of original material: *Our Army at War* #151, #153, #155; *Showcase* #57, #58; and the *Star Spangled* run.

The character has also been drawn by Neal Adams (*Detective* #404), Frank Thorne (*SSWS* #181–#183), and George Pratt (*Enemy Ace: War Idyll*).

Englehart, Steve

There were three phases to the Marvel Age: There was Stan, there was Roy, and if I may say so, there was me.

Steve Englehart was—if he may say so—the first of the Crusty Bunkers, the young artists working with Neal Adams at Continuity. In 1970 Englehart was in the U.S. Army, quartered at Aberdeen Proving Ground in Maryland, struggling to get his conscientious objector discharge, and every weekend he'd drive up to New York.

"I'd get out of Aberdeen at three in the afternoon and get up to DC at six," Englehart said. "We'd hang around there until one in the morning. In the old days, you could spend the night at DC Comics.

"Neal told me early on that the comic book companies routinely lied to you about their sales figures. Pretty much every Friday around midnight, we'd go down to one of the vice president's offices. Neal would jimmy the door, and we'd look at the sales figures. It meant nothing to me. But later on, people would tell him, 'Neal, you sold 37 percent,' or 'Neal, you sold 75 percent' (depending on which way they were trying to move on), and he'd know it was 53 percent. I learned a lot from Neal, and one of those things was you couldn't trust these guys."

Another thing he learned was that he couldn't draw. "I could see it in my head, but I couldn't get it out of my hand," Englehart said.

But he could put what was in his head down on the printed page. In 1971 Englehart—then 24 years old—got a writing job at Marvel. His first story ("Terror of the Pterodactyl") appeared in *Where Monsters Dwell*.

"There was a whole crew of people who got started at the same time," Englehart said. "We'd locked onto Marvel Comics in high school or college, and we all came on line at the same time. That crew included Don McGregor, Jim Starlin, Walt Simonson, and Steve Gerber. We'd all seen Marvel go from nothing to a sensation to something that was better every month. We had a chance to catch that wave and go with it.

"We were in the best of all possible worlds: We didn't understand work for hire, and royalties, and health benefits. We were in our early twenties, we were all stars, we were all together," Englehart said.

"We'd get up at noon, work all day on our fantasies, then watch kung fu movies, *The Waltons*, and *The Streets of San Francisco* . . . all of us doing the same thing. I'd call Starlin at three in the morning and say, 'You have to turn on Channel 9, there's an amazing movie on.' And he'd be up.

"The nice thing about comics in those days is you could move to New York and you would immediately have 300 friends," Englehart said. "If they were in the business, you knew them. If there was a party, you'd invite them. That was our subculture. It wasn't the '60s, but we partied pretty good. We'd rampage around New York City. There was one night when a bunch of us, including Jim Starlin, went out on the town. We partied all day, then did some more acid, then roamed around town until dawn and saw all sorts of amazing things (most of which ended up in *Master of Kung Fu*, which Jim and I were doing at the time). We found the ATT long lines building that night, which we made Fu Manchu's headquarters. We came around a corner and found guys working out of a manhole cover with torches and throwing four-story shadows.

"New York can be very evocative, and if it evoked, we made use of it. Art was life, and life was art. We were coming upon all of these things for the first time, whether it was Marx Brothers movies or four-story shadows."

Englehart remembers the day Marvel passed DC as the number-one company in total dollars or books sold: Martin Goodman, still hale and hearty, took the entire bullpen out to dinner at DC's favorite hangout. But when Marvel was sold to Cadence in 1973, Englehart realized

Steve Englehart

"The nice thing about comics in those days is you could move to New York and you would immediately have 300 friends."
STEVE ENGLEHART

he no longer lived in the best of all worlds. He was increasingly disgusted by the company's editorial direction, dictated by Stan Lee and the technocrats that paid Stan's salary, but his break with the company didn't come until Gerry Conway succeeded Marv Wolfman as editor in 1976.

According to Englehart, Conway immediately called him up and announced that he would be replacing Englehart on *The Avengers.*

"I said, 'Wait a minute. I've been writing this book for four and a half years. It's been selling fine.'"

That may be, said Conway, but I'm running the show and it's my call.

"And I said, 'Well, Gerry, I quit.'"

Starlin and Paul Gulacy soon followed Englehart out the door. "The people who came in afterwards seem to me like they want to 'do' Marvel Comics, rather than 'make' Marvel Comics," Englehart said. He landed at DC, where he put his pen to *Justice League, Detective,* and *Mister Miracle,* among other titles.

His scripts were good enough that Englehart won several writing awards for his work on *Detective,* but his interests were elsewhere. Near the end of the '70s, Englehart quit comics to concentrate on writing novels. He later did computer design for Atari, occasionally drifting back to comics when the spirit moved.

Esoteric Comics

A term coined by Carl Macek in 1975 and popularized by Scott Shaw! in late-night slide shows at the San Diego Comic-Con. Esoteric comics were originally obscure genres and odd lots featuring nurses, atomic bombs, androgynous funny animals, or drugs and other vices. In the marketing age, however, any comic that isn't selling is invariably classified as an "esoteric comic" in hopes of moving it off the shelf.

The Eternals

With *The Eternals* Jack Kirby essentially recreated the New Gods for Marvel ... or better yet, he recreated the Norse gods of Asgard. Kirby's clay first came to life in July 1976; in less than two years (19 issues), to dust they did return. Ajax and the Celestials deserved better.

Evanier, Mark

An early assistant to—and the ultimate scholar on—Jack Kirby, Mark Evanier has been lending scripts, expertise, and perspective to the comics industry since 1970. Since connecting with Kirby in 1971, only two years out of high school, Evanier has drawn most of his paychecks in the fields of television and animation. "I've always done comics out of love, not financial necessity," he said. "If you look at all the money I've spent on comic books, I've actually lost money in the industry."

The author of hundreds of sitcom and cartoon scripts, particularly for Hanna-Barbera and Warner Bros., Evanier is best known in comic book circles for writing *Crossfire,* which was based on his experiences in Hollywood, and for his team-up with artist Sergio Aragonés on *Groo.* "Those are the comics I used to give to people and say, 'This is as good as I get,'" Evanier said. "My résumé is littered with projects I wish I could tell people the other Mark Evanier did. You have those quiet disasters all the time. You regroup."

Evanier has attended every San Diego Comic-Con since the first one in 1970, and he writes a weekly column for the *Comics Buyer's Guide.* At the beginning of 1997, he was 100,000 words into an exhaustive biography of Kirby.

Evans, George

"The world's second greatest waste of talent ... Frazetta being the world's first greatest waste of talent," Roy Krenkel once said. "He's a guy who can do almost anything."

Comic fans, then, should consider themselves fortunate that George Evans wasted so much of his time in their world.

Ask Evans when it all began, and his first stop is 1929. At the age of nine, he was already a relentless reader. Visiting a friend's house, he stumbled across a copy of *Skybirds,* part of the pulp collection that belonged to his buddy's uncle.

"The *Skybirds* had a painted cover of this plane diving after a German plane with all its guns blazing," Evans said. "I picked it up, saw the interior illustrations and read a couple pages, then asked the uncle, 'Could I borrow this when you're done with it?'

"He said, 'I'll give it to you if you do me a favor.' These were Depression times and the

Mark Evanier

"I've always done comics out of love, not financial necessity. If you look at all the money I've spent on comic books, I've actually lost money in the industry."
MARK EVANIER

Although best known for his aviation stories and strips, George Evans also drew several memorable stories for EC's horror and crime books. The page below is from the final issue of *Crime SuspenStories* #27 (March 1955).
(© 1998 William M. Gaines, Agent, Inc.)

favor Mike and I did for him, to get this ten-cent magazine, was to walk the streets of Copemont, Pennsylvania picking up cigarette butts. We got a can full of them. He provided us with a little chopper device, like a guillotine, and we peeled the paper off the cigarette butts, chopped the gummy ends off the butts." Evans and his buddy then rolled a handful of new cigarettes and traded them for the *Skybirds*. "He smoked them," Evans said, "and lived to a ripe old age."

The pulp kicked off his fascination with airplanes and flight. Three years later, Evans came down with a mastoid infection. He spent three weeks in a hospital. "I sat there with my head bandaged and couldn't move it much because it was draining. The only salvation was a window by the bed and an airport that I could watch all day long. The buggers over there had these old biplanes. One of them would have been a Thomas Morse airplane, a little rotary plane, and the guys would get up in it and do the most incredible stuff.

"I could watch them all day long. There was always somebody up. I had been hooked on them from the old pulp magazines. Later, my folks took me over to the airport and they were the nicest people you could imagine. How could you not get hooked?"

A year later, Evans had a drawing and a poem accepted by the pulp *Daredevil Aces*, and he was off.

Evans tried to join the Air Force when the war began, "but you had to have perfect eyes and the equivalent of two years of college. I had bad eyes and no college." He ended up as a mechanic at Shaw Field in South Carolina, often test-driving the planes he'd retooled.

After the war, Evans pitched his sketch pad through the door at Fiction House and was stunned to receive a job offer. "I had gone into the service when 69 cents an hour was high pay, so when they offered me $35 a week, I thought, 'Oh my God,'" Evans said. "Frazetta was hired a little after me to do the same sort of thing, to assist the other staff artists that had been assigned the regular features. They were always behind deadline. All of us are."

The Fiction House gang was an unruly, undisciplined but talented bunch, led by Bob Lubbers, John Celardo, and Rafael Astarita. Evans got his first feature, "Tiger Man" in *Rangers*, when both Mike Peppe and Frank Doyle failed to impress editor Jack Burne; he soon took over "Jane Martin" from artist Fran Hopper and picked up "The Lost World" in *Planet*.

When Fiction House cut loose its staff, Evans did some scuz work for Standard, then followed Al Williamson's advice and signed on at Fawcett. A 15-year-old kid when he first stuck his head in the door at Fiction House, Williamson became Evans's "good friend and guardian angel. Everywhere he went looking for work, he connived to make sure they looked at my work. Even if he didn't get a job, I often did."

Evans was so busy at Fawcett that he didn't realize the company was finally about to surrender in its protracted legal battle with DC. Williamson called to tell him the end was near: "He said everyone in the trade knows they're going under, come on down and talk to the people at EC."

Evans remains best known for his work at EC, which culminated with his covers for the five-issue run of *Aces High*. Before he betrayed his knowledge of aerial combat, Evans was invited out for pastrami sandwiches with John Severin, Jerry De Fuccio, and Harvey Kurtzman. They were bragging about the authenticity of the material in EC's war books when Evans stuck a pin in their balloon: He told them they'd screwed up by showing rotary-powered planes with the engine cylinders standing still.

Kurtzman, who took great pride in nailing all the details, choked on his pastrami, then sputtered, "What do you mean, just standing there?"

"So I explained the idiotic genius of an engine that went merrily round and round along with the propeller," Evans later told Al Dellinges. "They were certain I was doing a complete put-on, until I diagrammed the thing. So, Harvey wasn't happy until I did some work for him. And what was the first job? Air stuff? Of course not! The story of Napoleon . . . with Harvey's untouchable roughs demanding 40,000 French troops, 70,000 opposing troops, every one visible in every panel, every face identifiable. Maybe it was punishment for questioning his authenticity?"

When EC died, Evans first tried to get work at DC. Warm, witty Bob Kanigher was waiting for him. After Kanigher invited Evans into his office, he starting screaming at him: "So here you are, one of those who ruined the comic business, coming in here begging for a job. Get the hell out of my office." Kanigher was apparently keeping a seat warm for another EC alum, Joe Orlando.

Evans moved on to work for Classics Illustrated and Gold Key. In the late 1960s, he joined George Wunder on the *Terry and the Pirates* strip for a dozen years. In 1980 he took over the art chores from Al Williamson on *Secret Agent Corrigan*. Like the cheap tobacco-sucking guy who gave him that copy of *Skybirds*, he has lived to a ripe old age.

Everett, Bill

Bill Everett spent most of his life dipping into the deep blue sea and jerking out aquatic characters. When he wasn't fishing in the drink, he was throwing one down.

Everett once told Roy Thomas that he had almost joined Admiral Robert Byrd for the assault on Antarctica. To make up for the lost opportunity, he spent years with a pair of ice cubes rattling in the bottom of an empty glass.

It was over drinks at New York's Webster Bar in 1939 that Everett and Carl Burgos dreamed up the Sub-Mariner and the Human Torch. Everett loved the sea—he began a two-year stint in the merchant marine at age 15 and he knew most of Samuel Coleridge's *The Rime of the Ancient Mariner* by heart—and when the Sub-Mariner took off, the affair was consummated. Everett dove back into the surf at least twice more, emerging with The Fin, another Timely hero, and Hydroman, who appeared in the first issue of *Reg'lar Fellers Heroic Comics*.

Born in 1917 (the same year as Burgos) Everett had little formal training: one year at the Vesper George School of Art. His first big hit was Amazing Man for Centaur; not long afterward, he quit John Hardy Publications, which produced Centaur comics, and helped found Funnies, Inc., with Burgos and Lloyd Jacquet.

Everett hacked around on a variety of second-class characters but never conjured up another success to match the Sub-Mariner. Maybe that's why he drowned himself in liquor. "Everett was a drinker," Kim Deitch once said, "and it brought him down." The alcohol watered down his considerable talent.

Everett left the comics in 1957, just before the Atlas implosion, then returned to Marvel in 1964, drawing the first issue of *Daredevil*. He tumbled hard into Alcoholics Anonymous for a spell and was marginally successful: He eventually died not of cirrhosis of the liver but of heart surgery complications. When it mattered, however, Everett was not unlike Coleridge's ancient sailor: Water, water, everywhere, and not a drop he drank.

Bill Everett's love for things maritime showed up in stories other than those featuring the Sub-Mariner. This page is from *Venus* #18 (February 1952).

(TM & © 1998 Marvel Characters, Inc. All rights reserved.)

Excelsior!

The battle cry of the Merry Marvel Marching Society. The word sits on the seal of the state of New York, but Stan Lee claims it slipped into his subconscious while he was reading the tales of King Arthur in a British magazine. "I do recall one of the good guys in the story shouting 'Excelsior' at a dramatic moment," Lee said, "and I somehow got the impression that it meant 'Upward and onward, to a greater glory.'"

Eyeball Kicks

This term relates to the jokes, visual puns, or caustic asides that cartoonists slip into the sides or corners of panels. In *A History of Underground Comics*, Mark Estren notes that if eyeball kicks first populated Bill Holman's *Smokey Stover*, they were popularized in the early pages of *Mad* (especially in Will Elder's stories).

LEARNING FROM AN OLD PRO

Mike Friedrich met Bill Everett in 1967, shortly after Everett's wife died, and shared an apartment with him for three years. Everett had already drunk himself out of a half-dozen jobs, but Marvel ("It was still a family business," Friedrich said) was taking care of him, handing him a variety of inking jobs.

"Bill Everett's style in the late '60s wasn't all that popular," Friedrich said, "so he wound up inking Jack Kirby's stuff. When I first met him, he was also inking Jim Steranko, who had specifically asked for him.

"I had a particularly embarrassing episode with him. Jack Kirby does all these weird design things in his backgrounds, these weird black things. There was a period of a month or so when I would ink those things in for Bill. Well, I wound up once getting up a head of steam, and inking in a background figure.

"It was horrible, of course. Bill got so royally pissed at me, he had to white it out and do it over. And he charged me for it. He charged me for his time. Listen, I was 19, and I learned a lesson there. I never did that again. I got to watch how long it took for a professional artist to deal with a mistake."

Bill Holman introduced "eyeball kicks" in his wacky daily, *Smokey Stover*.
(© News Syndicate Co.)

Fabulous Furry Freak Brothers

Gilbert Shelton's dope-infested trio—Fat Freddy, Phineas, and Freewheelin' Franklin—were first published by Rip Off Press in 1971. When Shelton wasn't coming up with ingenious ways for the Freak Brothers to end their various dope famines, he was tracking Fat Freddy's cat; the Freak Brothers' favorite 14-year-old runaway, Little Orphan Amphetamine; or Tricky Prickears, his blind-deaf version of Dick Tracy. Oddly reminiscent of Blondie and Dagwood in Shelton's reliance on a handful of familiar gags, the Freak Brothers' adventures have outsold every underground except *Zap*. The Freak Brothers are still being printed and reprinted by Rip Off, with Paul Mavrides having taken over a lot of the art and story chores for expatriate Shelton (who lives in France) in recent years. Other collaborators over the years have included Dave Sheridan, Ted Richards, and Willy Murphy.

Falk, Lee

In his first stab at creating a comic strip character, Lee Falk produced Mandrake the Magician in 1934 with artist Phil Davis. On his second thrust, Falk improved on his original and delivered the Phantom.

Born in 1905, Falk wrote ad copy and radio scripts until arriving in New York and selling Mandrake to King Features. When he wasn't writing the Mandrake and Phantom strips, Falk penned a variety of novels and plays. He is still writing in his 90s, and his creations, which have been heavily circulated around the world, have had a fierce impact on European cartoonists.

Famous Artists Course

> *We're looking for people who like to draw.*
> NORMAN ROCKWELL

Popularized by ads on the back of comic books, the Famous Artists Course was, Bernie Wrightson said, "one of the best damn art courses I've ever seen."

Wrightson first sent away for the "free talent art test" when he was 16, too young to take the correspondence course. When he tried again two years later, a salesman hustled to his door.

The course, Wrightson notes in *A Look Back*, was a three-year correspondence course; the core of the course was three textbooks, each containing eight lessons. At the end of each lesson, the budding artist was given an assignment, which he or she mailed in. The assignment was returned with art overlays, "telling you where you went wrong, what you could do to improve the drawing."

"They started the course assuming you knew nothing," Wrightson said. "They started assuming you would pick up the pencil and try to draw with the eraser. They told you, 'No, draw with the other end, but put a point on it first.' It was that basic."

The course cost $627—Wrightson's family had to take out a loan to pay the bill. "You received these three books, and as a bonus you had your choice of a drawing table—this was kind of a sales gimmick—or a box full of art supplies," Wrightson said. "I took the supplies because I already had a drawing table."

Famous Funnies

This was the first modern comic book—you can't get more famous than that.

The first two one-shots of *Famous Funnies* spun off the four-color rotary presses of the Eastern Color Printing Co. in 1933 and early 1934.

The first, *Funnies on Parade*, was a Procter & Gamble giveaway; the second, *A Carnival of Comics*, was a premium sold in department stores. Comic books might still be on the shelves at Woolworth's if an Eastern Color salesman named M. C. Gaines hadn't been inspired to paste "10¢" tags on several forgotten copies and dump them off at several newsstands. The next morning, every copy had been sold.

In May 1934, Eastern put the first monthly comic—*Famous Funnies* #1—on the stands. That first book contained more than a dozen Sunday strip reprints, but hey, it improved with age. And it never got any better than the eight-

Lots of aspiring cartoonists took this ad to heart and enrolled in the mail order school.

(© Famous Artists School)

issue run of #209–#216, solely because of the covers by Frank Frazetta.

If you've got your timeline out, 46 issues of *Famous Funnies* were out before *Action* #1 hit the stands, and 57 issues preceded *Detective Comics* #27.

Famous Monsters of Filmland

The first time Forrest Ackerman met Jim Warren, Forry was parked in "a broom closet that doubled for a room" in New York's old Chesterfield Hotel.

"Came a knock at the door," Ackerman later wrote. "I opened it. Now the scenario according to Warren was supposed to be that his girlfriend Phyllis Farkas would rush past me, rip open her blouse, throw herself on my bed, and start screaming, 'Rape!' Warren would be hiding around the corner. Before I could gather my wits he would come bounding into the room and confront Ack the Ripper. Instead, I ruined everything by intuiting who she was and saying, 'You must be Jim Warren's girlfriend,' at which point Jim jumped into sight."

Forrest J Ackerman

Warren, Ackerman said, had "just enough cash and credit left" in September 1957 to publish a one-shot magazine featuring—Warren hoped—Brigitte Bardot or Marilyn Monroe. Inspired by a *Life* magazine feature on monster movies, Warren had just enough sense to suggest a monster magazine, drawing on Ackerman's collection of 35,000 movie stills.

Famous Monsters of Filmland #1 rolled out the following February, with Warren and Farkas posed as Frankenstein and his love interest on the cover. The press run of 125,000, to everyone's amazement, sold out.

Based on the fan mail, Warren instructed Ackerman—then a literary agent for science fiction writers and the owner of an unparalleled collection of science fiction and Hollywood memorabilia—to lower the level of his writing to hit the adolescents where they lived. The result was an endless parade of puns and sight gags.

Where else but in *Famous Monsters of Filmland* could one find homages to Bela Lugosi, seminude pictures of Trina Petit (now Robbins), and advertisements for 10-foot inflatable rubber snakes and briefs with a *Creepy* cover on the crotch? The magazine's success allowed Warren to launch *Eerie, Creepy,* and—another Ackerman creation—*Vampirella*.

Fan Mail

Dear Stan and John,

I want to say that the **Silver Surfer** *mags so far have been quite lovely and far surpass the best efforts of your competitors. The artwork, coloring and plots are thoroughly enthralling. But Stan, my dear, sweet fellow, what bitter streak of melancholia lurks within the folds of thine ever-hallowed noodle. I believe in heroic suffering and all, but this is ridiculous! Do you realize that for all practical purposes your adorable Silver Surfer would have died of a broken heart by now? There was another time that a man so deserving of love was as brutally rejected, but that happened about 2,000 years ago. Surely, Stan, the human race must have learned something about tolerance in the past 20 centuries! In the* Silver Surfer, *more than in any of your other mags—even the Hulk—you portray humanity as being grossly selfish, cowardly, unbelievably cruel and ignorant. Stan, I'm hoping this is not your true opinion of "we, the people," but rather the exaggerated interpretation that the poor, frustrated SS could only naturally have developed by now. If so, this is a clever bit of craftsmanship on your part. But if you actually believe that this is the actual way that humanity would react to such an unusual situation—I suggest you borrow Surfy's board and buzz on over to your friendly neighborhood analyst! I realize that everything pertaining to a super-hero is on a grand scale; his looks, his environment, even the way people react to him. But please, Stan, don't let Alicia's comforting speeches to the Surfer about the potential goodness of the human race be forgotten. People can be pretty darn nice!*

WENDY FLETCHER, P.O. BOX 516
GILROY, CALIF. 95020

The letter that blew Richard Pini's doors off in 1969.

Pini was a college freshman in Boston when he read Fletcher's letter in *Silver Surfer* #5. "I said, 'This is a neat letter. A thoughtful letter.' The fact that it was written by a female wasn't lost on me. So I wrote her a letter. So did two or three hundred other guys."

Pini told Fletcher little about himself, telling her she'd have to write back if she was curious. "It was a shamelessly transparent ploy," Pini said, "but it worked. Mine was the only one she responded to. All the other letters were from guys who told her everything about themselves. I guess I put forward an air of mystery."

Richard and Wendy Pini were married in 1973. Five years later, they created *Elfquest*.

Fantagraphics

The foremost promoter and publisher of alternative comics, Fantagraphics got its motor running in the late '70s with *The Comics Journal*, the successor to *The Nostalgia Journal*. It has steadfastly published the work of the Hernandez Brothers (*Love and Rockets*), Peter Bagge (*Hate*), Dan Clowes (*Eightball*), and Roberta Gregory (*Naughty Bits*), along with several superb reprint volumes, from classic strips such as *Little Nemo in Slumberland, Prince Valiant,* and *Little Orphan Annie*, to *The Collected Works of R. Crumb*. Fantagraphics also launched Eros Comics in 1990 when, in the words of editor Gary Groth, "Fantagraphics Books, which Kim Thompson and I started and nurtured and loved, began to totter and head for collapse." The adult-oriented line has helped keep the company afloat ever since.

Fantastic Four

To appreciate what *Fantastic Four* #1 meant to the 1960s, we must first return to the 1950s. You remember the '50s. "Eisenhower was president, McCarthyism was rampant, and comics were scared shitless," Gil Kane said. "Their will was sapped. The scale was the scale of a cipher. It was the most sterile period in the whole history of comics."

How bad was it? Marvel was at the end of its rope. "Marvel was always 15 minutes away from firing everybody," Kane said. "They used to take a trend, turn out 150 different titles all built around that trend until they ran the trend into the ground, then fire everybody." A few months later, Marvel was publishing under a different name, feeding off a different trend. "By

Wendy and Richard Pini (at the San Diego Comic-Con in the mid-1970s) met through the letters column of *Silver Surfer.*

Kirby and Lee's *Fantastic Four* launched the Marvel Age of comics.
(TM & © 1998 Marvel Characters, Inc. All rights reserved.)

Fans

If you go to a convention, you'll see a lot of strange people. I've always wondered: Are these normal people who have been turned strange by comic books? Or were they strange already and comic books just attracted them?

A lot of people who buy books from me are very secure and have a well-rounded life. But there are others ... Comic books are their life. If you were to break into their house and steal their collection, they wouldn't have any reason to live. They'd be hanging from a rope in no time.

STEVE FISCHLER, METROPOLIS COMICS

the '50s," Kane said, "they had exhausted this as a way of staying in business."

How bad was it? "DC, the only stable company left in the entire field [besides Dell], was like a bank, it was so reserved and timid in the material it turned out," Kane said. "The Comics Code was created to defend comics, and it restricted anything that might draw unfavorable attention to them."

How bad was it? Jack Kirby couldn't find work.

The King was struggling. He was the greatest of the super-hero artists and the super-heroes were long gone, replaced by pale ghosts and their super-pets. Kirby's oversized figures were suddenly no match for the puny mortals drawn by Dan Barry. Artists like Wally Wood were assigned to ink Kirby's work, if only to deaden the impact. In desperation, Kirby even took a stab at several "World Around Us" books for Classic Comics. Say it ain't so, Jack.

When life couldn't get any worse, Kirby drifted back to Marvel, which was down to a staff of four and the lowest pay rates in the business. Waiting for him was Stan Lee and another trend that was just big enough to suit Kirby's style: monster books. Give us a Goom, give us a Googam, give us a Gorgilla.

Who knows how long they would have stayed there if Marvel's—make that Canam Publishers Sales Corporation's—Martin Goodman hadn't hit the links with DC's Jack Leibowitz. We don't know the name of the course of this mythical meeting, or who kept score, for it is only remembered for an offhand remark Leibowitz made about a new comic, *Justice League of America*.

"Super-heroes?" Goodman must have thought. "Super-heroes? Again?" Check 'em out, he told Stan Lee. You know our motto: If it worked for them, it'll work for us.

Not much original thought went into the creation of the Fantastic Four. You could argue that the quartet was Kirby's version of earth, air, fire, and water (Mr. Fantastic as liquid in a human shape). Or you might point out that Reed Richards was another Plastic Man, the Thing another Heap, the Human Torch another Human Torch. But when Kirby cut loose, the tremors registered 7.2 on the Richter scale. The scale of the art changed. "Jack's stuff was so much larger than life," Kane said. "After doing all this Dan Barry human style, we suddenly jumped to this godlike, ten-headed figure fit only to fight people from the cosmos. Everything looked Olympian."

Until Kirby left, almost ten years later, just about everything in the *Fantastic Four* read that way, too.

Key issues: #4, first Silver Age appearance of Sub-Mariner; #5, first Dr. Doom; #8, first Puppet-Master, first Alicia Masters; #12, FF vs. the Hulk; #13, first Watcher, first Red Ghost; #20, first Molecule Man; #26, Thing vs. Hulk; #35, first Dragon Man; #45, first Inhumans; #48, first Galactus and Silver Surfer; #52, first Black Panther; #67, first Warlock; #108, last Kirby issue

Fanzines

In the heyday of comics fandom, hardcore fans could choose from dozens and dozens of fanzines, from strictly amateur to the surprisingly professional (*Witzend*, for example). Here's our list of the most memorable fanzines from the 1960s and 1970s.

Alter Ego (Jerry Bails and Roy Thomas)
The Buyer's Guide for Comic Fandom (Alan Light)
CAPA-Alpha (Jerry Bails)
Comic Art (Don and Maggie Thompson)
The Comicollector (Jerry Bails)
The Comic Reader (Jerry Bails; later Roy Thomas, then Mike Tiefenbacher and Jerry Sinkovec)
The E.C. Fan Bulletin (Bhob Stewart)
Fantastic Fanzine (Gary Groth)
Fantasy Illustrated/Graphic Story Magazine (Bill Spicer)
Hoohah! (Ron Parker)
Komix Illustrated (Biljo White)
Rocket's Blast–Comicollector (G. B. Love)
Squa Tront (Jerry Weist/John Benson)
Star-Studded Comics (Larry Herndon, Howard Keltner, Buddy Saunders)
The Story of Superman (Ted White)
Witzend (Wally Wood)

Fawcett

Fawcett was known as the greatest imitator in the world. They never did anything first, they always were second.
C. C. BECK

Wilfred "Billy" Fawcett's publishing empire began with a joke book and ended, more than three decades later, in the shadow of an endless lawsuit.

The title of Fawcett's first comic book—*Whiz Comics* #2 (February 1940)—honored the company's roots in a mimeographed pamphlet of jokes, *Captain Billy's Whiz-Bang*. Not only did the comic nod obligingly to the Captain's first publication, but its hero, newsboy Billy Batson, shared his first name.

Captain Marvel, of course, was the Atlas of the Fawcett universe, carrying the world on his shoulders. When he wasn't the star attraction—in *Whiz*, *Captain Marvel Adventures,* and *America's Greatest Comics*—he was a guest star.

Fawcett's core talent included editors Bill Parker and Wendell Crowley; artists Pete Costanza and Mac Raboy; writers Jack and Otto Binder (of the 1,743 Marvel Family scripts published from 1941 to 1953, Otto Binder wrote 986); and the inimitable C. C. Beck, who gave Captain Marvel his clean, enviable lines.

When other companies went south in the '50s, Fawcett headed west, hitting the trail with the likes of *Hopalong Cassidy, Tom Mix, Rocky Lane, Smiley Burnette, Lash LaRue,* and *Tex Ritter*.

In 1951 a court ordered Fawcett and DC back into the dock to continue their six-year legal battle over DC's claim that Captain Marvel infringed on Superman's copyright (see **Legal Briefs**). Rather than keep a fleet of lawyers busy for the rest of the decade, Fawcett surrendered in 1953, settling with DC out of court and discontinuing their comics line.

Feiffer, Jules

Comic books, first of all, are junk.

The Pulitzer Prize–winning cartoonist broke in with Will Eisner at the age of 17. "When I went to work for Eisner," Feiffer once wrote, "my first assignment was the signing of his name to *The Spirit*. I was immediately better at it than he was."

He soon graduated to *The Spirit* and a strip of his own, *Clifford*, which Feiffer said Eisner let him draw so he wouldn't have to give him a raise from $25 to $30 per week. By the mid-1950s, Feiffer was doing a freebie titled *Sick, Sick, Sick* for *The Village Voice* and gathering speed for another 40 years of cartoons, screenplays, and novels.

But what commends Feiffer to fandom is his book *The Great Comic Book Heroes*, which was published in 1965. One of the first books to treat comic books with the wit and irreverence they deserved, Feiffer's retrospective reprinted the origins of many of the great Golden Age super-heroes.

Fans (continued)

Card collectors are more your mainstream, United States of America people. Average Joe Blows. Jocks. Comics are more of a back-room situation. You get a little more of … not an aberration, but the curve gets a lot steeper. I've had people stand in front of me, a guy there and a girl there and they're debating the merits of the latest Star Trek movie, and I feel like saying to him, 'Ask her out, she wants to go out with you.' They don't know how to communicate. They can't get that far.

Science fiction collectors just come up and babble at you. They don't even know what they're talking about. 'I was born on Mars in the year 4,000 where I escaped to the planet Pluto.' Go away …
RON PUSSELL, REDBEARD'S BOOK DEN

There are various types of fans: neo-fans, to whom Stan Lee and/or Julius Schwartz comics constitute the best of all possible super-hero worlds; indiscriminate fans, who would place Fantastic Four on an equal footing with Lassie if she were masked; and of course the Golden Age fans, who long for the days when Joe Shuster used to forget Superman's "S" every other panel.
ALTER EGO #9

Put tits on a cereal box and you could sell it to comic fans.
HOWARD CHAYKIN

An example of the increasing berserkness of fans? As fandom increases, there are more guys out on the fringes. When Frank Miller was sharing studio space with Chaykin and myself, after the issue of **Daredevil** *in which Elektra got killed, Frank got a death threat in the mail. I'm sorry, but this is fiction. These are comic books.*
WALT SIMONSON

For many kids growing up in the 1970s, a copy of *The Great Comic Book Heroes,* pulled off a foot-high pile of remainders and placed beneath the Christmas tree, was the first sign that their parents were trying to understand the junk they loved.

Feldstein, Al

I always felt Al was a reluctant dragon. He'd breathe fire, but it was cold fire. I felt Al wasn't really harmful at all.
WILL ELDER

Feldstein? He was an arrogant, snotty little guy. I went to lunch with him one day, in downtown New York, on Canal Street. Here I was, 17 or 17 and a half, and I remember him giving me some flowery advice: "You haven't got it, kid, get out of the business. You're no good, you never will be." I hated his guts from that day on ... You never tell that to a kid.
RAY OSRIN

And that was the big difference between me and Al. While I made a buck, Al made a bundle.
HARVEY KURTZMAN

EC's only left-handed artist, Al Feldstein was Bill Gaines's left-hand man. Gaines would arrive with the springboard—a story idea purloined from who knows where—and Feldstein would take the flying leap.

Feldstein got his start in Jerry Iger's shop. "A trash house," he said. "I got paid $3 a week erasing Lou Fine, Bob Powell, Bob Webb, and Reed Crandall. One day I was given the honor of putting leopard spots on Sheena's breasts. I drew jungle fronds till they were coming out of my ears. That's how you progressed in those days."

After being discharged from the service in 1945, Feldstein took a stab at teaching, discovered he couldn't make a decent wage, then "ran back to the comic book industry." He was soon freelancing for Victor Fox, drawing and writing *Junior, Sunny,* and—"my breakthrough"—*Meet Corliss Archer*. He was still working for Fox, he said in an interview in *Fanfare* #1, when he heard "an outfit downtown was looking for someone to do a teen book. The publisher had been killed in an accident, and his son was taking over and changing the line around. So I went down and met the man who was running the company, Sol Cohen, and was introduced to the son: a big, fat young man named Bill Gaines."

Gaines gave Feldstein a tryout on a teenage romance story titled "Going Steady with Peggy." "I drew girls with perpetual wet T-shirts and high heels," Feldstein said. Gaines never printed the art, but he hired the artist, tying the knot on one of the most productive marriages in comic book history.

They were both practical jokers, both soured idealists. "We were familiar with the same things, both being Brooklyn boys, and we were both fascinated by the same things," Feldstein once told John Benson. "When we were working on the science fiction, we would spend hours on theory—on just developing the time-loop stuff that we did, for example, to make sure that it worked exactly right, and that it was perfectly logical that this guy who went up to the bridge of the *Titanic* to stop the disaster was the guy who caused it."

Feldstein was a much better writer than artist; he admitted as much, saying he never liked his art. For 15 years, that art put bread on his table. When Benson got a little deep in his analysis of the EC books, Feldstein reminded him, "I was young and newly married, and I was trying to make a living. I had children, infants, and I was a freelance comic book artist-writer, and I had to make a living. Now, what I had to do was to grind out the material, and really, this may disillusion a lot of people, but to me this was a job—this was another job to do.

"I wrote a story as well as I could ... and then I drew it as best I could in my particular kind

Federal Express

Federal Express has forever changed this industry. Even in '84, to break in, you still needed to be in New York. That was the ideal: You were there, local, accessible. Now, it's reached the point where no one wants to see you in the office because you're a nuisance. We have Federal Express; it can be here tomorrow if you're in Guatemala.

Between '85 and '89, I noticed more people moving out to inaccessible locations. Lots of people are moving farther and farther away. People discovered, "I don't have to live in New York. I'm writing two books a month, I can buy a Victorian mansion in a depressed steel town and be king of my own local area."

There are a lot these guys moving off to Vermont, Virginia, buying estates. Even if you have to drive 15 minutes to meet your Fed Ex dropoff point, you're still accessible in a day.

Faxes were the second stage ... I can get it tomorrow! Weeks collapsed into days collapsed into hours. Once Federal Express went into place, people were very disappointed when they didn't get to use it. They liked the instant gratification. 'It's in! And the check is ready!' And nobody wants to go back.
BARBARA KESEL
LONGTIME COMICS EDITOR

> **GOING STEADY WITH PEGGY**
> Al Feldstein's tryout for EC Comics was a teenage romance story, "Lashes to Lashes." Feldstein had been doing similar stuff for Victor Fox, so Bill Gaines tested Feldstein's pencils on Peggy's nine-page adventure with false eyelashes. The story was never published—teenage romance took a big dive in the early 1950s—until John Benson tucked it into *Squa Tront* #8 in 1978.

of stiff, stylized style. And that was it! When I was finished with it, I got my check for $222.50, or whatever it was, and I went on to the next one, because I had to get the food on the table, you know, and pay for the car I was going to buy, and maybe someday own a house out on the Island, because I lived in a three-room apartment. So, really, my conscious drive was to make a buck. And if, in the process of making a buck, I turned out material that has become 'classic' in the comic format, and has a great deal of nostalgic feeling about it, and people are now analyzing it, and everything, I scratch my head. I really can't help you on that level."

Once Feldstein was freed up from his art at EC, he wrote—Benson observed—"just about all the stories that are generally thought of as being the core of the EC mystique, namely the horror, crime, and science fiction stories with cover dates from mid-1951 through the early months of 1954."

George Evans was fascinated watching him work: "If he planned to write a seven-page story, he'd start writing at page one, panel one, and it would end just right, on page seven . . . without any outlines or anything else. I asked him one time, 'Gee, Al . . . how do you do it?' and he said, 'I don't even want to talk about it! I just have it all in my head and when it comes out even in the end I just say a prayer of thanks.'"

When prayers failed to save EC, and the New Trend titles crashed, Gaines was forced to let Feldstein go. He was literally wandering the street, looking for work, when he bumped into Gaines, who was waiting for him at the Merrick subway station.

"Harvey quit," Gaines said. "Wanna come back to work?"

Feldstein become editor of *Mad* magazine, replacing Kurtzman after issue #28. "Bill was so cautious he only gave me two colors for my first cover," Feldstein said. They both loosened up. And *Mad* made them both rich.

Feldstein retired in 1984. After taking up skiing at age 62, he moved first to Jackson, Wyoming, then bought a ranch in Montana, less than two miles off the Yellowstone River. On his 270 acres, Feldstein roams with 6 horses, 17 cats, and 4 dogs and manages to paint EC cover reproductions for New York auction houses.

Felix the Cat

The history of this cat should be required reading for any creator who doesn't realize how lucky he or she is to be working in the 1990s and not the 1920s.

Felix the Cat was created by Otto Messmer while he worked for animation produc-

In a classic story for Weird Science *Gaines and Feldstein played themselves as the main characters, creating a fictional bomb that turns out to be identical to a top secret government weapon.*
(© 1998 William M. Gaines, Agent, Inc.)

Feldstein was the cover artist for many of EC's fantasy and science fiction books, as well as writing, on average, four stories each week.
(© 1998 William M. Gaines, Agent, Inc.)

> **Female Dismemberment**
>
> *At that time, really, it seemed that what male cartoonists were into more than anything else was female dismemberment. For most of them, rape was considered absolutely one of the funniest jokes in the world. If you tear the victims up afterwards, it's terrific.*
>
> TRINA ROBBINS, *reminiscing about the Golden Age of comic books*

er Pat Sullivan. Messmer devised and directed the shorts that made Felix "the first animated character in a film series to have a unique personality," John Canemaker wrote. But Sullivan sold the films and glued *his* name to the character.

"The Sullivan-Messmer 'partnership' was grossly inequitable," Canemaker notes: "Messmer never received public credit for his contribution to the Felix films, nor did he own any rights in the character's lucrative image."

Felix—drawn black because the color moved better on film—debuted in *Feline Follies* in 1919. He moved to the Sunday comics page in 1923 (Sullivan's name topped a strip that was written and drawn by Messmer), five scant years before young Walt Disney unveiled Mickey Mouse in *Steamboat Willie*. While Messmer gave his cat a personality, Disney gave his mouse a voice. By the time Felix made his first comic book appearance in 1942—Dell's *New Funnies* #67—the mouse was in a different universe altogether.

Fiction House

"The most perused, but least read, of Golden Age comics," the *Overstreet Comic Book Price Guide* notes, and the perusers were rarely disappointed. Artists such as Bob Lubbers, John Celardo, Graham Ingels, Rafael Astarita, Lilly Renée, George Tuska, Nick Viscardi, and the incomparable Matt Baker delivered some of the era's best good-girl art.

Fiction House hit the comic racks in 1938 with *Jumbo* #1 and kept them spinning for the next 15 years. That book held its own—its first eight issues were oversized black-and-white comics—for 16 months before *Jungle*, *Fight*, and *Planet* debuted with January 1940 cover dates. By the fall of 1941, *Wings* and *Rangers* filled out the Fiction House six-pack.

Will Eisner and Jerry Iger's shop supplied the early artwork and storylines for Fiction House, but in 1940 company president Thurman T. Scott decided to form his own comic book department. After Eisner went his own way, Iger continued to supply Scott with many of his complete stories, but whenever possible Scott sweet-talked Iger's mainstays into joining the Fiction House staff. Zolnerowich, Viscardi, and

> **COMPLETISTS**
>
> When Dave Curtis was growing up in Wisconsin in the 1940s, Mom had one rule about the comic books: The ones with the ladies in leopard skins were strictly for the kids growing up in Iowa.
>
> "My mom was very protective," Curtis said, and the Fiction House covers looked particularly threatening. So, Curtis did without until some time in 1982 when he stumbled on a short run of *Jumbo Comics* (#58–#61).
>
> He wanted them all, he soon decided. Not just the *Jumbo*s, but the *Jungle*s and the *Rangers* and the *Wings*. For the next nine years, Curtis went after the entire Fiction House run, picking up books when they came available, upgrading whenever he could.
>
> Curtis bought 95 percent of his books through the mail, taking his lumps when comics advertised as near-mint were near-disasters. He dealt with over 100 dealers and remained on good terms, he said, with all but Ernie Gerber. And in 1991 when he finally picked up *Planet* #14, Curtis had all 843 Fiction House comics. The complete set. The entire rack. The whole shebang.
>
> The *Planet*s were the toughest to track down, except for the four obscure *Toyland Comics*. *Wings* were the toughest to find in high grade. But none, it turned out, had incredible staying power. Eighteen months after completing his set, Curtis sold the entire lot to Harley Yee for about $40,000.
>
> "All and all, I probably made $800 on the whole thing," Curtis said. "I invested a lot of money. It's like putting your money in the bank and getting 1 percent interest."
>
> But how could he dump a collection that took nine years to put together? How could he invest that much time to bring the runs together, then scatter them, again, here, there, and everywhere?
>
> It was easy, Curtis said. "Once you've done it, you've done it. I've had a lot of different collections. I had that collection for 18 months, then I went on to something else.
>
> "The thing that set me to selling the comics was I was scared those things were going to deteriorate into nothing. Plus everyone's interested in the X-Men."

Fiction House comics are collected primarily for their good-girl cover art. Artists represented here include Maurice Whitman (*Fight* #74), Bob Lubbers (*Wings* #90, *Rangers* #42), and Joe Doolin (*Jungle* #75).

(© Fiction House)

DEEP SEX SHOT

The standard suggestion on a Fiction House script when the writers wanted the art to get a little suggestive was to order a "deep sex shot."

"They knew what people were buying," George Evans said. "I guess a lot of stuff would be considered sexist today, but it wasn't then. What's Shakespeare's line? 'Nothing is good or bad but thinking makes it so?'

"You'd get a script from the writers and it would say, 'a deep sex shot.' What that meant wasn't anything obscene or risque by today's standards. Let's say you had Nick Cardy doing Camilla. He'd have you looking past her legs, from the waist down, to wherever her hero was, fighting with some ape. What they called the deep sex shot might be her profile, with the leopard skin on."

Of course, Evans added, "When Nick did the the Camilla [pencils], she didn't have a stitch on. In every panel she was nude. When he inked the pages, he simply put the leopard spots on."

The "deep sex" designation left it up to the artist—be it Cardy, Bob Lubbers, Fran Hopper, or Lilly Renée—just how suggestive the shot should be. But the editor always had the last word. Murphy Anderson recalled when George Gross, one of the top pulp artists at Fiction House, unveiled a magnificent cover for a detective magazine.

"The cover was simply a blonde standing with a smoking gun in her hand and wearing a bathrobe that was open like this," Anderson said. "A very provocative cover. We all stood around looking at it. [Editor] Jack Byrne looked at it and said, 'No, George, this will never do.' George, of course, was crestfallen. Then Jack said, 'No, this will never do. You have to open up the robe a little more.'"

A Fran Hopper page from *Rangers*, amply illustrating what Fiction House scripters meant by a "deep sex shot."
(© Fiction House)

Baker all eventually came on board.

When Astarita arrived at the Fiction House office on 8th Avenue at 34th Street, he remembers two rooms—one for the pulp writers, the other for the cartoonists—separated by a glass-enclosed office. In that office sat the editors and a receptionist/production assistant named Jeannie Lippi.

Scott rarely showed his face in New York. Lubbers doesn't remember ever seeing him at Fiction House, and Anderson only saw him once. "He lived down in Georgia on a pecan plantation," Evans said. "He had married the daughter of the guy who founded or was operating the Fiction House line. One Christmas he came in and brought a bunch of pecans for everyone on the staff. I don't know how the others were, but most of ours were wormy."

Yet Scott had significant input on what mattered the most: the comic book covers. "All the covers were cleared by Scott," Anderson said. "Joe Doolin would send these little drawings down to Scott [in Georgia] and they'd come back with a lot of little corrections. 'Move a finger.' He was into it that much. As I understand it, that's the way he also controlled the pulp magazines. He felt—very correctly—that that's what actually sold the books."

Once the Second World War began, Iger had two criteria for the artists he hired: They had to produce provocative covers or they had to be ineligible for the military draft. The Eisner-Iger shop was hit hard by the draft when America first entered the war, so Iger (and, later, Scott) retaliated by hiring artists the Marines couldn't touch: Women. Lilly Renée Wilhelms Peters, Ruth Atkinson, Frances Hopper, Ann Brewster, Nina Albright, and Marcia Snyder. Iger also hired Lee Elias, whose local draft board was several thousand miles away in Britain.

When the war ended, Fiction House had moved to 670 Fifth Avenue. General manager Mal Reiss and Jack Burne, the managing editor, hired back most of their old talent, and once

again the publisher's talent pool overflowed.

Most of the artists agree that those were the days. They were paid on Fridays, Lubbers said, and every week Viscardi, Celardo, Artie Saaf, and Lubbers would cash their checks at Manufacturers Hanover, then head uptown to the Alexandra bar on 49th Street.

"We'd go for martinis starting at 12," Lubbers said. "Straight up. Buck and a half. I remember how delicious they were. We would soak those up all afternoon and recount war stories and just have a lot of fun.

"It took us a while to get back into civilian life. We were rejoining the civilized world, enjoying our freedom, enjoying the kind of camaraderie we still had when we were in the armed forces. Remember, when we got home, our wives wouldn't let us loose."

"When we came back, we were a wild bunch," Celardo said. "We might go out for martinis at lunch and never get back to the office. That was a carryover from the drinking we started to do in the service. There was an alcohol problem because of the loneliness and the trauma of war. We were sort of wild and crazy."

George Evans thought the "unrestrained zaniness" so annoyed the editors that it played a big part in their decision to close the office in the late 1940s and run Fiction House on a piecework basis.

Evans recalled that he, Frank Doyle, and Mike Peppe wrote text stories, such as the page of "Jungle Facts" for *Jungle Comics*. "These things were always related to the books they published," Evans said. "You might look through the encyclopedia and find that the cheetah ran 50 miles per hour. If you looked for the oddball stuff, which Frank and I were prone to do, we would dig a little deeper and find that the Disney people, while filming in Africa, actually determined that the victim has accepted the fact that it is the victim. It will give the cheetah a run, but it's really not trying to escape.

"Anyway, Bub Lubbers was an irrepressible devil of a guy. He went to a 'Famous Illustrators' show and was astonished to find that people like Ben Stahl, big names in the slick magazines, did porn drawings for private collectors or their own fun and games. So he came back with the idea to tag a couple pages 'Sex Facts' and 'Baseball Facts.' We spent a couple days concocting the baseball facts. In the 'high fly,' you'd see the outfielder with his pants over his head. 'Sliding into the bag?' You can imagine what that was all about. Anyway, Burne and Reiss caught this [when] they came walking through the office, talking about deadlines and a message from T. T. Scott that profits were down."

The next thing Evans knew, the editors had announced they were closing most of the office and the work would continue on a freelance basis.

Fiction House stumbled along for several more years, but the best years of its life were over.

Fighting American

This title was "the first attempt at satire in comics," co-creator Jack Kirby told *The Comics Journal*. The butt of the jokes was another Kirby creation, Captain America. Kirby and Joe Simon published seven issues of the comic, the first in April–May, 1954.

In that first issue, look for the panels in which the Fighting American punches a thug's head through the wall and the schmuck hangs there—his head in one room, the rest of him in another—for the rest of the story.

Fighting American revealed Simon and Kirby's knack for humor.

(© Joe Simon and Jack Kirby)

A typical Schomburg cover for *Fighting Yank* (#12, September 1945).
(© Standard Comics)

Lou Fine did some of his best interior work on the Black Condor series that appeared in *Crack Comics*.
(© Quality Comics)

Fighting Yank

This comic is truly forgettable except for the Alex Schomburg covers on issues #4–#29.

The Fighting Yank — who also appeared in *Startling* and *America's Best*—was Bruce Carter III. Issue after issue, he "dons the invincible robe of his patriot ancestor": the original Bruce Carter, who died fighting against the British in 1779. Whenever the robe fails, Carter's ghost materializes ("Whenever my country is in danger, you must live . . . to serve America!") to rescue the Yank and his female companion, Joan Farwell.

The storylines are absurd (in issue #6, Joan scrawls a message in lipstick on a scrap of her dress, then throws it from an airplane . . . right into the Yank's lap) and the Jack Binder artwork abysmal. Mort Meskin arrived to clean up the mess in the last five issues of the 29-issue run.

Adolf Hitler makes frequent cameos in plots that are merciless to the Axis powers. Backing up the title character are features such as "Don Davis, Espionage Ace," "The Oracle," "Super Sleuths," and—our favorite in a runaway—"Jill Trent, Science Sleuth."

Fine, Lou

When I first saw his work, I was flabbergasted. I couldn't believe anyone could create these action shots and this beautiful brush work he had.
BOB FUJITANI

He was almost a poet the way he drew his figures. The covers he did for Fantastic . . . *Words can't describe the way I felt seeing those covers.*
MURPHY ANDERSON

There's no question that Lou Fine was a genius.
GILL FOX

If I'm so famous, why aren't I rich? If I was so great, why aren't I rich?
LOU FINE

Lou Fine's work had a strange effect on other artists. Gill Fox used to dig his originals out of the trash. Fox didn't care if he could save only half a splash page or a cover stained with footprints. He couldn't bear to see Lou Fine's brushwork disappear into the incinerator.

Bob Powell used to say that Lou Fine could make a brush talk, and in *The Dreamer*, Will Eisner commemorates one thin, piercing scream. The story goes that when Eisner split with Iger, he stocked his new shop at Tudor City with Japanese brushes that cost one-tenth as much as the familiar, stable Winsor & Newtons. The brushes were so stiff that only Eisner and Fine could make them sing. And when Eisner tried to show what a tight, thin line he could produce with the brush, Fine drew one that was even finer.

Lou Fine was born in Brooklyn in 1915. He learned to draw while recovering from polio, a disease that left one of his legs shorter than the other, and hit the big time when he enlisted with Eisner and Jerry Iger in 1938.

No one in the shop had Fine's ability to invest a comic book cover with both raw power and grace, so Eisner handed him most of the Fox

Feature books, including *Fantastic, Science,* and *Mystery Men.* But Fine saved his best work for Busy Arnold. Joining the Quality staff in 1939, Fine drew the Black Condor for *Crack Comics* and Uncle Sam for *National Comics,* and *Dollman,* and he subbed for Eisner on *The Spirit* when Eisner disappeared into the Army. But he is best known for two epic efforts: The Ray in *Smash Comics* (under the house name E. Lectron) and his covers for the first 17 issues of *Hit Comics.*

Fine drew the Ray in *Smash* #14–#22, a stirring stretch that Jim Steranko compared to Jack Kirby's work in the first ten issues of *Captain America.* Ernie Gerber paid tribute to Fine's cover art when he tried to sell the Mile High run of *Hit* #1–#24 for $41,000 in 1991.

Fine left Quality for magazine illustration—in *American Weekly* and *Boys' Life,* among others—and advertising strips in the mid 1940s. When years later Gill Fox told Fine how highly his work was regarded by comics connoisseurs, he couldn't understand why anyone was extolling his comic book art, work that had never brought him fame or glory.

Hames Ware notes, "A lot of stuff that passes for Lou Fine is actually Bob Fujitani. He sneaked his name in a lot of places. The best way to tell the difference is that Fujitani's work has a humorous edge to it that Fine's does not. But no one bothers to differentiate. People who have this stuff want it to be by Lou Fine. Very few people know otherwise. A lot of comic books are given assigned credits by people who own them, who want to believe that some of the most famous people did the work. Nobody knows the difference except the rare few, some of whom aren't inclined to feed the price guides information."

Fine spent the final years of his life living in Connecticut, not far from Gill Fox's home in Westport. Fox said that after Fine's wife, Mary, died of a heart attack, "Lou lived alone and was lonely, he used to tell me. Then he told me he'd met a woman, who was a delight and all. He had two kids, she had two kids. So they got married, they had the four kids, and the four kids were driving them up a wall. So what did Lou do? He left her in the house and bought another house a couple blocks away. He lived in the studio there, him and his two kids, and she and her two kids lived in the other house. He and she had a beautiful relationship, despite that."

Fine worked on several comic strips, including *Tayler Woe, Adam Ames,* and *Peter Scratch.* He was developing another strip with Stan Drake in 1971 when he was found lying on the threshold of his studio, dead of a heart attack.

Lou Fine covers (with several assists by Will Eisner): *Blue Beetle* #1; *Fight* #1, 4; *Jumbo* #9, 10, 11; *Jungle* #1; *Hit* #1–14, 17; *Mystery Men* #1–5, 8, 9; *National* #14–16; *Planet* #1; *Science* # –2; *Wonder* #2; *Wonderworld* #3–12

> Lou Fine's covers are prized by collectors. This classic skull cover was for *Hit* #7 (January 1941).
> (© Quality Comics)

Finger, Bill

If he had lived to share the spotlight with Tim Burton, dance with Kim Basinger, and enjoy a Laker game with Jack Nicholson, we might be able to forgive what happened to Bill Finger. But Finger didn't survive to see *Batman* take Hollywood apart. He didn't survive to finally hear Bob Kane interrupt an orgy of gloating and name-dropping to concede that good ol' Bill "never received the fame and recognition he deserved."

"He lived in the shadow of Bob Kane, even though he helped create Bob Kane," said longtime DC editor Murray Boltinoff. "He built Bob Kane's reputation and was kicked in the behind for it."

Parceling out the credit for Batman, and his entourage, is a dangerous enterprise. Kane, of course, demands too much credit, and his detractors accord him too little, often to their

Finger, Bill

peril. When Mike Barr, then a DC editor, wrote to *The Comics Journal* in 1986 arguing that Finger had never received credit for his contributions to Batman, he was immediately fired by Dick Giordano. "Freelancers can speak out against the company; staff editors cannot," Giordano told Barr, adding that he considered Barr's letter his "resignation as DC editor."

Clearly, Finger—at the age of 25—wrote the first two Batman stories in *Detective* #27 and #28, the first Robin tale in *Detective* #38, and most of the best stories thereafter. He dreamed up the Penguin and Catwoman and discovered the look of the Joker in the twisted grin of Conrad Veidt and the details of the Bat Cave in an issue of *Popular Science*.

When Kane was struggling to put The Batman together, Finger suggested the ears, the mask, the cape, and who knows what else. Consider this: When DC editor Vin Sullivan asked Kane, in early 1939, for the new adventure series that became "Clip Carson," Kane called Finger for assistance. The Batman probably rose out of a similar cry for help.

DC writer Al Schwartz begs us to remember that Finger and Kane "were just kids when all this started." He believes "the real creation of Batman was Bill Finger's work. Bob's parents were much more skillful in getting the legal papers and getting the thing all signed up for him. Bill's parents weren't equipped to do that."

Although they were in high school together at De Witt Clinton in the Bronx, Kane and Finger didn't meet until a party after graduation. Finger was selling shoes at the time, so small wonder he jumped at the chance to do a little writing, even if he was only writing a few comic book scripts.

They conspired on "Rusty and His Pals" and "Clip Carson" before Kane went home one weekend, determined to dream up a moneymaker to match Jerry Siegel and Joe Shuster's. Finger was always tucked safely into the background of Kane's agenda; he wasn't hired at DC until the fall of 1939.

"Bill Finger was a genius," Dick Sprang once said, "the best writer in the comics." Finger had a clip file that major newspapers would kill for and a famous black book in which he would dive for gimmicks to keep his Batman tales rolling along. (Julie Schwartz paid tribute to that book when he created a Green Lantern villain with a book filled with tricks and named him "William Hand.")

Finger wrote the first Green Lantern story, and most certainly was late delivering it. "Bill was a very passive individual," Al Schwartz said, "and he tended to do things which are best characterized as passive-aggressive, like being late all the time."

"Anyone who had anything to do with Bill Finger would sooner or later run into problems, like his borrowing money or being late on deadlines," Boltinoff said. "Bill was always broke. He was almost a cliché as a writer. But I'd take Bill Finger over anyone in the stable. The finished product, you know. When you got it, if you got it, it would be a good script."

Good enough for a byline? "I never thought of giving him a byline and he never asked for one," Kane wrote in his autobiography. No, Finger never asked for much and ended up

Although he never received on-page credit for writing Batman, Bill Finger was credited for his Green Lantern work. This page from *All American* #16 (July 1940) tells the origin of the character, with art by Marty Nodell ("Mart Dellon").
(© DC Comics, Inc.)

with less. Just about everyone who knew Finger stammers when they recall the last time they saw him. A year before his death in 1974, Kane sat down with him in Central Park and heard Finger complain that "success had passed him by. I had to agree, for I realized that Bill could have become a great screenwriter or perhaps the author of a best-seller instead of hacking out comic book stories anonymously."

No one else ever suggested Bill Finger was a hack, but—while Bob Kane waltzed off with the credit for Batman—Finger died believing he was one.

Fisher, Bud

The creator of *Mutt and Jeff*, Bud Fisher was the first millionaire strip artist. Born in Chicago in 1885, Fisher struck it rich in San Francisco when, after a few years in the sports department and layout desk of the *Chronicle*, he started his *A. Mutt* strip in 1907. Within six years, he was earning $50,000 a year for his efforts.

"His contributions to the medium didn't end with defining its format," R. C. Harvey once wrote. "To begin with, Fisher had the foresight to copyright the strip in his own name. Further, he had the audacity to go to court to protect his rights." The court twice ruled that when Fisher moved *Mutt and Jeff* to another newspaper, his former employer could not continue to run a pale imitation of the comic duo.

As flamboyant a character as any he ever sketched at the drawing board, Fisher died of cancer in 1954. Rube Goldberg delivered the final farewell at the cartoonist's funeral.

Fisher, Ham

Before he hooked up with Al Capp, the relationship that would change his life and secure his wretched reputation, Ham Fisher was a hustler from Wilkes-Barre, Pennsylvania. "In the late 1920s Fisher moved to New York," Robert Boyle wrote in *Sports Illustrated*, "and went to work as a salesman for the McNaught Syndicate. In a whirlwind 39-day trip, Fisher sold Striebel and McEvoy's *Dixie Dugan* to 41 papers. Awed, Charles McAdam, president of the syndicate, succumbed to the Fisher sales line himself and gave Fisher permission to sell Palooka."

That would be *Joe Palooka*, of course, the comic strip that made Fisher famous before Al Capp made him infamous. "By the mid-1930s," Boyle observed, "the strip . . . was appearing in 600 newspapers and had more than 50 million readers. When, after one fight, Joe announced that he had trained solely on cheese, the sales of cheese shot up so spectacularly that the National Cheese Institute gratefully crowned Fisher 'Cheese King of 1937.' Fisher himself was well on the way to making $250,000 a year just from the strip alone, and he added to this with royalties from radio, movies, comic books and a slew of enterprises using the Palooka image. He hobnobbed with the rich and famous, and he drew them into his strip."

Better yet, Capp or another of Fisher's ghosts drew them. Shortly after arriving in New York in 1933, Capp was strolling through Central Park South when a sleek, expensive car snuggled up to him. As Martin Sheridan told the story, the driver of the car said, "I've made a bet with my sister that the roll under your arm consists of cartoons." When Capp confessed they were, Fisher invited him along for a ride and offered him a job assisting him on *Joe Palooka*.

"I worked with Fisher for several months," Capp told Sheridan, "and owe most of my success to him."

"I owe all my success to him," Capp wrote years later in his *Atlantic Monthly* dissection, "I Remember Monster" (see Al Capp sidebar). "From my study of this one li'l man, I have been able to create an entire gallery of horrors. For instance, when I must create a character who is the ultimate in cheapness, I don't, like less fortunate cartoonists, have to rack my brain wondering what real bottom-of-the-barrel cheapness is like. I saw the classic of 'em all. Better than that, I was the victim of it."

Fisher, understandably, felt victimized by Capp's literary jabs; he feared he'd lost all the glory that Palooka had helped him gain. Shortly after the National Cartoonists Society expelled him in 1955 for turning to forgery in his campaign against Capp, Fisher committed suicide with an overdose of pills.

The Flash

"Remember," Julie Schwartz once said, "the original *Flash* only lasted for nine years. We didn't think the new Flash would last half that."

The original arrived on the wings of Gardner Fox and Harry Lampert in *Flash* #1 (January 1940). In Fox's origin tale, Jay Garrick was your

"The creator of Mutt and Jeff, Bud Fisher was the first millionaire strip artist."

The revival of the Flash in *Showcase* #4 (October 1956) is often credited as ushering in the Silver Age of comics. The cover art is by Carmine Infantino and Joe Kubert.
(© DC Comics, Inc.)

Shary Flenniken

average Midwestern white boy until he was gassed in a chem lab. When Garrick came out of it, he was so fleet of foot that he could beat the horn of a New York cab off the line at a Manhattan intersection.

The Flash was a regular in *All-Flash, All-Star, Comic Cavalcade,* and his own book, finally retiring after *All-Star* #57 in 1951. Five years later, Julie Schwartz and Bob Kanigher brought the character back in *Showcase* #4, the cornerstone of the Silver Age.

In his second life, the Flash was Barry Allen, a police chemist who, after gaining super speed from being struck by lightning in his police lab, took the name of his favorite comic book character.

The Flash regained his own book in 1959, *Flash* #105. "That in itself shows how much things have changed," Schwartz told *Amazing Heroes*. "We thought then, 'We had this perfectly good comic. Let's pick up from there.' Now, companies fall all over themselves publishing first issues."

Two years later, Fox and Schwartz bent the DC universe past the breaking point. In *Flash* #123, Allen vibrated himself into the parallel world where his namesake, the Golden Age Flash, was still racing around like a house afire. The concept of multiple universes was born; it wouldn't die until *Crisis on Infinite Earths* in 1986.

"Of course [the concept] wasn't meant to continue for 25 years," Schwartz said. "Gardner Fox and I just thought it would be nice if the two Flashes could get together. It was just a story. I made my mistake when I called the new Flash's world Earth-1 and the original's Earth-2"

Allen died in *Crisis* #8. Now suiting up as the Flash is Allen's nephew, Wally West, the former Kid Flash and a charter member of the Teen Titans.

Flash Gordon

The comics' most famous polo player, Flash Gordon, was created by Alex Raymond and sent into orbit in 1934.

Once Flash, Dale Arden, and Hans Zarkov escaped this world, the strip was set on the planet Mongo, where Ming the Merciless supplied the necessary tyranny.

"Let's face it," said Al Williamson, who worked on the 1966 *Flash Gordon* comic book for King, "the strip when Raymond did it [had] pretty dull stories. But because it was the first, everyone was quite amazed by it."

That's because Raymond was such a consummate draftsman. "Never has art so transcended story in comics history," historian Rick Marschall observed, "and never has there been an artist like Raymond."

He had few peers when drawing women, whether she be Dale; Ming's daughter, Aura; Desira, the queen of Tropica; or Fria, the queen of Frigia, looking decidedly unfrigid in her "transparent garb."

Each Raymond page was a portrait gallery, but the beauty of the strip was only skin deep. Raymond joined the Marines in 1944, and his passion for *Flash* didn't survive the war. "Perhaps it was the grim reality of war that made Raymond forsake his fantasy hero," collector Woody Gelman once said.

And, sadly enough, our fantasy heroines, too.

Flenniken, Shary

A Seattle-based underground cartoonist and one-time cartoon editor for *National Lampoon,* Shary Flenniken got her start with the infamous Air Pirates. She first fell in with Dan O'Neill's crowd at the 1970 Sky River rock concert, where she and a dwarf named Maurey were cranking mimeographed concert updates out of the back of a pickup truck.

Flenniken hooked up with—and later briefly married—fellow Air Pirate Bobby London, but O'Neill was clearly leader of the pack that returned to San Francisco to draw comics and work the cons. The Air Pirates lived in the Zoetrope warehouse, which O'Neill had rented from Francis Ford Coppola, practicing improvisional theater ("The stage being the comic page," Flenniken explained) and living off the money O'Neill scammed from all number of places. They were still living there when the fed-

eral marshals showed up and told O'Neill his dream had come true: He was being sued by Disney for the Air Pirates' raucous, erotic parodies of the Disney cartoons.

Life was never quite so simple again. "I was suddenly married to a guy who was being sued for a quarter-million dollars, which wasn't any fun," said Flenniken, who may be best known for her *Trots and Bonnie* strip. The rest of the Pirates "were all doing this guy thing, this bonding thing. There was a lot of bonding and hash smoking and stroking each other, real macho 'we're all in a war together' with the guys. I grew up with boys; I'd seen that before. I thought it was real dumb. And I thought it was real dumb to waste their talent."

"This is why I'm Dan O'Neill's friend for life," Flenniken later told *The Comics Journal*. "When these other guys were mean and competitive—just being 20-year-old assholes—he was saying, 'We need you. We need women. You have to stay here.'"

Flessel, Creig

Even though he was the cover artist on all but one of the first 18 issues of *Detective Comics*, Creig Flessel still maintains, "The only claim I have to fame is longevity."

Born on Long Island in 1912, Flessel rolled out of Grand Central Art School in 1930, when the Great Depression had America by the throat and was gritting its teeth. "That was the bottom," Flessel said. "The age of illustration was dead. Magazines were going out. All the old illustrators were struggling to make a buck."

Flessel got by on the pulps until he spotted a DC help-wanted ad in 1936. He was chasing down every ad for artists or cartoonists; this one led him to Major Malcolm Wheeler-Nicholson.

The Major was, Flessel figured, old enough to be his father, and this new enterprise was forcing him to age at twice the normal speed. "He was part of the expeditionary force that went into Russia after the First World War,'" Flessel said. "I guess it was a bad job; they didn't stay long, but on the way back he picked up the lady-in-waiting to the queen of Sweden and married her."

Wheeler-Nicholson had some nice moves, in other words, but in the early days of comic books, he was in way over his head. "It was a fly-by-night operation," Flessel said. "There was no money around at all. Process servers were chasing the Major."

Flessel didn't want to join the chase. "I figured money was so scarce, I'd work right in the office. If you look at the early covers, I sat there and did all those covers with a half-dozen people climbing all over my back, which is why they're so bad. I did them all sitting there, so they had to pay me before they paid all the other guys."

They didn't pay him enough for his work on *Detective* and a half-dozen of the pre-superhero *More Fun Comics,* and several early Sandman appearances. "Whit Ellsworth and Vince Sullivan? They believed," Flessel said. "I didn't believe in it. I didn't believe comic books were going anywhere. As soon as I could, I got out and got into advertising."

Flessel went to work for Johnstone and Cushing, on accounts such as EverReady flashlights, Camel cigarettes, and Campbell soups. "All of that money that now is in TV was being poured into the bottom of the comic page," Flessel said, and he was there to snag his share.

That wasn't his only link to the comics. During the war, Flessel did some jobs for the Office of War Information; he created a character named Nurse Jane to help with the fat salvage effort. That's right, fat salvage. In letters

Creig Flessel's main claim to comics fame is his work on the Golden Age Sandman for *Adventure Comics.*

(© DC Comics, Inc.)

Creig Flessel

from the front, Nurse Jane would tell newspaper readers how much she appreciated the bacon fat they were pouring into the coffee can by the sink. "I think it was just a ploy to get people to do something worthwhile, like a lot of things that happened during the war," Flessel said.

And once a month, Flessel would catch a plane to Boston and perform some vital work on *L'il Abner* for Al Capp. "They needed someone to do the pretty girls," he said. "There was Andy Amato and Harvey Curtis and Al Capp himself, and none of them could do pretty girls. All I had to do was go up there and draw the big boobs. It was no problem. I could do most everything."

Those weren't the last big boobs Flessel penciled. In 1980, he started a feature for *Playboy* magazine called "Baron Firstinbed." It wasn't Flessel's best work, but it was a familiar theme: When the comic books got their start, Flessel was one of the first on board.

Flip

This two-issue magazine put out by Harvey in 1954 was one of the best of the *Mad* imitations, thanks to the work of Howard Nostrand.

Foster, Hal

> *Never shoot a sitting bird, never take more fish than would fit in a frying pan, never take more liquor than you can hold like a gentleman.*
> HAL FOSTER

"The best page I ever did," Hal Foster once said, "was Prince Valiant in the Aegean Sea, and he'd been cast away in a small boat, and through the mist, he saw this island with a palace on it, stretching up into the sky..."

The best page he ever did, Foster added, was never published: "Not enough action," the editor's note said.

The 1,789 pages that were, however, rank Foster as perhaps the grandest comic strip illustrator of them all.

Born in Halifax in 1892, Harold Randolph Foster was adept at fishing, hunting, and fur trapping before he left school at the age of 14 to support his family. "I always credited my natural stupidity," Foster told Arn Saba, "for putting me in the way of learning and experiencing things."

He even tried his hand at boxing, before deciding he could put his fists to better use. Foster once joked that he had learned to draw quickly because one couldn't go long in the Great White North without mittens, and Saba reported that, to perfect his art, Foster had sketched "himself in the nude in front of a mirror until he turned blue from the cold."

In 1921 Foster biked from Winnipeg to Chicago; within an hour of his arrival, he was robbed. But he picked up a job with Palkenski Young, a Chicago commercial art studio, and plugged along until his 1929 illustration of a newspaper Tarzan adaptation prompted Edgar Rice Burroughs to ask Foster to draw the daily *Tarzan* strip. It debuted on January 7, 1929—the same day as *Buck Rogers*—and two years later, Foster inaugurated a *Tarzan* Sunday page.

Foster was never a big Tarzan fan. Uninspired by Burroughs's writing, he often sought to improve on it. But his ambivalence never showed. "[Burne] Hogarth's Tarzan could never compare with Foster's," Russ Manning once said. "Hogarth seemed so concerned with the drawing style of his that the apeman and his world just didn't come through real to me. His Tarzan was never a real man... and those stylized muscles just get in the way... also those stylized trees and jungles. But Foster, now... Lordee, what a superb Tarzan! Great head, hard and masculine, but good expressions. And no one has ever drawn the figure in comics as well as Foster. There was one main thing that makes his Tarzan right to me, and none of the others who have ever drawn Tarzan (including myself, Jess [Marsh], Frazetta's 'Thun'da,' Maxon, Hogarth, Rubimore, Lubbers, Celardo... none of us)... the one thing that Foster's Tarzan

Hal Foster's version of Tarzan, from 1931.
(© Edgar Rice Burroughs, Inc.)

had, and it sets him down real and solid, is maturity."

William Randolph Hearst seconded Manning's emotion. In 1936 he wanted a new strip and he wanted no one but Foster to draw it. "Hearst had seen my work on *Tarzan*, and he said, 'Get Foster.' And when Hearst said anything, it was like an edict from Heaven. Everybody scurried around. That's why he was always right. All he had to do was say something, and there were so many people trying to make it come out right in the end."

Foster stiff-armed Hearst's King Features for 18 months while he researched Arthurian legend; *Prince Valiant* finally debuted on February 13, 1937. Thirty-four years later, Foster turned the artwork over to John Cullen Murphy; he continued to script the feature until 1980, two years before his death.

Everyone has a favorite Hal Foster page. Val on the bridge. Val marrying Queen Aleta of the Misty Isles. In those distant days, the comics were the heart of a Sunday newspaper, rather than the giftwrap for *Parade* magazine, and Foster's *Prince Valiant* was invariably the heart-stopping main event.

Four Color

Before any of this modern talk of diversity in comics, there was Dell's *Four Color*.

With *Four Color*, you never knew what was coming. You never knew *when* it was coming.

They came at you three, four, five times a month. One month—say, November 1947—you'd get Mickey Mouse (on Spook Island, no less!), Charlie McCarthy, Walt Kelly's Mother Goose, Flash Gordon, and Winnie Winkle. The next, Tillie the Toiler, Roy Rogers, Donald Duck, Santa Claus, and a brand-new grump named Uncle Scrooge would come knocking on your door.

Whenever the press at Dell was ready, another book would hit the rack. And the press at Dell was invariably red hot and rolling. Sometimes Mickey Dolenz ("Circus boy") would be staring at you from the cover, or Jerry Lewis or Dale

A panoramic Sunday page opener from Hal Foster's *Prince Valiant,* from 1949.
(© King Features Syndicate)

A typical month for Dell Four Color books: October 1947, issues #165–#169. Dell's motto should have been "Celebrate Diversity."

Evans or Annette Funicello or Francis the Talking Mule.

The interior art might be by Carl Barks, Alex Toth, Reed Crandall, Bob Fujitani—or the tracing of some utter hack.

And the hero of the story might be Nellie the Nurse, Oswald the Rabbit, Frosty the Snowman, or Smokey the Bear. Only the middle name remained the same.

The 1,300-odd issues of *Four Color* covered four decades and introduced us to the likes of Scrooge McDuck and Turok and Yogi Bear. The line expired in 1962.

4-F

Superman's draft classification during World War II (thanks to his X-ray vision, he read the eyechart in an adjacent room). Also flunking their physicals were Milton Caniff and a trio of Batman groupies—Bill Finger, Charles Paris, and Bob Kane—the last owing to a punctured eardrum and injured hand he suffered in a street fight at the age of 15.

Fox, Gardner

When Vincent Sullivan went looking for writers for *Detective Comics*, he immediately thought of an old Brooklyn grammar school buddy who'd taken a wrong turn and ended up in a law office. "He'd always wanted to write," Sullivan said. "I called him and he was very happy to get the call, because the law business wasn't that good. So, he decided to tackle some of the things that I offered to him. As he did more writing, he gave up the idea of continuing in law."

The first writer ever hired to script comic books, Gardner Fox stuck with his second career for 34 years. His first story—"The Murdered Ambassador," starring District Attorney Steve Malone—was written in 1938 for *Detective Comics,* and Fox once calculated he wrote 4,122 more.

In the course of those stories, Fox created the Flash, Sandman, Dr. Fate, Hawkman, Ghost Rider, the Justice Society, the Justice League, and those parallel worlds in the DC universe, Earth-1 and Earth-2.

Fox also wrote many of the early Batman stories, including his third adventure—"The Batman Meets Dr. Death"—which ran in *Detective* #29.

Fox once told Rich Morrissey that he did his own scientific research on Adam Strange ("I have two filing cabinets chock full of info, as well as part of the attic"), and his notebooks testify to the care he brought to his comic book scripts and numerous novels. Fox clipped dozens of *Prince Valiant* Sunday strips by Hal Foster and preserved them between notes on Italian Renaissance furniture and medieval lingerie ("In ancient times neither men nor women wore undergarments in warm countries").

He disassembled a copy of Wycliffe A. Hill's *The Plot Genie: Western Story Formula,* then pasted the pages into a loose-leaf notebook. Into that notebook, Fox inserted the names of various western theaters, such as the Bird Cage in Tucson or the Jack Harris Variety House in San Antonio; "borrowed" television plots; clips of western scenes from comic strips; "cowboy marshal ideas" (105, all told); descriptions of desert plants ("Paloverde—grim and sentinel-like, stands along shores of Colorado River where skirts deserts"); and notes to himself, such as "THINK before you write!"

And Fox maintained a notebook of basic comic plotting: "Don't have sympathetic villain. Reader must always be on side of hero. When hero meets villain, reader must want villain to get bopped and jogged."

If he intuitively knew how to get the most out of his talent, Fox never knew how to get his due from DC. In 1968 he joined several other writers in asking the publisher for fringe benefits. "Medical insurance, some sort of plan to lay aside some of our income for a retirement pension, that sort of thing," Fox said. "Jack Liebowitz didn't like the idea, so we were soon out on our necks, and other writers brought in."

Mike Barr's research for *WAP* #5 (August 1988) suggests the writers' disappearing act was a little more complicated than that. "We tried to form a union," Bob Haney told Barr. In on the formation were Fox, Arnold Drake, John Broome, Bill Finger, Otto Binder, and Haney. Clearly, the meetings were noteworthy for who wasn't there: Every DC artist except Kurt Schaffenberger refused to show. Carmine Infantino—soon to be Liebowitz's pick as DC's next publisher—attended one or two of the meetings, Arnold Drake said, then told the writers, "I'm sorry, I'm on the other side."

Gardner Fox

"Don't have sympathetic villain. Reader must always be on side of hero. When hero meets villain, reader must want villain to get bopped and jogged."
GARDNER FOX

The writers were looking for better page rates, reprint rights, medical insurance, and a noose for the cantankerous Mort Weisinger. The writers "were all basically pissed off at Mort Weisinger," Schaffenberger told Barr. "He was the one individual that precipitated the thing. He gave them absolutely no respect, he gave them nothing but grief . . . I was in Mort's office one time when he told Bill Finger—a real constructive piece of criticism—he said, 'I wouldn't wipe my ass with this script.'"

DC didn't fire the writers, just froze them out. Fox wrote the first 65 issues of *Justice League of America,* then was summarily pulled off the book. Within several months, he'd written his last issues of *The Atom* and *Hawkman* and *Detective Comics*. Mike Friedrich saw some of Fox's final scripts and said they were "90 percent copywritten by the editor."

There wasn't much left then at the end, which may explain why DC never offered a 21-gun salute to the only staffer who knew where the Paloverde flourished and the lingerie vanished.

Fox, Gill

A veteran of the Max Fleischer, Harry Chesler, and Busy Arnold shops in the 1930s, artist Gill Fox was still cranking out political cartoons in the 1990s.

Lou Fine created spectacular covers for Victor Fox's comics line. This is *Fantastic Comics* #3 (February 1940).
(© Fox Features Syndicate)

His father was a milkman, and Fox wanted to prove to both of them that he could make a living as a cartoonist. When Chesler offered him work "in the depths of the Depression," Fox said, "I was so excited that I got a nosebleed right in front of his desk."

He learned to pace himself. "Even as a young man, I had foresight," Fox said. "I saw a lot of guys burning out. I deliberately paced myself and therefore never got celebrity status. They treat you differently." Fox's ego didn't require the treatment. When he worked at Johnstone and Cushing during the 1950s, he was quite content in the shadow of Dik Browne and Stan Drake. "You couldn't top them," he said. "You just took the jobs they didn't have time for."

Fox worked on Popeye and Betty Boop at Fleischer, *Wun Cloo, Torchy,* and *Poison Ivy* at Quality, and on the military paper *Stars and Stripes* and for Army intelligence during the war. He was close friends with Lou Fine (he salvaged some of Fine's original art from the trash bin at Quality), Jack Cole, Creig Flessel, and Stan Drake. "I don't think I did anything that was special," Fox says now, but he never surrendered and he never burnt out.

Fox now lives on two acres of woodland in rural Connecticut. "I learned when I was over there during the war that the rural areas are the ones that are left untouched," he said.

Fox, Victor

Fifty years later, everyone would still love a piece of Victor Fox.

"A real badass," Howard Nostrand once said. "Fox was just one of the world's worst people."

"He was a thief in the real, true sense," said Will Eisner. "A real con man."

"Curse the guy," said Pete Morisi.

In the worst of times, Fox was one of the worst at paying his bills. "He would pay these lousy rates and he attracted the worst artists in the world," Nostrand told *Graphic Story Magazine*. "He'd get somebody fresh out of art school and offer them all kinds of money. 'Do this book.' The kid would sit down, and he'd crank out some comic book for a lousy $12 a page, just to get them into print. This is the way Victor Fox got them. And he would renege on it. He wouldn't pay."

Fox entered the fray in 1939, leaving National to form his own company. Rather than waste

time coming up with a novel super-hero, Fox asked the Iger-Eisner shop for another Superman. "He specified what he wanted," Eisner said in *Panels* #1. "He wanted me to create a character that had a red suit with a design on his chest and so forth and so on."

The result was Wonder Man and *Wonder Comics* #1. National's lawyers convinced a judge, with Will Eisner's help, that the comic was a flagrant ripoff (see **Legal Briefs** entry).

Fox got over it. Within a year, books such as *Blue Beetle, Fantastic Comics, Science Comics,* and *Weird Comics* were selling more than a million copies a month. And just so his readers would have something to spill on those books, Fox advertised Kooba Cola, "America's favorite cola drink with Vitamin B$_1$."

He fought in World War II, returning with an astute vision of what the kids would buy when their super-heroes retired. With the help of some future EC all-stars—Wally Wood, Jack Kamen, Johnny Craig, and Al Feldstein—Fox Features gave us *Phantom Lady, All Top, Zoot,* and (in the words of Fredric Wertham) "corpses of colored people strung up by their wrists." For readers who craved warmer, fuzzier images, Fox had *My Confessions, My Experience, My Great Love, My Love Affair, My Love Life, My Love Memoirs, My Love Secret, My True Love,* and *My Past Confessions,* if you catch My Drift.

And what about My Paycheck?

Pete Morisi was just one of the artists who fell for Fox's line in the postwar years. "I needed the money desperately," he remembers. "I had just gotten married. I was so hungry, so desperate to see myself in print, I just blinded myself to these things, I shut out all the voices. I did one or two stories and he paid me, and I said, 'This is all nonsense about dear old Victor Fox.' Then I did two or three more, and I had to start calling. 'Oh it's just a bookkeeping problem,' he said. The check would finally come for a thousand dollars, and I'd tell my wife we could eat this week. Then the bank would say, 'No, no, no.'

"One time, I took the bounced check up to Fox Features and asked the secretary where Victor Fox was. 'He's in meetings,' she said."

Usually that line worked. Bob Haney recalled, "Writers and artists he was stiffing would haunt his sleazy office and his hatchet-faced secretary would fend us off . . . while Fox skulked in his inner sanctum."

But Morisi wanted blood. "'Bull to that,' I said. Just like you see in the movies, I burst through the door. He was standing on the other side of a long table. I leapt across the table. My body was flush across the table with my hands on his throat. I grabbed Victor Fox by the throat and promised to take him apart. I was going to kill that bum. At that point, he grabbed me and all the other guys grabbed me. I said, 'You owe me money, you dirty so-and-so.' He wrote the check right then and there."

And?

"And it bounced. So the guy won. He got rid of me. He ended up owing me $15,000."

He ended up owing a lot of people money. He ended up in Canada, Jack Kirby once heard, but who knows for sure? Few people ever thought to ask about him.

Fradon, Ramona

Her hero, when she was younger, was Will Eisner. It's understandable that I think she surpassed his work.
CARTOONIST DANA FRADON

Understandable, yes, coming from Ramona's husband. Rational, no. Will Eisner? Try Mort Meskin. "Next to Mort Meskin," said Charles Paris, comparing the pencils that wandered beneath his pen, "she was probably the best of those people whose stuff I worked on. She was very creative. Quite versatile. Like Meskin, she left you some room to play around with stuff if you wanted to. You could sock in some blacks, or fiddle with the lighting. She was a fairly clean penciler, possibly cleaner than Meskin was. It was a pleasure to work on her stuff."

Ramona Fradon's first comics work was published by Timely in 1950, but within a year she had left the minors for a big-league job at DC. Her first assignment was a four-page Shining Knight story, and editor Murray Boltinoff was sufficiently impressed to assign her Aquaman, snorkeling at the back of *Adventure Comics*. Fradon drew Aquaman for years; created the unique look of Metamorpho, and impressed

Victor Fox's stable of cover artists was led by Matt Baker.
(© Fox Features Syndicate)

the heck out of writers such as Michael Fleisher.

"When I would do a mystery story and Ramona Fradon would draw it, she would see things in the story that I hadn't even thought were possible, that hadn't even occurred to me," Fleisher once said. "I would find myself looking at them and saying, 'My God, how did she think of that, how did she think of that?' She didn't rewrite the stories, and she wasn't unfaithful to them, but she explored them and gave them a whole new dimension."

In 1980 Fradon replaced Dale Messick drawing the daily comic strip *Brenda Starr*. Seven years later, she wrote a thoughtful farewell to her comic book career in *History of the DC Universe*:

"If I had few social complaints about working in a man's world, however, I had serious difficulty relating to super-hero subject matter, the staple of the comic book industry. I was quite happy in the Seventies, drawing mysteries for Joe Orlando, but when the mysteries phased out and I was reassigned to super-heroes, I knew my time was running out.

"I hated drawing super-heroes. I hated their one-dimensional, robotlike battles with evil. I hated drawing figures 'in extremis,' drawing page after page of unrelenting dynamic tension, and the impossible mass action scenes that were always called for in super-hero stories. Ten thousand figures that took a writer five minutes to describe and took me five hours to draw.

"I could not believe how preoccupied our mostly male readers and writers were with issues of power and control, with villains seeking to conquer the world, with mad scientists plotting to control the solar system or the universe, and with obsessive heroes struggling to defeat the evil scheming. Men and women, slugging, bopping, and zapping each other in the never-ending struggle of good against evil—men's fantasies all, and they're more than welcome to them. Having parted that world at last, I'd just like to send this message back: Relax if you can out there, fellows, things aren't quite as bad as they seem."

Ramona Fradon hit her stride at DC with her art for Metamorpho, the Element Man, in the mid-1960s.
(© DC Comics, Inc.)

Frazetta, Frank

I'm very physical-minded. Brain, fine, but this body is put here for use. If anybody could jump around like my heroes, it's me. Not many artists are physical types. I've been jumped on by twenty guys in a movie theater and got out alive. In Brooklyn I knew Conan, I knew guys just like him.
FRANK FRAZETTA
ESQUIRE, 1977

In 1970 the Doubleday Science Fiction Book Club shipped one of Frank Frazetta's paintings back to his home on Sheepshead Bay in Brooklyn and asked him to revise it.

Frazetta "didn't want to revise the painting," said Bob Barrett, a fan and friend, "so he just decided he'd do another painting for them. He was just dabbling, running his brush around the palette, swashing it around. And before I knew it, this painting began to emerge. All of a sudden, these gnarled trees started appearing and this genie was just there.

"I was just sitting there with my mouth hanging open. Frank is putting the finishing touches on it and he says, 'Ya know, this needs something, I don't know what I want to do with this.' He gets up from his easel and goes over and sits on the sofa and gets out his drawing pad, and all of a sudden he has this black girl sketched. He takes his knife and cuts it out of the sketch book, picks up the canvas and goes upstairs to this projecting machine. He put this cut-out image on the projecting machine and projects it onto the canvas, not to help him redraw it, just to see if it was the right size."

When Frazetta decided it was, he turned off the projector and took the cut-out swatch and the painting down to his easel. "He puts the swatch on top of the painting, outlines the swatch with his pencil and starts painting with no further drawing. In less than an hour the figure was there. He was talking and visiting, telling me what he was up to the whole time, saying, 'Ya know, she needs something more,' so he dipped his brush in the black and ran this flight down the canvas, and there was this staff. He dabbled a little more and there was this skull."

Barrett disappeared into a hefty sigh. "It comes so incredibly easy to the guy. What always infuriated me about him was that he

didn't have to work like other artists do."

"I know that many artists are totally devoted," Frazetta once said. "They'd rather work than eat or sleep. But my art was something that I 'snuck in' from time to time, between living."

Between living, between baseball games with the Fleagle Gang, between his 110 trips to see the movie *King Kong*, Frazetta had time to draw only one complete comic book (*Thun'da* #1) . . . and an array of cover paintings that reinvented Tarzan, Conan, and the idea that a Cat Girl might lurch off the canvas and tear you apart.

"I'm not a great painter," Frazetta told *Esquire*. "I know mood and action and concept." What he knew made his women erotic and his barbarians nasty enough to scare the creeps back in Brooklyn.

Frazetta was drawing at the age of three and a student at the Brooklyn Academy of Fine Arts by the time he was eight. "We used to sit around and draw anything we wanted to as students," Frazetta told *Esquire*. "It was very informal."

Informal was to his taste. George Evans remembers when Frazetta was hired at Fiction House after the war. "They wanted Frank to draw borders and make corrections in lettering and so on, the hack stuff," Evans said. "I don't know why he took the job in the beginning. Maybe they conned him into thinking they'd give him a serious character to do. And he was capable of doing it. Frank used to come in with a little notebook and he was creating his own stories. All day long. He would show it around to the rest of us. The work was as good as anyone there."

They knew it and Frazetta knew it. "When I was sixteen," he confided in the *Esquire* interview, "and finally saw some professionals at work, I knew I could do that stuff easily."

He only stayed at Fiction House for six months, then wandered over to Standard where art director Graham Ingels gave him a shot at Judy of the Jungle and Ralph Mayo gave him a book on anatomy. "I went home that night and decided to learn anatomy," Frazetta told Russ Cochran. "I just started with page one and copied the entire book . . . everything, in one night, from the skeleton up. I came back the next day like a dumb kid and said, 'Thank you very much, I just learned my anatomy.'

"Of course, he fell over and roared: 'Frankie, you silly bastard! I've been studying for ten years and I still don't know anatomy, and you went home and learned it last night?' But the odd part is that I had learned an awful lot. I had

Thun'da #1 was the only complete comic book (cover and interior art) that Frazetta ever produced.
(© Magazine Enterprises)

'67 NEW YORK SCIENCE FICTION CONVENTION

The past and future stars of fantasy illustration were all there at the 1967 New York Science Fiction Convention: Al Williamson, Frank Frazetta, Bernie Wrightson, Michael Kaluta, and Jeff Jones. "I was a lot looser in those days," Wrightson said. "It was a lot freer. For one thing, Frazetta was there; that ought to tell you something. This was just before he became God. He knew he was the best fantasy illustrator on the planet, but it wasn't like it is now, where everyone else knows it, too."

Kaluta said the rookies were hanging out one day at the con when Rich Hauser popped up and said, "Want to meet Frazetta?"

"We ran up nine flights of stairs," Kaluta said. "Frank was on his hands and knees trying to plug in the television set because his kids wanted to watch cartoons. He had no idea the impact his artwork was having. He found out at that convention."

"Bob Barrett and Frazetta went back to Brooklyn, Kaluta said in an interview in *Media Showcase*, "and came back with a big sack of his paintings. The room was filled with people oohing and aahing. Frazetta's standing there scratching his head, going, 'Wow!' He didn't realize that people were really flipping over his stuff, that people understood what he was doing, that he was creating these vibrant fantasy worlds."

Frazetta's cover art, made into prints and posters and collected into a series of books for Bantam, made him a household name in the 1970s.
(© Frank Frazetta)

the ability to absorb and he saw the improvement instantly in my work... I suddenly learned to draw figures that were more believable, simply because the anatomy was more accurate."

Mayo wasn't the only one to pick up the difference. Frazetta's work on "Dan Brand and Tippie," *Ghost Rider, Tim Holt,* and *John Wayne Adventure Comics* began to be noticed. Then the premiere issue of *Thun'da* came along in 1952 and blew everyone's doors off.

The success of *Thun'da* led quickly to work on *Johnny Comet, Flash Gordon* with Dan Barry, several EC assignments, and, in 1954, Al Capp's Sunday *L'il Abner* strip. Capp liked Frazetta's stuff enough not to object when his style took over the strip, but the syndicate was of a different mind. "So, I was forced to do it just like Capp, in his own style," Frazetta said. "You couldn't tell us apart after a while. It was dull, boring stuff, but I didn't care, because uppermost in my mind was the fact that I'm making big plans for me...I know what I'm doing. Any day now, I'm going to quit this stuff and take the world by storm. But it never happened ... nine years just slipped by ... nine damn years."

Actually, it was seven, Bob Barrett said: "He's just parroting what all the articles say. He started work for Al Capp in late 1954. He quit Al Capp in 1961 and went for a year, trying to find work, which was really difficult and hard for him."

How hard? When Frazetta showed a DC editor his portfolio, he was told that his work looked too old-fashioned. Too much like Hal Foster, and not enough like Jack Kirby.

"I started to meet all the thieves and pirates and louses in the business," Frazetta said later. "I am not shy to say it ... you know who you are out there, you bastards. I was getting ripped off right and left. If I got angry, they'd threaten to arrest me. I didn't know about copyright laws ... and I didn't know the world was so full of thieves."

In 1962 Frazetta's Burroughs covers for the Ace paperbacks hit the shelves. "Then he got this adulation, which he hadn't experienced before," says Barrett. "He began to think he was worth more than the rest of these guys; that's when he asked for his originals back and for more money."

After the Ace paperbacks came the Lancer Conan paperbacks and the Warren covers. The genie was loose; the cork was out of the bottle. Posters, calendars, movie posters, and coffeetable books were just around the corner. Fans were on the phone. "I would get through," recalls Bill Stout, "because I would ask the most arcane questions. Ellie, his wife, would run back and forth to Frank, and pretty soon Frank would say, 'Who the hell is this?' and get on the phone.

As late as the mid-'70s, Frazetta was still pretty accessible. Barrett dropped by whenever he was in the area. But not long after Frank and Ellie moved to a 60-acre farm in East Stroudsburg, Pennsylvania, the doors began to close. When old friends called, they had a hard time getting past Ellie.

The artist himself became increasingly stubborn; having experienced his share of rejection, he was more than happy to be in a position to dish it out. Like the time Dino De Laurentiis called, asking him to do the poster for his

Monster Talent

Frank Frazetta was just a monster talent. We've studied those pictures under red lights and blue lights, trying to break the covers apart and see how he did it. He could draw cellulite on the side of a model; put highlights on pubic hair without it being stiff. He could put fat where it belonged.

MIKE KALUTA

FRAZETTA GOES TO THE MOVIES

What do the movies *What's New, Pussycat? Yours, Mine and Ours, The Night They Raided Minsky's,* and *The Gauntlet* have in common?

No, not Panavision. Try again.

Frank Frazetta did the movie poster art.

According to William Stout's piece in *Fanfare #2*, you can look in two different places, 13 years apart, for Frazetta's "first" movie poster art. In 1952 Magazine Enterprises, the publishers of *Thun'da #1*, sold the rights to the character to Columbia Pictures. The Columbia serial *King of the Congo* was not only based on "the Dynamic Hero of 'Thun'da cartoon magazine," but the comic book's cover is part of the poster.

"Frank was never paid a cent for the character he created," Stout wrote, "which is why there never was a second *Thun'da* or any other work for M.E. by Frazetta."

In 1965 Frazetta received his first paycheck for movie poster art, getting $5,000 for *What's New, Pussycat?* One look at that poster and Hollywood quickly set up a hotline to Frazetta's home in Sheepshead Bay. In the next 30 months, he also did the posters for *The Secret of My Success, After the Fox, Hotel Paradiso, The Busy Body, Fitzwilly,* and the bottom half of *The Fearless Vampire Killers,* which included caricatures of its director, Roman Polanski, and its star, Sharon Tate.

Frazetta's favorite movie poster was *Luana,* an altered version of which appeared on the Ace paperback of *Savage Pellucidar.* But his favorite encounter with Hollywood probably came in 1977, when Clint Eastwood called Frazetta and asked him if he would paint Eastwood, Sondra Locke, and a demolished bus for his film, *The Gauntlet.*

"Frank's wife and business manager, Ellie, answered the phone," Stout wrote. "She didn't believe the man on the other end was Clint Eastwood, but went out to the yard and called Frank anyway. Frank was busy working and didn't feel like answering. Frank told Ellie, 'If it really is Clint Eastwood, he'll call back!' He did call back, putting the Frazetta household of Clint Eastwood fans into an uproar. After the filming of *The Gauntlet,* Clint called again about doing the art, and Frank agreed. Eastwood and Locke then flew out to Frazetta's to pose for the painting. For *What's New, Pussycat?* Frazetta got a fairly standard $5,000. For *The Gauntlet,* Frank asked for and got a phenomenal $20,000. And, to top that, sharp Ellie hit Eastwood up for an additional $5,000 for the original."

remake of *King Kong*. Now, Al Williamson guesses he and Frazetta saw the original together about 110 times: "He was in love with that film. He used to see it every time they showed it." When Dino called, Frazetta said, "Let me do it the Frazetta way or I'm not interested. He wants it his way. So, I'm not interested. Then he really is begging me! No, no. Next damn thing, there's electricity in the air. A plane is flying over. I mean, the heavens are shaking; you can feel it through your skin. It's Dino, landing a quarter mile up the road at the local airport in his own plane. He's coming personally. He comes right in here. I'm still not interested. And I don't get interested."

Friedrich, Mike

The publisher of *Star*Reach,* an early anthology of creator-owned work, Friedrich was also Marvel's first direct-sales rep. He had started writing comics at the age of 18, and at one time in the late 1960s he shared an apartment with Bill Everett before alcoholism finally dragged the Golden Age artist down.

Friedrich's early work for DC included writing for The Spectre and Justice League. In 1970 he featured a character modeled after science fiction author Harlan Ellison in a *JLA* story. The comic, Friedrich admits now, was "extremely embarrassing. Overwritten. Overwrought. Juvenile." But at the time he was so impressed by it that he sent a copy of the proof to Ellison.

"Ten Days later it came back. 'Refused.' Unopened," Friedrich said. "Why? Because there was postage due. So I sent it again, this time with enough postage. And I got this wonderful letter in which he justified why he returned it in the first place—a nickel is a nickel—but added that now that he'd read the script, we were soulmates."

Ellison was excited enough that he suggested to Friedrich that he might want to visit him the next time Mike was in Los Angeles. Friedrich wasted little time. "I took the invitation quite literally," he said. He rushed from New York to L.A. and presented himself to his hero, wanting nothing more than to watch him work.

And nothing less. When Ellison suggested

The first issue of Mike Friedrich's *Star*Reach* (1974) featured early work by "Howie" Chaykin, Jim Starlin, and Walt Simonson.
(© Star*Reach Productions)

Alan Moore's award-winning project for the 1990s: *From Hell*, with art by Eddie Campbell.
(© Alan Moore and Eddie Campbell)

that he needed to get some writing done, Friedrich said, "Okay," and burrowed down to watch the man grip a pen. "I sat and watched this guy for three days," Friedrich said. Nothing Ellison said could dislodge him.

"Think about it: This 35-year-old writer who's world famous suddenly has this 20-year-old houseguest who has no agenda, who's just there to be a leech," said Friedrich, who can laugh about it now. Ellison wasn't laughing when Mike finally called a cab and moved on, back to more pedestrian surroundings, such as Bob Sidebottom's Comic Collector Shop in San Jose.

While hanging out with Bob Sidebottom—"one of the old dinosaurs of comic retailing"—at his Comic Collector shop in San Jose, Friedrich met a variety of underground artists and was introduced to self-publishing. Sidebottom "was telling me as a retailer that this customers wanted more Marvel Comics and Marvel wouldn't give them to them," Friedrich said. "And there were particular artists they wanted to see more of and Marvel wasn't paying attention. A lot of these artists were personal friends of mine, guys like Howard Chaykin and Jim Starlin."

Friedrich also knew Roy Thomas, who had teamed with Barry Smith on another Robert E. Howard creation. He and Sidebottom decided to co-publish the comic but, after two years of negotiation, Thomas pulled out of the project. "Roy decided it would negatively affect his position at Marvel, so he backed out," Friedrich said.

Friedrich then turned to Chaykin and Starlin, publishing their work—and the first work of Walt Simonson—in the first 32-page issue of *Star*Reach*. He published several other creator-owned comics before switching careers—he is now a literary agent, representing comics writers and artists, many of whom he used to publish.

Fritz the Cat

In the beginning, Fritz was the Crumb family cat. "I did these comic strips about our cat to amuse my little sister and younger brother," Robert Crumb told *The Comics Journal*. "I drew it in pencil in my notebooks for years, probably starting in 1959 or 1960."

When the world at large came looking for Fritz and the creations in Crumb's notebooks, Crumb was unprepared for the assault.

"It happened real fast," he said in the same *TCJ* interview. "Within six months it went from me, my wife, Donahue, and a couple other people hand-stapling comics and selling them on the street out of a baby carriage to having all these fast-talking lawyers fighting over the rights and sleazy guys offering big money contracts . . . The hippie thing was a happenin' thing and the vultures were descending to find out how they could shear the sheep."

Ralph Bakshi was the "vulture" who came looking for Fritz the Cat. He wanted Fritz to headline the first X-rated animated film in movie history. "He was a schlock-meister, a no-talent bum, completely," Crumb said, and Bakshi was desperate for the rights to Fritz. Crumb claims that he never signed over those rights; unfortunately, his wife, who had his power of attorney, did.

Crumb hated the 1972 movie, which was produced by Bakshi and Steve Krantz. He also got over his fondness for the cat, eventually dispatching him with an ice pick to the back of the head in the final Fritz strip. There were few mourners and no funeral.

From Hell

Alan Moore and Eddie Campbell's "impressive, obsessive reconstruction of the Ripper saga," in the words of Max Allan Collins, is dominated by Moore's typically detailed plot, suitably footnoted. The 16-chapter saga, which began to unfold in *Taboo* #1 and continued in a series of volumes published by Tundra and Kitchen Sink, features the four whores of the apocalypse, the Freemasons, and the bloody retribution to an attempted blackmail of the Crown.

Fujitani, Bob

Bob Fujitani was 19 years old, and still hanging out at the American School of Design

opposite Bloomingdale's in Manhattan, when Tex Blaisdell called and asked him if he wanted a job.

"As soon as he said 'job,' I dropped everything and ran over," Fujitani said. When he stopped running, he was at Will Eisner's sweatshop in Tudor City, getting introduced to Bob Powell, Chuck Cuidera, Nick Viscardi, ol' Will himself, and Lou Fine, who worked upstairs. Eisner liked his samples, so Fujitani grabbed a chair and put his pencils to work for $25 a week. And near as he can remember, he was still cranking out the contract features for Quality Comics when the first bombs fell on Pearl Harbor.

It never occurred to Fujitani that there'd be a problem. His father had come over from Japan at the age of 18. His mother was part Irish and part English. Fujitani was born in Kingston, New York in 1921; he was totally Americanized. "You don't think of yourself as Japanese," he said, and there was no figuring the people who did.

Out west, the Americans of Japanese ancestry were interned in concentration camps. In the Northeast (he lived in Connecticut), they were viewed as less of a threat only because there were fewer of them.

When America entered the war, the Fujitanis were the only "Japanese" family in Cos Cob, a suburb of Greenwich, Connecticut. Bob and his brother Jim had played football at Greenwich High School, and he was good friends with the coach, J. B. Conlon. That's a friendship Fujitani remembers because Conlon was the guy who decided he wanted to market a game called Battleship. Conlon's version was different from the modern one played on plastic pegboards. "On this game, you had these cards printed up and the world laid out flat," Fujitani said. "On your card, you spotted your submarine bases and your airfields. You might have your bases in Singapore, and I would roll the dice and say, 'I'm going to bomb such and such a parallel.'"

Conlon had asked Fujitani to put together a marketing display that could sit on the counter at the drugstore or the stationery store. "I started to do it," he remembers, "and lost interest, and had it up in the attic, all these maps of the world with these little X's, these little silhouettes of battleships and airplanes, near Hawaii and Australia." He'd forgotten all about it when, two months after Pearl Harbor, two Greenwich cops came knocking on his door.

They were apologetic. They were just following orders. "They came to my door and said, 'Hey, Bob, how are you, gee, we hate to come in, but we just have to come in and search your house.'"

After a few minutes, he heard the cops rattling the chain that pulled down the trapdoor to the attic. "They go up in the attic and suddenly I hear, 'Hey, get up here!' and it's a whole different thing. I said, 'What's the matter?' And it's 'Get up here!' They're standing there with their hands on their hips, with all these maps spread out in front of them. They had me, they thought. You could tell just by the attitude, they thought they had me."

Fujitani explained the game, and they didn't buy it, so he told the two cops to call J. B. Conlon. Everyone in town knew J. B. Fortunately, Conlon was home and set one of the cops straight. The cop came back up to the attic and said, "J. B. says it's all right, but gee, Bob, you have to admit it looks bad."

"Then they went down into the kitchen and found a couple of big carving knives that my father had," Fujitani said. "They took that and the hatchet and a radio, because they thought it was possible to be used as a shortwave."

Not that they thought Fujitani would get the urge, but hey, there was a war on.

The war was still on when Fujitani enlisted in the Navy. He was sent out to an air station in Flatbush, where he took charge of the base library and served as the station portrait artist. He was sketching a lieutenant's portrait one afternoon when a yeoman marched in with a telegram and set it on the desk between the artist and his subject.

Fujitani was standing close enough to read it. "I could see my name on it. As I looked closer, I could see it said, 'It has come to our attention that Seaman Robert Fujitani is an enemy alien and we want him discharged and off this station in 2 hours or less.'"

The Lieutenant was awfully sorry, but hey, there was a war on. He called in the sergeant-at-arms. "He comes up with his gunbelt on and a .45 hanging on it and says, 'Sorry, but we're

One of Bob Fujitani's handful of covers: *The Hangman* #8 (Fall 1943).

(© MLJ Magazines)

going to have to keep you under armed guard.' I could hardly believe it. I was devastated."

Fujitani was left with a dishonorable discharge and a new draft status: 4-C. Enemy Alien. It was another ten years before the Red Cross helped him remove the prefix from his discharge.

He returned to comic books. He'd already left Eisner's shop, so now he did *The Hangman* for MLJ. After the war ended, he did crime books for Charlie Biro ("a big blowhard") and titles such as *Lassie, Turok,* and *Prince Valiant* for Western. Fujitani was working on the comic section in *Boys' Life* when Dan Barry finally called and asked for some help on the *Flash Gordon* strip.

"I started penciling and inking *Flash Gordon,* and eventually I was doing the whole thing for him," he said. "I think I did that for him for 25 years."

Fujitani still lives in Old Greenwich, not far from the little inlet in Cos Cob where, 50 years ago, he used to keep a small fishing boat. He had the boat tied up about 1,000 feet from the New York, New Haven, and Hartford railroad bridge, the only rail link between New England and points south.

During the war, that bridge was heavily guarded by searchlights and Marines with machine guns. "We used to do a lot of night fishing for striped bass," Fujitani said. "I'd go out with my father. I'd wave to the guards and they'd wave back to me. I could have blown that bridge up a thousand times. And here I'm a dangerous enemy alien."

> "I'd wave to the guards and they'd wave back to me. I could have blown that bridge up a thousand times. And here I'm a dangerous enemy alien."
> BOB FUJITANI

Full Figures in Action

What Jim Shooter demanded of his artists at Marvel. "He had a $1.50 lecture every year where he'd sit down with an artist and an old Jack Kirby page, usually a Fantastic Four," said Chris Warner. The bottom line? Never show a simple part of a hero: "Always full figure, facing forward, in ACTION!" Once the artists got the word, the acronym—FFIA—became another legendary part of the Marvel style.

Funnies, Inc.

The official Marvel version? "A salesman named Frank Torpey is credited with convincing [Martin] Goodman that comic books were the coming thing," we read in the gospel according to Les Daniels (*Marvel: Five Fabulous Decades of the World's Greatest Comics*). "In 1939, Torpey was sales manager for an outfit called Funnies, Inc., a collection of artists and writers who had talent and ideas but lacked the wherewithal for printing and distribution. Consequently, Funnies, Inc. was creating complete comic book packages to be sold to established publishers. With these packages Torpey enabled Goodman to venture into comics without having to hire a single person at the start."

And wouldn't you know? Martin Goodman got *Marvel Comics* #1, Frank Torpey got a new job, and Lloyd Jacquet and all the other bozos at Funnies, Inc.—lacking "the wherewithal," as they did—hardly rate a footnote.

The Human Torch and the Sub-Mariner—two of the three all-stars in the Timely lineup—arrived on Goodman's doorstep courtesy of Funnies, Inc. At the heart of the comics shop were Carl Burgos, Bill Everett, and Jacquet, formerly an editor at Harry Chesler's shop.

Jacquet's "collection of artists and writers" were loaded with ideas, and they unloaded on Goodman once Torpey convinced the magazine publisher to take the plunge. *Marvel Comics* #1 was their first comics package; Burgos dreamed up the Human Torch, Everett delivered the Sub-Mariner, and Paul Gustavson contributed the Angel.

Goodman took the characters and ran with them, never betraying any sign that he understood his sales owed more to inspiration than distribution. Witness his reaction when Jacquet suggested pitting Namor and the Torch against each other: He agreed to the concept but demanded that Jacquet produce the finished, 60-page fight scene (*Human Torch* #5) over the weekend, as Everett later told Jim Steranko. By 1942, after Goodman had hired whom he could from the Funnies, Inc., staff, he cut Jacquet loose.

Years later, when Jacquet gave Joe Orlando his first job, Orlando found he was working for a bitter man. "He hated Martin Goodman," Orlando said, "because he felt he had been double-crossed by Martin. He told me Goodman didn't know anything about comics. According to Lloyd, the minute this pipsqueak relative of Goodman's came around, he cut him loose and he [the kid] took over.

"And the pipsqueak," Orlando said, "was … Stan Lee."

Gaiman, Neil

There's no dreadful bloody incident that I can point to in my childhood and say, "This is where it all began"—one minute I was this cute little kid and then all my friends were disemboweled in front of me, and at that point I realized there was nothing but darkness.

But Neil Gaiman was, as a kid, quite the devotee of the *Batman* TV show. Maybe that explains it.

Generally accepted, with Alan Moore, as one of the best writers in comics over the last 10 years, Gaiman had minimal interest in the medium until he read Moore's work in *Swamp Thing*. In 1986, at the age of 25, Gaiman wrote *Violent Cases*. Drawn by Dave McKean, the graphic novel was published in black and white the following year in England.

Gaiman succeeded Moore on Eclipse's *Miracleman* in 1988. "You're going to be living in a world of miracles," Gaiman promised. "Like in the Marvel and DC Universes the laws of probability are twisted, so if you get bitten by a radioactive spider, you don't just die. The incredibly improbable happens to you instead. The incredibly improbable is going to start happening an awful lot in the *Miracleman* book."

And that was just his warm-up act. Describing his writing style, Gaiman once told Anya Martin, "I am one of those people who is probably a far less successful writer when I know exactly what's coming next. I was talking with Alan Moore about this recently. Generally speaking, the way he writes is that the first thing he does is design the whole thing almost like an architect. Then he'll construct it to a blueprint. I can't work like that—I'd be really bored. I like piling bricks on top of each other and seeing what kind of building you've got and what kind of shapes you're getting accidentally."

The 75-issue *Sandman* (published by DC and the core of their Vertigo line) is Gaiman's signature pile of bricks. His Sandman, a far cry from the sleep-inducing crusader of *Adventure* #40, is one of the seven Endless, personifications of Death, Destiny, Destruction, Delirium, and so on. "Mostly childhood is a nightmare," Gaiman said, "and mostly people seem to forget this." *Sandman* is one engaging memory lesson.

Gaiman's other award-winning projects have included the graphic novels *Signal to Noise* and *Mr. Punch* (both with Dave McKean) and *Death: The High Cost of Living* (a *Sandman* spinoff miniseries). He's also had success as a writer in other media (novels, poetry, TV scripts, short stories), but his heart still lies in comics.

Gaines, Max

Comic books existed because Max Gaines had presses that he needed to keep busy.
DENNY O'NEIL

He was the father of *Famous Funnies*, Bill Gaines, and the schlock operation.

In 1934 Max Gaines, a salesman at Eastern Color Printing Co., slapped the first price tag on a few comic books and abandoned them at a newsstand. When the comics were gone the next morning, comic books were here to stay.

Gaines's shop was, Sheldon Mayer once said, "a schlock operation. We bought the material for practically nothing and slapped the books together. Max wasn't concerned with the literary or entertainment part of it. I had to argue to get him to run story strips like *Terry and the Pirates* in chronological order. The dime comic books were just a small part of his operation. He was only interested in keeping those presses rolling."

Gaines was, Mayer added, "in a perpetual state of apoplexy." At the age of four, he had tumbled out of a second-story window, snaring his leg on a picket fence. Frank Jacobs, author of *The Mad World of William M. Gaines,* reports, "The leg gave him great pain the rest of his life," and Max passed the pain on quite liberally, particularly laying it on his son.

"You'll never amount to anything," he frequently told the lad.

During the final years of Prohibition, Gaines created the "We Want Beer" necktie. Clearly, he never underestimated the taste of the American public. In 1938, four years after the debut of *Famous Funnies*, Gaines was working for the McClure Syndicate when he fielded a call from Harry Donenfeld at National. Donenfeld was looking for a lead feature for his new book, *Action Comics;* Gaines just happened to have an amateurish strip from Cleveland sitting on his desk.

Donenfeld quickly hired Gaines to produce a comic line under the All-American imprint,

Neil Gaiman

"During the final years of Prohibition, Gaines created the 'We Want Beer' necktie. Clearly, he never underestimated the taste of the American public."

which led—thanks to Mayer's imagination and Gaines's paper contracts—to *Flash, Green Lantern, Wonder Woman,* and *All Star Comics.* By 1944, Gaines had wearied of the superheroes and the DC office politics and demanded that Donenfeld and his accountant, Jack Liebowitz, buy him out. Jim Steranko captured the ironies of the buyout:

"The most important factor in the deal was the paper contracts which Gaines controlled. The war had created a paper shortage and any publisher who could get paper had a guaranteed sale of over 90 percent of his run. Upon agreement, Gaines sold his half of the business for well over a half-million dollars, paper contracts and all. A few months later the war ended and paper became available again. Gaines's timing was flawless, much to Liebowitz's chagrin."

With the cash, Gaines started Educational Comics, a company that would have been forever mired in *Picture Stories from the Bible* and *Happy Houlihans* if Gaines hadn't died in a 1947 boating accident on Lake Placid.

"The accident had come with practically no warning," Jacobs wrote. "Elaine [Gaines's daughter] and a girlfriend had decided to swim across Lake Placid, and Max, Sam Irwin, and Irwin's son, Billy, were in Max's Chris-Craft, following the girls. Halfway across, another boat came charging through the water and plowed into the front of the Gaines's boat, instantly killing Max and Sam Irwin. Billy escaped unscathed; it is believed that in the brief moment before impact, Max grabbed the boy and threw him into the rear of the boat, thereby saving his life."

If anyone ever missed Max, they never reported it. They may have been preoccupied watching his son amount to something: the empire that was EC Comics.

Gaines, William

He used to loan us money without interest and if we were in trouble we'd go to him like big daddy. It was a little sick...
WALLY WOOD

There was a paternal quality about Bill that I liked. Bill, in order to express himself, fell into this paternal pattern... and I didn't resent it. After all, Bill did look older, he was bigger and he was richer. He was our rich father.
WILL ELDER

Oh, it is totally a paternalistic attitude, it's his paternalistic attitude. Mad *is kind of like the old father-kids relationship. Bill Gaines is the father image, and he handles the company the way he thinks companies should be handled.*
SERGIO ARAGONÉS

My long-running quarrel with Bill was always that he was paternalistic, in that

BILL GAINES'S ELEVATOR

Fresh out of high school, Jerry Weist and Roger Hill left Wichita, Kansas in 1965 for the World Science Fiction Convention in New York. Their mission was to track down their hero, *Mad* magazine editor Bill Gaines.

"Bill was living in this huge apartment building, complete with a doorman," Weist said. "The guy took us over to the elevator and said, 'Just go up to 30- or 40- whatever and Bill's apartment is real close to the elevator. He'll probably be waiting for you.'

"We punched the 'Up' button, but the elevator didn't come and didn't come. We panicked. We figured Bill was up there and he's thinking we're not coming. So, we ran up the 30 or 40 stories. We ran all the way up to the top and, of course, found out the door was locked.

"Then, we really panicked, and ran all the way back down again. Somehow, when we got there, the elevator had just come down. When we got up to Bill's floor, we found out he'd come out twice already. He'd wondered where we were, and when we told him, he started laughing hysterically. Bill Gaines hated exercise, remember? The idea that we'd been up and down those steps twice almost killed him."

While searching for something in his closet, Gaines showed Hill and Weist the 27 cardboard boxes that, more than a quarter of a century later, Bob Overstreet and Russ Cochran would open to pull out the Gaines file copies of all EC comics. "We were the first collectors to see them in storage," Weist said.

Gaines then took the boys to dinner at an Italian restaurant. "Bill Gaines is the only person I know," Weist said, "who was a hero to me when I was a kid, a hero when I was a teenager, and still had heroic proportions when I was an adult."

> *he had this feeling of responsibility for his people and possibly feeling a little too responsible. Like a father feels for his children…*
> HARVEY KURTZMAN

Let's just say Bill Gaines overcompensated a little. When *he* went looking for a father, he ran into a gruff SOB whose idea of a father-son talk was the gentle assurance, "You'll never amount to anything."

Max Gaines, the late Sheldon Mayer once said, "treated me like his own son: rotten." When Max Gaines died in a 1947 boating accident (see previous entry), Bill Gaines was at New York University, studying to be a chemistry teacher. Given a choice between a lifetime of chem labs and his inheritance, Gaines must have looked long and hard at his options. At the time, Gaines's publications included *Happy Houlihans, Fat & Slat, Land of the Lost,* and *Tiny Tot Comics*. Meaning no disrespect, but Max Gaines's company was also dead in the water.

Bill figured EC was $100,000 in debt when it tumbled into his lap. "As I said to my mother, 'If he was losing money, what do you expect me to do?'" His own expectations were certainly lifted when, in March 1948, Al Feldstein dropped in and introduced himself. Feldstein flashed Gaines the good-girl artwork he was cranking out for Victor Fox, and Gaines was mighty impressed. "All the broads had big busts," he told *The Comics Journal,* "and I was so taken with those busts that I hired Feldstein on the spot to put such a book out for me."

That book was *Going Steady with Peggy,* but before Gaines sent the pages to the printer, he decided it would never sell. Instead, he steered EC toward romances, westerns, or combinations (*Saddle Romances*) of the two. "We were like the smallest, crummiest outfit in the field," Gaines said. "We just imitated."

EC was already moving in the right direction when Gaines discovered horror. He long maintained that he invented the wheels on the genre—"I was the first publisher in the United States to publish horror comics. I am responsible," he boasted to the Senate Subcommittee—but that's not the case. At least three companies were publishing horror before EC entered the field in 1949, but Gaines's efforts put them all to shame.

Unlike his father, you see, Gaines was interested in a lot more than keeping the presses running. He assembled what remains the greatest ensemble of writers and artists ever under one leaky roof, including Harvey Kurtzman, Wally Wood, Graham Ingels, Jack Kamen, Jack Davis, Johnny Craig, and Al Williamson.

They flourished at EC because Gaines didn't treat them rotten. "He became personally involved with every one of them," Feldstein once said. "He became involved with them as a creative person and also with their personal problems. He was unencumbered by his own personal problems generally, since he was not married, and his whole life was the production of EC Comics and the social aura that developed around it."

Gaines reminded Roy Krenkel of "an unmade bed." He had a sizable gut—his weight varied between 185 and 285 pounds—and enough guts to go before the Senate Subcommittee and tell them that a *Vault of Horror* cover sporting a freshly decapitated female head wasn't in particularly poor taste. But Gaines usually led with his heart. He paid his staff when they turned their work in and lent them money when they showed up empty-handed. He took the troops on group vacations, and, long after nothing was left of EC but *Mad* magazine, he continued to mail out the royalty checks.

In brutal days, Gaines commanded amazing loyalty. "Just like I could never go against my father even if he's wrong, I could never go against Bill Gaines, even if he's wrong, because he's more than a friend," Aragonés said. "I will cut my salary if I know that'll avoid giving him a heart attack. Because I love the man."

Bill Gaines died in 1993. His father may have gotten comic books started, but Bill Gaines made them famous. Given a crippled comic book company when he least expected it, let's just say Gaines overcompensated a little, and fathered a fleet of overachievers.

Bill Gaines, as portrayed in old issues of EC Comics.
(© 1998 William M. Gaines, Agent, Inc.)

> *"Gaines had a sizable gut—and enough guts to go before the Senate Subcommittee and tell them that a* Vault of Horror *cover sporting a freshly decapitated female head wasn't in particularly poor taste."*

Galactus

After taking on all other comers, Jack Kirby decided to tackle God.

"Galactus was God, and I was looking for God," Kirby told *The Comics Journal*. "When I first came up with Galactus, I was very awed by him. I didn't know what to do with the character. Everybody talks about God, but what the heck does he look like?

"I drew him large and awesome. No one ever knew the extent of his powers or anything, and I think symbolically that's our relationship [with God]."

Preceded by his herald, the Silver Surfer, Galactus first appeared on the final page of *Fantastic Four* #48 (March 1966). He arrived with the words, "My journey is ended! This planet shall sustain me until it has been drained of all elemental life. So speaks Galactus!"

To whom he thinks he is speaking is unclear.

Gangsters at War #27

This was the telltale comic book in Dick Lupoff's 1988 murder-mystery novel, *The Comic Book Killer*. A limited edition of 500 copies of the comic were distributed with the hardcover edition of the novel. The cover was by Alex Schomburg, the interior art by Trina Robbins ("These Gams for Goering") and Steve Leialoha ("Dead Man's Revenge"), and the crucial true confession/text story by Nat Benson.

Garcia, Jerry

The late head of the Grateful Dead was a serious comic collector. "First thing he did with his first record royalty check was buy the complete run of EC comics," said Tim Truman, who drew for all nine issues of Kitchen Sink's *Grateful Dead Comics*.

Gasoline Alley

Frank King's comic strip began in the gutter of a full-page *Chicago Tribune* Sunday cartoon titled *Rectangle*. "Down in one corner in 1919 I started a stunt and called it *Gasoline Alley*," King told Martin Sheridan. "It had to do with a bunch of men who met on Sunday morning in the back alley of their apartments and talked automobiles. Cars had character in those days, and there was plenty to discuss."

The discussion has gone on for more than 75 years.

Gattuso, Paul

Children told me what the man was going to do with the red-hot poker.
FREDRIC WERTHAM
SEDUCTION OF THE INNOCENT

If you've read Wertham's book, you remember the line. And if you remember the art, you've met Paul Gattuso.

Gattuso began his career with Harry "A" Chesler in 1944, popping up in *Dynamic, Punch,* and *Scoop*. "An inimitable style," said Eric Margolis, who owns the only known copies of Gattuso's original art. "Everyone looks like they're dressed up in zoot suits. It reminds you of expressionist German films. Landscapes going off into the night. People always looking like they're on the run. The women all look like Olive Oyl, with these extremely pointy breasts."

When Margolis, a Pennsylvania neonatologist, first bumped into Gattuso's art in the late 1980s, he quickly connected him with that memorable image from *Seduction of the Innocent*. He pestered various comics historians for information about the artist until Hames Ware or Jim Vadeboncoeur (he doesn't remember which) remembered that Jim Steranko had advertised several Gattuso pages years earlier.

Margolis called Steranko and was told the publisher had culled five Gattuso pages, from a seven-page Black Dwarf story in *Red Seal* #14, out of the Chesler warehouse find.

"The quintessential, prehorror, esoteric comic book artist," Steranko called Gattuso. Which explained, Margolis figured, why Steranko had demanded $1,000 ten years earlier for the five pages.

They'd never sold. Steranko hadn't had a nibble. Margolis played that for all it was worth. "I was begging him to come down. I'm the only guy who called," Margolis said. "But he wouldn't come down a penny. He was convinced this guy's artwork was worth a lot. And, of course, I agreed with him. You don't find art

This undersized comic was packaged with the hardcover version of Dick Lupoff's novel.
(© Alex Schomburg)

from back then. He wouldn't come down a nickel, but I've never regretted buying them."

Geppi, Steve

He has three components: skill, luck, and timing. If you have all those together, you have the golden ring.
STEVE SCHANES
FORMER OWNER, PACIFIC COMICS DISTRIBUTION

When you finally have the golden ring, you appreciate the subtle ironies. Steve Geppi's first job was sorting comic books in the back room of a Baltimore liquor store. The store owner, Sam Boltansky, had the curious habit—curious, at least, in 1959—of pricing the older comics higher. Geppi had been showing up every week for months and buying $2 worth of comics out of the nickel box, when Boltansky asked him whether he wanted a job as a stock boy. Geppi took his pay in comics, and he relished life in that back room . . . until Alfred Hitchcock's *Psycho* hit the theaters in 1960. "Sam Boltansky was the spitting image of Anthony Perkins," Geppi said, "and he'd scare the hell out of me whenever he came into that dark back room. I kept expecting him to turn into his mother."

Today president of Diamond Comics Distribution (which grossed $222 million in 1993) and a part-owner of the Baltimore Orioles, Geppi is not exactly the product of a college business school education. In fact, he quit school in the ninth grade to support his mother. Although he was often short on cash—when Boltansky offered to sell him a *Superman* #1 for $5, Geppi decided he couldn't justify the expense to his mom—he wasn't short on ambition or survival instinct. At the age of 11, he was running football pools and editing the neighbors' tax returns. At 14, he was installing doorbells and burglar alarms. He was a hustler, an entrepreneur, a guy who nevertheless never risked his reputation for a quick buck.

Geppi began working for the U.S. Postal Service in 1969. Three years later, while vacationing in Wildwood, N.J., he caught his nephew George reading a copy of *Detective Comics*, starring Bat-Mite. Blinded by a "nostalgic flashback," Geppi returned to Baltimore and immediately called Marvel and DC, looking for back issues. "I was always the kind of person," Geppi says, "that would go straight to the top." The folks at DC suggested he call Phil Seuling, who ran the major comic convention in New York City, and Seuling gave Geppi a quick history lesson in what had happened to comic book collecting while he had been away.

Geppi started knocking on doors along his route, looking for old comics. Old Lady Denatell on Liberty Heights Avenue was the first to dump a collection in Geppi's lap. By 1974 he had enough stock to ditch the mailbag and open his first Geppi's Comic World in the basement beneath a TV repair shop. He spent his $1,600 postal retirement check on one of the first collections that came through the door. "I snowballed every dollar I had," Geppi says. "Everyone thought I was out of my mind; I thought it was a no-brainer." He instituted one of the first pull-and-hold systems, giving his regular customers a discount to boot. He bought comics wholesale for smaller retailers in Baltimore.

And he treated people right. When John Snyder, a veteran coin collector, walked into a Wheaton comic book show in 1974, he had $1,000 in his pocket and a need to show off for his 12-year-old son. The only expensive book at the show was *Special Edition* #1 at Geppi's booth, but when Snyder asked "this short guy in a T-shirt and jeans" whether he should buy it, Geppi said, "No, it's not one of the key books."

"That floored me," said Snyder, who now manages four of Geppi's companies. "In all my years in the coin business, I had never encountered anyone who had told me not to buy something. I became his biggest customer. I talked to him every week on the phone for the next 20 years."

Paul Gatusso's work was made (in)famous by Fredric Wertham.
(© Harry "A" Chesler)

Steve Geppi

Steve Gerber

During Frank Frazetta's early tenure as a ghost on *Li'l Abner*, his distinctive style had not yet fully adapted to Capp's.
(© Capp Enterprises, inc.)

Over that next 20 years, Geppi went into the distribution business, eventually taking almost total control of the direct distribution system that Phil Seuling had started (see **Direct Distribution** entry) . . . and nabbed his share of *Superman* #1's. He also bought his share of the Orioles, purchased *Baltimore* magazine, acquired the *Overstreet Comic Book Price Guide* and Gerber Publishing, set up Gemstone Publishing (a division of which puts out EC Comics reprints and publishes *Comic Book Marketplace*), and opened Diamond International Galleries. When his skill with people and collectibles wasn't serving him well, luck or timing were in his corner.

"I've put my whole life into this industry," Geppi says, "and I believe it has a bright future. I don't buy the idea that the Internet is going to replace all this and leave everyone reading off a screen. Comic books historically have partnered with the would-be competition, which is why the industry survived the war, survived TV, survived movies and video games. The bad news is that a lot of the players in the business are gone. The good news is that those of us who are left are stronger."

Gerber, Steve

And you thought Howard the Duck was "trapped in a world he never made."

Steve Gerber left Marvel in 1980 in a huff over creators' rights—in this case, a creation named Howard—and never fully recovered. He settled his lawsuit against Marvel after four years and $130,000 by deeding his character to the company, then settled for writing such projects as *Void Indigo* and *Nightmare on Elm Street*.

Gerber's name was attached to most of the myriad Marvel books in the early 1970s—*Man-Thing* and *Son of Satan*, *Marvel Spotlight* and *Marvel Presents*, *Tales of the Zombie* and *Monsters Unleashed*—but he wasn't having a very good time.

"Everything that's happened over the past two decades," Gerber told *Amazing Heroes* in 1989, "during the whole Shooter era at Marvel, and what happened to the alternatives during that period, just makes me sick."

Ghost Rider

Originally inspired by Disney's "The Headless Horseman," *Ghost Rider* #1 (1950) first appeared as part of Magazine Enterprises's *A-1 Comics* series (#27). Marvel resurrected the character in 1967 (*The Ghost Rider* #1), then redesigned him as Johnny Blaze in *Marvel Spotlight* #5 (August 1972).

Ghost Rider survived just over ten years in his own book. He was hauled out again in a glitzy, overhyped 1990 reprise, penciled and inked by Mark Texeira.

Ghosts

The uncredited artists on strips bearing a big name and a bigger ego, ghosts were assigned to carry on in the original artist's style. They were at the top of their form when no one knew who they were.

"I was a professional ghost," Gill Fox said. "One thing you have to forget about is ego: 'I could do a better job than this guy.' You can't do that. I could purge myself of style. It's like a character actor. You never truly ghost if it looks like your stuff. What you ghost is *their* high point, when they did their best work."

Both Frank Frazetta and Creig Flessel ghosted for Al Capp on *Li'l Abner*, even as Capp had ghosted for Ham Fisher on *Joe Palooka*. Milton

Caniff had a variety of ghosts on *Terry and the Pirates.* "At one time," George Evans said, "I was doing a ghosting job for Al Williamson, and Al was ghosting *Big Ben Bolt* for John Cullen Murphy, and John Cullen Murphy was ghosting stuff for Harold Foster on *Prince Valiant.*"

Round and round they went. No one took greater advantage of ghosts than Bob Kane, the co-creator of Batman. Few of his ghosts speak highly of him. "He was a lazy man and not a great artist," Shelly Moldoff said at the San Diego Comic-Con in 1992. "As soon as he had an opportunity to have someone help him, he took advantage of it." Added Al Schwartz, "Bill [Finger] had problems because he was late all the time; of course, Bob Kane had problems, too. He couldn't draw . . . His strip was saved by the ghosts he had draw for him."

But Kane still maintained, in an interview with Shel Dorf, "My name will be remembered when it's all over. No one will ever know the ghost artists' names. There can be 100 on *Batman,* but Bob Kane's name will prevail."

Giacoia, Frank

A native Neapolitan, Frank Giacoia broke into the comics business at Jerry Iger's shop in 1941. He served time at Timely, Hillman, and Lev Gleason before disappearing into the DC factory in 1948. In the early 1970s, he finally transferred to Marvel (after moonlighting there as "Frank Roy") as an assistant art director.

"An extraordinarily powerful inker," Gil Kane said. Giacoia, who had inked Carmine Infantino's pencils on the striking first cover of *Mystery in Space,* also inked the first appearance of the Punisher in *Amazing Spider-Man.*

Giant-Size Man-Thing

"The most obscene title ever published by the overground," Frank Brunner once said. The book itself was fairly tame.

Gibbons, Dave

There were two or three shops in St. Albans that Dave Gibbons and his buddy, Richard, used to haunt, but only one shopkeeper ever let them cut the string on the weekly bundles of comics. He would leave them tied up until the two kids tumbled through the door, then grant them the honor of cutting the knot. They'd then divide the pile in two and retreat to separate corners, each terrified that he'd just given away the only copy of *Justice League of America* that would ever spend the night in St. Albans.

When Gibbons thought about America in those days, he dreamed of a land where there were comic book racks on every street corner. Parts of England, after all, didn't even get some of the titles he saw advertised in *Action* or *Detective.*

The place to head for the best selection, Gibbons soon discovered, was the seaside, and he used to set sail for East Anglia, near Norfolk. Trusting that many of the kids in town were on vacation and had money in their pockets, the shopkeepers kept a better stock. If the British kids didn't buy them, the American lads—fresh off the U.S. Air Force bases—surely would. Gibbons befriended those Yanks every chance he got. "They had comics," he said, "and the biggest thing about America to me was the comic books. They also had some of the things you'd see advertised in the comic books, like American candy or toy soldiers."

By the time he turned 12 or 13, Gibbons was the class cartoonist at school. He had a lot of cheek and a lot of talent, and if a single teacher had encouraged him, he might have ignored his parents when they tried to break him of the cartooning habit. One of his uncles, it seemed, knew a commercial artist and the guy was always broke. So, Gibbons moved along: "I got interested in girls and drinking and driving a motorscooter. I was going to study to be an architect, but I had no great passion for it, so I ended up being a building surveyor."

Around 1968, Gibbons was out on a survey when he walked into a shop to buy a pack of cigarettes and bumped into *Green Lantern.* As he flipped through Gil Kane's art, the shivers of recognition began to climb his spine. "For my kid brother," he explained to the counterman, and took the comic home.

He brought his collection up to date at secondhand bookstores and began to study the art. "I'd always thought American comics were drawn by the Mafia or something," Gibbons said "There was this crowd of guys with Irish or Italian names who had this all sewn up in New York. But then I bought one particular comic—which was *Nick Fury, Agent of S.H.I.E.L.D.* [#1]—and in the letters page it said it was

Frank Giacoia inked Carmine Infantino on such popular covers as *Mystery in Space* #1.
(© DC Comics, Inc.)

Dave Gibbons secured his place in the comic book hall of fame with his art for *Watchmen.*
(© DC Comics, Inc.)

drawn by a young English guy who had just gone to the States and was so wonderful they let him draw a comic book. His name was Barry Smith."

Now, this provided two revelations for Gibbons.

The first was, *It can be done.* And the second? *It can be done better.* "Not only was this comic drawn by an English guy, but it wasn't drawn very well," Gibbons said. "It wasn't as good as I could draw it. So, I bought myself some paper and I redrew it."

Gibbons then took his pages to Dez Skinn, a fanzine publisher and an assistant editor at IPC, a British comics publisher. "By blind coincidence, he worked in the same office as a fellow named Steve Parkhouse, who had not only written this issue of *Agent of Shield* but who was Barry Smith's best friend. Who, of course, showed these pages to Barry Smith and said, 'Hey, here's a guy who thinks he could do better than you!' Barry Smith thought it was a hell of a cheek."

Smith didn't have much reason to remember the name. Gibbons got his surveyor's certificate, so his Mum would like at least one of his wall hangings, before diving into comics. Much of his early work was in fanzines or British comics like *2000 A.D.* His breakthrough in American comics didn't come until 1981, when DC editors Dick Giordano and Joe Orlando came to England looking for new talent.

"A theory I heard advanced about why they came over to get us is that American companies were expecting trouble with the artists," Gibbons said. "They thought the artists were going to start a guild. What they wanted was to have this Third World, offshore country . . ."

Giordano and Orlando offered a good salary, reprint royalties, and returned artwork, and Gibbons couldn't say no. Before he knew it, he was working with Julius Schwartz, who had edited his favorite comics when he was a kid. And it couldn't have been more then a year or two before Len Wein called, searching for a new approach to *Swamp Thing,* and asked, "Do you know a writer named Alan Moore? And do you have his phone number?"

Gibbons and Moore first met in 1980 when he would illustrate the short filler stories Moore was doing for *2000 A.D.* "We were on the same wavelength," Gibbons said. "We liked the same kind of comics; we had the same meticulous approach. Everything has to mean something."

In Moore's hands, *Swamp Thing* meant more than the comic ever had before or ever would again. Choking on their good fortune, DC asked Moore to come up with some new ideas. Maybe a new study of the Charlton characters that DC had acquired and parked on a shelf.

The day after Moore sent in his proposal for *Watchmen,* Gibbons called him on the phone. "That's the sort of thing I'd like to do," he told Moore. It didn't sound like a series that would revolutionize the industry, just the kind of story

Gibbons was dying to find when he cut the string on those bundles back in St. Albans.

Since *Watchmen*, Gibbons has worked on a variety of projects, most notably drawing the *Martha Washington* books written by Frank Miller. And he's always available, to American friends who visit him at home, for a memorable tour of St. Albans, complete with Roman legion walls, tales of the Picts, and scenes straight out of R. E. Howard.

Gibson, Walter

From the very beginning, Walter Gibson had a passion for magic, and he saved his neatest trick for *The Shadow* magazine. Between 1931 and 1949, the magazine ran 326 issues and Gibson—writing under the pseudonym "Maxwell Grant"—wrote 282 of the pulp novels.

Born in 1897 in Philadelphia, Gibson joined the staff of the *Philadelphia North American* in 1922. As Will Murray recounts in his exhaustive history of *The Shadow* magazine:

> *As a reporter, he was both dynamic and resourceful. When first called upon to interview the orchestra leader who conducted Caruso's first concert, he dragged along his Italian barber as translator . . . He conducted the final interview with Harry Houdini before his death. On one occasion, while covering a gangland killing, he found himself stranded on the other side of town with no way to get back to his beat, the Philadelphia morgue. He hitched a grisly ride in the back of the death wagon with the corpse, who twitched as if alive with every lurch.*

In December 1930, five months after "The Shadow" debuted on radio, Gibson was given a shot at doing the first story for a new experimental pulp magazine to be published by Street and Smith.

"The Living Shadow" hit the streets in April 1931. For 10 of the next 18 years, Gibson cranked out two 40,000–60,000-word novels a month, armed with a battery of typewriters (his publisher didn't have time for a broken ribbon) and fueled by four packs of cigarettes a day.

Gibson wrote the first 114 *Shadow* novels before Theodore Tinsley gave him a slight breather in the fall of 1936. The writer cranked out more than a million words a year, giving the Shadow his shape and form. When there was a spare typewriter available, Gibson also plotted *Shadow Comics* from 1940 until 1947, as well as *The Shadow* newspaper strip.

His final story for The Shadow magazine, "The Whispering Eyes," ran in its final issue in the summer of 1949. Gibson died in 1985.

G.I. Combat

Originally a Quality Comics Group production, *G.I. Combat* debuted in October 1952. After 43 issues, known mostly for its Reed Crandall covers and obsession with the Red Menace, the comic was passed to DC in 1956. Issue #44 was cover dated January 1957 and stamped with Joe Kubert art; the 288-issue run finally expired in March 1987.

Hellish issues: #1, "The Fires of Hell in Beyond the Call of Duty"; #3, "To Grandstand in Hell"; #4, "Bridge to Bloody Hell"; #5, "Glamour Guys of Hell" AND "Hell Breaks Loose on Suicide Hill"; #8, "Red Train to Hell"; #12, "All Hell Breaks Loose"; #14, "Trapped in Hell"; #16, "Airfield in Hell"; #23, "No Grandstand in Hell" redux

Red-Letter issues: #3, "Havoc Behind Red Lines"; #8, "Red Train to Hell"; #10, "Red Death in the Sunset"; #14, "The Red Goons of Berlin"; #18, "Red Battleground"; #19, "Red Invasion"; #21, "Red Sneak Attack"; #22, "Red Firepower Inferno"; #25, "Red Paratroop Raid"; #26, "Red Guerrilla Trap"; #27, "Red Helicopter Raid"; #28, "Infantry Assault on Red Mountain"; #29, "Red Treachery Assault"; #31, "Lair of the Red Wolf Pack"; #32, "The Reds' Last Stand"; #35, "Red Terror Tactics"; #36, "Red Train to Doom"; #37, "Red Ambush in Morocco"; #41, "Secret Red Guns"; #42, "Red Squads of Berlin"

Gill, Joe

Joe Gill penned 52,800 comic book pages, by Robin Snyder's count. In a letter to Snyder's *The Comics*, Gill wrote:

"In 1945, I left the service. November 19, 1945, to be exact. At that time I shared a storefront studio on Vandermeer Place in Brooklyn. The other occupants were my brother, Ray, one of the real pioneers in comics, and Mickey Spillane who got his first job in the comics field through Ray…

"I worked for Goodman in those days on *Captain America*, *The Destroyer*, *Kid Colt*, etc. Stan Lee had hair and he was the exec editor…

"Comics hit bottom in 1946. All the G.I.'s who'd been buying comics by the armload in PX's were home living on $20 in the real world. I worked alone, on the docks, merchant seaman, etc. Returned always to comics. Worked for St. John, Fiction House, and a dozen smaller publishers . . ."

Walter Gibson

Dick Giordano inked Irv Novick's pencils for numerous Batman stories in the 1960s.

(© DC Comics, Inc.)

Giolitti, Alberto

A week after Wally Green began working at Western Publishing's Madison Avenue office in 1959, someone dumped a load of comic books on his desk. No one had ever dumped such a bundle in his lap, so Green began idly leafing through them. The idyll ceased when he picked up a copy of *Jungle Jim*.

"The artwork was gorgeous," Green said. "Well drawn, well defined, the blacks beautifully placed. The setting was Bangkok, I think, and clearly he'd done a lot of research, the way he drew the temples. I took one look at it and ran to another editor and said, 'Who did this stuff?'"

Alberto Giolitti.

Giolitti began drawing for Western in the early 1950s; Green surmised his first pencils can be found on *Sergeant Preston of the Yukon*. "For some 30 years," Green wrote after Giolitti's death in 1993, "he was Western's premier illustrator of action adventure."

They met for the first time in 1960 when Giolitti was passing through New York on his way to Rome. "He was supposed to be going away for nine months," Green said, "and he never came back."

The artist sought refuge in a Rome studio, continuing to mail pages to Western as well as several European publishers. "His crisp, well-controlled pen and inks breathed life into *Gunsmoke; Have Gun, Will Travel;* and *Jungle Jim*," Green wrote. Giolitti also drew *Turok, Star Trek, Boris Karloff,* and *Twilight Zone*.

Green never knew how or when the pages would arrive. "Italy would have these postal strikes: He'd have to run to the Vatican and have them sent to us by Vatican mail," Green said. The pages continued to appear until Giolitti retired in 1984.

Giordano, Dick

Dick Giordano

He fell in love with comics in the usual way: In 1937, someone handed Dick Giordano a copy of *Famous Funnies,* and nothing was ever quite the same.

A steady inker and tenured editor at both Charlton and DC, Giordano took his first job at the age of 19 at Jerry Iger's shop, which he remembers as "a small two-story building in the middle of a couple skyscrapers." In his nine-month stay, he started out erasing pages and graduated to inking backgrounds. "I was too young to do anything else."

He joined Charlton on New Year's Day in 1952 and worked there, in one fashion or another, for the next 15 years, eventually editing the likes of Steve Ditko, Roy Thomas, and Denny O'Neil. "A lot of good people worked with us," Giordano noted, "because Marvel had laid off a lot of people. But the commitment was never made to the material. Eventually, my ability to make anything happen was minimal. And just about that time, Steve Ditko—who was moving because he needed to make more money—introduced me to the folks at DC."

When Giordano joined "the Wall Street Journal of the comic-publishing business," as he put it, in 1967, he was assigned to edit such titles as *Creeper, Hawk and Dove, Blackhawk, Aquaman,* and *Teen Titans*. He shared office space with Joe Orlando; they were rebels with a cause. "We were sort of against the rest of the world," Giordano once told *The Comics Journal*. "We were the first two editors hired under the new regime there and we were both artists—where all the other editors were writers, you know—and we were both Italian, and so was Carmine Infantino. God! I mean, in a Jewish community we were really the outcasts. We sort of stood back-to-back in the middle of the room."

Giordano fled the room in 1972, shortly after inking Neal Adams's work on the Green Hornet/Green Arrow stories. "We were a little stronger than Marvel when I first got there and getting weaker by the minute," he recalled. "They didn't think it was dignified to get into competition with Marvel. That's why I left."

He joined Adams at his Continuity studio and, for the next several years, serviced ad agencies, with a little comic book work on the side. He spun off his own business in the late 1970s, then rejoined DC in 1980, just about the time the white shirts and ties were coming off.

Giordano returned, he said, to find that DC's parent company was more interested in licensing than publishing: "They didn't care if we were publishing anything or not. At one point, I'm told, they asked, 'Do you have to publish so many comics? If you published fewer, we'd make more money.' That's how low the company had fallen."

Within five years, Giordano said, he and Jenette Kahn and Paul Levitz had turned DC into a publishing company again. Giordano helped find a home for the Charlton characters at DC, who eventually evolved, via Alan Moore, into the Watchmen. And he was the first editor on Frank Miller's Dark Knight project, banging around ideas with Miller over beers at a booth inside Pastrami & Things, a bar beneath the DC office.

Giordano retired from DC in 1992 but has continued to freelance for the company.

Giraud, Jean

"I'm so intimidated by him. He sees us as children."
GEOF DARROW

The artist was signing autographs at a show in Canada. The kid waited patiently in line and when his turn finally came, he asked Jean Giraud to draw something for him. Giraud went to work and, in a matter of moments, produced a dazzling pencil sketch. When the kid took the drawing in his hand, he stared at it for a moment, oddly dissatisfied.

"Can you ink it?" the kid asked.

Giraud never blinked. He reached for a Sharpie, a maliciously thick black magic marker, and slashed the drawing with a half-dozen brutal cuts. Then he handed what was left of the drawing back to the child, who stared slack jawed at the highways of black ink.

"We earned something today, didn't we?" Giraud asked.

He was born outside Paris in 1938 and drew his first Western strip at the age of 16. After meeting Belgium's Joseph Gillian ("Jije") in 1958, Giraud was hired in 1961 to ink one of Gillian's *Jerry Spring* stories, "The Road to Coronado."

Gillian, Giraud once said, could "talk for two or three hours about the graphic aspects of [Milton] Caniff's art, explaining the reasons for its quality. He was able to speak about Caniff in the same way art critics could talk about Raphael."

"I admired him boundlessly," Giraud said, particularly "his capacity for showing nature, and never in a cliched manner. For him, a tree was something living and breathing, it wasn't just an object that advanced a story."

In 1963, Giraud, now out on his own, began the epic Blueberry series with Jean-Michael Charlier. He founded *Metal Hurlant* in 1975 and began drawing as Moebius shortly thereafter.

"There was a spontaneity in the execution of certain Moebius stories," he said, "that freed my hands and head and showed me that it was wrong for me to be scared, that I shouldn't hesitate to do certain things, to leap without looking from time to time. The only thing you risk is blowing a drawing, and then you just start over 20 minutes later."

You just start over. Small wonder Italian film director Federico Fellini once wrote to Giraud, "To make a science fiction film is one of my oldest dreams. I have thought of this since I first beheld your drawings. You are without a doubt the ideal collaborator; but I never asked you because your work is too complete, too strong in vision and scope. I ask you, what would be left for me to do?"

Giveaways

The earliest comic books were giveaways of comic strip reprints, as Max Gaines sold such companies as

Jean "Moebius" Giraud

Canada Dry, Kinney Shoes, and Procter & Gamble on the idea of distributing premiums.

When Gaines suggested companies could slap a 10-cent sticker on the premiums, Woolworth's informed him that *free* was the only price for 64 pages of old comics.

Some of the more interesting giveaways:

Adventures of the Big Boy (Timely), 1956
Bob and Betty and Santa's Wishing Well (Sears Roebuck), 1941
Buster Brown Comics (Brown Shoe Company), 1945–1959
Call from Christ (Catechetical Ed. Society), 1952
Century of Comics (Eastern Color), 1933
Donald Duck Giveaways (Dell), 1944–1954
Double Talk (Feature), 1957
Dumbo Weekly (Disney), 1942
Eat Right to Work and Win (Swift), 1942
Fawcett Miniatures (Wheaties), 1946
Li'l Abner and the Creatures from Drop-Outer Space (Harvey), 1954
March of Comics (K.K.), 1946
Peter Penny and His Magic Dollar (American Bakers Assn.), 1947
Popsicle Pete Fun Book (Joe Lowe), 1947
Rudolph the Rednosed Reindeer (Montgomery Ward), 1951
Saks' 34th Street Store Robin Hood Giveaway (1942)
The Story of Harry S Truman (Democratic National Committee), 1948
Super Book of Comics (Dell), 1944
Superman's Christmas Adventure, 1940, 1944
Superman at Gilbert Hall, 1948
Superman & the Great Cleveland Fire, 1948
Superman Miniatures, 1953–1956
Stamp Day for Superman (U.S. Treasury), 1953
Trapped (Columbia University Press), 1951

Frank Miller and Dave Gibbons's *Give Me Liberty,* a four-part miniseries from Dark Horse, won them an Eisner Award in 1991 and launched the ongoing Martha Washington character.
(© Frank Miller and Dave Gibbons)

Give Me Liberty

Dave Gibbons had already drawn 30 pages of *Give Me Liberty* when he realized he wasn't going to draw a 31st. The magic—the magic that had seemed spontaneous with Alan Moore on *Watchmen*—wasn't happening. Gibbons liked Frank Miller's scripts well enough but where they were going—"a kind of social document, very long, very explicit, that spoke very much about the realities of life"—didn't feel right.

So, Gibbons took a deep breath and called Miller. "Frank, I've been thinking," he said. "I don't know how to say this, but I'll just say it: I don't really want to do it. There was an appalled silence. He said, 'Are you going to change your mind? Is there anything I can say?'"

No, Gibbons said, I've been wrestling with this for a long time and I've made up my mind. They said their good-byes, and rang off.

"And 20 minutes later," Gibbons said, "the phone rings and Frank says, "Dave, I know you don't want to do it, let me just say this. Supposing instead of doing it this way we do it that way?' And what Frank said was exactly what I wanted to do, but I didn't know how to verbalize it. He didn't want to do another social document, he didn't want to do another *Watchmen*. He wanted to do another adventure book. And that's what I wanted to do.

"That's the thing about Frank: In 20 minutes, he identified what was wrong and came up with a whole different way of doing it. That's thinking on your feet. And that's what Frank does. Frank has a much less controlled, a much more inspirational approach than Alan. Maybe 'spontaneous' is the word. Alan is a classical composer; Frank is a great jazz musician."

Gleason, Lev

Once the advertising manager at Eastern Color Printing, Leverett Gleason helped publish *Tip Top Comics* for United Features in 1936. But his name is synonymous with—and prominently displayed on the cover of—*Crime Does Not Pay,* the comic that sparked the boom in crime comics after World War II.

By 1947, *Crime Does Not Pay*—with Charles Biro and Bob Wood doing most of the grunt work—was selling more than a million copies each month. Because it was also generating considerable complaint, Gleason helped to form two self-policing posses, the Association of Comics Magazine Publishers and the Comics Magazine Association of America. The latter produced the abominable Comics Code, which prohibited the use of the words "Terror" and "Horror"—but not "Crime"—in a comic title.

Silver Streak (picked up from Your Guide Publications) was the first book Gleason published when he went out on his own. Other Gleason titles include *Boy Comics, Crime and Punishment,* and *Daredevil Comics.*

Golden Age

The sweet spot in the history of comics began with the advent of Superman—and the super-heroes—in *Action Comics* #1 (June 1938) and concluded, arguably, in 1949.

The heart of the Golden Age was beating between 1939 and 1943. After the end of World War II, most of the gold was flake and the most memorable covers were of good girls in distress.

"In those days, a 10-cent comic book went far," recalled Malcolm Willits, who was born in 1934 and opened Collectors Book Store in Hollywood in 1965. "They were 64 pages in length and hardly an ad in them except for the back covers, which often offered such items as whoopee cushions and vomit plaques...

"They were as indispensable to our lives as guns and syringes are to the present generation. You could spend an entire day with one comic book then. And it was something just for you. No adults would be caught dead with one. This is why so few of them survived."

"It was tough to buy a comic book," Willits added, "and even tougher to collect them. It is a shame, but most collecting periods arrive when few have money to collect. The greatest cars America ever built appeared in the 1930s, but few could buy them. Comic books, the first and greatest outpouring of true children's literature the world has ever seen, appeared at a time when not many could afford them."

The term "Golden Age" wasn't affixed to the era until the late 1960s, when it became necessary to differentiate the comics that had appeared in the medium's infancy with those that were part of its "Silver Age" resurgence. The term does not appear in Jerry Bails and Howard Keltner's 1963 index to DC Comics, but it is prominent in Michelle Nolan's *Golden Age Super Hero Index*, published in 1968; Nolan "liked the phrase" and wanted to popularize it.

Good-Girl Art

The marriage of the pin-up and the comic book, good-girl art first blossomed in France some 70 years before the appearance of *Phantom Lady* #17.

"The weekly magazine *La Vie Parisienne*, which had started publication in 1863, began to regularly feature drawings of girls *en deshabille*," Alberto Becattini wrote in *Glamour International*'s index of the genre. "Raphael Kirchner was the prophet of this tantalizing kind of art."

The drawings got considerably more tantalizing—and noticeably less subtle—in the magazine illustrations of the 1920s, in pulps such as *Weird Tales* and *Spicy Detective Stories,* and in the calendar art exemplified by the various Vargas and *Esquire* girls.

Two publishers, Fiction House and Fox, pinned their hopes on pin-ups, but even artists such as Carl Barks and Ernie Bushmiller had their turn at undressing women with a deft pen.

Alberto Vargas, Milton Caniff, Matt Baker, and Frank Frazetta are the acknowledged masters of good-girl art, but any retrospective must include the pulp covers of Margaret Brundage; the strip art of Stan Drake; the magazine illustrations of Virgil Finlay; the calendar art of Al Moore, George Petty, and Robert Patterson; and the comic book covers of Alex Schomburg, Joe Doolin and Bob Lubbers.

> "They were 64 pages in length and hardly an ad in them except for the back covers, which often offered such items as whoopee cushions and vomit plaques..."
> — MALCOLM WILLITS

The good-girl magazine illustrations of Virgil Finlay have influenced many a comic book artist.
(© Beverly C. Finlay)

Goodman, Martin

Fans are not interested in quality.

And Martin Goodman, with few exceptions, obliged the fans.

A pulp publisher in the 1930s, Goodman was persuaded by Frank Torpey, the sales manager at Funnies, Inc., to break into comic books in 1939. Funnies, Inc., proceeded to produce Goodman's first book: *Marvel Comics*.

He knew how to sell pulps and comics at the newsstand, and he knew whom to hire: his wife's cousin, Stan Lee.

Goodman sold the Marvel Comics Group in 1968, but Steve Englehart recalled that when Marvel finally leaped past DC as the top company in the industry, Goodman returned to take the staff out to dinner at DC's favorite hangout. "He was a good businessman," Englehart said, "who reached the top of the heap and sold out."

Goodwin, Archie

One of the nicest people I met in the comic book business. He rarely showed his temper.

Everybody wanted to work for Archie. A lot of people who didn't want to work at Marvel because of Jim Shooter, who was a black cloud, wanted to work for Archie.
GREG WRIGHT, COLORIST

When the EC fanzine *Hoohah* published a collectors' competition list in the early 1950s, guess whose hoard of 319 EC comics put him at the top of the tote board: Archie Goodwin.

Inspired by the various EC artist bios, Goodwin actually enrolled in the Cartoonists' and Illustrators' School in 1956. He graduated, unfortunately, into an era where even his heroes at EC weren't finding much work.

"For a long time, it looked as if there wouldn't be any comic books for me to work on when I was finally ready," Goodwin said, so he went to work at *Redbook*, doing paste-ups and layout.

His friendship with Al Williamson helped him get his first comic strip job, assisting Leonard Starr on *On Stage*. The EC connection was also crucial to Goodwin's first story for Harvey; titled "Hermit," it was drawn by Reed Crandall and inked by Al Williamson and appeared in *Alarming Adventures* #1 (October 1962).

Goodwin was soon writing scripts for Jim Warren's *Creepy*; Warren was so impressed that he asked Goodwin to edit the book beginning with issue #4.

"Jim liked being a character, played well to being a character," Goodwin said. "When he was talking me into taking over the editorship of *Creepy* and *Eerie*, he invited my wife and I out to dinner. We met him at his apartment. He said, 'I have a car waiting downstairs to take us to the restaurant,' so we went downstairs to the car. The car drove around the block, took a left, took another left, and pulled up at a restaurant on the other side of the block from his building. Jim was a lot of fun to work with."

Unfortunately, he didn't always have a lot of money to play with at the end of the workweek. When Warren could no longer pay his bills, Goodwin jumped—at the urging of Roy Thomas—to Marvel in 1966. "At Marvel, you actually had to take a writer's test to see if you could master the Marvel style," Goodwin said. "Stan had Gene [Colan] put an *Iron Man* job on his drawing board that he was about to script. They made me photostats of the first four pages; I wrote them that night, brought them in the next day. Stan looked at it, gave me a few pointers about what I was doing wrong about the characterization, then said, 'Here, you're writing *Iron Man*.' I always felt very lucky that I didn't come in on the day that he had *Millie the Model* on his drawing board."

Goodwin had tours of duty at DC and Seaboard, and a second hitch at Warren, before returning to Marvel in 1976 to become the company's eighth editor-in-chief. He hung tough for 18 months before giving way to Jim Shooter.

In each outpost, Goodwin picked up friends and admirers. "I'm not a big-cause type person," he said. "For me, it's a matter of whoever you work with, you try to treat them as good as you can. In your work situation, you create the best work situation that you can. If you want to work in comics, this is what you do: You cut the best deal you can and fight to make the deal better as you go along." This type of positive approach earned Goodwin the Bob Clampett Humanitarian Award in 1992, and an out-

Archie Goodwin

pouring of heartfelt tributes at his death.

Goodwin edited Marvel's Epic line in the 1980s, then returned to DC. "If I date my comics career from when I started working for Warren, in 1964, it's been 30 years," Goodwin reflected at the 1994 San Diego Con. "As a kid in my teens, I always wanted to do comic books. My first job in comics I was both writing and editing a line of comics in which I worked with the artists who were all my idols. I started at the top, maybe it's been a gradual decline ever since."

Or, better yet, an inexorable climb into the exclusive company of the comics heroes he always admired. Goodwin died March 1, 1998.

Gorillas

Julius Schwartz believes DC's gorilla madness began on the cover of *Strange Adventures* #8 (May 1951). An angry-looking gorilla behind the bars of his zoo cell is waving a small chalkboard on which is written, "Ruth . . . Please believe me! I am the victim of a terrible scientific experiment!—Ralph." (See page 364.)

When the circulation figures on the book

Here's just a sampling of some of the gorilla covers that boosted sales for DC Comics in the 1950s.
(© DC Comics, Inc.)

tumbled in, Schwartz said, "The editor-in-chief came in and said, 'What happened to the circulation, it almost doubled in sales.' I looked at it and said, 'Maybe it was the gorilla.' So I put another gorilla on the cover. And invariably every time I had a gorilla cover, it had wonderful sales. Finally, every editor wanted to use a gorilla cover, so Donenfeld said no more than one gorilla cover a month."

Donenfeld, Gil Kane added, "just looked at statistics and sales figures. He had a graph where he determined that gorillas sell, fire sells, earth sells, jail cells sell. So we would have various combinations of gorillas in cells with fire behind them. I did some gorilla covers and some earth covers, and the next thing I knew I was doing gorillas with earth covers. He [Donenfeld] would insist on these elements; he used to keep miniature examples of the covers so he could compare them."

The Super Grodd trilogy in *Flash* #106–#108—featuring the origin of Grodd and the Flash's first visit to Gorilla City—may be the most famous gorilla saga. But let's not forget:

Action #6 (November 1938), the first gorilla cover, with Leo O'Mealia art.

"The Gorilla Boss of Gotham City" in *Batman* #75.

The Nazi Gorillas in *Amazing Man* #22 (in a perfect world, Nazi Gorillas would be a separate category).

The transformation of Congo Bill into Congorilla, whenever Bill borrows the brains from a gilded ape.

Toto the chimp, who is transformed into "Titano the Super Ape" in *Superman* #127 (February 1959). Toto returns from space with a raging pituitary gland and kryptonite vision; Lois Lane serves as his handler until Superman casts him back in time. Titano returns in *Jimmy Olsen* #84 (April 1965) to star in a monster movie.

Yango, a Krypton ape with a hefty dislike of poachers in *Superboy* #172.

Tonga, a giant gorilla who struts his stuff in *Adventure* #410. And the good-hit-no-field types who hang out at the ballpark in "Gorilla Wonders of the Diamond" (*The Brave and the Bold* #49).

Gotham City

The Batman's haunts. "My standard definition of Gotham City is New York below 14th Street after eleven o'clock at night," Denny O'Neil said.

Bill Finger once told Jim Steranko that he planned to call Batman's haunts Civic City. "Then I tried Capital City, then Coast City. Then I flipped through the phone book and spotted the name Gotham Jewelers and said, 'That's it, Gotham City.'"

Gottfredson, Floyd

Born in a Kaysville, Utah, railroad station in 1905, Floyd Gottfredson produced his first *Mickey Mouse* comic strip on his 25th birthday. Walt Disney assigned him the strip while he went scavenging for another artist.

"After a month, I began to wonder if he was looking for anyone," Gottfredson later said. "After two months, I was worrying for fear he would find someone. By now, I was enjoying it and wanted to continue with it. Nothing more was ever said about it."

At least, nothing until Gottfredson retired in 1975. He drew the daily strip for over 45 years and—like Carl Barks—was never allowed to sign his name.

Gottfredson had arrived in Los Angeles in 1929 looking for work as a cartoonist but was working as a projectionist when he saw several Disney posters in a window. When he asked about them, he was told Disney was on his way to New York to hire animators. "So I hurried out to Hyperion in Hollywood where the old studio was then located," Gottfredson said in a 1968 interview with Malcolm Willits. "I wasn't the best businessman in the world, however. I was earning $65 a week as a projectionist, which was very good wages for the time. At Disney's I began at $18 a week."

Unlike Carl Barks, Gottfredson remained at Disney in the subsequent decades, "welcoming," to quote Willits, "each edict as it came down and changing his mouse accordingly." Gottfredson also determined that the Mickey Mouse in his daily and Sunday strip

Floyd Gottfredson wrote and drew the definitive Mickey Mouse for comic books.
(© The Walt Disney Company)

should convey "the spirit and the personality of the Mickey Mouse movies." Those adventure strips were eventually reprinted in *Walt Disney's Comics & Stories*.

Beginning in 1978, Willits (the owner of Collectors Book Store in Hollywood) commissioned Gottfredson to produce a series of 24 Mickey Mouse paintings. Willits had the Disney studio's permission to produce the art for a series of buttons featuring Mickey, but the studio refused to issue a license until it saw the final product. When the Disney lawyers realized Gottfredson was the one painting the scenes, they denied Willits his license.

"I selected the only person on the entire planet who wasn't supposed to paint Mickey Mouse," Willits said. "There were people there who didn't like Floyd Gottfredson because he'd had such an 'in' with Walt."

When the lawyers refused to budge, Willits wrote a letter to Disney's widow, Lillian, appealing for her help. Walt and Lillian had known Floyd and Mattie Gottfredson quite well in the 1930s; Willits not only told Lillian that Floyd was getting a raw deal but enclosed a Xerox copy of a thank-you note she'd sent him after he donated $750 to Cal Arts in her husband's name.

"I didn't hear from Mrs. Disney personally," Willits said, "but something happened. She either called or sent a letter to [Michael] Eisner and Eisner told his legal staff to give Mr. Willits what he wants. All I wanted was to get Floyd Gottfredson painting."

Mission accomplished. Gottfredson painted the last of the Mickey Mouse scenes in 1983 and died three years later of a stroke.

Gould, Chester

Living (at least until 1985) proof that writing—not draftsmanship—moves a great comic strip.

Gould was a three- (or was it six-?) time loser in 1931 when he submitted a strip entitled *Plainclothes Tracy* to Joseph Patterson, the head of the Chicago Tribune–New York News Syndicate. Bingo.

Al Capp once observed, "Everything I know about comic strip narration I learned not only through my own efforts but from the study of two great masters: Chester Gould and Harold Gray." And Bob Kane admitted that he tried to add the flavor of *Dick Tracy* to his Batman stories by copying such classic villains as Prune Face and Flat Top.

Gould mastered detail, mood, and the grotesque in *Dick Tracy*, which he continued to write until Christmas 1977.

Grading

Be honest, at least this once. You can't grade your own comics.

But don't despair. Long-time comic book dealers Dave Anderson (from Virgina) and Jim Payette have a tough time grading theirs, too.

In the interest of honest grading—which is always in the buyer's interest—we'd suggest following these two bits of advice from *Comic Source* editor Jon Warren: (1) When you buy a book, write the grade down. (2) Never change it.

You are always more honest—read "more strict"—when you are buying comics. Flaws too often diminish, or disappear, when you're the one applying the price tag.

In the beginning, there were two grades: Good-to-Mint and none of the above. When you ordered a Good-to-Mint book from Howard Rogofsky in the 1960s, you never knew whether there'd be gloss on the cover or rolls of tape on the spine.

In Bob Overstreet's first Price Guide, published in 1970, there were three grades—Good, Fine and Mint—but the Mint book was only worth 1.5 times its counterpart in Good con-

GERBER'S GRADING GRAPH

	Arm's Length Overall Appearance	Interior Page Condition	Cover Flaws	Color / Gloss	Other
Mint	Like New	Near White	None except 1/16" flaw, top and bottom spine	Bright colors, full original gloss	Flat, staples directly on spine, no "perked" up corners
Near Mint	Almost Like New	Off White	Faint stress lines on spine	Colors slightly faded, but cover gloss intact	Slight perking of cover corners, one 1/8" rip
Very Fine	Read a Few Times	Slight Yellowing	Slight off spine staples		1/8" corner creases
Fine	Read	Yellow	Minor stress lines at staples	Still clean and bright, colors & gloss losing original lustre	Stress lines around staples
Very Good	Well Read	Slight Browning	Creases along spine		One or two 1/4" rips
			Minor creases on cover corners	Original gloss mostly gone	1/2" spine roll
Good		Brown	"Chipping" along cover edges		1" cover rips
			Cover loose	No gloss but clean	1" spine roll
Fair	Worn		Well worn cover		Cover rips 1"-3"
			Multiple creases, folds, loose cover, pages and pieces missing	Faded colors, well worn and dirty covers	1"-2" pieces missing
Poor	Not Collectible	Brittle			Pages missing

To obtain the all-around Comic Grade at the left, take the average of the five columns to the right.

Ernie Gerber's approach to grading.
(© E. Gerber)

"Mint? It's a flavor."
MARK WILSON

Overstreet published this handy little card to help dealers and collectors with grading.
(© Robert W. Overstreet)

GRADING JARGON

The crucial lexicon in deciphering comic book grades:

Otherwise. As in: "*Adventure* #252, ketchup and creamed-corn stains, knife wounds, masking tape on spine, some sun bleaching, otherwise NM." Otherwise is the point at which the seller asks the buyer to suspend disbelief.

Scarce. In a March 1993 issue of the *Comic Buyer's Guide,* two-year-old copies of *X-Men* #1 were advertised at seven-times Overstreet Guide with the admonition that they were Scarce! Marvel printed eight million copies of this book. When there is nothing else to say about a book, it's usually declared "scarce." The scarcity usually has more to do with the number of interested buyers, not the number of available copies.

Nice pages. A dead giveaway for a ripped, tattered cover. If you tend to fold your Golden Age books open at the centerfold and insert them into your Mylar sleeves, "nice pages" may be just what you're looking for.

Xeroxed cover. The dealer's means, for the 89-cent charge of a color Xerox, of improving a coverless key book into a $1,300 "great buy."

Apparent Fine. Restored. For accuracy's sake, the dealer could say, "extensively restored to fine condition," but he's hoping there are still a few suckers out there who haven't figured out this cryptic reference to restoration.

Color touch. In all likelihood, the former owner of this book used it as a carpet guard when he was repainting his living room.

Highly sought after by collectors. Just not the one who's selling it and is seeking a $400 profit.

Call. When you hear the price, you'll burst out laughing, so the dealer wants you on the line to hear his counter-offer.

dition. In the 1996 Price Guide, by comparison, that ratio ranges from 7:1 to 10:1.

As collectors became more grade conscious, more grades evolved. (The corollary, we supposed, is that as collectors became more price conscious, more price guides were produced.)

In the 1996 guide, Overstreet lists eight grades: Mint (M), Near-Mint (NM), Very Fine (VF), Fine (F), Very Good (VG), Good (G), Fair (F), and Poor (P).

No one has ever argued eight is enough, or that the condition of a comic book can be summed up in one or two words. "Mint? It's a flavor," said Mark Wilson, one of the strictest graders in the industry. "Very good? What's that? What does Fine mean?" Because everyone has a different idea in the debates around the dealers' tables, the calibrations of these grades are endless. There have been doctoral dissertations on the difference between FVF and VF–.

In the 1992 guide, Overstreet finally began the conversion to a 100-point grading system, which had been previously championed by Atlanta dealer Keith Contarino and the Pacific Comic Exchange.

To illustrate those 100 points, Overstreet and Gary Carter published *The Overstreet Comic Book Grading Guide.* On this scale, a grade of 98 to 100 equals Mint; 90 to 97, Near Mint; 75 to 89, Very Fine; and so on. Unfortunately, the photographs used to illustrate the increasingly exact science of grading are poor, and there is no list of specific subtractions. What's a cover crease worth? How much do you dock for a dust shadow? You won't read it here.

The timing of this grading guide was also curious, arriving as it did when an increasing number of dealers were forgetting about grades and simply slapping price tags on the books.

This trend highlights the difference between *convention* and *mail-order* grading.

Books at conventions are invariably graded—and priced—to benefit the seller, not the buyer. Collectors who buy through the mail, or at comic shops, usually have the luxury of time and access to a price guide. Convention sales are aimed at impulse buyers or customers the dealers may never see again. Both targets encourage higher prices that have little, if any, relation, to grade and the guide.

"There are dealers who have two prices, the mail-order price and the convention price,"

said Steve Fishler of Metropolis Comics in New York. "They literally do not put the grades on the books if they're going to the convention."

Why not? The convention dealers have learned, Mark Wilson said, "You don't grade the book. That's taboo. You let them grade it. You take this *Wonder Comics* #1 that's VG/F and you put a sticker up, $75, just like that, and put it on your wall. A guy comes up, gets excited, opens his guide and says, 'Yo, in the guide it's only $68 in NM.'

"'Yeah,' you say, 'but it's a tough book and Schomburg's hot.' The guy says, 'Well, but it has a signature on the top.' And you say, 'Yeah, but the Mile Highs have a signature, too. So do the Larsons.' He says, 'Well, I wouldn't grade this NM.' And you say, 'Well, you grade it, but the price is $75.'

"The guy scratches his head, he wants to deal, and he says, 'I'll give you $60.' You say, 'I can't do that. Split the difference: $67.50?' The guy says, 'Okay, I'll do it.' He walks out of there with a VG/F book at $67.50, 50 cents less than the NM price. Was he robbed? Ripped off? What happened here?"

Your standard, and increasingly common, convention hustle.

But we were talking grading, not a dealer's sleight of hand. Be forewarned: An accurately graded book is annoyingly rare. It captures the degree to which the book has dodged the inexorable fate of all paper collectibles: disintegration. It includes not only the charm of the cover but the hue of the pages and the suppleness of the spine. And it doesn't change when the book is put up for sale.

Blessed are the honest graders.

Grandenetti, Jerry

He entered the field, at the age of 23, as a background artist for Will Eisner's *Spirit* in 1948. If his subsequent work never quite matched the impact of Eisner's—who, Grandenetti once said, "was like a god to us"—it strived, and sometimes succeeded, in being as distinctive.

Grandenetti paid homage to his former boss in his best known series, "The Secret Files of Dr. Drew," which ran in *Rangers Comics* #47–#60. As he moved through short stints with Ned Pines and Charlie Biro and a 12-year stint at DC (where he put Bob Kanigher's words to music in various war books), Grandenetti began to experiment with a cartoonish, surrealistic approach to his panels. By the time he joined Jim Warren's staff in the early '70s, his stories for *Creepy* were jammed with some of the quirkier elements of Alex Toth, Graham Ingels, and Jack Davis.

In 1972 Grandenetti did some final work for DC then abandoned the field to take a job as art director for the advertising firm of Young & Rubicam.

Graphic Story Magazine

GSM was perhaps the most intelligent fanzine in comics history, thanks to the deft editing of Bill Spicer, the critical writings by Richard Kyle, and several unsurpassed interviews.

Spicer, an old EC Fan-Addict, unveiled the fanzine in 1964 as *Fantasy Illustrated*. In an endless opening statement, Spicer observed, "Instead of an attempt to flatter the pro comics by outright imitation and duplication, it would seem to make more sense (and provide more fun) to, say, show off a bit by printing stories that they themselves wish they could publish but cannot, due to restrictions which prevail throughout the industry."

With his eighth issue, Spicer renamed the fanzine: "Because the comic book field will someday be joined by popular, commercially marketed advanced works in their own books—which might well become known as

Bill Spicer's 1960s fanzine, *Graphic Story Magazine*, had better writing and graphics than most of today's professional magazines about comics.

the graphic story field—the term 'graphic story' itself will be fair game for use as a title. I'm anticipating the scene. *Graphic Story Magazine* is here, right now."

And that, bear in mind, was written in 1967.

GSM had a superb letters column, highlighted by regular contributions from Landon Chesney, Hames Ware, Bhob Stewart, Larry Ivie, and Mike Barrier. There were adaptations of Edgar Rice Burroughs stories and of Earl and Otto Binder's "Adam Link."

But interviews were the highlight of the fanzine, particularly Bhob Stewart's with Howard Nostrand in #16, the final issue, and Spicer's with Harry Harrison in #13.

"Those early fan magazines like Bill Spicer's caught people when they were still uninhibited," said comic historian Hames Ware. "Bill would do esoteric stuff, guys like Will Gould. He was one of the lesser-known comic strip artists, so Bill devoted a huge issue (#12) to him. You never knew what was going to be in there.

"Bill Spicer is one of the great characters of all time," Ware added. "A genuine, living, breathing character. He loved to stir controversy. He has this wonderful, winsome smile, half sly and half benevolent. And unlike so many other people, he's content to let other people have the floor.

"I'd compare him to Ronnie Hawkins of Ronnie Hawkins and the Hawks [which evolved into The Band]. Ronnie played no instrument himself; he was free to move around. He would take his microphone when there were breaks in the lyrics and hold the mike in front of Robbie Robertson's guitar playing. He would delight in the musicians' ability to do what they did. He wasn't hogging the spotlight, he was sharing the spotlight.

"Bill Spicer did the same thing. He made no money off [the magazine]. It took an incredible amount of work on his part. Yet he didn't use it to pump himself. He allowed it to be a forum for the kids out there and the pros alike."

Gray, Harold

Gray was the creator of Bullion the Banker, J. J. Shark, Baron Slinkovitch, Mrs. Bleating-Hart, Phil O. Bluster . . . and, oh yes, Little Orphan Annie.

He was born in 1894 and married twice, and Annie was his only child. Al Capp once suggested Gray's characters had "all the vitality of Easter Island statues," but the strip made up in notion what it lacked in motion. Gray pumped his politics into his grim tableaus, a self-reliant conservatism that impressed Capp when they first met. Capp, who "was but a rumor that had just gotten started" when he met the legendary cartoonist, said Gray told him, "I know your stuff, Capp. You're going to be around a long time. Take my advice and buy a house in the country. Build a wall around it. And get ready to protect yourself. The way things are going, people who earn their living some day are going to have to fight off the bums."

Gray, who made quite a living off his orphan and her Daddy Warbucks, fought them off until his death in 1968.

Green Arrow

First appearing in *More Fun Comics* #73 (November 1941), the Green Arrow has hung around the comics for more than 55 years without headlining very many of them. The character was created by Mort Weisinger and George Papp, but the best years of his life occurred in the 1970s when sidekick Speedy got

"Take my advice and buy a house in the country. Build a wall around it. And get ready to protect yourself."
— HAROLD GRAY

Harold Gray dispensed his philosophy of capitalism and self-reliance on a regular basis in *Little Orphan Annie*.
(© Tribune News Syndicate)

hooked on heroine and Neal Adams and Denny O'Neil hooked the Green Arrow up with the Green Lantern.

Greene, Sid

When he finally arrived at DC in 1955, Sid Greene had had his passport stamped at Ace, Eastern Color, Lev Gleason, Holyoke, Marvel, Pines, Orbit, and Quality. He spent some 15 years at DC, drawing Adam Strange, Batman, Flash, Green Lantern, and Hawkman, among others. "I'm told," Don Rosa would later note, "Greene died in the mid-1970s after years of being unable to find work despite his decades as a very capable artist."

Green Hornet

Originally a radio star—first appearing on Detroit's WXYZ in 1936 and going national two years later—the Green Hornet reached the comics rack with *Green Hornet Comics* #1 (December 1940). The adventures of this urban Lone Ranger (he was the grand-nephew of the original masked man) and Kato were assembled in Bert Whitman's shop. The first six issues were published by Helnit; Whitman then sold the package to Harvey, which pumped out the final 41 issues.

Jerry Robinson, Bob Fujitani, Bob Powell, and Joe Kubert pitched in with interior art on the Harvey issues; Alex Schomburg provided eight covers (#15, #17–#23), which are several of the only surviving examples of his original cover art.

Green Lantern

Created by artist Martin Nodell, the Green Lantern debuted in *All-American Comics* #16 (July 1940), in a tale written by Bill Finger.

Inspired by Aladdin and his magic lamp, the Green Lantern was one of the dominant characters of DC's Golden Age, with lengthy runs in *Comic Cavalcade, All Star Comics,* and his own book.

An all-star cast worked on Green Lantern over the years, including artists Irwin Hasen, Paul Reinman, Lee Elias, and Alex Toth, and writers Alfred Bester, Henry Kuttner, and John Broome. Yet, as Jerry Bails first noted in *Alter-Ego* #3, whatever continuity the strip had should be attributed to chief editor Sheldon Mayer.

Mayer not only first recognized the potential in Nodell's crude creation but brought the character to prominence. "When Sheldon Mayer turned over his editorial cap to another man in 1948," Bails wrote, "an era came to an end—and Green Lantern was one of the first stars to fall. Oh yes, he did continue to appear as an active member of the Justice Society of America until its demise in 1951, but he lost out in *All-American Comics* in late 1948 to Johnny Thunder, the western hero." In his own book, the Green Lantern suffered a more ignoble fate, losing the cover in some of the late issues to Streak, the Wonder Dog.

Green Lantern's alter-ego was radio announcer Alan Scott; Finger said the name "Alan Ladd" was originally considered, then rejected as being "too obvious."

Green Lantern's Silver Age incarnation debuted in *Showcase* #22 (September 1959), written by Bob Kanigher, drawn by Gil Kane, and engineered by Julius Schwartz. GL—along with the Flash, the Atom, and cohorts— was instrumental in reviving the fortunes of DC.

Grell, Mike

In December 1970, Mike Grell was in Saigon, waiting for the discharge that would bring him home for Christmas. A top-secret briefing being drawn up for President Nixon and the chiefs of staff arrived at his desk; because Grell was the highest-ranking security-cleared illustrator in Southeast Asia, he was assigned to produce the accompanying graphs.

In the last 25 years, Grell has thought a lot about what he saw in those briefing papers. "It was the outline for the withdrawal of troops from Vietnam," he said. "That was Christmas of 1970. The withdrawal was begun in 1973 and ended in 1975 . . .

Shelly Moldoff drew an early bead on Green Lantern.
(© DC Comics, Inc.)

Mike Grell

GRELL'S GUN

Mike Grell appreciates the rough grain of his reputation and doesn't mind if a few preposterous legends precede him. But he is forced to admit that he never pulled a gun on Rick Obadiah in order to get a paycheck out of First Comics.

"Curious you should ask," Grell said. "The gun incident wasn't over money. It was a contract negotiation. The legend goes that I walked into the office at First to negotiate a contract, laid a .45 automatic on the table, and said, 'Okay, let's talk.'

"The truth won't do my reputation a lot of good. I had been given a .45 automatic as a birthday gift by my brother, who lives just a few miles from Chicago, where First's office is. I had it with me in my briefcase. After the contracts were signed, I was putting the documents into my briefcase and someone spotted the gun and asked if they could look at it. I passed it around, several people fondled it, then I put it away."

Okay, Mike, so you didn't pull a gun. But what about the professional wrestler? Didn't you send some steroid-soaked stud in to wring Obadiah's neck?

Not me, Grell said: "However, a friend of mine did. Denys Cowan. He sent a guy 7 feet tall."

And he got paid? "On the spot."

"I not only had the dates of the withdrawals but the troop movements, which units were going and when. I wasn't surprised to see it. I was surprised at the timing, that it was planned that far in advance. To find out the end was planned that far in advance, over such a slow period of time... It gave me a lot of trouble for a long time. Part of me says that I couldn't have done anything anyway. If I'd opened my mouth, I would have been visiting Leavenworth.

"But I carried a lot of guilt for a long time," Grell said, particularly when he first saw the Vietnam Memorial in Washington, D.C. "Visiting the Wall monument was pretty rough. If you've walked down along the wall, when you reach the maximum depth and the names begin to pile on top of one another, you suddenly hit this corner and there's just as long a walk back out of it. Well, that corner is about the time I was over in southeast Asia. That corner was very significant. It's something that happened for everybody. Everyone turned the corner. It's a long walk out of the hole. A lot of us are still walking out of that hole."

When Grell got out of the Air Force in 1971, he cruised through the Chicago Academy of Fine Arts, then marched on the offices of the Chicago Tribune Syndicate. In his hands was the comic strip called "The Savage Empire," which eventually became *Warlord*, but it failed to impress syndicate president William Colston.

"People just aren't buying adventure stuff these days," Colston told Grell. But he'd just gotten off the phone with Dale Messick, who needed help on the backgrounds for *Brenda Starr*.

Grell spent a year with Messick—"one of the sweetest, most charming, vivacious people I've ever met"—before seeking his fortune in New York. "I walked in thinking I'd take the town by storm, and found out that the hatches were securely battened down against intruders," Grell said. He was refused interviews with editors at several strip syndicates, but met Alan Asherman and Irv Novick, who urged him to go see Julie Schwartz at DC.

"I went in with my World Book Encyclopedia sales pitch," Grell said. "I got as far as, 'Good afternoon, Mr. Schwartz,' and he said, 'What the hell makes you think you can draw comics?' I unzipped my portfolio, threw it on his desk and said, 'You tell me.'"

A half-hour later, Grell walked out with an *Aquaman* script ("As the Undersea City Sleeps") under his arm. He had picked a propitious time to visit DC. As Grell was walking in looking for work, Dave Cockrum was strolling out. Editor Murray Boltinoff was stuck without an artist on *The Legion of Super-Heroes*, and Grell jumped at the chance.

Warlord soon followed, but Grell didn't feel that his Christmas stocking was full until he inherited the *Tarzan* Sunday page in 1981. "I always thought when I was doing comic books I was only passing through on my way to do comic strips," Grell said. "The *Tarzan* comic strip was the most fun I've ever had doing anything. Unfortunately, I could not afford to continue doing it. Economically, it was a bust. I was being paid the same thing that Burne Hogarth was being paid in 1951. Needless to say, in 1951 it was fairly serious cash."

In 1983 Grell created *Jon Sable, Freelance* for First Comics. "In later years, I wrote a story in *Sable* that had to do with POWs and MIAs," he said. "To write that story, I immersed myself in the war. For about three months, it was like living back in the battle zone again. I used to look up from my drawing board and be surprised by my surroundings.

"I remembered very clearly what it was like to be in the war zone and to read about the protests going on in the United States and to feel like I was betrayed by the people back here. Over the years, I've come to regard that viewpoint as totally wrong. The people who stayed

here and fought against the war were the true heroes. While working on that story, I had all that come back to me."

Grendel

Matt Wagner's knight errant first appeared in *Primer* #2 (1982), a black-and-white anthology from Comico. "It wasn't a tale I wanted to tell forever," Wagner said, but the character's ability to reinvent itself—as a woman, or a warrior in the future—in a continuing series of miniseries not only sustained Wagner, but set the stage for books such as DC's *Legends of the Dark Knight* (to which he became a contributor).

Griffin, Rick

"When he became a Jesus freak," Spain Rodriguez told the *San Francisco Examiner* after Griffin's death, "me and [S. Clay] Wilson, [Robert] Crumb, and Robert Williams went down there to try and bring him back into the fold. We bought a bottle of tequila to get him drunk and kidnap him, but wound up laid out on his bathroom floor ourselves, making these grandiose oaths about everything but the reason we came for. We swore some kind of blood oath that I got from this motorcycle club I was in called the Road Vultures, promising not to go after each other's women until six months after we broke up with them. It was pretty hilarious."

One of the original San Francisco poster artists, Griffin also created "Murph the Surf" for *Surfer* magazine. He joined the *Zap* staff in 1969. On his place in the underground, Bob Beerbohm once compared Griffin to "Al Williamson in the EC crowd—since he was the baby, everybody looked out for him, encouraged him, and so on. And like Williamson, Rick excelled beyond them all."

Griffin died in a Petaluma motorcycle accident in 1991. "He was always kind of like one of those real dreamers," Crumb told the *Examiner.* "He lived in his own world—or rather his own mythology. Even when he was a Jesus freak, it was his own crazy, romantic vision. He'd claim the Bible said the earth was populated with a race of giants. Stuff like that. I think he even found surfing in the Bible."

Griffith, Bill

The creator of *Young Lust* and *Zippy the Pinhead,* Bill Griffith grew up in the '50s in Levittown, New York, bouncing off a "very understanding, hip, smart, creative mother, and a very authoritarian, screwed-up, angry father," and the only beatnik in town.

That beatnik was Ed Emshwiller, a renowned science fiction artist who evolved into abstract expressionism and, later, into experimental film. "I first admired Emshwiller because he didn't go to work every day, he was not like my father," Griffith told *The Comics Journal* in 1993. "He worked in a studio up in his house right next door and he'd make $300 for a cover of a magazine. I even posed for quite a few of them, as did all of my family ... [Emsh] also did Mike Shayne mystery covers and he used my mother for a lot of those. She looked

Rick Griffin's mystical artwork graced the pages of *Zap* as well as many a Fillmore poster and the covers of Grateful Dead albums.
(© Rick Griffin)

An anomaly on America's newspaper comics pages, Bill Griffith's Zippy explores pop culture in imaginative and often surrealistic ways.

(© Bill Griffith)

kind of like Kim Novak. She was quite sexy. So she appears on many a cover of Mike Shayne mystery novels, her tits thrust forward in a cashmere sweater. And my father appears as these sort of authoritarian, finger-waving, finger-pointing figures. And my sister and I both appeared as these sort of maverick, runaway kids. He really had our family down perfectly. And as I look back over the years, I realize what an influence he was. He didn't point me to cartooning, but he pointed me into art in general and showed me a way of understanding how within one artist there could exist this pop culture impulse and a fine art impulse."

When Griffith realized he had to bring those impulses together ("There was a battle going on inside of me between Jackson Pollack and Milton Berle") he went to the Pratt institute, hanging out with Kim Deitch and smoking dope. He had early strips printed in *Screw* magazine and the *East Village Other* before developing *Young Lust,* a parody of romance comics, in 1969.

Griffith first met Art Spiegelman at Gary Arlington's comic book shop in 1972; three years later, they collaborated on editing the first issue of *Arcade.* The following year, Griffith published his first *Zippy* strip. By 1985, the daily strip, starring Zippy and Griffy, was nationally syndicated.

"What Griffy and Zippy represent," Griffith said, "is the dialogue between those two parts of myself, the critic and the fool."

Griffith is married to cartoonist Diane Noomin.

Groo the Wanderer

Groo was the first creator-owned comic to pop out of the direct-sales market onto the regular news rack. Created by Sergio Aragonés, Groo first appeared in Eclipse's *Destroyer Duck* (1982). After a 5-page preview in *Starslayer* #4, Pacific Comics published the first issue of *Groo the Wanderer* in December 1982. When Pacific folded, *Groo* eventually wound up at Marvel, for over 100 issues, before finally landing at Image.

The same creative team worked with Sergio on the title for over 15 years: Stan Sakai letters, Tom Luth colors, and Mark Evanier doing whatever it was Mark Evanier did.

Key issues? "I don't want people to collect *Groo,*" Aragonés once said. "I want them to read it and forget about it."

Guardineer, Fred

Beginning at Harry Chesler's shop in 1936, Fred Guardineer had a 20-year tour of duty, highlighted by his work on Zatara for *Action Comics* in its infancy. He moved on to Magazine Enterprises and Lev Gleason, then spent four years on The Durango Kid, ending in 1955. At the age of 42, Guardineer bailed out of the business, retiring to Long Island to become a postman and to dabble in reporting on fishing and hunting for newspaper and radio.

The most succinct review of his work? "He was one of the world's worst artists," Howard Nostrand once said. "He had a swipe file that went on forever. He did some work for Bob Powell at one point when I was there. The

Grothisms

Ten of the best quotes from Gary Groth, editor of *The Comics Journal* and the moral arbiter of the comics industry:

"Todd Loren: First Amendment Advocate or Lying Sack of Shit?"
HEADLINE, EDITORIAL, THE COMICS JOURNAL #138

The comics world is growing and we must grow with it. That, in a nutshell, is why we've raised our cover price by 45 cents.
THE COMICS JOURNAL #58

Has no one noticed that [Frank] Miller's stories are effective because they are manipulative? that his prose and dialogue, while unexceptional, are purple and occasionally dishonest? that the fight scenes are staged and executed awkwardly? that the drawing itself is too clearly derivative of Kane, Eisner, Kubert, Adams, and others? that Miller follows the precepts and formulas of detective stories without transcending them? that the plot twists are contrived and unrealistic? that the violence is not repellent, but revelled in and positively balletic (or as balletic as Miller can make it)? that the ideas that give it such legitimacy among intellectuals and critics are borrowed, trite, or commonplace? and that there is not a single truthful passage in the entire series?

Now, I am not blind to Miller's strong points as a writer and artist, and I don't mean to obscure them...
THE COMICS JOURNAL #171

Any ego thinking itself maligned can, if it has the tenacity and a potful of money, hire a lawyer and drag you through the court system.
THE COMICS JOURNAL #114

Libel suits aren't so bad.
HARVEY PEKAR INTERVIEW, THE COMICS JOURNAL #97

Everyone who cares probably knows what I think of Don Thompson, champion of the dull, the backward, the mediocre, the comics profession's most outspoken and ubiquitous apologist for the status quo.
THE COMICS JOURNAL #124

Dear Journal Readers,
Since my publisher, Berkley Books, hasn't seen fit to advertise my book anywhere, I thought I would take this opportunity to tell you a little about it.
ATOP A FULL-PAGE AD FOR THE NEW COMICS IN THE COMICS JOURNAL #127

If you don't believe WAP!'s ongoing smear campaign was malicious, you must be unaware of just how hated the Journal is among the hack class of comics professional. It's probably not unlike how the Reagan administration sees the Soviet Union—as that "evil empire."
LETTERS COLUMN, THE COMICS JOURNAL #125

It was an electric moment when I discovered that sex sells. I had already discovered that that which was not sex did not sell; in fact, I came to understand this with a vengeance when Fantagraphics Books, which Kim Thompson and I started and nurtured and loved, began to totter and head for collapse last year. When a publisher of integrity is about to die, he has one of two options: end it all or save the company by compromising. Enter: Eros Comix...

Starting the Eros imprint was not easy, spiritually, morally, or even practically. It's hard to say which was worse, the time before making the decision or the time immediately following it. The months leading up to it were a quotidian hell spent looking into a yawning abyss of mounting bills. One's spirit simply begins to crumble in the face of such ceaseless financial pressure, and putting a revolver in your mouth begins to take on a certain theretofore unrecognized romantic allure.
THE COMICS JOURNAL #143

The problem here is that when Gerber sued Marvel, he staked out moral territory, and his reasons for returning to Marvel... are wholly lacking in any moral dimension whatsoever. They are pragmatic, surely, and writers must make pragmatic decisions just as publishers must make pragmatic decisions (though there is no need to lecture publishers on this necessity), but once Gerber took the moral high ground, he was obligated to stay there.
THE COMICS JOURNAL #99*

*Groth later refers to "Gerber's responsibility to be morally consistent in the matter." In *The Comics Journal* #109, Howard Chaykin notes the irony of all this: "While you've been the Conscience of the Industry, you've also published *Focus on: George Pérez, Focus On: John Byrne, The X-Men Companion...*"

"Yes, as a practical matter," Groth said.

"I think it's only fair to grant to others the right to do the same, to support their lifestyle, to maintain their existence. Sorry, pal," Chaykin retorted.

In addition to his interior work for Centaur, Quality, National, and Timely, Paul Gustavson drew a variety of fine covers such as this for The Comics Magazine Company.
(© Comics Magazine Company)

whole thing was traced. He just traced everything."

Gustavson, Paul

Born in Finland, Gustavson and his comics career had trouble clearing the A's: He created The Angel for Timely and drew the Arrow for Harry Chesler.

"His stories—which often involved lovely blonde young women being threatened by loathsome monsters—were told in a fast-moving, almost hyperactive style," Hubert Crawford wrote in *Crawford's Encyclopedia of Comic Books*.

Gustavson had six hyperactive years on the comics beat, according to information he provided to *Who's Who of American Comic Books*. While freelancing for the Harry Chesler and Lloyd Jacquet shops, Gustavson worked on such features as Fantom of the Fair at Centaur, Here and There for National, The Angel and Patriot for Timely, and Midnight and Quicksilver for Quality.

By 1942 Gustavson had wearied of the page rates and cramped quarters. He was last seen working as a surveyor for the state of New York.

Hair

You can just draw a pretty girl with natural proportions, but, boy, you give her nice, fluffy hair. "Fluffy" is my term—draw the hair so that it looks like real hair that's blowing in the wind. When a woman walks, her hair does not sit still. Most guys, when they draw a woman's hair, it's like it's been sprayed with plastic—it doesn't move. Hair moves. The most movable part of a woman's body, besides her ass, is her beautiful hair ... Tell you what— shave a woman's head and have her walk down the street with a bald head. There's nothing erotic there. But take a wig, a nice soft blond wig, and have that blowing behind her, and that's sexy, boy.

You can do it with hair. You don't have to do it with big breasts.

STAN DRAKE COMICS INTERVIEW #26

Halloween Celebration

October's scary holiday was the excuse for some great parties in Rutland, Vermont. "There was a guy in Vermont, Tom Fagan, who was a comics fan," Steve Englehart said. "He lived in this wonderful old mansion—or rented it every year—a creepy old mansion that was perfect for parties. There was a parade through Rutland for comic book characters. After a while, the comic book people in New York would take the four-hour drive to Vermont and join this party. We spent a couple of very memorable Halloweens. You'd go to these parties and you'd come down and find the Hulk talking to Dracula, and you could believe that's who they really were."

Hama, Larry

Before the best parties moved to Archie Goodwin's place, Mike Kaluta said, they unraveled at Jeff Jones's pre-Studio pad at 135 West 79th Place. This must have been 1969, 1970. The regulars included Bernie Wrightson, Louise Jones (Simonson), Vaughn Bodé, Len Wein, and Marv Wolfman. "Roy Krenkel always showed up," Kaluta said. "So did Larry Hama, who was fresh back from 'Nam and still in sunglasses. We were all thinking, 'Get over it, dude,' never dreaming that he'd take it and make millions off *G.I. Joe* and *The Nam*. We were scared of him when we first saw him. Boy, did he look scary."

Hamlin, V. T.

A resilient man, to say the least. At the age of 9, Hamlin caught an arrow in the lip. At 16, he took a break from high school and joined the Army and World War I. He eventually shipped out to France, where he was hospitalized, it is believed, after exposure to poisonous gas.

Hamlin survived the war only to be shot by his father in a freak accident with a target pistol. He was twice fired from jobs in the 1920s and was so broke entering the Depression that he had to pawn his wife's wedding ring. He survived an airplane crash and an earthquake. At least three times he broke his drawing hand. "Glass hands," Hamlin explained.

Stout heart. He boxed, he drew maps, and on a west Texas oil field in 1924, he first tripped over dinosaur bones, the genesis of a comic hero who would, nine years later, roam the Earth: Alley Oop.

Hanna-Barbera

Bill Hanna and Joseph Barbera not only dominated the Saturday morning (with occasional excursions into prime-time) television cartoon market in the late 1950s and early 1960s but scored big at the comics rack with such animated stars as Huckleberry Hound,

Yogi Bear, Quick Draw McGraw, and The Flintstones.

Hanna-Barbera's first television cartoon, featuring Ruff and Reddy, appeared in December 1957; nine months later, the cartoon hit the funny books in *Four Color* #937 (September 1958).

Huckleberry Hound and Yogi first appeared less than a year later in *Four Color* #990. As Michael Naiman and Gary Carter once wrote in *Comic Book Marketplace*, "The entire comic (including the cover) was drawn by Harvey Eisenberg, the 'Carl Barks' of the Hanna-Barbera studios. Eisenberg was a layout man at MGM during the 1940s and was responsible for much of the layout work on the early Tom and Jerry shorts. When MGM's cartoon division folded in 1956, Hanna and Barbera opened their own studio and took Eisenberg with them."

Among the other Hanna-Barbera characters, Quick Draw McGraw first appeared in *Four Color* #1040; The Flintstones in *Dell Giant* #48; Top Cat in *Top Cat* #1; The Jetsons in *Jetsons* #1; and Jonny Quest in one of those Gold Key one-shot numbers that's impossible to forget, 10139-412.

Harlequin

One of the best female characters of DC's Golden Age, Harlequin is almost adequate cause to forgive Robert Kanigher for what he did to Wonder Woman. Almost.

Harlequin was introduced to Green Lantern fans on the cover of *All-American* #89 (September 1947); she was back on the cover of four of the next six issues. Molly Mayne, Alan Scott's secretary at his day job, was smitten by her boss, then forced to lament, "I never had a date because I was too athletic, no man could beat me in sports. I had to become a mousy secretary. Now, for the first time, I meet Green Lantern, my match, and he has no time for me . . . only for crooks."

So, Molly got a night job, matching wits with her beau until she was unmasked and fought at Green Lantern's side.

Irwin Hasen drew the Harlequin's first appearance and swears she doesn't resemble any of his women in his life. "I was just a kid in my early 20s," Hasen said. "I would never have done that."

Harrison, Harry

Best known for his science fiction stories and novels, Harry Harrison spent some seven years in comics from 1946 into the mid-1950s. He met Wally Wood at Burne Hogarth's Cartoonists and Illustrators School, and the two hung out together, selling work to the likes of Victor Fox, Avon, and EC. Harrison has claimed that he and Wood prodded Bill Gaines into doing a science fiction comic book, and his artwork is in the first three issues of *Weird Science*.

Gaines once told Rich Hauser, "There was this combination of Harrison and Wood, and I didn't know who did what. When they broke up, all of a sudden Harrison's artwork wasn't very good anymore. And I found out who did what."

Harrison and Wood later shared a studio with Joe Orlando on Columbus Avenue. "The first living atheist I ever met," said Orlando, who took his Catholicism quite seriously. "Harry would always give me the business with questions like, 'Okay, Joe, do you think the pope masturbated? Ever in his life? And if he did, was it holy?' Which made me go into the other room, make the sign of the cross, ask for forgiveness, and go back and face Harry. Harry and Wally would be laughing their heads off."

Harvey Publications

Everything's relative. Or—as was the case at Harvey—*everyone* is. "Harvey Comics, Inc. employed most of the clan," Howard Nostrand told *Graphic Story Magazine*. "In the early days, the only person who wasn't a relative around the office was the cleaning lady."

At the top of the clan were the three brothers: Alfred, Leon, and Robert. Alfred Harvey Wiernikoff was America's youngest Eagle Scout at the age of 13 and the oldest person, apparently, to still be publishing comic books in the

The entertainingly costumed Harlequin, as rendered by the team of Irwin Hasen and Joe Giella.
(© DC Comics, Inc.)

1980s. After a curious start—he tutored under Victor Fox, who most certainly never learned the Scout oath—Harvey produced his first comic, the 100-page *Pocket Comics*, in the spring of 1941.

Pocket Comics (its pint-sized format survived only four issues) featured the Black Cat. Before the year was out, and Pearl Harbor in flames, Alfred Harvey had purchased the rights to *Speed Comics* and *Champ Comics;* the following year, *Green Hornet* came aboard. When Harvey enlisted in the U.S. Army during the war, he produced educational comics for the Pentagon and made the connections that would serve him so well after the war. "Alfred had access to paper," said *Sad Sack* artist Fred Rhoads. "After the war, newspapers barely had enough paper to put out their editions, but Alfred had access. 'Fred,' he said, 'we're just pushing paper with some pictures on it. We buy paper for this amount, and sell it for this much more as comic books.'"

According to artist Pierce Rice, Alfred Harvey never looked at the pictures too closely. "Al gave very little attention to how the work was done," Rice said, "which made it a pleasure to work for him."

Harvey Publications survived the end of the Golden Age by stuffing their comic books with such strip heroes as Terry and the Pirates, Joe Palooka, and Blondie. The company is best known for such Fifties curios as *Sad Sack* (1949), *Casper the Friendly Ghost* (1952), *Little Dot* (1953), and *Richie Rich* (1953), but it had one foot firmly in pre-Code horror. Between 1951 and 1954, Harvey published 96 horror comics, 5 more than EC.

Harvey's five horror titles—*Black Cat Mystery, Chamber of Chills, Tomb of Terror, Witches Tales,* and a reprint title, *Thrills of Tomorrow*—featured a total of 144 stories from the company's top three artists, Bob Powell, Howard Nostrand, and Rudy Palais. Some of the stories are fairly extreme; of *Chamber of Chills,* the *Overstreet Comic Book Price Guide* notes, "About half the issues contain bondage, torture, sadism, perversion, gore, cannibalism, eyes ripped out, acid in face, etc." But George Suarez, a noted pre-Code horror expert, argues, "Sure, we'll find the occasional decapitated head and bloody corpse in a Harvey horror story, but the publisher never became dependent upon such devices for selling its comics ... Harvey was one of the few pre-Code horror publishers to make an effort to sell horror heavily laced with humor."

Harvey put out more horror titles than even EC Comics in 1951–1954, most with appropriately ghoulish covers by Howard Nostrand or Lee Elias.

(© Harvey Publications)

Irwin Hasen

Irwin Hasen's Golden Age comic book work is often forgotten in light of the fact that he drew the Dondi newspaper strip for 31 years.
(© Tribune News Syndicate)

The Harveys never bothered to license their horror books; they made up for that in the licensing deals they pulled off with Casper and Richie Rich. The brothers retired on the garnish from those deals. Alfred Harvey, the last survivor, died on Independence Day, 1994.

Hasen, Irwin

Irwin Hasen mentored Alex Toth, rode horses with Shelly Mayer, traversed America with Joe Kubert, and grew old with Milton Caniff, but he worshipped Willard Mullin. "I sat at his feet," Hasen said. "He was one of the greatest sports cartoonists that ever lived. These sports cartoons, they were genius. I snuck into the *World Telegram* in 1937 when I was 18, just a young kid, and I actually sat at his feet."

A year later, Hasen walked into Madison Square Garden with a portfolio of prizefighter drawings under his arm and was hired as a cartoonist in the Garden's public relations department.

Hasen quickly moved through three comic shops—Harry Chesler's, Lloyd Jacquet's, and Bert Whitman's—where he worked on a variety of strips, including Secret Agent Z-2 and Green Hornet. In 1941 he arrived at National, where he went to work for *All-American Comics* and quickly fell under the spell—and the wing—of Shelly Mayer. "He adopted me," Hasen said, and what's more, he got the five-foot two artist on a horse.

"Horseback riding was the last thing on my mind," Hasen said, "but he inspired me. There used to be stables in Manhattan, the Claremont Riding Academy. Shelly would take me there and tell me, 'You have to learn this.' I guess I was trying to prove something. We'd end up riding in Central Park and this one time, the horse ran away from me. Here's this little guy, five-two, 122 pounds on this huge steed. I'm holding this horse whose mouth was inured to pain many years before. It didn't know I was pulling him back. It could have been a death ride. Finally, by a stroke of God, the horse just got tired of running. Shelly ended up bawling me out, telling me I didn't handle it right. Of course I handled it right. The horse just didn't know it."

The second most memorable ride of Hasen's life came in the summer of 1947, when he and Joe Kubert drove from New York to California to attend Norman Maurer's wedding to the daughter of Moe Howard of Three Stooges fame.

Hasen still isn't sure why Kubert asked him to ride shotgun on the cross-country trip. "I told Joe I didn't think I could handle a trip like that, but he said, 'Don't worry about it,'" Hasen said. "He was like a bull. We drove out together in a Chrysler Town and Country, one of those cars with the wooden sides. I had just gotten out of the Army, and I couldn't get my license in the Army. I drove a jeep in the Army, but when it came time for me to drive the command car, I couldn't get my license because my feet couldn't touch the pedals. I managed to drive the damn thing with only the tip of my overseas cap showing through the window. I must have had a lot of guts in those days."

In 1952 Hasen was fired at DC. "I couldn't compete with the Meskins, the Infantinos, all those tough guys," Hasen said. Instead of sitting around New York and sulking, Hasen enlisted on a USO tour of Korea, then followed up with a National Cartoonist Society swing through Europe. In Germany, he met Gus Edson, who scripted *The Gumps* comic strip. Shortly after returning to the States, Edson wrote Hasen asking if he'd like to team up on a strip about a German war orphan and the G.I. who adopted him.

Dondi, of course, was Hasen's final refuge. "*Dondi* was the kind of thing I could handle,"

Hasen said. "I'm five-two; I related to a little boy. I had a Dondi-esque childhood. It was scary." And it was just about perpetual. *Dondi* ran for 31 years and survived several near-death experiences. When the *New York Daily News* tried to dump *Dondi* in 1985, the newspaper was besieged with calls and complaints until it plugged the strip back in. "I got a letter from Milton Caniff," Hasen said. "'Irwin,' it said, 'You'll be there forever.' A year later, the *Daily News* dropped it forever. "That's when I lost heart. I was on the back page of the *Daily News* for 18 years. That was enough for me in my life. But Caniff's note I'll never forget."

In the final years of Caniff's life, Hasen often met him for martinis at the Algonquin. "I was raised on his stories," Hasen said. "Let's forget about his art and his storytelling. As a human being, he was the ultimate. He loved the Algonquin. We'd share these moments over martinis, and would you believe it? This 83-year-old man, and I was the one who finally had to leave and go to bed, leaving him sitting at the bar."

After *Dondi* went down for good, Hasen retired to a cottage on Long Island and a life of tennis and teaching at the Kubert school. He draws political cartoons for the *Southhampton Press* "whenever I get irritated. I get irritated every two weeks."

But that's not the image Hasen wants to leave us with. We began with him sitting at the feet of Willard Mullin, and Hasen would prefer we end in the same vicinity. In 1960, almost 25 years after he'd first met Mullin, he bumped into him again at the Lamb's Club, an old actor's club in New York. Mullin was very drunk and Hasen begged him to forgo the long drive back to his home on Long Island. Hasen called Mullin's wife to tell her not to worry, then suddenly remembered that all he had to offer his hero was a one-room apartment in a nearby hotel.

"Somehow, I got Willard in the cab and he went home with me," Hasen said. "I got him in that one room, took his trousers off, so he's there just in his shorts, fixed the bed and threw a blanket down. Can you picture this? It was like Wallace Beery and Jackie Cooper in *The Champ*. Willard is sound asleep in the bed and I'm on the floor looking at him. It was a tableau. The master in the bed, and me on the floor. He got up the next morning, made coffee, and went home. But I will never forget that."

A Haunt of Fears

Martin Barker wrote this history of the British campaign against horror comics in the 1950s.

The campaign didn't have a cheerleader to match Fredric Wertham, but Barker argues that it "depended on the organised intervention of the British Communist Party." The party portrayed crime and horror comics as a clear sign of America's debased culture; that the comics were selling on British soil showed that American imperialism was still alive and well.

As Peter Mauger, a one-time history teacher, wrote, "These magazines, which boast of spreading the American way of life throughout the globe, also deal in sadism, whippings, torture, and a rather vulgar form of visual pornography."

Barker's book was published by the University Press of Mississippi in 1984.

Hawkman

In those days, they weren't interested in whether a feature was grotesque as long as it had mood, atmosphere, and action. Who cared?
GARDNER FOX

Forever hanging out in the wings of the comics Hall of Fame, Hawkman first appeared in *Flash Comics* #1 (January 1940). Ordered to produce a backup feature for the book, Gardner Fox figured why not a superhero with real wings? Fox wrote Hawkman's early adventures, then scripted his rebirth in the Silver Age, which began with *The Brave and the Bold* #34 (February/March 1961). Shelly Moldoff drew Hawkman's appearances on alternating is-

Bill Everett's rendition of Hawkman in an early *Flash* comic.
(© DC Comics, Inc.)

sues of *Flash Comics* during the 1940s, and Joe Kubert got the drawing assignments in both the 1940s and two decades later. Kubert's *Brave and Bold* covers finally managed to put some meat on this character's bones.

Hawkworld

Tim Truman and Gardner Fox first met at a gaming convention in the early 1980s. After several rounds of letters, Truman asked Fox—who had created the original Hawkman—if he wanted to take the character further into the realm of fantasy.

Fox was intrigued by the idea. "Unfortunately," Truman said in an interview in *The Comics Journal*, "I got involved with *Scout* and didn't hear from him for a long time. About a year later, I started a letter to Gardner, saying, 'Let's brush off this Hawkman idea and see if DC likes it.' I waited a few days before mailing the letter and found out that Gardner had died the very night, the very hour, I had written it. The whole thing deeply affected me. I promised myself I'd do a Hawkman story and that I'd dedicate it to Gardner Fox."

The three-issue miniseries, in a prestige format, was published in 1989.

Heath, Russ

One of the comics' better war artists, Russ Heath is best known for his work on *Sgt. Rock*, on which he succeeded Joe Kubert, and on the Marvel westerns. He also did several newspaper strips in the 1950s, assisting George Wunder on *Terry and the Pirates* and Dan Barry on *Flash Gordon*. "His stuff was brilliant," Gil Kane argued. More recently, Heath produced the comic book adaptation of Disney's *The Rocketeer*.

Heavy Metal

The American cousin of *Metal Hurlant*, the monthly mag of Les Humanoides Associes, *Heavy Metal* introduced the American audience to the likes of Moebius, Druillet, and Bilal. "The adult illustrated fantasy magazine" debuted in 1977, two years after the launching of *Metal Hurlant,* and quickly tripled the latter's circulation figures (*Metal Hurlant* never sold more than 100,000 copies). Although the editors—Sean Kelley, Julie Simmons, John Workman, and, later, Ted White—had cheap

"… a pretty face, a fetching dress, a realistic parachute with which to ride the wind that blows their dress up."

HEADLIGHTS

When male muscle was no longer sufficient to sell comics in the late 1940s, the industry turned—or returned—to female pulchritude.

This wasn't a particularly novel tack: the pulps had sold millions with the pin-up approach. Another round of hiked skirts and yawning cleavage might have passed relatively unnoticed if Fredric Wertham hadn't gotten so hot and bothered over *Phantom Lady* #17.

"Children call these headlights," Wertham wrote—possibly because adults tend to freeze when they're caught twixt the twin beams.

There are so many headlight covers to choose from that style and presentation count considerably more than mass. If quantity were our sole criterion, we'd end up in some frightening places. Furthermore, some artists—like most American males—draw as if breasts need not come with any accouterments: a pretty face, a fetching dress, a realistic parachute with which to ride the wind that blows their dress up. Exquisite headlights can shine on their own, but your authors have a weakness for a little luxury in the accompanying landscape.

Our Ten Favorite Headlight Covers

1. *Brenda Starr* #14 (March 1948) Some critics have never gotten comfortable with Jack Kamen's art, but there's a lot to like in this cover: the tattered dress, the tat-tat-tat of the Morse code, and that superbly rendered radiator.

2. *Cow Puncher* #6 (1949) Several artists took aim at headlights on the seven covers of this Avon title, including Kamen, but Walter Johnson comes away with top honors.

3. *DNAgents* #24 (July 1985) One of only two covers we chose from the modern era and one of the best from Dave Stevens.

4. *Exciting* #59 (January 1948) Clearly, 1948 was a banner year for good girl art. Alex Schomburg did some of his finest, uncluttered work with airbrush in hand, and this is his most revealing look at Judy of the Jungle.

5. *Fritzi Ritz* #1 (Fall 1948) "Aunt Fritzi was [Ernie] Bushmiller's excuse to draw good-girl art," Dwight Decker said several years ago. He's excused.

6. *L'echo des savanes* #19 (Summer 1976) This Neal Adams cover still leaves us speechless. Check out the look on Tarzan's face. We're talking one frightened dude.

Headlights **221**

7. *Phantom Lady* #18 (June 1948), much more appealing than Fredric Wertham's favorite headlight cover.

8. *Phantom Lady* #23 (April 1949) One Matt Baker cover simply isn't enough.

9. *Rangers* #31 (October 1946) Misogyny? In the comic books? Come on. But in the year leading up to this issue, Joe Doolin put two women on variations of the rack, two beneath the sword, one up against the bullwhip, and another tied to the stake. But no death threat quite matches this 25-foot serpent with fire in its eyes.

10. *Wings* #94 (June 1948) The best of Bob Lubbers's three-year run on the Fiction House title. Walter Johnson's dead-solid swipe of this cover appeared almost three years later on *Captain Science* #3 (April 1951).

reprint rights to the French material, they quickly turned to such creators as Howard Chaykin, Gray Morrow, and Michael Moorcock to beef up the American version. For the sake of aesthetics? Not exactly. In a 1979 interview, Simmons said Richard Corben and Jan Strnad's homegrown "Den" had gotten more comment than any other feature they'd published. "Some people think 'Den' is the greatest thing that's ever been in an comic book. Other people think it's nothing—they don't understand it, they don't understand why all he ever says is 'Argh' or 'Gargh' and runs around naked with big-breasted women. I'm not sure I do either, but we put it in the magazine anyway."

Heck, Don

Don Heck? "Look," Neal Adams said years ago, "everybody says bad stuff about Don Heck. I'll say this . . . Don Heck produced some of the best early Marvel comics ever: *Ant-Man, Iron Man*. Some of that *Iron Man* stuff was terrific. Whether he worked with Kirby or he didn't work with Kirby, the stuff was really good comic books. I got off on it."

So, what happened? "Don Heck lost his wife," Adams said. "When she died, he fell apart. Only people who knew about it knew and understood what happened to Don and his work . . . He was just surviving. He was hanging on by his fingernails. And it took a lot out of him."

In happier, healthier days, Heck drew the covers of all but two of the 27 issues of Comic Media's three horror titles, *Horrific, Terrific*, and *Weird Terror*.

In the early '90s, colorist Greg Wright took Heck to a Marvel party. "All the major talent, the big stars at Marvel, came running over to meet him,' Wright said. "He couldn't believe it. He was just trying to eat a sandwich. The new breed—the Jim Lees, the Todd McFarlanes, the Rob Leifelds—know fans are out there and how to take advantage of it. The older guys, they don't understand that there are fans."

Hell's Angels

The guy said he had Jimmy Olsen comics from the '40s, which made no sense, but Dave Alexander got in his car and followed the directions out to the North Hollywood address. The neighborhood was normal enough, but the half-dozen hogs parked in the driveway gave him pause. He knocked on the door, anyway.

"I thought I'd walked into a tattoo convention," Alexander said. Inside the house were two boxes of ragged comic books and a dozen guys trying to raise bail money for a biker buddy.

"These were the type of guys who'd say, 'I know you're going to give me $400 for this book! I know it!' And there were 12 other guys there who knew it, too," Alexander said. "They thought every book was worth $50 or more, and they were only selling it to get one of their buddies out of jail. They had to get Larry out before the weekend. There was some dope deal that he had to be involved in."

Alexander wanted nothing more than to back out the front door. "The books had an average value of $2 an item, but these guys weren't the kind of guys you could explain that to," he said. "They weren't involved in higher mathematics, but they weren't the kind of guys you'd want to disappoint."

He eventually bought $25 worth of stuff, explaining that his boss, back in civilization, had to approve the bigger deals. As Alexander slipped out the door, he told the boys that they could always contact a couple of other dealers and invite them over for a closer look. Ernie Gerber, perhaps. Or Steve Fishler. Maybe a couple of guys to whom Alexander owed a favor.

Help!

Another Harvey Kurtzman humor magazine (following *Trump* and *Humbug*), *Help!* ran from 1960 to 1965. Jim Warren provided the financing, and Kurtzman's editorial assistants included Terry Gilliam and Gloria Steinem, both of whom later found fame elsewhere.

Photo-funnies (starring folks like Monty Python's John Cleese) debuted in *Help!*, as did

Harvey Kurtzman's *Help!* helped launch the careers of Terry Gilliam, Robert Crumb, Gilbert Shelton, and even Gloria Steinem, who worked as an assistant editor.
(© Warren Publications)

the first published work of Robert Crumb, Gilbert Shelton, Jay Lynch, and Skip Williamson, but it had a hard time sustaining Kurtzman's interest. "I probably put less time into it, per page, than anything else I've done," he admitted in *From Aargh! to Zap!*

Henderson, George

"Captain George" to Canadian comic book fans, Henderson was the owner of the country's most famous comic book store, Memory Lane in Toronto. A parachutist in the Canadian Army and a successful writer of soft-core pornography, Henderson opened the bookstore on Markham Street in Toronto in 1967 and published several anthologies of out-of-print comics. He also opened one of the first showcases of comic art—the Whizzbang Gallery—and sponsored his first comic convention in 1968. Henderson died in 1992 at the age of 62.

Hercules

You can't keep a good mythology down, but none of Hercules's recent incarnations—Dell's in the '50s, Charlton's in the '60s, DC's in the '70s or Marvel's in the '80s—compare to the first version, designed by Lou Fine and delivered in the 1940–1942 run of *Hit Comics* #1–#21.

Herge

The author of the 23 Tintin tales, George Remi (his pseudonym was culled from the French pronunciation of his initials in reverse order) was born near Brussels, Belgium, in 1907. Only 19 when he spawned Totor, a precursor to his wandering journalist, Herge finally let Tintin out of the box in 1929. The character first appeared in *Le Petit XXe*, the weekly supplement to the Belgian daily, *Le XXe Siecle*.

Because Tintin continued to be published in a Nazi-approved magazine during World War II, Herge was charged as a German collaborator shortly after the liberation of Belgium in 1944. He was eventually released with considerably less fanfare.

Tintin appeared in his own magazine following the war, embarking on some of his classic adventures: *Prisoners of the Sun, Land of Black Gold,* and the companion lunar adventures, *Destination: Moon* and *Explorers on the Moon.*

Herge was working on the lad's 24th adventure when he died in 1983. He has had a tremendous impact not only on the kids who followed Tintin to Tibet or on Flight 714, but on the cartoonists determined to follow the simple clarity of his pen line.

Hernandez Brothers

There are five brothers, all told: Jaime, Gilbert, Mario, Richard, and Ismael (and one Hernandez sister, Lucinda). They all grew up drawing and grew up with comic books, but Gilbert claimed it was the music of the Sex Pistols, the Clash, and Black Flag that saved them from "the geek world" of "the comic book guys, the guys who sit home every Saturday, watching every horror movie possible."

Gilbert also told *The Comics Journal* that they rejected the underground approach "because we're the world's laziest human beings and we knew you'd starve if you were an underground cartoonist."

Safely above ground, Jaime, Gilbert, and Mario created *Love and Rockets,* which was published by Fantagraphics beginning in 1982. At a rate of two to four issues a year, it took until 1996 to reach issue 50, at which point the cult favorite comic (which had inspired the name of a rock group) ended, giving rise to separate projects by Jaime and Gilbert.

Herriman, George

The genius—a paltry adjective in his company—behind the comic strip *Krazy Kat*, Herriman first created a number of other strips—*Prof. Otto and His Auto, Two Jolly Jackies,* and *Major Ozone's Fresh Air Crusade*—that dominated the comic sections in the first decade of the century. But it is *Krazy Kat*—which ran from 1913 until Herriman took it to the grave in 1944—that dominates any discussion of his craft.

"Herriman was a cartoonist of almost pathological shyness," Rick Marschall wrote in *America's Great Comic Strip Artists*. "Gracious, withdrawn, and a bit gentle, he was a vegetar-

Jaime and Gilbert Hernandez

ian and an animal lover, a man who suffered migraine headaches and would slip away at parties only to be found washing dishes, an activity during which he claimed he could think best. Yet *Krazy Kat* is perhaps the most idiosyncratic and personal of all comic strips, confronting the reader and baring a fiercely individual vision; Herriman, the tentative personality, thought nothing of boldly climbing out on all sorts of artistic limbs."

Herriman was born in 1880 in New Orleans, the son of a Creole baker. His parents moved the family to Los Angeles when he was still a kid, shortly—Judith Sullivan has observed—after the enactment of various Jim Crow laws in Louisiana.

Herriman first met William Randolph Hearst when he joined the *New York American* in 1904; Hearst became such a fan that, when *Krazy Kat* was running in less than 40 papers in the 1930s—about 4 percent of *Blondie*'s total—Hearst refused Herriman's suggestion that he take a cut in pay.

The cat-and-mouse games of Krazy Kat and Ignatz began in the small panels running beneath Herriman's *The Dingbat Family*. Krazy Kat gained his own strip on October 28, 1913, and a Sunday page three years later. From then until the last brick flew, Herriman explored the nature of love, obsession, and the American landscape with language that Sullivan calls "as inspired as is his mastery of line. The verbal content of his strips—combining African-American linguistic conventions such as alliterative hyperbole with Creole patois, Hispanic slang, and evocative Native American place names—was to inspire a generation of poets, including e. e. cummings."

Herron, Ed

A formidable presence in the Fawcett universe, Ed Herron replaced Bill Parker as comics editor at Fawcett in October 1940. He recruited Jack Kirby to draw the first issue of *Captain Marvel Adventures*, created Captain Marvel Jr., introduced C. C. Beck to Otto Binder, and often stood at the right hand of Mac Raboy.

"Raboy was nothing much without Ed Herron," Wendell Crowley, a subsequent editor at Fawcett, once told Hames Ware. "Ed Herron pretty much drew those pictures for him."

Crowley added that alcohol took a heavy toll on Herron before his death in the late 1960s. "Another waste of liquor. He was my hero. A big bear of a guy who ended up wasted away to nothing."

Hershfield, Harry

The man who created *Abie the Agent* in 1914 was once asked what happened when he couldn't come up with a good idea. Hershfield replied, "That's when the bad ones get published."

Hit Comics

The 65-issue run from Quality Comics is best known for the spectacular covers by Lou Fine. Fine did only 62 comic book covers, and 16 of his finest, featuring either Hercules or the

Histories of Comics

They've all been crap.
JOE SIMON

Red Bee, grace the first 17 issues of *Hit Comics*. When Fine moved on, Reed Crandall and Kid Eternity tried to fill in the void, but *Hit* never packed the same punch.

Hitler, Adolf

None of our words can do the man justice, so let's begin with a few of the Fuhrer's. On the subject of mating, Hitler once told Albert Speer, "A highly intelligent man should take a primitive and stupid woman. Imagine if on top of everything else I had a woman who interfered with my work."

And on exterminating the Jews? "Nature is cruel; therefore we also are entitled to be cruel," Hitler said. "When I send the flower of German youth into the steel hail of the coming war without feeling the slightest regret over the precious German blood that is being spilled, should I not also have the right to eliminate millions of an inferior race that multiplies like vermin?"

One of the most successful mass murderers in history, Hitler was a failed artist. After quitting school in 1905, at the age of 16, Hitler applied to a Viennese art academy and was rejected. The director warned him, Hitler later remembered, that his drawings "incontrovertibly showed my unfitness for painting." Yet at the height of his world war, Hitler was still muttering that he would have much rather gone to Italy and struggled as "an unknown painter" than followed the demands of his conscience and the Third Reich.

Hitler had an immense impact on comic books during the war. Joe Simon has said he was the inspiration for Captain America: "Basically, we were looking for a villain first, and Hitler was the villain." On the cover of *Captain America* #1, which had a publication date 350 days before Pearl Harbor, Cap is landing a right to Hitler's jaw and we read, "Smashing thru, Captain America came face to face with Hitler."

Not quite. All we get is a note from Adolf to the Red Skull, which reads, "When America is within the fold of the Greater Reich, the post of minister of all American industry shall be the reward of your excellent spy work.—The

Love that bedspread
One of Alex Schomburg's many Hitler covers for Standard.
(© Standard Comics)

Jack Kirby and Syd Shores produced one of the first Hitler covers, for *Captain America* #2 (April 1941)
(TM & © 1998 Marvel Characters, Inc. All rights reserved.)

Daredevil took on Hitler in the very first issue of his comic (July 1941).
(© Lev Gleason Publications)

An oddly proportioned Hitler, with a worm exiting his ear, appeared on yet another dynamic Schomburg cover.
(TM & © 1998 Marvel Characters, Inc. All rights reserved.)

Fuhrer." Hitler does make an appearance in *Captain America* #2, in a story titled, "Trapped in the Nazi Stronghold."

Hitler's first cover shot was actually *Mystic* #7, which Timely cover-dated December 1940. He appeared on at least eight Timely covers, and George Olshevsky argues that it is no coincidence that the publishers at Timely, and many of the staffers, were Jewish.

"They were very much aware of the manic anti-Semitism that had engulfed the German nation under Adolf Hitler," Olshevsky once wrote. "They knew of the Warsaw ghetto, where thousands of Jewish people were systematically being starved to death each month. And certainly they knew of the network of forced labor camps dotting central Europe—Auschwitz, Treblinka, Dachau—which in the years to come became the scene of the Nazis' greatest horrors. As ordinary people in America, the Timely staff had little direct influence, but through the medium of the comic book they were able to express their bitterness and frustration. The sincerity and fervor of that damnation of the Axis powers transcended the crudeness of the plots and artwork."

But Stan Lee said Timely's assault on Hitler was more a matter of economics than social conscience or religious fervor. "The whole country was anti-Hitler. Hitler seemed to be the closest equivalent to Satan that anyone could ever find," Lee said. "Years later, we made the Communists the enemies in a lot of our books. That wasn't a religious thing. Most Americans felt that communism was the biggest threat. The things we were reading that Hitler was doing—conquering Czechoslovakia, Poland, all those countries—it looked like he wanted to gobble up the world. I think it went way past that the comic book publishers were Jewish. We were just making Hitler the villain."

They were just riding the wave. Besides countless appearances inside the books, Hitler appeared on the following covers (listed chronologically) during the war that made him famous:

Mystic #7 (December 1940); *Captain America* #1 (March 1941); *Captain America* #2, *Master* #13 (April 1941); *Mystic* #9 (May 1941); *Daredevil* #1 (July 1941);*Young Allies* #1 (Summer 1941); *Real Life* #3, *Great Comics* #3, *Weird* #20 (January 1942); *Military* #7 (February 1942); *Boy Comics* #4 (June 1942); *USA* #5 (Summer 1942); *Superman* #17 (July/August 1942);*Master* #29 (August 1942); *Big Shot* #28 (October 1942); *Boy Comics* #7, *Spy Smasher* #9 (December 1942); *Uncle Sam* #5 (Winter 1942); *Joe Palooka* #2 (1943), *Spy Smasher* #10, *Sensation* #13 (January 1943); *Big Shot* #32, *Captain Marvel* #21 (February 1943); *World's Finest* #9, *Boy Commandos* #2 (Spring 1943); *Supersnipe* #8 (April 1943); *Supersnipe* #9 (June 1943); *Green Hornet* #13 (July 1943); *Superman* #23 (July/August 1943); *Uncle Sam* #7 (Summer 1943); *Captain Marvel Jr.* #10, *Marvel Mystery* #46 (August 1943); *Batman* #18 (August/September 1943); *Young Allies* #9 (Fall 1943); *Four Most* #8 (Fall 1943); *Catman* #19 (September 1943); *America's Best* #7, *Catman* #20 (October 1943); *Prize* #37 (November 1943); *Captain America* #36, *Speed* #31 (March 1944); *Thrilling* #41 (April 1944); *Big Shot* #46 (May 1944); *Blue Beetle* #32 (July 1944); *Headline* #8 (Summer 1944); *Thrilling* #44 (October 1944); *Marvel Mystery* #63 (April 1945).

On April 30, 1945, Eva Braun—a woman who had never interfered with Hitler's work—finally succeeded in her third suicide attempt since 1932. The failed artist died at her side.

Hogarth, Burne

The second most famous Tarzan artist, Burne Hogarth is invariably compared to the most famous, Hal Foster, in a manner that serves neither particularly well.

Born on Christmas Day in 1911, Hogarth took over the daily *Tarzan* strip from Foster at the age of 26.

He drew Tarzan for most of the next 13 years, leaving for a brief time in 1945 to pursue an affair with *Drago,* a strip of his own creation.

Almost everyone agrees that Hogarth's first work on *Tarzan* was understandably derivative, while his later work is strikingly original.

"Burroughs's universe," wrote French author Francis Lacassin, "is only a component of Hogarth's universe, a component in competition with Hogarth's other interests. Hogarth is fascinated by Oriental art, by the vehemence of Goya's work, by the suffering portrayed by Grunewald, by the vitality of Rubens's compositions, by the narrative technique of the cinema, by the classicism of Greek sculpture, and by the ideas of German expressionism."

"He began as a successor to Hal Foster," Harry Hablitz wrote in 1969. "However, he was not content to emulate the dean of comic illustrators. He fused illustration and cartooning together with a stylized strip that was and is unique.

"Hogarth realized that an adventure strip must stress action and drama above all else. He was also aware that a comic page is swiftly read and as swiftly discarded. Its very nature prohibits a leisurely perusal of subtle details.

"Hogarth's Tarzan was the result of his frank acceptance that a cartoon is that first, and not just an illustration. A wealth of accurate, realistic detail would only distract the reader from direct communication.

"He realized that Tarzan was a dream hero; not an ordinary man in the romantic past like 'Val' of Ultima Thule. To draw Tarzan as a real man was out of the question; to fashion him as a demi-god, a grim, larger than life Hercules striding purposefully through everyman's conception of a mythical African jungle—this is the stuff of legends and Hogarth had the sense to realize it and the ability and courage to draw it as he saw it."

Hogarth quit *Tarzan* in 1950. He co-founded New York's School of Visual Arts, where he taught classes in drawing, anatomy, and art history until 1970. Graduates of the school included Wally Wood, Gil Kane, and Al Williamson.

Russ Cochran argues that "Hogarth is, in addition to being one of the great comic artists in history, one of the most literate and intellectually gifted artists of any time."

The artist also wrote the classic art texts *Dynamic Anatomy, Drawing the Human Head,* and *Dynamic Figure Drawing*. Hogarth died in Paris in 1996, after a triumphant appearance at the Angouleme Comics Festival.

Burne Hogarth

THE HOODED MENACE

Alex Schomburg remembers the Ku Klux Klan being pretty active in the 1940s, but he doesn't remember them performing the ritual he captured on the extraordinary cover of *Suspense* #3 (see page 103). The hooded figures, the kneeling damsel, the sacrificial sword? "It was just whatever came out of my stupid head," Schomburg said. "Then I put a swastika on them and made them Nazis."

No artist dressed his hoods in hoods quite as often as Schomburg. The other great "hood" cover—*The Hooded Menace*—was a 1951 Realistic/Avon one-shot, based (according to Overstreet) "on a band of hooded outlaws in the Pacific Northwest" at the turn of the century. But Schomburg's figures were more art than science. The KKK had such a sinister reputation that hanging a sheet over your villain added both malice and menace.

Hooded Villain Covers: *Avon* #27 (The Hooded Menace); *Black Terror* #20; *Blue Beetle* #29; *Daredevil* #27; *Daring* #2; *Detective* #191; *Exciting* #42; *Fighting Yank* #11, 23; *Flash* #20; *Green Hornet* #15; *Human Torch* #6, 16; *Kid Komics* #4, 9; *Marvel Mystery* #18, 28, 29, 45, 51, 52, 69; *Master Comics* #98; *Mystery Comics* #2, 4; *Mystic* #1; *Shadow* #61 (6/1); *Shock SuspenStories* #6; *Startling* #20, 40; *Sub-Mariner* #13; *Super Magician* vol. 4, no. 5; *Suspense* #3; *Terrific* #5; *Venus* #18; *Wow* #3

Horror comics covers did their job of attracting attention. This sampling includes the infamous Howard Nostrand cover for *Tomb of Terror* #15 (May 1954), a Bernard Baily cover for *Weird Mysteries* (#4, April 1953), and the classic Don Heck bullet-between-the-eyes cover for *Horrific* #3 (January 1953).

Holiday Inn

This was the hotel of choice in the early days of comic book conventions, "because they don't monitor how many people go in and out," Bud Plant said. "We'd get a single room and put six or seven guys in a room. Then, we'd play cards to see who got the pillow, who got the sheet, who got the box springs. We'd tear the bed apart."

"I didn't take any chances," interrupted Michelle (then Mike) Nolan. "I'd always pay Dick Swan 50 cents for the bed."

"Well, Michelle had a real job," Plant said. "She had a little more money, and she appreciated those luxuries."

Horror Comics

> *I was the first publisher in the United States to publish horror comics. I am responsible. I started them.*
> BILL GAINES

Sorry, Bill, you only perfected them. Despite Gaines's testimony before a Senate subcommittee, the first horror comic was *Eerie Comics* #1 (January 1947), which crept from the crypt more than a year before EC's first horror story, "Zombie Terror," appeared in *Moon Girl* #5.

A staple of the pulps before the super-heroes arrived, horror was one of the first places publishers turned when the super-heroes keeled over following World War II. Before EC's first regular horror title, *Crypt of Terror*, hit the stands in 1950, ACG (*Adventures into the Unknown*) and Trans-World (the one-shot *Mysterious Traveler Comics*) had gotten into the act, and Marvel had converted *Marvel Mystery Comics* and *Captain America* into horror titles.

EC published only 91 horror comics, less than one-fourth as many as Atlas (399 books) and behind both Ace (97) and Harvey (96).

Harvey? Not only did the company deliver some particularly fetid fare in *Witches Tales*, *Chamber of Chills,* and *Tomb of Terror*, but some of the art was delivered by Howard Nostrand and Bob Powell.

Horror comics never dominated the landscape but the pre-code books—published between 1950 and the advent of the Comics Code—continue to dominate fan interest. Unlike the crime comics, which had a gruesome predictability, the horror comics kept you guessing. Instead of ending in the electric chair, the stories began there.

"There is more room for the imagination [in horror comics]" said Erik Margolis, a Pennsylvania collector. "Once you enter the realm of the supernatural, anything can happen. You no longer have to search one person's human

PLEASE PASS THE COMICS

When an exhibition of crime and horror comics arrived at the House of Commons in 1954, Winston Churchill exclaimed, "Pass them over; I should like to read some horror comics."

Bernie Wrightson drew more than a dozen *House of Mystery* covers in the early 1970s.
(© DC Comics, Inc.)

motives for an explanation. In the realm of the supernatural, there are no morals or ethics involved."

That explains, we guess, why corpses routinely removed their heads; spouses feasted (quite literally) on each other; female victims were dispatched by paper cutter; the remains of a disemboweled chef might show up the next morning in the buffet line; and—gasp!—why the smaller publishers served up *reprints* in later issues.

These excesses clearly bothered EC's Harvey Kurtzman. He once argued in *The Comics Journal* that "the comics business brought censorship down on its head because of the kind of things the horror comics were doing. I always thought the horror comics were vile. At some certain point they'd turned sick, I thought, and I think they reached that point when EC was running short of classic book plots and had to turn inward; what came out was sheer gruel—ideas that sniffed of necrophilia. When the investigation turned on EC, it was like, 'I told you so! Look what you did to us.'"

Kurtzman forgot that Fredric Wertham's *Seduction of the Innocent* was primarily concerned with crime, not horror, comics, and that the industry's censorship was self-imposed.

House Ads

Haunted Thrills #2 (August 1952) features a house ad hyping nine Ajax-Farrell horror comics . . . five of which, George Suarez notes, were never published: *Bewitched, Dark Journey, Dark Shadows, Strange,* and *Suspooks.*

"For the Thrill of a Lifetime," the ad notes, "Don't Miss a Single Chilling Issue!"

House of Mystery

First published in December 1951, *House of Mystery* (at first based on a radio show) produced a classy array of covers, beginning with Neal Adams's work on issue #175. According to the *Overstreet Comic Book Price Guide,* the cover artists of interest are as follows:

Neal Adams: #175–192, 197, 199, 251–254; **Steve Ditko:** #277; **Mike Kaluta:** #200–202, 210, 212, 233, 260, 261, 263, 265, 267, 273, 276, 284, 287, 288, 293–295, 300, 302, 304, 305, 309–319, 321; **Joe Kubert:** #282, 283, 285, 286, 289–292, 297–299, 301, 303, 306–308; **Bernie Wrightson:** #193–195, 204, 207, 209, 211, 213, 214, 217, 221, 231, 236, 255, 256

Howard, Robert E.

"Two-Gun Bob," as H. P. Lovecraft called Howard, created Conan the Barbarian in 1932 and turned one of those guns on himself four years later.

Born in 1906 in Peaster, smack dab in the middle of Texas, Howard sold his first story in 1924 to *Weird Tales*. He prided himself on being "the first to light the torch of literature in this part of the country . . . I am, in a way, a pioneer . . . I was the first writer of the post oak country; my work's lack of merit cannot erase the fact."

In *The Miscast Barbarian,* de Camp's brief biography of Howard, de Camp claims the pulp writer was "puny and bookish" as a boy, reclu-

sive and oversensitive: "In one town, Howard could not leave his own yard for fear of being set upon by a gang. During this time, his mother read extensively to him, especially poetry. The resulting closeness between the two led both to Howard's literary career and to his eventual destruction."

Howard taught himself how to box, and to box damn well, but he was never empowered emotionally. He couldn't control his temper, his paranoia, or his disgust about the immigrant "mongrels" of Europe. Edgar Hoffman Price perceived "a fanciful, sensitive, imaginative soul, hidden in that big bluff hulk. A man of strange, whimsical, bitter and utterly illogical resentments and hatreds and enmities and grudges."

Added de Camp, "Howard was one to whom the things that he read about or imagined were more real than the people and things around him ... In assembling Howard, the gods somehow left out the cogwheel that furnished love of life."

Roy Thomas, who's lived with Conan for a lot longer than Howard did, observes, "That sounds like de Camp. He earlier wrote a biography of Lovecraft in which he also threw down his value judgments. It's very difficult to do psychoanalysis across the ages." But, Thomas added, "I couldn't quarrel with anything in there. The guy did have an illogical streak. He was hard-headed."

By de Camp's count, Howard sold 17 Conan sagas to *Weird Tales* and wrote nine others that were published posthumously. In the final years of his life, Howard turned to westerns populated with thugs that, he admitted, were "too stupid to do anything but cut, shoot, or slug themselves into the clear."

On June 11, 1936 Howard decided to follow their lead after being told that his mother, ravaged by cancer, would not regain consciousness. He walked out to his car and shot himself in the head. His mother died the following day.

Howard the Duck

Famous for bombing in two mediums, *Howard the Duck* flamed out as a Marvel comic (1976), a Steven Spielberg movie (starring Lea Thompson), *and* the 1986 adaptation of that Spielberg movie. Created as a spoof by Steve Gerber, the character got less interesting as it was taken more seriously.

The Hulk

Another Stan Lee/Jack Kirby creation, the character first appeared in *The Incredible Hulk* #1 (May 1962), which hit the newsstands 10 months before the first issue of *The Amazing Spider-Man*.

The first of the Hulk's countless metamorphoses occurred when Dr. Bruce Banner was ambushed by gamma rays while trying to rescue teen-aged Rick Jones from a bomb-testing site.

The early Hulk was gray and a dead ringer for Frankenstein, but the monster soon turned green. Jeff Rovin once observed, "Curiously, nowhere in the chronicles is it explained how the Hulk comes to wear his purple trousers regardless of what Banner was wearing at the time of the transformation."

The Hulk's first run lasted only six issues; he returned in *Tales to Astonish* #70, which was transformed into *The Incredible Hulk* with issue #102.

Key issues: *Incredible Hulk* #2, Hulk's skin begins to mold green; #102, Hulk finally wrestles his own book back from *Tales to Astonish*; #118, Hulk collides with the Thing; #162, first Wendigo; #180, first appearance of Wolverine; #181, first complete Wolverine story; #330, first Todd McFarlane art; #377, first new and improved Hulk

Human Torch

The original towering inferno. Created by Carl Burgos, the Human Torch was the cover boy of *Marvel Comics* #1. In the beginning, there was nothing human about the Human Torch. He was "a synthetic man—an exact replica of a human being," according to his maker, Professor Horton. The Torch's android roots were quickly forgotten, so that (Roy Thomas has observed) many of his early fans didn't learn of them until his origin was replayed in *Marvel Mystery* #92.

The Torch's original costume was blue; not until *Marvel Mystery* #5 did the suit match his flame. He was born with a fire in his belly, but he didn't learn to fly, or develop his bag of fiery tricks, until he learned how to control the nitrogen in the flame.

Hot Lot was the Torch during the Golden

The first issue of *The Human Torch* (#2) hit newsstands in October 1940.

(TM & © 1998 Marvel Characters, Inc. All rights reserved.)

Humbug was the only other humor magazine besides *Mad* that Kurtzman did in comic book format.

(© Harvey Kurtzman)

Age? He was the first Timely character to get his own book, six months before Captain America. The Torch also appeared in seven other Timely books: *All Select, All Winners, Captain America, Daring, Mystic, Sub-Mariner,* and *Young Allies.*

The Sub-Mariner appeared in more stories than any other Timely character, 292 to the Torch's 280, but the Torch had the edge in cover appearances, with a total of 178

In 1961, Stan Lee and Jack Kirby reincarnated, rather than revived, the Human Torch as Johnny Storm, the brother of the Invisible Girl, in *Fantastic Four* #1.

Humbug

This humor comic was Harvey Kurtzman's second enterprise (the first was *Trump*) after leaving *Mad*. First published in August 1957, *Humbug* lasted 11 issues, despite some marvelous sendups of television and expressive work by Bill Elder, Jack Davis, and Arnold Roth.

"Once, when things were getting a bit depressing after a few issues of *Humbug*, Harvey was giving us all a sort of pep talk," Roth told *The Comics Journal*. "Harvey's back was to the windows. About 80 feet away, there was another building at least as high as ours. We were looking at Harvey and he waved his arm to the window and said, 'Remember they're all out there.' Like in a movie, all our eyes went to the end of his hand and out the window. Right across in a window of the other building there was a guy screwing a woman on a couch. We all leapt to the window; he didn't know what the hell we were doing."

Ibis

Fawcett's contribution to the Comic Book Magician's Union first appeared in *Whiz* #2 (February 1940). C. C. Beck and Pete Costanza supplied the art for the Invincible One.

If

If you can dream—and not make dreams your master;
If you can think—and not make thoughts your aim;
If you can meet with Triumph and Disaster
And treat those two impostors just the same;
If you can bear to hear the truth you've spoken
Twisted by knaves to make a trap for fools,
Or watch the things you gave your life to, broken,
And stoop and build 'em up with worn-out tools...

Leave it to Marvel to make sure Rudyard Kipling didn't have the last word:

"If This Be Justice" (*Daredevil* #14)
"If in Battle I Fall" (*Daredevil* #50)
"If an Eye Offend Thee" (*Daredevil* #71)
"If a World Should Die" (*Dr. Strange* #181)
"If This Be Doomsday" (*Fantastic Four* #49)
"If I Kill You, I Die" (*Incredible Hulk* #130)
"If the Thunder Be Gone" (*Thor* #146)
"If This Planet You Would Save" (*Strange Tales* #160)
"If a Man Be Mad" (*Tales of Suspense* #68)
"If I Must Die, Let It Be with Honor" (*Tales of Suspense* #69)
"If This Be Treason" (*Tales of Suspense* #70)
"If This Be...Modok!" (*Tales of Suspense* #94)
"If a Man Be Stone!" (*Tales of Suspense* #95)
"If a Soul Be Lost!" (*Captain America* #161)
"If America Should Die" (*Captain America* #231)
"If Iceman Should Fall" (*Uncanny X-Men* #18)

Iger, Jerry

One of the giants—or at least, one of the giant midgets—of the Golden Age.

Born in Manhattan, seasoned in Oklahoma, and animated at the Max Fleischer Studios, Samuel Maxwell "Jerry" Iger lorded over the premier comic book shop in the late 1930s and early 1940s.

Iger formed the shop with Will Eisner in 1937 and produced reams of material for Fiction House, Quality, Standard, and Victor Fox. Eisner departed via the draft in 1941, but Iger kept rolling along, aided by the talents of Lou Fine, Nick Cardy, Reed Crandall, Joe Kubert, Jack Kamen, and George Tuska.

The talent didn't always treat Iger with the greatest respect. "We were all mean to Jerry Iger," Rafael Astarita said. "He looked like a little prizefighter, with a low profile projecting out over his eyes. It looked as though someone had broken his nose at one time. His lower lip was so full it was almost disfiguring. We all imitated him. When his back was turned, we would crouch down to approximate his height, stick our tongue in the bottom of our lower lip, and try to talk through that impediment.

"I'm ashamed to say I made fun of him, because he liked me," Astarita added. "I remember one day he came up next to me and saw I was working very carefully. He said, 'Jesus, Astarita, I like nice work, but don't make a career of each page, will ya? I got to make a small profit, okay?'"

On the strength of his inventions—from Sheena to Shorty Shortcake—Iger invariably turned a profit.

In late 1943 Iger met Al Kantner, the father of *Classic Comics* and *Classics Illustrated*. He assured Kanter that his shop could do the classics much better than Kanter's freelancers. Kanter told him to prove it, and—after *Classic Comics* #22, Iger took over as art director (with Ruth Roche as editor), and set about doing just that. The assignment packed some irony, since *Jumbo* —packaged by the Eisner-Iger shop— had contained a classic story, "Count of Monte Cristo."

On the strength of work by Matt Baker, Bob Webb, and Henry Kiefer, Iger made good his boast. He remained at Classic Comics/Gilberton Publications until he and Ruth Roche got out of the business.

If this be . . . a Marvel cover!
(TM & © 1998 Marvel Characters, Inc. All rights reserved.)

Image

> *For decades, rotten business practices caused a steady, slow brain drain, driving talent away one by one. One by one. Each individual artist or writer, more or less replaceable. There were always new kids to come along and feed the machine.*
>
> *Then along came ringmaster Todd McFarlane and his amazing friends. Instant millionaires, I'm told. Their popularity at a fever pitch. They had it made. They had money. They had fame. They had no reason to leave—except that they were smart enough to realize that the best you can get under work-made-for-hire is the status of a well-paid servant.*
>
> *So they left. Brilliantly they left all at once…*
>
> *They gambled and won. They shattered the work-made-for-hire mentality, showing how unnecessary it is. Even more surprisingly, they broke Marvel's stranglehold on the marketplace. The kids went with them.*
>
> *And people hate them for it.*
>
> *Consider this: The best-selling comic book in the country is creator-owned. And artists aren't celebrating. Too many of us are acting like galley slaves complaining that the boat is leaking…*
>
> *Consider this: Because of Image Comics, artists enjoy new opportunities and are paid better, even at Marvel Comics.*
>
> *And nobody's said, "Thank you."*
>
> *Let me be the first, then. Gentlemen. Thank you.*
> FRANK MILLER
> 1994 DIAMOND RETAILERS SEMINAR
>
> *Image is everything.*
> ANDRE AGASSI
> TV COMMERCIAL

In 1996 Image made fun of itself in the limited *Shattered Image* series.
(© Aegis Entertainment, Inc.)

Image was more than enough. Enough to make Todd "and his amazing friends" rich. Enough to leave Marvel Comics for dead, although the corpse would twitch for several more years. Enough to leave every creator shaking his or her head and reaching, with trembling hand, for a sketchbook.

McFarlane has argued that it was Jim Lee's defection that made Image's breakaway possible. Marvel regarded McFarlane and Rob Liefeld as "uncontrollable," McFarlane said, "an idiot and an asshole, but Jim was the company man. They felt they would have won the war if they lost us but kept Jim . . . That we could get a company man to leave, that sent shock waves through the business."

Because McFarlane was drawing one of Marvel's two premier books, "it would have been far easier," he noted, "to stick with *Spider-Man*, collect a big check, fly to conventions, and act like a big shot." But McFarlane didn't want to answer to anyone. He couldn't stand the idea that editors he considered failed writers had the

gall to tell him what worked and what sold. "I'm not going to listen to a guy younger than me," McFarlane said in 1992. "And I'm not going to listen to a guy who's never sold a comic book. You sell a million, I'll listen to you. Or you've written stuff that's won awards, I'll listen to you."

In the fall of 1991, Liefeld was listening to McFarlane. So was Erik Larsen. "He's the guy," McFarlane said, "who could be put in the time capsule, shoot back to 1961, and come into the office with Jack Kirby and Steve Ditko and Sol Brodsky and Stan Lee, and he'd fit perfectly. 'We're here to do comic books? Cool.' He didn't get involved in the politics and all the crap. He just wanted to do fun, rock 'n' rolling comic books." Marc Silvestri? "I just attacked him in New York," McFarlane said. "I started and didn't stop for about four hours. The next morning he was shell-shocked and said, 'I'm in.'"

Jim Lee took a little longer, but when he signed on, the new company had its company man. The Image lads were going, going, gone.

The original gang—McFarlane, Lee, Silvestri, Larsen, Liefeld, Jim Valentino, and Whilce Portacio—held their first press conference in February 1992 at the office of Malibu Comics, which agreed to provide support services to Image for a thin sliver of its profits. They surfed for a spell on the shock waves from their chutzpah. "Image hit like an atomic bomb," Valentino told *Comics Interview* in 1993, "not only in the direct-sales market, not just in the comic book market, but all over. We were interviewed for television. We were in newspapers. We were in magazines." When the interviewers finally backed off, McFarlane went to work on *Spawn*, Liefeld to *Youngblood*, and Lee to *WildC.A.T.S.*

"Image is the first sensible reaction to this basic truth of the direct market,'" Dave Sim said at Oakland's Pro/Con in 1993. "Will *Spawn* always be the number one comic book? No. Of course not. How long will it be at or near the top? There's no way of knowing. The critical difference with *Spawn* is that Todd McFarlane recognized that he is hot now, while he was working on *Spider-Man*. He recognized that he was making an enormous amount of money for Marvel Comics and that the percentage of that money that he was being paid was minuscule. He recognized that there was a window of opportunity now to make his future financially secure and to take control of his career. He recognized that at Marvel, his career was out of his control. A change of editor, of editorial policy, of company ownership, any number of things could throw him out in the street at a moment's notice. If Marvel could throw Chris Claremont away after 15 years, refusing even to let him write a farewell note on the letters page of the book he had made into the industry standard, what security is there? Todd McFarlane recognized that there is no security."

There was, however, a certain justice to the state of the industry in December 1995, when *Spawn* was outselling every Marvel comic and the "House of Ideas" was preparing to hire out four of its primary books—*Fantastic Four, Captain America, Avengers,* and *Iron Man*—to Jim Lee and Rob Liefeld.

A year later, Marvel had declared bankruptcy and Image was reflecting the chaotic nature of the direct market. Liefeld was deposed as the company's CEO and CFO and lurched off to form Maximum Press; Valentino closed his Shadowline Studio; Silvestri left Image, only to return; Lee started Homage Comics; and Larsen brought *Teenage Mutant Ninja Turtles*

Two of the founders of Image, Rob Liefeld (left) and Jim Lee (right) in happier times, with Megaton Man creator Don Simpson.

"Image hit like an atomic bomb, not only in the direct-sales market, not just in the comic book market, but all over."
JIM VALENTINO

INFINITY COVERS

Who cares? Hardly anyone, anymore, about covers in which the image is repeated an "infinite" number of times (usually about four). One of the earliest examples is *Batman* #8 (December 1941/January 1942), which shows Batman and Robin reading a copy of … *Batman* #8.

Illustration

Some artists draw. And some illustrate. Asked by Russ Cochran to explain the difference between a picture and an illustration, Roy Krenkel said:

This is the sort of thing that drove me out of illustration. Get this: "Seven gorillas, dressed in tuxedos, burst through the door, machine guns blazing. In the corner, the princess crouched, trembling, clutching the Amulet of Thoth to her bosom.

"The illustrator must: Show Amulet of Thoth. Show girl cringing. Show bosom. Show all seven gorillas as they burst through the door. Show that they are wearing tuxedos and that their machine guns are blazing."

Well, screw that! I mean, there are guys who can do this ... I ain't one of them fellows. Good luck.

But a picture is an entirely different thing. You sit down with an idea for a figure action. If it works and you're lucky, you draw this great figure and put a sword in his hand ... you see the background as a mist-shrouded land going off in the gloomy distance with a single light glowing in some evil castle. An invisible moon is casting dim light in the foreground.

Well, I can do that. But who the hell can do the seven gorillas with machine guns blazing? To hell with the Amulet of Thoth. Get the distinction?

and *A Distant Soil* under the Image umbrella. Keeping that Image umbrella upright before the winds of change was executive director Larry Marder.

Incredible Science-Fiction

After taking the baton from *Weird Science-Fantasy*, *ISF* ran for four issues, the last of which was the final New Trend comic published by EC. Exhaustion had set in at EC before the title began, Fan-Addict Larry Stark observed: "*Incredible* was an embarrassment to everyone, and it was a relief when it died."

Despite his long and varied career in comics, Carmine Infantino will always be remembered for his run as artist on the Silver Age *Flash*.
(© DC Comics, Inc.)

Infantino, Carmine

The art director at DC in the mid-1960s, when most of DC's art looked puny and insignificant compared to Jack Kirby's work at Marvel, Infantino got his first job in the comics as an intern in Harry Chesler's studio when he was 16. He bounced around at a variety of studios—Jack Binder's, Charlie Biro's, and Busy Arnold's, where he erased Lou Fine smudges—before Ed Cronin, the editor at Hillman, gave Infantino his first full-time job on *Airboy Comics*. Infantino both wrote and drew several Hillman features, often under the pseudonym "Rouge Enfant."

Joining his pencils with the inks of Frank Giacoia, an old high school buddy, Infantino eventually put down roots at DC. He worked on a variety of features—including Adam Strange and Captain Comet in the science fiction books and Bobo, Detective Chimp at the tail end of *Rex the Wonder Dog*—as well as helping to redesign the Flash in *Showcase* #4.

"Carmine Infantino's work could be a challenge at times," Murphy Anderson once told Gary Carter, "because if you tampered with it very much, you could wreck it. It also begged for you to do a few things like straighten out the anatomy here and there. Carmine didn't seem really that interested in anatomy. He was interested more in storytelling and panel design. He would often distort a figure on purpose and include unrealistic black [shadows] just for design purposes. In that way, we weren't in sympathy too much with one another."

According to Infantino, Harry Donenfeld went to his partner Jack Liebowitz and talked

him into making Infantino the art director for DC. "That meant I would design all the covers for the company. Period. I liked that that was fun for me. Shortly after that, Donenfeld leaves. Liebowitz says to me, 'You're running it now. You're the editor.' I said, 'What are you talking about?' But I was the editor. Then I became the editorial director. And that's when I started taking books apart, bringing new people in, and changing things all over the place."

Infantino hired artists Joe Kubert, Joe Orlando, and Dick Giordano as editors, and he signed Jack Kirby to bring his Fourth World series to DC. He is also remembered as the guy who later pulled the plug on the Kirby titles—"Remember, nobody hits 100 percent"—and who ordered staff artists to reshape Superman's head on all of Kirby's drawings of the Man of Steel during the King's stint on *Jimmy Olsen*. "Jack himself never objected to this," Infantino told Gary Groth. "He understood about when you had a licensed character, like Superman, you don't mess around with him."

In 1967, Infantino became DC's editorial director; he was later named publisher and president. His tenure at DC ended in 1975 when he "agreed to disagree" with company ownership about some of his editorial decisions. At that point he headed to Los Angeles, where he worked in animation for Hanna-Barbera and Marvel Animation and did occasional comics work.

Infantino swears he has no regrets. But . . . "The most important thing about my artwork . . . it never matured. Because just before it reached maturity, I stopped and became an editor. . . . My artwork to me is like an unfinished symphony, a painting that has never been completely done, a baby that never was produced … To this day, I never know what it would have become."

Ingels, Graham

He is, perhaps, the comics industry's most famous drunk, a notoriety that eclipses the horrors he could draw on the rare occasions he was sober. "Graham Ingels was an alcoholic," Bill Gaines, his editor at EC, once said. "Graham Ingels would as soon get drunk as not, but you know, in all the times he was drunk and in gutters and God knows where he was, he never lost a job, and he rarely was late. Don't ask me how he did it."

It's far too late to ask Ingels—he died on April 4, 1991, at the age of 75—but, truth be known, he didn't entertain, or tolerate, questions in the final 20 years of his life. When Ingels finally resurfaced in Florida, years after he'd abandoned his wife and children, he only allowed Gaines to contact him through his lawyer. When a comics fan wrote to him requesting an interview in 1990, Ingels threatened legal action if his anonymity was disturbed. Letters and phone calls to his daughter, Deanna, who was in touch with Ingels in the years before his death always went unanswered, presumably out of respect for her father.

In the absence of Ingels's self-portrait, George Evans would appreciate a moment with the brush. Their two families were good friends during the EC days, and the Ingelses were over one Saturday afternoon for a barbecue. "My

Graham Ingels excelled in creating a sense of place, as in this story from *Haunt of Fear*.

(© 1998 William M. Gaines, Agent, Inc.)

Haunt of Fear was Ingels's book—he had the lead story in every issue. This classic story from issue #22 (December 1953) has given readers the creeps for more than 40 years.

(© 1998 William M. Gaines, Agent, Inc.)

Following the end of the war and his stint in the Navy, Ingels signed on as the art director for publisher Ned Pines at Better Publications. Jerry De Fuccio has long argued that the job soured Ingels once and for all on the comics. He worked alongside Rafael Astarita for ten months, trying to resuscitate a decaying body of dead art. "Our job," Astarita once said, "was to try to salvage a huge pile of drawings done during World War II . . . Almost all of it was the work of one person [Ken Battefield] and might best be compared to something done by an arthritic aborigine, working with a charred hyena leg on a deflated buffalo bladder, while riding a lame camel through a sandstorm."

Ingels put down the hyena leg long enough to do the covers for *Startling Comics* #46–#48, then split with Pines and signed on with Bill Gaines at EC. His first EC story, "Smokin' Six Guns," appeared in *War Against Crime* #1, but Gaines would later say, "It didn't take us very long to realize . . . that Ingels was Mr. Horror himself."

Nor was there any mistake about Ingels's horrible handicap. "He knew he shouldn't drink, and he drank," George Evans said. And drank. The only time Roy Krenkel met Ingels, they hit the bar and "started to lather up." Howard Nostrand remembers Ingels staggering up to his home "stone blind drunk one night … He had this booze problem. He'd be all right if he drank beer, but if he got anything else, he'd turn into something fierce."

And Ingels is remembered much more for that inebriated ferocity than for the Old Witch and that "Ghastly" signature. Before dinner was

younger daughter was four or so," Evans said. "Graham fancied himself able to hold his booze, but he'd get three or four beers in him and get drowsy. My daughter would crawl up into his lap and every once in a while she'd take a sip of his beer. She didn't like it particularly, but if he was going to drink it, she was going to drink it. And she dozed off and he dozed off. None of us had a camera but what a picture. Both had that dopey smile on their face. Her head on his arm, sleeping away. What a marvelous picture."

Ingels began his freelance art career in 1935, at the age of 20. He started drawing for Fiction House's pulp magazines in 1943, shortly after joining the Navy and landing a desk job on Long Island. Between pulps, he also drew "The Lost World" for *Planet Comics* #24–#31, "Auro" for *Planet* #56–#61, and a half-dozen other FH features.

served at the Evans-Ingels barbecues, Evans said, "I would be so bleary from drinking that I wouldn't know what I was finally eating. And old Graham . . . he'd keep the drinks coming . . . and coming. I'd try to knock off one while Graham would have finished two or three cans of beer, and he'd take a look at me and shake my can and say, 'You're not keeping up!' And boy, what an effort to keep up."

Ingels couldn't keep up. Because Ingels was, in Evans's words, "a strange kind of devout Catholic," he took the criticism of EC's horror books to heart but remained with Gaines until the books folded. After a few years of forgettable efforts for *Classics Illustrated* and a teaching stint with the Famous Artists School, Ingels headed for Florida, determined to be forgotten.

"Let's just say that Graham Ingels was not happy with his home situation and so he ran away from home and disappeared so that his family could not find him," Gaines told *The Comics Journal*.

"His family began to break up," Evans added. "When it began to break, he assumed everyone would take his wife's side, so he cut away from everyone. After it was over, he just shut out contact with everybody, including us. I was Graham's friend. I would have been on his side. I would have stayed with him."

Ingels didn't want the company. When fans or other admirers came looking for him 20 years later, he would have nothing to do with them or their fascination with old comic books. He accepted royalty checks from Gaines, but little else. Not until the early 1980s did he go looking for his daughter. He found her through Evans, one guy who'd stayed in touch with her.

In the final years of his life, Ingels also retied the knot with the Old Witch, painting more than a dozen oils of the wench for Russ Cochran. Who knows what he thought as he sketched her features again? Perhaps she's the only self-portrait of Graham Ingels we'll ever have.

Injury-to-the-Eye Motif

Heads might be lopped off, bodies torn on the rack, and breasts hideously overinflated, but what bothered Fredric Wertham the most about comic books were injuries to the eyes.

True, the eyes were fair game in the comics: The cover of *Mister Mystery* #12, which Wertham may not have seen before he sent *Seduction of the Innocent* off to the printer, pulls up just short of a sizzling collision between a bloodshot eye and a white-hot poker. And how about Dr. Hyde, a Timely villain who would remove his victim's eyes and hold them for ransom?

But as Les Daniels observed in *Comix*, Wertham picked an odd panel to illustrate his point:

"The picture he chose came from a story entitled 'Murder, Morphine, and Me' in *True Crime* comics. When he wrote his book, this already defunct magazine was seven years old. More to the point, nobody in the comic book had an eye injured. What Wertham found was one panel from a *dream sequence* in which a female dope-pusher dreams that a junky threatens to take revenge for his destruction by sticking his empty syringe into her eye. The next panel shows her waking up safe and sound, all organs intact."

There is no mention of eye injuries in the original Comics Code, but those piercing panels were clearly covered in the opening section: "Scenes of excessive violence shall be prohibited. Scenes of brutal torture, excessive and unnecessary knife and gun play, physical agony, gory and gruesome crime shall be eliminated."

What impact did this have on comics 40 years later? Curiously enough, the "injury to eye motif" led to the final breakup between Todd McFarlane and Marvel Comics in 1991.

"I did a panel [for *Spider-Man* #16] where I stuck a sword in a guy's eye," McFarlane said. "And there's a Comics Code. The Comics Code kicked it back and said, 'You can't show a sword going into a guy's eyeball.' But if I did it in silhouette, i I took that whole panel and blacked it out that's okay. If I showed it from behind, if it's in your eye and it came from behind, that's also okay. If I stabbed him in the belly, that's okay. If I rammed it down his throat, that's okay.

> ### Inking
> *I think that inking is an invention of the publisher. It's not an invention of the penciler. The penciler's interest is to do the complete job, and no matter how good the piece of inking is on your penciling, if it isn't yours it's inconsequential to you. It has no value for you. It hides everything you've done. You have no way of knowing who's made the mistakes that you're looking at, and in the end, it's simply a convenience for the publisher, who in effect has arranged an assembly style of manufacturing his comic books.*
> — GIL KANE

"And how about Dr. Hyde, a Timely villain who would remove his victim's eyes and hold them for ransom?"

You can't get much more "injury-to-the-eye motif" than this quintessential Bernard Baily cover from the summer of 1953.
(© Media Publications/Aragon Publications)

But you can't do anything with the eyeball, thanks to the 1950s scare.

"I'm going... 'What is the code?' This is about the eighth time I've changed something because of the code. And between the eight buddies I know, that's about 100 changes in a year. If I was an editor, I'd first say, 'Can I get a friggin' printout of this Code?' I didn't put the sword in the eye because I'm vicious; I put the sword in the eye out of ignorance. I didn't know I couldn't do that. Now I'm making a stand that I'm not going to change that panel because you guys never told me I couldn't do it. I'm getting tired of making arbitrary changes."

When Marvel didn't yield, McFarlane made an unarbitrary change, rounding up the gang and storming off to form Image.

"Invasion from the Abyss"

This seven-page story in Avon's *Strange Worlds* #3 (1951) has been called "the most exciting jam" of the era. Al Williamson was famous for enlisting a little help from his friends, but this time Frank Frazetta, Angelo Torres, Wally Wood, and Roy Krenkel all chipped in. "Everybody's style gets showcased at one point or another," Robert Strauss writes in *The Art of Al Williamson,* "and to see all four of those guys do their particular versions of the same lovely lady in one story is, to my knowledge, a one-of-a-kind pleasure."

According to Williamson, he penciled the story, Frazetta inked it, and Krenkel supplied the backgrounds. "But the guy whom we did it for didn't like it at all," Williamson said. "He said we didn't follow the script or anything, and he gave it to Wally Wood to fix."

And where does Torres come in? Who the heck knows?

Iron Man

I had been toying with one idea that haunted me for months. As far as I knew, there had never been a major costumed comic book character who was a wealthy and successful businessman... [T]he more I thought about it, the more it grabbed me. I could envision a Howard Hughes type with almost unlimited wealth—a man with holdings and interests in every part of the world—envied by other males and sought after by glamorous females from every walk of life. But, like virtually all the mixed-up Marvel heroes, he'd have to be flawed. There'd have to be some tragic element to his life...

He'd be a playboy, a man's man. But he'd have some secret sorrow, some secret life-and-death problem that would plague and torment him each day of his life. And the more I thought about it, the faster it all came together. What if our hero had an injured heart—a heart that required him to wear some sort of metal device to keep it beating?

STAN LEE
SON OF ORIGINS OF MARVEL COMICS

Introduced by Stan Lee and Don Heck in *Tales of Suspense* #39 (March 1963), Iron Man finally found an opponent worthy of his mettle in 1979 when he was tripped up by alcoholism.

Tony Stark spent 15 years performing heroics inside a metal suit before he realized he had a bigger weakness than a bum heart. When David Michelinie and Bob Layton began plotting his future in *Iron Man* #116, they paid more attention to the drink that was so often in his hand.

"He was always an obvious candidate for [alcoholism]," then-editor Mark Gruenwald said, "always a millionaire, a socialite, a party animal. Until three years ago, he could drink without limit, with no effect on his personal life or his super-hero career."

After he went cold turkey in *Iron Man* #128, Stark's alcoholism returned with a vengeance four years later. "As long as there's a Tony Stark character," Gruenwald promised, "alcohol will be a real part of his persona. He'll never walk away from it, never escape it."

Demon rum eventually cost Stark his company, punished his personal life, and forced

him to AA meetings. Gruenwald admitted that Marvel was trying "to make up for the way his [drinking] has been sloughed off in the past. People have been smoking and drinking in the comics in the past with no consequence."

IRS Collection

The IRS name is a misnomer—collector Aran Stubbs worked for the Colorado Department of Revenue, not the Internal Revenue Service—but we're stuck with it, as we shall explain in a moment.

Aran Stubbs was, in the words of his lawyer, "a little different than the average person."

"Very eccentric-looking," said Dorothy Dahlquist, a publicist with CDR. "Very eccentric-acting. And absolutely brilliant."

"He had a very Spartan lifestyle," according to attorney Steven Katzman. "It was just Aran and his dog." And as far as anyone could tell, Stubbs didn't care a whole bunch about the dog. He had two passions in life—computers and comic books—and his genius was figuring out a way to use the first to acquire the second.

When Stubbs was first hired by the Department of Revenue, the agency didn't run background checks, so the agency never discovered that its new clerk had two convictions for burglary as a teenager and in 1979 had pleaded guilty to mail fraud, serving four months of a four-year sentence.

All CDR knew was that Stubbs was very good at his job and very adept with computers. He rose steadily through the ranks and kept his eyes open. By the time Stubbs became a chief computer programmer in 1990, he knew how the system worked.

He knew, for example, that if someone prepaid an estimated tax, then died due a refund, CDR would never send it out. Because no one would file for the refund, CDR would stow the money in that unopened account forever.

"Never say forever." That was Stubbs's motto. He had a huge comic book collection—several hundred long boxes—but he didn't have the money to fill in all the holes until he started tapping those unopened accounts.

"Aran would manipulate the system," Dahlquist explained, "forcing it to issue a check, either to himself or to the account. Then he would either intercept the check or have it sent to his house."

Dahlquist said agency investigators believe Stubbs began diverting funds in August 1991, and for several months no one was the wiser. Stubbs kept the checks small and his ears open, in case CDR had plumbers listening in for small leaks. As he hit the major-league mail-order dealers around the country, he always paid with cash.

But the caution didn't last. "The process got addictive," Katzman said. "You don't know when enough is enough. Greed overtakes your better judgment. The thing overtook him."

Stubbs's mistake was to begin paying for his larger orders not with cash but with the actual state warrants. "He contacted at least one dealer," Dahlquist said, "saying, 'I am representing

Iron Man made his debut in *Tales of Suspense* #39 (March 1963). The gray armor lasted one issue—by the next issue the suit was gold.

(TM & © 1998 Marvel Characters, Inc. All rights reserved.)

> "Stubbs…had a huge comic book collection—several hundred long boxes—but he didn't have the money to fill in all the holes until he started tapping those unopened accounts."

Tony Isabella

a group of people who want to invest in comic books. I will send you a Colorado state income-tax warrant. It will be endorsed. Just use that as a payment.'"

The scheme quickly pricked the suspicions of one dealer, Harley Yee of Detroit, who called the Department of Revenue and asked if the check was good. When the investigator researched the refund check, he discovered the name on the check belonged to a dead man.

Dahlquist said the agency security systems were already tracking a thief inside the agency: "We knew someone was doing it. The comic book angle identified Aran."

Stubbs was arrested on March 9, 1992. "If the scheme had run its full course," Katzman said, "Aran would have been out of the country. He didn't expect them to find out about it so soon."

Estimates of what Stubbs stole ranged from $150,000 to $500,000, but the state eventually settled on $180,000. Stubbs was charged with a Class 3 felony—theft over $10,000—and pleaded guilty to a Class 5 offense embezzlement of public property.

Stubbs could have gone to jail for up to 16 years on the original charge; he ended up escaping prison time entirely. Instead, he was sentenced to four years' probation and ordered to forfeit his collection to repay the Department of Revenue.

The collection consisted of 600 long boxes, or approximately 60,000 comics. Stubbs had stored the best of the lot—*Detective* #38, for example, and *Showcase* #4—in three freezers in his house. In no mind to go into the retail business, the CDR decided to auction off the entire array in one lot by sealed bid.

The winners of the auction—RTS Unlimited of Golden, Colorado—quickly dubbed their take the "IRS Collection" in huge, obnoxious ads in the *Comics Buyer's Guide*. Although others who had viewed the collection came away unimpressed by its quality or the number of key books, RTS promised buyers that "each comic will be issued with a certificate of authenticity to validate it's [sic] pedigree and unique origin from this important part of comicdom history."

How important? RTS demanded $22.85 ($19.95 for the catalog and $2.90 for shipping and handling) for the "100+-page inventory listing" of Aran Stubbs's ill-gotten gains.

Isabella, Tony

In more than 25 years in comics, Tony Isabella has certainly made the rounds, from retailer to distributor to editor to creator to cheerleader. In the 1970s he worked as an editor at both Marvel and DC Comics (his first job in comics was as Stan Lee's assistant in 1972). His writing credits range from well known titles (*Spider-Man, Incredible Hulk, Fantastic Four, Green Arrow, Hawkman, Ghost Rider*) to the more obscure (*Manphibian; It, the Living Colossus; Young Love*). In 1977 Isabella created Black Lightning, DC Comics' first black superhero, who had a short-lived revival in 1995. But Isabella is perhaps best known for his chatty, personable columns in *Comics Buyer's Guide*, originally titled "I Cover the Newsstand" and more recently "Tony's Tips."

Jigsaw Puzzles

The best puzzles are far more than the sum of their parts; their charm—small pieces that couple in subtle, unexpected ways—isn't always evident from the picture on the cover.

The best jigsaw we've found of comic books is from the Great American Puzzle Factory (#972). The 45 covers (most of which are ten-cent titles) cover a quarter-century, from *Liberty Scouts* #3 (August 1941) to *Superman* #177 (May 1965). It's an odd lot, a little heavy on the Dells. You'll find Tarzan and *Tales from the Crypt,* Dale Evans and Dick Tracy, Roy Rogers and Richie Rich, not to mention the final Golden Age issue of *Captain America.* And it's a treat piecing the 550 parts together.

Of the others, don't bother with Nordevco's entry in its "Collectible" series. The $7.99 puzzle (500 pieces) features 59 covers (and two more back covers), but 37 of them are the ragged junk from someone's DC closet. There are too many repeats—five *Jimmy Olsen*s, five *Batman*s, and four each of *Superboy* and *Detective.* The comics are adorned with other "mementos" of childhood, such as tinker toys, hand grips, Baby Ruth bars, hand buzzers, and Chuckles. Not one for the comics fan.

Jimmy Olsen

The *Daily Planet*'s cub reporter and Clark Kent's aide de "camp," Jimmy Olsen first appeared in *Action* #6, albeit blithely dismissed as "Jimmy the office boy." Olsen did not appear in the Fleischer brothers' cartoons that ran in 1941–1943, but he was a star of the radio series and the daily newspaper strip. After gaining his own book, *Superman's Pal, Jimmy Olsen,* in 1954, Olsen donned so many disguises that his own identity eventually disappeared.

Joe

When Bill Stout was doing advertising for the American Comic Book Company, an Asian gentleman named Joe often puttered into the store and began rooting through the stock. "He'd come in very calm and dignified," Stout said, "and the longer he was in the store, the more agitated he'd become. The more agitated he'd get, the more he'd buy. The object, then, was to keep Joe in the store for as long as possible. By the time he left, he was usually a wild man, buying everything in sight."

One of the best comics-related jigsaw puzzles features 45 different covers.
(© Great American Puzzle Factory)

Joe Palooka

Ruffy Balonki, Humphrey Pennyworth, Big Leviticus, and the French Foreign Legion: None was a match for Ham Fisher's lovable Polack. The first time his promoter, Knobby Walsh, spied Palooka, he correctly guessed, "Dumb as a clam," but the Wilkes-Barre boy could fight. From the day he took the title from Jack McSwatt until the dreary night McNaught Syndicate ordered him out of the ring, the big lug never met his equal.

When Fisher first dreamed up his boxer in 1921, he called him "Joe Dumbelletski," but the character was "Joe Palooka" when the comic strip first appeared on April 19, 1930. By the mid-'30s, the strip was running wild in more than 600 newspapers; Fisher was doing so well that assistants, such as Al Capp, drew the entire strip save for Palooka's face.

For viciousness, no fight of Palooka's ever matched Fisher's bitter feud with Capp, who left Fisher to create *Li'l Abner.* Capp landed the best shot in the April 1950 issue of *Atlantic Monthly,* a four-page mugging titled "I Remember Monster" (see sidebar in **Al Capp** entry).

Fisher spent the final five years of his life in a vain attempt to knock Capp off his feet. He repeatedly accused Capp of sneaking crotch shots and other pornographic snippets into his *Li'l Abner* panels. When he couldn't make a winning argument, Fisher manufactured one; in

Joe Palooka is the best-known sports-related comics character.

(© McNaught Syndicate)

1955, the National Cartoonists Society expelled Fisher for altering Capp's artwork.

"Capp was an acerbic, mean man," recalled Irwin Hasen, "but Ham Fisher was a very sick guy himself, past the pale of misery and unhappiness. For all his fame, he was the most miserable man that ever lived. They used to have these feuds at our [Cartoonist Guild] meetings. Capp was much stronger and ate him up alive in these things."

In 1945 Harvey launched a 118 issue run of *Joe Palooka,* which contains some of Bob Powell's best artwork. But once Joe left the ring, the champ had nowhere to go. He disappeared for good in 1984 and—curiously enough in this nostalgia-drenched world—he isn't missed.

"John Law"

Originally scheduled to walk the beat in 1948, Will Eisner's detective ended up drawn and quartered, recycled into four *Spirit* stories when Eisner couldn't sell the character. Thirty-five years later, cat yronwode discovered the stats for "John Law" among Eisner's papers; Eclipse pieced together Eisner's original story and published it in 1983. "John Law" was designed to be the backup feature in a book titled *The Adventures of Nubbin the Shoeshine Boy.*

Johnstone and Cushing

This advertising agency (founded by Tom Johnstone and Jack Cushing) proved to be a better-paying job for numerous comic book and strip artists, including Dik Browne, Creig Flessel, Ken Bald, Leonard Starr, and Stan Drake.

"Just out of the army, I went there brand new," Drake said. "I had my briefcase and went into the waiting room. There was a young kid sitting there, with his little portfolio. And the door opens, and out comes Dik Browne. With nothing on but his pants and his undershirt, and the undershirt was all torn and bloody.

"Here comes the art director behind him with a whip. He takes what are supposedly the original drawings of this guy, Dik Browne, and throws the drawings down in the hallway, screaming, 'And don't come back!' Then he turns to this young kid and says to him, 'And what do you want?' And the kid says, 'Na-na-na-nothing,' and goes out. Dik comes in from the hall with this tattered thing, which was covered with Mercurochrome. The whip hung right inside the door and every once in a while they'd do this with some young kid. That was the first time I ever met Dik Browne."

"I have more funny stories about Johnstone and Cushing than any other part of my life," Browne said. When he first knocked on the agency door, Johnstone was playing the piano. "In his office, very loud and very badly," Browne said in an interview in *Nemo* #1. "Ragtime, he was playing. And Betty Rhinehardt went in and said, 'There's a guy out here looking for work.' And he said, 'Can he play the piano?'"

When Rhinehardt relayed the question, Browne said no.

"Fuck 'im," Johnstone said.

Browne was about to walk out the door when Jack Cushing hustled out and said, "Hey, wait a minute. Don't pay any attention to him. Where are your samples?"

Browne said some kind of shenanigans were always going on in the office: "There were times when we had as many as 12 chessboards going." There were few times when the staff artists weren't pitching pennies or lighting tinfoil rockets and shooting them across the room.

"Yeah, we had a lot of laughs," Browne said. "We had a mural that Flessel painted that was unbelievable. He had a horse that went around

eight walls, and a woman's bosom that went around four, and he had baby feet marks that went clear across the ceiling, so that if you looked up you'd swear that a baby had walked like a fly. But you know the sad thing? They got so successful that they came in and they cleaned up the joint, got very businesslike. And of course the business immediately went to hell."

The Joker

The Harlequin of Hate. The Mad Maestro of Mirth. The Brazen Buffoon, the Clown of Crime, the Fiendish Funster, the Jeering Jackanape, the Grinning Gargoyle of Greed.

One and the same.

The Joker first appeared in *Batman* #1, which was also scheduled to be his final appearance. But Whit Ellsworth pulled writer Bill Finger aside and said, "Bill, are you crazy, we have a great character here." So, Finger told Jim Steranko, "the last panel was redrawn with an ambulance and a line of dialogue that he would live."

A playing card was Jerry Robinson's initial inspiration for The Joker. Robinson (privately) and Bob Kane (publicly) still argue over the creative billing, Kane insisting that Robinson flipped him the card only after Finger showed him a photograph of Conrad Veidt, playing the title character in *The Man Who Laughs*. That Kane refuses to surrender any credit to his former assistant is not surprising.

Jonah Hex

The real Deadman. First appearing in *All-Star Western* #10, the scarred one-time Confederate bounty hunter captured his own book—a 92-issue run—in 1977. Jack Jackson described Hex as "a sort of mid-19th-century Swamp Thing—an embittered loner torn between good and evil."

"If *Jonah Hex* can be ranked as one of the best western comics ever produced in America," Jackson said, "it is only average when compared with some of the westerns produced abroad . . . The early stories, written by John Albano and drawn by Tony DeZuniga, are the definitive ones." But a 1993 revival—Joe Lansdale and Timothy Truman's *Jonah Hex: Two-Gun Mojo* for DC's Vertigo imprint—had a uniquely demented charm.

Jones, Jeff

The Atlanta-born illustrator is best known for his fantasy art, his "Idyll" strips for *National Lampoon,* and his breathless, shameless swipes of Frank Frazetta. "Flat-out, cold swipes," Bernie Wrightson said. "Everyone could see it. Jeff never seemed to have any desire to do anything to disguise it. I can see Frank getting pissed. A lot of it was really, really obvious."

His swipe file was supplied, curiously enough, by Jerry Weist, an early EC fan and now the head of the collectibles department at Sotheby's. Weist, like fellow Kansan Bob Barrett, compiled a scrapbook of Frazetta pages removed from the comic books in which they appeared. ("I mean, who wants to keep *Coo-Coo* #27 for two pages of funny-animal draw-

Here's how the Joker looked in his first appearance, in *Batman* #1 (April 1940).
(© DC Comics, Inc.)

Jeff Jones

Jon Juan #1 has the distinction of being the only comic book for which Alex Schomburg did both the interior and the cover art.
(© Fawcett Publications)

Jumbo Comics was the home of Sheena; she reigned as cover girl for a dozen years, beginning with issue #13 (March 1940).
(© Fiction House)

ings," Weist said.) He eventually sold the book to . . .

Jeff Jones.

"Think about it," Weist said. "He bought my volumes at an early stage. He was probably using them as a reference source."

And, much to Frazetta's displeasure, using them quite well.

Jones arrived in New York during the blizzard of 1967; nine years later he joined Wrightson, Barry Smith, and Michael Kaluta in The Studio.

Jon Juan

This 1950 one-shot featured rare Alex Schomburg inside art and a Schomburg cover. Writer Jerry Siegel had Schomburg sign that cover "Al Reid" because, Schomburg said, "He wanted everyone to think he had more than one artist." It was Schomburg's only complete comic.

J'onn J'onzz

The Martian Manhunter's first appearance—*Detective Comics* #225—would have heralded the dawn of the Silver Age if that cover had been as luminous as the cover of *Showcase* #4.

J'onn J'onzz's 1955 debut in the back pages of *Detective* was the first of 102 consecutive stories in the book. In the middle of the run, he was discovered moonlighting in the starting lineup of the Justice League of America, which took the field in *Brave and the Bold* #28.

Two months after his departure from *Detective* #326 (April 1964), the Martian Manhunter scored his first solo cover, in *House of Mystery* #143.

Key *Detective Comics* issues: #225, origin and first appearance; #231, J'onn J'onzz walks on water, ponders Messianic complex; #232, first—and only—appearance of Jupiter, the Martian dog; #234, Tor, the robot criminal of Mars; #246, first appearance of Diane Meade, the Martian's Lois Lane; #275, Martian robot keeps Diane in the dark about secret identity (oh, Lois . . .); #301, J'onn J'onzz returns to Mars; #312, first appearance of Zook; #326, "death" of Martian Manhunter

Jughead

Archie's sidekick first appeared in *Pep Comics* #22, dated December 1941.

And what did the "S" on Jughead's sweater stand for? According to Bob Montana, "The 'S' on Jughead's sweater stands for Squirrel Hill Independent Tigers, which can only be abbreviated 'S' in the comics."

Suitably labeled, Jughead moved on over the years to star in such titles as *Archie's Pal, Jughead; Jughead's Fantasy; Jughead's Folly;* and *Jughead's Jokes.*

Jumbo Comics

As advertised, this was a jumbo comic (Jerry Iger named the book after P. T. Barnum's mammoth elephant), and it was Fiction House's initial leap from the pulps into comic books. The first eight issues were oversized (10½" x 14½"), black-and-white comics printed on cheap colored paper.

Jumbo Comics #1 (September 1938) arrived three months after *Action* #1 and featured, among other things, the first appearance of Sheena (by Mort Meskin) and Jack Kirby's first comic book artwork. The book reprinted material from Jerry Iger's shop that had first appeared in England.

Sheena, Queen of the Jungle, had her first full cover on *Jumbo Comics* #13 (March 1940). She captured the cover for good with *Jumbo* #17, remaining the book's cover girl for the next dozen years before she was dislodged on *Jumbo* #161 (July 1952).

Justice League of America

Julius Schwartz came up with the idea, Gardner Fox the story, and Mike Sekowsky

JUNGLE GALS

And they're not out of the woods yet. The Royalty in the Raw and their first appearances:

Sheena, Queen of the Jungle
Jumbo #1 (September 1938)

Camilla
Jungle #1 (January 1940)

Fantomah, Mystery Woman of the Jungle
Jungle #2 (February 1940)

Jun Gal
Blazing Comics #1

Nyoka, Jungle Girl
Jungle Girl #1 (Fall 1942)

Princess Vishnu, Tiger Girl
Fight #32 (June 1944)

Kara, Jungle Princess
Exciting #39 (June 1945)

South Sea Girl
Seven Seas Comics #1 (April 1946)

Princess Pantha
Thrilling #56 (October 1946)

Judy of the Jungle
Exciting #55 (May 1947)

Rulah, Jungle Goddess
All Top #8 (November 1947)

Tegra, Jungle Empress
Tegra, Jungle Empress #1 (August 1948)

Zegra, Jungle Empress
Zegra, Jungle Empress #2 (October 1948)

Jungle Lil
Jungle Lil #1 (April 1950)

Taanda, White Princess
White Princess of the Jungle #1 (July 1951)

Saari, the Jungle Goddess
Saari #1 (November 1951)

Lorna, the Jungle Girl
Lorna, Jungle Queen #1 (July 1953)

Jann of the Jungle
Jungle Tales #1 (September 1954)

Leopard Girl
Jungle Action #1 (October 1954)

Rima, the Jungle Girl
Rima #1 (April–May 1974)

Rulah was one of Fox's contributions to the jungle gals genre.
(© Fox Features Syndicate)

One of Alex Schomburg's many stunning airbrush renditions of Judy of the Jungle (May 1948).
(© Standard Comics)

Tiger Girl debuted in *Fight Comics* #32 (June 1944), took over as cover gal on issue #49, and fought gorillas, leopards, bad creatures, zombies, and assorted bad guys up through issue #81 (July 1953).
(© Fiction House)

The first-ever team-up of super-heroes was the Justice Society of America.

(© DC Comics, Inc.)

the artwork for the Justice League's first appearance in *The Brave and the Bold* #28.

And what a story it was. Inspired by Ray Cummings's opus "Tyranno the Conqueror," Fox brought us "Starro the Conqueror!" A giant starfish, Starro "travels across billions of miles of interstellar space" seeking a planet "teeming with intelligent life."

He settles on the DC Universe. He is mutating Earth's starfish to aid in his conquest of the planet when Aquaman happens by and dials the JLA.

Thanks, Gardner. Thanks a lot.

The charter members of the JLA were Aquaman, Batman, the Flash, Green Lantern, Martian Manhunter, Superman, and Wonder Woman. Green Arrow enlisted in *Justice League of America* #4, and the Atom joined ten issues later. By *JLA* #21, the lot of them were mixing with the Golden Age members of the Justice Society from the alternate universe Earth-2.

Kids in 1960 were so starved for entertainment that the JLA got their own book in October 1960, only two months after their three-issue run in *Brave and the Bold*. Salman Rushdie has popped out of hiding to admit publicly that *JLA* was his favorite comic book while he was growing up.

The JLA's success inspired Martin Goodman at Marvel to suggest to Stan Lee that he come up with a super-hero team. Tempted as they might have been by Starro and his friends, Lee and Jack Kirby came up with the Fantastic Four.

Justice Society of America

A creation of editor Sheldon Mayer and writer Gardner Fox, the first team of superheroes debuted in *All Star Comics* #3 (Winter 1940).

Half the cast of the JSA were characters from All-American Comics, which eventually merged with DC Comics. In those early appearances in *All Star Comics*, the team would convene, then scatter into solo chapters drawn by each character's regular artist.

The charter members were the Atom, Dr. Fate, the Flash, Green Lantern, Hawkman, Hourman, Sandman, and the Spectre. Batman and Superman were honorary members, a status that befell any character who secured his own book.

During the Golden Age, the Justice Society appeared in *All Star Comics* #3–#57. "Unlike the writers of today's comics," Jerry Bails wrote in his forward to volume 2 of the *All Star Archives,* "Gardner Fox, the author of the JSA, was able to build in me a faith in the brighter side of humanity. For better or for worse, I learned to believe that honest, caring human beings could band together in the pursuit of justice, decency and a better tomorrow."

Those were the days.

Kahn, Jenette

Queen of all she surveys at DC—and the closest the comics business gets to the monarchy—Jenette Kahn was named the company's publisher in 1976 at the age of 28. An art history major and the veteran of several kids' magazines, Kahn became DC's president five years later, in 1981. She spends most of her time nurturing the company's ties with Burbank and Hollywood on such productions as *Lois and Clark*.

Kalish, Carol

She collapsed outside New York's Port Authority bus terminal on a September day in 1991 and died of heart failure in a Manhattan hospital at the age of 36.

Born in Thailand and educated at Radcliffe, Kalish was working for Hal Shuster at New Media/Irjax when Mike Friedrich hired her in 1982 to assist him as Marvel's direct-sales manager. Friedrich admits he wasn't looking for an assistant, but a successor. "When I met her, I said, 'This is it. This woman is absolutely brilliant.' She had all of these great ideas about what could be done, some of which were a little off-the-wall. On her first day on the job, I told her I was quitting."

When Friedrich left, Kalish led with energy and ideas. She started a new Marvel fan club, convinced it was a key to making comics more accessible and Marvel more dominant in the market. She convinced Marvel to sell cash registers at a discount to retailers after her many trips into the boondocks showed her how many retailers could not grow—and order more Marvel comics—without one.

She made a lot of friends and inspired a lot of people. Regardless of whether Marvel was at the top of its game or in the pits, Kalish was in the trenches, convincing retailers that someone gave a damn. "She not only did worlds of good for Marvel's business ledgers but for its reputation as well," Mark Evanier wrote after Kalish's death. "Carol cared passionately about the field and the people in it, whether they were Jack Kirby or some kid with a funnybook nook in the local mall. She was an important person who quietly aided the lives and careers of a staggering number of comics people—not just retailers, not just wholesalers, but writers and artists as well."

Inside Marvel, however, Kalish was often caught up—and sometimes chewed up—in the power struggle.

"Carol was a woman with tremendous talent and major flaws," said Friedrich, who remained good friends with her after leaving Marvel. "She didn't do a good job of hiring people; she hired people who did not have an awful lot of initiative or particular brilliance for what they were doing. Either consciously or unconsciously, Carol hired people who would be no threat to her position. She was afraid of being undermined.

"I had tremendous respect for her intelligence and ambition," Friedrich said, "but as a corporate executive she was very poor in a few respects. You can't go around undermining the people you work for. And she never wrote anything down. Whereas Carol had all these beautiful plans in process, she didn't institutionalize any of them. When she died, they fell apart. People only had parts of the puzzle. There were dozens of things she was involved in, but her supervisors discovered they had no clue what she was up to."

When she died, Kalish was living with her long-time partner, Richard Howell, in a New Jersey house that had Jack Kirby original artwork glued all over the kitchen cabinets. "It was all just tarred up there," Friedrich said. "She was a gigantic fan of Jack Kirby's romance comics. Carol and Richard were packrats to the *n*th degree. It was the only bachelor apartment I've ever seen a couple have."

Kaluta, Michael

One of the most gifted and gregarious artists in the business, Kaluta saw his first published work appear in *Graphic Showcase* #1. By that time, he was already heavily under the influence of Edgar Rice Burroughs, Frank Frazetta, and Roy Krenkel. "Frazetta was the inspiration," Kaluta said, "but Krenkel was the guy I learned the technique from." Kaluta filled one early sketchpad after another with drawings in his "Roy Krenkel" mode.

In 1975 he joined Jeff Jones, Barry Smith, and Bernie Wrightson in the Studio. He'd met Wrightson and Jones at the 1967 World Science Fiction Convention in New York. "He's always been the most delightful, exasperating person I know," Wrightson said. "He's always putting

Carol Kalish

Michael Kaluta

Blowing It Big Time

When Steve Ringgenberg accused Mike Kaluta of "flawless" period detail in his work on *The Shadow*, Kaluta replied:

It's not flawless. I did a lot of research, but it's not flawless. As a matter of fact, there's some places where I really blew it. My favorite panel in the fourth issue, where Lamont Cranston and Shrevvy are getting out of the limousine in front of Bliss's mission, is one place. It's a long panel with the car and all these guys rummaging through trash cans and a Fatima cigarette ad. But it's on the Bowery. The only pictures I had of the Bowery were close-ups of the storefronts, showing the prices and showing the bums. And after I did the panel, after it was in production, I was looking at them again. I looked at the reflection in the window. The reflection was of the 6th Avenue elevated, which ran right down the Bowery. I left it out. No one except my father caught it. See, my father lived in New York as a kid. "Hey, you forgot the 6th Avenue el."

Kaluta found a niche as a DC cover artist in the 1990s.
(© DC Comics, Inc.)

things off. He never gets started on things right away. He will fill up sketchbook after sketchbook with these wonderful drawings. Completely uncommercial stuff. Then he'll get an assignment and just beat his head against the wall. He keeps finding other things to do to avoid work. He'll play with his computer. He'll research the hell out of things. Buy books. Buy videotapes. Go through this stuff for endless hours and get completely caught up with it. He has the most retentive mind of anyone I know. Anytime he needs it, he knows just where to go."

Kaluta's big break as a comic book artist resulted from an offbeat encounter with Carmine Infantino at the DC office.

"On a certain day, there was a field trip for the employees out to the color plant so you could see what happened to your work after it left your hand," Kaluta said. "I didn't want to go, so I was hiding out at the office, which was empty. And Carmine Infantino came by. He asked me if I'd ever thought of doing covers. Of course I wanted to do covers; I was an illustrator, not a comic book artist. So, he said, drop off some Batman ideas. I did four or five in consultation with friends, but my artwork wasn't up to the ideas."

His artwork got better. "Carmine helped me two or three different ways. One time I was just plain stuck and he dragged me into his office and said, 'Don't worry about it. You're just at that stage where your mind is doing more than your hand. Don't worry about it, it'll all come back. It's just another stage.'"

Neal Adams also provided guidance during Kaluta's days at DC, which were highlighted by his six issues on *The Shadow*. "He sat around and told stories and drew," Kaluta said. "He taught me a lot about how to ignore reality."

In 1979 Kaluta met writer Elaine Lee, with whom he would later produce *Starstruck*, a science fiction soap opera published under Marvel's Epic imprint.

He has lived in the same apartment on West 92nd for more than 20 years, wedged inside a U-shaped studio that features a plastic submachine gun over the fireplace and more clutter per square inch than any other in New York. "He's happy as a pig in shit there," Wrightson said. Kaluta often takes friends on his Used-to-Be-Tour of the neighborhood, during which he

is invariably sideswiped by gorgeous women whom he remembers as preschoolers. From his window, however, Kaluta said, "I never see the same person pass twice. The anonymity is incredible. Being in my room, the outside world doesn't impact me, but—Boom!—it's right outside the door."

Kamen, Jack

Typically ignored in the rousing discussions about the EC Comics artists, Jack Kamen was, for years, a dartboard for EC critics. "The least interesting of the group," M. Thomas Inge once wrote, "was Jack Kamen, whose wooden figures and poor use of perspective left much to be desired."

Kamen's misfortune, apparently, was to venture into EC's science fiction books, where Wally Wood, Al Williamson, and Frank Frazetta ruled, or disappear into the horror tales, where Graham Ingels dominated. Kamen's concise, uncluttered line never drew the fan approval meted out to his pencil pals at EC.

"Jack was hired originally for our love comics," Bill Gaines once said, "but by the time we hired him the love comics had died. But we kept him. He never missed a deadline. We used him in our humorous science fiction stories where equipment wasn't called for, because Jack was not strong on equipment. We also used him in the Grim Fairy Tales, and again his pristine qualities lent a delightful contrast to the dreadful things that were going to happen in those stories."

Most of the EC artists remembered Kamen as a pleasant guy with an arsenal of jokes. Marie Severin's caricature of the artist has a woman pinned between Kamen and the wall as Kamen asks, "Did you ever hear the one . . ."

Kamen also produced several memorable covers for *Brenda Starr*, *Cow Puncher*, and *Blue Beetle*. After leaving the comics field, he turned to advertising and fashion design.

Kane, Bob

In Bob Kane's staid, low-key, unassuming autobiography, *Batman and Me*, the reader must really dig to uncover those rare instances in which Batman's creator believes he deserves an inkling of credit.

Fortunately, our crack team of researchers read and reread this humble, self-deprecating monologue until they ferreted out several offhand, subtle claims by Kane regarding his "young, handsome and virile" cult figure:

I am such a compulsive doodler that I feel like I invented the art of graffiti. (page 1)

I was a superb copycat . . . (page 4)

Edison said that true genius is ninety percent perspiration and ten percent inspiration—so I suppose that I perspired profusely in those days. (page 20)

One of my gag strips was called Ginger Snapp and was about a mischievous little girl, a prerunner of Dennis the Menace. (page 20)

I was a great copyist . . . (page 35)

To a degree, cartoonists draw themselves or people they know into their strips, so I drew

Al Feldstein managed to build an entire story (in *Tales from the Crypt* #31, August/September 1952) around the mild-mannered Jack Kamen's coming to terms with doing horror stories for EC.
(© 1998 William M. Gaines, Agent, Inc.)

> **BAT CAVE**
>
> One more of Bill Finger's contributions to the mystique of Bob Kane. "The Batcave came directly out of *Popular Science*," Finger told Jim Steranko. "It had a cross-section drawing of underground hangars and how planes could be drawn up with winches. I cut that out and said, 'By God, that's great.' And I gave the drawing to Bob. He copied it line for line, adding the stalactites and stalagmites for the mysterious touch."

Bob Kane

Gil Kane

Bruce Wayne in my image, when I was young and handsome. (page 44)

I got a big kick out of picking up rival comic books to find that many of my imitators were literally stealing action poses of Batman and going so far as to virtually copy his costume. If "imitation is the sincerest form of flattery," then I must admit that I was, indeed, flattered by being such a great influence. (page 101)

I always fancied I could do a pretty good imitation of Bing's crooning, so much so that the kids around the block used to call me Bing. (page 125)

Norma Jean commented that I was a very talented mimic, and handsome enough to be a movie star. (page 128)

A two-time Academy Award winner, Jack Nicholson was always my first choice to play the nefarious Joker. (page 147)

As we stepped out of our limo, Elizabeth and I were greeted by a barrage of flashbulbs and reporters who thrust their microphones at me to get my comments on the movie. Press from all over the world was there. I felt that the adulation I received from the media and the crowd was the crowning tribute to my long career, and I savored every minute of it. For this moment at least, I felt like a big international celebrity ... Although I was surrounded by some of the biggest names in Hollywood, I was the one who was besieged by requests for my autograph. (page 150)

Kane, Gil

The ultimate "Been there, done that" in the field, Gil Kane has been doing comics for over 50 years. At the age of 14, he knew he wanted to draw comics; he knew because he'd seen the work of Lou Fine. "He was brilliant," Kane said. "He became my inspiration. And he became the inspiration for Murphy Anderson, for all of us. We were nuts about him.

"By the time I was 16, I started working; by 18, Murphy was working; at 17, Carmine [Infantino] was working. We began to pepper the field. We were the first generation of people who were influenced by comic books directly. We came in because we saw these comics. We were drunk on the material."

And it was a familiar, affirming buzz. "When we were young, the whole world was nothing but a pulp universe," Kane said. "All the movies that were made during the '30s were essentially pulp movies. The most popular authors were pulp authors. We were surrounded in every way by the things. There was no possibility that comics couldn't develop when pulp magazines and Sunday comic strips were as popular as they were. Comics were a natural expression, the way swing music was; it was natural for kids our age."

At 16, Kane worked as an assistant for Jack Kirby, then labored alongside Bob Montana at MLJ. He pitched his pencils on the shop circuit, working for both Jack Binder and Bernard Baily, and drew for Quality, Timely (where he penciled Captain America), Fawcett, Hillman, Fox, and a half-dozen other companies.

He ended up in the 1950s, of course, at DC. When the smoke cleared from the comics bonfires, Kane pointed out, "They were the only outfit in town. If you didn't get on there, you had to go into advertising or someplace. I never wanted to go into advertising."

The post-EC era was, Kane recalled, "the most sterile period in the whole history of comics." When artists such as Jack Cole, Frank Frazetta, and Al Williamson struggled to find work, Kane endured ... endured Julie Schwartz ("a control freak") and Bob Kanigher ("a no-good, unredeeming SOB who enjoyed little cru-

elties"), among other editors. He emerged in the 1960s as DC's lead artist on both the Green Lantern and the Atom.

At Marvel in the late 1960s, Kane claims to have worked on every character except the Fantastic Four, and he churned out some 900 covers. Although he concedes that Stan Lee's "mock irreverence" was perfect for that era, he has little patience with Lee's claim that he designed the covers for all the super-hero books. "After a while, he didn't even get involved in the covers," Kane said. "The covers very rarely had situations; they were pin-ups. In the early days, all covers were situational. They had to be based on something that happened inside the book. I did pin-ups all the time because we had to do them so quickly. There was no time for discussion."

Judas Goat

Do you know what a Judas goat is? It leads cattle into the stockyard; they let the goat go by, and then they knock the heads off the cattle as they pass through the gate right after the goat.

And that's what comics does... You work and you work, and all of a sudden you reach a point in your age, and comics just absolutely cut you to pieces, because there is no place to go for growth. You either have to regress or adjust, and it's impossible, if you've developed to any extent, to find a place for that development. Invariably what happens is that guys have to leave the field...

GIL KANE
THE COMICS JOURNAL

Kanigher, Robert

Far be it for us to attempt improving on the original. Here's DC writer/editor Kanigher himself:

I had carte blanche over the magazines that I edited. I was not restricted in any way. If I got a flash of an idea, I had the finest group of artists in the field to immediately set it in motion.

I never missed a deadline in my life.

I created and wrote and edited [Sgt.] Rock from the beginning. Alone. Without assistants or co-editors.

And his obsession with credit for the uncreditable disgusting and another reason why the assembly-line work in comics can not ever be taken seriously.

Every time [Bob] Kane saw me in the office, his conversation always was on the same subjects of cosmic importance. "Who looks younger: you or me? Who has the most hair? Whose hair is darker? Whose belly is fatter?"

For its treatment of humans Archie/MLJ was, and still is, the asshole of Mr. Scrooge.

Having fun in *The House of Mystery*: Gil Kane immerses himself in his work.
(© DC Comics, Inc.)

Kantner, Albert

The father of *Classic Comics* and *Classics Illustrated,* Kantner was born in Russia in 1897 and emigrated to New Hampshire at the age of seven. By his teens, he was working as a traveling salesman, eventually graduating from pots and pans to books. After his graduation, he brought plenty of his wares home. He had a library filled with the classics (Jules Verne's *Michael Strogoff* was his favorite) and a heart filled with the need to get kids to start reading them.

In 1941 Kantner convinced the Elliot Publishing Company to publish "The Three Musketeers," the first issue of *Classic Comics.* After only three issues, Kantner formed his own publishing company—Gilberton—and after the seventh, he had contracted with the Red Cross to send millions of copies of the Classics to GI's overseas.

Jerry Iger was hired as Kantner's art director in 1944, a post he held for a dozen years. L. B. Cole took over as art director in 1958 and oversaw the final three years of *Classics Illustrated*'s great 28-year roll.

Kantner died of a heart attack in 1973.

Katy Keene

Hey, Kids! Send in your own designs for Katy! Bill Woggon's dream girl first appeared as a backup feature in *Wilbur* #5 (Summer 1945). Katy Keene had dozens of appearances in such Archie titles as *Pep, Suzie, Laugh,* and *Wilbur* before claiming her own magazine in 1949.

"Of all the '40s girl humor characters," artist Barbara Rausch wrote in the 1984 *Overstreet Comic Book Price Guide,* "only Katy Keene has the individuality and elegance of the great newspaper strip beauties; her peers are not *Millie* and *Suzie,* but Tarpe Mills's *Miss Fury* and Dale Messick's *Brenda Starr.*"

Woggon has conceded that he was heavily influenced by George Petty's good-girl art in *Esquire* magazine. The character's considerable fan base gathered to stage Katy-Cons in the early 1980s, losing no opportunity to gush about the impact Katy and her cut-outs had on their formative years and the thrill of having seen their own designs in print—whether of fashions, cars, or rocketships.

"It's easy to see why Woggon's fans never deserted him," Trina Robbins once wrote. "He

> **SUMMER READING LIST**
>
> In all those times *The Comics Journal* solicited "summer reading lists," there was only one truly inventive reply, which appeared in issue #138 from (who else?) Robert Kanigher:
>
> *The Day Comics Ended,* Robert Kanigher; *The Secret Origin of a Comics Editor,* Robert Kanigher; *The Secret Sexual Escapades in Comics,* Robert Kanigher; *Secret Vendettas in Comics,* Robert Kanigher; *Secret Liars in Comics: Julius Schwartz, etc.,* Robert Kanigher; *The Secret Brainwashing in Comics,* Robert Kanigher; *The Day Before Comics Ended,* Robert Kanigher; *Comics and the New Impotent,* Robert Kanigher; *Comics and the Old Orgasms,* Robert Kanigher; *Comics: Frontal Lobotomies Without Surgery,* Robert Kanigher; *The Day After Comics Ended,* Robert Kanigher; *How to Make Money Writing for Comics,* Cambridge House, 1943; *Comics: The Ultimate Constipation,* Robert Kanigher; *The Old Testament,* Various Anonymous Geniuses.

In the 20 years I shared an office with [Julius Schwartz] I was daily astonished at his total lack of talent. I never heard an original character, story, or line come out of him. His sole creativity consisted of discussing on the phone what to have for dinner. His talent must have been in catering to the fans.

The Chinese believe that frankness is rudeness. They're right.

A long time ago, I made a decision. One can either be a Von Stroheim or a father image as a director: loving, gentle, comforting. I decided to be the Von Stroheim type. If you demand more than an actor can deliver, then that actor will deliver more than he or she thinks they are capable of. They will kill themselves to win your approval.

What I brought was not comics to comics, which is what's being done today, but the entire field of literature to comics. I used whatever I learned of literature and art, for comics. If you are going to borrow, why not from the best?

I have always welcomed genuine talent such as Toth's; not the papier-mâché version hailed by fan magazines and fans today, and castigated to hell tomorrow, because the hailers finally realized their emperors were ass-naked. Talent elates and challenges me to answer with a script which would challenge the artist to extend himself and produce the impossible. Whenever I expected the impossible, I received the improbable. The whole field profited.

told us, when it came to picking designs for the comic, he always kept an eye out for kids who seemed as though they could use that extra pat on the back, and indeed, Katy Keene pin-ups were full of credits for Katy's barrettes and bracelets—anything to include that extra contributor to whom getting printed meant everything in the world."

Katz, Jack

The true king of *The First Kingdom*. Let Clay Geerdes tell the story:

"I was hanging out with Jack Katz and Jack Kirby at one San Diego Con in the 1970s and the two Jacks were fun to watch. Kirby was telling Katz how 'they' were going to steal all his ideas from [Katz's] *The First Kingdom*. Katz knew that. He knew Kirby was going to steal a lot of them first because he had seen them. Jack [Katz] always gave copies of his books to people. Kirby was grinning. They both knew it was a game played by thieves. Everyone in the business has a swipe file. Kirby was swiped from so often he just laughed about it. Katz and I were sitting by the pool at the El Cortez Hotel and he said, 'Look at these kids oohing and ahhing over Kirby's stuff. One kid said Kirby could do four pages a day. Of course, he can pencil four pages a day, because he doesn't think.' Well, Katz was right, but it was Kirby's simplicity that made him accessible to all the kids. I didn't have any problem understanding *Captain America* when I was eight years old, but I would have had a lot of problems with the intellectual complexity of Katz's *First Kingdom* at that age. I have to smile at all of it now, because Katz is the artist who achieved what no one else in the field has ever done, a complete comic book epic, all of it written and drawn and inked by himself, and he has been ignored, not honored for all the achievement. Well, this is logical in our business, *n'est-ce pas?*

"Katz and I were close in those days. I spent a lot of evenings at his apartment reading over his originals, talking about art and philosophy. Jack is a brilliant man, one of the geniuses in the field, light years beyond Kirby and Steranko et al. He used to get out a page of Hal Foster's *Tarzan* and go over all the panels and tell me about the anatomy, about movement and gesture. He used to show me hundreds of anatomical flaws and cheats in the work of Hogarth. He

had contempt for the house artists, like Johnny Romita and Vince Colletta. I always liked the funny animals and Jack told me he couldn't draw them. They were too simple. Couldn't get himself to do it. We talked about the strip artists, because Jack had worked on corrections at King Features] for a time and he had a lot of stories to tell about the oldtimers and the jokes they played on each other. He said Ernie Bushmiller drew his characters with a ruler. Told me about Rube Goldberg waiting until Chic Young was gone to the john, then penciling in a Dagwood panel that was slightly obscene and when Young came back and sat down he inked the panel automatically without noticing until he was finished. They all had a laugh over that. Jack said most of the guys did obscene stuff about the characters in the margins.

"Jack was an amazing guy. He would call me up in the evening and we would talk for hours. I knew he was sitting there inking all the time. I took notes on a lot of the conversations and kept them. I still have them somewhere. This is the real history of comics, you know. Jack was inking Bulletman when he was 16. He worked for Sangwald. He knew all the people, knew where all the bodies were buried. But he was a bitter person. He had grown up poor in New York and he wanted to be rich and famous. He

Bill Woggon's *Katy Keene* was noted both for pulling in the readers and putting out sheer wackiness.
(© Archie Publications)

Jack Katz

Jack Katz's *First Kingdom* was a landmark series: creator owned, written and drawn by one artist, and planned from the beginning to be just 24 issues.

(© Jack Katz)

resented seeing all the attention given to artists he considered inferior to himself. He made a few well-to-do friends in California and tried to get in with them, though he never had time to do anything but draw. It is amazing to me that he managed to draw the 24 books of *The First Kingdom* in eight years. He couldn't have done it without the help of his wife, Carolyn, of course. She worked full time, cooked, cleaned, did the shitwork, and typed all of the dialogue and other copy to paste on Jack's originals. Just like countless other women.

"So the story ends sadly... Jack aspired to be wealthy, but the rich he knew weren't going to have a poor artist hanging around. Aspiring upward, he had to unload poor people like me. After the book was finished, Jack distanced himself from me. The last time I saw him walking down Telegraph he avoided my look and walked on by."

The Katzenjammer Kids

Katzenjammer—translated literally as "the howling of cats"—is German for "hangover."

And *Kids*? Hans and Fritz. They were rechristened "The Shenanigan Kids" during World War I, the days of liberty cabbage. "During World War II," comics historian Rick Marschall said, "no such silly re-alignments occurred."

The mischievous little punks were created in 1904 by Rudolph Dirks while at the New York *Journal*. He almost lost them when he moved in 1912 to the *New York World*. A year of legal maneuvering ensued, giving Dirks the images and names of the characters and leaving the title of the strip with new artist Harold Knerr. Knerr changed Hans to Fritz and Fritz to Hans, and continued the adventures for 35 years.

Kauffman, Stanley

The film critic for *The New Republic*—and former drama critic at *The New York Times*—Kauffman spent 13 months working as an editor at Fawcett.

In his memoirs, *Albums of Early Life,* Kauffman devotes a chapter to that stint, which began in December 1942. To avoid legal problems, he changes the names of his employer (to "Tappen") and the two major books he edited from *Captain Marvel* to *Major Mighty* and from *Captain Midnight* to *Nick Noonday*.

Kauffman first worked at Cinema Comics, which published four-page throwaways for Paramount and Warner Bros. After 18 months, he moved to Fawcett. Working under him was Robert Kanigher; working nearby was C. C. Beck. "A quiet little man who took his work very seriously," Kauffman said. "He took it just as seriously as any serious artist would take it. He didn't overvalue it: He didn't think he was painting for immortality, but he brought refinement to it within the scope of his ability. He didn't think he was slumming, in other words. I did think I was slumming."

With Frank Bourgholtzer, who later became a correspondent with NBC-TV, Kauffman plotted one issue of *Captain Midnight*, which featured four separate, but related, stories with the same villain: the Nazi Storm Von Kloud.

Of working at Fawcett, Kauffman said, "The best part—and maybe this is peerless hindsight—was feeling that I was doing static motion pictures. To plan these things was like planning a short film. You thought of them in terms of close-ups, two-shots, and three-shots."

Ka-Zar

First appearing in his own short-lived pulp magazine in 1936, Ka-Zar made a dramatic comeback in *Marvel Comics* #1 (October 1939). He aped Tarzan for the first 27 issues of *Marvel Mystery*. Ka-Zar reappeared in *X-Men* #10 with a new name (Kevin Plunder) and a new cat (not Zar, but Zabu).

Ka-Zar also appeared in the first issue of Marvel's *Savage Tales*. His domain is the Savage Land, which was once hidden somewhere beneath the Earth but lately, in the ever-evolving Marvel cosmos, has been accessible by helicopter.

Kelly, Walt

> *There is no need to sally forth, for it remains true that those things which make us human are, curiously enough, always close at hand. Resolve, then, that on this very ground, with small flags waving and tinny blasts on tiny trumpets, we may meet the enemy ... and not only may he be ours, he may be us.*

Walt Kelly was born in 1913, the son of a munitions worker, a man who believed no number of words, much less a thousand, could fill the vacuum of a picture. Kelly recalled his father saying, "We are ... bad at talking, bad at remembering language, and bad at spelling but we are just great at remembering pictures."

Before he began making memories with Pogo, Kelly drew editorial cartoons, comic pages for National, and animation for Disney. When he decided to devote himself full-time to the funny books, he realized he was ill-equipped to handle some of the major characters:

"It was impossible for me to draw a naked woman," Kelly said. "It was blinding work. I would no sooner have her clothes off than I would remove my hat, out of respect. With my eyes unshaded I couldn't see what I was doing. ... So I concentrated on puppies, kittens, mice, and elves ... every once in a while glancing back at the men who were grimly penciling out the Pueriles of Pauline, taking clothes off and dagging people with butcher knives."

Kelly's funny animals appeared in *Fairy Tale Parade*—which comics historian Hames Ware regards as one of the finest productions in the history of the medium—*Animal Comics*, *Looney Tunes*, and numerous Disney titles. Many fans prize his *Our Gang* comics, an intelligent take on the Little Rascals.

Pogo, Kelly's signature work, first appeared in *Animal Comics* #1 (December 1940–January 1941). *Pogo* began as a daily strip in the *New York Star* in 1949 and continued until 1974, a year after Kelly's death.

Ketcham, Hank

He was born in Seattle, conceived his famous strip in California, and, curiously enough, wrote *Dennis the Menace* from his home in Geneva, Switzerland during an 18-year stretch when it was at the height of its popularity.

Ketcham's son, Dennis, was four years old when the former animator realized he had more than enough material to devote a strip to the hyperactive kid. The strip hit the funny pages in 1951; what inspiration Ketcham didn't draw from his son, he garnered from his wife, Alice. After her death in 1958, Ketcham remarried and moved to Geneva where, Dennis Wepman quoted him as saying, he relied on "a great memory and a Sears Roebuck catalog" to maintain the menace in Dennis.

"When I went back and started looking at old artists," Jaime Hernandez told *The Comics Journal*, "I discovered that Hank Ketcham was the most subtle of all."

Walt Kelly created many a charming cover for titles such as *Pogo*, *Animal Comics*, *Fairy Tale Parade*, **and** *Walt Disney's Comics & Stories*.
(© Oskar Lebeck)

Kid Flash

Another open chemical cabinet, another bolt of lightning and—*voilà*—Kid Flash. The Kid, who prepared for super-stardom as Iris West's nephew, Wally, was transformed in *Flash* #110 (December 1959), and finally found his form—a mere 27 years later—when he took over for the Flash in *Crisis on Infinite Earths* #12. Wally West's assignment as the Flash was finally set in cement in DC's 1995 Zero Hour series.

Kids' Classified

The *San Jose Mercury* ran this service in the 1960s, allowing kids three free lines of advertising. The words "Wanted: Comics" were the introductory lines for many of the early fans in the San Francisco Bay Area, a lost-and-found for collectors who'd thought theirs was a solitary hobby. Mike Nolan, John Barrett, Jim Buser, and Bud Plant—four of the founders of Seven Sons, the first comic book store in the Bay Area—met by answering ads in the Kids' Classified.

King, Antane R.

Large virgin book collections from the Golden Age were almost impossible to find, mainly because they never existed in the first place. Who could have wanted to, or could have afforded to buy all the comic books which appeared during the late Depression and early years of World War II? Certainly no kid had that kind of money, or the space to keep them in. For complete mint runs of these comics to have survived, it required adults to buy and keep them—keep them through the wartime draft and paper drives, through household moves and periods of unemployment—to protect them from the ravages of silverfish and sunlight, extremes of temperature and the destructiveness of children and grandchildren.

For any comic book to survive over ten years during the Golden Age was little short of a miracle, as comic books were meant to be read and thrown away. Sure, some publishers, artists, and writers kept file copies, and even collectors kept runs of a particular title or two, but for accumula-

tions representing the entire field to survive the travails and upheavals most people experience, well, it just didn't happen.

Except it did. In two instances that I know of.
MALCOLM WILLITS
OWNER, COLLECTORS BOOK STORE, HOLLYWOOD

The two instances? The collection of Edgar Church, also known as the Mile Highs. And the collection of Antane R. King.

Malcolm Willits had been running ads for old comics in newspapers nationwide for several years when the first letter arrived from King, who was living in Providence, Rhode Island. "He wrote in a sort of broken English," Willits said, "as if it was a second language." But about one thing King was quite clear: "He had comic books for sale, thousands of them, all mint, untouched."

For several months in 1954, Willits, who was then attending Pacific University in Forest Grove, Oregon, would ride his bike down to the Railway Express office every now and then to pick up another package from King. For the first books—"Naturally," Willits said, "I purchased the Disney comics first"—he paid a dime, plus shipping. The later comics were only a nickel. On one trip, Willits and his bicycle returned with *Adventure* #1–#123, which set him back all of $6.15. On others, he opened the box to find *Super Comics* #1–#79, *Wings* #17–#88, *Pep Comics* #4–#64, or the 30 oldest *Captain America Comics*.

All in color, for a nickel.

The *Fight*s, the *Human Torch*es, the *Donald Duck*s. Eighty-seven pounds of comics in May, another 150 pounds in July. Not counting the Disney books, Willits's records indicate he bought at least 3,025 mint comics for $160.25.

Now and then, Willits would ask King where he got the comics, but King would never say. He did admit that the collection—which had run from mid-1935 into the mid-1940s—had been cherrypicked before he read Willits's ad. That explained why so many comic runs (*Planet, Captain Marvel, Superman, Batman, Famous Funnies,* and the *Four Color*s) were gone. "King never really told me he'd once had everything," Willits said. "I could tell, though, from what he still had that he'd once had everything."

For several years, Willits stored Antane King's books in the attic crawlspace of his Portland

"For any comic book to survive over ten years during the Golden Age was little short of a miracle, as comic books were meant to be read and thrown away. "
MALCOLM WILLITS

home, finally selling them when he was able to double his money and pick up a dime a book. Burt Blum at Cherokee Book Store in Hollywood got the *Adventure Comics;* Clinton White of Seattle got the run of *Super Comics.* Willits had unloaded most of the books by the time Leonard Brown, a Long Beach collector, came searching for what he had left. The two eventually combined forces to open Collectors Book Store in 1965, but not before Brown managed to track King down.

"When I finally did locate him," Brown said, "I didn't know what to say other than, 'Do you have any more?' He said, 'No, I don't have any more.' That was the gist of the conversation."

King Comics

The first issue in *King Comics*'s 16-year run—dated April 1936—featured the first comic book appearances of Flash Gordon, Popeye, and Mandrake the Magician. It was also the first book from David McKay Publications.

King, Frank

Born in Wisconsin in 1883, King brought huge helpings of middle America to his *Gasoline Alley,* which first appeared in the *Chicago Tribune* on November 24, 1918. Cars were the original heroes of King's strip, but family began its move toward center stage after a baby was left on a doorstep on Valentine's Day, 1921. "King was the first comic strip artist to age his characters with exact reference to the time progression of everyday life," Judith Sullivan notes in *The Great American Comic Strip.* And King was one of the best at bending his Sunday page into an imaginative layout.

Kinstler, Everett Raymond

Born in New York City in 1926, Kinstler broke into comics with Standard/Nedor at the age of 16. Before the lights went out on the 1940s, the artist had also worked for Farrell (*Captain Flight*), MLJ (*Black Hood*), Avon (*Phantom Witch Doctor*), and DC (*Hawkman*). By 1950 Kinstler had already turned to painting, but he squeezed out additional comic art for St. John, Dell, Ziff-Davis, and Avon before he decided he could survive on paperback cover art and portrait commissions.

"If he sat down with a blank sheet of paper," George Evans told *The Comics Journal* in 1995, "and took a pen and said, 'They want a picture of Wild Bill Hickock,' or something, and while he's maybe spooning up his lunch with his left hand, he's doing this stuff with the right. I don't mean it looked sloppy. He just made it look so easy."

Evans met Kinstler once, in the waiting room at *Classics Illustrated.* EC had just shut down. They both had portfolios in hand. "We got to talking," Evans said, "and later he asked my name and I asked his. He told me he needed this job because he was still studying. He told me, 'I don't plan to spend my whole life scratching away at the comics, and I hope you don't plan that either.'"

For the last 35 years, Kinstler has survived, and quite well, as a portrait artist, including U.S. presidents, even publishing a book on his craft.

King Comics reprinted newspaper comics from King Features from 1936 to 1952.
(© King Features Syndicate)

Everett Raymond Kinstler worked in a classical illustration style particularly well suited to science fiction covers.
(© Avon Periodicals)

Kirby, Jack

> *Actually, I was rather lucky because the second "comic book person" I ever met was Jerry Siegel, the third was Bob Kane, and the fourth was Jack Kirby—so right there, you have the history of comics in a microcosm: The man who created Superman, the man who created Batman, and the man who created Everything Else . . .*
> — MARK EVANIER

> *There's no one alive who knows how to draw comics who didn't pick something up from Jack Kirby.*
> — TY TEMPLETON

> *I'm essentially something else. I'm a storyteller.*
> — JACK KIRBY

Jack Kirby

We surrender. Raise the white flag. We're not even going to pretend we can do the King justice.

Jack Kirby is the all-time MVP. In his gallery, he isn't simply the *Mona Lisa*, he's the *Las Meninas*. He didn't create characters, he spawned genres, and generations of creators. "Singlehandedly," Frank Miller told *The Comics Journal*, "he developed the visual dialect, tone, and spirit of the modern super-hero comic. He brought a sense of operatic drama and mythological scope to a genre that was fat, bloated, old, and dying."

Old and fat, bloated and dying, because everything Kirby had created in the Forties and Fifties—Captain America, double-page spreads, super-hero parody, romance comics—had been sucked dry. So, Kirby came right back with the Fantastic Four, the Avengers, Thor, the X-Men, the Hulk, the Silver Surfer, Dr. Doom, the Kree and the Skrulls, the Watcher and Galactus, the old gods and the New Gods.

"Jack was so wildly creative that he would create a really great character on page two, then have it destroyed in a volcano or something," John Romita, Sr. said in *The Art of Jack Kirby*.

KIRBY'S 75TH

Frank Miller's introductory speech at the 1992 San Diego Comic-Con at Jack Kirby's 75th birthday celebration:

It's a deep honor for me to introduce Jack Kirby.

Normally, at these kinds of things, it's appropriate to list the man's accomplishments. But we haven't got all night. And I can't even really talk about the effect Kirby has had on my own career and my life, either. That would take all night, too.

Let me just say that nobody has done more for comics than Jack Kirby. Nobody.

We've all been inspired by him. And those of us fortunate enough to write and draw have been guided by him. And a whole lot of us have ripped him off, myself included.

But nobody has ripped off Jack Kirby more than Marvel Comics has.

While we enjoy this celebration of one of the field's true geniuses, while we enjoy this convention in which we reap the benefits from his work, let us keep this much in mind: We owe him.

We owe him. We owe Jack Kirby and Stan Lee and Steve Ditko and the rest of them for what they have given us.

As writers and artists, we owe them our best work, just to show them that we're still out there, still trying. Still believing that comics is a good and worthy story form. That comics are worth doing and worth reading.

As fans (and when it comes to this man, I'm a fan), we owe them our appreciation and respect . . . and if I may suggest it, we owe them one more thing, beyond the usual lip service to the legend.

It's a small thing. You can do it for Jack and Stan and Steve. And you can do it over and over again.

When you go to the Marvel booth, when you see Marvel personnel on stage, when you see them in the dealers' room, say two words:

Pay up!

Pay up! Give them something. Some piece of the pie that's made you so damned fat. Some piece of all the millions that never could have existed without Lee and Kirby and Ditko.

Pay up. If not out of gratitude, if not out of any sense of decency, if only for the sake of simple good manners, pay up!

But I want to be very clear on one thing. Suffering grave injustice does not make Jack Kirby a victim. Jack Kirby is a champion. It just so happens that he deserves one hell of a lot better from Marvel Comics than he's getting,

Come to think of it, there's only one way Marvel ever did right by Jack Kirby. Only one way they ever did him justice.

It was only a nickname, but it was the right one.

Ladies and gentlemen, this is the King.

"Stan would go nuts. He'd say, 'Are you crazy? I could build on that and make it last for five years!' I don't think Jack really cared because he kept on doing it.

"Jack would create costumes from page to page—costumes that would take most of us days to think of—and do this rather than look for the one he used in a previous issue. This was the kind of creative power that we were trying to harness."

For almost 50 years, Kirby was unharnessed and unmatched. And where did that get him? Mark Evanier recalled the afternoon in the mid-1980s when he and Kirby ended up in a Toys "R" Us parking lot. Kirby's wife, Roz, was shopping, and the boys had a couple of hours to kill, so Evanier suggested a quick dash through the store.

"I can't go in there," Kirby said.

"C'mon, Jack," Evanier said, "you're over 12. They're not going to card you."

"No, really, I can't go in there," Kirby said. He got almost physically ill, he explained, when he walked into such a store and passed the Hulk toys and Captain America dolls. He couldn't stomach seeing the fruits of his labor passing over the bar-code scanners, knowing he wouldn't earn a dime from the sale.

"Everywhere Jack went, someone else got rich," Evanier said. "He's made more money than any five people. And he got none of it."

He got some of it. One of the reasons Kirby was so willing to be led through his bitter 1991 interview with Gary Groth—*The Comics Journal* #134—was that he spent most of the Eighties listening to friends and disciples tell him he hadn't gotten enough.

Kirby wasn't particularly well served by such counsel. Marvel dragged the King through the mud in the tug-of-war over the rights to his original artwork—"Marvel was legally correct … and stupid, unfair," Jim Shooter admitted—but the bitter truth is that no one can do Kirby right. No one can pay him back for what he gave at the office.

Born Jacob Kurtzberg in New York City in 1917, Kirby cruised through the Pratt Institute at 14, joined Max Fleischer Studios at 18, joined Fox Features at 22, and created Captain America at the hazy old age of 24.

He had a frantic imagination, but it was locked in the cement of a rough-and-tumble life. When Cap fought ten guys on the rooftops of the city, Kirby could relate, and paint from memory, because he'd scuffled and bled on the same rooftops. "A climb-out fight," he once explained, "is where you climb a building. You climb fire escapes. You climb to the top of the building. You fight on the roof and you fight all the way down again. You fight down the wooden stairs, see. And, of course, I didn't win all of them. You fought fair. If the other guy wants to fight and you knocked him out, you did your best for him. You didn't want to hurt him any more. There was one time they knocked me out and laid me in front of my mother's door. And in order for my mother not to be shocked they readjusted my clothes and they saw that nothing was rumpled and I

Captain America was one of Kirby's earliest creations (in collaboration with Joe Simon). This cover is from issue #9 (December 1941).
(TM & © 1998 Marvel Characters, Inc. All rights reserved.)

In the 1970s Kirby created a number of titles for DC, including *Kamandi*, "The Last Boy on Earth!"
(© DC Comics, Inc.)

Kirby's Fourth World

Jack Kirby unchained.

Free of Stan Lee and the old gods. Spawning the new ones.

"I felt there was a time," Kirby was quoted in Will Jacobs and Gerard Jones's *The Comic Book Heroes,* "that a man had to tell a story in which he felt . . . there was no bullshit. There was absolute truth."

Kirby's story began in *Superman's Pal Jimmy Olsen* #133 (October 1970) and expanded, over the next four years, in *Forever People, Mister Miracle,* and—the flagship title—*New Gods.*

"I think Jack was building up to a great new era and it was aborted in midstream," Mark Evanier said. "It's an unfinished symphony."

In Kirby's war of the worlds, the good guys lived on New Genesis, the bad guys on Apokolips. Darkseid, the true bad seed on Apokolips, wanted to roll New Genesis over and stick a spike in its heart, but he was stymied by a truce in which he and Highfather, who lorded over New Genesis, had swapped sons.

Scott Free, the son of Highfather, was Mister Miracle. *New Gods* featured Orion, Darkseid's son, and the Forever People were a troop of New Genesis gods who landed on Earth and tangled with both its current residents and the Apokolips storm troopers.

Despite a great number of glowing critical reviews, DC pulled the plug on *New Gods, Forever People*, and Kirby's *Jimmy Olsen* in 1972, and *Mister Miracle* two years later. "Bad as it was when Jack [Kirby] left Marvel," Chris Claremont told *The Comics Journal*, "I think in a sense what happened to him when he went to DC was even worse—when his Fourth World series was literally cut out from him all at once because [DC publisher] Carmine [Infantino] didn't like it."

Infantino created a controversy that is still fresh today by having DC staff artists redraw Superman's head in Kirby's issues of *Jimmy Olsen*. "For the record," Infantino wrote in a 1995 letter to *Comics Buyer's Guide*, "I was not happy about having Kirby's version redrawn by our staff. It was costly, time-consuming, and embarrassing, but I took the blame. The sales of the Kirby issues plummeted, and we hastened to revert to our traditional artists. The sales soon recovered, proving my decision correct."

According to Mark Evanier, however, after Infantino was ousted at DC the subsequent management discovered that the sales on Kirby's books were much higher than previously reported.

looked very comfortable next to the apartment door, so when my mother would open the door it wouldn't be that much of a shock."

Greg Theakston recalled that when Kirby got some of his original art back from Marvel, they were flipping through the pages when Kirby stopped him at a *Fantastic Four* page that had an aerial shot of the Baxter Building. "Out of the top of the Baxter Building, a rocket is firing out," Theakston said. "And Jack points to that and says, 'That's the top of the Chrysler Building. That's the top of the Chrysler Building.' I said, 'I don't understand.' And he said, 'Well, when I was 14, My friend Izzy Cohen, or something like that, had a biplane and flew us over New York City in his biplane upside down.'

"To me, that was a revelation. I always wondered how Jack could possibly draw such fabulous aerial views of New York City. Where did they come from? Well, when he was a kid, it made this incredible impression on his head flying over New York City upside down. No wonder when the Silver Surfer was flying over the city that he had such a fabulous point of view. Jack had experienced that."

He had quite a few experiences. And no one in the history of the comics could share the experience quite like the King, or present them on such a grand scale. Gil Kane recalled the years the industry wasted trying to imitate Dan Barry at DC. Then, Kirby hit his stride at Marvel in the early 1960s and redesigned the comics.

"It was a keen experience, because we were all doing this Dan Barry-human style," said Kane, who was 16 years old when he first worked with Kirby. "And then we were jumping into this totally godlike ten-headed figure fit only to fight, not crime anymore, but people from the cosmos. Gods! Jack's figures were so extraordinarily godlike. Everything looked Olympian. Human scale looked ridiculous. Everything that Jack did had

Kirby, Jack

to be escalated, to the point where they were fighting Galactus because Jack's stuff was so much larger than life."

Because Kirby's ego was never as expansive as his "stuff," he was accorded the rarest respect.

"Clearly Jack was so much better than anyone else that there wasn't any jealousy out there," Kane said. "There was total acceptance that Jack was the best. He was the greatest single influence in comics all through the '60s as he was through the '40s. He was the only original Jack Kirby. Everyone else was simply an imitation of Jack Kirby."

Credit Where Credit Is Due

Near the end of the Great Kirby Artwork Scrap, Jim Shooter said that Jack approached him and said, "I won't take the artwork back and I will continue to slaughter you in the fan press until I get credit for all the characters I created, and until Stan Lee's name is taken off every comic book I worked on."

When they met again that summer at the 1986 San Diego Con, Shooter handed Jack a piece of paper. "Here's your list of characters you say you created. It includes Spider-Man."

"Yeah, I created Spider-Man," Kirby said.

"And he told me," Shooter said, "of Stan crying at his desk [back in 1961] because the company was going to go out of business. And he [Kirby] says, 'I'll save the company, Stan,' and he comes in the next day with Spider-Man all full-blown.

"I said, 'Ya know, Jack, I've asked Stan and Steve Ditko and Flo Steinberg and Sol Brodsky to tell me that story and they all tell it differently and they all tell it the same. That Stan asked you to do a sketch for Spider-Man, and you did, and he didn't like it. I've seen the sketch. He has little pants on, a gun, a cape, buccaneer boots . . . It's like The Fly. But after Stan didn't like it, Steve created Spider-Man . . . Look at Spider-Man: That's Steve.

"He said, 'Maybe you're right.'

"I said, 'Well, I want to give Steve and Stan credit on Spider-Man.' He said, 'Okay.'

"Then I said, 'Captain America, you and Joe [Simon], every one that you're sure of, we'll give you credit. But a friend of Don Heck says he had a lot to do with Iron Man. Do we include him or not?'

"Jack said, 'Okay.' Jack was real cool."

Even when it came time to give a little credit to Stan the Man?

"'There's no way I can take Stan's name off,' Shooter told Kirby. "Didn't he contribute at all?"

"'No, it's all mine,' Kirby said.

"'Didn't he contribute a little bit?'

"'Well, maybe a little bit.'

"'I've got to put his name on there,'" Shooter told Kirby.

"And Jack shrugged. 'Okay,' he said."

Characters TM & © 1998 Marvel Characters, Inc. All rights reserved.

Kiss, About That

This one-pager from *Young Romance* #33 (May 1951) gives the lowdown on flashy clothes, easy thrills, and what boys grab for when they're bored.

Kitchen Sink

Denis Kitchen still remembers speaking those fateful words—"Sure. Two is as easy as one"—that turned this card-carrying Socialist from Wisconsin into an intrepid capitalist.

When Jay Lynch came calling in 1970, Kitchen had already published his own *Mom's Homemade Comics*. Because Lynch, like Kitchen, had grown dissatisfied with the accounting practices of the San Francisco–based Print Mint, he asked the "tall hipster" artist to publish *Bijou Funnies* #5.

"I remember not hesitating," Kitchen said. "I didn't realize that was a major fork in the road. Not only was there #5, but Jay wanted the first four issues reprinted. Other artists came out of the woodwork. The next thing I knew, I had a dozen titles."

Kitchen, Lynch hastened to add, wasn't much of an improvement over Print Mint at first, "but Denis was operating out of his apartment and [Print Mint] had a warehouse. Denis's excuses were much more valid than their excuses. He came off like Geraldo, with all his confidence. He had no vices; he didn't take drugs."

Given his socialist roots—he had run for lieutenant governor of Wisconsin on the Socialist Labor Party ticket in 1970—Kitchen warmed slowly to the idea of running a company and forming a corporation, the Krupp Comic Works. "I had these terrible fears that I couldn't have employees, that whenever I was making a profit, I would be exploiting them," he said. "I paid the artists such an insanely high royalty, I made no money myself. For the first two years, I didn't draw a cent out of the company. When I finally realized the only person I was exploiting was myself, I lost faith in the basic Marxist tenet that profit was a dirty word and began to do business guilt free."

Robert Crumb's *home grown funnies,* which sold 160,000 copies, was Kitchen Sink's first big seller in 1971. The following year, the company's play list included *Bijou Funnies, Bizarre Sex, Death Rattle, Snarf,* and Crumb's *XYZ Comics*. And in 1973, Kitchen first published the work of Will Eisner and Harvey Kurtzman.

When Kitchen couldn't find his favorite strips at the library, he explained, he went looking for his favorite strip artists. "I was bold enough as a very young publisher to just approach the men I admired, like Will Eisner, Milton Caniff, and Harvey Kurtzman," he said. "It astonished me that no one else had done it."

When Kitchen decided to reprint The Spirit, the head-shop owners gave him a hard time. "The old hippie audience," he said, "was as set in its ways as the parents we were rebelling against. Although Eisner wasn't speaking to the youth of the early '70s, I thought his work had universal appeal. I began to diversify my publishing tastes. Suddenly, I was reaching older fans and straighter fans, the Bud Plants and the Phil Seulings."

On the strength of such diversity—William Stout and Kate Worley/Reed Waller, Trina Robbins and Al Capp, Ernie Bushmiller and Mark Schultz—Kitchen Sink, which absorbed Kevin Eastman's Tundra in 1993, celebrated its 28th birthday in 1997.

Klein, Bernie

He was a Golden Gloves boxer from Trenton, and when Jerry Robinson came home

to New Jersey from New York for New Year's Eve, Klein buttonholed Robinson at a party. Like everyone else at the party, Klein knew that Jerry drew Batman, and he knew that the 18-year-old artist must have inside info on how to succeed in the business.

"He drew sports cartoons for the local paper for $5 a cartoon," Robinson said, "but he was working as a laborer. That night at the party, he cornered me and said, 'How can I break in to the comic book field in New York?' He showed me his work; I saw that he had talent and told him exactly what to show for a presentation."

Robinson didn't hear from Klein for the next several months and forgot about him. Then he got a telephone call from Klein, who was working at MLJ. He'd left that New Year's Eve party, gone home, and stayed up all night following Robinson's advice. "Then he took it in to New York every day and made the rounds until he got the job," Robinson said. "He wanted to do it on his own before he called me."

Through Klein, Robinson met Mort Meskin, and the three artists soon had an apartment together. Robinson got Klein some work at DC and they both worked together on *Daredevil Battles Hitler*. They had other adventures planned when Klein was drafted and entered the Army as a combat photographer. "He was killed at Anzio," Robinson said. "He had gone through the whole North African campaign. He was shot down several times during that campaign. He was one of those guys you never thought would die. He looked like John Garfield. One of those lucky guys."

Kooba Cola

On the back covers of his 1940 books, publisher Victor Fox advertised this cola, "A Refreshing Cola Drink With a New Thrill—Vitamin B_1." Perhaps Fox simply wanted to give his readers something new to spill on their comics, but Kooba Cola never reached the supermarket shelf. Despite Fox's interest, the cola was never produced or sold.

Krazy Kat

George Herriman's strip immortalized the eternal love rectangle, featuring Krazy Kat, Offissa Pupp, and Ignatz Mouse and his brick.

Before the silhouettes of a surrealistic New Mexico/Arizona landscape and the constantly shifting backgrounds of Herriman's comic vision, these were constants. Krazy Kat doted on Ignatz; Ignatz unloaded on Krazy Kat; Offissa Pup tried to shield the cat, but invariably settled on retrieving the brick.

Krazy Kat first slipped into another Herriman strip, *The Dingbat Family*, in 1910 and began as a strip of its own in 1913. Its charm was pervasive. "Krazy Kat," art critic Gilbert Seldes argued in his 1924 book, *The Seven Lively Arts*, "is the most amusing and fantastic and satisfactory work of art produced in America today."

The amusement and satisfaction was much more subtle than the brick that Ignatz so frequently delivered and that Krazy Kat, in the absence of any other sign of the mouse's affection, so lovingly received. Krazy Kat's delicious wordplay and unsavory puns reflected Herriman's own delight in the special quirks of the spoken word.

Herriman moonlighted on a variety of strips while working on *Krazy Kat*, finally focusing on *Krazy Kat* alone after 1932. As R. C Harvey noted, "After the death of one of his two daughters in 1939 (a mere five years after his wife of 32 years had died), Herriman became a virtual recluse, confining himself to the living room of his Spanish-style mansion in Hollywood, where he slept on a couch near his drawing board. He went out only to take his strips to the post office."

Herriman took his last trip to the post office in 1944.

Herriman had fun with the layout of Sunday *Krazy Kat* strips.
(© King Features Syndicate)

Kooba Cola ads turned out to be fictitious.

(AND THE) KNEEBONE'S CONNECTED TO THE... THIGHBONE

All Winners, a superhero title, became *All Teen* with issue #20 (January 1947)—but then switched back again with issue #21!
(TM & © 1998 Marvel Characters, Inc. All rights reserved.)

In a world in which everyone is waving a Styrofoam mitt with a single finger aloft, it may be hard to believe there is no *More Fun* #1. Nor an *Adventure* #1, *Human Torch* #1, *Weird Science* #1, *Crime Does Not Pay* #1, *Blackhawk* #1, *Thor* #1, or *Tales from the Crypt* #1.

Not all the great comic book runs begin at the beginning. Some pick up where some weary, worn-out or poor-selling title left off. *All Select* became *Blonde Phantom*. *Weird Science* unhorsed *Saddle Romances*.

There are two reasons why so many books opened without a Chapter 1. In the first place, before the days of comics specialty stores, the Moms and Pops who had too many comic books to set out on the racks were none too thrilled when a new number 1 issue showed up. There was no guarantee the late arrival would ever leave the store without its cover ripped off. There was no assurance the sucker would sell. That big, bold "1" scared a lot of distributors and retailers off; it was the giveaway the comic had no track record. Slap a "5" or "6" on the book and no one was the wiser.

Second, every new magazine required another hefty postal deposit until it received its second-class postal permit. Hoping to forgo those deposits, publishers liked to pretend they weren't putting out a new book, just a slightly altered one.

That argument was a little easier to make when *Marvel Mystery* evolved into *Marvel Tales* than when *Women Outlaws* underwent its Kafkaesque metamorphosis into *My Love Memoirs*, or when *Moon Girl* became *A Moon, a Girl ... Romance*.

We'll let you decide if the Post Office was fooled when:

All Great #13 (became)	*Dagar, Desert Hawk* #14
Dagar, Desert Hawk #23	*Captain Kidd* #24
Captain Kidd #25	*My Secret Story* #26
All Select #11	*Blonde Phantom* #12
Blonde Phantom #22	*Lovers* #23
All Top #18	*My Experience* #19
All Winners #19	*All Teen* #20
Amazing Comics #1	*Complete Comics* #2
Blaze Carson #4	*Rex Hart* #6
Rex Hart #8	*Whip Wilson* #9
Whip Wilson #11	*The Gunhawk* #12
Blue Bolt #110	*Blue Bolt Weird Tales of Terror* #111
Blue Bolt Weird Tales of Terror #119	*Ghostly Weird* #120
Boy Explorers #2	*Terry and the Pirates* #3
Captain Midnight #67	*Sweethearts* #68
Captain Science #7	*Fantastic* #8
Fantastic #9	*Beware* #10
Beware #12	*Chilling Tales* #13
Casey Crime Photographer #4	*Two-Gun Western* #5
Charlie Chan #9	*Zaza the Mystic* #10
Zaza the Mystic #11	*This Magazine Is Haunted* #12
This Magazine Is Haunted #16	*Outer Space* #17
Comedy Comics #34	*Margie* #35
Margie #49	*Reno Browne* #50
Criminals on the Run #10	*Crime-Fighting Detective* #11
Crime-Fighting Detective #19	*Shock Detective* #20
Shock Detective #22	*Spook Suspense Mystery* #23
Fat and Slat #4	*Gunfighter* #5
Gunfighter #14	*Haunt of Fear* #15
Hangman #8	*Black Hood* #9
Black Hood #19	*Laugh* #20
Indian Braves #4	*Baffling Mysteries* #5
International #5	*International Crime Patrol* #6
International Crime Patrol #6	*Crime Patrol* #7
Crime Patrol #16	*Crypt of Terror* #17
Crypt of Terror #19	*Tales From the Crypt* #20
Journey into Mystery #125	*Thor* #126
Kid Eternity #18	*Buccaneers* #19
Marvel Mystery #92	*Marvel Tales* #93
Military #43	*Modern* #44
Moon Girl Fights Crime #8	*A Moon, A Girl ... Romance* #9
A Moon, A Girl ... Romance #12	*Weird Fantasy* #13
Phantom Lady #23	*My Love Secret* #24
Red Raven #1	*Human Torch* #2
Redskin #12	*Famous Western Badmen* #13

Saddle Romances segued to **Weird Science** with issue #12 (May/June 1950).
(© 1998 William M. Gaines, Agent, Inc.)

Saddle Romances #11	*Weird Science* #12
Silver Streak #21	*Crime Does Not Pay* #22
Strange Tales #168	*Dr. Strange* #169
Tales to Astonish #101	*Incredible Hulk* #102
Tales of Suspense #99	*Captain America* #100
Uncle Sam #8	*Blackhawk* #9
Voodoo #19	*Vooda* #20
War Against Crime #11	*Vault of Horror* #12
Western Thrillers #6	*My Past Confessions* #7
Women Outlaws #8	*My Love Memoirs* #9
Wonder #2	*Wonderworld* #3
Wow #69	*Real Western Hero* #70
Yellowjacket Comics #10	*Jack in the Box* #11
Jack in the Box #16	*Cowboy Western* #17
Cowboy Western #39	*Space Western* #40
Zegra #5	*My Love Life* #6
Zoot #16	*Rush* #17

Zegra (which was called *Tegra* in issue #1) went from the jungles to *My Love Life* in June 1949.
(© Fox Features Syndicate)

Kremer, Warren

Kremer created Richie Rich, naming him after his oldest son, Richard. A pulp illustrator who worked for Ace Magazines in the 1940s, Kremer provided both humor and horror work at Harvey. In a letter to Robin Snyder's *The Comics*, Ernie Colon noted, "His long career at Harvey Publications was almost mythical to those of us who worked with him and had the opportunity to see his work while still in the pencil stage."

Krenkel, Roy

That was a glorious period back then. It's as clear in my mind as yesterday afternoon; that's why I'm laughing. It was a fun period. I've always felt very lucky and privileged to have grown up with these particular guys, because they were all great guys in their own way. There were so many little anecdotes, usually unconnected to art. Like I mentioned Woody [Wally Wood] literally leaping out of his chair and rushing over and saying, "Hey, the script calls for this, but how about this?" and we'd chat and laugh and sometimes the goddamn chatting and laughing about the whole idea, when one thing led to another, you know, would go on for about an hour, and we'd consume some beer and finally go out, and the goddamn thing would be delayed another hour or two or three or four. A marvelous period. Indescribable.

I don't think there's very much like that going on today, because I know a lot of guys who are in comics now, and it's a grim business... In the old days it was a thing of fun and, as I say, we were all convinced (and I know nobody feels that way today) we were going to be President and somehow make it... We'd be the great artist. We would be Hal Foster tomorrow... That was the shining grail that kept the whole goddamn scameer together. Very innocent days. Then things only had one way to go—better. We couldn't miss."

FROM ROY KRENKEL'S FINAL INTERVIEW
THE ART OF AL WILLIAMSON

The first time Al Williamson met Roy Krenkel, he was sitting on a bed, turning the pages of an artist's pad on his lap, four or five guys looking over his shoulders. Williamson recognized the panels on the pages right away: "They were Hal Foster *Tarzan*s. I said I've got to see this."

What Williamson was looking for, he admitted, was someone who loved comics the way he loved them. Someone who didn't just recognize Alex Raymond and Milt Caniff, but was thrilled by their work. "I sat down next to him," Williamson said, "and he was pointing out how Foster had worked this panel..."

Tarzan & the Little Lion

where Tarzan had put his rope around this boulder and pushed it out into space. He was saying, 'Look at the strength, feel the weight of that rock.' And you could, looking at it. I started talking with him because I was a Raymond buff, I loved Alex Raymond. I asked him if he had any Sunday *Flash Gordon*s, and he said, 'Yes, I have the whole set.' We instantly gravitated toward one another."

Roy Krenkel had a healthy center of gravity. That owed to his sense of history, a fascination for the work of J. Allen St. John; his exquisite draftsmanship of cityscapes and ancient empires; and his sense of humor.

"Krenkel was just a flaky agitator," George Evans said. "He was always inciting a wild, passionate discussion about something idiotic or unnecessary, just to get some life into the party, or stir something up. Remember the flying saucer craze? Roy brought that up. Of course, there were those who wanted to believe everything about flying saucers. Roy came up with this story that he saw this light in the sky, and a pork chop bone fell and landed at his feet. He figured it must have come from a flying saucer. Everyone jumped on that."

"Roy Krenkel was as nutty as he was talented," Nick Meglin once said, "but his nuttiness kept his talent in a hammerlock. He encouraged Frazetta to greater heights, then suffered depression because he felt he couldn't do what Frazetta was doing. He encouraged Williamson to study and collect the great pen-and-ink masters and adventure painters, then suffered depression when Al stumbled upon or had the funds to buy something Roy had been looking for for years. He encouraged the social/professional world of our group, then suffered depression because he never knew when we were getting together, forgetting the fact that it was he who refused to get a phone so people could reach him."

Krenkel was born in the Bronx in 1918. He studied with George Bridgeman—as did the likes of Bob Lubbers and Stan Drake—and served in the Army, before meeting Williamson and EC's ex-GI's at Burne Hogarth's Cartoonists and Illustrators School.

"Krenkel never had a regular job," Russ Cochran wrote in his three-volume *Tarzan* study. "He lived with his parents in their home in Queens, he evidently had enough income from them to meet his spartan needs, and he continued doodling and working around the fringes of the professional art world until Al Williamson asked him for assistance in backgrounds for some of the EC science fiction stories that Al was illustrating."

"He did a lot of my backgrounds," Williamson said. "The hardware stuff. He was really into that late '20s, early '30s science fiction stuff that had that Winsor McCay feel about it. 'This is a world I'd like to live in.' He was able to convey that in his drawings."

Krenkel, best known for his covers of the Ace Tarzan books, also did the roughs for several of Frazetta's covers. At the 21st World Science Fiction Convention in 1963, Krenkel won a Hugo award for those Ace covers; at the same convention, his original art for *Tarzan Triumphant* sold for $75.

Twenty years later, Krenkel was dead from cancer. Five years before his death, Russ Cochran traveled to his Long Island home to interview him. 'Following Roy's directions, I drove to his home and pulled up in front of an older house in a middle-class Long Island neighborhood," Cochran wrote. "All the yards were neatly kept, except one. Roy's. It had a Graham Ingels atmosphere: The house did not look lived in, tall grass and weeds in the front yard were knee high. I knocked on the front door... no answer... and then noticed that the front door was nailed shut from the inside. I went around to the side door through the knee-deep weeds and tried again. Soon, Roy appeared at the door and greeted me..."

Krigstein, Bernie

I think that Bernie Krigstein was shining a light for us to follow, in terms of where the comic book could go. It's too bad the door was slammed on it.
AL FELDSTEIN

> "Krenkel was just a flaky agitator. He was always inciting a wild, passionate discussion about something idiotic or unnecessary, just to get some life into the party, or stir something up."
> GEORGE EVANS

The artist of "Master Race" (*Impact* #1), one of the most famous EC stories, Krigstein was perhaps EC's most idiosyncratic and stubborn illustrator.

Krigstein worked at a variety of companies after World War II, putting in considerable time on *Nyoka* and *Golden Arrow* at Fawcett. He turned down Harvey Kurtzman's first request to join EC because he was making more money at Hillman and Ziff-Davis, but he later reconsidered. When he joined the crew on Lafayette Street in 1953, his first assignment—to ink Al Williamson's art on "A New Beginning" (*Weird Science* #22)—so displeased Williamson that Amiable Al re-inked the piece, with an assist from Frank Frazetta.

Krigstein could be equally unyielding when he bumped into a story that didn't jibe with his moral compass or graphic perspective. In a 1962 interview with John Benson and Bhob Stewart, Krigstein recounted his final break with Bill Gaines, over a PictoFiction story:

"The ideological foundation of that book was that crime pays," Krigstein said. Appalled by a story ending that underlined that premise, Krigstein changed it.

"In the last panel, I did something that indicated that there was a moral reckoning insofar as the criminal was concerned. I don't mind cynicism," Krigstein said, "or realism, extreme realism, but I do mind, very deeply, propagating the notion that immorality or crime is moral, or good.

"So I changed the panel and brought it in, and Feldstein read it very happily until he came to the last panel: 'What's this, Bernie?'

"I said, 'Well, I changed the story; I don't like the way you ended the story.'

"And he said, 'Well, we can't do that.' And I said, 'Well, neither can I. I can't do it this way.'

"He said, 'Well, if you don't do it, this is it. You've got to do it this way; this is the new book.' I said, 'I can't do it, and I won't do it, and I'm afraid this is it.'

"And he called Bill Gaines and he told him, 'Bernie doesn't want to do this,' and you could hear Bill's excited voice over the phone, and Al said, 'Well, Bill, says you gotta do it,' and I said, 'Well, no.' And that was it. So I let them know that I didn't want to be credited for it, and he had [Reed] Crandall do the story, and I never went back there, and that was the end between me and EC."

"I used to daydream," Art Spiegelman later wrote, "about the possibility that Krigstein might be lured back into the field now that *maybe* the medium was beginning to catch up with his work of the 1950s." Never happened. Krigstein returned to teaching—he was a fixture at the High School of Art and Design in New York for 19 years—and painting. He died in January 1990 at the age of 70.

Krigstein refused to follow the standard EC layouts (here, for instance, breaking single panels into triptychs), which drove writer Al Feldstein nuts.
(© 1998 William M. Gaines, Agent, Inc.)

Kubert, Joe

He was born in Poland; his family crossed the Atlantic, bound for Ellis Island, when he was two months old. He wasn't more than 6 when friends of the family were buying him chalk so he could draw in the street, and he still remembers the physical rush of feeling the

chalk dissolve in his hands as it poured out his story.

Joe Kubert was 10, maybe 11, when he first stepped into a comic book studio. "A friend of mine happened to be related to [Louis] Silberkleit, who owned the MLJ outfit," Kubert said. "I did a page of drawings on oak tag, took the subway into New York (I lived in East Flatbush) and to their office on Canal Street in Manhattan. To this day, I can recall the smell of the place when I walked in.

"There were a half-dozen guys bent over their tables, the windows were wide open . . . Those guys were the kindest people I'd ever come across. Irv Novick gave me my first drawing lesson. He showed me how to draw a German helmet. But the smell of the place, the India ink. What really hit me were the beautiful drawings on the back of the artists' desks. They were pornographic, naked women. These guys were just kidding around, but to me, a kid of 10 or 11, it was incredible."

Kubert didn't know how to return home and tell his parents that he'd found the end of the rainbow.

"At the time, the idea of someone wasting time as a comic artist was ridiculous," Kubert said. "You learned a trade. You had to make a living. My parents were like that. My father was a butcher. I remember passing an artist studio; inside, there was a drawing table. It cost $11, which would be about $500 today. I remember passing the studio and saying, 'Gee, Dad,' and he said, 'I'll get that for you someday.'"

Kubert's father kept his word, though he could ill afford to. "I still have it, the same base, though I've been through several tops," Kubert said. "At the age of 12, I was making more money than my father was, but I never paid him back for that table."

His first summer job was at Tudor City, Will Eisner's studio, sweeping the floors and erasing excess pencil lines. "It was just kid's stuff, just terrible work," Kubert said, but he got high every day on the smell of the ink and the shape of the throwaway art. He brought his paychecks straight home and handed them to his mother. "I never cashed a check until I got married," Kubert said. "All the money went into the community pot. My mother was treasurer. If we needed something, we went to see the treasurer."

Once he got the drawing table, Kubert only needed time around comic artists. He was just entering high school when he and his lifelong buddy, Norm Maurer, took the 90-minute train ride to Stamford, Connecticut, and posed as co-editors of their school paper in order to interview Alex Raymond.

"I still recall the address: Mayapple Road in Stamford," Kubert once told Al Dellinges. From the train station, the two caught a bus, then walked a quarter-mile to Raymond's house, a "beautiful white mansion that must be the dream of every cartoonist that ever lived. If you're successful, as a cartoonist, this is the place you're going to live, this is where you'll

Joe Kubert was so popular at DC, he had a special issue devoted to him.
(© DC Comics, Inc.)

Kubert's war comics for DC are among his most highly praised and collected.
(© DC Comics, Inc.)

Joe Kubert

wind up. It was a long, low, one-story house, all white, with a portico in the front with pillars."

A butler ushered Kubert and Maurer into Raymond's studio. "The studio walls were studded with books and small framed pictures of things Raymond had done. One wall was all windows, facing out to acreage beyond: wood, trees. Just beautiful, just magnificent. That studio itself seemed like a half-acre in size, or so it seems to me in retrospect. It was the largest room in the world, and in my memory, it still is. To top it all off, in a corner of the studio, resting on a hooked rug, was a tremendous tan Great Dane."

For the next four hours, Kubert and Maurer grilled Raymond, too nervous to sit down or accept Raymond's offer of food or drink. It wasn't until they were on the train ride home that the two "editors" realized they'd never taken a note . . . and Raymond had never called their bluff.

Before he graduated from high school, Kubert was inking Lou Fine's work and churning out Crimebuster and Daredevil stories for Charlie Biro. ("There were times when at the last minute we put a book together during 24 hours of hyperventilating. We were like an assembly line. Irv did the letters, Norm made the figures, I inked the book. It was the greatest experience I ever had. And I was getting paid.") Before he cleared his teens, he was sharing a studio on Park Avenue with Alex Toth, Hy Rosen, and Carmine Infantino and was working alongside Mort Meskin.

And that only gets us through most of the 1940s. Dead ahead were 40 years of Sgt. Rock, Tor, Enemy Ace, Hawkman, Viking Prince, Tarzan, 3D comics, and the Joe Kubert School of Cartoon and Graphic Art. Not to mention the 1996 critically acclaimed graphic novel *Fax from Sarajevo*.

"If you look at the art of Michelangelo or Da Vinci, there's something magnificent about it," Kubert said one morning in his office at the school. "But to acquire the kind of ability I have, or a lot of guys in the business have, that comes with just drawing a lot. If you didn't improve your drawing, you'd be a lamebrain. If you have the interest, you can draw some really substantial stuff."

Kubert had the interest. And the drawing table.

Kubert School

The Joe Kubert School of Cartoon and Graphic Art opened in 1976 with a class of 22 that included Rick Veitch, Tom Yeates, and Steve Bissette. Other graduates of the school—which expanded to embrace a three-year curriculum in 1978—include Lee Weeks, Jan Duursema, Tom Mandrake, Dave Dorman, and Adam and Andy Kubert.

Joe Kubert, quite naturally, is the driving force and lead instructor at the school, which is located in Dover, New Jersey. Other instruction has been provided by Lee Elias, Ric Estrada, Dick Giordano, Irwin Hasen, and Hi Eisman. Classes are now held in the building that once housed Dover High School.

"The first year at the school was unlike anything you've ever seen," Bissette said. "Joe's studio was in the building. It was almost like an apprenticeship program. Joe was comfortable with us sitting up with him until two or three in the morning, watching him bang out six covers a night."

Kurtzman, Harvey

Kurtzman is the single most important cartoonist in my personal pantheon, the reason I, and many cartoonists of my generation, became cartoonists in the first place.
ART SPIEGELMAN

Harvey Kurtzman saved me from Long Island, the Fifties, and a career in plastics.
BILL GRIFFITH

I don't think it's any secret, I think he might admit it, Harvey always believed himself the greatest creative genius that was ever born.
DAN BARRY

Harvey Kurtzman's genius was to create something so revolutionary in the Fifties—*Mad* magazine—that no one noticed, or cared, that he created little else so significant in the final tumultuous 35 years of his life.

"I think Harvey's *Mad* was more important than pot and LSD in shaping the generation that protested the Vietnam war," Art Spiegelman wrote in *The New Yorker* following Kurtzman's death.

Kurtzman not only started the revolution, he published the revolutionaries. After he abandoned *Mad* to commercial success, Kurtzman returned in 1960 with *Help!*, a magazine that did less for the editor than it did for cartoonists such as Robert Crumb, Gilbert Shelton, Jay Lynch, and Skip Williamson, who were published for the first time within its pages.

Small wonder he is remembered as the spiritual, if irreverent, father of the underground comics.

Born in 1924 in the Bronx, Kurtzman was already dabbling in comic books before he was drafted in 1942. He never served in any of the war zones he would render with such force and emotion in EC's *Frontline Combat* and *Two-Fisted Tales*; in fact, the service didn't prevent Kurtzman from working for Ace, Quality, and Aviation Press.

After the war, Kurtzman joined Will Elder, a lifelong friend, and Charlie Stern to open the Charles William Harvey studio. He once complained that these were the days when only "hacks prospered," but all the hack work Stan Lee was publishing at Timely didn't prevent Lee from recognizing the curious thrills in *Hey Look!*, Kurtzman's one-page gag strip.

Those pages eventually got Kurtzman through the door at EC, where he was introduced to Bill Gaines and reunited with Al Feldstein and John Severin, other high school buddies.

There were no hacks at EC. Gaines was on the verge of turning the industry on its cauliflowered ear, simply by ignoring the competition and following his instincts. "I published what I enjoyed," Gaines said, "with the exception of Harvey Kurtzman's war books, where I let Harvey publish what he enjoyed."

"Enjoyment" is not a word that many associate with Kurtzman's approach to the war books. Kurtzman controlled every aspect of the publication because he sought perfection—"perfection in a ten-cent comic book," Gaines noted—and he didn't have much patience for shortcuts across his genius.

"I never felt quite right working for Harvey," George Evans once said, "because Harvey didn't want an artist or an illustrator. He wanted a hand, detached from any brain, to duplicate in a slightly different style every rin-bound, locked-in concept of each and every picture required to put his stories into print."

"He would supply the artists," Al Feldstein said, "with tissue overlays of exactly the layout that he wanted in each panel. To me, it was apparent that he frustrated, distracted, and limited the artists' own abilities which may have surpassed Harvey's. As I believe the artists' abilities surpassed mine."

Kurtzman had a hard time imagining his work could be improved upon. He had a passion for historical detail that was, Joseph Witek observed, "legendary among EC staffers, whom he sent on field trips to libraries, armories, and once on a dive in a submarine to research battles, weapons, and sound effects; an EC Christmas greeting featuring caricatures of the staff [by Marie Severin] shows a combat-helmeted Kurtzman demanding, 'Now I want you guys to get out there and make those stories real! REAL, YA HEAR!'"

"Harvey had a very annoying way of criticizing your work," said Wally Wood. "He would never pick on anything specific, he'd just say, 'Gee, it seems like you really didn't feel this one. Vague stuff like that. How do you respond to that? I responded by quitting. I didn't want to work for him anymore."

Others like Elder responded with some of their best work, much of which was on display in *Mad*.

Harvey Kurtzman

Kurtzman's earliest work included a one-page gag strip that appeared in Timely (Marvel) comics, such as *All Teen*.
(© Harvey Kurtzman)

While at EC, Kurtzman did a handful of crime stories in addition to the war books and, of course, *Mad*. His dramatic storytelling is obvious in this page from *Crime SuspenStories* #1 (October/November 1950).
(© 1998 William M. Gaines, Agent, Inc.)

Because Kurtzman toiled so arduously on the war books, he needed a fast buck—"a quick comic," as he put it—to keep bread on the table and beer in the fridge. As Kurtzman remembers it, the pace of production put him in the hospital with jaundice before he finally suggested to Gaines that they crank out a humor magazine. (Gaines disagrees, of course, but that's another story—see the *Mad* entry.)

There had never been anything quite like *Mad*, and there's been nothing to match it since. "The atrocious state of humor comics can be laid in a perverse way at Harvey Kurtzman's door," Alan Moore told *The Comics Journal*. "Harvey Kurtzman does a brilliant humor comic with *Mad*, and for 40 years thereafter the world is condemned to bad humor comics that are just trying to do what Harvey did with *Mad* over and over and over again."

After a falling-out with Gaines in 1956, Kurtzman fled to work on several variations on the theme. His first attempt—*Trump*, published with Hugh Hefner's bucks—survived two grand issues; his second, *Humbug*, lasted 11. Finally, there came *Help!*, which primarily sought laughs through recaptioned photos.

Help! did wonders for fledgling underground artists before folding in 1965, but Kurtzman's daily bread was provided by *Little Annie Fanny*, which had a 26-year run in *Playboy*. Much has been written about the love and labor that went into producing the strip, dressing up the naked truth. "*Annie Fanny* is tripe," Denny O'Neil once said. "It's superbly executed tripe, but you have this major visual comedian who's reduced to doing smarmy sex gags."

In his final three decades, Kurtzman taught classes at New York's School of Visual Arts, collected awards (some named after him), and received thank-you notes from cartoonists who had the opportunity to surf because Kurtzman made such waves. His final work was a reprise of *Two-Fisted Tales* that was packaged by Byron Preiss and published by Dark Horse. He died on February 21, 1993, after a long struggle with liver cancer and Parkinson's disease.

"Had he come along earlier (or even later) and gone into syndication with preeminent newspapers and well-received journals, he would have become wealthy, world-famous, and a prime celebrity in this field, equal to the best," Burne Hogarth said in his brutally frank remarks from *The Comic Journal*'s 1993 farewell to Kurtzman. "As it was, Harvey was victimized, his creations wrenched from him, deposed and deflected into superficial, tawdry work patterns; he became embittered and alien, much like Siegel and Shuster in this same period."

Lai Choi San

Milton Caniff's Dragon Lady was the most celebrated woman pirate in China. The name means "Mountain of Wealth." A Chinese half-caste, Lai Choi masqueraded as a dance-hall girl while running a drug-smuggling ring. Her first appearance was on December 16, 1934, in the *Terry and the Pirates* Sunday edition.

Laird, Peter

Co-creator of the Teenage Mutant Ninja Turtles.

Larsen, Howard

Howard Larsen worked for both Fiction House and Avon and drew at least five stories for EC. "Larsen's markedly individual style—lumpy looking people, thick black lines that resemble coils of tar, exaggerated perspective—is not likely to be everybody's cup of tea," notes the commentary in Russ Cochran's *Vault of Horror* set. "Everything that Larsen draws has a distinct, vaguely unwholesome erotic charge."

Lars of Mars

Bearing one of the great names in comics history, the "Fantastic Crusader from Mars" appeared in only two issues in 1951. "The title was a kind of an inside gag," creator Jerry Siegel later said. "I knew people would have difficulty forgetting a Martian with a Swedish name."

Lars was "a cross between Buck Rogers and Superman," said artist Murphy Anderson, who had put in an extended tour on the *Buck Rogers* strip. As far as Ziff-Davis was concerned, Lars didn't have the staying power of either; he vanished into the cosmos after issues #10—the premiere issue—and #11.

Larson, Lamont

Joe Tricarichi found the collection. Jon Berk found the collector.

When Tricarichi, a Cleveland dealer, unearthed Larson's distinctively marked collection of 1,000 Golden Age books in the early '70s, he jealously guarded the identity of the original owner.

It took Berk, the president of the American Association of Comic Collectors in 1994, to track Larson down, not far from where Larson grew up in Nebraska.

Born in 1927, Larson began reading comic books in 1936, picking up his favorite issues at the Cruetz Drug Store. Because the kid periodically missed a comic, store owner Fred Cruetz said, "I'll tell you what. We'll put them away and put your name on them... and when you want to come in and get them, they'll be here."

To reserve the comics, two store employees—Tyg Hagen and Cecil Coop—would scrawl his name on the covers. Larson told Berk that Hagen wrote either "Lamont" or "Larson" in a "flowing cursive," while Coop, who came on staff after Hagen died in 1940, wrote "Larson" in a somewhat tighter script.

The initials on some of the comics—"PN" for Publishers News and "ON" for Omaha News—marked the distributor to which unsold books would be returned.

Larson stopped reading the funny books in 1941, but he carefully stored his comics in a box. That box ended up in a Nebraska barn for most of the next 30 years. The comics were eventually purchased by antique dealer Dwaine Nelson, who in turn sold the collection for less than $100.

The condition of the Larson books varies, often falling far short of the Mile Highs, but the two characteristics of the collection—its original owner and the length of time it remained intact—warrant its pedigree.

Lee, Jim

The Korean-born artist—and one of the three creative cornerstones of Image—always figured he'd be a doctor. When he was traveling to medical conventions with his parents as a kid, Lee said, "The first thing I'd do when we hit a hotel is look in the Yellow Pages under 'books' or 'comic,' find a store, and bad-

Lars of Mars #10 was really the first issue (April/May 1951) of a two-issue run, with Norm Saunders providing the covers.
(© Ziff-Davis)

> "Todd McFarlane has long argued that Jim Lee's desertion from Marvel was *the* crucial factor in the creation of Image in 1991."

ger my parents into driving me. They'd buy me one and I'd read it over and over again. I remember riding in the back of the station wagon and drawing."

After graduating with a degree in psychology from Princeton, Lee spent several months in Europe and forgot about becoming a doctor. Cleaning out the station wagon, he lugged his portfolio to a weekend Creation Con in New York, where he showed the work to Archie Goodwin.

Lee started at Marvel the following Monday.

His first book was *Alpha Flight* #51; after 11 issues on that title, Lee was handed *Punisher War Journal* by editor Carl Potts. A year later, in 1989, Lee took his first stab at the mutants with *X-Men* #248.

Todd McFarlane has long argued that Lee's desertion from Marvel was *the* crucial factor in the creation of Image in 1991. "Rob Liefeld, Todd McFarlane, and Jim Lee were the three big names behind the Image thing," McFarlane said. "Marvel Comics felt they could lose me and Rob, because we were uncontrollable. Here's an idiot and an asshole. But Jim was the company man. They felt they would have won the war if they lost us and kept Jim. Jim ended up being the cornerstone piece. When we got a company man to leave, that sent shock waves through the business."

How tough was it for Lee to lose the chains?

"It was about two months of Rob and I hitting on him from both sides," McFarlane said. "We had to set up Image in such a way that we could meet everyone's needs. For me, it was 'Union Buster! Let's take these guys down.' For Jim, it was more on a level of security.

"When we actually went up to Marvel, and we were going to tell them we were giving them our quitting papers, I think Jim and a couple of the other guys still thought they could work at both companies. Just so they didn't burn any bridges. Rob and I? Not only did we burn 'em, we friggin' torched 'em and poured on the gas. You know why? We figured we'd build another bridge. We're just crazy enough to think we can build another bridge.

"Jim didn't want to burn no bridges," McFarlane said. "But when we went up to New York to tell the company we were quitting, they said a couple of the wrong things. It was, 'We couldn't fly your wife in to New York for this meeting.' And the president saying, 'Well, I don't get to bring my wife, and if I want to stay at the Sheraton instead of the Holiday Inn, that comes out of my own pocket.' That's the wrong thing to say to a guy like Jim. Jim does his homework. He knows he's probably brought in 22 million dollars in the last three months. And they can't spring for five bucks? They couldn't even spring for a $200 plane ticket? When they started saying that kind of stuff, that's when they pushed the wrong buttons."

Lee, Stan

The blackout? November of '65. Denny O'Neil and I were caught on a subway; we were stuck there for a couple hours. When we came out, we walked home. There was nothing to be done, we decided.

The next day, Stan came in with a bunch of pages. He started apologizing because he had only written ten pages because of the blackout. He'd set five or ten candles around the table while the rest of us were playing, and written one of those back-page Asgard features with this beautiful dialogue.

He didn't let anything get in his way. The first vacation he had in years, he went to Florida and wrote on the train. He was totally dedicated to getting the stuff out.
ROY THOMAS

If Stan Lee had been content to let others tell his story, he would have never lacked for credit. If his demands for glory hadn't been so outrageous and so insistent, his peers would have supplied it much less sparingly.

But Lee was totally dedicated to getting his side of the story out. He was so used to supplying the plot, he couldn't break the habit. He couldn't lose control of the dialogue.

In a conversation in the fall of 1991, Lee complained about one of the omissions in Les Daniels's newly released in-house history of Marvel Comics. "He mentions all the covers over the years, who drew this cover and who drew that one," Lee said. "I never had a chance

Jim Lee

to tell him that 99 percent of those covers were my ideas. I was the one who said, 'This is what the cover should be.'"

Twenty minutes later, Lee steered the conversation back to the covers. "In those [early] days, you would buy a book according to what cover appealed to you the most. You had to make your covers stand out. On every cover, I made up the title, I wrote the cover blurbs, and I designed the covers.'

Every cover? Or only 99 percent?

"The monster covers and everything. All the time I was there. For 50 years. Every cover that went through that place went through me. Covers were strictly my area."

Imagine that, if you will.

Imagine Jack Kirby waiting for the interoffice memo that would get him started on the cover to *Fantastic Four* #48. Imagine Jim Steranko hyperventilating, unable to put the hammer down on *Captain America* #110. Imagine Gil Kane … no, your imagination has already had a sufficient workout.

"That happens to be absolutely untrue," Kane said. "I did 900 covers and the only thing that he would say is, 'We need a cover for this.' You would have to submit ideas; after a while, he didn't even get involved in the covers."

Lee was, by all accounts and his own admission, a tireless reader of the competition, a shameless copyist, a relentless recycler of old ideas, and an odd duck who found adventure in leaping atop a four-drawer file cabinet and playing tunes on his recorder. But his ear for prose was almost as keen as his ear for praise. And his one spark of inventiveness helped start a bonfire at Marvel that raged for 30 years.

Stanley Lieber began working at Timely in 1939 as an office boy. He was 17. "Stan Lee was a bother," Jack Kirby once said. "Stan Lee was a pest. He liked to irk people and it was the one thing I couldn't take."

When Kirby and Joe Simon departed Timely in 1942, Lee took over as editor and art director. Why not? His uncle was the son-in-law of Martin Goodman, Timely's publisher.

Unlike Julie Schwartz, Mort Weisinger, Will Eisner, and others who inspired the industry, Lee had never worked outside it. He was always Goodman's relative; he always had a job. He wasn't required to come up with new ideas; he let others—Charlie Biro, Jack Kirby, or Bill Gaines—establish a trend, then steered Timely/Atlas into the chop of their wake. If crime was selling, he wrote and published crime. Ditto romance. "Stan has one speed," Jim Shooter said: High. He could crank the stuff out.

"Everything was fun. That's the only reason I stayed in this business," Lee said. "I enjoyed what I was doing, even those dumb monster books. I enjoyed making up names like Fin Fang Foom. I would have been happier if they were selling better, but I enjoyed doing them."

When the books weren't selling, Lee went on to something else and his staff went on unemployment. "There were two purges that I remember, when Martin Goodman had me fire the whole goddam staff," Lee said. "Those were the two worst moments of my life. Martin took off, he went down to Florida, and I was left to fire the staff. With great difficulty."

In 1961 Marvel was a demilitarized zone, publishing only eight books a month, which were distributed by DC (see **Atlas Implosion** entry).

Fortunately for Marvel, someone at DC had an idea; unfortunately for DC, someone shared it with Goodman over a game of golf. A team of super-heroes? Lee could handle that. Resurrect the Golden Age studs? Lee could work them in too.

And he had an original thought: Insecure, self-absorbed cartoon characters.

Stan Lee, as rendered by Marie Severin for a rock magazine.

(Characters TM & © 1998 Marvel Characters, Inc. All rights reserved.)

Gee. Where could that have come from?

"The inventions were essentially Jack's," Kane said, "but what Stan did was bring a mock irreverence that was entirely suited to the comic book market of the early '60s. This mock irreverence was picked up by college kids and high school kids, and Marvel simply became THE company." (See **Stan and Jack** entry.)

Some of Lee's peers remained unimpressed. Informed in the late '60s that Lee was behind the "so-called revitalization of comics," Bernie Krigstein told *Squa Tront*, "I'm delighted to learn that. Twenty years of unrelenting editorial effort to encourage miserable taste and to flood the field with degraded imitations and nonstories have certainly qualified him for that respected position."

In an industry that was still chewing on a 25-year-old cud, a new approach, a slight change of pace, was all that was necessary. Lee spent the '60s cranking out the plots, writing by candlelight when everyone else lost power. Because the editors at DC were slow to respond, unable to believe that Stan Lee could be ahead of the curve, Marvel rolled over its chief competitor, and never looked back.

In 1972 Lee finally supplanted Goodman as publisher, yielding editorial duties and responsibilities to Roy Thomas. While Thomas struggled for autonomy, Lee focused on Hollywood. By 1976 he was having such a tough time packaging the Marvel cast for Tinsel Town, he held a writer's meeting and said, "From now on, I do not want progress."

"This is a direct quote," Steve Englehart said. "And that was the new Marvel policy, that we would no longer really advance the storylines. He said, 'I don't want any more girlfriends dying. They can leave, but they've got to come back in three or four months because I don't want the cast changing.'"

"There was a very valid reason for that," Lee said. "People in Hollywood were interested. They would say to me, for example, 'Who is Iron Man, we're interested in Iron Man.' And I would say, 'He's a successful businessman, sort of our version of Howard Hughes.' And they would say, 'Hey, we just read the book and he's a drunken alcoholic and his company was taken away.' They were saying, 'How can we do a movie about characters when they're not the same as in the comic book? We'll do a movie based on a comic, and by the time the movie comes out, you may have killed one of these characters.'

"So, I said to the staff, 'Leave everything alone.' Now, as you know, there have been 50 million drastic changes. I didn't enforce that as vigorously. Once I said it, I decided if they still feel they have to make those changes to keep the books healthy, I would find a way to deal with the Hollywood community."

The string of videos—that bootlegged *Fantastic Four* movie, the *Captain America* movie, the *Punisher* movie—on your shelf attest to that.

After all these years, how do we sum up Stan Lee? At the very least, as the most visible personality the comics has ever had. And a writer who yearned for the neon lights, but settled for candlelight when nothing else was available.

Legal Briefs

All of the action, you understand, didn't happen between the comic book covers. Some of the industry's best crossovers, swipes, cons, and spine rolls have been highlighted in court. The litigious litany would fill volumes; the following are brief summaries of eight of the more memorable cases.

1. National Periodicals vs. Fawcett

The Man of Steel vs. The Big Red Cheese.

Although DC filed suit against Fawcett in 1941, claiming that Captain Marvel was a blatant imitation of their copyrighted Kryptonian, the case didn't go to trial until March 1948.

Superman was represented by Louis Nizer, who argued that his client, and not Fred MacMurray, was the model for Captain Marvel. Fawcett's attorneys countered that National's copyright was abandoned when the McClure Syndicate published the *Superman* newspaper strips and failed to properly display the copyright notice.

The judge found "evidence that there was actual copying" but ruled for Fawcett, agreeing that the copyright was lost when McClure published *Superman* strips without it.

As to National's claim of "unfair competition," the judge ruled, "The evidence does not justify any finding of unfair competition by either Fawcett or Republic; there is no proof either of palming off or of confusion; nor is there any misrepresentation of what equit-

> *"I don't want any more girlfriends dying. They can leave, but they've got to come back in three or four months because I don't want the cast changing."*
> STAN LEE

Legal Briefs

The original 1941 lawsuit by National Periodicals claimed that Captain Marvel was a direct steal from Superman. What do you think?
(© DC Comics, Inc.)

ably belongs to a competitor."

DC was granted an appeal in 1951. Two years later, Fawcett settled out of court, allegedly—we're quoting Steranko's *History of Comics*—"paying damages amounting to $400,000 and agreeing to discontinue any use of the character."

Otto Binder, who scripted most of Captain Marvel's adventures, and DC editor Jack Schiff disagreed on the causes of the settlement. Binder insisted Fawcett withdrew "because dropping sales and profits by 1953 convinced the Fawcett moneymakers that the comics had had their heyday and why not quit while ahead?"

Nonsense, Schiff quipped: "Two different judges, Judge Libell and Judge Learned Hand, had adjudicated the case as plagiarism. I had the task of assembling a scrapbook that documented all cases of plagiarism. An injunction was ordered, forcing Fawcett to close down the *Captain Marvel* line. Damages were awarded. The suit was settled for peanuts instead of the actual millions of dollars involved. Most damaging in the 1953 trial was the testimony of two former Fawcett employees who had been ordered to copy *Superman*."

DC now owns the rights to the Captain Marvel character—as the readers of the revived series, *Shazam,* can attest—but not to the character's name.

2. National Periodicals vs. Victor Fox

In 1939 Victor Fox hired the Eisner-Iger studio to produce Wonder Man, a Superman clone. Eisner was so precise in following Fox's instructions (compare the covers of *Action* #10 and *Wonder Comics* #1) that National quickly brought a lawsuit against Fox.

Eisner spoke at length about the obvious plagiarism in *Panels* #1. "He [Fox] specified what he wanted. He wanted me to create a character that had a red suit with a design on his chest, and so forth and so on," Eisner said.

"Well, I was very naive at the time. I knew a little about copyright law. [Jerry] Iger was the older and more experienced man. We discussed it, and Iger said, 'Well, there's really not much we can do about it. It's his magazine and he's asking for this and we'll do it for him.'

National's first Superman-related suit was in 1939, when Victor Fox's Wonder Man bore a striking resemblance to the Man of Steel. *Wonder Comics* **became** *Wonderworld Comics* **with issue #3.**
(© Fox Features Syndicate)

"I worried about it, but Iger made a very convincing argument, which was ... that we were very hungry. We needed the money badly. At any rate, when the first sequence was finished, Fox decided he wanted to put the title on, and he called it, strangely enough, 'Wonder Man.'

"Well, within about two or three months there was a lawsuit. And I was a material witness. It was quite an interesting experience for me, because late one night Fox had me up to his office, and sat down with me and said, 'Now look. You're going to be asked to testify. And I want you to tell them there was no intent to copy.' And I said 'As far as I'm personally concerned I had no intent to copy; I was following your instruction.'

"'Well,' he said 'if you get on the stand and talk like that . . . I owe you three or four thousand dollars, and you're not going to collect your money.' So I was faced with a very serious decision.

"I suppose when you're young it is easier to adhere to principles. I don't know. At any rate, when I did get on the stand and testified under oath, I told the truth, exactly what happened. Of course it resulted in Fox losing the suit. And it resulted in Fox telling me I wasn't going to collect my money. And indeed I didn't. And he owed us at that time—I'll never forget it—three thousand dollars, which was more money than I had ever seen in all my life. And I just thought we were going to go broke."

Fox, by the way, learned from the experience: He subsequently tried to sue National, claiming Batman was a plagiarism of the Green Mask. That would have been a neat trick for DC, in that Batman first appeared in May 1939, three months before the Green Mask popped into view in *Mystery Men Comics* #1.

3. Walt Disney Productions vs. Air Pirates Funnies

In a class all its own. See **Air Pirates.**

4. Steve Gerber vs. Cadence Industries and Marvel Productions

Like the character at the heart of it all—Howard the Duck—this lawsuit had a big buildup followed by a big letdown.

Gerber sued Cadence and Marvel in 1980, claiming copyright infringement on the character, which had debuted in *Fear* #19 (December 1973).

"What we're saying," said Henry Holmes, Jr., Gerber's attorney, "is that Steve Gerber owns Howard the Duck, and they [Marvel] don't have any rights other than the limited license he gave them initially to publish the magazine stories."

In 1982 Eclipse published the first issue of *Destroyer Duck*, donating the profits to Gerber for legal fees. All for naught. In 1984 Gerber settled out of court, claiming the lawsuit had already cost him $130,000 and that he didn't have another $25,000 to go to trial. Terms of the settlement were not disclosed, but in a subsequent letter to *The Comics Journal* Gerber admitted that "Marvel retained ownership and creative control over the character."

A year later, Gerber agreed to write a Howard script for Marvel, arguing that "all this nonsense was behind us." The editorial reaction to his script was so severe, however, that Gerber withdrew from the project.

5. Fred Rhoads vs. Harvey Publications

Fred Rhoads drew some 9,500 pages for the Harvey brothers, and he insists that they always swore they'd pay him when they repackaged them in reprints. In 1977 Rhoads stopped taking them at their word and took them to court.

The Harveys argued that Rhoads, who began working for them in 1955, was your typical work-for-hire slug who had no right to the artwork he'd produced. Rhoads insisted he was an employee of the company and had the benefits, hospitalization, and accrued vacation time to prove it.

The legal fun and games lasted six years before the Arizona Court of Appeals awarded Rhoads almost $2.6 million in damages in 1983. The Harveys appealed to the Arizona Supreme Court, which overturned the award when it could reach no decision on the case.

"How can they make no decision?" Rhoads asked his lawyer. "And my lawyer said, 'They can have you shot at dawn if they want to, Fred.'"

Rhoads was chewing on that revelation when the Harveys rubbed a little salt in his wounds, selling all 9,500 of his pages to a single collector.

"Naturally, I feel like I've been screwed," Rhoads said. "Is that putting it bluntly?"

Fred Rhoads: Did he get the shaft?

6. Michael Fleisher vs. Harlan Ellison and *The Comics Journal*

On October 7, 1980, Michael Fleisher sued Harlan Ellison, Gary Groth, and *The Comics Journal* for comments Ellison made in a 1979 interview with Groth that was published in February 1980.

Fleisher claimed he was libeled when the interview turned to Fleisher's comic book work and his new novel, *Chasing Hairy: A Novel of Sexual Terror.*

Ellison said of Fleisher:

There is a genuine, twisted mentality at work here, and it's fascinating to look at …

Fleisher—I think he's certifiable. That is a libelous thing to say, and I say it with some humor …

What's interesting is that the thing that makes Fleisher's stuff interesting was the same reason Robert E. Howard was interesting and nobody else can imitate him. Because Howard was crazy as a bed bug. He was insane.

Or take the lesser writers … They can't imitate Howard because they aren't crazy. They're just writers writing stories because they admired Howard, but they don't understand you have to be bugfuck to write that way. Lovecraft—you can tell a Lovecraft story from a Ramsey Campbell story, from all the rest of these shlobos trying to imitate him, all the nameless yutzes shrieking like Lovecraft, they still have not got the lunatic mentality of Lovecraft. And the same for Fleisher. He really is a derange-o. And as a consequence, he is probably the only one writing who is interesting. The Spectre stuff was fuckin' blood-chilling, which it was supposed to be. I mean, he really did the Spectre, man. For the first time since the '40s, that goddamn strip was dynamite. And the first time they looked at what they were publishing, they said, "My God, we have turned loose this lunatic on the world," and they ran him off.

According to *The Comics Journal* (which devoted 84 pages of its April 1987 issue to this "Fight for 1st Amendment Rights") Fleisher first demanded that *TCJ* print a retraction and an apology, ostensibly by the editor, but drafted by Fleisher. When Groth refused, Fleisher sued, demanding a total of $2 million in damages. The case did not go to trial until November 10, 1986. Fleisher's star witness—nay, his only witness—was Jim Shooter, Marvel's editor-in-chief, who argued that, as a result of the Ellison interview, Fleisher's reputation had indeed been damaged.

Ellison testified, "The only part of what I said about Mr. Fleisher that is quite clear is that I was praising him inordinately, praising him for excellence."

The jury agreed, deliberating for less than 90 minutes before agreeing that Fleisher had not proved his case.

7. Joseph Pulitzer vs. R. F. Outcault and William Randolph Hearst

After three years of drawing cartoons for Joseph Pulitzer's *Sunday World*, R. F. Outcault created *Hogan's Alley* with the Yellow Kid in May 1895.

Pulitzer did not long benefit from the cartoon's success; William Randolph Hearst, on a rampage to renovate the *New York Journal*, lured Outcault away with piles of cash. Hearst's coup began an intense bidding war between the two papers.

Pulitzer sued Hearst to regain his star cartoonist. "The result of the notorious court case," Rick Marschall wrote, "was that Outcault could draw his *character* for whomever he wished, while publisher Pulitzer could continue the *feature* with whatever artist he chose to employ. So New York had two Yellow Kids—one in *Hogan's Alley* in the *World* and one in *The Yellow Kid* in the *Journal*."

Outcault got tied up in similar legal wrangling in 1906 when he and *Buster Brown* jumped from the *World* to another Hearst paper. Once again, the court ruled that Outcault could continue to draw his feature but could not use the title.

> "There is a genuine, twisted mentality at work here, and it's fascinating to look at …"
> — HARLAN ELLISON

R. F. Outcault's *Buster Brown* was one bone of contention between Joseph Pulitzer and William Randolph Hearst.

8. Amy Grant vs. Marvel

In 1986, Amy Grant sued the industry's comic leader, claiming that Jackson Guice swiped the cover of her 1986 album—*Amy Grant: The Collection*—for his cover artwork on *Doctor Strange* #15.

The resemblance was indeed remarkable.

Grant, curiously enough, did not sue for copyright infringement. This was several years before she crossed over from Christian music to the pop charts. Instead, her lawyers complained that the use of her likeness in "publications dealing with the occult is likely to cause irreparable injury to Grant's reputation and good will."

The singer's fans, the suit suggested, "consider interest in witchcraft and the occult to be antithetical to their Christian beliefs."

The case was eventually settled out of court.

Legion of Super-Heroes

Cosmic Boy? Matter-Eater Lad? Chlorophyll Kid? Triplicate Girl? First appearing in *Adventure Comics* #247 (April 1958), the Legion was (a) a child of The Comics Code, (b) a dead giveaway of DC editor Mort Weisinger's grasp of his audience, and (c) the stuff of exquisite satire for years to come. A 14-year-old like Jim Shooter had no problem writing Legion scripts in the mid-1960s and watching them rushed onto the DC assembly line.

The Legion shifted to *Superboy* in 1973, eventually taking over the comic with issue #259 in 1980. Paul Levitz was the Legion's prime scribe through most of the 1980s, the delightful decade in which Infectious Lass joined the Legion of Substitute Heroes. More recently, the Legion survived the elimination of Superboy from DC's continuity in a "Pocket Universe" and has regained a sizable fan following.

> "Here [Jack Lehti] is lying out in the middle of nowhere, he might as well be on another planet with shells falling around and dead people and mud and dirt ... and there's a copy of a DC comic book."
> — CHARLES PARIS

Curt Swan's version of Lex Luthor.
(© DC Comics, Inc.)

Legion of Super-Pets

Got a brick wall, several blindfolds, and some spare ammunition? Line up Beppo, the Super-Monkey; Comet, the Super-Horse; Krypto, the Super-Dog; and Streaky, the Super-Cat.

First appearance: *Adventure* #293. Ready, aim…

Lehti, John

Jack Lehti, as he was known in the early days, jumped from the pulps to National Comics such as "Steve Conrad," "O'Malley of the Red Coat Patrol," and "Crimson Avenger." Lehti was in the Army reserves when the bombs fell on Pearl Harbor; he quickly told DC's Whit Ellsworth to hire his inker, Charles Paris, then headed to Europe.

"Jack Lehti was a dogface," Paris said. "He told me one time that he jumped into a foxhole in France and there was a copy of *Detective Comics*, with the Crimson Avenger. It gave him a funny damn feeling. Here he is lying out in the middle of nowhere, he might as well be on another planet with shells falling around and dead people and mud and dirt ... and there's a copy of a DC comic book. A whole other life flashed through his head."

Lehti survived four years on the front to return to that other life. He came back with a new idea: a comic strip featuring stories from the Bible. You couldn't beat the cheap source material, he told Paris. Lehti finally got rolling on *Tales from the Great Book* in 1954 and kept the strip going for 18 years.

"Jack once said, 'There's a price on everything and it has to be paid sooner or later,'" Paris said. "If you live long enough, you find out what the price is. If you live fast, die young, and have a good-looking corpse, you might not."

LeVay, Anton

The founder of the Church of Satan sold his collection of *Mickey Mouse Magazine*s to Malcolm Willits in the mid-1960s. Willits reportedly asked LeVay if his soul was available and was told that it was already spoken for.

Lex Luthor

Superman's biggest foe was an arms dealer when he was introduced in *Action Comics* #23. Not until *Adventure* #271 (April 1960) did

we learn that Luthor had turned bad when he lost his hair searching for an antidote to kryptonite radiation. The fact that baldness led to so much badness had a profound impact on the Sixties generation, forever making its children frightfully nervous about short hair.

Library of Congress

The destruction of this collection, which should be unequaled, is impossible to detail.

When Irene Schubert took charge of the collection in 1987 as head of periodicals, she found "a bootleg collection" of 60,000 comics. "Our acquisition policy statement stated the library would not retain comic books for its permanent collection, except sample copies as needed. So, we had 60,000 sample copies."

And not a one with a subscription crease.

As of February 1991, Schubert said the Library's collection had never been inventoried: "We have a fragmentary record of what we've got. The big, rare, important items are gone. The older the title, the more valuable it is, the more that are missing; there's been more time for them to circulate unofficially, never to return."

Not until 1990, Schubert said, was there more than minimal security in the Library's reading room. "Anyone could come in and say, 'I'm Mickey Mouse, I want to see my comic book.'" Access to the collection is now limited to scholars, or the likes of Ernie Gerber.

After spending months inside the library researching his *Photo-Journal*, Gerber figures, "I probably know their collection better than they do. I have inspected every comic book they have. What's interesting about the Library of Congress collection is that up until the late '50s, they were totally disorganized. They had all their comics in a big stack in a pile, just laying there. When they finally did organize, they found out the large majority of the most valuable comics were gone. From 1933 to 1960, they are only 25 percent complete. The expensive books that collectors collect were pilfered. The things they had were the ones that no one collected, and no one took home.

"Into the 1960s, comic books were the dregs of society. There wasn't a single library in the world that kept these books. Even the Library of Congress, which was required to keep two mint copies, only kept 25 percent."

Gerber estimates the Library of Congress now has almost every comic published since 1958, averaging Fine condition. Prior to 1958, the average condition is poor. "Ninety percent of the collection," Gerber said, "is brown and brittle."

Li'l Abner

Al Capp's hillbilly strip debuted in August 1934 and ran for 43 years. Colored by Capp's politics and drawn by the likes of Frank Frazetta, Bob Lubbers, and Andy Amato, the comic strip invariably evolved, and for the worse. That evolution was highlighted by Capp's decision to let Li'l Abner and Daisy Mae marry, an event that captured the cover of the March 31, 1952 issue of *Life* magazine.

"I never intended to do this," Capp wrote inside the magazine. "The fact that Abner always managed somehow to escape Daisy Mae's warm, eager arms provided me with a story that I could tell whenever I couldn't think of anything better. Frankly I intended to go through life happily and heartlessly betraying you decent, hopeful people who want to see

The big event that many feel changed the *Li'l Abner* strip forever, if not for better: He and Daisy Mae got hitched.
(© Capp Enterprises, Inc.)

things come out right. I never intended to have Li'l Abner marry Daisy Mae because your pathetic hope that I would was one of the main reasons you 50 million romance lovers read my strip."

So, why did Capp betray his best intentions?

To understand that, he said, "bear with me while I explain how and why I created [the characters] in the first place.

"When I was in my early 20s and about to start a comic strip, I found myself in a terrible dilemma. The funny comic strip, the kind I wanted to do, was vanishing from the funny page. A frightening new thing had been discovered: namely that you could sell more papers by worrying people than by amusing them. Comic strips which had no value except that they were comic were beginning to vanish from the funny papers . . .

"In their place came a sobbing, screaming, shooting parade of new 'comic' strip characters: an orphan who talked like the Republican platform of 1920; a prizefighter who advised children that brains were better than brawn while beating the brains out of his physically inferior opponents; detectives who explored and explained every sordid and sickening byway of crime and then made it all okay by concluding that these attractively blueprinted crimes didn't really pay; and girl reporters who were daily threatened with rape and mutilation."

Those "suspense" strips "disdain fun and fantasy," Capp said, but suspense is what the editors wanted. So, Capp said, "I tried to create smart and superior heroes, and submerged them in blood-curdling tragedies, increasing in complexity, hopelessness and horror and thereby creating reader anxiety, nausea and terror—i.e., *suspense*." But he couldn't pull it off. He didn't believe in his own one-dimensional characters.

"As I drew them, I discovered good things in the bad guys, and vice versa. So my hero turned out to be big and strong like the suspense-strip heroes, but he also turned out to be stupid, as big, strong heroes sometimes are . . . His girl, although wildly beautiful, is vaguely sloppy and, although infinitely virtuous, pursues him like the most unprincipled seductress.

"The good people in my hero's town, possibly like those in your town, often are a pain in the neck. And the bad 'uns, like some bad 'uns in real life, are often more attractive than the good 'uns. The Scragg Boys, Lem and Luke, are fiendish when they are snatching milk from whimpering babies or burning down orphan asylums to get some light to read comic books by (only to realize that they can't read, anyway); but even the most horrified reader can't help being touched by their respectfully asking their pappy's permission to commit all this manslaughter and mayhem. Monsters they certainly are, but they are dutiful children, too."

Adding such dimensions to his characters had made *Li'l Abner* quite successful, hoisting it onto the comics pages of 900 newspapers. "It was wonderful while it lasted; and I had no reason for marrying Abner off to Daisy Mae. But then something happened that threatens to shackle me and my kind of comic strip. It is what I call the gradual loss of our fifth freedom. Without it, the other four freedoms aren't much fun, because the fifth is the freedom to laugh at each other.

"My kind of comic strip finds its fun wherever there is lunacy, and American life is rich in lunacy everywhere you look . . . For the first 14 years, I reveled in the freedom to laugh at America. But now America has changed. The humorist feels the change more, perhaps, than anyone. Now there are things about America we can't kid."

This attitude problem dawned on Capp when he created the Shmoo and grabbed him by the throat when he created the Kigmy, "an animal that loved to be kicked around, thus making it unnecessary for people to kick each other around." The character sparked letters. Angry letters. Suspicious letters. "They asked the craziest questions, like: Was I, in creating the Kigmy, trying to create pacifism and, thus, secretly, nonresistance to Communism? Were the Kigmy kickers secretly the big bosses kicking the workers around? Were the Kigmy kickers secretly the labor unions kicking capital around? And finally, what in hell was the idea of creating the Kigmy anyhow, because it implied some criticism of some kinds of Americans and any criticism of anything American was (now) un-American? I was astounded to find it had

Introduction of the Shmoo in *Li'l Abner* led to a national craze for the cute little critters that multiplied faster than rabbits and had no reason to exist other than to sacrifice themselves to humans.

(© Capp Enterprises, Inc.)

become unpopular to laugh at any fellow Americans...

"So that was when I decided to go back to fairy tales until the atmosphere is gone," Capp said. "That is the real reason why Li'l Abner married Daisy Mae. At least for the time being, I can't create any more Shmoos, any more Kigmies... After a decade and a half of using my characters as merely reasons to swing my searchlight on America, I began all over again to examine them as people... I became reacquainted with Li'l Abner as a human being, with Daisy Mae as an agonizingly frustrated girl. I began to wonder myself what it would be like if they were ever married. The more I thought about it, the more complicated and disastrous and, therefore, irresistible, the idea became.

"For instance, Li'l Abner had never willingly kissed any female except his mother and a pig. Well—if he got married, he'd *have* to. Even he couldn't avoid it for more than a month or so. What would happen? Would he approve of kissing? Would he say anything good about it?"

All the questions boiled down to this, Capp said: "They are married, all right. But if you think the future is serene for them, you're ('Haw! Haw!') living in a fool's paradise."

Just like Li'l Abner and Daisy Mae.

Little Annie Fanny

> *Its message: that despite the fiction of Vladimir Nabokov and the nonfiction by David Halberstam and the illustrations by Brad Holland, in his heart of hearts the Man Who Reads* Playboy *will go out of his mind just to see a little tit.*
> R. FIORE

"Craft- and skill-wise, there is nothing that has ever touched *Annie Fanny*," said Bill Stout, who worked briefly on the strip in the late 1960s. To understand why—and why you didn't see *Annie* that frequently—you need only listen to how Harvey Kurtzman's *Playboy* cartoon was put together.

It all began, Stout said, with Kurtzman submitting several ideas to *Playboy* publisher Hugh Hefner. Kurtzman would sketch out a pencil and marker version of the ideas that Hefner okayed, then ship it back to his publisher for his "input."

"Hugh Hefner always wanted to be a cartoonist," Stout said. "He was a cartoonist for his college paper." You can imagine how well Kurtzman took Hefner's kibitzing.

Kurtzman would then start drawing the strip full size on a pad of vellum tissue. "He would start off with the yellow marker and rough it out," Stout said. "Anything he wanted to change would be with the orange marker. Anything he wanted to change on top of that would be with the red marker." The darker the marker, the closer Kurtzman was to slapping another tissue on top of the drawing and pulling out an extremely meticulous pencil.

Stout's job was to transfer those pencils to illustration boards. Because every piece of store-bought carbon paper left an unacceptable residue, Stout made his own carbons, scribbling on a piece of paper until it was completely black. "Using that, I would transfer every line and dot of Harvey's pencils onto illustration board. Then, very lightly with a 3H pencil, I would draw the whole thing.

"While I was redrawing it, Harvey would have taken his original 8½" × 11" pencil drawing of the story, Xerox that, and begin to watercolor over the Xerox. He would give that to me, which would provide me with the color scheme for the story." After Stout drew the word balloon circles, he would begin laying in the color washes, slowly building up color over the pencils. "When the page was half-finished, I would give it to Willie Elder, who would begin the final painting. Willie had this amazing ability to handle watercolor with a paint brush and make it look like an airbrush. After Willie would finish, this page would look like some iridescent jewel. I would take the page over to Harvey, who would lay a tissue over it and indicate about 300 things he wanted to fix, most of which were highlights and shadows."

Elder would make the corrections and Stout would deliver the page back to Kurtzman, who

Harvey Kurtzman and Will Elder produced *Little Annie Fanny* **for** *Playboy* **from 1962 to 1987.**

(© Harvey Kurtzman)

would lay another tissue over the page and make another 50 corrections. Stout would take the page back to Elder—yes, he got to know that 30-minute drive between Mt. Vernon and Englewood rather well—who would make the new revisions. Once more Kurtzman would take the cartoon and make another 50 to 75 corrections. "That would usually be it," Stout said.

All except for the lettering. Sometimes Ben Oda would handle the job, sometimes a guy whose name Stout doesn't remember but who "lived my fantasy of a New York life. He had 10 or 12 bolts on his door. I'd knock and the peephole would pop open. He would eye me very suspiciously and I would hold up the pages. There'd be all this unlocking of the bolts, then a hand would extend out the crack. He was constantly running B movie westerns, 16 mm prints. He'd snatch the pages real fast, then close the door. I had shoulder-length hair at the time. I'm sure he thought I assisted on the strip and did burglary on the side."

Little Lulu

Marjorie Henderson Buell's Lulu Moppet first appeared in comic books in *Four Color* #74 (June 1945), ten years after her mute debut in one-panel gags in the *Saturday Evening Post*. Henderson, who sold her first cartoons at the age of 17, created the character to replace "Herman" in the *Post*, but by the time *Marge's Little Lulu* reached comic books, the inspiration was all John Stanley's.

Stanley changed Lulu from a prankster to a smart, inventive little girl and added a cast of characters that included Tubby Tompkins and the other "Junior Paratroopers" (Iggy, Eddie, and Willy), the flirtatious Gloria, the wealthy Wilbur Van Snobbe, and Alvin. Fans of Stanley's work are particularly fond of the fairy tales Lulu spins for the pesky Alvin, all involving Witch Hazel and a "a little girl" portrayed by Lulu.

Stanley initially handled all the comic book art himself but in the late 1940s decided to concentrate on the writing. Irving Tripp and Charles Heddinger took over the artwork, Tripp inking Heddinger's pencils before he eventually took over both chores. Stanley continued to script all of Lulu's adventures until the mid-1950s, when Carl and Virginia Hubbel, Arnold Drake, and Wally Green began to contribute.

The *Little Lulu* comic book ran for 267 issues, ending in 1984. As Trina Robbins has noted, Lulu's "copyright and creative destiny were controlled by Marge Buell until the artist retired in 1972." Marge died in 1993 at the age of 88.

Little Nemo in Slumberland

Winsor McCay's classic Sunday fantasy strip debuted in the *New York Herald* on October 15, 1905. McCay's dream sequences starred the six-year-old Nemo, who was given a fresh set of wings each week and allowed to fly to some distant corner of McCay's imagination. The artist's pathos and graphic perspective produced one of the great early treasures of the comics pages until McCay's interests turned to animation and editorial cartoons.

Little Orphan Annie

Harold Gray's 1924 creation was dubbed "Little Orphan Otto" until Joseph Patterson, publisher of the New York *Daily News*, sized up the character and reportedly barked, "He looks like a pansy. Put skirts on the kid."

The adventures of Annie and her various protectors—Daddy Warbucks, the giant Punjab, the mystical Mr. Am, and Gray himself—were the cartoonist's attempt, he once wrote, to abandon convention and politics and "really tell the American story." That reality, not unlike the Depression, was gritty and brutal; nothing less than ingenuity and self-reliance could prevail. Annie, no pansy, had no shortage of either.

Using characters that, Al Capp once said, had "all the vitality of Easter Island statutes," Gray delivered wordy 42-panel sermons on responsibility, capitalism, tolerance, and charity. But whether they were handcuffed to good times or bad, Annie, Warbucks, and even Sandy the dog ("Arf!") had an enduring majesty.

Although Little Lulu began her comics life as the star of a single-panel gag, she came into her own in the Dell/Gold Key comics series.
(© Marjorie Henderson Buell)

Logos

Logos
Our ten favorites:

See page 364 for some of our all-time favorite cover quotes.

Lois Lane had some of her more bizarre adventures during the Mort Weisinger era at DC.
(© DC Comics, Inc.)

Gray drew and plotted Annie's adventures for 44 years until his death in 1968. After the Broadway musical *Annie* revived interest in the strip, Leonard Starr restored some of its spark in December 1979.

Lois Lane

The most significant accessory in the Superman universe, Lois Lane first appeared in *Action Comics* #1. Not surprisingly, she was the first member of the Man of Steel's supporting cast to earn her own feature, a four-pager in *Superman* #28. She later starred in her own comic, which ran for 137 issues beneath the subservient tagline, *Superman's Girlfriend*. She deserved better; opinions are mixed over whether she got it in the ABC series *Lois and Clark*.

Lone Wolf and Cub

The 8,500-page saga *Kozure Yokami* (28 manga volumes of more than 300 pages each) by Kazuo Koike and Goseki Kojima was Frank Miller's inspiration for his DC miniseries, *Ronin*. First Comics began reprinting the comic as *Lone Wolf and Cub* in 1987. Miller and Lynn Varley provided covers and introductions to the first 12 issues. Each chapter of the story of Itto Ogami, the Shogun's executioner, and his infant son describes, Miller noted, "in terms that are vastly unlike our own, what it is that makes the perfect warrior, even as it examines his ultimate futility and the utter tragedy of war."

Koike and Kojima's *Lone Wolf and Cub*.
(© Kazuo Koike and Goseki Kojima)

Loren, Todd

The publisher of the short-lived Revolutionary Comics ("Unauthorized and proud of it"), Loren was stabbed to death in his San Diego apartment on June 18, 1992. Loren (Stuart Shapiro at birth) had gambled $2,000 in 1989 to start Revolutionary, which published unauthorized, and invariably unappetizing, biographies, especially of vaguely unappetizing rock stars. His murder remains unsolved.

The Lost Generation

This term is sometimes used to describe the dozen years after the advent of the Comics Code, when the glut of available artists and writers was so extreme that little new talent entered the field.

When Mike Friedrich met Neal Adams at DC in the mid-1960s, Adams "drew up at the office they had in the production room," Friedrich said. "He was 25 and he was the youngest guy drawing for the company by a generation. There was the Lost Generation of the '50s. No one had entered the business since the '50s. It had been 15 years since anyone had drawn comics as a kid."

Len Wein: "Mike Friedrich, Marv [Wolfman], myself, and I think Roy Thomas, were the first neophytes to come into the business in years. Previous to this, there hadn't been any new talent per se in comic books in about 10 years, since the mid-'50s and the time of EC."

"The field was simply becoming middle-aged," Gil Kane said. "I was at that medium age where I was right at the center of things. Alex Toth and I and Frazetta and Carmine [Infantino] and [Frank] Giacoia and Mike Sekowsky, Russ Heath, Joe Kubert, were all within a year or two of each other. So we all came up at the same time and, for about 15 or 20 years, nobody came into the field after us. It was like a survivor's club, you know. It's like we were shut up and they were just feeding some gas into the room or something."

Love and Death

Gershon Legman's visionary examination of sex and violence in comic books and American society was published five years before the release of Fredric Wertham's *Seduction of the Innocent*.

Legman may very well have gotten Wertham's motor running; he clearly set the stage for many of Wertham's excesses.

He insisted that "all comic books without exception are principally, if not wholly, devoted to violence," and observed, "[The fact] That the publishers, editors, artists and writers of comic books are degenerates and belong in jail, goes without saying."

He wrote of the "trappings of Nazism" in the comics and was brutal in his heavy-handed treatment of the homosexual element in the books, including those "two comic book companies staffed entirely by homosexuals and operating out of our most phalliform skyscraper."

But Legman was much closer to the center of the target in his study of why sadism was allowed—in fact, celebrated—in the comic books of the 1940s while sex was not.

"Under American law—now brassbound in a Supreme Court decision—sex in literature is worse than murder," Legman wrote. So the publishers of the pulps, he reasoned, decided, "Make war, not love." The Fawcetts of *Whiz-Bang* fame and the Donenfelds of *Snappy Stories* did "nothing more than to substitute legal blood for illegal semen, crime for coitus."

Consider, Legman said: "The comic books show the woman half-naked. They lay her down on the sacrificial altar. They spread one leg here and one leg there—and then they beat her to death. If there can be any question that this is an aborted sexual act, I don't know in whose mind. Nevertheless, it gets by the censorship—both the legal censorship and the internalized censorship of the unconscious mind—because what looks as though it's going to end in sexual intercourse merely ends in death.

"Naturally, this formula is not popular with girls . . ."

A trace of humor there? No, for in *Love and Death* Legman had a much bigger target than the comic books. "Violence in America is a business—big business—and everybody is in it, either as peddler or customer," Legman wrote (in *1949*, not 1989). "Forget, for the moment, about comic books. What about murder mysteries? What about the pulps? What about newspapers, picture-mags, movies, radio, television—all plugging away as hard as ever they can on the same bloody one-note, while a civilization lathers itself up for murder?"

But the book has enough on the comics to keep us occupied. It has Superman's brand of vigilante justice. It pinpoints the "educational" message of *Classics Illustrated* and its ilk: "Alfred Nobel is made educational in eight pages of dynamite, Florence Nightingale in eight pages of Crimean war horror . . . Hypocritically or not, the crime comic does tell the child that murder is the act of a criminal, and will be punished. The educational comic tells him the opposite. It gives murder prestige. It sells children on murder the way toothpaste is sold. Movie stars do it, duchesses do it, men of distinction do it—why don't you? . . . Captain Eddie Rickenbacker killed so many and so many men. Go thou and do thou likewise."

And Legman found a pile of comic books in which sex was supposedly *verboten* but violence was . . everywhere: "The really surprising thing is the hypocrisy that can examine all these thousands of pictures in comic books showing half-naked women being tortured to death, and complain only that they're half naked. If they were being tortured to death with all their clothes on, that would be perfect for children."

Because Wertham had read *Love and Death*, even if few others had, you can understand his surprise when critics treated his book as the first plow over unfurrowed ground.

Love and Rockets

The critically lauded black-and-white series, created by Gilbert and Jaime Hernandez and published by Fantagraphics Books, debuted in 1982 and came to an end with issue #50 in 1996.

> "[The fact] That the publishers, editors, artists and writers of comic books are degenerates and belong in jail, goes without saying."
> GERSHON LEGMAN

Love and Rockets went out with a bang in issue #50.
(© Gilbert and Jaime Hernandez)

Lubbers, Bob

You may already know what Bob Lubbers could do with a pen, but you may not know about the notes he could squeeze out of a trombone.

He didn't have an eye for music (Lubbers never could read a note) but he had the lip and the ear. When he was 16 and still in high school on Long Island, he decided to prove it with Tommy Dorsey on the Raleigh-and-Kool's Cigarette Program. In the middle of the hour-long program, Dorsey would bring three rookies out for an amateur competition. A live audience in Studio C at NBC Studios in Rockefeller Center would select the winner, who would waltz home with $75.

Lubbers and his trombone breezed through an audition, earning a date with Dorsey and his band on an April night in 1938. Does he remember what he played? You've got to be kidding.

"I played 'Wabash Blues,'" Lubbers said. "I remember Johnny Mince was on clarinet, Joe Buschkin was on piano, Jack Leonard was singing…and there was Edythe Wright." Edythe had the look to match her voice. "Whoa … Jack Leonard was rubbing her shoulders to relieve her tension, and I'm a 16-year-old kid, thinking, 'Geez, I'd love to do that.'"

Instead, he caressed the trombone, and won the $75. Right away, Lubbers's dad took him down Northern Boulevard to a used car lot and helped him pick out and buy a 1934 Ford Phaeton. Not long after they got home, a local band leader named Billy Baker was on the phone. He'd caught Lubbers's act on the radio and wanted to sign him up.

For the next three years, Lubbers played five nights a week with Baker's ten-piece band out in Westbury. When it came time to learn a new arrangement, Lubbers said, "The trumpets would play my part over and over again until I learned it." That didn't take long; Lubbers had the ear and the lip, remember?

It was a great life. By day, Lubbers went to art school, jumping into the Phaeton at lunch and rolling over to the high school to pick up Grace Oestreich, the love of his young life, and as many of her friends as could cram into the car. At night, he'd back up Billy Baker.

There was only one problem: While he was playing that trombone, Lubbers said Grace "would come in dating, and dancing with, other guys. I decided I didn't like that very much. So, I made a career change."

Lubbers had always loved the comics; he'd wanted to draw them all his life. "I remember as a kid living down in Queens Village, and my father coming home from work with the *Brooklyn Daily Eagle* under his arm. I just couldn't wait to get ahold of that *Daily Eagle* and turn to the comics."

In early 1940, Lubbers and Stan Drake (whom he'd met at the Art Students League) marched down to 14th Street and sold themselves to Centaur.

Lubbers's first feature for Centaur was *Reef Kincaid*, which paid him $6 a page. He also drew *Liberty Scouts* and the Arrow before Thurman T. Scott, a friend of his father's, suggested he haul his pens over to Fiction House.

Save for a three-year stint in the Air Force during the war, Lubbers stayed at Fiction House until 1950. "The greatest college of all time," he says. "Comic magazines were the place I learned to draw fast, if not well. We were all just learning."

If not well? On the Monday morning that Lubbers returned to Fiction House after the war, Murphy Anderson had the day off. "They didn't have a desk set up for him," Anderson recalls, "so they just sat him at mine. I came in the next morning and there on my desk was a

Gershon Legman surely appreciated this Bob Lubbers cover, one of 36 he did for *Wings*.
(© Fiction House)

stack of artwork. There were seven penciled pages ready to be inked. I was aghast. Bob had done that on his first day back, and that was with the boss taking him out to eat and taking him around to talk to everyone because he was their star artist. I used to tell Bob that we could forgive him for being fast and we could forgive him for being good, but that it was unforgivable that he was both."

Aside from working on the feature Captain Wings with writer John Mitchell, Lubbers had several of the Fiction House female characters in his corner, most notably Firehair. He may be best known for producing 35 consecutive covers for *Wings,* beginning in mid-1946. Lubbers greets the celebrity of those covers with a tinge of pain. "I couldn't draw then," he says. "I didn't realize that until I went into advertising." The pretty girls he is most proud of wouldn't roll out of his pen for another 15 years.

In 1950 Lubbers took over the daily and Sunday *Tarzan* strips from Burne Hogarth and finally entered the world of decent paychecks. Three years later, he got a call from Al Capp, asking him if he wanted to team up on a comic strip called *Long Sam.* The strip didn't survive the Kennedy Administration, but Lubbers and Capp would have a golden anniversary before they quit working together.

"Until 1979, when Al died and the strip went with him, Al would send me his *Li'l Abner* pencils from Boston to tune them up and fix things that weren't right," Lubbers said. "All Al had up there was Harvey [Curtis] who did the lettering, and an old buddy named Andy Amato, who roughed out the scripts with grotesque drawings, so grotesque they couldn't be published. Al could draw, he could draw real well, but he drew so slowly that he couldn't produce a comic strip. So, Al would do the faces, then they'd shoot it down to me to have a draftsman hit it."

In the 1960s, Lubbers drew and scripted *Secret Agent X-9* under the pseudonym "Bob Lewis." The women in that strip—"I got into one groove that lasted a couple years"—are those he is the proudest of. His last strip was the short-lived *Robin Malone;* by the time it died, Lubbers was safely into anamatics, glorified storyboards that served as blueprints for television commercials.

Through it all, Lubbers—who lives on Long Island—kept caressing that trombone. For years, he played in a Dixieland band, one of seven guys dressed up in matching jackets. His ear never failed, but about the time Dixieland was going out of style, his lip finally gave out. "I put the horn away," he says, consoled by knowing that he still had the eye to put his hand on a sheet of paper and sketch out a few more lines of splendid music.

Lubbers's Fiction House covers: *Movie Comics* #1–4; *Rangers* #40–49, *Wings* #74–108

Bob Lubbers excelled at aviation strips.
(© Fiction House)

Lucky Fights It Through

This syphilis melodrama was published by EC for the Communications Materials Center at Columbia University, which also commissioned Harvey Publications' *Teen-Aged Dope Slaves.* Subtitled "The Story of That

Harvey Kurtzman's first EC story was for a VD education cowboy comic—how's that for a specialized genre?
(© 1998 William M. Gaines, Agent, Inc.)

Ignorant, Ignorant Cowboy," *Lucky Fights It Through* was Harvey Kurtzman's first work at EC.

It's hard to say which is the more entertaining part of the story, the syphilis or the melodrama. Drugged by a dance hall girl named Katy, Lucky gets cuffed by the clap in an upstairs room at the Desert Queen Saloon.

"Huh? Say—That's a sore down there—I—I don't like the looks of it!" we hear Lucky say several days later. But the ignorant cowboy doesn't realize what he's got his hands on until, with his sweetheart Sal on his arm, he stumbles upon a campfire serenade.

Everybody sing:

A ranch on the range isn't likely to find
Much use for a cowboy who's dead, lame or blind,
So if you've known Katy please listen to this:
Only a doctor can cure syphilis...

And Doc Brown cures Lucky, just in time for him to deliver a life-saving blood transfusion to Sal.

Lucky Fights It Through is reprinted in *Squa Tront* #7.

Lupoff, Dick

"Comic book fandom," Joe Staton once said, "was invented by a science fiction fan, Dick Lupoff, who basically realized what he'd done and disowned it, and then came back a few years later to make a buck off it."

In his inventive stage, Lupoff and his wife, Pat, edited the fanzine *Xero,* which they unveiled at the 1960 World Science Fiction Convention in Pittsburgh. One of the regular features of *Xero* was a nostalgic look at various Golden Age features called "All in Color for a Dime." A collection of those columns, co-edited by Lupoff and Don Thompson, was eventually published by Arlington Press.

If Lupoff ever made a buck off comics, it was probably with a series of detective novels, including *The Comic Book Killer,* which arrived in hardback with a special comic book featuring a cover by Alex Schomburg. Lupoff now works at a radio station in the Bay Area.

Pat and Dick Lupoff.

Mad

> *You see, Harvey could never realize that* Mad *was mine; he thought it was his.*
> BILL GAINES

They're still arguing about it in their exquisite little corner—what do you wanna bet 225 is the street number?—of the Great Beyond. Bill Gaines is complaining about the quality of the house wine, Harvey Kurtzman is picking at the sleeve of his red cardigan, and they're flogging each other, refusing to yield any ground in their 40-year feud over who deserves credit for dreaming up *Mad*.

"As I remember it," Kurtzman is saying once again, "I was desperate to do a quick comic. I wasn't making any money with my first love, the EC war books. I was averaging two stories a month, as opposed to Al Feldstein, who would write a story a day. I just couldn't hack it. I was tired, I got sick, I went to the hospital with yellow jaundice. I was cracking under the workload. *Mad* was my way out."

"You're fogging my glasses, Harvey," Gaines breaks in, yanking the dog-eared copy of *Two-Fisted Tales* #34 out from beneath the vine. "Your timeline is a bit confused. Look right here: There's a house ad for *Mad* #5. And there's this story, 'The Betsy,' written and drawn by Jack Davis, because you weren't there to write it. In the letters page we note, '*Two-Fisted Tales*'s brilliant writer-editor, who generally masterminds the mag from cover to cover, suddenly evolved a serious case of yellow jaundice and was quickly retired to a hospital bed.' So you were in the hospital with jaundice when we published *Mad* #5. I rest my case."

"So you got a better story?" Kurtzman asks.

"Feldstein was fast at making money, and you were slow—sorry, diligent—and getting ticked off," Gaines says. "The only way I could keep the peace between you and Feldstein was to suggest you put out a humor book."

"I suggested it," Kurtzman insists.

"They got rules for stretching the truth in these parts, Harvey. When you first walked through the door at EC, I busted a gut laughing at the stuff you brought in; then my gut fell asleep waiting for you to do something else that made me laugh. I said, 'Look, it takes you a month to research *Frontline Combat* and a month to research *Two-Fisted Tales*. Stick *Mad* in there and you'll boost your income 50 percent.' And that's why *Mad* was born. You needed a 50 percent raise.

'I'm the one who came up with the format. I proposed the title, which came from a phrase we used all the time in the old horror books, 'EC's mad mags.' *You* then stripped off 'EC's' and 'mags' and left us with *Mad*."

So it goes, we gotta believe, Kurtzman refusing to admit that Bill was there at the moment of conception, Gaines unwilling to concede that Harvey breast-fed the comic book through its infancy.

Mad debuted in October 1952. The first three issues lost money, Gaines said. "The fifth issue of *Mad*, of course, had my biography. That almost put us out of business."

In all seriousness, Gaines said the Superman parody in #4—"Superduperman"—finally edged *Mad* into the black.

Kurtzman edited the first 28 issues of *Mad*, which changed to a magazine with issue #24. Gaines insisted the change had nothing to do with dodging the Comics Code Authority. Kurtzman, he said, had been offered a job with *Pageant*, and Gaines offered to change *Mad* into a slick mag to keep him. Kurtzman lasted another six months before demanding Gaines give him majority control of the magazine. Gaines, of course, refused.

With that, the two greatest influences on comics in the Fifties were parted.

Given a decent bottle of wine, even Gaines would give Kurtzman credit for *Mad*. The idea for America's penultimate humor magazine may have been Gaines's, but all its power, parody, mirth, and madness were Kurtzman's.

"Kurtzman's *Mad* was the first comic enterprise that got its effects almost entirely from parodying other kinds of popular entertain-

Kurtzman drew many of the early *Mad* covers, when it was still in comic book format.
(© 1998 E.C. Publications, Inc.)

ment," Adam Gopnik wrote in *The New Yorker* after Kurtzman's death. "Like Lenny Bruce, whom he influenced, Kurtzman saw that the conventions of pop culture ran so deep in the imagination of his audience—and already stood at so great a remove from real experience—that you could create a new kind of satire just by inventorying them. To say that this became an influential manner in American comedy is to understate the case. Almost all American satire today follows a formula that Harvey Kurtzman thought up."

By the time Mad celebrated its 45th birthday in 1997, the in-house formula was still intact, even if "The Usual Gang of Idiots" was not. Alfred E. Neuman was still playing the cover and Dave Berg ("The Lighter Side of…") and Spy vs. Spy were still trapped inside the magazine, now edited by Nick Meglin and John Ficarra, and owned by DC Comics.

© 1998 E.C. Publications, Inc.

Madam Fatal

Madam Fatal was the only known transvestite crimefighter in the history of literature, according to Hubert Crawford (although who knows exactly what Rob Liefeld is plotting at the moment). Madam Fatal was created by Art Pinanjan and first appeared in *Crack Comics* #1 (May 1940).

Magneto

First appearing in *X-Men* #1, Magneto (or his editors) waited another 149 issues to reveal that he had been an inmate of Auschwitz as a child. He appeared so often in early issues of *X-Men* that readers went to their knees praying for new villains.

Magnus, Robot Fighter

Conceived by Western Publishing editor Chase Craig, and written and drawn by

WINE

"In the beginning," Sergio Aragonés said, "the only thing Bill Gaines drank was Manischewitz. Then he went to school to learn about it. He developed such a keen taste for wine that he became a member of the French wine academy. The man could tell you which wine it was just by smelling it."

Thus, it is not surprising to read, in Frank Jacobs's *The Mad World of William M. Gaines,* that Gaines's favorite tale about wine was "'Taste,' a brilliant, often terrifying tale by Roald Dahl. For years, Gaines was intrigued by the story, which deals with a wine connoisseur who makes a spectacular bet that he can identify, through taste only, the vineyard and vintage of an obscure Bordeaux. After reading the story, Gaines determined to lay his hands on a bottle of the wine, which was a Branaire-Ducru '34. After scouting wine auctions and browsing through countless shops, he finally found not one, but two, in a shop in Paris. He brought the wine home and wrote Dahl, who lives in England, that he wished to present him with one of the bottles."

Dahl returned what Gaines called "a charming letter," but that was the last he heard from him. The Branaire-Ducru was still parked in Gaines's wine cellar when Aragonés organized one of *Mad*'s annual safaris, this one to Mexico.

Because the staff was invading his homeland, Aragonés made all the preparations, including a wine-tasting party at his mother's house.

"The thing is that Mexico is not well known for the quality of its wines," Aragonés said. "But I went to a lot of different wineries and found a lot of different wines, none of them very good. I bought a lot of bottles of wine and prepared this very fancy wine-tasting, at a very long table with all the bottles in order and hundreds and hundreds of cups and cheese and bread. All the waiters were dressed in white. And as Bill came in and started testing them, they went from bad to worst. You could see him giggling every two minutes. After he tasted another one, more giggling. By the fourth bottle, he was in hysterics. The *Mad* guys were so impressed by the display, they didn't know it was joke. Bill was just smelling them [the bottles] and going, 'Ha, ha, ha.'"

The *Mad* staff had a tradition of presenting Gaines with a memory book at the conclusion of each trip. "Every artist would make a drawing based on the experiences of that particular trip. We have dinner, usually in New York, and give him the book, and he goes through the pages and laughs at every cartoon," said Aragonés. "After that one in Mexico, I made my drawing to give to his book. So, we arrive to the dinner and instead of giving the book to him, they give it to me. All the artists have made drawings of different memories of the Mexico trip. And Bill Gaines gives me a lawsuit, suing me for a million dollars, because I have ruined his palate with all the cheap wines."

The Branaire-Ducru '34 must never have tasted the same.

Russ Manning, Magnus first popped in from the forty-first century in *Magnus, Robot Fighter* #1 (February 1963). Manning's beautiful art highlighted the Gold Key series, which reverted to reprints by #29. Valiant resurrected the character in 1990.

Male Call

After failing in his first volunteer effort to boost WWII GI morale—VD posters that were turned down "because the girls were too good looking"—Milton Caniff inaugurated the weekly *Male Call* on January 24, 1943.

The star of the show was the glorious Miss Lace, the embodiment of Caniff's belief that anticipation is a much bigger thrill than an inevitable roll in the hay.

"I began to realize after I got into it that the unattainable nature of Lace was more useful over the long haul than portraying somebody that you knew had been in the hay with the lieutenant over the weekend," Caniff said in Kitchen Sink's 1987 reprints of the strip, which was originally published by the Camp Newspaper Service.

"The whole thing hung on the point of view of the American GI, the American guy suddenly dumped in a place he'd never heard of before. What he's really thinking about is the girl back home, not the tavern wench near the air base in England. . . . It was a wish fulfillment, a two-minute furlough back home for the guys when they read the strip."

Lace gave *Male Call* its life. In the early days of the strip, Caniff and the GIs simply positioned her—over a dice game or the Thanksgiving turkey—so that she'd be forced to lean forward and show more of her glorious cleavage.

But she was a lot more than a body. Twice Caniff had her on the arm of a veteran who'd lost his other wing to the war; on another occasion, she escorted a blind GI. She called every soldier "general."

Caniff drew *Male Call* from his Catskills studio, always beginning with the punch line in the last panel. The strip ended on March 3, 1946, beneath the caption, "Back to the Ink Well." When Lace disappeared, she left behind a note:

> *Generals and Admirals:*
> *I could tell from your conversation that my mission has been accomplished. I've gone back where I came from—I'll be there if you ever need me again. So long!*
> *Love,*
> *Lace and MILTON CANIFF*

Russ Manning got to draw pretty girls, rocketships, and futuristic cities for *Magnus, Robot Fighter*.
(© Western Publishing)

The early *Male Call* strips emphasized Miss Lace's physical charms.
(© Milton Caniff)

Manning, Russ

Russ Manning had a soft spot for animals. "He had sort of an Albert Schweitzer philosophy," Bill Stout, who once worked in Manning's studio, said in a Comics Feature interview. "When ants invaded the studio, he wouldn't kill any of the ants because he didn't feel it was his place to take the life of one of God's creatures... He tried to put that philosophy into the Tarzan strip, too. You notice that in the way Tarzan relates to the animals and treats the animals.

"I remember one time I pointed out a series of photos in Life magazine to Russ. They were incredible photos. A gazelle had been wounded by a crocodile, and the crocodile was coming up to finish off the gazelle. A hippo came down, knocked aside the crocodile, very tenderly picked up the gazelle in its jaws, and carried it up onto the shore. He stayed and watched over the gazelle until it had healed and was in full health again, and wouldn't let any other animals near it. That really impressed Russ—the strange workings of the animal kingdom and of nature—and he put that sequence into a Tarzan strip. He had Tarzan observing this same thing."

Often called "the third great Tarzan artist"—behind Hal Foster and Burne Hogarth—Russ Manning drew the ape man for the first time in 1952, a story titled "Horns of the Kudu." As Bob Bartlett reported in The Burroughs Bulletin, the story was intended for a 3D issue of Tarzan that was never published. It finally appeared in March of Comics #114 (June 1954), 18 months after Manning's first "Brothers of the Spear" feature was published in Tarzan #39.

Jesse Marsh first introduced Manning to the Western editors. Manning spent 15 years working for Western, illustrating Western Roundup, Dale Evans, Roy Rogers and Trigger, Wyatt Earp, and—of course—Magnus, Robot Fighter. But the heart of his legacy is his Tarzan work, beginning with the Dell comics and moving on, in 1967, to the newspaper strip.

Manning drew the "Brothers of the Spear" backup feature in Tarzan from 1952 through 1966. By 1954 he was also writing stories for various Tarzan and Dale Evans books. "The only way I can get to draw women," Manning once said, "is to write the things myself."

The same could be said for robots. Manning wrote about half of his 21 issues of Magnus, Robot Fighter. According to Bartlett, Manning charged the office of editor Chase Craig when he heard Western was considering a book set 2,000 years in the future. When Craig asked Manning if he knew anything about science fiction, Manning reminded him that his lust for the genre had earned him the nickname "Moon Boy" when he was in high school.

In 1967 Manning succeeded John Celardo on the Tarzan newspaper strip. He worked on the strip for five years, then spent the final decade of his life doing overseas Tarzan projects, drawing the first Star Wars newspaper strips, and painting a mural on the walls of the mission at San Juan Capistrano. When the swallows returned to the mission in 1982, Manning was gone, dead of cancer at the age of 52.

Man or Monster?

"Is He Man or Monster or ... Is He Both?" asked the cover of The Incredible Hulk #1. You make the call:

"The Monster and the Machine" (Incredible Hulk #4)
"The Missile and the Monster" (Tales to Astonish #85)
"Less than Monster, More than Man" (TTA #83)
"When the Monster Wakes" (TTA #99)
"This Monster Unleashed" (Incredible Hulk #105)
"Monster Triumphant" (#108)
"The Monster and the Murder Module" (#123)
"The Monster and the Madman" (#144)
"Where Monsters Meet" (#151)
"Destroy Cries the Monster" (#167)
"A Monster in our Midst" (#208)
"The Monster and the Mystic" (#211)
"The Monster and the Machine" (#235)
"Trial by Monster" (#253)

Man-Thing

He beat Len Wein and Bernie Wrightson's Swamp Thing out of the box by a month. Man-Thing first appeared in Savage Tales #1 (May 1971), 30 days before Swamp Thing oozed out of the muck in House of Secrets #92.

Russ Manning

Management

[The industry] tends to draw people who are most happy when they can sit in a room by themselves and entertain themselves. I can't understand someone who says, "I'm not creative, I think I'll make a career managing creative people."

STEVE ENGLEHART

Marble, Alice

In 1942 Will du Pont, the Delaware millionaire, stopped Max Gaines at a party and introduced him to the three-time defending U.S. Open champion in women's singles.

"We were chatting about Wonder Woman and Superman, the current rages with the kids," Alice Marble wrote in her autobiography, *Courting Danger*, "when I asked, 'Why don't you do real-life wonder women, the women who have made history?'

"'Such as?'

"'Clara Barton, Dolly Madison, Eleanor Roosevelt...'

"Before the evening was out, I had agreed to do some research and rough out the dialogue for a few comics. In less than a month, I had my own desk in the Lexington Avenue offices of All-American Comics, as associate editor of the Wonder Woman series. My cocktail-party inspiration netted me nearly fifty thousand dollars..."

And set Marble up for what must have been the least exciting episode of her life.

Alice Marble was an amazing woman. The subject of her first feature for *Wonder Woman* #1 was Florence Nightingale, and the Angel of Mercy had nothing on the author.

Marble's autobiography, subtitled, "My Adventures in World-Class Tennis, Golden-Age Hollywood and High-Stakes Spying," only begins to tell the story. America's #1 player from 1936 to 1940, Marble not only won the Wimbledon singles title in 1939 but the women's doubles and mixed doubles, the last with Bobby Riggs.

Her coach, Eleanor "Teach" Tennant, introduced her to the Hollywood set when she was 20. On the only night that George Bernard Shaw spent in the United States, Marble was his dinner partner at San Simeon, the Hearst castle. She played tennis with Charlie Chaplin (he cheated unmercifully) and palled around with Carole Lombard, who once confided about Clark Gable, "I love him dearly, but wouldn't all those swooning women be devastated to learn that he's not all that great in bed?"

Nothing devastated Marble. She was raped at the age of 15 and knocked off her feet by tuberculosis at the age of 21. Her husband was shot down and killed over Germany in World War II, a month after Marble, five months pregnant, had been hit by a drunk driver and lost the baby.

No, a few months with Max Gaines and *Wonder Woman* weren't the high point of the woman's life. ("Everyone else seemed to be involved in the war, and I was writing comic books!") The high point probably came in 1945 when the FBI recruited her to spy on an old flame in Switzerland. The war was winding down; the Nazis who were making plans to flee to South America were stockpiling their gold, jewelry, and currency with a Swiss businessman in Geneva. He and Marble had met in 1938, and they had a hot, hectic affair before Teach finally pried them apart. Seven years later, the FBI asked her to go back to Geneva and—after the essential hop through his bedroom—to gain access to the records of his transactions with the Nazis, which were stored in a basement vault.

Marble almost pulled it off. She duped her old lover and photographed his books, but when she tried to hand off the film, she was shot in the back by a Russian double agent. Marble recovered from the wound, and her photographic memory (no we're not making this up) allowed her to pass on most of the names in the files.

Marble died in December 1990, at the age of 77. *Courting Danger* is a refreshingly candid account of her life at war and at peace, if not in that office on Lexington Avenue.

> ### Married to the Mob
>
> *The scuttlebutt in publishing circles ran like this: Shortly after World War II, an obscure sheet-music publisher in the northeast was taken over and turned into a comics and magazine publishing and distributing company. Much of the artwork was done by Italian artists who spoke no English, were brought in and lived as, effectively, indentured workers, in company housing and in debt to the company. The product was distributed in a crude but effective method: News dealers were shipped large quantities of every title and told they could keep the receipts on everything sold over a basic number. Say they sent 20 copies of a comic. After the dealer had sold ten, he could sell the remaining ten for 100 percent profit...*
>
> *The lower rungs of the publishing industry have been mob-dominated since the end of Prohibition—when a lot of mob money went looking for "legitimate" enterprises... If one traces the lineage of most of the comics publishers of the '40s and the pulp publishers of the '30s and '40s, one finds a mob connection—and companies whose business practices were shoddy and who routinely ripped off the artists and writers who worked for them.*
>
> TED WHITE
> THE COMICS JOURNAL

Jesse Marsh's primitivistic version of Tarzan has brought both praise and criticism.

(© Edgar Rice Burroughs, Inc.)

Marsh, Jesse

No less a critic than Gilbert Hernandez believes Marsh's crude rendering of Tarzan was one of the best.

After warming up with *Gene Autry*, Marsh got his first *Tarzan* job in 1946. When Dell cut loose a bimonthly comic two years later, it handed the pencils to Marsh. He didn't hand them back for 18 years.

Marsh also pounded out the art on such books as *Annie Oakley* and *Roy Rogers* and produced a Sunday page that featured the best of Disney.

Marston, William Moulton

A psychologist and a Harvard man, Marston created Wonder Woman *and* the systolic blood pressure test used in polygraphs.

Marston's widow—who died in 1993, outliving the inventor by a mere 46 years—said he created Wonder Woman after being informed by Maxwell Charles Gaines, the owner/publisher of All-American Comics, that a woman character couldn't sell. "Like hell it can't," Marston reportedly replied.

"Wonder Woman was an embodiment of his ideas, rather than mere entertainment," Marston's widow told Denny O'Neil. "He was expressing a fundamental psychological doctrine. It wasn't just another action comic. Wonder Woman would battle people, but she would control them; she didn't pound them. Never."

The pseudonym "Charles Moulton" was a blend of Gaines's and the scripter's middle names.

Martin Don

Six years ago, a shy, unassuming, talented artist walked into the Mad offices with a collection of the funniest, the cleverest, the most absurd cartoons we had ever seen. When we gathered around to look them over, we literally rolled on the floor laughing. The cartoonist's name was Charles Addams. Unfortunately, we couldn't afford Charles Addams, so we hired the next guy to walk in after him ... a virtually unknown cartoonist named Don Martin.
AL FELDSTEIN
"FOREWARNED," DON MARTIN STEPS OUT

The guy may have sold more copies of *Mad* than any other. Don Martin's maniacs were forever enjoying "One Saturday Morning at the Dentist" or "One Fine Day at the Adult Ma-

gazine Store." The caricatures of "*Mad*'s maddest artist"—magnificent jowls, beer bellies and nary a neck in sight—were instantly recognizable. Martin's first cartoon appeared in *Mad* #29 and his work was invariably one of the magazine's highlights until the cartoonist broke ranks in a dispute with publisher Bill Gaines over the ownership of his original artwork. Martin, whose work also appeared in a dozen paperbacks, now lives in Florida; Dark Horse published *Don Martin's Droll Book* in 1993.

Marvel Chipping

Also known as "the Marvel edge." As early as 1957, the 30-pound paper Marvel used — on Martin Goodman's orders—was so thin and so cheap that all but the sharpest broadknives pulled tiny triangular chips from the edge in the cutting process. "If you still used such cheap stock," said Gary Carter, "you'd still get Marvel chipping if the blade is dull."

Few of the early Marvel key issues, such as *Amazing Fantasy* #15 or *Amazing Spider-Man* #1, come without those missing chips.

Marvel Comics

Notice is Hereby Given That:
1. On December 27, 1996, Marvel Entertainment Group, Inc., The Asher Candy Company, Fleer Corp., Frank H. Fleer Corp., Heroes World Distribution, Inc., Malibu Comics Entertainment Inc., Marvel Characters Inc., Marvel Direct Marketing Inc. and Skybox International Inc. (collectively, the "Debtors") filed with the United States Bankruptcy Court for the District of Delaware (the "Bankruptcy Court"), a proposed Joint Plan or Reorganization (the "Plan") . . .

It was great fun while it lasted. The Marvel Age was vastly entertaining, if not overwhelmingly inventive, while Stan Lee and Jack Kirby were at the top of their game. Before the wine turned to vinegar, Lee and Kirby and Steve Ditko gave the comics industry another solid 20 years of life.

In the beginning in 1961, and throughout most of the 1960s, you never knew what to expect. You didn't know who'd appear on the cover of *Fantastic Four,* who'd unthaw with the Avengers, or what Captain Stacy might whisper to Peter Parker as he died in Peter's arms. All you knew was that the Marvel Universe was a far different galaxy from DC's, where the editors treated the characters (not to mention the readers) as buffoons. Lee's irreverent wit—as expressed in the cover captions and editorial boxes as well as in the interior dialogue—gave you permission to curl up with both the Norse gods and the skinny teenagers, to fall in and sing right along with the Merry Marvel Marching Society.

In its prime, Marvel raised your expectations, your faith in the quality of storytelling the medium could deliver. "Stan Lee and Jack Kirby," said writer Kurt Busiek, "produced the biggest wellspring of good faith in comics history."

Kirby supplied the dynamics; Lee the sales pitch. And at Marvel the marketing was easily

Generations of kids grew up on Don Martin's demented strips in *Mad.*
(© 1998 E.C. Publications, Inc.)

Marvel began in 1939 as Timely. Some of the Golden Age Timely heroes (most notably Sub-Mariner and Captain America) were revived for the Silver Age Marvel. In the case of the Human Torch, the Golden Age version was completely different from the Fantastic Four's Johnny Storm.
(TM & © 1998 Marvel Characters, Inc. All rights reserved.)

FOOM (Friends of Old Marvel) was one of Marvel's follow-up attempt (to the Merry Marvel Marching Society) at a company-sponsored fan club.
(TM & © 1998 Marvel Characters, Inc. All rights reserved.)

as important as the material. The combination created a new wave of readers and inspired another generation of artists and writers. "We'd all seen Marvel go from nothing to a sensation to something that was better every month," said Steve Englehart. "We had a chance to catch that wave and go with it."

In the company's first incarnation as Timely, Marvel had been a second-string company and had remained one for some 22 years, cranking out pale imitations of war books, romance titles, or whatever else was selling at the time. Kirby, however, was an original, the true light bulb in "The House of Ideas." He not only plotted the comic book renaissance of the 1960s but populated the era with the Fantastic Four, the X-Men, the Avengers, a revived Captain America (a Timely character, along with the Sub-Mariner), the Silver Surfer, and scores of villains and supporting players.

When Kirby finally departed for DC and more artistic freedom in 1970, Marvel lost much of its energy and its originality. "When I was working there in the '70s, Marvel was past

MARVEL BULLPEN

Let us go back to a simpler time when Marvel was a goofy gang of get-along guys and Stan "the Man" had a nickname for everyone. Lest we forget, they were:

Amiable Al Williamson
Bashful Barry Smith
Bashful Berni Wrightson
Cheerful Chic Stone
Dapper Danny Adkins
Dashin' Donny Heck
Fabulous Flo Steinberg
Fearless Frank Giacoia
Genial Gene Colan (or Gene "Dean" Colan)
Groovy Gary Friedrich
Happy Herbie Trimpe
Jack "King" Kirby (or Jolly Jack Kirby)
Jaunty Jim Steranko
Jazzy Johnny Romita
Jolly Solly Brodsky
Joltin' Joey Sinnott
Jumbo Johnny Verpoorten
Laughin' Larry Lieber
Lonesome George Tuska
Lovable Leslie Dixon
Marvelous Marie Severin
Merry Gerry Conway
Mischievous Mimi Gold
Nefarious Neal Adams
Nifty Nancy Murphy
Rapturous Ross Andru (or Ross "Boss" Andru)
Rascally Roy Thomas
Reckless Reed Crandall
Sturdy Stu Schwartzberg
Terrific Tom Parker
Titanic Tony Mortellaro
Valiant Vince Colletta
Wild Bill Everett
Wondrous Wally Wood

the first flush of its great creative eruption," Walt Simonson said. "The ideas had been exhausted. Most of what was being done was to take the existing pieces, throw them up in the air, and have them come down again in a somewhat different order. Some of the pieces would be rightside up, some upside down, some in a different pile. To use a different metaphor, they were ringing all the same bells but in a different order to get different sounds."

By the time Frank Miller took over *Daredevil* in 1979, he realized that the key to success at Marvel was working against the grain, not going with the flow. "I've found that I can ignore most of the Marvel Universe painlessly," Miller said. He would turn *Daredevil* into Marvel's best book simply because he was willing to cut most

of the traditional strings that tied the character down.

Marvel's misstep was its insistence that its characters were unbeatable and its talent replaceable. In the early 1980s, Marvel had what Walt Simonson called its own "silver age." Miller was on *Daredevil,* Simonson on *Thor,* and Chris Claremont and John Byrne on *The Uncanny X-Men.* But Marvel was determined to maintain what Bob Schreck, a former editor at Dark Horse and Comico, called "a master-slave relationship with its creator base." When Simonson asked editor Jim Shooter about getting royalties for his work on a 1982 *New Teen Titans/X-Men* one-shot, Shooter turned him down cold: "Jim explained that it just wasn't possible; Marvel didn't make enough money. The company would have to fold."

Because Marvel was the industry leader, it embodied what Mark Evanier described as "a pernicious system that penalized people for creativity. It was a system that did not allow writers and artists to retain any sort of dignity or financial or creative possession of their work. Their work was taken from them in every possible way. Their artwork was destroyed. Their names were expunged from the strips. Other artists were brought in to prove they were expendable."

Some top artists—specifically, Todd McFarlane, Jim Lee, and Rob Liefeld—finally rebelled in 1991, but the hemorrhaging of Marvel's talent may have begun as early as 1986, three years before Ron Perelman bought the company for $83 million and took it public. Simonson argues that many of the writers who had "brought ideas into the mix"—including Claremont, Doug Murray, Bill Mantlo, and Louise Simonson—were cast adrift in the late 1980s. Some believe they lost work because the new breed of artists were determined—and, in some cases, talented enough—to write their own books.

Even when McFarlane and his merry men departed to form Image, Marvel retained a 40 percent market share with what Mark Verheiden called its "icon characters." Unfortunately, Marvel also had an icon mentality, the firm conviction that it could do no wrong. As the price of Marvel stock climbed to $35 a share, the Perelman braintrust decided the company didn't need fan favorites to sell its books and didn't need Diamond or Capital to distribute them. In 1993 Marvel bought out Heroes World Distribution and with it brought distribution of its comics in-house. And inside that house, money managers were arguing that the company's licensing deals were much more important than its literary ambitions.

Slap *X-Men* on anything, they argued, and it would sell. Flood the market and Marvel would eventually bob to the surface.

"They pandered to speculator dollars," said Schreck. "Rather than seek out quality work they put out glossy covers and gimmicks. They took the trust of their loyal readers and traded it in for the quick buck."

MARVEL STYLE

A Stan Lee invention, in this style of producing comics, the writer (usually Stan the Man) would hand a script outline to the artist, who would draw the story. The artist would then hand the pages back to the writer, who would fill in the blanks with copy.

"The one great thing that Stan Lee, by accident, is responsible for is the fact that when Marvel was turning out all that work, he tried to write it all by himself," Gil Kane told *The Comics Journal.* "He couldn't do all that work, so he let Jack Kirby and Steve Ditko make up all the plots... [A]fter it was completely drawn, he would come by and put in the copy. That led to a system that I think is the best thing now, in terms of writing and drawing and affecting a balance. Just like a writer and a director get together when they are going to do a picture and discuss it."

In 1994 Kurt Busiek and Alex Ross's *Marvels* recreated the Silver Age of Marvel Comics from a new viewpoint, with stunning painted artwork. The four-part series won numerous awards—and was Marvel's last effort to produce a "prestige" product.
(TM & © 1998 Marvel Characters, Inc. All rights reserved.)

Formerly the most valuable comic book, *Marvel Comics* #1 has fallen to fourth place. The cover was by well-known SF artist Frank R. Paul.

(TM & © 1998 Marvel Characters, Inc. All rights reserved.)

"Who would have thought, that when Jack Kirby died, he would have taken Marvel Comics with him?"
MARK EVANIER

The squandering of what Busiek called the company's "good faith" culminated when Marvel, in desperate measure because its stock price was falling, surrendered several of its icons, including Captain America and the Fantastic Four, to two of the Image deserters in 1995. Lee and Liefeld were given carte blanche to rewrite the characters' history in pursuit of a new audience.

"The Marvel reader is essentially being told," Busiek said, "that Marvel's long-term history is more or less irrelevant. It's secondary to what will make the characters more popular and what will make the company more money."

The remaining staff noticed. "I was rather amazed the last few times I visited the Marvel office how rotten the staff thought their own books were," Mark Evanier said. After Evanier and Sergio Aragonés parodied the Marvel Universe in *Sergio Massacres Marvel* (1996), Evanier noted, "People were stopping us and saying, 'You weren't nasty enough to us. You could have been much more vicious.' I've been writing parodies all my life and I've never had that reaction."

No parody could do this corporate death wish justice. By the end of December 1996, there wasn't much staff left; almost 420 former members of the old MMMS had been given their marching orders over the past year. Reeling from a loss of over $400 million, much of it due to its untimely investments in Skybox and Fleer trading cards and the plummeting of its stock to $1.75 a share, Marvel declared bankruptcy on the eve of the new year. What had been the House of Ideas was now the House of Cards.

"A couple of years ago, I would have said, 'Hallelujah, the beast is dead,'" said Denis Kitchen, the head of Kitchen Sink. "They destroyed a decent distribution system, putting a lot of people out of business who were friends of mine. They were the evil empire. On the other hand, what's left still depends on Marvel. If Marvel goes away, one has to wonder if the whole system crashes."

It was great fun while it lasted.

"Who would have thought," Evanier said, "that when Jack Kirby died, he would have taken Marvel Comics with him?"

Marvel Comics

"The most sought after of all Golden Age comics."

For years, the *Overstreet Comic Book Price Guide* introduced *Marvel Comics* #1 (October 1939) with that fanfare.

Small wonder. The first comic book published by the company that has dominated the industry since the late 1960s, *Marvel Comics* featured the first appearances of not one, but two major characters: the Human Torch, who appeared on the cover drawn by Frank R. Paul, and the Sub-Mariner (only advance copies of his debut in *Motion Picture Funnies Weekly* were ever distributed). The comic also included the origin of Ka-Zar, on loan from publisher Martin Goodman's pulp empire, and Paul Gustavson's The Angel.

George Olshevsky knows of only four copies of *Marvel Comics* without "Nov." stamped over the October 1939 cover date. Olshevsky also observes, "The cover was printed in the process colors (magenta, yellow, cyan, and black) and not primary colors (red, yellow, blue, and black) ... This gave it a wider chromatic range, so that it resembled a pulp magazine more than a comic book."

With the second issue, Goodman changed the title to *Marvel Mystery Comics* and replaced the Human Torch on the cover with The Angel. But the Torch and the Sub-Mariner returned

soon enough, teaming up in battles that guaranteed the book's popularity.

Until 1989 *Marvel Comics* #1 was the most valuable book in the *Overstreet Comic Book Price Guide*. As late as 1984, a near-mint copy was listed as more than twice as valuable as a copy of *Detective Comics* #27 ($17,500 compared to $8,000). But the 1989 *Price Guide* hastily added the hedge "Possibly" to *Marvel Comics* "most sought after" tag, as *Action Comics* #1 moved to the top of the heap.

Marvel Comics's stock failed to match the boom in the major DC books in the last half of the 1980s. Between 1986 and 1990, the list price for a near-mint copy of *Marvel Comics* #1 increased only $4,500, while similar copies of *Detective Comics* #27 jumped $18,500 and *Action Comics* #1 increased by $14,000.

Marvelman

This variation on Captain Marvel, published in the British magazine *Warrior*, surfaced in 1954 after the original got taken out by DC's plagiarism suit. Instead of copyboy Billy Batson you had copyboy Micky Moran; instead of the word "Shazam!" unlocking his universe, you had the word "Kimota!" which is—well almost—"atomic" spelled backward.

The Mightiest Man in the Universe Marvelman never got temporary residence status back in the U.S. Denying him a visa was Marvel Comics, a denial that caused a permanent rift between the publisher and Alan Moore.

Moore thought that he was on safe ground when he tried to revive the character; Marvel didn't disagree until Eclipse Comics picked up the rights to publish Marvelman on this side of the Atlantic. Moore was forced to change the name of the character to Miracleman.

"Marvelman was created in 1954," Moore told *The Comics Journal*. "That's when he was copyrighted. Marvel Comics was copyrighted in 1961. It's a matter of simple math." To keep the peace with Marvel, however, Moore suggested they call the magazine *Kimota*. "We were quite willing," Moore said, "to put a disclaimer in there saying that Marvelman was in no way connected with Marvel Comics or any of their trademark characters. We thought we were being as obliging as possible given the fact that we had a cast-iron case . . .

"Basically, the response from Marvel was, 'If you bring out a comic with the name Marvelman anywhere in it, we're going to sue you.' The logic behind that was not that they were right, but that they were big enough. It meant that they could keep us in court forever with their lawyers whether they were right or wrong. That is just simple bullying, and I can't accept that. I couldn't work for a company that had done that to me, who had that sort of approach, that sort of might-is-right, John Wayne approach. I couldn't do business with people like that."

Eclipse's *Miracleman* ran 24 issues from 1985 to 1988, with Moore scripting the first 16 issues and Neil Gaiman the final 8.

Marvel Mystery

The pride of the Timely fleet, *Marvel Mystery* was one of the most significant titles of the Golden Age.

Martin Goodman launched his comic book line with *Marvel Comics* in the fall of 1939, then—possibly hoping to suck in his Red Circle pulp fans—changed the title to *Marvel Mystery*. The early issues were produced by Funnies, Inc., a shop that employed Bill Everett and Carl Burgos. Their creations—the Sub-Mariner and the Human Torch—were Hall of Famers compared to the sandlot crew (The Phantom Reporter, Stuporman, and Flexo the Rubber Man) thrashing around in other early Timely titles.

Marvel Mystery #8 featured the comics' first great crossover, as Namor and the Torch began an epic battle that concluded in the following two issues. George Olshevsky suggests the idea for the collision came from a reader responding to Timely's offer to pay $25 to the reader with the best 100-word essay on his or her favorite character.

Marvel Mystery's run

The first crossover in comics began in *Marvel Mystery* #8 (June 1940), as water (the Sub-Mariner) took on fire (the Human Torch).

(TM & © 1998 Marvel Characters, Inc. All rights reserved.)

ended in 1949 with its 92nd issue, in which readers finally learned the identity of the villain on the cover of *Marvel Comics*.

Key issues: #1, first appearances of Sub-Mariner, Human Torch, and Ka-Zar; #4, Sub-Mariner's first cover appearance; #8, 9, Sub-Mariner vs Torch battle issues; #13, first appearance of The Vision; #21, first appearance of The Patriot; #30, Remember Pearl Harbor; #36, Invasion of New York; #46, 63, Hitler covers

Alex Schomburg covers: #3–11, 13–25, 27–29, 33–36, 39–48, 50–60, 62–69, 71, 74, 76

Masturbation

Neil Gaiman is the first to admit that DC editor Karen Berger rarely censors him, but she put her foot down when he stuck an allusion to masturbation in a *Sandman* script.

"Neil," Berger explained, "there is no masturbation in the DC universe."

"And that," Gaiman said, "explains a lot of things about the DC universe."

Matheson, Tim

Long before he toga'd down in the movie *Animal House*, Matheson provided the voice of Jonny Quest in the Saturday morning cartoon. He also provided the pipes for Jayce in *Space Ghost*. And he ended up owning *National Lampoon* for a while.

Maurer, Norman

An artist with experience in both comic books and television, Maurer joined with his brother Lenny and Joe Kubert to produce the first American 3D comic in 1953.

Kubert and the Maurer boys—childhood friends—stumbled over the special effect while stationed with the Army in Germany. Intrigued, they worked up a model with pages of Kubert's *Tor* and Maurer's *Three Stooges* (Maurer was married to Joan Howard, Moe's daughter), then presented it to Archer St. John. "He said, 'Could you turn this [*Mighty Mouse*] into 3D?'" Kubert recalled. "Sure we could. And 72 hours later, without sleep . . ."

For Charles Biro, Maurer drew Crimebuster, Daredevil, and Iron Jaw as well as stories for *Crime Does Not Pay*. By the end of the 1950s, he was working in Hollywood, writing, directing, and producing such movies as *The Three Stooges Meet Hercules* and *The Three Stooges in Orbit*. He then moved on to TV, doing Saturday morning Three Stooges cartoons.

Lung cancer finally killed him in 1986. "He smoked himself to death," Kubert said. "That's a pity. He was a certifiable genius."

Maxon, Rex

The son of a house painter, Maxon inherited his father's brush, slashing away at the daily *Tarzan* strip from 1929 until 1947. A graduate of the Chicago Art Institute, Maxon's first paying job was drawing shoes for $3 per week. He moved to New York in 1917, at the age of 25, and almost starved to death.

Maxon replaced Harold Foster on the *Tarzan* strip in 1929 and produced over 5,200 strips before making his break from the Lord of the Jungle to join Western Publishing, where, in 1954, he created *Turok* with Matt Murphy. He also drew western romances for Trojan comics in the 1950s.

Maxon died in 1973.

Mayer, Sheldon

Shelly Mayer fancied himself a cowboy, cartoonist Irwin Hasen said. "He came from Washington Heights, a middle-class kind of place, and he fancied walking bowlegged. He'd go down into the Village and drink most of the evening. He'd find a place where they all knew him and he'd walk in and say, 'Howdy, pardner, set up the drinks.'

"Most of these guys weren't businessmen, they were children."

The child in Sheldon Mayer was never too hard to find, bubbling up in such creations as Scribbly, the boy cartoonist; *Leave It to Binky*; and Mayer's best-known effort, *Sugar and Spike*.

Mayer went to work for Major Malcolm Wheeler-Nicholson at National in 1935, then joined M. C. Gaines the following year. He was crucial in convincing Gaines that the Superman strip that had been lying on his desk for weeks was just what Irwin Donenfeld needed to kick off a new action comic book. Mayer, some believe, may personally have cut up Siegel and Shuster's strip and pasted it into comic book form.

Mayer's first work appeared in *New Comics* #1. By 1939 he was a full-time editor at All-American Comics, managing—if not creating—their funny animal and humor books. He also had a fine eye for young talent: He hired

> "[Sheldon Mayer] came from Washington Heights, a middle-class kind of place, and he fancied walking bow-legged. He'd go down into the Village and drink most of the evening. He'd find a place where they all knew him and he'd walk in and say, 'Howdy, pardner, set up the drinks.'"
> IRWIN HASEN

Julius Schwartz in 1944 and, three years later plucked Carmine Infantino straight out of art school.

"Shelly was a jumping jack of enthusiasm zeal, and passion," Robert Kanigher wrote in the *History of Comics*. "He acted out all his fantasies. A born performer."

"A creative but overly eccentric genius," said Hasen, who considers Mayer his mentor. "If he didn't like your submissions, he'd fling the drawings about the room to punish you for engaging in mediocrity.

"He had a lot of contradictions. He was a tyrant in the office. He was a little boy. He had a little rabbit face. Everyone felt he was the boy genius of the comic book editors. He did indeed fashion and mold a lot of the comic book artists who came out of that era."

Hasen said he lost touch with Mayer in the final 20 years of his life "because he became a hermit, he went up into the woods." Hasen argues that "something snapped" for Mayer. "Shelly was offered a job by DC as an executive director, and he chose to do a cartoon strip that was so out of date. You know what this is sounding like? Rosebud. He kept doing this strip in the style of Ving Fuller, a cartoonist way before your waking hours. He was Ving Fuller and Milt Gross. They were the '30s. Sheldon Mayer had a snap in his psyche and wanted to remain there. He was the great young editorial genius and he decided to go up into the mountains and do his little cartoon, *Scribbly*. It was like going back into the womb."

Mayer died on December 21, 1991.

Mazzucchelli, David

He originally gained fame as the artist on two significant Frank Miller projects "Batman: Year One" (*Batman* #404–#407) and "Born Again" (*Daredevil* #227–#234).

"When you're drawing, you're able to turn the whole world on its end, to flatten things out to make things huge, to bend the line in any number of directions," Mazzucchelli once said. "You can create a new reality . . .That's why I find an artist like Chester Gould so exciting. When he created a character, he wasn't reacting so much to what he saw when he lifted his head from the drawing board as to what he saw when he put a mark down with a pencil or a brush. That's how you create characters like Flattop or Pruneface. You see the marks that are going down on that paper, and you make more marks, and you play off those marks, and you've got a reality that exists and works in and of itself. And if you make that reality coherent and believable, then you don't have to be bound by the laws of what we see in our everyday lives.

Mazzucchelli left the world of mainstream comics to concentrate on his own personal projects that have won him acclaim and awards sans Frank Miller. His self-published anthology *Rubber Blanket* (produced with his wife, Richmond Lewis), his stories in *Drawn and Quarterly,* and his art for *Paul Auster's City of Glass* have established him as one of the influential graphic storytellers of the 90s.

McCay, Winsor

> *McCay and I served the same master, our child selves. We both drew not on the literal memory of childhood but on the emotional memory of its stress and urgency. And neither of us forgot our childhood dreams.*
> MAURICE SENDAK

It's impossible to do justice to the genius of Winsor McCay.

An art student at Ypsilanti Normal and a poster painter for Kohl and Middleton's Vine Street Dime Museum in Cincinnati, McCay first found his stride with *Tales of the Jungle Imps by Felix Fiddle,* which first appeared in the *Cincinnati Enquirer* in January 1903. From "How the Lion Got His Roar" to "How the Alligator Got His Big Mouth," each tale detailed the unique transformation of an animal to keep pace with Mother Nature.

Although Sheldon Mayer's greatest contribution to comics may have been behind the scenes as an editor, he is best known to fans as the cartoonist behind the irrascible Sugar and the gullible Spike.
(© DC Comics, Inc.)

How could we pick a *Little Nemo* page? All of Winsor McCay's strips were beautifully rendered and colored and must really be seen full size to be appreciated.

McCay's fun and games with panel construction caught the eye of James Gordon Bennett, Jr., who hired him at the *New York Herald*. Bennett could never complain about McCay's productivity. First out of the cartoonist's bag was *Hungry Henrietta*, followed by *Little Sammy Sneeze*, and, on September 10, 1904, *Dreams of the Rarebit Fiend*.

The indigestion wrought by Welsh rarebit sent McCay's heroes on surrealistic adventures, such as the page in which a disgruntled suitor complains to the lady at his side that she is a puzzle, even as she splits and divides into hundreds of pieces. "A conundrum—You are a puzzle!" the suitor concludes. "Oh! I'll never put you together!"

Dreams of the Rarebit Fiend was a marvelous achievement, but McCay topped it when he allowed a child to pilot the dreamboat in *Little Nemo in Slumberland*.

Debuting on October 15, 1905, *Little Nemo* was a strip of unlimited fantasy and possibility. Time and space were no barriers to McCay's dreamer or his dreams; every panel exhibited the artist's passion for his pen. "He employed architectural perspective in more accurate and inspiring a fashion than any comic artist before or since," Thomas Inge has written, "whether he is providing a baroque palace as an incidental background, sending Nemo and his companions off to investigate the awesome interior of a massive palace, or portraying with incredible accuracy what New York must have looked like from hundreds of miles in the air from a spaceship."

Adds historian Judith O'Sullivan, "Much of the imagery of *Little Nemo* is borrowed from the art nouveau vocabulary. Peacocks, lilies, swans, and water flora abound. Elements of the traditional fairy tale are also retained, exemplified by the old king with his beautiful young daughter (as in the tale of King Midas) and the contest in which the young man must test himself. Added to this vocabulary and contest is personal imagery derived from McCay's association with carnivals and the dime museum: exotic animals, clowns, performers, and freaks. In several aspects, McCay's vision anticipates Surrealist explorations: appearances are unstable, nature is hostile, objects come together in irrational conjunctions, mechanical devices are frequently threatening. In these fantasies, McCay creates an alternate world in which the unexpected is ordinary, and from which the mundane is excluded."

By 1910 McCay had a vaudeville act and was spinning out animated cartoons; *Little Nemo* was released in 1911, *The Centaurs* in 1913, and *Gertie the Bashful Dinosaur* a year later. O'Sullivan notes that these "animal features are fantastic, as are the dragon in *Little Nemo* and the protagonists of *The Centaurs*; microscopic, as is the main character in *The Story of a Mosquito*; extinct,

as are Gertie and her friends. These protagonists were intentionally chosen to avoid the charge that the motion created within the animation was based on transcription of photographs . . . By inventing animals that never existed, or by approximating the motions of insects too small to study, McCay demonstrated his understanding of the principle behind all motion while at once displaying his vast imaginative ability."

To the bitter end, McCay wanted everyone to know he was an original. And the end came far too soon: The cartoonist was slowing down by 1915, and spent the rest of his days as an editorial cartoonist.

McFarlane, Todd

You've read Calvin & Hobbes. Just tell people that Calvin did not get killed by the bus driver for driving him crazy, he actually grew up to be 30 years of age and changed his name to Todd McFarlane. That's me.

Todd McFarlane always wanted to be a baseball player. He wasn't built for baseball—"That first year I played, I got no hits: 0 for 44"—but he was built for speed. "I could outrun anybody," he said. "Never lost a race in my life. I could steal bases. I was fast and I was left-handed, and that carried me a long way."

It carried this Canadian kid to a scholarship at Eastern Washington State College and a free-agent tryout, but he never planned on it carrying him all the way to the Big Time. "Early on, I knew the odds of ever playing major league baseball were minute," he said. "As much as I wanted to be a ballplayer, you come to grips with that. You figure the odds. The odds are stacked against you. Instead of being stupid about it . . . and a lot of my buddies, unfortunately, were stupid about it: They wouldn't go to class, they wouldn't do their homework, because they were going pro. You're a frustrated athlete if that's all you wanted to be. I had other things I wanted to be in my life."

He wanted to reach the Big Time in comics, and he did it his way. What bothers so many people about Todd McFarlane is that he never seemed to break a sweat. One minute he was adding a few strands of spaghetti to Spidey's web, the next he was co-founding Image Comics and clearing a million bucks off *Spawn* #1 and sinking it into cartons of hockey cards. He never had to pay his dues, they whined.

Todd McFarlane

FAN MAIL

After a 1988 convention in Singapore, Todd McFarlane and Mike Grell agreed to an interview with a group of marauding Malaysian journalists at the artists' hotel. Unfortunately for McFarlane, the reporters first stopped off at Grell's room. At midnight, McFarlane was still waiting, so he called over to Grell's room, told him that he was going to leave his door unlocked, and asked him to tell the Malaysians to wake him up when they came by.

Hey, he wasn't famous yet.

They stumbled in just after 2:30 A.M. and led off with a simple request: One reporter asked McFarlane to get dressed so they could take his picture.

"Buddy," McFarlane said, "I am not getting dressed at three in the morning. But here's what I'm going to do. I'm going to sit up, you take a picture. Here's the white wall. I'll give you a smile, you crop it at the neck ram it in there and we're done." Two minutes later, the reporters were done and hustled out. The night was still young.

A month later, letters began to arrive at McFarlane's home on Vancouver Island. "They were proposals to get married," he said. "Pictures of girls. 'I will cook for you.' 'I'm a little bit overweight, but I would be glad to lose 20 pounds.' 'I'm 19 years of age, here's my picture . . .'"

McFarlane's wife was not amused. It was another month before someone sent McFarlane a Malaysian newspaper article that helped him figure it out. "What they had done—bless those people—was take the photo of me in bed . . . and never cropped it. And I sleep in the buff," he said. "I'm sitting like this, and the blanket is down to my crotch, and I'm naked, looking like I'm out of *Playgirl*."

And that wasn't all. In the story, McFarlane was described as having a seven-figure salary—"At the time, I wasn't even making six"—and the readers were handed his home address.

"I finally got it: There's Todd, GQ, half-naked. I'm sure every dad in Malaysia was saying to his daughter, 'America. Visa. America. Money. Visa.' All these women. They were all going to cook and clean and lose weight for me. God bless those people."

Todd McFarlane's *Spawn* has been consistently in the top-ten selling comics since the first issue came out in 1993.
(© Todd McFarlane)

What did he do but pic Marvel's flagship for a couple years before he started demanding "respect"?

"I was very talented, I was a trailblazer and I was a bleepface and an asshole. To me they're all the same thing," McFarlane told *The Comics Journal*. "I wear all those names with a badge of honor. It's a lot better than being afraid, or being content."

In his 1992 interview with the *Journal*, McFarlane had a grand time jerking Gary Groth around, continually gosing Groth with his moral insipidness. Groth always figured he'd bow down and worship the artist/creator who could bring Marvel to its knees, but he found himself in a philosophical duel with an unarmed man.

The vaunted principle of his rebellion against the companies? "I look at it this way," McFarlane said. "I quit a couple months ago, I was doing a monthly Marvel comic book. If Image falls flat on its face, I'm good at groveling, I can go back there and I'll be doing a monthly Marvel comic book or a DC monthly comic book. I haven't lost one thing."

His training regimen for writing *Spawn*?

"I don't read anything . . . I can't read black and white, other than the box scores. I just don't have that mentality. I've got to have pictures in front of me. I don't read comics! I don't read nothing really . . . I don't read *Sports Illustrated* because the articles are too long."

His quest to produce a better comic book?

"[D]oing something better, and it happens to be comic books, is not all that big of a thing to me personally. Could I turn out a better comic book? Yeah. Would it make a difference? If I got a better writer, would that make you any happier? . . . I doubt it, and it probably wouldn't affect the sales one iota, so given that it's not going to make you any happier, and it's not going to make the kids any happier, and it sure as hell ain't going to make me any happier . . . why go to that level, then? It's not going to do anything, really. It's just going to be better for better's sake, but it doesn't keep you happy, it doesn't solve your problem, it doesn't solve the kids' problems, it doesn't solve my problem."

What is this guy's problem, you ask?

Playing dumb. Remaining oblivious. Laughing all the way to the bank.

Since his first work for Marvel—*Coyote* #11—in 1985, McFarlane has been to the bank and back several times. He needed Roy Thomas's help to get inking jobs on *Infinity, Inc.* in those early years, but McFarlane's art was speaking for itself by the time he took on *The Incredible Hulk* with issue #330 (April 1987). A year later, he was all over *The Amazing Spider-Man*, beginning with #298, and gaining the popularity with fans that didn't sit well in a Marvel galaxy where the characters were the brightest stars.

When Marvel sold, on the strength of McFarlane's appeal to both the collector and speculator market, three million copies of

Spider-Man #1 (August 1990), McFarlane was getting rich and feeling stiffed. He wanted control at a time when Marvel "wanted to pull back on the leashes on everything. The looks of the book, the qualities of the book, the characters that were coming in, how you portrayed the characters." He said two incidents finally inspired him to quit: the birth of his daughter, Cyan, and a clash with his editors over *Spider-Man* #16.

McFarlane was particularly miffed that he was ordered to redraw a panel in which he stuck a sword in someone's eye. That Comics Code violation (see **Injury-to-the-Eye Motif** entry), a throwback to the Fifties, infuriated the artist: "I didn't put the sword in the eye because I'm vicious, I put the sword in the eye out of ignorance," he told his new editor, Danny Fingeroth. "I didn't know I couldn't do that. Now, I'm making a stand that I'm not going to change that panel because you guys never told me I couldn't do it. I'm getting tired of making arbitrary changes."

And he had no patience with Fingeroth. "I could not work with this man," McFarlane said. "I had worked on *Spider-Man* up to that point for 40 issues. I built the *Spider-Man* energy up. This guy jumps in there and starts editing. I'm saying, 'No, if it ain't broke, you don't fix it. I don't take orders very well. He came in and started playing editor. I said, 'No, this is how I do it, you just leave it alone, this is how it works. Who are you to come in here and tell me how to do a comic?' I'm not going to listen to a guy younger than me. And I'm not going to listen to a guy who's never sold a comic book. You sell a million, I'll listen to you."

McFarlane has a mouth built for speed, and for years those who took him too seriously foundered in his wake. Whenever he put pencils and inks to paper at Image, he sold a million, then mocked those who thought he should have a higher ambition than being successful. McFarlane may be an asshole, as he'll be the first to tell you, but he's also a very talented trailblazer who knocked the comics industry on its butt.

McManus, George

He had just recently graduated from the art department broom to a comic strip fit for the dustbin—*Alma and Oliver*—when George McManus sat down to get his shoes shined in the lobby of the *St. Louis Republic*.

The bootblack informed McManus that Hamburg Belle, a longshot running at 30–1, planned on winning the Futurity that afternoon. On a hunch, McManus scraped together $100 and placed the bet.

His $3,000 winnings financed his exodus to New York where McManus caught a job with the *New York World*. After a half-dozen strips, McManus struck it rich with *The Newlyweds*. The strip was the cartoonist's ticket to the Hearst papers, for whom he created his magnum opus, *Bringing Up Father*, in 1912.

McManus ended up fat, happy, and chewing on a cigar in southern California. The whereabouts of the bootblack are less certain.

Meet the Press

Because reporters and photographers can disappear for hours—whether on assignment or into a bar—with no questions asked, the newspaper office has long been a popular hangout for comic book characters anxious to make an honest living.

The Daily Star, The Evening News, The Daily Planet: Clark Kent worked for them all. And, of course, Clark's best-known co-journalist at the

McManus made imaginative use of the comic strip medium.
(© King Features Syndicate)

Planet for some 60 years has been the intrepid Lois Lane.

Beginning in *Sensation* #97, Wonder Woman worked ever so briefly as a romance editor for the *Daily Globe*, following in the journalist footsteps of such comic strip heroines as Brenda Starr, Debbie Dean, and Jane Arden.

Scribbly, Sheldon Mayer's alter-ego, first appeared in 1930 in his role as a newspaper cartoonist. Peter Parker? He sold his first photographs (of the Vulture) to J. Jonah Jameson at the *Daily Bugle* in *Amazing Spider-Man* #2. And don't get us started on the Newsboy Legion, lurking down in Suicide Slum . . .

Meskin, Mort

Mort was a wonderful cartoonist, one who's been sadly neglected by history.
JERRY ROBINSON

Mort Meskin's art (here for a Vigilante story) is easily recognizable by his use of round panels and figures intruding from panel to panel.
(© DC Comics, Inc.)

Mort Meskin's lot was not an uncommon one: His peers were bigger fans than the fans were. "No inker of Mort's fine pencils ever altered the character of his work," Alex Toth once observed. "And Mort enjoyed the best of the lot at DC—Joe Kubert, Jerry Robinson, and George 'Inky' Roussos."

Meskin was, Toth said on another occasion, "a design genius. [He] used to smudge up an entire page blank with soft pencil lead, black or blue, and then pick out panel breakdowns, and figure shapes within them, with a kneaded eraser. Thus, he worked from dark to light, picking out white silhouettes of all his pictorial elements. Lovely. I tried it for a while . . . without much success."

Meskin broke in, at the age of 22, in 1938, drawing Sheena for the Eisner-Iger shop. Robinson—who shared a studio with Meskin and Bernie Klein—soon got him a job at DC, where he drew Johnny Quick, Starman, and the Vigilante, among others.

"Mort was the most accomplished artist at the time," Robinson said. "He was the only one who had really studied art, a graduate of Pratt Institute. If I couldn't figure out something anatomically, I would ask Mort; his usual reply was, 'Well, work it out.' But I learned a lot from just watching his drawing. He was very influential at the time."

"His employment at DC was, however, interrupted by occasional interludes in mental institutions," Joe Simon wrote in *The Comic Book Makers*. "He claimed that this was a natural extension of his comic book work, and there came a time when he had difficulty in differentiating reality from his comic book drawings . . . There came a time when he could no longer function as a comic book artist. He was in such a condition when he came to our Crestwood office, out of work, out of hope, and nearly out of funds."

Simon added that Meskin couldn't face a blank page; he was so incapable of scratching the surface of a clean slate that someone would come into the office each morning, scrawl some "meaningless lines and circles on a blank page," and get Meskin moving.

Between DC and Crestwood, Meskin and Robinson teamed up for the only decent art to be found in *Black Terror* and *The Fighting Yank*. After those and the other super-heroes died,

Meskin dabbled with various genres in the 1950s and backup features for DC in the 1960s, then bailed out, disappearing into television and advertising.

"His meaning and intellect were not given the editorial, environmental, or fiscal appreciation due him," Toth wrote in *History of the Comics*, "and so, as in so many other cases in our curious profession, he was distressed enough with it until his only solace was to leave it—and so he did."

Meskin died in 1995.

Messick, Dale

Dale Messick has a simple way of remembering the year Hollywood made a movie out of *Brenda Starr*: "Brooke Shields was 20 and I was 80," she said. Hollywood never asked Messick for help on the film and never flew her to one of the countries where it hit the silver screen. "But I've heard reports," Messick said, "that they depict the cartoonist at the beginning of the movie drawing *Brenda Starr* and that cartoonist is a man."

A man? It figures, doesn't it? Dalia Messick never would have gotten her foot in the door at the *Chicago Tribune* if she hadn't de-gendered her name and made 'em think she was a man. And as she was exiting her 80s, she was still contending that the Tribune–New York News syndicate never forgave her for being female.

"They treated me very badly," Messick said, "and when I write my autobiography, I'll tell it like it is. I was never recognized or given anything. If I hadn't had a husband who was an attorney, they wouldn't have given me a pension, and I devoted 43 years of my life to *Brenda Starr* and never missed a deadline. In recent years, I've become very bitter about the whole thing. They really did me in."

Financially, maybe, but not spiritually. Nothing ever bruised, much less crushed, Messick's spirit. Ten years after the syndicate forced her to retire, at the age of 75, Messick was juggling three boyfriends. "At our age," she said, "it takes three to make one good date."

Born in 1906, Messick was drawing long before she was dating, but was dating long before she started getting paid a decent wage. A 1951 promo piece in the *Chicago Tribune* reported that after leaving the Art Institute in Chicago, she got a job in an engraving plant, painted names on motorboats, and she painted lovely scenes on spare tire covers of oilcloth for a soft drink firm. None of these pursuits seemed very fascinating, so she started designing greeting cards. When one card sold a million copies and she didn't get a dime of bonus, she quit."

Brenda Starr debuted "full-grown, beautiful and bosomy," (said the *Tribune*) as a Sunday strip on June 30, 1940. The artist lobbied for years before she got the strip accepted. Messick first cast her comic strip heroine as a bandit, then recast her as a reporter, naming her star after Brenda Frazier, the era's leading debutante.

Week after week, year after year, Messick and *Brenda Starr* rolled on. "What made her popular was that she was every young girl's idea of what was wonderful and glamorous," Messick said. "She could be in a fire, or under the seat, and she'd come out and her hair was always gorgeous. And every little girl wants that."

Although Messick continued to draw Starr's amazing wardrobe and the paper-doll cutouts that ran with the strip for years, she had assistants drawing much of the action by the early 1950s.

Mike Grell came on board in the early 1970s. "Dale Messick set the stage for a lot of people who followed in her footsteps," Grell said. "This was the last great male bastion. She was quite put out that the National Cartoonists' Society was a bunch of old fuddy-duddy men who were only interested in her because she was cute. And she was gorgeous. It was very difficult for her to overcome with talent that tremendous beauty. She was extraordinarily pretty, and it was hard to get around that."

> **Memory**
>
> *Comics as a medium do not have an institutional memory. It has a lot of creators who imprint on the medium at a certain time, and want to recreate that time. You have a constant succession of recidivist historians. But the industry has always felt that the audience leaves every three years anyway. If you redo everything every four years, no one notices.*
>
> CHRIS CLAREMONT

Dale Messick

"I was never recognized or given anything. If I hadn't had a husband who was an attorney, they wouldn't have given me a pension, and I devoted 43 years of my life to **Brenda Starr** *and never missed a deadline."*
DALE MESSICK

Grell could relate: "She's one of the sweetest, most charming, vivacious people I've ever met. A living doll. If she had been a few years younger, or I a few years older, I would have found her completely irresistible."

Twice divorced, Messick has a home on a Santa Rosa, California, golf course. She is working on her autobiography (*Still Stripping at 80*); "Granny Glamour," a one-panel cartoon; and whatever catches her fancy. "I still like to get out and sashay around, wear pretty clothes and go dancing. I can travel just about everywhere and say I'm a half-assed celebrity, because nobody knows me and everyone knows Brenda. But I don't figure-skate anymore. It's kind of sad when your spirit is willing but your body is weak."

Metal Men

Created by Robert Kanigher, the Metal Men first appeared in *Showcase* #37 (March/April 1962). The charter robots were Gold, Iron, Lead, Mercury, Platinum, and Tin. Doc Magnus was the convenient scientist who pieced them together.

Kanigher zipped out the 23-page story one weekend when DC was shy one *Showcase* story. Thirteen months later, the robots had their own magazine, produced by Ross Andru and Mike Esposito.

In *Metal Men* #2, our heroes fought Aluminum, Barium, Calcium, Plutonium, Sodium, and Zirconium.

Metal Men #21? The plastic perils of Ethylene, Methacrylate, Polyethylene, Silicone, and Styrene.

Dave Barry thinks we're making this up. No, just remembering DC in the Sixties.

Metamorpho

Metamorpho, the Element Man, "The Fab Freak of 1000-And-1 Changes," first appeared in *Brave and the Bold* #57. Ramona Fradon drew the early stories for this "normal, green-blooded, all-American freak," who turned chemical whenever the criminal element got a little out of control.

Mickey Mouse

The crown prince of the Disney empire, Mickey first appeared in a 1928 cartoon, *Steamboat Willie*, which opened November 18 at the Colony Theater in New York. *Steamboat* was actually Mickey's third cartoon to be made, but unlike the other two, *Plane Crazy* and *Gallopin' Gaucho,* it had a synchronized soundtrack.

Walt Disney conceived the character on a plane ride from New York to Kansas City. "Walt had lost his creation, Oswald the Rabbit, to Universal Studios, so he began searching for a new character," said Floyd Gottfredson, who drew the Mickey Mouse comic strip from 1930 until 1975.

"He thought of the idea of a mouse, and made all the preliminary sketches. These were somewhat stilted by nature, and it was Ub Iwerks, Walt's top animator, who designed him and gave him the appearance the world was soon to know."

As for Mickey's popularity, Gottfredson quoted Disney as saying, "Sometimes I've tried to figure out why Mickey appealed to the whole world. Everybody's tried to figure it out. So far as I know, nobody has. He's a pretty nice fellow, who never does anybody any harm, who gets into scrapes through no fault of his own, but always manages to come up grinning. Why, Mickey's even been faithful to one girl, Minnie, all his life. Mickey is so simple and uncomplicated, so easy to understand, that you can't help liking him."

Metal Men was one of many series launched in *Showcase* in the mid-1960s. This issue (#20, June/July 1966) sports the ever-popular "go-go chex," DC's attempt at being hip (hey, the *Batman* TV show was going strong at the time).
(© DC Comics, Inc.)

In 1994 Steve Geppi presented the Museum of Cartoon Art in Boca Raton, Florida with Iwerks's original drawings of Mickey and Minnie, which were valued in excess of $5 million.

Midnight

Created by Jack Cole, Midnight first appeared in *Smash Comics* #18 (January 1941). Ten months later, the detective and his talking monkey, Gabby, grabbed the cover of *Smash* and held on to it through the rest of the run—68 issues all told.

Cole did most of the interior art on Midnight, who was clearly inspired by Will Eisner's Spirit, while Gill Fox, Alex Kotzky, and Reed Crandall took turns working him over on the covers.

The Mighty Crusaders

One of the first signs that the Silver Age was showing its age was Archie Comics's foray into super-hero teams.

In 1959 MLJ had hired Jack Kirby and Joe Simon to revive its super-hero line, beginning with the reintroduction of the Shield in *The Double Life of Private Strong* in June 1959, followed by *The Fly* #1 (August 1959). *The Jaguar* soon followed, but all three books were scrapped by 1965, when the Mighty Crusaders arrived.

Chronicled by Jerry Siegel, who was also showing his age, the squad—the Black Hood, the Shield, the Comet, Fly Man, and Fly Girl—first stumbled into action in *The Mighty Crusaders* #1 (November 1965).

Will Murray conjectures the team may have been inspired by a letter from Paul Seydor in *Jaguar* #8. Seydor suggested a team of the Archie Adventure characters called the Anti-Crime Squad.

Mighty Mouse

Originally a spoof of Superman—which explains his original tag, "Super Mouse"—Mighty Mouse was the premier character to leap off Paul Terry's drawing board. Animator Izzy Klein first conceived of the character as a fly, but Terry changed him to a mouse and unveiled him in a 1942 cartoon called "The Mouse of Tomorrow." Renamed "Mighty Mouse" two years later, the mouse reached the comics in 1945 (in *TerryToons* #38), but made his biggest mark in print when he starred in the first 3D comic, *Mighty Mouse 3-D* (September 1953). Produced by Joe Kubert and Norman Maurer the book sold out its initial print run of 1.5 million copies. Mighty Mouse, however, remains best known in his animated version, which invariably featured Pearl Pureheart, Oil Can Harry, and the theme song, "Here I Come to Save the Day."

Mile High (Edgar Church) Collection

The telephone call that changed Chuck Rozanski's life—and the comic collectors' market—came in 1977. He won't say who called, whether it was Edgar Church's wife, Helen, or his son or his daughter or one of the grandkids, but they wanted Rozanski to come out to their Denver home and look at some comic books.

The comics, all 18,000 of them, were in a 6-foot by 8-foot closet in the basement. They were stacked in relatively neat piles, stacked in the order they were bought, most of them unopened. In one pile or another was an untarnished, untouched, unblemished, unbelievable copy of almost every comic book published between 1939 and 1953.

And they were for sale.

Rozanski's mouth went dry; that much we can assume. But what went through his mind?

Alex Kotzky's cover for *Smash* #45 employs Midnight but evokes the Spirit.
(© Quality Comics Group)

The cover of Rozanski's Mile High catalog displayed artwork by Edgar Church himself.

Stacked in that Denver basement was every collector's dream. The fruit of a time capsule.

Did the mother lode conjure up the phrase "pedigree books" and the concept of triple Guide? No, that stuff was still months or years away. But Rozanski must have known there would never be another moment like this, another such ransom. Did he wonder if he could fit all the boxes in the back of his truck? How in the world did he come up with an opening bid?

In the last 20 years, Rozanski has kept his mouth shut about the books of Edgar Church. You can hardly blame him. "It's a tough situation," said Ernie Gerber, who would later buy thousands of the comics and make tens of thousands reselling them. "Here's a perfectly honest gentleman who ends up getting a multimillion-dollar collection for not very much. He's faced a lot of envy and criticism. Visualize going into a room filled with 18,000 mint comics from 1939 to 1953. You know instantly when you go into that room what the value is. And the people who want you to buy the comics don't know the value. You're in a delicate situation. What do you say to them? What do you do?"

Chuck Rozanski says that he handed the family a copy of the latest *Overstreet Comic Book Price Guide* and said, "Here's what they're worth."

And the Churches said . . .?

A shrug. A sigh. Rozanski wasn't the first dealer they'd called about the old man's comic books, but he was the first one willing to journey out to see them.

"They said, 'We want to do this deal with you,'" Rozanski said. "'We want the deal to be discreet. And what you end up getting out of them, we don't really give a damn.'"

They didn't want a lot of money, Rozanski said, and they didn't want a story in the *Denver Post*. Edgar Church, after all, was 94 and still ticking, living out the final year of his life down at the Iliff Nursing Care Center on East Iliff Avenue. Maybe they didn't want him to know what became of the treasure he'd hidden in the cool darkness of that basement.

Back in 1977, however, Rozanski told a slightly different story about the Church books. And one of those he told it to was an old friend named Jack Dickens.

Dickens knew Rozanski quite well; he'd worked for him back in 1975, laboring without pay to learn the business. Rozanski owed him a favor, and when they met at Casual Con in Anaheim, less than a month after Rozanski had stepped into the Church basement, Rozanski squared things by handing Dickens—a huge Bill Ward fan—a mint run of *Torchy* #1–#6.

Then he regaled Dickens with the tale of where the books had come from.

As best as Dickens could remember 17 years later, Rozanski said the Church heirs came looking for him as Edgar's estate was headed for probate. "They were going through the house to inventory the stuff," Dickens said, "and they discovered this stuff in the basement. [The books] weren't listed, so their idea was to get rid of them before it got listed for probate. And they wanted cash."

When Dickens asked which books were part of the collection, Rozanski said, "Name a title."

Action? "A run starting from 1," Rozanski said.

Adventure? Detective? "Every question had the same answer—'A run starting from 1'—so I stopped asking the question after awhile," Dickens said.

Dickens, who would later operate San Diego's Comic Kingdom, said the Churches did not have a price in mind for the 18,000 comics. When they asked Rozanski what the books were worth, Dickens said, "Chuck was very careful. 'Well, they're worth something,' he said."

"What can you pay for them?" the Churches asked.

Again, Dickens said, Rozanski measured his words. He didn't want to give away too much, and he didn't want the words to ever come back and haunt him.

"I can only afford $50 a chicken box," he said.

The chicken box, a familiar carrier for comics before the mylar revolution, was made of double-corrugated cardboard. It had waxed handles, was specially designed to distribute the weight, and could hold 500 comics.

In other words, "$50 a chicken box" worked out to cover price on these 10-cent Golden Age books. "But they saw these chicken boxes adding up," Dickens said, "and they wanted cash . . ."

The cash they wanted was in the neighborhood of $1,800. Rozanski didn't have the cash in his pocket, and the Churches wondered aloud if they should call in another Denver dealer, one of Rozanski's chief competitors.

Once again, Dickens said, "Chuck was very careful. 'Well, I've had dealings with him,' he said, 'and I really don't want to do that.'"

Rozanski needed a week to scare up the $1,800 out of the cash flow from his three stores. "He was really sweating bullets during that week," Dickens said, but if he was frightfully anxious until he loaded up his truck with mint and near-mint comics for the second and final time, he showed the Churches a poker face.

"I've always said to myself that he was meant to have those books," Dickens said. "He was able to stay calm. I know I'd have blown it. I would have been dazzled by the whole thing."

Not Rozanski. Raised by his mother, a department store buyer who lectured her son about the nuances of the deal every day at lunch, Rozanski had the ability to see the collection as the beginning, not the end, of the rainbow.

Once Rozanski got the comic books home, the thrill of finding them dissolved in the chill of what to do with them.

"When I found the collection, my wife and I were living in a small apartment," said Rozanski, who opened his first store in 1974 with $800 and 20 boxes of comics. "We moved all the books in. That was a tremendous security risk. We had to go and find a house and get an alarm system and transport all the books. It really disrupted our lives. It actually became a burden."

A burden, Chuck? "Okay, so it was a pleasant burden."

Rozanski had to share the burden; he couldn't afford not to. His original plan, Dickens argued, was to convert the Golden Age books into a healthy chunk of cash and invest heavily in Silver Age Marvels. With no cash flow to speak of, Rozanski needed some help to advertise the collection. Fortunately, he had sufficient collateral.

Bruce Hamilton and Burrell Rowe got the first crack at the Mile Highs. Rowe was at a convention in Houston in June when Rozanski arrived with most of the ECs. "The comics looked fake to me, they were so beautiful," Rowe said. "I bought all of those from him, and I was so excited looking at them, I called him back and asked him if he had any more."

Plenty more. Rowe and Hamilton—who would later team with Russ Cochran to open the Camelot comics store—flew out to Colorado to see the rest of the collection. Rowe bought most of the Fiction House runs. They each spent at least $10,000. "I offered him a quarter of a million for all of them," Rowe said. "That was quite a lot more then than it is now.

"He wouldn't take it. I thought that was foolish on his part. He was a much smarter businessman than I."

"Bruce and Burrell both offered to buy the whole thing in one shot and allow me to retire," Rozanski said. "Why? I was 21 years old then. What was I going to do?"

When Hamilton showed his cache to Gary Carter and his brother, who had almost a complete run of DCs, the Carters were dumbfounded. "We were so awestruck, we coined the term 'glow-in-the dark' mint," Gary Carter said. "I would have paid any price to get them." The Carters also flew to Denver to see the rest of the Church comics. The two brothers had spent years upgrading books in their collection, sometimes one quarter-grade at a time. Now, they sat in Rozanski's basement, fanning through a box of *More Fun*s so flawless, so beyond anything they'd ever imagined, and it brought tears to their eyes (see **We Just Know We Loved to Read Them** on page 317).

You had to see the books to understand, Gerber said. He had little patience with the Mile Highs until—it must have been 1986—he saw the *Jungle Comic* run from #1 to #55. "When you have a collection of comics, similarly marked, that came from the same collector, that was stored in the same place for all those years, that was purchased by the same collector, there's something a lot more than collecting

Chuck Rozanski

"After picking up that first Mile High collection, I was addicted for life. There are no others like that. One man collects 18,000 comics and never read a single one. All he did was buy them to store them away."
ERNIE GERBER

Rozanski's centerspread ad that ran in all issues of Marvel comics for September/October 1980.

(© Chuck Rozanski)

But only at prices that I feel will reward me for my efforts and loss…

"If you are a serious collector, I encourage you to look through my catalog. You will find books that have been unavailable at any price for years. The price will probably be higher than you had wanted to pay…

Much higher. And that's why, for an amazing chunk of time, most of the Mile Highs sat in Rozanski's vault.

Rowe took the ECs and Fiction House runs, the Carter brothers ran off with a bunch of the DCs, and unrelated books," Gerber said. "There's a magnetism. It came from a single human being. It's a preserved unit.

"After picking up that first Mile High collection," Gerber said, "I was addicted for life. There are no others like that. One man collects 18,000 comics and never read a single one. All he did was buy them to store them away."

To introduce the Church books to other collectors, Rozanski published a 52-page catalog in *The Buyer's Guide;* its "forward" contained the following:

Hello! My name is Chuck Rozanski and I own Mile High Comics.

I am very pleased to present to you the following catalog of Golden Age Comics… The catalog you are holding is an experiment. It is the result of years of accumulation and a great deal of luck. It is the finest collection of its size ever offered…

As a collector, I find it very painful to break up my collection, but as the years have gone by, I have become more and more enchanted with the idea of going national with my concept of the comic book store. I am now willing to make the sacrifice to do just that.

the rest of the collection?

"No one touched it," said Ron Pussell of Redbeard's Book Den. "At Guide-and-a-half, no one touched it. The dealers thought you had to be out of your mind to pay those prices.

"You have to understand what was hot and cold in comic books back then. When the Mile High collection was released, it was like *Action #1, Captain America #1,* who cares? Everyone wanted the good-girl art. They didn't care for super-hero stuff; they were trying to get out of Golden Age super-hero because it was dead. What Chuck was selling right away was *Attack on Planet Mars, Earthman on Venus,* that kind of stuff. Those books were in the Guide for about $20. They had enormous upside growth."

Jon Snyder made the first big move, swooping in to buy the Golden Age keys. When Pussell followed, he was stunned at what was available.

Batman? Almost the entire run from #2 up.

"*Captain America?* The whole run. Just sitting there. It wasn't in anyone's interest to advertise. 'You know the book you're trying to sell for a little bit over Guide? Well, you can get the finest copy available for Guide-and-a-half. The best there is. It's just sitting there.' We didn't want that published. It wasn't in the best

We Just Knew We Loved to Read Them

The first time Gary Carter ever emptied his pockets for a comic book, he walked away with *Showcase* #4. "The cover lit up the room," he said, and sent him bouncing off the walls. Two years later, in 1958, Carter and his brother, Lane, began to collect. "We never sold anything," Carter said. "We just amassed stuff. In those days comics were a nickel apiece. There was no such thing as condition. No one cared. We were just little kids. We didn't know anything. We just knew we loved to read them."

In the next 19 years, the Carter brothers first cleaned out the attics and book stalls of Coronado, California, then stripped nearby San Diego of every comic book that wasn't nailed down. They virtually completed each DC run. They thought they knew what a near-mint book looked like. They thought they'd seen everything.

But in 1977, the phone rang. Bruce Hamilton was on the line. He'd just picked up $10,000 worth of comic books from a gentleman named Chuck Rozanski and wanted to know if Carter wanted them.

"When we saw the condition of the books, we were blown away," Carter said. "Bruce came in and laid those books on our table. They were the best books we'd ever seen. Mind-boggling. We'd deluded ourselves into believing we knew what mint and very-fine were. We were so incredibly wrong. The Mile Highs straightened us out. This was what a mint book looked like. It instantly downgraded our collection of 13,000 books one full grade. One full grade. Boom boom boom."

The Carter's weren't content with the pile on their coffeetable. "We took one look at those books," Gary said, "and said 'We have to get more.' We found out that Chuck's ad to sell them was coming out the following Monday in *The Buyer's Guide,* so we had three days. My brother and I flew to Colorado with two empty suitcases and $44,000."

The $44,000 was what Carter cleared after mortgaging his home and borrowing every cent his father had. Carter converted the money into traveler's checks, only to find that Rozanski wouldn't accept them. He would, however, let the Carters have the books on credit.

"We went in there and cherry-picked every DC," Carter said. "We hit *More Fun, Detective, Action,* and *Adventure* first. Then, we went on to *All-American* and *Flash.* That's when we started running out of money. When you bought a key, it negated another 50 books you could get, so we decided to skip the keys. That was our strategy. Do you want the *Detective* 27 or 28 through 30? Do you want *Action* 1 through 10 or 11 through 100? That's the choice we made."

The comics were laid out on the floor of Rozanski's basement, piled in alphabetical order in wooden boxes. He had them on tables and underneath the tables. The basement was as big as the whole house, a four-bedroom, two-bathroom house, and the boxes completely covered the floor. There were more comics than he could fit."

While the brothers were in Rozanski's basement, their father called to say he'd raised another $5,000. And to spend it. He wanted to buy every nonmainline, weird DC title, such as *All-Funny* or *Mr. D.A.* For $5,000 Carter's father bought 20 boxes of books.

"We took the suitcases home with the mainline stuff," Carter said. "They weren't locked. And we had to check them. When one of the suitcases came down the luggage ramp, one of the clips was up and one of the books was hanging out. It was a high-number *Adventure,* 96 or 97. It didn't hurt the book. By the way, none of this stuff was in bags."

When the Carters got home, they had the $10,000 chunk, the $44,000 chunk, and the $5,000 chunk of the Mile High collection ... "and we still wanted more. We were hooked. Totally hooked. We looked at our existing collection and realized we had junk by comparison. We started dumping our lower-grade copies as fast as possible to generate cash. We wanted to catch up to Chuck at Casual Con in Anaheim."

The Mile Highs "changed our lives," Carter said. "A profound, inexplicable alteration of our life view. The word got around quick that we were buying [Mile Highs], that we were paying three times Guide. We got hate calls for two years, blaming us for buying into this sham that Rozanski was perpetrating on the market. People were so resentful that anyone would sell anything over Overstreet. We were nuts, or idiots, or in it with him somehow. I can remember my brother saying, 'It's been almost two years and people are still telling us how much they hate us.'

"Chuck probably had a million bucks' worth the first year, sold off half of it ... and the Guide went up and he still had a million bucks' worth the next year. And what was interesting was guys like me picked off the DC stuff and other guys picked up the Timelys. But when you go back and think about how much wonderful material there was... If I could go back and do it again, I wouldn't do it the same way. I would have picked off every single book that cost under $20. Hey, *Startling* 49 was $2. You could have had the Mile High for $6."

> **OOPS!**
>
> *I screwed up. I could have bought the Mile High* Flash *#1 for $500, but I said that was crazy. I was of the opinion that a book should be what it is because of its grade. I would get irritated: So what if it's mint? I can buy a mint* Flash *#1 for guide, why pay four times guide for a Mile High? The fallacy of my thinking is that there aren't any other mint copies out there.*
>
> KEITH CONTARINO

interest of the marketplace to let that be published, that the finest copies in existence hadn't sold."

Rozanski was undeterred. He argues now that he sold the books very slowly "for tax reasons," but clearly he had plenty of patience. The arrival of these gorgeous books on the market increased interest in high-grade stock, which made the rest of the collection more valuable.

"If you go back and look at the 1977 *Overstreet*, a comic in mint sold for twice the same comic in good," Rozanski said. "That's ludicrous. I knew it was ludicrous. My mother was a coin dealer. In the coin business, coins in mint sell for hundreds of times what an average coin will sell for."

When the books glowed in the dark, the prices began to rise. "For the most part," Rozanski said, "I sold the books from Guide-and-a-half to two times Guide." Profits from sales helped Rozanski challenge Phil Seuling in the direct market.

And they paid for an ad that Rozanski believes changed the course of human destiny. Or thereabouts.

"The first time I gave up a big batch of the key Mile Highs, the *Batman* #1, the *Whiz* #2, a bunch of the cherry books, was in early 1980," Rozanski said. "I flew to Steve Geppi's house and took him a big batch, in exchange for which I got $20,000.

"Those books today would sell for $300,000 or $400,000, but I would do the deal again in an instant. I sold those books for the purpose of prepaying Marvel Comics for a double-page ad in the September/October books.

"It was the first time that prices of back issues of Marvel comics were published for casual readers to see. The information hadn't gotten out; no one had bought a full page in the comics. I paid up front for the centerfold of June and July of the entire Marvel line.

"That first ad grossed $106,000 in the first 90 days," Rozanski said. "And it gave me a mailing list that was five times the mailing list I had prior to that. We went from grossing $1,000 a week to grossing $10,000 a week. That's the point at which collecting really took off. Those full-page ads introduced tens of thousands of people to the awareness that what they were reading was more than entertainment that they should not just turn around and throw away."

Almost 20 years after stumbling upon Edgar Church's collection, Rozanski believes that a creative work ethic, not a lucky find, is his legacy. By early 1995, several individual Mile High comics had sold for upwards of $100,000, but Rozanski proudly claims, "In all my sales of the Mile High books, I never generated even a million dollars."

When pressed to empty the vault of all the gorgeous details about Edgar Church and his deal with the Church family, Rozanski declines.

"No matter how I respond, I leave myself open to criticism," Rozanski said. "I would rather leave the situation in doubt. I promised I would be discreet about the deal, that I would reveal nothing, and I have been true to that. I said that I would keep my mouth shut. There are very few people that will promise to keep their mouth shut and keep their word."

Those 18,000 comic books speak volumes. For most collectors, a run of Mile Highs is the Holy Grail. "There is nothing in the entire world that compares to this," Gerber said. "Suppose someone next week uncovers a cache of 3,000 Rembrandts. That's what we're talking about. Every single solitary serious comic book that was ever published was stored—unopened and untouched—in a sterile, cool environment. It's so far removed from anything . . . except King Tut's tomb."

Miller, Frank

There's no one who can touch Frank in his evangelism on behalf of comics.
BILL SIENKIEWICZ

I lived only to kill the scum and the lice that wanted to kill themselves. I lived to kill so that others could live. I lived to kill because my soul was a hardened thing . . . I lived because I could laugh it off and others couldn't. I was the evil that opposed other evil, leaving the good and the meek in the middle to live and inherit the earth.
MICKEY SPILLANE, *ONE LONELY NIGHT*

Miller, Frank

He was reading Mickey Spillane when he was 13. And when he visited New York City for the first time in 1975 at the age of 18, Frank Miller came looking for Spillane, anxious to find his sin-scarred city, his heroes and villains, his blacks and whites.

"I arrived in New York with a bunch of sample drawings of crime stories, with these guys in trench coats with guns," Miller said years later. "And I was very quickly informed that the only thing anyone published was super-heroes."

Miller didn't retreat to his home state of Vermont. "I honestly felt," he said, "that I couldn't imagine living and not drawing comics. It's all I ever wanted to do."

Even if all he was doing was drawing men in tights. Even if, as he later told *The Comics Journal*, he went "for days without food, the whole down-and-out New York scene. Existing without a place to live. There were months of near-starvation. I really didn't know much of anyone in town, so it was pretty rough until I started working regularly."

Helping him find work—a few *Twilight Zone*s for Gold Key, *Weird War Tales* for DC, and Doc Samson for Marvel—was Neal Adams. In those early days, Miller would spend a week penciling a single page, trying to get comfortable with heroic musculature. "I learned a trick," he says now, "that amateurs never learn about drawing comics: Drawing is knowing what things look like. This sounds self-evident, but it's true. Neal would always preach that an artist knows how things work. He got me to investigate things much more thoroughly. It reached the point that I wouldn't dare to show him a chair that didn't look like a chair."

In 1979 Miller got his first shot at a regular series with *Daredevil*, a second-tier Marvel book. Almost immediately, he tried to give the art a film noir edge. He was still reading Spillane and Jim Thompson, studying Bernie Krigstein and Will Eisner, and planning crime comics. "That became my dream project," Miller said, "but I wasn't good enough. And the market was resistant to anything outside the mainstream."

When Miller introduced the character Elektra—an idea he admits "borrowing" from Eisner—in the first story he plotted, *Daredevil* #168 (September 1981), the market quit resisting. His writing and panel design turned *Daredevil* into Marvel's best comic for the next two years; his storytelling perhaps peaked in a seven-issue run (*Daredevil* #227–#233) in 1986.

Miller produced the *Ronin* miniseries for DC in 1983. "I hoped that book would be part of a trend in 1984," he recently said. "I had to be patient because the trend really started in 1994."

The Japanese-inspired *Ronin* had only marginal sales; Miller's next project changed the margins. In 1986 his four-part *Batman: The Dark Knight Returns* knocked the industry for a loop, re-creating the Batman character and setting the stage for a Batman revival at the movie box office. But Miller wasn't particularly satisfied.

"Real early on, I decided I wanted to be in command of the material, not just a hired hand brought on to kick something back into gear," Miller said at the 1994 San Diego Comic-Con. "I love working on the super-heroes, but you do get tired of doing CPR.

"After a while, I was feeling a bit like a grave-robber. I was working on characters that had been created by great talents two generations before mine. And I thought, 'If my generation is ever going to rise to the occasion, we have to stop strip-mining the past.'"

When DC began toying with the idea of a comics rating system, the game propelled Miller toward independence. He convinced Alan Moore and Howard Chaykin to join him in raising a ruckus until DC backed down.

"Of all the things I've been involved in, that may be the one I'm proudest of in helping to prevent disaster," Miller said. "It was the same damn way that everything wrong seems to happen in comics. Quietly, with no one talking about it. It is infuriating. For some reason public debate is seen as indecent in this field. The industry tends to wander into making big, stu-

Miller drew nationwide attention to Batman and to comics (and influenced filmmaker Tim Burton, among others) in 1986 with *The Dark Knight Returns.*
(© DC Comics, Inc.)

Frank Miller
(drawing by Nghia Lam)

Miller is having the time of his life writing and drawing various episodes in the chronicles of Sin City.
(© Frank Miller)

Millie was Marvel's longest-running title.
(TM & © 1998 Marvel Characters, Inc. All rights reserved.)

pid mistakes. That's how we instituted censorship in the '50s."

Even as Miller turned up the volume on the issues of creator freedom and artistic debt—particularly to Jack Kirby—he arrived at Dark Horse Comics and finally unveiled his dream project: Sin City, which debuted in *Dark Horse Presents* #51 (June 1991).

"I wish I had started Sin City sooner,' Miller said, "but Sin City never would have happened if I hadn't read Mickey Spillane and the great hard-boiled writers, and if I hadn't seen those great black-and-white movies, and eventually seen Johnny Craig's [EC Comics] work."

Once unleashed at Dark Horse, Miller formed the Legend imprint with several other writers and artists who were developing creator-owned properties. His collaborations under the Legend label have included *Give Me Liberty* with artist Dave Gibbons (and follow-up series starring that award-winning book's heroine, Martha Washington) and *Hard-Boiled* and *The Big Guy and Rusty the Boy Robot* with artist Geof Darrow.

In subsequent Sin City miniseries—including *A Dame to Kill For, The Big Fat Kill,* and *That Yellow Bastard*—Miller has continued to experiment with black and white, hoping to deliver his stories in a fashion that is both visually stimulating and economically feasible. More than 20 years after that first trip to New York, Miller is still drawing comics. And he's finally getting to do those crime stories that compelled him into comics in the first place.

Millie the Model

Millie the Model, Nellie the Nurse, Tessie the Typist . . . small wonder they'd one day call Marvel "The House of Ideas." Millie debuted in her own book in 1945. She held on that title for 28 years and 207 issues before the changing times decreed she was no longer a model for little girls. Millie had been Marvel's longest-running title when it folded.

Mills, Tarpe

One of the first, and best, female artists in the comics, Tarpe Mills got her start in Lloyd Jacquet's shop in 1938; three years later, she quit the field for the rewards of comic strip syndication.

"Tarpe Mills was that rarity—a female adventure strip cartoonist," Maurice Horn wrote. "Her heroine was a strong and often lethal woman, who never shrank from violent physical action."

Added Trina Robbins and cat yronwode in *Women and the Comics,* "Cartoonist Hilda Terry remembers Tarpe Mills as a beautiful woman who bore a great resemblance to her heroine, Marla Drake, and who had a fondness for high-heeled, ankle-strap shoes . . . Mills rarely drew costumed heroes, preferring to give her work a certain degree of adventurous realism. 'Jaxon of the Jungle,' 'The Purple Zombie,' and 'Mann of India' are wonderfully well drawn."

Mills's best-known heroine is Miss Fury, which began syndication in 1941 and kept food on Mills's table for almost a dozen years. Timely reprinted the strip in a book of the same name.

Mint

"Mint? It's a flavor," said Mark Wilson of World's Finest Comics and Collectibles. And Phil Seuling before him. More often, it's a myth. A figment of a collector's imagination.

"Mint" is supposed to mean the book is perfect. Flawless. Because it's not, the terms "gem mint" and "pristine mint" have been coined.

For the near-misses, of course, there is always "near mint."

The Minutemen

Shortly after the completion of the *Watchmen* series by Alan Moore and Dave Gibbons, DC's main editors went on retreat. The retreatees included Karen Berger, Mike Gold, Denny O'Neil, Mike Carlin, and Andy Helfer.

The brain trust returned with three "sequels" to *Watchmen:*

• *The Minutemen,* the story of the main characters during the war
• "The Comedian Goes to Vietnam"
• "Rorschach's Diaries"

When Barbara Randall (now Kesel), the editor of the original series, saw the plot outlines, she thought, "Bad idea, bad idea, bad idea."

Before any of the series could get up a head of steam, Randall engaged in what she calls "the only internal sabotage I ever did while I was on staff. I called Alan and Dave and said, 'This is what they're planning to do. I think you should call Jenette [Kahn].'"

They called. They complained. And *The Minutemen* were history.

Moldoff, Sheldon

An artist who was never afraid to sign his name, Shelly Moldoff is, curiously enough, convinced he never got proper credit for his two greatest achievements: ghosting Batman for 16 years and giving Bill Gaines the idea for the EC horror comics.

Before he disappeared behind the crowded curtain of Bob Kane's byline, Moldoff drew the Black Pirate in *Action* and *Sensation*, created the original Green Lantern cover for *All-American* #16, and put in major-league duty with Hawkman. Ron Goulart has a delightful way of describing how Moldoff paid homage to the likes of Hal Foster, Burne Hogarth, and Henry Vallely: "He was fond of adapting and modifying their panels to his own ends."

When Kane asked Moldoff to adapt and modify his style in a desperate attempt to make it look as bad as Kane's, Moldoff swallowed his pride and signed on. "At that point, it never bothered me," he said. "You were paid by the man to do the work for him. He had half a dozen [ghosts]. He had a girl making paintings up in the Catskills. Those things didn't bother Bob. He had a tremendous ego."

Moldoff dates his career with Kane to the removal of "The" from "The Batman," a deletion he suggested. "One day when I was over there, I said, 'Why don't you just drop the "the" and call him Batman?' That's the period when I was helping him." He was back helping Kane in 1953. "I would walk into DC—I was doing work for Julius Schwartz and Murray Boltinoff—and I'd see Bob come in with the pencils, and they were my pencils. I never said a word."

And what about the word he whispered to Bill Gaines?

Moldoff had known Gaines before Bill's father died, when Bill had no interest in comics. After M. C.'s funeral, Shelly said Gaines told him "his family was going to give him $150,000 to play with in the comic books. And if he could make it, he'd stay in the business; otherwise, he'd fold it up.

"I said, 'Bill, if I gave you an idea, would you give me a percentage of it?'

"He said, 'Absolutely.' I came back a little while later with the layouts of horror magazines. *Tales of the Supernatural. This Magazine is Haunted.*"

Moldoff—who drew the EC covers for *Moon Girl* #3–#8—said he even suggested an artist for the prospective books: Graham Ingels. "He had a free style. He used to pencil very loosely. He had a style that I thought was eerie and would be great for horror. I got it all set up."

Moldoff said he then got a lawyer to help draw up a contract with Gaines. "I helped him develop the first book. It was called *Tales of the Supernatural*. And I waited and waited and nothing happened. A couple months later, I walked past a newsstand and saw *Crypt of Terror* and *Vault of Horror*. I went down to see him and he said, 'I knew you'd be here.'

"I said, 'We had a deal.'

"And he said, 'I know, but I'm not using your book.'"

You must be kidding, Shelly said. It's my concept. Gaines demurred. Besides, he said, "I'm not paying percentages."

So, Moldoff said, "I called on my lawyer." I said, 'We signed an agreement with Bill Gaines, and now he's come out with these books.' He put his arm around me and said, 'Sheldon, chalk it up to experience. You don't have a leg to stand on.'

"I said, 'What about the contract?'

"He said, 'It doesn't mean anything. You can't do anything about it.'

"I said, 'Well, I'm going to do something about it.' And he said, 'If you do, I'll blackball you in the industry.'

"I was just a kid," Moldoff said. "I almost crapped in my pants."

Sheldon Moldoff

In addition to drawing numerous DC covers and stories, Moldoff drew the covers for six issues of EC's *Moon Girl*.

(© William M. Gaines, Agent, Inc.)

Another lawyer later told Moldoff the obvious: He should have jettisoned that first attorney. "There are many artists and writers who have the same story. There's a lot of that going on. If I had had my own lawyer, I would have been more specific on the first contract. I never went back and saw Bill again."

Montana, Bob

"John Goldwater claims the creation for Archie now simply because he asked Bob Montana to give him a character like Henry Aldridge," says Gil Kane, who joined MLJ at the age of 16. "Henry Aldridge was the leading teen character on American radio, played by an actor named Ezra Stone.

"Bob Montana created Archie; he wrote, he drew, he designed it. He did everything to set it on its course, then went into the Army after he created it and never came back to the comic book. But John Goldwater, for merely saying, 'I would like an imitation of Henry Aldridge,' claims creation. He didn't write it, he didn't draw it, he didn't do anything."

Montana was born in 1920 to a pair of vaudeville entertainers Fay Coleman and Roberta Pandolfini, a Ziegfeld girl. He wasn't yet in grade school when his parents changed their name to "Montana," hoping it would improve their son's chances of someday playing quarterback at Notre Dame.

When Montana was 15, his father died of a heart attack; he followed his mother and her new husband to Haverhill, Massachusetts.

"There Montana would spend what he later called the three best years of his life, at Haverhill High," Charles Phillips wrote in *Archie: His First 50 Years*. "In front of the school sat a bronze replica of The Thinker, not Rodin's (as would appear in *Archie*) but Michelangelo's *Il Penseroso*." Haverhill had a school paper called the "Brown and Gold," and the local hotshots hung out down the road at a place called "The Chocolate Shop."

Now, does this sound like the origins of a comic tale? Or do you prefer this "official" version:

The Archie Series was not just an "idea," it was the culmination of the experiences of the creator, John Goldwater, who hitchhiked throughout the country from coast to coast as a youngster, working as a farmhand, secretary and as a newspaper reporter in a small town in the Middle West, where eventually the Archie Series settled, Riverdale, USA.

… Superman actually was the catalyst for the concept of the Archies Series, which was born as the antithesis to Superman: normal, believable characters in contrast to someone having greater powers than ordinary men.

Montana went to Phoenix Art Institute and graduated to freelance work at MLJ, among others. His first Archie story, drawn on Vic Bloom's script, appeared in *Pep* #22. A versatile artist, he also did realistic art for titles such as *Crime Does Not Pay*.

Montana drew the Archie newspaper strip from 1946 until 1975, when he died of a heart attack while cross-country skiing.

Moore, Alan

We are to some extent in the wake of Alan: We are the Tremeloes and the Derek & the Dominos to his Rolling Stones.

NEIL GAIMAN, *asked why the British dominated American mainstream comics in the 1990s*

Bob Montana drew the Archie comic strip for 29 years.
(© Archie Publications)

"People would stop what they were doing when a [*Watchmen*] script arrived," Barb Kesel said, reflecting on her days at DC. "If anyone heard that a package had come with Alan's address, they were in my office, waiting for me to open it so they could photocopy it. If anybody heard there was a package from Dave [Gibbons], it was 'Open it right now.' When it was printed, it was almost an anticlimax. The excitement was the raw boards and the raw script. Not only was it wonderful, but you're seeing it first. People would crowd around and want to see those.

"Alan changed the role of the writer in comics," Kesel continued. "His script contains more than a complete story. You can read his script and get the full impact of the comic. With most writers, you tend to read the script and it's a framework for the artist to embroider on. There are certain of Alan's scripts where a single panel description will go on for two or three pages.

"He'll describe the mood, all the little elements in the scene. He'll talk about how the flowers are wilting because they've been left there for a day or two. He'll build every portion of the scene until you have the picture in your head so strongly that reading the comic is like seeing Shakespeare again."

Alan Moore didn't start with Shakespeare; he'd read Harold Robbins' *The Carpetbaggers* by age 10. "I was grateful for the Blake and the Shakespeare," he said much later, "but by and large most of the books that were later to form the foundation stones of my literary knowledge didn't come to me via school or via home."

Moore grew up in Northampton, the son of a blue-collar laborer. He was expelled from school when he was 17. "I was sort of mild-mannered, a relatively polite and orderly sociopath," Moore told *The Comics Journal*. "I don't think I could have been described as a delinquent. I didn't used to do a lot of drinking and hell-raising. I did the same amount of drinking and throwing-up that most teenage boys do."

After several years in the local Arts Lab, Moore said he "tended to just drift into whatever jobs were available that would pay the rent, which ranged from working in a skin yard ... which is where the animal skins go immediately after the slaughterhouse, which was quite an interesting job in its way, I suppose. That was quite grim and bleak; you'd have to get there at least half past seven in the morning and pull these sheepskins—about 50 sheepskins each—out of a huge, freezing cold vat of mingled blood, water and urine that they'd been soaking in overnight, and you've usually got a hangover. After that I became a toilet cleaner at a local hotel..."

Moore began to hit his stride in 1982, writing *Captain Britain*, *V for Vendetta*, and *Marvelman*. The following year, Dave Gibbons got a call from Len Wein at DC, asking him if he knew Alan Moore and, perchance, could lay his hands on Moore's phone number. "We think he may be able to do *Swamp Thing*," Wein said.

Good thinking. Moore wrote 44 issues. The series would knock the critics for a loop, but the book's sales figures weren't that impressive when Moore and Gibbons set to work on *Watchmen*.

"Alan and I were at the eye of the hurricane," Gibbons said. "Alan and I first met in 1980. He did some little filler stories for *2000 AD*. Just to keep a presence in the comics, I asked them if I could do these little filler stories. So I got a lot of Alan's scripts, which at that time were O. Henry type twist ending stories. We were on the same wavelength. We liked the same kind of comics. We had the same meticulous approach: Everything has to mean something."

Watchmen meant something. Not only that the super-heroes would never look the same, but that a lot of writers and artists could only aspire to someday producing the second-best series in comics history.

"I can write comics perhaps better than the majority of people can write comics," Moore said in his 1990 interview in *The Comics Journal*. "That's all, for all that's worth. Comics is hardly the field with the highest standards in

Alan Moore

THE ICE CREAM SHOP

They were sitting in an ice cream shop during a break in the San Diego Comic-Con when Len Wein held up a bulky script. "We just hired this new guy to write *Swamp Thing*," Wein told Mike Barr, Paul Levitz, Marv Wolfman, and Barb Kesel. "And he's doing better work than I could have ever done. He's embarrassing me."

Kesel has long since forgotten the store or the flavors, but she remembers Alan Moore's first script for *Swamp Thing*. "You have seminal experiences," Kesel said. "You know: After this, the industry changed. Here's the moment we all became aware that something had changed forever. There were four pretty good writers sitting there, realizing they'd just been made into dinosaurs."

> **MOST VALUABLE PLAYERS**
>
> The 1930s—Max Gaines
> The 1940s—Jack Kirby
> The 1950s—Bill Gaines
> The 1960s—Jack Kirby/Stan Lee
> The 1970s—Phil Seuling/Bob Overstreet
> The 1980s—Frank Miller
> The 1990s—Todd McFarlane

the world. It doesn't take a lot to be the best comics writer—or the second best or third best. It takes work, but it's still nothing that deserves the degree of idolatry, or that degree of contempt on the flip side."

Moore's recent work has centered on the award-winning *From Hell*, with Eddie Campbell, which was completed in 1996, and various projects for Image Comics, including recasting Rob Liefeld's *Supreme* as an Image version of Superman.

Moores, Dick

Best known for his artwork on the *Gasoline Alley* strip, Dick Moores assisted Chester Gould for five years on *Dick Tracy* before joining the studio of *Gasoline Alley* creator Frank King. Moores drew Disney's *Uncle Remus* and *Scamp* for 15 years before beginning work on King's daily strips. He also worked extensively in comic books, primarily for Dell, doing funny animals strips. He took over *Gasoline Alley* in 1980, at the age of 71, and the characters aged with him until his death in 1986.

More Fun Comics

This is one of the premier DC titles for Golden Age collectors. *New Fun Comics* became *More Fun Comics* with issue #7 (January 1936), 30 months before *Action Comics* appeared. The title is best known for the first appearances of The Spectre (#52) and Superboy (#101).

Key issues: #14, first color appearance of Siegel and Shuster's Dr. Occult, a Superman prototype; #52, first appearance of The Spectre; #67, first Dr. Fate; #71, first appearance of Johnny Quick; #73, first appearances of Aquaman, Green Arrow, and Speedy; #101, first Superboy

Of Bernard Baily's many Spectre covers for *More Fun*, this is perhaps the most memorable (#54, April 1940).
(© DC Comics, Inc.)

Morisi, Pete

Another of the Brooklyn-born artists, Pete Morisi is best remembered for his work on *Thunderbolt* and *Johnny Dynamite* for Charlton. He was not one of the giants of the industry, as he'd be the first to admit. "I want to be remembered as a guy who loved comics, and who always tried," Morisi said. "I never had the ability of a Toth or a Barry, but I still tried."

When he was still in high school, Morisi was already bugging Mort Meskin, Alfred Andriola, and Frank Robbins, begging for some clues about how to bring comics to life.

"As a kid, they triggered my imagination," Morisi said. "They got the juices going. They started me thinking." He'd drop by Andriola's place in the Village or Robbins's on West 23rd and just look over their shoulders and ask questions. "I remember Alfred Andriola saying when you have an action scene, forget all the backgrounds: Just have the guy punching the guy. Some artists smother the action with the background. He said, 'Just get the point across, keep it as simple as possible.'

"Amazing stuff would sound so simple."

After graduating from the war and the Hogarth school—where he was classmates with Wally Wood, Al Williamson, and Roy Krenkel—Morisi briefly worked with Colton Waugh, inking *Dickie Dare*. Over the years, he knocked around at Hillman, Lev Gleason, Standard, and Timely, where he inked *Sub-Mariner* over Chic Stone's pencils and was fired because he couldn't do it fast enough to please Stan Lee. Nothing, however, quite matched his adventures with Victor Fox (see entry).

At Fox, Morisi was not allowed to sign his artwork, which he found a trifle annoying: "So in the background, normally in a restaurant, there'd be a Morisi Special, a sandwich for 45 cents. At the time, I was going out with my wife, Louise, Lu-Lu, so you'd also see Lu-Lu's ice cream. The perfect spot, where editors never check, is where you feature a newspaper. The headline will say "Joker Escapes," which is what the reader sees. But in the scribbly lines underneath, that's where you'd put your name. One or two outfits caught it, but there was nothing to say about it. They just whited the damn thing out."

He eventually ended up at Charlton, pumping out westerns such as *Kid Montana, Lash LaRue,* and *Gun Master*, and getting *Thun-*

derbolt off the ground. "He had a photographic style," says Hames Ware, "a trace of George Tuska." And more than a trace of devotion. "I remember I was in the studio one time and some guy was delivering stuff to one of the other artists," Morisi said. "He glanced over at my table and saw me working on pages. A glow came into his eyes. 'My God, you're working on comic books?'

"I said, 'Yeah, why?'

"He said, 'Do you know what you're doing here? You're making dreams for kids!' I got a charge out of that. I could have bought him dinner that night."

Mr. Mind

The worm that killed 186,744 people and perhaps the most beloved mass murderer of all time.

First appearing as a disembodied voice, Mr. Mind had a 25-issue reign of terror in *Captain Marvel Adventures* #22–#46. Not until issue #27 did the Big Red Cheese wade through enough of the Monster Society of Evil to realize he was pitted against an unreasonably bright, unfathomably twisted worm from a distant planet.

© Fawcett Publications

Mr. Mind went to the electric chair in the serial's final chapter. "I won't exactly say tears were in our eyes that day," Otto Binder told Jim Steranko, "but, in all honesty, I think we all felt a loss of some kind."

Mr. Monster

Who knows exactly what Michael T. Gilbert was reaching for in 1971 when he stuck his hand into a bargain bin of Golden Age comics at Phil Seuling's con in New York City. He came away with Mr. Monster.

Actually, Gilbert came away with a coverless copy of *Super-Duper Comics* #3, a Canadian comic published in 1947 by Bell Features. The lead story featured Mr. Monster; Gilbert later wrote he assumed it must be "the sole Mr. Monster story, since the title folded with that issue. The art and story, by a Canadian cartoonist named Fred Kelly, was 1940s rough—but it gave the story a crude driving power that I found irresistible! I decided then and there that if I ever got the chance to revive the character, I would."

He got the chance. In 1983 an editor at Pacific Comics came knocking on Gilbert's door, soliciting a new feature for the company's *Vanguard Illustrated* anthology. Gilbert revamped Mr. Monster and his alter ego, Jim Stearne, for a three-issue run in *Vanguard*. That run was two issues shy of a full set when Pacific Comics went belly up.

No problem: Eclipse picked up the character's option and published ten issues of *Mr. Monster* along with ten specials. But in the summer of 1987, poor sales forced Dean Mullaney to pull the plug.

Next stop: Dark Horse. Mr. Monster first appeared in *Wacky Squirrel's Halloween Special,* then debuted in his own title in February, 1988. Gilbert spent almost four years completing his eight-issue run at Dark Horse, then packed up Mr. Monster and carried him over to Kevin Eastman at Tundra, for a three-issue miniseries.

Since then, Gilbert has produced hardcover book collections for two different publishers and a new Mr. Monster story for *Penthouse Comix*. Recent deals include foreign reprints and a movie option.

All in all, a pretty amazing return on a 50-cent investment in a coverless comic!

Mr. Natural

The name came to Robert Crumb, he confessed in the film *Comic Book Confidential*, one day back in 1966. He was stoned on LSD when he heard a DJ rolling out of a Motown song with some chatter about "Mr. Natural."

Adorned in a white robe and flowing beard, Mr. Natural first appeared in *Yarrowstalks #1*, a Philadelphia underground paper.

His credo? "Don't mean sheeit."
His secret of life? "Hang loose!"
His decade? The '60s, natch.

> **Movie Impact**
>
> *The Wizard of Oz is probably my all-time favorite film; there's a moral truth in it and, of course, no factual truth at all. What a nice lesson it teaches when it says, "There's no place like home" and "You should go back to Auntie Em," and things like that. I believe in* The Wizard of Oz *the way I believe in* King Kong, *which technically and factually has nothing to do with what's true, but at the same time has a moral truthfulness that I enjoyed enormously.*
> HARVEY KURTZMAN

© R.Crumb

My Oh My

Do you have yours? I've got mine, and Fox certainly had theirs:

- *My Confessions* (Fox)
- *My Date* (Hillman)
- *My Desire* (Fox)
- *My Diary* (Marvel)
- *My Experience* (Fox)
- *My Favorite Martian* (Gold Key)
- *My Friend Irma* (Atlas)
- *My Girl Pearl* (Atlas)
- *My Greatest Adventure* (DC)
- *My Great Love* (Fox)
- *My Intimate Affair* (Fox)
- *My Life* (Fox)
- *My Little Margie* (Charlton)
- *My Little Margie's Boy Friends* (Charlton)
- *My Little Margie's Fashions* (Charlton)
- *My Love* (Marvel)
- *My Love Affair* (Fox)
- *My Love Life* (Fox)
- *My Love Memoirs* (Fox)
- *My Love Secret* (Fox)
- *My Love Story* (Atlas)
- *My Love Story* (Fox)
- *My Name Is Chaos* (DC)
- *My Only Love* (Charlton)
- *My Own Romance* (Marvel)
- *My Past* (Fox)
- *My Personal Problem* (Ajax/Farrell)
- *My Private Life* (Fox)
- *My Real Love* (Standard)
- *My Romance* (Marvel)
- *My Romantic Adventures* (ACG)
- *My Secret* (Superior)
- *My Secret Affair* (Fox)
- *My Secret Confession* (Sterling)
- *My Secret Life* (Charlton)
- *My Secret Life* (Fox)
- *My Secret Marriage* (Superior)
- *My Secret Romance* (Fox)
- *My Secret Story* (Fox)
- *My Story* (Fox)
- *My True Love* (Fox)

Mutt and Jeff

Originally titled *A. Mutt* when it first appeared—on November 15, 1907—in the sports pages of the *San Francisco Chronicle*, Bud Fisher's comic strip was the first to survive more than a trial run on the daily grind.

The featured players were Augustus Mutt, a rabid fan of the horses, and Jeff, whom Mutt rescued from an insane asylum. But the enduring character was Fisher; Richard Marschall notes that both Al Capp and Walt Kelly seized upon "the publicity of Fisher's wealth and his showgirl affairs as much as if not more than, his cartooning talents" as their inspiration to succeed in the funny pages.

Mystic Comics

Timely's third book—following *Marvel Comics* and *Daring Mystery*—rolled out in March 1940, with Alex Schomburg's rendition of the Blue Blaze on the cover, backed by a feature of the same name produced by "Harry Douglas" (probably a pseudonym for artists Harry Ramsey and Douglas Grant, says comics historian Hames Ware).

Nadir

The first of the comic book magicians first jerked a rabbit out of a hat in *New Adventure Comics* #17 (Summer 1937).

New Fun Comics

The first comic book composed of original material was published in February 1935. It was also DC's first comic book. When *New Fun Comics* wasn't fun enough, it became *More Fun Comics* with issue #7.

Newman, Paul S.

Fresh out of Dartmouth College in 1947, Paul Newman (an aspiring playwright, not the salad dressing king) wrote a plot for the *I Love Lucy* radio show. The producer liked the script but told Newman, "This is so visual, I think you ought to go talk to the people doing the comic books."

So, Newman went to see Jack Schiff, an editor at DC. Schiff told the rookie he had the pacing and formatting down; four rewrites later, Newman had made his first sale. On the next story, three rewrites were all it took.

"Pretty soon," Newman said, "I got the hang of it." Within a year, he was writing five stories a week for as many as 12 different companies. Nearly half a century later, he is still writing, adding to an almost unmatched collection of more than 4,000 stories.

Newman scripted *Turok* for 26 years and *The Lone Ranger* for 24. He worked with Ernie Bushmiller on *Nancy*, with Milton Caniff on *Steve Canyon*, and with Stan Lee on *Sub-Mariner*. He also handled five comic strips: *Space Cadets*, *Smoky the Bear*, *Robin Malone*, *Laugh-In*, and *Lone Ranger*.

And he never complained that his name rarely popped up in the credits. "As long as they had my name on the check, I didn't care about the story," Newman said.

"I would come into four or five different publishers with a bunch of plots and go from one place or another," Newman said. "I usually needed two and a half to three plots to get one approval."

Newspaper Reprints

Reprints were the original idea for comic books—reprints of the Sunday newspaper color comic sections. And curiously enough, the publishers only went looking for original material when they had exhausted all the material that was fit to reprint.

In 1911, 27 years before the first appearance of Superman in *Action* #1, the *Chicago American* delivered, in exchange for a half-dozen coupons clipped from its pages, a collection of *Mutt and Jeff* reprints.

George Delacorte (who would one day lend his name to Dell Publishing) attempted to publish original material with *The Funnies* in 1929, but the format didn't catch on. Four years later, Harry Wildenberg, the sales manager at the Eastern Color Printing Company, hit upon the idea of folding four sheets of 36" × 23" newsprint into a 64-page book of "comics."

After selling the books as premiums to the likes of Procter & Gamble and Canada Dry, an Eastern Color salesman named Max Gaines slapped a 10-cent sticker on several copies of his reprint anthology, *Famous Funnies*. When the comics sold out, the various syndicates took note.

By 1936 Gaines was producing *Popular Comics*, featuring reprints of the *Tribune News*'s Sunday strips *Dick Tracy* and *Moon Mullins*; Lev Gleason, the former advertising manager at Eastern, was rolling out the reprints of United Features' *Li'l Abner* and *Tarzan* in *Tip-Top Comics*; *King Comics* was rerunning the McKay Company's *Blondie* and *Popeye*; and Walt Disney was flooding the land with reruns in *Mickey Mouse Magazine*.

When there were no premier strips left to recycle, Major Malcolm Wheeler-Nicholson began to fill his book *New Fun Comics* (which became *More Fun Comics* with issue #7), with previously unseen material. The various reprint anthologies would hang around for several years, but they were quickly reduced to so much spit on Superman's cape.

New Universe

This is going to be the most spectacular comics event in the last 25 years. We're making comics history again, and everyone has the chance to get in on the ground floor.
JIM SHOOTER, MARVEL'S EDITOR-IN-CHIEF

And how many of the eight books in the New Universe can you name?

Greg Wright has a story about the ground floor of comics history. When the New Universe

The Katzenjammer Kids, Tarzan, Li'l Abner, and Nancy were among the many United Features strips reprinted in the long-running *Tip Top* comics.
(© United Features Syndicate)

hit the streets, he and Mark Gruenwald shared a 15-foot by 15-foot office. After a few issues of this event, they had a hard time finding their office door, what with all the boxes of covers from returned books that were piled in the hall.

So, Wright suggested they try to fill their office with crumpled up covers. "We literally crumpled enough that we got the paper chest-deep in the office," Wright said. "We used to climb up onto the desks and dive into the paper. There was so much of it that generally we didn't get hurt."

Cushioning their fall were *D. P. 7; Justice; Kickers, Inc.; Mark Hazzard: Merc; Nightmask; Psi-Force; Spitfire and the Troubleshooters;* and *Star Brand.*

But they didn't cushion Shooter's fall. When he left Marvel, John Byrne held a party, during which the guests built an effigy out of New Universe comics, pinned Shooter's face to the figure, then burned it in Byrne's backyard.

Nexus

A mass murderer's worst nightmare, Mike Baron and Steve Rude's SF character first appeared in a 1981 black-and-white version published by Capital City. The first color issue appeared two years later, just before Capital sold *Nexus* to First Comics. First eventually sold the book to Dark Horse, which returned ownership of *Nexus* to its rightful creators, as well as continuing to publish the book.

Steve Rude has won many an award for his Nexus art and covers.
(© Baron and Rude)

Niño, Alex

Six bucks a page. As late as 1974, Alex Niño thought $6 was a decent page rate. And who can blame the Filipino artist? That's the word he got from his agent, fellow Filipino Tony DeZuniga.

"We were looking for exposure," Niño said in 1997. "I didn't know there was a chance for me to go and talk to DC and Marvel all my myself. Six dollars compared to $75 . . . It was unfortunate. But I don't blame Tony DeZuniga. Let bygones be bygones. Agents take big cuts. And a lot of people were taking money off what we were owed."

Born in 1940, Niño began drawing at the age of 7, inspired by his father, a professional painter. He was quite accomplished at his craft when DC's Carmine Infantino and Joe Orlando, accompanied by DeZuniga, arrived in the Philippines in the late '60s, looking for fresh talent.

"They started recruiting people," Niño said. "I was one of the suckers."

Because they were based in the Philippines, artists such as Niño, Nestor Redondo, and Alfredo Alcala had no idea their work was worth considerably more than $6 a page. Not until Niño was invited to the World Science Fiction Convention in 1974 did he deduce that he was getting far less than his fair share. When Niño asked DC's Sol Harrison to pay him the full $75 rate, he was turned down. When he got back to his hotel room, Marvel's Roy Thomas was waiting with an offer to pay Niño $85 per page.

Niño returned to the United States in 1976 when Ralph Bakshi hired him to do backgrounds for *Lord of the Rings.* Allocated a visa on the basis of that assignment, Niño violated his immigration status when he picked up several freelance jobs. He was living in a stripped-down Detroit apartment in 1977 when Immigration caught up to him and shipped him back to the Philippines.

"It wasn't a happy time," Niño said. "I thought America was a prosperous country, but I didn't belong to the land. So, I started drinking, and drinking made it worse. I was in a strange country. I was away from my family. I was over the edge. I was ready to go home and forget all about it."

Niño worked for Warren on such titles as *Creepy* and *Vampirella* before finally returning to the U.S. in 1983, aided by the sponsorship of Byron Preiss. Through the rest of the decade, Niño worked on several Preiss productions, including *Tales from the One-Eyed Crow* and *Mission to Microworld,* a DC graphic novel, and a variety of other projects.

Niño began doing animation for Disney in 1990. "At first, I thought I was backtracking," he

said. "When I saw these people cleaning other people's mess, I thought I was going back to grade school.

"But I got other ideas. There are three stages in a career. With comic books, you can see your characters. With animation, you see them move. And with live action, you can talk to your characters. I thought, well, maybe I could do some live-action movies. And I hope I do. Someday."

For now, Niño is on the treadmill at Disney. "If you work for the establishment, you forget who you are," he said. "They own you. Forget Alex Niño. Forget about your ego. I've been a fugitive, I've been a rebel. I'm tired of running, I'm tired of hiding. Let someone own me now. And that's Disney."

Does he still take joy in his work?

"Only when I'm at the drawing table," Niño said. "That's when I'm really happy. That's a big escape, getting into those panels. That's where I belong."

Nocenti, Ann

Her parents never let Ann Nocenti read comic books, so she didn't know what she was getting into when she answered an ad in the *Village Voice* and showed up at Marvel Comics. She'd been a painter in college, and her freelance writing ran toward solar technology, so when Marvel's personnel department asked her about comic books, she had to fake it.

Yes, she got the job. Nocenti started at Marvel as an assistant to Jim Shooter. "I used an old trick my mother taught me: Never be good at anything you don't want to do. I made myself quite bad at the secretarial side of things. I was quickly promoted to being an editor there."

She admits she was pretty flat on the medium until she saw the work of Bill Sienkiewicz on *Moon Knight*. Nocenti had long been in love with words and pictures, and she suddenly saw fascinating possibilities in combining the two.

Her pulse rate picked up. "You go through a phase where you get very excited about the medium," Nocenti said. "The intimacy: You're there alone with the comic book. You go through this period when you think it can be something so wonderful. Then you find that there's something innate about the medium, that . . . it has to be trashy. They're grand the way they are. They're a little pornographic. They're a little forbidden. They're trashy. I was an editor there long enough to see that if you did a thoughtful, intense, quiet story, your sales dropped."

For four years in the mid-Eighties, Nocenti edited the mutant books at Marvel. This was before the X-plosion, before X-Force, Rob Liefeld and Jim Lee, and covers A, B, C, D, and E. On her watch the mutants were still a docile population. The mutants of the 1990s are much like the industry that cashes in on them. "It's H. L. Mencken: 'No one ever went broke underestimating the taste of the American public,'" Nocenti says, "This is not a beast that I know."

Nodell, Martin

In 1940 Marty Nodell couldn't buy a job in New York, not in advertising and not in the theater, where he'd spent his spare time in Chicago. Comic books? Why not? "If I knew how a play was put together, I could put together a story and tell it with pictures," Nodell figured.

He was young; he had a right to such foolishness. Nodell got a few odd jobs—"A western, some horror, a military thing. I got my feet wet"—then took his squishy shoes up to see Sheldon Mayer at DC's All-American Comics.

Mayer looked at Nodell's samples, then told him, "We're in line for another title, maybe a hero-type thing. See what you can come up with."

Nodell knew he had an opening, and no time to waste. "When I left, I realized if he was going to tell me that—someone who just came through an open door—I'd better get to work on this thing in a hurry."

DC's office was downtown; Nodell had to head up to 34th Street to run some errands. "I got back on the subway and in the trough where the train comes in, a trainman was checking the tracks. He was waving a red lantern for the train not to come in. Then he went behind a post and waved a green lantern." Thirty seconds later, Nodell was sitting on the train, taking notes.

When Nodell handed his sto-

Alex Niño

Creating Green Lantern is Marty Nodell's claim to fame.
(© DC Comics, Inc.)

Martin Nodell

> "Because Nodell had no intention of hanging out in the comics for too long, he refused to put his name on Green Lantern's first appearance in All-American #16, instead transposing a few letters and signing the story 'Mart Dellon.'"

ryline to Mayer, the editor wasn't too impressed. "I didn't want to take it," Mayer admitted years later. "I thought, what the hell, this is the direction we're already going in, but Nodell didn't seem good enough to handle it."

Mayer told Nodell he'd pass his idea—the Green Lantern—on to Max Gaines, All-American's publisher. Gaines bought it; Mayer still didn't think Nodell was up to the job, but he said, "He walked in with the idea. I wasn't going to use Green Lantern and do it with somebody else. So Bill Finger and I fleshed out the concept."

Bill Finger? Nodell chewed on the name for a minute: "For the most part," he said, "that [Green Lantern] was a character I developed."

Because Nodell had no intention of hanging out in the comics for too long, he refused to put his name on Green Lantern's first appearance in *All-American* #16, instead transposing a few letters and signing the story "Mart Dellon."

He kept his hooks in his creation—Nodell's only mark on the history books—until 1947, then plugged into the assembly line at Timely, joining the likes of John Buscema, Dan DeCarlo, Gene Colan, and Pierce Rice. He was still churning out five- to eight-page scripts when the purge hit in 1950. He still remembers Stan Lee calling each staffer into his office and telling him he was fired. "After each fellow, Stan would make a beeline for the men's room," Nodell said. "From what people told me, he regurgitated. He was a pretty sick boy. I don't think he came in for four days after that."

In 1950 Nodell finally got his job in advertising. He didn't miss comics (he dumped his old ones in 1961) until 1980, when a few fans with long memories started dragging him to shows. He's on the road a lot these days, selling sketches of the original Green Lantern. His wife, Carrie, is usually at his side, dressed in green and signing every card and address note with a green pen.

Nordling, Klaus

The Finnish-born artist is best known for his sleight-of-hand with Lady Luck. Nordling joined the Eisner-Iger shop in 1939, at the age of 24, and worked for Fox, Quality, Harvey, Fiction House, Standard, and Marvel before wearying of the change-of-address postcards and leaving the industry in 1950.

"I thought he was funny," Jules Feiffer, who worked with Nordling at Eisner's shop, told *The Comics Journal*. "I liked that kind of wooden style. No one else drew like him, it was very expressive, it was clearly his own personality. He didn't look like anybody else."

Nostrand, Howard

"The Comics Code," Bhob Stewart observed, "served to erase Nostrand's name from comics history. Rather than remain snarled in the starting gate, Nostrand dropped out of the race."

And almost out of sight. During his six years in prime time, beginning when he joined Bob Powell's shop in 1948, Howard Nostrand never signed his name, never left more than a piece of it hanging around to tease the amateur detectives who loved his stuff.

Hames Ware began picking up the pieces early in the 1950s. Ware was always reading the small print in shop windows and on newspaper headlines in comic book panels, and he kept encountering Nostrand's clues. Not until 1959, when Nostrand finally signed his name to a *Bat Masterson* comic strip, did Ware complete the puzzle.

A Pratt Institute reject and an art school dropout, Nostrand was 18 when he ducked under Powell's wing. "There were three of us working for Powell when I started with him," Nostrand wrote in a piece for *Graphic Story Magazine*. "The others were George Siefringer, who did backgrounds, and Martin Epp, who inked, lettered, and helped George on backgrounds. I started out inking and then got into doing backgrounds (when George was too hung over or just AWOL) and then penciling."

Powell did the original penciling for features published by Street and Smith (including Doc Savage, Nick Carter, and Red Dragon), Harvey, and—later—Magazine Enterprises and Fawcett. Nostrand labored in his shadow until 1952, when he went to work for the Harveys. Nostrand has said he was influenced by Jack Davis and Wally Wood, and he loved parodying their styles. When Nostrand complained about the company's approach to humor ("The people at Harvey's had no concept at all of what comedy was. I said their scripts stank"), he was given several assignments in *Flip*, Harvey's *Mad* ripoff. They are some of his best works, partic-

ularly "Ivan's Woe" (*Witches Tales* #24), Nostrand's homage to Wood's "Trial by Arms," which appeared in *Two-Fisted Tales* #34.

When the market crashed in 1954, Nostrand was out of work. "This was a very bleak period in my life," Nostrand said in *GSM*. "All the training I'd had was directed at producing comic book art, and there wasn't any market for it. I was informed that my linework 'looked like *Flash Gordon*.' Two years earlier it would have been considered a compliment; now it was like a goddamn albatross around my neck."

Nostrand said he "finally ended up in a dump called Penthouse Studios on Eighth Avenue at 58th Street—the only second-floor penthouse I was ever in." He eventually rose above the seedy surroundings, but later noted, "Most studios I worked for were run by a bunch of lying, cheating, larcenous blackguards who would sell their own mothers down the river for the price of a subway token."

Nostrand fared much better than the moms in question, signing on with *National Lampoon* and doing illustrations for *Crazy* magazine and Atlas/Seaboard. He died sometime in the 1980s.

Novick, Irv

Some guys talk a good game; others know how to finish the play. When the game is on the line and the final seconds are ticking down, they want the clock in their face and the ball in their hands. They're closers. In the clutch, they'll deliver.

That was Irv Novick's gift. He could finish the play. "He could be depended on to deliver the work," said Pierce Rice, who went to art school and served in the Army with Novick and snuck his pencils beneath Novick's inks on *The Shield* and *Steel Sterling*. "There are plenty of artists who don't show up when the printer expects them. Editors set more store in dependability than in drawing or creative ability." Novick never choked or bailed out or pulled up lame in the middle of a tough panel.

Novick was born in the Bronx in 1916. "a year," he observes, "you can't even imagine." He was seven years old when rheumatic fever knocked him off his feet, keeping him bedridden for a year. Novick eventually got up with a heart murmur, a condition that may have saved his life. When Novick was stationed at Camp Shelby during World War II and serving as division artist, a general tried to take him overseas with him. Novick's application was rejected; the general and his entourage died in a plane crash.

"I began in illustrations," Novick said, and they remained his first love. Comic books? "It was a job. It was a way of supporting my children, and supporting my family and getting them through college. I couldn't get excited about advertising, either. Or fine art. It was just a means to an end. There are other guys in this field who could get very excited about comics. It was their whole life. It wasn't mine."

He answered a Harry Chesler ad in 1939, thinking they were scrounging for comic strip artists. Next thing Irving knew, he was doing work for MLJ in the company of Charlie Biro and Mort Meskin. After warming up on one comic he no longer remembers, Novick was handed a script featuring a character called the Shield. "The first star-spangled hero,' Novick said. "I don't remember who wrote the first issue [Harry Shorten], but I made that character. I created the look."

Novick was one of the stars of the show at MLJ, also drawing Steel Sterling and the Black Hood, before he was drafted. His style loosened up during the war, moving in the general direction of Jack Kirby, but Novick insists "All the

One of Howard Nostrand's most memorable stories for *Black Cat Mystery* was "What Happens at 8:30?"—a noirish tale about a strange-looking character who turned out to be . . . a germ.
(© Harvey Publications)

"Most studios I worked for were run by a bunch of lying, cheating, larcenous blackguards who would sell their own mothers down the river for the price of a subway token."
HOWARD NOSTRAND

Irv Novick

Novick is best known as being one of Bob Kane's ghosts on Batman and an inspiration for Ray Lichtenstein.
(© DC Comics, Inc.)

time I was in the Army, I never saw a comic book. They would send me work down to Camp Shelby and I'd sit on my bunk and draw there while everyone was playing cards at night."

He had one curious encounter at camp. He dropped by the chief of staff's quarters one night and found a young soldier sitting on a bunk, crying like a baby. "He said he was an artist," Novick remembered, "and he had to do menial work, like cleaning up the officers' quarters.

"It turned out to be Roy Lichtenstein. The work he showed me was rather poor and academic." Feeling sorry for the kid, Novick got on the horn and got him a better job. "Later on, one of the first things he started copying was my work. He didn't come into his own, doing things that were worthwhile, until he started doing things that were less academic than that. he was just making large copies of the cartoons I had drawn and painting them."

Shortly after the war, Shorten came to Novick with an idea for a comic strip. *Cynthia* lasted five years before Novick burned out on the writing and drawing chores and enlisted with Carmine Infantino at DC. Novick credits his 40-year relationship with DC to Bob Kanigher, who was totally sold on Novick after he outlined a Steel Sterling story to him over the phone and the artist was able to put those words to pictures.

In 1955 Novick wrote a letter to Frank Lloyd Wright, asking him to design his new house in Dobbs Ferry, New York, overlooking the Hudson River. Wright agreed, then

> **POP ART**
>
> *I was at [Novick's] studio once, when he was drawing one of my Johnny Cloud scripts. The scene was of an aerial dogfight. Irv held the model of a P-51 in one hand, twisting and turning it like a fighter pilot, describing a fight with his swooping hands. With his free hand Irv drew the scene while conversing with me without dropping a syllable. Talk about Merlins. Irv's a magician. Irv and I later saw a famous pop artist's painting reproduced in* The New York Times. *It was duplicate of a Johnny Cloud panel, a dogfighting plane, with sound effects. That artist got thousands for that oil. He should have split it with Irv.*
> BOB KANIGHER

later wrote Novick and told him he wouldn't be back in New York for another year, forcing him to choose a second architect, Robert Green.

For the next five years, Novick drove up from New York City to Dobbs Ferry almost every weekend and built the house himself. Every dime he made drawing Batman or illustrations for *Boy's Life* he plowed into lumber, bricks, and mortar. Novick, his wife, and their four children moved into the house in 1960, and he remembers their adventures together much more than anything he ever did in comics. "I worked hard, that's about it," he says. "People used to say to me, 'Irv, you're real lucky.' Hey, the harder I worked, the luckier I got." Now retired, he still lives in that Dobbs Ferry house.

Nowlan, Philip

Nowlan (with an assist from Richard Calkins) created *Buck Rogers*. A Philadelphia journalist, Nowlan was 40 when he first sent Buck through time and space in 1928 (in *Amazing Stories*). The newspaper strip was launched in 1929.

Obscenities

When he was editing the Atlas line of comics in the mid-1970s, Jeff Rovin battled the Comics Code Authority on just about every issue. "I didn't win a single dispute with the Code," Rovin wrote in *The Comics Journal*. "However, sharing my pique, artist Mike Sekowsky did manage to slip one past the blue-pencil brigade in *The Brute* #1, lettering '5H17' on the wing of a plane, which reduced to 'Shi' on the printed page. Childish? You bet. But at Atlas, we learned not to let any victory slip through our fingers, no matter how moronic."

Olshevsky, George

George was one of the few collectors ever to put together (more than a quarter century after their publication) a complete set of Timely comics to go with his complete Marvel set.

Best known for the comic indexes he assembled for Marvel, Olshevsky first got interested in comics while at the Massachusetts Institute of Technology in 1966, but he didn't get into back issues until he discovered Memory Lane and Captain George Henderson, in Toronto.

Memory Lane was still selling some Golden Age books for a nickel, but Henderson got Olshevsky to bite on a box of 40 Timelys, including *Marvel Mystery* #6–#15, for $400. It was, Olshevsky conceded, "a huge expense for me, a monthly paycheck."

In those innocent pre-Overstreet days, Olshevsky had no idea how many stars there were in the Timely universe, so he wrote to Jerry Bails asking for back issues of *The Panelologist*.

Armed with Bails's catalogues and Mike Nolan's *Timely Comic Index*, Olshevsky set himself to the task of collecting the Timely set. In the first 18 months, he tracked down 150 of the books; he had almost completed the collection in 1975 when he attended the first Marvel Con, run by Phil Seuling, in New York.

"I was just making the rounds, when a fellow walked up to the dealer I was talking to and asked if he was interested in buying old comics in nice condition," Olshevsky said. "The dealer turned him down, saying, 'I can't afford these.' My God, if they weren't Timelys. They were in unbelievable condition. Spectacular. You couldn't take your eyes off them."

In a word, they were some of the books comics dealer Joe Sarno had discovered in Chicago. Sarno had a suitcase full and Olshevsky bought them for 95 percent of Guide (Guide being the glass ceiling in those days), a total of $1,500 that he borrowed from a friend.

The original collector, Olshevsky learned, had bought them off the stands, read them, and put them away, individually in Manila envelopes, and into a filing cabinet full of comic books for 25 years. The book in the worst shape was *Marvel* #1; he'd let his kids play with it, and they'd shredded the cover.

Olshevsky flew to Chicago and bought it anyway for $1,800.

He finally completed his collection when he bought *Blonde Phantom* #22 just before the 1977 San Diego Comic-Con.

Olshevsky spent 12 years putting together a Marvel Index that was published in regular installments. "The carefully crafted chronology I had developed for the entire Marvel Universe was universally ignored," he says, "so I eventually bailed and put my collection up for sale." Today he's a professional indexer— but not for comics.

Omega Men

They made their first appearance in *Green Lantern* #141, co-created by Marv Wolfman and Joe Staton in December 1982. They stumbled into their own book, which became better known for the introduction of Lobo in *Omega Men* #3.

O'Neil, Denny

When he got out of the Navy—a tour of duty that found him circling Cuba in 1962 as part of the Cuban missile blockade— Denny O'Neil took a brief stab at teaching, then signed on with the a small newspaper, the *Southeast Missourian* in Cape Girardeau. He

Naughty, naughty! Here's another one of those obscenities slipped past the folks at the Comics Code Authority.

(TM & © 1998 Marvel Characters, Inc. All rights reserved.)

Denny O'Neil

> "We discovered comic books didn't have to be lighter than soap bubbles. They were capable of dealing with real issues; maybe we taught the world that."
> DENNY O'NEIL

was assigned to fill the children's page, a harrowing task while school was out during summer vacation, and in desperation, he picked up a few comic books.

It must have been the summer of 1964. And those comics must have been Marvels. "They were a lot better than I remembered them," O'Neil said. "It was Stan's writing that got me. He was walking a very interesting line—I perceived it as self-satire. It was so much tongue in cheek that it gave permission to a 'sophisticated' guy like me to read them. Had I perceived them as a comic book, I wouldn't have read them."

Because Roy Thomas's parents subscribed to the *Southeast Missourian*, O'Neil got to know Thomas and, by and by, found himself with a copy of the Marvel writing test. "I took the test in lieu of reading the paper or staring out the window," O'Neil said. "It was too goofy to pass up. A week later, they called and asked me to move to New York and write comic books."

O'Neil spent a year under Stan Lee's wing, then spun off to do freelance work. Dick Giordano eventually hired him at Charlton, where O'Neil churned out the stories for $4 a page. "I was glad for my newspaper experience: You learn to write fast and get it right the first time. I didn't consider every word precious."

When DC fired a handful of writers who were demanding health benefits in 1968, Giordano brought in Steve Ditko, Jim Aparo, Pat Boyette, Steve Skeates, and O'Neil to fill the gaps. O'Neil's first big splash was teaming up with Neal Adams on the Green Lantern/Green Arrow "relevance" issues of the early 1970s.

"The 'relevant comics' were very much a result of my journalism," O'Neil said. "We didn't do real stories, but we did real issues. We discovered comic books didn't have to be lighter than soap bubbles. They were capable of dealing with real issues; maybe we taught the world that."

Of Adams, O'Neil said, "Neal was always better than what I had in my head." And he argues that the two of them "brought back the dark version of Batman" long before Frank Miller came along. "When I left Charlton, Batman's writers were still taking half their cues from the TV show. I read the early stories and took what Bob Kane and Bill Finger implied in 1939 and made it explicit. The Batman of the Fifties and early Sixties was a daylight character. They completely lost the essense of this dark obsessed character. We redefined it."

O'Neil is now the group editor for the Batman books at DC. "In the last ten years," he said, "I've spent most of my waking professional hours thinking about this one character."

On the Road

The van was loaded with West Coast comics dealers and their wares and was barreling out of Houston, bound for New Orleans and a couple days of R&R. Bud Plant was driving, Bob Beerbohm was riding shotgun, and Terry Stroud and Dick Swan were somewhere in the back, sleeping on top of the boxes of comic books. Rain had just begun to fall and the freeway underpass was a little slick, too slick for the speed Plant had in mind.

When the skid began, Stroud remembers Plant hitting the brakes and the van laughing at him. Dick Swan woke up to find himself in midair; he had just enough time to dig his nose into his pillow before the van slid into a concrete pylon, and Swan took the entire windshield out.

The first step Swan took when he picked himself off the gravel was onto a board with a nail in it. Plant was on the other side of the van, staggering around with a broken kneecap and a broken nose. "Beerbohm," Swan said, "was rolling around on the ground, screaming and yelling."

And Stroud was somewhere inside the wreckage, buried in comic books.

"We were out in the middle of nowhere," Swan said, "but there was a farmhouse close by." He went tromping across the field and knocked on the farmhouse door, not knowing that, owing to a small piece of glass in his forehead, his face was covered with blood.

No problem: *Texas Chainsaw Massacre* hadn't made it to Texas yet. The farmer called the police; when they arrived, comic books were scattered across the freeway but Stroud was still stuck in the van. The same boxes of comics that had cushioned his fall had swallowed him whole.

To pull Stroud from the belly of the whale, the cops were starting to rip boxes apart. Knowing the cost of some of those books, Swan broke into a sweat. Before he could say any-

thing, however, one of the cops bumped into some of the underground comics Plant was dealing at the time.

"Look," he cried out loud, holding his prize aloft, "fuck books!"

"I had a broken nose, I was bleeding all over the place, I couldn't even get a handkerchief to stop the bleeding, and the police are looking at these underground comics and calling them 'fuck books,'" Plant said.

The Texas mounties eventually decided not to run these hippies in for possession of pornography. They eventually got back around to freeing Stroud. Plant limped into a dealership to pick out a new van the next day, Swan found his wallet—and his $700—in the wreckage of the old van, and the boys made it to the next convention in Dallas.

But that wasn't the best of it. When they surveyed the damage to their stock, they discovered the only real hurt was on a couple cases of *Shazam* #1. They took the hit and never looked back.

Original Art

The history of original comic book art in the collector's market is a gallery of sob stories, outrageous good fortune (and foresight), outright malice, and flagrant lack of interest.

Through the 1940s and 1950s, few (the most notable exceptions being Bill Gaines and Frank Frazetta, who had a famous wrestling match over the cover of *Weird Science-Fantasy* #29) saw much value in original comic art. Al Williamson walked into a room-painting session at King Features one morning and realized they were using Hal Foster's original *Prince Valiant* pages to catch the excess paint. Sam Moskowitz recalls the auction where he couldn't raise a two-bits bid on a black-and-white sketch by Virgil Finlay, so he took it home himself. And that didn't compare to the night Moskowitz walked out of Hugo Gernsback's office just before midnight and found 13 Frank R. Paul framed originals piled on top of the garbage cans.

"Waiting for Saturday morning pickup," Moskowitz said. He lugged each one of the framed paintings up the stairs to his fourth-floor office, then went for his car. "Most of the artwork I have," he says now, "I got inadvertently, from a garbage can."

Garbage-can stories? We got a million of 'em. A garbage can is where Gil Fox found Lou Fine's unparalleled cover to *Hit Comics* #17. Williamson pulled the finest *Prince Valiant* page in his collection (Val knocking the Vikings off the bridge) from a trash can. And Bill Stout rescued a stegosaurus cel from *Fantasia* just before it was going down for the third time in the acid vat.

"It was such a trash medium to begin with that no one thought about keeping the art," Greg Theakston said. Including the artists. "We never placed any value on what we did, other than to be paid for it," said John Celardo, who worked for Fiction House and on the *Tarzan* comic strip. "That's the simple truth. We figured we were producing a product. We attached no intrinsic or artistic merit to it."

Golden Age original art, such as this Doll Man page by Reed Crandall, is highly prized.

(© Fiction House)

This Michael Kaluta Batman cover managed to survive being sliced and diced at DC.
(© DC Comics, Inc.)

"King Features used to have a big warehouse where all this stuff was stored. Of course it was plundered."
GEORGE EVANS

Neither did the publishers. When they weren't throwing the stuff away or shredding it, they were giving it away. DC editor Julie Schwartz, you may recall rewarded the writer of the best letter about a certain issue with that issue's cover; Don and Maggie Thompson ended up with the cover of *Flash* #123, which sold at Sotheby's, 30 years later, for $16,000. Dick Swan, one of the early desperadoes at the S.F. Bay Area's Comics and Comix, remembers buying a ton of Wally Wood artwork from *T.H.U.N.D.E.R. Agents* in the '60s for $3 a page. "We'd turn around and sell them for $8 a page," Swan said. "Marvel would sell whole stories for five bucks."

Why didn't the publishers return the art? "It was malice," Dave Sim said on a *Prisoners of Gravity* segment. "It was the malice of the nonartistic that must hurt and punish the artistic. The ostensible reason was the artwork might get out there and get reproduced by someone else without permission... 'We could have this counterfeit edition coming out of Brazil.' But a lot of it was that artists could make some money off that. If you're only paying an artist $7 a page, you don't want someone coming up and offering them $100 for the original."

When publishers couldn't be moved to move their original art toward the scrap heap or the fanboys, it piled up in the warehouse. "King Features used to have a big warehouse where all this stuff was stored," George Evans said. "Of course it was plundered," Evans added, which explains how so many *Prince Valiant* pages reached the black market.

"At Quality, there was a supply room where they kept all the original art, the covers, and the current books," Bill Ward said in *Overstreet's Comic Book Price Guide* #8. "It was expected that the artists would go in there as they left and help themselves. The original artwork was always destroyed eventually, so it didn't matter to them."

And destroyed with impunity. Sol Harrison ordered the production staff at DC to routinely destroy the comic art, Theakston said, "so it wouldn't be stolen or given away or somehow removed from the office. He consciously got rid of it, so that other people couldn't have it." In the same *Prisoners of Gravity* segment, Neal Adams recalled walking into the DC production room and finding a man at the cutting board, slicing and dicing original art.

"I walked up to him and he was grumbling, 'Grrr, they always make me do this, I hate this job,'" Adams said. "I said, 'What are you doing?'"

"He said, 'Getting rid of this stuff. Every three months I have to do this. It's a pain in the ass.'"

"I said, 'Look, why don't you not do that anymore, or I'll hit you.'"

Adams charged in on Carmine Infantino, then DC's art director, and told him artwork was being destroyed. Infantino shrugged. "Each person I told the artwork was being destroyed looked at me like I was crazy. They told me it had to be destroyed because they had to get the drawers empty. I suggested, 'Why don't you return it to the artists?' and they said, 'Nobody wants this.'

"That was the beginning. That day was the day DC stopped destroying artwork. Why? Because I made a fuss."

Marvel wasn't famous for destroying art, just misplacing or misappropriating it. In early 1980, a staffer named Irene Vartanoff waded into what she described as "the most incredible mess I'd ever seen": a warehouse on West 22nd Street between Fifth and Sixth Avenues. Her mission? To catalog Marvel's original art.

By sorting through shipping crates stuffed with envelopes, many of which had not been

opened since being returned from the color separators, Vartanoff counted 35,000 pages of art, the vast majority from 1961 through 1974.

Jim Steranko and Gray Morrow had signed contracts to have their art returned, but almost everything else was there, including almost complete issues of *Amazing Spider-Man* #1–#17, *Fantastic Four* #7–#27, *Avengers* #1–#3, *X-Men* #1, *Daredevil* #1, and *The Incredible Hulk* #3–#6. There were also 937 covers.

Once Vartanoff catalogued the art, it was hardly secured. Jim Shooter, then Marvel's editor-in-chief, moved some of the art from key issues to his office, then moved it to a commissary/vending area near the back of Marvel's new office on Park Avenue. "There was a freight

THE CLOSET

A forgotten closet, and its long-lost contents, waits in the shadows of a lot of imaginations in this business. John Buscema remembers when Martin Goodman fired his entire bullpen after "someone opened a door at Marvel and found a closet filled with artwork that had never been published." The Allentown and San Francisco collections of high-grade books sat in closets for 40 years, waiting to be discovered and sold at double Guide.

But the best closet story may be Robin Snyder's. In 1981, while working at DC for Dick Giordano, Snyder was handed the keys to a large closet and asked to clean it out. Inside the closet—"a room about the size of a small bathroom"—Snyder found thousands upon thousands of pages of original, unreturned art.

"Imagine piles of artwork higher than yourself. And this artwork goes all the way back to 1936," Snyder said.

Stacked by year and sorted by artist, of course? Not even close. "The pages were not in order, and they weren't filed away in packages," Snyder said. "They were just loose. A Jerry Grandenetti mystery page might be right next to a John Romita romance."

These pages had been piling up for years, not because DC was hoarding them but because no one knew what to do with them. Even if someone could identify Ed Whelan's art, no one at DC knew where to find Ed Whelan. Neither was anyone anxious to decide who should get a page that was roughed out by Shelly Mayer, broken down by Joe Kubert, and inked by Nestor Redondo.

Snyder closed the door behind him and went to work. He examined each page, identifying the pencils and the inks, searching for clues when the style was familiar but the name escaped him.

"I remembered this one guy from when I was little," he said. "Distinctive style. Unmistakable. I asked all over the company, from Jack Adler to Paul Levitz to Dick Giordano, and nobody could tell me this guy's name. He was strictly romance, usually the leads. I had this mystery artist and 1,000 pages of his to return.

"They're lying on my desk on top of a pile when [Bob] Kanigher walks in and glances at the artwork and says, 'Where did you find Tony Abruzzo's pages?'"

Unfortunately, identifying Abruzzo's work was one task, and locating him was another. Tony Abruzzo—whose romance panels were blown up, and made famous, by Roy Lichtenstein—had disappeared, probably somewhere in Ed Whelan's neck of the woods. "The last I heard he was somewhere out in Brooklyn," Snyder said, "but I ran into a dead end."

The artists who were easier to track down: "Joe Simon lived a few blocks away, Carmine a few blocks in another direction, Ditko a few blocks downtown," Snyder said. Jack Kirby was also close by, but he wasn't happy with the package Snyder hand-delivered. "Kirby was upset because I returned 35 percent of the pages to [Vince] Colletta. Kirby had the idea that all the material was his. I told him, 'You get 65 percent, and because you designed the pages and penciled them, you get the initial 65 percent.'"

After Snyder had been working in the closet for several weeks, he began to notice that art dealers were hanging around, anxious to chat, quick to gasp when Snyder turned up something remarkable. He wasn't all that surprised when a few of the pages—including several of Jim Starlin's—disappeared when his back was turned.

The largest cache of pages were those that DC had purchased from Fawcett in 1973 when the company acquired the rights to Captain Marvel. Part of the purchase was the loan of the original C. C. Beck pages, and Paul Levitz suggested Snyder return them to Fawcett.

"It took me two deliveries to get all of this over to the Fawcett building," Snyder said. "When I finally delivered the last page, I ran into a secretary who was unfamiliar with their comics background and insisted it wasn't their property, that I'd delivered it to the wrong place."

Snyder had to bend the woman's arm for 10 minutes before she finally signed for the art. He still remembers her final words:

"I suppose we can find some closet to dump it in."

Original Carl Barks pages from his Disney years are hard to come by. This page is from *Uncle Scrooge* #61.
(© The Walt Disney Co.)

elevator about 10 feet from the cafeteria," Theakston said, and any number of Marvel employees had the opportunity to lift several pages before diving onto the elevator. Theakston later reported seeing art from *Amazing Spider-Man* #1, #3, #5; *X-Men* #1, *Strange Tales* #110; and *Hulk* #3 on sale on the open market.

(DC also lost over 1,900 pages of original art when the company moved from Third Avenue to the Warner Communications Building at Rockefeller Center.)

The artists discovered the value of their art soon after fandom did. Small wonder P. Craig Russell rebelled against a new Marvel policy that split original artwork between the artist and the writer. Russell responded by carefully cutting all the Roy Thomas word balloons from one set of his pages and returning them to Marvel. "Let Roy have the words," Russell said. "I'll keep my art."

"Comic books had their genesis in the Depression," Scott McCloud reminds us. "In general, labor could not be terribly picky about what sort of conditions they would work [under] in order to make a living for their family, especially when that living, even when they were able to obtain it, was pretty meager. The idea of quibbling over the return of original artwork and ownership at the time may have seemed pretty trivial when it was a matter of life or death whether they obtained this job."

When it was a matter of cashing in a few extra bucks, artists were more in a mood to quibble. Gaines recalled getting a letter from Jerry Siegel. "He sent me copies of correspondence he had had with my father," Gaines said, "which proved to my satisfaction that my father had borrowed [some original pencil] sketches and that in truth they were Jerry's, so I sent them back to him. I was appalled to discover them selling at a dealer's booth in Dallas for a relatively small amount of money. Jerry told me when he wrote me that he had great love for these sketches and he wanted to have them so he could cherish them . . . and he cherished them to the nearest dealer. If he had told me that he wanted to sell them, I would have been happy to pay more than the dealer was offering, which I think was something like $700 or $800."

Jerry Weist, who wrote the first edition of the *Original Comic Art Price Guide*, notes, "The single most important event that created the modern comic art market is when Bill Gaines told Russ Cochran, 'You can auction off all the EC artwork.' When those auctions began, you have the beginning of the modern era in which comic art is defined as a collectible."

But, Weist added, "The truth is, there were a lot of people even in 1950 who valued comic art and were saving it. If they didn't, if they weren't there in the '40s and '50s, we would have nothing today."

Moskowitz was one of those early collectors; he kept the seven pulp covers that Alex Schomburg did for *Science Fiction Quarterly* in the early '50s. When Schomburg expressed a desire to regain those covers 40 years later,

Moskowitz said, "Tell Alex these pieces are safe and are in excellent condition. And I will not let him have them. If it weren't for me, they wouldn't exist. I love Alex. I think he's a sweet human being. But artists don't have much regard for their work when they do it. When it becomes valuable, they go searching for it. If it weren't for collectors like me, there would be nothing to search for. It's safer with me than it is with him."

Orlando, Joe

Joe Orlando grew up in East Harlem, on 115th Street between First and Second Avenues, before the Hispanics moved in and the Italians moved out. He didn't see any of the city beyond East Harlem until he was 10 years old. "I remember my first sight—and I thought it was like Shangri-La—when I was taken to a five-and-dime and I discovered Big Little Books," Orlando said. "It was the first time I'd seen a collection of comics. My father didn't buy the papers with the comics in them, which were the *Journal American* and the *Daily News*. He bought *Progresso*, which was the Italian-language paper, and the *New York Times*. I grew up with one comic: *Progresso* ran *Tarzan* by Harold Foster, in black and white, but in Italian, At that point, I couldn't read Italian. I had to make up the story. But I liked the pictures."

Orlando only saw the comics otherwise when his mom set off after the week's groceries. "My mother shopped in East Harlem off the pushcarts," he said, "and at the time they wrapped all the vegetables in paper, in newspapers that had expired. Fresh stuff. Right off the press. Still bound. These merchants would buy them by the stacks and wrap vegetables in them. If you looked carefully, and you were agile, you managed—or I managed—to grab the comic inserts before they picked them up and wrapped the vegetables in them. It would break my heart sometimes when I wasn't shopping with my mother to see it come home all wrinkled around a head of lettuce or a head of broccoli. I'd take it out and fold it flat and try to save it."

Orlando got his art training in high school: New York's School of Industrial Arts. "When we came out of that high school," he said, "we had portfolios that qualified us to work at countless New York agencies …We were ready to make a living. This was a Depression generation. We didn't agonize over what we wanted to be when we were growing up. We were grown up."

Orlando's father was a craftsman, a tile-setter, a proud man who agonized when the union agreed to put tiles on plasterboard. "That was a sin," Orlando said. "When my father was done, he'd come home and hold his head and say, 'They forced me to do a glue job today.'" His father was laying tile in a building on 45th Street in 1949, just after Orlando had gotten out of the Army, when he made friends with the elevator operator. "He told him, 'I have this son home from the Army who keeps on going to school and he isn't making a penny.' The elevator operator said, 'Gee, there's a studio in this building that buys comics.'

Joe Orlando drew himself into this Superman anniversary issue.
(© DC Comics, Inc.)

> **Osmosis**
>
> *When you work in the mainstream comics industry, you absorb a lot of values and preconceptions without noticing them. You read the fanzines, you go to conventions. You get all of the commonly received wisdom in the industry, and often you can ignore it or judge it according to your own perceptions. But you still can't help but absorb a lot of those values just by osmosis. They sink in. You read those comics, and subconsciously you're absorbing those values. I've found it very necessary to distance myself to a Greta Garbo–like degree from the comics industry. It's not through any sense of standoffishness; I just need to get my head straight.*
>
> ALAN MOORE
> THE COMICS JOURNAL

"It was Lloyd Jacquet," Orlando said. "The elevator operator told Lloyd that I was his cousin. This Italian immigrant network... The guy says, 'I'll tell them you're my cousin, and since I take him [Jacquet] up and down every day, he might pay attention to it.' Because it was very hard to even get an interview right after the war. Everyone was out looking for jobs. We had a wonderful, resplendent American time in the sun during the war, but getting it started right afterwards was very hard."

Jacquet hired Orlando not because he was Italian, but because he was Catholic, putting him to work on "Chuck White" in *Treasure Chest*. "Chuck White was a Catholic boy with a Protestant father," Orlando said. "Lloyd felt that I was Catholic and I would understand the issues we were talking about. He was very, very kind. On my first job, I totally froze up. The deadline came and went, and I still hadn't touched the page. I was totally frozen. I showed up with empty pages, just the lettering balloons. I had given up, I wasn't going to come back... and he sat me down, and he said, 'Do it.'

"People in the industry now wouldn't have that kind of patience. Or understand the psychological trauma."

When Orlando eventually went looking for more work, he bumped into Wally Wood in an agent's office. "Wally was sitting there and I was sitting there, and he said, 'Show me your work and I'll show you mine,' like two boys behind the barn."

They both liked what they saw; so did the agent. When he gave them work, Wood and Orlando decide to work together, Orlando doing the layout and pencils, Wood the inks.

They shared a studio (with Harry Harrison) and worked together for several years, ending up living together *after* Wood got married. Wood's wife, Tatjana, "was pretty gracious," Orlando said, "but I guess it got on her nerves after a while. Finally, Wood called me and said, 'You know, Joe, I really think you're ready to go out on your own. You don't need a partner anymore.'

"I said, 'I'd like to get into EC.'"

Wood promised to introduce Orlando to Al Feldstein if Orlando would come up with a sample. Orlando slaved over a penciled sketch until it resembled an inked page by Wood, then delivered it to the EC office. "After a half hour of waiting, Feldstein comes out and says, 'Well, we think we have another Wally Wood.'"

The first time EC asked Orlando to prove he could ink like his old buddy, he almost died. "But they liked it," he said. "I was surprised. It went on from there. I even tried to break away from Wally Wood."

When EC collapsed in the mid-'50s, Orlando worked at Atlas and Warren and on Bill Gaines's *Mad,* before joining DC permanently in 1966. He has edited several DC titles and served, at various times, as the company's production manager and creative director.

Our Love Story

The Marvel romance comic's 38-issue run has two books of interest to collectors: #5 (February 1970), which contains artwork by Jim Steranko, and #14 (December 1971), with new art by Golden Age artist Tarpe Mills.

Outcault, R. F.

The creator of The Yellow Kid and Buster Brown, Richard Fenton Outcault was born in 1863. He honed his cartooning skills by painting pastoral scenes on safes before going to work for Thomas Edison in 1888.

On May 5, 1895, Outcault debuted *Hogan's Alley* in Joseph Pulitzer's *Sunday World*. In the

"[Outcault] honed his cartooning skills by painting pastoral scenes on safes before going to work for Thomas Edison in 1888."

midst of a motley crew of kids, in what looked like the South Bronx, was an Irish kid named Mickey Dugan, hiding out inside a yellow smock. He soon took over the single-panel cartoon that sent every newspaper scrambling after its own Sunday color comics page.

In 1902 Outcault sired Buster Brown. In *America's Great Comic Strip Artists*, Rick Marschall observed, "When Outcault died in 1928, newspaper articles hailed him as Father of the Comic Strip; those notices that called him Father of the Funnies were closer to the truth. The comic section, not the comic strip, was his legacy and is his monument … Because of the Yellow Kid, the comic strip had a place to experiment, innovate, expand, and mature."

Out of This World

This pulp magazine has the distinction of being the only one ever to contain a comic book.

The cover of the first two 1950 Avon pulps announced, "Plus 32 Pages of Fantasy Stories Illustrated in Full Color." In the first issue that special story section included two stories illustrated by Joe Kubert ("Lunar Station" and "The Man-Eating Lizard") and a "Crom the Barbarian" story scripted by Gardner Fox and illustrated by John Giunta.

Crom—"a man born of the yellow-haired Aesir … a man strong with muscle, his brain keen in these days of brute-like superstition and savagery"—is a thinly disguised Conan. His fighting words ("Yield, you foul hounds of Hel!") are completely in the spirit of Robert E. Howard and Roy Thomas, a big Gardner Fox fan.

Out of This World #2 (December 1950) features another Fox-Giunta story—"The Spider God of Akka"—and the Kubert-drawn "Corsairs from the Coalsack."

Overstreet, Bob

He simply wanted to do something that had never been done. To become the most influential person in the hobby. He has a huge ego but there's nothing wrong with that. He's never used it to hurt people.
MICHELLE NOLAN

Contemporary audiences can still relate to the antics of Outcault's Yellow Kid from 100 years ago.

Bob Overstreet

He collects rare books. Arrowheads and meteorites. He has a complete dinosaur fossil. And that sabertooth tiger skull? "They come out of this river formation in Nebraska, Wyoming, that area," Bob Overstreet said. "They only find two a year. I put a bid out that I wanted one. I had to wait two years."

But Overstreet will always be remembered for the comic book price guide that, in all likelihood, will always bear his name.

Overstreet started collecting comics in 1952. An EC Fan Addict, he bought every EC that came out, but it wasn't until he slipped into science fiction that he put serious hooks into the network of fandom.

In the early 1960s, Overstreet said, he began to realize comic book fans were getting steamrolled by a market that was running amok. There was too little information to bank on. When Gary Carter bought *Superman* #1 from Howard Rogofsky in 1963 for $75, he thought he was buying the first Superman story. "We didn't know about *Action* #1," Carter said. "There was no guide, no book, no nothing. There was just a fanzine [*Rocket's Blast*] filled with ads and 300 people in the United States who even cared about this stuff."

Overstreet cared more than most. A statistician and cartographer for a large paper company, he did what came naturally: He started keeping lists, ever mindful of how instrumental a price guide had been when he began collecting coins in the 1950s. And because he didn't believe a price guide would ever come out of his home turf, Tennessee, he began shipping those lists around. He thought he had the first draft of history and somebody—Jerry Bails? Robert Bell?—would be happy to type up the final version. "The more of these experts I sent my lists to, the more they offered to help me instead of me helping them. So, I decided to go ahead and do it."

"Kicking and screaming," Carter said. "He was talked into it. He almost went bankrupt doing it."

His first price guide was published in 1970. By the time he arrived at the 1994 San Diego Comic-Con, bankruptcy was no longer a serious threat. "I'll always be a collector," Overstreet said. "I'm still just as excited when I see a comic book I've never seen before. I still love the hobby just as much as I did many years ago."

Before the end of that year, however, Overstreet—recently stung by divorce—had passed the torch, selling his price guide and his comic book collection to Steve Geppi and Diamond Distribution. Overstreet remained editor of the guide, but his comic books—at least those not in the hands of his former wife—were offered to the highest bidder at the opening of the Diamond International Galleries in January 1995.

Overstreet Comic Book Price Guide

The most significant publication in the history of comic-book fandom, Bob Overstreet's price guide wasn't the first of its kind. An earlier price guide popped out of the Argosy Book Shop in Hollywood in 1965. Offered at $5 in the November 1965 issue of *Rocket's Blast—Comiccollector*, Bill Schelly notes, its price was slashed to $1.98 in the subsequent issue. Barely more than a glorified dealer's list, the *Argosy Comic Book Price Guide* was a blip on the collecting screen.

And the *Overstreet Comic Book Price Guide*, when its first 244-page edition was published in 1970, wasn't greeted with critical acclaim.

"When the Price Guide first came out, those of us in the business knew it was nonsense," said Ken Thies, a San Diego–based aerospace engineer. "A lot of old-timers like myself laughed at it. Information was wrong. They didn't know what continuity was; they didn't know what the special issues were. Their ideas on prices were shots in the dark."

And, argued Malcolm Willits, the co-owner of Collectors Book Store in Hollywood, there was hardly an earnest attempt to find the target, particularly among dealers on the West Coast. Overstreet, Willits said, "never checked with us, and we were one of the biggest dealers in the country." Furthermore, he argued, "The comics were artificially worth more so that everyone would buy the Price Guide and find out what their collection was worth."

"The first Price Guide? Hit or miss," Michelle Nolan said. "Admirable, but crude. Most of the facts were wrong. It was laughable. But it was a great attempt. We were astounded at it."

Because he had Jerry Bails's green-bound *Collectors' Guide to the First Heroic Age* on hand as a reference, Overstreet had the 1940s down fairly well in that initial effort, but there were huge gaps in the pre-hero books, the romance

"When the Price Guide first came out, those of us in the business knew it was nonsense. A lot of old-timers like myself laughed at it. Information was wrong. They didn't know what continuity was; they didn't know what the special issues were. Their ideas on prices were shots in the dark."
— KEN THIES

Here's an early Overstreet Guide (1973), when Bob was still self-publishing it.
(© Robert M. Overstreet)

"The Price Guide changed the hobby and made it much, much worse for those of us who knew comics. It destroyed our ability to collect cheaply."
MICHELLE NOLAN

comics, and the early Silver Age books. As Erik Andresen observed in a 1992 review of *The Overstreet Comic Book Price Guide* #1 (published in *Comic Book Marketplace*) Overstreet flaunted his preoccupation with the EC books and Frank Frazetta but dismissed *Classics Illustrated* in a mere four lines and made no mention at all of Carl Barks, Alex Schomburg, Matt Baker, L. B. Cole, Lou Fine, or Alex Toth.

"The market seems to have stabilized over the past two years, making it now possible to have a realistic, dependable Price Guide," Overstreet wrote in his introduction to the first edition. The Guide did firm up the ground rules on condition—the ratio between a "Good" and "Mint" book was 1:1.5, compared to the 1995 ratio of 1:7—but it also caused a dramatic shift in the hobby, sweeping it out from under the long-time fanatics and making it accessible to the rookies and speculators.

"The Price Guide changed the hobby and made it much, much worse for those of us who knew comics," Nolan said. "It destroyed our ability to collect cheaply. The average antique dealer might know *Superman* #1 was worth something, but he didn't know *Flash* #1 was worth anything. I was making a living because I was one of the few people in the world who knew which books Frazetta was in. I would make hundreds of dollars buying and selling at the conventions."

Frank Frazetta was listed 48 times in the first Price Guide; over the years, Overstreet would warm up to Barks, Schomburg, and L. B. Cole, thanks to other collectors who'd adored them for years. "Most collectors rejected the first three years of the Guide," said Gary Carter, editor of *Comic Book Marketplace*. "They hated it. But that was changing by 1975. People bought into the Guide because if they turned in data, Bob gave them credit. Pretty soon, the data-contribution list became the most elite list in fandom. In a world that hated comic books and hated you for collecting them, this was one of the first strokes you could get. Suddenly everyone wanted to be part of the book. It wasn't just Bob's book, it was fandom's. And by giving us credit, Bob engendered a great deal of loyalty."

Throughout the 1980s, nothing challenged the Guide as the preeminent reference material in the field. "As I grew up as a collector, I always believed that what was in Overstreet was law," Ernie Gerber said. "You looked at Overstreet and said, 'This is God's word.'" But after Gerber invested five years in tracking down the comic book covers for his *Photo-Journal,* he became a more heretical message: "I realized that a lot of his material was creative guessing. I was astonished to find that this Bible was not a Bible; it was a very good reference work on an extremely difficult field, in which 99 percent of the material was destroyed. It's to be commended but it's to be understood. I found several hundred inaccuracies."

When Gerber published the *Photo-journal* in 1990, his "Scarcity Index"—a rating system that predicted the number of existing copies of all the Golden Age books—gradually became almost as significant a measure of a book's value as the Overstreet near-mint price. By the end of 1995, the Price Guide was so far behind the market's asking price on many Golden Age books—particularly among minor publishers such as Nedor and St. John—that Overstreet and Gemstone Publishing hustled out a 500-page update.

Twenty-five years after it helped turn a hobby into an industry, the *Overstreet Comic Book Price Guide* lacks much of its former vitality. The dozen pages of color cover reproduc-

Over the years Overstreet has commissioned original covers for the Guide from such greats as Wally Wood (right), Carl Barks, Will Eisner, Alex Schomburg, Jerry Robinson, Bill Woggon, and, uh, Bill Ward.

(© Robert M. Overstreet)

tions pale beside those in the *Photo-Journal*. The listings in the 25th edition are accompanied by 185 pages of ads, most of which are competing testimonials by dealers. Overstreet's "Market Report" is only a cursory review of recent sales and his prices are more revealing of the Guide's historical preferences than the changing shape of the market.

But give Overstreet credit for putting his heart and soul into a project that other collectors wouldn't touch. If you deride the brutal price increases of the last quarter century, you might thank Overstreet for putting some of those pricey numbers into your hands. "Sharing the knowledge with the mass market saved a lot of comic books that would have been thrown away," Overstreet said. "We're paying more for these comic books, but they've been preserved. They could have been thrown away. When the big collections began coming out in the 1970s, there was a time when I was afraid there was more old material out there than there were collectors to absorb it. The feeling passed."

Pacific Comics

When the folks at Pacific Comics realized there was room in the market for a company that gave creators ownership of their work and paid them higher royalties, Bill Schanes came up with another idea to make Pacific's books unique: He asked Spartan Printing if they had a better quality of newsprint than DC and Marvel were using.

"In all the years Spartan had been around," said Pacific's former editor David Scroggy, "no one had ever asked them that question. They'd only asked if Spartan had something cheaper."

In the beginning—1971—Pacific Comics was a San Diego–based comic book store. As it evolved into a chain of stores, owners Bill and Steve Schanes had an increasingly difficult time getting new comic books out of Phil Seuling. When the Schaneses tried to get their books directly from DC and were refused, they wrote to Warner Brothers, DC's parent company, asking for a definition of "restraint of trade."

When Warner warned DC that it had to offer everyone the same terms, Seuling's monopoly was effectively broken.

Once Marvel and DC took their first timid steps into the direct market, Pacific came on with a rush. Given that work-for-hire world, there was "a tremendous void," in Scroggy's words, and Pacific filled it with Jack Kirby's *Captain Victory* (which debuted in 1981), Neal Adams's *Ms. Mystic*, Sergio Aragonés's *Groo the Wanderer*, and Mike Grell's *Starslayer*. Pacific was also the first to publish Dave Stevens's Rocketeer stories.

Bill Schanes handled Pacific's distribution, Steve Schanes its publicity. Scroggy was the editorial director. "We were a bunch of kids who didn't know what we were doing," he said, "who latched onto something big and powerful and didn't know what to do when we evolved into a corporate structure and it all blew into a million pieces."

Although Pacific disappeared down bankruptcy road by 1983, it had made its mark. If Marvel and DC hastened Pacific's demise by flooding the market with upscale, high-priced reprints, they were forced to respond to the company's creator friendliness by offering higher compensation or venues such as the Epic line. Pacific also introduced "cycle sheets," an inventory control system. After leaving bankruptcy court, Steve Schanes started Blackthorne Publishing, had a retail store, and briefly worked as marketing manager for Jim Shooter's Broadway Comics; Bill Schanes joined Steve Geppi at Diamond Distribution where he remains as vice-president in charge of purchasing. Scroggy ran the Comic Book Expo trade show in San Diego for a number of years before joining Dark Horse Comics as vice-president of publishing.

In Pacific Comics's heyday, the company included distribution and publishing arms, with a giant warehouse in San Diego. Here, Bill Schanes, David Scroggy, and Steve Schanes show off their new facilities.

Panic

As Frank Jacobs noted in *The Mad World of William M. Gaines*, when the censors first targeted EC, they were offended not by the horror but by the humor.

Panic, Bill Gaines's satirical companion to *Mad*, debuted in early 1954. "To honor the season," Jacobs wrote, "Will Elder was assigned the job of illustrating 'The Night Before Christmas.' Never had Clement Clark Moore's classic been adorned with such unusual art."

Santa's sled was decorated with a meat cleaver, daggers, and a "Just Divorced" sign, and those "visions of sugarplums" included Marilyn Monroe and Jane Russell. That was a little much for a local distributor in Holyoke, who refused to move the comic book.

And if a magazine got the hook in Holyoke, you know "Banned in Boston" couldn't be far behind. In Boston, Attorney General George Fingold ought to outlaw *Panic* for its "pagan" depiction of Christmas.

Gaines's reaction was typically subtle: He

EC's *Panic* lasted 12 bimonthly issues in 1954–1955.
(© 1998 William M. Gaines, Agent, Inc.)

pulled all copies of *Panic* in the state of Massachusetts, threatening never to return with the comic. Jacobs said he also succeeded in pushing a news story saying he'd also yanked *Picture Stories from the Bible* off the stands, when that staid book had actually ceased publication five years earlier.

Paper

The key to selling comic books, in the beginning, was paper. It is no coincidence that many of the early publishers were printers with presses and paper on their hands. "In war-time, the great challenge was access to paper and print," Golden Age artist Pierce Rice said. "If you could print something, you could sell it. I don't know why kids besieged the newsstand, but they did. If you could get something circulated, you could sell it."

And after the war? "Some of my psychiatric friends regarded my comics research as a Don Quixote enterprise," Fredric Wertham complained in *Seduction of the Innocent*. "But I gradually learned that the number of comic books is so enormous that the pulp paper industry is vitally interested in their mass production. If anything, I was fighting not windmills, but paper mills."

Parade of Pleasure

Geoffrey Wagner's 1954 denunciation of popular culture included a chapter in which he agreed with Fredric Wertham's contention that comic books contributed to the "psychological mutilation of children."

Wagner, a British-born writer with degrees from Oxford and Columbia, argued in *Parade of Pleasure: A Study of Popular Iconography in the USA* that comics stripped young readers of their imaginations and "crippled" their minds.

His examples of the comics' various excesses, duly noted in the Overstreet Guide, are almost as popular among collectors as the exhibits in *Seduction of the Innocent*.

The books mentioned in *Parade of Pleasure* include:

Action #176
Beyond #18
Blackhawk #91, 92
Captain Marvel, Jr. #104
Down with Crime #6
Fight #78
Fight Against Crime #6, 15
Murder Incorporated #3
Planet #69
Rangers #63
Superman #81
Tales from the Crypt #34
Terrifying Tales #11
Terrors of the Jungle #21
Thrilling Crime Cases #47
Vault of Horror #26
War Report #4
Wonder Woman #50

Paris, Charles

Batman was never my favorite comic strip. Batman was my main source of income for a lot of years. The character was no alter ego of mine.

For 17 years, beginning in 1948, Charles Paris was the regular inker on Batman's romps through *Detective, World's Finest,* and *Batman,* and not once did he regret that his name wasn't on the splash page. "I signed [Bob Kane's] name to a lot of stuff and I was glad it was his and not mine," Paris said.

"My interest in comics was because it was a steady gig. I didn't have to chase anyone for the money. The check was always waiting for me, and for an artist, that's a big plus."

Paris never begrudged Kane his celebrity. "Where would a lot of us have been if he hadn't come up with this thing?" Paris said. "It was a gravy train for a lot of guys."

Paris got his share of the gravy but never rode that train anywhere but around the office. "When I washed out my brush at the end of the day, that stuff never entered my mind until I picked it up again," he said. "I never dreamed about it. I never thought about it. I never read it except when it was necessary."

Born in Greensboro, North Carolina in 1911, Paris was, like his father before him, both an artist and a musician. He remembered the bandstand as "a very good place to observe

human nature. I don't think it has a beneficial effect on you because it makes you quite cynical quite young if you have any brains at all. You're like a busboy. You're just a part of the service, part of the surroundings. It gives you a chance to see a lot of stuff going on. You look out there and you see who's dating whom and who's cheating on whom. You learn to separate the real people from the poseurs."

During the Depression, Paris took a job in a clothing store until he raised $250, enough to sustain him when he headed to New York to seek his fortune in 1934. While he took classes at the Art Students' League, he worked nights ushering at a Loew's movie house on upper Broadway. He was paid $3 a week. "I don't think you could call it good money," Paris said, "but it was more money than I could make standing on the corner," an all-too-familiar resting place during the Depression.

In 1940, while studying under Harvey Dunn at the Grand Central School of Art, Paris met Stan Kaye and Cliff Young, who were already parked in the bullpen at National. He also met Jack Lehti, who hired him to ink his work on Crimson Avenger in *Detective Comics*. When Lehti went to war, editor Whit Ellsworth hired Paris and put him to work inking Mort Meskin's work on *Vigilante* and *Johnny Quick*. "I regard Meskin as one of the geniuses in the field," Paris said. "He left you some room to play with his stuff. And he was very patient with me."

Paris picked up the inking chores on the *Batman and Robin* newspaper strip in 1943. By the end of the decade, he was inking everything that Dick Sprang, Shelly Moldoff, and Jim Mooney threw at him. "It was my job to try to coordinate this stuff so it looked like it came out of the same paint pot," Paris said. "I went in to Whit one day and said, 'Mr. Ellsworth, can't you give me something else to work on besides The Batman

"He said, 'Nope.'

"I said, 'You mean it's The Batman or nothing?'

"He said, 'Yep.'" From Ellsworth's seat, Paris was more valuable coordinating the Batman pencilers than sailing off into another book.

"All I brought was an honesty of effort," Paris said. "I gave it my best shot."

Paris left New York for Tucson, Arizona in 1958, from where he continued to send inked pages back to editor Jack Schiff through the mail. From the benefits of that steady paycheck, Paris indulged in several other passions, including painting the west and studying avian genetics. His home was full of his art and his finches in 1988 when the fire broke out.

"It started in a wall plug," Paris said. "I was looking right at it. Sparks were shooting out of the plug on to my bed. I reached over to the fire extinguisher and turned it on, but some of the sparks caught the curtains on the window over the bed." Because Paris had osteoporosis, he couldn't wrestle with the heavy mattress, which was foam rubber. "The bed exploded—BOOM, just like that—with me squirting the fire extinguisher. My brother dragged me out."

Paris didn't go without a fight. "I wanted to go open my window and let my birds out. You don't think right at a time like that. He said, 'Man, you're going to die.' He grabbed me and pulled me back and dragged me out. On the way out, I grabbed the telephone and called the fire department.'

Paris lost most of his art, his birds, and his patience for those television shows about folks who have battled tragedy. "By the time you get

"Mr. Ellsworth, can't you give me something else to work on besides The Batman?"
CHARLES PARIS

Charles Paris inked Bob Kane's pencils on the Batman newspaper strip starting in 1943. He went on to be one of the star inkers on the Batman comic book.
(© DC Comics, Inc.)

as old as I am," Paris said "you've had enough tragedy in your own life that you don't get inspired by someone else's."

He was, however, stunned to learn how many people got inspired by his. After the fire, a variety of comic and fantasy art collectors, led by Joe Desris, set up a fund that allowed Paris to rebuild. "I was surprised at the number of people who contributed," he said. "I didn't know there were this number of people who knew who I was, or cared. The comics hadn't entered my mind in 20 years, yet there were people out there who collected this stuff. My name wasn't signed to it, but they knew who I was. Life is very strange."

On March 12, 1994 Paris was the passenger in a car driving from Tombstone to Tucson when the automobile was hit broadside. He died a week later in a Tucson hospital.

Parker, Bill

He was Fawcett's first comic book editor and the creator of Captain Marvel. Jim Steranko reported that when Parker returned in 1945 from a five-year stint in the National Guard, "he bypassed the comics for a job on Fawcett's *Today's Woman Magazine,* and later became editor of *Mechanix Illustrated.*"

Paul, Frank R.

Frank R. Paul was already 58 years old when Martin Goodman asked the pulp artist to draw the cover of *Marvel Comics* #1 in 1939. Paul had also been the cover artist for the first issue of Hugo Gernsback's *Amazing Stories* in 1926

A cartoonist for the *Jersey Journal* before he hooked on with Gernsback, Paul was more creative than spectacular. "Paul had to be admired for his versatility," Michael Ashley argued: "It was claimed that he never drew the same space ship design twice. Paul's failing, however, was with people, and continuous studies of his work will soon invoke a disdain for his flat-chested, jodhpur-clad females."

Payette, Jim

One of the country's top dealers in old comics, Payette operates out of Bethlehem, New Hampshire, in the heart of the White Mountains. In New Hampshire, Payette notes, there's no income tax on sole proprietorships.

Payette collected Marvels as a kid but didn't begin dealing comic books until the late 1970s. Tired of working as the operations manager of an Austrian resort, he bought his first *Overstreet Guide* (#8) from a publishers' clearinghouse catalogue. After exhausting the comics mines of New Hampshire, he went national.

Payette has rooted out several pedigree collections, including the Allentown and Denver books, but not all his scavenger hunts have turned out quite so well. He once flew to Arizona to look at a collection: "The guy picked me up in his Model-T Ford," Payette said, "and took me to his home. I'll bet that thing hadn't been dusted in five years. He left me at his home alone to work on the books. After a while, I was thirsty and thought I'd go to his refrigerator and get a coke."

The refrigerator didn't open at first yank; when Payette jerked the door a little harder, he found out why. "The refrigerator had stopped working two years before: Fungus had created a seal." Payette doesn't want to talk about what he saw living inside the ketchup bottle and milk carton. "I shut the door as quickly as I could. I don't know how he slept in his bed."

Pedigree Books

The Mile High collection of Edgar Church spawned a new concept for comic collecting: *pedigree books,* which invariably sell at *multiples of guide.*

Pedigree books are part of collections that are celebrated for their size, condition, key issues, and page quality.

Among Golden Age books, the Mile High collection is in a class by itself, but other pedigree collections are the Allentown, Cosmic Aeroplane, Denver, Lamont Larson, and San Francisco books.

Frank R. Paul liked to paint rocketships and space stations.
(© Ultimate Publishing Co, Inc.)

The only two post–Golden Age pedigrees belong to the William Gaines file copies and to the books from the White Mountain collection.

The idea that comic books can attain some kind of pedigree is frequently criticized, usually by Silver Age dealers. Says Chris Budel of the College of Comic Book Knowledge, "To me, it's like a giant pyramid scheme, especially all the pedigree stuff. Collectors are not going to sell their books at a loss, so they have to suck that many more people in to buy them."

Pekar, Harvey

The comics' Clerk Kent—he's worked as file clerk, sales clerk, and shipping clerk over the years—Harvey Pekar has turned morbid preoccupation with self into an art form. He grew up in Robert Crumb's Cleveland neighborhood, first meeting the cartoonist in 1962 and tracking his subsequent career. When Crumb returned to Cleveland for a visit in 1972, Pekar showed him several autobiographical stories "about a guy who's working a 40-hour-a-week job as a file clerk at a Veteran's Administration Hospital." Crumb liked one story, "Crazy Ed," enough to illustrate the piece in a 1972 issue of *The People's Comics*.

"I want to write literature that pushes people into their lives rather than helping people escape from them," said Pekar, who was born in 1939. By diverting money he was spending on 1920s jazz records, Pekar plunged into self-publishing in 1976 with the first issue of *American Splendor*. He published an issue annually for the next 15 years. In the mid-1980s Pekar gained quite a late-night following with his televised squabbles with David Letterman.

More recently, he combined forces with his wife, Joyce Brabner, to write the award-winning *Our Cancer Year*, a somber look at Pekar's brush with the disease.

Penis Envy

If you're not looking for the little yellow penis, you're probably not going to find it. No one examining the color proofs for *Captain America: The Classic Years* picked up on it. Not until Marvel sent Joe Simon his copy did anyone stumble across the artistic ad lib, poking out of the sheets covering Bucky on page 1 of Simon and Kirby's "Horror Hospital."

"His first reaction was outrage," said Greg Wright, who edited the book. "Then he thought about it for a while and decided it was pretty funny someone had played the prank." Simon took the book to Marvel editor Tom DeFalco and together they called Wright.

"Are you aware of this?" they asked.

"Aware of what?"

"Aware of the penis?"

Greg Theakston of Pure Imagination, which colored the reprint volume, said Wright might have been aware of the penis but "he was down to his last month at Marvel, and wasn't keeping a careful eye on the project, to say the least."

Theakston and Wright agree that a disgruntled color separator was responsible for the prank. "He was long fired by the time the book came out," Wright said. "There was no opportunity for justice."

Sometimes a comics colorist had a sharper eye. This from Larry Harrison's account (in *Graphic Story Magazine* #15) of life among the romance artists:

Harvey Pekar

Harvey Pekar as portrayed by Frank Stack in the critically acclaimed graphic novel *Our Cancer Year*.

(© Joyce Brabner and Harvey Pekar)

> *We did two or three stories which gave us some laughs monkeying around with the artwork, mainly to relieve us from the boredom of having to illustrate lousy scripts. One was on a story called "Playtime Cowgirl" for an EC western romance, where we brought the thing in originally with a big dong in the horse's crotch, about four feet long, circumcised, with crabs, real crabs and lobsters hanging from it, spider webs, bandaids all over it. Turned it in to [Bill] Gaines, who loved it and kept it to show his advertising man, Lyle Stuart. They showed it around, then forgot about it. Finally it went to the engraver where they took black plates of it, then proofs, which got as far as the colorist who was the one who caught it. "Mr. Gaines, isn't this kind of a funny looking horse?" Gaines screamed to think it could get so close to going through. We just painted it out. They reshot the black plate, but it almost got by.*

Many artists were content to doodle away in the studio. Bob Fujitani recalled goofing around with Jack Cole and several other artists, drawing penises. "Big, long ones. Short, fat ones. Uncircumcised ones with a hunk of skin hanging over. You know, funny ones," Fujitani said. "Fifteen years later, I bumped into Jack Cole at a party. Jack Cole looked at me and said, 'Hey, you're the guy who draws the cocks!' That's all he remembered. If he were alive today and I bumped into him, he'd think of only one thing."

A Penny Saved

In the summer of 1978, DC's Jack Harris asked Steve Englehart to write three stories for the company. Englehart wanted more than the top page rate of $32 and (according to Englehart) Harris said, "Don't worry about the money. We didn't know if we could get you for this. This is a special project, and I'll get you more than $32."

"So I came to New York," Englehart told *The Comic Times*, "I turned in the stories, and Jack told me how they were going to make a lot of money off this. It was the big news of the month that Englehart and [Marshall] Rogers were back at DC . . .

"Then I went down to Paul Levitz and he said, '$31, take it or leave it.' And I said, 'But Jack promised me at least $33.' And he said, 'Jack has no authority to do that, $31, take it or leave it.'"

Englehart is not a take-it-or-leave-it kind of guy. He went home, stewed for a few days, then came back and told Levitz he was taking his scripts back. This proclamation sent Levitz, Harris, and publisher Jenette Kahn into an emergency meeting. When they emerged, Harris said, 'Well, I don't remember what I said to you, but we'll compromise, we'll give you $32.'"

As Englehart tells the story, "I said, 'No, I get at least $33 or nothing.' And he said, 'Well, we can't do anything about that.' And I said, 'Fine,' and I took the scripts back. Two 25-page things for Jack, which had been a Madame Xanadu, Deadman, and Demon team-up, and one 17-page story that I'd done for Julie [Schwartz]: a Superman and Creeper team-up."

After Englehart tried unsuccessfully to peddle the stories to Marvel, he got a call from Dean Mullaney at Eclipse, who bought the stories for $33 per page.

"I was so amazed when this came down," Englehart said. "We were talking 67 pages—two 25-page stories and a 17-pager—and so at an increment of a dollar, we're talking $67. In exchange for the $67, they lose the big news from DC for the month and they lose three Englehart and Rogers stories which would have made them a bunch of money. The Superman/Creeper story was already being drawn by Curt Swan, so they lose all that artwork. They can't get somebody else to write a story to fit those pictures, because it's my story and I never signed anything. I mean, they're taking an incredible loss over $67 and you'd have to ask them why they felt that that was worth it."

Pep Comics

By wrapping The Shield in the American flag and unfurling him in *Pep Comics* #1, MLJ Magazines had the honor of publishing the comic books' first patriotic superhero. *Pep* had a publication date of November 16, 1939, a full 13 months before Joe Simon and Jack Kirby delivered *Captain America*.

The Shield was MLJ's all-time leading man (at least until Archie Andrews came along). He appeared in 99 stories before bowing out in *Pep* #65.

Joe Higgins, a.k.a. The Shield, was an apprentice chemist when his father, an Army

"Many artists were content to doodle away in the studio. Bob Fujitani recalled goofing around with Jack Cole and several other artists, drawing penises."

intelligence officer, died in the explosion of an ammunition ship. Papa Higgins was your typical research scientist of the late '30s, desperately trying to scrounge up the chemical formula that would turn Steve Rogers into Captain America. Or whomever. Before he died, Lt. Higgins gave his son enough clues that—one skintight fibro-metallic suit and a J. Edgar Hoover G-Man commission later—The Shield was born.

Some might argue that *Pep Comics* saved its best delivery for another two years when, in issue #22, Archie and Jughead burst upon the scene. You make the call. Archie didn't grace the cover of the book until #36, whereon he is held aloft by The Shield and The Hangman. Identical triplets? Not quite. Archie had the real muscle in this trio, and the real staying power.

Irv Novick drew The Shield in the first 28 issues of *Pep*, and doggone well. Other features before Andrews & Co. completed its takeover included Madam Satan, pugilist Kayo Ward, The Comet by Jack Cole, The Hangman and—a personal favorite—The Press Guardian. Whenever anyone threatened members of the fourth estate, The Press Guardian kicked butt. Mort Meskin did the art honors.

Key issues: #1, first Shield, Comet, Kayo Ward; #11, first appearance of Dusty the Boy Detective, The Shield's sidekick; #15, petticoat cover; #16, origin of Madam Satan, DOUBLE HYPODERMIC COVER!; #17, origin of Hangman and death of the Comet (The Hangman's brother)—the first hero's death in all of comics; #22, first Archie and Jughead; #26, "Remember Pearl Harbor" issue, first Veronica; #23, Hangman vs. Capt. Swastika; #29, Schomburg cover; #30, first Captain Commando and the Boy Soldiers; #34, Fujitani takes over Hangman; #36, first Archie cover, by Montana; #38, Schomburg cover; #47, last Hangman; #49, Archie takes lead story; #50, last cover appearance, The Shield

Pérez, George

Born in the South Bronx in 1954, George Pérez is one of the few Puerto Rican artists to break into the field, carving out a nice niche through the 1980s. His work first appeared in the back pages of *Astonishing Tales* #25 in 1974, and he proceeded to draw both Fantastic Four and The Avengers for Marvel. But his popularity peaked when he moved to DC and joined Marv Wolfman on *The New Teen Titans* in 1980. "Marvel taught me power. It was DC who taught me subtlety," said Pérez, who also drew *DC's Crisis on Infinite Earths* in 1985. He went on for a successful run writing and drawing *Wonder Woman* and introduced his own creator-owned series, *Crimson Tide*, in 1997.

Peters, Lilly Renée Wilhelms

Rafael Astarita remembers Lilly Renée from their days together at Jerry Iger's studio as ' tall, perhaps 5-6, slender, with very poor posture. She had well-developed breasts and seemed somehow to be ashamed of it. She had dark hair and dark slanted eyes, an attractive mouth, and poor teeth. She smoked quite a lot and her teeth were noticeably discolored.'

That Astarita remembers Lilly Renée's teeth and breasts, and not her drawing ability, says quite a bit about how women fared in the Golden Age shops. At Fiction House Bob Lubbers said that "Fran [Hopper] and Lily took a lot of abuse, a lot of gags." One suspects either woman occasionally looked up and discovered that she was the unsuspecting model for Camilla, Tiger Girl, or Mysta of the Moon.

After getting her start at Timely, Wilhelms joined Iger in 1943. As Trina Robbins and cat yronwode note in *Women and the Comics*, Wilhelms best work was on three Fiction House features: "The Lost World," "Werewolf Hunter," and "Senorita Rio."

"Other artists, notably Nick Viscardi, drew Senorita Rio over the years, but it is Lilly Renée who is most closely identified with the series.

The Shield was comics' first patriotic super-hero. Irv Novick did the art chores on the Shield stories and covers for the first 28 or so issues of *Pep*.
(© MLJ Magazines)

George Pérez

Lilly Renée was one of two female artists at Fiction House; both were masters of "good girl" art.
(© Fiction House)

The Phantom has been "walking" through newspaper comics pages for over 60 years.
(© King Features Syndicate)

She must have also felt the identification, for after she left Fiction House and joined her husband, Eric Peters, on the St. John comic Abbott and Costello in 1948–49, she introduced a Latin lovely named Rosita to the title, drawing her as a Senorita Rio lookalike in all but name."

The Phantom

The most popular comic in the world is probably The Phantom. It's the type that really makes it, a guy with no eyeballs wearing a purple suit.
HARRY HARRISON

"The Ghost Who Walks" is, as Maurice Horn noted, not a man but a dynasty. When Lee Falk introduced *The Phantom* (a King Feature) on February 17, 1936, a score of previous Ghosts were already in the grave and the 21st was keeping the peace in the jungle. Ready to spawn the 22nd was Diana Palmer, an Olympic diver and, presumably, the only living soul who had crept beneath The Phantom's mask.

A superb equestrian, The Phantom was usually accompanied by his wolf, Devil, and a skull ring. Falk and Ray Moore produced the comic strip, which was reprinted in a variety of David McKay publications—*Ace Comics, Future Comics,* and *King Comics*—beginning in 1938. Both widely popular and influential abroad—Falk once reported 100 million readers in 40 languages—the character's comic book license was picked up in 1951 by Harvey, which reprinted 11 Phantom adventures in *Harvey Comics Hits* and *Harvey Hits.*

In Jerry Robinson's *The Comics: An Illustrated History of Comic Strip Art,* Falk wrote:

> *During World War II, the German occupation of Norway was rigid and harsh. The Germans controlled the Norwegian press and daily in their papers printed untrue propaganda that the United States was being destroyed, New York and Washington bombed, etc. But at the same time, The Phantom was being smuggled across the border from Sweden and being printed daily in Norwegian in these same papers. The German occupying authorities paid no attention to this comic strip and did not know it was of American origin. But the Norwegians knew where it came from. And while their controlled newspapers were telling them each day that the USA (and other Allies) was in ashes, The Phantom kept appearing—thus assuring readers that the USA was still going strong.... Because of this, one of the passwords of the Norwegian underground in World War II was "Phantom."*

The Phantom Stranger

A mysterious figure who played the avenger, the moral arbiter, or a Rod Serling-style narrator, depending on the mood of the writer, the Phantom Stranger debuted in his own book in September 1952, with a script by John Broome and art by Carmine Infantino and Sy Barry. The character was resurrected in *Showcase* #80 (February 1969), then appeared for the next seven years in *The Phantom Stranger* (2nd series). The artists for those 41 issues included Mike Kaluta, Mike Grell, Tony De Zuniga, Mort Meskin, and Bernard Baily; Neal Adams did the covers for issues #3–#19.

The Photo-Journal Guide

We consider this the second most important book in the history of comic book fandom, after the *Overstreet Comic Book Price Guide,* and the only one of the top two that hasn't made a passel of inside players rich.

Ernie Gerber's desire to get even with Bob

Overstreet played a part in the genesis of the *Photo-Journal*, but so did his desire to pay tribute to the memory of his sister, Gerda.

In December 1976, Gerda—seven years Ernie's senior—died in a car accident while returning from a skiing trip. "I really wanted something to remember her by, but her grieving husband wouldn't let anything out of the house," Gerber said. "So I had nothing of my sister's." Then, Gerber remembered the *Classics Illustrated*s that his sister read to him when he was a little kid in the late 1940s. "I ravaged my house to find a half-dozen with her name written on them. I thought it would be a tremendous tribute to go out there and try to complete the *Classics* collection."

By 1985 that initial impulse to collect comics had evolved into a booming auction business. The heart of Gerber's auction that year—which brought in $675,000—was Rick Durell's collection of Golden Age books. "I remember the fateful day when I put my first shipment together, the first comics to be sent out," Gerber said. "I said, 'These are complete runs of *Superman* and *Action*. They're going to be gone. I'll never be able to see this again.' I was a month behind in shipping, but I couldn't ship them without photographing them. So, I unwrapped that entire first shipment and photographed it. From then on, before I shipped a book, I photographed it."

Those early photographs were nothing special; Gerber had yet to lay his hands on the $3,000 lens that was designed to photograph flat objects, nor to experiment with lighting. All of that would come. Next up for the contentious Gerber was his falling out with Bob Overstreet.

"Bob Overstreet really pissed me off," Gerber said. "He took away one of my advertising spots [in the *Price Guide*] and gave it to someone else. You know, Bob has a rule that if you have an advertising spot in the *Guide,* you get that for life, as long as you continue it. I had the last spot before the body of the *Guide,* right by *Action Comics*. He took that away. So, I got ticked off and said, 'Okay, I'm going to do a competitive guide.'

"It was going to be called *SOLD: The Collector's Price Book*. I had the covers drawn, I had done all the research. The photos. It was going to be based on computer printouts of actual prices sold at all the auctions around the country."

When Gerber tried to market the book, it went nowhere; even with prepublication specials, he sold only 200 copies. Gerber abandoned the project, refunded the money, and stared at his cover photographs—a pile of some 8,000 slides—wondering where to go next. In 1986 he finally hit it: Instead of going head-to-head with Overstreet year after year, why not publish one definitive book filled with all the comic book covers people rarely, if ever, get to see?

In the beginning, Gerber envisioned a book with 7,000 photographs that would sell for $49; he figured he could pull the project off with a budget of around $250,000. He knew he couldn't include every comic book in his *Photo-Journal*. "Between 1933 and 1965, there were approximately 50,000 different issues. That would have meant a price tag of $300–$400 a set, and it never would have sold. I had to make some decisions."

Gerber eliminated many of the romance and funny animal issues but had a tough time drawing the line with the major titles. He thought he could get away with *Superman* #1–#100 until he ran into a collection of #1–#300. He was a little wishy-washy on the jungle titles until he saw the Mile High run of *Jungle* #1–#55. Each time he was given access to another collection, his

Gerber's original *Photo-Journal* was published in two volumes.

(© Gerber Publishing Co.)

"Why not publish one definitive book filled with all the comic book covers people rarely, if ever, get to see?"

The original *Photo-Journal* was followed up with a two-volume Marvel Comics set.
(© Gerber Publishing Co.)

goals increased. Within 18 months, Gerber was advertising a set of books with 18,000 photographs for $125.

Armed with a Nikon F3 and enough weights to eliminate all the vibration in his photo stand, Gerber toured the country, photographing the finest collections. "Even the real eccentrics in the business, who never let anybody see their collections, let me come in because they wanted their books in the thing," Gerber said. He claimed he never carried a list of comics with him. "I knew by memory which comics I'd photographed. If I saw a book I knew that was better quality, then I'd photograph it again." Very quickly, Gerber focused on the Mile Highs. "Out of the original 18,000, I probably photographed 13,000," he said. If the collector wouldn't let him photograph his Mile Highs, Gerber often bought them.

"One of the absolute coups was the collection of an eccentric millionaire who has rarely let any people into his house at all," Gerber said. "He had about 3,000 to 4,000 Mile Highs, but they were all the esoteric ones. He must have had 1,000 books that no one else had. Some of them were the only ones in existence, or at least the only ones that I've ever seen."

Gerber's other major find was the Library of Congress. The librarians there rarely allow visitors to view their comics, must less photograph them, but because Gerber had the patents on much of the equipment the Library of Congress used for archival storage he had a few friends in high places, "who introduced me to the right people in the other right places, who got me into the stacks," says Gerber.

"I spent two days in the Library of Congress photographing all their books. They have nothing of value. All the rare books were stolen years ago. Visitors would steal them blind. They used to throw the comics into this big room with big stacks. They never filed them, they just threw them into the room. When they finally organized the collection, they found out that 90 percent of the valuable comics were gone.

"But I didn't need those. All the collectors around the world have the key, valuable books. What I didn't have were the esoteric, cheap ones that no one collects."

When Gerber returned to Nevada from that trip to the East Coast, which included photo sessions with 11 collectors and his two-day shoot at the Library of Congress, he developed his 175 rolls of film and discovered he didn't

> **COVER PIECES**
>
> Before the *Photo-Journal*, relatively few collectors had ever seen more than several dozen Golden Age covers. If the cover wasn't on display in the *Overstreet Comic Book Price Guide* or on the wall of the local comic book pit, it didn't exist. Collectors didn't know what they were missing. When they saw an ad for *Hit* #5 or *Brenda Starr* #14, they had no frame of reference—nowhere to go to catch a sneak preview.
>
> Small wonder the Overstreet Guide for years grouped and priced most Golden Age books by number (say, *Exciting* #31–#40) as if the comics had no distinguishing characteristics other than the date in the indicia. Only after Ernie Gerber spent five years producing his photographic record was there proof to the contrary for the average collector. When the collector could curl up with page 243 of the *Photo-Journal*, only then did he or she discover that *Exciting* #38 was a routine car chase and *Exciting* #39 an indelible image of Nazi atrocities.
>
> When collector Jon Berk paid 3.5 times Guide for the Mile High copies of Hit #1–#7 and Fantastic #1–#14 in early 1994, he credited Ernie Gerber. He didn't discover the breathtaking cover art of Lou Fine, he admitted, until the covers skipped off the glossy pages of the *Photo-Journal* and slapped him in the face.

have a single frame he could use, thanks to a resistance short in his flash cable.

"I'd spent three weeks out there. After a few stiff drinks, I was ready to say, 'That's it, it's over, I'm not doing the book, I will *never* do this book as long as I live,'" Gerber said. "Then I went back and rescheduled everything, including some sensitive negotiations with the Library of Congress. I said, 'I missed a couple, I just need a couple more hours.' It ended up being a couple of days."

When the dust had settled, Gerber had almost 70,000 slides, including numerous multiples of all the key books. He'd exceeded his $250,000 budget by more than $600,000. "And it wiped me out," he said. "It Wiped Me Out. I had to raise almost $900,000 in advance. Naturally, I mortgaged my house, my family, my pets, and it wasn't enough."

It certainly wasn't enough to keep his marriage together. Before his second wife, Mary, left, she helped Gerber sort the slides and cull the 22,000 cover photographs that made Gerber's final cut.

His outrageous costs forced Gerber to print 20,000 sets of the *Photo-Journal*, and by the 1992 San Diego Comic-Con, Gerber had marked down the sets from $145 to less than $50. The following year, he sold his massive inventory of Mile Highs and the publishing rights of his enterprise to Steve Geppi.

That Gerber insists he lost money on the original *Photo-Journal* (a companion guide to Marvel Silver Age books was published in 1990) only adds to its charm. The visual impact of Gerber's labor is still immeasurable. It allows collectors—even those who will never own a Golden Age book—to skim across the surface of all the color and frenzied action that kept the comic book racks spinning before the dawn of Mylar and backer boards. If Bob Overstreet published a book for dealers and investors, Ernie Gerber produced one for the fans.

A toast, then, to his stubborn inspiration.

Picto-Fiction Magazines

A curious, and curiously half-baked, idea from William Gaines, the Picto-Fiction books debuted with *Shock Illustrated* #1 in October 1955.

The series featured four black-and-white, 25-cent magazines: *Confessions Illustrated*, *Crime Illustrated*, *Terror Illustrated*, and *Shock Illustrated*, the only one of the quartet to publish a third issue.

"Gaines launched the series without any reference to his previous operation," J. B. Clifford, Jr. reported. "The Picto-Fictions were never promoted in any of the existing EC comics; they did not refer to the existing or deceased comics; they were not promoted to the more than 20,000 members of the EC Fan-Addict Club."

The Illustrators included Reed Crandall, George Evans, Johnny Craig, and Graham Ingels. *Shock Illustrated* #3 was at the bindery in 1956 when Gaines finally gagged on the low sales numbers and pulled the plug.

"So, the picture was this," Clifford notes: "*Shock Illustrated* #3 was ready to be bound and sent to the distributor. Gaines did not have the money to have the entire print run [of 200,000+ copies] bound. Even if he could raise the credit and find a new distributor, the title was certain to lose money. And so, to cut losses, the entire print run went to the scrap dealer, except for approximately 100–200 copies, which were hand-bound and sold or given away from the New York offices of EC." Only 26 of the books, including Gaines's dozen file copies, were recovered.

Picto-Fiction Magazines:
Shock Illustrated #1 (October 1955)
Terror Illustrated #1 (December 1955)
Crime Illustrated #1 (December 1955)
Shock Illustrated #2 (February 1956)
Confessions Illustrated #1 (February 1956)
Crime Illustrated #2 (April 1956)
Terror Illustrated #2 (April 1956)
Confessions Illustrated #2 (May 1956)
Shock Illustrated #3 (May 1956)

Pied Piper

The Pied Piper Bookstore sat next to the Wichita State University campus, a little house full of books and cats. The owner was an old bear named Jack Whitshell, who arched his bushy, Russian eyebrows whenever a kid came through the door looking for comic books. "He considered comic books a waste of time," Jerry Weist said. "Back then, there was no money in

The short-lived *Shock Illustrated* was one of four titles in the EC Picto-Fiction series.
(© 1998 William M. Gaines, Agent, Inc.)

them, and they just encouraged kids to come in and go out of control. He never kept used comics in the store."

Whitshell kept most everything else. He loved the old pulp heroes of the 1930s, and they had a prominent place in the store, among the digests, the paperbacks, and magazines. Bob Barrett used to pop through the door looking for Edgar Rice Burroughs books. Weist was invariably looking for the Ace-double paperbacks, and Whitshell took note of how carefully he lifted each book from the rack, determined not to crack its spine.

One day in 1962, Whitshell interrupted Weist's reverie and led him into the back room of the Pied Piper. "The back room was where no one went," Weist said. Sitting there was a collection of comic books Whitshell had just purchased. "There must have been 75 percent of every DC and Marvel comic from 1958 to 1962. Mint," Weist said. "He said, 'They're six for a quarter. And you can have all summer to buy them.'

"I did."

Weist is now Sotheby's main consultant on their annual auctions of comic books and comic art.

Planet Comics

The comics' first science fiction series is also the most popular Fiction House title among collectors. Three of the publisher's earliest titles debuted in January 1940 (*Jungle, Fight,* and *Planet,* in that order), and the first issue of *Planet* is listed at $8,200 in the 1996 *Overstreet Price Guide,* almost twice the price of the first issues of *Jungle* ($2,800) and *Fight* ($1,600) combined.

In almost the entire *Planet* run, the quality of the interior artwork matches the superb cover illustrations of Dan Zolnerowich, Joe Doolin, and Lilly Renée.

Plant, Bud

Bud Plant has never had a job in his life.
JIM VADEBONCOEUR

In 1965, Jim Vadeboncoeur was looking for back issues at Twice Read Books in San Jose when a young Latino offered to find him some early *Fantastic Four*s. "Tell me what you want," he told Vadeboncoeur, "I'll go get it and meet you someplace."

Because Vadeboncoeur had never seen a turnip truck, much less just fallen off the back of one, he replied, "No, you're not riding off into the sunset with my money."

"The way we finally arranged it was that he would take me to meet people who had comics," Vadeboncoeur said. "If I bought comics from them, I would pay him the same amount I paid the people I bought the books from. When they're a nickel apiece, you don't care about a dime apiece: I wanted the books. So, he took me around to a lot of young kids who had boxes of comics stuck inside their bedrooms. The third person he took me to was Bud Plant.

Joe Doolin produced dozens of stunning covers for *Planet*; this is #58 (March 1948).
(© Fiction House)

"Bud was a 13-,14-year-old kid. I looked at his box of comics and said, 'I don't think I better buy all the ones I want this time.' I basically bought a few things, drove the Spanish kid back someplace, and drove right back up to Bud's."

Bud's stock was always the kind that brought you back for more. In 1968 Plant—who was barely old enough to drive—joined John Barrett and five other guys to open Seven Sons (see entry) in San Jose, the first store in California to deal exclusively in comic books. The store survived six months before being sold to one of the other partners, but in 1969 Plant and Barrett opened a second store, Comic World. The following year, Plant set up a mail-order distribution business that specialized in underground comics.

"He wasn't old enough to buy them," Vadeboncoeur said, "but he was selling them."

"The mail-order business was underground comics and fanzines and anything I could get my hands on," Plant said. "Sometimes it was underground newspapers or *Rolling Stone*. *Rolling Stone* did a story on Marvel back in '74 and I was buying copies off the newsstand for 50 cents and selling it through the mail for a buck.

"No one was selling underground comics to speak of, outside of whatever strange distribution system there was back then. So I'd buy a whole bunch and take them to conventions. Whenever the cops would come in, the convention organizer would be aware that something was going on and they'd say, 'You better cover up your table.' We were selling what easily could be classified as pornography."

Mike Nolan—another of the Seven Sons—introduced Plant to conventioneer Phil Seuling in 1970 when the two of them drove back to New York for Seuling's July 4th show, which Nolan helped Seuling run. Plant had just graduated from high school, Nolan said, but "Phil immediately recognized Bud's business acumen and began feeding Bud the East Coast fanzines."

Plant never balked at distributing the softcore porn that so alarmed Buddy Saunders and Steve Geppi. His business grew so quickly that he changed his college major from English to business, if only to learn about such economic necessities as paying taxes. "I think I was grossing $40,000 a year," Plant said, "and I thought I better start paying taxes on this."

Plant's business emphasis shifted from mail order to distribution when he bought out Charlie Foarr in the early 1980s. After Plant sold his distribution business to Diamond's Steve Geppi in 1988, Diamond controlled 40 percent of the direct-sales market. Plant continued to trade in art books, trade paperbacks, and rare books; in 1995 he celebrated his 25th year in business. "Bud and Phil [Seuling] began the process that led to the invention of the direct market," Nolan said. "Bud won't take credit for it, but I think he played an important role in shaping Phil's ideas. Bud's probably the most honest person who ever walked the face of the earth."

Plastic Man

Created by Jack Cole—who planned to christen his hero "India Rubber Man"—Plastic Man had to stretch to debut in *Police Comics* #1 (August 1941). A reformed gangster named Eel O'Brian, Plastic Man was displayed in all his glory by Cole's dazzlingly elastic splash pages and layouts. In *Police* #13 (November 1942), Plastic Man picked up a sidekick, Woozy Winks, an invulnerable butterball who expanded the comic possibilities of the feature.

"It is very difficult to blend humor and

Bud Plant

Jack Cole's Plastic Man starred in *Police Comics* before eventually getting his own title.
(© Quality Comics)

> **Poetry**
>
> *I just wonder where the poetry is. It's hard to talk about "poetry" in comics, but that's what attracted me. Everything in Louie Fine's work, when I saw it in comics—its lyricism, the extraordinary Olympian grace of the figures, all of those things—I would have followed those things anywhere. As a matter of fact, I followed them into museums, I followed them wherever I could see them. In these sculptured forms, George Bridgeman's figures, these are the things that stirred my life. I don't see the kind of lyricism and poetry, the imagery in comics that would attract me today.*
> GIL KANE, 1990

drama successfully in the same story," Larry Herndon once observed. 'Cole achieved it by depicting Plastic Man as the only sane person in an insane world... Plas's mind was cool, logical, intelligent, but everyone else in his world, including the villains he fought and even his partner, Woozy Winks, were all slightly bananas."

Plastic Man ran through the first 102 issues of *Police Comics* and all 64 issues of his own title. DC Comics, which bought the rights to most of the Quality characters, attempted four Plastic Man revivals, the first in 1966 featuring Arnold Drake scripts and later efforts that highlighted the pencils of Ramona Fradon (1976) and Joe Staton (1980).

All believers in reincarnation realize, however, that Plastic Man was recast in 1961 as Mr. Fantastic.

Pogo

Walt Kelly's best-known creation first played possum in *Animal Comics #1* (December 1940/January 1941) and graduated to his own title in 1949. Pogo's swamp, the Okefenokee, was populated by, among many others, an alligator named Albert, a turtle named Captain Churchy La Femme, and the inventive Dr. Howland Owl. "I chose animals," Kelly once told the *London Times*, "largely because you can do more with animals. They don't hurt as easily, and it is possible to make them more believable in an exaggerated pose than it is a human."

Nationally syndicated in 1949, Pogo was already running for president by 1952. Although Pogo and his friends played wild and frantic games with the language and the conventions of the comic strip, *Pogo* may be best remembered for its political mischief. Kelly was at his best with the bobcat named Simple J. Malarkey, a deft slap at Senator Joseph R. McCarthy. Even though he appeared twice on the cover of *Newsweek*, Pogo never rose to higher office. The strip descended as Kelly aged into an increasingly political and volatile bog. After Kelly's death in 1973, the strip was sustained for a year by his family and enjoyed a short-lived revival in the 1980s by Larry Doyle and Neal Sternecky.

Popeye

First of all, forget the spinach. The original source of the sailor's superpowers wasn't a vegetable, but an animal: a female wiffle hen fresh off the gambling tables of Dice Island. Popeye was riddled with 15 bullet holes when he first scratched the wiffle hen's head in June 1929, and he promptly made the first of his leg-

True Pogo-philes have committed to memory Pup Dog's little speech here, apparently the only thing the tad could say besides "Wurf."
(© Selby Kelly)

endary comebacks. The spinach came later with the Fleischer Studio cartoons, long after E. C. Segar had secured Popeye's popularity in the comic strip *Thimble Theatre*.

The sailor first appeared in January 1929 and, with a hefty assist from the wiffle hen, quickly became the star of a show that included the Sea Hag, Castor and Olive Oyl, J. Wellington Wimpy, Swee'Pea, and a fourth-dimension vagabond named Eugene the Jeep.

"Popeye is much more than a goofy comic character to me," Segar once said. "He represents all my emotions, and he is an outlet for them. I'd like to cut loose and knock the heck out of a lot of people, but my good judgment and size hold me back."

Popeye was not similarly constrained. The sailor's first cartoon appearance was in a 1933 Betty Boop short, *Popeye the Sailor*, which also introduced Sammy Lerner's famous theme song. The Fleischer Studios released the first official Popeye cartoon, *I Yam What I Yam*, later that year.

Powell, Bob

Born Stanley Pulowski, Powell did major stints for Harvey, Street and Smith, Magazine Enterprises, Quality, and Fiction House, often under the pseudonym "W. Morgan Thomas." He has developed quite a fan club since his death in 1967. "The man was a giant," Michael T. Gilbert once said. "He had a wonderful sense of storytelling, moody blacks, and elastic bodies that could move and twist any way he wanted."

Beginning in the mid-1940s, Powell's signature fronted for a variety of assistants, including Martin Epp, George Seifringer, and Howard Nostrand. Nostrand was a big fan of Powell's creativity—insisting that Powell was the real brains behind Sheena and Blackhawk—but not of his politics. "Powell was a bit of an anti-Semite," Nostrand told Bhob Stewart. "He didn't like [Will] Eisner because Eisner was Jewish." Nostrand noted on another occasion that Powell was "after all, an expert on bigotry, having practiced it since he was old enough to know that not only had the Jews killed Christ, but they also had horns."

Powell's most famous (and undisputed) creation is probably "The Man in Black," which haunted the back of various Harvey books for parts of three decades. Al Dellinges has published a fairly complete index of Powell's artwork, from *Adventures in 3-D* to *Young Romance*.

Pratt, Hugo

The Venice-born, Ethiopia-bred, Argentina-seasoned creator of Corto Maltese began his comics career when he was 18 with the 1945

In his strips, E. C. Segar placed Popeye in lots of situations you won't see in the animated version. In one sequence, Popeye as newspaper editor had to deal with prima donna cartoonists.
(© King Features Syndicate)

One of Bob Powell's most memorable stories was "Colorama" for Black Cat Mystery.
(© Harvey Publications)

© Dell Publishing Co.

publication of *The Ace of Spades*. The first Corto Maltese adventure—*The Ballad of the Salty Sea*—was published in 1967.

The Presidential Zeal

I thought you might be interested in learning I know that you killed Jack Kennedy.
SUPERMAN

Who, Superman, who? The CIA? The Mafia? The second gunman on the grassy knoll?

Not even close. Superman spoke those words to a lounge singer named Bea Carroll... in 1938.

That was *Action* #1. Twenty-six years later, in *Action* #309 (dated February 1964), Jack Kennedy made another surprise appearance (imagine the readers' surprise, the comic hitting the racks the month after the president's death). To protect Superman's identity, JFK masquerades as Clark Kent.

"Superman, I told you to call on me if ever you needed help—and I'm glad you did," Kennedy says. "And I'll guard your secret identity as I guard the secrets of our nation."

Presidents were guest-starring in the comics as early as *Captain America* #1, when two Army officers informed Franklin Roosevelt that the ranks were rife with fifth columnists.

"What would you suggest, gentlemen?" FDR asks. "A character out of the comic books? Perhaps the Human Torch in the Army would solve our problems?"

In *Sgt. Fury Annual* #3, Lyndon Johnson convenes the Howlers and packs them off to Vietnam to fight the Cong.

Presidential cover appearances:

George Washington—*Flash* #45

Thomas Jefferson—*Real Life* #6

Zachary Taylor—*Real Life* #29

Abraham Lincoln—*Dell Giant* #1, *Flash* #45, *Picture Stories from American History* #4

Teddy Roosevelt—*Real Life* #4; *True Comics* #10, #11; *Classics Illustrated Special* #141A

Woodrow Wilson—*Real Life* #2

Franklin Roosevelt—*Real Heroes* #1, #4; *Real Life* #6; *True* #39; *Mystic* #4

Harry S Truman—*The Story of Harry S Truman* (Democratic National Convention giveaway)

Dwight Eisenhower—*Mystery in Space* #30; *Real Life* #12; *True* #19

John F. Kennedy—*John F. Kennedy* #1, #2

Ronald Reagan—*Fawcett Movie Comic* #14; *Miss Beverly Hills of Hollywood* #8; *Movie Love* #13; *Sweet Sixteen* #7

Richard Nixon—*From Beyond the Unknown* #17

Washington, Lincoln, and Eisenhower—*Dell Giant* #52 (*Life Stories of American Presidents*)

© DC Comics, Inc.

© Dell Publishing Co.

Prince Valiant

William Randolph Hearst's question was, "Can you top *Tarzan*?" Hal Foster's answer was *Derek, Son of Thane*. Which, once it was renamed *Prince Valiant*, became the grandest of all the Sunday comic strip pages.

Set "in the days of King Arthur," Foster's classic offering first appeared on February 13, 1937. Steeped in chivalry and unmarred by word balloons, the strip paid as much attention to Val's struggle as husband and father as it did to his battles in the kingdom of Thule.

Foster was heavily influenced by the work of illustrator Howard Pyle and, when searching for a setting for his new strip, followed Pyle back to the Round Table. The Arthurian legend was patiently supplemented by the marvelous detail Foster acquired during extensive tours of Europe.

"I wanted a strip that would permit me to do fantasy," Foster said in a 1974 interview. "I wanted to show magicians, ogres, and dragons beside knights. However, the characters in the strip became too real . . ." And the landscapes too breathtaking, the fantasy too inspiring, the romance too ennobling for newsprint and a Sunday morning.

Foster produced 1,789 pages of Val's life before his own death in 1979.

Pseudonyms

A half-century before Todd McFarlane and Jim Lee cashed in on cult acclaim, many artists were in no mood to be linked to their comic book drawings in perpetuity. Sign their work? Whatever for?

Some of these artists (writers rarely had to worry about credits) had reputations to protect; they didn't want their public to know they were making a few bucks on the side drawing comic books. Others had lost their reputation to age or alcohol but they still had enough pride that they didn't want to be remembered for saying good-bye in the funny books.

So, they took refuge in pseudonyms.

These pen names are different than the house names several shops and publishers employed. Jerry Iger didn't want his shop artists to develop a big head or a fan following, so he hid their identities behind a name (if you'll forgive the switch in mediums) such as Franklin Dixon. When Iger was in a joking mood, he'd tag "The Red Bee" story with the byline "E. H. Apiary." When he was feeling a little more ornery, he'd have the artist sign off with the words "Use Nevagess."

Ace Atkins and Major T. E. Bowen were well known to Fiction House fans but they never drew a paycheck. They simply provided continuity, covering for the artists who came and went. As Hames Ware has pointed out, long after Will Eisner quit doing "The Hawk" in *Jumbo Comics*, the stories continued to unfold beneath the name "Willis Rensie."

The most well-known pseudonym, of course, is "Stan Lee," the pen name for Stanley Lieber. Other pseudonyms of note include:

Bill Brown (Al Feldstein)
Smoky Carter (Munson Paddock)
Lynette Cooper (Gardner Fox)
Larry Dean (Gardner Fox and Bert Christman)
Sam Decker (Sam Glanzman)
Anton Drew (Don Simpson)
Scott Fleming (Hazel Marten)
Bob Fuje (Bob Fujitani)
Jack Harmon (Wayne Boring)
Iger (Alex Blum)
Jewell (Harry Sahle)
Ralph Johns (Jack Cole)
Leger and Reuths (Jerry Siegel and Joe Shuster)
T.M. Maple (Jim Burke, the legendary fanzine letter writer)
Marcia (Marcia Snyder)
William Erwin Maxwell (Will Eisner)
Edgar Ray Merritt (John Broome)*
Frank Morrison (Mickey Spillane)
Richard Norman or Remington Brant (Dick Briefer)
Greg Page (Matt Baker)
Vee Pearson (Virginia Quintal)
Frank Ray (Frank Giacoia)
Mike Ross (Mike Esposito and Ross Andru; Esposito also uses Mickey Demeo and Joe Gaudioso)
Gregory Sykes (Joe Simon)
W. Morgan Thomas (Bob Powell)
Xela (Alex Schomburg)

*In a letter to *Comics Buyer's Guide* #892, Julius Schwartz says he and Weisinger deserve credit for dreaming up "Edgar Ray Merritt" when they were members of a New York City science fiction club and publishing a bulletin called *The Planet*. "Twenty years later when I was editing *Strange Adventures* I'd dream up a house name for a writer who'd have more than one story in that issue. Thus, Gardner Fox did double duty as Robert Starr, and John Broome masqueraded as John Osgood. When Broome and I dreamed up the science-fictioney Captain Comet . . . we opted to use a science fictioney byline—hence Edgar Ray Merritt!"

Veteran artist Sam Glanzman used the pseudonym Sam Decker.

(© Centaur Publications)

Psychoanalysis– The Punisher

PRICES
NEWSTAND COMIC PRICE

[Chart showing newsstand comic prices from 1939 to 1994: 10¢ (1939), 12¢ (62), 15¢ (69), 20¢ (71), 25¢ (74), 30¢ (76), 35¢ (77), 40¢ (79), 50¢ (80), 60¢ (81), 65¢ (85), 75¢ (86), $1.00 (89), $1.25 (92), $1.50 (94)]

In his heyday, The Punisher spearheaded a line of titles for Marvel.
(TM & © 1998 Marvel Characters, Inc. All rights reserved.)

Punching Scenes

American artists can't handle real life; they need a punching scene.
EDDIE CAMPBELL
BRITISH CARTOONIST LIVING IN AUSTRALIA

Psychoanalysis

Mort Weisinger used to tell this story on himself. He was going through analysis, and one day he said to his shrink, "You know, this coming in one day a week for an hour at a time is a lot of crap. Why not come over to my house for one weekend, and we'll sit around the pool and you can do the whole job in one weekend?"

And the analyst said, "Mr. Weisinger, I have trouble putting up with you for one hour at a time. How am I going to stand you for a whole weekend?"
WALLY GREEN, WESTERN PUBLISHING EDITOR

The Punisher

Gerry Conway's idea of a street-tough thug, the Punisher first appeared in *Amazing Spider-Man* #129. "The main difference between him and Daredevil," Frank Miller told *The Comics Journal*, "is Daredevil's sense of responsibility to the law. The Punisher is an avenger—he's Batman without the lies built in. They come from the same root. They're created by the same fears. The same kind of fear that I feel every time I ride the subway."

Quality Comics

An outgrowth of the Centaur line, Quality Comics published its first original book—*Smash #1*—in August 1939. Its characters were eventually bought out by DC Comics in 1956.

By 1942, Hubert Crawford notes in his comic encyclopedia, "the small, independent art studios were beginning to wither away. Everett Arnold proved to be the exception among his publishing peers. He continued to maintain an informal arrangement with many outside studios which, as they began to lose their clients, decided to pool the best of their freelance talent and form a single group to produce art for Arnold's new titles."

Those titles included *Hit, Police, Military, National, Uncle Sam,* and *Plastic Man.*

"Everyone remembers DC, but the great artists were at Quality," said Hames Ware, pointing to Lou Fine, Reed Crandall, and Jack Cole. "I've often wondered what DC would have looked like if it had Quality's artists or what Quality would have become if it had DC's characters."

This gorgeous Uncle Sam cover was rendered by Lou Fine and Reed Crandall.
(© Quality Comics Group)

Chuck Cuidera produced some nifty covers for Quality.
(© Quality Comics Group)

You could always count on Jack Cole for imaginative cover images.
(© Quality Comics Group)

Quotes, Cover

We're not big fans of word balloons on covers, but on occasion the balloons contain just the right amount of hot air and *le mot juste*. At the same time, the quotes unwittingly remind us of the wit that was supposed to be the lead in the *comic* book.

Culled from the thousands of worthless cover quotes, these 10 are almost worth the color they replaced:

I know you are a mute, Miss Kimberly, but even if you could yell, the people downstairs couldn't call the police. You see . . . I already cut their tongues out.
LAW BREAKERS SUSPENSE STORIES #11

Yes, Robin, I've become a human fish.
BATMAN #118

Butcher . . . You killed us with your beef . . . Now you can hang with the rest of your poisoned meat.
DARK MYSTERIES #18

Look, Tom Darling! Our wedding an–nouncements just came from the printer's . . . OH TOM!
MY OWN ROMANCE #4

Ruth . . . Please believe me! I am the victim of a terrible scientific experiment!—Ralph
STRANGE ADVENTURES #8

Sorry, fella! We're hired killers! In our business we don't make lasting friendships.
HEADLINE COMICS #29

You're not kidding, Perry! It's really Caesar's Ghost!
SUPERMAN #91

Oh, Ralph . . . Ralph! I miss you so! Why did you have to die? If only you could come back to me!
VAULT OF HORROR #19

Heads up, Commies! It'll only hurt a minute.
BATTLE BRADY #11

You must need money pretty bad, mister, if you're robbing blind war vets.
CRIME AND PUNISHMENT #2

Raboy, Mac

Born Emanuel Raboy in New York in 1914, Mac was at his best drawing Captain Marvel Jr. in the early 1940s. "Raboy's style was as important to Captain Marvel Jr. as Kirby's was to Captain America or Beck's was to the Big Red Cheese," Jim Steranko wrote.

A graduate (along with Will Eisner and Bob Kane) of De Witt Clinton High School, Raboy joined Chesler's shop in 1940 and moved to Fawcett a year later. "He had chosen Alex Raymond as his idol years earlier when the *Flash Gordon* Sunday strip had begun," Steranko noted. "Raboy compiled a big volume of Raymond material to study and use during his career."

Speed was never Raboy's strong suit. John Belfi, one of Lou Fine's assistants on the Black Condor, once observed that Raboy rarely cleaned his brush. He'd let the ink dry on the brush until it was hard as a rock, then dip it back into the ink and produce the fine line all the other artists went nuts over. Using that technique, Raboy was lucky to produce a page a day.

In 1948, Raboy got the chance to consult his Raymond volume when he was offered the *Flash Gordon* Sunday page.

Raboy worked the page until his death in 1967. Few were praising his work at the end, with the exception of Dan Barry. "It looked like he was getting bored and his art was starting to reflect his boredom," Barry told *Amazing Heroes*. "What we didn't know was that the man was slowly dying of cancer and that was showing in the artwork.

"He didn't have Raymond's looseness, but he was an even more solid draftsman. I don't know if you were aware that Mac Raboy had work in the Metropolitan Museum of Art—woodcuts. He was a magnificent serious artist. He never made it as a painter but he was an incredible draftsman and printmaker."

RAW

After his adventures with Bill Griffith on *Arcade*, Art Spiegelman swore he'd never embark on another fling in magazine publishing. His wife, Francoise Mouly, had a better idea:

The Graphix Magazine For Damned Intellectuals.

Or:

The Graphix Magazine That Lost Its Faith in Nihilism.

First published in 1980 with a print run of 4,500 copies, *RAW* was much more of an art book than a comic book. The magazine introduced such artists as Charles Burns, Jacques Tardi, Gary Panter, Kaz, and Mark Beyer. After the first one," Spiegelman once said, "we were sort of pushed into the second one by friends and people who wanted to be in it. And after that we were sort of pushed into the third."

RAW also supplied the first chapters of Spiegelman's *Maus*, which popped up as small signatures bound into the magazine's large-format pages. Until Penguin began publishing *RAW* as a trade paperback, Spiegelman made sure the magazine arrived with a stylish twist. When copies of issue #7 ("The Torn-Again

Mac Raboy drew dozens of stunning covers for the title he's most associated with, Fawcett's *Captain Marvel Jr.*
(© Fawcett Publications)

Each issue of the first run of *RAW* had a different theme. Number 7 was the famous "torn-again" issue.
(© Art Spiegelman and Francoise Mouly)

Graphix Mag") came off the press, a corner was ripped off each cover; the tattered pieces were then jumbled together and randomly put back with each copy, taped to the contents page.

Raymond, Alex

He's the reason I became an artist.
AL WILLIAMSON

There was a man who could combine craftsmanship with emotions and all the gimmicks that went into a good adventure strip. He was a master.
CARL BARKS

One of comics' most influential artists, Raymond, at the age of 24, was at the artistic controls of three separate strips: *Flash Gordon, Jungle Jim,* and *Secret Agent X-9*.

A clerk on Wall Street in 1929, Raymond crawled out from beneath the rubble of the Great Crash to enroll in art school. In short order, he served as an apprentice on Russ Westover's *Tillie the Toiler* and Chic Young's *Blondie*.

Shortly after joining King Features, Raymond teamed with Dashiell Hammett on *Secret Agent X-9*. Not satisfied with that gem, Raymond pitched two other strips—*Flash* and *Jungle Jim*—to King as a complete Sunday page.

Flash Gordon "was wittier and moved faster

'56 CORVETTE

Alex Raymond loved the women Stan Drake drew and the cars he drove, but when he showed up at Drake's house that September afternoon in 1956, he wanted to experience the curves himself. Drake had less than 1,000 miles on his '56 Corvette and Raymond was aching to take that rocket for a ride. They rolled the Corvette out of the garage, buttoned up the top against the light September rain, and sailed up into the Connecticut hills.

Raymond, who had raced several times at the Thompson racetrack in the northern corner of the state, couldn't handle the view from the passenger seat. Drake was gracious enough to trade places, and they were off again. The moment Raymond took a hit on the 'vette's 450 horses, he was addicted.

"Great," Raymond said as they started up the banks and turns of Clappard Hill Road, picking up speed. Raymond was jubilant and he jumped the accelerator. Even Drake was surprised by the kick. "Easy, Al," he said.

Raymond never answered. They dived through an intersection, then shot up Clappard Hill Road on the other side. They were going almost twice the 25 mph speed limit when the road suddenly disappeared, and the Corvette became airborne. Drake remembers watching a pencil that had been on the dash floating in free fall in front of him before the car landed and shot into the woods. The last thing he saw was Raymond trying to steer through a gap in the trees.

Drake woke up lying in a field with the soft rain in his face. His shoulder was crushed and his ears badly torn; it was two days before the shock wore off and he remembered Raymond, who was killed when the impact shoved the engine into the driver's seat.

"I think he hit the accelerator by mistake," Drake said. "On that Corvette, the goddam brake came straight out of the wall, right above the accelerator. You had to pick your knee up and push straight in. I think he thought the brake was to the right of the gas pedal. I don't think he could find the brake, and he hit the accelerator. But I'll never know.

"The big mystery about it all is how the hell did I get out of the car? The door was closed, the soft top was up. I wasn't wearing a seatbelt. If I had been wearing a seatbelt, I'd be dead since 1956 because the steering post went right through the seat.

"Alex was killed, God knows why I wasn't. I adored the guy."

than *Buck Rogers,*" Stephen Becker (in *Comic Art in America*) observed; "it was prettier and less boyish than William Ritt's and Clarence Gray's *Brick Bradford.*" As Raymond's style evolved, the strip also became the raw material for the swipe files of future generations.

Raymond abandoned *Secret Agent X-9* in 1936 to concentrate on the other two strips and a new "feathering" technique. In 1944 he joined the Marines . . . and designed the official 1944 Marine Corps Christmas card.

When he left the service in 1946, Raymond returned to civilian life with a new strip: *Rip Kirby*. He did superb work with that private eye until the September morning in 1956 when Raymond took the wheel of Stan Drake's '56 Corvette and, with Drake in the passenger seat, set out over the rain-slicked roads of southern Connecticut (see sidebar).

Red Ryder Comics

Red Ryder was a better comic strip, owing to the touch of creator Fred Harman, than a comic book, but the comic book lasted until issue #151, running from 1940 through 1957.

In *Crawford's Encyclopedia of Comic Books*, Hubert Crawford observed, "One aspect of Red Ryder that was often overlooked was the character's use in the successful promotion of the Daisy Air Rifle, commonly called the 'Red Ryder B-B Gun' and the pride and joy of many a 10-year-old. The Red Ryder B-B Gun was the standard back-cover advertisement for almost every comic book published during the early 1940s, especially the DC titles. This advertisement was the one that helped establish the comic book as an extremely effective advertising media."

Every Alex Raymond *Flash Gordon* page is a thing of beauty.
(© King Features Syndicate)

Fred Harman drew all the covers as well as the interior stories for *Red Ryder Comics.*
(© Laswell & Slesinger)

Red Skull

I'll even make Hitler shake with fear.

When he grabbed his first victim, one Major Croy, the Red Skull growled, "Stare into my eyes, Major! Look until you see the DEATH!" In the end, however, the eyes didn't have it, and the Skull had to resort to a hypodermic needle.

Like the Joker, the Red Skull was slated for death in his first appearance, in *Captain America* #1, but he proved too popular for premature burial. He was back two issues later, ravaging Ebbetts Field with a massive underground power drill.

The Skull's Golden Age appearances include *Captain America* #1, 3, 7, 16, 37, 61, and 74; *All Select* #1; and *Young Allies* #1 and 4. His first Silver Age appearance is *Tales of Suspense* #65 (June 1965).

Red Sonja

Robert E. Howard's creation first appeared in comic books in *Conan* #23. A minor REH character who caught writer Roy Thomas's fancy, Sonja was drawn there by Barry Smith, but she became more closely associated with artist Frank Thorne ("I suppose she uncorked some repressed sexual fantasy inside me") and with Wendy Pini, who used to dress up as the daughter of death at various cons.

Hollywood's *Red Sonja* starred Arnold Schwarzenegger as Conan and Brigitte Neilsen in the lead role. Neilsen caught Arnold's eye by sending him nude photographs.

Fortunately, those etching photos were never passed on to the Robert E. Howard estate, which has shown Thorne considerable gratitude for developing Red Sonja into a major character.

Rex, The Wonder Dog

Not Barfy, not Ruff or Rufferto, not Dizzy Dog or Trypto the Acid Dog. No, only Rex, the Wonder Dog ever took part in a lunar landing.

Or lapped water from the Fountain of Youth.

Rex first appeared in *The Adventures of Rex, the Wonder Dog* #1 (January 1952). That would make him, oh, 322 in dog years. The mutt was clearly inspired by Streak of *Green Lantern* fame, another Alex Toth creation. Early issues of the book's 46-issue run are rumored to be rare because, in the Fifties, the book was rumored to be suited to a select taste.

Rhoads, Fred

As many years as Fred Rhoads has spent in court, you might think his story began there, but no: He did have a life before he sued the Harveys.

When Rhoads was 22, and the Marines were preparing to pluck him out of boot camp and toss him into the war in the Pacific, his captain called him in. "Rhoads," he said, "do you want to go to war or do you want to go to Washington?"

"What are you talking about?" Rhoads asked.

The Marines, he was told, wanted him to draw cartoons for *Leatherneck Magazine* in Washington. Of course, if he insisted on shipping out for Guam or Iwo Jima . . .

"Captain," Rhoads said, "I think I can serve my country best in Washington."

As it turned out, he didn't see much of Washington in the next year. Along with a combat correspondent named Hank Felsen (who would one day write the *Hot Rod* books for teenagers) Rhoads toured the Pacific, cranking out the *Gizmo and Eightball* strip for *Leatherneck*.

"Before we left, my captain told me, 'Now, we don't want you going off and getting killed. No one can draw like you do.'" But Rhoads and Felsen took fate for a wild ride. With orders signed by Nimitz or Vandergrift, the commandant of the Marines, they had clearance to follow the Marines wherever the action was. Boganville. Guam. Okinawa and the Marshall Islands.

"I remember one time a general saying, 'I want to send you up to Iwo Jima, all hell's breaking loose there. You'll love it,'" Rhoads said. "And I said, right off the bat, 'General, we were told not to get killed.'"

Felsen wrote the stories, Rhoads drew the pictures. "A lot of this stuff went to headquarters," he said. "They wanted all the war art they could get." Even from the end of the world. Even Nagasaki. "We went to Nagasaki, but we didn't go anywhere that looked devastated to me. There weren't many solid structures. Buildings of bamboo and rice paper. A strong wind could have blown them over. The

Wendy Pini as Red Sonja, with Frank Thorne as "The Wizard."

[Japanese] looked at us like we were something that just came in from Mars. But they would always bow."

The nightmare of the war didn't follow Rhoads home. "You never see World War II veterans going down and crying at the statues," he said. "I was rather young, and when you're young you just want to get on to the next thing. I wanted to be a cartoonist."

He got his start with Jimmy Hatlo on *They'll Do It Every Time* and Fred Lazlo on *Snuffy Smith*, then went to work for Mort Walker on *Beetle Bailey*. Lazlo, Rhoads said, taught him how to write gags. When he showed off his gift to Walker in 1954, "Mort was amazed. He said, 'My God, Fred, you could pick up this strip and draw it and write it and no one would ever know the difference.' He told me I was the best gag writer he'd ever met and he'd met them all."

After a year with Walker, Rhoads accepted an offer from Harvey Publications to do their *Sad Sack* comics. The creation of George Baker, Sad Sack might as well have been a deaf-mute in his creator's hands. All the gags were in pantomime. The Harveys—brothers Alfred, Leon, and Robert—were running Baker's World War II strips in their new comic books, and they weren't working.

"George Baker was at his best when he was dirty, the syndicate told me," Rhoads said, "and they couldn't do that in the comic books."

Rhoads to the rescue. He delivered the gags and a new cast of characters: Slob Slobinsky, Hi-Fi, Captain Softseat, General Rockjaw, and entertainer Thunder Storm. The formula worked. Sad Sack went forth and multiplied, from one book in 1955 to a half-dozen monthly books by 1964: *Sad Sack Comics, Sad Sack's Funny Friends, Sad Sack and the Sarge, Sad Sack Laugh Special, Sad Sack's Army Life,* and *Sad Sad Sack World*. The comics were distributed in 19 countries. Over the years, their cover price rose from a dime to a dollar. All the while, Rhoads was paid the same page rate and not a single dime for the reprints of his work that ran in the back half of the books.

By 1977 Rhoads had 9,500 pages in the Harveys' vault and a lawsuit on the Harveys' desk. He wanted to be paid for his reprinted work, as he claimed the Harveys had promised him, time and again, they would do. The legal battle is detailed in **Legal Briefs.**

Rice, Pierce

Rice was one of the most thoughtful nimble ("I was literally the fastest in the business"), and unpublicized artists in the first two decades of the comic book business.

Like so many other artists, Pierce Rice got his start when, at the age of 23, he answered a newspaper ad for the Eisner-Iger shop. It was 1939 and Rice was fresh out of art school and fresh out of options. Iger took one short look at his samples and nodded to the nearest chair.

"I sat down next to Arturo [Cazeneuve], who was just off the boat from Argentina," Rice said. "His brother Louie had been a fairly prominent cartoonist in Buenos Aires and decided he could conquer North America, and came to New York. He got a job in the cartoon business and Arturo came up to join him in this brand-new world he'd discovered."

Rice soon joined the Cazeneuves and Charlie Sanders in a studio at 415 Lexington Avenue. In that studio (and a later one at 109 West 42nd Street) Rice pumped out comic pages for Fox, Harvey, MLJ, Hillman, and DC. "Whatever could be stirred up or would come in over the transom, you'd draw," Rice said.

Little, if any of the work was fitted with his signature. "I never ran into anyone who

Rhoads still does gag cartoons in his retirement.
(© Fred Rhoads)

Fred Rhoads

Pierce Rice's art could be found in such odd-ball titles as *Champ Comics*.
(© Family Comics, Inc.)

felt deprived if his name was left off what he was doing," Rice said. Heck, they were all destined for greater things. "Almost nobody in the business took it seriously. Even the great lions—Kirby and Eisner—all thought something else lay in wait for them. When you're an artist you have grand ideas." And little inclination to take credit for all the silly things you do on your way up.

At "415" or "109," Rice drew Steel Sterling, The Shield, the Green Hornet, the Green Arrow, the Black Cat, the Blue Beetle, the original Thor (a 1940 story in Fox's *Weird Comics*), and The Hangman. He took over the Manhunter from Simon and Kirby and—an orgasmic revelation for DC buffs—subbed for Bernard Baily on the Spectre in *All Star* #14. As for what else he did out of the studios Rice admits, "Sometimes I barely recognize myself to be perfectly fair."

His artwork easily rises above the usual collection of swipes. From his earliest days with Iger, when Rice would take a pad down to the cafeteria and sketch during lunch, Rice said he always "drew from life. I never knew of any of my colleagues in the comic magazine business who did that. Who studied nature. Who drew what they saw. The convention in the comics was to copy and make up. The old joke was, 'Do you swipe or fake?' —the point being that it was more conscientious to swipe something than to do it out of your head.

"Most artists can't sit down and draw pictures," added Rice, who would later teach at the Philadelphia College of Art. "They can trace photographs and use the pantograph or 'render,' but the peculiar ability that comics demanded wasn't that widespread. Most guys were copyists. The business was so conventionalized. What Stan Lee finally did at Marvel was to get all his artists drawing the same. There was more and more homogenization of what everyone was doing."

In 1948 Rice joined the staff at Timely and got up close and personal with Lee. "An imitator par excellance," Rice remembers. "A tireless reader of the competition. I never saw any sign of originality on Stan's part. He always had the competition's books strewn around his desk. He has a reputation as a pioneer, but I laugh at that. Mimicry was the main thread in his mind."

When the crime sagas of Charlie Biro and Bob Wood were the comics strewn across Lee's desk, Rice said Lee failed to grasp that the strength of the books was their characterization. "What Stan got out of that book was that the layouts were very undramatic. When *Crime Does Not Pay* started to go over big, Stan got the idea that the equal-size panels were part of it. The decree came down: Every panel had to be the same size. He missed the point entirely, that it was the content of those panels."

The work at Timely was a 9-to-5 effort on the 17th floor of the Empire State Building. Rice remembers several long rooms, each with a table and as many as 20 artists: "Two long corridors full of artists and the division was very sharp. We hardly knew the artists in the other room."

Working in one room or the other were Bill Everett, Carl Burgos, Gene Colan, Dan DeCarlo, Marty Nodell, Syd Shores, and Russ Heath. "One of the mistakes Stan made is whenever a penciler finished a job, he'd have him hand it to any inker," Rice said. "Whichever inker was free. No partnerships developed, and no continuity." He lived in fear of two inkers on the staff: Hing Chu and Fred Eng. "I used to dread the thought of something falling into Fred's hands, but we had no choice in the matter."

At Timely, Rice remembered "general executions when a whole portion of the staff" was hung out to dry. "You were happy to survive it." He didn't survive a purge in 1950; in 1955, he made his final exit from what seemed a dying business and moved to Washington, D.C., to work as a portrait painter. In later years, he drew for the Housing and Home Finance Agency, the predecessor of Housing and Urban Development; designed baseball cards and paint-by-number kits; drew covers for the CIO's magazine; and designed the huge bronze medallion that hangs outside Philip Morris headquarters on Park Avenue.

In other words, Pierce Rice survived quite well. He remembers his career in the comics with a definite fondness, without the slightest angst that no one knows his name.

Rico, Don

A Golden Age artist and the first president of L.A.'s Cartoon Arts Professionals Society (CAPS), Rico got his start when he answered a

"The old joke was, 'Do you swipe or fake?' —the point being that it was more conscientious to swipe something than to do it out of your head."
PIERCE RICE

RICHIE RICH

So you're a completist. Missing any of the following Harvey books?

Richie Rich #1–#294
Richie Rich And… #1–#11
Richie Rich and Billy Bellhops #1
Richie Rich and Cadbury #1–#29
Richie Rich and Casper #1–#45
Richie Rich and Dollar the Dog #1–#24
Richie Rich and Dot #1
Richie Rich and Gloria #1–#25
Richie Rich and His Girlfriends #1–#16
Richie Rich and His Mean Cousin Reggie #1–#3
Richie Rich and Jackie Jokers #1–#48
Richie Rich and Professor Keenbean #1–#2
Richie Rich and the New Kids on the Block #1–#4
Richie Rich and Timmy Time #1
Richie Rich Bank Books #1–#59
Richie Rich Best of the Years #1–#3
Richie Rich Big Bucks #1–#8
Richie Rich Billions #1–#48
Richie Rich Cash #1–#47
Richie Rich, Casper and Wendy National League #1
Richie Rich Diamonds #1–#59
Richie Rich Digest #1–#34
Richie Rich Digest Stories #1–#17
Richie Rich Digest Winners #1–#16
Richie Rich Dollars & Cents #1–#109
Richie Rich Fortunes #1–#63
Richie Rich Gems #1–#43
Richie Rich Gold and Silver #1–#42
Richie Rich Gold Nuggets Digest #1–#5
Richie Rich Holiday Digest Magazine #1–#4
Richie Rich Inventions #1–#26
Richie Rich Jackpots #1–#58
Richie Rich Million Dollar Digest #1–#9
Richie Rich Millions #1–#113
Richie Rich Money World #1–#59
Richie Rich Profits #1–#47
Richie Rich Relics #1–#4
Richie Rich Riches #1–#59
Richie Rich Success Stories #1–#105
Richie Rich Summer Bonanza #1–#4
Richie Rich Treasure Chest Digest #1–#3
Richie Rich Vacations Digest #1–#8
Richie Rich Vaults of Mystery #1–#47
Richie Rich Zillionz #1–#33

© Harvey Publications

1939 ad in *The New York Times* requesting an "artist to draw comic books in the style of Flip Falcon, Blast Bennett, The Sorceress of Zoom. Fox Publications." Rico eventually landed at Timely, taking over Jack Kirby's assignments when the King enlisted. A television and movie scriptwriter in the 1960s, Rico died in 1985 at the age of 72.

Riddler, The

The Prince of Puzzles first appeared in *Detective* #140 (October 1948), popped back up two issues later, then disappeared until *Batman* #171 (May 1965).

His real name is Edward Nigma (E. Nigma). Frank Gorshin played the character on the *Batman* television show, and of course Jim Carrey played him in *Batman Forever*.

Robbins, Trina

"In the beginning," Trina Robbins said, "I had a boutique." She was 28, divorced, living in New York, and drawing a single-panel strip called *Suzy Slumgoddess* for *The East Village Other*. "We called them 'hip comics,'" Robbins said. "It wasn't until a year later that they got the title 'underground comics.' It wasn't until 1968, actually, that I saw my first underground comic book, which was *Zap Comix*."

In the beginning of her cartooning career, Robbins would spend the first Friday night of each month at the parties Archie Goodwin held at his house on the Upper West Side. "Archie was a sweetheart," she remembered. "I was more accepted by that crowd than the underground crowd. The Marvel guys didn't have to feel threatened by me; they didn't have the

Although best known these days as a comics historian, Trina Robbins has drawn a wide variety of comics, including one graphic novel, *The Silver Metal Lover*.

(© Trina Robbins)

same boys' club mentality as the underground artists."

In 1968, Robbins sold several cartoons to *Yellow Dog*, an underground tabloid in San Francisco. "San Francisco was the Mecca; San Francisco was where it was happening," she said. Most of the cartoonists who hung around Manhattan's Lower East Side bolted for the Left Coast, "a lemming-like movement that stopped just short of the ocean."

Robbins, and then-husband Kim Deitch, were caught up in the tide, but Robbins quickly lost her taste for the underground trip. "The sexism in the underground comics was incredibly graphic," she said. "As soon as I saw the stuff, I said, 'This is hostile to women.'"

"The biggest influence on everyone in the undergrounds in producing graphic sexual violence was Robert Crumb. He was such a hero; if Crumb does it, then everyone could do it. I stopped reading his stuff long ago."

To counter Crumb and the cartoonists beneath his table, Robbins helped produce *It Ain't Me, Babe*, a comic by all female artists. She also contributed much of the labor that gave birth to *Wimmen's Comix*.

Robbins has been active in promoting the role women have played in the history of comics and has written two books on women cartoonists, one in collaboration with cat yronwode, and a book on female super-heroes. Her other claim to fame is having designed Vampirella's form-fitting costume.

Robin

An obnoxious orphaned runt, Robin arrived in *Detective Comics* #38 and has been tagging along with Batman ever since. Bill Finger always assumed that Jerry Robinson simply cut off the last syllable of his name in christening the character, but Bob Kane isn't going to let any of the credit slip away. "I named him after Robin Hood," Kane said in *Batman and Me*. "Robin evolved from my fantasies as a kid of 14 when I visualized myself as a young boy fighting alongside my idol, Douglas Fairbanks, Sr."

Alvin Schwartz later said, "In my own view, the original Dick Grayson/Robin was little more than an editorial imposition, a kind of marketing afterthought... Robin, as he was then, was just so much excess baggage that had to be trundled along and fitted into the plot somehow."

When it came to be Frank Miller's turn in *Dark Knight,* he stretched the plot until it had room for the only female Robin.

Robinson, Jerry

The great story about Jerry Robinson, the creator of the Joker (which Robinson retold in *Amazing Heroes* #167) begins with an ice cream cart. Not a motorized truck, but one of those carts hooked to the back of a bicycle.

In the summer of 1939, before he went to college, Robinson got a job selling ice cream. "As the last hired," he said, "I got the franchise far out in the suburbs. I had to pick up the bicycle and the cart full of ice cream in the center of town and pedal to the outskirts before I could start selling.

"I was then about 98 pounds. I was on the track and tennis teams—tennis was my passion—so I was always very thin. Well, after pedaling that bike back and forth all summer selling that ice cream, I was down to about 76 pounds. And my mother felt that I would never last the first year in college. So she persuaded me to take $25 of hard-earned money—I got a penny for every Popsicle sold—and suggested I go to a mountain resort, eat three big meals a day and fatten up, so I could survive the first semester at Syracuse."

Robinson doesn't remember the name of the

Jerry Robinson

resort. "I took my tennis racket and also a particular jacket, which is the heart of this story. How one's life can change over such an insignificant thing as a jacket! It was the fad in colleges in those days to buy ordinary white painter's jackets of linen with a lot of pockets, and decorate them yourself. We in high school imitated them (we lived near Princeton).

"So I decorated one with my own drawings. There was a pocket in one place and I drew a comb there as if it were sticking out of that pocket—stupid things—and various cartoons on the back. I used it as a warm-up jacket and one of the first days (at the resort), I rushed out to the tennis court with this white jacket on, looking for a game. And some fellow standing nearby asked me, 'Who did the drawings on your jacket?' I said, 'I did.'

"He said, 'Oh, I'm a cartoonist.' And it was Bob Kane.

"He had just started Batman earlier that summer. I never heard of it. So he took me down to a little village nearby to find a copy to show me. I wasn't terribly impressed. I hadn't seen a comic book before . . . [Bob] said he was going to need an assistant and if I came to New York, I could get a job with him and probably make $25 a week to begin with. As it turned out, I think at first I made $6 a week."

Robinson "assisted" Kane for a year; after National hired him, and began writing him bigger paychecks, he penciled and inked Batman stories and produced covers—29 for *Batman* and *Detective Comics* between 1941 and 1946. Robinson named Robin, the Boy Wonder [see **Robin** entry], and, when Batman was given his own book in 1940, Robinson dreamed up the Joker. Kane took the first shot at fleshing out the character, but Bill Finger completed the job for the villain's first appearance in *Batman* #1.

Robinson is quick to remind us, "Batman was a part of my youth. It's long gone. For a long time, comics were looked on with snobbery. I'm an illustrator, a writer. Many times I found it was a detriment to say I drew comics."

In the late 1940s, Robinson teamed with Mort Meskin on Johnny Quick and the Vigilante; the pair contributed the only decent art to appear in either *Black Terror* or *The Fighting Yank*. Robinson's first comic strip, *Jet Scott*, debuted in 1953. Over the next three decades, Robinson did political cartoons, quarterbacked the National Cartoonists Society, wrote *The Comics: An Illustrated History of Comic Strip Art*, and created his own international cartoonists' syndicate.

Robinson was never able to gain Bill Finger co-credit for creating Batman, but he worked overtime with Neal Adams to help Jerry Siegel and Joe Shuster negotiate a settlement with Time Warner when Superman's creators sought parental rights for their baby. Robinson is still very active in his New York office.

Robinson's version of the Joker is considered definitive by many a Golden Age fan.

(© DC Comics, Inc.)

Roche, Ruth

The main writer, executive editor, and, eventually, co-partner in Jerry Iger's shop, Roche was born in 1921 and outwriting the big boys by the age of 20. She scripted numerous Fiction House series—including Senorita Rio, Sheena,

Dave Stevens's original Rocketeer stories were collected in an oversize graphic album by Eclipse Comics, giving his art the size and paper quality it deserved.
(© Dave Stevens)

Ghost Gallery, and Camilla—as well as the daily adventure strip *Flamingo*. When Roche wasn't packaging comics for Gilberton, Fox, Ajax-Farrell, and Superior, she was writing such titles as *Frankenstein*, *Ellery Queen*, and *Aggie Mack*. After the Iger shop dissolved in 1961, Roche also designed children's books, edited kid videos, created a television series (*Fear*), and cranked out a political comic for U.S. Senator Lloyd Taft.

The Rocketeer

Dave Stevens's creation, exquisitely drawn and sporadically produced, first appeared in Pacific Comics's *Starslayer* #2 (April 1982), nine years before it reached the silver screen.

Subsequent chapters of the Rocketeer saga appeared (in order) in *Starslayer* #3, *Pacific Presents* #1 and #2, and *Rocketeer: Special Edition* #1. The last book has a Rocketeer portfolio with full-page visions from the likes of Mike Kaluta, Al Williamson, Murphy Anderson, Gray Morrow, Bill Stout and—the inspiration for the Rocketeer's mechanic, Peevy—Doug Wildey.

Comico later published new stories in *Rocketeer Adventure Magazine* #1 and #2. The final saga finally came out from Dark Horse in the mid-1990s.

In the movie version of *The Rocketeer*, Disney deliberately played down the Bettie Page angle on the Rocketeer's girlfriend by putting actress Jennifer Connolly in the "Betty" role, out of concern that the real Bettie might reappear with lawsuit in hand.

Rocket's Blast–Comicollector

The Rocket's Blast and *The Comicollector*, two fanzines that first appeared in 1961, finally tied the knot in a 1964 ceremony.

The Comicollector was originally published by Jerry Bails as a spinoff of *Alter Ego*, which Bails co-edited with Roy Thomas. Bails promoted it as "an advertising zine devoted to the swaps and sales announcements of comic collectors and dealers," but quickly lost interest in the project, passing it on to Ronn Foss and, later, Biljo White. With White the fanzine would have died had not G. B. Love, editor of *The Rocket's Blast*, offered to publish the pair in one volume.

Love, who was 25 at the time, had cerebral palsy and more than enough energy for the pair. The first *Rocket's Blast–Comicollector* (#29) appeared in April 1964, with a Buddy Saunders cover and a 35-cent price tag. Within three years, the fanzine's circulation topped 1,000, and it continued to flourish until advertisers began migrating to Alan Light's *The Buyer's Guide for Comic Fandom* (which evolved into *Comics Buyer's Guide*).

Love passed *Rocket's Blast–Comicollector* on to his assistant, James Van Hise, in 1974. Van Hise published another 39 issues before the fanzine finally expired with its 151st issue in 1980.

Rogofsky, Howard

> *Rogofsky? He's still around. A dinosaur. Covered with tape.*
> STEVE FISCHLER, METROPOLIS COMICS

Tape? Someone say tape? "Carefully applied Magic Tape," Howard Rogofsky said in 1967, "does not constitute a defect."

That was the problem with Rogofsky, arguably the first full-time comic book dealer. When you ordered from the king of Queens, you never knew if the mail would bring a book that was pristine mint or buried in tape. "He had a general condition description: All books were good or better," Bud Plant said. "You might get a book in 'fair' condition that was a piece of junk, or you might get a really nice copy."

Rogofsky, you must understand, didn't know why you'd care. He was never high on condition; he was just high on price.

"He was the first dealer to overcharge," said Michelle Nolan, who visited Rogofsky in the mid-1960s and remembers seeing thousands of old books rotting away on his shelves. "When everyone else was charging $5 for an old *Batman*, he was charging $15."

"It was always 'Rip-off-sky,' because he was ripping everyone off, the prices were so high," Jim Vadeboncoeur agreed. "He didn't give a shit about comics. Not one iota did he care about comics. But he saw something. He saw what Terry Stroud and others saw later on: There's a market there. There's money to be made."

In 1955, at the age of eight, Rogofsky moved to Queens. Five years later, he picked up two comic book fanzines and discovered that somewhere out there people were selling comic books. The commerce was contagious. By 1965, he was in the mail-order business full time. In 1966 he grossed $60,000. The following year, he took out a half-page ad in the Sunday comics section looking for old comics and got over 20,000 responses.

"His key," said Steve Fischler of Metropolis Comics, "was that he would buy comic books for nothing. When you're able to buy a lot of comic books for a penny apiece and sell them for a dollar apiece, you're doing fine. Nowadays, you need a lot more capital to keep a business going. You might have a collection that forces you to shell out $50,000. A lot of that material is slow-selling. You won't make your money back for two years."

In those prehistoric Sixties, this dinosaur had no such problems. "I remember buying comic books like *Boy* #1 for a dollar and *Detective* #38 for two dollars," Rogofsky told *Comic Book Marketplace*. "Then there was a trade deal with a customer. He traded me *Action* #1 through #232 . . . He demanded three *Lone Ranger* comic books in return because he complained that Superman 'had too many girlfriends' and the Lone Ranger just had Tonto . . .

"The early to mid-'60s were a very exciting time in the history of collecting. It seemed like deals were everywhere! Fandom was still a new idea and I'm sure there were less than 500 active collectors back then. And nobody much cared about condition. They were just glad to find any copy of what they needed."

Even if their copy had Magic Tape (carefully applied, of course) on the cover.

A lot of collectors, though, bought (if only once) from the 5-foot-5 Rogofsky. "He would type all his correspondence on this crummy little typewriter that would put all the vowels in superscript," Steve Turner recalled. They sent away to that Queens address and held their breath waiting to see what would come back. When collectors began caring about condition, they stopped writing to Rogofsky, but he never missed them. He shaped the market, and he made his money.

Romance Quiz

Identify which of the following are lifted from the romance comics and which are buried elsewhere:

(1) "I could hardly believe my ears. I was being bartered like livestock on the auction block: A toy for Mike's desires and a pawn for Pa's greed!"

(2) "It was all too fast, too ridiculous and too true. It came back with the effect of a tidal wave, sweeping over me, washing out the old and planting the new. She was all beautiful and slippery and blonde and brunette at once with those crazy, curving hills and sloped, wet banks like a rained-on race course that heaved and undulated with tiny muscular spasms aching to be relieved . . ."

(3) "My warning was too late. Mike was dead and I had a flesh wound in the shoulder. But my worries had only begun."

He was Howard *M.* Rogofsky in Marvel ads, Howard *D.* Rogovsky in DC ads, and so on.

"When you're able to buy a lot of comic books for a penny apiece and sell them for a dollar apiece, you're doing fine."
STEVE FISCHLER

ROMANCE COMICS

He could feel it in his fingers, he could feel it in his toes. Love was all around in 1947, Jack Kirby once said "There were love story pulps, and there were love story sections in the newspapers. There were love stories in the movies. Wherever you went, there were love stories. That's how we got our new material, and it suddenly struck me that that's what we haven't done. We haven't done any romance stories! There it was right in front of our eyes hanging from the newsstand. A love story! A romance story! So Joe [Simon] and I sat down one night and came up with the title *Young Romance*. And *Young Romance* sold out."

In the year following the arrival of *Young Romance* #1 (September/October 1947), publishers were hardly smitten with the new genre. Only three more romance titles were on the racks by the end of 1948. But a year later, there were 125 romance titles, according to comics historian Michelle Nolan. As many as 143 different romance books—churned out by 26 different publishers—were cluttering the racks during the first half of 1950.

Nolan refers to that era as "the love glut," and the public's gluttony for romance comics was quickly appeased: Only 29 of the books were published without interruption until the end of the year.

"Romance books," Nolan argues, "were the last frontier in terms of knowing about comics. They were 50-cent books forever. Overstreet made massive mistakes [in his Price Guide] forever because no one had a database on them. Other than the *Personal Loves*, four or five Frazetta issues, romance books weren't collected at all."

That finally changed in the 1980s; collectors finally realized, Nolan said, that the genre contained a splendid array of good artwork and social history. Matt Baker, the best artist in the bunch, drew for St. John; Jack Kamen, Wally Wood, and Al Feldstein for Fox; Alex Toth, Alex Schomburg, and Nick Cardy for Standard; Reed Crandall and Chuck Cuidera for Quality; Bob Powell for Harvey; and, of course, Jack Kirby for Prize.

Nolan—with considerable help from Dan Stevenson and Jim Vadeboncoeur—argues there were "about 3,760 romance comics published during the 1947–1959 period." Marvel/Atlas produced 445 issues, followed by Quality's 358, Harvey's 311, Ace Comics's 278, Charlton Comics's 256, Prize Comics's 246, and DC's 243.

When the companies publishing the best of the romance comics, such as St. John and Standard, went out of business, DC's schlock dominated what was left of the field.

What audience did covers like this one intend to reach?

(© Avon Periodicals)

(© Prize Comics)

Classic romance covers from Simon and Kirby, Matt Baker, and L. B. Cole.

(4) "Today's the Day. After four long, lonely years! If . . . If only Steve hasn't forgotten those wonderful words he whispered to me before he left. If only he knew how I've lived on those promises, how I've waited for the only boy I've ever loved to come back and take me away from this dreary, little town! Away from its drabness, and into the land of romance! And now that Steve's finally got his geology degree, he's sure to be offered a good job in the east! Maybe we'll even travel: Mr. and Mrs. Stephen Carter, on a perpetual honeymoon."

(5) "And she was mad with desire of him. She could not see him without touching him. In the factory, as he talked to her about spiral hose, she ran her hand secretly along his side. She followed him out into the basement for a quick kiss; her eyes, always mute and yearning, full of unrestrained passion, she kept fixed on his."

(6) "Long after Chip had fallen asleep, Mary Hilton sat thinking about her son and the problems he was now facing and would have to face in later years. And she was happy because Chip had shown that he could make his own decisions."

(7) "For the past three years at State, it had always been 'Rhoda and Jerry.' They'd sat together in classes, walked home from the library through the gathering twilight of autumn evenings. They had gone to all the college dances together. Picnics in spring, baseball games, even church. They had laughed together, quarreled and made up a dozen times. He knew the things that made her giggle, the movies that made her cry. He could tell from her walk whether she was gay or sad."

(8) "Why, you pig! You brutal pig! You're no different than the rest! Go on, scald me with your sermons! Condemn me before heaven! But I dare you to hold me in your arms again without asking for my kisses!"

(9) "I said nothing. I pushed her softness back into the room and went in after her. I ripped her shirt off. I unzipped the rest of her. I tore off her sandals. Wildly, I pursued the shadow of her infidelity; but the scent I traveled upon was so slight as to be practically undistinguishable from a madman's fancy."

"Go on, scald me with your sermons! Condemn me before heaven! But I dare you to hold me in your arms again without asking for my kisses!"

> *"I always figured it was a temporary thing, because I thought comics were in the last gasps of [their] existence. I predicted that television was going to destroy comics."*
> —JOHN ROMITA, SR.

John Romita, Sr.

(10) *"She lay supine, docile, under his hungrily groping hands. They roamed over her body unhindered, nothing forbidden nor withheld. And her mouth received his in long, breathtaking kisses. It was almost too much, more ecstasy than he could bear."*

Answers: (1) *Young Romance* #3 (2) *The Erection Set* (Mickey Spillane) (3) *My Past* #7 (4) *Search for Love* #1 (5) *Sons and Lovers* (D. H. Lawrence) (6) *Dugout Jinx* (Clair Bee) (7) *Cinderella Love* #27 (8) *Young Romance* #17 (9) *Lolita* (Vladimir Nabokov) (10) *A Swell-Looking Babe* (Jim Thompson)

Romancing the Trunk

The hunt began way back in 1966 when Leonard Brown and Malcolm Willits heard about a king's ransom of comic books locked up in an old trunk.

Brown and Willits had opened their Collectors Book Store in Hollywood a year earlier. "We had tracked this collection down; we knew what was in the trunk," Willits said. They just didn't know where to find it.

A customer said it belonged to a guy in Burbank, but the word in Burbank was that the owner had moved to Harrisburg, Pennsylvania. "All we had was his name," Brown told a reporter for the *Los Angeles Times,* "so we used a phone book and wrote to everyone by that name in Harrisburg. Finally, we got a letter from his uncle."

The uncle had lost touch with his nephew but, curiously, knew just where to lay hands on the trunk: It was stored in a Burbank warehouse.

"So, we finked around the way we always do and contacted every warehouse in Burbank," Brown said. When they stumbled on the right warehouse, they learned the trunk was slated to be auctioned off as unopened, unclaimed storage.

Not knowing exactly what the trunk looked like—and not wanting to ask the kinds of questions that would raise either suspicions or bidding—Willits and Brown decided to buy every trunk off the block until they snared the right one.

The contents of the first two trunks were worthless. The third—secured by a winning bid of $4.16—contained near-mint, complete pre-1943 runs of *Batman, Superman,* and *Captain Marvel* and numerous science fiction pulps and Big Little Books.

"We just stood there awestruck, I mean like—*wow!* Brown told the *Times*. "Think of something you've wanted all your life, then write yourself into it."

That 1966 *L.A. Times* article calculated the value of the trunk's contents at $10,000, with several of the comics sure to bring between "$100 and $200 apiece."

"There was a complete run of *Batman,* up to at least #30," Willits said 28 years later. "Adam West's agent found out about it, and called us up. He thought the set would be a great gift for Adam. We didn't want to give it up."

Romita, John, Sr.

Give the man credit: He gave Gwen Stacy the looks that launched a thousand shipments. And he twice stepped into the breach when Stan Lee needed someone to follow Steve Ditko on *The Amazing Spider-Man* and to follow Jack Kirby on *The Fantastic Four*.

Schooled as an illustrator but scrambling for work, Romita began ghosting comics in 1949 at the age of 19. "My first story was a love story, for *Famous Funnies*," Romita once said. "The editor must've been a philanthropist because they paid me for it, but never printed it."

Romita began working part time for Stan Lee at Marvel in 1951. "I always figured it was a temporary thing, because I thought comics were in the last gasps of [their] existence. I predicted that television was going to destroy comics. I was just married at the time, and I told my wife, Virginia, that I would continue in comics until they dried up."

And he just might. Romita left Marvel during one of Lee's periodic purges in 1958 and spent eight years at DC doing romance comics.

"For a long time, I didn't know what my father was," Johnny Romita, Jr. said. "My brother and I would watch him go up to the attic and disappear for a couple days, then come back with a beard and dirty fingernails."

The younger Romita never noticed the sketches under his dad's arm until his father came down from the attic one day with the cover art for *Daredevil* #12. "From the moment I saw that cover," Romita, Jr., said, "and realized this was what my father did, that's when I realized he was the greatest and this is something that I might want to do."

Romita, Sr. drew a half-dozen issues of

Daredevil before Ditko abandoned *Spider-Man* in the summer of 1966. Lee was not caught unprepared; he'd already tested Romita on the webslinger in *Daredevil* #16. Romita arrived for his six-year run just in time to give Mary Jane Watson a face (in *Amazing Spider-Man* #42) and Gwen Stacy a lot more besides.

In 1984, Romita was named Marvel's art director. His wife, Virginia, entered the '90s as the company's production manager. As Romita Sr. eased into retirement, J.R., Jr. picked up the family's artistic reins, collecting sterling reviews for such projects as *Daredevil: The Man Without Fear*, the 1993 miniseries scripted by Frank Miller.

Rosa, Don

For the longest time, Don Rosa told anyone who would listen that he was the only American who was born to write and draw Uncle Scrooge comic books.

Those were his exact words. When Gladstone got the license for the Duck books, Rosa called up Byron Erickson. "I told him that I was the only American who was born to write and draw Uncle Scrooge comics," Rosa said. "I told him it was my manifest destiny." He told Carl Barks the same thing in letters to the Duck Man going back to 1972. "In his letters, and in mine, we couldn't figure out how that would come about."

When the opportunity finally came, Rosa gave it straight to his partner in the family construction business: "I said I was going to save the company a lot of money because I was only going to work two days a week. The other three days I was going to do something with my life, and write Donald Duck comic books."

Rosa loved the characters, plain and simple. It was just his luck that he loved them a lot more than did the Disney Company.

Before Rosa ran smack into Disney, he was a collector, specializing in the books that filled his house when he was growing up in the 1950s. Over a period of 27 years, he filled his collection with 40,000 books. He helped Bob Overstreet start his price guide and was the Guide's resident authority on 1940s and 1950s comics for its first five editions. In those days, Rosa reminds us, comic books were a "mainstream medium, not a cult hobby."

He pursued his hobby at night, catching a couple of hours of sleep in the early evening, then cranking out the fanzine articles into the wee hours of the morning. He tracked the best days in the lives of Timely, Standard, DC, and Dell. Disney? What did he care about Disney? "They never did anything with comic books," Rosa said. "All Disney ever did was produce movies, run theme parks, and sue people. Those were their three industries."

By the mid-1970s, the Duck books were fading badly as sales sagged and Western Publishing, Dell's parent company, lost interest in the medium. But in 1986 Disney passed the rights to Gladstone, a six-bit operation in Arizona.

"Gladstone was a company formed of Disney fans, they were Disney collectors," Rosa said. "They loved the characters, respected the

Rosa's *Life and Times of Scrooge McDuck* brought him fans all over the world.
(© The Walt Disney Company)

Don Rosa

"If I worked for Disney, they would own my unspoken thoughts. I didn't even have to utter them. Now, that I was unwilling to sign ...That was a document that showed utter contempt for me."
DON ROSA

characters and understood them. That was the difference between Gladstone and Disney. Suddenly, on the newsstands, you had the best Disney comics this country had ever seen. Why did they get the rights? They asked for them. Disney didn't care; they knew no one else was interested."

Rosa called Gladstone begging for work. He got his wish. While the family construction business shut down in his absence, Rosa started writing and drawing the Duck books full time. "Gladstone couldn't pay a lot, but I figured from what they paid and what I could sell my original artwork for, I could just make it. If I could do that and live the dream I'd had for as long as I could remember, that would be plenty to get out of life. There aren't many people in the world who can fulfill their fondest dream."

He was in Narnia for about 18 months. Then Disney adopted a new corporate policy: reclaim all licenses worldwide. Why should we let other companies make money off our characters, the Disney accountants asked?

Because Gladstone was fulfilling all the requirements of its licensing agreement, Disney decided it could not simply strip the company of its right to publish. So, Disney simply tightened the screws. The corporation ordered Gladstone to submit the comics for editorial approval. And in a proprietory frenzy, Disney told Gladstone it could no longer return Rosa's original artwork.

Rosa was stunned; reselling that art to Duck fans provided 50 percent of his income. "By the federal copyright laws, freelance artwork is the property of the artist," Rosa said. "Disney knew this. Disney knew the artwork didn't belong to Disney." But Gladstone had no choice but to comply with Disney's decree; Gladstone publisher Bruce Hamilton didn't want to jeopardize his licenses for the Carl Barks Library and his Barks lithographs. Besides, Rosa observed, "You can't sue Disney. They own their own lawyers. If someone is doing something Disney doesn't like, [Disney] can sue and force them to spend hundreds of thousands of dollars to defend themselves. Even if Disney loses, they'll put someone out of business."

Did Rosa take all this personally? You better believe it. "Very personally. After a lifetime of devotion, I have a house full of toys and comics, I have introduced I don't know how many people into collecting Disney comics, and after all that, they drove me into bankruptcy, or close to it."

So much for living his fondest dream. Rosa went to work drawing Scrooge and the ducks for Gutenberghus (now Egmont), the massive European publishing company. Disney stripped Gladstone of its license and set up its own comics publishing operation, only to discover that it didn't know quite as much about publishing comic books as its accountants thought.

And so it came to pass that in 1990 Disney approached Rosa and asked him to work for them. Rosa agreed to do a 12-page story for Disney's first new Donald Duck comic. "We never discussed contracts," Rosa said. "But after the story was completed, they sent me this thing and said, 'Before you can get paid, you have to sign this contract.'

"Let me tell you about some of the things in this contract. Truth is stranger than fiction. The entire purpose of this document was to remove any shred of right I had to everything I did. It said that Disney owns the copyrights and rights to the stories, and the artwork I do throughout 'perpetuity in all media existing now or invented in the future throughout the universe.' I assume this covers space stations on Mars.

"The contract went on for five pages. Disney has the right to use my name or likeness in any way they wish, but I cannot claim I work for Disney. I can't go to a convention as a guest saying I work for Disney.

"It said if I submit a story to Disney and they reject it, they still own it and I cannot submit it to someone else. How do you like that?

"One of the best ones was that if . . . Disney breaches the contract, this does not affect Disney's ownership of the material. In other words, if they do not live up to their part of the contract, you have no legal right to object to it."

"Still," Rosa said, "these are all things I would have signed. I knew how they were. And I knew that if I got royalties and reprint residuals, I'd be one of the best-paid comic book artists in the world.

"But here's the one I wouldn't sign. Not only did it say Disney owned my original artwork without paying for it . . . not only do they own the original artwork, but they also own all other

notes, scripts, outlines, sketches, reference material, research data—these are all direct quotes—plus Disney owns all other ideas and concepts either tangible or intangible."

Capiche? "If I worked for Disney," Rosa said, "they would own my unspoken thoughts. I didn't even have to utter them.

"Now, *that* I was unwilling to sign. I was not going to sign away my unspoken thoughts. That document showed utter contempt for me. If you put your name on that document, you show utter contempt for yourself."

Rosa was unemployed for almost a year before going to work for Egmont in 1990; his stories sell millions of copies each week in Europe and Asia. Rosa's *Life and Times of Scrooge McDuck*, a 12-issue series, won several awards. And he eventually signed a much better contract with Gladstone. But Disney-Don Rosa never made the mistake of caring too much about Disney.

Roy Rogers

Six years after Roy Rogers hit it big on the silver screen with *Under Western Stars*, he made his first comic book appearance in *Four Color* #38 (April 1944). That was, the *Overstreet Comic Book Price Guide* notes, the first western comic with a photo cover, and Rogers would ensure that there were many more. Rogers once noted, "When my time comes, just skin me and put me right up there on Trigger, just as though nothing had ever changed." Many of the photo covers appear as if he's rehearsing for that final, wooden pose.

Rude, Steve

The Dude has a high school confidential: "I was obsessed with the artwork of Paul Gulacy."

Say what? "It was the most bizarre thing," Rude concedes. "This guy was my god in high school, when I was really into idol worship. He did things in storytelling I've never seen anyone do since. After hearing this guy was going through eternal back pain from being hunched over a drawing board 17 hours a day, I conned my Mom into sending him $1.98 for a tube of Ben-Gay.

"She sent him a check; I thought the tube might get squished in the mail. That was my way to introduce myself to Paul Gulacy. That's part of the timeline for The Dude, how everything started to happen."

The real happenings for The Dude—he picked up the nickname while working at a Pizza Hut—were still several years off. After graduating from art school in 1978, Rude extended his Gulacy obsession by hitchhiking from his home in Milwaukee to Gulacy's in Youngstown, Ohio. He arrived to find Gulacy in the middle of a *Sabre* page, but willing to lend him time and encouragement.

"He had a burning desire like no one I've ever seen," said Gulacy, who would one day serve as best man at Rude's wedding. "He was determined to be one of the best."

In numerous trips to New York in the late '70s and early '80s, Rude struck out with Marvel

In the 1990s Rude continued to top himself with his drawing and layouts for *Nexus*.
(© Mike Baron and Steve Rude)

Steve "The Dude" Rude

Jack Kamen provided cover art for most of the Rulah comics.
(© Fox Feature Syndicate)

and DC, but all the while his artwork was maturing under the guidance of Owen Kampen. An old vet of the Famous Artists School, Kampen had been slowly dissolving at the Madison (Wisc.) Area Technical College when Rude showed up. "I was probably the last guy he taught all his stuff to," Rude said. "The fundamentals of art. How shadows fall across form. Values and color. No bullshit."

Rude was trying to sell comic strips to one of the many leftist rags in Madison in 1979 when he met Mike Baron. "When he met me, he found someone who could draw his stories," Rude said. He drew *Nexus* for the first time that year and is drawing it still having in the ensuing period picked up more Eisner Awards for his penciling than any other artist in the history of the awards.

"My emotional spirit," Rude said, "comes from the artists of the comic books I read. They inspired me to the sky. That's why I've never turned into a hack after all these years. I have a constantly burning furnace. It's not part of my makeup to burn out or give up. It's just not going to happen."

Rulah

The jungle goddess is most famous for tying up two African natives and dangling them like Christmas ornaments on the cover of *All Top* #8. *All-Top* 's cover girl was an identical twin to the cover gal in *Jo-Jo Comics*, except that the *Jo-Jo* jun-gal's outfit featured yellow stars on an orange background, while Rulah's leopard skin had yellow lines instead of stars. Even Trina Robbins, who considered these women stunning feminist heroines, found Rulah a little hard to take. "The Rulah comics," Robbins once said, "were really the most twisted and violent and sick of that whole bunch."

Rulah appeared in *All Top, Terrors of the Jungle,* and—in the late 1940s—11 issues of her own comic, *Rulah, Jungle Goddess.*

San Diego Comic-Con

As he stood at the door of the basement of the U.S. Grant Hotel, on a March morning in 1970, Shel Dorf thought he might finally have the answer to: Who's buried in Grant's tomb?

Our comic book convention.

For all Dorf knew, no one was going to show. Forrest Ackerman—the con's big-name guest—would have to spend the entire day counting the ceiling tiles. Months of planning were going down the tubes.

Twenty-four years later, Dorf—sitting in the lobby of the San Diego Hyatt, a slightly more elaborate hotel—recalled how the day turned out. "I remember standing at the door thanking each person as they came in," he said. "We had, maybe, 65 to 70 people at that first one. It was so hard getting people to come."

Even as Dorf spoke, fans were already lining up half a block away to storm the San Diego Convention Center. Getting people to come had gotten a little easier: Some 15,000 would arrive that day, many of whom had turned the trip to San Diego into an annual pilgrimage.

The first "official" Comic-Con—dubbed San Diego's Golden State Comic-Con—ran August 1–3, 1970, but the fun began five months earlier. A coordinator at the San Diego Convention Bureau told Dorf that if he promised the U.S. Grant a three-day convention, the hotel would give the organizers an extra day free. "On that one free day," Dorf said, "we created a little minicon to raise money for the expenses of the three-day convention."

Ackerman, then editor of *Famous Monsters of Filmland* magazine, headlined the one-day show; Jack Kirby and Ray Bradbury arrived in August for the three-day convention, which attracted a crowd of 300.

"Those two names," Dorf said, "put us on the map."

Dorf started the convention, he said, "because I thought cartoonists were the only entertainers who never hear the applause." And he believes the "convention" designation, despite the confusion it sparked, gave the whole affair a considerable boost.

"No one knew how to deal with us," Dorf said. The sales departments at various hotels "would say, 'Well, how big a bar bill can we expect?' And I'd say, 'Well, if you change that to milkshakes and sodas and hot dogs, you can expect a big bill. These are children. These are not drinkers. This is not like a Shriners' convention.'"

Okay, but how many hotel rooms can we rent?

"In those days," Dorf said, "I knew kids would go to these things, and five kids would pile in and sleep in sleeping bags on the floor. We didn't want the hotels to know that. Everyone was on a budget. Our first film rooms were open 24 hours a day because we knew there were some kids who couldn't afford to stay in a hotel room and they could sleep in the film room at night."

After trying various other venues, the Comic-Con settled in at the El Cortez Hotel in 1974 for a glorious five-year run.

"Whenever I look back, I invariably think of the (late, lamented) El Cortez Hotel," Paul Sammon wrote in the 20th anniversary program. "More importantly, I remember its pool. As the old-timers know, the El Cortez was home base for the Comic-Con during its formative years—but the pool was its social nexus. Day or night, this is where the action was. During the bright hours there was swimming, socializing, and drinking; when it got dark, the swim trunks came off as the socializing grew more intense and the drinking swelled exponentially."

And when the darkness turned toward dawn, you might stumble across the King.

"We invited Jack back year after year," Dorf said. "He only missed once. There were times at four in the morning when he couldn't sleep and he'd be down at the swimming pool of the old Cortez. Someone would look out their window and say, 'Hey, Kirby's down there!' All of a sudden Jack was holding court with the fans."

A lot of devout fans hit the Comic-Con for the first time when the art auctions were held poolside at the El Cortez. "The Cons now are fine," Bill Warren wrote in the 25th anniversary program, "but they're almost too big to grasp,

All attendees at the San Diego Comic-Con receive a souvenir book. The cover for the 1990 book was painted by Bill Morrison, who later went on to write and draw *The Simpsons* comics.

(© Comic-Con International)

Longtime Comic-Con attendees have fond memories of poolside activities at the El Cortez Hotel.

Simon and Kirby revamped the Sandman in 1974.
(© DC Comics, Inc.)

too huge to have a personal connection with. But the El Cortez, ah, the El Cortez..."

Whether the party was at the El Cortez or its current home, the San Diego Convention Center, you never knew who you were going to bump into at the door. "They'd have some of the most outrageous guests compared to the other conventions," said Bruce Ellsworth, a New Mexico dealer. "I remember the Rifleman, Chuck Connors, I ran into him. Who ever thought you'd see the Rifleman at a comic convention? These people would just come. You'd always see movie stars. Lynda Carter was there. She wasn't even in costume. Mr. T. All sorts of rock 'n' roll stars. Gene Simmons of Kiss. Mickey Dolenz of the Monkees. Sammy Hagar." Or Frank Capra. Timothy Leary. Mark Hamill. Frances Ford Coppola. You never know.

Dorf retired from the San Diego Con in 1984. Run by a board of directors as a nonprofit corporation, the Con now fills the entire giant San Diego Convention Center for four days every summer. From 300 attendees in 1970 to 40,000 in 1997—who knew? Now it takes more than 300 volunteers just to put it on.

In the early 1990s the Comic-Con changed its name to Comic-Con International: San Diego to reflect the fact that pros and fans from all over the world now flock to San Diego to spend a week talking, buying, selling, eating, and sleeping comics.

Sandman

Created by Gardner Fox and first drawn by Bert Christman, Sandman debuted virtually simultaneously in *New York World's Fair 1939* and *Adventure Comics* #40 (there is some debate about this) He was splendidly resurrected by Neil Gaiman half a century later. But our favorite Sandman is the 1974 Simon and Kirby version.

In the dawn of the direct market, the S&K *Sandman* #1 was the first "hot" book to come through the door at Comix and Comics in Berkeley. John Barrett, one of the store's original partners, said he and Bud Plant stockpiled 10,000 copies, thinking they'd make a killing sooner or later in the speculation market.

And? "We ate them," said Dick Swan. "We thought that was going to be a great book." As it turned out, the guy who bought most of their load ended up rolling the comics up, soaking them in creosote, and using them as fireplace logs.

Hot to the bitter end.

San Francisco Collection

On the last day of the 1973 Berkeley Con, the first underground comix convention, Michael Manyak was checking passes at the door. Out of the elevator came a guy dragging a dolly, upon which sat a canvas-lined, three-layer trunk.

When he popped open the trunk, Manyak saw that each of the lift-out trays was full of comic books. "On the top," Manyak said, "was *Captain America* #1, with a rubber band around it. Yeah, it was a loose rubber band."

Feeling something tighten in his throat, Manyak and Nick Marcus, his partner at Shazam Comics in the East Bay, hustled the guy to an empty room upstairs. As Manyak began to dig carefully through the trunk, the guy told them the story behind the comics. "It was a real sad story," Manyak said, "because everyone was dead."

When his nephew went off to war, the man said, the soldier had asked his father to keep buying his favorite comics. His dad followed orders, adding at least a dozen unopened books to the pile in his son's closet every month . . . until he got word that his son had died overseas.

For the next 30-odd years, the contents of that closet and the rest of the bedroom went untouched, a memorial to the dead. When the soldier's parents finally died, the house and everything in it passed to his uncle.

And that uncle was now standing in front of Mike Manyak and Nick Marcus, asking them if they wanted to buy his comic books.

"Nick and I bought all the Timelys," Manyak said. "There was the *Cap* #1, *Torch* #1, *Sub-Mariner* #1, and *Young Allies* #1. The *Human Torches* were 1 through 12, with all the key battle issues. The *Sub-Mariners* were 1 through 12. There were a couple issues of *Mystic*, but they only had a couple *Captain America*s. We paid $24 a copy. At that point, the *Cap* #1 was $1,000 or $1,500 [in Overstreet]. We guided them and he gave us a substantial discount on the books.

"It was kind of a low blow on our part," Manyak said, "because we scooped the stuff that we wanted. Then we got ahold of the other boys who had put together the show, and they got together to buy the rest of the books. That's when things got hairy, because other people at the show got involved. They knew he had the books, and they knew they were pristine."

The rest of the collection—considerable lots of Quality and Fiction House books, but relatively few DCs—was purchased by John Barrett and Bud Plant of Comics and Comix in Berkeley. Barrett said the uncle had only part of the complete collection, which had been divided among several other relatives. "We traced down the other relatives and bought those parts of the collection, too," Barrett said. "There was only one part that never surfaced."

The entire collection numbered somewhere between 800 and 1,000 books. Their condition? "Crystal," Manyak said. "Just perfect." About three-fourths of the collection are stamped with the name of the original owner—Arnheim—on the back cover.

Because the San Francisco books surfaced before the Mile Highs (the first collection to be marketed as "prestige" books) it wasn't named until years after the comics had gone their separate ways. And the books had a much rougher ride than the Mile Highs. The *Captain America* #1 and several other Timelys were stolen out of the back room of Shazam Comics. Another 150 books were stolen from Comics and Comix's San Francisco store that same summer.

And every once in a while, Manyak said, he'll turn over a glittering Golden Age book at a small show in Fairfield or Alameda and find the small, telltale stamp. It takes him back.

Saunders, Allen

The creator of the comic strips *Mary Worth*, *Steve Roper*, and *Kerry Drake*, the Hoosier also had a hand in—or a hand on—*Rex Morgan*, *Judge Parker*, and *Dan Dunn* during his 52-year career.

Saunders, Norm

He forgives, we trust, those fans who believe his 53-year career as an illustrator peaked with the 1962 Topps card series, *Mars Attacks*.

Saunders stumbled into his first job in 1928 when, while wandering the halls of Fawcett Publications, he was mistaken for another artist by editor Weston Farmer.

"I was looking for Captain Billy [W. H. Fawcett]," Saunders once said, "when Westy came out into the hall, grabbed me, and said, 'Hey! Are you an artist?' Well, I said that as a matter of fact I was. He asked me if I could do a gouache, and I said, 'Why,

Books from the San Francisco collection bear a distinctive stamp on the back.

And you thought *Mars Attacks* was Norm Saunders's worst nightmare.
(© Fawcett Publications)

> "What in the hell is a gouache?"
> NORM SAUNDERS

sure. That's one of my best things.' So he gave me a sketch of a boat and told me to bring him a gouache day after next. Right away I went into town and got hold of an artist friend there and asked him, 'What in the hell is a gouache?'"

Saunders figured it out and spent six years at Fawcett, then used art school as a springboard onto the covers of the pulps. He never saw a woman he couldn't undress on the covers of *Uncanny Tales* or *Mystery Adventures*. Street & Smith reportedly paid him up to $150 per cover two or three times each week.

After consecutive stints with the Army and alcohol, Saunders shifted his energy to paperbacks and comic books, drawing for Fawcett, Ziff-Davis, and *Classics Illustrated*. Topps came looking for him in 1961, and Saunders caught his second wind: He painted cards and wrappers for the company for the next 20 years, including *Mars Attacks*, *Civil War*, and a 1966 *Batman* set.

Saunders retired in 1981 and died eight years later at the age of 82.

Schiff, Jack

An editor at National/DC from 1942 until his retirement in 1967, Schiff was hired to hold Mort Weisinger's place when Weisinger (his old buddy at Standard Magazines) went into the Army.

When Weisinger returned, Schiff remained as managing editor. He helped introduce *Real Fact Comics*, plotted a vast number of books, and took over the editing of *Strange Adventures* and *Mystery in Space* from Julius Schwartz in 1964.

Schiff also edited the *Superman* syndicated strip, which provoked a visit from the FBI in 1943. "They told us to change the *Superman* syndicated strip then running in order to eliminate a cyclotron that was featured," Schiff recalled. "We really should have suspected what was happening: The A-bomb was being developed and this was a possible leak."

Schomburg, Alex

> *I always felt Alex Schomburg was to comic books what Norman Rockwell was to* The Saturday Evening Post.
> STAN LEE

Alex Schomburg

Alex Schomburg is not unwilling to glance back toward the past, now and then, but when you point Schomburg in a certain direction, he doesn't always end up there. Push him toward Stan Lee and he may lead you to Hugo Gernsback. Ask him about life in the bowels of New York, and he may end up on the roof above the National Screen Service offices, where he worked in the early '30s. He's never forgotten the view, you understand. "We all had binoculars," Schomburg said, "and at lunch we'd all go up and watch the chorus girls sunbathing on a nearby roof. They didn't want the sun to burn them, so they'd take their tops off so the tan lines wouldn't show. We'd send the office boy out for sandwiches..."

Alex, Alex... Snap out of it. Or pass the binoculars.

From a distance, Schomburg is best known for the comic book covers he produced between 1939 and 1945. Small wonder: His work included 296 covers for Standard/Nedor and another 199 for Timely. He drew all but 11 of the first 69 issues of *Marvel Mystery Comics*.

But when you nudge Schomburg toward the best work of his life, he takes you for a walk through the work he did away from comic books, particularly in science fiction.

His first cover art appeared not on the September 1939 issue of the pulp *Startling Stories* or splashed across the third issue of *Marvel Mystery* (January 1940), but a full 15 years earlier. In 1925, Schomburg, then 20, met Hugo Gernsback in the latter's New York office. Gernsback would later become famous for publishing such pulps as *Amazing Stories* and *Wonder Stories,* but Schomburg was attracted by a Gernsback gambit titled *Radio News*. He'd carefully followed the magazine's instructions to construct a small radio, but the contraption wouldn't work. So, he marched straight to Gernsback for a lesson on what he'd done wrong.

Gernsback had designed the first home radio set in 1905, and he found the flaw in this kit about the time Schomburg pulled out some art he'd done for a typewriter-instruction pamphlet. Gernsback liked what he saw and asked Schomburg for some circuitry illustrations. By December, Schomburg had worked his way onto the cover of a Gernsback magazine called *The Experimenter*.

"Schomburg's early work for Gernsback was pretty crude," said Sam Moskowitz, who edited

Gernsback's revival magazine, *Science-Fiction Plus,* in the '50s. "He wasn't a polished artist then, and Gernsback had some pretty polished artists working for him, like Frank R. Paul. He didn't need Schomburg."

Ah, but then the war began. America had an enemy and Schomburg had the perfect subjects.

"Caricature" is too kind a word for the way Schomburg manhandled the Japanese and the Germans. The "Japs" were saddled with jaundiced yellow skin, grotesquely slanted eyes, and piranha overbites. The Nazis sported Colonel Klink's monocle and Sgt. Schultz's girth. Almost without fail they were equipped with the cruel, ingenious tools of torture. If the Japs weren't bayoneting injured prisoners, they were branding the Rising Sun on the tender breasts of a woman tied to a stake.

The Nazis employed boiling acid, the executioner's ax, and the barbecue spit. In one of the most famous Schomburg covers, *Exciting* #39, the Nazis are injecting poison into candy, then offering the sweets to kids.

On his other assignments, Schomburg betrayed a lighter touch. After Pearl Harbor, Gernsback drafted him to produce some 50 covers for *Radio Craft* magazine. Each month, Gernsback would drag Schomburg into his office and toss out some half-baked fantasy. A mobile radio station. An electronic artillery locator. The dreaded robot television tank. "They were stupid ideas," Moskowitz said. "He had lots of them." Schomburg was required to transport each brainstorm to paper and somehow make it believable.

Schomburg, who had drawn hundreds of naked women for sadistic horror pulps such as *Uncanny Tales* and *Mystery Tales,* also continued to chase after the ladies with an airbrush;, and he supplied covers and interior art for such Standard magazines as *Popular Crossword Puzzles, Astrology,* and *Everyday Astrology.*

For all the heart and toil and countless hours he poured into it, Schomburg never thought his work was that special, particularly those covers for the comic books. If his cover was worth the 10-cent price tag, the stories inside usually weren't. National Screen Service, which made film shorts, paid his $100 weekly salary for drawing film backgrounds until 1944; Schomburg did the comic artwork in the moonlight. When he got the phone call from the editors at Timely or Standard, he opened the window into his imagination and took a flying leap. Schomburg was paid $40 or $50 for each of the covers he drew. He figured that was fair compensation, at least fair by the standards of an industry in which the artist supplied all the color and the publishers made off with all the dimes. It never occurred to him that anyone would keep the comics, much less collect them, much less sell the original art for thousands of dollars at auction.

"I never dreamed it," Schomburg said. "I never ever dreamed it."

And that's why, Schomburg admits "I pulled a stupid thing. I just pulled up stakes and didn't let anyone know where I was going." The publishers of several science fiction magazines, for whom he did at least four dozen covers between 1950 and 1954, knew he'd headed west, but with the comic book publishers, Schomburg didn't leave a forwarding address. He didn't know his audience or understand his legacy.

Times were tough after the move. Schomburg remembered searching for work in downtown Spokane, armed with some of his best science fiction and movie trailer art. "The first thing they wanted to know? Have you done anything in Lumber?"

Lumber? After the Red Skull and the Black Terror, Schomburg could handle lumber. Three thousand miles removed from his *Thrilling* and *Exciting* days, Schomburg survived on whatever he could find. He painted real estate and neon signs. He drew artist's renderings of how office buildings would look with aluminum awnings. On the good days, he produced endpapers for the Winston juvenile science fiction books and color-by-number sketches for the Venus pencil company. He spent the bad days bent over his table-saw, building

Some of Schomburg's most erotic work appeared in the horror and terror pulps.

And after the Nazis poisoned the candy, they passed it out to war orphans.
(© Standard)

Another Schomburg style: airbrush color for science fiction comics covers.
(© Better Publications)

red-and-white donation-box chimneys for Volunteers of America.

When the bad days began to pile up, Schomburg moved to the little town of Newberg, Oregon, 25 miles south of Portland. "That's when people thought I was dead," he said. "People thought Schomburg had died."

No, he'd simply escaped. Luckier than many of his peers, he had escaped New York. He had slipped away from a business that has never been very kind to its better craftsmen, then had the tenacity to live long enough for fans of his art to track him down and thank him for the memories.

Film director Stanley Kubrick called once, asking Schomburg to help with the artistic development of *2001: A Space Odyssey*. Collector's Showcase in Hollywood phoned, asking him to re-create some of his covers from the war. The San Diego Comic-Con called to see if he'd come down as a special guest.

In the 91st year of his life, Schomburg was no longer strong enough to receive them. He spent most of his day in a sun-drenched bed, looking out over the Oregon woods. At the foot of his bed, a cardboard cutout of Captain America, almost life-size, stood guard, saluting Schomburg with his shield.

When presented with a fragile relic of his former passion, Schomburg would soon hand the comic back. It was only a fading photograph of someone he used to know. They were only figures on a distant rooftop and, after all these years, he had passed the binoculars. Schomburg died in 1998, a month shy of his 93rd birthday.

The Schomburg comic covers: *Alley-Oop* (Standard): #17, 18; *All New Comics* (Harvey): #7–11; *All Select Comics* (Timely): #1–10; *All Winners Comics* (T): #1, 7–18; *Amazing Comics* (T): #1; *America's Best Comics* (Nedor): #5, 7–31; *Billy West* (S): #7, 8; *Black Terror* (N): #2–27; *Boots and Her Buddies* (S): #6; *Brick Bradford* (S): #6, 7; *Broncho Bill* (S): #6, 7, 9–13, 16; *Captain Aero* (Holyoke): #15, 16; *Captain America Comics* (T): #3, 26–29, 31, 33, 37–39, 41, 42, 44–54, 58; *Captain Easy* (S): #13, 16; *Catman* (H): v3/13; *Complete Comics* (T): #2; *Daring Mystery Comics* (T): #1–4; *Daring Comics* (T): #9–12; *Dear Beatrice Fairfax* (S): #5–9; *Exciting Comics* (S): #26–68; *Fighting Yank* (S): #4–29; *Freckles and Her Friends* (S): #10, 11; *Green Hornet Comics* (H): #15, 17–23; *Human Torch* (T): #1–3, 5–23; *Invaders Annual* (Marvel): #1; *It Really Happened* (S): #1–11; *Jon Juan* (Toby Press): #1; *Kathy* (S): #2; *Kid Komics* (T): #2–10; *Marvel Mystery Comics* (T): #3–11, 13–25, 27–29, 33–36, 39–48, 50–60, 62–69, 71, 74, 76; *Miss Fury* (T): #1, 5, 6; *Mystery Comics* (Wise): #1–4; *Mystic* (T): #1–6; *Mystic* (Atlas): #4; *Pep* (MLJ): #29, 38, 39; *Real Life* (S): #1–7, 11, 13–40, 42, 45–47, 49–52, 55; *Speed Comics* (H): #31–36; *Startling Comics* (N): #21–43, 47–53; *Submariner Comics* (T): #1–4, 6, 8–18, 20; *Suspense Comics* (Continental): #3; *Terrific Comics* (C): #5; *Tim Tyler* (S): #12, 13; *USA Comics* (T): #6–10, 12, 13, 15–17; *Wonder Comics* (N): #1–10, 13–20; *Young Allies* (T): #5–13, 15–19 **Totals:** Timely 199, Standard 196, Nedor 100, Harvey 19, Wise 4, MLJ 3, Holyoke 3, Continental 3, Atlas/Marvel 2, Toby 1

School of Industrial Arts

This school was one of the great New York City training grounds for many Golden Age artists, including Joe Orlando.

"My art school was high school. Four periods of art. A great school, supported by New York City," Orlando said. "The School of Industrial Arts—it's now called the School of Art and Design. When we came out of that high school, we had portfolios that qualified us to work at countless New York agencies. We were ready to make a living.

"When I got out of the Army, I went to Art Students League and painted every day. But I was working already. The portfolio I prepared in high school got me the work. This was a specialized high school. We majored in everything from illustration to show-card design. We had a course in leather. Bookbinding. We were ready to make a living. This was a Depression generation. We didn't agonize over what we wanted to be when we were growing up. We *were* grown-up. The high school diploma was our entry to the adult world. We were expected to make a living.

"I have children now who, three years into college, still don't know what they want to be. They actually agonize. I'm going to have to send them to psychiatrists to figure out what they want to be when they grow up. My daughter said to me, 'I don't know what I want to be when I graduate. The only thing I know I want to be is rich.' I said, 'That's not a career. Money comes. Success comes. But having a passion for something?' They don't have a passion for anything. They don't know . . ."

Schultz, Mark

A great example of the value in letting an artist pursue his private obsessions.
PAUL CHADWICK

"I discovered Burroughs when I was 13 years old, and it changed my life," Mark Schultz said. "And with Burroughs comes Williamson and Frazetta and Krenkel, of course. Up until then, I'd been searching for something. I'd always been interested in comics, but I hadn't found something that sucked me in and created a whole new world for me."

Schultz's passion was to tell stories through sequential art. "I studied Kurtzman stories and Eisner and Caniff: what made them work, why they chose certain scenes, how they paced the stories. I studied them on my own. Unless you go to the Kubert school, you don't get that type of education."

The self-educated result was the black-and-white *Xenozoic Tales*, a fantasy of Cadillacs and dinosaurs first published by Kitchen Sink in 1987. Schultz had submitted the story to seven companies, including Marvel, DC, and Eclipse. "Kitchen Sink was the only one interested in the story and the concept," he said. "I was willing to take a chance to do my own stories."

And to do them at his own speed. In terms of cranking out the pages, Schultz makes Dave Stevens look like Jack Kirby...although Chadwick notes that "his beautiful art—all the best aspects of Wood, Frazetta, and Williamson—is making the wait [between issues] absolutely painless."

"It was very tough the first couple of years," Schultz said. "We could only get by because my wife [Denise] works as well. I'm always comparing myself with the guys I loved in the past. They seemed to turn out the stuff so quickly. I take so long. I try to compensate for the patience in my readers by giving them a little extra in my art.

"After I finish a story, I can't go right into the next one. I need a couple weeks. I can take anywhere up to a month to write the story. Most of the work is just sitting there, trying to beat out the details in your head.

"I don't think I would be happy working in the field. I want control of every aspect of the book. *Xenozoic Tales* is my ambition. I don't want to use this as a steppingstone to become the next artist of *Iron Man*."

Schultz is good friends with Al Williamson, who lives two hours from him in rural Pennsylvania. Schultz rarely sells his original art, but he has swapped several pieces for Williamson originals.

"When he first saw my stuff," Schultz said, "he said, 'This is wonderful what you're doing; it's obvious you're looking at the EC guys.' Then he said, 'Don't look at us, look at the guys we looked at.' I was centered in on this one particular aspect of comic book art, and I didn't see the picture. The closer you get to the source, the better your art gets. You weed out the mannerisms that progressive generations of artists have added to the art."

Xenozoic Tales ended up as a short-lived Saturday morning cartoon, *Cadillacs and Dinosaurs*, in 1994 (that title was also used for reprints of the comic, both in color—published by Marvel—and in graphic albums put out by Kitchen Sink). The demands of doing the show made issues of the comic even fewer and farther between.

Schultz's EC influences are quite evident in the pages of *Xenozoic Tales*.
(© Mark Schultz)

Mark Schultz

Schwartz, Alan

In the early 1940s, Al Schwartz—like every other writer he knew—was slowly starving to death. "I had a little apartment on 8th Street in

> "I hated kryptonite stories. I wouldn't do them unless Mort [Weisinger] pushed one down my throat."
> ALAN SCHWARTZ

Julie in his early DC days, as caricatured by Sheldon Mayer.

the Village, with a mattress and a wife," he said. "We were hungry. It was still the Depression, especially for writers. I would sit in the window and every once in a while a friend would go by and I'd run down and borrow a quarter. You could get a great meal for a quarter."

One afternoon, Schwartz spied artist Jack Small from his window seat and sprinted down with his palm out. Small gave him more than two bits; he suggested that Schwartz write a Russian fairy tale for a comic book he'd been working on, *Fairy Tale Parade*.

Schwartz figured, why not? The last time he'd gotten a paycheck, he'd had to pretend he could operate a drill-press while teaching a carpentry class. He wrote the tale and remembers dropping the manuscript off uptown. By the time he got back to the Village, his wife, and his mattress, the phone was ringing and his drill-press days were over.

"I've led a very bifurcated career, in pop culture and literature," Schwartz said. He was in the room when Jackson Pollock was slapping paint on several of his most famous canvases. He scripted Captain Marvel tales and what *The New York Times Book Review* called "the first consciously existential novel in America," *The Blowtop*. He not only helped plot the *Phantom Detective* pulp but authored Canadian domestic policy for the Pierre Trudeau government. He wrote the first teamup of Superman and Batman in *World's Finest* (#71), and a scholarly piece on "The Influence of Media Characteristics on Coupon Redemption."

The latter, needless to say, paid better.

Using the pen name "Vernon Woodrum," Schwartz estimates that he wrote 2,000 comic book stories, including several dozen for Shelly Mayer. (Schwartz said he met Mayer at Alex's Borscht Bowl in the Village, where starving artists and pregnant women could always count on the wild Russian for a free bowl.) He also pumped out two Superman operas, but he is best known for his work on the Batman and Superman daily strips.

He much preferred Superman, "as long as I was allowed to handle him with a touch of fantasy." Schwartz said the challenge in writing about him "was to find him vincible without relying on such gimmicks as kryptonite. I hated kryptonite stories. I wouldn't do them unless Mort [Weisinger] pushed one down my throat. Instead, you'd find him vincible psychologically, vincible in terms of the double identity problem. It isn't a question of conquering him, but creating stories around the character that bypassed his invincibility. Or tested his psychological character."

Schwartz conceded that his work "tended to be a little wordy; my stories were complex. I tended to think like a novelist." By 1958 he was out of comics. He didn't attend his first comic book convention until 1991. He and Ryeson "Johnny" Johnson, who worked on Doc Savage and Batman, were scratching out a few autographs, Schwartz said, "when some guy says to us, 'You both are unsung heroes.' Johnny and I looked at each other and said, 'What the hell is this shit?'"

Schwartz, Julius

> *So, don't forget, if it wasn't for Mort and me, none of you would be here.*
> JULIE, WONDER CON 1992

Julie Schwartz has never surrendered any ground to the historians. He has never gotten out of their way. Wherever there is a Silver Age panel at a major convention, Schwartz is smack dab in the middle of it, telling stories, claiming credit, holding the revisionists at bay.

After 49 years at DC, pride is sometimes more faithful to Schwartz than memory. At Wonder Con in 1992, Schwartz told the story of Will Eisner and Gil Kane going out on a double date while they were high school buddies at De Witt Clinton and being forced to wash dishes when they couldn't pay their dinner tab.

Kane remembers it a little differently: "I didn't go to high school with Eisner."

Were you both at De Witt Clinton? "He's ten years older than me."

Well, Julie's story is that you and Eisner went out on a double date and ended up washing dishes . . .

"He is absolutely insane. Eisner is the generation before me."

Schwartz isn't crazy, just stubborn, stubborn and proud. He began as a science fiction agent for the likes of Ray Bradbury, Henry Kuttner, and Manly Wade Wellman. With Mort Weisinger, Schwartz uncorked the first science fiction fan magazine, *The Time Traveller,* in 1932,

and he lived comfortably off science fiction for another dozen years.

By 1944, Schwartz once claimed, he'd never read a comic book. "To this day," Kane argues almost half a century later, "he hates comics. Julie never had any sympathy for them. He was always a science fiction man." But science fiction wasn't selling in 1944, so Schwartz took the advice of Alfred Bester and applied for a job with All-American Comics. Shelly Mayer was short on editors and decided to take the chance.

When reviewing all that Schwartz meant to DC over the next 25 years, fairness demands that we note that others were in the room when the decision was made to resurrect the Flash, and that if he breathed new life into Batman in 1964, so did the television show two years later.

But Schwartz doesn't need to share any credit for his editing on DC's science fiction titles, *Strange Adventures* and *Mystery in Space*, which debuted in 1950 and 1951, respectively. He attracted the best writers and artists and—unlike several other DC editors, notably Weisinger—kept his heavy hands to himself. "Julie was the only one who had the right approach to dealing with freelancers," Dick Giordano said. "Even if he dictated the stories, he made the freelancer feel that it was his idea."

Schwartz helped bring tremendous stability to DC in the Fifties. He had fairly simple ideas of what he liked in the comics, and he had simple instructions to get those ideas across. Kane refers to him as a "benevolent despot," firmly set in his ways. "If you did something that was better, but different, he said, 'No, change it back.' He couldn't recognize that it was better, he only knew it was different. That's how rigid was his need to control every situation. He always had your check. He always had your script. He was like a demanding father, who treated his people like children."

Sometimes the kids didn't appreciate it. Alex Toth once interrupted Schwartz's lunch-hour card game to ask for his paycheck. Schwartz was so adamant in his refusal to take a break from his game of pinochle that the two almost came to blows.

And if Schwartz was perfect for the Fifties, he was ill-prepared for the Sixties. Dave Sim once observed that from 1956 until about 1968, "if Julie Schwartz didn't like you or didn't like the way you drew, the odds were that you weren't going to get work. Because he controlled the only books that were even remotely, possibly interested in getting new talent."

DC's interest was pretty remote. They had Batman, Superman, and the other characters; they had no use for the likes of Jack Cole and the refugees from EC, much less young, fresh talent like Jim Shooter.

When Shooter returned to DC in the early 1970s he said Carmine Infantino walked him down to Schwartz's office, introduced him and said, "I want him to write Superman."

Schwartz grunted, and Shooter got to work. But the editor and writer didn't mesh. "At first, I thought I was just bad, because he was sending things back to rewrite for crazy reasons," Shooter said. "And I'd never rewritten anything before in my life. Later, I found out he thought I was Carmine's boy, Carmine's buddy, and when Carmine rammed me down his throat, he did his best to get rid of me.

"I went through three drafts on this one story," Shooter recalled, "and each time I did what he told me to do, he would reject it.' Frustrated, Shooter wrote a letter to Infantino, laying out his grievances, and concluding the letter by saying, "What do I expect you to do? Nothing. I expect you to stand by your editor. But I want you to know what happened."

The letter, Shooter said, was intercepted by Schwartz. "I got a note in the mail from him. It said, 'Dear fellow JS: You'll never work in this business again.'

"Of course, now Julie and I are big buddies."

Schwartz knew what sold—gorillas, jails, and fires, all of which broke out like hives on DC's covers in the Fifties—and he knew how to solve the puzzle posed by the typical comics

Pick a finger, boys and girls, pick a finger.

(© DC Comics, Inc.)

When Schwartz was presented an Inkpot Award by Ray Bradbury (left) at the 1981 San Diego Comic-Con, not only did Sergio Aragonés (background) add Julie to his caricature collection, but Harlan Ellison (with mike) made a surprise appearance to present the editor with a long-promised Superman script.

Austin Briggs, who also ghosted on the *Flash Gordon* strip for Alex Raymond, was a memorable and innovative artist on *Secret Agent X-9*.
(© King Features Syndicate)

scripts of the decade. He had a rare tolerance for Weisinger and a nice touch in reviving super-heroes that had been left for dead. But he was no match for the creative forces that allowed Marvel to overtake DC, once and for all, when dusk fell on the Silver Age.

Secret Agent X-9

Hatched in 1934 to sop up some of the success of *Dick Tracy*, *Secret Agent X-9* (which was rechristened *Secret Agent Corrigan* in the late 1960s) began in the most capable hands. In its first year, the comic strip was written by Dashiell Hammett and drawn by Alex Raymond.

The marriage didn't last; Hammett and Raymond were both gone within 18 months. But X-9—who shared many of the charms of two other Hammett creations, Sam Spade and the Continental Op—survived. He has been captured in various disguises over the years by such artists as Charles Flanders, Austin Briggs, Mel Graff, Bob Lubbers, Al Williamson, and, for the last decade, George Evans.

Early on, X-9's employer was a mystery, but in the late 1930s, Ron Goulart notes, "The strip finally came out and admitted that X-9 was with the FBI. His chief became a dead ringer for J. Edgar Hoover." And you thought comic strips about corruption, gambling, and closet homosexuals didn't exist in the good old days.

Seduction of the Innocent

I reply proudly that I have read and analyzed thousands of comic books—a horrible task and really a labor of love.
FREDRIC WERTHAM

Seduction of the Innocent is one of the most important books about comics in their history . . . because it inadvertently saved the comics from themselves.

Fredric Wertham's opus, published in 1954, is a mess. So obsessed is the psychiatrist in his 397-page (Wertham's publisher, Rinehart & Co., stripped an additional two-page bibliography of comic book publishers from most copies of the book) tirade against "crime comics" that he slices and dices both the good—purposely misreading the irony in numerous EC *Shock SuspenStories*—and the bad. Comic books, Wertham argues, are the bogeymen hiding under the bed that drag innocent little kids into lives of murder and mayhem.

His arguments are often asinine, his abuse of the critical method absurd. "A 14-year-old boy was found hanging from a clothesline fastened over a hot-water heating pipe on the ceiling. Beside him was a comic book open to a page showing the hanging of a man." Well, I guess that explains it.

If Wertham's intention was to kill the industry, he failed miserably; instead, *Seduction of the Innocent*—and the Comics Code that it helped inspire—was the catalyst for a breathtaking transformation. The industry that went into hibernation in the mid-1950s *was* overdosing on violence, sex, and cheap thrills; the creature that emerged took one or two tentative

steps, then tumbled into the Silver Age. EC was gone, but Stan Lee and Jack Kirby were about to happen.

Wertham's sins, in keeping with the spirit of his work, have been greatly exaggerated; he's on target with his critique of comic book advertising and racial caricatures. He is more Sancho Panza than Don Quixote, but *Seduction of the Innocent* isn't all tilted buffoonery. Those who consider Wertham the cause of a half-century of public relations problems are usually those who only know the man in paraphrase.

Let the good doctor—at both his best and worst—speak for himself:

Worst Overstatement: "All child drug addicts and all children drawn into the narcotics traffic as messengers, with whom we have had contact, were inveterate comic book readers."

Best Overstatement: "The atmosphere of crime comic books is unparalleled in the history of children's literature of any time or any nation. It is a distillation of viciousness . . . Hostility and hate set the pace of almost every story."

Worst Leap of Logic: "There are quite a number of obscure stores where children congregate, often in back rooms, to read and buy secondhand comic books. The proprietors usually permit the children to spend a lot of time in their establishments and to pore over the comic books. In some parts of cities, men hang around these stores, which sometimes are foci of childhood prostitution. Evidently comic books prepare the little girls well."

Worst Example of Cause-and-Effect: "A boy of thirteen committed a 'lust murder' of a girl of six. After his arrest, in jail, he asked for comic books. 'I refused, of course,' said the sheriff."

Best Premonition of the Horrors to Come: "My studies of the effect of television on children grew out of the comic-book studies naturally—I might say inevitably. More and more children told me that they did not read so many comics because they were looking at television. A few children gave up comic books for television. Many combined both."

Worst Forecast: "I have never come across any adult nor adolescent who had outgrown comic-book reading who would ever dream of keeping any of these 'books' for any sentimental or other reason."

Segar, E. C.

He was the choreographer, drama coach, and creative director of *Thimble Theatre*, which debuted on December 19, 1919. Before setting foot on that comic strip stage, Elzie Crisler Segar drew *Charlie Chaplin* (with a voice, yet) and *Barry the Boob*. *Thimble Theatre*—which advertised "Humor—Drama—Asbestos—Pathos—Action" in one promotional piece—had been open for more than nine years before Popeye the Sailor arrived in 1929.

Segar died of leukemia in 1938, at the age of 44. Jules Feiffer has reported that on his deathbed, Segar signed a contract revision that denied his family any future benefits from Popeye.

Sekowsky, Mike

This journeyman's journey began at Timely in 1944 and included stops at Hillman, Fiction House, Lev Gleason, Sterling, Western, and DC before his death in 1989. Sekowsky may be best remembered for penciling Justice League of America in their extensive run in *The Brave and the Bold* in the 1960s.

"Sekowsky wasn't as polished as Murphy Anderson and some others," Gardner Fox once said, "but he knew how to tell a story. A lot of today's artists can't."

Sendak, Maurice

According to Jerry Bails's *Who's Who of American Comic Books*, Sendak, most famous for *Where the Wild Things Are*, worked on DC's *Mutt and Jeff* in the 1940s.

Seuling, Phil

He invented it. Clean, blank slate of paper. No one else had a clue. Apple fell on his head, and he made it happen.
PAUL LEVITZ

The "he" is Phil Seuling, the "it" is direct distribution and the invention remains the single most important event in comic book history since Fredric Wertham met Phantom Lady.

Why Seuling? Why did the apple choose his head? "He dreamed a lot," Levitz said.

"The heart of understanding Phil as an individual is to understand Phil was an English teacher, a writer, a communicator, someone who loved words and ideas, and who loved them in comics.

Portrait of E. C. Segar by Stan Drake.

Joe Simon provided a cover for the 1974 "Seuling Con."

"You may or may not have known people like that in your life, who have a sheepdog-like quality of wanting to bound in your lap and say, 'Look at this goddamn great bone I found in the backyard. Do you want to give it a chew?'"
PAUL LEVITZ

"He was the kind of person that if someone gave him pleasure, he desperately, urgently wanted to share it with other people to whom it would give pleasure, whether that was food, a comic book, the work of an artist, a conversation with an interesting person. You may or may not have known people like that in your life, who have a sheepdog-like quality of wanting to bound in your lap and say, 'Look at this goddamn great bone I found in the backyard. Do you want to give it a chew?'"

The last stop on the tour was Seuling's annual July 4th con. Dick Swan remembers paying the outrageous price of $100 for two tables at the show and leaving four days later with $4,000 in his pocket.

Because Seuling seemed to know everyone, and because he was the hub of the comic book culture in New York, he was the catalyst for many of the early comic book conventions.

"He didn't invent the comic book convention, but he refined it," said Michelle Nolan, who had been Seuling's primary assistant at the 1969 New York con. "Seuling had the contacts, he had the energy, he had the vision, he had the history of the hobby, and he had the books. He

The Seventies

A lot of us who got into comics in the late '60s and early '70s, we really thought we were going to be the last guys to do comics. There wasn't much money to be made. There were no royalties, no fancy format editions. Sales had been dropping for months, and that was on everyone's mind. The general feeling was that given ten years, everything would atrophy to nothing. Wolfman, Wein, Starlin, Wrightson, Kaluta, Chaykin... That's why we got into comics. We thought within a few years, we'd all be doing something else. Imagine our surprise...
WALT SIMONSON

was a living dynamo. He was also an extremely opinionated, extremely bombastic, extremely egotistical person, in a constructive way. He put out a price list that would sometimes have a drawing of him beneath the title 'Comic Book King.' It was kidding on the square. Seuling *was* Mr. Comic Book in New York City."

"Phil envisioned two things from which much of the shape of the business today flows," Levitz said. "The comic convention before Phil came to it was a bunch of people getting together in a room they had rented because it was too big to have at somebody's house.

"Phil saw this infrastructure: He had the idea of panels, the idea of programming. When Kirby had disappeared from view, he talked Jack into coming back to New York for a comic convention as a 'guest of honor.' That had never been done in that fashion. He found Hal Foster and Will Eisner, who were unconnected to the mainstream of comic stuff, and pulled them back in. He got the publishers involved; he was the first person to reach out and say, 'You know, you ought to have a booth at a comic convention.' That was an extraordinarily radical concept 25 years ago."

Of course, Levitz added, we're dealing with secondary historical notes here. Seuling's pièce de résistance was another brainstorm: direct distribution (see entry).

That was in 1974. Ten years later, Seuling died of liver disease at the age of 50. "He fell on hard times," said Nolan, who met Seuling at a time when Nolan was just beginning to ask the questions that would eventually lead to a sex-change operation. "He became rather bitter in some ways. Phil changed. I don't know why. I was changing, too."

Seven Sons

The first comic-book store in the San Francisco Bay Area, Seven Sons opened on April Fool's Day in 1968, next door to Navelet's Flower shop on San Fernando Street in San Jose.

Gary Arlington's shop at Mission and 23rd in San Francisco had opened at least 18 months earlier, but, unlike Seven Sons, it didn't deal exclusively in comic books.

The Seven Sons were Bud Plant, John Barrett, Jim Buser, Al Castle, Mike Nolan, Tom Tallman, and Frank Scadina. Nolan signed the

business license, presumably because he was 20 and the only one old enough.

The shop was small ("I could stretch out my arms and touch both walls," Barrett said). The proprietors dealt a lot more cards than comic books. "We'd sit around upstairs playing black-jack and poker," Jim Buser said. "Occasionally, someone would wander in and toss some money up and we'd throw the change down."

The seven friends opened Seven Sons to sell their surplus books and cherrypick the collections that came in the door. After six months, all the partners sold out to Scadina, who promptly changed the name of the store to Marvel Galaxy.

In the summer of 1969, Barrett and Plant hit the Southwestern Con in Oklahoma and returned with enough comic books to open a second store, Comic World.

And that was just the beginning. In 1972, Barrett and Plant opened Comics and Comix in Berkeley, the first chain of comic book stores. They were on Phil Seuling's heels when he pioneered the direct-sales market in 1974, eventually settling for exclusive rights to distribution in the Bay Area.

Severin, John

Just before Charlie Stern (the unknown soldier who shared a studio with Harvey Kurtzman and Will Elder) left New York to study art in France, John Severin saw Kurtzman scribbling in a corner and asked Stern what Harvey was doing.

"Drawing comics," Stern replied.

"I said, 'Hey, that's great. How much do you get paid for doing a page of that?'" Severin later told John Benson. "And he told me. I said, 'Charlie, forget this business. How do you get into this comic book stuff?'"

Severin was fresh out of the Army and determined not to go back. He'd bought one comic book in his entire life. But in November 1947, several months after he saw Kurtzman scratching away, Severin had his first assignment, a job order from Joe Simon and Jack Kirby. Elder inked the page and the pair were off and running.

"We both supplied what the other guy needed," Severin said. "He couldn't draw and I couldn't ink."

Yes, Harvey Kurtzman would love to elaborate: "There were two elemental differences between John's and Willie's inking: accuracy of detail, which John runs circles around Willie with; and graphic clarity, which Willie runs circles around John with. Willie understands priorities in graphics. He knows when a drawing should be light, and when it should be dark, and he knows how to make it light and dark. John gets confused; he stumbles all over."

Severin maintained his balance often enough, as he proved with *Two-Fisted Tales*, *Cracked*, the American Eagle stories in *Prize Comics Western*, and at Warren. An interviewer once asked Severin who he thought had the most outstanding technique in the field, and Severin's answer was brief and to the point: "Me."

He didn't want to waste that technique in EC's horror books. "I didn't want to do those

John Severin's draftsmanship and storytelling ability are evident in this shoot-out from *Two-Fisted Tales* #39.

(©1998 William M. Gaines Agent, Inc.)

ghastly stories," Severin once said. "I told Gaines that, and somebody said to me in Gaines's presence, 'It's because you *can't* do them.' So, I went home, and I did a couple of drawings. I took a head and split it with an ax, and I had all the things dribbling out. And I had a guy drop an ax on his foot and cut it, through the shoe and all. I had all the bones and tendons exposed. Gaines said he threw up when he got the head in the mail. I said, 'It serves you right. You said I couldn't do it.' Hell, I got sick when I drew it. I just couldn't do that kind of stuff, with intestines running around the baseline and so forth. Boy, it chilled me."

Severin, Marie

The only self-censorship that we ever had [at EC] was Marie Severin.
BILL GAINES

Marie Severin didn't make an announcement when she decided Bill Gaines or Al Feldstein had gone too far; EC's colorist simply colored the panel dark blue.

"Feldstein has called her 'the conscience of EC,'" Frank Jacobs once wrote. "Nevertheless, it was Marie who stretched out Gaines on a stockroom table and created his death mask out of plaster of Paris. Her dream was to see the office walls lined with the masks of the horror comics crew."

Severin, the sister of artist John Severin, worked at EC, Atlas, and Marvel, and as a commercial artist, for more than a dozen years before Stan Lee gave her her first drawing assignment.

Color was always her first love. "I remember when I was a kid, comics were out and I bought them," Severin said, "but I wasn't that interested. I was interested in a thousand other things. I wanted to do stained glass windows but there was no market for them. I loved the light and color.

"In the '40s, the guys who couldn't get into the *Saturday Evening Post* went into the comics." Severin's heroes weren't comic book artists. "When I think back to graphic arts, I thought of Howard Pyle and Andrew Wyeth, who illustrated the fairy tales I loved growing up."

Severin, who worked on several humor titles at Marvel, including *Not Brand Echh!* quit romanticizing the comics long ago. "When you think about the two guys who created Superman, there's nothing romantic about that," she said in 1992. "It was a cold-hearted business. It killed those guys. There was much more heart in Bill Gaines. I still get royalty checks from Bill Gaines."

Gaines treated Severin well at EC, but neither of them lost sight of the fact that she was a girl in the boys' club.

"Had I been a guy with my talent, I would have been privy to a hell of a lot," Severin said. "But because I was a girl, I wasn't interested. I didn't want that much stuff. It was a masculine world. Comics are for boys. I can do just as well as they do, [but] I'm not as interested in trashing through and kicking butt.

"I made out okay without feeling I was intruding. I was a woman in the industry, so I wasn't privy to all the fun these guys had. I didn't want to make a million dollars. I didn't have the ambition the guys did. I didn't have to provide the home. I'm a woman of the '40s and '50s. I didn't expect to be the boss."

Sgt. Rock

I know Rock, because Rock is me.
BOB KANIGHER

Bob Kanigher's alter-ego—invariably drawn by Joe Kubert over the years—first appeared in *Our Army at War* #81. "Unlike all my other characters, which sprang full-blown, as from Zeus," Zeus (dressed up like Kanigher) once said, "Rock came to full term in his own good time . . .

"In the beginning he was 'The Rock,' an ex-sports star, the man they couldn't budge. He carried that reputation with him into combat. ["Combat Anchor Man," *All-American Men of War* #28, December 1955].

"In 'Fireworks Hill' [*G.I. Combat* #45, February 1957] he was an ex-sports reporter who stood like a rock against the human wave of NK [North Korean] vets.

"He was just a nameless marine on a cover, wounded, choosing to remain behind, TG [tommy gun] in his hands, his back against a tree to cover his buddies' retreat, to his own death [*All-American Men of War* #49, September 1957].

"He was a marine drill instructor in 'The DI—and the Sand Fleas' [*G.I. Combat* #56, January 1958] who inspired the boots he

Marie Severin

trained, even though he never reached the front, except in the minds of his trainees.

"Next, he was an ex-heavyweight contender who listened to his manager when he was knocked down, to take the count of nine; he got up too late, lost, and vowed he would never stay down again. When he was dazed by an exploding shell, he thought an enemy tank was the Champ and that he was back in the ring. He fought the tank to the death ['The Rock,' G.I. Combat #68, January 1959]."

Any last words, Bob? "I created and wrote and edited Rock from the beginning," Kanigher said. "Alone. Without assistants or co-editors."

And, presumably, without Bob Haney, who wrote the first Rock story—"The Rock of Easy Company"—in *Our Army at War* #81.

"To understand the Rock genesis, let me explain what writing for Kanigher was like," Haney said in a letter to Robin Snyder's *The Comics*. "I'd come up with a hook or story line as I did for the first Rock strip, he'd make some minor input, I'd write it, Kanigher would edit it. That editing was, in the main, a travesty. In about the time of the average Mike Tyson fight he'd slash out every panel and rewrite them pretty much as already written. Even after I learned to simply mimic his own slapdash impressionistic style, this 'slash and burn' editing continued. Reason: Kanigher was in intense competition professionally, personally, psychologically with any writer. I soon learned not to object to his kind of 'editing'—when dealing with deficient egos, there can be no teamwork or true collaboration."

The Shadow

Two years after buying the comic book rights—and forty-three years after the character first came lurking over CBS Radio—DC revived *The Shadow* in 1973. The 12-issue series featured the art of Michael Kaluta, the publisher's *fourth* choice, after Bernie Wrightson, Jim Steranko and Alex Toth all bowed out.

Faced with a character that was once brought to life by the voice of Orson Welles, that had been a mainstay of the pulps, and that headlined a Street & Smith comic for 101 issues in the 1940s, Kaluta held his own, providing eight covers and six issues of interior art. Twenty years later, Kaluta returned to *The Shadow* as a comic book when Dark Horse obtained the rights from Marvel, which had published a Kaluta Shadow graphic novel in 1988. Handling mostly plotting and writing chores (and some covers), Kaluta turned the art over to Gary Gianni.

Shaw!, Scott

A lot of cartoonists are known for their mounds of shit.

But the most famous mound in fandom history took the stage at the 1972 World Science Fiction Convention in Los Angeles and featured Scott Shaw! as its liquid center.

In the early '70s, comic book dealers weren't particularly welcome at sf conventions. ("We almost had to sneak in because they thought we were selling an inferior product," John Barrett said. "There was running animosity.") And comic book fans like Shaw! weren't particularly starstruck by the con's elaborate costume contests.

"I wasn't a dyed-in-the-wool science fiction fan," Shaw said, "and I was astounded at the amount of work that went into the costumes. They were so ornate, so opulent. People put a year's worth of work into them."

So? So, Shaw! and Terry Stroud, of the American Comic Book Company, were sitting

Scott Shaw!

Michael Kaluta drew most of the covers for DC's short-lived *Shadow* series of the early 1970s. DC revived the character in the 1980s, with modern takes by Howard Chaykin and the team of Andy Helfer and Kyle Baker.
(© DC Comics, Inc.)

around when Shaw! said, "Wouldn't it be funny if someone entered with a costume that literally looked like it had been put together in five minutes?"

The peanut butter was Stroud's idea. Shaw! marched down to a discount grocery store and bought three 6-pound tubs of the chunky spread, some canned corn, a plumber's helper, and a pair of pantyhose, then carted it all back to Stroud's room at the L.A. International Hotel. After turning the pantyhose into a mesh mask, Shaw! stripped down to his shorts and slathered 18 pounds of peanut butter onto his frame. Stroud, decked in a three-piece suit, then escorted him down to the ballroom and introduced him as hailing from "the bowels of Uranus."

Had there been any comic fans in the audience, they might have recognized the Turd, a comic character Shaw! had created in the underground *Gory Stories Quarterly* in 1969—his tribute to all those gooey, fecal, repellent creeps like The Heap and Swamp Thing.

But the science fiction fans? They couldn't even figure out the canned corn. No one laughed when the Turd said, "I stink, therefore I am."

"No one got the gag," Shaw! said. "Especially when the stuff started rubbing off on everyone. Other costumes. The carpet. The phony velour wallpaper."

Owing to Shaw!'s body heat, the peanut butter began melting fairly quickly. "One guy followed me around asking if I needed any help cleaning it up," Shaw! said. "I think he was enchanted with me." Shaw! needed an entire bottle of Johnson's Baby Shampoo to clean the goo from his hair, and after seven or eight showers, peanut butter was still bubbling out of his skin.

"Two weeks later," Shaw! noted, "the pipes exploded all over the hotel. I guess the peanut butter packed in and . . ."

In his lengthy career in comics and television animation, Shaw! has co-created Captain Carrot and his Amazing Zoo Crew for DC, directed and produced the Flintstone commercials for Post Pebbles cereal, and entertained the late-night audience at San Diego's Comic-Con International with his oddball comics slide show (which has been published in abbreviated form as trading cards from Kitchen Sink).

On more than one occasion, he left Jack Kirby speechless . . . such as the time he did a poster-sized tribute to one of Kirby's prehero Marvel covers in which a bulldog humanoid is growling, "No human can beat me." Shaw!'s poster added a huge phallus and changed the wording to, "No human can beat me off."

"I gave one to Jack," Shaw! said. "I thought he'd like it. 'I can't take this,' he said. 'Why not, Jack? It's in honor of you!' And he said, 'I have a family. Where would I hang it?'"

But no stunt has ever quite matched the 1972 appearance of the Turd. "Most people have forgotten it was me," Shaw! said. "I can stand at the edge of a group of fans and when the subject comes up, I can laugh and say, 'Yeah, what an asshole!'"

Sheena

Conceived by Jerry Iger for a British newspaper strip, Sheena first appeared in *Jumbo Comics* #1, drawn by Mort Meskin. Iger gave the woman her name. "For some reason," Iger once said, "my mind wandered to early days in New York, when Jewish people were sometimes called 'Sheenies' as an insult, and I piped up, 'Why don't we call her Sheena?'"

Iger's Sheena was apparently inspired by Cynthia Evans, but we can trace her ancestors back to H. Rider Haggard's *She,* Edgar Rice

Shaw! got back into costume as a member of the "All-Human Orchestra," which entertained at many a San Diego Comic-Con masquerade in the 1970s and early '80s.

Sheena, a product of the Eisner-Iger studio, was queen of *Jumbo Comics.* This cover is by Dan Zolnerowich.
(© Fiction House)

Burroughs's La, *Trader Horn's* Nina ("White Goddess of the Pagan Tribes, the Cruelest Woman in All Africa"), and Dorothy Lamour's *The Jungle Princess*.

On the 1955 syndicated television show, Sheena was played by Irish McCalla.

Shock SuspenStories

If our only criteria were sheer impact and nerve, we'd name this the best of the EC comics.

No other EC book so consistently tackled social issues in the 1950s; no comic book has handled them so persuasively and powerfully since. *Shock SuspenStories* grappled with racism in "The Guilty" (#3) and "In Gratitude" (#11); anti-Semitism in "Hate" (#5); the Ku Klux Klan in "Under Cover" (#6); rape in "A Kind of Justice" (#16); and mob violence on a half-dozen occasions.

The stories invariably had a nicer touch than the editors' closing comments. After the KKK murders a woman, then guns down the reporter who witnessed the slaying in "Under Cover," the readers are reminded these men are safe:

"Yes . . . Safe! Safe behind their masks of prejudice, these hooded peddlers of racial, religious, and political hatred operate today! Mind you, they are shrewd and ruthless men such as those in our story! How long can we stay 'cool' and indifferent to our democratic way of life?"

Although EC's horror stories are best known for their shock endings, several of the finest final twists occur in *Shock*. The best occur in "Confession" (#4), after a police lieutenant beats a confession out of a suspected hit-and-run driver; "My Brother's Keeper" (#16); the gut-wrenching baby thefts in "The Kidnapper" (#12); and the stunning climax of Ray Bradbury's "The October Game" (#9).

The best story in the run? "A Kind of Justice," written by Carl Wessler and penciled by Reed Crandall (#16).

Jack Kamen was the only artist to appear in all 18 issues of *Shock SuspenStories;* 15 times he had the lead-off spot. Wally Wood had 14 stories (and six covers), followed by Joe Orlando (11), Crandall (9), George Evans (7), Jack Davis (5), Graham Ingels (3), Bernie Krigstein (2), and Frank Frazetta, Al Williamson, and Johnny Craig with one each.

Shooter, Jim

Everybody's got Jim Shooter horror stories. I'm not the only one.
BILL MANTLO

And most of the stories are damn entertaining. Let's step into Professor Peabody's Way-Back machine and go back, back before all the Machiavellian machinations, before Defiant and Valiant, back to when Jim Shooter

Shock SuspenStories went for the jugular on social issues, as in the racially charged "Blood Brother," drawn by Wally Wood.

(©1998 William M. Gaines, Agent, Inc.)

Jim Shooter, as editor-in-chief of Marvel Comics

was a 12-year-old kid reading comic books in a Pittsburgh hospital bed.

Shooter was chained to that bed for what seemed like forever; he read quite a few comics. "Marvels and DCs," Shooter said. "I hadn't read comics for years. The DCs were about the same as when I'd left them, and there were these newfangled Marvel comics that were so much better. I was stunned at the difference. Here's Superman doing the same things he was doing back in 1957, and here are these new Marvel comics, which were so good…"

He studied the difference for a year, working out the Marvel magic. "My family, we needed money," Shooter said. "When you're 12 or 13 years old, what are you going to do? Deliver papers? You can't get a job in a steel mill. You can't do anything serious. The only thing I could do, I decided, was to make something and sell it. And I thought, I'll make these. After studying them for a year, I wrote a script for DC trying to use what I'd learned from reading Stan's stuff."

The script starred Superboy and the Legion of Super-Heroes "I knew DC was asleep at the switch. That's why I sent the script to them," Shooter said. "I knew I couldn't write as well as Stan, but I knew I could compete with the guys at DC, especially if I tried to do the stuff I saw Marvel doing. That's how my stuff was, more personality-oriented. But I was smart enough not to be too evolutionary. I knew they wouldn't buy that. I knew that if I changed all the Legionnaires' names or changed their clubhouse in the first issue, they wouldn't buy that. I had to play within their rules."

Shooter was 13 years old. What caught Mort Weisinger's eye on that first story were the layouts Shooter provided for each panel. They betrayed a sense of design many of Weisinger's writers didn't have. He asked Shooter for another story. After reading the subsequent 46-pager, Weisinger cut Shooter a check for $200.

"That first check for $200, that saved my family's house," Shooter said. "We were desperate. My mother is a religious lady and to this day, she refers to it as her miracle.

"I lived in Pittsburgh and worked through the mail," Shooter said. "Mort would call me every Thursday night, right after the *Batman* TV show. He'd go over whatever I sent him that week, panel by panel, word by word. It was a great education. He was a superb editor, a great technical guy, who knew the structure and the mechanics. But he was tough. At the end of every one of those phone calls, I'd be apologizing and offering not to work anymore. Mort was always going, 'You moron, how can you do this? Why can't you write like you used to?' He was saying this to a 14-year-old. I was 14 and a big important man in New York was telling me I was a moron. I believed him. It got to the point where if I heard the phone ring at school, I'd jump. I just knew he'd found me and was going to yell at me."

When Shooter was 14, and Weisinger finally realized he wasn't cutting checks to a college

SECRET WARS

Jim Shooter, John Byrne explained, "was fine at the start. One of the first conversations I had with him, he said, 'The first rule to remember is there are no rules.' One of the last conversations I had with him, he was telling me what all the rules were. That was a gap of about seven years.

"I've always blamed *Secret Wars*. Shooter used to say that Marvel—and for 'Marvel' read 'Jim Shooter'—would rather publish a great book that didn't sell than a piece of crap that sold through the roof. He always cited Roger Stern's *Dr. Strange* as a great book that didn't sell.

"Then they did *Secret Wars*. Which, in the opinion of most people is the biggest piece of crap Marvel ever produced. And it sold through the roof. Better than anything up to that point. Shooter had to justify it in his mind. He had to convince himself it hadn't sold just because it had every super-hero in the world in it. It sold because it was brilliant. From the point of *Secret Wars* on, we would get notes on our make-readies. He would read the make-readies and grade them. It was wonderful being in school again. 'C-minus. See me.' And he would add notes that said, 'See *Secret Wars* whatever for how to do this right.

"I don't think so. I don't think I'd see *Secret Wars* for how to do anything but possibly fold it."

kid, Jim took his first trip to New York to meet his editor. "My mother had to come up with me because I couldn't travel alone," Shooter said. "He came to my hotel room. When I opened the door, he was very pleased to see I was taller than he was and I had on a little sport coat and a tie. He was afraid I was going to be some freckle-faced kid with a Charlie Brown T-shirt."

After four-plus years at DC, Shooter wearied of Weisinger's abuse and decided to lobby Marvel for a job. "I got on a plane and flew to New York. In those days, it cost $12.50. I took the bus in; in those days, it was 55 cents. Now, I'm in Manhattan and I call for an appointment. Miraculously—you can't get Stan Lee on the phone—I asked to speak to Stan and the receptionist said, 'Okay.'

"Then this voice said, 'Hello, Stan Lee.'

"Hello, I'm a writer for DC and I'd really like to work for Marvel. Marvel is where I've always wanted to be," Shooter said.

"We don't need any writers," Lee replied.

"Could I at least show you my stuff?"

"Look," Lee said, "we don't like DC comics. They're terrible. If you're a DC writer, you can't write for us."

"Just look at the stuff," Shooter said. "My influence is all Marvel. At DC, they make fun of me. They say I'm their Marvel writer and it's an insult."

"All right," Lee said, "I'll give you 15 minutes. Come up at one."

Shooter arrived on time and spent the entire afternoon in Lee's office. "After they led me into this little office, Stan closed the door and started giving me this little lecture about why DC comics suck.

"I said, 'Oh, yeah? Well, this is why they suck worse than you think they do.' I started telling him my theory of comics, and what I thought he did and why I thought it worked. Before too long, he was into it. He was doing all the Stan Lee stuff. Jumping up onto his coffeetable and sword fighting with the yardstick."

Lee hired Shooter for $125 per week, and Shooter spent the next three weeks realizing just how little money that was to survive on in New York. "My first day at Marvel, I got this phone call from Mort, screaming, hateful, 'How dare you, I raised you from a pup, I taught you all you know, and now you stabbed me in the back, you weasel.' I'm thinking, 'Wait a minute, this is the same guy who used to call me every Thursday night and say, 'You're my charity case. I'm only buying stories from you because I know your family would starve to death if I didn't.'"

That, of course, was not the last time Shooter heard screaming over the telephone. After taking a lengthy sabbatical from comics, he returned to Marvel as an associate editor in 1976. Two years later he was editor-in-chief, a post he held for ten years. Under Shooter Marvel was on a roll, its success peaking with Marvel Super-Heroes *Secret Wars* (1984). Shooter bailed out long before the Marvel blimp burst into flames, first to help found Valiant Comics (from which he was ousted in a power struggle), then to found Defiant (which crashed and burned), and finally to create the short-lived Broadway Comics in 1996.

Showcase

Showcase was one of the premier DC titles in the Silver Age, kicking things off with the first appearance of the Silver Age Flash in *Showcase* #4 (September/October 1956).

"I can tell you quickly that *Showcase* was my bright idea, in conjunction with Whit Ellsworth," Jack Schiff noted in Robin Snyder's *The Comics*. "I was talking about trying out new features and we both hit on the idea of having a showcase to display them in."

Receiving fabulous display in the book were the debuts of Challengers of the Unknown (#6), Space Ranger (#15), Adam Strange (#17), Rip Hunter (#20), the Silver Age Green Lantern (#22), Sea Devils (#27), the Silver Age Atom (#34), Metal Men (#37), the Silver Age Spectre (#60), the Inferior Five (#62), the Creeper (#73), Anthro (#74), Hawk and Dove (#75), Bat Lash (#76), and Angel and the Ape (#77).

Sickles, Noel

A studio-mate of and major influence on Milton Caniff, Noel Sickles is best known for his brief tour on the *Scorchy Smith* strip in

Jack Kirby's Challengers of the Unknown was one of many concepts to get its first tryout in *Showcase*.
(© DC Comics, Inc.)

> "Everything—lettering, panel layout, motion-picture camera techniques, the design of blacks, locale, characters, the whole business, all Sickles inspired and based."
> — ALEX TOTH

Joe Shuster

the mid-1930s. After several months of ghosting for John Terry, Sickles took command of the strip when Terry died of tuberculosis in 1934. He spent less than three years on it before abruptly quitting, disgusted that the Associated Press syndicate would not reward him for the strip's tremendous boost in circulation.

"When I was in high school," Alex Toth told *Graphic Story Magazine*, "Caniff was *it*, and it was only by accident that I discovered Sickles by way of *Famous Funnies* reprints of *Scorchy Smith*; but due to the reduction, I couldn't make out the signature in the panels. Later on, when I saw his illustrations in *Life*, It seemed to suggest the work I'd seen years before, and I recognized it as Noel Sickles.

"He initiated the modern adventure strip's camera technique. His renditions of scenes, his knowledge of composition, light and dark, perspective, continuity, action, combined with a loose impressionism, made me see that this was the man to study. Caniff had adopted the surface of Sickles's techniques to his own uses. When they talk about the 'Caniff style,' what do they really mean? . . . Everything—lettering, panel layout, motion-picture camera techniques, the design of blacks, locale, characters, the whole business, all Sickles inspired and based."

In a 1986 interview with Arn Saba, Caniff said the evolution of his style in his first year on *Terry and the Pirates* was "Sickles's doing. It was Sickles who said there wasn't enough drama in it. He was doing all that in *Scorchy*, and we were doing the strips facing each other. He said, 'Why don't you use more black, and jazz it up?' So I started rather gingerly at first, coming down heavily on the blacks. There was more drama in the night scenes, and that's when you notice it.

"In a very real sense, it was Sickles's style, because he was the one experimenting with it in *Scorchy*, which he didn't give a damn about, really. But it was a great canvas to noodle and doodle around with. He was developing this stuff day by day."

Siegel and Shuster

They were so raw. Everything was in those days, in the heart of the Depression, but Jerry Siegel and Joe Shuster were more raw than most. They were lightweights, geeks, science fiction fans. And they were stuck in Cleveland. When they dreamed of escape, they dreamed of losing their vast virginity at a newspaper. Before they ever met, Siegel had written a one-act play called *The Fighting Journalist*, and Shuster had drawn a comic strip called *Jerry the Journalist*.

They met at Glenville High School in 1931. Shuster's father was a tailor; Siegel's parents managed a men's clothing store. Siegel was only 14 when he cranked out his first science fiction fanzine, and once he hooked up with Shuster, he only picked up speed. They were both *Little Nemo* fans and they could spin comic strips in their sleep. Their first strip together was *Interplanetary Police*. It didn't sell. Neither did *Steve Walsh* or *Snoopy and Smiley*.

Not knowing what was possible, Siegel and Shuster never got discouraged. They created Superman in 1933 and for five years it was just another brainstorm that didn't sell. Their first story, "The Reign of the Superman," appeared in the third issue of their fanzine, *Science Fiction*, and Superman was a villain. But they kept tinkering with the idea. Superman became a hero; then the comic book idea became a comic strip concept.

By the late 1930s, Siegel and Shuster were selling some of their ideas—Federal Men, Slam Bradley, Radio Squad—to Major Malcolm Wheeler-Nicholson, but they weren't getting rich. Shuster once recalled that when they submitted Henry Duval and Dr. Occult to the Major, "one was done on brown paper, and one on the back of wallpaper. When it was sold, they told us to redraw it and we went out and bought good paper."

In 1938 Harry Donenfeld made the good paper a little easier to afford. Looking for material for a new comic book called *Action*, Donenfeld called up Max Gaines and asked if he had anything lying around. Gaines scraped the mold off Siegel and Shuster's Superman strip and sent it along.

When the boys from Cleveland signed the standard release form, they received $130.

That wasn't their last paycheck, of course. Superman made too much money for DC to keep it all. In 1940 *The Saturday Evening Post* reported their annual earnings at $75,000. But there was a war on and nothing was ever quite the same after Siegel—unlike Superman, he wasn't classified 4-F—went off to fight in it.

While Siegel was gone, DC followed his

advice and got Superboy running not long before the end of the war. Because he never had the chance to sign the release form, Siegel sued for the rights. Siegel and Shuster eventually got $400,000, according to Neal Adams, but most of that settlement went to their attorneys. And because they had the audacity to quarrel with DC about their creation, Siegel and Shuster struggled for years to get even meager assignments in the industry.

"They settled out of court with Donenfeld for a sum much less than they would have received if they had continued working for the company," Joe Simon noted in *The Comic Book Artists*. "And the fight, of course, cost them their jobs . . .

"After the legal bout, Joe Shuster tried to earn a living elsewhere . . . Siegel, however, continued to harass his foe. He penned raging letters which were mailed to Donenfeld's competitors . . . One of these letters, allegedly written and signed by Siegel, proclaimed that at five o'clock on a stated day, he would dress in a Superman costume and leap to his death from the roof of the Grand Central Palace Building. And it was on that day that the crowd of illustrators and comic book employees congregated on New York's busy East Side, waiting to see if the dramatic suicide would actually be carried out.

"The heavy-set figure of Jerry Siegel never appeared."

And after a time, his voice, like Shuster's, was seldom heard. "For 15 years, they were silent for 15 years they did nothing," Adams told *The Comics Journal*. "Why? God only knows. Joe Shuster lived with his brother and went progressively blind. Jerry got jobs in various places to support himself, I assume in the belief that one day they would indeed have the rights to do Superman again."

While they waited, their lives fell apart. "They were absolutely destitute," said Jerry Robinson, who had known them both well at DC. "Joe was picked up by a policeman in Central Park one time. He looked hungry, like he needed some nourishment, so the cop took him to a luncheonette for coffee and a sandwich. To prove he'd created Superman, he drew a little picture of Superman at the luncheonette for a little kid who didn't want to believe him. And Jerry? Jerry worked as a postal employee. He had a mental block, he couldn't write. Can you imagine walking down the street and seeing Superman all over the place? He would get physically ill."

Siegel and Shuster lived private lives; it wasn't until the late 1970s that anyone discovered how bad off they were. Robinson was astounded when Jerry Siegel popped up on a talk show just before the release of the first *Superman* movie and described the creators' plight.

Adams and Robinson eventually led the fight to force Time Warner, which then owned the rights to Superman, to give Siegel and Shuster some compensation. "We tried to bring enough pressure just on humanitarian grounds to give these creators a lifelong annuity," Robinson said. "They made millionaires of dozens of people."

Adams and Robinson were sure they could convince the court that copyright laws prevented creators from signing away their lifetime rights in perpetuity, but they knew they (much less Siegel and Shuster) didn't have the money to battle Time Warner in court. They just prayed Time Warner didn't know that, or—with *Superman* set to debut in 1,000 movie theaters in 1978—couldn't take the risk.

The day before the final negotiations, Siegel ordered Robinson to accept a settlement. "He said he'd never survive another five years," Robinson said, but Robinson wanted one more thing from Time Warner: He wanted Siegel and

Jerry Siegel

Jerry and Joe with their creation in 1938, as drawn by Joe.
(© DC Comics, Inc.)

Guns and cupids—Sienkiewicz knows how to create a winning cover.
(TM & © 1998 Marvel Characters, Inc. All rights reserved.)

Shuster's names permanently restored to the strip.

At midnight, he called a Time Warner vice president and made his final pitch. We'll go on TV, we'll go to the newspapers, if we don't get this, Robinson said. Two hours later, the exec called back. Blinking. Siegel and Shuster finally had their pension.

Robinson hosted a party for Siegel and Shuster the following night. Eli Wallach and his wife were there, but everyone was waiting for Walter Cronkite to arrive. Cronkite and a camera crew, you see, had followed the case in its closing days. When the CBS news came on, everyone gathered around the TV set. "It was their closing piece," Robinson said. After reporting the settlement, CBS spun up some animation with Superman flying across the screen to the tune of "It's a bird, it's a plane . . ."

"And then Cronkite comes in," Robinson said, "and says, 'At last, truth, justice and the American way won out.' Something like that. We were all there drinking, and I'll tell you, we all had tears in our eyes.

"It was a very moving time, with Jerry and Joe there."

Joe Shuster died in 1992; Jerry Siegel, in 1996.

Sienkiewicz, Bill

Sienkiewicz was born in Pennsylvania in 1958 and first published at the age of 21. Asked to draw *Moon Knight* when he had no idea who the character was, Sienkiewicz dominated the book for its four-year run, then jumped to *New Mutants*. He shared a studio with Stan Drake and Leonard Starr in the mid-'80s while his style grew more cartoony and painterly, finally busting out in his collaboration with Frank Miller, *Elektra Assassin*. His style was full blown in his own 1986 miniseries, *Stray Toasters*. After influencing a number of younger artists, Sienkiewicz left comics for a while after the disaster of Alan Moore's *Big Numbers,* an ambitious series that saw only one Sienkiewicz-drawn issue. His best-selling Jimi Hendrix biographical novel *Voodoo Child* brought him back into the comics world in 1995. Since then his inking and illustrative work have graced many a project.

Silver Age

This era in comics history marked the major revival of comic books following the collapse of EC and the surrender to the Comics Code Authority. Although the first appearance of the Martian Manhunter in *Detective* #225 (November 1955) was an eye-popping prelude, the Silver Age officially began with *Showcase* #4 (September/October 1956). It ended with the final 12-cent issues of comics in 1969.

Silver Age Keys

On this subject, collectors have all gotten a little carried away.

"We have too many Silver Age keys," says Keith Contarino, who has added a few trinkets of his own to the Silver Age key chain. "People have gotten so into keys that now everything is a key [collectible issue]. You can't find an early

The Grail

DC changes personnel in the offices, people die, the freelancers come and go. Fortunes rise and fall, shares are transferred, the physical offices are moved, torn down, rearranged. Pages are kept. Pages are returned. And somewhere in the bowels of DC comics is the grail of the industry, the centerpiece of the real DC Universe. The contract signed by Jerry and Joe. It is the only constant. An unchanging asset. It has moved millions and millions of dollars through the economy of DC and each new generation of employees has suckled at its teat.

DAVE SIM

Spider-Man that's not a key anymore."

Amazing Spider-Man #2 is the first appearance of the Vulture, don't you know? No. 3 is the first appearance of Doc Ock, #4 the first appearance of the Sandman, #5 a Dr. Doom cover, #6 the first slink-on by the Lizard . . . you get the drift.

Where did this madness begin? If there has been any manipulation in the market by dealers over the years," Contarino said, "that's something we're guilty of doing. Collectors want every book to be something special."

And the dealers are there to help.

Where does this madness end? Read on.

Silver Age keys shall not include second, third, fourth, or 44th appearances; first appearances of clothing, sidearms or sidekicks; revisionist keys (that is, the first appearances of characters that didn't impress anyone for a good 10 years); or any appearances by such minor twerps as Cave Carson or Bizarro Mxyzptlk, which only became important when the major keys were priced through the roof.

Here are the consensus Silver Age keys:

Detective #225 (**November 1955**)—First Martian Manhunter
Showcase #4 (**October 1956**)—First Silver Age Flash
Showcase #6 (**February 1957**)—First Challengers of the Unknown
Adventure #247 (**April 1958**)—First appearance of Legion of Super-Heroes
Showcase #17 (**December 1958**)—First Adam Strange
Flash #105 (**March 1959**)—First Silver Age Flash in own magazine
Action #252 (**April 1959**)—First Supergirl
Our Army at War #81 (**April 1959**)—First Sgt. Rock
Adventure #260 (**May 1959**)—First Silver Age Aquaman
Showcase #22 (**October 1959**)—First Silver Age Green Lantern
Brave and the Bold #28 (**March 1960**)—First Justice League of America
Green Lantern #1 (**August 1960**)
Justice League of America #1 (**November 1960**)
Brave and the Bold #34 (**March 1961**)—First Silver Age Hawkman
Flash #123 (**September 1961**)—"Flash of Two Worlds" and introduction of Earth-2
Showcase #34 (**October 1961**)—First Silver Age Atom
Fantastic Four #1 (**November 1961**)
Tales to Astonish #27 (**January 1962**)—First Ant-Man
Incredible Hulk #1 (**May 1962**)
Fantastic Four #4 (**May 1962**)—First Silver Age appearance of Sub-Mariner
Fantastic Four #5 (**July 1962**)—First Doctor Doom
Amazing Fantasy #15 (**August 1962**)—First appearance of Spider-Man
Journey into Mystery #83 (**August 1962**)—First Thor
Amazing Spider-Man #1 (**March 1963**)
Tales of Suspense #39 (**March 1963**)—First Iron Man
My Greatest Adventure #80 (**June 1963**)—First Doom Patrol
Strange Tales #110 (**July 1963**)—First Dr. Strange
Avengers #1 (**September 1963**)
X-Men #1 (**September 1963**)
Avengers #4 (**March 1964**)—First Silver Age Captain America
Daredevil #1 (**April 1964**)
Amazing Spider-Man #14 (**July 1964**)—First Green Goblin
Fantastic Four #48 (**March 1966**)—First Silver Surfer
Lois Lane #70 (**November 1966**)—First Silver Age Catwoman

Silver Surfer

And somewhere in the deep vastness of outer space, an incredible figure hurtles thru the Cosmos! A being whom we shall call the Silver Surfer, for want of a better name!
FANTASTIC FOUR #48

"The kids in California were beginning to surf," Jack Kirby once explained. He never went down to the beach, he only read about these surfing safaris in the paper, but that was enough, enough to get his mind working.

Stan Lee and Kirby were in the middle of plotting the coming of Galactus; when Kirby returned with the first 20-page story, Lee was surprised to find (his words, now) "a silver-skinned, smooth-domed, sky-riding surfer atop a flying surfboard."

Who's this, he asked? And Kirby patiently explained his latest revelation, the herald to a god.

In his first appearance—*FF* #48 (March 1966)—the Silver Surfer was seen "disregarding

Jack Kirby created the original Silver Surfer (as a Fantastic Four villain), but Stan Lee put all those words in the character's mouth.

(TM & © 1998 Marvel Characters, Inc. All rights reserved.)

Silver Surfer Soliloquies

Silence him! I will hear no more!
MEPHISTO, SILVER SURFER #9

In all the galaxies—in all the endless reaches of space—I have found no planet more blessed than this ... No world more lavishly endowed with natural beauty ... with gentle climate ... with every ingredient to create a virtual living paradise. Possessed of rainfall in great abundance ... soil fertile enough to feed a galaxy! And a sun ... ever-warm ... ever constant ... ever symbolizing new life, new hope! It is as though the human race has been divinely favored over all who live! And yet—in their uncontrollable insanity—in their unforgivable blindness—they seek to destroy this shining jewel ... this softly spinning gem ... this tiny blessed sphere ... which men call Earth!
SILVER SURFER #1

As for me, let there be an end to vain self-pity! Though I am shunned by those who dwell below, still do they have need of my power! A power which must never be denied them ... Not so long as they are plagued by ... poverty and want ... the cancer of crime ... and the brutal scourge of tyranny!
SILVER SURFER #2

He was created to be my equal! But the very weakness that he mocked—the emotion he called pity—brought me victory ... and brought him death! I was strengthened by compassion for my fellow living beings! I would willingly have died to save mankind—but, having no compassion, the thought of death made him panic ... made him lose control ... weakened him enough to cause his downfall! How strange it is—that I have risked so much—to save those who hate me most!
SILVER SURFER #7

And I am the Silver Surfer! I cannot bow to evil! If death must be mine—then let it come! All life is fleeting! But a soul is more than mere life! The soul is forever! I would spend a million times a million eternities in limbo—than be bereft of my soul ... for the space of a heartbeat! Man is just flesh and blood—he lives and he dies! Only his soul endures!!
SILVER SURFER #9

Too long have I displayed restraint! Too long have I refused to flaunt my power! But now—my very soul is aflame with burning rage! In a world of madness—I tried to practice reason—but all I won was hatred, and everlasting strife! So I'll have done with reason, and with love, or mercy! To men they're only words—to be uttered and ignored! Since a fiendish fate has trapped me there with a hostile race in a nightmare world! I'll forget my heritage—blot out my space-born ethic— No longer will I resist their Earthly madness! No longer mine a lonely voice, pleading peace in a world of strife! From this time forth, the Silver Surfer will battle them on their own savage terms! Let mankind beware! From this time forth—the Surfer will be the deadliest one of all!
SILVER SURFER #18 (THE LAST ISSUE)

the humans with utter and complete disdain" as he signaled Galactus that he'd found him another world on which to feed.

When that disdain is replaced by delight, and the Silver Surfer decides to upset the dinner cart, Galactus exiles him to planet Earth. In his subsequent adventures, the herald wears the anguish of that exile from his native Zenn-La on his silver sleeve.

Lee never tried to hide his affection for the character, pumping him full of bloated nobility. When no earthly villain could pop that balloon, Lee summoned Mephisto. "Since the dawn of time," cooed the Lord of the Lower Depths in *Silver Surfer* #3, "seldom have I sensed such goodness of soul, such purity of spirit, as I sense within the Silver Surfer!" Lee pushed the Christ imagery to the limit in that issue, as Mephisto offers the Silver Surfer "treasure beyond calculation" in exchange for his soul.

Although Kirby handled the character in issues of the *Fantastic Four*, he penciled only the last of the 18 issues of the *Silver Surfer*, which debuted in August 1968; John Buscema handled the other 17. By that time, the character had grown a little stale; Spider-Man, the Human Torch, Shield, and the Inhumans were all dragged out in the final issues to keep him busy.

Sim, Dave

He's a very powerful artist but not a very pleasant dinner guest. I see in his work a self-centeredness I try to avoid in my experiences with Grendel. The self-centeredness is fairly genuine.
MATT WAGNER

Just how unpleasant? "Many of my friends earn their daily bread off of characters created by Jack Kirby and Steve Ditko," Dave Sim said at the first Pro/Con in 1993. "I like them as

people, but I know that professionally, they are enemies of everything I stand for and everything that I believe in, and most of my time that is not spent writing and drawing and promoting *Cerebus* is spent in fighting them and the system that they keep alive and reinforce by their participation in it."

Just how much time is that? Enough. Sim is "productive, continually productive," Wagner said. "That's what I mean about being a powerful artist. He's an artist more dedicated to art than to life."

Sim's dedication has been on full display since 1977 when, after the first issue of *Cerebus* was rejected by Mike Friedrich, Sim decided to self-publish.

That act and this actor have been inseparable ever since.

Sim was born in Hamilton, Ontario, and grew up in Kitchener. His first of many appearances in *The Comics Journal* came when he ran an ad offering his freelance art services for $10 a page.

He faced down temptation when Marvel Comics called, asking if he'd like to write *Howard the Duck*. Fortunately, he'd just decided to take *Cerebus* monthly.

"When I came into the field," Sim told *The Comics Journal* in 1989, "there was nobody there. I came in because Barry Windsor-Smith and Bernie Wrightson and Jeff Jones and Mike Kaluta and Neal Adams built this enormous musical instrument and they were all playing these amazing tunes on it and then they went away.

"And I'm staring at this amazing musical instrument and thinking, 'If somebody doesn't show up and do something in the next two years, I'm going to go up and play the fucker.'"

Everyone who showed up had signed over their soul to Marvel or DC, Sim decided, so he struck up his own tune. He declared his independence with *Cerebus*, a 26-year project spanning 300 issues and a 6,000-page storyline.

"My commitment to you," he reminded retailers at the 1992 Diamond Comics Distributors seminar, "is that *Cerebus* #1 sold exclusively in comic book stores, and in March 2004, right on schedule, issue #300 of *Cerebus* will be available exclusively in comic book stores."

Early in his career, Sim was forced to sell copies of his comics and original artwork at $20 a page at conventions to maintain his independence. But *Cerebus* soon took him beyond that.

"What Dave has managed to do with an aardvark barbarian character that started off as a Barry Smith *Conan* parody, what he's managed to say in the context of that strip is staggering," Alan Moore has said.

Since *Cerebus* gave him breathing room, Sim has endlessly beaten the drum for self-publishing. "All companies are pyramid schemes, pure and simple," he said at the 1993 Pro/Con. "The people at the bottom of the pyramid, the creators, labor on behalf of the people at the top, the publishers. Money, like hot air, rises."

But Sim has had only limited success helping those determined to follow his lead. "The top guys in the business have tried it and made a mess of it," Eddie Campbell said. "Virtually everyone Dave has given money to has made a mess of it. There are businessmen and there are creative people. It's a rare person who's both. Dave Sim is one of those."

Simon, Joe

The forgotten (much to his chagrin) half of the inventive team that brought us Captain America, romance comics, and kid-gang comics, Joe Simon was born in Rochester, New York, in 1915, and reborn when he met Jack Kirby in 1940.

They met in the office of Victor Fox, where Simon ended up after several months with Lloyd Jacquet at Funnies Inc. Like everyone else, Simon got high off Kirby's exhaust, but he insists he pulled his weight in a partnership that lasted nearly

Dave Sim, as seen by Eddie Campbell in Eddie Campbell's Bacchus.
(© Eddie Campbell)

Boy Commandos was one of the "kid-gang" comics created by Joe Simon with partner Jack Kirby.
(© DC Comics, Inc.)

two decades. "In almost everything we did in those days, I would sit down at the board and put everything in pencil, and Jack would get the stuff and tighten it up," Simon told *The Comics Journal*. "I'd put the story on the board, I'd rough it up, and Jack would tighten it up." Simon added that he also wrote most of the stories.

Their fathers were both tailors, and Simon figured they didn't gain much in the way of business sense from their dads. Not that it mattered. "We were like Donald Trump then," Simon said. "We did *Young Romance* and *Black Magic*. We were getting 50 percent of the profits there . . . Our business deals weren't that bright. It just turned out that we made a fortune off it. Jack and I were drawing over $1,000 a week, when people were making $50 and $75 a week. And we were taking home a salary, over $1,000, from our little company."

Nothing slowed that little partnership down. After creating the Young Allies for Timely and the Newsboy Legion and the Boy Commandos for DC in the early 1940s, Simon and Kirby unleashed their own projects in the late 1940s for Crestwood (Prize): *Young Romance* (the first romance comic) in 1947, followed by *Young Love* in 1949 and *Boys' Ranch* in 1950. They briefly had their own company (Mainline Publications) in 1954–1955. The tandem reunited to create the Fly and the new Shield for Archie Comics in 1959, then went their separate ways. After that little company dissolved, Kirby went to Marvel and soared to the top of the marquee; Simon created Prez and Brother Power the Geek at DC and in the early 1990s wrote a book about his Golden Age adventures titled *The Comic Book Makers*.

Simonson, Louise

When Bill DuBay washed his hands of *Creepy*, *Eerie*, and *Vampirella* in 1978, publisher Jim Warren looked everywhere for a new senior editor. "At everyone but me," said Louise Simonson (then Louise Jones), who was Warren's assistant editor. "So, I went in to him and told him I wanted to edit the magazines.

"Jim Warren said to me, 'What? Girls can't edit horror comics.' He was pushing the button that would make me jump and get mad at him. If it'd been someone else, he would have pushed a different button."

Simonson didn't blink and she didn't jump.

"I said, 'Here's the deal. Give me six months with the magazines and I'll get them on schedule with the salary I have and with no assistant.' He wasn't an idiot; he said, 'Sure.' I managed to do all the things I said I would. It wasn't that difficult."

Simonson made a lot of things look easy. She was doing magazine advertising promotion in 1976 when a good friend, Michelle Brand, called and told her there was a higher-paying job waiting for her at Warren. Simonson wrote advertising copy, massaged letters columns, and plugged holes in the dike until Warren moved her to editorial.

Jim Shooter persuaded Simonson to bring her editing skills to Marvel in 1980. Four years later, she pitched him an idea for a team book with kids as superheroes. "He looked at me," she said, "as if I'd lost my mind." Simonson was writing up the idea when she bumped into artist June Brigman and asked her if she could draw kids. "She used to sketch them at amusement parks; it was one of her summer jobs." When Shooter saw the roughs she did for Simonson's crew, Brigman had a new job as the penciler for *Power Pack*.

"I had never written comics before and June had never drawn a comic in her life," Simonson said. The series survived seven years on the strength of characters who thought recovering a lost first tooth was as significant an event as stiff-arming the latest alien invaders. Simonson eventually moved on to *New Mutants* in 1988. She has spent the last several years doing freelance writing for a variety of companies, including DC and Dark Horse.

Simonson is married to artist/writer Walt Simonson.

Simonson, Walt

He remembers the Alamo. After 25 years in the business, Walt Simonson still knows what made it all possible: a two-bit, 3-page story on the Alamo that he drew in 1972.

DC didn't have much use for the first art samples that Simonson showed them. "I was blown off because they were science fiction, and science fiction didn't sell," he said. But Simonson wasn't blown too far before Don Krarr, one of the writers who hung out at Neal Adams's Continuity Studio, came along with a 3-page Alamo story based on the escapades of

"I'd put the story on the board, I'd rough it up, and Jack would tighten it up."
JOE SIMON
THE COMICS JOURNAL

Louise Simonson

James Butler Bonham, who broke back *into* the Alamo to tell its defenders that no help was coming. "I penciled it and inked it," Simonson said. "It probably took me a couple weeks. I read at least two books on the Alamo so I could draw structures of old Texas that looked persuasive."

His work persuaded Archie Goodwin to publish the story in the back of an issue of *Star Spangled War Stories*. And it persuaded the DC editor to give Simonson another back-up feature, Manhunter, that secured his career. "That strip ran for a year and when it was over," Simonson said, "I was well known enough that I never had trouble getting work in the industry again.

"I shudder at the drawing of the Alamo now, but that job was as important as anything I ever did. You never know where the connections are going to be. That kind of stuff was possible then. I don't know if it's possible now."

The possibilities—if not the page rates—were limitless in the early '70s. The first time Simonson showed up at DC looking for work he walked into the coffee room and bumped into Howard Chaykin, Bernie Wrightson, Mike Kaluta, and Alan Weiss. Chaykin was doing Iron Wolf, Wrightson was drawing *Swamp Thing* and Kaluta was on *The Shadow*. When you saw that kind of work day after day, Simonson said, "It was pretty inspirational. You'd look at what this guy was doing and say, 'I'd better go home and get to work.'"

Simonson was, he said, part of "one of the last generations of comic professionals who essentially had to move to New York and all of whom knew each other. There isn't a guy in my comics generation that I didn't know and didn't know personally." The gang usually hung out at Continuity on East 48th just off Fifth Avenue. And they fed off the comic genius of an earlier generation.

In 1976 Simonson joined Marvel, where the page rate for artists was higher and where a creative revival was slowly brewing. By 1979, John Byrne and Chris Claremont were reigniting the X-Men and Frank Miller was performing his Heimlich maneuvers on *Daredevil*. "That was the best time to work on comics in my career," Simonson said. "When the creative juices flow like that, they really flow."

Simonson began his 46-issue run on *Thor* with #337 (January 1984), then moved on to *X-Factor*. At the end of the '80s, he said, Marvel had "lost a lot of the people who brought ideas into the mix. Several friends of mine were let go, and they were let go badly. It made it a lot more difficult for me to work there. I wasn't into the characters anymore. It was easy to work there and not realize there was life after Marvel . . . which was what I found out after I left."

In the mid-1990s, Simonson combined with Frank Miller on a *Robocop vs. Terminator* miniseries, drew a *Star Slammers* miniseries, and did quite a bit of writing. Since hitting the age of 50, he admits he finds it harder and harder to pick up your average comic book and make much sense of it. But he has never forgotten those early years, when a quick peek at the work of Mike Kaluta or Bernie Wrightson would send him flying back to Brooklyn and his ground-floor apartment just south of Prospect Park. Simonson's drawing board was set up between the two windows that fronted onto Argyle Road. There were no bars on the windows ("Back in those days, we didn't need them"), just small metal railings. And as Simonson would draw, deep into those muggy summer nights, kids from the neighborhood would climb atop those railings, watch him draw and talk about comics. "They just loved comics," Simonson said, "and they thought what I was doing was pretty cool."

Sinnott, Joe

An artist who saw Marvel at its best and its worst, not necessarily in that order, Sinnott joined the bullpen in 1950 and was still freelancing for the company in the mid-1990s. Born in 1926, Sinnott served on Okinawa and studied under Burne Hogarth, which left him prepared for anything Stan Lee could throw at him. Stan lobbed assignments at him for more than 40 years, then signed Sinnott to help produce the Sunday *Spider-Man* strip. Many fans consider Sinnott to have been Jack Kirby's best inker, especially on the Fantastic Four.

Skywald

This short-lived company was formed by Sol BrodSKY and Israel WALDman in 1970. Most of its color comics (*The Heap* and *Butch Cassidy*) and black-and-white magazines

Walt Simonson

Joe Sinnott (self-portrait)

SKULL COVERS

Giant skulls were a favorite motif of cover artists, especially for pre-Code horror comics. Among the best:

Dark Mysteries #2 (August/September 1951)
Haunted Thrills #5 (June 1953) and #18 (November/December 1954)
Hit #7 (January 1941)
Kid Eternity #15 (May 1949)
Liberty Comics #12 (March 1946)
Mysterious Adventures #13 (April 1953)
Mysterious Traveler #1 (November 1948)
Plastic Man #1 (Summer 1943)
Punch #12 (January 1945)
The Shadow vol. 2 #10 (January 1943), vol. 5 #4 (July 1945), vol. 9 #5 (August 1949)
Smash #50 (December 1943)
Strange Mysteries #12 (July 1953) and #15 (January 1954)
This Magazine Is Haunted #14 (December 1953)
Weird Mysteries #4 (April 1953)
Witchcraft #2 (May/June 1952)

(*Crime Machine* and *Hell-Rider*) lasted no more than three issues, but horror titles such as *Nightmare*, *Psycho* and *Scream* kept the shop doors open until 1975.

Skywald published the likes of Robert Kanigher, Syd Shores, Bill Everett, Mike Kaluta, Jeff Jones, Bernie Wrightson, and Doug Wildey. John Byrne's first artwork appeared in *Nightmare* #20 (August 1974).

Smith, Barry Windsor-

The British-born Smith has forever been pressed to match his painstakingly elegant work on the first 24 issues of *Conan the Barbarian.*

Conan, Smith told Archie Goodwin in a 1981 interview, "was just pure unadulterated luck for me. Anybody could have got the job . . . I got *Conan* because I was dirt cheap, about twenty dollars a page or something like that. It was an experimental book and couldn't afford to pay much to the artist.

"I read the *Conan* books because I was asked to by Roy [Thomas]. I didn't know who Conan was before that. The first three issues are simply super-heroes masquerading in loincloths.

"It was the fourth issue that changed everything with 'The Tower of the Elephant' . . . 'The Tower of the Elephant' was just one of those magical stories, and I think it's really a magical comic book, even now. Even at the times, in later years, where I pooh-poohed the things I did in comic books and stuff like that, just because I was angry at comic books, I never changed my mind about 'The Tower of the Elephant.'"

Smith was heavily influenced by the Pre-Raphaelites, a group of 19th century British artists that included Dante Gabriel Rossetti and John Everett Millais—"the Beatles of the nineteenth century," Smith said. "It's the airless claustrophobia that I go for. Getting so close to each blade of grass that all intended reality is voided."

Smith made little money at Marvel ("I was too damn slow") and spent that on antiquarian books. "I quit Marvel because I had to," he told Goodwin. "After *Conan* there was nothing else to do. I didn't want to go backward to *Iron Man* or some such nonsense."

Smith eventually formed the Gorblimey Press to distribute his posters, portfolios, and limited prints. In recent years, he has returned to comics with a 13-issue Wolverine story for *Marvel Comics Presents,* a stint at Valiant that greatly increased his popularity with a new audience, *Rune* and various other projects for Malibu Comics, and his incomplete magnum opus, *Barry Windsor Smith: Storyteller,* for Dark Horse.

"I'm not your actual macho Frank Frazetta type who'd rather be playing baseball, nor am I your well-adjusted Hildebrandts who paint very well because they're terribly talented and enjoy themselves," Smith said. "My charm and my downfall is being pursued by demons of the mind."

Soglow, Otto

He was the power behind the throne of The Little King, who first appeared in *The New Yorker* in 1931. Soglow's mute monarch eventually starred for King Features and *King Comics,* never claiming to be their namesake.

Spa Fon

The EC password debuted in *Weird Fantasy* #14, on the third page of a story called "The Ad."

Asked who thought up "spa fon' and "squa tront," Bill Gaines said in 1972, "Those were Al [Feldstein]'s. Well, of course, 'spa fon' is a little bit of Italian. What's the expression, 'spa-fon gool'? I think that's where it came from, because Al didn't know it was wrong."

Va fan goule is an Italian obscenity.

Both *Spa Fon* and *Squa Tront* became names of EC fanzines.

The Pre-Raphaelite influence is seen in such BWS works as *Pandora*
(© Barry Windsor-Smith)

The Spectre

Created by Jerry Siegel, the Spectre first appeared in *More Fun Comics* #52 (February 1940). Police detective Jim Corrigan was tucked into a tub of cement and drowned, but there was no rest for the weary: In Purgatory, he was informed he would not be allowed the blissful rot of the grave until he rid the Earth of evil.

Bernard Baily's spooky Spectre covers lured many a buyer for *More Fun Comics*.
(© DC Comics, Inc.)

Art Spiegelman

The Spectre was certainly equipped for the clean-up operation. Medusa had nothing on this grim ghost, and the luckiest of his opponents were those who were felled by a sideways glance. The Spectre could bend time and space, run down meteors, and—it goes without saying—had no fear of death.

The Spectre haunted *More Fun* for more than four years, then disappeared for 22 years. Julius Schwartz, Gardner Fox, and Murphy Anderson finally located him and repackaged him in *Showcase* #60, but nothing came of the reunion until Michael Fleisher began plotting his revenges in *Adventure Comics* #431 (February 1974).

Fleisher scared people to death by presenting the Spectre as a vengeful killing machine, one that Siegel would recognize. He had an encyclopedic knowledge of the character and he wrote from memory. "The Spectre that I did with Joe Orlando was really derived from the Golden Age Spectre," Fleisher told *The Comics Journal* in 1980 (just before their six-year legal battle began—see **Legal Briefs**). "When The Spectre would zap those crooks in my stories, a lot of those devices were just stolen from early *More Fun Comics*."

DC breathed new life into the Spectre in 1992, with Tom Mandrake penciling John Ostrander's scripts.

Spiegelman, Art

I feel very saddened by the death of communism. Because it's not like it means that America won, it means that America is dying slower. I think communism lost because it died first ... This is just going to become a more toxic place to live ... Living in New York you get to see it up close.

The creator of the Pulitzer Prize–winning *Maus*, Art Spiegelman was born in Stockholm in 1948 and drawing a paycheck from the Topps bubblegum and card company before he turned 18. Among other projects, Spiegelman produced the Garbage Pail Kids, a spoof of the dolls from Cabbage Patch that drew some serious heat from the humorless. "Ultimately," Spiegelman told the *St. Louis Post-Dispatch* in 1991, "I think the Garbage Pail Kids were a great moral work. It teaches kids to 'just say no.' Just say no to received ideas. To things that are being peddled to them that they don't have to think about, that they aren't supposed to think about."

Spiegelman has often noted that he "spent a lot of time in libraries because I wasn't that good on the playground." When he offered his first cartoons to the *East Village Other* in 1967, editor Walter Bowart told him, "Well, this is really interesting, but it's gotta have more sex and drugs in it."

"This was about the time I was just finishing high school," Spiegelman said. "I didn't know much about either sex or drugs. So, I went to college, learned about sex and drugs ..."

His education complete, Spiegelman co-edited *Arcade* with Bill Griffith in 1975–76. The magazine was, Spiegelman said, "a life raft for lots of people involved in underground comics when that whole movement seemed to be sinking."

Beginning in 1978, Spiegelman kept his head above water by working on *Maus*, a tale of cats and mice, fathers and sons, and the Holocaust. The first six chapters first appeared in *RAW*, a comix anthology (see entry) that Spiegelman co-edited with his wife, Francoise Mouly, before being packaged as *Maus: The Survivor's Tale* in 1986. The odyssey of Spiegelman's parents, Vladek and Anja, through Auschwitz and beyond was eventually completed in 1991 with volume 2, *And Here My Troubles Began*.

"*Maus* is a book that cannot be put down, truly, even to sleep," Umberto Ecco observed.

When Mouly joined the *New Yorker* magazine in 1993 as design director, Spiegelman and several other *RAW* renegades were part of Mouly's grand redesign. Spiegelman produced several controversial covers for the *New Yorker,* including his depictions of a Hassidic Jew kissing a black woman (February 15, 1993) and a crucified Easter bunny (April 17, 1995).

Spillane, Mickey

Spillane was a rather prolific writer at Funnies, Inc., before turning to the street-punk prose and beer commercials that made him famous.

Spillane was working in the basement at Gimbel's in New York when he decided he could make a better living writing comic books. Max Allan Collins and James Traylor have written that Spillane "began by matching the output of any other three writers in his average single day, inventing a new style of comics writing that consisted of outlining the book so that each sentence stood for a picture and each paragraph for a full page."

Spillane told Collins and Traylor he wrote for *Captain America, Captain Marvel, Human Torch, Sub-Mariner, Blue Bolt, Target,* and *4-Most.* At the 1991 San Diego Con, Dan Barry recalled "a cocky guy who worked with me. Every day at noon they'd send us out to all the Irish bars to find him. He'd come back and crank out enough pages of *Blue Bolt* for me to go back to work. The man's name was Mickey Spillane."

Spillane most recently lent his name to a comic series for Tekno•Comics: *Mike Danger,* written by Max Allan Collins.

The Spirit

Will Eisner's classy crimefighter first appeared in a Sunday newspaper section on June 2, 1940. "The Spirit" was the lead feature in a 16-page section that Eisner contracted with E. M. Arnold at Quality to produce for the Register & Tribune Syndicate of Des Moines.

Eisner went the newspaper route because he refused to surrender control of his creation. Unlike Jerry Siegel and Joe Shuster, he realized what he would lose by signing away his rights: "Creative sovereignty. I knew that owning my own property gave me the creative sovereignty that I needed. I was in a world where when you gave up your child for adoption, you lost that child forever. I took on 'The Spirit' not because it promised to make me a very wealthy man, but because it promised me creative and intellectual freedom."

"The Spirit himself was as confused about his role in society as I was," Eisner told *The Comics Journal.* "I could never figure where super-heroes got the absolute, unmitigated gall to stand up and say, 'Well, I will solve the world's problems. The Spirit was a very middle-class kind of guy. Always has been."

Splash Page

Legend has it that Jack Kirby invented the splash page for *Captain America* in 1941, but he really started cranking splash pages out in the late 1960s. "There was a period of time," said Jim Shooter, once Marvel's editor-in-chief, "when Jack was doing a splash page every issue. Everyone thought, 'Jack Kirby, wow, another revolutionary breakthrough in comics!'

"Bullshit."

The issue was money, Shooter said. Kirby wanted a raise, and Stan Lee couldn't give him one. "The company was run by Martin Goodman [Lee's uncle's father-in-law], and Martin Goodman's idea of fair was that *he* got it

Everything you need to know about the Spirit—in one handy splash panel.
(© Will Eisner)

SPORTS COMICS

Michelle Nolan has catalogued 126 "factual" sports comics published between 1940 and 1970, and counts among the best Eastern's *Amazing Willie Mays* (1954); Magazine Enterprises' *Pride of the Yankees* (1949), scripted by Gardner Fox and drawn by Ogden Whitney; and the 18 Fawcett titles.

Her complete list, first published in *The Comic Book Marketplace* #20, follows:

Street and Smith (50 comics)
Sport Comics #1–4 (1940–1941)
True Sport Picture Stories Vol. 1 #5 through Vol. 5 #2 (1942–1949)

Fawcett (18 comics)
Jackie Robinson #1–6 (1949–1952)
Joe Louis #1, 2 (1950)
Ralph Kiner (1950)
Don Newcombe (1950)
Roy Campanella (1950)
Larry Doby (1950)
Yogi Berra (1951)
Phil Rizzuto (1951)
Eddie Stanky (1951)
Thrilling True Story of the Baseball Giants (1952)
Thrilling True Story of the Baseball Yankees (1952)
Baseball Heroes (1952)

Harvey (11 comics)
Babe Ruth Sports #1–11 (1949–1952)

Marvel/Atlas (4 comics)
Sports Stars #1 (1949)
Sports Action #2–4 (1950–1952)

Ziff-Davis (8 comics)
Baseball Thrills #10(1)–3 (1951–1952)
Football Thrills #1, 2 (1952)
Bill Stern's Sports Book vol. 1 #10, #3, vol. 2 #2 (1951–1952)

Hillman (7 comics)
Real Sports #1 (1948)
All Sports #2, 3 (1948–1949)
All Time Sports #4–7 (1949)

Star Comics (5 comics)
Sport Thrills #11–15 (1951)

Parents Magazine (4 comics)
Sport Stars #1–4 (1946)

Standard (2 comics)
Mel Allen Sports Comics #5, 6 (1949–1950)

Magazine Enterprises (2 comics)
Pride of the Yankees (1949)
Home Run #3 (1953)

Eastern (1 comic)
Amazing Willie Mays (1954)

Eisner (1 comic)
Baseball Comics (1949)

Essenkay Publications (1 comic)
Smash Hit Sports Comics (1949)

American Visuals (1 comic)
Baltimore Colts (1950)

Charlton (1 comic)
Charlton Sports Library, Professional Football (1970)

all," Shooter said. "He was like a good old benevolent dictator, running a family-owned business. He gave everyone Christmas bonuses and treated them well, but he wasn't about to share the wealth. So, Jack would be asking for a raise and Stan couldn't give it to him because Uncle Martin wouldn't let him.

"So, Stan said, 'Look, Jack, time is money. If you can do a page faster, it's like getting a raise, right? So, every issue, do one full-page shot.'"

That was fine by Jack. He put the same amount of time into his art and came away with a little extra cash. "People on the outside," Shooter said, "thought Jack was introducing this wonderful new technique to comics: the full-page head shot. Hey, it was his raise."

Sprang, Dick

A pulp illustrator in the 1930s, Sprang shared a studio loft with Norman Fallon and Ed Kressey between 5th Avenue and Grand Central on 42nd Street before signing on with DC's Whitney Ellsworth to be the fifth artist to work on Batman. Sprang drew the Riddler's first appearance in *Detective Comics* #140.

In 1946 Sprang became one of the first pros to leave New York City, settling in Sedona, Arizona. His editors, Jack Schiff or Mort Weisinger, would send Sprang the pages to pencil, with notes on the deadline and "a few clippings that some fine writer like Bill Finger would graciously provide."

After Sprang sent the pages back to New York, the editors would get them lettered and ship them right back to Arizona for Charles Paris's inks. "Occasionally," Sprang said, "I would send my pencils directly to Charlie if we were held up on a deadline by some writer not sending me all the pages I needed."

Que pasa? "As I recall," Sprang said, "there were a number of writers who were drunk all the time."

Stan and Jack

You and I ought not to die before we have explained ourselves to one another.
JOHN ADAMS, IN A LETTER TO THOMAS JEFFERSON

Since one out of every two marriages ends in divorce, no one should be surprised that the union of Stan Lee and Jack Kirby, the best marriage in the comics' Silver Age, failed so miserably.

Both diligently sought—or gracelessly accepted—all the credit for creating the characters that saved Marvel's skin in 1961. This paternity case shouldn't require a blood test: Jack Kirby provided the characters' divinity, Stan Lee their humanity.

When Kirby and Lee first met at Timely in 1940, they didn't meet as equals. "I could never get close to Kirby, because he was sitting at his desk drawing all the time, puffing on his cigar,"

Lee said. Presumably, Kirby puffed a little harder whenever he glimpsed Stan through the smoke.

"I thought Stan Lee was a bother," Kirby told *The Comics Journal*. "You know, he was the kind of kid that liked to fool around—open and close doors on you. Yeah, in fact, once I told Joe [Simon] to throw him out of the room. Yes, because he was a pest. Stan Lee was a pest. He liked to irk people and it was one thing I couldn't take."

In the next 20 years, Kirby—whose departure from Timely elevated Lee to the positions of editor and art director—teamed with Simon on DC's Manhunter and Sandman. They created the Boy Commandos and Newsboy Legion, as well as *Young Romance*, the first romance comic. He did superb work on books such as *Boys' Ranch* and *Black Magic*.

And Stan Lee? "Twenty years of unrelenting editorial effort to encourage miserable taste," Bernie Krigstein once said, "and to flood the field with degraded imitations and nonstories."

They had taken, in other words, wildly divergent paths before they met again at Marvel Comics in 1958 and began churning out Monteroso, Xemnu, and Fin Fang Foom.

"The perception is that a bunch of all-time greats got together and built Marvel," Jim Shooter said more than 30 years later. "Wrong. Stan got his job because he was Martin Goodman's relative. Jack, Steve [Ditko], and most of the other artists there were complete losers. They were guys that couldn't get work at the good company, which was DC. The other companies had all died. At DC, those guys were a joke. They couldn't shine the shoes of Curt Swan. This was a bunch of has-beens and never-wases."

That was then. In 1961 the has-been (Kirby)

The credits pages on Lee-Kirby collaborations were constantly in search of superlatives for the team. This one is from *Fantastic Four Annual* #2 (1964).
(TM & © 1998 Marvel Characters, Inc. All rights reserved.)

and the never-was (Lee) pooled their talents and sired the Marvel Age.

Misled by bitter memories, neither has been a reliable guide to how these adventures began. Take the genesis of *Fantastic Four* #1. The sanitized Lee version, from the 1974 *Origin of Marvel Comics*:

"After kicking it around with Martin and Jack for a while, I decided to call our quaint quartet The Fantastic Four. I wrote a detailed first synopsis for Jack to follow, and the rest is history."

Not so fast. The vengeful Kirby version, from his memorable 1991 interview in *The Comics Journal*:

"It came about very simply. I came in [to the Marvel offices] and they were moving out the furniture, they were taking desks out—and I needed the work. I had a family and a house and all of a sudden Marvel is coming apart. Stan Lee is sitting on a chair crying. He didn't know what to do, he's sitting in a chair crying—he was just out of his adolescence [Lee was 39]. I told him to stop crying. I says, 'Go in to Martin and tell him to stop moving the furniture out, and I'll see that the books make money.' And I came up with a raft of new books and all these books began to make money. Somehow they had faith in me. I knew I could do it, but I had to come up with fresh characters that nobody had seen before. I came up with the Fantastic Four. I came up with Thor. Whatever it took to sell a book I came up with. Stan Lee has never been editorial-minded. It wasn't possible for a man like Stan Lee to come up with new things."

You can't synchronize those two versions. "Jack had a tendency to get things just plain wrong, for factual reasons if nothing else," said his good friend Mark Evanier. "Jack was very sensitive about certain issues. You could push his hot button about certain things. His feelings changed from time to time. So did Stan's feelings. I've gotten fairly close to Stan in the last couple years, and a couple of things I tell him he was quoted as saying, he tells me I must be making them up."

What truly matters, of course, is that the Fantastic Four et al. thrived, nourished by Kirby's pacing and Lee's dialogue, Kirby's characters and Lee's characterization.

"Whatever he might say or others might believe, Stan, I think, always knew that he was dependent on having the right people around him," Roy Thomas once said. "Jack, however, though in many ways more the type of creative artist deserving of the overused 'genius' label, never really analyzed these things, and so he ended up merely resenting Stan and thinking that Stan had ridden to glory totally on his [Jack's] shoulders. Which was only half true. No, there wouldn't have been a successful company called Marvel Comics without Jack Kirby … but there wouldn't have been one without Stan, either."

Kirby gained huge numbers of sympathy votes during the 1980s when Marvel refused to return his old artwork.

"I have a feeling that Jack feels everyone is making all this money. Somehow he has focused this feeling against me," Lee said. "What he doesn't take into account is that I don't make any more than he does. [Actually, Marvel paid Lee $375,000 in 1990.]

"I don't have any royalties. I don't have any ownership. I think Jack thinks I'm getting all the glory. Jack is the guy who quit. Jack would have been there with me. I wanted to make him the art director, or the associate publisher. I would have made him anything he wanted."

Stan and Jack had an opportunity to make their peace at Marvel's 25th anniversary party at the San Diego Comic-Con in 1986. Shooter and Lee were standing near the back door when Lee, in a typically demonstrative move, slammed his hand against the bar. Unfortunately, he was holding a glass of wine. "He lacerated his hand," Shooter said. "He was bleeding. Go-to-the-hospital type bleeding."

At that moment, Jack and Roz Kirby came through the door.

Shooter welcomed Kirby, then watched as the two men eyed one another. Finally, Kirby said, "Hi, Stan," and stuck out his hand. Lee

Another "crowning achievement" for Stan and Jack.
(TM & © 1998 Marvel Characters, Inc. All rights reserved.)

frantically tried to wipe the blood off his hand before meeting Kirby's grasp.

"He wants to talk to Jack," Shooter says. "And they had what almost was the reconciliation conversation."

With Roz impatiently hovering nearby, and Shooter anxious to referee, Lee and Kirby danced around each other. "Stan was saying, 'Gee, I really want it to work out,' and 'Jack, I don't have any control over this corporation. I miss the old days. I just want things to be good,'" Shooter said.

"Jack was responding in kind. So, Stan says, 'Why don't you come over to the house sometime? You know my number. I know yours. If I call you, will you come see me?'

"Jack says, 'Yeah, I'd like to come over.' And Stan says, 'Just tell me when. We'll go to lunch, or whatever.'

"I'm watching history here. They're really getting friendly again. They really seemed to be becoming friends. Then Stan says, 'Ya know, Jack, I don't care who owns it. I don't care who gets the credit. You can own it, you can have the credit. I'd just like to work with you once more.'

So, what does Kirby say? Shooter said he began to nod. "He's like, 'Well, that will be fine.' And then Roz says, 'Over my dead body.' And she drags him away."

Lee took it pretty hard. Then, he caught a ride to the hospital to take care of his hand.

The possibility of reconciliation ended forever after Kirby's interview in the *The Comics Journal*, in which he demanded sole credit for the creation of Spider-Man.

"I think he's gone beyond the point of no return," Lee said. "Some of the things he said, there is no way he could ever explain that to me. I would have to think he's either lost his mind or he's a very evil person."

Or maybe just a tired one.

When Kirby died in 1994, Lee had some mutual friends call Evanier to make sure he was welcome at the memorial service. "Roz wanted to see him," said Evanier, who delivered one of the eulogies. "She wanted to bury ill feelings."

Lee sat in the middle of the pack during the service. Roz was in the receiving line when she saw Lee duck out a side door. "She called to him," Evanier said, "but Stan didn't hear her. I guess he figured he better get out of there. I went after him in the parking lot. It was too late."

More credit for the creative duo—without mention that Jack originally created Captain America with Joe Simon in the '40s.
(TM & © 1998 Marvel Characters, Inc. All rights reserved.)

Standard Comics

Fresh out of college, Ned Pines founded Standard Publishing in 1932 and began putting out pulps such as *Thrilling Mystery*, *Thrilling Detective*, and *Thrilling Adventure*. To have a veteran in the editor's chair, Pines hired 36-year-old Leo Margulies.

In 1936 Margulies bought *Wonder Stories* from Hugo Gernsback and resurrected it as *Thrilling Wonder Stories*, one of the mainstays of the golden age of pulps. Editing the book was none other than Mort Weisinger, who would later supply most of the gadgets in Superman's universe.

In 1939 Weisinger published three new pulps: *Startling Stories*, *Strange Stories*, and *Captain Future*, which Margulies and Weisinger conceived at the first World Science Fiction Convention. At the end of the year, Standard—which also published under the Better and Nedor imprints—rolled out its first comic book *Best Comics* #1.

That book was quickly fol-

Alex Schomburg got out the airbrush for this cover.
(© Standard Comics)

John Stanley was a master of funny dialog, as in these brief scenes from a *Little Lulu* story.
(© Western Publishing)

lowed by such titles as *Thrilling, Exciting, Startling, Black Terror, Real Life, America's Best Comics,* and *Fighting Yank.* Other than some interior artwork by Mort Meskin and Frank Frazetta, little commends these books except for the cover art of Alex Schomburg.

Stanley, John

Stanley took Marge Henderson Buell's Little Lulu from the magazine pages to the comic book pages, scripting and providing storyboards for the first 135 issues of *Little Lulu* from 1945 through 1959. He also produced some other humor titles for Western Publishing including *Melvin Monster, O. G. Whiz,* and memorable issues of *Nancy.* He left the field for commercial art in the early 1960s and died in 1993. Mike Tiefenbacher calls Stanley "the funniest comic book writer ever, bar none."

Starlin, Jim

I'm from Detroit and it was a cultural wasteland. Comics were my culture.
JIM STARLIN

Best known for taking Captain Marvel off life support, Starlin also created Shang Chi, Master of Kung Fu, with Steve Englehart; Darklon for Warren; and Dreadstar for Marvel's first Epic comic.

Starlin had a free hand with Captain Marvel. "They went from 18 books to, like, 48 books in two years' time," Starlin told *Amazing Heroes.* "Roy Thomas was the editor and tried to read everything, but it just wasn't humanly possible ... A lot of the things that happened in those books was just because nobody stopped us."

In 1976 Starlin and Englehart finally rebelled against Marvel's work-for-hire policies. "We were both radical guys. We were both known to drop off projects if we couldn't get what we thought was fair," Englehart said. "We were known as people who would get up and go. And we got up and went in 1976. We wanted reprint money. We wanted royalties."

Starlin carried Dreadstar to First Comics, then later returned to Marvel to work on *Silver Surfer, Infinity Gauntlet,* and a second run with Warlock. In 1993 he began producing the creator-owned *Breed* for Malibu Comics.

Starman

Debuting in *Adventure* #61, Starman is one of several DC characters erroneously credited to Gardner Fox. The Astral Avenger was created by Murray Boltinoff and Jack Burnley, with a possible assist from Whitney Ellsworth.

Burnley designed and named the character; no one has laid claim to the first Starman script. When Burnley complained about the quality of the second script, Ellsworth called on Fox, but Burnley argues that the best of the arguably mediocre Starman scripts belonged to Alfred Bester.

The character was resurrected by DC in 1994 in a critically acclaimed new series written by James Robinson with art by Tony Harris and Wade von Grawbadger.

Starslayer

This title first appeared in 1982 as a Pacific Comics production and was picked up by First Comics with issue #7. The book had an auspicious opening run: In its first 10 issues, *Starslayer* presented the first appearance of the Rocketeer (#2), the second appearance of Groo the Wanderer (#7), and the first appearance of Grimjack (#10). The title character, a Mike Grell creation, recently reappeared briefly from Acclaim in 1995.

Starstruck

Originally a play by Elaine Lee, her sister Susan Norfleet, and Dale Place, *Starstruck* was first performed off-Broadway in the spring of 1980, with Michael Kaluta serving as costume and set designer. When the play shut down due to insufficient funds (to pay the actors), Kaluta suggested adapting the play for the European comics market.

After the first issue of *Starstruck* was published in *Heavy Metal,* Kaluta took the series to Epic Comics, which began publishing it in 1985. The series was revived by Dark Horse in 1990.

Star Trek

You'd need a few years aboard the *Enterprise* to visit all the places *Star Trek* has popped up in comic book form. Gold Key got the ball rolling in 1967 with the first of 61 issues, then passed James T. Kirk and the gang on to Marvel in 1979. DC carried both the *Star Trek* and *Star Trek: The Next Generation* titles from 1984 through 1996, leaving Malibu Comics to pick up *Star Trek: Deep Space Nine* off the tube. More than enough said.

Star Wars

"*Star Wars* #1 debuted two or three months before the movie opened anywhere for one reason alone: The Lucasfilm organization insisted on it, as the major term of the contract," Roy Thomas wrote in a letter to *Rockets Blast-Comicollector*.

Lucas, who reportedly handpicked Howard Chaykin to do the art for the book, "simply wanted as good a job as they could get and still get the first issue out in advance of the movie," wrote Thomas, who provided the script. "Why? Because a helluva lot of money was riding on *Star Wars* the movie, and they wanted the few hundred extra thousands of kids to see the comic before the movie opened. One has to go back, mentally, to before May/June of 1977, to a time when there'd have been virtually no national publicity on a movie which had cost 10 million dollars to make, in a genre not known for producing blockbusters. Two weeks before the film opened, I personally heard some TV producers discussing it and saying that Lucas was a one-film director, that *Star Wars* was a bomb."

Dark Horse acquired the Star Wars license in 1991, then won an intense bidding war against Image and DC to retain that license in 1997. Dark Horse dramatically expanded the Star Wars line and was the first to publish "prequel" material.

Joe Staton

The co-creator (with Nicola Cuti) of E-Man, Staton burst into the business at Charlton in 1971 and did his best work at DC in the 1980s. His "cartoony" style? "I call it highly stylized, leaning to exaggerated plasticity," Staton once said. He had stylish runs on *Green Lantern* (1979–1982) and *Wonder Woman* (1980–1983) before signing on as art director at First Comics in 1983, where he revived E-Man. Staton, who co-created the Huntress and the Omega Men, has never hesitated to express his opinion. He suggested to *The Comics Journal* in 1979 that Barry Windsor-Smith "and his clones are attracted to the pre-Raphaelites, who are certainly the most superficial and useless group of artists in the last 300 years." And what about *Conan the Barbarian*? "It's a glorification of mindless, masculine destruction written by a man who went out into the desert and shot himself when his mother died."

In the last decade Staton has worked primarily for DC, most notably drawing a crime noir digest-sized series for Paradox Press, *Family Man*.

Steranko, Jim

Jim was, in essence, the Will Eisner of his generation ... Nearly 30 years ago, Steranko laid it down, providing us then budding artists with a road map for the future of comic illustration that a few of us are just now catching up to.
DAVE STEVENS

I look at Kirby as being the architect, Steranko building the framework, and the rest of us doing the finish work.
PAUL GULACY

"When God was throwing around talent," Gulacy said, "he gave this guy a ton of it. He salted his ass down." But salt, it turns out, isn't the preservative it used to be. Steranko didn't keep.

Timing was part of the problem. "Steranko and [Neal] Adams proved there were some people out there with a dedicated approach to comics as

Joe Staton

Steranko brought a designer's approach to comic book covers.
(TM & © 1998 Marvel Characters, Inc. All rights reserved.)

Jim Steranko

Steranko's *Shadow* paperback covers are now collectibles.
(© Conde Nast)

an end in itself," Matt Wagner said. But their dedication didn't pay their bills in the days before the direct-sales market boom.

Those three wordless pages that announced Steranko's 1968 stint on *Nick Fury, Agent of S.H.I.E.L.D?* Sol Brodsky, Marvel's production manager, refused to pay Steranko for scripting those pages, reasoning that zero words deserve zero dollars.

"He was probably maimed by the business," Wagner said. "You had to be a workhorse like Jack Kirby in those days to get anywhere. If you were precious about your work... or finicky..."

You looked elsewhere. You made your escape. "Why else," Wagner said, "would Steranko go from doing these wonderful, intricate comics to doing a magazine about cheesecake?"

"It was the *Captain America* books that did it for me," Paul Chadwick said. "They had a density that is rarely achieved in comics. An interesting new idea in every panel, and there were a lot more panels on those pages."

And now? "*Prevue*, right?" Chadwick said. "Which is awfully disappointing for someone who has seen his real genius. It's the lightest press-release treatment of movies and a thousand ads for lingerie photography books. Why is this guy wasting his time? He could be rich and lionized if he were still doing comics."

As a teenager, Steranko was an escape artist. One of his premier tricks was to challenge his audience—of fairgoers or buddies—to lock him into a box or corner or cell from which he could not escape. "I have the ability to release myself from any form of confinement," Steranko often proclaimed. "No lock can resist me. If I were a criminal, no jail could hold me."

When he later wrestled with a comic book page, no convention could restrain him. After developing several characters for Harvey, Steranko convinced Stan Lee to give him a job at Marvel in 1966. Beginning with his work on *Strange Tales* #151 and continuing with *Nick Fury* and *Captain America*, Steranko delighted in the challenge of giving himself a seemingly impossible task and drawing his way out of it. His cinematic approach, graphic skills, and originality knocked both fans and other artists for a loop.

Steranko worked at his own speed. "If you're a publisher, and you want my work," Will Jacobs and Gerard Jones quoted him as saying, "you get it my way or you don't get it at all." When Stan Lee realized he couldn't count on getting that work on time ("He couldn't care less about deadlines," Lee said), he brought in other artists to work on Steranko's titles.

When he made his break from comics in the early 1970s, Steranko produced some paperback cover paintings, including 23 for a series of Shadow reprints. He published two volumes of his *History of Comics*, then turned to magazines. "His heroes are Guccione and Hefner," said Gulacy. Steranko wanted his hands on the publishing controls.

"It's a wonder that he lasted as long as he did in an industry so resistant to change," Dave Stevens said in a tribute to Steranko in *Comic Book Marketplace*.

No one's forgotten the guy—it's difficult to miss the echoes of Steranko's influence in the generation of artists to follow him—but no one thinks much about him anymore. "I still have a pile of his books that I use as my bible," Gulacy said, but the pages are brittle and yellow. Aside from an occasional cover, Steranko has stayed away from comics for over two decades, despite regular announcements of an impending comeback.

Steve Canyon

Anxious for more control of his comic strip creations, Milton Caniff abandoned *Terry and the Pirates* in 1947 and fired up *Steve Canyon*, his (and, Ron Goulart has suggested, the comics') final adventure strip.

Steve Canyon ran for 41 years, limping along for most of the final quarter century. World War II was the perfect backdrop for *Terry;* Korea and Vietnam were imperfect foils for Steve Canyon, a pilot who all too infrequently appeared in uniform.

The strip died with Caniff in 1988. The final strip, on June 4th, was a two-panel tribute; the

Stevens, Dave

He was looking for Bettie Page, the 1950s pin-up model, long before he found her. Looking, he says, "for the quintessential female to draw, the perfect model. I came upon a picture of her in a magazine, and that was it."

The magazine was the December 1956 issue of *Frolic*. Digging through a used bookstore in 1979, Stevens—who was all of 16—found a Bunny Yeager photo of Page in a bikini at the beach with a piece of driftwood in her hand. "It was the perfect blend of a fantastic, curvy body, yet muscular, and a face that could belong to any girl on the street," Stevens said. "She had a real sweetness about her that a lot of models in the '40s and '50s didn't have. That's what sucked me in."

Stevens kept his obsession for Page—and he admits that's exactly what it was—semi-private for several years while he tested his limits. At the age of 19, he was assisting Russ Manning on the Sunday *Tarzan* strip. "The first stuff of his I saw was his inking over Russ," William Stout said. "I told him on the spot, 'Your inking of Russ's stuff is light years beyond mine.'" But Stevens quickly deduced he couldn't handle the pace. "Comics were not a good avenue for me. I was too meticulous, too slow to slam-bang 'em out every day."

His first Rocketeer story, which began in *Starslayer* #2 (June 1982), was banged out as a favor to Pacific Comics' publisher Steve Schanes. "They had pages to fill. I filled them as a personal test to see if I could do comics solo," Stevens said. And in the following issue of *Starslayer*, Stevens went public with his passion for Bettie Page, introducing her as Cliff Secord's girlfriend, Betty.

"I never intended to merchandise her...per se. All I was doing was paying tribute to her in a comic book," Stevens said. "I thought when I drew a character that looked like Bettie and called her Betty, but not Bettie Page, I'd reach a few old codgers who remembered her. And a few friends of mine who knew about my obsession for her. It was an in-joke. I had no idea that it would draw the response it did."

Beyond *The Rocketeer*, Stevens' work in comics has been limited to several dozen covers for such books as *Cheval Noir*, *Alien Worlds*, *Jonny Quest*, *DNAgents*, and *Vanguard Illustrated*. "My status in comics? I don't ever do anything. I'm the lazy man of comics," Stevens said. "I've never had any illusions about this business being a playground for me. I'm an illustrator; I'm not a cartoon guy. My meat and potatoes are covers and poster art. I have a lot of ideas that will never get down on paper if I'm the one who has to draw them."

One of Stevens's most persistent ideas—meeting Bettie Page, the "perfect model"—was finally rewarded with a personal audience in 1993. He has since helped the reclusive woman obtain royalties for uses of her likeness over the years.

St. John Publishing

A fan favorite owing to the prevalence of artwork by Matt Baker, St. John Publishing was named after its owner, Archer St. John. The company was the delighted recipient when Joe Kubert, Norman Maurer, and Lenny Maurer returned from an Army tour in Germany in 1951 with 3D on the brain.

"We went to work on a Mighty Mouse book because St. John felt it would be the best vehicle for 3D and get the best chance on the news-

Basing the character of Betty in *The Rocketeer* on pinup queen Bettie Page led to Dave Stevens' finally meeting the legendary model.
(© Dave Stevens)

St. John tested the 3-D comics waters with a Mighty Mouse story.
(© St. John Publications)

Bill Stout

Bill Stout produced a lasting work in 1981's *The Dinosaurs.*
(© William Stout)

stands," Joe Kubert told Ray Zone. "The first publication of the 3D Mighty Mouse was a little over a million copies. It had an immediate 100 percent sellout and we went back to press with the book.

"St. John wanted to convert all his books to 3D regardless of the subject matter. We took a whole floor of a building and set up an assembly line . . . Suffice it to say, by the tenth or eleventh book, the sales were down to about 19 percent, so we had to stop publication of 3D."

For that, Baker fans are eternally grateful. Baker worked extensively for St. John from 1948—when he left the Iger shop—until 1955.

Because it owned the rights to the Paramount Pictures cartoons, St. John published the first Casper and Little Audrey comics, then sold the rights to Harvey. St. John ceased publishing in 1956 after a decade, then made a brief comeback in 1958 before vanishing for good.

Stout, William

The comics' foremost dinosaur artist was 14 years old when his dad left, so William Stout didn't have a male role model in his teens. He went without until, shortly after he sent seven illustrations off to *ERBdom,* the phone rang and there was Russ Manning asking for his help.

Stout, who was living in Los Angeles, began commuting to Manning's place in Silverado Canyon, working on the Sunday and daily *Tarzan* strips and waiting for the fire alarm to go off. Manning was a volunteer fireman, and, when the alarm blared, "he'd be up and out and gone," Stout said. But those were the only times Manning deserted his apprentice. "He was a terrific role model for me. He had some of the best parenting skills I've ever seen.

"He wanted an assistant," Stout continued, "but he was also a decent enough human being that he couldn't in good conscience keep me from doing different things. When I was assisting him, I was expected to work in his style, but he'd bring in extracurricular things and hand them over to me."

Stout admits he was too wild and rambunctious to stay with Manning for any length of time (he was soon replaced by Dave Stevens). He did some cartoons for *Cycle Toons,* including a tribute to Harvey Kurtzman, Will Elder, and Wally Wood that he was so proud of that Stout mailed it away to each of the former EC artists.

Within three weeks, Kurtzman was on the phone, asking for his help on *Little Annie Fanny.*

"Kurtzman saw that I could duplicate styles," Stout said. After several months, Kurtzman also realized that Stout was a lousy second fiddle. "Bill, you're too creative for this strip," he told Stout.

"I wasn't content with just being involved," Stout said. "I wanted my mark to be in there."

He definitely made his mark in 1981 with his stunning book, *The Dinosaurs,* filled with his paintings and drawings of prehistoric creatures. He also did lots of commercial artwork, from portfolios to movie posters (*Rock 'N' Roll High School* was one of his).

Until the late '80s, Stout subscribed to what he called "the pinball scheme of career planning. It wasn't until I was about 39 that I figured out what the hell I was supposed to do."

Paint Antarctica.

Stout had seen numerous color photo books on the frozen continent, all of which convinced him the camera could not handle the job. "What a perfect opportunity," he thought, "for a painting to capture what a camera can't."

He hitched a ride on an American Museum of Natural History tour. "When I got to Anarctica," he said, "I was not prepared for how spectacular it was. Its beauty is not only in its scale; there's a mystic, spiritual quality as well. I thought, 'If I don't do anything to preserve this place, how can I come back and look my kids in the eye.'"

Stout fell in with a movement to turn

Rare photos of the four corners of the loft shared by Bernie Wrightson, Barry Windsor-Smith, Jeff Jones, and Michael Kaluta can be found in the long-out-of-print *The Studio*.

(© Dragon's Dream Ltd.)

Antarctica into the first "world park," a movement that didn't include then-President George Bush, who wanted to keep the continent open for oil drilling and development. "The American public needed to see Antarctica as more than snow and ice," Stout said. To attract both kids and their parents, he decided to produce a series of paintings depicting the beasts of its Jurassic past and the breathtaking colors of its present.

He dropped out of the film business in 1989 and painted for the next two and a half years. A show of those paintings, sponsored by the Los Angeles County Natural History Museum, opened in 1992, even as Stout headed back to Antarctica on a National Science Foundation grant, chasing another 50 paintings and drawings. On this trip, he took several dives beneath the 12-foot thick dome of Antarctic ice, where the water is so clear that a diver can see 800 feet.

Since returning from the Great White South, Stout has added to his reputation for bringing dinosaurs back to life on posters and comic book covers. As for that pinball career? "Years and years ago when people asked me what I liked to do best, I'd always say the same thing: oil paintings and comic books," Stout said. "For too long, I was doing everything but. Since I've focused on that, I've felt a sense of rightness."

The Studio

Not just any studio. *The Studio*. It filled the 12th floor of a brownstone at 37 West 26th Street. The room was 2,000 square feet, and the ceiling, at its lowest point, was 12 feet high. When the room became famous in 1975, the rent was only $400 a month. "An incredible place," Bernie Wrightson said. "There were no tall buildings to block your view. You could see clear down to the Trade Center."

The view outside couldn't match the view inside. Wrightson and Barry Smith were the two artists who discovered the room. Looking for someone to share the rent, they invited Jeff Jones and Michael Kaluta to join them. "We got Jeff right away,' Wrightson said. "He was a painter, he needed the room. Then we asked Kaluta... He said, 'I can't afford it.'"

The prospects of sharing a studio with Smith, Wrightson, and Jones soon convinced Kaluta he couldn't afford to miss it.

"Each guy had an idea what the thing was going to be, and it didn't turn out to be any of those things,' Kaluta said. "Bernie and Jeff built a model stand that turned out to be a shelf nothing more. I had no dreams; I thought it was perfection. Bernie moved all his furniture in. Barry went home to work when he got disgusted with the Studio and turned his section into a warehouse. Of all the Studio sections, Jeff's was

> *"But those four people... They just reached the pinnacle of perfection and then they left."*
> DAVE SIM

Bill Everett's Golden Age Sub-Mariner.
(TM & © 1998 Marvel Characters, Inc. All rights reserved.)

the most what you'd expect: giant canvases, works in progress, flat space to do something."

The foursome survived three years together in the loft. They survived the cold: "The heat went off at 5 o'clock," Wrightson said. "They shut it off at night and on weekends. During the wintertime, we were always working with coats and gloves on."

They survived the inevitable personality clashes. The artists would often get one another restarted by making suggestions, Kaluta said, but they always paid for it later, as if the artist needing help carried a grudge because some was offered.

They survived the expectations of the fans on the sidelines. "The renaissance that got me fired up to actually do a comic book was Neal Adams and the Studio guys," Dave Sim once said. "But those four people…They just reached the pinnacle of perfection and then they left."

"It was *The Studio* book that broke up the Studio," Wrightson said. "We were recognized as the Studio before we even knew it. One of the first things that happened was this guy came in from Big O Publishing in England. He wanted to do a book on the ten best American fantasy artists, and we, being mock arrogant, said, 'Well, you have your first four here.'

"The more we talked to the guy, the more we realized he could do a book on the four of us. About this place. About how this all came together. We convinced the guy that was what we should do, and he went along with it.

"That was *The Studio* book. It was constant arguments about the layout of the book and how it was to be written and whose work was going to be on the cover. The cover of *The Studio* book was a nightmare. All these ideas just so everyone was treated fairly. It's a piece of crap. You can't tell what's going on. We had four egos, and everyone had a completely different idea. That's what you get. It's so well reflected in the cover of that book, it's almost sad."

The brownstone, Kaluta said, "is now the Princess Kaimi. Almost all the floors are sweatshops in the upholstery industry."

Sub-Mariner

The schizophrenic Prince Namor was Timely's most popular Golden Age hero, appearing in 292 stories (the Human Torch was runner-up with 280), a suitable springboard to his reemergence in the Silver Age.

Sub-Mariner first appeared in *Marvel Comics* #1, a story that—arguably—was reprinted in *Motion Picture Funnies Weekly*. (Some comics historians believe *Marvel Comics* #1 contained the reprint.) Created by Bill Everett, the Sub-Mariner's best moments were often his seemingly endless fights with the Torch.

The character's Golden Age career ended in 1949. After a brief, groundhog-esque appearance in the mid-'50s, the Sub-Mariner disappeared until *Fantastic Four* #4 (May 1962).

Suchorsky, Mike

He was born in 1912 and died 43 years later while fishing on a stormy Saturday in October on the Delaware River. That Mike Suchorsky departed with a fishing pole in his hand didn't surprise anyone; he loved the sport and would rush through a week of drawing so he could spend his weekend on the water.

He picked the wrong weekend in 1955. The rains were relentless, and the river was up a good 10 feet when Suchorsky and an Elizabeth, New Jersey neighbor, Alex Alexa, packed their tackle and set out for Suchorsky's fishing cabin near Millford. Alexa's body bobbed to the surface the next day. Suchorsky's wasn't found for six months.

Or about 30 years before his comic book career was uncovered.

Suchorsky's story is a marvelous whodunit. In the 1960s, when Hames Ware was poring over comic book art, trying to identify the artists who produced it, for Jerry Bails's *Who's Who*, time and again he came across beautiful work he remembered from his childhood.

None of the work was signed. In the comics, Suchorsky never autographed a blessed thing. "Whenever he did a portrait or an illustration, he would sign it," said his brother, William. Why not the comic art? "Maybe he was reluctant, or he thought the end result was of no consequence."

A lot of fans disagreed on the end result, including Ware and fellow comic art historian Jim Vadeboncoeur, Jr. "It was unique and different, and unlike any other artist's work," Ware said. "In the early days, so many people were copying Alex Raymond and Hal Foster, and a lot of them were falling far short of the mark.

Suchorsky's style can be seen in his strip, *Air Force Andy*.

Mike Suchorsky

Suchorsky was a breath of fresh air. If there was anyone whose style his resembled somewhat, it was Edd Cartier, who was a famous pulp artist."

Vadeboncoeur and Ware had dozens of pages of Suchorsky's art and no idea whodunit. "Vadeboncoeur actually blew up copies of newspaper headlines in his drawings just to see if he'd sneaked anything into his strip," Ware said.

Nothing. Not even a hint. Ware wasn't getting anywhere on the road to find out until Fawcett editor Wendell Crowley suggested he get in touch with Jerry De Fuccio.

Ware ran with that advice; after a 20-year search, he had nowhere else to turn. He wrote to De Fuccio, and discovered De Fuccio also had (a) a soft spot for the mystery artist, and (b) no clue as to how to find him.

That clue was finally supplied when Ware was cross-referencing all four volumes of the *Who's Who*. He found that Herb Rogoff had worked at both Hillman and Ziff-Davis—two of the mystery artist's employers. He sent photocopies of the artist's work and begged Rogoff for help in identifying him.

Rogoff wrote back immediately: "Of course I know who this is. This is Mike Suchorsky."

De Fuccio took it from there. Rogoff believed Suchorsky was from Elizabeth, so De Fuccio hunted through the phone book until he found one of Suchorsky's two brothers, George. Finally, the stuff of the missing artist's life began to spill out.

It's hard to say who was happier, the Suchorksys or Ware and Vadeboncoeur. "Back before there was glory, there were men and women toiling in an industry who were turning out little minor pieces of art," Ware said. "Now, there are few unknowns in it, I am proud to say. We got at least some of these people's names, and the work they did, credited as they deserved to be."

So, what about Mike Suchorsky? He was the son of Ukrainian immigrants; his father passed through Ellis Island in 1903 and worked in the New York coal mines. According to Suchorsky's brothers, he was drawing pictures when he was a kid. He graduated from the Newark School of Fine Arts, spent four years at the *Baltimore Post*, and endured most of the war stationed in Nebraska or Mississippi, cranking out a comic strip called *Air Force Andy*.

After the war, the staff sergeant freelanced quite a bit. "He wanted to be an illustrator," William Suchorsky said. "*Collier's* was pretty famous; he would have loved to have been an illustrator for them. But he never broke into it. There were too many other artists."

Thus, Suchorsky began working for Hillman, Ziff-Davis, and, eventually, the American Comics Group. He smoked a pipe and worked in an attic studio in his father's house. "That studio was his aerie," said Mary Anne Zabawa, Suchorsky's niece. "There was an easel in the corner, a bed, an easychair, a rocker, and the old *Esquire* magazine characters of pin-up girls on the walls. He wasn't into kids much, but I always liked him. My brother and I would always go there to watch him work."

Suchorsky worked quickly. And every chance he got he closed the door to that attic studio early, grabbed the rod and reel, and went out looking for the fish. Even when the rain was brutal. Even when the river was high.

Suicide

Suicide was the preferred exit ramp for several comic book notables, including Robert E. Howard, Jack Cole, and Wally Wood.

Howard was the first to go. Shortly after he created Conan in 1932, Howard "began to dis-

Wally Wood, not long before his death.

play paranoid delusions of persecution," L. Sprague de Camp reported in *The Miscast Barbarian*. "He took to carrying a pistol against 'enemies,' who were probably imaginary... He owned several pistols, his favorite being a Colt .38 automatic."

On June 11, 1936, Howard plucked a beaut from his collection, jumped into his car, and shot himself in the head. He had been told that his mother, who was dying of cancer, would not regain consciousness, but Howard died before she did.

Ham Fisher overdosed on sleeping pills on December 27, 1955. The creator of *Joe Palooka*, Fisher spent the last 20 years of his life feuding with Al Capp.

The squabble escalated until Fisher publicly accused Capp of inserting pornographic images into his strip. The National Cartoonists Society eventually dumped Fisher for altering several Capp panels to prove his point, and shortly afterward Fisher hit the big sleep in his Manhattan apartment.

Next up (or next down?) Jack Cole, the inventive artist who created Plastic Man. After quitting the comics in 1954, Cole was hired by *Playboy's* Hugh Hefner to draw "Females by Cole."

"He was at *Playboy* long enough to become their ranking cartoonist," Gil Kane said. "He was an enormous success. He was riding high. But from what I understand, he was always a depressed figure, with a manic-depressive attitude."

Cole's father was an alcoholic, and Will Eisner once theorized that Cole might have thought he was becoming another one. On August 15, 1958, Cole left his home in New Milford, Connecticut and drove to a nearby town to buy a .22 pistol. After clearing the parking lot and driving for several minutes, Cole shot himself in the head.

Wally Wood called it quits at the age of 55. Wood was one of the stars at EC in the 1950s but there wasn't much left of him 20 years later.

"He was one of those guys who'd been beaten down by life, the system, whatever," said Steve Englehart. "He was very low-key; he would sit at a party and watch what was going on, rather than participate. He got old in comics and found out that his services were not required. He was one of those guys who found his moments of triumph were 20 years in the past, one of the guys who said, 'I think I made a wrong career choice.'"

Wood killed himself in 1982, apparently leveled by alcoholism and the prospect of spending the rest of his life chained to a dialysis machine. If we are to believe Harlan Ellison, his body roasted in "that squalid little room" for three days before anyone came looking for him.

Finally, Anton Furst, the set designer on the first *Batman* movie, jumped to his death in 1991. Some have suggested that Furst was heartbroken because he'd rolled over in bed one night and crushed the parakeet he lived with—I swear we're not making this up—but Dean Motter might have a different view.

Motter drew *Mr. X*, a bald guy with black sunglasses and a trench coat who walked around Radiant City muttering, "So little time, so much to do."

The visuals were the star of the show. While *Batman* was in production, Motter was told time and again that he had to check out the set designs. When he finally made the trip to the Universal lot, he discovered the set was a dark fantasy straight out of Radiant City.

Motter was still chewing on this when Furst walked in, wearing Mr. X's sunglasses and his trench coat. Doppelganger, anyone? When Furst admitted to Motter that he'd been inspired and influenced by his work, one of Motter's buddies whispered, "If he says, 'So little time, so much to do,' I'll kill myself."

It may be the most bizarre coincidence, but in the fourth issue of *Mr. X*, Motter's character throws himself off the top of a building.

Sullivan, Vincent

The editor of the two most significant books in the history of comics—*Action* #1 and *Detective* #27—isn't locked on his rearview mirrors. "I don't like to live in the past," Vin Sullivan said. "Oftentimes, it's disheartening to think of the things you could have done and didn't do. You don't live in the past. At least I don't."

But *Action* #1 and *Detective* #27 ... Let us take you back. Surely, Vin, you knew

"None of us realized." Sullivan said. "They were just another couple books that seemed to be a little more read than the others. It's hard to say that we had a purpose in bringing these things out because we thought they would

[take the world by storm]. That's not so. We were just producing things the same way a candy manufacturer would produce candy. Kids would eat them."

One of two great confectioners to roll out of Our Lady of Victory Academy in Brooklyn (Gardner Fox was the other), Sullivan got his start writing as a copy boy for the *New York Daily News*. But his interest was cartooning, and when he heard that Malcolm Wheeler-Nicholson was putting out comic books, he dropped by and asked for a job.

"He was a rather flamboyant guy," Sullivan said. "Always had a cane and wore spats. But he was sort of a con artist. Not sort of. He *was* a con artist. He was always in a financial jam, anyway. Not much of a businessman."

When the Major sold out to two businessmen—Harry Donenfeld and Jack Leibowitz—in 1937, Sullivan was part of the package. He was running the shop on Lexington Avenue when Max Gaines sent over a rough strip by a couple of kids from Cleveland.

Superman. "I thought it was good," Sullivan said. But the strip didn't get a rise out of his pulse until he saw the circulation figures from *Action Comics*. Slightly baffled by their good fortune, Donenfeld and Leibowitz made a few inquiries, Sullivan said, "and they discovered it was this character Superman. The kids liked it... or, at least, the boys liked it." So who made the decision to pop Superman back on the cover of *Action* #7? "I probably did. I was the only one handling it."

Sullivan admits that he, again, had little more than a front-row seat when Batman burst onto the scene. Bob Kane showed up one Friday asking what he could do to make the kind of bucks that Siegel and Shuster were taking home. "So I said, sure, see what you can do, bring in something," Sullivan said. "He brought in Batman."

Sullivan was definitely the guiding hand behind *New York World's Fair 1939*, the first appearance of the Sandman. When Grover Wheeland, a high roller in New York politics, was assigned to organize the fair, Sullivan suggested the comic book to Tom Dunavan, one of his Wheeland's assistants. Dunavan secured permission for Sullivan, who quickly began rummaging through the stories that were waiting for their tour of duty in *Detective Comics*.

"They were available and sitting around, so I took some of those and put them into *World's Fair*, even though they had been purchased for *Detective*." The book was sold at the fair for 25 cents. "That was unheard of at the time, but it had a stiff cover, a cardboard cover. It didn't do well at the Fair, so then they distributed it regionally."

The book turned out to be a crucial misstep in Sullivan's walk with Donenfeld and Leibowitz. He had been promised a percentage of the sales on the book, but when Donenfeld handed Sullivan his bonus check, he said, "I really don't have to do this, I'm doing this out of the goodness of my heart."

"That was ridiculous," Sullivan said. "He had promised me a percentage of the proceeds. Of course, there was simply a verbal agreement. I couldn't prove it. But that was the attitude at the company at the time. Siegel and Shuster weren't treated that well, either.

"If I had known, ultimately, what Batman and Superman would do; had they been fair and square in dealing with me as the editor; if I had known the future, I probably would have stayed on," Sullivan said. "But no one has a crystal ball. I didn't care for the attitude of those people and I don't think they particularly cared for mine."

So, Sullivan left DC and went to work at

Vincent Sullivan

Sullivan's own publishing company brought movie stars to comics. This issue of *Tim Holt* sports a Frazetta cover.
(© Magazine Enterprises)

A Charles Sultan cover for *Jungle*.
(© Fiction House)

> "He went through the daily papers and whenever he found a black-and-white drawing of a car or a house, he'd put it in the file. And whenever he needed a car or a house in the background, he'd just paste it on."
> — BOB LUBBERS

Columbia Comics, where he was given editorial control and a bigger paycheck. The control and the cash kept him happy until late 1943, when he formed his own company, Magazine Enterprises. If the books weren't as memorable, Sullivan didn't know it from the way his four sons tore into them when he brought them home.

Sullivan would usually just ring up the likes of Tim Holt, Dick Powell, and Ingrid Bergman (*Joan of Arc*) and sell them on the idea of appearing in the comics. He teamed up for a spell with Jimmy Durante on a comic strip called "Schnozzola," but it never caught fire. "Jimmy wanted $400 a week," Sullivan said, "and we could never get enough papers to pay that and my salary, too."

By the mid-1950s, Sullivan had soured on the comics. "I lost a considerable amount of money with the comic books," he said, "and I became disenchanted with them. The books weren't selling. The break-even point was 60 percent of your run, and when the book came back at 55 percent, you were losing money. How long could you keep that going? I stayed too long, I guess. It was having the proverbial tiger by the tail. You don't know when to let go."

When Sullivan finally let go in 1958, it was to secure the Popeye peanut butter franchise. "That was even worse than publishing," he admitted.

Sultan, Charles

This Golden Age artist worked at Fiction House and on such Fawcett features as Spy Smasher. "We called Charlie 'the paste-up king,'" Bob Lubbers said. "He went through the daily papers and whenever he found a black-and-white drawing of a car or a house, he'd put it in the file. And whenever he needed a car or a house in the background, he'd just paste it on."

Superboy

He first surfaced in *More Fun* #101 (January/February 1945), more than six years after Superman got the entire industry rocking. Superboy was not only mired in adolescence, but trapped in Smallville, where he hung out with Ma and Pa Kent and a host of other characters that, the reader knew, had little bearing on his future. Superboy appeared on only three *More Fun* covers before taking up new digs in *Adventure Comics* in early 1946 . . . and treating baffled readers to such classics as "Superboy's School for Stunt Men," "The Shutterbug of Smallville," and "The Super Pranks of Super-Dog." The Boy of Steel gained his own book in 1949, first teamed up with the Legion of Super-Heroes in 1958 (*Adventure* #247), and later vanished without much of an aftertaste.

Supergirl

> *Oh, yeah. I used to like Supergirl. You could see up her skirt when she was flying.*
> — GRANT MORRISON

She died—the tombstone reads *Crisis on Infinite Earths* #7—more gloriously than she had lived. Hatched in *Action Comics* #252 (May 1959), 15 years after DC had applied for the trademark on her name, Supergirl was created by Mort Weisinger, with assists from Otto Binder and Al Plastino. The artist most associated with her is probably Jim Mooney.

Weisinger's inspiration was undoubtedly the reader response to a "Super-Girl," who appeared and died in *Superman* #123 (August 1958). The character was so popular that Kara Zor-El, Superman's cousin, crash-landed the following year. Her male editors did little with her before she went toes up in 1985. She was revived in 1996 with Peter David handling the CPR.

Helen Slater played Supergirl in the abysmal movie of the same name.

Superior Comics

The most prominent of the Canadian publishing companies, Superior produced reprints and original comics from the mid-1940s until 1956, depending almost exclusively on the Jerry Iger shop. According to *Canuck Comics,* the company was owned by William Zimmerman and published under at least four imprints: Century Publishing, Herald Publishing, Dutchess Publishing, and Randall Publications.

Because American imports were banned in Canada in the late 1940s, Superior repackaged and reprinted comics by Magazine Enterprises, Gleason, and Toby, as well as two Farrell titles, *Brenda Starr* and the humor book *Aggie Mack.* In 1949 Superior unleashed *Bruce Gentry, My Secret,* and *Ellery Queen;* two years later, Zimmerman acquired the rights to publish the EC New Trends in Canada.

"Superior was the one company whose books were printed in Canada and circulated in the United States," comics historian Michelle Nolan said. In the company's prime, Ruth Roche was listed as editor and (reprising her role at Fiction House) wrote much of the original material.

Superman

"You don't tug on Superman's cape," songwriter Jim Croce advised. And you don't add too many words to his legacy: It's just more spitting into the wind.

It's a rare cartoon that evokes truth, justice, and the American way. Jerry Siegel and Joe Shuster's Man of Steel wasn't an original concept, but he sustained an original American art form.

Sixty years later, he is still the heroic epicenter of the American comics culture.

Superman was the amalgamation of everything that preceded him, from the boots to his cape, and the inspiration for all that has followed him to the comic rack. And unlike his early running mates, Superman approaches the millennium equally at home in the company of Jerry Seinfeld, one of his biggest fans, and Michael Jordan, his only real competition.

He had his weaknesses. For all of Superman's staying power, he couldn't come to the aid of his creators, who were forced to sign away his rights before *Action* #1 was published. He couldn't avoid the humiliating paces editor Mort Weisinger put him through in the 1950s. He couldn't get out of faking his own death when DC needed a marketing gimmick in the 1990s. And he can't elude the essayists who are still tugging at his cape, desperate to shake loose a metaphor.

But Superman's power and his strength have kept comic books alive. He was the industry's first success story. He's been a hard act to follow.

Superman: The Movie

When Ilya and Alexander Salkind came to DC chasing a Superman movie in the mid-1970s, Julius Schwartz suggested that Leigh Brackett write the screenplay. Brackett had scripted *The Big Sleep* for director Howard Hawks, cleaning up after a drunken William Faulkner, and would later plot *The Empire Strikes Back.*

Because Brackett lived in California, Ilya Salkind wanted nothing to do with her, Schwartz said, so he offered the job to Alfred Bester, one of his favorite science fiction writers. "Ilya interviewed Bester and was extremely impressed with him," Schwartz said—so impressed that he offered Bester $35,000 to do a movie treatment.

According to Schwartz, Ilya then went to his father and said, "I found the writer for *Superman.*"

The icon of American comics got his own title in the summer of 1939.
(© DC Comics, Inc.)

"Jerry Siegel and Joe Shuster's Man of Steel wasn't an original concept, but he sustained an original American art form. Sixty years later, he is still the heroic epicenter of the American comics culture."

The original Swamp Thing, as drawn by co-creator Bernie Wrightson.
(© DC Comics, Inc.)

"Who is it?" the senior Salkind asked.

"Alfred Bester."

"Who the hell is Alfred Bester?" Salkind said ("Although I'm sure he said it in French, or whatever the language was," Schwartz said.) "We don't want an unknown writer, we want a major writer. This is a major motion picture, we're spending millions and millions of dollars, we want to spend a lot of money for the screenwriter."

Salkind got whom he wanted: Mario Puzo.

"He was an interesting guy," said Eliot Maggin, who was scripting the *Superman* comic at the time. "He didn't know anything about comics. He came up to the office one day, introduced himself, and read comic books. He spent the first two days with Cary Bates and me, We sat around smoking these huge Havana cigars. He used to fly them in from Montreal.

"He doesn't grant interviews. I asked him why, and he said because he's too fat," Maggin said. "And he's huge. He's about so high and he must weigh 320 pounds. He was willing to talk about anything; he wasn't talked out. Mario sat around and listened to Cary and I talk about Superman. So after two days, he says, 'Oh, my gosh, this is a Greek tragedy,' and disappears for a month."

Why the Greek tragedy? "I think it was something about the loss of his parents," Maggin said. "Two days into the conversation he has an epiphany: He realizes this guy was an orphan and that was the essence of the character."

When Puzo finally returned, he had a 400-page screenplay under his arm. "No one had heard from him," Maggin said. "But he came back with a 400-page script that had to be sliced in half. It had to be changed at the beginning and end to make it into two movies. Puzo turned out a wonderful script, a beautiful piece of work, with a couple of problems. Superman wasn't powerful enough. The big deal at the end was Superman overcoming a hydrogen bomb; well, he did that every week [in the comic books]."

Maggin said Puzo was paid $400,000 for his treatment. He was one of a half-dozen writers who were eventually plugged into the final screenplay.

Swamp Thing

His first appearance was in *House of Secrets* #92 (June/July 1971), with a story by Len Wein and art by Bernie Wrightson. DC Comics had such an appreciation for Wrightson's visuals that when Swamp Thing finally reached Hollywood, Wrightson was paid a grand two grand.

In *Swamp Thing*, the movie, $2,000, coincidentally, was the total cost of Adrienne Barbeau's wardrobe.

The creature stands 7'5" and weighs 547 pounds, and takes root if he doesn't keep his feet moving. His first solo book lasted 24 issues (1972–1976), with Wrightson's artwork in the first ten. The creature spent some time hanging out with the Challengers of the Unknown (when Deadman needed a place to sleep for the night, he'd shack out in Swamp Thing's body) then returned in 1982 in *Saga of the Swamp Thing*, which is best known for Alan Moore's scripts in issues #20–#64.

Swan, Curt

For almost 30 years, beginning in 1955, Curt Swan gave Superman his dashing good looks. Thirty years. But he still remembers the day—and the paycheck—that taught him what working at DC was all about.

In the late 1950s, the Continental Insurance Company commissioned an ad showing Clark Kent changing into Superman in—where else—a phone booth. Swan supplied the pencils and Stan Kay the inks; Swan then sat back and waited for the money to roll in.

"I thought I was going to get a nice, juicy check," Swan said. "I thought I'd be on Easy Street for a week or two." He knew what ad agencies paid for such work. He knew the ad was running in *Look, Coronet,* and *Life* magazines. "That was big bucks. I should have been given a minimum of $1,500, which was a lot of money back then. And I got $200."

A company accountant told Swan just how much DC had shaved off his cut. The artist stomped in to see Mort Weisinger, his editor, shouting, "This is disgusting. This is an insult.

I don't know what you paid Stan Kaye for this job, but you take half this check and give it to Stan, and the rest of it you can shove."

Weisinger got red in the face and began to sputter, but Swan turned and walked out. "I could see right away that the company was pocketing the money and giving the creative people a pittance," Swan said. "We had no control over that. That was the last time I ever did a job like that."

But it was far from the last time he accepted a pittance from DC.

To get an idea of how Swan remembers three decades of drawing Superman, you have to go way back to the days when he never dreamed he'd make a living off comic books.

Like so many of the artists of his generation, Curt Swan was overseas during the Second World War. Before Pearl Harbor, he was stationed in Northern Ireland; after hooking on with *Stars and Stripes,* he quartered in London and Paris. He once got a battle star when he stowed away aboard a quarter-ton truck loaded with copies of the paper and—bound for a rendezvous with his wife-to-be in Belgium—he passed Patton's Army at the Maginot Line.

But after the war, oddly enough, Swan never went back to Ireland, his favorite London pubs, or the Parisian church where he was married in 1944. "I don't wax nostalgic about the military or Europe," Swan said. There was, after all, a war on.

Neither does he wax nostalgic about half a century working at DC. There was, after all, a war on.

When Swan returned from Europe in 1945, Frances Herron, a buddy from his stint at *Stars and Stripes,* introduced him to Weisinger and Whitney Ellsworth at DC. Ellsworth was a gem. "A steadying influence," Swan said. "He kept things from going way out yonder. All the editors worshipped the man."

Weisinger, on the other hand, was a jackass. "In the beginning, I was intimidated by him," Swan said, "but I soon realized that he was a very sick, insecure man. Most people were cowed by his presence. Eventually, I had no fear of Mort and I would chew his ass out. We had some terrible verbal battles."

The stress of working with Weisinger forced Swan to quit DC in 1951. He spent a month working at an ad agency, then dropped by Marvel's offices in the Empire State Building to see if Stan Lee was hiring. Lee was ready to hire him on the spot, then made the mistake of showing him the bullpen. Swan took one look at the artists crammed shoulder-to-shoulder in the rectangular room and realized that at DC, at the very least he could work at home.

So, Swan went back to Lexington Avenue. He was soon subbing for Wayne Boring on Superman, armed with a much more muscular, illustrative style. By 1955 he was the main man on the feature. "Wayne was trying to get more money, that's all, and he just got tired of them," Swan said. "He was getting jerked around. When I came in on the 3D assignment [*Three Dimension Adventures,* 1953] and was going to take over the syndicated strip, he told me, 'Watch out for them. They're going to really screw you.'

"I said 'You don't have to warn me, Wayne.'"

It wasn't the best of worlds, Swan said, and it wasn't the worst. He quickly learned not to think much about the scripts he was given—with their multicolored kryptonites and imaginary tales—or at least not to laugh out loud. "I treated it as a joke, and concentrated on my part of it, the drawing," Swan said. "It's survival. It put bread and butter on my table and a roof over my head.

"You have to be practical: Look for the plus-

> *"I could see right away that the company was pocketing the money and giving the creative people a pittance."*
> —CURT SWAN

The Curt Swan version of Superman is codified in these style sheets.
(© DC Comics, Inc)

Most of the EC artists kept their own "swipe files," but other artists seemed to have no problem swiping whole hog from the EC pencillers. A Jack Davis splash panel from Vault of Horror **#26 (August/ September 1952) apparently inspired the cover artist for** Beware **#6 (November 1953) within a year.**
(© 1998 William M. Gaines, Agent, Inc.; Marvel Comics Group;)

es and hang on to them. I got to work at home, and work as much as I wanted to and as long as I wanted to, as long as I kept them satisfied and made my deadlines. That kind of freedom didn't exist in any other job."

Swan retired from DC in 1992. He died in 1996.

Swipes

Don't you get the idea? You're supposed to swipe everything from Raymond and Caniff.
VIN SULLIVAN

Swipes—theft or tribute? As *The Comics Journal* notes, "They may be homages, parodies, ironic appropriations, bizarre coincidences, or outright ripoffs."

In the Golden Age, outright ripoffs were the name of the game. The cover of *Action Comics* #8 is straight off N. C. Wyeth's cover of the 1919 edition of *Last of the Mohicans*. Hack artists struggling to keep pace in the new industry stole everything that wasn't tied down from stylists like Alex Raymond and Milt Caniff.

Take Chuck Cuidera, an early Blackhawk artist. "Chuck was a very hardworking guy, but he had very little confidence," Bob Fujitani recalled. "It took him forever without Alex Raymond's swipes in front of him."

"The old joke," said Pierce Rice, "was, 'Do you swipe or fake?' The point being that it was more conscientious to swipe something than to do it out of your head.

"If it had been an age approaching our own in litigation, the syndicates would have been all over the comic books. But no issue was ever made of this. You'd see the stuff strewn around the comic shop table. Nothing about this was on the QT. It was universal."

And timeless. Swipes are now a part of every artist's arsenal. As Al Williamson said, "That's one thing I learned doing comic strips with John Prentice: I learned how to use swipe. I hadn't used swipe before."

Tarzan

"From the day he was born on September 1, 1875, in Chicago, until he submitted his first story to *All-Story Magazine* in 1911, Edgar Rice Burroughs failed in nearly everything he tried," Robert Hodes wrote in a preface to Burne Hogarth's *Tarzan of the Apes*.

"He attended half a dozen public and private schools before he graduated from Michigan Military Academy. Unable to secure a commission in any military unit—including the Chinese Army—he finally enlisted in the Seventh U.S. Cavalry. But at the time of his discharge, he was still a private. A succession of 18 different jobs and business ventures followed his marriage in 1900 to Emma Centennia Hulbert, and by 1911 he was pawning his watch to buy food for his family."

By 1912, however, Burroughs had written a serial, *Tarzan of the Apes*, which earned him $700 when it ran in *All-Story Magazine*.

And by 1914, he was the author of America's best-selling book.

Tarzan of the Apes first appeared on the comics page on January 8, 1929, a date that also marked the debut of *Buck Rogers*.

Hal Foster began the strip, passed it off to Rex Maxon for a spell, then returned to the Sunday *Tarzan* page in the fall of 1931. The artist and the ape man were virtually inseparable for the next seven years, although Foster confided in a letter to Russ Cochran, "Everyone assumes that I am a Tarzan buff. I never was and am not now. During the depression of the Thirties I was offered the artwork on the strip. To me it was just a job and I needed the money."

When Foster left the jungle to draw *Prince Valiant,* he was replaced by a Tarzan buff, Burne Hogarth.

In an interview with Argentinean Victor Sueiro, Hogarth observed, "[T]he success of *Tarzan* owed much to the time when it was first drawn. This was a little after the start of the great Depression: Big corporations were crashing and misery was widespread. You will note that Tarzan is a man who makes his first appearance in the middle of the jungle; in some ways the jungle was not unlike the surroundings of everyone who happened to live in the United States of 1934. Tarzan finds himself—again, like the American people—without weapons to fight off all the perils. All he has is a small knife... It is in this way, weaponless, naked, lost in the jungle with the desire to win by his own resources, that he most resembled the man in the street. People identified with him, not being aware in most cases of what Tarzan symbolized, and Tarzan was an enormous success."

And what did Tarzan symbolize?

"He is energy, grace, and virtue," Hogarth wrote in 1967. "He symbolizes the inevitable life source, the earth, the seed, the rain, the harvest, achievement, the triumph over adversity and death..."

Cochran, by the way, argues that while "Tarzan Sunday pages by Hogarth and Foster

Joe Kubert returned to the original Burroughs books for his Tarzan run at DC in the early 1970s.
(© Edgar Rice Burroughs)

> ### Tarzan in the Coal Bin
>
> *"Frazetta grew up reading Tarzan, too. His uncle read Tarzan and when he was through with the books, he threw them into the coal bin in the basement, not because it was full of coal but because it was a convenient place to store things. Frazetta would pull them out and curl up under the dining-room table and read them."*
>
> BOB BARRETT

Jesse Marsh was the regular Tarzan comic book artist at Dell in the 1950s.
(© Edgar Rice Burroughs)

had been extensively reprinted in the comic books *Tip Top, Sparkler, Comics on Parade,* and others, Tarzan did not come into his own as a comic-book character until Dell Publishing Co., in 1947, published two 'one-shot' comic books containing original material written especially for the comic book and illustrated by artist Jesse Marsh. These two one-shots were successful enough for Dell to start publication of a new monthly *Tarzan* comic."

John Celardo and Russ Manning both had stellar tours of duty on the *Tarzan* comic strip. When DC acquired the comic book rights to Tarzan in 1972, Joe Kubert illustrated the resulting series. Dark Horse currently has the Tarzan franchise and in 1995 unveiled a previously unpublished Burroughs novel, *Tarzan: The Lost Adventure.*

Teenage Mutant Ninja Turtles

We'll be brief. In 1983, Kevin Eastman and Peter Laird were living on peanuts—or the scrapings off the bottom of the peanut butter jar—in New Hampshire when Eastman doodled the first turtle in ninja garb.

He took his cue from Dave Sim and *Cerebus.* Where Sim had parodied Barry Smith's *Conan,* Eastman crossed Frank Miller's *Ronin* with Jack Kirby's version of the X-Men.

With a $500 income tax rebate and a loan from a generous, if perplexed, Eastman uncle, the pair published a first run of 3,000 copies. Knowing nothing about distribution, they took out an ad in *The Buyers Guide,* hoping to sell one copy at a time. Calls from curious distributors changed all that.

Eastman and Laird sold most of that initial print run at a 60 percent discount so they could afford a second run of 6,000 copies. Issue #2 generated a 15,000 print run.

Before they knew it, they had an animated TV series, 3D figures, movies, and parodies. And Eastman was running Tundra and paying (rumor has it) $10 million in taxes. So much for rebates.

The Turtles are now nostalgia items, and Eastman and Laird have gone their separate ways.

Teen Titans

Sidekicks Robin, Kid Flash, Aqualad, Wonder Girl, and Speedy first teamed up in *The Brave and the Bold* #54 (June/July 1964). The gang was briefly reintroduced in *DC Super-Stars* #1—which was dated March 1976, seven months after Marvel redesigned its premier team in *X-Men* #94. The "New Teen Titans," co-created by George Pérez and Marv Wolfman, finally arrived in late 1980 in *DC Comics Presents* #26. The revived squad featured Robin, Changeling, Starfire, Raven, Kid Flash, Cyborg, and Wonder Girl.

Terry and the Pirates

Milton Caniff's—and history's—most influential strip debuted as a daily on October 22, 1934. For the next 12 years, Caniff's *Terry* set the pace on the comics page with its dramatic tension and superb cast of characters. His journey on the strip, Jules Feiffer observed in the forward to the short-lived Remco reprint series, "was to remodel the adventure strip from boyhood and innocence (best exemplified by Crane's *Wash Tubbs* and *Captain Easy*), and drag it, kicking and screaming, into adulthood and sexual shenanigans."

Terry and the Pirates was helped on its way by Caniff's exquisite blend of locale, camera angles, dialogue, and chiaroscuro. "Black," Feiffer noted, "is Caniff's primary color," and his

blacks, once given room to grow, have an overwhelming impact.

The strip began its fade to black in December, 1946, when Caniff moved on to *Steve Canyon* and other creators (most notably George Wunder) took over the strip.

Tex Thompson

The Bernard Baily western feature appeared in *Action* #1. Tex later found himself in a super-hero strip, *Mr. America*.

This…This…This Limited Vocabulary

Another collection of titles from the Silver Age of Marvel:

"This Hostage Earth" (*Avengers* #12)
"This Battleground Earth" (*Thor* #144)
"This Power Unleashed" (*Avengers* #29)
"This Monster Unleashed" (*Incredible Hulk* #105)
"This World Enslaved" (*Fantastic Four* #123)
"This World Renounced" (*Thor* #167)
"This World Gone Mad" (*Marvel Premiere* #3)
"This Is the Way the World Ends" (*Avengers* #104)
"If This Be My Destiny" (*Amazing Spider-Man* #31)
"If This Be Justice" (*Daredevil* #14)
"If This Be Doomsday" (*Fantastic Four* #49)
"If This Planet You Would Save" (*Strange Tales* #160)
"This One's for Dino" (*Sgt. Fury* #38)
"This Man, This Monster" (*Fantastic Four* #51)
"This Man…This Frog" (*Amazing Spider-Man* #266)
"This Dream, This Doom" (*Giant-Size Dr. Strange* #1)
"This Issue: Everybody Dies" (*Uncanny X-Men* #142)

Thomas, Roy

Roy Thomas's admission ticket to the comics business was a letter from Mort Weisinger, perhaps the only DC editor Thomas hadn't bombarded with fan mail over the years. In 1965 Mort needed a new assistant editor (to replace E. Nelson Bridwell) and was willing to give Thomas a shot.

"Weisinger was such a malevolent turd," Thomas said. "He arranged when I got there, and told me that he couldn't start paying me until the next week. I arrived with nowhere to stay. Mort called the George Washington Hotel. I stayed there, but I didn't have a desk. All I took was one suitcase and my electric portable typewriter. When I did the Marvel writing test, I had the typewriter on my chair, which was great on my sore back."

The *Marvel* writing test?

"I wanted to meet Stan Lee, so I dropped him a line with the George Washington Hotel return address," Thomas said. "He left a message. Stan wasn't much on socializing with people.

"He suggested I try this writing test to see how to write dialogue for the Fantastic Four. It was just an annual with the dialogue whited out. I picked it up from Flo Steinberg and brought it back the next day. I wasn't thinking about quitting [DC], but it was hard to resist that kind of challenge."

Thomas was at DC, proofreading a Supergirl story drawn by Jim Mooney, when Steinberg called. "I went over during my lunch hour," Thomas said. "Stan and I talked for five or ten minutes; we never did discuss that writing test. After about ten minutes, Stan got up and just stared out the window at Madison Avenue and said, 'Well, what do we have to do to hire you away?'"

Why, bump my salary up $10, Thomas said. Weisinger had promised him $110 a week, but Thomas was told he would only be getting $100 per week on his first day on the job at DC. Thomas told Lee that if he could fork over $110, he had a new writer.

Thomas was 90 minutes late returning from lunch. "Mort was chewing out some other

Caniff's *Terry and the Pirates* debuted on October 22, 1934.
(© News Syndicate Co.)

Roy Thomas

assistant editor when I got back, so I had to wait," Thomas said. "I gave him indefinite notice. I told him I'd stay around until he got a replacement."

And Weisinger said, "That's awfully sweet of you, Roy," right?

"He kicked me out three seconds later," Thomas said. "I went back to Marvel and Stan gave me a *Millie the Model* story to do over the weekend."

Seven years later, Thomas became Marvel's editor-in-chief, its second in 30 years. "Stan didn't want to relinquish anything, he just wanted to move up the ladder," Thomas said. "He wanted to become the story editor and to create a triumvirate of equal power between me and John Verpoorten and Frank Giacoia. With a triumvirate, there's always a weak leg. I was about to quit, when Gil Kane said to me, 'My boy, don't quit, because everything will come to you. The art director isn't anyone Stan can depend on. The production manager doesn't care about anything but having a job.'

"In a couple weeks, Stan started complaining about some things that were done artistically, and I said, 'I can't do anything about it. You've created a situation where we're all equal partners.' Stan changed the situation and I became editor in name."

Thomas survived two years before Jim Shooter took him out. He continued to write extensively over the years for both Marvel and DC, venturing out to adapt *Dracula* and *Jurassic Park* for Topps in the '90s. Thomas was also a major player in comic fandom in the early '60s, creating the fanzine *Alter Ego* and writing scores of letters to Jerry Bails and Gardner Fox.

Thompson, Don and Maggie

Two members of the "first tier of comic fandom"—to quote Roy Thomas—Don and Maggie Thompson published their first fanzine, *Comic Art* #1, in the spring of 1961. Thirty years later, they were still in fandom's front row as editors of the *Comics Buyer's Guide*.

The Thompsons first met in 1957 at a science fiction fandom picnic, when Maggie was 14, and they were married in 1962. Active in many of the early mating rituals of comics enthusiasts (the Alley Awards, anyone?), the Thompsons published *Comic Art* throughout the '60s, the sixth and final issue appearing in 1968.

The couple developed a checklist of Dell *Four Colors;* managed the amateur press association CAPA-Alpha after Jerry Bails resigned; and were narrowly beaten to the discovery of Carl Barks's identity by Malcolm Willits. And Don Thompson co-authored, with Dick Lupoff, a collection of essays on comics, *All in Color for a Dime,* that was published in 1970 (a follow-up, *The Comic Book Book,* was published in 1973).

When Alan Light asked the Thompsons in 1970 to join him in publishing a newspaper for comics fans, they passed. Light subsequently decided to produce an ad-zine, which he dubbed *The Buyer's Guide to Comics Fandom.* The Thompsons eventually contributed a column, "Beautiful Balloons," to *TBG;* when Krause Publications purchased the tabloid in 1983 and renamed it *Comics Buyer's Guide,* Don and Maggie were hired as co-editors.

Don died of a heart attack in 1994, and Maggie has continued in the role of editor of the comics industry's only weekly trade publication.

Thor

First appearance? Probably a 1942 Sandman story, written by Jack Kirby, in which we find "The Villain from Valhalla," a musty creep named Thor who is armed with an exploding hammer dubbed Mjolnir.

"I always liked mythology," Kirby said in an *Amazing Heroes* interview. "I've been inclined in that direction ever since I've been looking for characters other than gangsters. That's how I got Galactus; that's how I got the Silver Surfer. I began to look through the classics, the Bible, any kind of work of that sort. Finally, you get yourself going to the gods..."

After 20 years of going to that well, Kirby's Norse hero finally caught on in *Journey into Mystery* #83.

Thrill Comics

This was one of two 12-page comics featuring Captain Thunder (the other being *Flash Comics*) that Fawcett printed in October 1939,

Don and Maggie Thompson in the 1970s

Thrill Comics

> ### Those Fabulous Fifties
>
> *And much in the same way that Hollywood killed itself off, so did the comic book business. If you can sell one war comic you can sell five, and if you can sell five you can sell a hundred. The same went for horror, love, funny, and 3D comics. When you turn out such a volume of stuff, the quality is going to suffer. There weren't enough competent artists around to turn out good work, so schlock was put on the stands. In a horror story it didn't matter if the story stank and artwork was rotten as long as it showed a lot of guts hanging out and blood-sucking and other perversions.*
>
> *Most of the comic book publishers showed the same lack of taste or any aesthetic sense that their Hollywood counterparts did... Like the moviemakers, publishers had the artists by the short hairs; and they knew it, the same way their brothers knew it in Hollywood. For every petty tyrant and tin god in Hollywood there was an equal in New York. For every tasteless, sadistic son-of-a-bitch with a collection of dirty pictures and a mind to match in the golden west there was another back east with his collection of whips and chains being serviced by a series of $100-a-night call girls. "Taste? Who needs taste? I can buy taste." Vulgarity was a way of life.*
>
> HOWARD NOSTRAND *GRAPHIC STORY MAGAZINE*

one month before the publication of *Whiz Comics* #2.

The black-and-white books were distributed for promotional purposes and to secure the copyright for the titles. Fawcett failed to nab either one; DC won the race for the rights to *Flash Comics,* and Better Publications was first on the block with *Thrilling Comics.* As for Captain Thunder, he metamorphosed into Captain Marvel for his debut in *Whiz.*

Although Fawcett probably printed several dozen copies of *Thrill* #1, no surviving copies surfaced until the mid-1980s. Old Fawcett artists remembered the book, but most historians had assumed all copies were destroyed.

In 1985 Steve Fischler of Metropolis Comics got word that CBS Magazines was selling off the Fawcett and Standard material that had been gathering dust for 40 years. The Fawcett files were stored inside an armory in Greenwich, Connecticut.

When Fischler made the drive to Greenwich, he found the armory guarded by "a bunch of little old ladies. It was one big room with these rows of filing cabinets. In each filing cabinet were bound volumes of Fawcett books. In the other corner of the room were boxes containing everything Fawcett had from its lawsuit with DC. Court evidence. Stamped on the bound volumes were, 'Please return these volumes by Oct. 21, 1942.' And there they were, still sitting there. They had *Action* and *Marvel* 1 through 20, all bound. It was incredible to look at."

Finally, there were two more cardboard boxes, about the size of liquor cartons, stamped "Fawcett Fan Club."

"I opened them up," Fischler said, "and there were all these Captain Marvel premiums. There was a Captain Marvel statue, all these different giveaways and watches. And in the back of one of the boxes was a manila folder. I opened up the folder and out came four *Thrill Comics* with Captain Thunder and eight *Flash Comics* with Captain Thunder."

Fischler could feel the chill nipping at the base of his spine: "It was literally one of the Holy Grails of comic books."

But there was a Monty Python twist to the story: This part of CBS Magazines inventory wasn't for sale. "They were going to destroy the Fan Club items," Fischler said. "CBS Magazines was a conglomerate, and they didn't want to get into any legal problems. They were only selling items they were sure they owned. The Frank Tinsley paintings and pulp and men's magazine covers? If they weren't sure who owned them, they would incinerate them. If we didn't take them out of there, they were going to destroy all the *Thrill Comics.*"

So, Fischler under the vigilant eye of the armory watchdogs, began moving the Fan Club items into the filing cabinets. While pretending to repack the materials and clean up his mess, he moved the comics and premiums from box to box until they were safely inside the cabinets.

Then he bought the lot of it and made his escape.

No other copies of *Thrill Comics* have ever been found. (see also the **Ashcan** entry)

The elusive *Thrill Comics* #1.
(© Fawcett Publications)

Steve Fischler

Thrilling Comics

After they published pulps such as *Thrilling Adventures*, *Thrilling Detective*, *Thrilling Love*, *Thrilling Mystery*, *Thrilling Ranch Stories*, *Thrilling Western*, and *Thrilling Wonder Stories*, no one was too surprised when Standard Publications uncorked *Thrilling Comics* in February 1940.

The title lasted 11 years and 80 issues, more than half with covers by Alex Schomburg. Doc Strange and the Commando Cubs usually captured the cover; Frank Frazetta's art appeared in issues #66–#73.

The long-running *Thrilling* sported many a Schomburg cover. This is #40 (February 1944).
(© Standard)

Thun'da

This six-issue title from Magazine Enterprises featured the only comic book that contains Frank Frazetta artwork from cover to cover.

Frazetta has also claimed, on occasion, that he wrote the first Thun'da story, but most of the credit should probably go to Gardner Fox. When Frazetta heard that ME was looking for a Tarzan ripoff, he walked into editor Ray Krank's office with sketches, drawings, and a rough story outline.

Krank called in Fox to flesh out the story. "They wanted a caveman story with jungle overtones," Fox said in a letter to Robert Barrett, "and Thun'da was the result…The story was mine, though based very definitely on Frank Frazetta's story idea."

The name "Thun'da" was suggested by Krank; it was meant to recall "thunder," not Edgar Rice Burroughs's Thandar.

T.H.U.N.D.E.R. Agents

The Higher United Nations Defense Enforcement Reserves, first appeared in *T.H.U.N.D.E.R. Agents* #1 (November 1965), published by Tower Comics. The team included three super agents (Dynamo, NoMan, and Menthor) drawn by Wally Wood.

The Ting-Ling Kids

Charles Saalburg's *Ting-Ling Kids* is, in Rick Marschall's mind, the first comic strip. The color adventures of the Asian urchins began in the *Chicago Inter-Ocean* in 1893. Saalburg later became the art director for Richard Outcault (creator of the *Yellow Kid*) at the *New York World*.

Tintin

In America, in the Congo, in Tibet, or fully engaged with the Red Sea Sharks or the Crab with the Golden Claws, Tintin was never one to duck controversy or a connecting flight. "Herge"—the Belgian cartoonist George Remi—unveiled his comic hero in 1929. A devout fan of Charlie Chaplin and Winsor McCay, Herge equipped his obsessive boy wonder with a cast that included Captain Haddock, Professor Cuthbert Calculus, the comic twins Thomson and Thompson, and Snowy (or Milou), Tintin's loyal fox terrier. Tintin, like his creator, never failed to plunge into a landscape of political turmoil, tumbling headlong into Communist Russia (*Land of the Soviets*), Japan's war against Manchuria (*The Blue Lotus*), and several battles against the despotic Musstler, the apparent marriage of Mussolini and Hitler. Herge was 22 when he wrote the first of his

Toilet Training

Comic books should be something that you read on the toilet and not worry too much about. So should everything else.
JAY LYNCH

Next to Mickey Mouse, Tintin is probably the most popular comics character around the world. This page is from *Land of Black Gold*, in a 1969 version.
(© Herge/Castermen)

22 Tintin tales, and he died on a March night in 1983... at 2200 hours.

Top Notch Comics

An MLJ title debuting in December 1939, *Top Notch* launched The Black Hood ten months later in issue #9. "The Man of Mystery" was a New York cop named Kip Burland who began his career battling an emaciated character called The Skull. The Black Hood was tough enough to survive the addition of a laugh track on the book, which became *Top Notch Laugh* with issue #28. But he ran for cover after issue #44, one month before the book shut down.

Torchy

Bill Ward's "Blonde Bombshell" is one of the comics' best-known good-girl art objects. Make that "good girl, bad art." Ward warmed up to the subject in a comic strip titled "Ack-Ack-Amy" in the *Quonset Point Scout,* a naval air base rag. Torchy first appeared in *Doll Man* #8 (Spring 1946) and began a run in *Modern Comics* that fall. A stick figure with breasts, Torchy is evidence of Ward's boast that he didn't learn much at art school.

Total War

Wally Wood's soldiers' tale was published by Gold Key in 1965. Wood wrote and illustrated both issues (as well as the first issue of the book's successor, *MARS Patrol* #3) of the clash between alien invaders and the Marine Attack Rescue Service team.

Toth, Alex

> *Several years ago, before I went into comics professionally, National gave conducted tours of their offices. Taped to one wall was a yellowed page of original Alex Toth art. Obviously, it had been there a long time. I asked, "Why?" and the answer was, "It shows how a story is told."*
> JIM STERANKO

Many feel Alex Toth reached a peak in his storytelling with Zorro.
(© Zorro Publications, Inc.)

> *I respond to honesty of skill, motive, talent, and preparation. I detest stupidity, ignorance, and arrogant disrespect for craft, in a professional—and I've made enemies of such people in the last 30 years. Much to my own disadvantage, I might add! But I am what I am, and it's the only way I know to live a life, in as honest a manner possible.*
> ALEX TOTH

"Next to Eisner," Gil Kane once said, "Toth was the comic medium's most important teacher." He taught Len Wein how an artist brings his life into balance: "The first half of your career," Toth said, "you learn what to put in; the second half of your career, you learn what to take out."

Toth was taking stuff out until the day he got out of the business. He got into the business as a freelancer for *Famous Funnies* in 1945, only to have a paper strike bounce him to the unemployment line. Shelly Mayer hired him at All-American Comics in 1947 and quickly put him on Green Lantern.

"At the age of 16 or 17, [Toth] was doing things far in advance of what we were doing," Joe Kubert once said. Added Gil Kane, "Alex Toth was, at 21 or 22, I think, the best artist in the entire business. And the work that he did at that time is work that even he finds difficult to touch."

Toth liked the cutting edge. "He's accepted so little of what's gone before," Dick Giordano once told *The Comics Journal.* "He struck out on his own in the beginning, and he's still on his own. He's done things nobody else would think to do, and nobody else would have the courage to do, and he's done it and insisted that it was correct."

Toth—whose influences include such illustrators as Noel Sickles and Austin Briggs—insisted on changing direction every few years. After a couple of years on titles such as *Green Lantern* and *Johnny Thunder,* Toth quit DC in 1952 and went to work at Standard, where his primary assignment was romance stories. Mike Peppe, an editor at Standard, said the publisher's artistic staff had one golden rule: "Draw like Alex Toth." The artist was in the service between 1954 and 1956, then spent four years at Western, where he was best known for his work on *Zorro.* Toth joined Hanna-Barbera's anima-

And so it went all morning, on 'locations' all over the city!

Toth experimented with a number of art techniques, including washes, in his stories for Warren's black-and-white magazines.
(© James Warren)

tion department in 1960 (where he did the character designs for *Space Ghost* and other shows) but did some of his finest work in the early 1960s for James Warren.

"I always felt," said Archie Goodwin, an editor at Warren at the time, "that sometimes my stories were not quite up to what Alex did."

Robert Kanigher, needless to say, never suffered from such insecurity. "I recall Alex doing the art on a story of mine, 'White Devil, Yellow Devil,'" Kanigher once said. "I told it from the viewpoint of a young Japanese sniper. His lieutenant was warning him and his companions that the Americans were white devils who would kill them and steal the teeth from their mouths. When the Lieutenant said that, I described something that people automatically do: I had the young Japanese sniper touch his gold tooth with his tongue in fear. It was just a touch, but Alex was able to bring it off. That's talent. Authentic talent."

As Toth retreated toward isolation in the 1980s, it didn't sit well with former cartooning buddies like Irwin Hasen. "He's a genius," Hasen argued. "We all realized that. A master of design, a master of simplicity. But he was a strange man. Toth is stuck in a time warp. He lives in the '40s and '50s. He never went past the potential of what you can do with your own genius and talent. You can't be a hermit. You can't isolate yourself. And that was his choice."

Jim Amash, a North Carolina dealer who got to know Toth well in the early 1990s, is more hospitable. "Alex is a '30s kind of guy," Amash said. "A lot of his values—morally, ethically—were formed then. He takes himself very seriously, but he's not full of himself. They call him the 'artist's artist'? Alex doesn't believe that. He's the sort of guy who wants to go to that old-fashioned diner sit at the lunch counter, have an old-fashioned meal, and strike up a conversation with the guy next to him."

"He *was* the artist's artist," Gil Kane said. "During the late '40s and '50s, Alex Toth dominated the field; he had the same influence that Jack [Kirby] had during the '60s. When he worked with DC, every friggin' issue would show a 7-foot-jump into a new stage of development."

"I don't think the general reader appreciated Alex," Murphy Anderson said. "He could tell a story when he wanted to, but he was so wrapped up in design that he forgot to tell the story."

Unlike Kirby, Kane added, flexibility wasn't Toth's strong suit: "When he went into animation, the field began to change. All of a sudden the super-heroes hit and he was totally out of touch. When Kirby went into the super-hero stuff, Alex went into the tank.'

That didn't disappoint those peers who didn't consider Toth the perfect luncheon-counter companion. 'Everyone always admired his excellence, but he was never a popular figure," Kane said. "I had so many fights with the guy, we haven't spoken in years. He never felt he was appreciated by the people who employed him. He was quirky. You couldn't question him. He always felt persecuted and misunderstood.'

The reclusive Mr. Toth lives in Los Angeles, doing occasional assignments that strike his fancy.

Alex Toth

Toth's own character, Johnny Bravo, bore quite a resemblance to him.
(© Alex Toth)

Towel Service

At The Inkpot Awards banquet held during the 1994 San Diego Comic-Con, Will Eisner got up and told a Jack Kirby story.

To set the stage, Eisner ferried everyone back to the Eisner-Iger shop of the early 1940s. "It was in those halcyon days, when we all worked side by side, all of us facing instant starvation," Eisner said.

At one point the shop's towel service was getting increasingly expensive, and Jerry Iger, getting increasingly irate, ordered Eisner to solve the problem.

When Eisner tried to negotiate the towel issue, the service told him they'd send an account exec right over. The account exec turned out to be at least eight feet tall and was packing cauliflower ears. You got a problem, he asked Eisner?

Eisner was speechless until a little guy with a cigar in his mouth left his drawing table and stepped up behind him. "Get out of here," Jacob Kurtzberg ordered the muscle. "We don't want your crappy towel service."

And the account exec, Eisner said, beat a measured retreat.

An hour later, Al Feldstein received his Inkpot. His first job in the business, he noted, was at that same Eisner-Iger shop, erasing fingerprints in the page margins.

Eisner told the "towel service" story in his graphic novel *The Dreamer*.
(© Will Eisner)

"And why," Feldstein asked, "were there all those fingerprints in the margins? Because they didn't have any damn towels!"

Treasure Chest

Published by the Catholic Guild and available only during the school year, *Treasure Chest* was the only legal comic book tender in most parochial schools between 1946 and 1972. The 365 issues—most of which feature the wholesome adventures of Chuck White, the All-American Catholic boy—have a considerable amount of artwork by Reed Crandall and occasional guest shots by Murphy Anderson and Bob Powell.

Trump

"But you know the history of *Trump*—we were out of business before we hit the stands," said noted cartoonist Arnold Roth. "Hugh Hefner, the publisher of *Trump*, had to fold the magazine because the bank called the loan in . . . Hefner had not put up any collateral—this is as I heard the story. He was the boy genius of Chicago because of *Playboy*, which had been booming for about four or five years. The bank asked him to put up pieces of *Playboy* as collateral and he wasn't going to do it. So they called the loan in and he lost money. Harvey [Kurtzman] always told me that we would have been making money by the fourth or fifth issue. He said some of the most famous writers in America were coming to the *Trump* office looking for work."

Tudor City

A Manhattan high-rise overlooking the East River at the east end of 42nd Street, Tudor City was home to Will Eisner's studio after Eisner split with Jerry Iger in 1941.

When Bob Fujitani arrived for his six-month stint, he found a "small room, maybe 20 feet by 12 feet." There were six drawing tables, jammed so close together that it was fortunate all six artists were right-handed. On one side of the room were Bob Powell, Nick Viscardi, and Fujitani; on the other side were Tex Blaisdell, Chuck Cuidera, and Dave Berg.

Cuidera was working on *Blackhawk*, Viscardi on *Lady Luck*, and Powell on the newspaper insert headlined by *The Spirit*. Fujitani and Berg worked closest to the door leading into a sec-

ond room, Eisner's domain. "He was all by himself," Fujitani said. "The room may have been a little bit smaller, but he had a bathroom."

Upstairs, in a separate apartment, was Lou Fine. Fine was working for "Busy" Arnold at Quality Comics, but owing to his polio wasn't equipped to make the daily commute to Quality's headquarters in the Gurley Building in Stamford.

The walls of the studio were bare, except for what Fujitani remembers as "a couple of Will Eisner's attempts at illustration. It was just a smoke-filled room. Eisner never smoked, but we all did. Everyone smoked like crazy. The air was just blue in there." The smoke had one blessing, Fujitani said: It obliterated the odor from a nearby slaughterhouse.

Although their drawing tables touched, the artists in the Tudor City shop rarely did. "There was a little playground down below. We'd go down and play handball once in a while," Fujitani said. "Lunch was a delicatessen down the street." But the shop artists rarely ate together or hung out together. Nine-to-five and home.

On one point they agreed: "They all hated Eisner," Fujitani said. "I know that's natural. I remember working as a teenager with an apple-picking gang, and we all hated the boss because he wanted more apples picked. Well, maybe hate is the wrong word. They were always annoyed with the boss."

Eisner relied on two people: Blaisdell and Alex Kotzky. "Tex was the guy," Fujitani said. "Tex was the supervisor in the studio. He had a tremendous sense of humor. He wasn't a very good straight artist, but he was good at cartoons. Eisner liked cartoon type drawings, too, as you could see in *The Spirit*. If you had any trouble, Tex would come around and he'd help break down and lay out the panel so it had a little humor in it. So many of us were involved in the technical part of drawing that we'd lose the humor in it."

And Kotzky? "He idolized Eisner. He did everything for him. He was an errand boy."

Most of the studio staff, along with Jack Cole and Gill Fox, were Creig Flessel's guests at the illustrator's club one night when Kotzky fielded a call from Eisner. The boss was over at the Advertiser's Club, Kotzky reported, and wanted everyone to come down for dinner.

> **Twenty-Year Phenomenon**
>
> *The 20-year phenomenon will continue to govern. As something matures to 20 years old, no matter how bad it was, no matter how unsellable it was, it becomes a collectible. People go, "Hey, it's 20 years old and it's only $1.50. I'll buy that."*
>
> RON RUSSELL
> REDBEARD'S BOOK DEN

A half-dozen pedestrians were tramped in the rush across town. After drinks, Eisner told everyone to order up. But after dinner he glanced at his watch, whispered a few words to Kotzky, then rushed out the door. According to Fujitani: "After he left, Kotzky said, 'Will wanted me to tell you he's a little short and if you pay for your own dinner, he'd really appreciate it.'

"Chuck Cuidera hit the ceiling: 'God damn that son of a bitch, I knew something like this would happen. The cheap bastard invites us down here and we end up paying for it.' That was typical of the Eisner-Kotzky relationship. Kotzky always had to deliver the bad news."

Turok, Son of Stone

Turok and Andar's lost weekend in the Lost Valley began in *Four Color* #596 (December 1954) and spawned, 15 months later, their own magazine. The series got its second wind with issue #24 when Alberto Giolitti drew the first of his 87 issues.

Valiant resurrected Turok in *Magnus, Robot Fighter* #12 (May 1992).

Tuska, George

Name a sweat shop or publisher. Any sweat shop or publisher. Chances are George Tuska worked there. Eisner-Iger? He started there. Chesler? Of course. Fiction House? "I sat next to George when I got to Fiction House," Murphy Anderson said. "He was there for a couple of weeks. George could walk in on almost any publisher and get work, so if he got a little miffed about something, or wanted a change, he'd simply leave."

He'd leave for Lev Gleason or Marvel or DC or wherever the spirit moved. For more than 50 years, beginning in 1939, Tuska worked here, there, and everywhere . . . and the main thing

> *"The smoke had one blessing. It obliterated the odor from a nearby slaughterhouse."*
> BOB FUJITANI

Tuska's most memorable Golden Age work was for Lev Gleason's crime comics, particularly the "Mr. Crime" stories.
(© Lev Gleason Publications)

the old-timers tend to remember about him is the right hook he tossed at Rafael Astarita.

"The story," Gil Kane said, "is one of the legends in the field." In later years, Astarita was the first to admit he didn't remember the punchline. "I was out on my feet," Astarita said, "he hit me so hard. They told me later that I knocked over some tables."

Tuska knocked over his share of tables in his haste to move on. Discharged from the Army in 1943 when a training accident cost him the hearing in his left ear, Tuska drew for Fiction House, Chesler, Fawcett, and Harvey before cutting back on his freelancing and settling down with Lev Gleason (and, occasionally, Ned Pines) in 1946. His work in *Crime Does Not Pay* is still drawing raves 50 years later.

Tuska drew two syndicated strips—*Scorchy Smith*, followed by *Buck Rogers*—between 1954 and 1965. When *Buck Rogers* was canceled in 1965, Tuska called Stan Lee looking for work, rekindling a relationship that served him, and comic fans, for the next 22 years. He penciled most of the Marvel characters, including Captain America, Daredevil, and the Avengers, but found Iron Man suited him the most. "While the Iron Man persona was invincible, the Tony Stark character was very fragile," Tuska told *Comic Book Marketplace* in 1996. "I liked the contrast."

If Tuska was a man of few words—Bob Fujitani, who worked with him at Lev Gleason, noted, "I don't remember him speaking at all"—his artistic output inspired considerable respect among his peers. Tuska was one of the major guests at San Diego's Comic-Con International in 1997, where he received an Inkpot Award for lifetime achievement.

Two-Gun Kid

One of the many western "kids"—Kid Colt, Rawhide Kid, Ringo Kid, and the Kid from Dodge City—running around Marvel and playing with guns in the 1940s and 1950s, the Two-Gun Kid first appeared in his own book in 1948. Before he was reduced to reprints, such fine artists as Al Williamson, John Severin, Reed Crandall, and Bob Powell supplied Stan Lee with the ammunition that kept the Kid going.

Uncle Sam

Will Eisner's patriot first appeared in *National Comics* #1 (July 1940) and remained on the Quality book's cover for the next 40 issues. Most of those covers were done by Lou Fine, Reed Crandall, or the two in tandem. DC revived the character in 1997 with a miniseries painted by Alex Ross.

Uncle Scrooge

Carl Barks's crowning achievement first appeared in "Christmas on Bear Mountain" in *Four Color* #178 (December 1947). In the beginning, Barks simply needed a rich uncle who owned a cabin in the woods; in the end, he had created a multifaceted miser with almost as much character as he had cubic yards of cash.

When Barks was honored by a joint memorial of the Oregon Senate shortly after his 94th birthday, his grandson, Brad Pattie, recalled when a familiar subject popped up in school back in 1951.

"They were talking about Scrooge," Pattie said, "and I raised my hand and told the teacher that my grandfather created Uncle Scrooge. Unfortunately, they were talking about the Dickens Scrooge and I was talking about the real one."

Undergrounds

Every hippie I knew in those days was eager to read Zap *or* Bijou *or* Homemade. *It didn't have to be brilliant; it just had to be honest."*
DENIS KITCHEN

Underground? "They were never underground in a revolutionary sense," the late Clay Geerdes once said. "They were always published in a known place and time by known people, and the police or the military could have come and closed them down at any time. They were called 'underground' because [Robert] Crumb called them underground. I always say that it was Harvey Kurtzman who coined the term, because he had a mock news item on the cover of *Mad* #16 that said 'Comics Go Underground.' The reference was to the Comics Codes and to McCarthyism and repression in general."

Kurtzman had impressive coin in those days: Most of those "known people" were weaned on *Mad* and the rest of the ECs. Most were campus humor magazine grads. They were hippies and poster artists and dopers, just looking—as Jack Jackson once said—for ways to entertain their friends.

And that could be a struggle. Jay Lynch was in Chicago in the early '60s, peddling a hippie magazine called the *Chicago Mirror* on the streets. "It didn't get much response," Lynch recalled. "The hippies didn't get satire; they wanted cosmic visions. You know what taught me I was doing something wrong? People were smoking banana peels and saying banana peels got you high. So I published a thing about dog poop. I said it was a power psychedelic, distributed by roving dogs, and gave directions how to cure poop. Then one day when I was selling magazines on the street, a hippie came up to me and said, 'Oh, man, thanks for the tip, that dog poop was great.' When I got that copy of *Zap Comix* in the mail, I thought maybe we should be doing a comic book instead . . . "

Zap, Geerdes said, "was the book that turned on all those light bulbs and taught people they did not have to submit to the East Coast comic book monopoly and wait for acceptance or rejection. *Zap* taught them they could do their own."

Crumb's seminal work wasn't, however, the first underground comic. That credit goes to Frank Stack and Gilbert Shelton, cartoonists

Lou Fine collaborated with Eisner on many an Uncle Sam story in *National Comics.*
(© Quality Comics Group)

Frank Stack's "Adventures of Jesus" is thought to be the first underground comix series.
(© Frank Stack)

Zap was the seminal work that inspired others to publish undergrounds. Victor Moscoso was one of the comix's mainstays.
(© Apex Novelties)

who first met while Stack was editing the humor magazine at the University of Texas. After the pair graduated, Shelton was publishing Stack's wry strips on the adventures of Jesus in *The Austin Iconoclastic Newsletter* in 1962 when he decided they needed a much wider audience.

"He took eight of Stack's single-page strips to a friend who had access to a photocopying machine and together they ran off about 50 copies of each page," R. C. Harvey noted in *The Art of the Comic Book*. "Shelton supplied the cover, a thumbnail-size drawing of the head of Jesus, with the title *The Adventures of J* and the byline 'By F.S.,' and stapled all the pieces together, thus creating the first booklet of comix."

At the time, Kurtzman's *Help!* was publishing Crumb, Shelton, Lynch, and Skip Williamson; by 1965, New York's *East Village Other* was also offering these revolutionaries space to fill. Still, fledgling cartoonists were so desperate for a paycheck that they were doing work for Topps and Bazooka. And when they couldn't find such work, they were, increasingly, drifting westward to San Francisco, with Crumb arriving in early 1967.

More often than not, the cartoonists were lured by the rock-poster business rather than a ready audience with flowers in its hair. That the poster business was beginning to dry up was just another fortuitous circumstance.

"The market was glutted due to overproduction," said Jackson, the creator of *God Nose*, and the artists were disenchanted. "People like Peter Max were coming in and taking the charisma out of it and turning it into really big bucks. And so when R. Crumb comes along with his little *Zap* #1 comix there, hawking it on the street, it was just like, 'Wow! Here's something we can do! Why didn't we think of this before?'"

And the cartoonists didn't have to hawk their wares on the street, Jackson added, "because the market already existed for the posters in the head shops. We could go around to them and say, 'Okay, you're not selling many posters? Well, here—try these: comix!' The distribution system and printers were already in place; we didn't have to start from scratch. And since none of the mainstream distributors would touch this outrageous material, it was really essential that we had this 'underground' system. If we hadn't had that system of head shops and various alternative outlets, the comix movement just wouldn't have gone anywhere. We all would have been sitting around with boxes of unsold comix."

Crumb's *Zap* #1 hit the streets in 1968. By the end of the year, Shelton had gotten his act in

gear with *Feds 'n' Heads,* Lynch had unleashed *Bijou Funnies,* and Rick Griffin, Victor Moscoso, and S. Clay Wilson had popped up in *Zap #2.* Sex, drugs, and violence were just the gateways to the comics' new frontier. Cured dog poop was just another munchie on the counterculture hors d'oeuvre tray.

Crumb—who would later say that he was in a "state of visionary grace" thanks to heaping doses of LSD—was the center of attention in San Francisco, which means he suffered the most before the onslaught of fame. "Within six months," Crumb once told Gary Groth, "it went from me, my wife, [publisher Don] Donahue, and a couple other people hand-stapling comics and selling them out of a baby carriage to having all these fast-talking lawyers fighting over the rights and sleazy guys offering big money contracts . . . The hippie thing was a happenin' thing and the vultures were descending to find out how they could shear the sheep."

The sheep in Chicago, the underground's Triple-A farm team—Lynch, Williamson, Art Spiegelman, Kim Deitch, Justin Green, and (swooping in now and then from the farm in Wisconsin) Denis Kitchen—must have been safer from the shearers. That would explain Kitchen's romantic memories of those days.

"None of us were saints, but there was a certain spirit of cooperation," Kitchen said. "There was a certain awareness that we were turning comics on their head. Someone like Jay Lynch was always calling me with the lead that there was a hot, young artist in Tampa I should check out. His rolodex was always open, even if it meant someone else might get more attention. Likewise, Crumb went out of his way to spread his work around. He was aware that he and Gilbert Shelton were the best-selling artists on the scene. He didn't want one publisher to control that scene, so he would alternate giving his work to different publishers.

"Among the publishers, with the exception of Print Mint, we would cooperate all the time. We would exchange mailing lists, recommend printers, help one another in a number of ways. It was almost communal. And it was more than having long hair and smoking dope. It was a sense of being kindred spirits. We were allies, and for most of the '70s that prevailed."

Crumb, the kingpin of the kindred spirits,

This issue of *Bijou* acknowledged the influence of *Mad* on undergrounds and even features a cover by Harvey Kurtzman, the godfather of comix.

(© Bijou Publishing Empire, Inc.)

didn't make enough money off his work to get off welfare until 1971. By then, Gilbert Shelton and Jack Jackson had Rip Off Press up and running, allowing the underground artists to leave the staplers and baby carriages behind. And, as Bill Griffith noted, there was still no shortage of material. 'It was a great time to caricature things," Griffith said in *The New Comics,* "because everything was so exaggerated . . . Everybody was flipping out. Everybody was walking around with a clown suit on, just asking to be lampooned and caricatured. It was a great time for satirists."

But not necessarily a great time for art. "I

UNDERGROUND TITLES Our ten favorite underground titles:

Big Ass Comics ("Weird sex fantasies with the behind in mind")

Overly-Busty Nekkid Amazon Space Bimbos

Snatch

Binky Brown Meets the Blessed Virgin Mary

Tales of the Leather Nun

Jesus Meets the Armed Services

Existential Slapstick of Waldo and Emerson

Vibratory Provincial News

Anal Retentive Horror Comics

Tooney Loons and Marijuana Melodies

think underground comics came out of a very volatile period of American history," Justin Green told Mark Burbey. "It was a time of heavy polarization of ideas between generations, and we had youth on our side, with this tremendous righteousness and optimism."

The optimism, at the very least, in the underground didn't last. By the '80s, the resident geniuses were losing their energy or moving to France. And some of the most creative talent were coming up for air to discover they could fold, spindle, and mutilate comic conventions in books shipped by the big comics distributors . . . or be nominated for the Pulitzer Prize.

As for Robert Crumb, he maintained his energy and his style. In the late '80s, Lynch and Crumb were eating at a Polish restaurant in Lynch's Chicago neighborhood. It was an old-fashioned restaurant, packed with retirees and war heroes, and Crumb arrived with an old-style '50s hat seemingly glued to his head.

When Lynch suggested Crumb plant the hat on the hat rack attached to their booth, Crumb declined. "Then I'd have to watch the hat so no one would steal it," he explained.

You must be kidding, Lynch said, checking out the greasy, battered, deflated hat: "No one would steal that hat."

"Well," Crumb said, "that's how *I* got it."

United Features

Much better known for its newspaper strips, which included *Peanuts* and *Nancy,* United Features first reached the comics rack by stuffing a bunch of reprints of its syndicated strips into *Tip Top Comics* #1 in April 1936. The book featured the first comic book appearances of Tarzan, Li'l Abner, Captain & the Kids, and Fritzi Ritz.

With rare exceptions—the 1941 debut of Sparkman was one—United Features relied on reprints in its three mainstay titles, *Tip Top Comics* (1936–1961), *Sparkler Comics* (1941–1955), and *Comics on Parade* (Single Series for its first 28 issues).

Comic strips owned by United Features were reprinted in *Sparkler, Tip Top,* and *Comics on Parade.*
(© United Features Syndicate)

Vadeboncoeur, Jim

Someone somewhere may have a more diverse collection of comic books than Jim Vadeboncoeur, but no one is more willing to share his books and knowledge with other collectors and historians. Vadeboncoeur's specialty is the '50s and '60s—he compiled the first checklist of the work of Al Williamson—and he has an almost complete stock of Marvel's Atlas Comics as well as the smaller, lesser-known publishers. As his collaborator and friend Hames Ware noted, "You can have all the ability in the world to recognize and credit artists, but if you can't see their books (and at the prices today's old comics go for, I could never have afforded to obtain them myself), what good is that knowledge?" Vadeboncoeur catalogues and sells art and antiquarian books for Bud Plant.

Vampirella

Named by Forrey Ackerman at the request of James Warren, Vampirella was first drawn by Frank Frazetta. Trina Robbins designed the costume that revealed Vampi's ample charms, describing it to Frazetta over the phone so he could dress her up for her debut (*Vampirella* #1, September 1969). Vampirella became a franchise character for Harris Publications in the 1990s.

Vampires

> NOTE: Full Frontal Nudity Cover not available in Canada, the UK, or Hong Kong.

Good girl art meets Bizarro... which creates bad girl art, with the emphasis on the first syllable. Vampires were the rage of the 1990s, popularity that owed as much to Anne Rice's *Interview with the Vampire* and *The Vampire Lestat* as to Vampirella. Every publisher rushed to jam fangs and cleavage on their covers, unveiling such bloody messes as *Vamperotica* (Brainstorm), *Valeria the She Bat* (Windjammer), *Lady Vampre* (Blackout), *Vampire Vixens* (Acid Rain), DC's *Vamps,* and High Impact's *Poison Red* ("Hot, sexy, blood-sucking vampire action"). Few of these books were meant to recall Jose Gonzalez's elegant work on Vampirella, but they were convenient excuses for nudity on covers and "adult" variants.

Jose Gonzalez's artwork was the major appeal of the original *Vampirella* series.
(© James Warren)

Verheiden, Mark

What goes around... Verheiden grew up in Oregon, where—through APA-5 (see entry)—he became friends with Mike Richardson and Randy Stradley in the early 1980s. "We all loved comics," Verheiden said, "but we weren't doing comics," so he moved in 1983 to Los Angeles to take a stab at screenwriting.

"Naturally, as soon as I left, Mike and Randy started a comic book company in Portland," Verheiden said. They had better luck than he did (see *Terror Squad,* a direct to-video release). By the time he met with them at the San Diego Comic-Con in 1986, he had soured on Hollywood. "I said, 'If this is the movie business, screw it, I'll just take classified ads,' which is what I was doing."

His old friends suggested that Verheiden write comics. He responded with *The American* in 1987 and the first *Predator* miniseries in 1989. And wouldn't you know it: When Joel Silver, who produced the movie *Predator,* read

"The Voice of My Conscience"

When Steve Bissette was at the Kubert School in the mid-1970s, the faculty included Lee Elias, Dick Giordano, and Hi Eisman, a journeyman artist who had the best stories about the industry.

Eisman would talk about the days when he drew movie comics for Dell and had to crank out "Lawrence of Arabia" in the space of a single weekend. But Bissette's favorite was the time Eisman got screwed by Jiminy Cricket.

Okay, so it was Cliff Edwards, the guy who provided the voice of Jiminy Cricket. Edwards approached Eisman with the idea of selling filmstrips of the Disney character to elementary schools. Eisman would supply the art, and Edwards would lend his voice to the record that would accompany the filmstrip.

So, what happened? "Hi never got paid," Bissette said. "They got all of his art. He got completely screwed. And he said, 'You know, I trusted him. It was Jiminy Cricket. The voice of my conscience.' Hi would tell us those stories, which were hilarious. We'd be in tears laughing. But the message coming through was, 'Watch out. You will be exploited from every end possible.' As I look back, that was some of the most valuable information we got from the school."

the latter comic, he asked Verheiden to come in to the studio and tell him how the story ended. At that meeting, Verheiden also pitched *The American,* which Warner Brothers promptly bought.

That film, Verheiden noted in late 1996, is "going nowhere." This is the movie business, after all. But Verheiden did write the screenplay for *Timecop* and also worked on *The Mask,* both of which were Mike Richardson creations. And when *Timecop* went to TV, he went along with it—until it was canceled after two episodes had been aired.

DC's Vertigo line sports unique covers by top artists, such as Glenn Fabry.
(© DC Comics, Inc.)

Veronica Lodge

Veronica Lodge entered Archie's world in *Pep Comics* #26, to the following tune:

"Egypt had its Cleopatra! Hollywood, its Hedy Lamarr! And now Riverdale had Veronica Lodge, who had just moved into town—and taken it—as far as the boys of Riverdale High School are concerned, anyway."

Veronica proved she was more than Archie or any of his classmates could handle when (in *Pep* #31) she changed out of her bathing suit into a blouse and skirt in the back seat of her limousine while Archie was driving and trying to keep his eyes off the rear-view mirror.

Her creator, Bob Montana, named her "Veronica" as a tribute to actress Veronica Lake, although he changed her hair color from blonde to brunette. "Lodge" was borrowed from the family of U.S. Senator Henry Cabot Lodge, who lived near Haverhill (Mass.) High School, Montana's alma mater.

Vertigo

The premier imprint of the 1990s, Vertigo was conceived by DC editor Karen Berger in 1992. Anchored by Alan Moore's *Swamp Thing* and Neil Gaiman's *Sandman,* the Vertigo imprint specialized in taking washed-up ideas out of the DC retirement home—Doom Patrol, Animal Man, Prez, Shade—and handing them off to British writers such as Garth Ennis, Grant Morrison, Jamie Delano, and Peter Milligan. Once the imprint got rolling with books such as Morrison's *The Invisibles,* Ennis's *Hellblazer* and *Preacher,* and Matt Wagner's *Sandman Mystery Theatre,* Berger put a near lock on the Best Editor plaque in the annual Eisner Awards.

Vess, Charles | 451

Vess has been illustrating classic songs and poems in his own self-published comic, *The Book of Ballads and Sagas*.
(© Charles Vess)

Vess, Charles

He was cruising through the back pages of one of the Dell *Tarzan* books, following the Brothers of the Spear through a maze of caverns and tunnels, when his tour guides broke into a panel that took his breath away.

"They come out and they're looking over this giant hidden valley with waterfalls and swinging bridges going over it, and clouds with their shadows cascading down the rocks," Charles

Charles Vess

Vess told *It* magazine. "I've tried to draw that ever since."

Vess—who now owns the original Russ Manning art from that story in *Tarzan* #52—grew up reeling under the romance of Hal Foster, the fantasy of *Lord of the Rings*, and the storytelling of Carl Barks. He spent three years working as an animator before Michael Kaluta called in 1976 and invited him to share his two-room New York apartment when Kaluta moved into the Studio (see entry).

"I didn't get into comics because all of those four guys at the Studio had just gotten out of comics and had nothing good to say about them," Vess told *It*.

As evidenced by his work with *Spider-Man, Sandman, Swamp Thing, The Books of Magic*, and his award-winning self-published *Book of Ballads and Sagas,* Vess was eventually able to change his mind.

Wagner, Matt

Matt Wagner's mother was an English teacher who encouraged him to pig out on reading, not caring if comic books were on the menu. He started on them at age three, "never expecting they'd grow up with me." Or that the sequential art would be so doggone useful. When Wagner was dating Barb Schulz, his future wife, his letters to her were often in the form of comic strips.

His two main comics characters, Grendel and Mage, were created for Comico in the early 1980s. Grendel first appeared in *Primer #2*, a black-and-white anthology. "It wasn't a tale I wanted to tell forever," Wagner said. "Mage is that: my personal allegory." Or, as Wagner told *The Comics Journal*, "Mage is where my heart resides, and Grendel is where my head resides."

Wagner makes no apologies for his resemblance to Mage's hero. "Have you met Dave Stevens? He looks just like Cliff Secord [the Rocketeer]. We were talking earlier about how much Jeff Smith actually looks like Bone, if you can imagine that. Barks looks like his ducks. Frazetta looks like a shit-kicker."

When Comico collapsed in 1990, Wagner took his storytelling gifts to Dark Horse and DC. For the latter, he has contributed a series of memorable storylines and superb female characters in *Sandman Mystery Theatre*. For Dark Horse he continues to write (and sometimes do the art) for various Grendel series. *Mage* was finally revived in 1997 via Image.

Walker, Al

Alanson Burton Walker was born in 1878 so he was already an old-timer by the time comic books came along. All of Walker's comics work was done for Fiction House. He is best known for Greasemonkey Griffin, but he also worked on Simba, Pvt. Elmer Pippin, Jeep Malarkey, and Norge Benson between 1941 and 1943. After a three-year break for the war (exactly what he did during that period we can hardly imagine, since he was in his 60s), Walker returned to draw Buddy Brain, Glory Forbes, Air Heroes, and more Greasemonkey Griffin until his death.

War Comics

The industry was still getting warmed up and, boom, the war was on. Twenty-one months before the bombs dropped on Pearl Harbor, the Sub-Mariner was slugging it out with Nazi submariners on the cover of *Marvel Mystery #4* (February 1940). That same month, Superman was floating above the action on *Action #23* with a bomb under his arm. The first patriotic super-hero appeared in January 1940, and for the next five years, The Shield and his successors fought the Nazis, pitched the fan clubs, and ordered their readers to collect glass and scrap metal.

Comic books grew up during World War II. In their formative years, the war was always playing in the background. War gave Alex Schomburg his cover material, Captain America his monthly mission, and the news rack its red, white, and blue hue. *Military Comics, Fighting Yank, Boy Commandos:* "War comics" weren't a genre; they were the general rule.

In a medium where publishers are typically loyal only to what flies out the door, something else was at work during the war, particularly at Timely. Many on the staff were Jewish, and they knew about how Jews were being treated in Europe (See the **Adolf Hitler** entry). As George Olshevsky has noted, "Through the medium of the comic book they were able to express their bitterness and frustration. The sincerity and fervor of their damnation of the Axis powers transcended the crudeness of the plots and artwork, and made their stories true comic classics."

Equally classic was Milton Caniff's inspiring work on *Terry and the Pirates,* segments of which struck such a patriotic chord that they were read into the Congressional Record. "During the Second World War, no other car-

Wagner makes it no secret that his Mage character Kevin Matchstick is based on himself.
(© Matt Wagner)

Alex Schomburg drew hundreds of action-packed World War II covers for Timely and other companies.
(TM & © 1998 Marvel Characters, Inc. All rights reserved.)

Harvey Kurtzman's EC war comics took a serious look at wars from many eras of history.
(© 1998 William M. Gaines, Agent, Inc.)

"At the height of the Korean war," Art Spiegelman noted in a *New Yorker* tribute after Kurtzman's death in 1993, "he edited, wrote and drew war comics—not jingoistic trash but thoroughly researched narratives with great moral purpose. His dramas reflected his humanism. They were about the pain and suffering of war. No macho he-men, only scared kids. The enemies weren't demons, only other people."

Kurtzman's stories, unlike most of the comic books of the early '40s, weren't designed to entertain or console the GI in the trenches of Korea. Instead, they highlighted the brutal terror and ironic unpredictability of battle. Kurtzman, who served briefly in the army, picked up much of his material from soldier interviews and borrowed an occasional storyline from such landmark works as *All Quiet on the Western Front*. With significant artistic assists from John Severin, Alex Toth, George Evans, and Jack Davis, Kurtzman devoted entire issues of *Frontline Combat* to Iwo Jima, the Civil War, and the Air Force.

Even as Kurtzman hit his stride—and even as the soldiers' lot was being played for laughs by the likes of Sad Sack and Beetle Bailey—DC Comics kicked off its war line in 1952. *Our Army at War* began in August of that year, the same month that *Star Spangled Comics* became *Star Spangled War Stories* and *All-American Western* was converted into *All-American Men of War*. DC's "Big Five" was rounded out with the addition of *Our Fighting Forces* in 1954 and the adoption of Quality's *G.I. Combat* in 1957.

"The war line was a very cheap date for DC," said Robert Kanigher, who edited the line from 1952 until 1968 and created most of the characters, including Sgt. Rock and Enemy Ace. "They never spent a penny publicizing it. It worked, so why fix it?" The DC war books worked because Kanigher, editor Murray Boltinoff, and a platoon of artists led by Joe Kubert fought so diligently to keep them at the top of the field. Although Kanigher was no match for Kurtzman as a writer, Kubert had no peer as a cover artist and illustrator. Other standout artists on the Big Five included Russ Heath, Jerry Grandenetti, Irv Novick, George Tuska, and Mort Drucker.

DC abandoned the field of battle in 1988 with *Sgt. Rock* #422, the first artist teamup of Joe Kubert and his sons, Adam and Andy. Other

toonist did more for the war effort than Caniff," Chris Jenson argued in *Milton Caniff's America*. "He devoted many hours of his spare time to the preparation of training manuals, pocket guides to foreign countries, bond-selling campaigns, and innumerable visits to veteran's hospitals. Besides all this, he designed 70 different unit insignia and drew *Male Call,* a weekly strip solely for the use of the armed forces." Caniff was of course, Jewish too.

When World War II ended, war comics pretty much disappeared and did not return until the early 1950s, when Harvey Kurtzman revived the genre at EC. There was nothing crude about the plots and artwork of the two war books Kurtzman slaved over, *Frontline Combat* and *Two-Fisted Tales*.

books of note in this rapidly fading genre are the four issues of Warren's *Blazing Combat*, Marvel's *Sgt. Fury and His Howling Commandos* (tucked safely back in the friendly surroundings of World War II) and *The Nam*, and Joe Kubert's 1996 graphic account of the conflict in Bosnia, *Fax from Sarajevo*.

War Stories

Fifty years ago, just about every young man in the comics industry went off to war and came back with a different view of the world. Before he enlisted, Will Eisner once said, "I was living a very cloistered existence, as most cartoonists do . . . I spent a lot of time reading. I lived within the frame of the art, I had a very narrow social life . . . Up to that point, most of my life was spent on the drawing board, fabricating experiences that I either borrowed or imagined." The war smacked him in the face with the real and the unfabricated.

If these guys didn't come back wounded, they came back with sobering stories.

In 1944 or 1945, **Murray Boltinoff** was stationed in Paris with Supreme Headquarters Allied Forces, working on division history:

"The scene is Paris, 8 or 9 at night. Bitter cold. All of Paris was cold because they had no fuel. Somehow or another, I walked down to one of the railroad stations that had been converted into an Army post. The trains that came in all bore the wounded from the front.

"I worked my way through the stretchers, then stopped in amazement because the guy looking up at me and smiling was Jack Kirby."

Kirby had the early warning signs of frostbite, Boltinoff said, so he took him back to his room at the Hotel Dudome and nursed him back to health. "He was there for a couple of weeks. The next time I saw Jack after he left was at a party at his apartment in midtown [Manhattan]. He was fully recovered."

Stan Drake was with the Corps of Engineers when they landed on Tinian in the Marianas, the island from which the *Enola Gay* would one day fly. "We were supposed to be part of the big task force. Hundreds of thousands of guys. We were going to invade Japan. And then they dropped the Hiroshima bomb and the Nagasaki bomb, and the war was over and we didn't have to.

"So we're there on Tinian. We knew that the Marines had wiped out the gooks, the Japs, but my captain said to me, 'Sgt. Drake we seem to see some smoke coming up over this hill. See if you can get to the hill and find out what's going on.'

"So, I took my squad with me, and each guy holds on to the other guy's foot. We're crawling through the grass. I'm crawling and crawling and crawling, I don't know where the hell I am. So, I sit up and as I sit up, from here to the wall down there, this Jap stands up. And he's got a gun and I've got a gun. Mine was on full discharge. I pulled the trigger. Oh, that looked so good. And I shot him. He bounced I was on full automatic. The whole clip hit him.

Joe Kubert was the main cover artist for DC's "Big Five" line of war titles in the 1960s and 1970s.
(© DC Comics, Inc.)

"I'm standing there and they had to come out to me and pry my finger off the trigger . . ."

George Evans spent the final months of the war stationed at Shaw Field in South Carolina. Handling the groundskeeping and KP chores at the Air Force base were several hundred German prisoners of war.

"We were absolutely forbidden to have any contact with them," Evans said. "But one day in the mess hall, one of the guys was reading a newspaper in line, and the headline was 'Dresden in Flames.' One of the Germans walked in, juggling the hot trays. Everyone was laughing; he was a POW, and glad to be out of it. Then he spotted the headline in the paper and his face sobered."

The German prisoner pointed to the paper and asked, in German, What about Dresden? And the paper's owner told him. Part of the city was lit up like a volcano. Melted asphalt was running through the streets and dripping down into the subways.

"The guy looked crushed," Evans said. "That was his neighborhood in Dresden. All his family was there. Someone hollered at him and he went on and did his stuff. But the next day we heard he'd hung himself in his barracks. With a coat hanger.

"I guess he was human, too."

Ward, Bill

The creator of "Torchy, the Blonde Bombshell," Bill Ward once claimed he had snuck into the art world by drawing beach bunnies on beer jackets in Ocean City, Maryland, and decided to hang around because it was a great way to meet chicks. Which is kind of funny when you realize where Bill Ward ended up.

A 1941 graduate of the Pratt Institute, Ward went to work with Jack Binder and Pete Riss in an old barn in Englewood, N.J., just before life in the barn—the Binder sweat shop—got hectic. He got his big break when he was hired at Quality to fill in on Blackhawk for Reed Crandall, who had just been drafted.

Although it ran for only six issues (1949–1950), *Torchy* made enough of a splash for artist Bill Ward to put him on the comic-collecting map.
(© Quality Comics Group)

Ward was parked at the Quonset Point Naval Air Base in Rhode Island when he went back to his beer-jacket art. He was no doubt inspired by his wife, a red-headed British expatriate who was the original Torchy. In her first comic incarnation, Torchy was a brunette named "Ack-Ack-Amy" in the base newspaper. She was blonde and still busting out of her dinner jacket in her first comic book appearance, *Doll Man* #8.

But it was the erotic, stripped-down version Ward drew for the troops in *Yank* that had such a dramatic impact on his career.

When Lance Casebeer, an Oregon collector of comics and paperback books, met Ward in 1968, the artist was divorced, living in New Jersey . . . and still cranking out the pornographic art that he'd lived off since the late 1940s.

Ward told Casebeer he was virtually blackballed from the industry because of his softcore strip in *Yank*. He could have lived off his wife's money, Ward said, but he was too proud for that. He wasn't too proud to turn down the offer to do racy cartoons for magazines and paperbacks for the Eros Goldstripe line.

In the early 1950s the comic book industry came looking for Ward; he joined the staff of *Cracked* and drew numerous romance books for Quality. But the majority of his time was still spent pumping out porn for several of his mob-based partners.

Ward was, Casebeer said, amazingly prolific. When he wasn't working in charcoal or watercolor for the likes of *Knight, Juggs, Leg Show, Stolen Sweets,* and *Sex to Sexty*, he was filling as many as eight paperbacks a month with up to 64 illustrations each. "And he never used models," Casebeer said. "After his wife, it was all done ad lib."

Ward, in other words, never met the chicks he thought he would.

The instructions for what his publishers wanted in each drawing arrived on a 30-minute reel-to-reel tape. "Bill was given concise, explicit instructions on tape for each illustration." Casebeer said. "Then he would do what he was told. He could put out an illustration in under 10 minutes.

"I don't think he was happy doing the hardcore. The softcore was OK, and he really enjoyed the 'Torchy' strips, but I don't think the hardcore was in his veins. He was milquetoast,

the last person in the world you'd expect to produce this stuff. I always had the feeling the only reason he did this stuff was he felt an incredible obligation to a criminal organization for hiring him and paying him during those years when the real art world wouldn't accept him."

Ward's erotic art was still appearing in *Cleo* magazine as late as 1990.

Ware, Hames

> *America has always felt the need to idealize those who contributed to its collective daydreams—its statesmen, the cowboy and Indian, and in the twentieth century its sports heroes. Rock icons and entertainment stars have now been joined by comic book creators and characters.*
> HAMES WARE

Fandom's debt to Hames Ware cannot be overstated. He's not the only kid who ever hauled his red wagon around the neighborhood, loading up on the comic books no one else wanted. And he's not the only guy—although he is one of the few—who ever took an interest in the men and women who were drawing the pictures that captivated him so.

But Hames Ware, unlike so many collectors who understand that knowledge is power, didn't hoard the information he acquired. He didn't get rich off the details he culled from the years he spent identifying, or corresponding with, unknown artists. By and large, Ware sat quietly by while others profited from his exquisite eye and his love for the funny book.

Ware was four years old when he received, for Christmas 1947, a subscription to *Walt Disney's Comics & Stories*. The hook was set. The books captivated an imagination uncluttered by television. He taught himself to draw from the comics and by watching fellow elementary school classmate Mercer Mayer, who even then manifested the talent that would propel him into fame as one of America's top children's book illustrators.

Early on, Ware discovered he had the ability to recognize similarities in the style of the artwork. And he was able to hone that gift because he had the luxury, he said, "of a tremendous collection." Ware would recognize in one of the *Classics Illustrated*s the style he had seen in a Quality book. What he couldn't identify, because so much of the artwork was unsigned, was the name of the artist.

That didn't sit right with him. He wanted to know who these anonymous artists were who had brought him so much joy as a kid.

Ware wrote his first letter to a comic book company in the early 1950s. Classics Illustrated. "They never answered. They were a miserable company for someone to interact with. They would not answer questions about the artists; if anything, they'd send form letters."

By contrast, EC assistant editor Jerry De Fuccio answered Hames personally, which began a correspondence spanning decades. Ware also had better luck when he wrote to Richard Hughes, the editor of ACG Comics, looking for Paul Gustavson, one of his favorite artists. "In his letter, Hughes said, 'The last I heard, he was in Warwick, N.Y.' That was my first contact with an artist I grew up with."

The first of many. Unlike the fans living in New York City, hanging out like groupies at the studios, Ware was stuck in Arkansas. All he could do was pick up the phone. Or the phone book.

The Manhattan phone book.

When Ware's grandfather, Fred, sent him that tome, Hames had the tool he needed to track down the artists he loved as a kid. Sometimes luck and the passing years were unkind. Alex Blum? "My letter missed him by a matter of days," Ware said, "but his daughter answered my letter and turned out to be a comic book artist herself."

Other times, he hit it big. He found Rafael Astarita. Lou Cameron. Fawcett editor Wendell Crowley. They developed abiding friendships. They exchanged letters, reel-to-reel tapes, and phone calls.

"As an adult, I tried to give voice to the child

Ware worked with Jerry Bails to produce the original four-volume *Who's Who of American Comic Books*

(© Jerry Bails and Hames Ware)

I'd been in letting them know how much I appreciated the work they'd done," Ware said. "Almost to a person, the response was, 'Why do you care about this stuff?' I had to get them to talk. I would overwhelm them with my enthusiasm. To penetrate both Astarita's and Cameron's barriers, I had to be sincerely caring."

He was. He was also sincerely committed. For years, he's happily identified hundreds of art samples and old comics art, along with fellow unsung comics historians Lee Boyett and Jim Vadeboncoeur Jr.

"The *Who's Who* was my idea in the beginning," Ware said. "I wrote Jerry with this idea because I had these ledgers filled with this data. The way I was able to identify unsigned art is that I was also able to collect comic strips and pulp magazines. The comic book was the low rung on the cartoon ladder. A lot of artists dabbled in the comics on the way up and on the way down. I taught myself the different styles."

He also learned that his brand of perfectionism was rare in the field. Too often, Ware discovered, historians followed the advice of director John Ford: "When the legend becomes fact, print the legend."

"History is being altered because memories are being relied upon second- or third-hand," Ware said. "These people weren't taking notes. Their memories are fallible. It's no wonder we had to sift through a lot of misinformation. It's like identifying art. There are very few people who can step forward and say, 'That's not the work of such and such an artist, or that *is*.'"

Ware is blessed with both an eye for art and an ear for voices. Not only has he made a living by creating voices of his own, but he has also spent years listening to animated cartoons, trying to identify the voices of the different characters.

That quest has taken Ware to Hollywood, now and then, but he still lives in Little Rock, close to his comics, his letters and tapes, and the ledgers he has kept for 40 years. In a business where knowledge is power, and the powerful are loath to admit that they begged, borrowed, or stole what knowledge they have, Ware will never get the credit he deserves for putting a name and a face to the artists of the comics, but he's content in knowing *they* will get some credit.

Warren, James

Bernie Wrightson had just begun working for James Warren in the early '70s when he decided to move out of his apartment and into an old church. Unable to scrape up a deposit, he marched into Warren's office and asked for an advance on one of his first assignments.

"I never give advances," Warren announced.

"And for an hour and a half," Wrightson said, "he goes on this tirade about why. 'You can't trust artists, and on top of that, what if I give you this money and you get hit by a truck.' An hour and a half. I'm sitting there getting depressed as hell because I'm not going to get the money, and then he finally says, 'So, that's why I won't give you an advance, but I will give you a personal loan.' He writes me a personal check. Everything is fine."

Three weeks later, Wrightson had paid Warren back and decided to move back into the city. "Once again, I'm strapped for money, so I go in to see Warren. I say, 'Jim, I know this is awfully close on the heels of the last time, but I really have to ask you for a personal loan.'"

"I never give personal loans," Warren replied.

"And for an hour and a half," Wrightson said, "he sits there and tells me why he won't give anyone personal loans and they're the same reasons he doesn't give an advance. He goes through the whole thing and at the end he says, 'But I will advance you on the job you're working on.'

"He's a maniac. I thought it was great. The man was totally unpredictable."

Warren began publishing *Famous Monsters of Filmland* under the auspices of Forrest J Ackerman in 1958 when he was 29. He then pinned the readers' ears back with the 1964 introduction of *Creepy*. He had the ability to attract and entertain the best artists in the business: Frank Frazetta, Reed Crandall, Alex Toth, Al Williamson, Neal Adams, and George Evans were but a few of those drawn beneath his roof.

The first time Wrightson met him, Warren sparked an argument with what seemed like an outrageous statement, then suggested they end

James Warren went after the best—and got it with Frank Frazetta.
(© James Warren)

the debate with a bet. "A dollar," Wrightson agreed, dropping the bill on Warren's desk.

"When he proved me wrong, he took my dollar and said, 'Would you sign it?'" Wrightson said. "I said, 'Sure,' and signed the bill. Then he opens his desk drawer and pulls out this wad of dollars. Vaughn Bodé, Billy Graham, Ken Kelley, Frazetta, Crandall, anyone who'd ever worked for him, he'd trapped into this stupid thing and got them to sign a dollar bill. It was terrific."

When Warren's wad began to run low, he filled his magazines with reprint material, sold the artists' original artwork, and rapidly expanded the mail-order section of his magazines. In *The Spirit* #1, for example, which is cover-dated April 1974, 14 of the 74 pages are devoted to mail order, hawking back issues of *Vampirella*, 8mm movie projectors (for $29.95), super-hero action figures, and 6-foot-high Frankenstein pinups.

"The catalog was how he made his money," said Louise Simonson, one of Warren's assistant editors. "The comic broke even; his profit was in the mail order."

Realizing that his profit was in mail order, and not in the art of Frank Frazetta or Alex Toth, eventually wore Warren down.

"People in this business try to create what they loved as a child; they want to remake what grabbed them," Simonson said. "But redoing that wasn't doing it for him. He wasn't making something new that was his own."

In the end, Warren was less and less interested in comics and up to his hipwaders in real estate deals. "He would go away for the entire summer," Simonson said, "to his beach house on Long Island, where he had a full-size model of a Sopwith Camel. Then he'd come back into the office in the fall and everything would be wrong. He was like one of those head gorillas who goes off and leaves his primary group, when he comes back, he must, on general principle, bat people around, just to prove he's the alpha gorilla. That's pretty much what Warren would do. He'd go away, then come back and complain bitterly about everything. Around Christmas, he'd yell at us again, give us our Christmas bonus, and then he'd be gone again."

By 1983, the big gorilla was gone from publishing for good. He has successfully kept a low profile through the last decade. In 1997, *Creepy* fan Mike Catron reported Warren was "hale,

hearty, and still full of fire and vinegar" but disinclined to talk about his life. "There's a great deal of the Warren story that has yet to be told," Catron posted on the Internet, 'but Warren doesn't give the impression that he's in any hurry to tell it anytime soon."

Warren Publishing

The magazines are legendary: *Famous Monsters of Filmland* (1958). *Help!* (1960). *Creepy* (1964). *Blazing Combat* (1965). *Eerie* (1965). *Vampirella* (1969). *The Spirit* (1974).

So are the artists: Neal Adams. Gene Colan. Johnny Craig. Reed Crandall. Steve Ditko. George Evans. Frank Frazetta. Jeff Jones. Gray Morrow. Joe Orlando. John Severin. Tom Sutton. Alex Toth. Al Williamson.

"If Warren had started his line a year later, he wouldn't have been able to get the same people he got," said Archie Goodwin, who was recruited from *Redbook* in 1964 to edit *Creepy* and *Eerie*. "Comics were just starting to heat back up. Marvel books were just beginning to catch the public eye. The fact is that a lot of the artists who worked for Warren, who also worked for the great EC comics, were not super-hero artists. A lot

Here's a Frazetta cover for *Eerie*...
(© James Warren)

...and another Frazetta for *Blazing Combat*.
(© James Warren)

of them weren't getting a lot of work. And I think they also liked the idea of being able to work in black and white. At that time, comics coloring wasn't nearly as sophisticated."

"Our offices were, a great amount of the time, in Jim Warren's apartment," Goodwin said. "He had a duplex apartment on the east side of New York. A moment I would always look forward to once a month: We would get the cover engravings and Jim, who liked to sleep late, would come down out of the shower with a bath towel wrapped around him and usually with shaving cream on his face, to go over the cover engravings with us.'

Warren paid $250 for those covers, but (other than the expected concession to Frazetta) refused to return the original art. "When I worked for Warren, there were no creator rights," Goodwin said. "I would nag Jim Warren that we should give back the original artwork. I could never make him budge on it."

"I did pencil-and-ink pages for something like 30 dollars [each]," Tom Sutton told *Amazing Heroes*. "That was big Jim. You'd never see the artwork. Somebody's got the artwork someplace. Ah, what a sweetheart. Lots of luck, Jimmy."

The fate of that artwork may not be quite so mysterious. A 1983 note in the *Comics Buyer's Guide* detailed the August auction in which the contents of Warren's office were sold to Harris Publications. The original artwork—including pieces by Wrightson, Crandall, Sutton, and Mike Ploog—sold for $27,250. Harris paid an additional $67,000 for just under a million back issues, which works out to about 15 cents apiece.

Watchmen

Why are so few of us left active, healthy and without personality disorders? The first Nite Owl runs an auto-repair shop. The first Silk Spectre is a bloated, aging whore, dying in a Californian rest resort. Captain Metropolis was decapitated in a car crash back in '74. Mothman's in an asylum up in Maine. The Silhouette retired in disgrace, murdered six weeks later by a minor adversary seeking revenge. Dollar Bill got shot. Hooded Justice went missing in '55. The Comedian is dead.
RORSCHACH'S JOURNAL

I think to some degree the serious post-modern super-hero boom, or whatever it was, came about because of the coincidence of Dark Knight *and* Watchmen *appearing on the stands at roughly the same time.*
ALAN MOORE

Written by Alan Moore, with art by Dave Gibbons, *Watchmen* may be, quite simply, the best comic series ever published.

DC had just swallowed the Charlton universe, and when the company pushed Moore for another project after *Swamp Thing*, he asked for the Charlton characters. DC handed 'em over, and Moore prepared a synopsis. "At that time, it was just another grandiose super-hero fantasy," Gibbons said. "There was no notion of 'Let's do something that will revolutionize the industry.'"

DC eventually saved the Charlton characters when Moore had their heads on the chopping block. Moore's script called for most, if not all, of the cast to be knocked off.

Moore and Gibbons adjusted; Dick Giordano signed on as the editor. When the creators took *Watchmen* #1 in to DC, their peers were

Alan Moore and Dave Gibbons changed the face of comics with 1986's *Watchmen*.
(© DC Comics, Inc.)

stunned. "What really clinched it," Gibbons said, "was Howard Chaykin, who doesn't give praise lightly, and who came up and said, 'Dave what you've done on *Watchmen* is fuckin' A.'"

The series debuted in September 1986. "I think the stars were in the right place and we were the right people," Gibbons said. "I don't think we could ever do another *Watchmen*; it was so unexpected, we were so much in sync. I don't want to get all New Age and California about it, but it was like it was being done through us. Coincidences would happen. Alan and I would start talking about the plot on the phone, just as I opened a book on the solar system and there's a picture of Mars, where Alan wants Dr. Manhattan to go. And there's a smiley face on Mars. Stuff you just wouldn't believe…"

Weekly Alternative Strips

When cartoonists produced work that was too ribald, outrageous, or irreverent to play on the comics pages of the staid metro dailies, they often turned to the alternative weeklies. Jules Feiffer—whose 40-year career at *The Village Voice* ended in 1997—had the best-known detour, which eventually ended in a Pulitzer Prize. The next generation of cartoonists to opt for the alternatives included Matt Groening (*Life in Hell*), Lynda Barry (*Ernie Pook's Comeek*), and Ben Katchor (*Julius Knipl*). Groening and Barry, who went to school together at Evergreen State College, still do their strips but have taken their creations to other media, Groening to television (*The Simpsons*) and Barry to the theater.

Wein, Len

> *Kids used to come up who became important in comics later, people like Marv Wolfman and Len Wein. They were all just little fans at the time. I'd wish them well and tell them to finish high school.*
> FLO STEINBERG
> MARVEL COMICS STAFF

High school completed, Len Wein created Swamp Thing for DC and Wolverine and the second batch of X-Men for Marvel.

Steinberg, clearly, planted her best wishes in some rather fertile soil.

In one of his last moves as editor at Marvel, Roy Thomas suggested that Wein develop a Canadian character to promote Canadian sales. In *The Incredible Hulk* #180 (October 1974), Wein whipped out Wolverine.

Seven months later, *Giant-Size X-Men* appeared with Wolverine and the rest of a new cast engineered by Wein and artist Dave Cockrum. Because Wein had already succeeded Thomas as Marvel's editor-in-chief, he begged off on writing the X-Men's new adventures.

"I was down to writing just *X-Men* and *The Incredible Hulk* and one of them had to go," Wein told Les Daniels. "And the Hulk had always been my favorite Marvel character. Who knew?"

Weird Science and Weird Fantasy

"Somewhere along the line," Harry Harrison once told Bill Spicer, he and Wally Wood "talked Bill [Gaines] into trying to start a science fiction comic, only instead of doing real science fiction he copped out and called it *Weird Science*…

"We had no control over the titles of the two science fiction comics or their exact formats. We just kept nudging Bill every once in a while to try them out… Bill was a very friendly guy whose presence encouraged mad things to go on in the office, footprints on the ceiling, that kind of thing. He was always open to sugges-

Len Wein

Al Feldstein did most of the covers for *Weird Science* and *Weird Fantasy*.
(© 1998 William M. Gaines, Agent, Inc.)

Weisbecker, Clem

The straight scoop from Otto Binder, from the *Steranko History of Comics:*

"Weisbecker was a fabulous character. He looked and talked like a gangster. He was born ugly and had a case of smallpox that had pitted his skin, but when he took a pencil in his hand everybody watched in reverence. His color paintings were even better, far better . . .

"His character was most ebullient of all, and he feared no man or authority. When he would turn up the day after an assignment was given him with a whole 8-page story penciled, Will Lieberson would say, 'Didn't you kind of rush this, Clem? After all, we're paying you good money to take your time and . . .'

"Clem would sneer and interrupt, 'Ah, you know my work is worth ten times the friggin' money you give me. And look, I need a check by 4:00 today, see!'

"He always got the check, and more work, for his pencils were better than any other artist taking a week. Clem's language almost required the girl editors to wear earmuffs. Every third word was a cussword of the rawest variety. When 'shusssshed' by some male editor, Clem would lower his froggy voice to a whisper that was still heard by every girl within 100 feet as he vented some more cuss-talk.

"And 'Clem's Classic,' which Wendell Crowley always liked to tell, occurred when Clem showed Wendell one of his paintings (his real love, of course), which he had arisen early to do, and said, 'Wen, isn't that the God damnedest best sunrise you ever saw?' Clem was dead serious. Wendell doubled with laughter. Clem said frowningly, 'Whattsamatta? Haven't you any sense of $%&#@ beauty in your soul?' God knows how Wendell ever recovered.

"But beast and the beauty—they were blended in Clem in a strange and awesome way."

Beauty didn't kill the beast; alcoholism took care of the job.

Weisinger, Mort

Early on, Mort Weisinger was a decent sort, and one hell of a midwife. He delivered to DC's doorstep Aquaman, the Green Arrow, Supergirl, and—with Mort Meskin—the Vigilante. Of the *Fifty Who Made DC Great*, Weisinger is the one credited with dreaming up the

WHAT IF?

Mort Weisinger and Julius Schwartz were teenage buddies in a science fiction club and Weisinger recalled, "We were hiking in New York's Palisades Park—Julie, Otto Binder, myself, and some of the other Scienceers—when suddenly, we woke up in the hospital! A car had hit us and knocked us over like a row of clay pigeons. We could have all been wiped out but we were very fortunate. I often wonder, immodestly [How unlike you, Mort], what would have happened to science fiction and comics if we'd all been obliterated there."

tions, so Wally and I just kept pushing and pushing."

Weird Science's twin sister, *Weird Fantasy*, picked up where *A Moon, A Girl . . . Romance* left off in May 1950 and ran 22 issues before the twins merged into *Weird Science-Fantasy.* Al Feldstein produced the first 17 covers; he also inked Al Williamson's pencils on the cover of #18, the issue that contained "Judgment Day," one of EC's most memorable stories.

When EC editor Bill Gaines could no longer afford to lose money on two science fiction titles, he combined them into one, *Weird Science-Fantasy.* The first issue, #23, was cover-dated March 1954. With #30, the book took another alias—*Incredible Science Fiction*—to satisfy the Comics Code Authority. The series ended with #33.

Weisinger is noted for many things, not the least of which was making every Superman character a giant at some point.
(© DC Comics, Inc.)

Phantom Zone, Brainiac, the Bizarros, red kryptonite, Krypto, and imaginary tales.

The problem? Weisinger became successful. "Mort was a very nice guy," Murray Boltinoff said, "until he became successful."

And then?

"Weisinger was the worst thing that ever happened to comics. He was a monster," said Al Schwartz, who used the pen name Vernon Woodrum. "Weisinger, like Bob Kane, must have had a miserable childhood. Everything he did was to hurt someone else. Don Cameron once tried to push him out a window. He told me that this is the only place where you can try to push an editor out the window and they'll still beg you to work for them."

"I gladly would have started the fund to hire a good defense lawyer," Boltinoff said. "Mort had enormous talent, but he was irascible. He was cantankerous. He was an egomaniac. You don't want me to go on. I'd be lambasting the dead."

Ramble on, Murray, you're speaking for legions.

A teammate of Jack Schiff's at Standard, Weisinger joined DC in 1940 as a story editor under Whit Ellsworth. When Weisinger went off to war, Schiff was hired to hold the fort down until his return.

"When Weisinger came back, he dominated the whole show," Schwartz said. "Whit kept him in line while he was there. But Whit didn't like comics any more than I did at the time. Whit came into the office one day, sat down, and said, 'How long can grown men keep turning out this crap?' Whit finally got out of there and went to [produce the *Superman* television show], and at that point Weisinger went wild. That's when everything went to hell.

"Weisinger was a terror. He couldn't stand the idea of paying writers in advance. And he couldn't stand that writers made more than he did. He tried to put an end to that. He was responsible for more rewrites . . . He destroyed my income in that business. He made it impossible for me to sell a story. He took plots that I would give him and hand them out to other writers. And I wasn't the only victim. Anyone who had any dealings with Weisinger, like John Broome, absolutely refused to work for him."

And no one ever reined Weisinger in? "There was no one above him except Jack Liebowitz, who was vice president and publisher," Boltinoff said. "And Mort bought a house in Great Neck so he could be near Jack Liebowitz. He was always a fawning son-of-a-bitch. He always had the inside track with Jack.

One of Weisinger's lasting legacies is the Bizarro world.
(© DC Comics, Inc.)

Distortion was another Weisinger favorite, along with making the Superman regulars either babies or really old.
(© DC Comics, Inc.)

"Mort could break people if he wanted, because of that proximity. And his stuff sold. You couldn't argue with that. Of course, there were some great disasters. We did a book on firemen. A terrific disaster. Mort's contention was that the book should sell well because kids loved firemen. You could have made a beautiful bonfire with all the returns we got. When Mort fell, he fell hard."

Schwartz argued that he eventually took DC with him: "He was a litmus paper for mediocrity, as Don Cameron observed. He bowdlerized the stories. The fact that DC became old-fashioned and didn't keep up with Marvel was a result of Weisinger. He kept the quality level way down. If he didn't recognize it as having been done before, he wouldn't go along with it.

"I remember the day Weisinger came into the office yelling he had made *The New Yorker*. S. J. Perelman had done a takeoff on Mort, ridiculing his literary style. Mort is waving it around, saying, 'Look, fellows, I made *The New Yorker*.' Everyone was giggling. And this was the guy who was really running the show there. That's why things went to pieces."

In the end, Boltinoff said, Cameron would have had one whale of a time shoving Weisinger out that window. "He must have been 5-8, 280 pounds," Boltinoff said. "At the end, I tried to avoid speaking to him or seeing him when he came up to the office. He was a rambunctious, egotistical schmoe, king of the realm, and suddenly he was a poor old man, really sick. He had a heart problem, which proved he had a heart, anyway. A lot of people doubted that."

Fredric Wertham, drawn by William Auerbach-Levy

The Role of Ads

Comic book stories teach violence, the advertisements provide the weapons. The stories instill a wish to be a superman, the advertisements promise to supply the means for becoming one. Comic book heroines have super-figures; the comic book advertisements promise to develop them. The stories display the wounds; the advertisements supply the knives. The stories feature scantily clad girls; the advertisements outfit peeping Toms.
FREDRIC WERTHAM

Wertham, Fredric

My line of demarcation is 1953, '54, '55. Old-time radio ended. Rock 'n' roll began. Roy Rogers and Gene Autry made their last westerns. The Comics Code arrived. The things that had created imagination, and fed and fostered and nurtured it, all seemed to come to an end, and a different generation began. Television did not nurture any of those things, did not understand any of those things, and aided the destruction of that group of things. It wiped out the connection.
HAMES WARE

That Fredric Wertham, a German-born psychiatrist waging war on an American art form, was a crucial instrument of that destruction owes to a severe case of nostalgia.

In *Seduction of the Innocent*, the 1954 book that revealed Wertham's vanities and sent comic books to the bonfire (see entry), the author agonized over the innocents who have turned to violence. He could not cope with the pain and anguish children were suffering at the hands of other children.

The "boy of thirteen [who] committed a 'lust murder' of a girl of six."

The "fifteen-year-old boy . . . accused of having shot and killed a boy of fourteen . . . of having thrown a cat from a roof, of having thrown a knife through a boy's foot, of sadistic acts with younger children."

The fourteen-year-old girl "actually raped" during recess "in one of the corridors on the sixth floor."

Wertham could not understand this violence; it made him sick with nostalgia for the old days when recess and the rooftops were safe. "Realistic games about torture, unknown 15 years ago, are now common among children," he wrote. He had to know what went wrong. Original sin, he believed, was the cheap way out.

"The social forces that Wertham first cited as causing violent behavior were poverty and racism," Dr. Mark West wrote in *Children, Culture and Controversy*. "In 1947, however, his interest in these causes of violence started to diminish after he began treating some of the Lafargue Clinic's younger clients.

"Over the course of his discussions with

these children, he discovered that reading comic books was one of their preferred pastimes . . . Since most of the children who showed their comic books to him had committed either criminal or violent acts, he concluded—to the considerable surprise of many of his fellow psychiatrists—that a causal relationship existed between reading comic books and juvenile delinquency."

Because Wertham insisted on explaining the inexplicable, he picked one of the kids' common props (and 90 million copies a month made comic books damn common) and blamed them. "Brutality in fantasy creates brutality in fact." Case closed.

Why else would children dive underground and read comic books except to acquire the proper technique for breaking into banks, beating up women, or staging the perfect hanging? Eleven years later, Jules Feiffer delivered a more plausible explanation for comics' appeal:

"It should come as no surprise, then," Feiffer wrote in *The Great Comic Book Heroes*, "that within this shifting hodgepodge of external pressures, a child, simply to save his sanity, must go underground. Have a place to hide where he cannot be got at by grownups. A place that implies, if only obliquely, that *they're* not so much; that *they* don't know everything; that *they* can't fly the way some people can, or let bullets bounce harmlessly off their chest, or beat up whoever picks on them, or—oh, joy of joys!—even become invisible! A no-man's land. A relief zone. And the basic sustenance for this relief was, in my day, comic books."

In our day, of course, no-man's land is patrolled by the Bloods and Crips, the crack and the smack, the Skinheads, the condom cops and MTV. Relief isn't delivered all in color for a dime. If Fredric Wertham were still alive—he died in 1981 at the age of 86—he'd be awfully nostalgic for the days when all there was to fear was comic books.

And what of Wertham's legacy? Forty years on, the psychiatrist more closely resembles a patron saint than the angel of death. When Wertham dominated the debate, quality comic books, such as many of those published by EC, were the exception. Who knows where comic books were going when Wertham interrupted the flow? He forced them to start over. And in less than five years, comic books—with nowhere else to go—went back to the beginning, dragging the Golden Age heroes into another age.

Wessler, Carl

So many of these tales end bitterly, the artists and writers swept away without paychecks or applause. That's how Bill Gaines classified Carl Wessler. "I was in Florida recently and I called Carl," Gaines said at the 1972 EC Convention, "and he was practically crying. He said, 'For 20 years, every time I send them a plot they censor it. Why don't you come back in the business so I can write?' It's a real problem for these guys. A real old professional horror writer just can't work under the Code."

Mary Wessler, Carl's widow, wants you to know that it really wasn't all that bad.

Twenty years after EC shut down, Carl was

Wessler wrote a number of memorable stories for *Shock SuspenStories*, including this classic drawn by Bernie Krigstein for issue #18 (the last issue in the series).

(© 1998 William M. Gaines, Agent, Inc.)

"Wessler parked himself on the third floor of his Scarsdale home and, fueled by a steady supply of Cokes from the icebox, let the ghosts and demons out of the box."

still at work cranking out the scripts, mostly for Harvey Publications and DC. He wrote plot synopses; if a publisher liked a plot, Carl would flesh out a script.

"He would work whenever he had an opportunity," Mary Wessler said. "He would sometimes work six days a week; if he had a story due, a seventh. He took it very seriously. He was really wrapped up in his work. And Carl enjoyed it."

Wessler started out in the animation department at Fleischer Studios. When the studios moved to Florida—enticed, no doubt, by the city of Miami's offer of free air conditioners—he met his future wife.

Wessler quit Fleischer in 1943 (a year after the studio returned to New York) to begin a 44-year career as a freelancer. In the next ten years, he would script stories for Timely (at least 700, by his estimate), Hillman, Lev Gleason (*Crime Does Not Pay* and *Black Diamond*), Quality, and Orbit, as well as romance stories for Prize and Ziff-Davis.

His best-known stories were written for EC. On October 1, 1953, Al Feldstein introduced himself on a 2-cent postcard, which read:

Dear Mr. Wessler

Will you kindly get in touch with me regarding comic script work if you are interested

ALBERT B. FELDSTEIN

No punctuation. No problem. Thirteen days later, "Wessler mailed out his first EC script," John Benson wrote in *Squa Tront* #9. "Over the next 16 months he sold nearly 100 scripts to EC, about 60 of which were for the crime and horror titles."

Wessler wrote the stories for several entire issues, including *Vault of Horror* #38 and #39, *Tales from the Crypt* #44 and #45, *Haunt of Fear* #28, and *Shock SuspenStories* #16. That issue of *Shock* contains two of his best EC efforts, "A Kind of Justice" and "The Pen Is Mightier."

He loved working for Gaines. Wessler parked himself on the third floor of his Scarsdale home and, fueled by a steady supply of Cokes from the icebox, let the ghosts and demons out of the box. If he never told anyone he was writing for the horror comics—"You kept that to yourself," Mary Wessler said—he enjoyed the credit Gaines gave his writers.

And what of the ensuing censorship? "The weight of censorship came down because Bill Gaines stopped publishing," Mary said. "Carl lost a very good account."

But he didn't lose his talent for pumping out good stories. In the late 1950s and beyond, he wrote reams of material for Harvey and Charlton and at least 700 stories for DC, including *Tomahawk* scripts for editor Murray Boltinoff.

Wessler finally quit writing stories in the mid-1980s. "He wanted to write books, but he just wasn't able to," Mary said. "He just got old."

Carl died on April 9, 1989. He had George Bailey's kind of life, to hear his widow talk. "He was working at home and we were very compatible," she said. "We had a beautiful life. We were married 46 years.

"It was amazing how Carl's mind could come up with plots. The synopses that weren't accepted were just as good as the ones that were. They would come as automatically to him as you and I talking. It was just a gift. I often wonder about all those synposes, if they could be of use to somebody. I have boxes full. We have thousands of stories hanging around here. I wish somebody would tell me what to do with all of them."

Western Comics

What interests me in the western, what I enjoyed, was this universe of signs, circumscribed as a place and a time. As soon as you move a little bit too far north — or south, or east, or west — it's no longer a western. If you go back just 10 years, before the invention of the revolver, or if you go past the moment when there's too much barbed wire in the desert, or too many automobiles, or too many roads, or too much long-distance communication — that's it, it stops being a western.

JEAN "MOEBIUS" GIRAUD
THE COMICS JOURNAL

What interested Moebius doesn't get much of a rise out of comic enthusiasts: Westerns have steadfastly defied retrospective or sustained collecting interest. When Maurice Horn argues the westerns "constitute a veritable paper jungle in which it is very easy for the unwary reader to get lost," he may be overestimating the genre's readership.

Blaze Carson, The Fighting Sheriff!, Outlaw, Western Crime, Tom Mix Western . . . these are not the crown jewels of any collection. As exotic as it must have been waiting to see if Roy Rogers would wear the same shirt month after month on his photo covers 40 years ago, few are looking for those books now.

When the super-heroes lost their legs after World War II, comic publishers turned to crime or horror or romance . . . or headed west. They borrowed liberally from Hollywood and hung on to their cowboys for dear life: *Roy Rogers* lasted 158 issues, *Gene Autry* endured for 130, why, even *Rocky Lane* chugged along for 87. The advent of the Comics Code hardly slowed westerns down, simply putting cowboys on the trail of commie lowlifes as the Fifties wore down.

Aside from the odd Jack Kirby story, Matt Baker interior art, or Dan Zolnerowich cover, little in these Westerns was at all memorable until Moebius and Jean-Michel Charlier began the 22-book Blueberry saga in 1963.

Western Printing and Lithography

Western was "the biggest comic book company in the history of mankind and by a wide margin," Mark Evanier told *The Comics Journal* in 1990. "For one brief period, one comic—*Walt Disney's Comics and Stories*—was selling more copies per month than the entire DC line now does. They used to move something like 40 million comics a month when their books were going out under the Dell imprint. They used to cancel a book that sold under half a million . . . I guess this proves that there's no such thing as a company that's too big to ever fold.

"A lot of things went wrong for them. Changing times for one. Western used to think that if it sold in 1955 there was no reason why it shouldn't sell in 1975 . . . Western was like a record company that refused to stop trying to sell Four Lads' albums. They had a cover format that they loved and wouldn't alter for the world. They had a policy of doing a lot of short stories in each book and there was proof that this was a wise move in 1960, but they wouldn't budge from it in '72 . . . They were very conservative: If a book was selling well for them as a quarterly . . . they'd wait a year or two and see how it did before edging it up to bimonthly. One of their best-selling books of all time was *Space Family Robinson*, and I don't think that was ever made monthly. In its prime, it outsold any of the current DC or Marvel books, and I think it probably declined largely because Western wouldn't publish it more often. Kids don't follow quarterlies, not when *Spider-Man* is out every month. And Western had a lot of distribution problems. There were whole states where their books didn't get out."

And whole states where their books did. Don Rosa's research into Western's publishing output prompted Evanier to suggest that "Western was responsible for well over half the comic books sold in this country ever. I think of this every time someone at DC or Marvel speaks of their firms as if they were primal forces of nature and destined to live forever."

The 1950s were definitely an era for westerns, in films, on TV, and in comics. Case in point: Roy Rogers Comics *ran from January 1948 to September 1961.*
(© Roy Rogers)

Walt Disney's Comics and Stories was Western's longest-running title. Walt Kelly did most of the early covers; Carl Barks took over later in the run, including producing this classic.
(© The Walt Disney Co.)

Jerry Weist

"This guy had nearly 5,000 comics from 1948 to 1970, and he only wanted to sell a few at a time."
Jerry Weist

Wheeler-Nicholson, Major

Although [Max] Gaines is given the credit, if that is the word, for fathering the idea of the comic strip magazine, his Famous Funnies *was, however, a reprint job. The man who invented the magazine as it is today, that is original pictorial stories of terror, crime, fantasy and miracles, was Major Malcolm Wheeler-Nicholson who, in the fall of 1934, published a 64-page, four-color magazine called* New Fun."
Douglas Gilbert
New York World-Telegram, 1942

"He died, all but forgotten, in 1968," Les Daniels writes in the opening chapter of the official history of DC Comics. He died without ever granting that Bill Spicer interview, selling that mint set of *New Fun*s, or sitting in the belly of the San Diego Convention Center during Comic-Con International, marveling at the madness he'd unleashed.

Wheeler-Nicholson was born in Tennessee in 1890 and retired from the Army in 1924 after a sterling career in the cavalry. It didn't take the major long to return to the saddle, drawing on personal experience to craft stories for the pulp magazine *Adventure*.

By the early 1930s Wheeler-Nicholson decided—erroneously, as it turned out—that his future was in publishing, not writing. "He started out with reprints and whatnot," editor Vin Sullivan said. "He was always in a financial jam. Not much of a businessman. He was a rather flamboyant guy. Always had a cane and wore spats and a beaver hat. He was sort of a con artist. Not sort of: He *was* a con artist. But he had ideas."

The major's idea was to forget the reprints, which required licensing fees, and to go with "all new" material. To emphasize the freshness of his wares, Wheeler-Nicholson put the key word in lights on his first two comics, *New Fun* and *New Comics*.

The books survived—under two new marquees, *More Fun* and *Adventure Comics*—as did the company that published them, but Wheeler-Nicholson sold out to Harry Donenfield and faded from the scene, pursued by debt collectors. We'll never know whether he really married a duchess or ever glanced at a comic rack with some degree of pride.

White Mountain Collection

The owner of the premier Silver Age pedigree collection first came down out of the White Mountains of New Hampshire in 1985 to knock on the door of the Million Year Picnic in Cambridge, Massachusetts.

He wanted to sell some books, he said. "The reaction he was getting from dealers," owner Jerry Weist said, "was they didn't have enough money to buy them. The comics were too good. The condition was too good. I've been [selling] comics since 1964; that's always the talk. Usually, it doesn't produce anything."

The gentleman—let's call him Mr. White—didn't want to sell all his books at once, just his ECs, a run he said was 95 percent complete in VF-NM condition. Russ Cochran had published his EC Library; White knew he could still read the books in collected form. And he was in no hurry. Weist talked to him for several months before they agreed that he would first bring in his duplicates.

"I think I bought 40 comics," Weist said. "And they were unbelievable. I was stunned." What impressed him most was the paper quality. The paper quality of ECs is notoriously poor: "Bill Gaines had a horrible distributor in the '50s," Weist said, "and he didn't have a lot of money. The paper supply wasn't as good as other companies."

But he had no complaint about the paper quality on these books . . . even though they were White's *extras*. "The White Mountains have better paper quality than the Gaines file copies, which is extraordinary," Weist said.

Four months later, Weist bought the rest of the ECs, which he quickly turned around and sold to Steve Geppi at 2.25 times *Overstreet Comic Book Price Guide* price. Then he waited for his next visit from Mr. White.

"This guy had nearly 5,000 comics from 1948 to 1970, and he only wanted to sell a few at a time," Weist said. "If someone would have come to him with $50,000 in a briefcase, they would never have spoken to him again. I'm convinced he developed a relationship with me because (a) I wasn't greedy, and (b) I was patient. That was incredibly difficult. What I knew was there were most of the Atlas Comics, all the great Atlas horror comics in near-complete runs. There was also complete *Mystery in Space* [from #] 1–up. *House of Mystery* #1–up. I

just had to be patient and wait for it to unfold."

The owner of the books, Weist soon learned, had inherited the collector's passion from his father, who hoarded antique cars. "The son emulated the father; he was really meticulous. He placed his comics into these metal storage boxes back in the '50s. Even as a kid, he never cracked the spine. The comics never went into bags.

"This guy's love, and his main focus, is science fiction and horror," Weist said. "When I first asked him about super-hero comics, he said, 'I don't have any.'"

But the first time Weist went to visit him, White said, "I have something to show you." He brought out a pile of books, the last issues of several runs he'd bought, out of habit, even after Marvel abandoned his beloved science fiction. "What he brought out that afternoon was *Hulk* #1, *Amazing Fantasy* #15, *Amazing Spider-Man* #1, *Journey into Mystery* #83, *Tales of Suspense* #39, *X-Men* #1. I opened one of the books, and it made that sound that comic books make when they've never been opened before.

"I looked up and said, 'Well, of course, you didn't read these, right?' He said, 'That's right.' He said he didn't want to sell them, so I had to wait."

A year after Geppi bought the White Mountain ECs, Weist took a chunk of the collection to the San Diego Comic-Con. The books included *Mystery in Space* #1–#60, *Strange Tales* #1–#40, *Strange Adventures* #20–#90, and the *Tales of the Unexpected* and *My Greatest Adventure* runs. "I was asking two and a half times Guide for everything," Weist said.

The dealers' reaction? Jay Maybruck of Sparkle City was one of the first to come by. "This is a classic," Weist said. "He told me, 'Well, you're a nice guy, Jerry, but this will never happen. Take the dream pipe out of your butthole. They're nice, but we've seen comics like this before. *But* we do have a client. If you want to sell the whole set, we can do the whole deal."

Weist didn't make any sales, but on the second day, he came through the doors and ran smack into Gary Carter's table. He'd never met Carter, but he knew about the Carter brothers and their massive holding of Mile High comics. When Bob Overstreet pulled a few comics from Weist's box to mull over, Carter asked for a closer look.

"He cracked the *Mystery in Space*," Weist said. "He just sat there. He went through about seven of them. Then he looked around the room. And he looked at me. And he said, 'You know, this isn't the place to do this. Come out to the house tonight. We're having a bunch of guys over.' I went over that night. He bought every DC I had. He swept *Mystery in Space* and *Strange Adventures*."

"It reminded me," Carter later said, "of '78, when I looked at the Mile Highs for the first time. I had been collecting these titles avidly for 35 years. Every single issue upgraded my collection."

Overstreet eventually bought the *Tales of Suspense*, *Tales to Astonish*, and *Journey into Mystery* runs. "Mark Wilson was also there [that night in San Diego]," Weist said, "and he said, 'Whatever Gary doesn't want, I'll take. At two and a half times Guide.' The previous day, I was met with derision; that night, everything I took was swept up by two people. And you could see the impact on the faces of Jim Payette, Bob Overstreet, Bruce Hamilton, guys who had been in the business for years. At that moment, the White Mountain collection was born."

At the 1993 Sotheby's auction, Mr. White's copy of *Amazing Fantasy* #15 sold for just under $40,000.

Whitman Publishing

The publisher of the Big Little Books, Whitman didn't cast much of a shadow on the comic book industry, but the company churned out a lot of print on the cheapest possible paper. Such Whitman titles as *Dick Tracy*, *Invisible Scarlett O'Neil*, and *Boots and Her Buddies* came tucked into attractive jackets, but the paper was likely to fall apart in the reader's hands. Whitman also published a variety of incredibly cheap kids' books with plastic bindings in the '50s. The company assumed the Gold Key logo in the late 1970s and subsequently packaged comic books for drugstores.

Whiz

The most valuable comic book not published by DC or Timely, *Whiz* #2 got the show rolling at Fawcett. Why #2? The first issue, an ashcan designed to secure a copyright for its title character, one Captain Thunder, was trashed when Fiction House (which had its

> "I opened one of the books, and it made that sound that comic books make when they've never been opened before."
> JERRY WEIST

Whitman published both the Big Little Books and Better Little Books lines.
(© Marjorie Henderson Buell)

One of the most popular comics of all time, *Whiz* ran from February 1940 to June 1953. This is #89 (September 1947).
(© Fawcett Publications)

own Captain Thunder slated for *Jungle Comics* #1) beat Fawcett to the copyright desk.

As Jim Steranko observed, *Whiz* is the only magazine in comic publishing history in which each of its five major characters Captain Marvel, Spy Smasher, Ibis, Golden Arrow, and Lance O'Casey—spun off into his own title.

As late as 1946, *Whiz* had a circulation exceeding 1.3 million. The book ran 155 issues, finally lowering the flag in 1953.

Wild

An underground fanzine first published in 1959, *Wild* published work by Jay Lynch and Skip Williamson before they surfaced in Harvey Kurtzman's *Help!* The fanzine was co-edited by Don Dohler and Mark Tarka and survived for three years (11 issues) before the editors went broke. In keeping with the spirit of fanzines of that day, issue #10 (and its Kelly Freas color cover) was heavily damaged by a flood in Dohler's garage, and #11 was never mailed.

Wildey, Doug

I hated the damn dog.

His first comic book work was a *Buffalo Bill* story in 1949; his last, an unfinished page from a *Rio* graphic novel (Wildey's own western character), was on his studio drawing board the day he died in 1994.

Doug Wildey is best remembered for creating *Jonny Quest* for Hanna-Barbera, and that suited him. "I always thought that comics were a way stop," Wildey said at the 1992 San Diego Comic-Con. "It seemed like a way to make grocery money before I went on to richer things."

He never got rich working through the 1950s at Avon, Cross, St. John, Fawcett, Ace, Gleason, Western, and other places known and unknown. Wildey reached Atlas in 1954, where he drew a variety of horror, romance, war, and science fiction titles before Stan Lee gave him *Outlaw Kid*. "That was my ticket out of New York," said Wildey, who migrated to Arizona. "When [Lee] sent me a script, there were various names on it, but every story was exactly the same. And the writing wasn't very good."

Wildey picked up *The Saint* newspaper strip in 1959; shortly afterward, Milton Caniff called and asked him to ghost *Steve Canyon* for five weeks. "All his life he'd been writing about the Far East and he'd never been there," Wildey said. "So, he decided to go. I was his relief."

In 1962, Wildey dropped *The Saint* and joined Hanna-Barbera. "They hired me to do *Jack Armstrong, the All-American Boy,* which had four principal characters. That went on until the owner of Jack Armstrong hit them up for more than they wanted to pay. So, Joe (Barbera) said, 'Just create one for us, Doug.' I used the same setup, the same four characters. The dog was not my idea. I hated the damn dog."

He grabbed the names Jonny Quest from the L.A. phone book and Race Bannon from an old automotive strip. "The upper execs at Hanna-Barbera forced Bandit on him, in an effort to make the show more kid-friendly," noted Diana Schutz, who was editor at Comico when the company secured comic book rights to *Jonny Quest* in 1986. "Twenty-some-odd years later, Doug had met countless people named after the show's characters—something I don't think he ever quite fully understood—and had spawned an entire generation of canines named Bandit. He *hated* that damn dog."

Animation didn't do a much better job than comics at paying Wildey what he was worth. But when Hollywood didn't make him rich, Dave Stevens did his best to make Wildey famous, using him as the model for Peevy in *The Rocketeer*. In his later years, Wildey fleshed out the Old West with oil and brush and returned to his western character, Rio. He was 72 and living in Las Vegas when he died.

Williams, Robert

Do you understand? The picture doesn't exist for your approval, it exists for your reaction.

Doug Wildey

One of the original underground artists ("I remember when I started in underground comics, there was maybe about eight or nine of us"), Robert Williams was born in 1943 and drawing for the comix at the age of 25. Casting his lot with the undergrounds' "graphic faction" (which includes S. Clay Wilson and Rick Griffin) and not the "literary" likes of Gilbert Shelton and Robert Crumb, Williams did early work for *Zap* and *Yellow Dog*. He eventually concentrated almost exclusively on rowdy, multi-layered oil paintings. "The average painting," Williams told *The Comics Journal* in 1993, "takes nine to twelve days and that's getting up at 4:20 in the morning and hammering 12 hours a day for seven days a week." The result of his hammering is never boring.

Williamson, Al

> *I never could draw an incredibly good-looking naked woman ... I can't draw women worth a darn unless I have a photograph. It's hit or miss. Guys who could draw women are guys like Frazetta, Roy [Krenkel], Wally Wood, they could sit down and just ... It took me quite a while to draw women.*
> AL WILLIAMSON

After all these years, someone should sit down with Al Williamson and tell him it was worth the wait.

Not that Williamson would listen. You have to understand this about Al: In the years when he was doing some of the best work of his life—the Fifties—he was not a happy guy.

Williamson was "still in the process of growing up at the time," said Marie Severin, his den mother at EC, "which was ... like a breath of fresh air. It may have been Moon air or Mars air, but he had a nice freshness about him." And growing up wasn't always easy to do.

He was 15 years old when he first walked through the door at Fiction House in 1946, 17 when he had his first strip published ("Thin Ice on Shell Bank Creek" in *Heroic Comics* #51), and all of 21 when he landed at EC. The Fifties arrived before he was ready for them.

"Everybody seems to love the Fifties, but they were really pretty depressing," Williamson told James Van Hise. "There were a lot of people with problems who started going to shrinks, including me... In the Fifties, you couldn't walk around like I do, in jeans and sandals... I was still considered a Bohemian or the Fifties' equivalent of a hippie before the word was even coined. That's the way I used to be. I didn't want to wear ties and suits and shoes and shit like that. I wanted to be myself, and it was very hard to be yourself. You had to conform, and if you didn't conform they'd shoot you."

"He was a fish out of water," said Bill Stout, Williamson's good friend. "He really felt he'd missed something by growing up in the Fifties instead of the Sixties. In the Fifties, being a skinny guy, you were really an outcast. It was the big beefy guys who got the girls. That changed in the Sixties with the skinny rock-and-roll stars.

"Al is a very strange, down-home kind of guy, real comfortable in a T-shirt and jeans. Well, in the Sixties, that was the uniform.

Robert Williams's paintings are so detailed they must really be seen in person. This one is titled "Pantyhose and Shorts Nibblin', Pulp-Paper Goons Aren't for Junior and Sis."
(© Robert Williams)

Here's how Marie Severin portrayed the "Bohemian" Al Williamson of the 1950s.

Williamson's work for EC was often a collaboration with studio mates, including Roy Krenkel and Frank Frazetta, as on this story for *Weird Fantasy* #14 (July/August 1952)
(©1998 William M. Gaines, Agent Inc., Agent, Inc.)

He felt a real kinship in that rising Sixties generation. He was a nonviolent guy and the Fifties was a violent era. The Sixties was a romantic, idealistic time, and that was Al, too. He's a romantic and an idealist; you can see that in the stuff he draws."

In the '50s, Williamson could never get comfortable with women, which may explain why he could not get comfortable with the idea of drawing them. "When you're 20 and you can't get dates, you can't get laid, it's pretty rough," Williamson said. "When everyone else is screwing like a bunny and you're here looking at pictures . . . That was one of the things I went through. I was adjusting to working with other people. How else can I explain it? I was always very shy and not very sure of myself personally, as well as with my work. I never thought I was good enough. That was one of the things I had to straighten out. By the end of the '50s, I was joining the crowd. I never made out that great, but I felt more comfortable with myself, and more at ease with women."

By the end of the '50s, Williamson had an incredible body of work in his portfolio and a love affair with comics that was already almost 20 years old. Born in New York, Williamson was growing up in Colombia when, at the age of eight, he began reading Mexican reprints of *Terry and the Pirates*. But he was hooked for good when, on the night before Pearl Harbor was bombed in 1941, he caught a Flash Gordon serial—*Flash Gordon Conquers the Universe*—at a Bogota movie house.

"All my life I've wanted to do *Flash Gordon*," Williamson said. "Since I was 12 years old, I thought when [Alex] Raymond decides to give it up, I want to take over *Flash Gordon*. They didn't call."

So, Williamson went out looking for work on his own. Even today, he's not sure why the artists at Fiction House were so patient with him. The skinny teenager hadn't been hanging around the shop for a week when he knocked a bottle of ink over a page that George Evans was working on. "Bob Lubbers was in the back," Williamson recalled, "and he says, 'Goddam it, we oughta keep those kids in school during the summer.' But no one ever said anything else about it. No one told me to leave. No one threw me out."

How talented was Al Williamson at the age of 15? "I look back, and I was terrible," he admits. But even then, he loved what he was doing. Williamson has always rated artists by their love for their craft and their predecessors, and he always favored the company of those who could match his passion. Take Roy Krenkel, whom Williamson met in 1948. "I had met a lot of artists by that time, and there didn't seem to be the love of comics that I had, that I always had," Williamson said. "That's the one thing that disappointed me the most. They were working in comics, but they didn't seem to appreciate what they were doing. They knew that Foster was good and Raymond and was good and Caniff was good, but there wasn't that real love that you find with European artists and with Latin American artists."

After Fiction House, where he never had a

full-time job, Williamson popped up at Standard Comics, where he met Frank Frazetta. By this time, he had quit school: "All I wanted to do was work, do comics. I just loved to go to movies, write comic books, and go off and listen to music. I still like the same stuff." After an apprenticeship with Burne Hogarth on the *Tarzan* Sunday strip, Williamson and Frazetta made the trip together over to Toby Press in 1950, where they worked primarily on *John Wayne*.

Next stop, EC. Bill Stout has argued that despite all the raves, Williamson's best work was not for EC but for Atlas and ACG, but you can understand why the EC days get the fans cranked up. Williamson was, Bill Gaines once said, "so undisciplined and unstructured and such a nut in those days." He had a tough time finishing a lot of the pages he started without assists from Krenkel, Frazetta, or Angelo Torres. But he still scared people with what he could do with a pencil. "You know, Al would do doodles back then," Krenkel once said. "He would just whip the stuff out and that stuff was incredible. No one ever drew better. The guy was a master draftsman."

After four years of science fiction stories at EC, Williamson joined the exodus to Atlas in 1955. In the next four years, Williamson did some 90 stories for Atlas, according to Jim Vadeboncoeur, "more than he produced for any other company in his career." In the same period, he also worked for ACG, Dell, Charlton, and Harvey.

In 1961 Williamson headed to Mexico with John Prentice for a 17-month stint on the comic strip *Rip Kirby*. Williamson remembers making $130 a week as Prentice's assistant, but the job got him some permanent work in comic strips. He drew the Sunday pages for John Cullen Murphy's *Big Ben Bolt* for four years and had a full-time lock on *Secret Agent X-9* for 13 years, beginning in 1967. Williamson also pinned everyone's ears back with his work on the *Star Wars* comic strip with Archie Goodwin.

Williamson has primarily done inking for Marvel in the last decade (plus art on a two-issue *Flash Gordon* series), but he's also had plenty of time for going to the movies or listening to music in his studio in northeast Pennsylvania. He weathered the tragic loss of his first wife, Arlene, and later remarried. What his art lost in "sheer whiz"—Krenkel's term—he regained with an expanded range. And he has remained a fast and loyal friend to all those who shared his love for comic art.

Wings

The best of the Golden Age airplane comics was also probably the most underrated series from Fiction House. The publisher's fifth title, launched in September 1940, *Wings* features some fine interior artwork by Matt Baker, Lilly Renée, George Evans, Rafael Astarita, and John Celardo. It also bears a spectacular array of covers by Artie Saaf (#34–#48, #50–#57), Lee Elias (#58–#72), and Bob Lubbers (#74–#108).

In the opening minutes of Steven Spielberg's

This is one of 16 covers Gene Fawcette drew for *Wings*: #32 (April 1943).
(© Fiction House)

Empire of the Sun, which is set in 1941, the young airplane enthusiast is seen reading a *Wings* comic, but the cover is not one of the 124 shown in Ernie Gerber's *Photo-Journal Guide to Comic Books.*

Witzend

The first of the "pro-zines," *Witzend* debuted in 1966 with the exorbitant price tag of $1. As Bill Schelly reported in *The Golden Age of Comic Fandom,* the magazine was a Dan Adkins idea that went through one editorial and two name changes before Wally Wood finally dragged the first issue to the printer. It was worth the wait, given the art by Al Williamson, Frank Frazetta, Roy Krenkel, Steve Ditko, and Wood himself. Like the pro-zines that followed, *Witzend* allowed creators to maintain control of their published work.

A Wally Wood *Witzend* Cover.
(© Wally Wood)

Woggon, Bill

Born into a family of artists, Woggon created Katy Keene in 1945 as a tribute to George Petty's stable of show-off girls. He got his start in comic art by supplying gags to his brother Elmer for use in the strip *Big Chief Wahoo,* which evolved into *Steve Roper.* Like Dale Messick with *Brenda Starr,* Woggon solicited fashion designs from his readers for Katy and her pals credited those who sold him an outfit that made Katy's eyes light up. The industry of comic books, paper dolls, and premiums soon proved too exhausting for Woggon, who hired on such assistants as Hazel Martel, Floyd Norman, Tom Cooke, and Bill Ziegler.

Wolfman, Marv

One of the more congenial guys in the business, Wolfman—a fanzine editor at the time—published Stephen King's first story, changing the title from "I was a Teen-Age Grave Robber" to "In a Half-World of Terror." Not content with that bit of editing, Wolfman later tried his hand at rewriting the history of the DC universe.

As teenagers in the early 1960s, Wolfman and pal Len Wein used to go over to Jack and Roz Kirby's house for milk, cookies, and a glimpse of comics greatness. Marv sold his first script (*Blackhawk* #241) in 1968 at the age of 22. He freelanced with DC until joining Marvel as an associate editor in 1973. Two years later—those were interesting times at the House of Ideas—Wolfman was named editor-in-chief.

He rejoined DC in 1979, where he masterminded the second revival of *New Teen Titans,* quickly turning it into DC's best-selling book. In 1985 Wolfman took the entire DC galaxy back to the drawing board for *Crisis on Infinite Earths,* although some DC editors balked at his plans for their heroes and the past.

Nobody was supposed to remember the past, you see. "I sent them back in time with the idea of starting it all over with the January, 1986, books," Wolfman once said. "I insisted upon it repeatedly. The best compromise I could get is only the heroes remembered. I didn't want anyone to remember."

A dozen years later, no one remembered much about *Crisis* at all.

Wolfman also had stints at both Warren and First Comics.

Wolverine

Created by Len Wein, Wolverine and his adamantium (*adamantium?*) claws first appeared in *The Incredible Hulk* #180 (October 1974). "The wolverine," Wein reminds us, "is a very small, very nasty little animal with claws." Wein made this particular animal a mutant just in case Marvel needed him to complete a proposed remake of the X-Men.

As for Wolverine's place in the Marvel universe, the four "Classic Marvel Stories" reprinted in Marvel's corporate history are a 1954 Sub-Mariner story, a 1963 Spider-Man piece, a 1966 Fantastic Four story, and a 1987 "Wolverine adventure" that was "sold exclusively through Sears stores."

Wolverton, Basil

During the '60s, I sold Basil's comic book collection for him to a collector. When the check arrived, I called and asked if it would be okay for me to drop by with it that evening. He said they were going out to dinner at that time, but that if I felt like dropping over with it anyway, to just put the money in a huge envelope, nail it to the front of the house and paint a giant arrow pointing toward the envelope along with the words, "Here's The Money!"
DICK VOLL

Marv Wolfman

Mel Blanc? "We both struck out for Hollywood at about the same time," Basil Wolverton once said. "Mel came home [to Oregon] in a 1929 Cadillac, and they carted me home in a 1910 wheelbarrow."

Stan Lee? They met in the 1940s. "I remember I was wearing a plaid shirt at the time, and when I walked in, he asked, 'Where's your ax?'"

Boris Karloff? Frank Sinatra? Salvador Dalí? They judged the 1946 contest to determine the real Lena the Hyena.

Lena the Hyena? That's right. The ugliest woman in Al Capp's universe or any other. Wolverton submitted seven entries to the *Li'l Abner* contest and, after the judges picked what Wolverton considered the least offensive of the lot, he finally landed that Cadillac . . . not to mention the cover of *Mad* and the cover of *Life*. "At long last," Wolverton later reminisced, "I was able to afford an eraser for each hand."

Wolverton was all of 11 years old when he sold his first cartoons at the Vancouver (Washington) Farmers Market. "Each week I'd make a cartoon likeness of some popular newspaper comic strip character; I'd take it in, and the man there would give me four bits for each one," Wolverton told Voll. "They displayed them there, and this probably meant more to me than selling to a magazine does today."

Voll found Wolverton "small, graying, plump, well-kept, and intense." His eccentric comic characters, in other words, weren't self-portraits. After an early vaudeville career and missing syndication on several newspaper strips Wolverton sold his first stories ("Disk Eyes the Detective" and "Spacehawks") to *Circus Comics* in 1937. Soon after came "Space Patrol" in *Amazing Mystery Funnies,* Meteor Martin in *Amazing Man,* and Rockman, Underground Secret Agent in *USA Comics.*

Few illustrators have brought such a unique perspective to the comics. Wolverton produced over 1,300 pages of art, and the vast majority were populated by outlandish aliens that could have knocked Lena off the cover of *Mad.* After leaving comics, Wolverton provided illustrations for a religious publication called *The Plain Truth.* He died of a stroke in 1974.

Wonder Woman

Comicdom's Eve, fashioned out of clay by William Moulton Marston, danced into the light in *All Star Comics* #8 (December 1941/January 1942).

Marston (who also created the lie detector) spent too few years with his creation; Robert Kanigher spent far, far too many. Marston gave her the golden lasso, the bracelets of submission, Paradise Isle, and Steve Trevor, the male Lois Lane. Kanigher eventually stripped her of all that, and her dignity besides.

George Pérez revived the feminist and mythological themes when DC kicked off a new *Wonder Woman* series in 1987. Brian Bolland's covers, Mike Deodato's art, and William Messner-Loeb's scripts had that series rolling by 1995, when DC inexplicably passed the character on to John Byrne. Alas, the poor Amazon is cursed.

Wood, Bob

On the morning of August 27, 1958, 45-year-old Violette Phillips was beaten to death in Room 91 of the Irving Hotel in New York's Gramercy Park. The murder weapon was an electric iron. The alleged murderer—who was being held without bail—was "a 41-year-old cartoonist" named Bob Wood.

As an editor at Lev Gleason, Wood's name appeared on literally hundreds of books during the 1940s and 1950s, invariably teamed with

Basil Wolverton's most infamous creation was Lena the Hyena, originally for Li'l Abner.

Wonder Woman starred in Sensation Comics *before getting her own title. The covers were by H. G. Peter.*
(© DC Comics, Inc.)

Bob Wood's lurid criminal episode was media fodder in 1958.
(Headline collage courtesy of Joe Simon's book *The Comic Book Makers*)

"They'd been arguing about whether they should get married when Wood grabbed the electric iron and ended the discussion."

Charlie Biro. While Biro deserved the lion's share of script and cover credits, Wood was described as "managing editor" in the indicia and probably paid the bills and kept the presses greased.

With Wood, there was a steady supply of grease. When Gleason's *Crime Does Not Pay* was at its peak popularity, some believe it was selling 4 million copies a month. More often than not, Wood drank his share of the profits.

Drinking may not have been the worst of Wood's problems. Jack Cole once told Gill Fox the story of meeting Wood and one of his girlfriends at a downtown street corner. When a sailor beat the woman to a taxicab they all wanted, she and Wood began to argue. "And Wood came over and started beating the hell out of her," Fox said. "There was something wrong with him [Wood] when he got around women."

He'd apparently been drinking with Violette Phillips in their room at the Irving Hotel for most of 11 days when Wood let go for good. They'd been arguing about whether they should get married when Wood grabbed the electric iron and ended the discussion. He then grabbed a cab ride to Greenwich Village, telling the cabbie en route that he had just killed a woman and, after catching a few hours of sleep, he was going to jump into the East River.

When the police caught up to Wood, he was still drunk and splattered with blood. He didn't deny doing any of the damage that the cops discovered back at the Irving Hotel.

Convicted of manslaughter, Wood spent three years at Sing-Sing. "When Bob Wood got out of jail, he called me and wanted to know if he could come up and see me," Fujitani recalled. "He had some deal with an art director he'd met in jail. Bob Wood had to get some samples together and he wanted me to do them for him. He wanted me to lay them out for him and he'd touch them up.

"When I met him at the train station, he was bombed out. His hand was shaking like a leaf. We stayed up half the night and I did this stuff for him. The next day I took him into the city. I really don't know what happened. A year later, someone told me he got killed. He was drunk, walked out from behind a parked car and a truck hit him."

Wood, Wally

When I first met Wally [in 1966] he had been working in the same room for 12 years, so there was a lot of clutter. The first time I saw his studio I couldn't figure out what was hanging from the ceiling. There were all these things with gray felt on them. They turned out to be hundreds of model airplanes on strings, covered with dust.
RALPH REESE

Woody could have had the world at his feet at one point, but didn't do it. He just stayed in comics. One of the best, maybe the best comic man that ever lived. Even his comics stuff started getting stale after a while. He was just a very unhappy man, very disillusioned, very bitter. I mean, for a long time, like the last 30 years of his life.
BERNIE WRIGHTSON

This is my world. This is the world I love. It is a steaming tropical swamp, damp and stinking and alive …
WALLY WOOD
"MY WORLD," WEIRD SCIENCE #22

When Wally Wood finally pulled out a gun and put an end to that unhappy, bitter life (see **Suicide** entry), there wasn't much left of his world. "Woody? His work was like unto a God for a lot of us," said Walt Simonson, who did two issues of *Hercules Unbound* with Wood for DC in 1976. "The later ECs and early *Mad*s are just unbelievable. But Woody was pretty burned out. Comics can use you up, especially back in the times Woody was working, when

> THIS IS MY WORLD. THIS IS THE WORLD I LOVE. IT IS A STEAMING TROPICAL SWAMP, DAMP AND STINKING AND ALIVE WITH SCREAMING BIRDS AND SLITHERING LIZARDS AND HUMMING INSECTS AND GIANT DINOSAURS THAT SPLASH THROUGH ITS STAGNANT POOLS AND SLOSH THROUGH ITS SUCKING BOGS IN SEARCH OF FOOD TO FILL THEIR CAVERNOUS BELLIES...

> FOR MY WORLD IS THE WORLD OF SCIENCE-FICTION... CONCEIVED IN MY MIND AND PLACED UPON PAPER WITH PENCIL AND INK AND BRUSH AND SWEAT AND A GREAT DEAL OF LOVE FOR MY WORLD. FOR I AM A SCIENCE-FICTION ARTIST. MY NAME IS WOOD.

Wally Wood's most famous EC science fiction story ends with a self-portrait.
(© 1998 William M. Gaines, Agent, Inc., Agent Inc.)

you were just getting piece-rate work. His curse may have been that he was so damn good at doing comics."

Born in Menahga, Minnesota, in 1927, Wood came back from World War II and began assisting George Wunder on *Terry and the Pirates*. His first penciling job was *True Crime Comics* in 1949; soon thereafter, he was churning out romance comics for Fox Features.

Wood and Joe Orlando shared the same agent, one, Orlando said, who "didn't like his artists knowing where their work was being printed. He was afraid we would go directly to the companies for the work, I suppose." When they met one afternoon in the agent's office, Wood suggested they get a studio together. "Wally was fascinated with how fast I could pencil something he could ink," Orlando said. They got a studio at 63rd and Columbus Avenue and worked together there, on titles such as *Captain Science* and *Strange Worlds*, until the construction of Lincoln Center brought a condemnation notice to their door.

As Wood had just married this wonderful, beautiful girl named Tatjana,' you might think Wally and Joe parted company. Not so. As reported in the Orlando entry, Joe moved in with the couple in their new apartment and stayed there working with Wood until it was gently hinted that he wend his own way in the world.

Wood slipped in the door at EC through John Severin. He'd hit the pavement, Wood once said, and he'd gotten "thrown out of every place in town. Then I went into one office, some religious comic or something, and there was this guy sitting there and he started talking to me and we showed each other our stuff." Severin invited Wood over to the studio he shared with Harvey Kurtzman, Will Elder, and Charlie Stern.

Wood's stories for the original *Mad* comic are all worth revisiting.
(© 1998 E.C. Publications, Inc.)

"Harvey was kind of nasty—'Why are you letting a kid hang around here?'—but they each did me an original and wished me luck and gave me a couple of lessons," Wood said. "It seemed that overnight I was working for EC, and there was Harvey and he was my editor."

Jules Feiffer never liked Wood's stuff at EC—"I just didn't get it," Feiffer told *The Comics Journal*. "He always seemed to me derivative. And heavy-handed and unripe"—but Feiffer was an exception. These were the best years of Wood's life. He did superb work for Bill Gaines on *Weird Fantasy, Weird Science*, and *Mad*. When the EC comics died, he ghosted *The Spirit* for Will Eisner, teamed with Jack Kirby on a short-lived comic strip, and did bubble-gum cards for Topps.

Wood also got drunk a lot. "Wally had a tension in him," said Kurtzman, "an intensity that he locked away in an internal steam boiler . . . I think it ate away his insides and the work really used him up." Small wonder Wood could dream up the Alka-Seltzer ad that warned, "Stomachs get even at night." He sucked all the energy in, instead of pushing the envelope. The last 25 years of his life were marked by mediocre work for Marvel, the topless trivia of his own *Sally Forth*, the explicit sex of *Gang Bang*, a famous poster in which Snow White is sexually molested by the Seven Dwarfs, and the occasional brilliance of *Witzend*, which Wood self-published with more than a little help from his friends.

"He was one of those guys who'd been beaten down by life, the system, whatever," Steve Englehart said. "He was very low-key. He would sit at a party and watch what was going on, rather than participate. He got old in comics and found out his services were not required. He was one of those guys who found his moments of triumph were 20 years in the past, the guys who said, 'I think I made a wrong career choice.'"

All the stories about him aren't sad and bitter. Paul Kirchner recalled the time Wood moved uptown to 84th Street: "He had some fan who owned a truck help him move, and he paid the guy off with a set of the first 30 issues of *Mad*." Dan Adkins remembered the rare breaks in their 18-hour days when Wood would drop his pencils, pick up his guitar, and sing. But everyone could tell he was tired of carrying the tune. When he committed suicide in 1982, rather than face the prospect of being hooked up to a dialysis machine for his diabetes, Orlando was one of the few people who was surprised. "The Wally I knew loved life," Orlando said.

He just soured on what he could add to it.

Wooden Legs and Guitars

Gene McDonald was on the Fawcett staff as a helper for Mac Raboy. Gene McDonald was a guitar player. Not a twang-twang guitar player, a Spanish guitar player. A Segovia lover. He was terrific.

Gene McDonald had only one leg. He would go berserk if he had more than a certain amount of drinks. After a party at Fawcett one time Gene McDonald became berserk. We had to call the cops. He grabbed a hold of one cop, ripped his tunic up, knocked all the buttons off it. Then he took his wooden leg off and flailed around with it. It took five cops to subdue him with three cops sitting on him until the paddy wagon pulled up to take him away. That's Gene McDonald.

WENDELL CROWLEY, FAWCETT EDITOR

Wordiness

In the category of most words on a cover, all of the finalists are Stan Lee/Atlas covers from 1949 or 1950.

Justice #18 (May 1950) looks like a sure thing with 162 words. But it isn't even close.

Take a look at *Suspense* #3 (May 1950) and you have our second runner-up with 234 words, four of which are "suspense."

First runner-up honors go to *Man Comics* #2 (March 1950). We're talking 236 words on the cover of this puppy. Note the cover blurb: "Each Book-Length Story is From TRUE Life."

Yep, and each book-length cover is from Stan Lee.

But the winner is *Justice* #9 (April 1949) with 264 words. Like the Energizer bunny, it just keeps going and going:

(TM & © 1998 Marvel Characters, Inc. All rights reserved.)

Wrightson, Bernie

When Bernie Wrightson handed his first comic book pages to Carmine Infantino at DC in 1968, Infantino skimmed the pencils, then said, "Well, to be honest, they could be better. They could be a lot better."

They got better. A lot better.

A superb graphic artist, Wrightson is the most illustrious survivor of the Studio. Heavily influenced as a kid by ECs, *House of Frankenstein*, and the Famous Artists' Course, Wrightson joined the *Baltimore Sun* in 1967 as an editorial cartoonist. He unjoined shortly thereafter. "God, it was depressing," Wrightson said. "The office politics. Dealing with the petty jealousies. My attitude was, 'I'm just passing through. I'm not going to be here for the rest of my life like you guys.' I'd take walks at lunch time . . . The walks got longer and longer. One day I took a walk and never came back."

Wrightson's best work at DC was his 10-issue run on *Swamp Thing*, which he co-created with Len Wein. Owing to a scheduling mixup, he was forced to wrap up the entire first issue in a single weekend. "I used photographs of friends to take the place of the main characters," Wrightson said in *A Look Back*. "Mike Kaluta is the villain, Jeff Jones's former wife is the female lead, and the hero is myself. It was really great fun taking all these pictures, doing costume changes and running around in a state of near frenzy. We kept that pace up all weekend."

When Kaluta met Wrightson in 1967, he said Wrightson was already "full-blown. Drew better than anybody I'd ever seen that was that young." That wasn't good enough for Stan Lee, who recruited Wrightson, then ordered him to draw in the house style. "He wanted me to take the type of facial expressions used in early silent movies and magnify them by 20 times," Wrightson said, again in *A Look Back*. "It was a lot of smiles and back slapping and pep talk. I felt I was on a football team."

Wrightson quit the squad when his decision to slowly drain the color from a King Kull story called "The Skull of Silence" was altered to add

Bernie Wrightson (second from right) is a major modern comics luminary, along with contemporaries (left to right) Frank Miller, Neil Gaiman, Bill Sienkiewicz, and Dave Gibbons.

"MEMENTOS"

It's not meant to be a cute picture," Bernie Wrightson says in *A Look Back*. "I doubt if it's what many people would hang on their walls. But even then, it's not a 'sick' picture. Had I gone for the effect, I would have put feet on the fence in place of the heads."

Asked to explain, Wrightson told *The Comics Journal*, "If you're going to sever something, it seems a lot more horrible for me to think of a row of severed hands or, worse than that, fingers, just all lined up on a shelf or something, than heads. It's like a head, a complete severed head sitting on a shelf, there is still that humanity about it. But you get something like toes or kneecaps, elbows…It's like suddenly, 'Oh, my God!' You can cut somebody's toes off and they can still live. Cut somebody's head off, that's pretty much it, except for some athletes…if you get into parts of the body, you become increasingly creepy."

© Bernie Wrightson

color. "You couldn't get me to do another story for them," Wrightson said later.

By the end of the Studio years, in the mid-1970s, Wrightson was doing stories for Jim Warren's black-and-white horror titles. Phil Seuling commissioned him to produce a monster portfolio in 1974 that Russ Cochran auctioned off. A year later, Christopher Enterprises commissioned him to do 21 paintings based on the work of Edgar Allen Poe, then went bankrupt before Wrightson could collect his last check.

Wrightson later did an extensive series of illustrations for Mary Shelley's original *Frankenstein*, which have been published in book form. In the early 1980s he hooked up with Stephen King, doing the comic book adaptation of the anthology film *Creepshow* and illustrating King's *Cycle of the Werewolf*. Wrightson's full-color series *Captain Stern*, expanded from his own segment in the *Heavy Metal* movie, was published by Tundra in 1993. Most recently, he has drawn several particularly scary *Aliens* for Dark Horse.

Xenozoic Tales

This exquisite award-winning comic is delivered at the current rate of one issue every 18 months or so by Mark Schultz. The feature first appeared in *Death Rattle* #8, another Kitchen Sink production. It has since been collected into book form and made into a short-lived Saturday morning animated series, *Cadillacs and Dinosaurs.*

X-Infatuation

As the Marvel universe slowly evolved—or disintegrated—into the X-Men universe, it seemingly became paramount to slap an "X" somewhere on the cover of each hot new book. If it wasn't *X-Factor* or *X-Force,* it was *X-Man* or *X-Calibre* or *X-Terminators* or any one of the dozen *X-Men* spinoffs. In a world where imitation is the sincerest form of salesmanship, most other publishers took the hint. When Valiant published *X-O Manowar* in 1992, it made sure the "X" was positioned directly over the "Man." In 1993, Dark Horse paid the ultimate tribute to the 24th letter, introducing a character named simply "X" and daring anyone to top that.

X-Men

The characters by which all other characters' sales figures are measured, the X-Men first appeared in *X-Men* #1 (September 1963). Stan Lee created the original team; it was remade in the modern Marvel's image in 1975. Al Landau was Marvel's president at the time. In *Marvel: Five Fabulous Decades of the World's Greatest Comics,* Les Daniels observed, "Appointed by Cadence Industries, Marvel's parent company, Landau had no direct publishing experience but he headed TransWorld Features Syndicate, an organization that licensed American publications like Marvel's for reprinting around the world. As [Roy] Thomas remembers the meeting, Al Landau said that if we could come up with a group book that had characters from several different countries—and of course we would target particular countries—we could sell the book abroad."

What a concept. There's little evidence Len Wein—who both edited and wrote *X-Men* #94—ever received those marching orders. When Wein decided he'd rather write the Hulk than the X-Men, he passed the latter book on to Chris Claremont, who provided the comic with its cohesiveness and direction for the next 17 years.

Yarko the Great

Will Eisner's entry into the comics magicians union first appeared in *Wonderworld* #3 (June 1939). Yarko wasn't a full-time member in that union; he held down a variety of part-time jobs to pay the bills.

The Yellow Kid

Mickey Dugan by name, the Yellow Kid evolved into the most engaging character in R. F. Outcault's *Hogan's Alley,* a single-panel cartoon that first appeared in the May 5, 1895 edition of New York's *Sunday World.*

The cartoon inspired, in the words of Stephen Becker, "that first, gentle wave of mass hysteria which accompanies the birth of popular art forms." Rising to meet that hysteria were the marketers, and Rick Marschall argues that Yellow Kid's commercial popularity made the comic section an essential part of the Sunday newspaper.

You Can't Get There from Here

The woman had 1,600 Golden Age books, but she didn't have enough cardboard boxes to ship them to Los Angeles. David Alexander wrestled with her on the phone for a year before he resigned himself to the fact that if he wanted the comic books, he'd have to drive up to Butte, Montana and pick them up himself.

Alexander decided to make the best of the trip and loaded his wife and three kids into the van. They hit Seattle and Vancouver, caught the sights, had a grand old time. All was well until Alexander reached the outskirts of Butte, found a telephone, and called the woman, asking for directions to her house.

"They couldn't tell me how to get there,"

There haven't been many issues of *Xenozoic Tales,* but what's been published is cherce.
(© Mark Schultz)

Young Allies is among the many Simon and Kirby creations.
(TM & © 1998 Marvel Characters, Inc. All rights reserved.)

Alexander said. "They said, 'We know where you are, but we just can't tell you how to find us. Go someplace else and call us again.'

"So I went someplace else and called them again." This time Alexander got directions, but they were incomprehensible. The street where they lived was out in the sticks, not on any map.

Alexander was 1,500 miles from home; he couldn't simply abort the trip. He drove down one dirt road, then veered down another, diving deeper and deeper into the bush. "The road was cantilevered out: Instead of being banked so you wouldn't fall off the hill, it was slanted so that you would," Alexander said. "I figured, 'No one can live down here,' but there was nowhere to turn around. I went for five or six miles, almost slipping down the hill, before I got to this little clearing. And here's this house. This 35-year-old kid comes out in a ripped, sweaty T-shirt and five days' beard. His mother looked almost as bad."

But she had the goods: 1,600 Golden Age books. Alexander wrote them a check that must have made them think they'd won the lottery, then loaded up the comics and the kids and pointed the van back toward civilization. He didn't ask for directions.

Young Allies

The first ever kids' gang comic was created—natch—by Jack Kirby. Timely's tenth title—sandwiched between *All Winners* and *Tough Kid Squad Comics*—*Young Allies* #1 arrived in the Summer of 1941.

As usual at Timely, Bucky and Toro were the gang ringleaders. Historian George Olshevsky described the rest of the cast: "Jeff (the smart one), Tubby (the fat one), Knuckles (the tough one, with the obligatory Bronx accent), and Whitewash (the token black), all Sentinels of Liberty, naturally, on immense, multichapter quests versus the minions of the Axis."

Youngblood

Rob Liefeld's contribution to the thesis that "Image is everything" was first published in April 1992 and ridiculed for months thereafter.

"I was sitting there reading these copies of *Youngblood* I was sent," Neil Gaiman told *The Comics Journal*, "and thinking to myself, 'I no longer have anything to say to any young writers who send scripts and ask, 'Am I good enough to be published?' The answer from now on, no matter what they send me, is, 'Yes! Yes! You too can be published! You don't even need to spell!'"

Young Lust

Bill Griffith came up with the idea of an X-rated parody of romance comics in 1969, and Jay Kinney convinced him they could expand the concept into a book. The major underground publishers—Rip Off, Last Gasp, and Print Mint—rejected the book, so Griffith took it "around the corner" to Company and Sons. "They barely looked at it, they just accepted it right off the bat," Griffith told *The Comics Journal*. "*Young Lust* #1 sold 20,000–30,000 copies within about three months, four months."

When Company and Sons drifted toward bankruptcy, Griffith transferred the printing rights to Print Mint. "We wanted to get the copies they had in stock in exchange for royalties they owed us and then sell them to the Print Mint," he said. "And in the process we came across a huge amount of books that had been printed without telling us—something in the neighborhood of one hundred thousand books that were sitting in a warehouse that we, through detective work, managed to find... So we wound up selling those through the Print Mint."

Griffith estimated the first of *Young Lust*'s seven issues sold "hundreds of thousands of copies."

Young Romance

This was the first romance comic if we don't count Kirby's *My Date*, a teen humor book with romantic-themed backup stories, published two months earlier. In 1947 Joe Simon realized he'd grown up surrounded by true love and *True Confessions*, the stuff of a new breed of comic book. He dropped his mockup of the first cover on Jack Kirby in the latter's attic, and the pair sold the idea to Crestwood Publications.

When the first issue of *Young Romance* appeared in September bearing the proclamation "Designed for the more ADULT readers of COMICS," Timely publisher Martin Goodman fired off a letter, complaining the concept "borders on pornography." Beginning with the fourth issue, the cover bore a yellow heart and the words "True Love Stories."

Romance comics buffs put Simon and Kirby's work at the top of the list, for the mature-themed stories and dynamic artwork. *Young Romance* was such a success it spawned three more Simon and Kirby titles (*Young Love*, *Young Brides*, and *In Love*), all published under the Prize imprint. Although the partners had other writers and artists on board, their distinctive touch is still evident, as Richard Howell notes in the introduction to *Real Love*, a collection of S&K romance stories.

Key issues: #1, "I Was a Pick-Up"; #7, "I Stole for Love!"; #8, "My Big Sister's Beau!"; #10, "This Man I Loved Was a Mama's Boy!"; #11, "The Town and Toni Benson" (a sequel to "I Was a Pick-Up!"); #14, first photo cover; #28, Bob Overstreet memorial spanking scene; #29, "You're Not the First"; #35, "Temptations of a Car-Hop," "Shabby Sally," and "The Catskill Man-Chasers"; #58, "Love That Landlady!"

Zansky, Louis

The Gilberton Company, publishers of *Classics Illustrated,* was not at all responsive to questions from its audience, even when that audience included its best artists.

Louis Zansky was a freelancer who drew numerous *Classics* in the early years after the Jacquet shop had passed the ball and before Jerry Iger's shop picked it up.

When Zansky, who also drew romance comics and the Cross-Draw Kid for Ace Publishers, wearied of waiting for one of his paychecks, he walked down to the Gilberton offices.

"He was a giant of a man, a huge man," said Hames Ware, who was told the story by Classics historian Bill Jones, who heard it from Zansky's widow. "He went into the outer office and the

Another Simon and Kirby creation: *Young Romance.*

(© Joe Simon and Jack Kirby)

secretary said, 'I'm sorry, you can't go in there.'" Zansky didn't slow down. "He walked right into the office, leaned over the desk of this individual and said, 'You will write me a check for my work, or I will pick you up and throw you out the window.'

"The man wrote the check and Lou strode out of the office to great applause from the office staff and the other artists waiting to be paid."

That overdue check carried Zansky a long way. In 1976, the year he died, one of his paintings was hoisted onto a wall at the White House.

Zap Comix

When Charles Plymell, a San Francisco printer, first caught Robert Crumb's work in *Yarrowstalks* and the *East Village Other* in 1967, he was both amazed and unable to find a soul who could tell him the first thing about the cartoonist.

Crumb was living in Haight-Ashbury all the while; when Plymell and Don Donahue finally tracked him down, they offered to publish a comic book that he'd been sitting on: *Zap* #1.

Crumb had already lost one copy of *Zap*. He'd given the artwork to Brian Zahn, the editor of the Philadelphia-based *Yarrowstalks*, who promptly disappeared with it. As Patrick Rosenkranz noted in *Artsy Fartsy Funnies*, "Rumor has it that he [Zahn] sold it piecemeal to pay his way to Tibet, where he hoped to improve his karma."

The print run for *Zap* #1 was 5,000 copies, some of which were sold out of a baby stroller on the streets of San Francisco by Crumb and Donahue.

That first issue of *Zap* also found its way into print. Crumb had kept a photostat of the purloined pages—"The only time I made a photostat of anything," he said—and, after Plymell left town, Donahue published the comic as *Zap* #0.

According to Rosenkranz, the seven issues of *Zap* are the best-selling underground comics of all time, selling almost a million copies.

Ziff-Davis

Founded by former cartoonist William B. Ziff and publisher B. G. Davis in 1935, the Chicago-based company was best known for *Popular Photography* before buying the pulp rights to *Amazing Stories* in 1938. Editor Raymond Palmer restored the pulp to its former glory, which is considerably more notoriety than Ziff-Davis achieved when it began publishing comics—titles such as *Space Busters* and *Lars of Mars,* with the trademark painted covers—in the early 1950s.

Zippy the Pinhead

Bill Griffith's yin—or is he Bill Griffith's yang?—Zippy may be the most alternative character on the mainstream comics page. "When I see Zippy on the page next to *Hagar the Horrible* in the *Examiner,* and the strips just to the right of mine are *Marmaduke* and *Family Circus,* I just think of it as some weird *Mad* magazine parody of the daily page," Griffith once told *The Comics Journal.* Griffith

Zap #0, which came out after #1, printed the material that was originally intended for #1 but had been purloined.
(© R. Crumb)

took Zippy and Griffy daily in 1985. "Griffy," he once said, "tries desperately to make sense of everything, and Zippy tries to point out it's a futile effort."

Zolnerowich, Dan

One of the two major cover artists at Fiction House, Dan Zolnerowich produced most of the art that swept its books off the shelves during the first half of World War II. Gene Fawcette sent *Wings* airborne but Zolnerowich had his hands on the controls of Fiction House's five other major titles: *Fight, Jumbo, Jungle, Planet,* and *Rangers.*

Zolnerowich inked all but 12 of the 98 comics cover-dated between January 1941 and May 1943. Before he left Fiction House to assist Bernard Baily at DC, Zolnerowich produced 95 covers, more than anyone but Joe Doolin.

His parents were Belarussian peasants who decided, just before the outbreak of World War I, that America offered them a better shot than their village in the shadow of the Polish border. Once they cleared Ellis Island, they settled in South River, New Jersey, drawn there by the town's Russian community and Russian Orthodox church.

Zolnerowich was drawn to the city. "Everything I gained I got in New York City: my wife, my work, my school," he said. He was barely 20 when he took his samples into the city and dropped them on the desk of the art director at *Collier's,* who proceeded to brush him off. "When I left *Collier's,* I found the first trash basket in New York and plopped everything into it, everything I had, and said, 'So much for that dream of illustration.'"

As it turned out, only the samples were trashed. Zolnerowich took a correspondence course with a school in Chicago, cruised through Pratt, and in 1940 walked in on Will Eisner and Jerry Iger and asked for a job. He got one. "It was easy in those days," Zolnerowich remembers. "The comics were just beginning, and it was easy to get in if you had any amount of ability."

Zolnerowich was always slow to acknowledge that he had more ability than most. "Dan is one of the unsung heroes of the business," said Murphy Anderson. "He was never a household word; neither was Lou Fine. His work is what sold Lou, and that's the way it was with Dan."

Zolnerowich didn't stay long with Eisner and Iger. When Fiction House decided to organize its own art department, Zolnerowich was Fawcette's first recruit. Fawcette designed the covers and Zolnerowich inked them; the teamwork suited them so well that, in 1942, they decided to take the team on the road.

They didn't get very far. Fawcette was drafted, and Zolnerowich headed over to DC, where he was quickly signed to assist Baily, who was buried under more pages than he could pencil, much less ink. Zolnerowich tightened up those pencils for two years, before

This is one of many standout Zolnerowich covers for Fiction House: *Planet* #21 (November 1942).
(© Fiction House)

Ray Zone

the pair split and set up their own shop in the Newsweek building on 42nd Street. Mac Raboy would later join them.

Next stop, Quality Comics, where Zolnerowich succeeded Reed Crandall on Blackhawk, and Hillman, where he teamed with Fred Kida on *Airboy* and his inks repaired the mess on editor Ed Cronin's desk. "I think that was the happiest time in all the years I was in comics," he said.

Zolnerowich spent the last part of his career—25 years—working for Eisner (and later Anderson) on *P.S.*, the Army's preventive maintenance magazine. He retired in 1983, convinced he'd never gotten his hand on his dream. "I have nothing against comics," he said, "but my ultimate goal was to become a magazine illustrator, which I never made. I liked comics, but I knew so many artists who were better than I was that it wasn't too pleasant to be running in their dust all the time."

Zolnerowich is now retired and living in New Jersey.

Fiction House Covers: *Fight* #11, 12, 14–26; *Jumbo* #21–23, 28–50; *Jungle* #11, 12, 18–41; *Planet* #10, 11, 13–25; *Rangers* #1–11; *Wings* #15, 21.

Zone, Ray

The obsessive master of 3D, Zone's first brush with the visual circus was an issue of *Three Dimension Comics Starring Mighty Mouse*, published by St. John in 1953. "I was six at the time and it was really my first religious experience."

"There are beauties and limitations to that technique [the acetate method]," Zone begs us to remind his disciples, "which, by the way, was actually invented in 1936 by a man named Freeman Owens for use in animated cartoons, unbeknownst to Joe Kubert, who reinvented the same process for comics in 1953."

Index
Names

Name Index

A

Aamodt, Kim, 1
Abarr, Charlie, 357
Abruzzo, Tony, 1, *1*, 337
Ackerman, Forrest J., 160, *160*, 383, 449, 458
Adams, Art, 3–4, *3*
Adams, Neal, 4–5, *4, 5*, 6, *24*, *30*, 57, 123, 154, 199, 209, 220, 230, 250, 288, 300, 319, 334, 336, 345, 352, 373, 403, 407, 419, 424, 458, 459
Adamson, Joy, 35
Addams, Charles, 6
Addams, Marilyn, 6
Adkins, Dan, 300, 474, 478
Albano, John, 245
Albright, Nina, 168
Alcala, Alfredo, 328
Alexander, David T., 98, 152, 222, 481–482
Allen, Heck, 35
Allison, W. A., 125
Alterbaum, Dave, 321, 322
Altshuler, Tom, 96
Amash, Jim, 441
Amato, Andy, 176, 283, 291
Anderson, Dave, 205
Anderson, Harry, 62
Anderson, Murphy, 6, 16–17, *16*, *33*, 45, *120*, 168, 170, 236, 252, 275, 290, 374, 393, 412, 441, 442, 443, 485, 486
Andresen, Erik, 343
Andriola, Alfred, 76, 324
Andru, Ross, 57, 300, *312*, 361
Aparo, Jim, 17, 334
Aragonés, Sergio, 18–20, *19*, 43, 124, 155, 190, 191, 212, 294, 302, 345, *392*
Arlington, Gary, 20–26, 394
Arnold, Everett "Busy," 26, 90, 104, 105, 147, 171, 363, 413, 443
Arnold, Mark, 78
Asherman, Alan, 210
Ashley, Michael, 348
Astarita, Rafael, 28–30, *29*, 135–136, 156, 166, 168, 233, 238, 444, 457, 458
Atkinson, Ruth, 30, 168
Auerbach-Levy, William, *464*
Avenell, Donne, 36
Avery, Tex, 35–36
Ayers, Dick, 17, 32, 36

B

Bagge, Peter, 37, *37*, 161
Bails, Jerry, 12, 13, 28, 37, *37*, 111, 163, 201, 248, 333, 342, 374, 393, 424, 436
Baily, Bernard, 37, *229, 240*, 252, *324*, 352, *412*, 435, 485
Baker, George, 37–38, 369
Baker, Kyle, 397
Baker, Martin, 219
Baker, Matt, 38–39, *38*, 52, 88, 100, 102, *110*, 166, 168, *181*, 201, 221, 233, 361, 376, *377*, 421, 422, 467, 473
Bakshi, Ralph, 113, 186, 328
Bald, Ken, 244
Barbera, Joseph, 215, 470
Barker, Clive, 145
Barks, Carl, *22*, 39–42, *40, 41, 101*, 124, 131, 134, 135, *135*, 201, 204, *338*, 343, 366, 379, 436, 445, 452, 453, *467*
Barks, Garé, 42
Baron, Mike, 42, *42*, 328, 382
Barr, Mike, 60, 172, 179, 180, 323
Barrett, Bob, 104, 106, 182, 183, 184, 245, 356, 434, 438
Barrett, John, 128, 258, 357, 384, 385, 394, 395, 397
Barrier, Mike, 208
Barry, Dan, 7, 42–43, *43*, 47, *122*, 184, 188, 220, 262, 272, 365, 413
Barry, Lynda, 461
Barry, Sy, 352
Bartlett, Bob, 108, 296
Bates, Cary, 430
Battlefield, Ken, 238
Bauman, Barry, 96

Becattini, Alberto, 201
Beck, C. C., 36, 44–45, *46*, 73, *73, 74*, 76, 98–99, 138, *138, 163*, 224, 233, 256, 337, *470*
Beck, Joel, 20
Becker, Stephen, 367, *481*
Bee, Clair, 378
Beerbohm, Bob, 211, *334–335*
Belfi, John, 365
Bell, John, 75
Bennett, James Gordon, Jr., 306
Benson, John, 96, 144, *163*, 164, 165, 270, 395, 466
Benson, Nat, 192
Berg, Dave, 294, 442–443
Berger, Karen, 304, *320*, 450
Berk, Jon, 275, 354
Bester, Alfred, 209, *391*, 418, 429
Beyer, Mark, 365
Binder, Earl, 46–47
Binder, Jack, 42, 46, *47*, 163, 170, 252, 456
Binder, Otto, 45, 46–47, 51, 73, 96, 163, 179, *234*, 279, *325*, 428, 462, 462
Biro, Charles, 7, 47–48, *47*, 85, 109, *110*, 111, *111*, 115, 121, *188*, 200, 207, 272, 277, 304, *332*, 370, 476
Bissette, Steve, 48–49, *49*, 119, 121, *121*, 146, 272, 450
Black, Bill, 1
Blair, Joe, 52
Blaisdell, Philip "Tex," 51, 187, 442–443
Blanc, Mel, 475
Blitz, Marcia, 135
Bloom, Vic, 322
Blum, Alex, 87, 361, *467*
Blum, Burt, 83, *83*, 259
Boatner, Barbara, 40–41
Boatner, E. B., 90
Bodé, Mark, 52–53
Bodé, Vaughn, 20, 52–53, *53*, 215
Bodé, Vincent, 53
Bolland, Brian, 53, *58*, 55, 475
Boltansky, Sam, 193
Boltinoff, Henry, 54
Boltinoff, Murray, 5, 53–54, 63, 119, 136, 171, 172, 181, *311*, 418, 454, 463, 464, 466
Bolton, John, 53, 54–55, 55
Boring, Wayne, 56, *56*, 361, 431
Bourgholtzer, Frank, 256
Bowar, Walter, 412
Boyett, Lee, 458
Boyette, Pat, 334
Boyle, Robert, 173
Brabner, Joyce, 349
Brackett, Leigh, 429
Bradbury, Ray, 39, *142*, 143, 383, 390, *392*, 399
Brand, Michelle, 408
Brand, Roger, 20
Breger, Dave, 57
Brennert, Alan, 57
Brewster, Ann, 168
Bridgeman, George, 58–59, 98, 137, 147, 269, 358
Bridwell, E. Nelson, 59, *59*, 435
Briefer, Dick, 59–60, *59*, 361
Brigman, June, 408
Briggs, Austin, *392*, *392*, 440
Brodsky, Sol, 263, 300, 409, 420
Broome, John, 34, *50*, 75, 179, 209, 352, 361, 463
Brown, Chester, 60
Brown, Leonard, 8*4*, 259, 378
Brown, Robert, 104
Brown, Tina, 412
Browne, Dik, 45, 60–61, 244
Brundage, Margaret, 61–62, *61*, 201
Brundage, Myron, 62
Brunner, Frank, 195
Bruzenak, Ken, 82
Buell, Marge Henderson. *See* Henderson
Burbey, Mark, 448
Burden, Bob, 63, 63

Burgos, Carl, 63, 64, 80, 111, 157, 188, 231, *303*, 370
Burke, Jim, 361
Burne, Jack, 16, 156, 168, 169
Burnley, Jack, 44, 63–64, *64*, 418
Burns, Charles, 365
Burroughs, Edgar Rice, 1, 104, 208, 389, 399, 433, 434
Burton, Tim, 44, 319
Burtt, Robert Morris, 74
Buscema, John, 36, 64–65, *65*, 95, 330, 337, 406
Busch, Wilhelm, 130
Buser, Jim, 258, 394, 395
Bushmiller, Ernie, 65, 201, 220, 255, 264, 327
Busiek, Kurt, 130, 299, 301, 302
Byck, Sylvan, 61
Byrne, John, 12, 45, 65–66, *66*, 301, 328, 400, 409, 410, 475

C

Calkins, Dick, 16, 62, *62*, 332
Cameron, Don, 463, 464
Cameron, Lou, 39, 67, *67*, 87, 88, 457, 458
Campbell, Eddie, 49, 186, *186*, 324, 362, *407*
Canemaker, John, 166
Caniff, Milton, 21, 45, 67–69, *68, 179*, 195, 199, 201, 218, 219, 268, 275, 295, 327, 389, 401, 402, 420, 432, 434–435, 435, 453–454, 470
Caplin, Elliot, 138
Capp, Al, *69*, 69–71, 173, 176, 184, 194, 195, 205, 208, 243–244, 264, 283–285, 283, 284, 286, 291, 326, 426, 475
Capp, Catharine, 70–71
Capra, Frank, 384
Carey, Nick, 18, 43, 76–77, 168, *133*, 376. *See also* Viscardi, Nick
Carlin, Mike, 320
Carlson, George, 77–78, *78*
Carrere, Jim, 371
Carrere, Linda, 384
Carter, Gary, 206, 216, 236, 299, 315, 317, *317*, 342, 343, 469
Carter, Lane, 317
Carter, Linda, 384
Cartier, Edd, 425
Caseveer, Lance, 456
Castel, Al, 394
Catron, Mike, 459
Cazeneuve, Arturo, 49, 369
Celardo, John, 29, 79–80, *79*, 155, 166, 175, 176, 296, 335, 434, 475
Certa, Nick, 57
Chadwick, Paul, 17, *17*, 80–81, *80*, 95, 116, 116, 389, 420
Chabot, Jean-Michel, 52, 81, 195, 467
Chaykin, Howard, 6, 49, 82–83, *82, 83*, 163, 175, 213n, 319, 397, 409, 429, 461
Chester, Harry "A," 16, 28–29, 84–85, 192. *See also* Chesler shop *in subject index*
Chesney, Landon, 208
Christman, Bert, 85–86, *86*, 125, 361, 384
Chu Hing, 370
Church, Edgar, 258, 313–315, 348
Churchill, Winston, 230
Claypett, Bob, 35
Claremont, Chris, 45, 86–87, 87, 235, 262, 281, 311, 409, 481
Clowes, Dan, 48, 88, 88–89, 161
Clifford, J. B., Jr., 355
Cochran, Russ, 46, 89, 144, 188, 190, 227, 236, 239, 269, 275, 315, 339, 433, 463, 480
Cockrum, Dave, 210, 461
Cohen, Sol, 36, 164
Colabuono, Gary, 27, 28
Cole, Gene, 16, 89, 202, 300, 330, 370, 459
Cole, Jack, 26, 80, 89–90, *89, 90*, 104, *120*, 122, 313, 350, 351, 357–358, 357, 361, 363, 377, 391, 410, 425, 426, 443, 476
Cole, L. B., 75, 88, 90, *91*, 110, 254, 343, 377
Coletta, Vince, 255, 300
Collins, Max Allan, 126, 186, 413

Colon, Ernie, 268
Colston, William, 210
Conlon, J. B., 187
Connelly, Jennifer, 374
Connors, Chuck, 384
Contarino, Keith, 206, 318, 404–405
Conway, Gerry, 97, 155, 300, 362
Cook, Bill, 26, 80
Cook, Tom, 474
Coop, Cecil, 275
Cooper, Sam, *75*
Coppola, Francis Ford, 384
Corben, Richard, 222
Costanza, Pete, 44, 98–99, *163*, 233
Cowan, Denys, 210
Crabbe, Buster, 76, 99–103
Craig, Chase, 294, 296
Craig, Johnny, 103–104, *104*, 109, 142, *142*, 143, 146, 181, 191, 320, 355, 399, 459
Crandall, Reed, 26, 50, *50*, 58, 104–106, *105, 106*, 142, *143*, 202, 224, 233, 270, 300, 313, *335*, 355, *363*, 378, 399, 442, 444, 445, 456, 458, 459, 460, 486
Crane, Roy, 75, 106–107, *107*, 434
Crawford, Hubert, 26, 214, 294, 363, 367
Croce, Jim, 429
Cronin, Ed, 236, 486
Crosby, Percy, 46
Crowley, Wendell, 26, 111–112, 163, 224, 425, 457, 462, 478
Cruetz, Fred, 275
Crumb, Charles, 112
Crumb, Max, 112
Crumb, Robert, 20, 37, 112–113, *112,113*, 186, 211, 222, 264, 273, 325, 349, 372, 445–447, 448, 471, 484, *484*
Cruse, Howard, 114, *114*
Cucinotta, Bill, 90, 92
Cudera, Chuck, 50, *105*, 114, 187, *363*, 376, 432, 442–443
Cummings, Ray, 248
Curtis, Harvey, 176, 291
Cushing, Jack, 244
Cuti, Nicola, 419

D

Dahl, Roald, 294
Dahlquist, Dorothy, 241, *242*
Daigh, Ralph, 73
Dali, Salvador, 475
Dallas, Charles, 20
Daniels, Elvi, 137, 138
Daniels, Les, 133, 188, 239, 276, 461, 468, 481
Darrow, Geof, 116–117, *117*, 199, 320
David, Peter, 429
Davis, G. B., 484
Davis, Jack, *32*, 109, 117–118, *117*, 142, 143, 144, 146, 191, 232, 293, 330, 399, *432*, 454
Davis, Jim, 118
Davis, John, 69, 129, *129*
Davis, Phil, 159
DeBeck, Billy, 42, 123
de Camp, L. Sprague, 230–231, 426
DeCarlo, Dan, 123, 330, 370
Decker, Dwight, 39, 220
DeFalco, Tom, 349
De Fuccio, Jerry, 11, 18, 157, 238, 425, 457, 458
Deitch, Kim, 20, 157, 212, 372, 447
Deitch, Simon, 26
Delacorte, George, 327
Delano, Jamie, 450
De Laurentiis, Dino, 184
Dellinges, Al, 157, 271, 359
Dent, Lester, 134
Deodato, Mike, 475
Desris, Joe, 27, 348
De Zuniga, Tony, 245, 328, 352
Dickens, Jack, 314–315
Dille, John Flint, 62
Dirks, Rudolph, 130, 255
Disbrow, Jay, 75

Index
Names

Disney, Lillian, 205
Disney, Walt, 130–131, 135, 166, 312, 327
Ditko, Steve, 13, *13*, 14, *22*, 32, 35, *35*, 52, 75, 81–82, 96, 124, 132–134, *132, 133, 134*, 139, *139*, 198, 230, 260, 263, 301, 334, 337, 379, 415, 459, 474
Dixon, Leslie, 300
Dohler, Don, 470
Dolenz, Mickey, 384
Donahue, Don, 112–113, 186, 447, 484
Donenfeld, Harry, 2, 11, 135, 147, 189–190, 236–237, 289, 402, 427, 429
Donenfeld, Irwin, 204, 289, 304
Doolin, Joe, *100*, *102*, 135–136, *136, 167*, 168, 202, 221, *247, 356*, 485
Doré, Gustav, 136–137
Dorf, Shel, 37, 96, 97, 195, 383, 384
Dorman, Dave, 272
Dorsey, Tommy, 290
Douglas, Harry, 326
Doyle, Frank, 137, 156, 169
Doyle, Larry, 358
Dozier, William, 10
Drake, Arnold, 60, 123, 136, 179, 286, 358
Drake, Stan, 5, 45, 58, 71, 79, 137–138, *137*, 171, 201, 215, *215*, 244, 269, 290, 367, 393, 404, 455
Drucker, Mort, 139–140, *139*, 454
Druillet, Philippe, 140, *140*
DuBay, Bill, 408
DuBois, Gaylord, 60, 140
Dunavan, Tom, 427
Dunn, Harvey, 347
Durell, Rick, 353
Duursema, Jan, 272

E
Eastman, Kevin, 49, 109, 141, *141*, 264, 325, 434
Eastwood, Clint, 185
Ecco, Umberto, 412
Edson, Gus, 218
Edwards, Cliff, 450
Eisenberg, Harvey, 216
Eismar, Hi, 48, 272, 450
Eisner, Michael, 205
Eisner, Will, *23*, 26, 48, 50, 79, 90, 94, 104, 134, 147–149, *147, 148, 149*, 151, 163, 170–171, 180, 181, 187, 207, 233, 244, 279–280, *279*, 313, 319, 359, 361, 389, 390, 394, 413, *413*, 426, 440, 442, *442*, 442–443, 445, *445*, 478, 481, 486
Elder, Will, 143, 144, 149–150, *150*, 158, 164, 190, 232, 273, 285–286, *285, 294*, 345, 395, 422, 478
Elias, Lee, 49, 151, 168, 209, *217*, 272, 450, 473
Elliott, Brad, 30
Ellison, Harlan, 77–78, 151–152, 185–186, 281, *392*, 426
Ellsworth, Bruce, 384
Ellsworth, Whitney, 63, 64, 175, 245, 282, 347, 401, 415, 418, 431, 463
Emshwiller, Ed, 211–212
Eng, Fred, 370
Englehart, Steve, 5, 154, *154*, 215, 278, 296, 300, 350, 418, 426, 478
Ennis, Garth, 450
Epp, Martin, 330, 359
Erickson Byron, 379
Esposito, Mike, 57, *312*, 361
Estrada, Jackie, 84
Estrada, Ric, 272
Estren, Mark, 158
Evanier, Mark, 17, 18, 50, 120, 121, 124, 155, *155*, 212, 249, 260, 261, 262, 301, 302, 416, 417, 467
Evans, Cynthia, 399
Evans, George, 29, 51, 76, 88, 104, 105–106, 109, 142, 143, 155–157, *156*, 165, 168, 169, 183, 195, 237, 238, 239, 259, 269, 273, 336, 355, 392, 399, 454, 455, 458, 459, 472, 473
Everett, Bill, 13, 63, 80, 111, 115, 157, *157*, 158, 185, 188, *219*, 300, 303, *303*, 370, 410, 424, *424*

F
Fabry, Glenn, *450*
Fagan, Tom, 215
Falk, Lee, 159, 352
Fallon, Norman, 415
Farkas, Phyllis, 160
Farmer, Weston, 385
Fawcett, Wilfred, 75, 163, 289, 335
Fawcette, Gene, 79, *473*, 485
Feiffer, Jules, 45, 56, 67, 68, 71, 74, 147, 163–164, 330, 393, 434, 461, 465, 478
Feldstein, Al, 11, 18, 45, 117, 139, 141, 142, 164–165, *165*, 181, 191, 251, *267*, 269, 273, 293, 298, 340, 361, 376, 396, 411, 462, *461, 462*, 466
Felsen, Hank, 368
Fellini, Federico, 199
Feuerlicht, Roberta Strauss, 88
Ficarra, John, 294
Fine, Lou, 26, 83, *101, 102*, 104, 134, 147, 148, 170–171, *170, 171, 180*, 187, 223, 224, 233, 252, 272, 354, 358, *363*, 365, 443, *445*, 485
Fine, Mary, 171
Finn, Richard, 49
Finger, Bill, 44, 50, 60, 78, 96, 119, 171–173, 179, 180, 195, 204, 209, 245, 252, 330, 334, 372, 373, 415
Fingeroth, Danny, 309
Finlay, Virgil, *202*, 335
Fiore, R., 285
Fischler, Steve, 11, 59, 162, 207, 374, 437, *437*
Fisher, Bud, 173, *173*, 326
Fisher, Ham, 69, 70, *70*, 173, 195, 243–244, *244*, 426
Flanders, Charles, 369, 392
Fleisher, Michael, 6, 182, 281, 412
Flenniken, Shary, 8, 9, *174*, 174–175
Flessel, Creig, 5, 85, 175–176, *175, 176*, 194, 244, 443
Flinton, Ben, 33
Ford, John, 458
Foss, Ron, 374
Foster, Hal, *21*, 56, 106, 124, 176–177, *176, 177*, 195, 227, 255, 268, 296, *321*, 335, 361, 394, 433, 452
Fox, Gardner, 6, 33, 37, 60, 63, 96, 138, 173, 174, *179*, 179–180, 219, 220, 246, 248, 341, 361, 384, 393, 412, 414, 418, 427, 436, 438
Fox, Gill, 48, 85, 170, 171, 180, 194, 313, 335, 443, 476
Fox, Victor, 180–181, 217, 265, 279–280, 407
Fradon, Dana, 181
Fradon, Ramona, 18, 54, 58, 181–182, *182*, 312, 358
Franke, Rudi, 96
Frazetta, Ellie, 184, 185
Frazetta, Frank, 1, *1, 24*, 51, 71, *100, 101*, 102, 109, 120, *142*, 143, 146, 156, 160, 176, 182–185, *183, 184*, 194, *194*, 201, 240, 245, 244, 269, 270, 283, 288, 335, 343, 389, 399, 418, *427*, 434, 438, 449, 453, *458, 459*, 471, *472*, 473, *474*
Freas, Kelly, 470
Friedkin, William, 148
Friedrich, Gary, 300
Friedrich, Mike, 4, 5, 80, 93, 128, 158, 180, 185–186, 249, 288, 407
Froehlich, Monroe, Jr., 30, 31, 33
Fujitani, Bob, 26, 42–43, 47, 48, 51, 109–110, 114, 148, 170, 171, 186–188, *187*, 209, 350, 351, 361, 432, 442, 443, 444, 476
Furst, Anton, 426

G
Gabrielle, Al, 49
Gaiman, Neil, 121, 189, *189*, 303, 304, 322, 384, 450, *479*, 482
Gaines, William, 7, 10, 19, 26, 39, 45, 89, 103, 111, 139–140, 141–142, 149 164, 165, *165*, 189, 190–191, *191*, 216, 229, 237, 238–239, 251, 270, 274, 277, 293, 299, 304, 321–322, 324, 335, 338, 340, 345–346, 349, 350, 355, 396, 411, 429, 461–462, 473, 478

Gaines, Maxwell, 2, 11, 135, 141, 159, 189–190, 191, 199, 297, 298, 321, 324, 327, 330, 402, 427, 429, 468
Garcia, Jerry, 192
Gattuso, Paul, 192–193
Geerdes, Clay, 20, 255, 445
Gelman, Woody, 174
Genalo, Joe, 109
Geppi, Steve, 3, 69, 94 125–126, 128–129, 193–194, *193*, 231, 313, 318, 342, 345, 355, 357, 468, 469
Gerber, Ernie, 3, 93, 94, 171, 205, 283, 314, 315–316, 343, 353–355, 474
Gerber, Gerda, 353
Gerber, Mary, 355
Gerber, Steve, 19, 107, 124, 145, 154, 194, *194*, 213, 280
Gerhard, 80
Gernsback, Hugo, 14, 335, 348, 386–387, 417
Giacoia, Frank, 195, *195*, 236, 288, 300, 361, 436
Gianni, Gary, 397
Gibbons, Dave, 45, 195–197, *196*, 200, *200*, 320, 321, 323, 460–461, *460, 479*
Gibson, Walter, 197, *197*
Giella, Joe, *216*
Gilbert, Douglas, 468
Gilbert, Michael T., 132, 325, 359
Gill, Joe, 132, 197
Gill, Ray, 197
Gilliam, Terry, 112, 222
Gillian, Joseph (Jije), 199
Giolitti, Alberto, 198, 443
Giordano, Dick, 5, 77, 81, 108, 118, 120, 133, 172, 196, 198–199, *198*, 237, 272, 334, 337, 391, 440, 450, 460
Giovinco, Gerry, 90
Giraud, Jean (Moebius), 52, 81, 117, 199, *199*, 466, 467
Giunta, John, 7, 341
Glanzman, Sam, 361
Gleason, Lev, 42, 109, 200–201, 327
Gluckson, Rob, 83
Gold, Mike, 80, 320
Gold, Mimi, 300
Goldberg, Rube, 69, 173, 255
Goldwater, John, 20, 127, 322
Gonzalez, Jose, 449, *449*
Goodman, Chip, 30, 453
Goodman, Jean, 31
Goodman, Martin, 30, 31–33, 63, 154, 162, 188, 202, 248, 277, 278, 303, 337, 348, 413–414, 415, 416, 453, 483
Goodwin, Archie, 51, 109, 146, 202–203, *202*, 215, 276, 371, 409, 410, 441, 459–460, 473
Gopnick, Adam, 294
Gorshin, Frank, 371
Goscinny, Rene, 140
Gottfredson, Floyd, 131, 204–205, *204*, 312
Gottfredson, Mattie, 205
Goulart, Ron, 75, 321, 392, 420
Gould, Chester, 126, *126*, 205, 305, 324
Gould, Will, 208
Graff, Mel, 392
Grandenetti, Jerry, 207, 454
Grandey, Bill, 40
Grant, Amy, 282
Grant, Douglas, 326
Grant, Maxwell, 197
Gray, Clarence, 58, 367
Gray, Harold, 205, 208, 286–288
Gregory, Roberta, 161
Green, Justin, 447, 448
Green, Wally, 198, 286, 362
Greene, Sid, 209
Grell, Mike, 58, *209*, 209–211, 307, 311–312, 345, 352, 418
Griepp, Milton, 69, 129
Griffin, Rick, 26, 211, *211*, 447, 471
Griffith, Bill, 56, 89, *97*, 112, 211–212, *212*, 272, 365, 412, 447, 482–483, 484–485, *485*
Groening, Matt, 461

Gross, George, 168
Groth, Gary, 89, 161, 163, 213, 237, 261, 281, 308, 447
Gruenwald, Mark, 72, 240–241, 328
Guardineer, Fred, 212–214
Gulacy, Paul, 145, 155, 381, 419, 420
Gustavson, Paul, 80, 85, 188, 214, *214*, 302, 457

H
Hablitz, Harry, 227
Hagar, Sammy, 384
Hagen, Tryg, 275
Haggard, H. Rider, 399
Halgren, Gary, 8
Hama, Larry, 215
Hames, Fred, 28
Hamill, Mark, 384
Hamilton, Bruce, 3, 89, 315, 317, 380, 469
Hamlin, V. T., 11, *11*, 215, *215*
Hammett, Dashiell, 366, 392
Haney, Bob, 136, 179, 181, 397
Hanna, Bill, 215
Hannah, Jack, 135
Hardy, Joseph, 80
Harman, Fred, 367, *367*
Harold, Hazel, 145
Harris, Jack, 350
Harris, Tony, 418
Harrison, Harry, 36, 76, 208, 216, 340, 349–350, 352, 461–462
Harrison, Sol, 27, 127, 336
Harvey, Alfred, 216–217
Harvey, Leon, 216
Harvey, R. C., 173, 216, 265, 446
Hasen, Irwin, 68, 69, 209, 216, *216*, *218*, 218–219, 244, 272, 304, 305, 441
Hastings, Dan, 47
Hatlo, Jimmy, 369
Hauser, Rich, 183, 216
Hawks, Howard, 429
Haydock, Ron, 13
Hayes, Rory, 26
Hearst, William Randolph, 130, 177, 224, 281, 360
Heath, Russ, 57, 220, *220*, 288, 370, 454
Heck, Don, 32, 222, *229*, 240, 263, 300
Heddinger, Charles, 286
Hefner, Hugh, 113, 274, 285, 426, 442
Held, Claude, 96
Helfer, Andy, 320, 397
Henderson, George, 223, 333
Henderson Buell, Marge, *178*, 286, *286*, 418, *469*
Hendrix, Jimi, 404
Herge (George Remi), 223, 438–439, *439*
Herman, Rae, 6
Hernandez, Gilbert, 133, 161, 223, *223*, 289, *289*, 298
Hernandez, Ismael, 223
Hernandez, Jaime, 161m 223, *223*, 257, 289, *289*
Hernandez, Mario, 223
Hernandez, Richard, 223
Herndon, Larry, 163, 358
Herriman, George, 223–224, *224*, 265, *265*
Herron, Ed, 50, 224
Herron, Frances, 431
Hershfield, Harry, 224
Hill, Roger, 190
Hill, Tex, 85, 86
Hill, Wycliffe A., 179
Hitler, Adolf, 225–226, 453
Hodes, Robert, 433
Hogarth, Burne, 79, 176, 216, 227, *227*, 255, 269, 274, 291, 296, 321, 409, 433, 473
Holdaway, Jim, 36
Holman, Bill, *158*
Hopper, Fran, 137, 156, *168*, 351
Horn, Maurice, 320, 352, 466
Howard, Joan, 304

Index
Names

Howard, Moe, 218, 304
Howard, Robert E., 95, 186, 230–231, 341, 368, 425–426
Howell, Richard, 249, 483
Hubbel, Carl, 286
Hubbel, Virginia, 286
Hughes, Richard, 14, 457

I

Iger, Jerry, 38, 87, 147, 168, 233, 254, 279, 361, 398, 442
 See also Iger studio *and* Eisner-Iger studio *in subject index*
Infantino, Carmine, 6, 17, 45, 64, *120*, 121, 123, *174*, 179, *195*, 236–237, *236*, 250, 252, 262, 272, 288, 305, 328, 332, 336, 337, 352, 391, 479
Inge, M. Thomas, 251, 306
Ingels, Graham, 88, *141*, 142, 143, 166, 183, 191, 237–239, *237*, *238*, 269, 321, 355, 399
Irons, Greg, 26
Irwin, Sam, 190
Isabella, Tony, 242, *242*
Ivie, Larry, 96, 208
Iwerks, Ub, 312, 313

J

Jackson, Jack, 26, 245, 445, 446, 447
Jackson, Wilfred, 135
Jacobs, Frank, 10, 189, 294, 345
Jacobs, Will, 34, 50, 60, 262, 420
Jacquet, Lloyd, 7, 63, 157, 188, 320, 340, 407
Jenson, Chris, 454
Johnson, Lyndon B., 360
Johnson, Ryeson, 390
Johnson, Walter, 220, 221
Johnstone, Tom, 244
Jones, Bill, 87, 483
Jones, Chuck, 35
Jones, Gerard, 34, 50, 60, 262, 420
Jones, Jeff, 183, *245*, 245–246, 249, 407, 410, 423–424, 459, 479
Jones, Jim, 124

K

Kahn, Jenette, 108, 121, 199, 249, 350
Kaler, Dave, 96
Kalish, Carol, 129, 249, *249*
Kaluta, Michael, 183, 184, 215, 230, 246, 249–251, *249*, 250, 336, 352, 374, 397, *397*, 407, 409, 410, 418, 423–424, 452, 479
Kamen, Jack, *52*, 55, 85, 141, 142, 143, 191, 220, 233, *247*, 251, *251*, *267*, 376, *382*, 399
Kampen, Owen, 382
Kane, Bob, 43–44, 54, 64, *101*, 107, 171–173, 195, 205, 245, 251–252, *252*, 253, 321, 332, 334, 346, *347*, 372, 373, 427
Kane, Gil, 5, 48, 75, 83, 87, 106, 119–120, 134, 161–162, 195, 204, *209*, 220, 227, 239, *252*, 252–253, *252*, *253*, 262, 263, 277, 278, 288, 301, 358, 390, 391, 426, 436, 440, 441, 444
Kanigher, Robert, 1, 5, 17, 45, 49, 52, 108, 120, 153, 157, 174, 207, 216, 252, 253–254, 256, 305, 312, 322, 332, 396–397, 410, 441, 454, 475
Kantner, Albert, 87, 88, 233, 254
Kaplan, Barry, 128
Karloff, Boris, 475
Katchor, Ben, 461
Katz, Carolyn, 256
Katz, Jack, 255–256, *255*, *256*
Katzman, Steven, 241, 242
Kauffman, Stanley, 44, 77, 256
Kaye, Stan, 347, 430
Kaz, 365
Kelley, Sean, 220
Kelly, Fred, 325
Kelly, Walt, *131*, 257, *257*, 326, 358, *358*, 465
Keltner, Howard, 163, 201
Kennedy, John F., 359–360, *360*

Kennedy, Michael, 8
Kesel, Barbara, 121, 320–321, 323
Ketcham, Hank, 124, 257
Kida, Fred, 7, 486
Kiefer, Henry, 87, 233
King, Antane R., 258–259
King, Frank, 192, 259, 324
King, Stephen, 474, 480
Kinney, Jay, 482
Kinstler, Everett Raymond, 76, 259, *259*
Kipling, Rudyard, 233
Kirby, Jack, *6*, 13, 17, 18, *24*, 32, 35, 45, 50, 52, 56, *71*, 72, 73, 75, 76, 81, 102, 108, 109, 121, 122, *124*, 132, 155, 158, *161*, 162, 165, *169*, 192, 224, *225*, 231, 232, 237, 246, 248, 249, 252, 255, 260–261, *260*, *261*, *262*, *263*, 277, 299–300, 301, 302, 313, 320, 324, 337, 341, 376, *376*, 383, 384, *384*, 394, 39, 398, *401*, 405–406, *405*, 407–408, *40*, 409, 413–414, 415–417, *415*, *417*, 434, 436, 441, 442, 455, 467, 473, 482, 483, *483*
Kirby, Roz, 261, 416–417
Kirchner, Paul, 478
Kirchner, Raphael, 201
Kitchen, Denis, *127*, 264, 302, 445, 447
Klaw, Irving, 132
Klein, Bernie, 264–265, 310
Klein, Izzy, 313
Knerr, Harold, 256
Koike, Kazuo, 288
Kojima, Goseki, 288
Kominski, Aline, 118
Kotzky, Alex, *313*, 413
Kramer, Jerry, 90
Krank, Ray, 438
Krantz, Steve, 186
Kremer, Warren, 264
Krenkel, Roy G., 1, 55, 191, 215, 236, 238, 240, 249, 268–269, *268*, *269*, 324, 389, 471, 472, 472, 473, 474
Kressey, Ed, 415
Krigstein, Bernie, 1–2, 143, 269–270, *270*, 278, 319, 399, 415, 465
Kubert, Adam, 272, 454
Kubert, Andy, 272, 454
Kubert, Joe, 45, 48–49, 54, 57, *57*, 84, 85, 119, *120*, 147, 151, 152–153, *153*, 174, 174, 197, 209, 219, 220, 230, 233, 237, 270–272, *271*, *272*, 288, 304, 310, 313, 341, 396, 421–422, *433*, 434, 440, *455*, 455, 486
Kubrick, Stanley, 388
Kurtzman, Harvey, 10, *22*, 51, 65, *102*, 113, 117, 141, 143, *143*, 144, 149–150, 157, 164, 165, 191, 222–223, 230, 232, 271, 272–274, *273*, *274*, 285–286, 292, 292, 293–294, *293*, *325*, 389, 395, 422, 443, 445, 446, 447, 454, 470, 478
Kuttner, Henry, 230, 390
Kyle, Richard, 201

L

Lacassin, Francis, 227
Laird, Peter, 49, 109, 141, 275, 434
Lam, Nghia, 319
Lamour, Dorothy, 399
Lampert, Harry, 173
Landau, Al, 481
Lansdale, Joe, 245
Lantz, Walter, 356
Larsen, Eric, 235
Larsen, Howard, 275
Larson, Lamont, 275
Lash, Batton, 483
Lasorda, Dennis, 92
Lasorda, Phil, 90, 92
Lawrence, D. H., 378
Lawseth, Ed, 93–94
Layton, Bob, 240
Lazlo, Fred, 369
Leary, Timothy, 384
Lee, Elaine, 250, 418
Lee, Jim, 12, 58, 66, 234, 235, *235*, 275–276, *275*, 301, 302

Lee, Stan, 13, 14, 31, 32, 33, 35, 45, 47, 58, 64, 73, 74, 97, 115, 132, 133, 139, 155, 158, 161, 162, 188, 202, 226, 231, 232, 240, 242, 248, 253, 260, 263, 273, 276–278, 277, 299–300, 301, 320, 324, 327, 330, 333, 370, 378, 386, 396, 401, 404–405, 409, 413–414, 415–417, 420, 431, 435, 436, 444, 470, 475, 479, 481
Legman, Gershon, 288–289, 290
Lehti, John, 282, 347
Leialoha, Steve, 192
Lennon, John, 69, 71
Lerner, Sammy, 358
Letterman, David, 349
LeVay, Anton, 282
Levitz, Paul, 59, 108, 118, 120, 121, 126–127, 129–130, 199, 282, 323, 337, 350, 393, 394
Lewis, Richmond, 305
Lichtenstein, Roy, 1, 332
Lieber, Larry, 17, 30, 300
Lieberson, Will, 462
Liebowitz, Jack, 54, 56, 64, 135, 147, 153, 162, 179, 190, 236–237, 427, 463
Liefeld, Rob, 235, *235*, 276, 301, 302, 324, 482
Light, Alan, 163, 374, 436
Lincoln, Abraham, 360, *360*
Linkenback, Sean, 80
Lippi, Jeannie, 168
London, Bobby, 8, 9, 174
Loree, Todd, 288
Love, G. B., 163, 374
Lovecraft, H. P., 230
Lubbers, Bob, 29, 58–59, 71, 79, 135–136, 156, 166, *167*, 169, 176, 202, 220, 269, 283, 290–291, *290*, *291*, 352, 428, 472, 473
Lucas, George, 419
Luboff, Dick, 12, 192, 292, *292*, 435
Lupoff, Pat, 292, *292*
Luth, Tom, 212
Lynch, Jay, 223, 264, 273, 438, 445, 446, 447, 448, 470

M

Maack, Carl, 155
Maggin, Eliot, 430
Mahon, John, 26, 80
Maiello, Robert, 127
Main, Daniel, 136
Makrake, Tom, 272, 412
Manning, Doris, 108
Manning, Russ, 60, *60*, 108, 136, 295, *295*, *296*, 296, 421, 422, 434, 482
Mansfield, John, 66
Mantlo, Bill, 12, 301, 399
Manyak, Michael, 384–385
Marble, Alice, 297
Marchand, Arthur, 31
Marcus, Nick, 385
Marder, Larry, 236
Margolis, Eric, 192, 229
Margulies, Leo, 417
Maris, Don, 99–103
Marschall, Rick, 45, 68, 107, 223, 256, 281, 326, 341, 438, 481
Marsh, Jesse, 60, 176, 296, *298*, 298, 434, *434*
Marsh, Norman, 125
Marston, William Moulton, 298, 475
Marten, Hazel, 361, 474
Martin, Anya, 189
Martin, Don, 298–299, *299*
Matheson, Tim, 304
Mauger, Peter, 219
Mauldin, Bill, 421
Maurer, Lenny, 304, 421
Maurer, Norman, 47, 84, 218, 271–272, 304, 313, 421
Mavrides, Paul, 159
Max, Peter, 446
Maxon, Rex, 176, 304, 433
Maybruck, Jay, 469
Mayer, Mercer, 457

Mayer, Sheldon, 11, 189, 190, 191, 209, 219, 248, 304–305, *305*, 329–330, *390*, 390, 391, 440
Mayerik, Val, 83
Mayo, Ralph, 183, 184
Mazzucchelli, David, 305
McCalla, Irish, 399
McCay, Winsor, 269, 286, 305–307, *306*, 438
McCay, Winsor, Jr., 77
McCloud, Scott, 125, 145, *145*, 338
McDonald, Gene, 478
McFarlane, Todd, 14, 66, 109, 145, 231, 234–235, 239–240, 276, 301, 307–309, *307*, *308*, 324
McGregor, Don, 50, 145, 154
McKean, Dave, 121, 189
McManus, George, 309, *309*
Meglin, Nick, 18, 269, 294
Mehdy, Mitchell, 3
Merritt, Edgar Ray, 361n
Meskin, Mort, 52, 57, 60, 119, 170, 181, 246, 265, 272, 310–311, *310*, 324, 331, 347, 351, 352, 373, 398, 418, 462
Messmer, Otto, 165–166
Messner-Loebs, William, 475
Messick, Dale, 57–58, *58*, 132, 210, 254, *311*, 311–312, 474
Michelinie, David, 240
Milgrom, Al, 98
Miller, Frank, 5, 17, *25*, 44, 57, 80, 92, 102, 108, 109, 115, *115*, 115–117, 121, 151, *151*, 163, 197, 199, 200, 213, 234, 260, 288, 300, 305, 318–321, *319*, *320*, 324, 362, 372, 379, 404, 405, 434, 479
Miller, Sarge, 17
Miller, Steve, 17
Milligan, Peter, 450
Mills, Tarpe, 80, 254, 320, 340
Mingo, Norman, 11
Mitchell, John, 291
Moebius (Jean Giraud), 52, 81, 117, 199, *199*, 466, 467
Moldoff, Sheldon, 44, 108, 195, 209, 219, 321–322, *321*, 347
Monsky, Leo, 61
Montana, Bob, 20, 246, 252, 322, *322*, 351, 430
Mooney, Jim, 347, 428, 435
Moore, Al, 202
Moore, Alan, 45, 49, 122, 186, 189, 196–197, 199, 200, 274, 303, 319, 320, 321, 321–324, 323, 340, 404, 407, 430, 450, 460, 481
Moore, Ray, 352
Moore, Wilfred Gibbs, 74
Moores, Dick, 324
Morales, Lou, 38
Morisi, Pete, 108, 180, 131, 324–325
Moreira, Rueben, 105
Morgan, Henry, 10
Morrissey, Rich, 179
Morrison, Bill, 383
Morrison, Grant, 136, 423, 450
Morrow, Gray, 337, 374, 459
Mortellaro, Tony, 300
Mortimer, Win, 347
Moscoso, Victor, 446, 457
Moskowitz, Sam, 335, 338–339, 386–387
Motter, Dean, 426
Mouly, Francois, 365, 412
Moulton, Charles, 298
Mullaney, Dean, 145, 325, 350
Mullaney, Jan, 145
Mullin, Willard, 218, 219
Murphy, John Cullen, 177, 195, 473
Murphy, Matt, 304
Murphy, Nancy, 300
Murphy, Willy, 159
Murray, Doug, 301
Murray, Will, 81, 197, 313

N

Nabokov, Vladimir, 378
Naiman, Michael, 216
Nanovic, John, 134
Nash, Clarence, 134–135

Index
Names

Natwick, Grim, 45
Nelson, Dwaine, 275
Newman, Paul S., 140, 327
Newmar, Julie, 79
Nicholas, Charles, 52
Niño Alex, 328–329, *329*
Nixon, Richard, 360, *360*
Nizer, Louis, 278
Nocenti, Ann, 95–96, 124–125, 329
Nodel, Norman, 87, 88
Nodell, Carrie, 330
Nodell, Martin, 172, *172*, 209, 329–330, *329*, *330*, 370
Nolan, Michelle (Mike), 83, 96, 201, 229, 255, 333, 342, 343, 357, 375, 376, 394, 395, 414, 429
Noomin, Diane, 212
Nordling, Klaus, 330
Norfleet, Susan, 418
Norman, Floyd, 474
Norris, Paul, 18
Nostrand, Howard, 4, 50, 67, 176, 180, 208, 212, 216, 217, *217*, *229*, 238, 330–331, *331*, 359, 437
Novick, Irv, 198, 210, 271, 331–332, *332*, 351 454
Nowlan, Philip, 62, 332

O

Obadiah, Rick, 210
O'Connor, Bill, 32
Oda, Ben, 42–43, 109, 146, 286
O'Neil, Denny, 43, 96, 133, 189, 204, 209, 274, 276, 298, 320, 333–334, *334*
O'Neill, Dan, 8–9, *8*, *9*, 174, 175
Oksner, Bob, 17
Oleson, John, 58
Olshevsky, George, 115, 226, 302, 303, 333, 453, 482
Ono, Yoko, 69, 71
Orenstein, Peggy, 113
Oriolo, Joe, 78
Orlando, Joe, 19, 36, 51, 54, 88, 109, 119, 120, 141, 143, 146, 150, 157, 188, 196, 198, 216, 237, 328, 339–340, *339*, 388, 399, 412, 459, 477, 478
Orzechowski, Tom, 98
Osrin, Ray, 38–39, 164
Ostrander, John, 412
O'Sullivan, Judith, 306
Otomo, Katsuhiro, 10
Outcault, R. F., 65, 138, 281, *281*, 340–341, *341*, 438, 481
Overstreet, Bob, 3, 55, 190, 205–206, 324, 341–344, *342*, 353, 355, 379, 469
Owens, Freeman, 486

P

Pachter, Richard, 56
Paddock, Munson, 361
Page, Bettie, 132, 374, 421
Palais, Rudy, 217
Palmer, Raymond, 14, 34, 484
Panter, Gary, 365
Papp, George, 208
Paris, Charles, 45, 69–70, 119, 179, 181, 282, 346–348, *347*, 415
Parker, Bill, 73, 138, 163, 224, 348
Parker, Ron, 163
Parker, Tom, 300
Patterson, Joseph, 67, 205, 286
Pattie, Brad, 445
Parkhouse, 196
Patterson, Robert, 202
Patterson, Russell, 69
Paul, Frank R., *302*, 335, 348, *348*, 387
Paul, George, 13
Payette, Jim, 11, 124, 205, 348, 469
Pekar, Harvey, 349, *349*
Peppe, Mike, 156, 169, 440
Perelman, Ron, 301
Perelman, S. J., 464
Pérez, George, 351, *351*, 434, 475
Peter, H. G., *475*
Peters, Eric, 352

Peters, Lilly Renée Wilhelms, 166, 168, 351–352, *352*, 356, 473
Petty, George, 202, 254, 474
Pfeiffer, Michelle, 78, 79
Phillips, Charles, 322
Phillips, Violette, 476
Pierce, Ken, 36
Pinanjan, Art, 294
Pines, Ned, 118, 207, 238, 417
Pini, Richard, 161, *161*
Pini, Wendy (Fletcher), 160, 161, *161*, 368, *368*
Place, Dale, 418
Plant, Bud, 43, 121, 229, 258, 334–335, 356–357, *357*, 375, 384, 385, 394, 395
Plastino, Al, 428
Ploog, Mike, 460
Plymell, Charlie, 112, 484
Pollock, Jackson, 390
Portacio, Whilce, 235
Potts, Carl, 276
Powell, Bob, 50, 147, 170, 209, 214, 217, 229, 244, 330, 359, *359*, 361, 376, 442–443, 444
Pratt, George, 154
Pratt, Hugo, 98, 359–360
Preiss, Byron, 274, 328
Premiani, Bruno, 136
Prentice, John, 56, 137, 432, 473
Price, Edgar Hoffman, 231
Pulitzer, Joseph, 281, 340
Pussell, Ron, 135, 163, 316, 443
Pyle, Howard, 361, 396

Q

Quintal, Virginia, 361

R

Rahm, Linda, 13
Raboy, Mac, 15, 42, *63*, 102, *103*, 163, 224, 365, *365*, 478, 486
Ralston, Henry, 134
Ramsey, Harry, 326
Rand, Ayn, 134
Randall (Kesel), Barbara, 320–321
Rankin, Marty, 54
Rausch, Barbara, 254
Raymond, Alex, 21, 105, 174, 268, 259, 271–272, 365, 366–367, *367*, 392, 432
Rechtor, Ed, 85
Redondo, Nestor, 328
Reese, Ralph, 476
Reiker, Heinie, 67
Reinman, Paul, 32, 209
Reiss, Mal, 168, 169
Reit, Seymour, 78
Remi, George (Herge), 438–439
Renée, Lilly. *See* Peters, Lilly Renée Wilhelms
Rhinehardt, Betty, 244
Rhoads, Fred, 217, 280, 368–369, *369*
Ricca, Gus, *84*, *85*
Rice, Anne, 449
Rice, Pierce, 49, 217, 330, 331, 346, 369–370, *369*
Richards, Ted, 8, 9, 159
Richardson, Mike, 14, 17, 49, 80, 115–116, 449, 450
Rico, Don, 370–371
Ringgenberg, Steve, 250
Riss, Pete, 456
Ritt, William, 58, 367
Rivera, Alberto, 114
Robbins, Frank, 324
Robbins, Trina, 30, 160, 166, 192, 254–255, 264, 286, 320, 351, 371–372, *372*, 382, 449
Robinson, James, 418
Robinson, Jerry, 107, 115, 119, 132, 209, 245, *245*, 264–265, 310, 352, 372–373, *372*, *373*, 403–404
Roche, Ruth, 87, 233, 373–374, 429
Rockwell, Norman, 159, *159*
Rodriguez, Spain, 20, 211
Rogers, Marshall, 350
Rogers, Roy, 381, *467*

Rogoff, Herb, 425
Rogofsky, Howard, 96, 205, 342, 374–375
Romero, Enrique, 36
Romita, John, Jr., 14, 151, 378, 379
Romita, John, Sr., 255, 260–261, 300, *378*, 378–379
Romita, Virginia, 378, 379
Roosevelt, Franklin, 360
Rosa, Don, 40, 73, 209, 379–381, *379*, *380*, 467
Rose, Millicent, 136
Rosen, Hy, 272
Rosenkranz, Patrick, 52, 484
Ross, Alex, *301*, 445
Roth, Arnold, 65, 149, 232, 442
Roth, Big Daddy, 37
Roussos, George, 115, 310
Rovin, Jeff, 30, 51, 231, 333
Rowe, Burrel, 89, 315
Rozanski, Chuck, 89, 126, *127*, 127–129, 313–318
Rude, Steve, 42, 328, *328*, 381–382, *381*, *382*
Rushdie, Salman, 248
Russell, P. Craig, 338

S

Saaf, Artie, 169, 473
Saalburg, Charles, 438
Saba, Arn, 176, 402
Sahle, Harry, 361
St. John, Archer, 421
St. John, J. Allen, 269
Sakai, Stan, 212
Saladino, Gasper, 146
Salkind, Alexander, 429
Salkind, Ilya, 429–430
Sammon, Paul, 383
Sarno, Joe, 333
Saunders, Allen, 385
Saunders, Buddy, 163, 357, 374
Saunders, Norm, *275*, 385–386, *385*
Scandia, Frank, 395
Schaffenberger, Kurt, 60, 179, 180
Schanes, Bill, 50, 129, *129*, 345, *345*
Schanes, Steve, 50, 129, 193, 345, *345*, 421
Schelly, Bill, 37, 83, 342, 474
Schiff, Jack, 54, 81, 279, 327, 347, 386, 401, 463
Schmich, Mary, 58
Schomburg, Alex, 58, *58*, 73, 77, *77*, 100, 102, *103*, 115, 122, 170, *170*,*192*, 202, 209, 220, *225*, *226*, 228, *228*, 246, *246*, *247*, 292, *300*, 304, 326, 338–339, 343, 351, 361, 376, 386–388, *386*, *387*, 388, *417*, 418, 438, *438*, *453*
Schreck, Bob, 3, *63*, 92, 301
Schubert, Irene, 283
Schultz, Denise, 389
Schultz, Mark, 264, 389, *389*, 481, *481*
Schutz, Barb, 435
Schutz, Diana, 80, 92, 145, 152, 470
Schwartz, Alan, 172, 195, 389–390, 463, 464
Schwartz, Julius, 5, 6, 10, 12, 34, 37, 54, 59, 60, 75, 120, 172, 173, 174, 196, 203–204, 209, 246, 252, 254, 305, 321, 335, 350, 361n, 372, 386, 390–392, *390*, *392*, 412, 429–430, 462
Schwartzberg, Stu, 300
Scott, Thurman T., 166–168, 169, 290
Scroggy, David, 345, *345*
Segar, E. C., 359, *359*, 393, *393*
Seifringer, George, 359
Sekowsky, Mike, 57, 73, 246, 288, 333, 393
Seldes, Gilbert, 265
Sendak, Maurice, 305, 393
Seuling, Phil, 43, 96, 130, 193, 194, 318, 320, 324, 333, 345, 357, 393–394, 480
Severin, John, 51, 109, 120, 142, 143, 144, 150, 157, 273, 395–396, *395*, 444, 454, 459, 477–478
Severin, Marie, *142*, *149*, 251, 273, 277, 300, 396, *396*, *471*
Seydor, Paul, 313
Shaw!, Scott, 90, 155, *397*, 397–398, *398*

Shelton, Gilbert, 159, 222, 445–446, 447, 471
Sheridan, Dave, 159
Sheridan, Martin, 173, 192
Shetterly, Will, 75
Shir-Cliff, Bernie, 10, 11
Shooter, Jim, 19, 65–66, 75, 89, 95–96, 121, 128, 188, 261, 263, 277, 281, 282, 301, 327, 329, 337, 345, 391, 399–401, *400*, 408, 413–414, 415, 416, 436
Shores, Syd, 51, 64, *225*, 370, 410
Shorten, Harry, 331, 332
Shukin, Ed, 128
Shuster, Hal, 127, 128, 249
Shuster, Irwin, 127
Shuster, Jack, 127
Shuster, Joe, 2–3, *2*, *27*, 43, 45, 56, *100*, 107, 108, 125, *279*, 324, 361, 373, 402–404, *402*, *403*, 427, 429, *429*
Sickles, Noel, 68, 401–402, 440
Sidebottom, Bob, 186
Siefringer, George, 330
Siegel, Jerry, 3, 43, 45, 56, 107, 108, 125, 246, 275, 313, 324, 338, 361, 373, 402–404, *403*, 411, 427, 429
Sienkiewicz, Bill, 151, 318, 329, 404, *404*, 479
Sienkovec, Jerry, 163
Silberkleit, Louis, 271
Silver, Joel, 449
Silvestri, Marc, 235
Sim, Dave, 80, 93, 109, 123, 235, 336, 391, 404, 406–407, *407*, 424, 434
Simmons, Gene, 384
Simmons, Julie, 220, 222
Simon, Joe, *6*, 45, 52, 56, 71, 72, 73, 75, 109, 115, 169, *169*, 225, 263, 277, 310, 313, 337, 349, 361, 376, *376*, 384, 394, 395, 403, 407–408, 417, *482*, 483, *483*
Simonson, Louise, 215, 301, 408, *408*, 459
Simonson, Walt, 83, 154, 163, 300, 301, 408–409, *409*, 476
Simpson, Don, *235*, 361
Sinatra, Frank, 475
Sinnott, Joe, 300, 409, *409*
Skeates, Steve, 75, 334
Skinn, Dez, 196
Slater, Helen, 429
Slott, Mollie, 57
Small, Jack, 390
Smith, Barry Windsor-, 95, *95*, 186, 196, 246, 249, 300, 368, 407, 410–411, *411*, 419, 423–424
Smith, Jeff, 453
Smith, Kevin, 384
Smith, Lloyd, 140
Smith, Paul, 132
Smith, Thomas, 43
Snyder, John, 65
Snyder, John, 193–194, 316
Snyder, Marcia, 168, 361
Snyder, Robin, 12, 134, 268, 337, 397, 401
Soglow, Otto, 411
Solomon, Robert, 30
Spain. *See* Rodriguez, Spain
Spenser, Jay, 74
Spicer, Bill, 143, 163, 207–208, 461, 468
Spiegelman, Art, 65, 212, 270, 272, 273, 365, 412, *412*, 447, 454
Spiegle, Dan, 50
Spielberg, Steven, 50, 78, 231, 473–474
Spillane, Mickey, 144, 197, 318, 319, 320, 361, 378, 412–413
Sprang, Dick, 57, 119, 172, 347, 415
Stack, Frank, *349*, 445–446, *446*
Stahl, Ben, 169
Stanley, John, 286, 418
Stark, Larry, 236
Starlin, Jim, 83, 154, 155, 186
Starr, Leonard, 137, 202, 244, 288, 404
Stanton, Eric, 132–133
Staton, Joe, 57, 292, 333, 358, 419
Stein, Harry, 50
Stein, Marvin, 109
Steinbeck, John, 70

Index
Names/Subjects

Steinberg, Flo, 96, 133, 147, 263, 300, 435, 461
Steinem, Gloria, 222
Stenzel, Al, 61
Steranko, Jim, 5, 29–30, 44, 46–47, 50, 63, 72, 73, 104, 105, 138, 147, 171, 188, 190, 192, 204, 244, 252, 279, 300, 325, 337, 340, 348, 365, 397, 419–420, *419*, *420*, 441, 470
Stern, Charlie, 150, 273, 395, 478
Sternecky, Neal, 359
Stevens, Dave, 7, 145, 220, *221*, 345, 374, *374*, 389, 419, 420, 421, *421*, 422, 453, 470
Stevenson, Dan, 376
Stewart, Bhob, 163, 208, 270, 330, 359
Stewart, Jan, 145
Stewart, Jim, 144–145
Stoelting, Wally, 17
Stone, Chic, 300, 324
Stone, Vince, 75
Stout, William, 150, 184, 185, 243, 264, 285–286, 296, 335, 374, 421, 422–423, *422*, 471, 473
Stradley, Randy, 17, 115–116, 117, 449
Strauss, Robert, 240
Streckler, Ben, 34
Strnad, Jan, 222
Stroud, Terry, 334–335, 375, 398
Stuart, Lyle, 350
Stubbs, Aran, 241
Sturgeon, Foolbert, 144
Suarez, George, 217, 230
Suchorsky, Mike, 424–425, *425*
Suchorsky, William, 425
Sueiro, Victor, 433
Sullivan, Judith, 71, 224, 259
Sullivan, Pat, 166
Sullivan, Vincent, *118*, 119, 172, 175, 426–428, *427*, 432, 468
Sultan, Charles, *84*, 85, 428, *428*
Sutton, Tom, 459, 460
Swan, Curt, 59, *282*, 350, 415, 430–432, *431*
Swan, Dick, 43, 334–335, 336, 384, 394

T
Takei, George, 116–117
Tallman, Tom, 394–395
Tanaka, Grace, 4
Tardi, Jacques, 365
Tarka, Mark, 470
Templeton, Ty, 260
Terry, Hilda, 320
Terry, John, 402
Terry, Paul, 313
Texeira, Mark, 194
Thailing, Bill, 96
Theakston, Greg, 262, 335, 336, 338
Thies, Ken, 342
Thomas, Roy, 12, 13, 37, 74, 95, 96, 157, 163, 186, 202, 231, 276, 278, 288, 300, 308, 328, 334, 341, 368, 374, 410, 416, 418, 419, *435*, 435–436, 461, 481
Thompson, Don, 12, 163, 213, 292, 336, *436*, *436*
Thompson, Jim, 319, 378
Thompson, Kim, 161, 213
Thompson, Maggie, 163, 336, 436, *436*
Thorne, Frank, 154, 368
Tiefenbacher, Mike, 163, 418
Tinsley, Frank, 437
Tinsley, Theodore, 197
Todd, Larry, 20, 52
Torpey, Frank, 188, 202
Torres, Angelo, 51, 143, 146, 240, 473
Toth, Alex, 1, 12, *25*, 57, 120, 124, 209, 218, 272, 288, 310, 311, 368, 376, 391, 397, 402, *440*, 440–441, 454, 458, 459
Totleben, John, *121*
Traylor, James, 413
Tricarichi, Joe, 275
Trimpe, Herb, 300
Tripp, Irving, 286
Truman, Tim, 192, 220, 245

Turner, Les, 107
Turner, Steve, 375
Tuska, George, 166, 233, 300, 443–444, *444*, 454

U
Urry, Michelle, 113

V
Vachss, Andrew, 55
Vadeboncoeur, Jim, 17, 30, 32, 62, 356, 375, 376, 424, 425, 449, 458, 473
Valentino, Jim, 235
Vallely, Henry, 321
Van Hise, James, 374, *471*
Vargas, Alberto, 201
Varley, Lynn, 288
Vartanoff, Irene, 336–337
Veitch, Rick, 272
Veitch, Tom, 26
Verheiden, Mark, 14, 17, 80, 301, 449–450
Verpoorten, John, 300, 436
Vess, Charles, 451–452, *452*
Viscardi, Nick, 147, 166, 169, 187, 351, 442–443
 See also Cardy, Nick
Voll, Dick, 474, 475
von Grawbadger, Wade, 418
Vosberg, Mike, *457*

W
Wagner, Geoffrey, 346
Wagner, Matt, 5, 44, 80, 90, 92, 124, 211, 406, 407, 419, 420, 450, 453, *453*
Waldman, Israel, 409
Walker, Al, 453
Walker, Mort, 61
Waller, Reed, 264
Ward, Bill, 336, 440, 456–457, *456*
Ware, Hames, 26, 28, 62, 67, 87, 108, 115, 171, 192, 208, 224, 325, 326, 330, 363, 424, 449, 457–458, 464, 483
Warner, Chris, 17, 80, 188
Warren, Bill, 383
Warren, Jim, 51, 109, 212, 160, 202, 207, 222, 408, 441, 449, 458, 459, 460, 480
Warren, Jon, 205
Waugh, Colton, 324
Webb, Richard, 74
Webb, Robert, 87, 233
Weeks, Lee, 272
Wein, Len, 5, 196, 215, 288, 323, 430, 440, 461, *461*, 474, 479, 481
Weinberg, Robert, 61, 62
Weisbecker, Clem, *462*
Weisinger, Mort, 18, 56, 59, 75, 180, 208, 282, 288, 361n, 362, 386, 390, 392, 400–401, 415, 417, 428, 429, 430, 431, 435–436, 462–464
Weiss, Alan, 409
Weist, Jerry, 190, 245, 338, 355–356, 468–469, *468*
Wellman, Manly Wade, 390
Wepman, Dennis, 257
Wertham, Fredric, 55, 56, 87, 88, 109–110, 181, 192, 220, 230, 239, 288, 346, 392–393, 464–465, *464*
Wessler, Carl, 399, 465–466
Wessler, Mary, 465, 466
West, Adam, 378
West, Corinna, 17
West, Mark, 464
Westover, Russ, 366
Wheeland, Grover, 427
Wheeler-Nicholson, Major Malcolm, 125, 175, 175, 304, 327, 402, 427, 468
White, Biljo, 163, 374
White, Clinton, 259
White, Ted, 163, 220, 297
Whitman, Maurice, *167*
Whitney, Ogden, *14*, 414
Whitshell, Jack, 355–356
Wildenberg, Harry, 327
Wildey, Doug, 374, 410, 470, *470*
Williams, Robert, 141, 211, 470–471, *471*

Williamson, Al, 14, 51, 88, 99, 105, 106, 109, 142, *142*, 143, 146, 151, 156, 157, 174, 183, 185, 191, 195, 202, 211, 227, 240, 268–269, 270, 300, 324, 335, 366, 374, 389, 392, 399, 432, 444, 449, 453, 459, 462, 471–473, 471, 472, 474
Williamson, Jack, 151
Williamson, Skip, 223, 273, 446, 447, 470
Willits, Malcolm, 74, 83, 96, 201, 204, 205, 258, 282, 342, 378, 436
Wilson, Mark, 94, 125, 206, 207, 320, 469
Wilson, S. Clay, 144, 211, 447, 471
Windsor-Smith, Barry. *See* Smith, Barry Windsor-
Witek, Joseph, 87, 273
Woggon, Bill, 254–255, *255*, 474
Woggon, Elmer, 474
Wolfman, Marv, 5, 89, 155, 215, 288, 323, 333, 351, 434, 461, 474, *474*
Wollenberg, J., 9
Wolverton, Basil, 13, 80, *101*, 474–475, *475*
Wood, Bob, 48, 85, 109, 200, 370, 475–476
Wood, Dave, 115
Wood, Dick, 115
Wood, Tatjana, 340, 477
Wood, Wally, 17, *36*, 51, 75, *76*, 81, 83, 102, 104, 105, 119, 141, 142–143, 144, 150, 163, 181, 190, 191, 216, 227, *228*, 240, 268, 273, 300, 324, 330, 336, 340, *344*, 376, 399, 422, 425, 426, *426*, 438, 440, 461–462, 471, 474, *474*, 476–478, 477, *478*
Woolfolk, Bill, 50
Workman, John, 220
Worley, Kate, 264
Wright, Farnsworth, 61
Wright, Greg, 202, 222, 327–328, 349
Wrightson, Bernie, 5, 159, 183, *215*, *230*, *245*, 246, 249–250, 300, 407, 409, 410, 423–424, 430, *430*, 458–459, 460, 476, 479–480, *479*, *480*
Wunder, George, 157, 220, 435, *477*
Wyeth, Andrew, 396
Wyeth, N. C., 432

Y
Yates, Bill, 43
Yeager, Bunny, 421
Yeates, Tom, 272
Yee, Harley, 242
Young, Chic, *51*, 255
Young, Cliff, 347
Young, Dean, 138
yronwode, cat, 36, 145, 320, 351

Z
Zahler, Leslie, 6
Zahn, Brian, 112, 484
Zansky, Louis, 483–484
Ziegler, Bill, 474
Ziff, William B., 484
Zimmerman, William, 429
Zolnerowich, Dan, 7, 17, 166, 356, 398, 467, 485–486, *485*
Zone, Ray, 422, 486, *486*
Zwigoff, Terry, 112, 113

Subject Index

A
AC Comics, 1
Academy of Comic Book Arts, 5
Acclaim, 126, 418
Ace Comics, 89, 209, 229, 268, 376, 483
Ace Books "F" series, 1, *1*, 184, 259
ACG. *See* American Comics Group
Adam Strange, 6, 179, 209, 236, 401, 405
advertising, 7, 464
advice columnists, 6–7
Air Pirates, 8–9, 174, 175
Airboy, 7
Ajax-Farrell, 230, 326, 374
Albert, 358
Alfred, 10
Alfred E. Neuman, 10–11, *10*, 294
Alicia Masters, 162
All-American Comics, 11, 297, 304, 329–330, 391, 440

All Winners Squad, 12
Allentown collection, 11
Alley Oop, 11, *11*, 215
Alpha Flight, 12
alternative comics, 161, 461
Amazing Man, 13, 80, 157
American, 14
American Eagle, 395
American Comic Book Company, 243
American Comics Group (ACG), 4, 118, 229, 326, 425, 457, 473
American Greetings, 112
American News Co. (ANC), 31
American School of Design, 18
American Visuals, 414
Ange, 188, 214, 302
Angel and the Ape, 17, 401
Angouleme Comics Festival, 113, 229
Animal Lad, 6
Animal Man, 450
animation, 35–36, 186, 215–216, 306–307, 313, 328, 358–359, 422, 436
Ant-Man, 17, 35, 405
Anthro, 401
APA-5, 80, 116, 449
Aqualad, 6, 434
Aquaman, 18, 57, 248, 324, 405, 462
Archie Andrews, 20, *20*, 322, 322, 351, 450
Archie Comics, 20, 123, 137, 313, 408
Argosy Book Shop, 342
Arlington Press, 292
Arrow, 214
Art Students League, 137, 1–7, 290, 347
ashcans, 26–28, 146
Asp, 286
Associated Press, 67
Association of Comics Magazine Publishers, 110, 200
Atlas Comics, 30–33, 64, 104, 118, 157, 229, 277, 326, 340, 376, 388, 396, 414, 473
Atlas/Seaboard, 30, 202, 311
Atom, 33–34, *33*, 57, 248, 59, 401, 405
Atomic Knights, 34
Aunt May, 14, 34–35, *35*
Avengers, 17, 35, 260, 300, 351, 444
Avon Periodicals, 36, 216, 240, 259, 275, 341
Axa, 36

B
Badger, 42
Bandit, 470
Bantam Books, 184
Barney Google, 42
Bat Cave, 252
Bat Lash, 43, 401
Bat Mite, 108
Batman, 11, 43–44, *44*, 57, 101, 125, 172, 173, 179, 209, 243, 280, 319, *319*, 321, 332, 334, 345, 346, 347, 390, 391, 415, 427
Bazooka, 446
Beast Boy, 6
Better Publications, 238, 417, 437
Betty, 20, *322*
Betty Boop, 45, 180
Betty Brant, 14
Big Little Books, 45, *45*, 59, 469
bigfoot cartooning, 45
Billy Batson, 73, *73*, 163
Binder shop, 111, 236
Biro studio, 236
Bizarro Superman, 47, 463, *463*
black-and-white glut, 49, 116, 141, 145
Black Canary, 49, 57
Black Cat, 49, 370
Black Condor, *170*, 171, 365
Black Hood, 20, 313, 331, 438
Black Lightning, 242
Black Orchid, 6
Black Panther, 50, 162
Black Pirate, 321
Black Widow, 50–51
Blackhawk, 50, 359, 362, 486

Index
Subjects

Blackthorne Publishing, 50, 345
Blonde Phantom, 51–52
Blondie, 51, 217
Blue Beetle, *46*, 52, 82, 370
Blue Blaze, 326
Blue Bolt, 52
Blueberry, 52, 199
Bob Hope, 6
Bobo, Detective Chimp, 236
bondage, 55–56
Boy Commandos, 125, 408, 415
Brainiac, 3, 463
Brenda Starr, 57–58, *58*, *221*, 311
Broadway Comics, 345, 401
Brooklyn Academy of Fine Arts, 183
Brother Power the Geek, 408
Brothers of the Spear, 60, *60*, 451–452
Buck Rogers, 62, *62*, 332
Bucky, 12, 72, 482
Bulletman, 62–63, *63*, 255
Buster Brown, 65, 138, *281*, 340, 341

C

Cadence Industries, 154, 280
Camp Newspaper Service, 295
CAPA-Alpha, 17, 37, 436
Capital City Distribution, 69, 126, 129, 130, 328
Capt. Stacy, 14
Captain America, 12, 35, 71–73, *71*, *72*, 169, 225, *225*, *233*, 260, 261, *261*, 263, 300, 302, 405, 407, *417*, 444, 453, *453*
Captain & the Kids, 448
Captain Atom, 81, 82
Captain Carrot and His Amazing Zoo Crew, 398
Captain Comet, 236
Captain Commando and the Boy Soldiers, 351
Captain Flag, 75, *75*
Captain Marvel (Fawcett), 44, 73–74, *73*, *75*, 278–279, *279*, 348, 390, 437, 470
Captain Marvel (Marvel), 74, 418
Captain Marvel Jr., 62–63, *103*, 163, 365, *365*
Captain Midnight, 74
Captain Science, 76, *76*
Captain Thunder, 73, 436–437, *437*, 469–470
Captain Wings, 151, *291*
Cartoon Arts Professionals Society, 370
Cartoonists and Illustrators School, 202, 216
Casper, 422
Catholic Guild, 442
Catwoman, 78–79, 125, 172, 405
Cave Carson, 57
Centaur, 63, 80, 85, 157, 214, 290, 363
Century Publishing, 429
Cerebus, 80
Challengers of the Unknown, 81, 401, *401*, 405, 430
Chameleon Boy, 3
Changeling, 434
Charles Atlas ads, 7
Charles William Harvey studio, 273
Charlton Comics, 81–82, 133, 196, 198, 199, 223, 324, 326, 334, 376, 414, 419, 460, 466, 473
Cheech Wizard, 52
Cherokee Book Store, 83–84
Chesler studio, 28, 46, 47, 63, 84, 90, 188, 192, 212, 214, 218, 236, 331, 365, 444
Chicago Academy of Fine Arts, 210
Chicago Art Institute, 304, 311
Chicago Tribune–New York News Syndicate, 205
Chick Publications, 114
Chlorophyll Kid, 6, 282
Christopher Enterprises, 480
Churchy La Femme, 358
Cinema Comics, 256
Clark Kent, 309–310, 359
Collector's Book Store, 83, 201, 342, 376
Columbia Pictures, 185, 428
Comet, 90, 313, 351
Comic Art Convention (Seuling), 96, 394
Comic Book Expo, 345

Comic Magazine Association of America (CMAA), 127, 128, 200
Comico, 92, 145, 211, 301, 374, 453, 470
Comics & Comix, 336, 384, 385, 395
Comics Code, 14, 92–93, 110, 141, 144, 162, 200, 229, 240, 288, 293, 305, 330, 333, 392, 404, 462, 465, 467
Comics Magazine Company, 80, 125, 135, 214
Company and Sons, 482–483
Comstock Lode, 93–94
Conan, 65, 95, *95*, 230, 231, 410, 425
Congo Bill, 204
Congorilla, 204
Continental Magazines, 90
Continuity Studio, 5, 199, 408
conventions, 96–97, 183, 206–207
Corto Maltese, 98, 359–360
Cosmic Boy, 282
covers, 100–103
Creation Con, 3, 276
creator rights, 107–109, 115–116, 124, 145, 148, 179–180, 186, 234–235, 280, 320, 373, 407, 413, 460, 474
Creeper, 134, 401
Crestwood/Prize, 6, 408, 483
Cross-Draw Kid, 483
crime comics, 109110, *109–111*
Crimebuster, 272, 304
Crimson Avenger, 125, 282, 347
crossovers, 111, 303
Crypt Keeper, *117*
Curtis Distribution, 87
Curtis Publishing, 32
Cyborg, 434
cycle sheets, 345

D

Daddy Warbucks, 208, *208*, 286
Dagwood Bumstead, 51
Daisy Mae, 283–284, *283*
Daisy Red Ryder rifle, 7
Daredevil (Gleason), *115*, 272, 304
Daredevil (Marvel), 115, *115*, 362, 444
Dark Horse Comics, 4, 11, 14, 55, 80, 108, 115–116, 126, 134, 145, 200, 274, 299, 301, 320, 325, 328, 345, 374, 397, 408, 411, 418, 419, 434, 453, 480, 431
Darklon, 418
Darkseid, 262
David McKay Publications, 259, 327, 352
DC Comics, 5, 6, 11, 16, 17, 27, 28, 31, 32, 36, 48, 50, 53–54, 56, 57, 59, 60, 64, 76, 81, 107, 108, 118, 118–122, 125, 126, 127, 128, 129, 133, 134, 135, 154, 155, 157, 162, 163, 172, 189, 196, 198–199, 216, 223, 236–237, 242, 249, 250, 252–253, 259, 261, 262, 277, 294, 305, 310–311, 312, 319, 321, 326, 327, 328, 332, 334, 336, 337, 338, 340, 351, 358, 363, 376, 390–392, 397, 400–401, 402, 403, 408, 415, 418, 419, 429, 430–431, 434, 435, 437, 445, 450, 453, 454, 460, 462–464, 466, 465, 474, 475, 479, 485
see also National Periodicals
Deadman, 4, 123, 430
Defiant, 401
Dell, 1, 89, 90, 123–124, 140, 177–179, 200, 223, 259, 296, 324, 379, 380, 434, 467, 473
Demon, 124, *124*
Denver collection, 124
Detroit Triple Fan Fare, 37, 96
Diamond Comic Distributors, 3, 50, 69, 125–126, 193–194, 342, 345, 357, 407
Diamond International Galleries, 193, 194, 342
Dick Tracy, 126, *126*
Dickie Dean, 90
direct market, 69, 118, 126–130, 194, 235, 249, 345, 394, 395
Disney Productions, 8–9, 40, 41, 124, 131, 135, 175, 200, 324, 328–329, 374, 379, 380
Doc Octopus, 14
Doc Savage, 134, 330, 390
Doll Man, 105, 134, *335*
Donald Duck, 39–40, *40*, *101*, *131*, 134–135, *135*

Doom Patrol, *54*, 136, 405, 450
Doomsday, 3
Dormammu, 139, *139*
Dr. Doom, 162, 260, 405
Dr. Fate, 138, 179, 248, 324
Dr. Strange, 138–139, *139*, 405
Dr. Occult, 324
Dr. Sivana, 74, 138–139, *138*
Dragon Lady, 275
Drawn & Quarterly, 60
Dreadstar, 418
Dream Girl, 6
Duo Damsel, 6
Durango Kid, 212
Dusty the Boy Detective, 351
Dutchess Publishing, 429
Dynamo, 438

E

E-Man, 419
Earth-2, 3, 179, 405
Eastern Color Printing Co., 123, 159, 189, 200, 209, 327, 414
EC Fan-Addict Convention, 7, 39, 465
EC Fan-Addicts, 89, 144, 207, 342, 355
EC Comics, 6–7, 11, 20–26, 39, 92, 104, 105, 117–118, 141–144, 156, 157, 164, 165, 190, 191, 202, 216, 229, 230, 236, 238–239, 251, 270, 273–274, 275, 291–292, 293, 321, 338, 340, 355, 392, 396, 399, 429, 432, 445, 454, 465, 466, 471, 473, 477–478
EC Comics collection, 144–145
Eclipse Comics, 7, 108, 124, 145, 189, 212, 244, 325, 374
Educational Comics, 190
Eerie Publications, 63
Egmont, 131, 380
Eighty-Page Giants, 146, *146*
Eisner Awards, 81, 200, 382
Eisner studio, 51, 114, 147, 148, 187, 271, 414, 442–443
Eisner-Iger studio, 37, 104, 147, 166, 181, 233, 279, 310, 330, 369, 398, 485
Electro, 14
Elektra, 115, 151, *151*, 319
Element Lad, 6
Enemy Ace, 153–154, *153*, 272
Epic Comics, 19, 203, 250, 418
Eros Comics, 161, 213
Essenkay Publications, 414
Eternity, *139*
Eugene the Jeep, 358

F

Fabulous Furry Freak Brothers, 159
Falcon, 73
Famous Artists Course, 159, 382
fandom, 12, 37, 162–163, 292, 436
Fantagraphics, 37, 88, 161, 213, 223, 289
Fantastic Four, 161–162, *161*, 260, 300, 302, 351, 405, 409, 415, 474
fanzines, 12–13, *12*, 162–163, *162*, 207–208, 333, 357, 374, 375, 390–391, 411, 436, 470, 474
Farrell, 259, 429
Fawcett Publications, 27, 28, 44, 47, 62, 74, 85, 111, 124, 156, 163, 224, 233, 252, 256, 278–279, 330, 337, 348, 365, 385–386, 414, 428, 437, 444, 469–470, 478, 485
Federal Express, 164
Felix the Cat, 165–166
Fiction House, 16, 28, 29, 30, 38, 76, 79, 89, 104, 135, 137, 151, 156, 166–169, 183, 198, 201, 233, 238, 246, 275, 290–291, 330, 351, 352, 356, 359, 361, 373, 393, 428, 443, 444, 453, 469, 471, 472, 473, 485, 486
Fighting American, 169, *169*
Fighting Yank, 170, *170*
Fillmore posters, 211
Fin, 157
Fire Lad, 6
Firebrand, 105
Firehair, 151, 291
First Comics, 108, 210, 328, 418, 419, 474
Flaming Carrot, 63

Flash, 11, 32, 46, 57, 60, *120*, 173–174, *174*, 179, 209, 236, 248, 391, 401, 405
Flash Gordon, 82, 174, 259, *367*
Fleer, 302
Fleischer Studios, 180, 261, 358, 359, 466
Flexo the Rubber Man, 303
Flintstones, 216
Fly, 313, 408
Fly Girl, 313
FOOM, 300
Forever People, 262
Fourth World, 237, 262
Fox Features (Victor Fox), 108, 110, 164, 170–171, 180–181, 191, 201, 216, 233, 252, 261, 279–280, 324, 326, 330, 369, 371, 374, 376
Fritz the Cat, 113, 186
Fritzi Ritz, 448
Funnies, Inc., 7, 63, 157, 188, 202, 303, 407

G

Galactus, 162, 192, 260, 406, 436
Garbage Pail Kids, 412
Gateway Con, 96
Gemstone Publishing, 194
General Zod, 6
Ghost Rider, 179, 194
ghosts, 194–195
Giant-Man, 17, 35
Gilberton Company, 87, 88, 90, 233, 254, 374, 483
giveaways, 199–200
Gladstone, 131, 379–380
Godzilla, 3–4, *3*
Gold Key Comics, 5, 124, 134, 140, 157, 295, 319, 326, 419, 440, 469
Golden Age, 26–28, 201, 258, 300, 303, 324, 343, 348–349, 353, 354, 432
Golden Arrow, 470
Golden State Comic-Con, 383
Goliath, 17, 35
good-girl art, 167, *168*, 168, 201, *201*, 254, 352
Gorilla City, 204
gorillas, 203–204, *203*
Gotham City, 204
grading, 205–207
Grand Central School of Art, 347
Green Arrow, 57, 199, 208–209, 248, 324, 334, 370, 462
Green Goblin, 14, 405
Green Hornet, 218, 370
Green Lantern, 11, *46*, 60, 172, *172*, 199, 209, *209*, 216, 248, 253, 321, 330, 334, 401, 405, 440
Green Mask, 280
Grendel, 453
Grimjack, 418
Groo the Wanderer, *19*, 124, 212, 418
Gutenberghus, 131, 380
Gwen Stacy, 14, 97, 378, 379

H

Hangman, *187*, 351, 370
Hanna-Barbera, 155, 215–216, 237, 440–441, 470
Harlequin, 216, *216*
Harris Publications, 449, 460
Harvey Publications, 78, 200, 216–218, 229, 268, 280, 291, 330, 352, 359, 369, 376, 388, 414, 420, 422, 444, 466, 473
Hawk and Dove, 134, 401
Hawkman, 57, 179, 209, 219–220, *219*, 248, 272, 321, 405
headlights, 220
Hearst Syndicate, 64
Herald Publishing, 429
Hercules, 105, 223, 224
Heroes World Distribution, 69, 126, 130, 301
High School of Art and Design, 270
Hillman, 7, 195, 236, 252, 270, 324, 326, 369, 393, 414, 425, 466, 486
Hobgoblin, 14
Holyoke, 209
Homage Comics, 235
horror comics, 14, 217, 229–230, 321

Index
Subjects

Hourman, 6, 248
Howard the Duck, 19, 231, 280
Howland Owl, 358, *358*
Huckleberry Hound, 215
Hulk, 35, 46, 162, 231, 264, 461
Human Torch, 12, 63, 157, 162, 188, 231–232, *231*, 300, *301*, 302, *302*, 303, 304, 406, 424, *453*
Humor Publishing, 125
Huntress, 419
Hydroman, 157

I
Ibis, 233, 470
Iger studio, 28, 29, 38, 164, 195, 233–234, 246, 351, 361, 373, 429
Iger-Eisner studio. *See* Eisner-Iger studio
Ignatz Mouse, 224, 265, *265*
Image, 212, 234–235, 240, 276, 301, 302, 324, 419, 453
Independent News Co. (IND), 31, 32, 120
Inferior Five, 59, 401
infinity covers, 235
Inhumans, 162, 406
injury-to-the-eye motif, 239–240, 309
inking, 239
Inkpot Awards, 392, 444
International Association of Direct Distributors (IADD), 63, 129
Invisible Girl, 232
Iron Jaw, 304
Iron Man, 35, 240–241, *241*, 263, 405, 444
Iron Wolf, 409
IRS collection, 241–242

J
Jacquet studio, 218
Jetsons, 216
jigsaw puzzles, 243, *243*
Jimmy Olsen, 3, 243
Joe Kubert School of Cartoon and Graphic Art. *See* Kubert School
Joe Palooka, 217, 243–244, *244*
John Carter, 1
Johnny Bravo, *441*
Johnny Quick, 310, 324, 373
Johnny Thunder, 49, 209
Johnstone and Cushing, 4, 61, 138, 180, 244–245
Joker, 125, 172, 245, *245*, 372, 373, *373*
Jonah Hex, 245
J'onn J'onzz (Martian Manhunter), 57, 246, 248, 404
Jonny Quest, 216, 304
Judy of the Jungle, *247*
Jughead, 20, *322*, 351
Justice League of America, 57, 179, 246–248, 393, 405
Justice Society of America, 12, 49, 138, 179, 209, 248, *248*, 405

K
Kamandi, *261*
Katy Keene, 254–255, *255*, 474
Kayo Ward, 351
Ka-Zar, 256, 302, 304, *333*
Kelly Green, *137*
Kid Colt, 444
Kid Eternity, 224
Kid Flash, 174, 258, 434
Kid from Dodge City, 444
Kigmies, 284–285
King Features, 42, 43, 64, 79, 107, 159, 255, 259, 335, 336, 366, 411
King Kull, 479
Kingpin, 14, 115
Kitchen Sink Press, 69, 141, 186, 192, 264, 295, 302, 389, 398, 481
Kraven, 14
Kooba Cola, 181, 265, *265*
Krazy Kat, 224, 265, *265*
Krupp Comic Works, 264
Krypto, *462*, 463
Kryptonite, 463
Kubert School, 48, 51, 119, 151, 272, 389, 450

L
Lady Luck, 330
Lance O'Casey, 470
Lancer Books, 184
Last Gasp, 482
lawsuits, 8–9, 11, 163, 175, 181, 194, 213, 278–282, 437
Legend imprint, 320
Legion of Super-Heroes, 3, 47, 282, 405, 428
Legion of Super-Pets, 282
Les Humanoides Associes, 140, 220
Lena the Hyena, 475, *475*
Lev Gleason, 7, 47, 48, 110, 111, 195, 200–201, 209, 212, *324*, 393, 429, 444, 466, 475
Lex Luthor, 3, 282–283, *282*
Library of Congress, 280, 354, 355
Li'l Abner, 69, 283–285, *283*, 448
Lion Books, 31
Little Annie Fanny, 285–286, *285*
Little Audrey, 422
Little King, 411
Little Lulu, *178*, 286, *286*, 418, *418*
Little Nemo, 286, 306, *306*
Little Orphan Annie, 208, *208*, 286–288
Liz Allen, 14
Lobo, 333
logos, 287
Lois Lane, 3, 204, 288, *288*, 310, 463
Lone Ranger, *178*
Lucasfilm, 419

M
Madam Fatal, 294
Madam Satan, 351
Magazine Enterprises, 36, 185, 194, 212, 330, 359, 414, 428, 429, 438
Mage, 453, *453*
Magneto, 294
Magnus, Robot Fighter, 294–295, *295*
Mainline Publications, 408
Malibu Comics, 235, 411, 418, 419
Man-Thing, 296
Mandrake the Magician, 159, 259
Manhunter, 6, 370, 404, 415
Martha Washington, 32
Martian Manhunter (J'onn J'onzz), 57, 125, 246, 248, 404, 405
Marvel Animation, 237
Marvel chipping, 299
Marvel Comics, 10, 12–32, 36, 51, 65–66, 69, 89, 93, 95, 97, 108, 115, 118, 120–121, 126, 127–128, 129, 134, 154–155, 194, 195, 202, 212, 213, 222, 223, 229, 235, 242, 249, 261, 276–278, 280, 299–302, 319, 326, 327–328, 329, 334, 336–338, 370, 376, 388, 396, 400, 401, 408, 409, 414, 415–417, 419, 420, 431, 435–436, 444, 473, 474, 481
see also Atlas Comics; Timely
Marvel Index, 333
Marvelman, 303
Mary Jane Watson, 14, 379
Matter Eater Lad, 282
Maximum Press, 235
McClure Syndicate, 189, 278
McKay Company. *See* David McKay Publications
McNaught Syndicate, 173, 243
Memory Lane, 223
Menthor, 438
Merry Marvel Marching Society, 299, 300
Metal Men, 312, 312, 401
Metamorpho, 57, 182, 312
Meteor Martin, 475
Metropolitan Museum of Art, 365
MGM, 35, 216
Mickey Mouse, 9, 168, 204, 205, 312–313
Midnight, 90, 313, *313*
Mighty Crusaders, 312
Mighty Mouse, 313, 421–422, *421*
Mile High collection, 9, 127, 258, 275, 313–318, 348, 352, 354
Millennium, 134
Millie the Model, 320 *320*
Miracleman, 303

Miss America, 12
Miss Fury, 320
Miss Lace, 295, *295*
Mister Miracle, 262
MLJ, 20, 47, 85, 90, 188, 252, 259, 265, 322, 331, 350, 369, 388, 439
Molecule Man, 162
Monster Society of Evil, 325
Morbius, 14
Mouse Liberation Front, 8
Mr. A, 1, 4, *134*
Mr. Am, 286
Mr. Fantastic, 162, 358
Mr. Mind, 325, *325*
Mr. Monster, 325
Mr. Natural, *112*, 113, 325
Ms. Marvel, 35
Multi-Con, 99
Museum of Cartoon Art, 313
Mutt and Jeff, 173, 326
Mysteric, 14

N
Nadir, 397
Nancy, *112*
National Cartoonists Society, 173, 204, 311, 373, 426
National Periodicals, 2–3, 37, 123, 125, 135, 139, 181, 189, 278–280, 282, 347, 373, 386, 429
See also DC Comics
National Screen Service, 387
Nedor, 17
New Gods, 260, 262
New Media/Irjax, 69, 125, 127, 249
New Trend, 142, 236, 429
New Universe, 327–328
New York ComiCon, 96, 126
New York School of Industrial Arts, 339, 388
New York School of Visual Arts, 227, 271
New York Science Fiction Convention, 183
Newsboy Legion, 408, 415
newspaper strips, 94, 327
newsstand distribution, 127–128
Nexus, 12, 328, *381*
Nick Carter, 330
NoMan, 438
Northstar, 12

O
Officissa Pupp, 265, *265*
Oil Can Harry, 313
Old Witch, 239
Olive Oyl, *178*, 358
Omega Men, 333, 419
Orbit, 6, 209, 466
original art, 335–339
Orion, 262
Oswald the Rabbit, 312

P
Pacific Comic Exchange, 3, 206
Pacific Comics, 19, 50, 118, 129, 185, 193, 212, 325, 345, 374, 418, 421
Paradox Press, 114, 419
Paramount Pictures, 78, 422
Parents Magazine, 414
Patriot, 304
Peacemaker, 82
Pearl Pureheart, 313
pedigree collections, 11, 93–94, 124, 144–145, 241, 258, 275, 313–318, 348–349, 378, 384–385, 468
Peevy, 470
Penguin, 125, 172
Penthouse Comix, 325
Percival Popp the Super Cop, 37
Peter Parker, 310
Phantom, The, 82, 159, 352, *352*
Phantom Lady, *181*
Phantom Reporter, 303
Phantom Stranger, 352
Phantom Zone, 463
Phoenix Art Institute, 322
Pictofiction magazines, 355, *355*
Pied Piper Bookstore, 355–356

Pines, 1, 209, 444
Plastic Man, 90, *90*, 357–358, *357*, *363*, 410, 426
Pogo, 257, *257*, 358, *358*
Popeye, 82, *178*, 180, 259, *259*, 358–359, *359*, 393
Prankster, 3
Pratt Institute, 137, 310, 456, 485
presidents, U.S., 360
Press Guardian, 351
Prez, 408, 450
Prince Valiant, 176, 177, *177*, 360–361
Print Mint, 264, 447, 482, 483
Prize Comics, 376, 466, 483
Pro/Con, 80, 235, 407
pseudonyms, 361
pulp magazines, 14, 61–62, 134, 196, 197, 238, 341, 348, 386–387
Punisher, 14, 97, 195, 362, *362*
Punjab, 286
Puppet-Master, 162

Q
Quality Comics, 26, 50, 85, 89, 90, 104, 105, 147, 171, 180, 187, 197, 209, 214, 224, 233, 252, 330, 336, 358, 359, 363, 376, 413, 443, 445, 456, 466, 486
Question, The, 82, 134
Quick Draw McGraw, 216

R
Randall Publications, 429
Raven, 434
Rawhide Kid, 444
Ray, 105, 171
Red Bee, 102, 224
Red Circle, 20
Red Dragon, 330
Red Ghost, 162
Red Ryder, 367, *367*
Red Skull, 72, 225, 368
Red Sonja, 368, *368*
Register & Tribune Syndicate, 413
Revolutionary Comics, 288
Rex, the Wonder Dog, 368
Riddler, 125, 371, 415
Ringo Kid, 444
Rip Hunter, 401
Rip Off, 159, 482
Robin, 125, 172, 372, 434
Rocketeer, 345, 374, *374*, 413, 421
Rockman, Underground Secret Agent, 475
romance comics, 1, 375–378, 407, 415, 483
Rufferto, 19
Rulah, 382, *382*

S
Sad Sack, 369
San Diego Comic-Con, 96, 97, 128, 155, 161, 195, 203, 255, 263, 319, 323, 355, 383–384, 388, 392, 398, 413, 416, 442, 444, 449, 469, 470
San Francisco collection, 275, 384–385
Sandman (DC), 6, 6, 85, 175, 175, 179, 189, 248, 384, 415, 450
Sandman (Marvel), 14
Sandy, 286
Scorpion, 14
Scribbly, 304, 310
Scrooge McDuck, 40, *41*, 179, 379, 445
Sea Devils, 401
sea monkeys, 7
Seaboard. *See* Atlas/Seaboard
Secret Agent X-9, 392
Secret Six, 59
self-publishing, 16, 49, 80, 148, 186, 256, 305, 407, 478
Senorita Rio, 351, 373
Sentinels of Liberty, 72, 482
Seven Sons, 258, 357, 394–395
Sgt. Rock, 272, *272*, 396–397, 405, 455
Shade, the Changing Man, 134, 450
Shadow, 336, 397, *397*
Shadowline Studio, 235
Shang Chi, Master of Kung Fu, 413
Sheena, 246, *246*, 359, 373, 394–399, *398*

Index
Subjects/Titles

Shield, The, 20, 313, 331, 350–351, *351*, 370, 408, 453
S.H.I.E.L.D., 406
Shining Knight, 6
Shmoos, 284, *284*, 285
Silver Age, 174, 300, 301, 343, 349, 391, 392, 401, 404–405
Silver Surfer, *65*, 160, 162, 192, 264, 405–406, *405*, 436
Sin City, 320, *320*
Skippy, *46*
Skrulls, 260
Skull, 439
Skybox, 302
Skywald, 255, 409–410
Sotheby's auction, 3
Southwest Con, 96
Southwestern Con, 395
Space Ranger, 401
Spark Plug, 42
Sparkman, 448
Spartan Printing, 345
Spectre, 6, 37, 120, 248, 324, *324*, 370, 401, 411–412, *412*
Speedy, 209, 324, 434
Spider-Man, *13*, 97, 132–133, *132*, 263, 405, 406, 474
Spirit, *148*, 313, 413, *413*
splash pages, 413–415
Spy Smasher, 428, 470
St. John Publishing, 38, 78, 89, 90, 198, 259, 352, 376, 421–422, 486
Standard Publications, 123, 124, 183, 233, 259, 324, 326, 330, 376, 386, 388, 414, 417–418, 438, 440, 463, 473
Star Publishing, 90, 91, 414
Star-Spangled Kid, 3
Starfire, 434
Starman, 6, 57, 63, 310, 418
Starslayer, 418
Starro, 248
Steel Sterling, 47, 331, 332, 370
Sterling, 326, 393
Streak, the Wonder Dog, 209
Street & Smith, 134, 330, 359, 386, 414
Studio, 423–424, 479, 480
Stuporman, 303
Sub-Mariner, 12, 63, 157, 162, 188, 300, 302, 303, 304, 405, 424, 453, *453*, 474
Sugar and Spike, *305*
suicide, 425–426
Suicide Squad, 57
Sun Boy, 6
Super Grodd, 204
Superboy, 6, *119*, 282, 324, 428
Supergirl, 3, 6, 405, 428–429, 462
Superior Comics, 326, 374, 429
Superman, 2–3, *2*, 11, 13, 56, *56*, 100, 125, *146*, 179, 200, 248, 278–279, *279*, 282, 360, 390, 403–404, *403*, 427, 429, *429*, 430, 431, *431*, 453, *463*
Supreme, 324
Swamp Thing, *121*, 430, *430*, 450, 461
swipes, 245–246, 432

T
Tarzan, 1, *1*, 176–177, *176*, 227, *227*, 272, 296, *298*, 433–434, *433*, *434*, 448
team-ups, 64, 390
Teen Titans, 57, 174, 434
Teenage Mutant Ninja Turtles, 109, 141, 275, 434
Tekno•Comics, 413
Terry and the Pirates, 217, 434–435, *435*
Tex Thompson, 435
Thing, 162, 231
Thor, 35, 260, 370, 405, 436
3D comics, 272, 304, 313, 421–422, 486
Thun'da, 176, *183*, 185
T.H.U.N.D.E.R. Agents, 438
Tiger Girl, *100*, *167*, *247*
Time Warner, 403–404

Timely, 32, 85, 123, 157, 181, 195, 214, 226, 252, 273, 277, 300, 303, 320, 324, 326, 330, 351, 370, 371, 383, 388, 393, 408, 424, 453, 466, 482, 483
Tintin, 438–439, *439*
Titano, 47, *203*, 204
Toby Press, 388, 429, 473
Tonga, 204
Topps, 29, 37, 385, 386, 412, 436, 446
Tor, 272
Torchy, 440, 456, *456*
Toro, 12, 482
Tower Comics, 438
Trans-World, 229
Triplicate Girl, 3, 6, 282
Trojan comics, 304
Tubby, 286, *418*
Tundra, 49, 141, 186, 264, *325*, 434, 480
Turok, 179, 443
Two-Face, 125
Two-Gun Kid, 444

U
underground comics, 8–9, 20–26, 112–113, 119, 159, 186, 211, 212, 264, 273, 274, 325, 357, 371–372, 412, 445–448, 470, 471, 482–483, 484
Uncle Sam, 105, *106*, 171, *363*, 445, *445*
Uncle Scrooge. *See* Scrooge McDuck
United Features, 104, 123, 200, 327, 448
Universal Studios, 312
University of Texas, 446
Unknown Boy, 6

V
Valiant Comics, 295, 401, 411, 443, 481
Vampirella, 372, 449, *449*
Venom, 14
Veronica Lodge, 20, 351, 450
Vertigo, 121, 189, 450
Victor Fox. *See* Fox Features
Vigilante, 310, *310*, 373, 462
Viking Prince, 57, *57*, 272
Viz, 69
Vortex, 60
Vulture, 14, 310

W
Walt Disney. *See* Disney Productions
Walter Lantz Studio, 35, 124
war comics, 453–455
Warlock, 162, 418
Warner Brothers., 35, 124, 155, 450
Warren Publications, 51, 105, 133, 202, 328, 340, 395, 408, 441, 455, 456, 459–460, 474
Wasp, 35
Watcher, 162, 260
Watchmen, 82, *196*, 199
Wendingo, 231
Western Printing and Lithography, 41, 93, 108, 123–124, 128, 129, 188, 198, 296, 304, 379, 393, 418, 440
western comics, 466–467
White Mountain collection, 468–469
Whitman Company, 45–46, 140, *469*
Whitman studio, 218
Whizzbang Gallery, 223
Whizzer, the, 12
Wimpy, 358, *359*
Wise, 388
Witch Hazel, 286
Wolverine, 72, 231, 411, 461, 474
Wonder Girl, 434
Wonder Man, 181, 279–280, *279*
Wonder Woman, 53, *119*, 248, 297, 298, 310, 475
WonderCon, 390
Woody Woodpecker, *178*
Woozy Winks, 357
Word Books, 124
work for hire, 107–108, 235, 345, 418
World Science Fiction Convention, 249, 269, 292, 328, 397, 417

X
X, 481
X-Men, *66*, 260, 300, 409, 461, 474, 481

Y
Yango, 204
Yarko the Great, 481
Yellow Kid, 138, 281, 340–341, *341*, 481
Yellowjacket, 17, 35
Yogi Bear, 179, 216
Young Allies, 408, 482, *482*
Your Guide Publications, 200

Z
Zatara, 212
Zero Hour, 258
Ziff-Davis, 14, 16, 62, 89, 123, 259, 270, 275, 386, 414, 425, 466, 484
Zippy the Pinhead, *97*, 212, 484–485, *485*

Title Index

A
A-1 Comics, 194
Abbott and Costello, 352
Abie the Agent, 224
Ace Comics, 352
Ace King, 125
Ace of Spades, 359
Aces High, 156, 157
Action Comics, 2–3, *2*, 64, 189, 201, 204, 212, 243, 279, 282–283, 288, 303, 321, 360, 402, 426, 427, 428, 432, 435, 453
Action Comics (ashcan), 27, 28
Action Funnies (ashcan), 27, 28
Adam Ames, 171
Addams Family, The, 6
Adventure, 468
Adventure Comics, 6, 18, 28, 63, 85, *119*, 175, 181, 189, 204, 206, 282, 283, 384, *384*, 412, 418, 428, *462*, 468
Adventures into the Unknown, 14, *14*, 229
Adventures of Bob Hope, The, 6, 139
Adventures of Jesus, 446, *446*
Adventures of Nubbin the Shoeshine Boy, 244
Adventures of Rex the Wonder Dog, The, 236, 368
Adventures of the Big Boy, 200
Aggie Mack, 374, 429
Air Ace, 77
Air & Space, 74
Air Fighters Comics, 7, *7*, 77
Air Force Andy, 425, *425*
Air Pirates Funnies, 8–9, *9*
Airboy Comics, 7, 236, 486
Akira, 10
Alarming Adventures, 202
Albums of Early Life (Kauffman), 256
Alien Worlds, 421
Aliens, 11, 116, 480
Aliens vs. Predator: Deadliest of the Species, 55
All-American Comics, 33, *46*, *172*, 209, *209*, 216, *216*, 218, 321, *329*, 330
All-American Men of War, 396, 454
All-American Western, 454
All-Flash, 11, 118, 174
All in Color for a Dime (Thompson & Lupoff), 12, 77–78, 436
All Select, 51, 52, 232, 368, *453*
All Star Comics, 12, 33, 37, 118, 138, 174, 209, 248, *248*, 370
All Star Comics (ashcan), 28
All Star Comics Archives, 12, 248
All Star Western, 12, 245
All-Story Magazine, 433
All Teen Comics, 266, *266*, 273
All Top, 382, *382*
All Winners Comics, 12, 52, 232, 266, *266*, 300, 482
Alma and Oliver, 309
Alpha Flight, 12, 276
Alter Ego, 12–13, *12*, 37, 48, 134, 163, 209, 374, 436
Amazing Adult Fantasy, 13, 99
Amazing Adventure Funnies, 80

Amazing Adventures, 13, 32
Amazing Fantasy, 13, 35, 133, 299, 469
Amazing Heroes, 37, 58, 174, 194, 365, 372, 418, 436, 460
Amazing-Man Comics, 13, 80, 204, 475
Amazing Mystery Funnies, 13, 80, 475
Amazing Spider-Man, 13–14, *13*, 35, *35*, 93, 97, 123, 132, *132*, 133, 195, 231, *287*, 299, 308, 310, 362, 378, 379, 404–405
Amazing Stories, 14, 46, 47, 62, 332, 348, 386, 484
Amazing Willie Mays, 414
American, The, 449, 450
American Flagg, 16, 82, *82*
American Splendor, 16, 349
American Weekly, 171
America's Best, 170, 418
America's Great Comic Strip Artists (Marschall), 68, 223, 341
America's Greatest Comics, 163
Animal Comics, 257, 358
Animal Man, 53
Annie Oakley, 298
APA-5, 17, *17*
Aquaman, 76, 198, 210
Archie, 99, 322, *322*
Archie Annual, 20
Archie: His First 50 Years (Phillips), 322
Arcade, 212, 412
Argosy Comic Book Price Guide, 342
Army of Darkness, 55
Art of Al Williamson, The (Strauss), 240, 268
Art of Jack Kirby, The, 260
Art of the Comic Book, The (Harvey), 446
Artsy Fartsy Funnies, 484
Asterix, 140
Astonishing Tales, 351
Astro City, 130
Atlantic Monthly, 69, 70, 173, 243
Atom, The, *33*, 180
Atomic War, 34
Austin Iconoclastic Newsletter, The, 446
Authentic Police Cases, 110
Avengers, The, 5, 35, 74, 155, 235
Axa, 36

B
Bacchus, 407
Ballad of the Salty Sea, 359
Baltimore Post, 425
Baltimore Sun, 479
Barney Google and Spark Plug, 42, 123
"Baron Firstinbed," 176
Barry the Boob, 393
Barry Windsor-Smith: Storyteller, 411
Bat Masterson, 330
Batman (comic book), 5, 10, 32, *44*, 78, 79, 195, *203*, 204, *236*, 245, *245*, 305, *336*, 346, 364, 371, 373
Batman (movie), 80, 426
Batman (newspaper strip), 347, *347*
Batman (TV show), 10, 189, 371
Batman: Manbat
Batman: The Dark Knight Returns, 44, 121, 319, *319*, 372, 460
Batman: The Killing Joke, 53
Batman and Me (Kane), 251–252, 372
Batman Forever, 371
Batman Returns, 78
Battle, 32
Battle Brady, 364
Ben Casey (newspaper strip), 5
Beetle Bailey, 369
Best Comics, 417
Beware, 432
Beyond Mars, 151
Big Ben Bolt, 195, 473
Big Chief Wahoo, 474
Big Guy and Rusty the Boy Robot, The, 320
Big Numbers, 404
Bijou Funnies, 264, 445, 447, *447*
Bizarre Sex, 264
Blab, 20, 141, 144
Black Cat, 99, 122, 151, 217, *331*, 359

Index
Titles

Black Diamond, 466
Black Dragon, 55
Black Hood, 259
Black Kiss, 82
Black Magic, 132, 408, 415
Black Terror, 99, 310, 373, 418
Blackhawk, 50, *50*, 82, 105, 198, 442, 474
Blackstone, 52
Blaze Carson, 467
Blazing Combat, 455, 459, *459*
Blonde Phantom, 52
Blondie, 51, 138, 224, 327, 366
Blowtop, The (Schwartz), 390
Blue Beetle, *46*, 52, *52*, 82, 171, 181, 251
Blue Bolt, 413
Blue Lotus, The, 438
Blue Ribbon Comics, 52, *75*
Blue Ribbon Mystery Comics, 52
Bob and Betty and Santa's Wishing Well, 200
Bogeyman, 26
Bonanza, 140
Bonomo Ritual, The, 56
Book of Ballads and Sagas, The, *451*, 452
Books of Magic, *250*, 452
Boots and her Buddies, 469
Boris Karloff, 198
Boris the Bear, 116
Boy Comics, *15*, *47*, 47, 122, 201
Boy Commandos, 217, *407*, 453
Boy's Life, 62, 90, 171, 188, 332
Boy's Ranch, 408, 415
Brave and the Bold, The, 57, *57*, 79, *120*, 204, 219, 220, 246, 248, 312, 393, 434
Breed, 418
Brenda Starr (comic book), 220, *221*, 251, 429
Brenda Starr (newspaper strip), 57–58, *58*, 182, 210, 254, 311
Brick Bradford, 58, *58*, 67, 367
Bridgeman's Life Drawing, 58
Bringing Up Father, 309, *309*
"Brothers of the Spear," 60, *60*, 296
Bruce Gentry, 429
Brute, The, 333
Buck Rogers (newspaper strip), 16, 176, 275, 332, 367, 433, 444
Buffalo Bill, 470
Buffalo Bill, Jr., 62
Bulletman, 63
Burroughs Bulletin, The, 296
Buyer's Guide to Comics Fandom, 374, 436
Buster Brown, 65, 281, *281*
Butch Cassidy, 409
Buz Sawyer, 80, 106, 107

C

Cadillacs and Dinosaurs, 389, 481
Calgary Eye-Opener, 41
Call from Christ, 200
Calling All Girls, 99
Camelot 3000, 53, 55
Campus Loves, 99
Canuck Comics, 429
CAPA-Alpha, 163
Captain America, 32, *71*, 72–73, *72*, 171, 225, *225*, 229, 232, 235, *261*, 360, 368, 413, 420
Captain America: The Classic Years, 349
Captain Billy's Whiz-Bang, 163
Captain Britain, 323
Captain Easy, 106, 107, 434
Captain Flash, 73
Captain Flight Comics, *91*, 259
Captain Future, 417
Captain Marvel (Marvel Comics), 32, 98
Captain Marvel Adventures (Fawcett), *15*, 46, 47, *75*, 76, 163, 224, 256, 325, 413
Captain Marvel Jr., 103, *365*
Captain Midnight, 15, 74, 256
Captain Science, 76, *76*, 221, 477
Captain Sternn, 480
Captain Victory, 345
Captain Video, 99
Carnival of Comics, 159

Casper (movie), 78
Casper the Friendly Ghost (comic book), 78, 217
Catman Comics, 91
Cavalier, 52
Centaurs, The, 306
Century of Comics, 200
Cerebus, 80, *80*, 93, 109, 123, *407*, 434
Challengers of the Unknown, 81, 123
Chamber of Chills, 217, *217*, 229
Champ Comics, 217, *369*
Charlie Chaplin, 393
Chasing Harry: A Novel of Sexual Terror (Fleisher), 281
Cheval Noir, 421
Chicago American, 327
Chicago Inter-Ocean, 438
Chicago Mirror, 445
Chicago Sun-Times, 68
Chicago Tribune, 192, 259, 311
Children, Culture and Controversy (West), 464–465
Cincinnati Enquirer, 305
Cinderella Love, 378
Circus Comics, 475
City of Fire, 117
Classic Comics, 87, 233, 234, 254
Classics Illustrated, 67, *67*, 87–88, *88*, 105, 157, 233, 239, 254, 259, 289, 343, 353, 386, 457, 483
Classics Illustrated: An Illustrated History (Jones), 87
Clifford, 163
Clue Comics, 122, *122*
Collected Works of R. Crumb, The, 161
Collector's Guide: The First Heroic Age (Bails), 37, 342
Collier's, 485
Comic Art, 163, 436
Comic Book Artists, The (Simon), 403
Comic Book Book, The (Thompson & Lupoff), 436
Comic Book Confidential, 325
Comic Book Heroes, The (Jacobs & Jones), 262
Comic Book Killer, The (Lupoff), 192, 292
Comic Book Makers, The (Simon), 310, 408
Comic Book Marketplace, 194, 216, 343, 414, 420, 444
Comic Cavalcade, 174, 209
Comic Reader, The, 132
Comic Source, 205
Comic Times, The, 350
Comico Primer, 92, 211, 453
Comicollector, The, 37, 163, 374
Comics, The, 197, 268, 401
Comics: An Illustrated History of Comic Strip Art, The (Robinson), 352, 373
Comics Buyer's Guide, 140, 155, 242, 262, 316, 317, 361n, 374, 434, 436, 460
Comics Feature, 296
Comics Interview, 215, 235
Comics Journal, The, 5, 6, 8, 18, 42, 50, 60, 65, 71, 80, 81, 88, 93, 95, 106, 109, 114, 142, 147, 161, 169, 172, 175, 186, 191, 192, 198, 211, 213, 220, 223, 230, 232, 239, 253, 254, 257, 259, 260, 261, 262, 274, 280, 281, 291, 301, 303, 308, 319, 323, 330, 333, 340, 362, 403, 407, 408, 412, 413, 415, 416, 417, 419, 432, 440, 453, 466, 467, 471, 478, 480, 482, 484
Comics Magazine, The, 80
Comics on Parade, 434
Comix (Daniels), 239
Complete Color Terry and the Pirates, The, 45
Complete Crumb Comics, The, 113
Complete EC Library, The, 89, 275
Conan the Barbarian, 55, 65, 95, 368, 410–411, 419
Concrete, 80, 81
Concrete: Fragile Creature, 81
Concrete: Killer Smile, 81
Confessions Illustrated, 355
Contact Comics, 91
Contract with God, A, 149

Counter Media, 52
Courting Danger (Marble), 297
Cow Puncher, 220, 251
Coyote, 98
Crack Comics, 170, 171, 294
Cracked, 37, 395, 456
Crawford's Encyclopedia of Comic Books, 214, 387
Crazy, 391
Creeper, 198
Creepy, 109, 160, 202, 207, 328, 403, 458, *458*, 459
Crime and Punishment, 110, 201, 364
Crime Does Not Pay, 47, *47*, 109–110, 111, 111, 200, 287, 304, 370, 444, *444*, 466, 476
Crime Illustrated, 355
Crime Machine, 410
Crime SuspenStories, 103, 104, 142, 143, 156, 474
Crimson Tide, 351
Crisis on Infinite Earths, 174, 258, 351, 428, 474
Crossfire, 155
Crumb, 112
Crypt of Terror, 229
Cycle Toons, 422
Cynthia, 332

D

Dale Evans, 296
Dan Dunn, 125, 385
Daredevil Aces, 156
Daredevil Comics (Lev Gleason), 47, 89, 115, 115, 122, 201, 226, *226*, 265
Daredevil (Marvel), 89, 151, *151*, 157, 300, 301, 305, 319, 378, 379, 409
Daredevil: The Man Without Fear, 151, 379
Daring Comics, 122, 232
Daring Mystery Comics, 115
Dark Horse Presents, 52, 80, 95, 116, 116, 320
Dark Mysteries, 364
Dazzler, 118
DC Comics Presents, 434
DC Special, 271
DC Superstars, 434
Deadman, 5
Death: The High Cost of Living, 189
Death Rattle, 264, 481
Deli Geni, 216, 360
Den, 22
Dennis the Menace, 257
Dennis the Menace and the Bible Kids, 124
Destination Moon, 223
Destroyer Duck, 19, 124, *124*, 145, 222, 280
Detective Comics, 11, 44, 56, *101*, 113, 118, 124, 125, 154, 172, 175, 179, 180, 246, 282, 303, 346, 347, 371, 372, 373, 404, 415, 426, 427
Detective Dan, Secret Operative No. 48, 125
Detective Picture Stories, 125, *125*, 135
Detroit Mirror, 126
Diary Loves, 99
Dick Tracy, 126, 205, 324, 327, 392, 469
Dickie Dare, 67, 324
Dingbat Family, The, 224, 265
Dinosaurs, The (Stout), 422, *422*
Distant Soil, A, 236
Dixie Dugan, 173
DNAgents, 220, *221*, 421
Doc Savage (pulp), 134
Doctor Strange, 32, 134, 282, 400, *432*
Doll Man, 171, 440, 456
Don Martin Steps Out, 298
Don Martin's Droll Book, 299
Donald Duck, 41, *101*, 135, *135*
Dore, 69, 218–219, *218*
Doom Patrol, 136
Double Life of Private Strong, The, 313
"Dr. Jekyll and Mr. Hyde" (Classics Illustrated), 88
Dracula, 436
Drago, 227
Drawing Book, The, 138

Drawing the Human Head (Hogarth), 227
Drawn and Quarterly, 305
Dream Corridor, 152
Dreamer, The, 147, 170, *442*
Dreams of the Rarebit Fiend, 307
Dugout Jinx (Bee), 378
Dumbo Weekly, 200
Dynamic Anatomy (Hogarth), 227
Dynamic Comics, 85, 122, 192
Dynamic Figure Drawing (Hogarth), 227

E

E.C. Fan Bulletin, The, 163
Earth Man on Venus, 36
East Village Other, 112, 212, 371, 412, 446, 484
Eat Right to Work and Win, 200
Eerie (Avon), 36, 229
Eerie (Warren), 145–146, 160, 402, 408, 459, *459*
Eerie Tales, 146
Eightball, 88, 161
Elektra: Assassin, 151, 404, 464
Elektra Lives Again, 151
Elfquest, 93, 161
Ellery Queen, 374, 429
Empire of the Sun, 474
Enemy Ace: War Idyll, 154
EREdom, 422
Erection Set, The (Spillane), 373
Erich Fromm's Comics and Stories, 26
Ernie Pook's Comeek, 461
Esquire, 3, 131, 182, 201, 285
Eternals, The, 155
Exciting Comics, 77, 115, 220, 247, 354, 387, *387*, 417
Experimenter, The, 386
Explorers on the Moon, 223

F

Fairy Tale Parade, 257, 390
Family Man, 419
Famous Funnies, 100, 123, 159–160, 189, 198, 327, 378, 402, 440, 458
Famous Monsters of Filmland, 160, 383, 458, 459
Fanfare, 164, 185
Fantastic Comics, 171, *180*, 331, 354
Fantastic Fanzine, 163
Fantastic Four, 32, 50, 66, 95, 123, 161–162, *162*, 192, 232, 235, 242, 262, 287, 378, 405, 406, 416, 424
Fantastic Four Annual, 415
Fantasy Illustrated, 163, 207–208
Fat & Slat, 191
Fatman, The Human Flying Saucer, 45
Fawcett Miniatures, 200
Fax from Sarajevo, 272, 455
FCA/SOB, 45
Fear, 280
Fearless Vampire Killers, The, 185
Feature Book, 126
Feature Comics, 26, *26*, 134
Feature Funnies, 26
Feds 'n' Heads, 446
Feline Follies, 166
Fight Against Crime, 122
Fight Comics, 100, 136, 136, 166, 171, 247, 356, 485, 486
Fighting American, 169
Fightin' Marines, 99
Fighting Yank, 77, 170, *170*, 310, 373, 418, 453
First Kingdom, The, 255–256, *256*
Flamingo, 37, 374
Flash Comics, 11, 32, 33, 4, 173–174, 190, 204, 219–220, 219, 253, 287, 336, 436, 437
Flash Gordon (newspaper strip), 42, 43, *43*, 67, 174, 184, 188, 220, 269, 365, 366–367, *367*, 392, 472
Flip, 330–331
Fly, The, 313
Forbidden Love, 99
Forbidden Worlds, 14

Index
Titles

Forever People, The, 123, 262
Four Color, 177–179, *178,* 216, 286, 381, 436, 443, 445
4-Most, 413
Fox and Crow, 118
Frankenstein, 59, 374, 480
French Connection, The, 148
Frisky Animals, 91
Fritzi Ritz, 220
Frogmen, 1
Frolic, 421
From Aargh! to Zap! (Kurtzman), 150, 223
From Beyond the Unknown, 360
From Hell, 49, 186, *186,* 324
Frontier Romances, 99
Frontline Combat, 20–26, *102,* 141, 273, 293, 454
Funnies, The, 327
Funnies on Parade, 159
Funny Pages, 80, *214*
Future Comics, 352, 454

G
G.I. Combat, 197, 396, 397
G.I. Joe, 99
"G.I. Joe," 57
Gallopin' Gaucho, 312
Gang Bang, 478
Gansters at War, 192, *192*
Gasoline Alley, 192, 259, 324
Gasp, 14
Gauntlet, The, 185
Gertie the Bashful Dinosaur, 306
Ghost Rider, 184, 194, 242
Ghostly Haunts, 133
Giant-Size Man-Thing, 195
Giant-Size X-Men, 461
Giggle Comics, 14
Girls Love Stories, 17
Give Me Liberty, 116, 200, *200,* 320
Gizmo and Eightball, 368
Glamour International, 55, 201
God Nose, 446
Godzilla Color Special, 4
Going Steady with Peggy, 191
Golden Age of Comic Fandom, The (Schelly), 83, 474
Golden Age Super Hero Index (Nolan), 201
Golden Arrow, 270
Gone With the Wind (Mitchell), 77
Gory Stories Quarterly, 398
Gothic Blimp Works, 52
Grateful Dead Comics, 192
Graphic Showcase, 249
Graphic Story Magazine, 1, 163, 180, 207–208, *207,* 216, 330, 349, 402, 437
Great American Comic Strip, The (Sullivan), 259
Great Comic Book Heroes, The (Feiffer), 163–164, *164,* 465
Green Arrow, 242
Green Hornet, 217
Green Lantern, 190, 195, *287,* 333, 419, 440
Grendel, 92, 453
Groo the Wanderer, 19, 123, 155, 212, 345
Gumps, The, 218
Gun Master, 325
Gunsmoke, 198
Gunsmoke Western, 31

H
Ha Ha Comics, 14
Hagar the Horrible, 60, 61
Hangman, The, 187
Happy Houlihans, 190, 191
Hard Boiled, 116, 117, 320
Harvey Comics Hits, 78, 352
Harvey Hits, 352
Harveyville Fun Times!, The, 78
Hate, 37, 161
Haunt of Fear, 118, *141,* 143, 237, 238
Haunt of Fears, A (Barker), 219, 466
Haunted Thrills, 230, *410*
Have Gun Will Travel, 198
Hawk and Dove, 198
Hawkman, 180, 242, 259
Hawkworld, 220
Headline Comics, 364
Heap, The, 409
Heart of Juliet Jones, The, 138
Heavy Metal, 140, 220–222, 413, 480
Hell-Rider, 410
Hellblazer, 450, *450*
Help!, 112, 222–223, *222,* 273, 274, 446, 459, 470
Hercules Unbound, 476
Heroic Comics, 30, 471
Hey Look!, 273, *273*
Hi and Lois, 60, 61
Hick Chick, The, 36
History of Comics (Steranko), 29, 50, 105, 279, 420, 462
History of the Comics (Snyder), 12, 134, 153, 305, 311
History of the DC Universe, 182
History of Underground Comics, A (Estren), 158
Hit Comics, 101, 102, 171, *171,* 223, 224–225, 354, 363
Hogan's Alley, 281, 340, 481
Home Grown Funnies, 264
Homer the Happy Ghost, 31
Honeymoon Romance, 99
Hooded Menace, The, 36, 228, *228*
Hoohah!, 163, 202
Hopalong Cassidy, 163
Horrific, 222, *229*
Hound & the Hare, 118
House of Frankenstein, 479
House of Mystery, 230, *230,* 246, 253
House of Secrets, 296, 430
How to Draw Comics the Marvel Way (Lee), 58
Howard the Duck, 231
Human Torch, The, 77, 188, *231,* 413
Humbug, 222, 232, *232,* 274
Hungry Henrietta, 306

I
I Yam What I Yam, 359
"Idyll," 245
Imagine, 69
Impact, 270
Incredible Hulk, The, 12, 32, 231, 242, 296, 299, 308, 461, 474
Incredible Science-Fiction, 236, *463*
Incredible She-Hulk, The, 66
Infinity, Inc., 308
Infinity Gauntlet, 418
Inside Comics, 112
Interview with the Vampire (Rice), 449
Intimate Secrets of Romance, 377
"Invasion from the Abyss," 240
Invincible Iron Man, The, 32, 202, 235, 241
Invisible Scarlet O'Neil, 469
It, the Living Colossus, 242
It Ain't Me, Babe, 372

J
Jack Armstrong, the All-American Boy, 470
Jaguar, The, 313
Jerry Spring, 199
Jersey Journal, 348
Jesus the Magician (Smith), 60
Jet Scott, 373
Jetsons, 216
Jimmy Olsen, 204, 237, 243, 262
Jingle Jangle, 77–78, 77
Jo-Jo, 55, 382
Joe Palooks (comic book), 244
Joe Palooka (newspaper strip), 69, 70, 173, 195, 243, 426
John Byrne's Next Men, 66
John F. Kennedy, 360
John Law, 244
John Wayne Adventure Comics, 184, 473
Johnny Comet, 184
Johnny Dynamite, 324
Johnny Quick, 347
Johnny Thunder, 440
Jon Juan, 246, *246*
Jon Sable, Freelance, 210
Jonah Hex, 245
Jonny Quest, 421, 470
Journey into Mystery, 436
Joyce of the Secret Squadron, 74
Judge Dredd, 53
Judge Parker, 385
Julius Knipl, 461
Jumbo, 38, 136, 166, 171, 233, 246, *246,* 361, 398, *398,* 485, 486
Jungle Action, 31, 50
Jungle Comics, 79, *79,* 109, 136, 166, *167, 168,* 169, 171, *287,* 356, *428,* 470, 485, 486
Jungle Jim, 198, 366
Jungle Princess, The, 399
Junior, 164
Jurassic Park, 436
Justice, 479, *479*
Justice League of America, 37, 155, 162, 180, 185, 248, *391*
Justice Traps the Guilty, 109, *109*

K
Ka-Zar, 333
Kaänga, 79
Kamandi, 261
Katy Keene, 99, 255
Katzenjammer Kids, The, 130, 256
Keen Detective Funnies, 80
Kerry Drake, 385
Kid Colt Outlaw, 32
Kid Montana, 324
King Comics, 58, 259, *259,* 327, 352, 411
King Kong, 183, 185, 325
King of the Congo, 185
King-Size Canary, 35
Komix Illustrated, 163
Kozure Yokami, 288
Krazy Kat, 223, 224, 265, *265*

L
La Nuit, 140
La Vie Parisienne, 201
Lady Luck, 442
Lady Vampire, 449
Land of Black Gold, 223, *439*
Land of the Lost, 191
Land of the Soviets, 438
Lars of Mars, 275, 275, 484
Lash La Rue, 163, 324–325
Lassie, 188
Laugh, 254
Laugh-In, 327
Law Breakers Suspense Stories, 364
Le Mystere des Abimes, 140
Le Petit XXe, 223
Le XXe Siecle, 223
Leatherneck, 368
Leave It to Binky, 304
L'echo des savanes, 220
Les Six Voyages de Lone Sloane, 140
Leading Comics (ashcan), 28
Legion of Super-Heroes, The, 210
Les Travaux d'Hercule, 136
Liberty Scouts, 290
Lieutenant Blueberry, 52, 81
Life, 160, 283, *283,* 296, 402, 475
Life and Times of Scrooge McDuck, 379, 381
Life in Hell, 461
Li'l Abner, 69, 70, 71, 151, 176, 184, *194,* 195, 243, 283–285, *283, 284,* 291, 327, 475
Li'l Abner and the Creatures from Drop-Outer Space, 200
Little Annie Fanny, 150, 274, 285–286, *285,* 422
Little Dot, 217
Little Iodine, 48
Little Lulu, 178, 286, *286,* 418, *418,* 469
Little Nemo in Slumberland, 161, 286, 306, *306*
Little Orphan Annie, 51, 161, *208,* 286–288
Little Sammy Sneeze, 306
Lloyd LLewellyn, 88
Lois and Clark, 288
Lois Lane, 288, *288,* 463
Lolita (Nabokov), 378

London Times, 358
Lone Ranger, The, 178, 327
Lone Wolf and Cub, 288, *288*
Long Sam, 291
Look Back, A, 479, 480
Looney Tunes, 257
Lord of the Rings, 328, 452
Los Angeles Times, 378
Lost in Space, 140
Love and Death (Legman), 288–289
Love and Rockets, 161, 223, 289, *289*
Love Problems, 92
Love Romances, 32
Luana, 185
Lucky Fights It Through, 291–292, *292*

M
Mad, 10, 19, 118, 139–140, 141, 143, 144, 150, *150,* 158, 165, 190, 191, 232, 272–273, 274, 293–294, *293, 294,* 298–299, *299,* 340, 445, 475, 476, *478*
Mad Reader, The, 10
Mad World of William M. Gaines, The (Jacobs), 189, 294, 345
Madame Xanadu, 118
Magnus, Robot Fighter, 295, *295,* 296, 443
Major Ozone's Fresh Air Crusade, 223
Male Call, 68, 295, *295,* 454
Man Comics, 479
Manbat, 55
Manphibian, 242
Many Ghosts of Dr. Graves, The, 133
March of Comics, 200, 296
Marines in Battle, 32
Mars Attacks, 385, 386
MARS Patrol, 440
Martha Washington, 197
Marvel: Five Fabulous Decades of the World's Greatest Comics (Daniels), 133, 188, 481
Marvel Comics, 188, 226, *226,* 231, 256, 302–303, *302,* 348, 424
Marvel Comics Presents, 411
Marvel Family, 46
Marvel Mystery Comics, 52, 77, 111, 138, *228,* 229, 231, 232, 256, 302, 303–304, *303,* 386, 453
Marvel Spotlight, 194
Marvel Super-Heroes, 74
Marvelman, 323
Marvels, 130, *301*
Mary Worth, 385
Mask (Four Star), *91*
Mask, The (Dark Horse), 450
Mask of Dr. Fu-Manchu, 36
Master Comics, 62–63, 111
Master of Kung Fu, 154
Maus, 365, 412
Max und Moritz, 130
Mechanix Illustrated, 348
Media Showcase, 183
Meet Corliss Archer, 164
Melvin Monster, 418
Men's Adventures, 72
Metal Hurlant, 140, 199, 220
Metal Men, 312, *312*
Metamorpho, 182
Mickey Mouse, 204
Mickey Mouse Magazine, 282, 327
Mickey Mouse Meets the Air Pirates, 9
Mighty Crusaders, The, 313
Mighty Marvel Western, 32
Mighty Mouse, 304, 313, *422,* 486
Mike Danger, 413
Military Comics, 50, 114, 363, *363,* 453
Millie the Model, 30, 32, 123, 202, *320,* 436
Milton Caniff's America (Jenson), 454
Minutemen, The, 320–321
Miracleman, 126, 145, 189, 303
Miscast Barbarian, The (de Camp), 230, 426
Miss America, 32
Miss Fury, 254
Mission to Microworld, 328
Mister Miracle, 155, 262, *262*
Mister Mystery, 122, 239, *240*

Index
Titles

Modern Comics, 50, 440
Modern Love, 6
Modesty Blaise (newspaper strip), 36
Molly O'Day, 36
Mom's Homemade Comics, 264, 445
Moon, A Girl . . . Romance, A, 6, 462
Moon Girl, 229, 321, *321*
Moon Knight, 329, 404
Moon Mullins, 327
More Fun Comics, 6, 18, 80, 138, 175, 208, 287, 324, *324*, 327, 411, 412, *412*, 428, 468
Motion Picture Funnies Weekly, 302, 424
Movie Comics, 291
Mr. America, 435
Mr. Monster, 145, 325
Mr. Punch, 189
Mr. X, 426
Ms. Tree, 145
Ms. Mystic, 345
Murder Incorporated, 99
Mutt and Jeff, 173, 326, 327, 393
My Date, 483
My Desire, 326
My Girl Pearl, 32
My Greatest Adventure, 54, 136
My Life, 326
My Love Life, 267, *267*
My Own Romance, 32, *32*, 364
My Past, 378
My Private Life, 326
My Secret, 429
"My World," 477
Mysterious Traveler Comics, 229
Mystery in Space, 6, *16*, 17, 195, *195*, 386, 391
Mystery Men Comics, 52, 171, 280
Mystery Tales, 387
Mystic Comics, 51, *51*, 226, 232, 326

N
Nam, The, 455
Namora, 52
Nancy, 65, 327, 418, 448
National Comics, 106, 171, 363, *363*, 445, *445*
National Geographic, 41
National Lampoon, 8, 9, 174, 245, 331
Naughty Bits, 161
Navy Combat, 32
Neat Stuff, 37
Nemo, 2, 61, 244
New Adventure Comics, 6, 80, 327
New Comics (Groth and Fiore), 6, 125, 304, 468
New Fun Comics, 125, 324, 327, 468
New Funnies, 166
New Gods, 262
New Mutants, 404, 408
New Republic, The, 77, 256
New Teen Titans, The, 351, 474
New York American, 224
New York Daily News, 67, 68, 151, 219, 286, 427
New York Herald, 286, 306
New York Journal, 61, 256, 281
New York Star, 257
New York Times, The, 38, 43, 256, 332, 371, 390
New York World, 256, 281, 309, 340, 438, 481
New York World-Telegram, 468
New York World's Fair Comics, 64, *64*, 93, 384, 427
New Yorker, The, 273, 294, 411, 412, 454, 464
Newlyweds, The, 309
Newsweek, 358
Nexus, 328, *328*, 381, 382
Nick Fury, Agent of S.H.I.E.L.D., 32, 195, 419, 420
Nickel Comics, 62
Nickel Library, The, 20
Night of Mystery, 36
Nightmare, 410
Nostalgia Journal, The, 161
Not Brand Ecch!, 396
Nuts, 99
Nyoka, 270

O
O. G. Whiz, 418
Omega Men, 333
On Stage, 202
One Lonely Night (Spillane), 318
Origin of Marvel Comics (Lee), 416
Original Comic Art Price Guide, 338
Our Army at War, 153–154, 272, 396, 397, 454, *455*
Our Cancer Year, 349, *349*
Our Fighting Forces, 454
Our Gang, 257
Our Love Story, 340
Out of This World, 341
Outlaw Kid, 470
Outlaws, 467
Overstreet Comic Book Grading Guide, The, 206
Overstreet Comic Book Price Guide, 11, 55, 56, 80, 88, 94, 125, 127, 128, 146, 166, 194, 206, 217, 230, 254, 302, 303, 314, 318, 336, 342–344, 344, 348, 352, 353, 354, 356, 376, 381
Overstreet Update, 34

P
Pacific Presents, 374
Panels, 94, 147, 181
Panic, 345–346, *346*
Parade of Pleasure: A Study of Popular Iconography in the USA (Wagner), 346
Patsy and Hedy, 32
Patsy Walker, 30, 32
Paul Auster's City of Glass, 305
Peanuts, 448
People's Comics, The, 349
Pep Comics, 20, 90, 246, 254, 322, 350–351, *351*, 450
Personal Loves, 376
Peter Penny and His Magic Dollar, 200
Peter Scratch, 171
Phantom, The, 352, *352*
Phantom Detective, 390
Phantom Lady, 38, 55, *181*, 201, 220, 221
Phantom Stranger, The, 352
Phantom Witch Doctor, 259
Philadelphia North American, 197
Photo-Journal Guide to Comic Books, The (Gerber), 94, 275, 283, 343, 344, 352–353, 353, 474
Photo-Journal Guide to Marvel Comics, The (Gerber), 354
Picture Parade, 34
Picture Stories from Science, 99
Picture Stories from the Bible, 190, 346
Pilote, 140
Piracy, 105
Pittsburgh Sun-Telegraph, 64
Plain Truth, The, 475
Plainclothes Tracy, 205
Plane Crazy, 312
Planet Comics, 16, *102*, 136, 156, 166, 167, 171, 238, 352, 355, 356, 485, 486
Plastic Man, 90, 363, 410
Playboy, 90, 113, 118, 150, 176, 274, 285, 426, 442
Plot Genie: Western Story Formula, The (Hill), 179
Pocket Comics, 217
Pogo, 257, *257*, 358, *358*
Poison Ivy, 180
Poison Red, 449
Police Comics, 90, 357, *357*, 363, *363*
Popeye, 178, 327
Popsicle Pete Fun Book, 200
Popular Comics, 123, 327
Popular Photography, 484
Popular Science, 172, 252
Porky's Duck Hunt, 35
Power Pack, 408
Predator, 116, 449–450

Pre-Teen Dirty-Gene Kung-Fu Kangaroos, 49
Prevue, 42
Primer, 92, 211, 453
"Private Eyeger," 57
Prince Valiant, 56, 124, 161, 177, *177*, 179, *179*, 195, 335, 360–361
Pride of the Yankees, 414
Prisoner of Gravity, 148, 336
Prisoner of the Sun, 223
Prize Comics, 59
Prize Comics Western, 395
Prof. Otis and His Auto, 223
Professor Coffin, 82
Progress, 339
P.S. Magazine, 148–149, 486
Psycho, 410
Punch, 91, 192, *410*
Punctuate It Right!, 39n
Punisher, The, 42
Punisher Anniversary Magazine, The, 362
Punisher War Journal, 276

Q
Question, The, 82

R
Radio Craft, 387
Radio News, 386
Radioactive Adolescent Blackbelt Hamsters, 49
Ranger Comics, 136, 156, 166, 197, 207, 221, 321, 291, 485, 486
RAW, 365–366, *366*, 412
Real Clue Crime Stories, 99
Real Fact Comics, 386
Real Heroes, 360
Real Life, 418
Real Love, 483
Real Screen Cartoons (ashcan), 27
Real Screen Funnies (ashcan), 27
Real Screen Gems (ashcan), 27
Rectangle, 192
Red Rider Comics, 367, *367*
Red Seal, 192
Red Sonja, 368
Redbook, 202
Reed Kincaid, 290
Regular Fellers, 78
Regular Fellers Heroic Comics, 157
Rex Morgan, 385
Rexton Wonder Dog, 236, 368
Richie Rich, 217, 371
Richie Rich Cash, 371
Richie Rich Money World, 371
Richie Rich Vaults of Mystery, 371
Rime of the Ancient Mariner (Coleridge), The, 157
Rio, 470
Rick Kirby, 56, 367, 473
Robert Malone, 291, 327
Robocop vs. Terminator, 409
Rocket to the Moon, 36
Rocketeer, The, 145, 220, 345, 374, *374*, 421, 421, 470
Rocket's Blast–Comicollector, 133, 342, 374, 419
Ruby Lane, 163
Romantic Love, 376
Romeo, 121, 288, 319
Roy Rogers, 64, *178*, 296, 298, 467
Rubber Blanket, 305
Rudolph the Rednosed Reindeer, 200
Rulah, Jungle Goddess, 382
Rune, 411

S
Sabre, 145
Sad Sack, 37, 217, 369
Saddle Romances, 191, 267, *267*
Saga of the Swamp Thing, 436
Saint, The, 470
Saks 34th Street Store Robin Hood Giveaway Comic, 200
Sally Forth, 478
San Francisco Chronicle, 326
San Francisco Examiner, 64, 211
San Jose Mercury, 258

Sandman (Simon & Kirby), 384
Sandman (Gaiman), 121, *121*, 135, 304, 452
Sandman Mystery Theatre, 453
Saturday Evening Post, 57, 286, 402
Savage Tales, 256, 296
Scamp, 324
Science Comics, 171, 181
Science Fiction, 402
Science-Fiction Plus, 387
Science Fiction Quarterly, 338
Science Wonder Stories, 348
Scoop, 84, 192
Scorchy Smith, 68, 85, *86*, 401, 402, 444
Scout, 220
Scream, 410
Screw, 212
Scribbly, 304, 305
Search for Love, 378
Secret Agent Corrigan, 157, 392
Secret Agent X-9, 291, 366, 367, 392, *392*, 473
Secret Diary of Eerie Adventures, 36
Secret Wars, 400, 401
Seduction of the Innocent (Wertham), 56, 87, 110, 192, 230, 239, 288, 345, 392–393, 464–465
Sensation, 310, 321, 475
Sergeant Preston of the Yukon, 140, 198
Sergio Massacres Marvel, 362
Seven Lively Arts, The (Seldes), 265
Seven Seas, 100
Sgt. Fury and His Howling Commandos, 360, 455
Sgt. Kirk, 98
Sgt. Rock, 220, 455
Shade, the Changing Man, 134
Shadow, The (comic book), 250, *250*, 397, *397*, 409, 410
Shadow, The (newspaper strip), 197
Shadow, The (pulp magazine), 134, 197
Shadow, The (paperback), 420
Shadow Comics, 197
Shadows from Beyond, 133
Shattered Image, 234
Shazam!, 45, 279
She (Haggard), 399
Shield, The, 331
Shock Illustrated, 355, *355*
Shock SuspenStories, 103, 142, 143, 228, 392, 399, *399*, 465, 466
Shocking Mystery Cases, 114
Showcase, 6, 17, 32, 33–34, 37, 43, 57, 81, 154, 174, *174*, 209, 236, *236*, 312, 352, 401, *401*, 404, 412
Sick, Sick, Sick, 163
Signal to Noise, 189
Silver Metal Lover, The, 372
Silver Streak Comics, 89, 90, 109, 111, 200
Silver Surfer, The, 32, 65, 66, 130, 161, 406, 418
Simpsons, The, 461
Sin City, 109, 320, *320*
Skull, 26
Skybirds, 155–156, 157
Slow Death, 26
Smash Comics, 171, 312, 313, 363
Smiley Burnette, 163
Smokey Stover, 158, 158
Smokey the Bear, 327
Snarf, 264
Snuffy Smith, 369
Son of Celluloid, 145
Son of Origins of Marvel Comics (Lee), 240
Sons and Lovers (Lawrence), 378
Southeast Missourian, 333, 334
Southhampton Press, 219
Spa Fon, 411
Space Adventures, 52
Space Busters, 484
Space Cadets, 327
Space Family Robinson, 150, 467
Space Ghost, 441
"Spacehawks," 475
Sparkler, 434, 448, 449

Index
Titles

Spawn, 235, 307, 308, *308*
Spectre, The, 5
Speed Comics, 217
Spicy Detective Stories, 201
Spider-Man, 240, 309
Spider-Man (newspaper strip), 409
Spirit, The, 51, 90, 147, 148, *148*, 151, 163, 171, 413, *413*, 442, 443, 459, *459*, 478
Sport Thrills, 414
Sports Illustrated, 173
Spy vs. Spy, 18, 294
Squa Tront, 105, 141, *162*, 163, 165, 278, 292, 411, 466
St. Louis Post-Dispatch, 412
St. Louis Republic, 309
Stamp Day for Superman, 200
Star Comics, 77
Star Ranger Funnies, 80
*Star*Reach*, 93, 185–186, *186*
Star Slammers, 409
Star-Spangled Comics, 454
Star-Spangled War Stories, 1119, 53, 154, *287*, 409, 454
Star-Studded Comics, 163
Star Trek, 198, 419
Star Wars, 116, 296, 419, 473
Stars and Stripes, 180, 431
Starslayer, 212, 345, 374, 418, 421
Starstruck, 250, 418
Startling Comics, 77, 100, 170, 238
Startling Stories, 386, 417, 418
Steel Sterling, 331
Steranko History of Comics, The, 29, 50, 105, 279, 420, 462
Steve Canyon, 68, 327, 420–421, 435, 470
Steve Roper, 385, 474
Steamboat Willie, 166, 312
Still Stripping at 80 (Messick), 312
Story of a Mosquito, The, 306
Story of Harry S Truman, 200
Story of Superman, The, 163
Strange Adventures, 4, 34, 123, 203, *203*, 361n, *364*, 386, 391
Strange Stories, *417*
Strange Suspense Stories, 133
Strange Tales, 32, 34, 98, 139, 420
Strange World of Your Dreams, 99
Strange Worlds, 36, *36*, 240, *259*, 477
Stray Toasters, 404
Stuck Rubber Baby, 114
Studio, The, *423*, 424
Sub-Mariner, 32, 52, 89, 232, 324, 327, 413
Subliminal Tattoos, 112
Sugar and Spike, 304, *305*
Sun Girl, 52
Sunday World, 281
Sunny, 164
Super Book of Comics, 200
Super-Duper Comics, 325
Super-Mystery Comics, 122
Superboy, 282
Superboy (ashcan), 28
Superman (comic book), 15, 32, 48, 66, *100*, *203*, 204, *287*, 288, 364, 428, *429*, 430, *463*
Superman (Columbia serial), 13
Superman (movie), 403, 429–430
Superman (newspaper strip), 278, 386
Superman (TV show), 463
Superman & the Great Cleveland Fire, 200
Superman at Fifty, 429
Superman at Gilbert Hall, 200
Superman Comics (ashcan), 27, *27*, 28
Superman Miniatures, 200
Superman's Christmas Adventure, 200
Superman's Pal, Jimmy Olsen, 204, 237, 243, 262
Suspense Comics, 103, 228, 479
Suzie, 254
Suzy Slumgoddess, 371
Swamp Thing, 49, *121*, 123, 189, 196, 323, 397, 409, 430, *430*, 452, 479
Swell-Looking Babe, A (Thompson), 378

T

Taboo, 49, 186
Tales from the Crypt, 141, 143, *251*, 466
Tales from the Great Book, 282
Tales from the One-Eyed Crow, 328
Tales of Suspense, 32, 51, *233*, 240, 241, 368
Tales of the Jungle Imps by Felix Fiddle, 305
Tales of the Mysterious Traveler, 133
Tales of the Supernatural, 321
Tales to Astonish, 17, 32, 231, 296
Tapping the Vein, 145
Target, 413
Tarzan (comic book), 60, 140, 296, 298, *433*, 434, *434*, 451–452
Tarzan (newspaper strip), 59, 79, 176, *176*, 177, 210, 227, *227*, 255, 268–269, 291, 296, 304, 327, 339, 421, 422, 433–434, 473
Tarzan: The Lost Adventure (Burroughs), 434
Tarzan and the Lost Empire (Burroughs), 1
Tarzan of the Apes (Burroughs), 433
Taylor Woe, 171
Tegra, 267
Teen-Age Romances, 377
Teen-Aged Dope Slaves, 291–292
Teen Titans, 198
Teenage Mutant Ninja Turtles, 49, 235, 434
Terminator, 116
Terrific, 222
Terror Illustrated, 105, 355
Terrors of the Jungle, 382
Terry and the Pirates, 45, 67, 68, *68*, 107, 157, 195, 220, 275, 402, 420, 434–435, *435*, 453, 477
TerryToons, 313
Tex Ritter, 163
They'll Do It Every Time, 369
Thimble Theatre, 358, *359*, 393
Thing, The, 122, 132
This Magazine Is Haunted, 132, 321
Thor, 301, 409
Three Dimension Adventures, 431
Three Dimension Comics Starring Mighty Mouse, *422*, 486
Three Stooges, 304
Thrill Comics, 28, 436–437, *437*
Thrilling Adventure, 417, 438
Thrilling Comics, 28, *225*, 417, *417*, *437*, 438, *438*
Thrilling Detective, 417, 438
Thrilling Love, 438
Thrilling Mystery, 417, 438
Thrilling Ranch Stories, 438
Thrilling Western, 438
Thrilling Wonder Stories, 417, 438
Thrills of Tomorrow, 217
Thun'da, 183, *183*, 184, 185, 438
T.H.U.N.D.E.R. Agents, 438
Thunderbolt, 82, 324, 325
Tiffany Jones, 36
Tillie the Toiler, 366
Tim Holt, 427
Time, 140
Time², 82
Time Traveller, The, 390
Timecop, 450
Timely Comic Index (Nolan), 333
Ting Ling Kids, 438
Tintin, 223, 438–439, *439*
Tiny Tot Comics, 191
Tip Top Comics, 200, 327, *327*, 434, 448
Tito and His Burrito, 118
Today's Woman Magazine, 348
Tom and Jerry, 140
Tom Mix, 163, 467
Tomahawk, 76, *120*, 466
Tomb of Dracula, 89, 123
Tomb of Terror, 122, 217, 229, *229*
Top Cat, 216
Top Notch Comics, 439
Tor, 304

Torchy, 180, 314, 440, *456*
Total War, 440
Tough Kid Squad, 482
Tower of Shadows, 420
Trader Horn, 399
Trapped, 200
Treasure Chest, 340, 442
Tribune News, 327
Trots and Bonnie, 175
True Comics, 99, *414*
True Crime, 239, 477
True Sport Picture Stories, 414
True to Life Romances, 91
Trump, 222, 232, 274, 442
Turok, Son of Stone, 62, 140, 188, 198, 327, 443
TV Guide, 118
Twilight Zone, 198, 319
Two-Fisted Tales, 51, 141, *143*, 273, 274, 293, 331, 395, *395*, 454, *454*
Two-Gun Kid, 32
Two Jolly Jackies, 223
2000 A.D., 53, 196, 323
2001: A Space Odyssey, 388
Tyrant, 49, *49*

U

Uncanny Tales, 387
Uncanny X-Men, The, 5, 12, 66, *66*, 86, 136, 256, 276, 294, 301, 434, 481
Uncle Remus, 324
Uncle Sam, 363
Uncle Scrooge, 338
Under Western Stars, 381
Underwater, 60
USA Comics, 475

V

V for Vendetta, 323
Valeria the She Bat, 449
Vamperotica, 449
Vampire Lestat, The (Rice), 449
Vampire Vixens, 449
Vampirella, 160, 328, 408, 449, *449*, 459
Vamps, 449
Vanguard Illustrated, 325, 421
Vault of Horror, 117, 141, 143, 191, 364, *432*, 466
Venus, 157
Vicky, 99
Vigilante, 347
Village Voice, The, 163, 461
Violent Cases, 189
Voodoo Child, 404

W

Wacky Squirrel's Halloween Special, 325
Walt Disney's Comics and Stories, 15, 131, 135, 205, 457, *467*, *467*
WAP, 179
War Against Crime, 238
War Comics, 99
"War of the Worlds" (*Classics Illustrated*), 67, *67*
Warlord, 210
Warrior, 303
Wartime Romances, 99
Wash Tubbs, 106, 107, 434
Watchmen, 121, 196–197, *196*, 200, 320, 323, 460–461, *460*
Web of Evil, 122, *122*
Weird Comics, 181, 370
Weird Fantasy, 142, *165*, 411, 461–462, *461*, *472*, 478
Weird Mysteries, 37, *229*
Weird Science, 143, 216, 267, *267*, 270, 461–462, 478
Weird Science-Fantasy, 101, 143, 236, 335, 462
Weird Tales, 61–62, *61*, 95, 201, 230, 231
Weird Tales of the Future, 101
Weird Terror, 222
Weird War Tales, 319
Weirdo, 37
Western Crime, 467
Western Fighters, 99

Western Roundup, 296
What's New, Pussycat?, 185
Where Monsters Dwell, 154
Where the Wild Things Are (Sendak), 393
Whiz Comics, 28, 62, 73, 98, 163, 233, 437, 469–470, *470*
Who's Who of American Comic Books, The (Bails), 28, 37, 111, 393, 424, 425, *457*, 458
Wilbur, 20, 99, 254
Wild, 470
Wild Hare, A, 35
WildC.A.T.S., 235
Willie Lumpkin, 123
Wimmen's Comix, 372
Wings Comics, 29, *29*, 136, 166, *167*, 221, *221*, *287*, 290, 291, *291*, 473–474, *473*, 485, 486
Witches Tales, 217, *217*, 229, 331
Witzend, 53, 162, 163, 474, *474*, 478
Wizard of Oz, The, 325
Wolff & Byrd, Counselors of the Macabre, 43
Women and the Comics (Robbins & yronwode), 320, 351
Wonder Comics, 171, 181, 279, *279*, 388, *388*
Wonder Stories, 386, 417
Wonder Woman, 53, *53*, *119*, 190, 297, 351, 419
Wonder Woman (ashcan), 27, 28
Wonderworld Comics, 171, 279, 481
Woody Woodpecker, 178
World of Fantasy, 32
World War III, 34
World's Finest, 346, 390
Worlds of Fear, 385
Wow, What a Magazine, 147
Wow Comics, 15
Writer's Digest, 56
Wun Cloo, 180
Wyatt Earp, 32, *32*, 296

X

X-Factor, 409
X-Men, 87
X-O Manowar, 481
Xenozoic Tales, 389, *389*, 481, *481*
Xero, 292
XYZ Comics, 264

Y

Yank, 37, 456
Yarrowstalks, 112, 325, 484
Yellow Dog, 372, 471
Yellow Kid, The, 281, 438
Young Allies, 77, *77*, 232, 368, 482, *482*
Young Brides, 483
Young Love, 242, 408, 483
Young Lust, 211, 212, 482–483
Young Men, 72
Young Romance, 19, *264*, 376, *376*, 378, 408, 415, 483, *483*
Youngblood, 235, 482
Yummy Fur, 60

Z

Zap Comix, 112, 159, 211, *211*, 371, 445, 446, *446*, 447, 484, *484*
Zegra, 267, *267*
Zippy, 97, 211, 212, *212*, 484–485
Zoo Funnies, 81
Zorro, 440, *440*
Zot!, 145, *145*